A HISTORY OF AFRICAN-AMERICAN ARTISTS

A HISTORY OF
AFRICAN-AMERICAN
ARTISTS

FROM 1792 TO THE PRESENT

Romare Bearden & Harry Henderson

Pantheon Books New York

Illustration credits are on pages 533–540.

Permissions acknowledgments are on page 541.

Library of Congress Cataloging-in-Publication Data

Bearden, Romare, 1911–1988.
A history of African-American artists: from 1792 to the present / Romare Bearden
and Harry Henderson.
p. cm.
Includes index.
ISBN 0-394-57016-2
1. Afro-American art. 2. Afro-American artists—Biography.
I. Henderson, Harry (Harry Brinton), 1914– . II. Title.
N6538.N5B38 1992
704′.0396073—dc20 89-42782

BOOK DESIGN BY FEARN CUTLER

Manufactured in the United States of America
First Edition

CONTENTS

SPECIAL ACKNOWLEDGMENTS

In the twenty-odd years this book has been in preparation we have been indebted to many librarians, researchers, artists, friends, and editors. We thanked them individually at the time and have tried to acknowledge in each chapter and its footnotes specific assistance, sources, and references.

However, there are some individuals to whom we returned again and again for assistance. They include Jean Blackwell Hutson, formerly head of what is now the Schomburg Center for Research in Black Culture; Deirdre Bibby, now of the Museum of African Art in Tampa, Florida; Adelyn Breeskin and Lynda Roscoe Hartigan, curators of African-American art at the National Museum of American Art; Professor Richard A. Long of Emory University, Atlanta; Elton C. Fax, artist-author of *Seventeen Black Artists*. Archie Motley of the Chicago Historical Society responded to many queries concerning his father's work and that of other early Chicago artists. Professor Mary Schmidt-Campbell and Kinshasha Conwill, director of the Studio Museum in Harlem, aided and encouraged us. Samuel Vaughan and James and Ruth Dugan were early and persistent advisers. Robert D. Kempner made himself our twenty-four-hour reference librarian.

We are particularly indebted to Patricia Gloster for some interviews and to Michelle Davis for transcribing the Anne Whitney correspondence. The late James A. Porter and Dorothy Porter Wesley provided guidance and answered many queries. So did David C. Driskell, now of the University of Maryland, who made the Fisk University's Van Vechten Gallery an exhibition center for African-American artists at a time when they were not being shown elsewhere. Clifton H. Johnson and Andrew Simon, archivists of the Amistad Research Center, Tulane University, and James Kennedy of the Ethnic American Art Slide Library at the University of South Alabama in Mobile were helpful in locating "missing" paintings. Margaret Di Salva of the Newark Museum was a important source on works of the 1930s. The staff of the Croton-on-Hudson (New York) Free Library obtained books long out of print.

June Kelly of the June Kelly Gallery in New York was a special resource. Corinne Jennings of Kenkeleba Gallery, New York, supplied us with much material on Edward M. Bannister and other artists. Dr. Tritobia Benjamin and curator Eileen Johnson of the Howard University Gallery of Art, and Tina Dunkley, curator of the Georgia State University Art Collection, aided in locating many paintings. The artist Ethel Stein led us to Consuelo Kanaga, a friend of Sargent Johnson and William Edmondson. Charles Blockson, Philadelphia "underground railroad historian"; Elwood C. Parry III of the University of Iowa; Reginald Gammon of the University of Western Michigan; and Anita Duquette of the Whitney Museum added to our information in many ways.

We had also had help from the Royal Collection in Stockholm and the National Gallery of Canada in Ottawa, as well as from Ekpo Eyo, formerly of the National Museum of Nigeria, and Professor Oyaemi, director of that museum in Lagos.

Our families constantly helped. Nanette Bearden and Beatrice Henderson typed and retyped early chapters as new research made changes necessary. Edward Morrow, Romare Bearden's cousin, was an informed source of information on the twenties and thirties in Harlem. Joseph Henderson helped photograph paintings at the Studio Museum in 1966. Elizabeth Henderson introduced us to Jay Leyda and his role in making Jacob Lawrence's work known to the art world. Theodore Henderson filed hundreds of photographs, notes, and clippings. Albert Henderson was our mainstay in all of this, especially being available to deal with computer glitzes at any hour. Karl Yung supplied his own computer when that became necessary.

Sam Vaughan suggested that we take our work to Erroll McDonald, then senior editor at Random House. McDonald appreciated it and had the courage

to publish it. He also assembled a spirited and dedicated team—editor Yoji Yamaguchi, art director Fearn Cutler, production manager Kathy Grasso, production editor Jeanne Morton, and copy editor Sue Heinemann. These people made this book possible, and I am deeply grateful to them.

Owen Laster and Daniel A. Strone of the William Morris Agency considered this book important and persisted over many years in seeking its publication. I am deeply grateful to them.

I only regret that Romare is not alive to see the final production.

H.H.

To
Nanette Rohan Bearden
and
Beatrice Conford Henderson

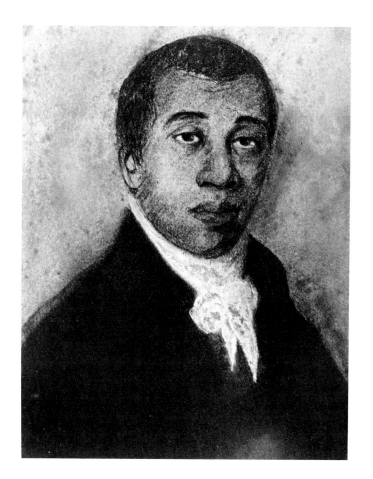

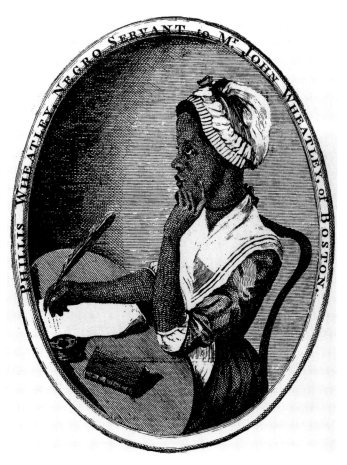

This pastel portrait, believed to be of the Reverend Richard Allen, a founder of the African Methodist Episcopal church, was long erroneously attributed to a Reverend G. W. Hobbs, a white Methodist minister in Baltimore (1842–1925). He was identified by Thomas C. Battle, of the Moorland-Spingarn Research Center, Howard University.

This engraved portrait of poet Phillis Wheatley appeared in a 1773 London edition of her work. The original has been attributed to Scipio Moorhead, a slave of the Reverend John Moorhead in Boston, whose master's wife taught him to draw. Wheatley, whose poems supporting the Revolution won General George Washington's praise, dedicated a poem "To S.M., a young African painter, on seeing his works," which celebrated Moorhead's artistic abilities. Moorland-Spingarn Research Center, Howard University

INTRODUCTION

In 1880 Thomas Eakins, one of America's greatest art teachers, admitted a frail young African-American named Henry Ossawa Tanner, on the basis of his drawings, to classes at the Pennsylvania Academy of Fine Arts. However, as Tanner's skill became apparent, snide remarks about him became frequent. Unbeknownst to Eakins, he was increasingly insulted and made the butt of sneers. He was referred to as "the nigger." His statement that he "painted too" was considered assertive, outrageous, and ridiculous.

One night Tanner and his easel were seized by his fellow students and dragged out onto Broad Street, where he was tied to his easel in a mock crucifixion and left, struggling to free himself. This incident was described by one of its participants, Joseph Pennell, the well-known etcher of city scenes, who saw nothing wrong in this action. Indeed, he referred to it as "The Advent of the Nigger." He asserted there had never been "a great Negro or a great Jew artist. . . . Rembrandt and Turner were accused of being Jews but they never admitted it."[1] Pennell wrote his account, a continuing attempt to demean Tanner, many years later—at a time when Tanner, already famous in the European art world, was finally achieving recognition in this country from such major institutions as the Philadelphia Museum of Art and the Metropolitan Museum of Art in New York.

This episode, so painful that Tanner could never speak of it lest he lose control of his rage, ended his attendance in Eakins's class. For ten more years Tanner persisted in his effort to become an artist, finally acquiring enough money to get to Paris. However, trying to get by on a starvation diet made him vulnerable to a nearly fatal illness. Sick and out of money, he was forced to return to his Philadelphia home to regain his health. This became the great turning point of his life.

Convalescing, he gradually realized that his picturesque Brittany scenes were the road to nowhere—no better than anybody else's. He also realized that if he drew upon his own experiences as an African-American and expressed the deep religious faith that had sustained him, he might create paintings very different from the superficial, archaeologically "authentic" illustrations of biblical stories characteristic of the religious painting of that day. Returning to Paris, he developed a style that reflected a mystical searching yet hopeful quality in which radiant light played an important symbolic role. His work soon won Paris Salon prizes, awards previously achieved by only a few Americans—John Singer Sargent and James McNeill Whistler, to name two. Tanner's acclaim in Paris was great. Yet a Baltimore newspaper, reporting his Salon award, published a photo of a black dockworker as one of Tanner.

Such virulent racism was not true everywhere in the United States. In contrast to Tanner's ordeal, Edward M. Bannister developed among constructive friendships. Born in Nova Scotia, where his chalk drawings on fences demonstrated his talent, Bannister first worked as a seaman on a coastal schooner and learned to love sailing. He then became a photographer's assistant and later a hairdresser in Boston, to support himself while he acquired skill as a portraitist. At the Lowell Institute, he attended the stimulating lectures and anatomical drawing demonstrations of Dr. William Rimmer, whose concepts and sculpture had a lasting impact on many American artists. Bannister and some fellow students were so eager to apply Rimmer's approach that they secured a room at the institute to study the nude model. These students, later well-known artists in Providence, Rhode Island, became his lifelong friends.

In Boston, Bannister became acquainted with the work of William Morris Hunt, who brought from France the nature-loving, outdoor style of the Barbizon school of painting. Hunt had been a close friend of Jean-François Millet, a Barbizon founder. Bannister was strongly attracted to this direct style of landscape

painting on seeing the wooded shores of Narragansett Bay while visiting his Providence artist friends.

In 1870 Bannister moved to Providence. There his landscapes were increasingly admired, and he had almost the opposite experience from that of Tanner in the United States. Tanner's attempt to return to the United States was made impossible by prejudice that barred him and his wife from many public places, such as restaurants and theaters. Bannister, in contrast, was fully accepted and indeed a beloved artist in the community, well known for his landscapes and bay scenes.

In Bannister's studio the Providence Art Club was founded. Its discussions later led to the establishment of the well-known Rhode Island School of Design. He was also a leading member of the "A.E. Club," a literary and philosophical group. One of Bannister's landscapes won the 1876 Centennial Exposition award for oil painting.

Yet not a word of these achievements by Tanner and Bannister appears in most American art histories. According to some art histories, the first African-American has yet to pick up a brush. And while it is widely recognized that our indigenous African-American music, jazz, received its first critical acclaim in Europe, what is not widely known is that important early African-American artists were also acclaimed outside the United States.

Robert S. Duncanson of Cincinnati spent several successful years in Canada, where he helped initiate the training of Canadian artists. Some of his most beautiful paintings now hang in the National Gallery of Canada in Ottawa. Duncanson's work was also a stunning success in London. We found his long-lost *Land of the Lotus-Eaters* in His Majesty's Royal Collection in Stockholm, Sweden. When Duncanson's situation in Cincinnati as the Civil War loomed is understood, the meaning of this imaginative work becomes clear, providing a new insight into its relationship to that struggle.

That Duncanson, Tanner, and Bannister are all omitted from Barbara Novak's *American Paintings of the Nineteenth Century*,[2] to cite a typical work, deprives us not only of our own American history, but also of what Arthur A. Schomburg called "the full story of human collaboration and interdependence."[3] Although recent art histories have improved slightly—*American Paradise: The World of the Hudson River School*,[4] for example, at least briefly describes Duncanson and reproduces one of his works—there are only two exceptions among earlier art histories. E. P. Richardson mentioned Tanner and Duncanson in his *Painting in America*,[5] and Oliver W. Larkin, in *Art and Life in the United States*, briefly mentioned Duncanson's *Blue Hole, Little Miami River*, but said nothing of his success in England.[6]

Such omissions are not limited to nineteenth-century artists. Milton W. Brown's *American Painting from the Armory Show to the Depression* ignores the flat, modern work of Aaron Douglas and other artists of the Harlem Renaissance.[7] Barbara Rose's *American Art Since 1900* mentions only Jacob Lawrence.[8] Although

The bronze Benin rooster on the right, now in the Metropolitan Museum of Art, New York, bears a certain resemblance to the rooster (left) carved in wood by a slave of Jean Lafitte about 1810, a drawing of which is in the Index of American Design, National Gallery of Art, Washington, D.C. Fine Ife-Benin bronze casting, developed in the 1400s, was only an eighth of a inch thick. (See R. S. Wassing, *African Art* [New York: Abrams, 1968], p. 165.)

the Works Progress Administration aided the development of hundreds of African-American artists, *The New Deal for Artists* by Richard D. McKinzie largely ignores that fact.[9] The only African-American artist mentioned is Dox Thrash, for his role in the development of the Carborundum print. McKinzie implies the existence of more African-American artists by mentioning African-American art centers and noting that the Harlem Artists Guild fought to reinstate artists dismissed in WPA layoffs. Thus there is a great blind spot in American art history, one that is color-sensitive, not color-blind.

Our attempt to create a history of African-American artists grew out of a request in 1965 from the Museum of Modern Art to Romare Bearden that he talk with a group of students about the history and development of black artists in America. He found that he could put together a few scanty notes on only a dozen artists before his own generation. His concern about this situation led to our discussions, our research, and to this book—a book of discovery, a challenging effort to uncover the history of African-American artists.

It is a history full of surprises. Like archaeologists, every time we uncovered one significant factual stone, we found another beneath it—individual breakthroughs in training, in concepts, in identity and subject matter, in color and style; the stimulation of friendships, teachers, and social and political conditions; as well as the complex obstacles that had to be overcome by resolute courage and persistence. As we came to see it, this book is a record of the triumph of the artistic drives of African-American artists over social conditions and despair, closely linked to and profoundly influenced by their concern for their people and their identification with them.

Believing individual histories to be most revealing, we focused on significant individual artists in each period and how they developed. We sought to examine their work and how it related to that of other American artists, to influential art movements in Europe, to prevailing American social and political conditions, and to the artists' lives and problems.

However, because historically African-Americans have been grossly deprived of education, employment, and civil rights, our task was complicated. We were often unable to establish even simple vital statistics

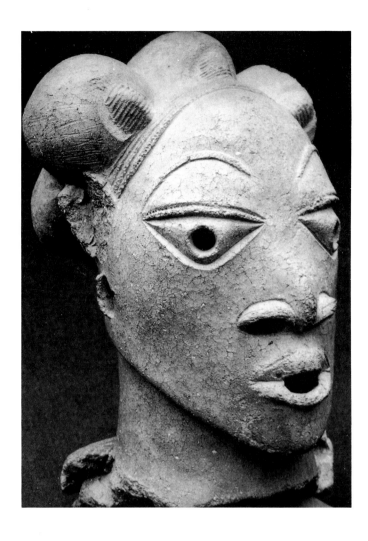

This head comes from the most ancient known culture of black Africa, called "Nok" after a village in a region of northern Nigeria where tin is mined. One of a group excavated there by Bernard Fagg, archaeologist brother of William Fagg, this head dates back to the Iron Age (400 through 100 B.C.). Even at that early date the African sculptor demonstrated a remarkable gift for balancing naturalism with stylization in the treatment of facial features, as Michael Kan has pointed out (see *African Sculpture* [Brooklyn, N.Y.: Brooklyn Museum, exhibition catalog, 1970], p. 15). (Clay, 14″ h.) National Commission for Museums and Monuments, Lagos, Nigeria

because they were unrecorded. Sources considered prime by art historians—such as letters, diaries, and dealers' records—were almost nonexistent. Even among relatively well-known artists living into the 1960s or later, simple dates were difficult to establish. Few books are helpful. Cedric Dover's *American Negro Art*, for example, is a chaotic collection of reproductions accompanied by a romantic, often false and misleading text; Tanner, for instance, is characterized as a "weak" man and his relationships with young African-American artists are inaccurately described.[10]

We had special problems in establishing titles, dates, dimensions, and current locations for paintings and sculptures. All artists are careless in these matters, often giving the same title to various works. But in the case of African-American artists, these data often were never recorded; the only visual record of the work was in the Harmon files in the National Archives. We bought five negatives of paintings by Edward Bannister shown in 1966 in Providence, but the program for the exhibition listed only "landscapes," no titles or sizes. Later Hale Woodruff gave us excellent photographs of some of his early works, but he no longer knew their dimensions or present locations, and our efforts to find them failed. As a result, dimensions and locations are absent in many cases. And, of course, over the years ownerships have changed. All the paintings we have included in this book were done in oil on canvas, unless otherwise indicated. Height precedes width in measurements.

Our understanding and our concepts changed as we worked. We first planned a simple book of reproductions with a few paragraphs about each artist and major influences on his or her work. The more we worked, the more inadequate such an approach appeared, particularly as we became aware of previously unrecognized factors.

The development of artists in Western countries has generally depended on the achievement of economic stability, wealth, and technical skills. Nowhere is this clearer than in the United States, where—apart from a few itinerant immigrants trained in Europe—the first artists were artisans, part-time "face-painters," who sought a likeness—often on a canvas bearing a prepainted figure in better clothes than the sitter could afford. Among these sign and banner painters, house painters, varnishers, tailors, mechanics, and other artisans skilled with their hands, there were black artisans.[11] What is known of them is largely limited to advertisements of their abilities. The obscurity of these

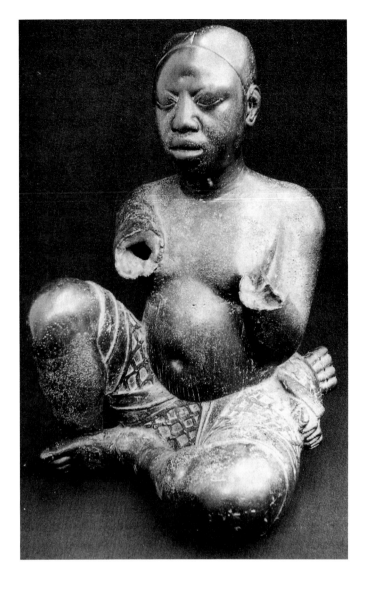

This seated bronze figure, a masterpiece of naturalistic African art from the Ife region of Nigeria, was found in the village of Tada. The Ife style dates back to A.D. 1000. This figure, which required great metallurgical knowledge and skill as well as artistic ability to create, can match the bronzes of Greece and Rome, both technically and in terms of style. It was shown at the Brooklyn Museum in 1970 in an exhibition organized by William Fagg of the British Museum, the leading Western authority on African art. (Bronze, 20½" h.) National Commission for Museums and Monuments, Lagos, Nigeria

early black face-painters makes it clear that the history of African-American artists is painfully intertwined with the history of slavery, its concept of the inferiority of black people, and racial prejudice.

Moreover, painting and sculpture are lonely pursuits, which require knowledge of the artistic traditions of a country, prolonged study, and disciplined practice in many technical skills with special materials. Poverty and the isolation of rural life prevented access to the implements of painting and sculpture, such as brushes, paper, canvas, and modeling tools. There really could not be many African-American artists until the great migration of their people to northern cities took place.

Another factor was the role of caricatures. While Charles Willson Peale and other artists of the Revolutionary period portrayed African-Americans as servants, they were always depicted with dignity and respect; Paul Revere's famous engraving of the Boston Massacre showed black Crispus Attucks among the first to die. However, such sympathetic portrayals largely disappeared as the struggle over slavery intensified and slave owners caused the image of the African-American to be vilified and treated with out-

rageous contempt in caricatures. While such caricatures existed earlier, they were not widely circulated until the period between 1840 and 1850, when they were used to counter the abolitionists' effective demonstrations of talent among African-Americans, such as Benjamin Banneker, the mathematician. These caricatures reached their flood tide after the Civil War, when— with slavery abolished and African-Americans voting in the South—they became a major instrument of achieving social and political control in both the South and the North, conveying their prejudicial message instantly to millions who would not have read a book or pamphlet or listened to a discussion.

Such caricatures, including the Currier & Ives *Darktown* series, became a problem for African-American artists in several ways. Indeed, one cannot even estimate the damage done to all African-Americans' self-esteem and feeling of identity as Americans by these caricatures. Booker T. Washington noted in 1909 that as a result of the juxtaposition of pictures of naked Africans with those of George Washington and other "cultivated" people, he unconsciously "took over the prevalent feeling that there must be something

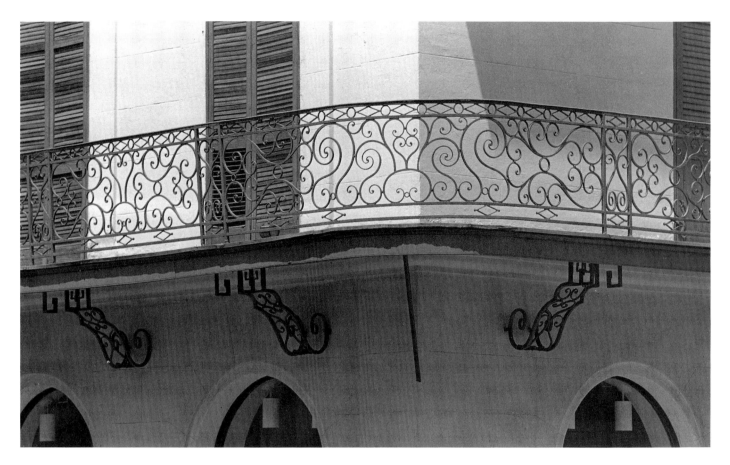

The graceful wrought-iron balconies of the French Quarter in New Orleans, such as this one on Royal Street, were created by slaves who modified French and Spanish designs. Slave craftsmen also created the decorative wrought-iron gates and fences of Charleston, South Carolina (see Vlach, *Afro-American Tradition,* pp. 110–20). Cleveland Museum of Art. Photo: Martin Linsey

wrong and degrading about any person who was so different."[12]

Such caricatures made African-Americans extremely sensitive about how they were depicted—and African-American artists were criticized if they depicted their people as not neatly dressed, as loafing, dancing, or gambling. Archibald J. Motley, Jr., defied this attitude in his portrayal of black city nightlife. However, the problem, although diminished, persists and has affected nearly every artist since the 1920s, when African-American artists began, in large numbers, to depict their own people as a result of their growing self-esteem.

We attempted to examine the work and lives of the artists whom we felt, however arbitrarily, to be significant. We wanted to know who their parents were, their education and where and how they were trained, influences of any kind, and their personal struggles and turning points. While we had great difficulties because theirs is a history embedded in slavery and institution-

alized prejudice, we were able to interview many of the leading artists of the 1920s, the 1930s, and the post–World War II period; nearly all have since died. Often we were the first to interview them. "This is the first time that anyone who wrote about me came and talked to me," said Eldzier Cortor, whose work first gained attention in *Life* in 1946.[13] Our interviews also included many excellent artists who, although not treated at length in this book, generously aided our efforts. Our approach yielded much new, original, and unusual information not only about individual African-American artists, but also about aspects of all American art and what influenced and shaped it.

We have limited this work to artists born before or in 1925. Artists born after that year were less than twenty-five years old in 1950 and faced very different artistic and social conditions than earlier artists. Although prejudice continued, artistic training, once extremely difficult to secure, was generally available and, in many cases, paid for by the GI Bill. Commercial galleries had begun to accept African-American artists, some of whom presently became active in all areas of art and began teaching in leading schools and universities. The development of the civil rights movement marked the beginning of a new phase in the history of African-American artists, one that lies beyond the scope of this book. Today African-American artists, although they still contend with prejudice, participate in every aesthetic development in the United States.

We hope that readers will find in this book not

The first portraitist to advertise himself as black did so in the *Massachusetts Gazette*, January 7, 1773. Such an advertisement contradicted the slaveholders' view that African-Americans were incapable of art, and warned off the prejudiced. This artist predated Joshua Johnston by about twenty-five years; his identity has never been established.

Good Allowance to those who buy to sell again

At Mr. *M'Lean's*, Watch-Maker near the Town-House, is a Negro Man whose extraordinary Genius has been assisted by one of the best Masters in *London* ; he takes Faces at the lowest Rates. Specimens of his Performances may be seen at said Place.

only the history of African-American artists, but the basis for a better understanding of all art. We also hope that our work will serve as a stimulating challenge to American art historians to reevaluate the participation and contributions to our culture of African-American artists. In our own view we have sketched little more than an outline and washed away some old varnish that has contributed to the denial of recognition of African-American artists and their participation in American art.

I cannot close these introductory remarks without noting that Romare Bearden was my friend for twenty years before we began this effort. Once we began the work, we met weekly for more than fifteen years to discuss our progress; thereafter, we met frequently but less regularly. Although we were both pursuing full-time careers, we found this work exciting and informative about many aspects of American art and life. Bearden had insights and interpretations, both as an artist and as an African-American, that deepened and enhanced our knowledge and understanding.

By the time of Bearden's tragic death on March 11, 1988, a few months after contracting for its publication, the book was basically complete. After his death I continued research, which then inevitably required the updating of our manuscript. Other researchers also reported new data on individual artists, such as Tanner, and this too has added to the history of African-American artists.

HARRY HENDERSON
Croton-on-the-Hudson, N.Y.
1993

A HISTORY OF AFRICAN-AMERICAN ARTISTS

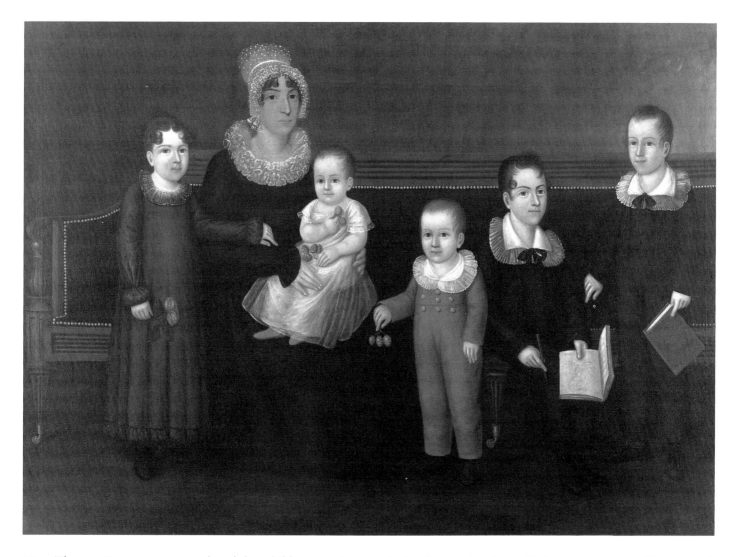

Mrs. Thomas Everette, portrayed with her children on a brass-tacked sofa, noted in her will that the artist was "J Johnson." This provided the first documentation of Joshua Johnston as the "brass-tacks" artist who Dr. J. Hall Pleasants believed might be an African-American. However, Mrs. Everette did not characterize her portraitist as being of African descent. Such documentation is still sought. (38⅞ x 55³⁄₁₆″) Maryland Historical Society Museum, Baltimore

THE LATE EIGHTEENTH AND NINETEENTH CENTURIES

THE QUESTION OF JOSHUA JOHNSTON

A history of African-American artists must deal with the question of whether Joshua Johnston, a portraitist in Baltimore in the late 1700s and early 1800s, was of African descent. If he was, he would be the earliest known African-American artist to produce a distinguished body of work.

Johnston's portraits reveal him to have been a master of composition, imaginative and skillful in his use of color, painting in what today is considered a flat, modern manner. Among portraitists of the period, he was unusual in that he often posed children standing, although he also did head and shoulder poses. His compositional devices—ranging from books, berries, and butterflies to small animals and, in one case, a sextant—were particularly interesting. His family portraits included individuals of varying ages, and at times he made brass-headed upholstery tacks a part of the composition. He is beyond a doubt an important early American portraitist. Although the advertisements of still-unknown black portraitists have established their existence in this period, documentation of Johnston's African heritage would demonstrate the achievement of a high level in the traditions of American art by an early African-American—something that has continued to be denied. That is to say, omitted from standard American art reference books.

Proof that Joshua Johnston painted the paintings attributed stylistically to him was established in 1976 by the discovery of his name in the will of Mrs. Thomas Everette, the widow of a Baltimore merchant. She left a portrait of herself and her children to her eldest daughter, designating that it was by "J Johnson."[1] This is the only such documentation, but it does not reveal Johnston's race.

Portraits of this period were generally not signed or dated, which is part of the problem. And there is the very curious and baffling fact that none of Johnston's white sitters, except Mrs. Everette, and none of his many white competitors ever mentioned him or his race. However, since he was listed as a "Free Householder of Colour" in the Baltimore directory of 1817, he could not have been unknown to that city's large free black population or to its many abolitionists.

The core problem is that Joshua Johnston's identity is embedded in slavery. He developed in Baltimore, a major slave-shipping center at the time, and his most prominent sitters were slave owners and their children. Denied education by the slave owners who feared it, slaves had no opportunity to write the letters and diaries that are the mainstays of art history. More important are the attitudes on which slavery was founded and which created the virulent institutionalized racism in America that denied that African-Americans had artistic talent. Art historians never dealt with the distorting impact of these attitudes on American art until recently.[2] It was not until the New Deal in the 1930s officially recognized the injustice of racial prejudice that the possibility of an early African-American portraitist in slaveholding Baltimore first saw print.

During the last fifty years it has been increasingly accepted that Joshua Johnston was indeed an African-American. We believe that to be the case, but belief is not proof. In 1987 an elaborate, well-funded effort headed by Carolyn Weekley of the Williamsburg Folk Art Center, and frankly biased in support of the theory that Johnston was of African descent, set out to confirm his identity as a free black.[3] Unfortunately, while uncovering a number of important details about Johnston's work and sitters, its bias led to serious and confusing omissions. It omitted, for example, Johnston's own signature, changed the spelling of his name to leave out the *t*, failed to compare his relationship with Baltimore abolitionists with that of other talented free black Baltimoreans in the same period, and ignored church records that did not fit its presumptive theory. As a result of these omissions, one can read the Weekley report without gaining a clear understanding of the contradictions in the problem of Johnston's racial identity. We can find no valid reason to ignore Joshua

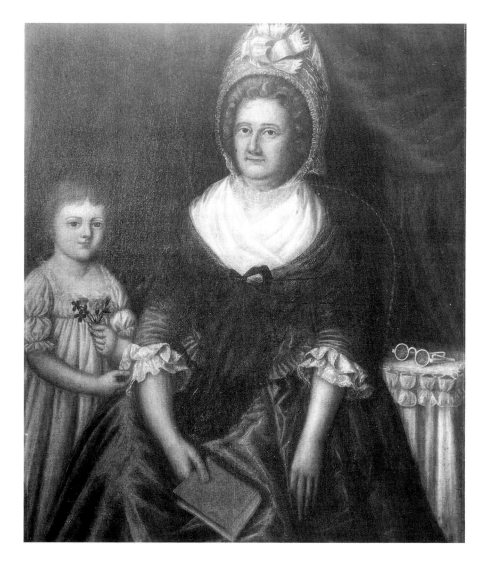

This complex portrait of Mrs. John (Ellin North) Moale and her namesake granddaughter was painted by a slave named William Johnson, according to a family story. Dr. J. Hall Pleasants, a Moale descendant, was stimulated by this story to begin his search for such an artist. He found Joshua Johnston, a portraitist, listed in the 1817 city directory as a "Free Householder of Colour." This remains the only recorded indication of Johnston's race. The Moale portrait, supposedly painted about 1798–1800, is in the collection of the Abby Aldrich Rockefeller Folk Art Center in Williamsburg.

Johnston's own signature, confirmed in its spelling in one advertisement, and clearly that of the portraitist from other records.

Overall, it is revealing to follow the development of interest in Joshua Johnston over the last fifty years—to see new questions raised, new evidence found, relating the growing interest in Johnston to social and political changes. In a sense Joshua Johnston provides a history of America awakening to the presence of unknown talent.

The quest for the racial identity of Joshua Johnston began with the willingness of J. Hall Pleasants, a retired physician who had become a nationally known expert on early Maryland artists, to investigate fuzzy and conflicting Baltimore family stories of "a slave who painted" their ancestors. He found such stories were handed down in three prominent families. In a fourth family the story was that the artist had come from the West Indies, but there was no indication of his race. In his own family, the Moales, the story was that the

portraitist had been a slave of a well-known artist. While the artist's name was forgotten, the slave was said to be William Johnson.

That name gave Pleasants a starting point. His inspection of early Baltimore directories led to no William Johnson, but there was a Joshua Johnston, portrait painter. And in the directory for 1817, in a ten-page section devoted to "Free Householders of Colour," Joshua Johnston, portrait painter, was listed as living on Nelson Street in the Old Town section. In 1819, listed as a limner, he was still there but without a racial designation.

Pleasants, surprised to find an artist he did not know, immediately wondered if Johnston was the "brass tacks" artist whose portraits he had been unable to identify. Looking for other paintings in this artist's style over many years, he eventually identified thirty-four paintings in this style and concluded the artist was probably Joshua Johnston. But he could not document this identification beyond the 1817 directory entry. Nevertheless, in the June 1942 issue of the *Maryland Historical Magazine*, Pleasants published an article titled

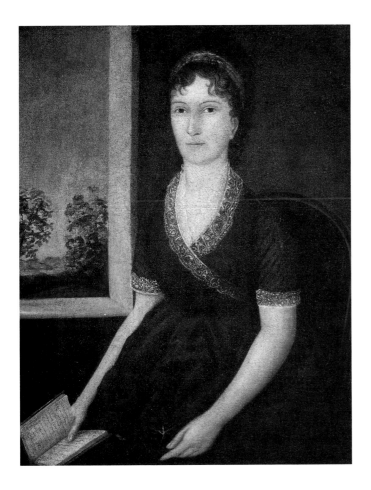

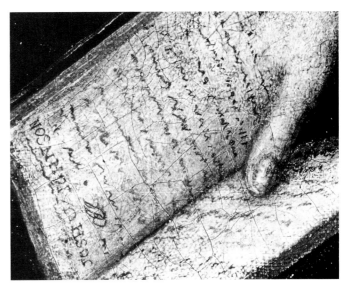

This portrait of Sarah Ogden Gustin, found in Berkeley Springs, West Virginia, is in Johnston's style. Its importance lies in the crudely lettered name JOSHU JOHNSON on the book held by the sitter. The lettering and spelling do not match Johnston's graceful signature, though the crudeness might be explained by the fact that the artist had to turn the painting upside down to letter it. No record shows that Johnston was ever in West Virginia, but Sarah Gustin may have come to Baltimore around 1800.

"Joshua Johnston, the First Black American Portrait Painter?" Amplifying notes he had published in the 1939 *Walpole Society Notebook*, Pleasants theorized:

> A nebulous figure, a Negro painter of considerable ability and with a style peculiarly his own, was a limner of portraits in Baltimore during the last decade of the eighteenth century and the first quarter of the nineteenth. As far as can be learned, Joshua Johnston, or Johnson, was the first individual in the United States with Negro blood to win for himself a place as a portrait painter. . . . He deservedly should arrest the attention, not only of those interested in the history of American painting, but also of students in the cultural development of the American Negro.[4]

Pleasants may have been prompted to publish his Johnston notes, gathered over twenty-odd years, by discussions in 1938 among the trustees of the Baltimore Museum of Art, of which he was a leading member. In these discussions the trustees had approved a proposal by Alain L. Locke of Howard University and Mary Beattie Brady of the Harmon Foundation for the first museum exhibition of a group of contemporary African-American artists.[5] Held in 1939, the exhibition was a great critical success. It helped stimulate a growing serious interest in black artists in the 1930s, which

had been initiated by the Museum of Modern Art's exhibition of African art and its exhibits of William Edmondson in 1935 and Horace Pippin in 1937.

Public attention had already been drawn to Johnston by the reproduction of a family portrait attributed to him in *Life* magazine on December 9, 1940. This exposure had resulted in the discovery of four more paintings attributed to Johnston.

Although Pleasants presented the existence of the African-American portrait painter Johnston as a theory, it was immediately widely accepted as a fact. This acceptance was reinforced by a 1948 exhibition of twenty-three "Johnstons" at the historic Peale Museum in Baltimore, curated by Pleasants and the museum director, Wilbur H. Hunter.[6] By that time even Pleasants had dropped the question mark of the title of his article in the *Maryland Historical Magazine*. Pleasants continued to identify works by Johnston until his death in 1957, arriving at a total of about fifty. However, neither he nor anyone else undertook any extensive research to prove that this "nebulous figure" was black.

By that time the quiet but persistent hunt for portraits in the Johnston style was well under way. In 1961 a portrait in the Johnston style of a young woman, Sarah Ogden Gustin, was found in Berkeley Springs, a West Virginia spa. The sitter held a book containing the crudely lettered name JOSHU JOHNSON (without

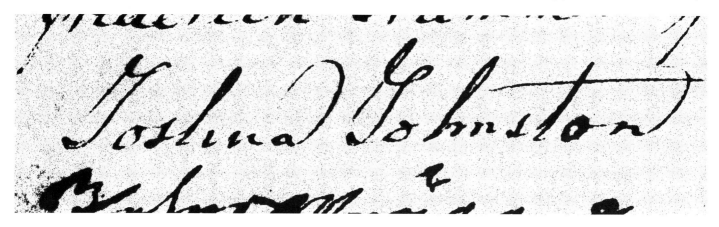

Joshua Johnston's graceful, rhythmic signature, with a *t,* was found on a 1798 neighborhood petition to pave German Lane. Slaves could not sign such petitions. Would a free black portrait painter have been accepted by his neighbors in slave-holding Baltimore—or successfully concealed his race? The signature indicates an educated hand and is a critical but unsolved element in establishing Johnston's racial identity.

the *t).* Below the name, there were initials in script that some perceived as JJ. The painting was purchased for $250 by Edgar and Bernice Chrysler Garbisch, folk art collectors, who were quite aware of Pleasants's research on family stories of "a slave who painted." They already owned a Johnston portrait, *A Man of the Shure Family,* and had lent it to the 1948 exhibition that Pleasants and Hunter curated. At the time of the Gustin portrait's purchase there was no family story attached

to the work about its artist being a black, a slave, or a servant, although more than ten years later there was hearsay evidence that it was painted by a valet of a Peale, "a very bright Black young man."[7] At the time Garbisch took the precautionary step of having conservators examine the crude lettering. They reported that the lettering was an integral part of the painting and not added later. Eventually the Garbisches gave the painting to the National Gallery of Art in Washington.

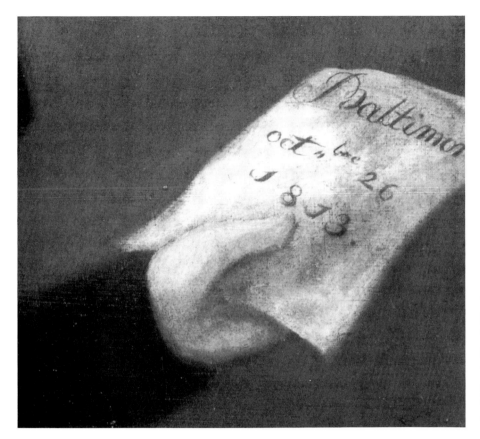

The inscription on a note held by young Basil Brown in an 1813 Johnston portrait— "Baltimore octbre 26, 1813"—compares favorably with Johnston's own signature. The French abbreviation for October supports the idea that the artist was from the West Indies. Private collection, courtesy Washburn Gallery, New York

When this gift and its background became known, Johnston prices soared. In 1973 three portraits attributed to Johnston brought $31,000 in a Washington auction.[8]

The auction outraged Hunter, who had helped curate the 1948 exhibition with Pleasants. In the *Baltimore Evening Sun* of July 16, 1973, he emphasized that Pleasants had presented only a theory and that there was "no substantial proof" for it. "I defy anyone," Hunter challenged, "to present hard evidence that (1) these paintings are by Joshua Johnston and (2) that Joshua Johnston was really black. . . . I call upon other historians and art historians to be heard. It is a disservice to black people to let this go on." (That Johnston painted the portraits was confirmed by Mrs. Everette's will, which was unknown to Hunter.)

The year before, at Hunter's suggestion, two Goucher College art history students, Sian Jones and Barbara Halstead, had spent a dusty, tedious summer searching the Baltimore city archives. Eventually they found Joshua Johnston's signature on a 1798 neighborhood petition seeking the paving of German Lane (where Johnston then lived) to get rid of its stagnating puddles.[9]

Although the signature could not reveal Johnston's race, it did indicate acceptance by his neighbors. Did this mean he was white or a free black man? This signature also raised sharp questions about the signature on the Gustin portrait. Would Johnston misspell

his name the only time he ever put it in a painting? Would he be likely to use the crude lettering of the Gustin portrait when his own signature flowed in a rhythmic and graceful manner? His was not an unschooled hand, but an educated and practiced one.

The only other portrait with lettering attributed to Johnston is that of a young boy, Basil Brown. He holds a letter inscribed "Baltimore Octbre 26, 1813," in a flowing script that is similar to Johnston's signature on the paving petition.[10] Did the same artist who crudely lettered "Joshu Johnson" create the script on Basil Brown's letter?

Even if these questions can be answered, Johnston's race is still not established. Although many articles and books have assumed that Joshua Johnston was a free black man who was a Baltimore portrait artist,[11] the documentary evidence of racial identity that Hunter demanded is still lacking.

Various advertisements demonstrate the existence of other African-American artists in the 1700s. An advertisement by one black artist mentioned his race but not his name.[12] Such racial identification steered the prejudiced away. At the same time it contradicted the slave owners' claim that black people were incapable of "the finer things."

Johnston advertised twice but he did not mention his race. In his first advertisement he described himself

Portrait Painting.

THE subscriber, grateful for the liber-al encouragement, which an indulgent public have conferred on him, in his first es-says, in *PORTRAIT PAINTING*, returns his sincere acknowledgments.

He takes liberty to observe, That by dint of industrious application, he has so far improved and matured his talents, that he can insure the most precise and natural likenesses.

As a *self-taught genius*, deriving from nature and industry his knowledge of the Art; and having experienced many insuperable ob-stacles in the pursuit of his studies, it is high-ly gratifying to him to make assurances of his ability to execute all commands, with an ef-fect, and in a style, which must give satisfacti-on. He therefore respectfully solicits en-couragement. ☞Apply at his House, in the Alley leading from *Charles* to *Hanover Street*, back of *Sears's* Tavern.

JOSHUA JOHNSTON.

Joshua Johnson,
No. 52, *North Gay-Street*,
RETURNS his most grateful thanks to his friends and the public in general for the encou-ragement they have been pleased to afford him, towards establishing him in the line of POR-TRAIT PAINTING; he, therefore, flaters himself, from an unremitting attention to give general satisfaction to the ladies and gentlemen of Baltimore, to merit a continuance of their favors, as he is determined to reduce his prices agreeable to the times, and use every effort to please them.

October 11 482 di st*

Johnston's first advertisement, in the *Baltimore Intelligencer,* December 19, 1798, spelling his name with a *t,* emphasized that he was a "self-taught genius" who had overcome "many insuperable obstacles in the pursuit of his studies." This suggests he was not trained by members of the Peale family, as has been claimed. The overcoming of "insuperable ob-stacles" may indicate he was an African-American. Yet he was never mentioned in the voluminous writings of the Peales or other artists working in Baltimore at the time.

Johnston's second advertisement, in the *Baltimore Telegraphe,* October 11, 1802, appears more assured professionally and emphasizes that he meets competitive prices. The *t* does not appear in his name. His advertisements suggest he was known to the other artists in Baltimore as well as to shops selling paints, brushes, and canvas. A label for one such shop on the back of a Johnston portrait reads: "Fitzgerald's Em-porium of the Fine Arts, No. 5[5?] N./ Gay street." This was near Johnston's location at 52 North Gay Street.

as a "self-taught genius" who had overcome "in-superable obstacles in the pursuit of his studies," a statement suggesting the prejudice against African-Americans and their artistic skills.[13] His second adver-tisement offered competitive prices.[14] In the first ad-vertisement he spelled his name with a *t*, as he did in the paving petition.

Johnston was listed as a limner or portrait painter at nine different addresses between 1796 and 1824. In three directories, African-Americans were identified by either a typographical dagger or such words as "col'd" or "black man." As previously noted, only once in the twenty-eight-year period was Johnston identified as black: in the 1817 directory, where he was listed as a "Free Householder of Colour." Without this listing, there would be no objective evidence that John-ston was black.

Pleasants also found Johnston listed in the 1800 census as a free white householder whose household

included his wife, three daughters, three sons, and a free black.[15] No address or occupation was given. Pleasants concluded that Johnston was a mulatto so light-complexioned that his appearance deceived the census taker.

The directories were not official registers, but commercial ventures put out by various publishers. There was no consistency in alphabetization, spelling, or racial designation. For example, when Solomon Johnson, a cordwainer (shoemaker) known to be a free black man, was traced through the directories, he was sometimes identified as black, sometimes not. How-ever, as Pleasants put it, "to have listed a white man as a Negro would have been a serious matter."[16] The result, he noted, would have been a libel suit; a physical attack on the publisher and a retraction are other pos-sibilities. However, nothing has been found to suggest any of these reactions.

This single piece of evidence, not consistently fol-

lowed up in other directories and not reliable in character, has not proved very satisfactory. Once Mrs. Everette's will proved Johnston to be the portraitist, questions about whether he was an African-American became more urgent.

Almost a decade after Hunter's challenges, the Abby Aldrich Rockefeller Folk Art Center in Williamsburg, Virginia, initiated a well-financed multidisciplinary Joshua Johnston project in collaboration with the Maryland Historical Society.[17] Headed by Carolyn J. Weekley, curator of the Folk Art Center, the project was frankly biased in its determination to prove Pleasants's theory that Joshua Johnston was black.

One aspect of the project was a report by Leroy Graham on the life of free blacks in Baltimore during the time when Johnston was active. From a different perspective, Sian Jones, who had become an art conservator, examined two controversial paintings in regard to their canvases, backings, uses of color, and painting techniques—all of which showed they were painted by the same person. The project also assembled a catalog providing brief histories of eighty-three paintings attributed to Johnston. An exhibition of these works was mounted at the Maryland Historical Society, traveling to Williamsburg and then to the Whitney Museum of American Art in New York and its Stamford, Connecticut, branch in 1988.

At about the same time, in January 1988, the Whitney Museum sold its only Joshua Johnston, an unusual and imaginative portrait of a young girl standing beside a goblet filled with strawberries that is her height. The museum received $660,000.[18] With so much at stake, the question of Joshua Johnston's race was becoming more pressing than ever. It is worth noting that Joshua Johnston probably received only $25 per portrait in 1800, judging by competitors' prices.

Much of the Folk Art Center study was devoted to reexamining what Pleasants had said in 1942 and in his notes about families' stories of "a slave" or black man who painted their ancestors. It gathered more of these stories, making a total of eight, however inconsistent. None named Johnston. Also missing, as already noted, were any relevant letters, notes, or diaries by Baltimore African-Americans of that period. But the Folk Art Center study did show that existing official records showed a careless indifference, if not contempt, regarding African-Americans, their names, and their addresses.

The main focus of Weekley's study was on the possibility that Johnston came from the West Indies. Two paintings that Pleasants attributed to Johnston belonged to the prominent McCurdy family. However,

according to the family, they were painted by an artist from the West Indies with no indication that he was black. All three other family stories recorded by Pleasants held the artist was a slave.

The suggestion that Johnston had come from the West Indies has a special meaning in Baltimore history. Fleeing the revolution led by the black rebel Toussaint L'Ouverture against slavery and French domination, about 1,000 white French people and 500 French-speaking slaves arrived in Baltimore during a two-week period in July 1793.[19] The French-speaking slaves alarmed Baltimore slave owners, who feared their own slaves might be inspired to revolt. Moreover, the French-speaking slaves ignored commands in English and spoke to one another in a language the slave owners could not understand. The frightened Baltimore slave owners secured passage of very restrictive laws against French-speaking slaves, threatening them with being sold in the Caribbean if they violated the laws.

The West Indies connection had also had a special meaning for Pleasants. Among the white French refugees, there were a number of skilled silversmiths and artisans. In his early publications Pleasants had written about these silversmiths and was well aware of their artistic abilities.[20]

Pleasants, knowing the other artists who painted in Maryland in that early period, recognized that stylistically Johnston was close to Charles Willson Peale, his son Rembrandt, and his adopted nephew Charles Peale Polk. They had all painted in Baltimore when Johnston worked there. In Pleasants's words, some Johnston portraits bore "a striking generic resemblance to the work of these three members of the Peale family."[21]

However, Pleasants noted, the idea that the portraitist came from the West Indies "did not fit well into the theory of the Peale-Polk influence." Yet Pleasants did not dismiss the possibility altogether, remarking that if the artist had come from the French West Indies, "he certainly adopted a new name, possibly to fit better into a new environment."[22]

The most important new document reported by Weekley in the Folk Art Center study suggests a way of reconciling the McCurdy story of a West Indies artist with Pleasants's recognition of Johnston's stylistic affinity with the Peale-Polk group. Weekley found that Robert Polk, the father of Charles Peale Polk, operated a small schooner as a privateer in coastal shipping. He may have transported slaves to the Carolinas or Georgia. At some point, long before the Toussaint L'Ouverture revolt, he owned a black boy who spoke French. In 1777 Polk, sailing as master of a larger ves-

sel, was killed during an attack by a British warship. Earlier that year Polk had revised his will, ordering "The Negro boy to be sold, the whole to be divided equally amongst the three children"—Charles Peale Polk, Margaret Polk, and Elizabeth Bordley Polk.[23]

Charles Willson Peale and his brother, St. George Peale, who were Polk's brothers-in-law, became the estate's executors. Charles Willson Peale wrote to St. George: "I have a desire to purchase the Negro boy to wait on me. I have long wanted one, and if I remember right, Bobby [Polk] told me he spoke French—which will be a recommendation."[24]

No evidence of such a sale has been found. Nevertheless, Weekley speculates that this transaction occurred and that the French-speaking black boy, who may have been ten years old at the time (close to Charles Peale Polk in age), became an assistant to Charles Willson Peale. Weekley projects the idea that the French-speaking boy, by working as a painter's assistant, cleaning brushes, stretching canvases, grinding colors, and observing how portraits were made, acquired a portraitist's skills. She goes on to speculate that since the Peales painted portraits of the Moales and other prominent Baltimoreans, their assistant could have gained acceptance among these families.

This speculation adds still another new twist: Johnston as a French-speaking artist—something the McCurdy story, which did not describe him as black, did not mention. And all of this is based on a sale of which there is no record. A further complication lies in the fact that Charles Willson Peale held abolitionist views.

Charles Willson Peale's wanting to buy Polk's Negro boy has a resonating significance. Peale believed slavery should be abolished, that it was destructive to Caucasians. In 1778, on the same day that this kindly man took in a stray dog that followed him, he recorded in his diary his disgust with Virginia cavalry officers, their constant swearing, dissipation, and laziness—which he blamed on slavery.[25] On coming across a slave whose skin had lost its pigmentation, Peale rushed to paint his portrait and tell his story to the American Philosophical Society.[26] What intrigued Peale was the idea that blacks might turn white—which he felt would wreck slavery if it could be encouraged. He later painted a dignified portrait of a wise, good-humored, very old free Muslim black man, Yarrow Mamout.[27] "The very idea of slavery is horrible" is how he summed up his attitude.[28]

Yet this abolitionist already owned two slaves, Scarborough and Lucy Williams. How Peale acquired these slaves is unclear; his biographer suggested that

perhaps they had been given to him by a planter instead of payment for portraits.[29] The Williamses were "a family within a family." When Lucy and Scarborough had children, Peale recorded their births in the Peale family records.

Peale proposed to free the Williamses when they could support themselves. When Moses Williams, their son, approached twenty-eight years of age, Peale warned him that he would be set free even if he couldn't support himself. Moses then learned to cut silhouettes with a physiognotrace, a device that even the sitter could operate. Visitors to the Peale Museum liked to have Moses cut their silhouettes. He cut 8,800 in 1803, his first year, earning eight cents for each one. In this way Moses earned enough money to buy a house and to marry the Peales' white cook, Maria, who had once declined to sit at the same table with him.[30] He was the last of the Peale slaves to be freed.

Everything known about Charles Willson Peale, who had endured a bitter twelve-year indenture to a saddler as a youth, indicates that he treated his children and the black family within his family with affectionate indulgence. His children, named Raphaelle, Rubens, Titian, and Rembrandt, were encouraged to become artists, and the Peales became America's first family of artists.

Significantly, Charles Willson Peale did not believe artistic ability was magic.[31] He believed that anyone could learn to draw and paint, that what was required was work at drawing and painting. In such an environment a black French-speaking boy, even if a slave, could have learned the rudiments of drawing and painting. And a man like Charles Willson Peale might have made the French-speaking boy an indentured servant, who would be freed after having served a number of years (usually seven).

Why would Charles Willson Peale have wanted a young black boy who spoke French? Because he believed French, which he himself had learned as a grown man, opened one's mind to the scientific discoveries and the philosophical and artistic ideas of Europe. In the late 1770s Peale was about to begin teaching French to his children—and a French-speaking boy, regardless of race, could help. Judging by his treatment of the Williams family, Peale would have freed the boy when he could support himself.

Of course, as already stated, no documentary evidence exists to show that Charles Willson Peale bought Robert Polk's "Negro boy." Peale was a busy letter writer, diarist, and note taker, recording the comings and goings of his large family. His writings include references to members of the Williams family, but there is no mention of a French-speaking black boy after his 1777 letter. It is known that Peale had a "French serving

man," who was injured in the 1784 fire that destroyed Peale's *Arch of Triumph*.[32] However, neither this servant's name nor his race is mentioned in the voluminous Peale family records. In fact, the serving man's repeated designation as French presumes that he was Caucasian.

Despite the lack of concrete evidence, in her study Weekley goes on to speculate that somehow the French-speaking boy became Charles Peale Polk's slave or servant and learned how to paint portraits from Polk. She presumes further that when Polk, the least successful of the Peale portraitists, failed and left Baltimore in 1796, Joshua Johnston emerged as a portraitist in his own right, listed as such in the city directory of 1796. While lacking documentation, this conjecture does explain the similarity of Johnston's early portraits to those of Polk. As Pleasants observed, the most pronounced similarities are in the sitter's pose, the painting of the eyes and mouth, the use of certain objects such as books for design purposes, the unskilled painting of hands, the thinness of the paint, and the stiffness of the figure. However, while Polk employed a rainbow of colors, Johnston used color more somberly and more effectively in his design.[33] It must also be said that as his skill developed, Johnston became a better and more imaginative painter than Polk ever was.

Unable to support his family of nine children, Polk eventually abandoned portraiture for a government clerkship in Washington in 1796. The Weekley study speculates that Johnston was employed by Polk until about that time, and then Polk either "cancelled his services or freed him."[34] Because Johnston also had a growing family to support by that time, it is difficult to see how Polk could ever have paid or supported Johnston and his family when he couldn't support his own.

In considering Johnston's connection with the Peale family, one of the greatest frustrations is that he is not mentioned in any of the Peales' extensive writings, although the Peales opened a museum near one of Johnston's listed addresses and presumably were competing with him for portrait commissions.

In fact, none of the many artists with whom Johnston would have competed mentioned him.[35] Pleasants, with his extraordinary knowledge of Maryland artists, did not even know of Johnston until he found the name in the city directories. This unusual "anonymity" seems all the more peculiar given the fact that we know the names of the many artists, both well known and not so well known, who came to Baltimore for brief stays during the years when Johnston was active. They were, even though some stayed for a few years, like tourists. On the other hand, Johnston remained in Baltimore. He was, so to speak, the resident portraitist—which makes his identity all the more mysterious.

Portrait painters have always complained of the strain of having to converse with the sitter, making the sitter feel comfortable, at a time when the artist must concentrate his attention on seeing and painting. Moreover, portraitists usually cannot choose whom they will portray—a situation that finally caused John Singer Sargent to refuse to do portraits. In this regard, one must ask: Would a free black painter have had the social poise, verbal skills, and sufficient confidence about his artistic ability to handle such conversations, especially when his sitters were slave owners who tended to view free blacks with great suspicion and hostility?

One answer is Weekley's speculation that Johnston came to be known by prominent Baltimore slave-owning families through the Peales. On a less speculative level, there is Weekley's finding that most of Johnston's adult sitters were his middle-class neighbors and that more than half of the portraits attributed to Johnston (forty-six of eighty) are of children.[36] Portraits of children would have required less in the way of conversation, so it is of interest that Johnston's portraits of children are among his most confident works, full of color, imagination, and charm. Moreover, as the Weekley study has noted, these portraits would have prompted a system of referrals from family to family, making it less necessary to advertise—which Johnston did only twice in more than twenty-five years.

An important question in trying to identify Joshua Johnston's race concerns his relationship with African-Americans in Baltimore. The 1817 city directory listing of "Joshua Johnston, portrait painter" as a "Free Householder of Colour" must have been noticed by such black Baltimoreans as the Reverend Daniel Coker. He was also listed as a "Free Householder of Colour." And, like Johnston, he lived in the Old Town section of the city. Outspoken against slavery,[37] Coker had come to the conclusion that African-Americans should withdraw from the Methodist church because they were not treated as equals. In fact, in 1815 he and his followers left that church and formed the African Bethel church, eventually affiliating with the new African Methodist Episcopal church. Coker became the outstanding leader of Baltimore's black population, where free blacks outnumbered slaves, making slave owners nervous.

Coker was born in Baltimore County, the son of a white indentured woman and a slave.[38] He first attended school as the valet of his white half brothers, the issue of his mother's first marriage. After running away to New York, he gained an education and, ordained by Bishop Asbury, began to preach Methodist doctrine and to speak and write effectively against slavery. Because he was still a fugitive, he was smuggled

These matched portraits of two African-Americans have been identified as being in Johnston's style and may provide evidence that he was black. It seems likely that such a pair of dignified portraits of black men was the work of an African-American artist. Comparison with a known portrait (ca. 1811) of the Reverend Daniel Coker of the AME church (opposite) has led to speculation that the center portrait is also his. If so, the portrait on the left is probably that of Abner Coker, a lay preacher and an AME cofounder. The Cokers were also listed in the 1817 directory as "Free Householders of Colour" and lived in the same section of Baltimore as Johnston, who probably knew the Cokers and may have painted them. The portraits are on canvas, thinly painted in feigned ovals. That believed to be of Daniel Coker is in the American Museum in Britain, Bath, England. That believed to be of Abner Coker is in the Bowdoin College Museum of Art, Brunswick, Maine.

into Baltimore at night and hidden until his purchase could be arranged by black friends.

In 1816 Coker was elected the first bishop of the African Methodist Episcopal church, but he resigned mysteriously the next day. Although not confirmed, one rumor is that there were objections because he had too light a complexion to head a church called African.[39] If anyone in Baltimore could have understood the problems of a light-complexioned black man, which Pleasants suggested was one of Johnston's features, it would have been Coker.

Coker undoubtedly knew Johnston since they lived near one another in the same section of Baltimore. Building on this connection, the Folk Art Center study compared a profile portrait known to be that of Coker, from about 1811, with one of two portraits that Pleasants had identified as by Johnston but that lacked family histories.[40] "Unknown Maryland Gentlemen," Pleasants had called them.

In a peculiar lapse Pleasants did not recognize that one of these gentlemen was obviously a black man and that the other might be, although his negroid features

were not pronounced. The eyebrows of both men suggested to Pleasants, with his trained physician's eye, that they were brothers or "of the same family." He attributed their dark facial tones "in part to discolored varnish."[41]

In comparing the profile of the Reverend Daniel Coker with the portrait of the man who is not obviously negroid, the Folk Art Center study noted that both are "slender men with similarly shaped heads, ears, aquiline noses, and downward slanting eyebrows."[42]

If Daniel Coker is correctly identified as the sitter in one portrait, who is the man in the other—the "Unknown Cleric," as that portrait has become known? He is probably Abner Coker, who may have been Daniel Coker's brother or relative. Abner Coker was also listed in the 1817 directory as a "Free Householder of Colour," a laborer living in Union Alley, in the Old Town section. However, we have found that in a list appended to a sermon by Daniel Coker at the African Bethel church on January 21, 1816, Abner Coker was identified as a "local preacher" of that church.[43] Moreover, according to Bishop Daniel A. Payne, who for

art of that period. They might well have been painted in connection with the founding or some anniversary of the African Bethel church.

Certainly more research is needed to document that these portraits are of the Cokers. One difficulty is that Daniel Coker, losing faith in the possibility of abolishing slavery in this country, led ninety African-Americans to Liberia and then to Sierra Leone. However, his sponsor, the American Colonization Society, replaced him with new agents, and his effort failed. Coker later established a church in Freetown, where he died in 1846. Of Abner Coker, little can be confirmed at this time beyond the facts that in 1822 he was a deacon of the AME church in Baltimore and that he died in 1833.[47]

In a psychological sense such a pair of portraits would require an artist who was an African-American or who saw these particular black men as especially worthy of dignified portrayal. Regardless of whether the men in the portrait are the Cokers, these paired portraits of two black men in Johnston's style provide strong evidence that Johnston was indeed an African-American. They may be considered documents signed by Joshua Johnston.

Unfortunately, there are other documents in Catholic records that undermine this possibility.

many years was the inspired, shaping leader of the African Methodist Episcopal church, Abner Coker was a member of the eighteen-man group that founded the AME church in 1816.[44]

In any case a family connection is reinforced by the fact that when Pleasants first saw the two portraits, the antique dealers who owned the portraits said that they both "had come out of 'an old Baltimore family residing in the vicinity of Calvert and Chase streets.' "[45] In addition, the canvases have many physical similarities—both are painted in feigned ovals on finely woven but rough canvas with somber color values. The painting techniques are also similar.[46]

Who would have painted such a pair of portraits? Dignified portraits of individual African-Americans were not unknown in that period. Joshua Johnston, who lived near the Cokers and undoubtedly knew them, might have painted them. So might the abolitionist Charles Willson Peale or his son Raphaelle, who painted an impressive portrait of the Reverend Absalom Jones of Philadelphia. Charles Peale Polk seems an unlikely candidate, for by 1816 he had given up painting and left for Washington. Moreover, these paintings are not in his style.

Painting a single portrait is one thing; painting a matching pair of well-dressed black men is something altogether different. There is nothing like them in the

Even if Joshua Johnston painted the two portraits of the "Unknown Maryland Gentlemen," whom we believe to be Daniel and Abner Coker, it does not necessarily follow that Johnston was a member of their church. The dominant religion of the French West Indies in the 1700s was Catholicism. Records of Joshua Johnston as a Catholic would tend to support the McCurdy story that the artist came from the West Indies, although that story did not indicate that he was of African descent. While an examination of the archives of the Baltimore diocese of the Roman Catholic church did not uncover marriage or burial records for Joshua Johnston, there were baptismal records of five children from his marriage to Sarah Johnston.[48] These records—all but one entered in the hand of the Reverend Francis Beeston, rector of St. Peter's, the principal church of the diocese—spell the name without the *t*.

None of the records bear the signatures of Johnston or his wife. They do not give any address or occupation, nor do they certify that the parents were present at the baptism, although that might be expected. At each baptism there are two sponsors, who had to be members of the church. These sponsors varied with each ceremony, and efforts to identify them through the city directories have proved inconclusive. One

sponsor, Jacob Lawrence, was listed in the 1799, 1801, and 1802 directories as a nail maker on Duke Street and Fells Street, Old Town, but he was never identified as black.

The baptisms of two Johnston sons took place on June 2, 1793, six years after the birth of the first son, John, and about six weeks after the birth of the second, George.[49] This would place the birth of John in 1787. Weekley speculated that Johnston may have been owned by or was working at this time for Polk or one of the Peales. If this made another family within the Peale family, why wasn't it written about, as the family of Scarborough and Lucy Williams was?

The baptism of a third son, Samuel Joshua Johnston, did not take place until June 1, 1827—twenty-one years after his birth in 1806.[50] This fact suggests that the Johnstons were not the most devout Catholics. However, such an idea is offset by the fact that a daughter, Sarah, was born on November 15, 1794, baptized on May 19, 1795, and died on October 22 of that year.[51] Another daughter, Mary, born on October 1, 1796, was baptized December 4, 1796,[52] although there are no certain records of her marriage or burial because her first name was very common.

Most important in terms of Pleasants's hypothesis, the diocese records systematically registered the status of black people with such designations as "slave," or "free Negro," or "mulatto," or "fr negro," or "sl" or "a negro of Pat Bennett" or whatever the master's name was.[53] In no records are Joshua Johnston/Johnson, his wife Sarah, or any of their five children identified as black. All these records, except the belated baptism of Samuel Joshua Johnston, were written by Father Beeston, who, in view of these repeated ceremonies over many years, must have known them.

In fact, as far as Father Beeston was concerned, over a period of twenty-five years and with all the private information that might be available to a priest, Joshua Johnston was white; so were his wife Sarah and all their children. These multiple entries raise serious questions about the Weekley study, which does not mention Father Beeston's identifying racial notations of slaves, free blacks, and mulattoes.

Yet the data in the records, such as Sarah Johnston being Johnston's wife, are used in Weekley's speculations.[54] Can it be that the cathedral records refer to a Joshua Johnston who was not the portrait artist? If that is the case, Joshua Johnston is further away from being identified than ever.

Yet the McCurdy family story, the predominance of Catholicism in the West Indies, and Johnston's name in the cathedral records suggest that Johnston may indeed have come from the West Indies. That possibility is also supported, as the Folk Art Center study notes, by the portrait of Basil Brown, who holds a letter inscribed with the French abbreviation for October—Octbre.[55]

But there are pieces to this puzzle that do not fit. The McCurdy family story, in contrast to other family stories, does not indicate the artist's race. And if Joshua Johnston did come from the French-speaking West Indies, as Pleasants commented, what was his name there? Surely not Joshua Johnston. When did he get that name? If he was indeed purchased as a boy by Charles Willson Peale, did Peale so name him? It is difficult to believe that Peale, who took note of nearly everything including stray dogs, would not have recorded it.

The cathedral records do not prove that Joshua Johnston was white. They do demonstrate that a critical and unresolved question in the puzzle of Johnston's identity revolves around the cathedral records and his Catholic relationship.

Another part of the puzzle of his Catholic relationship arises from a change in attribution by the Folk Art Center. Would a good French-speaking black Catholic artist paint a portrait of Archbishop John Carroll, head of the diocese and one of Baltimore's most prominent figures, and also paint dual portraits of the city's leading black African Methodist ministers, participants in the founding of the AME church and significant rebels during slave-time?

Archbishop Carroll's portrait has, until the Folk Art Center study, always been attributed to the Philadelphia artist Jeremiah Paul, who was in Baltimore from 1806 to 1808.[56] The Folk Art Center study attributes it to Johnston on the basis of his Catholic affiliation. This change warrants skepticism. For example, in nearly all Johnston portraits the eyes are lidded, but that is not the case in this portrait. Moreover, the Archbishop appears about to smile in a benign fashion, a facial expression not characteristic of Johnston's portraits, and the skin tones are warmer than those in most Johnston portraits. If Johnston painted Archbishop Carroll's portrait, one might expect that he would portray other Catholic sitters. So far no evidence of this has been reported. Pleasants was familiar with this portrait and considered it the work of Jeremiah Paul, not Joshua Johnston.

Certainly omission from the Folk Art Center study of Father Beeston's racial notations confuses the question of Johnston's identity, because the records are factual, not speculation, and they were not subject to the possible error of a one-look census taker. Yet Father Beeston's records cannot be considered conclusive evidence that Johnston was white. They do demonstrate the depth and complexity of the problem created by slavery, its fundamental attitudes, and their lingering

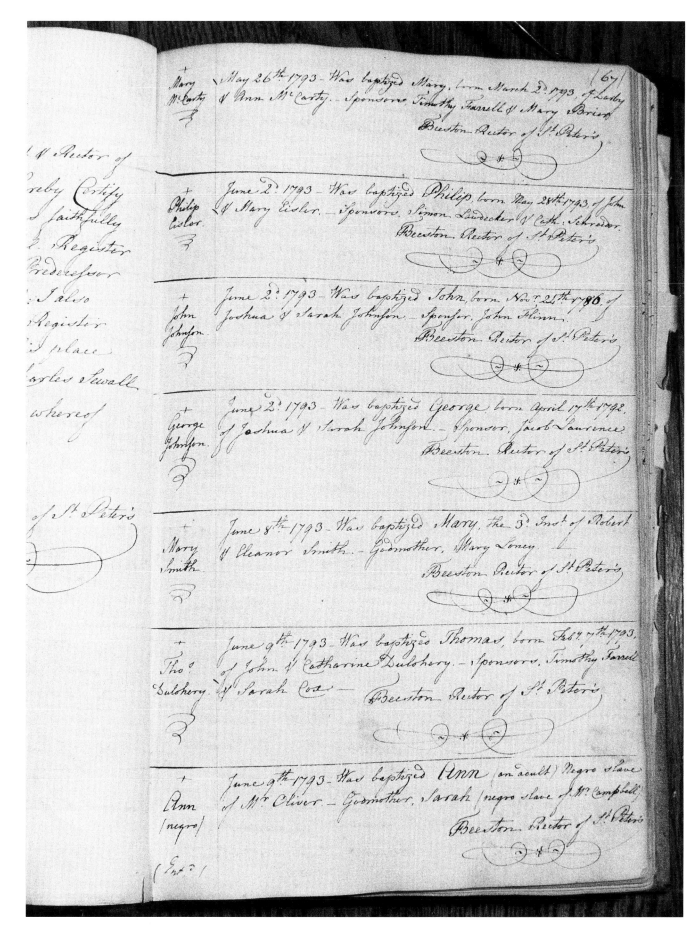

This page from the baptismal records of St. Peter's Church in Baltimore shows that the Reverend Francis Beeston baptized John and George, the children of Joshua and Sarah Johnston, on June 2, 1793. On the same page he recorded: "Was baptized Ann (an adult) Negro slave of Mr. Oliver—Godmother, Sarah, negro slave of Mr. Campbell." No such racial designation appears in connection with Johnston or his children over a period of more than twenty-five years. This raises questions about his racial identity.

effect today. In this situation one must look at other possible sources for confirmation of Johnston's race, such as the abolitionists of Baltimore.

As the leading authority on Maryland's artists from the earliest days, Pleasants was fascinated by the possibility that the portraitist Joshua Johnston was an African-American in days when Baltimore was a major slave-shipping center. It promised something new in a field that he had nearly exhausted. Although he had the courage to break with his own southern upbringing and consider such a possibility, his research nevertheless was limited by his background, particularly in regard to African-American organizations in Baltimore and its abolitionists.

Pleasants knew little or nothing of African-American churches in Baltimore, the only organizations that African-Americans were allowed in during slave-time. Since he did not recognize that the two "Unknown Maryland Gentlemen" were black, he could not suspect that they might be clergymen of the African Bethel church and later the AME church. Similarly, he apparently did not realize that a black artist, reported to be a slave in family stories, would have been regarded with special interest by Baltimore's numerous abolitionists. He also apparently did not realize there were other African-American artists in Johnston's time.

There may have been still other African-American artists at the time. For example, in a letter to the first American art historian, William Dunlap, the nineteenth-century portraitist Henry Inman described his student days under John Wesley Jarvis, Johnston's competitor in Baltimore between 1810 and 1813. Inman said that when he and another student tried to copy a landscape, Jarvis termed their efforts "the damn'dest attempts I ever saw." He then called out, " 'Here, Philip!' (turning to a mulatto boy who was grinding colors in another part of the room) 'take the brushes and finish what these gentlemen has so bravely begun.' "[58] Inman was mortified because strangers were present and, implicitly although not said, because Philip was black. For the next seven years Inman painted backgrounds, drapery, and costumes in many of Jarvis's striking portraits. Presumably Philip did similar work. Yet not even his full name is recorded.

If, unlike Philip, Joshua Johnston became known through his portraits, advertisements, and directory listing in Baltimore, his relationship with the city's abolitionists should be helpful in identifying him as an African-American.

Baltimore had nearly 100 active abolitionists. They included many prominent men—Philip Rogers, James Casey, General Joseph Sterett, William Pinkney, Judge Chase, Adam Fonderden, and Elisha Tyson. They secured repeal of laws that prohibited the freeing of slaves by last will and testament and the rescuing of slaves from slave kidnappers, a frequent problem in Baltimore. Like abolitionists everywhere, they tried to demonstrate the immorality and loss to America created by slavery and its basic concept that black people were inferior. To that end they publicized and supported talented African-Americans.

The Baltimore abolitionists particularly did this with Benjamin Banneker, a free black, self-taught mathematician and astronomer. He correctly calculated an almanac for 1790, establishing the positions of the sun, moon, and other planets for the year; solar and lunar eclipses; sunrises and sunsets; and tidal tables. In 1791 he did the astronomical calculations that Major Andrew Ellicott used for the initial survey of the wilderness that is now the District of Columbia. Banneker sent Thomas Jefferson his almanac calculations, stating that he wanted to demonstrate that black people had for too long been abused and "considered rather as brutish than human, scarcely capable of mental endowments."[59] Jefferson sent Banneker's tables to the French Royal Academy of Science, emphasizing that they were the work of a black man who aided in surveying the new capital site.

In a July 4th speech in Baltimore, John Buchanan, a leading abolitionist and prominent physician, praised Banneker's work as a demonstration of the talent of African-Americans. Others helped arrange publication of his 1792 almanac. Constantly updated by Banneker, there were twenty-eight editions of the almanac within six years, the last in 1797. In contrast to the total obscurity of Joshua Johnston's death, Banneker died on October 9, 1806, and was buried near his home outside Baltimore. Without question, his work was well known to the Reverend Daniel Coker and other influential black Baltimoreans.

However, there is no evidence that Johnston knew Banneker or painted a portrait of him. The woodcut portrait of Banneker on the 1795 almanac cover was done by an unknown artist and is very unlike Johnston's work stylistically.

Did the abolitionists support Johnston and publicize his work as they did with Banneker? Although Graham, who has written extensively about Baltimore abolitionists, speculates in the Folk Art Center study that many of Johnston's commissions were "for families intricately tied to abolitionist leaders he must have known,"[60] there is no list of abolitionist sitters as there

is for Robert S. Duncanson in Cincinnati (see Duncanson chapter). Only one portrait of a known abolitionist, Andrew Aitkin, a charter member of the abolitionist society, is credited to Johnston. One portrait in twenty-five years hardly compares to the recognition and support given to Banneker. Portrait commissions from abolitionists would not necessarily have upset the slave owners who were Johnston's principal patrons initially, although they would have been disturbed if he had been as outspoken an advocate of abolition as Coker and Banneker were. The lack of abolitionist portraits is another mystifying and challenging aspect of the Johnston puzzle.

Graham asserts that the abolitionists living near Johnston "provided [Johnston], a free black, with a degree of protection from kidnappers, and others who might question his status."[61] This could well be true, for Baltimore was a major slave-trading center and kidnappings were frequent. Nevertheless, the lack of abolitionists among Johnston's sitters would appear to be a true reflection of his relationship with them.

The Folk Art Center study made an important step toward identifying Joshua Johnston and his sitters despite the fact that much of its report on his racial identity is conjecture. Such conjectures help delineate areas to be explored. Yet the true identity of Joshua Johnston remains to be documented beyond family stories.

Whatever his racial heritage, he was a painter of outstanding ability and deserves further research.

There are now more than eighty portraits attributed to Joshua Johnston. These were not secret portraits; whole families were involved. Somewhere there is a letter, a diary entry, a bill of sale, a note that will document his identity beyond any question. When the Maryland Historical Society was bequeathed the portrait of Mrs. Thomas Everette and her children, the society's registrar found in its files a copy of Mrs. Everette's will, naming "J. Johnson" as the portraitist. Knowing the questions that had been raised by Pleasants, he recognized the importance of the will in establishing Johnston as the Baltimore portraitist. This is why it is important for people to know about the unsolved problems in Johnston's racial identity.

Like many portrait painters of that time, Johnston probably also worked as a sign painter, a varnisher, a house or carriage painter. Rembrandt Peale and Charles Peale Polk were unable to survive as portraitists in Baltimore. Johnston had a family to support and probably could not have done so by portrait painting alone. The records of merchants who sold paint, brushes, and canvas and of cabinetmakers who employed varnishers may yield the pertinent document.

With eighty sitters and over ninety active members of the abolitionist society to be researched, not to mention the records of the African Bethel church and its members, we are confident that the true identity of Joshua Johnston will finally be established.

The Rising Mist (1867). Duncanson's great skill achieved monumental effects in this small canvas. It depicts a Scottish lake with sunlight piercing the early morning mist, a characteristic of his paintings there. The close details of his American paintings are absent and the people are active, not spectators. (6⁷⁄₁₆ x 12″) Cincinnati Art Museum

ROBERT S. DUNCANSON

In 1841 a young black man left the safety of Canada, where fugitives from slavery had gathered by the thousands, and traveled south to the edge of slavery, at Cincinnati, Ohio. It was a time when Americans were shaking off their dependency on European standards and creating what writers called "Young America"—a recognition of the unique cultural character of the American experience and a vision of Europe as decadent and dying.[1] Nowhere was the drama of Young America cheered more enthusiastically than in Cincinnati. Bordering the great western wilderness, Cincinnati was a "southern" town on free soil, whose geographic location made it the main station of the Underground Railroad. And it was in Cincinnati that Robert Scott Duncanson, having traveled the Underground Railroad in reverse, became the first African-American artist to achieve national and international prominence.

Duncanson was born in Seneca County, in upstate New York, in 1823, according to his 1853 passport.[2] His mother was a young African-American from Cincinnati who probably had sought refuge in Canada. His father was a Canadian of Scottish descent. Nothing else is known of him (inquiries in Canada proved fruitless). How Duncanson came to be born in New York is unknown, but his father may have had work there.

Duncanson's parents eventually separated. His mother returned to her Cincinnati relatives, leaving young Robert in his father's care. Why and when this separation occurred is not known, but apparently it did not occur when he was very young. That Duncanson later moved south to be with his mother on the edge of slavery, when many African-Americans were seeking the safety of Canada, indicates a strong filial relationship. Possibly the death of his father contributed to his move.

Growing up in Canada, Duncanson attended public schools that were excellent by the standards of the day. He developed a love of English poetry and received an education that was systematically denied most Africans, the overwhelming majority of whom lived in the slaveholding South. His knowledge of English poetry and literature was to provide him with themes for many of his paintings.[3]

Duncanson undoubtedly knew that he possessed artistic talent before he left Canada for Cincinnati in 1841. He may have believed that he had better opportunities to develop as an artist in that city than in Boston, Philadelphia, or New York, where African-Americans were denied admission by art schools. He probably knew from his mother, and from Underground Railroad connections, that some Cincinnati artists held antislavery views and would welcome black talent.

Cincinnati, which had had art schools since the early 1800s, had nearly 100 active artists when Duncanson arrived. The leaders of this pork-packing center ("Porkiopolis") believed their city would become a great cultural center and called it "the Queen City of the West." Nicholas Longworth and other leading citizens were determined to outdo eastern cities in cultural achievements. They enthusiastically built colleges, an opera house, law and medical schools, observatories, and scientific institutions. Chicago and Detroit were then only small towns, but Cincinnati's population had more than doubled between 1840 and 1850, rising from 43,000 to 115,000 and surpassing that of Pittsburgh.[4]

Many diverse cultural forces converged in Cincinnati; there were eastern businessmen, western hunters, preachers and abolitionists, rivermen, black and white southerners (including planters, runaway slaves, and slave hunters), and German and Irish immigrants seeking a chance. The three groups that Constance Rourke has identified as fundamental contributors to the formation of the American character—backwoodsmen, Yankees, and black Americans—were especially active.[5]

Cincinnati's African-American population was composed mainly of former slaves, many of whom

had escaped to Ohio's free soil a generation earlier. Some, who had been quietly set free by guilty fathers (masters), received continuing financial support. Altogether, these 3,000 black people constituted one of the largest concentrations of free African-Americans in America. They owned considerable property, and they had their own churches, schools, stores, hotels, and places of entertainment. Their leaders—John I. Gaines, Robert J. Harlan, Peter H. Clark, and others—were widely respected.[6] And they were the principal concealers of fugitive slaves who crossed the Ohio River from Kentucky nightly.

Backwoodsmen and western hunters came to Cincinnati to buy ammunition, guns, and camping gear. Plantation owners came for tools, farm equipment, and furniture. Some Yankees came to establish businesses, and others came to help slaves escape to Canada and to combat slavery. The Yankee influence was particularly strong in the pulpit and the courtroom. For example, the lawyer Salmon P. Chase, born in New Hampshire and later a member of Abraham Lincoln's wartime cabinet, fought many legal battles for fugitive slaves in Cincinnati with skill and tenacity. Harriet Beecher Stowe came to gather material for *Uncle Tom's Cabin*. Other Yankees aided the Underground Railroad and the city's abolitionist newspaper, which had 1,700 readers—a surprising number for a city on the edge of slavery and economically dependent on it.

These geographical, social, and cultural variables helped make Cincinnati a dynamic frontier. The city's numerous artists contributed to this excitement. Many were self-taught, engaged in portraiture and the painting of panoramas. They made huge scenic strips of canvas, approximately eight feet high, which were unreeled horizontally across a stage from giant vertical spools while a narrator extolled the depicted sights—Niagara Falls, the growing eastern seaports, biblical and American history, or a trip down the Mississippi. For people starved for education and "sights," these panoramas were the educational television of the day, and they helped make Cincinnati an artistic center.[7]

Most of Cincinnati's artists began as sign or house painters. But many became awed by the magnificence of the untamed wilderness at their doorstep and turned to landscape painting with a spiritual feeling. They saw the wilderness as God's work, allied with freedom and nature, but threatened by the destructive wastefulness of civilization. Panorama painting, which required landscape painting, fostered this interest.

Duncanson could not have found a more favorable environment for his artistic development. The rapid growth of Cincinnati's racially diverse population and the city's frontier spirit created a more tolerant appreciation of gifted African-Americans than could be found in older eastern cities. Here, in 1826, Edwin Forrest, a young actor who had been playing in blackface in a local theater, persuaded an old black woman to join him in an improvisation that was the first effort on the American stage to delineate African-American character without buffoonery.[8]

In Cincinnati it was possible for a black artist to participate in the city's artistic life and ultimately gain recognition as a significant contributor to the Hudson River school of landscape painting, a uniquely American phenomenon. Yet it was not clear sailing. The combination of Yankee abolitionists and free black people—and the way most Cincinnatians tolerated them—enraged the southern plantation owners who held the city's economic purse strings. Three times, in 1826, 1836, and 1841, they unleashed destructive rioting, led by Kentucky roughnecks, against black Cincinnatians and abolitionists.

In the spring of 1841 Duncanson joined his mother at her cottage at 7358 Hamilton Avenue in Mount Pleasant (later called Mount Healthy), a village fifteen miles north of Cincinnati.[9] The community had a small furniture factory and John P. Laboiteaux's barrel-making plant, its principal industry. The Laboiteaux family was particularly friendly to the Duncansons, and Duncanson may have worked as a varnisher or finisher in the furniture factory.

Employment was not always available for black men in Cincinnati itself. In 1807 and 1840 Ohio had passed "black laws" that, among other things, barred blacks from most skilled occupations and from serving as witnesses or militiamen. At times these laws were harshly enforced. In 1830, for example, the president of a unionlike association was publicly tried for helping a black youth learn a trade.[10] In prosperous times, however, enforcement lapsed. Just before Duncanson arrived in Mount Pleasant, prejudice against black men learning skills had weakened in Cincinnati. White and black artisans and mechanics were beginning to not only work together but also associate socially.

In this situation Mount Pleasant represented security for Duncanson. Its people generally were antislavery, and it had a number of black families. Like nearby College Hill, it was an important Underground Railroad station. One of its leading antislavery families was the Cary family. General S. F. Cary edited Cincinnati's temperance journal, and Freeman G. Cary had established the Farmer's College, near Mount Pleasant, to teach scientific agriculture. Freeman and William Cary later sat for portraits by Duncanson.[11]

Educated in Canadian public schools, where he had not been humiliated because of his race, Duncanson

did not have the apprehensions and inhibitions of most African-Americans, who had suffered constant harassment. Sociable, good-humored, modest but ambitious, he did not hesitate to declare his determination to become an artist—an unheard-of occupation for African-Americans. After he showed his sketches and drawings to Mount Pleasant abolitionists, they introduced him to artists in Cincinnati.

In the first days of September 1841, however, Cincinnati erupted with a massive new attack on African-Americans. Following the pattern set in 1826 and 1836, a mob led by slaveholding Kentuckians assaulted black people on the street, in their homes, stores, and churches. These attacks, ignored by the police, went on for four days. Black Cincinnatians, who vividly recalled how some 1,500 of them had been driven from the city in 1826 and forced to flee to Canada, defended themselves with firearms. The mayor and the police set about arresting black men, many of whom went into hiding. Finally, in an effort to stop the destructiveness, some 300 African-Americans agreed to go to jail if the mob could be stopped from wrecking homes. But once they were in jail, their homes, wives, and children were assaulted. The homes of abolitionists were also attacked, and the presses of the abolitionist paper were smashed and thrown into the Ohio River.[12] Duncanson and his mother undoubtedly were among the black and abolitionist families in Mount Pleasant who took in women and children fleeing from the terror in Cincinnati.

The violence , however, did not deter Duncanson. He was soon able to visit various artists in Cincinnati. On seeing Duncanson's sketches, they advised him to enter his work in the annual exhibition of the Western Art Union.[13] Its galleries matched those of the New York Art Union and could display 300 pictures. Anyone could join the Art Union for five dollars, entitling him or her to visit the galleries at will and to a chance in the annual lottery of paintings and statues. People as far away as Boston and New Orleans belonged in hope of winning a landscape painting by Thomas Cole or Asher B. Durand, or a statue by Hiram Powers, a Cincinnati clock repairer who had become America's most famous sculptor.

Through his contacts, Duncanson became acquainted with Thomas Worthington Whittredge, later a president of the National Academy of Design; Miner K. Kellogg, one of the city's most prolific portraitists; James H. Beard, an able portraitist who also did genre pictures of backwoods life, and James's brother, William. In addition, Duncanson met Thomas Buchanan Read, who had left an intolerable apprenticeship as a tailor to work as a sign painter in Cincinnati and then became a portraitist, a romantic historical painter, and a poet. He also came to know the artists William Penn Brannan, Charles Soule, William L. Sonntag, William Walcutt, and Joseph Oriel Eaton.

Although not entirely free of prejudice, some Cincinnati artists had been raised in Europe and, as a result, accepted talent in black people. In particular, it seems that Duncanson was helped by the Frankensteins, a large family of German-born painters prominent in Cincinnati art circles.[14] John, the oldest, was painting portraits in Philadelphia when Duncanson arrived. Godfrey, about Duncanson's age, was president of the Cincinnati Academy of Arts in 1841. Marie, a teacher, painted, as did Eliza, who often accompanied Godfrey on painting tours of New England. George was also a painter, working with John and Godfrey on a huge panorama of Niagara Falls. Another brother, Gustavus, specialized in seascapes. As a group, the Frankensteins were a warm, engaging family. Even though their own paintings were overly literal, with a limited artistic value, they enthusiastically believed that everyone had talent and needed only encouragement.

A basic purpose of the Cincinnati Academy was to conduct "self-improvement" sessions in drawing. Duncanson may have asked to join these sessions as a way of improving himself and then been encouraged to submit work to the Western Art Union exhibition. In any event he delivered three paintings to the 1842 Art Union exhibition: *Fancy Portrait*, *The Miser*, and *Infant Savior*, a copy. As Edward H. Dwight suggests, these paintings may all have been copied from engravings—a common practice for beginners.[15] Nevertheless, they had sufficient merit to be accepted and hung by the artists who controlled the exhibition, and they were listed in the exhibition catalog along with works by Cincinnati's best artists. Duncanson thus became the first African-American artist to exhibit work with other American artists, although it is not certain that he, his family, and black friends were allowed to attend the exhibition.

While Duncanson's general social acceptance can be documented, it remains a puzzle. Some writers have suggested that his light complexion resulted in his being considered white.[16] In fact, Cincinnati newspapers never mentioned that he was black until after his death. However, Duncanson was widely known as black, as Nicholas Longworth's later letter to the sculptor Hiram Powers indicates, and he consistently associated with other well-known black Cincinnatians. Merely being light-complexioned would not have accounted for his widespread social acceptance. In all probability Duncanson was considered an "exception" because of his superior Canadian education and speech, lack of timidity, and considerable artistic gifts. It was as "exceptions" that a number of extremely gifted

Man Fishing (1848) reveals marked improvement in Duncanson's handling of the figure over earlier efforts, which were often copied from engravings—for example, *Shakespeare on Trial*. (18 x 30″) Babcock Galleries, New York.

black Americans were permitted to gain prominence in sports, music, opera, and literature. Along with the mathematician Benjamin Banneker, Duncanson may have been one of the first African-Americans to be treated in this way.

Initially Duncanson may have had an easier time because, after the riots of 1841, some Cincinnati leaders were revolted by the injustices to African-Americans. Cincinnati artists appear to have genuinely accepted Duncanson as a talented colleague, and nothing in the press of the day, letters, or diaries indicates otherwise.

So why did neither the Cincinnati newspapers nor Charles Cist, the busy chronicler of the city's achievements and activities, mention Duncanson's race until long after he was dead? They all knew that he was black. There may have been friendly and sympathetic

reasons for this omission. Mentioning Duncanson's race might have resulted in a denial of his artistic abilities in addition to hurting his sales and commissions.

In the 1843 Art Union show Duncanson exhibited only one painting, a historical scene. Entitled *Shakespeare on Trial*, it was derived from an engraving of an 1837 painting by Sir George Harvey, a Scottish academician, showing the playwright's trial for poaching.[17] Duncanson created his own composition, but the stiff figures reveal a lack of knowledge of anatomy and drawing, something that would have been difficult for him to obtain without formal training.

Although it has been repeatedly reported for many years that the "Anti-Slavery League" sent Duncanson to Edinburgh for art training,[18] we have not been able to confirm this either in abolitionist records, diaries,

correspondence, or visits of inquiry to the Royal Scottish Academy of Art in Edinburgh in 1979. Duncanson was largely self-taught, although he benefited from discussion and association with other Cincinnati artists. That he was abroad in 1853 and in Edinburgh in 1866 may have prompted the myth of support from the "Anti-Slavery League."

After 1843 Duncanson was not represented in the Art Union exhibitions for the next few years. With so many artists in Cincinnati, he may have felt that the situation was too competitive, for he moved to Detroit in 1845. At the time that city had only 10,000 people and virtually no artists. Moreover, the major African-American communities in Canada were located near Windsor, across the river from Detroit, and Duncanson may even have been brought up in that area.

In Detroit, Duncanson painted the portrait of young William Berthelet, a member of one of its oldest and wealthiest families.[19] The *Detroit Daily Advertiser* reported on February 2, 1846:

> We have intended for some time to call the attention of our citizens to the paintings of Mr. Duncanson, a young artist who has been some weeks here, and has rooms in the Republican Hall over James Watson's store. Mr. Duncanson has already taken the portraits of a number of our citizens and has designed and finished several historical and fancy pieces of great merit.
>
> The portraits are very accurate likenesses and executed with great skill and life-like coloring. A copy of the "School-room," just finished from a picture in one of the annuals, is full of the spirit and beauties of the original, and a portrait of a young bride, who has recently come amongst us, is one of the most striking likenesses and tasteful pictures we have ever seen from the pencil of so young an artist. Mr. Duncanson deserves, and we trust, will receive the patronage of all lovers of fine arts.

Despite such praise, Duncanson could not count on sales and commissions. Detroit was a far cry from the culturally striving Queen City. Unable to pay his rent, Duncanson grew increasingly despondent. One day he met Henry N. Walker, a prominent merchant, on the street. Learning that Duncanson had been evicted from his quarters and recognizing that he was severely depressed, Walker gave him fifty dollars. With that money, Duncanson retrieved his belongings from his landlord and returned to Cincinnati. Years later, after a successful tour abroad, Duncanson insisted on giving Walker one of his most beautiful still lifes, *Fruit Still Life*.[20] (Duncanson's still lifes, particularly his fruit and "fancy" pieces, had an engaging quality that attracted much interest.)

After Duncanson's return to Cincinnati, his work gradually began to be purchased by influential people, such as Calvin T. Starbuck, publisher of the Cincinnati *Times*; James Foster, publisher of the *Chronicle* and *Atlas*; Thomas Faris, a leading daguerreotypist; Dr. Robert S. Newton and Dr. James Oliver, two physicians; and Charles Stetson, president of the Ohio Life Insurance and Trust Company. One of the first to buy Duncanson's work was Dr. William H. Brisbane, who had been an editor and slaveholder in Charleston, South Carolina, and then became an abolitionist. He helped organize the 1852 Cincinnati Antislavery Convention, at which Frederick Douglass took a leading role.

Duncanson also painted a portrait of James G. Birney, a southerner who had freed his slaves and become an abolitionist in Cincinnati. He did this portrait in 1846 after Birney ran for president on the Liberty Party platform, urging the abolition of slavery; it has since been lost. That same year Duncanson also made a portrait of Lewis Cass, Michigan's pioneer governor, statesman, and later a presidential candidate.[21] It is in the Michigan House of Representatives.

Another purchaser was Nicholas Longworth, Cincinnati's leading art patron. An early supporter of Hiram Powers, Longworth had financed the sculptor's trip to Florence, Italy, where he remained for the rest of his life.

Sometime in 1847–48 Longworth invited Duncanson to his Pike Street mansion, Belmont, which was filled with work by the nation's leading artists. In addition to Powers's sculptures, there were paintings by Benjamin West, Asher B. Durand, and Thomas Cole, the founder of the Hudson River school, whose famous series *The Voyage of Life* was featured at the 1847 Western Art Union exhibition. Longworth asked Duncanson to paint a series of landscapes directly on the plaster panels of the mansion's center hall. This was a major commission, with eight large vertical panels and two horizontal panels. Whittredge, James Beard, Read, Sonntag, or any other of the city's well-known artists would have been delighted by such an assignment. Longworth's personal sponsorship guaranteed other commissions and sales as well as recognition for Duncanson.[22]

The Belmont murals demonstrate Duncanson's mastery of large canvases and decorative spatial design. One panel shows a swirling stream moving from the far distance, over a falls, and into the foreground. Broad foliate forms and red berries, similar to those Duncanson painted in his fruit still lifes, appear in some of the murals. Another panel depicts an ancient ruin in the middle distance, with houses typical of early

Nicholas Longworth's selection of Duncanson in 1858 to paint murals in the hall of Belmont, his Cincinnati mansion, greatly aided the artist. These panels of the Longworth murals depict such scenes as a typical English thatched cottage (far left) facing a stream, with houses characteristic of early Cincinnati in the distance, showing Duncanson's skill in combining European pictorial themes and American landscapes. (91 x 109″) Taft Museum, Cincinnati

Cincinnati overlooking a broad stream in the background.

In one mural huntsmen gather about a fire on a point high above a river. In another panel European-type courtiers on horseback cross a bridge in the foreground while a baptism occurs at the river's edge; a castle in the middle distance completes the composition. The next mural presents a hilly landscape, typical of those around the Queen City, with a winding stream and a palatial building at the water's edge, and brightly costumed figures disembarking from boats. Another mural shows a broad placid stream, flowing from hazy hills and mountains in the distance and breaking into a cascade amid lush tropical plants in the foreground. Still another mural portrays an encampment with human figures and a waterfall rendered in a small scale to emphasize the feeling of vast space suggested by the hazy atmospheric effect of far mountains and hills. A final large mural depicts a typical thatched English cottage of the eighteenth century, facing a stream in the middle distance, while far off are, once again, houses characteristic of early Cincinnati.

There are four shallow horizontal panels over doorways. Two depict an eagle with outspread wings.

The other two show a compote holding fruit and flowers, a favorite subject of Duncanson.

The murals reflect Duncanson's growing command of western landscape painting as well as an understanding of European pictorial themes, which he had probably acquired from studying engravings. Duncanson skillfully combined lush tropical vegetation and horsemen—European-type courtiers rather than western American riders—with American images, such as vast distances, hazy mountains, and swift-flowing streams and waterfalls. The large murals are set in painted rococo frames that are so deceptive that one has the illusion that the frames are real.

Delighted with the panels, Longworth invited his friends to see them. In a letter to his sister, he described the panels as "excellent examples of the period" by the "well-known painter Duncanson, who had a studio in Cincinnati."[23] The murals greatly enhanced Duncanson's reputation.

Today these paintings are considered among the finest wall paintings in an American home. They have remained a major feature of Belmont, which is now the Taft Museum. Although a later owner covered the Duncanson murals with wallpaper, they fortunately

J. P. Ball's Daguerreotypy Salon, Cincinnati's most fashionable portrait center, displayed landscapes by Duncanson, who worked with Ball. This engraving appeared in *Ballou's* (formerly *Gleason's*) *Drawing Room Companion* in 1854. General Research Division, New York Public Library

had already been protected by many layers of varnish. When Mrs. Charles Phelps Taft had the wallpaper removed in the 1930s, the murals were still in excellent condition.[24]

In 1849, probably while completing the Longworth murals, Duncanson began working with one of the most extraordinary daguerreotypists America ever produced—James Presley Ball, an African-American of considerable artistic talent and organizing ability who signed his work "J. P. Ball." Born in Cincinnati, Ball worked as a waiter on riverboats and later in White Sulphur Springs, West Virginia, the nation's most fashionable spa. At this resort Ball saw his first daguerreotypes in 1845 and learned the trade. He then opened a daguerreotype studio in Pittsburgh. When it failed, he moved to Richmond, where he succeeded so well that in 1849 he decided to try a larger city, Cincinnati.[25]

Like many artists, Duncanson was fascinated by daguerreotypes, although he may have shared the feeling of some who believed that the photograph meant the end of portrait painting. In any case, after the Longworth murals were completed, Duncanson learned how to make daguerreotypes from Ball and decided to join him.[26] Although continuing to paint, he became preoccupied with working with Ball, who was not only an expert photographer but also a showman and entrepreneur.

By 1851 there were thirty-seven daguerreotype studios flourishing in the Queen City. Ball's was the most elaborate and fashionable, patronized by the leading families and famous far beyond Cincinnati. One of Ball's most famous daguerreotypes was of Jenny Lind, the "Swedish nightingale." Ball employed nine assistants and boasted that his work took only minutes—"not a whole day." An engraving in the April 1, 1854, issue of *Gleason's Pictorial Drawing Room Companion* shows six of Duncanson's landscapes hanging in Ball's main salon, helping to make it the most artistic and elegant in the city. The landscapes were also mentioned in advertisements, Ball's salon serving as a commercial gallery for Duncanson's paintings.[27]

Ball had an acute sense of what fascinated people. One day he had the idea of doing a panorama that depicted the history of slavery and the life of black people in the United States. Well aware that white people had little knowledge of the real lives of black people or their history, Ball created his famous panorama, which took nearly half a mile of canvas. It combined views of the United States with the history of black people under the title *BALL'S SPLENDID MAMMOTH PICTORIAL TOUR OF THE UNITED STATES, Carrying Views of African Slave Trade, Northern and Southern Cities: Of Cotton and Sugar Plantations: Of the Mississippi, Ohio and Susquehanna Rivers, Niagara Falls, etc.* Although there is no direct proof, and the panorama itself has been lost, Duncanson probably

played an important role in the work, because he was Ball's close collaborator and an expert landscapist.

As the panorama was unreeled, moving horizontally from one huge upright spool to another, it was accompanied by a narrative lecture explaining the scenes. Ball's lecture notes, published in 1855, indicate that the panorama opened with a sunrise view of an African village, with the people going off on a lion hunt. Afterward the village was raided by slavers. Then came scenes showing the loading of chained slaves onto ships and the way the ships eluded the antislavery patrol at sea by casting some of their human cargo overboard to lighten the load. Next there was the auctioning of the slaves along with cotton, liquor, and cigars, in New Orleans and Charleston.

The scene shifted to a Louisiana plantation, where the slaves were skilled in many trades, including carpentry, blacksmithing, leatherworking, cooking, and picking cotton. This was followed by depictions of the overseer's cruel beating of slaves and a view of some exhausted runaway slaves asleep in a swamp while slave hunters with bloodhounds approached.

Successful escapes from slavery were portrayed, including a runaway slave crossing the Ohio River on a log—a scene well known to Cincinnatians. That part of the panorama concluded with a view of Niagara Falls and the fugitives arriving on Canadian soil, which was a scene that Duncanson had probably personally witnessed.

Ball brought his "splendid mammoth pictorial tour" up to date by adding scenes of recent local events. He included depictions of the assaults on black people in Cincinnati in 1826, when many were forced to flee to Canada, as well as the wrecking of the abolitionist press in 1836 and 1841, and the famous trials of fugitive slaves. As the panorama ended, Ball recited Henry Wadsworth Longfellow's poem "The Warning," in which black people were compared to "a poor blind Sampson" who might some day "raise his hand/and shake the pillars of our commonwealth,/till the vast temple of our liberties,/a shapeless mass of wreck—and rubbish, lies."[28]

Without Ball's commentary, we would not even know about this extraordinary early visualization of the history of black Americans as seen by black men. And we can only speculate about the artistic merits of the panorama, what Duncanson's contribution was, and the impact on those who saw it. One indication of its merit is that, although few panorama narratives were ever published, Ball's narration was published by Achilles Pugh, an abolitionist printer whose shop was wrecked in 1836 and again in 1841. The incredible nature of the project is underlined by the fact that not

until the 1930s, about seventy-five years later, when Aaron Douglas created his murals in the Harlem library, did a black artist again paint such large scenes of African-American history.

Duncanson's association with Ball provided a steady income. Although still residing in Mount Pleasant, he apparently spent most of his time in Cincinnati. Shortly after coming to Mount Pleasant in 1841, Duncanson had married a young black woman who, according to some sources, had escaped from slavery.[29] She bore him a son, Reuben, but died soon afterward, (exactly when is unknown). Reuben was apparently raised by Duncanson's mother in Mount Pleasant while Duncanson tried to earn a living as a painter and daguerreotypist in Cincinnati. When Reuben was old enough to work, Duncanson helped him obtain work as a clerk in Cincinnati.[30]

During his association with Ball, Duncanson continued to paint and often visited his friends' studios. He was increasingly impressed by the work of William L. Sonntag,[31] who had been born of German parents in East Liberty, Pennsylvania, outside Pittsburgh, in 1822, only a year earlier than Duncanson. Imbued with the concepts of the Hudson River school, Sonntag had come to Cincinnati shortly after Duncanson. While many of the city's artists were both sentimental and literary, Sonntag was relatively free of these tendencies and concerned himself with the structure of his composition.

In their early efforts as artists, Duncanson and Sonntag apparently shared many experiences and thoughts. Like Duncanson and most Cincinnati artists, Sonntag also worked on panoramas, particularly a depiction of John Milton's *Paradise Lost*. Duncanson's knowledge of Milton may even have played a role in the development of their friendship.

While Duncanson was painting the Longworth murals, Sonntag was gaining recognition in eastern cities. In 1851, for example, Cist noted that "many of Sonntag's best works are in our Atlantic cities."[32] When Duncanson resumed painting full-time, he was greatly influenced by Sonntag, whose canvases were highly disciplined and precise in the placement of every object and brushstroke. Sonntag and Duncanson may have gone on sketching expeditions together outside Cincinnati; some of their paintings have strong similarities.

In 1851 or 1852 Duncanson completed one of the most distinguished American midwestern landscapes, *Blue Hole, Little Miami River*, which is his best-known work today.[33]

The setting, near the junction of the Ohio and

Duncanson was much influenced by W. L. Sonntag, also a Hudson River school artist. Duncanson's *Landscape with Classical Ruins, Recollections of Italy* (top: 1854; 34 x 59"; Howard University Gallery of Art) seems almost a twin of Sonntag's *Classical Italian Landscape with Temple of Venus* (1860; 36 x 60"; Corcoran Gallery of Art, Washington, D.C.). The two artists traveled to Europe together.

Little Miami rivers, was well known to Duncanson. It was a favored escape route for fugitive slaves.

The painting has a classical composition. A diagonal begins in the top of the trees in the upper right, passes through the center, and continues in the shading of the river; a similar diagonal moves down the left. Light and dark areas are balanced on both sides. The triangular-shaped sky is repeated in the water's reflection, forming an hourglass shape in the center. Similar classical arrangements were utilized by Claude Lorrain

and such great seventeenth-century Dutch landscapists as Aelbert Cuyp, Meindert Hobbema, and Jacob van Ruisdael. In *Blue Hole* every detail is rendered in a sharp, analytical, and meticulous manner. This style characterized not only Duncanson's work at the time but also that of Sonntag and many other painters of the Hudson River school.

The work disappeared soon after Duncanson finished it. In 1926 architect Norbert Heermann, recognizing the painting to be a classic western landscape, purchased it at a New York auction for eighty dollars, according to E. H. Dwight.[34] Heermann (who was the biographer of a later Cincinnati painter, Frank Duveneck) and his friend Alexander Helbig presented the work to the Cincinnati Art Museum, where it hangs today.

Early in 1853 Duncanson painted an illustration of *Uncle Tom's Cabin*, which was titled *Uncle Tom and Little Eva* by Francis W. Robinson of the Detroit Institute of Arts. The work was commissioned by James Francis Conover, an editor of a Detroit newspaper who had once been a lawyer in Cincinnati and who knew that Duncanson was familiar with the river crossings of fugitives. The painting, a tranquil river scene, radiant and misty with sentimental idealism in depicting Uncle Tom and Little Eva, hardly matches the antislavery drama of Harriet Beecher Stowe's book.[35]

During this period Duncanson achieved a long-standing goal: he traveled to Europe to see the great masters, and to paint and study there. Duncanson arranged for his son to stay at the Laboiteaux home. His friend Sonntag accompanied him on this trip.[36]

At the time Italy was an important gathering place for American artists and writers. Sculptors like Horatio Greenough, Thomas Crawford, and William Wetmore Story, as well as painters like Washington Allston and William Page, had clustered in Rome and Florence. Many Cincinnati painters, including Whittredge, Kellogg, and W. H. Powell, had studied in Italy.

Duncanson carried a letter from Longworth to Powers, whose studio in Florence attracted many distinguished visitors, including Nathaniel Hawthorne, the Brownings, and Mrs. Trollope. Longworth had already written to Powers about Duncanson a year earlier.[37] Now he wrote: "This letter will be handed to you by Mr. Duncanson, a self-taught artist of our city. He is a man of integrity and gentlemanly deportment, and when you shall see the first landscape he shall paint in Italy, advise me the name of the artist in Italy that, with the same experience, can paint so fine a picture."[38]

In addition to Powers, Duncanson and Sonntag met most of the other American artists in Florence. Read, another Cincinnati artist aided by Longworth, had pre-

ceded them, although it was his romantic poetry rather than his painting that was winning attention.

During his eight months in Europe, Duncanson toured the museums and saw for himself exactly what the great masters of the past had done. He was inspired by painting and sketching trips in Italy, as well as his visit to England. In London he met Charlotte Saunders Cushman, the greatest actress of that day and an extraordinary personality who later played a significant role in his life.[39]

Alive with confidence, Duncanson returned to Cincinnati at the end of 1853. In a long letter to Junius R. Sloan, a young Pennsylvania painter who had visited Cincinnati three years earlier and admired his work, Duncanson poured out some of his reactions to Europe: "Every day that breaks, to my vision, sheds new light over my path. What was once dark and misty is gradually becoming brighter. My trip to Europe has to some extent enabled me to judge of my own talent. Of all the landscapes I saw in Europe (and I saw thousands) I did not feel discouraged."[40]

Reporting that he was using the studio of another artist, Duncanson described his work on a view of Tivoli, "a scene near Rome and one of the grandest scenes in Italy. As I progress, I can see my improvement. My friends are looking for something great from the knowledge gained abroad. So you see, I must not fag. Cincinnati, in the absence of Sonntag and Your Humble Servant, has not progressed much in the Art."

His lengthy letter hailed the masterpieces in London, the English watercolorists, the masters of the Italian Renaissance, the French historical painters, and Rembrandt, Titian, Van Dyke, Raphael, and Michelangelo. Praising English landscapists generally, Duncanson hailed "the landscapes of J. M. Turner. He was a modern phenomenon in the art of landscape. He was neither good nor bad, but singular—singular indeed— I could describe to you his pictures by word of mouth, but not in black and white. Suffice it to say—he was a singular genius. *Praise to his ashes!*"

This astute evaluation of Turner reflected Duncanson's new appreciation of an art that did not attempt to copy nature meticulously—a daring idea in America in 1854 and in great contrast to his own *Blue Hole, Little Miami River.* Duncanson concluded his letter: "Now I will let you know why I returned so soon. I was disgusted with our artists in Europe. They are mere copyists, producing pictures [that are] hardly mediocrity. All I wanted was to see, and I have seen. Some day I will return and refresh my memory."

In other letters to Sloan, Duncanson revealed that he was working on paintings ranging from views of

In a letter to Junius Sloan on September 17, 1854, Duncanson sketched an illustration for Bunyan's *Pilgrim's Progress* showing Christian and Hopeful entering the land of Beulah in sight of the Celestial City. He had just returned from touring Europe and was made confident by what he had seen. Newberry Library, Chicago

Richard S. Rust I was the first president of Wilberforce University and a prominent Cincinnati abolitionist. He helped to establish colleges for African-Americans in each of the southern states during Reconstruction. This portrait (1858) has remained in the Rust family. (30 x 24") Collection Richard S. Rust III, Cincinnati.

After his trip to Europe, Duncanson's portraits had more feeling for the character of their subjects. One of the best depicted Richard S. Rust, a Methodist antislavery educator and Wilberforce University's first president. Rust aided Bishop Daniel A. Payne in arranging for the African Methodist Episcopal church to assume responsibility for that university in 1863. Rust also purchased other Duncanson paintings, most notably *The Cave*, which is still owned by the Rust family in Cincinnati.[41] Some of Duncanson's portraits of this period awkwardly combined a daguerreotype-like realism in the treatment of the face with a romantic Neoclassical background in the popular style of the time, including fluted columns, billowing drapes, marble floors, and symbolic devices. Some portraits also suffer from the sitter's stilted posture, possibly because the portrait was derived from a daguerreotype.

The Rust portrait and the full-length portrait of Longworth, both done in 1858, are exceptions. Longworth was the sitter whom Duncanson probably knew best and toward whom he felt warm gratitude. In paint-

The Cave (1869), depicting men and women on a wilderness path to a cave, reflects Duncanson's focus on the intrusion of civilization on unspoiled nature, a Hudson River school theme. Duncanson's work places him in the front rank of that school, yet his greatest recognition came in Canada, England, and Sweden. (36 x 31″) Collection Richard S. Rust III, Cincinnati

homes to *The Lone Indian*—"one of the best I ever painted"—and *The Tuscan Flower Girl*. He reported that a Detroit gentleman had offered $1,000 for a scene from John Bunyan's *Pilgrim's Progress*, and he sketched his basic composition in the letter. None of these paintings have been located.

Duncanson's letters also amusingly mentioned his visits with other Cincinnati artists:

> Now to Art and artists: Well, the Art Union is going on, getting a subscriber once in two months—that will not pay, you know, but so it is. The artists are working. Sonntag is painting the same old pictures he painted three years ago. Beard is at work on portraits. Eaton is at work, painting some fine heads. Frankensteins [John, Godfrey, and others in the family] are here, painting the same green grass landscapes. They will keep them in their rooms for fear they will get eaten up by the cows. John K. Johnson!!! Ha, ha, he is hard at it, painting all kinds of pictures. The Lord save him, for his paintings will not. Friedland [John] is improving very fast. He paints well.

Duncanson's portrait of Nicholas Longworth (1858) sought to reflect his patron's diverse interests, the grapes symbolizing his effort to develop American wines. The envelope addressed to Duncanson constitutes his signature. (84 x 60″) Fine Arts Collection, University of Cincinnati

ing this portrait Duncanson drew on almost everything he had learned as a painter. He rendered the face realistically, but he blended into the background elements of Neoclassicism and Romanticism, such as the lifted curtain and the distant Cincinnati hills (from which Longworth made his fortune). To show Longworth's interest in artists, an envelope lying at his feet is addressed to Duncanson at his studio. The portrait avoids the pomposity typical of the period and converts the obvious symbolism of Neoclassicism into decorative devices. What comes through is a sense of the sincerity and purposefulness of Longworth as a man. He was then seventy-six years old, which may account for the arthritic stance of the figure. Longworth sat for many artists, including Powers, but Duncanson's portrait is the most memorable.

On returning from Europe, Duncanson became increasingly interested in the American landscape. His work was freer. It was also in greater demand. He made painting trips to the western plains, the Ozarks, Minnesota, Niagara Falls, and the White Mountains of New England, a favorite locale of the Frankensteins. These expeditions were an important influence on his greatest work.

In about 1857 Duncanson moved from Mount Pleasant to Cincinnati and married a young Kentucky-born woman named Phoebe.[42] The couple soon had a son, whom they named Milton, reflecting Duncanson's love of the English poet's work. Later, they had a daughter, Bertha. Reuben, Duncanson's son from his first marriage, was working as a clerk in Cincinnati, according to the U.S. Census of 1860; he was about eighteen years old.

By 1860 Duncanson was well established, with commissions from as far away as Boston. In 1858 he had bought and sold real estate in Detroit,[43] which he often visited. However, Cincinnati continued to be his base. He owned a house valued at $3,000, with personal effects worth $800—which reflected a considerable degree of financial success for any artist in those days.[44]

Yet Duncanson was aware that only eastern artists were part of the National Academy of Design and only they could gain national attention. Cincinnati artists were simply ignored, and many of them raged about this state of affairs—especially after Whittredge, just home from Europe, announced he was settling in New York. Duncanson's old traveling companion, Sonntag, had already established himself there. So had others.

Although Whittredge later became president of the National Academy, he found it difficult to leave his old Cincinnati friends. If Duncanson considered going to New York or Philadelphia, he would not just lose friends—he would be confronted with the probability that as a black man he would not be accepted in eastern art circles. He had a strong supportive base in Cincinnati's African-American community and among its influential abolitionists.

Yet, geographically, Cincinnati was deep within slaveholding territory, and it had become a magnet for both runaway slaves and slave hunters. As the threat of civil war thundered out of Washington, Cincinnati's large free black population grew both tense and determined. Duncanson felt the tensions and anxieties of the people with whom he lived—and he could not risk starting all over again in New York, Boston, or Philadelphia. He had to find another way to keep pace with other leading artists.

No artist escapes his time and place. Late in 1860 Duncanson became fascinated with the idea of depicting the mythical land created by Alfred Tennyson in his 1842 poem "The Lotos-Eaters." The poem describes how the war-weary Greek warriors of Odysseus stop at a beautiful island on their way home and eat the fruit of its lotus trees. They then lose all interest in going home, making war, or doing anything except living a sensual existence on this magical island. Pervaded by a melancholic yet dreamlike escapism, Tennyson's poem entranced millions of American and British readers, who saw it as a conflict between idyllic dreams and duty.

"The Lotos-Eaters" had a particular meaning for Duncanson. On his expeditions into the western wilderness, he had encountered natural scenes so beautiful, so peaceful and enchanting, that he had frequently wished to stay there forever. These vistas conflicted with the wearying complexity of his life as a black man in a society burdened with racial prejudice and the growing general awareness that the struggle over slavery could not be postponed. Thus Duncanson's approach to the poem did not stem from a simple escapist wish. Instead, it derived from two deeply felt realities. He had direct experience of nature's beauty. But, more important, at the end of his trips Duncanson, like Odysseus' warriors, did not want to return "home," for there he would have to face the other reality: the tensions engendered by slavery and racial prejudice. To express this conflict imaginatively in a painting Duncanson needed to portray the allure of another world—not the western landscape, but one possessing its aura of innocence and peace.

Before Duncanson could complete his large canvas of *The Land of the Lotus-Eaters*, the Civil War began. African-Americans in Cincinnati, knowing the city's close economic and social ties to the South, realized

how extremely vulnerable they were to an invasion by Confederate troops. Determined to defend their freedom, Peter H. Clark, John I. Gaines, and other black leaders began organizing "Home Guards" among their people to challenge a Confederate invasion at the Ohio River's edge. But they were harassed by the police, forced to take down the American flag at their recruiting post, and told: "Keep out of this! This is a white man's war."[45] Cincinnati mayor George Hatch was pro-slavery, and the black community feared that Hatch, his political friends, and the police would surrender the city to the Confederates.

Amid these tensions Duncanson worked on *The Land of the Lotus-Eaters,* but he could not seem to finish it. After six months' work, he finally exhibited it. The *Cincinnati Weekly Gazette* of May 30, 1861, reported that it was on view in Pike's building, noting that it was reminiscent in some ways of Frederick E. Church's glowing *Heart of the Andes,* which had been shown earlier in Cincinnati. Indeed, Duncanson's difficulties in finishing his painting may have developed because some scenic aspects of his work inevitably suggested the idealized and peaceful grandeur of Church's mountains. The *Gazette* also reported that after exhibiting the painting for eight days, Duncanson planned to exhibit it and another painting, *Western Tornado,* in Canada and then take it to London to be sold. Presumably *The Land of the Lotus-Eaters* would bring the highest price in Tennyson's native land.

On June 3, the *Gazette* reported the praise of viewers and asserted that if New York art lovers studied Duncanson's painting, "they will not hesitate to enroll the name of the author in the annals of artistic fame. So with Boston and Philadelphia." The next day the *Gazette* announced that the painting would be held in Cincinnati for another week before being taken to Canada.

The *Gazette* plea to New York art lovers underscored the neglect felt by Cincinnati artists, who strongly believed they were the equal of eastern artists. None believed this more than John Frankenstein, a child prodigy who by age eighteen was a professional portraitist in Philadelphia. He exhibited widely there before returning to Cincinnati. Frankenstein's irritation with the attention paid to eastern artists prompted him to write a provocative book of satirical doggerel entitled *American Art—Its Awful State.* In it he attacked eastern writers like Ralph Waldo Emerson, who wrote abstractly about "Art," and he lambasted adulation of Church's work, especially his painting of Niagara Falls. Depicting Niagara Falls was then a kind of national competition among artists, including Duncanson. Incensed by the way Church ignored naturalistic detail and color, Frankenstein concluded:

Yet in *Niagaras* he is almost shamed
in his own way by two who're not so famed,
by George L. Brown and R. S. Duncanson—
Some very curious things the Lord has done
He made Niagara—then made this trio,
Church, Brown and Duncanson! Rejoice Ohio!
Of these great painters of Niagara,
thy colored son deserves the most *éclat.*[46]

When Frankenstein's verses were finally published in the winter of 1863, they delighted Cincinnati artists and scandalized Church's eastern worshippers. Duncanson, however, was already convinced that he could not attain national recognition if he remained in Cincinnati. He wanted to travel to Canada and then to London with what he considered his greatest work, *The Land of the Lotus-Eaters.* But events intervened, and his move to Canada did not occur immediately. First, a Cincinnati lawyer, Samuel T. Harris, commissioned a replica of the *Lotus-Eaters.* Then, Duncanson received a commission to copy Charles Wimar's then new *Buffalo Hunt,* with Indians astride racing horses overtaking buffalo.[47] At some point Duncanson took some paintings, including perhaps the *Lotus-Eaters* and *Western Tornado,* to Toronto, where they were exhibited in the fall of 1861.[48] He then traveled in the western United States, sketching a prairie fire and painting the forests, lakes, and streams of Minnesota, which had the untamed quality that the Hudson River artists sought. After this trip Duncanson returned to Cincinnati.

With the war centered in the eastern states, many Cincinnati artists headed for the wilderness. Noting that the war and "fear of being arrested for endeavoring to evade the draft, and many other considerations consequent on the war, have prevented them [Cincinnati artists] from traveling so much this year," the *Cincinnati Daily Gazette,* on November 24, 1865, described the sketching tours of sixteen local artists who did travel. Duncanson was second on its list, which included James Beard, Joseph Oriel Eaton, Thomas Buchanan Read, William Porter, Thomas C. Lindsay, Henry W. Kemper, and William Penn Brannan. Duncanson had spent "three weeks sketching on the upper Mississippi," the *Gazette* reported on October 22, 1862. On completing *The Falls of Minnehaha,* a scene sketched in Minnesota, Duncanson was immediately commissioned to make a copy for a Boston gentleman, the *Gazette* also reported.

Late in the summer of 1862, after Duncanson, Eaton, Read, and other artists had returned, Confederate forces under General Kirby Smith began to move

31

on Cincinnati. The city appeared defenseless, with only its black people and abolitionists prepared to fight.

Still busy with summer sketches, Duncanson must have been as surprised as anyone when an unknown Union officer from Indiana, General Lew Wallace, later famous as the author of *Ben Hur,* arrived with a handful of officers and called for a citizens' defense of the city that "must be performed equally by all classes." He closed all businesses and saloons, stopped the ferries to Kentucky, and summoned all people to defend the city: "Citizens for labor, soldiers for battle." Wallace appealed for Ohio and Indiana volunteers, promising every man a choice: "Those who say fight, we will organize into companies and regiments; to the others we will give spades and picks and set them to digging" fortifications.[49] But then, ignorant of local politics, Wallace put pro-Confederacy Mayor Hatch in charge—and Hatch promptly ordered the arrest of every black man his special police could find, locking them up in a Plum Street pen.[50]

Many outstanding African-American men, including Clark and Gaines, eluded Hatch's police. Some hid in the Lane Seminary, Walnut Hills, College Hills, or Mount Healthy. Whether Duncanson, J. P. Ball, and others hid or were captured remains unknown. However, General Wallace had appointed Read, whom Duncanson knew well from studio visits, as his personal adjutant soon after his arrival, and Duncanson may have served in a liaison role between Read and the black leaders in hiding. At the time black leaders counseled their people to remain calm lest a race riot destroy the possibility of a citizens' defense of the city.

When General Wallace learned of the mass arrests, he immediately stripped Mayor Hatch of all authority over African-Americans. He appointed a longtime friend of black Cincinnatians, Judge William M. Dickson, to be the colonel in charge of all matters related to them. Dickson promptly released the jailed African-Americans, urging them to volunteer for the city's defense. The next day more black men poured out of hiding to volunteer, with Colonel Dickson hailing them as "The Black Brigade of Cincinnati." Working a mile closer to Confederate troops than armed Union forces, the Black Brigade fortified Cincinnati while some 60,000 self-armed volunteers called "Squirrel Hunters" poured into the area from Ohio and Indiana farms. They formed such a reckless, massive army that the Confederates retreated—and Cincinnati was saved without the loss of a single man.

In the city's jubilant celebration, the Black Brigade was counted among its special heroes. A letter in the *Tribune* of September 7, 1862, noted: "While all have done well, the Negroes as a class must bear away the palm. . . . Whenever the men of the Black Brigade appear, they are cheered by our troops." Thus virtually overnight the status of black people changed from being abused, or at best merely tolerated, to being recognized as worthy and patriotic citizens.[51]

There is no direct evidence of Duncanson's role in these events. He is not listed as a member of the Black Brigade. He may have been out of the city, even in Canada. What is important is that as an African-American, Duncanson could not be immune to the life-and-death tensions experienced by his family and friends in Cincinnati—or the wish to escape such a situation. These pressures, not simply his love of English poetry, were released in his unusual American painting *The Land of the Lotus-Eaters,* painted *before* Cincinnati had to be defended. Unless this is recognized, *The Land of the Lotus-Eaters* is a simply an illustration of Tennyson's poem and there is nothing African-American about it.

Two days after the Black Brigade was mustered out, President Lincoln announced that the Emancipation Proclamation would be issued on January 1, 1863. For the African-American men and women of Cincinnati, this prospect linked their own vigorous defense of their homes and freedom with the great dream of ending slavery forever. They saw themselves—and were seen by others—with new eyes and a new kind of confidence, an optimism that Duncanson undoubtedly shared.

It gave him the confidence to move toward gaining recognition far beyond Cincinnati and even the East. Duncanson was keenly aware that painters whom he considered his friends and equals were being elected to the National Academy of Design. Both Sonntag and Whittredge were elected in 1861; Kellogg and Eaton were added soon afterward. Surely Duncanson dreamed of achieving membership, but he was too realistic not to be aware of the difficulties he faced. One way that Duncanson could significantly advance his status in the United States, leapfrogging virulent racial prejudice and forcing consideration of his painting in eastern cities, was by gaining recognition abroad.

In May 1863 Duncanson confided to an Englishman visiting Cincinnati that he intended to go to England "for a home" and would bring with him his large canvases, including *The Land of the Lotus-Eaters, Prairie Fire,* and *Oenone,* another work based on a Tennyson poem.[52] That summer he collected the *Lotus-Eaters* and other paintings in Toronto and moved on to Montreal, the economic, political, and social center of Canada. There Duncanson immediately met William A. Not-

how extremely vulnerable they were to an invasion by Confederate troops. Determined to defend their freedom, Peter H. Clark, John I. Gaines, and other black leaders began organizing "Home Guards" among their people to challenge a Confederate invasion at the Ohio River's edge. But they were harassed by the police, forced to take down the American flag at their recruiting post, and told: "Keep out of this! This is a white man's war."[45] Cincinnati mayor George Hatch was pro-slavery, and the black community feared that Hatch, his political friends, and the police would surrender the city to the Confederates.

Amid these tensions Duncanson worked on *The Land of the Lotus-Eaters,* but he could not seem to finish it. After six months' work, he finally exhibited it. The *Cincinnati Weekly Gazette* of May 30, 1861, reported that it was on view in Pike's building, noting that it was reminiscent in some ways of Frederick E. Church's glowing *Heart of the Andes,* which had been shown earlier in Cincinnati. Indeed, Duncanson's difficulties in finishing his painting may have developed because some scenic aspects of his work inevitably suggested the idealized and peaceful grandeur of Church's mountains. The *Gazette* also reported that after exhibiting the painting for eight days, Duncanson planned to exhibit it and another painting, *Western Tornado,* in Canada and then take it to London to be sold. Presumably *The Land of the Lotus-Eaters* would bring the highest price in Tennyson's native land.

On June 3, the *Gazette* reported the praise of viewers and asserted that if New York art lovers studied Duncanson's painting, "they will not hesitate to enroll the name of the author in the annals of artistic fame. So with Boston and Philadelphia." The next day the *Gazette* announced that the painting would be held in Cincinnati for another week before being taken to Canada.

The *Gazette* plea to New York art lovers underscored the neglect felt by Cincinnati artists, who strongly believed they were the equal of eastern artists. None believed this more than John Frankenstein, a child prodigy who by age eighteen was a professional portraitist in Philadelphia. He exhibited widely there before returning to Cincinnati. Frankenstein's irritation with the attention paid to eastern artists prompted him to write a provocative book of satirical doggerel entitled *American Art—Its Awful State.* In it he attacked eastern writers like Ralph Waldo Emerson, who wrote abstractly about "Art," and he lambasted adulation of Church's work, especially his painting of Niagara Falls. Depicting Niagara Falls was then a kind of national competition among artists, including Duncanson. Incensed by the way Church ignored naturalistic detail and color, Frankenstein concluded:

> Yet in *Niagaras* he is almost shamed
> in his own way by two who're not so famed,
> by George L. Brown and R. S. Duncanson—
> Some very curious things the Lord has done
> He made Niagara—then made this trio,
> Church, Brown and Duncanson! Rejoice Ohio!
> Of these great painters of Niagara,
> thy colored son deserves the most *éclat.*[46]

When Frankenstein's verses were finally published in the winter of 1863, they delighted Cincinnati artists and scandalized Church's eastern worshippers. Duncanson, however, was already convinced that he could not attain national recognition if he remained in Cincinnati. He wanted to travel to Canada and then to London with what he considered his greatest work, *The Land of the Lotus-Eaters.* But events intervened, and his move to Canada did not occur immediately. First, a Cincinnati lawyer, Samuel T. Harris, commissioned a replica of the *Lotus-Eaters.* Then, Duncanson received a commission to copy Charles Wimar's then new *Buffalo Hunt,* with Indians astride racing horses overtaking buffalo.[47] At some point Duncanson took some paintings, including perhaps the *Lotus-Eaters* and *Western Tornado,* to Toronto, where they were exhibited in the fall of 1861.[48] He then traveled in the western United States, sketching a prairie fire and painting the forests, lakes, and streams of Minnesota, which had the untamed quality that the Hudson River artists sought. After this trip Duncanson returned to Cincinnati.

With the war centered in the eastern states, many Cincinnati artists headed for the wilderness. Noting that the war and "fear of being arrested for endeavoring to evade the draft, and many other considerations consequent on the war, have prevented them [Cincinnati artists] from traveling so much this year," the *Cincinnati Daily Gazette,* on November 24, 1865, described the sketching tours of sixteen local artists who did travel. Duncanson was second on its list, which included James Beard, Joseph Oriel Eaton, Thomas Buchanan Read, William Porter, Thomas C. Lindsay, Henry W. Kemper, and William Penn Brannan. Duncanson had spent "three weeks sketching on the upper Mississippi," the *Gazette* reported on October 22, 1862. On completing *The Falls of Minnehaha,* a scene sketched in Minnesota, Duncanson was immediately commissioned to make a copy for a Boston gentleman, the *Gazette* also reported.

Late in the summer of 1862, after Duncanson, Eaton, Read, and other artists had returned, Confederate forces under General Kirby Smith began to move

on Cincinnati. The city appeared defenseless, with only its black people and abolitionists prepared to fight.

Still busy with summer sketches, Duncanson must have been as surprised as anyone when an unknown Union officer from Indiana, General Lew Wallace, later famous as the author of *Ben Hur,* arrived with a handful of officers and called for a citizens' defense of the city that "must be performed equally by all classes." He closed all businesses and saloons, stopped the ferries to Kentucky, and summoned all people to defend the city: "Citizens for labor, soldiers for battle." Wallace appealed for Ohio and Indiana volunteers, promising every man a choice: "Those who say fight, we will organize into companies and regiments; to the others we will give spades and picks and set them to digging" fortifications.[49] But then, ignorant of local politics, Wallace put pro-Confederacy Mayor Hatch in charge—and Hatch promptly ordered the arrest of every black man his special police could find, locking them up in a Plum Street pen.[50]

Many outstanding African-American men, including Clark and Gaines, eluded Hatch's police. Some hid in the Lane Seminary, Walnut Hills, College Hills, or Mount Healthy. Whether Duncanson, J. P. Ball, and others hid or were captured remains unknown. However, General Wallace had appointed Read, whom Duncanson knew well from studio visits, as his personal adjutant soon after his arrival, and Duncanson may have served in a liaison role between Read and the black leaders in hiding. At the time black leaders counseled their people to remain calm lest a race riot destroy the possibility of a citizens' defense of the city.

When General Wallace learned of the mass arrests, he immediately stripped Mayor Hatch of all authority over African-Americans. He appointed a longtime friend of black Cincinnatians, Judge William M. Dickson, to be the colonel in charge of all matters related to them. Dickson promptly released the jailed African-Americans, urging them to volunteer for the city's defense. The next day more black men poured out of hiding to volunteer, with Colonel Dickson hailing them as "The Black Brigade of Cincinnati." Working a mile closer to Confederate troops than armed Union forces, the Black Brigade fortified Cincinnati while some 60,000 self-armed volunteers called "Squirrel Hunters" poured into the area from Ohio and Indiana farms. They formed such a reckless, massive army that the Confederates retreated—and Cincinnati was saved without the loss of a single man.

In the city's jubilant celebration, the Black Brigade was counted among its special heroes. A letter in the *Tribune* of September 7, 1862, noted: "While all have done well, the Negroes as a class must bear away the palm. . . . Whenever the men of the Black Brigade appear, they are cheered by our troops." Thus virtually overnight the status of black people changed from being abused, or at best merely tolerated, to being recognized as worthy and patriotic citizens.[51]

There is no direct evidence of Duncanson's role in these events. He is not listed as a member of the Black Brigade. He may have been out of the city, even in Canada. What is important is that as an African-American, Duncanson could not be immune to the life-and-death tensions experienced by his family and friends in Cincinnati—or the wish to escape such a situation. These pressures, not simply his love of English poetry, were released in his unusual American painting *The Land of the Lotus-Eaters,* painted *before* Cincinnati had to be defended. Unless this is recognized, *The Land of the Lotus-Eaters* is a simply an illustration of Tennyson's poem and there is nothing African-American about it.

Two days after the Black Brigade was mustered out, President Lincoln announced that the Emancipation Proclamation would be issued on January 1, 1863. For the African-American men and women of Cincinnati, this prospect linked their own vigorous defense of their homes and freedom with the great dream of ending slavery forever. They saw themselves—and were seen by others—with new eyes and a new kind of confidence, an optimism that Duncanson undoubtedly shared.

It gave him the confidence to move toward gaining recognition far beyond Cincinnati and even the East. Duncanson was keenly aware that painters whom he considered his friends and equals were being elected to the National Academy of Design. Both Sonntag and Whittredge were elected in 1861; Kellogg and Eaton were added soon afterward. Surely Duncanson dreamed of achieving membership, but he was too realistic not to be aware of the difficulties he faced. One way that Duncanson could significantly advance his status in the United States, leapfrogging virulent racial prejudice and forcing consideration of his painting in eastern cities, was by gaining recognition abroad.

In May 1863 Duncanson confided to an Englishman visiting Cincinnati that he intended to go to England "for a home" and would bring with him his large canvases, including *The Land of the Lotus-Eaters, Prairie Fire,* and *Oenone,* another work based on a Tennyson poem.[52] That summer he collected the *Lotus-Eaters* and other paintings in Toronto and moved on to Montreal, the economic, political, and social center of Canada. There Duncanson immediately met William A. Not-

The only known photograph of Duncanson was made by by W. A. Notman, the great Canadian photographer who sought to develop painting there. He admired and photographed *The Land of the Lotus-Eaters*. Notman Photographic Archives, McCord Museum, Montreal

Canadian Falls (1865) is one of Duncanson's best waterfall paintings. He spent several years in Montreal, painting and teaching some of Canada's first notable artists, before sailing for England with *The Land of the Lotus-Eaters*. (20⅛ x 16″) National Gallery of Canada, Ottawa

man, an extraordinary photographer and a prime mover in the development of art in Canada.[53] No comparable figure exists in the history of photography in the United States.

Notman had wanted to be an artist as a youth in Scotland, but his father pushed him into the dry goods trade. Coming to Montreal in 1856, he initially worked for a dry goods firm. However, when the freezing of the harbor curtailed commercial activity, Notman, who had been an amateur photographer in Scotland, opened a photographic portrait studio. He was immediately successful and never returned to dry goods.

Notman had retained his interest in art, and he urged his growing staff of photographers to study great paintings and to paint. He also employed artists to help pose subjects and compose portraits as well as paint backdrops and tint photographs. When Duncanson met him, Notman was the leading photographer in Canada, providing portraits of its major political, government, religious, and social figures. The stereoscopic pictures Notman had made of the Prince of Wales and his tour of Canada's scenic splendors so delighted Queen Victoria that she named him "Photographer to the Queen."

Much of what Notman did paralleled what Ball did, but Ball was limited by being in a provincial midwestern city. In contrast, Notman photographed national and international leaders, including Canada's British governor-generals and others with close ties to leading circles in England. His work won prizes in London and Paris. Socialites and political leaders from cities all over Canada flocked to his studio. He made the only known photograph of Duncanson.

The quality of Notman's portraits is superb. His photographs of workmen, Native Americans, marketplaces, kitchens, and restaurants have a social and documentary character. Notman also developed the composite photograph. He had one of his artists make a sketch of a large skating party at a pond; then numerous well-known people were posed and photographed in skating costumes and postures. These figures were then cut out and inserted in a more finished version of the original sketch, which was then retouched and rephotographed.

Notman may have met Duncanson through A. J. Pell, Montreal's largest art dealer and framer. Greatly impressed by *The Land of the Lotus-Eaters* and Duncanson's other work, he was equally impressed by

Duncanson's knowledge of photographic problems from his experiences with Ball. Notman immediately hired Duncanson to work with his art director, John A. Fraser, who eventually became one of Canada's best-known artists.

Duncanson continued to paint, turning to local scenes. In December 1863 Notman published his first volume of *Photographic Selections,* which consisted of forty-four photographs of paintings plus two photographs of natural scenes. It included two of Duncanson's paintings, *The Land of the Lotus-Eaters* and *City Harbour of Montreal,* which he had recently completed. Notman's concern with developing painting in Canada led, as the Canadian art historian Dennis Reid has noted, to his direct association with three artists—Duncanson, Fraser, and Charles J. Way, an English artist.[54]

Duncanson, valued and respected in Montreal, painted many local scenes, which were collected by a number of Canadians. Fortunately, he had arrived at a time when influential Canadians were attempting to develop an artistic and cultural life, as Notman had urged. When the Art Association of Montreal opened its second exhibition on February 11, 1864, Duncanson showed *The Land of the Lotus-Eaters* and *Prairie Fire* alongside the work of such Canadian artists as Herbert Hancock, William Sawyer, Otto Jacobi, and William Raphael.[55] Most of the work shown came from Notman, dealers like Pell, and collectors.

During this period a young Pell employee, Allan Edson, studied painting with Duncanson, and he later became an important Canadian artist. Dennis Reid of the National Gallery of Canada has pointed out that one of Edson's early paintings, *The Pike River, near Stanbridge,* "is a lush, exotic thing, with a brilliant sunset and strange palm-like trees—like a miniature variation on Duncanson's *Lotos-eaters.*"[56] He believes that Duncanson directly supervised this work and was Edson's first teacher.

Enthusiasm for painting grew rapidly in Canada. By February 27, 1865, when the Art Association of Montreal opened its next exhibition, some 400 people had subscribed to its Art Union lottery. Among the artists exhibiting were George Inness, J. F. Cropsey, and Albert Bierstadt. Duncanson, one of four Montreal artists participating, exhibited seven oils and one watercolor.[57] His paintings included *The Vale of Cashmere,* which may have been another title for *Oenone,* and *Recollections of the Tropics,* presumably a fantasy since there is no record of Duncanson ever having been in the tropics.

Duncanson's success in Montreal only reinforced his desire to get to London with *The Land of the Lotus-Eaters.* Yet his route was not direct, as Reid has shown.[58] Being a resident of Montreal for more than a year, exhibiting there and in Toronto, painting local scenes and teaching younger artists, associated with the "Queen's Photographer," he had no trouble in getting *The Land of the Lotus-Eaters* and *Chambiere Falls, near Quebec* included in the Canadian section at the Dublin Exhibition of 1865. This doubtless also took care of some expenses and opened new doors. Also, before leaving Montreal, Duncanson had sold a number of paintings of local scenes, including *Owl's Head Mountain* and *View of the St. Anne River.*

At last, in the summer of 1865, he arrived in London, feeling he was on the verge of triumph, having successfully exhibited in Dublin, Glasgow, and Edinburgh. He had sold completed canvases and won new commissions as he went, aided by Canadian connections and antislavery societies in Scotland.

By coincidence Duncanson's *Land of the Lotus-Eaters* had already come to the attention of Scottish and English antislavery circles through a small book published in London. In it the Reverend Moncure D. Conway, an abolitionist who had once owned slaves and become the editor of the *Cincinnati Dial,* discussed the unknown talent of black people. Calling his book *Testimonies Concerning Slavery,* Conway cited the talent of the black mathematician Benjamin Banneker and others. He wrote: "My belief is that there is a vast deal of high art yet to come from that people in America. Their songs and hymns are the only original melodies we have, and one of the finest paintings which I have ever seen is a conception of Tennyson's *Lotos-eaters* painted by a Negro."[59]

In London Duncanson again met Charlotte Cushman, the international stage star, who had come from Rome because her mother was fatally ill. In 1862, while still in Cincinnati, and in anticipation of seeing Cushman again, Duncanson had begun what many considered an attempt to portray her in the costume of Lady Macbeth, one of her most famous roles. However, Duncanson left this full-length canvas, later known as *Faith,* in Cincinnati.[60]

Charlotte Cushman's theatrical fame opened doors for Duncanson. Although she was not feeling well, she introduced him to many people, including the Duchess of Sutherland, the intimate and powerful friend of Queen Victoria, whom she served as Mistress of the Robes. Lady Sutherland was a determined abolitionist and spoke at the first world congress to abolish slavery in 1840. She and her brother and daughter, the Duchess of Argyll, were close friends of Charles Sumner, the abolitionist senator from Massachusetts.[61] They also had connections with Tennyson; it was the Duke of Argyll who had originally persuaded Ten-

Ellen's Isle, Lake Katrine (ca. 1868) was inspired by Sir Walter Scott's poem *The Lady of the Lake*. It resulted from Duncanson's visit to the castle near Lake Katrine of the Duchess of Argyle, a leading Scottish abolitionist. Duncanson tried to give the painting to Senator Charles Sumner in gratitude for his fight against slavery. Sumner, who knew the scene from his own visits, held it in trust and kept it in his bedroom until Duncanson died. (29½ x 50″) Detroit Institute of Arts

nyson to take up the theme of the quest for the Holy Grail.

The Duchess of Sutherland and her family and friends were enthusiastic supporters of Duncanson's work. He sold paintings to them, and the Duchess of Argyll invited him to her castle in western Scotland. They also arranged for Tennyson to see Duncanson's painting. This in itself was a singular honor. Tennyson reportedly characterized *The Land of the Lotus-Eaters* as the best painting he had ever seen based on his work, which was often a source of inspiration for literary-minded artists.

Tennyson wrote Duncanson a note, inviting him to supper at his home, which Duncanson proudly carried with him. When he met his Cincinnati friend Rev. Moncure Conway in a London museum, he showed him the invitation. Conway promptly wrote the *Cincinnati Weekly Gazette:* "Think of a Negro sitting at a table with Mr. and Mrs. Alfred Tennyson, Lord and Lady of the Manor, and Mirror of Aristocracy!"[62]

London was a great triumph for Duncanson. His work with Notman no doubt enhanced and enlarged his acquaintanceships. He was invited to many fine homes, including those of the Marquis of Westminster

and Edward Radford, who had seen him in Cincinnati. Miner K. Kellogg, one of Cincinnati's leading portrait artists, was in London and reported that Duncanson was "living in high style."[63]

Duncanson was able to sell a number of the completed works he had brought with him. He also painted new landscapes in Scotland and Ireland. For example, he spent considerable time at the Duchess of Argyll's castle in western Scotland and sketched at nearby Lake Katrine with its "Ellen's Isle," made famous by Sir Walter Scott's poem *The Lady of the Lake*. In addition, Duncanson continued to exhibit *The Land of the Lotus-Eaters,* although he refused a number of offers to buy it. The London *Art Journal,* the most influential art publication in England, described the painting at length, quoting passages from Tennyson's poem, and praising it highly: " 'Slender streams' come down from the mountains, the bare and barren summits contrasting with the verdure of a hundred hues of their feet, while over all is a glowing sunset that makes of the whole a very paradise of earth. . . . The picture is full of fancy. It is a grand conception, and a composition of infinite skill; yet every portion of it has been studied with the severest care. . . . The picture is of large size,

and has obviously been a work of time, but time well bestowed. The sight of it cannot fail to be a source of intense enjoyment."[64] Inexplicably, this lengthy review does not say where the work was being exhibited.

In 1866 Duncanson returned to Cincinnati after quietly arranging for the sale of *The Land of the Lotus-Eaters*. Among the works of Cincinnati artists, only Powers's *Greek Slave* had achieved greater fame. Yet its sale was not reported, and for many years the painting was considered lost. A belief among some Duncanson descendants that the painting was in the British Isles prompted James A. Porter, a pioneer in Duncanson research, to write to every museum there in vain. Finally, in 1969, working from the notes of Francis W. Robinson, curator at the Detroit Institute of Arts, we deduced that it must be in His Majesty's Collection, the Royal Palace, Stockholm, Sweden, and this was confirmed by Ake Setterwall, the collection's curator.[65]

In Scotland Duncanson learned that Senator Charles Sumner had also been a guest at the Lake Katrine home of the Duchess of Argyll, an abolitionist, and that Sumner had a serious interest in art. Indeed, Sumner had one of the most extensive private art collections in America at the time, including paintings by Tintoretto, Albrecht Dürer, Caravaggio, Hans Holbein the Younger, and Thomas Gainsborough, as well as a large collection of fine engravings.[66]

Duncanson decided to give *Ellen's Isle,* which he had painted at Lake Katrine and which he considered one of his finest efforts, to Senator Sumner. He felt that in this way he could express the gratitude of all African-Americans for Sumner's courageous fight against slavery in the Senate; in 1856 Sumner had been beaten unconscious with a cane on the Senate floor by Congressman Preston Brooks of South Carolina, disabling him for years. That Sumner knew the Lake Katrine scene as well as Sir Walter Scott's popular romantic poem *The Lady of the Lake,* which immortalized the lake's island, seemed to make the gift even more appropriate. Undoubtedly, Duncanson also felt it would help bring him significant recognition in the East, for Sumner was considered a discriminating collector.

Duncanson took *Ellen's Isle* to Boston, where it was framed and exhibited. He then called on Senator Sumner to arrange for its formal presentation. However, Sumner, while touched by the spirit of the gift and the memories of Lake Katrine and Scott's poem that it evoked, declined the painting. He pointed out that he had made it a principle not to accept gifts for what he did as a legislator. Dismayed and hurt, Dun-

canson begged that the painting be accepted. Sumner said that the painting was far more important to Duncanson than it could be to him. Steadfastly declining the gift, he suggested that Duncanson sell it, promising to remember the tribute paid by Duncanson's offer.

Disheartened, Duncanson left but renewed his offer by letter, saying he was leaving the painting with the Boston framer in Sumner's name. Sumner responded that he would only hold the painting in trust for Duncanson. He sent it to Barlow's Gallery in Washington, where it helped make Duncanson's name known to influential people. Later Sumner hung *Ellen's Isle* in his bedroom, one of the paintings "for which he had an especial love," according to his secretary.[67]

Whether Duncanson knew it was so treasured by Sumner is unknown. He continued to feel deeply rejected by Sumner's unwillingness to accept the gift of one of his best works. Because Sumner was known as an important collector, he felt it was rejected as unworthy of Sumner's collection. Sumner's oral reasoning for rejecting the painting did not persuade Duncanson. All he felt was the rejection.

This rejection was not isolated in his mind, but connected with other rejections—the many rejections he suffered as a black man in a white-controlled society. Although he was light-complexioned and might be taken as a white man, he was always in an ambiguous position. He had tried to accept his not being elected to the National Academy of Design while lesser artists were elected as reflecting the fact that America was not ready to accept an African-American as an artist. But Sumner had been among the most vigorous in advocating full rights for African-Americans. He was a leader in the fight to win the vote for blacks during the ongoing Reconstruction. Because of Sumner's status as a abolitionist, as a friend of African-Americans, a champion of their rights, and as an art collector, Duncanson took the senator's rejection of his gift in a deeply personal way.

He grew depressed, irritable, and restless. He shuttled back and forth between Detroit, where his wife and children lived, and Cincinnati, where he continued to paint. In Detroit and in his travels, Duncanson was treated as a white person while in Cincinnati he was considered black, which J. D. Parks has noted "must have been confusing and frustrating."[68] He also felt exhausted and perplexed about his direction as an artist.[69] Increasingly, his painting reflected his mood of depression and conflict.

Duncanson's romantic, literary-inspired landscapes had reached an imaginative peak in *The Land of the Lotus-Eaters.* The color is emotionally conceived, emphasizing the wishful and dreamy mood. The foreground, foliage, and mountains are considered as

Sunset on the New England Coast (1871) portrays nature in turbulent conflict, in contrast to the serenity of Duncanson's wilderness scenes. It reflects his disturbed emotional state a year before his death. (36 x 66″) Cincinnati Art Museum

masses, not carried out in the detailed rendering found in *Blue Hole, Little Miami River* and other earlier works. Although the human figures in the *Lotus-Eaters* are small in relation to the scale of the landscape, they are in keeping with the poetic otherworldliness of Tennyson's poem.

Duncanson's success in England increased his tendency to paint in an emotional manner, more closely following his feelings than the scene and becoming less concerned with precise realism and more expressive in his romanticism. At times this resulted in a reflective, lyrical quality that surpassed his earlier efforts. At other times, it led to dark and moody paintings. Some paintings, like *Storm off the Irish Coast* and *Sunset on the New England Coast* (long known as *Seascape*), seemed to express deep conflicts in nature—and in Duncanson. This vision was not characteristic of the Hudson River school painters, who saw nature as one with itself.

In 1870 Duncanson, more restless than ever, went back to Scotland and its highlands for a brief painting trip, perhaps in an effort to throw off his periods of depression and irritability by returning to a place where he had done some of his best paintings. On his return to America he began working from sketches on new canvases, painting scenes from a great variety of places in Scotland, Canada, and the United States. He worked fast, dependent on his output to support himself and his family. By October 21, 1870, the Chicago art dealers Jenkinson and Keltz announced through the *Tribune* that they were exhibiting a new view of Lake Katrine by Duncanson entitled *Silver Strand,* with "some admirable effects of foliage and water." This scene and its title again came from *The Lady of the Lake.*

However, Duncanson's health, physical and mental, was clearly deteriorating. Melancholic at times, elated and grandiose at others, he was often quarrelsome, irritable, and accusatory. At one point he bought from Robert and Mary Harlan a lot in Mount Healthy for $250, perhaps thinking of building a house and returning there.[70] He told people that the spirit of an old master had entered him and was helping him to create masterpieces. He grandiosely announced to his family that a wealthy patron had assured him of a large steady income—yet in reality he was having a difficult time making ends meet. He wrangled constantly with relatives over things real and imagined, asserting they were jealous of his relationships with influential white friends and were unjustly accusing him of trying to "pass" as white. In a heated, bitter letter in June 1871, he blamed Reuben for such accusations, saying, "Shame! Shame! Shame!"[71] He also blamed Reuben and Mary for exploiting their grandmother. (The "Reu-

ben" referred to cannot be definitely identified. He may have been Duncanson's son Reuben from his first marriage. Ruth E. Showes, a relative identified by Parks, suggested that he was Reuben Graham, possibly a step-grandson of Mrs. Graham. Showes identified the "Mary" in the letter as Mary Harlan, which adds to the confusion because she was married to Robert Harlan and it was from them that Duncanson presently bought the Mount Healthy lot.[72])

Yet, despite his turmoil, Duncanson went on painting. In the early fall of 1871, he exhibited two paintings at the Western Art Gallery in Detroit. The *Detroit Free Press* reported on September 16, 1871, that one was an illustration of Thomas Moore's *Paradise and Peri* (Spirit of Air), with atmospheric effects that "are startling and original." The second painting was "entitled *Ellen's Isle* . . . a superb work, and during the first day of the exhibition attracted a great deal of admiration. It represents the island and a portion of Lake Katrine with the sunlight shining full upon the scene. A mountainous background and rich glory of clouds add a charming effect to the warm and glowing foreground, giving the whole picture a harmony of coloring and graceful outline that cannot fail to please the eye."

This painting was not the *Ellen's Isle* in Senator Sumner's bedroom, but another version; Duncanson often painted differing versions and replicas. From the paper's description, the *Ellen's Isle* in the Detroit gallery lacked the boats that are described in Scott's poem and are a central feature of the painting held by Sumner.

After the exhibition Duncanson's mental condition steadily worsened. In September 1872, in a state of mental and physical collapse, he was admitted to Michigan State Retreat, a mental hospital in Detroit.

Senator Sumner soon learned of Duncanson's illness. Believing Duncanson's paintings were being sold to meet his medical needs, Sumner had *Ellen's Isle* appraised. Adding $100 to that sum, he sent it to Mrs. Duncanson in Detroit.[73] Without income, she had had to find work to maintain herself and her family. Her visits to Duncanson so upset her that by December she stopped going for two weeks. But on December 17 she wrote to Mrs. Harlan: "Dear Friend—The sister-in-charge said today that he had been entirely unconfined since last Thursday and is very quiet and natural. His physical health has improved and he eats and sleeps and walks in the hall with the other quiet ones."[74] A few days later, on December 21, 1872, he died.

Duncanson's relatively rapid death in a mental hospital is not consistent with the major forms of mental illness. Schizophrenic and psychotically depressed patients generally live for many years; some spend forty years inside mental hospitals. Although Duncanson's death certificate is missing,[75] his shifting moods, irri-

tability, and fits of crying and rage, as well as his death at the age of about fifty after only a few months in a mental hospital, suggest that he may have had a rapidly growing brain tumor. Such a tumor killed the composer George Gershwin, whose initial symptoms were similar to those of Duncanson. When Gershwin suffered from severe headaches, irritability, and depression, his friends suggested that these symptoms were psychosomatic, caused by his work on Hollywood film scores instead of composing the symphonies he wanted to write. This lead Gershwin to seek the help of a famed psychoanalyst, Dr. Gregory Zilboorg, in late 1934. However, psychoanalysis did not relieve his worsening symptoms. By June 1937 Gershwin was hospitalized for pounding headaches, dizziness, and olfactory hallucinations. Even earlier, he had been listless, with impaired coordination—dropping forks, stumbling on stairs, blacking out during concerts, and fingering the keyboard eccentrically. He once tried to push a friend out of a speeding car. Another time he crushed chocolates and spread the resultant mess over his body as an ointment. On July 9 neurosurgeons found that he had an inoperable, fulminating brain tumor, and he died the next day.[76]

At the time of Duncanson's illness, neurosurgery had not been developed. Autopsies were rarely performed. As a result, it is impossible to confirm the diagnosis of brain tumor, but the course of his illness and death after only three months of hospitalization strongly suggest it.

One of the most fascinating episodes in American art history developed after Duncanson's death. By adding $100 to what *Ellen's Isle* was appraised at and sending that sum to Mrs. Duncanson, Sumner had changed the relationship from a painting held in trust to a sale. Phoebe Duncanson, whose letters reflect intelligence and a good education, knew what the painting had meant to Duncanson. And she had, in the words of Sumner's secretary, "come to know that the Senator's action in the matter had been prompted by a desire to relieve the artist's wants, rather than to own this evidence of his skill." Therefore "she asked and received from him a promise that the picture should revert to the family under certain conditions."[77]

These conditions are unknown today. Sumner died in 1875, and by that time Mrs. Duncanson had moved to Chicago, where she worked as a door-to-door salesperson. Sumner left all his paintings and engravings, which included an engraving of two black children by Wenceslaus Hollar in 1645, to the Boston Museum of Fine Arts. His will directed the trustees to do what they wished with the collection. They sold most of the paintings and engravings. However, in 1884, twelve years after Duncanson's death, Mrs. Duncanson re-

minded the trustees of Sumner's promise and asked for *Ellen's Isle*. They promptly authorized its shipment to her.[78]

Living in Chicago in straitened circumstances, Phoebe Duncanson offered the painting on May 7, 1884, to Ralzemond D. Parker, a Detroit lawyer who had defended her son in some difficulties, for $150 and cancellation of whatever she owed him on her son's account.[79] Parker accepted the offer. *Ellen's Isle* then hung in his home until 1953, when a librarian, called to the home to examine some books, noticed it and recognized the artist's name as one that Francis W. Robinson, a curator of the Detroit Institute of Arts, was researching. Parker's son and daughter gave *Ellen's Isle* to the Detroit Institute of Arts. Few paintings in American art are so rich in historic cultural associations.

In its obituary, the *Detroit Tribune* mentioned Tennyson's interest in Duncanson's work and his friendship with Charlotte Cushman. Of his achievements, the *Tribune* said: "He was an artist of rare accomplishments and his death will be regretted by all lovers of his profession, and by every American who knew him either by reputation or personally."[80]

The *Tribune* did not mention that Duncanson was black. Nor did a resolution signed by leading Cincinnati artists, led by Charles T. Webber, president of the Artists' Association. Published in the *Enquirer* on December 31, 1872, the resolution noted that "in his death his family has lost a devoted husband and father, our city one who has honored her name at home and abroad, and art one of her most earnest and enthusiastic followers." It pointed out that "his long life of arduous toil and continuous effort to elevate the aims and use of landscape art command our admiration, and though endowed by nature with the highest poetic conceptions, and eminently successful in placing his chosen branch of art beyond the plane of the merely imitative, he deserves the greater appreciation that he never forgot the kindly word and generous sympathy for the humblest beginner who sought advice from the rich storehouse of his experience."

Among the well-known artists who signed this resolution were, in addition to Webber, H. F. Farney and Henry Mosler. Having known Duncanson intimately and something of the great effort required for an African-American to succeed as an artist during the time of slavery, they understood what he had accomplished. If they did not mention his race, it was in part because it had long ago ceased to concern them. They knew him as a genial and modest man, and they considered him one of the finest landscapists.

Duncanson had been an important contributor to the creation of an American phenomenon, the Hudson River school of painting, and in this way had enriched their lives.

Yet the conflict over race that pervaded the nation and denied him election to the National Academy undoubtedly contributed significantly to the frustration and emotional pressures that destroyed him at the start of his fifties. His life is the story of the making of an African-American artist at a time when the nation was less than a hundred years old, when the character of life in America was being formed. It was still a nation of vast forests and open plains, an untouched wilderness rich in minerals and resources, innocence and "promises," to use Archibald MacLeish's term. Duncanson lived during a period when African-Americans were emerging from slavery and their contributions to the emotional and cultural depth of American life were beginning to be felt. Others had come to America to be free, had struggled for freedom, and had won it—and now so had black Americans.

It was in this context that Duncanson, by living in the Queen City of the West and expending great effort, was able to become recognized as an artist and appreciated for his contribution to the lives of those around him in developing America. The great scenes of natural wilderness portrayed by the Hudson River school artists reflected not only the actual spaciousness of the American landscape but also the nation's democratic ideals. There was room for whatever was created by nature. When Duncanson came to Cincinnati, no one thought it unusual for him to desire to become an artist. It seemed part of the growth of America. "The young American Narcissus had looked at himself in the narrow rocky pools of New England and by the waters of the Mississippi; he had also gazed long at a darker image," observed Constance Rourke in her study noting the black contribution in forming the American character.[81] Yet, despite the ending of slavery in Duncanson's day, the right of African-Americans to participate freely in the nation's cultural development became restricted and was often denied altogether, creating an undergound stream unknown to most Americans and only gradually filtering into the mainstream. For African-Americans, participation is the American dream, and they have maintained it to this day, insistently contributing to many aspects of American life.

Today Duncanson's paintings can be understood as the searching and idealistic dreams of a lonely, isolated, and sensitive man with a deep love of nature and the American landscape. Ultimately Duncanson will be considered one of the most unique and noteworthy landscape painters of nineteenth-century America.

EDWARD M. BANNISTER

Only four years after Robert S. Duncanson's tragic death, an African-American unknown to him won one of the highest art prizes awarded at the United States Centennial Exposition of 1876 in Philadelphia, the first national art exhibit. He was Edward Mitchell Bannister, whose Barbizon-style landscapes focused on the serene, low-lying scenery around Narragansett Bay in Rhode Island. Until the rediscovery of Duncanson's work in the 1930s to 1950s, many people believed that Bannister was America's first important black artist. His work can be found today in the Providence Art Club, the library of Brown University, the Museum of Art at the Rhode Island School of Design, and many Rhode Island homes. In 1965 and 1966 major Bannister exhibitions were held in Providence.[1] One of its citizens, C. William Miller, then presented fourteen Bannister paintings to the Frederick Douglass Institute and Museum of African Art. They have since been transferred to the National Museum of American Art, Washington, D.C.

In 1992 the largest Bannister exhibition since a memorial exhibition in 1901 was presented at Kenkeleba House in New York, providing New Yorkers with their first opportunity to see more than an occasional isolated Bannister painting.[2]

What made Bannister's life so different from that of most black artists of the period, as well as those who came later, was the warm respect and admiration he received from the people of Providence. The reminiscences of its leading artists at the time are rich in references to Bannister, conveying the image of a man who knew poetry and literature, and was also reflectively religious; who displayed charm, good humor, and modesty in conversation; and who was a constant observer of nature.

Although he had to struggle against racial prejudice, Bannister was generally an active participant in the artistic life of the community. The initial plans for organizing the Providence Art Club, which is still active, were formulated in his studio. Its members de-

Bannister, shown here as he appeared in about 1885, was admired and beloved by Providence artists and an active participant in their affairs. Rhode Island Historical Society, Providence

veloped the Rhode Island School of Design, making Providence one of the nation's notable art centers before the turn of the century.

Another indication of Bannister's community relationships is that in 1890 his wife, a remarkable woman in her own right, organized a home for aged black women. Known today as Bannister Nursing Care Center, it is an interracial institution supported by the entire

community. The center owns Bannister's portrait of his wife.[3]

This acceptance by the community makes Bannister an unusual figure in the history of American artists of African descent. Undoubtedly, it contributed to the serenity of his landscapes.

Bannister was born in November 1828, in St. Andrews, a New Brunswick village across the St. Croix from Maine, on the edge of Passamaquoddy Bay.[4] His father, Edward Bannister, a black man from Barbados, had married Hannah Alexander, a woman of Scottish descent who had been born in St. Andrews. Edward was their second son, after William. His father probably worked on the village fishing fleet or loaded lumber from Canadian forests into coastal schooners. When Edward was six years old, his father died, causing considerable economic distress for the family.

Because he was born in Canada and shortly after his birth the British abolished slavery in all their dominions, Bannister, like Duncanson, did not face the same oppression and deprivation that thousands of African-American children did. He attended the village grammar school and received "a better education than persons generally in his position," according to William Wells Brown, who wrote the earliest biographical sketch of Bannister in 1863, long before he became nationally recognized.[5]

From early childhood, Edward demonstrated a remarkable ability to draw. George W. Whitaker, the "dean" of Rhode Island painters and Bannister's intimate for thirty years, said that Bannister told him: "The love of art in some form came to me from my mother, who was born within a stone's throw of my birthplace on the banks of the St. Croix river. It was she who encouraged and fostered my childish propensities for drawing and coloring. She helped me with my lessons, which I was prone to neglect, for the more congenial work of drawing."[6]

In his boyhood, according to Whitaker, Bannister had "a supersensitive appreciation of the beauties of nature," which "led him to study the sunset, the rolling clouds and flitting shadows." Bannister claimed that the dark nights "were a relief for him [so] that he could see newer colors on the following day."[7]

Bannister's mother died during his adolescence. His older brother went to Boston to earn a living, but he could not support "Ned," as Edward was known to intimates.[8] As a result, young Ned was, in the idiom of the day, "put out to live" with Harris Hatch, one of the wealthiest lawyers in St. Andrews and the owner of a prosperous farm.[9] At the farm Bannister was given an attic bedroom and assigned certain

Bannister's portrait of his wife, Christiana Carteaux Bannister, is one of his few identified portraits. It hangs in what was originally a home for aged African-Americans founded by her in 1890. (35½ x 28″) Bannister Nursing Care Center, Providence

chores. He also had access to the Hatch library, where there were two old, fading family portraits, perhaps the first he had ever seen. Bannister studied and copied the portraits endlessly. "On barn doors, fences and every place where drawings could be made, the two ancient faces were to be seen."[10]

It is not known when Bannister left the Hatch farm. But presumably in late adolescence he set out, as many young men in St. Andrews did, to work on fishing boats and coastal schooners. Initially a cook, he became an expert sailor, alert to shifts in the winds and tides, and a student of clouds.

As a seaman, Bannister often visited Boston and New York, where his trips to libraries, museums, and galleries significantly enlarged his view of art and his desire to learn this craft. However, he could find no one to teach him. In order to remain in Boston and continue his efforts to draw and paint, Bannister became a barber.[11]

About this time, in the 1840s, daguerreotypes arrived on the American scene. Many artists were at-

Dorchester, Massachusetts (ca. 1856) was one of Bannister's earliest paintings. He was then a sailor on schooners shipping Nova Scotia lumber. (14⅛ x 20⅛″) National Museum of American Art

tracted to this early form of photography; others correctly feared it would largely end portrait painting. Bannister saw it as an opportunity to get into the art field and learned the technique. A short time later the development of "wet-plate" photography made it possible to produce enlargements, which could be tinted. Bannister became highly skilled at tinting photographs. At one point he was hired by a Broadway photographer in New York, but he stayed only a year, returning to Boston.

To survive, he returned to barbering and learned how to style women's hair in the latest fashion. Eventually he was hired, according to research by Corrine Jennings of Kenkeleba House in New York, by "Madame Carteaux"—an unusual woman, whose expertise in hairstyling and in business enabled her to have busy shops under that name in both Boston and Providence. Many prominent Boston and Providence social leaders sought her attention because she had charm, social poise, and an intuitive understanding of their needs. Six years older than Bannister, Christiana Babcock Carteaux had been born in North Kingston, near Providence, in 1822. She and Bannister became close friends and married in 1857.[12]

She encouraged Bannister to paint from the beginning. In the early 1850s, although continuing to tint photographs, he began exhibiting and selling paintings. He gradually gave up hairstyling and photographic work to share a studio with Edwin Lord Weeks, a portrait artist who later gained popularity with paintings of subjects from India. Bannister's paintings, usually based on biblical stories and themes, were shown in group exhibitions at the Boston Art Club and Museum.[13] He also painted portraits, landscapes, genre, and historical scenes.

Few of Bannister's works of this period have survived. One, painted before 1855 and titled *The Ship Outward Bound,* was owned by Dr. John V. DeGrasse,

the first black physician in Boston and a friend of Bannister.[14] He also did portraits of DeGrasse (1854) and his wife (1852).[15] In 1857 he completed a lake and mountain scene titled *Dorset, New Hampshire.*[16] Judging by this landscape, Bannister painted in a strong, straightforward style but still had the stiff mannerisms of a student painter.

Uncertain at times about his talent, Bannister took one of his biblical scenes to Francis Bicknell Carpenter, a New York artist who painted the famous *The First Reading of the Emancipation Proclamation* in 1864.[17] Carpenter told him he should continue to paint and become a professional artist.

Unquestionably, Bannister did not feel confident in handling the human figure. He was already taking a drawing class at the Lowell Institute in 1856, when he learned that D. William Rimmer would lecture on anatomy there. Bannister promptly decided he must attend.

Bannister was not alone in that decision. Rimmer's lectures interested most Boston artists. Through his dissections, Rimmer knew much more about anatomical structure and skeletal and muscular functioning than most artists, and he could draw the figure with extraordinary speed and accuracy. His realistic and dynamic statues of *Saint Stephen* and *The Falling Gladiator,* so very different from the bland, idealized Neoclassical style then in vogue, led artists to demand that Rimmer discuss anatomy in art.

Making swift chalk drawings to demonstrate skeletal and muscular relationships as he talked, Rimmer awed his audience. Bannister was greatly excited by these lectures,[18] as was Daniel Chester French, who later became a famous sculptor.

To enhance their education, Bannister, a young sculptor named Martin Milmore, and two painters, William Norton and John Nelson Arnold, prevailed on the institute to set aside a room where they could draw

from a nude male model.[19] This marked the beginning of a lifelong friendship between Arnold and Bannister.

Another event that influenced Bannister's work was the return from France of William Morris Hunt in 1856. Hunt had been the close friend of Jean-François Millet, creator of *The Angelus* and *The Man with the Hoe,* and a leader of the Barbizon school of French landscape painting. Hunt's Barbizon style generated considerable excitement in Boston and greatly impressed Bannister, who began painting in this manner. It was a style that permitted Bannister to express both his observation of and reverence for nature.

For Bannister and many other nineteenth-century artists, the woods and fields were a sacred place, "God's own outdoor temple." Their attitude toward the role of nature in art was summarized by Ralph Waldo Emerson, whom Bannister read: "Nature predominates over the human will in all works of even the fine arts, in all that respects their material and external circumstances. Nature paints the best part of the picture, carves the best part of the statue, builds the best part of the house, and speaks the best part of the oration."[20]

That Boston was a center for antislavery sentiment undoubtedly aided Bannister. In other cities he could not have attended a school such as the Lowell Institute or exhibited in leading art associations. During the 1850s Boston became increasingly abolitionist, the home of many of John Brown's supporters and nearly all his financial backers.

One of the black abolitionists gathering material to prove that blacks could be great artists was William Wells Brown, who outlined Bannister's life and achievements in his book *The Black Man: His Antecedents, His Genius, and His Achievements,* which was published in Boston in 1863 by James Redpath, the first biographer of John Brown.[21] Presenting lively sketches of some fifty highly diverse black men and women, the book included the rebel Nat Turner, who led an uprising against slavery in Virginia; the writer Alexandre Dumas; the mathematician Benjamin Banneker; the educator Charlotte Forten; and Captain André Callious, who died leading black troops in an assault on Confederate forces at Port Hudson, New Orleans. In addition, there were two black artists: Bannister and the sculptor Edmonia Lewis. Brown's book astonished many Americans with its overview of black history.

Brown described Bannister, who then had his studio in the Studio Building in Boston, as "spare-made, slim, with an interesting cast of countenance, quick in his walk and easy in his manners." Brown also described several paintings. One was a landscape; another, a genre scene, *Wall Street at Home,* depicting "the old gent, seated in his easy chair, boots off and slippers on and intently reading the last news." The latter might well have been derived from a Currier and Ives print. Yet another painting Brown described was historical, *Cleopatra Waiting to Receive Marc Antony.*

Bannister was thirty-five years old when Brown's book appeared. By identifying him with outstanding black men and women, the book brought Bannister to the attention of many people, particularly in Boston, who otherwise might never have heard of him.

In the same year that Brown's book was published, the demand of Frederick Douglass and other African-American leaders that black men be given the opportunity to fight as soldiers against slavery was approved by President Abraham Lincoln. Both Bannister and his wife became active in the struggle to obtain equal pay for black soldiers in the Union army. In Massachusetts Governor John Andrews had been authorized to organize black regiments. Black men rushed to Boston to join, only to discover that Union army leaders had decided to pay them $10 a month with $3 deducted for clothing, while white soldiers received $13 a month plus an allowance of $3.50 for clothing. This differential pay scale was rationalized on the grounds that black soldiers were not fighters but laborers.[22]

On learning of this, the Bannisters immediately set out to raise funds to pay the difference. With the approval of Governor Andrews, who had called the state legislature into session to consider the matter, Bannister's wife organized a large fair to sell valuable articles obtained from prominent Bostonians, including many of her clients. Bannister directed the decorating of the hall and the arrangement of tables of objects, which were sold outright or at auction. In this way about $4,000 was quickly raised and the issue of unfair pay was publicized, helping to make Congress act to equalize the pay. When Governor Andrews formally addressed the black Massachusetts Fifty-fourth Regiment as it set off to join the Union army, he asked Bannister's wife to present the regiment's colors to the unit, which she did.[23]

At that time Bannister painted a portrait of Colonel Robert Gould Shaw, the young Boston patrician who led the black regiment and eventually died on the battlefield.[24] For some years this portrait, now lost, hung in the State House in Boston and brought him considerable attention.[25]

When Bannister and his wife moved to Providence in 1870, he already knew from friendly meetings with Providence artists in Boston studios and galleries that he would be welcome there. One of these artists was John Nelson Arnold, who had been his friend since his

Moon over a Harbor (1868) has a more modern character than much of Bannister's work. A small painting, and his only known moonlit scene, it was done when he was nearing the peak of his career. (9⅝ x 15¼″) National Museum of American Art

days at the Lowell Institute. In addition, Bannister's wife had strong connections in Providence, both with relatives and with socially prominent Providence women who came to her shop to have their hair styled.

The move to Providence gave Bannister easy access to the rural and wooded scenes that are so fundamental to Barbizon painting. He established his studio in the Woods Building, where Arnold and other artists had their studios. As he concentrated more and more on landscapes and Narragansett shore scenes, Bannister gradually reduced the number of religious and historical works he did.

About four years after coming to Providence, Bannister visited the farm of William Goddard, near Potowomut, on a sketching expedition. There, attracted to a group of oak trees, he created the painting *Under the Oaks.*[26] Bannister and the artists who visited his studio felt that this was his best work, unusual and distinguished.

All the Providence artists and their friends were very much aware that the coming 1876 United States Centennial Exposition in Philadelphia would present

the greatest assemblage of art ever seen in the country, which was then a nation whose museums were just coming into existence. In addition to showing famous paintings and statues from Europe, the exhibition would include many of the works of America's early masters, such as Benjamin West, John Singleton Copley, Gilbert Stuart, and Charles Willson Peale and his sons, as well as pieces by contemporary American artists.

Bannister entered *Under the Oaks,* sending the painting to a regional jury in Boston. It was selected as their choice entry. The art critic of the Boston *Traveler* called the painting "the greatest of its kind that we have seen by an American artist," according to Sydney Burleigh.[27]

At the Centennial, Bannister's painting competed with the great work of Albert Bierstadt, J. F. Cropsey, and Frederick E. Church. Listed as "No. 54—Under the Oaks—E. M. Bannister," his entry was selected for the bronze medal, the major prize for oil painting of the art exhibition. According to the *Providence Journal* of January 11, 1901, this medal was the highest award for painting.

In his reminiscences George W. Whitaker, Bannister's close friend for thirty years, described Bannister's personal experience at the Centennial. On finding his painting listed in the catalog, Bannister "was so glad that he sat down and thought of his boyhood

This preparatory sketch for *Under the Oaks,* which won Bannister a Centennial award, was reproduced in the *Massachusetts Artists' Centennial Album,* 1876. Both the sketch and the prizewinning painting, believed sold in New York, have disappeared.

dreams. . . . [Then] like one in a dream, he found his way through the crowd and stood before his masterpiece, his heart bounding with joy. The picture hung in a favorable place." Later, as Bannister told Whitaker:

I learned from the newspapers that "54" had received a first-prize medal, so I hurried to the committee rooms to make sure the report was true. There was a great crowd there ahead of me. As I jostled among them, many resented my presence, some actually commenting within my hearing in a most petulant manner: What is that colored person in here for? Finally when I succeeded in reaching the desk where inquiries were made, I endeavored to gain the attention of the official in charge. He was very insolent. Without raising his eyes, he demanded in the most exasperating tone of voice, "Well, what do you want here anyway? Speak lively."

"I want to inquire concerning No. 54. Is it a prize winner?"

"What's that to you?" said he.

In an instant my blood was up; the looks that passed between him and others in the room were unmistakable. I was not an artist to them, simply an inquisitive colored man. Controlling myself, I said deliberately, "I am interested in the report that *Under the Oaks* has received a prize. I painted the picture."

An explosion could not have made a more marked impression. Without hesitation he apologized to me, and soon everyone in the room was bowing and scraping to me.

That Bannister was an African-American was not hidden from the public, and his success was noted by his people. Descriptions of his prize-winning painting were made by two knowledgeable African-Americans and appeared in the American Methodist Episcopal church's *Christian Recorder.* One review, signed "R. D.," was by Robert Douglass, Jr., a well-trained Philadelphia artist, portraitist, and miniaturist. He described *Under the Oaks* as "a quiet pastoral scene, a shepherd and sheep beneath a fine group of oaks." He continued: "It is much admired and gave me great pleasure to find that it is one of the really meritorious works that have gained a medal. To me, it recalls some of the best efforts of [John] Constable, the great English landscape painter."[28]

A more detailed description was given by John P. Sampson, an editor, lawyer, and minister who had been in charge of African-American education in North Carolina during Reconstruction and was a trustee of Wilberforce University. His review suggested that he had met Bannister. In his words:

"Under the Oaks" is a beautiful oil painting. It has attracted great attention. The press speak of it [as] one of the finest paintings in the Department [of American paintings in the exposition].

Mr. B. is a colored gentleman of modest bearing and general intelligence; he comprehends fully the importance of competing in the world of art and takes just pride in his picture . . . [which has won] one of the four prizes to be given for the four best pictures and [he] will no doubt take rank at once among the best American artists.

It is a four by six [foot] picture, representing in the foreground, a herd of sheep along the branch [of a creek] while further in the background is a beautiful ascent [hill], with a cluster of oaks, widespread in their branches, like a great shed; and beneath this shelter can be seen numerous cows and sheep taking shelter from the storm.[29]

From these descriptions, one gains some sense that

Oak Trees (1876), combining the elements of nature that Bannister loved, has the serenity that marked his work. His treatment of the oaks probably resembles that in his lost Centennial prizewinner. (33⅞ x 60¼″) National Museum of American Art

this pastoral scene was under a darkening but high-lighted sky reminiscent of Constable's landscapes. This is not surprising, for Constable greatly influenced the Barbizon school of painting that Bannister admired.

After winning the prize, *Under the Oaks* was sold through Williams and Everett, art dealers, to a Mr. Duff of Boston for $1,500, a high price for a painting in those days. Bannister received $850 as his portion. However, as was characteristic of dealer-artist relations at the time, Bannister did not initially learn who had purchased his painting. Only years later did he discover accidentally where it was, and he then obtained per-mission to see it. He found it "well hung on a French landing in the front hall of the Duff residence," with an easy chair placed so that Duff could observe the serene painting every morning before going to his of-fice.[30] Today, however, neither the painting nor the medal Bannister received can be located.[31]

Bannister's success undoubtedly contributed to the enthusiasm of a delegation of visitors to the exhibition from Providence, led by Mrs. Jesse H. Metcalf. They "left Philadelphia fired with the urge to establish a museum of art and school of design in their own city."[32] This group's activities helped establish the Rhode Is-land Museum of Art and School of Design, long one of the nation's outstanding art schools. Many of Ban-nister's artist friends were among the school's initial teachers, although Bannister himself was not. Bannis-

ter did, however, accept private students, including W. Alden Brown.

An honored leader after his Centennial exposition triumph, Bannister was approached in 1878 by Whit-aker, who suggested that "the artists of our city form themselves into a club for the purpose of bringing the professionals, amateurs and art collectors together."[33] As Whitaker reported, "Mr. C. W. Stetson [another well-known Providence artist] joined us, and a meeting was held in Bannister's studio." At first the discussions focused on dealer relationships. At the time paintings were sent to out-of-town dealers, who charged high prices but gave the artists little, and who often kept the purchaser's name secret so that the artist could not determine what price his work actually sold for. More-over, there were few exhibitions or opportunities for sales.

Bannister, Whitaker, and Stetson discussed these problems for two years before they invited a larger group of artists to join them on February 12, 1880. At first the group considered opening a gallery and a sales-room, but this idea was abandoned in favor of forming an art club composed of artists, amateurs, and art lov-ers, including those devoted to musical and literary arts. This proposal promised to gain wide community support.

Robert S. Duncanson *Blue Hole, Little Miami River* (1851) is considered a classic in the Hudson River school style. The scene was familiar to fugitives from slavery. In the 1920s a New York architect recognized the qualities of Duncanson's painting at an auction, bought it, and gave it to the Cincinnati Art Museum. (29¼ x 42¼″) Cincinnati Art Museum

The Land of the Lotus-Eaters (ca. 1861) was inspired by Tennyson's poem of warriors who found an island so peaceful that they never wanted to go home. A Hudson River school painter, Duncanson found the American wilderness just such an enchanting island. Created in Cincinnati, on the edge of slavery as the Civil War loomed, the painting represented Duncanson's desire for peace. A success in Cincinnati, then in Toronto, Montreal, Glasgow, and London, it was acquired about 1900 by the Royal Collection in Stockholm. (51½ x 87½″) His Majesty's Royal Collection, Stockholm

Mount Royal (1864), an unusual watercolor, was painted by Duncanson while living in Montreal. Its meticulous realism is far from the imaginary *Land of the Lotus-Eaters*. Duncanson worked with the great Canadian photographer William A. Notman and taught young Allan Edson, later a leading Canadian artist. (Watercolor, 37⅛ x 27⅝″) National Gallery of Canada

Edward M. Bannister *Sabin Point, Narragansett Bay* (1885) reflects Bannister's love of the sea, sailboats, and clouds. His color derives from simple harmonies in his subjects. However, this painting does not have the sketchy massing of shapes characteristic of the Barbizon school and his own early landscapes. (37¼ x 64¼″) Brown University, Providence

In Morton Park, Newport, R.I., Looking Southward. Bannister loved to paint scenes that combined clouds, the wooded shore, and Narragansett Bay. This small painting is unusual for its inclusion of spring flowers and what is presumably a distant lighthouse or windmill. (11 x 15¼″) National Museum of American Art

Robert S. Duncanson *Fruit Still Life* (1849) was given by Duncanson to Henry N. Walker sometime after Walker had given fifty dollars to the artist, who was discouraged at his lack of success in Detroit and about to be evicted. Many years later Walker's daughters gave the painting to the Detroit Institute of Arts. (14 x 20″) Detroit Institute of Arts

David Bustil Bowser *Landscape* (1856) is one of the few surviving works by Bowser, a Philadelphia artist. He studied under his cousin, Robert M. Douglass, Jr., and initially worked in Douglass's sign shop. (13 x 16″ at oval's widest points) Historical Society of Pennsylvania, Philadelphia

Joseph Proctor *Fruit with Watermelon,* a charming "fanciful" work balanced in composition and color, was painted by Proctor before the Civil War. His paintings are extremely rare, only three having been reported. This one, marked "No. 6" on the back, was found in the Midwest. It was sold in 1979 by Richard A. Bourne, of Hyannis, Massachusetts, to singer Andy Williams for $69,000.

Proctor lived at 45 Elizabeth Street, New York, with his wife Sophia, according to the 1860 U.S. Census (vol. 51, p. 166). His age, forty-four; hers, forty-two. Both were born in Maryland. They may have been fugitives, or born free, or may have earned their freedom; Maryland had many African-American artisans who had earned their freedom.

Old city maps show 45 Elizabeth Street was a large tenement that ran through from Elizabeth to Mott Street. A chair factory occupied No. 47 and a furniture factory in the block fronted on both Hester and Mott streets. Next door was a large "Mahogany Yard," which supplied fine woods to the many chair and furniture factories in the neighborhood. Proctor may have worked as a varnisher and decorator of chairs and furniture, which then often bore painted fruit, flower, and leaf designs, and may have painted his "fanciful" pieces to please himself.

Many other African-Americans lived in that Lower East Side neighborhood. "Colored School No. 1" was nearby on Mulberry Street. "Old Bethel" of the African Methodist Episcopal church was at 225 Second Street; there the Reverend Daniel A. Payne was ordained a bishop and later became its foremost leader in the Civil War and Reconstruction periods. Half a century later Jacob Riis, in *How the Other Half Lives,* noted that " 'old Africa' was fast becoming modern Italy"— now "Little Italy." (24 x 24″) Collection Andy Williams, Palm Springs

Above: **Henry Ossawa Tanner** *The Raising of Lazarus* (1896) won an 1897 Salon prize in Paris. It won over works by leading artists with its lighting, emphasis on human reactions, and ignoring of archaeological detail, then the focus of religious painters. For some Americans, it symbolized the raising of African-Americans from slavery through faith. (37⅜ x 47¹³⁄₁₆″) Musée National d'Art Moderne, Compiègne

Left: *The Banjo Lesson* (1893), Tanner's most famous work, shows Thomas Eakins's influence in the solidity of the figures, but its use of color and light is decidedly Tanner's own. Depicting the generational transmission of African-American culture, symbolized by the African banjo, and highlighting the dignity and sincerity of its subjects, this painting raised hopes that Tanner would devote himself to similar portrayals. But Tanner deeply felt that his own religious faith demanded he attempt to express its power in overcoming barriers that denied the common humanity of all peoples. That inner faith determined his work. (49 x 35½″) Hampton University Museum, Hampton, Va.

Above: **Nicodemus Visiting Jesus** (1899) depicts the secret night meeting with Christ of the old Pharisee, a leader of the sect ruling Jewish temples. He is told he has to be born again to enter the kingdom of God. The meeting can be likened to secret meetings of slaveholders with abolitionists, who told them they couldn't get into heaven while owning slaves. Tanner used light coming up the stairs to illuminate Christ's face rather than a halo, which was then the traditional way of signifying a holy person. (33^{11}/$_{16}$ x 39½") Pennsylvania Academy of Fine Arts, Philadelphia

Left: **The Good Shepherd** (ca. 1902). This is an early version of Tanner's most repeated theme. A robed, mystical figure—neither man nor woman, black nor white, Arab nor Jew—the shepherd protects the flock and sick or lost lambs. In later versions the shepherd is dominant, significantly more important than the environment. (27 x 32") Jane Voorhees Zimmerli Art Museum, Rutgers University

Left: **Fishermen Returning at Night** (ca. 1930) is a small painting that attempts a difficult feat—the depiction of two fishermen, a man and a boy, returning from their boats at night, their only light from a lantern at knee level. Earlier versions lost the figures in the darkness. Obsessed with darkness and half-seen figures in moonlight, Tanner used light to symbolize a spiritual force, lighting mankind's path. (Oil and tempera on Academy board, 9⅜ x 7½") Collection Merton Simpson, New York

Right: **Midday, Tangiers** (1912) is characteristic of the paintings Tanner made during visits to North Africa from 1908 to 1912. These paintings had more brilliant and unusual color, freer brushwork, and a greater simplification of forms than other works. Although Tanner's singular approach to religious painting prevents his being classed with any movement, his North African paintings demonstrate transient Impressionist influences. (24 x 20") Sotheby's Inc., New York

In 1878 artist George Whitaker described the founding of the Providence Art Club in Bannister's studio. Whitaker's literary skills prompted his appointment as poet laureate of the "A.E. Club," named for Ann-Eliza, the waitress who served its members. Rhode Island Historical Society, Providence

A few days later, on February 19, 1880, the Providence Art Club was formed in Eimrich Rein's studio in the Wayland Building. Bannister was the second to sign the original agreement, placing his name after that of J. S. Lincoln, a notable portraitist, who was elected president. Rein, a Norwegian-born landscape painter who had studied in Paris and exhibited in the Salon, also signed the document, as did Bannister's friend Arnold; George L. Miner, who later wrote an extensive history of the founding of the Providence Art Club in his book *Angel's Lane;* Whitaker, who had been encouraged to paint by George Inness; Charles Walter Stetson, a unusual colorist who ultimately spent most of his life in Italy; and George M. Porter, whose belief that life drawing should be taught from the start of art education eventually made the Rhode Island School of Design one of the most advanced schools in the nation. Several women artists were also among the art club's founding members, and Rosa Peckam, who painted portraits and watercolor landscapes, was secretary and then vice president of the club. Bannister served on the executive committee for many years.

The Providence Art Club membership grew to include some of the city's most prominent social and business leaders. Some distinguished Rhode Islanders, such as Governor Royal C. Taft and Senator Nelson Aldrich, joined by mail. When its first exhibition was held on May 11, 1880, sixty-four artists exhibited works, and the art club was considered a huge success. Many paintings were sold, and the club began providing training, lectures, forums, and guest exhibitions, which it continues to do today. In addition to showing art, it also had programs that included music. In 1887 the art club acquired a building and silhouettes of some of the founders, including Bannister, still hang in the club.

Within the Providence Art Club, Bannister was a member of a select handful who called themselves the "A.E. Club," a whimsical name based on the idea that all the group's members were married to Ann-Eliza, the waitress who served them. At meetings they read witty and informative essays, reminisced about great artists they had known, and discussed one another's work as well as work they had seen abroad.

Discussing artists and their critics in a paper read on April 15, 1886, Bannister denied that Millet's peasant scenes were the seeds of social unrest, as some critics complained. He characterized Millet as "the profoundest, most sympathetic and deeply religious artistic spirit of our time." Bannister defined the goal of the artist as spiritual expression. "He becomes the interpreter of the infinite, subtle qualities of the spiritual idea centering in all created things, expounding for us the laws of beauty, and so far as finite mind and executive ability can, revealing to us glimpses of the absolute idea of perfect harmony."[34]

Bannister also rejected the idea that rural landscape painting was a reaction to an industrialized society. He held such painting to be an affirmation of the harmony and spirituality in "all things created" that permitted the artist to inject into natural scenes his own individual and poetic sentiments.

Bannister's sensitive and thoughtful comments won him the title "Artist Laureate," a special distinction according to Whitaker. "He was a person of gentlemanly bearing who could enter and leave a room with ease and grace. He conversed with more than ordinary intelligence on the principal topics of the day and all deemed it a privilege to be in his company. His opinions were of a decided nature." Bannister was thoroughly conversant with the Bible, Shakespeare, English literature, classical themes, and mythology; he also loved music.

A professional artist who lived by his painting, Bannister painted primarily what he knew intimately—the somber blue-gray skies with breezy white cumulus clouds in the late afternoon and the hilly sweep of the Rhode Island landscape and its Narragansett dunes and shores. He welded these motifs in flat planes, initially very much in the fashion of William Morris Hunt, his admired master, so that his best works have a compelling unity. The Barbizon influence waned as he gathered confidence in his own vision of nature.

Bannister's paintings always have a certain seriousness, a solidity. The work achieves its statement not through brilliance or cleverness, but through simplicity, patience, and circumspection. All his paintings arise directly from nature in contrast to the late works

Landscape with Man on a Horse (1884) evokes an intriguing sense of impending action arising from the turbulence of the sky, the distances, and the vague figures of the horse and rider. Something seems about to happen, yet that action is not defined. Creation of a mood was a major Bannister goal. (26 x 40⅛″) National Museum of American Art

of Duncanson and Church, whose landscapes express poetic, imaginary, dreamlike visions of nature. Bannister loved the countryside and the sea, and his work always reflects his persistent wonder at the gifts of nature. At the same time his paintings, like his personality, seem tranquil, balanced, and steady.

In his *Reminiscences,* Whitaker observed: "Never before has any artist in this locality thrown upon canvas such restful, soulful scenes, where pasture pools, rock and laurel, oak and brambles, swale-land and drowsy cattle all combine to ultimate dreams of peace." Whitaker emphasized that Bannister "was a spiritually minded man and from the beginning of his art career to its close he felt deeply that the ideal was the real. This ideality obtained in all his canvases, making them poems of peace."

Whitaker, who had studied Barbizon painting in France with Millet and other masters, recalled with delight a trip that he and Bannister made to a major exhibition of Barbizon paintings in New York City:

There my friend was in his element. As we walked from picture to picture, talking more earnestly than

we were aware, we noticed we were being followed by a stately old gentleman of the old school who soon introduced himself, giving his name and saying he was an officer of the Metropolitan Museum, and would we, after doing this exhibit, be his guest at the Museum? I am sure he had been attracted by Bannister's talk and actions—namely, with hands, feet, body, and head, so enthusiastic did he become. We accepted and were royally entertained. It was one of the greatest treats I ever enjoyed and reminded me of a day spent with George Inness in Paris twenty-five years ago.

One aspect of his friend that puzzled Whitaker was that although Bannister was an experienced seaman and spent much time sailing, he did not concentrate on marine paintings. "For more than 25 years he sailed his small yachts in Narragansett Bay and Newport harbor," Whitaker noted. "I have had the pleasure of being in his company on his boat for weeks at a time and I fancy that here he made his mental studies of Cloudland. . . . These were days when his cup of joy was full."

Approaching Storm (1886) demonstrates a marked difference from the Hudson River school, which usually presented nature in serene grandeur. Bannister, influenced by the Barbizon school, tried to be more realistic, sometimes showing conflict in nature as in this depiction of a threatening storm. (40¼ x 60″) National Museum of American Art

Contributing to Bannister's happiness were various regional honors. At the Massachusetts Charitable Mechanics Association annual exhibit, a major Boston show, Bannister won a bronze medal in 1878 and silver medals in 1881 and 1884. Among those who bought his paintings were Isaac C. Bates, Eliza Radeke, H. A. Tillinghast, and others associated with the Rhode Island Museum of Art.

Despite the recognition, Bannister always regretted his lack of formal training. In a letter to Whitaker, written late in life, he complained: "All that I would do, I cannot, that is all I could in art—simply from lack of training; but with God's help I hope to be able to deliver the message he entrusted to me."[35]

Like most American landscapists in the nineteenth century, Bannister sought God in nature and tried to convey a moral sentiment in his work. He was, for example, fond of titles like *Pleasant Pastures, Sunset Repose,* or *Approaching Storm.* Along with his contemporaries, Bannister saw man as diminished in relation to the power and beauty of nature. As a result, he was not concerned with the human figure and rarely painted portraits in his mature years.

Unlike the painting of the Hudson River school in which every leaf, branch, stone, and root is meticulously detailed, in Bannister's painting, details are lost in massive but revealing shapes of trees, mountains, rocks, and trails. These shapes are developed through sharp contrasts of light and shade so that his work often appears to be based more on black-and-white values than on color relationships. Whitaker put it this way: "He was one of the few artists who knew the value of deep shadows as a foundation of his painting. His color was not of a voluptuous nature but rather a quiet kind that juggled with greys."

In *Approaching Storm,* one of the few works in which Bannister attempted a less than tranquil landscape, we look down, as if from the vantage point of a nearby hill, upon a man hurrying to find shelter. The path he follows is in the foreground; trees shuddering in the wind are in the middle distance. The hills on the left and the sky above constitute the background in this painting, which is conceived in a rather narrow spatial depth. If the reproduction of *Approaching Storm* (see above) is turned upside down, it becomes apparent that the foreground, trees, and hills are all massed in

This untitled landscape (1897) is characteristic of Bannister's painting. Details are swallowed up in massive forms of trees, foliage, clouds, and distances. His emphasis on contrasting light and shade gave his work a black-and-white quality rather than one built on color relationships. (36⅛ x 48″) National Museum of American Art

one large silhouette—against which the figure of the man is silhouetted.

In his landscapes Bannister depended on his own observations, suggesting mood and emotion with bold but often sketchy brushwork. This sketchy, unfinished style has some of the spontaneity of the English landscapist John Constable and some Barbizon painters. It differs significantly from the controlled and polished finish sought by Asher B. Durand, Thomas Cole, and other Hudson River school painters, including Duncanson.

Bannister was fascinated by conflicting, accidental effects in nature—what happens to clouds, light, trees in the wind or other varying weather conditions. This interest is clearly demonstrated in his *Approaching Storm*. The unity of his best work comes from its un-

derlying feeling and atmosphere, as well as its careful balancing of elements; it is not at all the constructed landscape of Claude Lorrain, or, later, Paul Cézanne. Where the classical landscapists tried to show nature in calm grandeur, Bannister felt it was contrary to nature itself to depict it in such a perfectly finished manner. He derived his colors from his subjects, and as a result they tended to be earthy rather than the imaginative and romantic glowing tones of Church and others.

As he grew older, Bannister experienced more and more difficulty in selling his work because tastes had changed. He became discouraged, and the family had trouble making ends meet. His health began to deteriorate, and he had to give up sailing. Lapses of memory made it impossible for him to stroll safely. As Arnold, his oldest artist friend, described it: "With a mind clouded and bewildered, a hand that had lost its cunning, mentally and physically a wreck, he passed away in his beloved church."[36] Bannister died of a heart attack while attending a prayer meeting at the Elmwood Avenue Free Baptist Church on the evening of January 8, 1901.[37]

The artists of Providence marked Bannister's grave with an eight-foot-high boulder bearing a bronze pal-

Sunset (1875–80) presents a poetic picture of nature, depicting a swallow swooping low over a pond as the shadows of the trees deepen in the waning light of the sun and its reflection in the water. (20¼ x 28¼″) National Museum of American Art

ette with a pipe, modeled after his favorite, laid across it.[38] Arnold said somewhat bitterly that it reminded him of what Robert Burns's mother had said when she saw the magnificent monument raised in his honor: "He asked for bread and they gave him a stone."[39] For Arnold, more than Whitaker, realized the great obstacles that Bannister had overcome to become one of the most noteworthy artists of his time.

Arnold, a well-regarded portraitist, believed that Bannister's contribution would endure. He wrote that Bannister "went to nature with a poet's feeling—skies, rocks, trees, and distances were all absorbed upon canvas with a virile force and a poetic beauty which in time will place him in the front rank of American painters."[40]

Living in a period when American painting was secondary to European work, Arnold could not see that eventually the peculiarly American Hudson River school of painting, with its emphasis on the untamed wilderness and vastness of the nation, would rise to preeminence. Even more, having witnessed the Civil War and end of slavery, and having seen his black friend win a national competition and acceptance by a large community, Arnold could not anticipate that continued racial prejudice would contribute significantly to the omission of Bannister's name from histories of nineteenth-century landscape painting in America.

Bannister is important today not only for his paintings, but also because his life shows that America was not always in the grip of virulent racism. His achievements attest to how much black members of a democratic society have to offer that will enrich the lives of all its people.

After Bannister's death in July 1901, Providence artists and friends erected a large boulder bearing a bronze palette and a poetic tribute to his memory. They are shown at its November dedication. Boston Public Library, Department of Rare Books and Manuscripts

GRAFTON T. BROWN

The earliest known African-American artist on the West Coast of the United States was Grafton Tyler Brown. Active before the Civil War, he specialized in scenes of snowcapped mountains and shimmering lakes.[1] There were no museums or galleries in the Far West then, and Brown's work was unknown to eastern art critics and magazines at that time. Today his best-known work is a painting of Mount Rainier, entitled *Mount Tacoma*. This work is in the Kahn Collection of the Oakland Museum, which also owns Brown's *Grand Canyon of the Yellow Stone from Hayden Point*.

Brown was born in Harrisburg, Pennsylvania, on February 22, 1841, apparently of free parents. In 1848

gold was discovered in the West, and in 1849, when California's state constitution was framed, its people specifically excluded slavery, prompting southern congressmen to declare their intention to secede if California was admitted to the union with such a constitution. This situation attracted a large number of black people to California.[2] Whether Brown's family took him west as a child during the early migration of black people between 1849 and 1851 or whether he went himself as a young man is not known.

By 1862 Brown was listed in the San Francisco directory as a lithographer employed by Kuchel and Dresel.[3] A draftsman of considerable skill, Brown was frequently sent to visit new towns and cities to draw views of their principal streets and buildings, which were then lithographed. Such views were in great demand. New settlers in the booming Far West wanted them to boast of their "city" and proclaim their faith in its future, while would-be settlers in the East wanted to see where they might go. Virginia City, Nevada, one of the most booming boomtowns, was one new

Mount Tacoma (1885). Brown was attracted to the picturesque qualities of the Northwest, such as this view of Mount Tacoma (now Mount Rainier). However, his sales were limited, and eventually he gave up painting to become a government draftsman. Oakland Museum, Oakland, Calif.

city that Brown sketched.[4] Within a few years he established his own lithograph business, G. T. Brown & Co., at 520 Clay Street, San Francisco.

Brown was already painting landscapes by this time. Many well-known artists, such as Albert Bierstadt, came to the West for brief stays to sketch its spectacular scenery and then completed their work in the East. Brown stayed in the West and delighted in painting mountain scenes.

In 1872, when he was thirty-one years old, Brown felt confident enough about his artistic skills to sell his lithography business and to concentrate on landscapes. He traveled as far north as Victoria, British Columbia.[5] Finally, attracted by the snowcapped mountain ranges, he settled in Portland, Oregon, where he was listed in

the city directories from 1886 through 1890. A bill from that period indicates that one of Brown's mountain views sold for sixty-five dollars.

His letterhead advertised his work as follows: "Views of Mt. Tacoma, Mt. Hood, Mt. Baker, Mt. Adams and others. Scenes on the Columbia River, Ore., and Puget Sound, W.T., on hand and painted to order."[6] At times Brown traveled into the interior, going to the Grand Canyon of the Yellowstone where he painted the Lower Falls in 1889 and again in 1891. He apparently never painted portraits.

About 1896 Brown married, and some time later went to St. Paul, Minnesota, where he was employed by the U.S. Army Engineers as a draftsman. Later, he was similarly employed by the city. Whether he continued to paint is unknown.

On February 13, 1918, he was admitted to St. Peter State Hospital in Minnesota in a psychotic state, and he died there on March 2 of pneumonia and arteriosclerosis, at the age of seventy-seven years. Brown's mental illness began, his wife told hospital authorities, about seven years earlier, when he had a seizure or stroke that rendered him unconscious. On regaining consciousness, he did not initially recognize his wife. Although he recovered, his health gradually deteriorated and, by 1914, he had become psychotic.[7]

As a pioneer artist in the Far West, Brown is related to Bierstadt, Frederic Remington, Charles M. Russell, and others who recorded western scenes. Brown attempted to create a faithful reproduction of what he saw. His paintings have a picture-postcard quality because, like a camera, he tended to give equal emphasis to all the objects on his canvas. Brown lacked an ability to select a focal point for emphasis and to organize his painting around it. This may have been a result of his training as a draftsman, when he was expected to include everything in his views of new towns.

EDMONIA LEWIS

"The striking qualities of the work are undeniable and it could only have been produced by a sculptor of very genuine endowments" is how Walter J. Clark, a pupil of George Inness and a leading New York artist and critic, summed up his impression of Edmonia Lewis's *The Death of Cleopatra*.[1] Its realistic portrayal of the death agony of the asp-bitten queen upset the prevailing Victorian sentimentalism about death and made this statue the sculptural sensation of the 1876 Centennial Exposition in Philadelphia.

Ten years earlier Henry T. Tuckerman, in his famous *Book of the Artists,* had published a letter from Rome characterizing Lewis as "the most interesting American artist working in Europe. . . . She has great natural genius, originality, earnestness, and simple genuine taste."[2]

The obstacles Edmonia Lewis overcame are unparalleled in American art. Paradoxically, the art of her day demanded a style, Neoclassicism, that made the work of one artist virtually indistinguishable from that of another. Requiring a bland conformity, it was a style that smothered individual creativity. Nevertheless, within the Neoclassical style, Lewis's work held its own with that of her contemporaries. Despite the harsh difficulties of prejudice and poverty that she confronted, hers is a triumphal story.

Yet she was virtually ignored after the Centennial until the civil rights and feminist movements in the late 1960s aroused interest in her achievements as an African-American woman artist emerging in the Civil War period, 100 years earlier. These years of neglect cannot be undone. Important details about Edmonia Lewis remain obscure, if not missing altogether. In understanding her life, one must rely at times on circumstantial information. Although she became a religious artist, only one of her original religious statues, *Hagar,* is known in the United States and other major works cannot be located; her copy of Michelangelo's *Moses,* which retains its monumental character al-though small, is in the National Museum of American Art in Washington. When and where she died remain unknown.

On July 14, 1845, in the village of Greenbush, across the Hudson from Albany, New York, a second child, Mary Edmonia Lewis, was born to an African-American father and a mother of Mississauga and African-American descent.[3] The Mississauga are a Chippewa (Ojibway) band, who then lived on the Credit River Reserve, now the site of the city of Mississauga on Lake Ontario.

Although the parents' full names are unknown, Canadian records show that an African-American, John Mike, presumably a fugitive from slavery, married an independent-thinking Mississauga woman named Catherine and that one of their daughters married "a colr man named Lewis."[4] There are no dates for these marriages. Racial prejudice stemming from British settlers and government grants made to members of the Mississauga band caused the band council to vote a ban against John Mike and his children living on the reservation and receiving the annual government payment. The rationale behind this ban was that if blacks, who were arriving in increasing numbers, intermarried with the Mississauga for several generations, the government might at some point declare their children were not Mississauga and deny them the annual grants. Yet there was no objection to whites marrying Mississauga, reflecting the prejudicial character of the ban. While the council held that Catherine Mike was a full member and entitled to all rights, membership in the band was derived from the father.[5] This information indicates that Edmonia Lewis's grandfather, as well as her father, was an African-American.

The council had no authority to enforce its ban. The Mikes were considered members of the commu-

nity but not members of the band, although the Mississauga council made repeated demands over many years that they leave. This form of social pressure may help to explain how Edmonia Lewis's parents came to meet in Albany and live in Greenbush.

Edmonia Lewis described her father as a "full-blooded African" and "a gentleman's servant" and her mother as a "full-blooded Chippewa,"[6] which could not have been the case if John Mike was her grandfather. However, by the time Lewis made these statements she had learned that it was often necessary to tell white people what they wanted to hear to win their sympathy and support. And at that time white people respected only full-blooded Native Americans and liked to describe them as "wild."

In any case, both parents died when Edmonia was about nine years old. Her brother, who was considerably older, was then attending a boarding school for Native American boys.[7]

After their parents' deaths, Mary Edmonia and her brother were taken in by two aunts, their mother's sisters, who belonged to a small group, composed mostly of Mike relatives, that had split off from the main Mississauga band. They lived near Niagara Falls. To raise cash for fishing gear, clothing, ammunition, guns, and supplies, this group made and sold baskets, moccasins, blouses, snowshoes, belts, and other souvenirs to tourists at Niagara Falls and in Buffalo and Toronto. But mostly they hunted and fished along the Niagara River and the northern shores of Lake Ontario. The Niagara, which forms the border between United States and Canada, was a major crossing point for fugitives from slavery.

Growing up on the Canadian border, seeing both the fugitives from slavery and the owners and slave hunters hotly pursuing them, Mary Edmonia learned about slavery in a special way. Her parents and Mississauga relatives taught her that her negroid features put her at special risk of being kidnapped by slave hunters. When her mother realized she was fatally ill, she feared that Mary Edmonia, soon to be approaching her teens, would be seized by slave hunters or be caught up in the oppression of black people in the United States. On her death bed, she asked Mary Edmonia "to promise [to] live three years among her people,"[8] perhaps hoping that she would marry within the Mississauga band in Canada.

Like other Native Americans, the Chippewas—or to use the Canadian term, Ojibways—did not share white people's preoccupation with conquering nature, owning more and more land, ravaging forests, building towns, railroads, and industries. Highly knowledgeable about trees and the useful qualities of their woods, the Chippewas were famous for their birch-bark canoes. Considering the sun the primary creative force of life, they worshipped it. They considered the earth the nurturing mother of all things and sought to be at one with nature. They appreciated the interdependence of all creatures and believed everything—trees, fish, animals, lakes, even rocks—had a spirit. This belief made them both imaginative storytellers and fearful.[9]

Chippewa life was not new to Mary Edmonia and her brother. "Mother often left her home and wandered with her people, whose habits she could not forget, and thus we children were brought up in the same wild manner. Until I was twelve years old, I led this wandering life, fishing, swimming, and making moccasins. . . . I made baskets and embroidered moccasins, and I went to the cities with my mother's people and sold them," Lewis later said.[10] Her mother was highly regarded—"famous," said Lewis[11]—for creating new patterns in moccasin and embroidery designs. She had encouraged her daughter to make things with her hands, such as baskets, and let her try to work out designs with porcupine quills and beads.

In later years Lewis gave her brother's name in English as Sunrise, which in Chippewa would be *Waubun.* She said her own name was Wildfire, a name apparently designed to fascinate the white people with whom she had to deal.[12] However, the Chippewas had no concept of "wild," at least in terms of plants, places, or animals. To them, everything was natural, a part of nature, according to Basil H. Johnston, a Chippewa himself and a linguistic expert at the Royal Ontario Museum.[13] If fire was part of her name, he said, the Chippewa would focus on the character of the fire. Her name then might have been *Naning-au-koane* ("Sparkling Fire"). However, since a girl was usually named after a flower that reflected her character or personality, Lewis may have been given the name *Ish-scoodah* ("Fire Flower")—the Chippewa word for the cardinal flower (*Lobelia cardinalis*).

With his boarding-school education, Mary Edmonia's brother became aware of the limitations of the nomadic life of his aunts' group. Some time in the 1850s he left and went west to join thousands of others in developing the towns and cities that grew out of the gold rush. He may also have dug for gold.

Several years later Sunrise returned, relatively rich from his success in California. He insisted that Mary Edmonia go to school at his expense. He took her to a Baptist abolitionist school, New York Central College, in McGrawville, a village that has since disappeared. Although delighted to be with a number of other children her own age for the first time in her life,

Mary Edmonia had speech difficulties because certain consonants—*r, l, f, v, x,* and *th*—are not part of the Chippewa language, which runs many syllables together.[14] Moreover, when confronted with strange foods, academic drills in spelling and reading, as well as restrictive rules about dress, meals, bedtime, chapel, and other aspects of boarding-school life, she rebelled. She was "declared to be wild—they could do nothing with me," she later said.[15] No records show when she left. The school, which had always been under attack for admitting black and female students, closed in bankruptcy in 1858.[16]

Nevertheless, she had grasped the rudiments of reading and writing. Selling moccasins and baskets had already taught her arithmetic. Back in the Niagara valley, camping and cooking with her solemn, silent aunts, she missed the life she had with young people at "McGraw," as she called it (she could not say "ville" easily).[17] When Sunrise proposed that she try school again, in the college preparatory department at Oberlin College near Cleveland, she readily agreed.

When Mary Edmonia Lewis arrived at Oberlin College in 1859, it was a major abolitionist center. Oberlin's leaders believed in "Christian perfectionism"—an introspective religious searching to purify oneself and gain salvation by taking responsibility for one's sins.[18] Believing that owning another person was a grave sin, they provided room and board for fleeing slaves and physically battled police and slave hunters to rescue fugitives. They also admitted women and African-American students. Thus teenage Mary Edmonia entered a red-hot crucible in the conflict over slavery.

She was admitted to the three-year preparatory course by the head of the Ladies Department, Mrs. Marianne F. Dascomb, who controlled all female admissions with unquestioned authority.[19] Pious and puritanical, she restricted women students with severe rules, partly because the college was under attack from nearby towns for admitting both women and black students. Lewis, as an orphan and under fifteen years old, was required by regulations to be placed on probation and assigned to a home where she would be closely supervised—that of the Reverend John "Father" Keep, a retired theologian.[20] As a trustee, he had cast the pivotal vote that secured admission of women and black students.

Most students came from nearby communities that did not share Oberlin's abolitionist fervor and its Christian perfectionism. The college put interracial association on an individual basis. "If both are agreed, colored and white students walk together, eat together,

attend classes together, and worship together," said one official.[21] Lewis was the only African-American girl among twelve girls living at the Keeps'. Taking an interest in this orphan girl, Mrs. Keep gave her a second-floor room to herself.

Dascomb selected Lewis's studies, which included composition, rhetoric, botany, algebra, and the Bible. Lewis also took an elective course, "linear drawing," taught by an experienced artist, Georgianna Wyett.[22]

Discovering she could draw, Mary Edmonia worked steadily to impove her skill. She also saw her first sculptures—small casts of Greek and Roman classics. Ever since Hiram Powers's *Greek Slave* had been exhibited in Cincinnati in 1847, small casts of that and other statues were widely available.

Mary Edmonia passed through her probationary studies without difficulty,[23] but she still had trouble speaking English. Her persistent childhood speech habits contributed to her difficulty in finding herself in this social milieu. She loved the vocal music already making Oberlin famous, but she could not sing because of her speech problems.

Unschooled in conventional social behavior, indifferent to many materialistic values, Lewis was considered by other students to be cheerful but too independent and brusque in her direct expressions of thought and feeling. She did not offer the "niceties" then expected in "young ladies' talk." Raised among the nature-loving Chippewas, she did not readily accept the Oberlin obsession with "perfectionism." Struggling with her personal and cultural identity, she initially thought of herself as Chippewa rather than African-American, although that would change.

In October 1859, soon after Lewis arrived at Oberlin, John Brown and his small band seized the Harpers Ferry arsenal, hoping to set off a slave revolt. Brown's father had been a founder of Oberlin, and two Oberlin African-American men were with Brown: Lewis Sheridan Leary was killed and his nephew, John A. Copeland, was captured.[24] With Brown and Copeland on trial for their lives, Oberlin exploded with anxiety, grief, and protest. When Brown was hanged, the chapel bell tolled for an hour and faculty members led a protest meeting of students, faculty, and townspeople—about a quarter of the town's population was African-American.[25]

As an orphan, Mary Edmonia had remained at the Keeps' when other students went home for Christmas. Thus, on Christmas Day she joined Father and Mrs. Keep at a memorial service for Leary and Copeland that was attended by their bereaved parents, faculty members, and most Oberlin black people. No other town in the United States was so deeply involved in

Left: The Reverend John Keep, a theologian, cast the deciding vote as a Oberlin trustee to admit women and African-Americans. Lewis, entering Oberlin in 1859, was sent to live in his home because she was so young. This portrait was painted by Alonzo Pease of Cleveland. Oberlin College Archives. Right: Mrs. Marianne Dascomb (photograph ca. 1860), head of Oberlin's Ladies' Department, came from a strict, pious abolitionist background. She refused to let Lewis register for her final term, although she had been exonerated of all charges against her. Oberlin College Archives

the fate of Brown and his followers. Brown's image as a kind of avenging angel, formed at Oberlin, was to be important in Lewis's artistic development.

Thus in her first months at Oberlin, Mary Edmonia Lewis gained a real sense of her talent as an artist and of the world of art. At the same time she felt the heat and tragedy of violent opposition to slavery.

In her third year at Oberlin, well liked and with an unblemished record, Mary Edmonia Lewis had become close friends with two girls at the Keeps'[26] who came from nearby towns. In January 1862, before the term began, these girls returned to the school to keep a sleigh-riding date with two young men. During the ride they became ill, vomiting and suffering from cramps. Driven to one girl's home, where they had expected to have dinner, their symptoms were diagnosed as caused by cantharides, or "Spanish fly," then considered an aphrodisiac. Asked about taking this substance, the girls accused Lewis of secretly putting

it into some hot spiced wine she had supposedly served them before the ride.

The accusations of the girls, reportedly "at death's door" for days, shocked Oberlin, particularly because Spanish fly suggested sexual behavior in a puritanical college that went to extraordinary lengths to prevent sexual expression. Women could not leave their rooming houses without permission. Men and women students were forbidden to walk together in certain places. A visit to the room of the opposite sex resulted in expulsion. Even engagements were forbidden because they provided a rationale for intimacy.[27]

When Father Keep and his wife confronted her with the girls' accusations, Lewis satisfied them of her innocence. The Keeps knew the other girls well and were deeply concerned, for the charges implied a lack of supervision. Dascomb, as head of the Ladies Department, also questioned Lewis and apparently felt the best course was to see what legal charges might be made. The accusations called into question Dascomb's supervision and wisdom in admitting Lewis and the

John Mercer Langston, an Oberlin graduate and African-American lawyer, successfully defended Lewis against charges by two white girls, also living in Keep's home, that she had poisoned them with cantharides. These charges were dismissed for lack of evidence.

accusing girls. Neither the college nor the village took any immediate action against Lewis.

However, these accusations by local girls brought anti-black and anti-Oberlin feelings to a boil in nearby towns, which had long resented Oberlin's abolitionist efforts and its admission of blacks and women. Both accusing girls came from nearby towns, where many felt that the Oberlin officials were "going to let her get away with it" because she was black.[28]

Mary Edmonia was also questioned by a young African-American lawyer, John Mercer Langston, an Oberlin graduate and the uncle of Lewis Leary, who had died in Brown's raid. He believed her innocent; he also realized that if the accusing girls died, a murder charge could set off violent attacks on black people in Oberlin, Cleveland, and Cincinnati. He thus set out to find the facts.

Learning that cantharides poisoning could be established only by analysis of the vomitus, urine, and feces, Langston and an Oberlin physician, Dr. William Bunce, interviewed the physicians who had treated the girls. Then Bunce alone interviewed the girls, which so enraged one girl's father that he attempted to shoot Langston.[29] At this point Lewis was arrested, charged with poisoning by cantharides, and a hearing date to determine if she should be indicted was set.

Before the hearing, as she stepped outside the Keeps' back door one cold winter night, Lewis was seized, dragged into the field behind the house, brutally beaten into unconsciousness, and left for dead in the snow. When others noted her absence, the Keeps had the village alarm bell rung, for threats against Lewis were well known. Torch-bearing students and faculty found her unconscious, battered form. Her severe lacerations and multiple bruises and contusions, combined with exposure to the February night air, suggested death was her assailants' goal. On regaining consciousness, however, she could not identify her attackers.[30]

Lewis's disabling injuries forced postponement of the hearing. When it was finally held, she had to be helped into the room on friends' arms. Two justices presided. The prosecution and the packed audience, which undoubtedly included such interested parties as Father Keep and Mrs. Dascomb, expected the evidence to be the word of the two local white girls, from respectable families, against that of black Mary Edmonia Lewis. The two girls testified, then their boyfriends, then the physicians who treated them. As the hearing went into its second day, Dr. Bunce testified that proof of cantharides could not be determined by symptoms like vomiting and cramps, which occur in many disorders. Instead, the presence of cantharides had to be demonstrated in the vomitus, urine, and feces. This had not been done.

Langston moved for immediate dismissal because no proof had been provided that the girls were poisoned by cantharides, the main charge. Moreover, no motive had been demonstrated and no evidence had been presented that Lewis had cantharides. The accusing girls had simply claimed it was put into their mulled wine secretly.

Langston's classic defense scientifically demolished the case, stunning the audience and the well-known prosecuting lawyers hired by one girl's family. Known as corpus delicti, this defense holds that substantive evidence is missing and is derived from the logic that a murder cannot be proved unless the body is found. After lengthy arguments, both justices concurred that "the evidence was insufficient"[31] to hold Mary Lewis, as everyone called her, for a court trial. Fully exonerated, Lewis "was carried on the arms of her excited associates and fellow students from the courtroom . . . fully vindicated in her character and name."[32]

Although she returned to classes, her mental anguish persisted for years. The false accusation by young women she considered friends, its sexual implications, the terrifying brutal beating by unknown attackers,

followed by the need to defend herself everywhere, including the two-day public hearing, left deep emotional scars. She became unable to trust anyone, which affected her development as an artist. Much of the mystery and difficulty of her later life can be understood in light of this severely traumatic episode.

Curiously, there is no evidence that a serious investigation of her beating was carried out by village or college officials.[33] College officials dominated the town, and if they had desired an investigation, there would have been one. However, such an investigation would have prolonged the scandal and its sexual implications, something Oberlin officials did not want.

What caused the girls' illness remains unknown. There was no evidence that Lewis had cantharides. There was not even any evidence that Lewis had wine, for Oberlin was a strict temperance town. If the question of who had access to cantharides and wine is considered, then it becomes clear that Mary Edmonia Lewis, with her closely circumscribed life, had the least access to such substances.

Lewis consistently denied the charges. The accusing girls, embarrassed because their stories were not accepted, did not return to the college. The Keeps seemingly believed Lewis, because she continued to live in their home. Langston, writing his autobiography in the third person some thirty-two years later, devoted a chapter to his defense of Lewis—without naming her or others involved in the trial. Yet he made it plain that it was Lewis, asserting "that she has very justly been termed the first artist of the Negro race of the Western continent. Her works of art as displayed in marble tell now how wisely and well her attorney labored in her case to vindicate justice and innocence."[34] At the time Langston had served as a congressman, founded the Howard Law School, and been the United States minister to Haiti. He was especially proud that he had defended Lewis against the advice of some frightened Oberlin African-Americans.

The charges and the hearing marked a significant turning point for Edmonia Lewis. Things were never the same for her afterward.

Resuming classes, Mary Edmonia Lewis found herself ostracized and the butt of snide "Spanish fly" comments.[35] When a loyal friend, Clara Steele Norton, decided to marry Judson Cross, a former student on leave as a Union soldier, Lewis made them a wedding present. She did a pencil drawing of an engraving of a Roman statue of the Greek muse Urania. Since Urania was the mother of Linus, the inventor of rhythm and melody, the drawing seemed an appropriate remembrance of musical Oberlin.[36] The drawing, handed

Urania, Lewis's only signed drawing, was created in 1862 as a wedding gift for an Oberlin classmate who was marrying a former student on leave from the Union Army. Although stained by candle wax, the drawing was preserved and handed down through generations of the couple's family. It demonstrates that as a teenager Lewis had become a skilled draftsman, familiar with the Neoclassical use of drapery. (14¼ x 12") Oberlin College Archives

down by generations of the Cross family, is now in Oberlin archives.[37]

The only known drawing by Lewis, this work demonstrates that she was an accomplished draftsman at age seventeen years and already familiar with the Neoclassical style and its penchant for drapery. Significantly, the drawing is signed "Edmonia Lewis," indicating that she had formed a new identity as an artist, taking the distinctive name *Edmonia* and dropping the more common name *Mary,* by which she was generally referred to.

Always independent and free of social cant, Lewis was very much alone after Clara Norton Cross left. Her brusque directness and unwillingness to cringe in shame and guilt made her seem arrogant to some. She insisted on participating in student activities, such as skating parties.

A year after her hearing, in February 1863, Lewis was accused of stealing brushes from the studio of an unorthodox art teacher, a "Professor Couch," who was not affiliated with the college and cannot be further identified.[38] She was immediately exonerated for lack of evidence.[39] She was also accused of stealing a picture frame from J. N. Fitch's bookstore under Couch's studio, but this charge was never formally made, presumably also for lack of evidence.[40] Obviously, Lewis had become a scapegoat, under constant prejudicial scrutiny. New charges, however false, might be made at any time.

The mere airing of new charges put Mrs. Dascomb, who had total, unquestioned authority over all female students, on the spot. She was apparently criticized for Lewis's continued presence. Since she could not support a call for Lewis's expulsion at a faculty meeting once the legal charges had been dismissed, Dascomb simply refused to accept Lewis's registration for her final term. This punitive action denied Lewis the right to graduate while avoiding any faculty discussion. Lewis simply was not a student. No one could challenge Dascomb's authority; she had been begged to take her post by the trustees. Thus Edmonia Lewis was shut out of Oberlin College without technically being expelled.

Humiliated, Lewis was determined to show that Oberlin had misjudged and mistreated her. In the Chippewa tradition, revenge for humiliation is required, according to Henry R. Schoolcraft.[41] Lewis set out to expose the falsity of the accusations and the hypocrisy of Dascomb by demonstrating her skills and determination. Only eighteen years old, she left Oberlin in late February or early March 1863 and went to Boston to become a sculptor. She probably carried a message from Father Keep, who knew William Lloyd Garrison, asking him to help her find instruction.

In Boston, with a letter of introduction from Garrison, Edmonia Lewis sought out Edward A. Brackett as a teacher. His inspired bust of John Brown was created from measurements he made of Brown in prison shortly before his execution. "I thought the man who made a bust of John Brown must be a friend to my people," she later told Lydia Maria Child.[42]

Brackett gave her some clay and the cast of a child's foot to copy. After many trials, she succeeded. One of Brackett's clients paid her eight dollars for it. She promptly hung a tin sign—"EDMONIA LEWIS, ARTIST"—on her door in the Studio Building, where her brother had rented a small studio for her.[43]

Using Brackett's bust of Brown as her model, she worked tirelessly at learning how to model small, clay relief portraits, which required no supporting internal armature. Brackett also loaned her a damaged Voltaire

John Brown, by Edward A. Brackett, who gave Lewis her first lessons in modeling clay, was based on a visit to Brown in jail just before he was executed. Brackett allowed Lewis to make medallions based on this portrait, enabling her to survive while she learned.

bust, which she repaired and used as a model. She learned how to cast her best relief portraits in plaster and was soon selling plaster medallions of John Brown and other abolitionists at abolitionist receptions and church affairs.

At one of these events, in the summer of 1863, she met Lydia Maria Child, one of America's most famous women writers at the time and the former editor of the *National Anti-Slavery Standard.* A leading abolitionist, Child had offered to nurse the wounded John Brown in his prison cell. As a friend of Harriet Hosmer, the best-known woman sculptor of that day, Child was intrigued by a black woman's desire to become a sculptor. Lewis invited Child to see her *Voltaire,* saying, "I don't want you . . . to praise me for I know praise is not good for me. Some praise me because I am a colored girl, and I don't want that kind of praise. I had rather you would point out my defects for that will teach me something."[44]

Child became an important friend. She described Lewis as brown and slight, "with that quickness and brusqueness of voice and motion which indicate a want of drill in conventional rules of society, but [with] a degree of natural modesty and frankness far more agreeable to me than the uniform smoothness of fashionable manners, always lifeless and generally hypocritical."[45]

With regard to Lewis's *Voltaire*, Child wrote that she improved on her model: "The mouth had a slightly humorous expression as if he were inwardly smiling."[46] Yet the sixty-year-old Child had observed Hosmer's prolonged training, so she considered Lewis's background in education and art deficient. Child felt that as a black person and a woman Lewis was at a great disadvantage. Uncertain of Lewis's talent, she was also troubled by her poverty. She urged Lewis to seek work that would pay for instruction. That Lewis had to sell immediately whatever she made and was determined to succeed worried Child.

Lewis simply ignored Child's repeated suggestions about instruction. If she followed Child's suggestions, she feared she would never become recognized as an artist. Instead, she proceeded directly to become a sculptor, to model clay and find out for herself what she could do.

To achieve her goal, Lewis had to have certain personal characteristics. She was, from many diverse accounts, cheerful and playful, not at all overawed by her task. She possessed good health, physical strength, and "an indomitable spirit of energy and perseverance," as Child put it.[47] With stoic determination, she stuck to her difficult trial-and-error method of learning to create sculpture and endured condescending and critical attitudes toward her and her "strange" ambition.

Lewis showed the Chippewa indifference to money and rules about it, which alarmed Child, who had written America's first book on frugal household management for housewives. Lewis was not concerned with fine clothes, furnishings, or food. Harsh Niagara winters has accustomed her to the cold and little food. A skilled survivor, she knew how to win sympathetic support and shrewdly made pieces that would fit any pocketbook, not just those of the rich—a tactic she had learned from selling Chippewa souvenirs.

In her first interview with Child, Lewis identified the origins of her interest in sculpture: "I always wanted to make the form of things. My mother was famous for inventing new patterns for embroidery, and perhaps the same thing is coming out in me."[48]

Since she had to exist by selling her work as she learned to produce it, Lewis affected a certain naiveté in the interests of what might be called "a good sales pitch." A much-repeated story relates that Lewis was inspired to try sculpture on seeing Richard Greenough's bronze Benjamin Franklin on the Boston Common. Implying that she did not know the word for statue, she referred to it as "a stone man." This story, which she told at times, evoked a desire to help "the poor soul," as some Bostonians referred to her.[49] It also confused later researchers, who believed it literally, failing to recognize a black woman's difficulties in being accepted as an artist at a time when even ardent abolitionists did not believe it possible.

In her initial meetings with Child and in later years, Lewis never mentioned her Oberlin ordeal. Those brutal events had created a deep distrust of others in her. Any mention of the poison charges or her cruel beating would have provoked questions and more questions, inevitably arousing suspicion—the very thing she needed to avoid. She did not want to go on reliving this terrifying experience, and although abolitionists would have been sympathetic, there is no evidence that she ever mentioned it. What Child saw in her was an intense drive to succeed in spite of all obstacles—a drive fired by her secret desire to demonstrate her worthiness and the unworthiness of those in Oberlin who had hurt and humiliated her.

On May 28, 1863, Lewis watched from the curb as young Colonel Robert Gould Shaw of a socially prominent Boston family led the now-famous black Fifty-fourth Massachusetts Regiment out of Boston. Among them were twenty-one young men from Oberlin,[50] many of whom had been recruited by John Mercer Langston and some of whom she knew—heightening her emotional involvement in their departure for battle. Six weeks later Colonel Shaw was killed with most of his troops as they charged Fort Wagner in South Carolina.

Determined to make a bust of the heroic Shaw, Lewis begged Child, who knew his family well, for photographs of him. Believing Lewis too "inexperienced a hand," Child refused.[51] Lewis would not give up. Working from memory and photographs obtained elsewhere, she completed the bust. Fearing the worst, Child and Maria Weston Chapman, Garrison's aide, came to see it and were much impressed. Child found "the likeness extremely good, and the refined face had a firm but sad expression, as one going consciously though willingly to martyrdom for the rescue of his country and the redemption of a race."[52] Both women found it touching that a young black artist had created the bust. Lewis's feelings of gratitude and admiration for Shaw were "one reason why she succeeded so well," Child wrote.[53] Lewis had told Child that in her intense effort to recall how Shaw looked, "it seemed

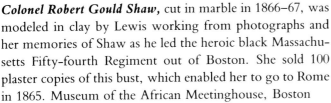

Colonel Robert Gould Shaw, cut in marble in 1866–67, was modeled in clay by Lewis working from photographs and her memories of Shaw as he led the heroic black Massachusetts Fifty-fourth Regiment out of Boston. She sold 100 plaster copies of this bust, which enabled her to go to Rome in 1865. Museum of the African Meetinghouse, Boston

John Brown became the subject of several busts by Lewis, which cannot be found today. This bust (1876) and one of Charles Sumner were destroyed when a tornado struck the Wilberforce University library in 1974. The authors had had this photograph made several years before that.

to me as if he was actually in the room," and that as she worked, she "kissed the clay."[54]

Encouraged, Lewis advertised in *The Liberator:*

MEDALLION OF JOHN BROWN—The subscriber invites the attention of her friends and the public to a number of medallions of John Brown, just completed by her, and which may be seen at room No. 69, Studio Building, Tremont Street. Edmonia Lewis, Boston, Jan. 29, 1864.

In *The Liberator* of February 19, 1864, Child described her first meeting with Edmonia Lewis, her racial background, Chippewa upbringing, Brackett's help, and her modesty. Child's article helped increase Lewis's sales.

Meanwhile Shaw's parents, accepting the bust as a reasonable likeness of their son, gave Lewis permis-

sion to sell copies.[55] In November 1864 she sold about 100 plaster reproductions at the Soldiers' Relief Fund Fair, an effort to raise funds to equalize the pay of black soldiers. Edward M. Bannister, who had a studio in the same building as Lewis, organized the decorations for the fair and gave her table display a good location.

Harriet Hosmer, whose *Zenobia* had attracted thousands in New York and Boston, praised the modeling in the Shaw bust.[56] She told Lewis that Italy was the best place to learn sculpture. Lewis also received advice from another sculptor with extensive art training, Anne Whitney, an abolitionist and feminist about twenty-five years older than Lewis. Although she considered Lewis's work crude and thought that the idea of a poor black young woman becoming a sculptor was a romantic abolitionist dream, Whitney gave Lewis some practical tips on handling clay.[57]

By the summer of 1865, Lewis had sufficient funds

to go to Italy. Worried, Child suggested that she seek work with decorative plaster workers there to support herself. She also cautioned that Lewis should have nothing cut into marble until she had someone to pay for it.[58] But this was the least of Lewis's worries. She already had two commissions: one from Shaw's sister for a marble copy of her brother's bust and another for a copy of her portrait of Dioclesian Lewis, a leading advocate of the radical idea of exercise for women.

On August 19, 1865, Lewis sailed for Florence,[59] the site of great works by Michelangelo and Donatello and the home of Hiram Powers, America's best-known sculptor at the time. Determination was her chief characteristic, Child felt, saying that Edmonia Lewis's indomitable spirit would "cut through the heart of the Alps with a penknife."[60]

In Boston, in striving to make portraits, Lewis had sought realistic likenesses. In Italy she sought to join the dominant art movement of that time—Neoclassicism—which had developed from Johann Winckelmann's demand for "pure beauty" nearly 100 years earlier. In his view this quality of form, without regard for content, was achieved only in ancient Greek statuary. Adopting this perspective, the Neoclassical artists sought to imitate ancient Greek sculpture, rejecting the decorative Rococo curlicues doted on by the European nobility.

Neoclassicism coincided with the American and French revolutions and idealized democracy, even portraying contemporary politicians in the togas of ancient Greek democracy. While the work of the Neoclassical virtuoso Antonio Canova had a passionate, sensual vitality, most Neoclassical artists could not achieve that inner bloom. They sought interest and significance by using the work to symbolize some issue, such as "The Death of Socrates," giving the work a historical or literary meaning that compensated for its aesthetic blandness. For example, the issue of slavery helped to make Hiram Powers's aesthetically conventional *Greek Slave* the first American sculpture to achieve great popularity.

Neoclassicism was then considered the most elevated form of artistic expression. In adopting this technically difficult style, Lewis hoped that it would enoble her portrayal of the essential humanity of all peoples.

In Florence Lewis saw how pointing devices guided stone carvers in enlarging small clay models into life-size marble statues. She also met two leading American Neoclassical sculptors, Powers and his friend Thomas Ball. From poor families themselves, Powers and Ball were sympathetic, giving her tools and inviting her to their studios to see how they assembled armatures and modeled clay. Later Lewis said she had studied with Powers, who was known for his strong instructional bent.[61] In any case, within a few months, she was introduced to the fundamental techniques in Neoclassical sculpture.

Although Sunrise sent her some funds, Lewis basically had to learn and earn her own way. From talks with Powers, Ball, and other artists, she realized that Rome, not Florence, attracted the mainstream of American visitors—the people most likely to buy her medallions, portraits of abolitionist leaders, and small copies of Roman busts.

Early in 1866 she went to Rome, where, she wrote Child, she was warmly welcomed by Harriet Hosmer: "It would have done your heart good to see what a welcome I received. She took my hand cordially and said, 'Oh, Miss Lewis, I am glad to see you here!' and then while she still held my hand, there flowed such a neat little speech from her true lips. Miss Hosmer has since called on me and we often meet."[62]

In 1866 Rome was the center of a fashionable international society that included many wealthy Europeans, English nobility, famous writers like the Brownings, and artists. Prominent American writers such as Nathaniel Hawthorne, Henry Wadsworth Longfellow, and Harriet Beecher Stowe, as well as artists like Randolph Rogers and Thomas Buchanan Read, made prolonged visits. Sculptor William Wetmore Story, arriving in 1847, had become an important social functionary in the British-American colony. "Entertaining" titled socialites, celebrities, cardinals, artists, and writers and climbing the status ladder preoccupied nearly everyone in the palazzi and villas of the international set. These status-seekers and their visiting friends were the artists' main patrons.

In Rome, Americans felt free of the stuffy puritanical "no-nos" they knew at home. Story felt he could never again "endure the restraint and bondage of Boston."[63] Hosmer wrote, "I can learn more and do more here in one year than I could in America in ten"[64]—an attitude she had enthusiastically conveyed to Lewis in Boston.

Hosmer had been introduced to Rome by Charlotte Cushman, America's first great dramatic actress. When Lewis arrived, it was to Cushman that Hosmer took her.[65] Cushman's Via Gregoriana home, a social centerpiece of the international colony, aroused much gossip because it harbored several female artists. Hosmer, for example, lived there for five years. The letters, diaries, and biographies of the women around Cushman indicate that they formed their closest relationships with members of their own sex. Elizabeth Barrett Browning had noted that Cushman and her intimate

friend of the moment "have made vows of celibacy and of eternal attachment to each other."[66]

An international star who played opposite Edwin Booth and William Macready, a friend of Longfellow and Abraham Lincoln's Secretary of State William Seward, Cushman was a homely woman who wore masculine clothes, managed her own theatrical business brilliantly, and declaimed in a mannish voice at her "evenings." Although not an abolitionist before the Civil War, she thoughtfully valued her African-American maid, Sally Mercer,[67] and had helped Robert S. Duncanson when he came to Europe in 1853.

Cushman liked women who challenged attitudes that restricted them. She immediately adopted Edmonia Lewis as her "cause." Hosmer arranged for Lewis to have her old studio, once Canova's, which had historical connotations. And Cushman set out to attract attention to Lewis as an untaught black artist, the first sculptor of her newly emancipated people to appear.

Plunged into this world on a sink-or-swim basis, Lewis adopted the costume of many artists in Rome—a velvet jacket with slashed sleeves, a byronic collar, a bright cravat, and a crimson working cap to keep marble and clay dust from her hair. Overnight she became the subject of much attention in what was the most sophisticated, gossipy, and trendy international colony in the world. At Cushman's soirées, she was considered exotic and mysterious. Already experienced in being the object of curiosity and subtle hostility, Lewis defensively adopted an attitude of cheerful naïveté, as if she were the untaught child of the forest—a role her shortness enhanced. With Cushman sending her acquaintances, Lewis's studio was soon "visited by all strangers who looked upon the creations of this untaught maiden as marvelous."[68]

Edmonia Lewis was what was new. Within two months, the London *Art Journal* included Lewis in notes on "Lady Artists in Rome," reporting her Shaw and Dioclesian Lewis commissions and first studies of *Hiawatha* and *Hagar*. A statue of a freed black woman on her knees thanking God for freedom's blessings was described as "close to her heart."[69] To Child, Lewis wrote that she considered this a humble work "but my first thought was for my father's people and how I could do them good in a small way."[70]

Another London magazine devoted to the arts, *The Athenaeum,* portrayed Lewis as "naive in manner, happy and cheerful, and all unconscious of difficulty, because obeying a great impulse she prattles like a child, and with much simplicity and spirit pours forth all her aspirations."[71]

Her relatively swift transition from religious Oberlin to Rome's gossipy, sophisticated international col-ony put Edmonia Lewis under high pressure. Her challenge to the prevailing attitude that black people were incapable of the "finer things" created a relentless, continuing trial. Her ambition disturbed many who considered themselves beyond prejudice. In Oberlin the *Lorain County News* reprinted the London *Art Journal's* article, but snickered about "her checkered career."[72] Even Child continued to be ambivalent about Lewis's becoming a sculptor.

In Rome, among the members of the American and British colonies, nearly everything Lewis did was noticed, considered "marvelous" but "strange" and subtly rejected with words of praise for "the poor soul." Unable to trust anyone, denied supportive intimacy, she was relegated to being a kind of exotic "conversation piece." Under such pressures she could be brusque and rude, refusing to yield to prying questions.

Like most sculptors then, Lewis felt she would not be taken seriously unless her work was in marble. In the winter of 1866–67 Cushman boosted Lewis's desire to get her work in marble. Cushman raised funds—mostly her own—to have Lewis's *Wooing of Hiawatha* carved in marble. Then in May, when Lewis completed the final polishing of this romantic group, Cushman offered it as a gift to the Boston YMCA.[73] She hoped to gain attention for Lewis outside the old abolitionist crowd with a subject drawn from Longfellow. She also hoped that YMCA members would be so charmed that they would buy its companion piece, *The Wedding of Hiawatha.*

However, it took until December for the *Wooing* to be accepted[74] and publicity about it to appear. As spring arrived, it was clear that the YMCA members would not buy the *Wedding.* By then Cushman was busy with her own project—keeping her nephew Ned in his job as the U.S. consul, which he had jeopardized by joining papal troops against Giuseppe Garibaldi's forces.

Seeing one of her two-figure pieces in marble excited Lewis. She was well aware that to continue meant buying marble and employing carvers and polishers. Hosmer, whose *Puck* made her fortune, employed nine carvers, but Lewis could afford neither marble nor carvers at the time.

Nevertheless, ignoring Child's cautions, Lewis was determined to put her work in marble. She had created a complex two-figure statue, near life-size, in celebration of the Emancipation Proclamation. Borrowing money for marble and carving, she had it cut in marble. She first called it *The Morning of Liberty.* Today, titled *Forever Free,* it is one of her best-known statues.[75] She then shipped the work, along with bills for the marble, carving, and freight, to Samuel E. Sew-

Forever Free (1867–68), created by Lewis in Rome, was the first sculpture by an African-American to celebrate the Emancipation Proclamation. Its realism about contemporary African-Americans and their feelings broke with Neoclassicism, the prevailing style of her time, although that style influenced Lewis's work. She borrowed the money to have it cut in marble. An earlier work, *The Freedwoman and Her Child,* has been lost. (41¼″ h.) Howard University Gallery of Art

all, a wealthy abolitionist lawyer and one of Garrison's inner circle.

Sewall and other Garrisonians were startled. According to Child, the statue was simply sent without notice, along with the bills.[76] Sewall had to pay $200 immediately to keep customs agents from auctioning the work off. In a letter, not yet found, Lewis explained that the statue was a tribute to Garrison and she had presumed the money could be easily raised by subscription among abolitionists. However, some members of that aging group felt that with emancipation now five years old, their work was done. They were trying to raise funds for a pension for Garrison, who had never made a living from *The Liberator.*

Although he did not respond to Edmonia's letter, Sewall began to try to raise the money. He decided, with Garrison's agreement, that the money could be raised by subscription if the statue were to be presented to the Reverend Leonard A. Grimes, the pastor of the 12th Street Baptist Church, Boston's most popular African-American church. Grimes had been an African-American abolitionist of great courage. Years before, as a Washington hackman, he had smuggled many slaves out of Virginia in his carriage; he had been caught and imprisoned but had never stopped his activities. However, the money raising went slowly, with $1 here, $5 there, and $800 to go.

By May 1868, Lewis was desperately writing to Maria Weston Chapman, Garrison's aide, who had always been sympathetic: "Will you be so kind as to let me know what has become of it [*Forever Free*]? And has Mr. Sewall got the money for it yet or not? I am in great need of the money." The statue represented two years of work, she said. "Dear Mrs. Chapman," she continued, "I have been thinking that maybe you have met with some who think that it will ruin me to help me, but you may tell them that in giving a little something towards that group—that will not only aid me but will show their good feeling for one who has given all for poor humanity."

Begging Chapman to see Sewall, she asked "if he had been paid the $800, will he be so kind as to send to me the sum. . . . Unless I receive this money I will not be able to get on this year—I beg you will excuse the liberty I have taken in sending this letter."[77]

Although upset by Lewis's costly shipments, Child in part defended her. She told Colonel Shaw's mother that Lewis's behavior was not the result of vanity, but of her "restless energy, which makes her feel competent for any undertaking, coupled with her want of education and experience, which makes her unconscious as a baby of the difficulties which lie in her way."[78]

Yet Child concluded that "somebody must check her thoughtless course."[79] In a sharp letter, which she compared to having a tooth pulled, Child bluntly told Lewis to stop cutting marble and shipping it with the bills. Child's criticism hurt Lewis, for she had been a helpful and loyal friend.

In Rome Lewis had no real friends, and she did not fit into the jealous, emotional hothouse of the Cushman villa. The only artist to take a continuing interest in Lewis was Anne Whitney, who had once won a competitive commission and then been denied it because she was a woman. Whitney lived quietly with her painter friend Adele Manning, near Lewis's studio. She and Lewis sometimes had tea or supper together and visited casually. She was amused by Lewis's di-

rectness and impulsiveness. Although an abolitionist, she wrote her sister it was "delightfully funny" when Lewis ordered a southerner out of her studio when his sister refused to sign the guest book of a black artist.[80]

While she felt that Lewis was doing better than she could have in Boston, Whitney considered Lewis's work technically flawed and believed that she was held back by a fear "of being instructed."[81]

There was a real basis for such a fear by Lewis. Many people did not believe a woman—let alone a black woman—could create art. Gossip that Hosmer's work was really done by her Italian stonecutter circulated for years. When a leading London art journal published this rumor as fact, Hosmer had to threaten suit to gain a retraction. Lewis knew of this incident and so did Whitney. Nevertheless, Whitney interpreted Lewis's silence in response to her suggestions as both irrational fear and a determination to go "her own way."[82] And indeed Lewis was determined, in the self-reliant Chippewa attitude of her childhood, to achieve recognition on her own. This was the way she lived and the way she had created the Shaw bust, in spite of Child's opposition to her even attempting it.

It was a period of hard times and thin gruel for Edmonia Lewis, black woman artist.

Lewis's technical skills were in fact improving, and were already comparable to those of most American sculptors of the day (almost none of whom had Whitney's approval). It was less her technical skills that worked against Lewis than a subtle, unconscious unwillingness to accept a black person as an artist. Three influential people who knew her did not fully believe in her artistic talent. Child was always doubtful, conceding Lewis might be "above mediocrity if she took time enough. But she does not take time."[83] Story, as reflected in Henry James's account, sneered that color was "the pleading agent of her fame."[84] Similarly, Whitney long considered encouragement of Lewis to be "color indulgence."[85]

That this might indeed be the case was one of Lewis's greatest fears, expressed in her first interview with Child. It is a fear that persists today among black artists because they continue to be either excluded or shown only as "black artists"—that is, not "real" artists.

Added to this fear was Lewis's inability to trust anyone. Charlotte Cushman, a shrewd student of human character, recognized that Lewis "has to conquer something within herself which I am afraid will pose a stumbling block for her."[86] The roots of this inability to trust can be traced directly to her Oberlin experiences.

This copy of Michelangelo's *Moses* is signed on the back of the base: "Copied by Edmonia Lewis from original Roma 1875." Such copying of classics for sale to tourists was a basic way for most sculptors to survive in Rome. (26¾" h.) National Museum of American Art

Lewis herself made one statement that throws some light on certain difficulties she faced, not in a personal sense, but as an artist: "I thought I knew everything when I came to Rome, but I soon found I had everything to learn."[87] Like all developing artists, Lewis had to determine her own values and establish her own identity as an artist, a process begun in Oberlin. The sympathy and publicity that Cushman provided could not help her find the feelings and values on which she could create an artistic identity.

Day-to-day encounters with unconscious prejudice created difficult and peculiar problems for Lewis. Tourists who bought her medallions, small busts, or copies of Roman busts sometimes demanded to watch her work—unable to believe that black people were capable of artistic creation. And Lewis knew that prejudiced people often insisted the work was not really

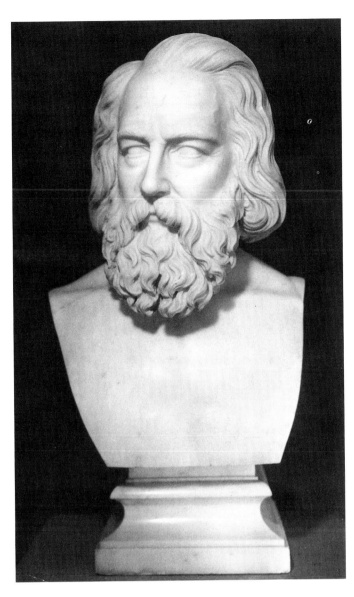

Henry Wadsworth Longfellow (1869). Longfellow was a hero to Lewis because his *Song of Hiawatha* had changed attitudes toward Native Americans. She made this bust by observing the poet on the street in Rome—her favorite method—then asking him to sit for the finishing touches. It is an excellent example of Neoclassical portraiture. (28¾" h.) Schlesinger Library of the History of Women, Radcliffe College

done by a black person, that it must be the work of a white artist. (John Mercer Langston was admitted to the Ohio bar only when his examiners decided he must be white.)

Demands to see her at work distracted her from her creative efforts. In this situation, knowing of Hosmer's and Whitney's difficulties, Lewis felt that as a black woman artist she was required to do all the work—the heavy massing of clay, as well as the exhausting carving and grinding. Few other sculptors did so much heavy physical work. Whitney wrote her sister that Lewis is "haunted by the bugbear of a fear that people will say she doesn't do her own work."[88]

Edmonia Lewis's struggle was unique. Like other artists, she had to establish her own aesthetic values and artistic identity—but she had to do this in the face of strong prejudices against women, African-Americans, and Native Americans. In addition, she had to struggle with her suspicions, her inability to trust others—the scar tissue from the scandalous charges brought against her at Oberlin, her brutal beating, and her humiliating "expulsion" despite exoneration. Nothing like this was endured by any other artist of her day.

From her earliest days in Rome, and probably beginning in Oberlin, where she first heard the biblical story, Edmonia Lewis had identified herself with Hagar. In the biblical story Hagar, an Egyptian (African, or black) handmaiden was driven out and left to wander in the wilderness after doing everything asked of her, even bearing her master's child. A woman used, abused, and cast out, Hagar expressed Lewis's deepest feelings about herself. Early in Rome she made several models of Hagar but was not satisfied with them. No one linked Hagar to Lewis's expulsion from Oberlin, because that event was unknown to them. No one asked, "Why Hagar? Why does she mean so much to you?" because many nineteenth-century artists, including Story, had already used Hagar as a symbol of exploitation and slavery.

In Rome Lewis formed the habit of going to St. Peter's at sunset—sitting in its vaulted chambers at twilight to listen to plaintive Latin vespers, which evoked memories of Chippewa chants and Oberlin choirs. In these surroundings, she could ponder the fate of Hagar wandering in the wilderness, the wilderness she knew as Rome's fashionable international colony. As the only black person at vespers, she attracted the attention of priests. Their discreet, friendly inquiries and conversations helped her identify her spiritual yearnings.

Although most of the Mississauga band had become Methodists, the Chippewas had had Catholic connections since the 1600s. Lewis was apparently baptized, perhaps in the Niagara area, with the traditional Catholic name *Mary*; *Edmonia*, derived from *Edmund*, may have been her father's name. Yet Lewis had never been a practicing Catholic. She later said she was a Catholic in Oberlin but "the atmosphere was uncongenial."[89] Protestant Oberlin did not have a Catholic church; its first mass was said in a private home in 1863. In Boston her abolitionist supporters were Protestant, and Child was fiercely anti-Catholic because of Pius IX's assertions of papal infallibility.

That her mother had named her Mary made it seem

Hagar (1869). The biblical Egyptian, cast out into the wilderness after bearing Abraham's child, was someone Lewis strongly identified with after her Oberlin experience. She is depicted as just having heard the angel ask, "What aileth thee, Hagar?" This statue expressed Lewis's feelings of hope on becoming a Catholic. Many artists, interpreting "Egyptian" to mean "African," used Hagar as a symbol of African-American slavery. (52⅝″ h.) National Museum of American Art

to Lewis that in joining the Catholic church, she had at last come full circle to her spiritual home. There was a profound and comforting feeling of relief, of being wanted and accepted, releasing her from the Hagar-like despair that underlay her cheerfulness. (During the 1867 cholera epidemic, which claimed 6,000 lives in Rome, Lewis said she kept a Bible and a bottle of whiskey at her bedside so that if one gave out, she could turn to the other.[90])

Among the Americans in Rome, only Anne Whitney appears to have known that Lewis became a Catholic, writing her sister on February 9, 1868: "The American clergy here took no notice of her and her Catholic acquaintances were very friendly." Whitney considered her reasons for becoming a Catholic "better than her Catholicism."[91]

Lewis was undoubtedly known to Cardinal Pecci, Story's neighbor in the Palazzo Barberini, who had many American contacts and a particular reason to be interested in an African-American woman artist. After emancipation was declared, Pius IX agreed that missionaries should be sent to convert the former slaves to Catholicism. In 1866 he directed the newly formed Josephite fathers, headed by the English priest Herbert Vaughan, to assume this task and in 1871–72 they established themselves in Baltimore.[92]

Joining the Catholic church became a major turning point in Lewis's life and in her art. It led to roots in Rome far stronger than her ties to her native land.

Sometime after becoming a Catholic, Lewis created an altarpiece that impressed several priests. Then, perhaps at Cardinal Pecci's suggestion, a young Scotsman, a "Mr. Stuart," came to her studio. Like Lewis, he was an orphan and a recent convert. He was actually the Marquis of Bute, the enormously wealthy heir to the Scottish title and lands, as well as the coaling center in Cardiff.[93] He was raised a Presbyterian, but his studies of religion at Oxford led him to become a Catholic, causing a sensation in England and Scotland. A brilliant linguist and scholar, he had just begun his greatest work, the translation of the Latin Breviary into English, when he bought Lewis's altarpiece for $2,000.

"A fine group of the Madonna with the infant Christ in her arms and two adoring angels at her feet"

is how Laura Curtis Bullard, a feminist writer and patent-medicine heiress, described this work in 1871.[94] Blessed by Pius IX, the altarpiece was given by Bute, along with other works of art, to Catholic institutions in Scotland, England, and Wales. However, no records of these purchases and gifts were kept, according to the archivist of the Marquis of Bute; the work itself has not been located.[95]

While the Marquis of Bute's purchase was reported in America, the pope's blessing, rare among American artists' works, was not. More than forty years later Lewis revealed that it was one of her "proudest remembrances."[96]

These developments significantly altered Lewis's situation and outlook, providing inner satisfaction and spiritual peace. Bute's purchase stabilized her finances and introduced her work to a sizable group of English Catholics. By this time Cushman and Hosmer—although not Whitney—were traveling or so busy with social activities that they rarely saw Lewis. In the social terms of that time, she had been "dropped." They felt they had done what they could for her.

Not surprisingly, in the winter of 1868–69, Lewis turned to modeling figures of Hagar, the outcast. This time she created a life-size Neoclassical Hagar—a mature, robed figure with an upturned, hopeful face and hands clasped prayerfully. She described it as that moment in exile when Hagar's despair is ended by the angel of the Lord asking, "What aileth thee, Hagar?" Later she explained the work in these words: "I have a strong sympathy for all women who have struggled and suffered. For this reason the Virgin Mary is very dear to me."[97]

Although clearly meant to express the hope that Lewis felt on becoming a Catholic, the work peculiarly does not evoke the sympathy and identification with Hagar that Lewis felt and intended others to feel. In part, this may be due to the Neoclassical style, which ruled out a realistic portrayal. The statue depicts an idealized, rather plump, angelic young woman in no distress. Child felt it resembled a "stout German or English woman" more than a "slim Egyptian emaciated by wandering in the desert."[98] Whitney, believing the work not good enough to be cut into marble, was afraid to tell that to Lewis lest she be "mortally offended."[99]

Emboldened by her deep identification with Hagar, Lewis borrowed the money from an English financier to have it carved in marble. Later, when she could not repay him, she had to face his demands and threats to seize her work and studio.[100] To solve this problem, she borrowed from others.

In 1870, perhaps at the advice of friends in the United States who put her in touch with John Jones in Chicago, she took the statue there. Jones was a very successful African-American businessman who operated that city's largest tailoring and dry cleaning establishment.[101] His advertisements, emphasizing quality workmanship, ran on the first page of the *Chicago Tribune*. His hospitality was well known; both John Brown and Frederick Douglass and other abolitionists had stayed at his large home. He and Douglass toured much of Illinois, speaking on behalf of full citizenship for African-Americans. Unlike African-American leaders who were ministers, Jones did not plead for justice or morality. He asserted that in their own self-interest whites should provide African-Americans with voting, jury, and other citizenship rights. He successfully argued that it was in the self-interest of whites to have blacks able to testify in courts in cases of accidents, thefts, and other situations in which whites faced losses.

In August 1870 Edmonia Lewis, apparently acting on his advice, rented space in Chicago's largest meeting center hall, Farwell Hall, to exhibit *Hagar*. She advertised the statue in the *Chicago Tribune*, describing herself as "the young and gifted colored sculptress from Rome."[102] She charged twenty-five cents admission, and the tickets probably became raffles for the statue. She later told Whitney she got $6,000 for *Hagar*.[103] In all of this, she undoubtedly had Jones's advice. He may even have sold raffles through his business.

Jones was soon to be elected a Cook County commissioner, becoming the first major African-American political leader in a northern city. He led the struggle for racial integration of the public schools, and he could point to Edmonia Lewis and her statue as an excellent example of what African-Americans might achieve if given educational opportunities.

Whitney had concluded by 1869 that Lewis was "very plucky."[104] Yet there was more to it than pluck. Lewis was the first African-American artist to advertise herself by name as a "colored artist." In doing this, she took the slaveholders' contention that black people were incapable of art and turned it on its head to her advantage, making it a reason to see her work.

Meanwhile, in his 1867 *Book of the Artists,* the historian and critic Henry T. Tuckerman, an advocate of American themes in literature and art, had published a Rome correspondent's high praise for Lewis. His article suggested that she might develop "a distinctive if not entirely original style which may take high rank as the 'American School.' "[105] Yet the author was critical of her sentimental concern with the Hiawatha-Minnehaha romance and suggested that Lewis would find a more satisfying subject and style in the great Native

The Old Indian Arrowmaker and His Daughter (1872), inspired by lines in *Hiawatha,* is one of Lewis's best works. Although the faces are not those of Native Americans but Neoclassical generalizations, the garments, poses, and decorations reflect those of the Mississauga, the Chippewa band in which Lewis spent most of her childhood. The arrowmaker was an important and legendary figure among the Chippewa because they depended on his arrows to obtain food. (21½″ h.) Permanent Collection, Howard University Gallery of Art

American chiefs and Aztec leaders than in Neoclassicism. Unfortunately, Neoclassicism was what sold.

In some ways, however, Lewis oscillated between Neoclassicism and naturalism. Her naturalism came from seeking likenesses in portraits and her rejection of the Neoclassical focus on ancient myths. At times she used her intimate knowledge of Native American life in naturalistic details. *The Old Indian Arrowmaker and His Daughter,* also suggested by Longfellow's *Song of Hiawatha,* is an excellent example of this. Although the idealized faces are not characteristic of Native Americans, the attitudes of the subjects and much of

the detail in the costumes and setting are based on her own observations and experiences as a Mississauga girl. Moreover, Lewis's knowledge of the importance of the arrowmaker in Native American mythology gives the work a unique authenticity. Artistically, it is superior to Horatio Greenough's much-reproduced statue *The Rescue.* That overly dramatized, idealized work has no feeling for human struggles, although it depicts violent combat between a frontiersman and a Native American. It is like a panel from a comic strip.

Much of Lewis's work in Rome was inspired by *Hiawatha,* and Longfellow was a hero to her. His poem had created a new awareness of Native Americans as capable of noble aspirations—lovers of nature and peace, rather than savages, as the press asserted. The poem was based on Henry R. Schoolcraft's translations of Chippewa legends, which Lewis knew from childhood.

Discovering that Longfellow was in Rome in 1869, she unobtrusively studied his face on the street, catching repeated glimpses of him going about his daily affairs. Working from these incisive memories, she created a portrait that his brother Sam considered "quite a respectable likeness."[106] Longfellow readily sat for finishing touches.[107] Whitney, always critical, found it "quite a creditable performance."[108] Months later, after a visit to Lewis's studio, Whitney wrote her sister, "I must confess I was not only surprised but greatly pleased at the progress she has made. As I gave you my first impressions, I desire to convey my second. She is working her way up."[109]

Lewis caught a certain quality in her Longfellow that the poet's friends and family, who had seen many busts of him, recognized with delight. This portrait, along with those of Charles Sumner, Wendell Phillips, and many other abolitionists, demonstrates Lewis's mastery of the Neoclassical portrait style. The success of her Longfellow bust, now in the Schlesinger Library of Radcliffe College, added to her confidence in having *Hagar* cut in marble.

During this period in Rome, Lewis was deeply disturbed at not hearing from Sunrise, whom she felt was "the only person in the world who cared about her success."[110] On a trip to the United States in 1868, she headed west in search of him. She surprised one of her aging Mississauga aunts on the road to their camp near Niagara Falls. Her aunt barely recognized Edmonia in her artist's costume, crying "Is that you, Ish-scoodah?" Edmonia "threw her arms around the old lady who straightened up in true Indian style without embracing her in turn and maintained the same frigid exterior during her stay for a fortnight with her in her hut."[111]

From her aunts, Edmonia learned that Sunrise had married. According to Whitney, she spoke of this "with great disgust."[112] Whitney suggested that she had counted on Sunrise "for her own" financial support. However, it seems more likely that her annoyance came from the fact that she had not heard from him about such an important event in his life. Sunrise continued to help her, stimulating interest in her work in San Francisco, and she continued to worry about him. From her conversations with Lewis, Whitney felt "it was in good part a hankering for her Indian relatives that drew the girl on her long and lonely journey" several years later, in 1873.[113]

Edmonia Lewis made a trip to Boston in 1871, when *Forever Free* was presented to the Reverend Leonard A. Grimes at Tremont Temple. Although both figures in *Forever Free* are in general carried out in a Neoclassical way, this work reveals Lewis's conflict with that style. The man's head is realistic, clearly that of an African-American, while that of the young woman is idealized and without African characteristics.

This two-figure group, a difficult and ambitious composition for a young sculptor, was the first work by an African-American artist to celebrate the Emancipation Proclamation. In *The Christian Register* Elizabeth Peabody, a founder of kindergartens in this country, wrote a sentimental account of the ceremony:

> No one not born a subject to the 'Cotton King' could look upon that piece of sculpture without profound emotion. . . . And when it is remembered who created this group, an added interest is given to it. Who threw so much expression in those figures? What well-known sculptor arranged with such artistic grace those speaking forms? Will anyone believe it was the small hands of a small girl that wrought the marble and kindled the life within it? A girl of dusky hue, mixed Indian and African, who not more than eight years ago sat down on the steps of City Hall to eat the dry crackers with which alone her empty purse allowed her to satisfy her hunger.[114]

During this visit Edmonia Lewis met Dr. Harriot K. Hunt, the first woman physician in Boston and a pioneer in winning the right to study medicine for women. A friend of such leading feminists as Elizabeth Cady Stanton and Susan B. Anthony, Hunt saw Edmonia Lewis and her struggle to become an artist as inspiring; it also resembled her own self-taught effort to become a physician.

Seriously ill with kidney disease, she commis-

Hygieia (1874). This statue of the goddess of health was commissioned by Dr. Harriot Hunt for her grave in Mount Auburn Cemetery, Cambridge, Massachusetts. Dr. Hunt was one of the first women physicians and a pioneer feminist. The graceful life-size marble figure has been severely damaged by air pollution, and its base, decorated by relief panels, is also badly eroded.

sioned Lewis to create a life-size statue of Hygieia, daughter of the Greek god of medicine, for her own grave in Mount Auburn Cemetery in Cambridge. This statue, possessing a distinctly feminine grace, is one of Lewis's most unusual works. Hunt died in 1875. Unfortunately, air pollution and acid rain have badly

Asleep and *Awake* (1874) demonstrate Lewis's mastery of modeling in the Neoclassical style. *Asleep* won a gold medal in a Naples exposition and was shown at the Centennial Exposition in Philadelphia in 1876. Both groups were later exhibited in San Francisco and in San Jose, California, where they were sold. San Jose Public Library

eroded the facial features and relief panels on the base.

During this period Lewis also created two Neoclassical groups depicting sleeping and playful infants—*Asleep* and *Awake*. These groups, which are excellent pieces of modeling, won the gold medal award at an international exhibition sponsored by the Naples Academy of Art and Science.[115]

In the summer of 1873 Lewis traveled all the way from Rome to California with nearly a ton in crated marble statues. This trip, perhaps provoked by a desire to see her brother, was only possible after cross-country rail travel began in 1869. Asked in San Francisco why she had come, she said, "Here they are more liberal, and as I want to dispose of some of my works, I thought it best to come west."[116]

Lewis stopped first in New York, where she sold a large bust of Lincoln for $1,100.[117] She then took to San Francisco a life-size bust of Lincoln, copies of *Awake* and *Asleep,* a copy of *The Wedding of Hiawatha,* and *Cupid Caught*—a typical Neoclassical Cupid entangled in flowers while stealing a rose. These works were shown at the galleries of the San Francisco Art Association, then headed by Mayor William Alvord.

The opening on September 1 brought out 150 "white and colored citizens," reported the *Pacific Appeal,* whose circulation reached African-Americans up and down the West Coast.[118] The African-American community had proposed an elaborate reception, but Lewis said frankly that "it would do her more honor for them to take the cost of the proposed reception and purchase the bust of President Lincoln."[119] No longer "the child of the forest," she knew that selling Lincoln's bust would be her most difficult task. She also recognized that she could not afford to ship anything unsold back to Rome. One way or another, the statues had to be sold.

Even before the exhibition opened, the San Francisco papers reported on the event. The *Pacific Appeal* published an article with biographical information on August 16, while the *Chronicle* carried an advance story on August 26. *The Elevator,* another African-American paper, published an article on August 30. When interviewed, Lewis credited Harriet Hosmer and Hiram Powers for helping her.[120]

Reviews followed the opening. Although complaining that the statues were small and had a "labored

finish," which actually was characteristic of all Neo-classical sculpture, the *Chronicle* critic conceded Lewis had "acquired a certain excellence in art."[121] *The Elevator,* scoffing at this "carping," compared her work with that of Powers.[122]

The romantic *Cupid Caught* and *Wedding of Hiawatha* were promptly sold. When the week-long exhibition ended, Lewis moved the remaining statues to the San Jose Market and later to the Catholic Fair.[123] To meet the competition from a free exhibition of 100 paintings, Lewis cut the admission price from fifty to twenty-five cents. *Awake* and *Asleep* were purchased by a wealthy resident and given to the San Jose Library.

When it appeared that the Lincoln bust might not be sold, the Friends of the San Jose Library purchased it by subscription.[124] Once that was settled, Edmonia Lewis headed back to Rome, satisfied that she had broken new ground.

This long journey was extraordinary for a black woman to make alone at that time, and it made Lewis one of the first sculptors to exhibit in culture-hungry California. In part, it may have been motivated by the desire to see her brother, although there is no evidence that she saw him.

Back in Rome, Lewis found that all the American artists were preparing for the Centennial Exposition.

Congress was sending a ship to carry their work to Philadelphia. William Story was sending his *Cleopatra* and his *Libyan Sybil,* which had been highly praised at the 1862 London exhibition. Anne Whitney had already left with her *Roma,* a forlorn beggar woman, symbolic of what Rome had become in her eyes.

Lewis decided immediately to send copies of *Asleep, The Old Indian Arrowmaker and His Daughter,* and terra-cotta portraits of John Brown, Charles Sumner, and Longfellow.[125] She also wanted to challenge Story, the preeminently popular sculptor of that day, who had sneered at women sculptors. She had mentally prepared for this for years, selecting as her subject Cleopatra in the throes of death, not contemplating death as Story had done. She made clay studies several years before the Centennial. In the final sculpture she abandoned Neoclassical concepts to create a strikingly original work.

Of the 673 sculptures exhibited at the Centennial, 162 were by Americans. No sculpture prizes were awarded. Of 43 "certificates of excellence," only five went to Americans, but neither Story nor Lewis received one. Nevertheless, Lewis's *Death of Cleopatra* became one of the Centennial's most talked about statues. In his *Centennial Exposition,* J. S. Ingram wrote:

The most remarkable piece of sculpture in the American section was perhaps that in marble of *The Death*

of Cleopatra by Edmonia Lewis, the sculptress and protégé of Charlotte Cushman. The great queen was seated in a chair, her head drooping over her left shoulder. The face of the figure was really fine in its naturalness and the gracefulness of the lines.

The face was full of pain, for some reason—perhaps to intensify the expression—the classic [i.e., neoclassic] standard had been departed from, and the features were not even Egyptian in their outline, but of a decidedly Jewish cast. The human heads which ornamented the arms of the chair were obtrusive, and detracted from the dignity which the artist succeeded in gaining in the figure. A canopy of Oriental brightness in color had been placed over the statue.[126]

Lewis had actually modeled the face from depictions of Cleopatra on ancient Roman coins. Story, on the other hand, had used contemporary Egyptian faces as his models.

Anything realistic in art, especially the death throes of a great queen in the days of Queen Victoria, was very disturbing to those who doted on the idealization of "noble suffering." What was expected was a presentation like Story's sculpture of Cleopatra, showing her sitting in regal repose, calmly contemplating the asp without apparent suffering. The distaste for realism was so strong that Centennial officials refused to show Thomas Eakins's realistic depiction of surgery, *The Gross Clinic,* as art, relegating it to a section on medicine. Art was supposed to be noble, not bloody.

Despite this attitude, Ingram and some other critics considered Lewis's statue outstanding. So did thousands of visitors. Lewis was particularly pleased when one of Oberlin's best-known citizens, A. A. Wright, the father of a former classmate, who knew what she had been through at Oberlin, pushed through the crowd to shake her hand and congratulate her.[127] The *Oberlin Review,* identifying her as "the renowned sculptor," boasted: "Miss Lewis took her first lessons in art in Oberlin about 16 years ago."[128] These Oberlin reactions were a bittersweet triumph for Edmonia Lewis, a vindication she had sought ever since her humiliating experiences there. It satisfied her Chippewa desire for revenge.

An artist himself, Walter J. Clark wrote of *The Death of Cleopatra:* "This is not a beautiful work, but it is a very original and striking one, and it deserve[s] particular comment, as its ideals [are] so radically different from those adopted by Story. . . . The effects of death are represented with such skill as to be absolutely repellent. Apart from all questions of taste, however, the striking qualities of the work are undeniable, and it could only have been produced by a sculptor of genuine endowments."[129] Reflecting the

The Death of Cleopatra (1875) was a sensation at the 1876 Philadelphia Centennial Exposition and the Chicago Exposition of 1878. Unlike William Wetmore Story, whose *Cleopatra* calmly contemplates the deadly asp, Lewis depicted Cleopatra after death, shocking many people but impressing the critics. Long considered lost, the life-size, two-ton statue was finally identified in a Chicago suburb in 1989. The asp in Cleopatra's hand has been broken off. Forest Park Historical Society, Forest Park, Ill.

bias that confronted Lewis throughout her career, the only words in Clark's comment to be widely quoted were "absolutely repellent." His praise continues to be ignored even today.

Edmonia Lewis did not find much appreciation among Philadelphia's African-American "better class," as W. E. B. Du Bois later characterized its middle class.[130] The leaders of the AME church, the largest in the city, appeared to have been embarrassed by *The Death of Cleopatra.* The *Christian Recorder,* the influential AME publication edited by the Reverend Benjamin T. Tanner, father of the painter Henry Ossawa Tanner, had urged that African-American artists be included in the Centennial Exposition. It also published critical

commentaries by the Philadelphia artist Robert Douglass, Jr., about the Centennial art. Yet Douglass did not mention Edward M. Bannister's prize-winning *Under the Oaks* until a week before the Centennial Exposition closed.[131] And he never mentioned Lewis or her work—not even her portraits of such abolitionists as John Brown and Senator Sumner, or Longfellow, or her infant group *Asleep*.

A few weeks before the Centennial Exposition closed, however, the *Christian Recorder* did publish a letter from John P. Sampson, a prominent Wilberforce University educator and an AME minister. In it, Sampson praised *Cleopatra* as a "magnificent work of art." He revealed that he had met Edmonia Lewis while admiring her statue and that she had shown him her other work. Describing Lewis as 'a downright sensible woman . . . of no foolishness, a devoted lover of her race," Sampson reported that she resented her treatment by "some of her own people who had been more favored in point of opportunity." Instead of encouraging her, she said, "they came to criticize her work, of the merits of which they know nothing." And "instead of fooling here, with our people aping the prejudices of the whites, 'I am going back to Italy, to do something for the race—something that will excite the admiration of the other races of the earth.' "[132]

Reactions to this outburst have not been found. That Rev. Benjamin Tanner published the letter indicates that he may have had second thoughts about not reporting on her work. Perhaps he felt that publicizing her work in an AME publication was inappropriate, since she was a Catholic.

When the Centennial closed on October 31, Lewis stored her statues, planning to take them to Chicago, and returned to Rome. There, in 1877, she modeled a portrait (now lost) of former President Ulysses S. Grant, who was making a world tour. She again used her favorite method: starting with quick observations on the street and then having Grant sit for final corrections.[133]

Lewis's portrait method had its origins in her early experiences, when Child opposed her trying to make a bust of Colonel Shaw. She had learned that a direct approach might be rejected. Her method also eliminated the distracting social talk necessary to make a sitter feel comfortable, which in those days might have been difficult for both a black woman artist and her prominent sitters.

Returning to the United States in the summer of 1878, Lewis shipped her Centennial statues to the Chicago Interstate Exposition, a booming demonstration of its recovery from the great 1871 fire. Her *Cleopatra* was a major drawing card, featured in advertisements along with a "Battle of Gettysburg" panorama by James Walker, a specialist in battle scenes.[134] After the exposition closed, *Cleopatra* was a main attraction at Farwell Hall in a week-long benefit for the Catholic House of the Good Shepherd,[135] now a home for abused women.

Exactly where *The Death of Cleopatra* was stored after the Chicago exposition remains unknown. Lewis had known from the start that if she did not sell it, she could not ship it back to Rome. The Metropolitan Museum of Art had already bought Story's *Cleopatra*, and there were no other museums likely to purchase a major work like her *Cleopatra*. The Art Institute of Chicago had barely come into existence.

From all the descriptions, *The Death of Cleopatra* represented a daring break with Neoclassicism in the direction of realism. But Lewis did not sustain this approach. When she returned to Rome, she concentrated on idealized religious sculpture.

Late in December 1878, on her way back to Rome, Lewis stopped in Brooklyn. She probably stayed at the home of Laura Curtis Bullard. There, at the Shiloh Presbyterian Church, she presented a copy of her bust of John Brown to the Reverend Henry Highland Garnet, an outstanding African-American abolitionist, who had begun his career in Troy, New York, near her birthplace. Lewis herself was honored with a reception by New York African-Americans.[136]

Meeting with Garnet, who knew the Hudson Valley of her childhood, marked the completion of another circle for Edmonia Lewis. She knew that she would not be coming back to America. The old abolitionists, so long her supporters, were disappearing. That she could not sell her most original work marked the closing of that approach. And in Rome she knew she faced a new world.

The Centennial marked the end of Neoclassicism, the style she had struggled to master. With the emergence of the expressive Romantic movement led by Auguste Rodin, Paris replaced Rome as the world's art center. Most American sculptors, including Anne Whitney, never returned to Rome after 1876, but Edmonia Lewis did. She had come to the conclusion that she could not live in the United States.

Doubtless there were many reasons for this decision, including the U.S. Supreme Court's scuttling of the Civil Rights Act of 1875. However, her principal one was that she had created a satisfying way of life in Rome, with opportunities to create sculpture that expressed her spiritual feelings. Her work sold steadily there. She had already sold some statuary to members of the English nobility and wealthy Catholics. That Louisa Lady Ashburton, a sparkling personality and

an intimate friend of Harriet Hosmer, had purchased a copy of *The Old Indian Arrowmaker* impressed the international set. Her religious statues, reliefs, and altarpieces were in demand among English and European Catholics.

Within her religious framework, Lewis did not abandon her racial awareness. In 1883 Bullard reported that Lewis had completed an unusual bas-relief in marble for a church in Baltimore. It depicted the infant Jesus attended by three adoring "wise men" with definite racial characteristics—Caucasian, Asian, and African. "Of the three, the African is given the greater prominence," wrote Bullard.[137] This work has not been found.

During this period Lewis counted among her friends in Rome Caroline, Sarah, and Mariche Remond, the sisters of Charles Remond, one of the most eloquent African-American abolitionist orators. Also an eloquent antislavery orator, Sarah had become a physician in Florence, beginning her medical studies there about the same time as Edmonia arrived to become a sculptor. They had all shared experiences in the abolitionist movement in Boston and knew many of the same people. Thus Lewis continued emotional ties that dated back to her Massachusetts days.

In late January 1887, Frederick Douglass and his new wife, strolling on the Pincian Hill promenade overlooking Rome, encountered Edmonia Lewis. He had known her ever since she sold copies of her Shaw bust in Boston; his sons had been in the Fifty-fourth Massachusetts Regiment. On January 26, 1887, Douglass recorded in his diary: "Called to see Miss Edmonia Lewis who loaned Helen Louise books. Found her in a large building near the top [of Pincian Hill] in a very pleasant room with a commanding view, No. 4 Via Venti Settembre, Roma. Here she lives, and here she plies her fingers in her art as a sculptress. She seems happy and cheerful and successful. She made us obliged to her for kind offers to serve us in any way she could. She has resided in Rome for twenty years and constantly speaking Italian has somewhat impaired her English" (a reference to her early difficulties in pronunciation stemming from her Chippewa childhood, of which Douglass was not aware).[138]

The touring Douglasses were accompanied to Naples by Edmonia Lewis and Adelia Gates, who had begun painting at age fifty and distinguished herself as a flower painter.[139] There Douglass, with Lewis acting as his guide, toured the National Museum's extraordinary pictures and statuary from the ruins of Pompeii and Herculaneum. He felt these ancient works "transcended modern art." He also noted that the Pompeiians who enjoyed such art "were wealthy and powerful slaveholders."[140]

Douglass's diary entries constitute the last known report by someone who knew Lewis in the past.

By 1900 Lewis was virtually forgotten. In 1903, in his *History of American Sculpture,* Lorado Taft reported nothing had been heard from her since the Centennial.[141] However, in February 1909, *The Rosary,* an American Catholic magazine, reported that although "advanced in years, she is still with us." Very briefly summarizing her career but saying nothing of her current activities or circumstances, the magazine noted that one of her proudest memories was "the day Pope Pius IX blessed a work upon which she was engaged."[142]

Lewis was then sixty-four years old, and this is the last known reference to her life. How she survived to 1909, roughly twenty-two years after Douglass's visit, and what she created during this time are not known. No record of her death or burial has yet been discovered.

Yet that is not the end of her story.

While Edmonia Lewis was in Chicago during the 1878 exposition, she presumably stayed at the large home of her friend John Jones. He was no longer a county commissioner, having lost that post due to a political scandal that did not involve him. When he died in 1879, Lewis's busts of John Brown and Senator Charles Sumner were on the mantelpieces at the funeral services in his home.[143] Lewis may have given them to Jones in gratitude for his help and hospitality or left them with him in hopes of their being sold.

After the exposition it had made no sense for Lewis to ship the two-ton *Cleopatra* back to Rome, and it was put in storage. She may have hoped that Jones could persuade the newly formed Art Institute of Chicago to buy it. However, with Jones's death and Lewis back in Rome, nothing is certain, not even where *Cleopatra* was stored.

At some point a notorious gambler, political "fixer," and racetrack owner, "Blind John" Condon, acquired *The Death of Cleopatra.* Considering it a beautiful memorial, he placed it on the grave of his favorite horse, "Cleopatra," in front of the grandstand of the Harlem Race Track, now a part of Forest Park, a suburb west of Chicago.[144] There it sat for nearly 100 years, even after the racetrack became a golf course and golfers played around the statue.

Condon died in 1915. In the racetrack's deed he had inserted a covenant that the statue must remain in place in perpetuity.[145] When a World War II munitions plant was built on the site in the early 1940s, the statue remained untouched. However, in 1972, when the U.S. Postal Service's Bulk Mail Center was built on the site,

Edmonia Lewis's *carte de visite,* made in Chicago by Rocher in 1878, shows her in her traditional artist's costume. Schomburg Center for Research in Black Culture, New York Public Library

the statue was hauled off to the contractor's heavy-equipment yard, where it sat among cranes, bulldozers, and clamshell buckets.

One day in the mid-1970s a fireman, Harold P. Adams, looking for fire hazards, saw it in its bizarre surroundings—"like a big white ghost."[146] He considered it one of the most beautiful things he ever saw. He had it moved to a more protected site. Then, recruiting his son's Boy Scout troop, he tried to get the statue, marred by graffiti, grease, and various chipped places, restored.

Years passed. In 1987 restoration was taken up by the Forest Park Historical Society, whose president, Frank Orland, established that the E. LEWIS ROMA carved on its base identified it as Edmonia Lewis's long-missing *Death of Cleopatra.* Once again, more than a century after the 1878 Exposition, the statue was mentioned in the *Chicago Tribune.* It began a new life with a new and deeper level of appreciation.

That Edmonia Lewis was "a sculptor of very genuine endowments," to repeat Clark's assessment, appears accurate and perceptive. Her struggles and achievements have a legendary, inspirational quality that makes them unique in American art. Yet until the late 1960s, she remained unknown.

Although Hosmer, Whitney, Lewis, and other American sculptors working in Rome in the 1860s and 1870s were serious artists, none produced a larger vision of life or one uniquely expressive of America. Instead, they turned for the most part to the outworn myths of ancient times with a literary and sentimental approach that was devoid of the severity required by the classical idiom. As a consequence, their art has a frozen, cosmetically "ideal" quality without passion or transcendence.

Every artist is part of his or her time. It is tragic that Edmonia Lewis had to work against herself. In her effort to gain acceptance as an artist, she adopted the same bland style as her colleagues—a rigid, mannered style in which no artist could develop a distinctive, recognizable voice. Sculpture had to await the appearance of Rodin in France and Augustus Saint-Gaudens in the United States to gain a new vitality.

What must be remembered is that a major portion of Edmonia Lewis's energies were devoted simply to being accepted on the same aesthetic level as her fellow artists at the time. Within that framework, she struggled to honor in her work those whom she felt represented the best in American life—Colonel Shaw, John Brown, Lincoln, Sumner, Longfellow, and Harriot Hunt. She also honored her own dual heritage in such works as *The Old Indian Arrowmaker and His Daughter,* the *Hiawatha* series, and *Forever Free.* In *Cleopatra* she dared to break away from sterile conventionality. Hers was a daring life.

Edmonia Lewis rose above the meanness and violence she experienced in her homeland. In courageous men and women who fought against slavery, in women like Hagar and Harriot Hunt who struggled against the oppression and suffering of women, in the spirituality of Native Americans, and ultimately in her religious faith, Lewis found her great themes. In her work she attained a dignity that, in her own life, she was often denied. Years of silence have deprived most Americans of knowledge of her historic achievements.

She is a heroic and legendary figure in American art.

HENRY OSSAWA TANNER

Henry Ossawa Tanner was the first American artist of African descent to attain world-wide recognition in Paris, winning an honorable mention at the Salon of 1896 after a leading French artist, Jean-Léon Gérôme, pointed out his work. In 1897 his *Raising of Lazarus* became a major Salon attraction and was purchased by the French government for its Luxembourg Museum, making Tanner one of the first Americans so honored (works by James McNeill Whistler and John Singer Sargent had previously been purchased). In 1906 Tanner's *Disciples at Emmaus* was purchased for the same museum. For a black man born when slavery was the lot of most African-Americans, his achievements were extraordinary.

Interviewed in the late 1960s, Erwin S. Barrie, director of Grand Central Art Galleries in New York and Tanner's dealer for many years, commented on how impossible it was for contemporary people to realize the difficulties Tanner overcame.

> For a Negro to achieve what he did at that time was incredible. It required great humility and even greater courage. He was a tenacious man. He conquered in spite of racial prejudice that was monumental. Even when he visited here during the twenties and thirties, there was no first-rate restaurant in midtown Manhattan that I could take him to lest he be embarrassed by being refused service. We find this hard to believe today because things have changed.
>
> Tanner showed the whole world that a Negro could be an outstanding artist and a cultured gentleman. This is forgotten or ignored today. In my opinion, he never has received credit for what he did at the turn of the century.[1]

Every problem faced by contemporary African-American artists confronted Tanner. Should he paint black subjects? Should he ignore the racial prejudice in the United States and devote his life to "art"? Should he escape such a stifling atmosphere? What is art for an African-American in the light of problems faced by his people? Do the aesthetic problems of black artists differ from those of white artists? These questions persist to this day. Tanner's international success gave him a unique position of influence among later black artists, and his attitudes on these questions affected the next generation.

Tanner was born in Allegheny, now the Pittsburgh Northside, on June 21, 1859. His father was the Reverend Benjamin Tucker Tanner, ordained as an African Methodist Episcopal minister six months earlier. His mother, Sarah Miller Tanner, six inches taller than her husband, was a gentle, devoted person who had been born in slavery in Winchester, Virginia, in May 1840; her father, Charles Miller, was the son of a white planter and, when freed in 1841, took his wife and children to Pittsburgh. There Sarah went to school and met and married Benjamin Tanner.

When Henry Tanner was born, America was in the grip of the mounting tensions over slavery that led to the Civil War. *Uncle Tom's Cabin* had aroused thousands. The 1857 Dred Scott decision had extended the boundaries of slavery, arousing thousands more. The next year Abraham Lincoln and Stephen Douglas began the debates that made Lincoln a national leader. On October 16, 1859, four months after Henry was born in a home that was an Underground Railroad station, John Brown led his desperate—and to many black Americans, heroic—raid on the Harpers Ferry arsenal, only 150 miles from Pittsburgh.

All these events were intensely followed by Rev. Benjamin Tanner. Although only four foot, eleven inches tall, he was a forceful natural leader and one of the few black Americans to gain a college education before the Civil War. Born of free black parents in Pittsburgh on December 25, 1835, he was independent, intellectually curious, continuously self-educating, sensitive, and self-assertive. As a sixteen-year-old barber

in Chicago, he began a "day book—a journal of everyday life" in 1851.[2] In it he noted his height and weight, how many shaves and haircuts he gave, lectures he attended, and things that he saw, from the play *Romeo and Juliet* to a street scene of "cruel men fighting dogs." A vigorous champion of civil rights, he was outraged by the 1850 Fugitive Slave Law and a celebrator of the black soldiers who defended New Orleans in 1812.

In Pittsburgh Tanner met Charles Avery, who was rich from dealing in lead and cotton, yet whose Methodist beliefs made him an abolitionist. In his own mansion Avery established a college for black students, which Tanner entered in August 1853.[3] He turned down Avery's offer of a scholarship, supporting himself as a barber. Deeply spiritual, Tanner felt religious organizations offered the best means of improving conditions for black Americans. On completing his studies at Avery College, Tanner entered the Western Theological Seminary in Pittsburgh to prepare for ministry of the African Methodist Episcopal (AME) church, then one of the few national black organizations.

Although devout, Tanner did not believe in leaving everything to God. He was a "doer" and a fighter. Years later Henry Ossawa Tanner recalled that "when his fur was rubbed the wrong way," his father would assert that he was "a Pittsburgher of three generations"[4]—meaning he was free, independent, and fearless. The remark delighted Henry, "a Pittsburgher of four generations," and presumably even more independent and fearless.

In 1859, when his son was born, Rev. Benjamin Tanner was a leader in a group of Pittsburgh African-Americans who considered "John Brown, a hero, a patriot, and a Christian."[5] By giving his son the middle name *Ossawa,* Tanner further expressed his admiration for John Brown, who had in 1856 killed pro-slavery vigilantes attacking antislavery homesteaders in Osawatomie, Kansas.[6] Shortening the name to Ossawa was mere prudence; Pittsburgh, less than 100 miles north of slave territory, had violent pro-slavery groups.

At birth Henry was small, delicate, and thin. If his mother, he later wrote, "had carried out the toughening process so often advised by overknowing neighbors, I should probably have added one to that already heavy column in vital statistics—'infant mortality.' "[7] Rev. Benjamin Tanner's Day Book entry for June 21, 1860, reflects the young parents' love and concern: "This is the first birthday my dear little son, Henry Ossawa Tanner, ever saw. The Lord has blessed both him and us wonderfully. Whether the preservation of Henry's life and health will prove a blessing the Lord only knows . . . The Lord give us, Oh give us, wisdom to bring him up . . . in the nurture and admonishment of God."

The artist's parents, Sarah Miller Tanner and Bishop Benjamin Tanner, supported him for many years when he was denied training on racial grounds.

Bishop Daniel A. Payne selected Rev. Benjamin Tanner for leadership training; took him to churches in Baltimore, Cincinnati, and Brooklyn to see their problems; then assigned him "on loan" to a major congregation in Washington, the 15th Street Colored Presbyterian Church. On the eve of the Civil War Rev. Benjamin Tanner was in a position to help maintain political communications between church leaders and influential congressmen. Expecting war, church leaders advised him not to have a church. When war came, he immediately established a school in the navy yard for black sailors and navy yard workers who had not had the opportunity to learn to read and write. After organizing a similar school in nearby Frederick, Maryland, he helped organize schools and churches in the wake of the Union armies.

In 1864, when his son was five years old, Rev. Benjamin Tanner was selected for a major leadership role in the AME headquarters in Philadelphia and moved his family there. During the crucial years of Reconstruction, he edited the major AME organ, the *Christian Recorder.* He changed this publication from one devoted to theological questions and AME organizational problems to one that also covered secular and social conditions. In 1881 he represented his church at ecumenical conferences in London. He also founded the AME Church Review to help consolidate the church's rapid growth and served on the boards of Howard University and other black colleges. He wrote several books, including one combatting the misinter-

pretation of Charles Darwin's *Origin of Species* as justifying racism.[8] Thus, throughout Henry Tanner's childhood, his father was vigorously participating in the leadership of African-Americans during the Civil War and Reconstruction periods.

The Philadelphia home that Henry Tanner grew up in was "the intellectual center of the black community."[9] It was a religious, active household. There were chores for everyone and prayers at all meals, as well as services at Mother Bethel, the founding church of the AME, where Henry's father preached. There were also prayer meetings, meditation, and more prayers before going to sleep. Yet there was no false piety, no heavy religiosity, no empty ritualizing. Almost as soon as he learned to talk, young Tanner learned to pray, and he found it reassuring and satisfying. He often heard the great biblical stories of persecution, struggle, and faith rewarded.

Years later, Tanner's friend, the poet and civil rights leader James Weldon Johnson, prefaced the famous collection of spirituals that he and his brother assembled with these words:

> It is not possible to estimate the sustaining influence that the story of the trials and tribulations of Jews as related in the Old Testament exerted upon the Negro. This story at once caught and fired the imagination of the Negro bards, and they sang, sang their hungry listeners into a firm faith that as God saved Daniel in the lion's den, so would He save them; as God preserved the Hebrew children in a fiery furnace, so would He preserve them; as God delivered Israel out of bondage in Egypt, so would He deliver them.[10]

Henry's parents regularly took him to Mother Bethel, where he heard and met the great spiritual leaders of his race. He learned what they were like as human beings at the dinner table and waiting for trains as well as in the pulpit; he came to know their visions, their prayers, their laughter and troubled challenges, their faith and calm assertiveness. He saw their pride in being black, how they rejoiced in their faith and marveled at the work of the Lord—for slavery, by then, had legally ended.

The Tanner family first lived in the vicinity of Third and Pine streets in Philadelphia. Nearby, at Arch and Front streets, was the studio of a pioneer African-American artist, Robert Douglass, Jr., who, like many artists of that day, had started as a sign painter. He then studied with Thomas Sully, the noted portraitist. Sully recommended that he study abroad, but initially Douglass was denied a passport on the ground that "people of color were not citizens."[11] Eventually this barrier was overcome, and he studied drawing at the British Museum and painting at the National Gallery in London. Despite his recognized ability, Douglass's principal income came from painting banners for fire companies and businesses, signs, and Masonic emblems. Except for a portrait of a relative and an 1827 seal of the State of Pennsylvania, none of his work has been located.[12] Douglass taught his cousin David Bustil Bowser, who made signs, portraits, landscapes, and marine paintings, few of which have survived.[13]

Young Henry Tanner knew Robert Douglass and his work because they lived in the same neighborhood and Rev. Benjamin Tanner was alert to such talents among African-Americans. In fact, he had Robert Douglass write for the *Christian Recorder* on art at the Centennial Exposition. However, there is no record of Henry Tanner studying with Douglass or even being attracted to his occupation or paintings. Eventually the growing Tanner family left the neighborhood for a larger home in north Philadelphia, near Fairmount Park, which reduced opportunities for contact with Douglass.

By this time Henry was thirteen years old, physically slight and sensitive, not at all athletic. A bright student at the Robert Vaux Consolidated School for Colored Students, he later became valedictorian of his class. But at thirteen he was moody and resistant to his father's suggestions that he prepare himself for the ministry. His father was aware of the fact that he had often been away from his family for months during Henry's early years. To get to know his son better, he often took him for walks in Fairmount Park.

One day, Tanner recalled, while he and his father were walking in the park's wooded hills, they came across an artist painting a landscape. As the artist shaped with color a large tree, a rising wooded knoll, and the flat grassy area from which a great elm rose, father and son watched attentively.

Henry Tanner determined then and there that he must try to paint. What he had seen was more exciting than anything he knew. That night his mother gave him fifteen cents for brushes and paint. He made a canvas out of a torn awning and a palette from the cover of an old geography book, punching a hole in it for his thumb. With cheap brushes and paint, he returned the next day to the exact location where the artist had worked. Mixing his colors in excitement and frustration, with his canvas laid across his knees, Tanner worked diligently. Despite paint on his clothes, he discovered "that I was happy, supremely so—[and] coming home that night, I examined the sketch from all points of view, upside down, downside up, decidedly admiring and well content with my first effort."[14]

Tanner now became intensely aware of color everywhere. He turned eagerly to Philadelphia gallery windows. Thirty years later he could recall specific paintings from these tours, especially stormy seascapes.[15]

In 1876, when Tanner was seventeen years old, the mammoth Centennial Exposition opened in Fairmount Park. In a nation still without notable museums, the cavernous Memorial Hall and its annex displayed one of the largest international collections of art ever assembled. With Italian sculpture, Turkish rugs, Wedgwood pottery, and numerous paintings from Europe, it stimulated a growing hunger for art among Americans. Tanner could wander among the brilliantly colored Gainsboroughs that made up most of Britain's exhibit, the dark paintings of the Munich school, or historical scenes by French Neoclassical painters.

In the American sector, Tanner could inspect Gilbert Stuart's already legendary portrait of George Washington, the work of Charles Willson Peale and his sons, of Thomas Sully or John Singleton Copley. He could also see the work of contemporaries, such as Winslow Homer, well known for his Civil War sketches in *Harper's Weekly,* and the painter Eastman Johnson.

And, with nervous circumspection, he could glance in passing at Edmonia Lewis's seminude *Death of Cleopatra.* Her statue, shocking to many in its portrayal of the effects of death, was undoubtedly discussed by his father and other AME leaders. Although their reactions are not recorded, they were apparently embarrassed by it and inclined to give it the "silent" treatment. In any event, her statue was not mentioned in the *Christian Recorder* until the Centennial was almost over.[16]

Young Tanner was far more comfortable studying Edward M. Bannister's prize-winning landscape, *Under the Oaks.* That impressive painting won high praise from both Robert Douglass, Jr., and Professor John P. Sampson in the *Christian Recorder.*[17] That Bannister was a black man was well known as a result of William Wells Brown's biographical sketch in *The Black Man: His Antecedents, His Genius, and His Achievements* (1863), which predicted that his work would some day create "a sensation."[18] Bannister's painting may have helped the seventeen-year-old Tanner convince his father that painting could be an admirable career.

Like many adolescent artists, Tanner first wanted to paint turbulent seascapes. He later confided this to a friendly animal painter, J. N. Hess, who pointed out that there were already too many marine painters. He suggested that Tanner paint animals instead. Impressed, Tanner bought a goose and later a sheep in order to have some models.

Tanner's enthusiasm for becoming an artist—"boasting," he later called it—amused his relatives, schoolmates, teachers, and neighbors. Sometimes they teased him about how he would always be poor and live in a garret. "[I'm not going to be] that kind of an artist," he would respond, "not one of your everyday kind."[19] This caused even more amusement.

His family and friends saw only a frail black youngster struggling to paint a goose. No one understood his inner vision, his confidence, or his capacity for perseverance, nor did anyone recognize his sense of color. Moreover, no one knew of a great black artist. He should study something useful, they said. His father still hoped he would get "the call" to the ministry.

Seeking art lessons, Tanner immediately found his race was a problem. The first teachers he went to rejected him on sight. Finally a well-known portraitist, Isaac L. Williams, accepted him at two dollars a lesson, a huge sum for a black minister's son in those days. For his first lesson he was told to draw straight lines. Disheartened, he never went back and struggled on alone.[20]

One summer, while working as a menial at an Atlantic City hotel, Tanner sketched a wrecked schooner. A watching amateur artist, Henry Price, encouraged him and offered tips on brushwork.[21] To Tanner, starving for help and artistic acceptance, Price seemed a magnificent, all-knowing friend. At summer's end, when Price proposed that Tanner move into his Philadelphia home, just as old masters had their apprentices live with them, Tanner gratefully accepted.

However, he soon realized that his chance to learn really meant only listening to Price. Discussing art endlessly, Price did not permit Tanner to question or oppose his ideas. When Tanner proposed attending the Pennsylvania Academy of Fine Arts, then the finest art school in the nation, Price was so vehemently opposed that Tanner felt he dared not apply. This went on for a year.

One day a visiting physician-collector saw and praised Tanner's work. This attention would, Tanner knew, subject him to days of morose silence from Price. That evening, after his routine weekend visit to his family, Tanner returned to find his belongings outside the studio door. Price refused to even answer the doorbell. Tanner sadly went back to his family.

Tanner's father wanted him to receive formal education, but all Tanner wanted to do was paint. Alarmed at his son's poor prospects of earning a living, his father obtained a job for him in a flour mill. The work was heavy and dusty. He finished his twelve-hour day white with dust and coughing. But he refused

to quit painting, rising before dawn to snatch some moments of daylight.

Under the strain of this effort, Tanner's health, never robust, broke down completely. Seriously ill for a long time, he was sent to Rainbow Lake in the Adirondack mountains to convalesce.[22] There he gained strength, painted, and learned to ride.

This breakdown in Tanner's health changed his father's attitude. Recognizing that his son was determined to become an artist at any cost, Tanner's father accepted that choice as God's will. He abandoned his dreams of his first son becoming a minister and made up his mind to help in any way that he could. For the next eighteen years Tanner's parents supplemented the meager sums he earned from occasional sales of paintings and illustrations to magazines.

On returning home in the fall of 1879, Tanner met Christopher H. Shearer, a prominent Philadelphia artist who had spent his own student days in Munich. Unlike Price, he advised Tanner to study at the Pennsylvania Academy of Fine Arts.

Tanner entered its "antique" class, where his drawing of casts soon qualified him for the life class of Thomas Eakins, who had just become director of the school. Although today he is ranked as one of the most important American painters, Eakins was not held in great esteem at the time. His works were too uncompromising for Victorian critics; his now-famous *Gross Clinic* was not shown as art at the Centennial but was placed in the medical section. Eakins did not sell many paintings, but his integrity in exploring reality attracted students.

Having studied in Paris under Gérôme, at a time when Neoclassicism had given way to the demand for naturalism, Eakins stressed objectivity. This demand, in part stimulated by Louis Pasteur's scientific discoveries, was reflected in the reportorial novels of Emile Zola and increasing struggles for democracy and socialism. Honoré Daumier's caricatures as well as the realistic landscapes and peasants of Gustave Courbet were also aspects of this development. In America, Eakins's rigorous search for objectivity had led him, along with Winslow Homer and Thomas Hovenden, to portray African-Americans in a dignified and aesthetically significant manner.

Eakins's teaching departed from academic traditions. He insisted on students working from nude models and introduced dissection and medical studies of anatomy. He also used photography to demonstrate muscles in action. More important, in terms of Tanner's development as a colorist, he insisted, "a student should learn to draw with color. There are no lines in nature . . . there are only form and color."[23]

Tanner was delighted to be at last studying under an inspired teacher. Later he utilized many of the procedures that Eakins taught, such as modeling figures in wax in preparation for painting, using photography in preliminary studies, making small oil sketches in full color as a means of organizing masses of color, and emphasizing the solidity of all forms. So far as is known, Tanner never utilized a nude female figure in his paintings, although his superb drawings of males reflect Eakins's emphasis on anatomy and objective observation.[24]

Tanner did not have an easy time. Despite his acceptance by Eakins and other instructors, he was increasingly subjected to racial abuse, subtle and gross, by some students. An account of this appeared in the autobiography of a fellow student, Joseph Pennell, later well known for his picturesque etchings of city scenes and a member of the National Academy.[25] Although Pennell did not name Tanner, there is no doubt that Tanner was the black student involved.

According to Pennell, Tanner was initially accepted on the basis of a drawing, and Pennell admitted that he drew "very well." Pennell also noted that Eakins and others had asked students if they objected to a black student and "I do not remember a dissenting voice."

In Pennell's opinion, at first Tanner was "quiet and modest . . . unnoticed," but this attitude did not last. Titling his racist account "The Advent of the Nigger," Pennell wrote that he "could hardly explain" the change in attitude except that Tanner "seemed to want things" and "began to assert himself."

Not only did Tanner draw, Pennell remarked, but he said that he "also painted." That a black person dared to paint was too much for Pennell and his racist friends: "One night his easel was carried out in the middle of Broad Street and, though not painfully crucified, he was firmly tied to it and left there."

Pennell concluded his account: "There has never been a great Negro or a great Jew artist. . . . Rembrandt and Turner were accused of being Jews but they never admitted it during their lives." Yet when he wrote this account in 1925, Pennell undoubtedly knew that Tanner had triumphed at the Salon in Paris and that the Pennsylvania Academy now honored him. His account was meant to hurt Tanner again. Years earlier, when the demeaning incidents occurred, they hurt Tanner deeply and filled him with so much pain, anger, and despondency that he eventually left the academy.

During the months that this abuse went on, Tanner turned to his friend Shearer, who encouraged him to talk about these difficulties and his feelings. Many years

later in his only published account of his difficulties at the academy, he wrote of Shearer:

> I can never too highly appreciate his personal service to me, and how his kindly nature and gentle disposition helped me to reduce the bitterness I (at times) had in my life, and gave me a more hopeful view of my individual situation; in fact, a visit to him always renewed my courage, not that courage which was necessary for my work but the courage that was necessary to overcome the unkind things I had to struggle with. He would remove, at least for a time, that repressing load which I carried. . . .
>
> I was extremely timid, and to be made to feel that I was not wanted, although in a place where I had every right to be, even months afterwards caused me sometimes weeks of pain. Every time any one of these disagreeable incidents came to my mind, my heart sank, and I was anew tortured by the thought of what I had endured, almost as much as by the incident itself.
>
> Well, it was to endure these things that he helped me. It was he who first gave me the idea that I might have qualities that, cultivated, would be of great help in the battle of life. And it was done in a manner hardly to be calculated upon. It was by believing in me, and how necessary it is to have someone (besides one's family) to believe in you.
>
> I shall ever remember when he said to me, "You have nice manners and a quality that will make people like you." It was the first time I ever had a compliment from the outside world, and the effect was like magic. How many things I forgot and forgave to make those sweet words come true! It really sweetened my life . . . This was indeed no small benefit conferred upon me.[26]

Tanner was twenty-one or twenty-two years old when these events took place. He was frightened by the intense violence of his reactions to such prejudice. Fear of loss of control of his rage became even more frightening than the actual incident.

Eakins, who probably did not know of these incidents, continued to show a strong interest in Tanner's progress. One day, when Tanner was concentrating on what he felt was his best painting to date, Eakins encouraged him to go on. "But instead of working to make it better, I became afraid I should destroy what I had done, and really did nothing the rest of the week," Tanner wrote.[27]

"What have you been doing?" demanded Eakins. "Get it—get it better or get it worse! No middle ground or compromise!" From Eakins's direction,

Thomas Eakins painted this sensitive portrait of his former student (ca. 1900) after Tanner had gained recognition in Paris. It was made during one of Tanner's visits to his family in Philadelphia. (24⅛ x 20¼") Hyde Collection, Glen Falls, N.Y.

Tanner formulated a rule of making an honest effort regardless of outcome and he tried to apply it "in all walks of life."[28]

Officially, Tanner was enrolled at the academy for two years, 1880 and 1881. During this time he became acquainted with Hovenden, who is now remembered chiefly for two paintings, *John Brown Going to His Hanging,* which showed the bearded abolitionist pausing to kiss a black baby held up by its mother, and *Breaking Home,* showing a boy setting off for a distant land.

Tanner apparently studied privately with Hovenden, whose sympathies with black people increased Tanner's confidence.[29] His contact with Eakins also continued. When he wanted to sketch lions and other animals at the Philadelphia Zoo, Eakins gave him a note that admitted him free. Asked in a 1924 interview how long he had studied with Eakins, Tanner told Jessie Fauset that it had been four or five years.[30]

Trying to support himself, Tanner painted seascapes on the Jersey shore. His most encouraging patron was

Tanner survived by making an occasional sale of an illustration, such as this one showing children feeding deer at the Philadelphia zoo. A wood engraving made from his drawing appeared in *Harper's Young People,* January 1888. National Archives, Harmon Collection

Bishop Daniel A. Payne. Interested in developing the arts among black Americans, he bought three paintings, not only to encourage Tanner but also to stimulate the interest of others.[31] Beginning in 1880, Tanner exhibited at the annual Pennsylvania Academy shows. Yet he rarely sold anything; if it was any consolation, Eakins also rarely sold.

In 1884, however, Tanner's *The Battle of Life,* portraying an elk attacked by wolves, attracted newspaper attention when it was displayed in Hazeltine's Gallery. Although the painting has been lost, it seems to have been a sublimated expression of the racist attacks on him at the academy.[32]

In the spring of 1885, the jury of the annual National Academy of Design exhibition in New York accepted Tanner's *Lion at Home.* To his delight, it was bought for eighty dollars.[33] Acceptance of his work at this leading institution meant more than the money. When Rev. William J. Simmons saw his *Battle of Life* in an exhibition in New Orleans, he enthusiastically included him, along with Centennial prize-winner Bannister, in his biographical sketches of outstanding African-Americans, *Men of Mark.*[34] Tanner had ambivalent feelings about this. Although he was pleased to find himself in such company, praised for his "perseverance, pluck, and brains," he felt that he had not accomplished anything close to Bannister's achievement.

The Philadelphia and New York academy shows were held only once a year. In the meantime Tanner worked diligently at illustrations. He sent drawings of animals sketched at the zoo to New York magazines and book publishers and was once astonished to get a check for forty dollars. Although he dreamed of studying in Europe, he could barely maintain himself in brushes and paint.

Nearly thirty years old, Tanner wanted desperately to end his dependency on his parents, who had four other children to help. Finally, in 1889, eight years after leaving the academy, according to its records, he decided to set up a photographic portrait studio in Atlanta. That city was already an important educational and business center for black Americans, with black colleges, insurance companies, and banks. As an artist, Tanner knew how lighting could create a good portrait and, thanks to Eakins, he knew how to use a camera. He believed his photography studio would support him and give him time to paint.

However, the studio was a failure, bringing in only four dollars a week. Tanner did not know how to stimulate business, to sell extra prints or frames. "I could neither make it go, nor dare to let it go—because with 'blood and tears' I got enough out of it to pay my board each week," he said.[35] Living mostly on cornmeal and applesauce, he felt trapped, unable to paint.

Tanner encountered a friendly former academy classmate who had become a leading Atlanta artist, and this lifted his spirits. However, because of segregation, they had to meet surreptitiously, and the relationship could not be satisfactorily maintained.[36] Tanner's despair increased and so did his belief that only in Europe could he gain the training he felt he still needed.

Learning that a painting of his had been auctioned in Philadelphia for $250 boosted Tanner's spirits, even though he received only $15. About the same time Bishop and Mrs. Joseph C. Hartzell of the Methodist Episcopal church in Cincinnati took an interest in his work. As white missionaries in Rhodesia, they had become interested in African art and believed black

people had artistic talent.[37] In Cincinnati, where he had led the struggle for better jobs and schools for black people, Bishop Hartzell was revered.

When Jeannie Hartzell learned of the failure of Tanner's studio, she went to her husband, who was a trustee of Clark University in Atlanta, and asked him to have Tanner appointed as an art instructor there. Bishop Hartzell did so and Tanner gave up his photography studio to become the first African-American painter teaching at a black college.[38]

Two things happened while Tanner awaited the fall semester at Clark. One was that he spent most of the summer photographing summer cottages for their owners and picturesque highland scenes in North Carolina for tourist postcards.[39] He earned more money than he had ever taken in from his photography studio.

Second, his trips to North Carolina and northern Georgia gave him a close, firsthand look at the life of black people in the South. He witnessed their back-breaking work; their leaky cabins; their singing, banjo-playing, storytelling recreation. He also saw how their religious faith sustained them in desperately poor conditions that were a far cry from the black life in Philadelphia, harsh as that was for thousands. Visiting shabby, weather-beaten but well-attended churches, Tanner listened to the heartfelt singing of spirituals that he knew had impressed the world. Not a success himself, Tanner experienced firsthand the devoted faith with which impoverished southern black people faced their troubles. He felt, in a new way, the richness of their faith, the depth of their sorrow, the dignity of their lives. However, if he made sketches, as has been suggested, they have not survived.

When Tanner returned to Atlanta that fall to begin teaching, his students were primarily faculty members, who paid privately for their lessons; he was not on the faculty payroll. Occasionally someone commissioned a portrait, as did Professor William Crogman, the only African-American on the faculty, who was to become a distinguished educator. During this time Tanner also modeled a bust of his old friend Bishop Payne, who in his 1894 autobiography was to prophesy that Tanner "will go down in history as one of the most successful American artists which the present century has brought forth."[40]

When the Hartzells visited, Tanner confided that he would like to study in Rome and then paint biblical scenes in Palestine. To help him raise money, Jeannie Hartzell arranged an exhibition of his work in Cincinnati, his first one-man show. However, no buyers appeared even though Cincinnati had given many artists, including Robert S. Duncanson, their start.

After the show had been up for three weeks, the Hartzells prevented a psychological disaster for Tanner by buying the entire exhibition for $300. This sum, plus a $75 commission from "Mr. E" of Philadelphia,[41] enabled Tanner to sail to Europe on January 4, 1891. Traveling in a cheap berth directly over the ship's vibrating propeller, Tanner sought the freedom of Europe to help him become an artist of distinction. He was thirty-one years old.

Tanner's opportunity to study abroad had a lifesaving but desperate "do-or-die" quality. En route to Rome, he stopped in Paris to see the Louvre and friends from the Pennsylvania Academy studying there. His inability to speak French made him feel "depressingly lonesome."[42] His friends, however, urged him to visit the art schools.

Within a week, Tanner abandoned his plans to study in Rome. What attracted him was the Académie Julien, which had two of France's leading painters on its faculty: Jean-Paul Laurens and Jean-Joseph Benjamin-Constant. Its atmosphere was exciting and challenging, with its walls smeared with palette scrapings, caricatures, and such quotations from Jean-Auguste Ingres as: "Drawing is the probity of art." Noisy with talk and laughter, with newcomers relegated to the back rows of a crowded forest of easels, the large studio class made Tanner feel completely at home.

Years later he recalled: "The Académie Julien! Never have I seen or heard such bedlam—or men waste so much time. Of course, I had come to study at such a cost that every minute seemed precious and not to be frittered away."[43] There was so much smoking "that those on the back rows could hardly see the model." At times the students sang—salacious ditties, love songs, and, to Tanner's astonishment, spirituals, apparently picked up from European tours of the Fisk Jubilee Singers and earlier American students. The warm, welcoming attitude of the students, even their practical jokes as part of the ritual of acceptance, made Tanner feel at ease. He could laugh at his own mistakes, his errors in French, his own anxieties. How different from the snide, sometimes overt, racism of the Pennsylvania Academy!

Paris constantly surprised Tanner. In its stimulating atmosphere—so different from the segregation of Atlanta—he developed a sense of personal freedom he had never known before.

Working among people who did not care if he was black, Tanner felt himself truly begin to emerge as a person and as an artist. He had, as Shearer said, a capacity to make people like him. His good manners, noted by everyone who came in contact with him, were primarily a mechanism for preventing inner pain—the distress of humiliation and its subsequent

lacerating self-contempt and rage. His genuine concern made people respond to him warmly. In Paris, with students from many distant lands—Russia, Holland, Spain, South America, Poland—all struggling with French and the effort to find themselves artistically, Tanner found validation for his father's comments that prejudice was also directed toward people other than blacks.

Tanner's devoted churchgoing, his timidity about wine, his refusal to visit bordellos, his respect for women, his quiet persistence in learning French and trying to improve his work, at first amused his classmates. In time they recognized in his earnestness a quality of anxious responsibility, stemming from his being older and feeling the pressure of time. That he knew their favorite songs solidified their acceptance of him.

From the first, upon entering the Académie Julien, Tanner wanted to compete in its weekly concours, a drawing competition based on a given theme. Drawings were to be made on Sunday, submitted Monday, and judged later. Tanner's religious feelings forbade his drawing on Sunday. When he asked other students to sign a petition to change the day of drawing to Monday, they shrugged off his religious scruples. At last he succeeded and won permission to make his drawing on Monday.

To his great delight, his initial effort, based on the biblical Deluge, won the week's prize, attracting the attention of Benjamin-Constant. Tanner greatly admired his mentor's work, which had an exotic "oriental" flavor, based on his studies in Morocco and other places in North Africa.

Tanner's skill, earnestness, and modesty impressed Benjamin-Constant. Usually, the maître toured the class once a week, commenting with a word or two or a question to students whose work interested him. Going beyond that, Benjamin-Constant invited Tanner to his studio and steadily encouraged him with attention. Eventually he gave Tanner his photograph, inscribing it: "A mon élève Tanner, son maître et ami, tous jours confiant dans le succés de son fini."[44] (To my pupil Tanner, his master and friend, always confident of his final success.) Such belief in him markedly increased Tanner's confidence. Benjamin-Constant's photo hung in his studio the rest of his life.

In Paris, Tanner began anew the task of finding himself, both as a person and artistically. Terrified lest "I might grow to like it," he tried sipping wine for four or five days, then refused it for a week.[45] At the year's end he did not care whether he had it or not.

At the Académie Julien, Tanner met the sculptor Hermon A. MacNeil, later famous for his portrayals of Native Americans. Finding their outlooks compatible, they shared a studio at 15, rue de Peine, until 1893.

In the spring of 1892, coming from church, Tanner was startled to find thousands of people pouring into the Salon du Société des Artistes Français in the old Palais d'Industrie. Although he had been in Paris two years, this was the first time he realized this annual exhibition drew 10,000 people a day. Moreover, recognition at the Salon was the main road to success for an artist. Inside, he was even more surprised. There were "hundreds of statues that appeared to me nearly all fairer than the 'Venus de Milo' and upstairs the paintings—thousands of them—and nearly all much more to my taste than . . . the old masters in Louvre."[46]

What excited Tanner was that the paintings "were within my range." He immediately felt himself, his life, his studies, and his goal come into focus: "Here was something to work for . . . to be able to make a picture that should be admitted here—could I do it?"[47] Benjamin-Constant encouraged him to try.

Creating such a work was no simple matter. Tanner felt that, first of all, he should improve his French. Partly for that reason, when summer came, he went to Pont-Aven, a small Brittany fishing village, where he thought he would be alone among French people. But there were so many British and American artists there that his French studies lapsed.

Some of these artists were interested in the work of Paul Gauguin, his theories about design and color, and his arguments with the Impressionists. For the first time Tanner was introduced to emerging aesthetic ideas, such as the emphasis on flatness, which sheered away from academic traditions. It was exciting, but Tanner was not sold. He felt that he had to prove himself by the old standards.

The next summer, aiming at Salon jury acceptance, Tanner created a painting that he later described as showing an apple orchard. Recently this painting has been identified as *The Bagpipe Lesson* by Dewey F. Mosby and Darrel Sewell of the Philadelphia Museum of Art.[48] It depicts a young boy blowing a bagpipe while two old men listen appreciatively under a white-blossomed apple tree. The painting's high-key colors reflect the influence of Impressionism in a tentative way, although basically it is quite traditional.

More important, this painting initiated a theme—the learning process of the younger generation under the eye of its elders—that became significant in Tanner's maturing as an artist. It was followed in 1893 by

studies of a young boy learning to drill out sabots with a large auger.

Before he could complete *The Young Sabotmaker,* however, Tanner collapsed with typhoid fever. He had tried to live so frugally—spending only five francs a day on his meals—that he neglected adequate nutrition, which weakened his immunological defenses.[49] Friends hospitalized him in the old Hôtel-Dieu. Delirious, he feared the hospital performed terrible experiments; what he thought was an operating table turned out to be, when he was recovering, a steam-heated food table. Not understanding French well, he asked a nurse to write down what ailed him. "When I saw that dreaded word 'typhoid,' it was only by exercising all the will power I possessed that I kept myself from taking again to my bed," he wrote.[50]

After he was discharged, Tanner was too weak to work, out of funds, and despondent over his setback. His parents had always said, "Remember, if the worst comes to the worst, you always have a home."[51] Asking his friends to roll up some of his canvases and pack his few belongings, he returned to Philadelphia to convalesce.

At home, renewing his family ties, he gradually regained his strength. His oldest sister, Halle, had become one of the first black women physicians in America and was establishing a school for nurses at Tuskegee. Isabel, a leader in religious education, had married a minister. Mary, always close to Henry, had married and was raising a family; her daughter Sadie had become the first black woman to graduate from the University of Pennsylvania Law School and to be admitted to the bar. His brother, Carlton, was becoming a minister, fulfilling hopes his father had once had for Henry.

In their midst Tanner realized how long and lovingly his family had supported him and how much they yearned for his success. Although his old dream of becoming a great artist seemed as remote as ever, he felt a new confidence as his strength grew. Yet he no longer thought of Philadelphia as home. Paris was now his home, a place from which he could look at America and everything that happened in it with deeper understanding.

Tanner now began sorting out what his experiences had meant and how they might be used artistically. Having experienced the freedom of Paris and having gained a sense of acceptance and belonging there, he found the harsh treatment of black people in America blindly cruel. Few white Americans seemed aware of the positive side of black people's lives, of the kind of loving attention his parents provided, of their inherent dignity, their courtesy, intelligence, and talents in many fields. His scholarly father, for example, was delivering a series of theological lectures at the time and had represented the AME church at international religious conferences in London. Only in America, it seemed, was prejudice so virulent, so blind.

As a result of his religious beliefs, Tanner reflected again and again on the self-righteousness of so-called Christian groups in the face of cruel discrimination. What could be done to establish the truth of Christ's concern for all humanity?

Singing familiar hymns in Mother Bethel, listening to its expressive choir and to his father preach, Tanner felt more strongly than ever his obligation to succeed as one way of demonstrating an aspect of African-American talent unseen by most Americans. These were his people and his traditions. Although set apart by his artistic vision, he wanted to express his people's humanity, their insights, and the deep faith that eased their lives.

At about this time he was invited to participate in a symposium as part of the Congress of Africa at the World's Columbian Exposition in Chicago. The three-day congress considered African-American life as well as that of Africans. Discussing "The Negro in American Art," Tanner "spoke of Negro painters and sculptors, and claimed that actual achievement proves Negroes possess ability and talent for successful competition with white artists."[52] Undoubtedly he talked about Edward M. Bannister, Edmonia Lewis, and the Philadelphia artists Robert Douglass, Jr., and David Bustil Bowser. He may have discussed Robert S. Duncanson. He could point out that Edmonia Lewis's *Death of Cleopatra* had been exhibited in Chicago after its success at the Centennial. He was not speaking of "some day," but of real demonstrations of talent that had burst through the barriers of prejudice. In many ways he was talking about himself and his dreams.

Whatever impression Tanner's talk made on his listeners, its greatest impact was on himself. Preparing for it forced him to consider the humiliating caricatures that were then the standard visual depiction of African-Americans. He kept contrasting his own deep knowledge of the integrity and dignity of his people despite years of abuse and exploitation.

Setting up a studio on Chestnut Street, Tanner created a painting that expressed his own understanding and feeling about his people. It conveyed their warmth, their uniqueness, their concern for one another. It also demonstrated the transmission of certain cultural values from the older generation to the younger one—a similar theme to the one in *The Bagpipe Lesson* and his sketches for *The Young Sabotmaker.*

Tanner's painting was to become one of his most famous works, *The Banjo Lesson.* Although this paint-

Negro Boy Dancing (1878). Eakins's watercolor of a young boy dancing to banjo music demonstrates his influence on Tanner. (Watercolor, 18⅛ x 22⅝″) Metropolitan Museum of Art, New York

ing reflects the naturalism taught by Eakins in its objective treatment of two individuals, the colors are far from Eakins's somber palette. It is a brilliant, challenging painting in which the cool light from an unseen window and the warm light from an unseen fireplace play on the dark skins of an old man and a young boy who is getting his first lesson on the banjo. There is a compelling authenticity to the figures, who convey tenderness, knowledge, and nurturing humanity at its best. In its own way the painting celebrates the music of African-Americans through their invented instrument, the banjo, and the transmission from generation to generation of that music.

About a year later Tanner wrote a statement in the third person that gives some insight into his own feelings at that time about painting African-Americans:

> . . . He [Tanner] feels drawn to such subjects on account of the newness of the field and because of a desire to represent the serious, and pathetic side of life among them, and it is his thought that other things being equal, he who has the most sympathy with his subject will obtain the best results. To his mind many of the artists who have represented Negro life have only seen the comic, the ludicrous side of it, and have lacked sympathy with and appreciation of the warm big heart that dwells within such a rough exterior.[53]

Tanner's sympathy—indeed, identification—with his black subjects in *The Banjo Lesson* makes his earlier *Bagpipe Lesson* and sketches for *The Young Sabotmaker* appear to be almost technical exercises. When *The*

Banjo Lesson, which Tanner initially called *The First Lesson,* was exhibited at James Earle's gallery in October 1893, it immediately won praise from viewers. Although the *Daily Evening Telegraph* critic lapsed into racial stereotypes, referring to the old man as "Uncle Ned," he described the painting sympathetically, complaining only that light from a single source would have helped unify the painting.[54]

Encouraged by the painting's reception, Tanner sent it to the Paris Salon of 1894, where it was accepted.[55] According to W. S. Scarborough, who knew Tanner and his father well, it was hung in "an honorable place" amid thousands of paintings, and won "high praise from Benjamin-Constant,"[56] which must have been gratifying to Tanner. However, for the most part, French critics and crowds were indifferent. *The Banjo Lesson* was outside the French experience and could not be expected to have the same impact in France as it did in the United States. This is peculiarly an American painting and could have been painted only by an African-American of great skill and with profound emotional identification with his subjects.

Sometime in the spring or summer of 1894 Tanner completed a second major work dealing with African-American life, *The Thankful Poor.* Perhaps inspired by the North Carolina scenes Tanner had witnessed earlier, it depicts an old man and a young boy at opposite ends of a table, their heads bowed in prayer before their empty dishes. The figures, treated objectively, again show Eakins's influence. The light comes from a single source, a window behind the old man. It leaves the old man's face in shadow and highlights the face of the boy, symbolic of the future. Once again, the trans-

The Thankful Poor (1893–94) was painted in Philadelphia at the same time as *The Banjo Lesson* and shows Eakins's influence except for its color. It was apparently Tanner's first religious painting. Loaned to the Philadelphia School for the Deaf by its purchaser but never reclaimed, the painting was auctioned off in 1981 for a record-breaking $250,000. (34 x 44") Collection William H. and Camille Cosby, New York

mission of a cultural value from one generation to another is the theme. The high-key color of the wall nearly silhouettes the figures, underlining their significance. As in the later work of Horace Pippin and Jacob Lawrence, it is the emotional intensity of the painting that authenticates it, that makes it transcendent, true to life but bigger than life.

Portraying religious faith among the poor was not new or original. This subject had been dramatized by Jean-François Millet in *The Angelus,* a popular and sentimental painting in the Louvre, which Tanner had undoubtedly seen. Tanner's achievement was to express deep faith objectively in terms of his own experience in America. This painting was close to his heart and soul, his very existence. It exemplified his belief that "he who has the most sympathy with his subject will achieve the best result."[57]

The Thankful Poor has had an unusual history since its first showing in Philadelphia. It was probably shown at the Cotton States and International Exposition, which opened in Atlanta on September 18, 1895. There Booker T. Washington made his famous speech defining the role of the African-Americans as farm and industrial workers, without interest in civil liberties, politics, higher education, or the arts.

One of the exposition's major attractions was an art exhibition. It included works by Eakins, Winslow Homer, Mary Cassatt, and Tanner. Each of these artists was awarded a medal, Tanner's being for *The Bagpipe Lesson,* his apple orchard scene. He also exhibited two other paintings—which Mosby and Sewell, authors of

the Philadelphia exhibition catalog, suggest were *The Thankful Poor* and *The Banjo Lesson.*

However, Tanner's paintings were not displayed with those of Eakins, Homer, and Cassatt. Instead they were shown in a special "Negro Building," which had been entirely created by African-Americans as a demonstration of their skills. This segregated display of Tanner's work was ordered by Robert C. Ogden, head of the John Wanamaker store in New York, a trustee of Hampton Institute and Tuskegee Institute, and an admirer of Tanner.[58]

Ogden wrote Washington that he had made the Tanner paintings part of the Hampton exhibit in the Negro Building because the art department of that building did not provide an adequate position for them. Reflecting the confused racial attitudes of well-intentioned white people at the time, Ogden felt the Tanner paintings "would have lost their distinct race influence and character if placed in a general art exhibition"—that is, alongside Eakins, Homer, and Cassatt. "My purpose," he explained "was to get the influence of Mr. Tanner's genius on the side of the race he represents and at the same time I did not want it degraded by inharmonious association with inferior work"—that is, with other artwork by African-Americans in the Negro Building.[59]

Tanner, who had sent *The Banjo Lesson* to hang alongside the best European art in the Paris Salon, may never have known of this segregation of his work. In any event the incident did not disrupt his friendship with Ogden, who later purchased *The Banjo Lesson* and *The Bagpipe Lesson* and gave them to Hampton Institute, where they have remained.

The Thankful Poor was purchased by the Philadelphia philanthropist John T. Morris. He loaned it to the Philadelphia School for the Deaf, of which he was a trustee, with the proviso that he might reclaim it. He never did. At some point the painting was put in a storeroom where it sat for seventy-five years. In 1981 the school, needing funds, put it up for auction at Sotheby's.[60] It was purchased by William H. and Camille O. Cosby for a reported $250,000, the highest price then paid for a work by an African-American artist.[61]

By the time the Atlanta exhibit took place, Tanner had already returned to Paris. To raise money for his return, he organized an exhibition in Philadelphia in which he tried to sell everything he could lay his hands on at whatever price he could get—"an auction," he later called it.[62] This exhibition was held at Earle's gallery from April 20 to May 5, 1894. By coincidence Hovenden's work was also shown there at the same time.

Altogether Tanner showed sixteen paintings and sketches, including some completed years earlier as well as *The Thankful Poor* and *The Bagpipe Lesson*. The exhibit raised "several hundred dollars," and Tanner returned to Paris.

Tanner's return brought a change in subject matter. *The Banjo Lesson* and *The Thankful Poor* had raised hopes, among African-American leaders, that in Tanner "a portrayer of Negro life by a Negro artist had arisen," as Scarborough put it. Indeed, they hoped "that the treatment of race subjects by him would serve to counterbalance so much that has made the race only a laughing stock subject for those artists who see nothing in it but the most extravagantly absurd and grotesque."[63] However, on his return to Paris, or perhaps even before, Tanner privately decided not to continue painting African-American subjects in order to pursue his original goal of honors in the competitive Paris Salon. He may have felt that *The Banjo Lesson* was as powerful a portrayal of African-American life as he could make.

Yet it had received no critical or press attention at the Salon. If it had achieved some distinction, the course of Tanner's painting—and his life—might have been different.

Certainly Tanner knew that works like *The Banjo Lesson* would be classed as genre paintings—those depicting everyday life. In that day critics held that high art should deal with noble characters, great historical incidents, or classical themes. Genre paintings were not considered very important.

Nevertheless, Tanner completed one more genre painting before shifting the direction of his work, *The Young Sabotmaker*. As if to reiterate his view of black people as positive rather than exotic subjects, he abandoned his previous sketches of a white youth and made the figure in the final painting a sturdy black youth. He had the satisfaction of seeing the painting accepted by the Salon.

However, thinking more and more about his own work and that of contemporary masters, Tanner concluded that picturesque charm, as in *The Bagpipe Lesson* or *The Young Sabotmaker*, would never be enough to achieve recognition as a world-class painter. *The Young Sabotmaker*, which he had hastened to complete, was simply another genre painting. Tanner recognized that he had come to a crisis in his career. He had achieved superb technical mastery under a leading artist of the day, but he was clearly at the end of his apprenticeship. He could no longer go on painting genre scenes. What did he, Henry Ossawa Tanner, really have to say? What did he deeply feel and believe?

As a possible theme for his art, Tanner began to review the richness of religious faith—its profound role in helping his people and its universal character, even among non-Christian peoples. However bleak, even terrible, the circumstances, the underlying promise of such faith is hope.

Moreover, faith was something Tanner possessed, that had helped him endure his long and at times tormented struggle to become an artist. Scarborough has suggested that Tanner turned to religious painting because his father had long hoped that he would illustrate biblical stories.[64] But Tanner sought something beyond illustration. He realized in a profound way that his religious faith gave him a core around which he could organize the complex emotions of his life. That deep faith, unattached to formal dogma, was central to his character, the essence of his being. At times he wrote down notes for daily meditations:

> Monday—I am thankful for Thy unfailing bounty.
> Tuesday—I rejoice in my ability to give blessings to others.
> Wednesday—I invite the Christ spirit to manifest in me.
> Thursday—I realize the meaning of Peace on Earth, good will toward men.
> Friday—I follow the star (high ideal) that leads me to Christ.
> Saturday—I am poised. I am not worried or hurried.
> Sunday—Joy, peace, and plenty are now mine.[65]

Tanner found support for his decision to turn to

religious painting in the work of Rembrandt, the Italian Renaissance masters, and others. He studied these past masters and the way that religion had provided great art with content for centuries. In placing himself within this tradition, Tanner sought to clarify his personal vision. He was acutely aware that the Salon was awash in superficial illustrations of biblical scenes. Most focused on imaginary winged angels and haloed Madonnas with Child. Many of the best-known artists of the time turned to the exotic aspects of the Near East, its architecture, costumes, Semitic and Arabic faces. James Tissot, for example, carried out archaeological studies to paint elaborate temple scenes, without providing any of the spiritual feeling of the biblical incident portrayed.

This is what Tanner sought to avoid. Of course, he was influenced by his religious upbringing, his father's hopes that he would paint biblical illustrations, and his own knowledge of the Bible. Without all this, Tanner could not have been a religious painter. But he was not seeking to illustrate biblical scenes in any literal way. Such incidents were merely the symbols of what he was trying to express—faith. So while he might draw upon biblical stories, the Christian vocabulary of faith, so to speak, he was concerned with faith and hope as universal feelings—the essence of all religions.

Tanner began his first religious painting, *Daniel in the Lions' Den,* with all the seriousness and resourcefulness he could command. Returning to his early studies of animals, he drew lions by the hour at the Jardin des Plantes zoo. Anxious yet determined to be thorough, he joined a class taught by Emmanuel Frémiet, France's leading animal sculptor. Shown a sketch of Tanner's proposed painting, Frémiet responded matter-of-factly: "If you do it well, it would be a good painting. If not, it will be a very ordinary one."[66]

As he worked on the painting, Tanner followed Caravaggio and Rembrandt in having a light from an outside source dramatize the central character. This effect was subtly carried out, with light falling on only the lower half of Daniel's body and catching the paw and head of just one lion in its circle, while the other menacing lions lurk in the shadows. On the wall Tanner included barely visible Assyrian tiles, following the example of Tissot, Eugène Delacroix, and Benjamin-Constant, who used such Near Eastern artifacts to establish authenticity.

Tanner's use of light created a dramatically tense and anxious mood. He then offset this with the calm, affirming faith of Daniel, whose relaxed figure suggests serenity in the midst of danger. Only Daniel's head, slightly tilted upward, hints at a hopeful seeking of salvation. The overhead light may also be seen as a protective shield representing Daniel's faith, for the lions prowl outside it. (In a later version of this work, painted in 1917 and now in the Los Angeles County Museum of Art, Daniel's head is tilted downward, conveying a sense of resignation and passivity rather than faith and hope—a change in expression that may have been due to Tanner's depression about World War I.) What Tanner expressed in this painting, as well as the later version, was his own need for faith. He had, in his own words, "the most sympathy with his subject."

When it was completed, Tanner submitted *Daniel in the Lions' Den* to the Salon of 1896. Touring the Salon before its official opening, the French master Gérôme, who had been Eakins's teacher, felt it was poorly hung, and at his suggestion it was moved to where the jurors could better appreciate its qualities. The painting won an honorable mention. "This first little 'mention honorable' gave me a courage and a power for hard work, and also a hope that I had never before possessed."[67]

Contributing to Tanner's confidence at the time was his membership in the American Art Club, which had been founded by A. A. Anderson; Rodman Wanamaker, a member of the Philadelphia merchant family; and Whitelaw Reid, the United States minister to France. It gave Tanner a satisfying sense of belonging to go to the club for lunch with fellow artists, to play billiards, or to read American newspapers and books in its library. Tanner was a modest man, but winning a Salon award had distinguished him and he was considered one of America's most promising stars by Walter Gay, Hermon A. MacNeil, and Dudley Murphy, important artists in their own right and his friendly colleagues. It was the kind of acceptance he never knew in Philadelphia.

Robert C. Ogden was also delighted to hear of the honorable mention. During this time Tanner had been partially supporting himself by writing "art notes" on Paris exhibitions, but he suddenly faced a loss of these assignments for refusing to "come home and paint American subjects."[68] When Ogden learned of Tanner's financial difficulties, he and Tanner's parents provided funds so that he could continue painting.

The Salon's honorable mention convinced Tanner he was on the right track. He next concentrated on a conception of the raising of Lazarus that differed greatly from the large, complex canvases of his contemporaries in dealing with this theme. Choosing a relatively small canvas, he abandoned the tightly drawn and detailed figures of other artists. Instead, he made the light radiate from Jesus and the prone Lazarus, illuminating the intense faces of the surrounding group. The figures, fading into shadows, became undefined shapes in the glowing light.

Daniel in the Lions' Den (1895), in its original form (left), was a vertical painting with an open skylight highlighting Daniel, calm in his faith, among the menacing lions. This painting won an honorable mention in the Paris Salon, Tanner's first such recognition, but is now lost. Photo: National Archives In a second version (right), painted about 1916, Tanner turned to a horizontal structure, which provides a closer view of Daniel and the pacing lions while eliminating the skylight and thus making the light more mystical. (Oil on paper, on canvas, 41⅛ x 49⅞") Los Angeles County Museum of Art

Tanner did numerous studies for this painting. He spent the summer searching for Hebraic faces of all ages for the crowd surrounding Jesus and Lazarus—a crowd that included one turbaned black man. He also created models of the scene, like miniature stage sets, so that he could vary the light angles and sketch various groupings and compositions, with shadows falling one way, then another. At a friend's suggestion he even made a large version of the painting, which he ultimately destroyed as a mistake, going back to the small canvas.

When at last satisfied, Tanner brought the painting to Benjamin-Constant. That master was so enthralled that he carried it into a bedroom to let his son see it. Members of the American Art Club felt Tanner was about to score a major success. Rodman Wanamaker was deeply moved by the painting. Disturbed that Tanner had never been able to afford a visit to the Holy Land, he offered to send him there—an offer that Tanner promptly accepted.

After sending several paintings to the Salon, Tanner left Paris on January 12, 1897. In Cairo he inspected old mosques and traveled to the Pyramids. He then visited Jerusalem, the river Jordan, the Dead Sea, and Jericho, and he walked through miles of arid countryside. Steeped in biblical stories since his earliest childhood, he was a sensitive observer. The images he saw would feed his work for many years. As he later wrote:

The great barren hills were to me a natural setting, a fitting setting to a great tragedy. The country, sad and desolate, is big and majestic. The only marked exception that I saw to this aridity was Bethlehem— a garden spot. All around parched and searing, this little Bethlehem was green and refreshing, and, as it seemed so to fit in with our feeling, it seemed "blessed of Heaven." Believe this or not, the difference is striking; Jerusalem, barren, broken-cistern, sterile—Beth-

lehem, six miles away in the midst of olive groves, green, refreshing, quiet, still the peaceful shepherds upon the hilltops—blessed.[69]

To be closer to the common people, who he believed were like the parents and followers of Christ, and to extend his funds, Tanner shunned a hotel and lived in a boarding house. Intensely caught up in the mystery of why God had chosen Bethlehem as the birthplace of Christ, he liked to go walking in the moonlight. Its bluish light and strange shadows made both the robed Jews and Arabs and the landscape more intriguing than ever.

Tanner next went to Alexandria and from there to Naples, Rome, Florence, and Venice, studying the masterpieces of the Italian Renaissance. In Venice a much-postmarked letter caught up with him—his *Raising of Lazarus* had been awarded a medal of the third class and, more important, the French government had offered to purchase it.

Tanner was overjoyed. Aware that the letter had been following him for weeks, and fearing that his failure to respond promptly might have caused the offer to be withdrawn, Tanner hurriedly cabled his acceptance. The next day congratulatory messages from artist friends reassured him. One said: "Come home, Tanner, to see the crowds before your picture."[70]

There were indeed crowds before his painting. The *Boston Herald* correspondent, personally attracted to the picture on press day, before the official opening, wrote: "I was surprised to find . . . when attention is more given to the presence of celebrities and smart costumes and canvases signed by big names . . . that there was group after group before this quietly beautiful picture."[71]

Less than forty years after slavery a black American had won one of the world's major art prizes. Only a few Americans had achieved such an honor, the most notable being John Singer Sargent. In 1889 Walter Gay's *Bendicte* had been purchased by the French government, and in 1891 James McNeill Whistler's famous portrait of his mother had been purchased.

The American Art Club rejoiced in Tanner's success. Ogden and Wanamaker, already his patrons, interested others. Then, late in 1897, Tanner met Atherton Curtis, an art collector and heir to a patent medicine fortune, who became his close friend and lifelong patron. Curtis belonged to the same family as Laura Curtis Bullard, who befriended Edmonia Lewis and wrote sympathetically about her. Both owed their fortunes to Mrs. Winslow's Soothing Syrup, a morphine-loaded concoction to put babies to sleep, which was later banned—although neither Curtis nor Bullard was active in the patent medicine firm.[72] Curtis was a serious collector of prints; Bullard bought work by Lewis.

As a result of his award, Tanner was besieged by the press for interviews. The *Boston Herald* correspondent found that Tanner had virtually nothing to say about himself or the incidents of his life. Knowing the prejudice that Tanner must have overcome, the correspondent was astonished to discover that the European press, concentrating on the merits of the painting, did not allude to what he called the "picturesque fact" that Tanner was of African descent. He thought this might be because France was "accustomed to clever men of African descent," possibly a reference to Alexandre Dumas, the writer.

Tanner was dismayed and hurt when a Baltimore newspaper passed off a photo of a black dockworker as one of him. Not having a picture of Tanner, its editors decided any black face would do, a reflection of the prejudice that Tanner had hoped his achievement would dissolve.[73]

Tanner did not rest on his success. He immediately began working on a painting stimulated by his visit to the Holy Land, *The Annunciation*. In it his acute observation of architecture, pottery, textiles, and people in Palestine was put to use. In *Daniel in the Lions' Den* Tanner had drawn heavily on his studies of light and shade while maintaining marked linear qualities. In *The Raising of Lazarus* he had largely abandoned the linear aspects in favor of color and deep shadow, prompting the French critic and painter Aman-Jean to write: "I find in his talent something of the genius of Rembrandt."[74]

In *The Annunciation* Tanner's use of light was more innovative. His painting shows a simple, freshly awakened young woman—Mary. She looks expectantly, yet anxiously and perplexedly, at a hovering iridescent golden glow, symbolizing the angel Gabriel, who has just told her of the child she will bear. One of the best descriptions of this painting was written by Helen Cole in 1900: "The young Jewish peasant [sits] on the edge of a couch, wearing the common striped cotton dress of the Eastern women of the poorer class, a costume they have kept to the present day, no halo or celestial attributes about her, and only the flood of golden light to herald the approach of the angel."[75]

That "flood of golden light," mysterious, undefined, yet obviously symbolizing the angel in the biblical story, stunned Salon-goers in 1898. They were used to angels with wings and halos. And the perplexed and anxious expression on Mary's face sharply contrasted with the beatific expression with which she was generally depicted.

In contrast to the darkly dramatic style of *Daniel*

A preparatory study for *The Annunciation* shows how freely Tanner painted when initially developing his picture. (8½ x 10½″) Photo: Peter A. Juley & Son

The Annunciation (1898), in its finished form, is a closely controlled, meticulously detailed painting. Tanner took great pains to study the ancient architecture, carpets, textiles, and garments of what is now Israel. What excited the critics and public when this painting was first shown in the Paris Salon of 1898 were his representation of the angel Gabriel as radiant light instead of the conventional haloed figure and Mary's apprehensive look on hearing the angel say that she is to bear the Son of God. (57 x 71½″) Philadelphia Museum of Art

and *Lazarus,* Tanner painted the scene in high-key color, warm and vibrant, with firm linear control. He maintained authentic details in Mary's costume, the rug, the bed, the structure of the room's arches, and the stone floor. Thus, in one painting, Tanner combined a realistic style with an inexplicable mysticism and brilliant color. On seeing it the Salon jury reportedly cried, "Bravo! Bravo!"[76]

The painting was later exhibited at the Art Institute of Chicago and the Pennsylvania Academy. Eventually it was sold to the Philadelphia Museum of Art, where it has been ever since. It was Tanner's first work to gain a permanent place in an American museum.

Both Odgen and Wanamaker were enthusiastic about Tanner's achievement. Wanamaker promptly staked Tanner to a prolonged stay in the Jerusalem area. Tanner spent six months in late 1898 sketching and painting around Jerusalem and the Dead Sea—a visit, he claimed, that "gave me an insight into the country and the character of the people that my shorter previous visit only whetted my appetite for."[77] Traveling on foot and by donkey, seeking the sites of New Testament incidents, Tanner was fascinated by the barren landscape and made many drawings and oil sketches. In the moonlight and at early dawn, he made notes of the land's color and mysterious shadows for later paintings. In the desert, with its rocky mountain eruptions and deep canyons, humankind seemed to be dwarfed by the overwhelming forces of nature.

Tanner studied fishermen and their boats and how they handled their nets. He also drew and painted the heads of characteristic Hebraic and Arabic people. He was fascinated by the way the shepherds gathered their robes about them, and he was moved by the "deep pathos" of old Jewish men at Jerusalem's Wailing Wall—"those tremendous foundation stones of that glorious temple . . . worn smooth by the loving touch of tearful and devout worshippers from all over the world."[78] He made several paintings of Jews praying at the ancient site.

Tanner also made many sketches of traditional garments, recording their color combinations and the ways of wearing robes and burnooses. These studies would help in re-creating the atmosphere of biblical times. Delacroix, Tissot, Benjamin-Constant, and others had made similar sketches in Tangiers and Morocco. Tanner later bought the costumes that Mihaly Munkacsy, an earlier religious painter, had acquired in the Holy Land.

The biblical sites had a profound emotional meaning for him. Since childhood he had heard the biblical accounts of the enslavement and persecution of the Jews. Walking across the arid desert, riding a donkey into Jerusalem, Tanner could readily imagine what it

Jews at the Jerusalem Wailing Wall (ca. 1897). Tanner's nearly photographic study of old Hebrew men at what he called the Jerusalem Wailing Wall reflects his profound interest in the expression of religious feelings. In the 1920s he painted an unusual portrait of Rabbi Stephen Wise, which has disappeared. Museum of Art, Rhode Island School of Design, Providence

was like to be a follower of Christ 1,900 years earlier. People still dressed as they did then. He could see in the evening shadows how the disciples must have looked as they walked on the road to Bethany each evening with Christ. He could observe how old men stood, sat, talked, and gestured.

Inspired by all that he saw, Tanner began a major new painting depicting the old Pharisee Nicodemus, described in the Bible as "the ruler of the Jews," meeting secretly with Christ on a rooftop. With this work Tanner moved steadily away from details that impeded his use of color, letting his color define shapes in the bluish haze of twilight.

As rigorous traditionalist priests, Nicodemus and the other Pharisees had been angered by Christ's driving the money changers out of the temple. Nicodemus could not understand Christ's emphasis on the spirituality of mankind. The biblical story, which ends with Nicodemus becoming a convert, was a favorite with Tanner's father. It is analogous to tales of slaveholders who, in secret conversations with abolitionists, became converted to their cause.

In *Nicodemus Visiting Jesus,* Tanner maintained an overall bluish tonality, which creates a mood of mystery and expectancy. A bright yellowish patch of light cast from a lamp against the stair to the roof is the only break in the twilight blue, and it helps to illuminate the face of Jesus. This brilliant use of light from an outside source is characteristic of Tanner.

Tanner completed this painting in Jerusalem. Years later he remembered "with pleasure the fine head of the old Yemenite Jew who posed for Nicodemus."[79] Exhibited in the 1899 Salon, the painting was awarded the Lippincott prize at the annual exhibition of the Pennsylvania Academy of Fine Arts and purchased by the academy in 1900.

Tanner visited Philadelphia during this period, and Thomas Eakins painted a portrait of his now-heralded former student. The portrait, one of Eakins's best, reflects Tanner's dignity, inner tension, and determination. It now belongs to the Hyde Collection in Glen Falls, New York.

On returning to Paris as a result of his Palestinian stay, Tanner often turned to moonlit scenes for his religious paintings. This kind of lighting appears in *The Flight into Egypt, The Good Shepherd,* and *Christ and His Disciples on the Road to Bethany* (he made several versions of some of these paintings, confusing researchers). The figures in these works become indistinct silhouettes in the misty bluish light of evening or moonlight. Increasingly, Tanner ignored natural appearance in favor of a saturated color that set the pervasive mood he wanted. An all-embracing blue tone dominates the skies, gateways, garments of the figures, and even the foreground. In most of his later works, Tanner departed almost completely from the linear expression and restrained color of his earlier paintings and the works of his mentors, Eakins and Benjamin-Constant. In fact, he abandoned all that seemed irrelevant to his organic, all-encompassing inner vision. A great charge of energy seems to direct Tanner's resonant color, so that even the deepest tones seem imbued with an inner radiance.

During the summer of 1898, just after the success of *The Annunciation,* Tanner met a young opera singer of Swedish-Scottish descent from San Francisco, Jessie MacCauley Olssen, who had been studying music in Germany with her sister. Touring France with their mother, the Olssen girls met Tanner at an artist's party near Fontainebleau. Talented, warm, and spontaneous, Jessie was intrigued by Tanner's modesty in the face of his achievements. He was very different from the boastful, self-indulgent artists she had encountered.

Although they were strongly attracted to each other, their courtship was delayed by Tanner's departure for six months in Palestine. On February 25, 1899, Jessie put an end to that with a telegram that said: "Come to me."[80]

On his return, with the positive response to *Nicodemus Visiting Jesus,* Tanner felt economically secure enough to ask Jessie to marry him. With the approval of both sets of parents, they were married in London on December 14, 1899. The Olssens were devoted to Tanner, who now took a studio on the boulevard St. Jacques, which he was to occupy for many years.

In his new studio Tanner began work on the painting *Christ Among the Doctors.* A *Cosmopolitan* writer, impressed by the unfinished painting, wrote that Tanner seemed destined "to give the world a new conception, at once reverent, critical and visionary of the scenes of the Bible."[81]

Edward Bok, editor of the widely circulated *Ladies' Home Journal,* had been greatly impressed by Tanner's work at the Pennsylvania Academy shows. He commissioned a series of paintings entitled "Mothers of the Bible" to be used as magazine covers. Of six projected paintings, only four—Sarah, Hagar, Rachel, and Mary—were reproduced.[82] These illustrations made Tanner's name known to millions of women.

The increased possibility of sales in America apparently contributed to the Tanners' acceptance of a proposal to move to the United States. His friend and patron Atherton Curtis and his wife were hoping to establish an art colony in Mount Kisco, north of New York City.[83] Curtis built four houses and offered one to the Tanners, who visited briefly in the winter of 1902, before sailing for France and Spain. They returned in the summer of 1903 and Tanner resumed painting, completing a statesmanlike portrait of Bishop Hartzell.

On September 25, 1903, their son, Jesse Ossawa Tanner, was born in New York City, an event of great happiness. By giving his son the middle name *Ossawa,* Tanner retained a family symbol of the fight against prejudice.

Their stay in the United States did not last. Within a few months the Tanners returned to Paris, and they were soon followed by the Curtises. What happened? One factor may have been the isolation of what was then a rural village of 2,400 people, where the Tanners were cut off from the type of social life they had enjoyed in Paris. Racial prejudice in America, however, was probably the major factor, although no specific incident in Mount Kisco has been identified. Tanner could not travel freely with his wife; he could not stop in a restaurant or go to concerts, art galleries, theaters,

or the opera (which was important to Jessie) without risking insults. When his parents or black friends came to visit, they may also have encountered prejudice.

With the birth of his son, Tanner was forced to contemplate the cruel racial barriers his child would face growing up in the United States. Psychologically, nothing could more quickly or more painfully make him relive his own bitter humiliations. Tanner did not want to see Jessie and their young son hurt. Even hearing of incidents of racial prejudice produced such inner rage in Tanner that he feared he could not control it. These thoughts made it impossible for him to work.

Many years later, Sadie Tanner Mossell Alexander, his niece and a prominent Philadelphia lawyer, told Walter Simon that Tanner became very upset when prejudice was discussed: "He became disturbed not because of any rejection of—or refusal to become identified with—the problem, but because he felt so strongly on the subject that his reaction was emotional. Hence he normally chose either to deal with this problem obliquely or not to discuss it at all."[84]

A decade after leaving Mount Kisco, in an emotional letter to Eunice Tietjens, a writer who had written sympathetically about his being an African-American, Tanner jabbed ironically at the idea of racial "purity," ridiculing the idea that either "pure" Anglo-Saxon or "pure" African blood was the source of his talent. The American obsession with race, he said, "has driven me out of the country," and "while I cannot sing our national hymn, 'land of liberty,' etc., still deep down in my heart I love it and am sometimes sad that I cannot live where my heart is."[85]

Back in France in the spring of 1904, the Tanners settled in the Paris suburb of Sceaux, with Jessie's parents. They bought an old, converted peasant house in the artists' colony at Trépied, near Etaples, on the English Channel.

Tanner then returned to religious painting with renewed energy. He began prolonged experiments with glazes as a means of creating luminous blues and blue-greens as well as radiant light. Some, although not all, of these qualities were apparent in the paintings he sent to the 1905 Salon, *The Good Samaritan* and *Christ Washing His Disciples' Feet.*

There were many religious paintings in that Salon, but Tanner's work stood out for its color rhythms, tone, and composition, bearing witness to his strong beliefs. He spoke with scorn of mediocre painters who exploited biblical themes as a means of achieving recognition. "It is as hard in art to give something when you possess nothing as in anything else," he said. "Religious pictures must measure up to the requirements

Jessie Olssen, Tanner's wife, posed for many of his studies for a series of portraits of biblical mothers commissioned by a magazine.

of good art or they can never command respect. The want of high ideals in religious art will, as in other things, be fatal."[86]

During this period Tanner painted the first of many versions of *The Good Shepherd,* in which a tall, robed figure, sometimes holding a lost lamb, appears in a mystical setting. Also in this period Tanner created what he later described as his "most difficult effect"[87] in a *Christ at the Home of Mary and Martha* (now in the Carnegie Museum in Pittsburgh). This "difficult effect" appears to refer to the dark, mysterious, barely discernible figure in a painting that is otherwise highly

Moonlight Hebron (ca. 1907) contrasts one of this ancient city's massive buildings with a few figures descending the steps on the right. The moonlight intensified the mystery that Tanner felt in this region. (25¹¹⁄₁₆ x 31⅞") Milwaukee Art Museum

illuminated. Who is this figure? Is it Judas? In one version of the biblical story Judas had admonished Mary for not giving to the poor the money spent on a costly perfume to anoint Christ's feet. It is a perplexing painting.

In 1906 Tanner's *Disciples at Emmaus* was purchased from the Salon by the French government,[88] increasing the demand for his work. Prices for his paintings had risen markedly. The *Disciples* sold at four times the price of *Daniel.* Yet Tanner had persistent financial problems. Early in Tanner's career, Wanamaker often bought paintings to keep him in funds, later selling them to museums. At one point Curtis established a regular buying program to maintain Tanner.[89]

In 1908 the jury placed Tanner's *Wise and Foolish Virgins* in a special section called the Salon d'Honneur. This painting was Tanner's largest and one of his most unusual. Acclaimed by the *Journal des Débats* as his masterpiece, this huge painting, measuring 15 by 20 feet and containing twelve life-size figures, was held by the *Revue des Deux Mondes* to surpass the work of the French master Jean-Paul Laurens. Also known as *The Bridegroom Cometh,* this painting was once held by Wanamaker but cannot be located today.

Meanwhile, in the United States, Tanner's paintings were purchased by the Art Institute of Chicago and many other institutions and collectors. His striking portrait of *Two Disciples at the Tomb,* which won the Harris prize of the Art Institute, was widely reproduced in America. In its emphasis on the lighting of the faces and general coloring it resembles the approach used by Tanner in *The Raising of Lazarus* on a larger, close-up scale.

An exhibition in New York brought Tanner fresh recognition in his native land. Contrasting his work to the labored conceptions of other religious artists, the *New York Tribune* of December 19, 1908, said: "There is an almost artless simplicity about his work. He seems to have been able to project himself back into the past and to paint religious subjects realistically without a trace of that archeological reconstruction of Tissot . . . Rarely, in anything he has done, is there a hint of shrewd stage management."

Among artists, Tanner's unique qualities were widely recognized. He was elected an associate member of the National Academy of Design in 1909. Elected along with him was Mary Cassatt, whose paintings of mothers and children reflected the concepts of the Impressionists. Interestingly, she, like Tanner, had been born in Allegheny in the mid-nineteeth century.

Tanner's paintings are saturated with an emotional understanding of biblical themes. One senses, even without knowing the biblical stories, that these are not superficial dramatizations but paintings that deal with some mystical inner search for the meaning of life.

It is noteworthy that nothing harsh or cruel, such as the Crucifixion, ever appeared in his work. Above all, Tanner's painting expressed his need to make his own humanity count for all humankind. In a certain sense Tanner's work expressed a romanticism with

Two Disciples at the Tomb (1906), with the disciples' faces dramatically lit, became Tanner's best-known religious painting in the United States. Competing against 350 other works, it won the Harris Prize at the Art Institute of Chicago. (51 x 41⅝") Art Institute of Chicago

Disciples on the Sea of Galilee (ca. 1910) has a feeling of action, even adventure, that is unusual in Tanner's work. It was given to the Toledo Museum of Art by Frank Gunsaulus, whose knowledge of Tanner may have prompted him to support Archibald J. Motley, Jr.'s first year of studies. (21⅝ x 26½") Toledo Museum of Art, Toledo, Ohio

Angels Appearing Before the Shepherds (1910) demonstrates the effect Tanner sought in using transparent glazes over a ground color. His glazing experiments sometimes failed to achieve the chemical bonding of different paints, fading or darkening with age and producing strange shapes. (24⅝ x 31⅞″) National Museum of American Art

which the life of the time seemed imbued. This essential romanticism was even being expressed in politics, in books like *The Promise of American Life* by Herbert Croly and *A Preface to Politics* by Walter Lippmann. To many people, the world seemed on the verge of a unifying belief in its brotherhood.

Yet, primarily because he was black, Tanner was constantly beset by people who felt they knew better than he did what he should paint. He was told that he should paint American scenes, or that he should paint black people and establish a racial school of art, or that he should become a Post-Impressionist, like Paul Gauguin or Paul Cézanne, who were the newest excitement in the art world. One cannot imagine Whistler or Sargent experiencing the kind of pressures Tanner was confronted with—and was expected to be pleasant about.

As Tanner became more successful, the pressures

increased. For example, Booker T. Washington, who had been greatly moved by *The Banjo Lesson* and knew Tanner and Tanner's father well, came to see him. He may have hoped to persuade Tanner to create, in the style of *The Banjo Lesson,* more paintings that would convey the inner dignity and character of black people to offset the caricatures of A. B. Frost, Edward W. Kemble, and others.

However, Tanner quickly convinced Washington that as an artist he must follow his own inner feelings and vision. Later, when Tanner's attitude was misinterpreted by some as a rejection of his black heritage, Washington wrote: "Tanner is proud of his race. He feels deeply as a representative of his people he is on trial to establish their right to be taken seriously in the world of art."[90]

Some publications completely omitted mention of Tanner because he was black. Others emphasized his

race, making that fact, rather than his achievements as an artist, the reason for attention. And with all of this, despite prizes in Paris and in America, Tanner still could not enter most restaurants in New York with any certainty that he would be served. In this situation, Tanner saw the world, in a symbolic sense, as continuing to confront the basic theme of the New Testament—God's love for each person and the opportunity for salvation.

Tanner came to consider his basic subject to be the fate of humanity. Many of his figures appear sustained by a subtly expressed faith and hope, achieved by his use of color, while they are engaged in a mysterious and lonely search in a barren world. In other paintings Tanner adopted a scale in which human figures are very small, much as in Asian landscapes, and the landscape—literally the total environment of the subject—becomes the dominant element in the picture, both in terms of color and emotionally. In his moonlit scenes with vast canyons and craggy mountain ridges, Tanner symbolized the greatness and power of nature. The human figure appears as only a small, humble part of a grander scene. In some paintings one must look closely to discern any human presence.

Such compositions no doubt derived from Tanner's growing mystical concern with man's relationship with the universe. In expressing this, he increasingly gave more emphasis to color and steadily sacrificed realistic detail, seeking monumental but simple forms and using the dynamics of color to make the painting radiate light. His many small oil sketches, painted very freely, demonstrate this in a masterful way.

Eventually, to meet his needs as a colorist, Tanner abandoned his use of dramatic light. Initially, the sharp contrasts created by this light had prompted him to experiment with glazes to bring color into the shadows and to avoid murkiness. He now turned to glazes to gain an inner luminosity in his canvases. In this method, developed by the Renaissance masters, a basic color is laid down and then a thin, transparent coat of another color is applied over it, then another and another. Tintoretto reportedly used as many as fifty different glazes to gain certain effects.

For example, instead of painting an area green, the artist may apply a basic coat of yellow and then follow it with thin transparent coats of blue, creating a luminous green. It is a slow process, requiring time for glazes to dry. A visitor to Tanner's studio might find nearly twenty canvases in different stages of completion. Tanner became so skillful in employing glazes that unusual luminous greens, blues, purples, and other colors appear harmoniously in his canvases in an almost undefinable manner.

A visit to North Africa in 1910 greatly stimulated his use of more brilliant color. Tanner and his wife traveled on mules to the ancient city of Tetuan in the Moroccan interior and there he did oil sketches of local scenes for later religious works. The clarity of the natural high-key colors in North Africa produced a marked change in his usually dark palette. At the same time his figures were much more freely brushed than before, reflecting the impact of the Impressionists.

Tanner's new approach was not lost on sensitive critics. Harriet Monroe, who would soon start *Poetry* magazine but was then writing art reviews for the *Chicago Tribune,* found that the paintings in his 1911 show were

> infused with this quality of spiritual mystery and poetry . . . [But] more important from the artistic point of view . . . is the beauty of color, the clarity of light and shadow, and the serene and lofty poetic feeling which the best of these pictures attain. These qualities are noticeable especially in *The Holy Family,* an interior remarkable for the grace of its composition and for the soft richness and depth of its shadowy greenish tone crossed by a streak of yellow light, and in that wonderfully transparent blue, moonlight scene called *Morocco,* which showed a group of Oriental figures outside the dim white walls of a town.[91]

The *New York American* critic also analyzed Tanner's glazing effects:

> If you examine his canvases closely, you will find that the blue is threaded through the strokes of purple, gray and pinkish mauve, and more sparingly with pale, creamy yellow. On the other hand, where the "local color" is creamy, it is found to be dragged over with threads of pink, pale mauve and green. It is in this way that Tanner [has] introduced chromatic relations into the dark and light colors of his canvas and so draws them into a unity of vibrating and resonant harmony.[92]

While such comments were satisfying to Tanner, he never knew what the popular taste was. Some painters knew instinctively how to please, he complained in 1909. "Their 'pot-boilers' always sold—mine usually remain on my hands and I was worse off than before."[93]

Tanner steadily went his own way despite the art movements of the day. Although initially interested in the

Impressionists' analysis of color and light on surfaces, he essentially differed from them in his search for luminosity within color. He was not attracted to the violent color and distortions of the Fauves or, later, to the concepts of Cubism. Although, as he often said, he was for revolt within the traditional framework of art, he did not join in the denunciations of the "modernists" that many showered upon them. Kenyon Cox, a leading American painter, denounced Cézanne as "absolutely without talent," Gauguin as "a decorator tainted with insanity," and said of Henri Matisse: "It is not madness that confronts you but leering effrontery."[94] William Merritt Chase, another leading painter, joined in, charging Matisse was "a charlatan and a faker."[95]

What Tanner respected was the indifference of the modernists to popular taste and quick financial rewards. But he never believed the movement would amount to much; it seemed too chaotic. Still, he was willing to exhibit such work. In 1913 he helped arrange the annual show at Trépied which included the paintings of a promising young American modernist, Alfred Maurer. Tanner was president-elect of the Trépied Société Artistique de Picardie that year.

In the summer of 1914 Tanner was delighted that his work was in London's first comprehensive exhibition of American artists. The show included the work of Benjamin West, Gilbert Stuart, John Singleton Copley, Thomas Sully, Thomas Cole, John Singer Sargent, James McNeill Whistler, Winslow Homer, and many other well-known artists.

However, Tanner's pleasure was dimmed by a series of notes from Philadelphia reporting his mother's decline and death following a stroke. From the start she had been his great supporter. When his first efforts failed, she reminded him he always had "a home to come to." Proud of his success, she felt that he had justified her faith. Tanner's decision to be an artist had isolated him from others within the family to some extent. His mother's death was a saddening loss of what had always been a reassuring relationship to him.

Then, in August 1914, came the outbreak of World War I. Because he had never been interested in political or international affairs, Tanner was absolutely astonished by this development. Most Americans in Trépied immediately headed home. Presiding over the annual exhibition of the Société Artistique de Picardie, Tanner was dismayed because everyone talked only about the war, not about the paintings. He did not begin to grasp what the war meant until a few days later when the exhibition hall was commandeered for refugees. Soon after that, as cannons boomed in the distance, the Tanners fled across the channel to England.

Crossing the channel, the Tanners were shocked by the sight of a badly wounded British aviator on the boat. In England they found wounded soldiers everywhere and the sight overwhelmed Tanner. When they settled in Rye, outside London, he tried to paint but found he could not. At first he blamed his general dislocation, but that rationalization soon collapsed. Obsessed with the terrible destruction of war, he was paralyzed with despair over the killing of the young men of Britain, France, and Germany. He poured out his despair in long, often unfinished and unmailed, letters to his friend Atherton Curtis. Seeing Canadian and other volunteers going to the front made him feel so guilty that he felt he had no right to paint.

"One reads the papers all day—but only once in a while, thank God, does one realize the suffering and despair that is contained [in] a sentence like 40 killed, 400 killed, 400 missing, 40,000 losses," Tanner wrote in one unfinished letter. "How many loving, carefully raised sons in that number, how many fathers, how many lonely wives, mothers, children, sweethearts, waiting for the return that never comes."[96]

When the Germans retreated, the Tanners returned to Trépied. They found their home intact, but friends' studios had been stripped, the garden and countryside devastated. Savagery had replaced civilization, it seemed to Tanner.

The destructiveness of war and its endless toll of lives so depressed Tanner that he could not work. His basic religious themes of faith and hope had become meaningless amid the carnage. Feelings of hopelessness, which he tried to conceal by not sending the letters that expressed them, undermined his belief in the essential goodness of man, as expressed in his work. Tanner perceptively sensed in war's destructiveness the loss of the social framework on which his painting depended. That both sides were Christian and claimed God to be on their side was devastating.

Writing to Curtis, Tanner poured out his anguish, his feeling of being utterly worthless, of having achieved nothing. He saw his paintings as failures. Curtis sought to get Tanner to take a less distorted view of himself, reminding him of the struggles of other artists. When John Milton sold *Paradise Lost* for five pounds, Curtis wrote, "he cannot have thought his years of work were very well paid. But *Paradise Lost* was no less one of the great masterpieces of world literature."[97]

As Tanner's depressions continued, Curtis reminded him, "You are living in times that are not conducive to artistic production. Do what one will, one cannot get rid of the awful war. You have been trying in these two years of awful anxiety and awful world suffering to produce a work of art. . . . You will

have to encourage yourself by thinking of the beautiful things done in the past by you and start again for the future." Curtis also recognized the special anguish that Tanner experienced every time he had to go to America—which his gallery connections required. "I am sorry for your having to go to America again next winter. It is very unpleasant, I know," Curtis wrote.[98]

Despite Curtis's sympathy and encouragement, Tanner could not paint. He gave up the trip to America. To try to lift his spirits, he and Jessie went to Vittel, a health resort in northeastern France. There Tanner began to seek some way to help in the war effort, convinced that only that kind of activity could lift his depressed feeling of uselessness. After the United States entered the war and began drafting young black men, his search became a desperate emotional necessity. After reading the July 1918 editorial in *The Crisis* by his friend W. E. B. Du Bois—"Let us, while this war lasts, forget our special grievances and close our ranks, shoulder to shoulder, with our own white fellow citizens and the allied nations that are fighting for democracy"—Tanner felt he must do something to help win the war.

In the hospital in Vittel, Tanner saw many despondent soldiers who were recovering from amputations and internal wounds. He had learned from his own youthful illness that planting and cultivating were therapeutic. He had the idea of converting nearby fields into vegetable gardens, which could be tended by convalescent soldiers as a form of therapy—and would even improve their diet. Winning the support of the United States ambassadors to England and France, Tanner was commissioned a lieutenant in the Farm Service Bureau of the American Red Cross and authorized to develop his program.[99]

His plan succeeded. Gardens in Vittel and at other nearby hospitals eventually raised tons of potatoes, other vegetables, hay, and livestock. They also achieved marked psychological improvement among many despondent soldiers.[100] As his plan succeeded, Tanner felt his own depression disappear. He even thought he could paint again.

Yet he knew he could not return immediately to religious painting. The feelings out of which he had created his religious work were buried in the savagery of the war. In August 1918 he began painting scenes of soldiers at the busy Red Cross canteens in Toul and Neufchâteau in northeastern France. However, his soldiers appear stiff and lacking in character. In view of the depth of feeling in his best work, these paintings, the first efforts after nearly four years of depression, are shockingly superficial. They bear witness to the destructive impact of the war on Tanner—a destruc-tiveness all the more forceful because of his renewed encounter with American racial prejudice.

Like most African-Americans at the time, Tanner believed that vigorous participation in the "war to end all wars" would ensure black Americans of their full rights as citizens. However, while mingling with his fellow Red Cross officers, he became aware that some army officers viewed black soldiers as capable only of labor or serving as cannon fodder. At the same time he was aware that some black regiments that had been transferred to French commands had proved heroic in battle.[101]

In Neufchâteau, in 1918, one of his diarylike jottings concerned a dinner at which a Captain R. inspired the group with an account of a heroic regiment. "But we will have to kill several of those niggers down home before we will be able to get them back in their place," he added—Tanner's first indication that the regiment was black. A Mississippian, Captain R. had been quite friendly with Tanner, and they had seen "I-to-I," to use Tanner's shorthand, on many subjects. As the captain, who liked to talk about religion, continued his tirade against African-Americans, no one challenged him. They "forgot to apply any of Christ's spirit upon a subject in which their own prejudices and weaknesses were concerned."[102]

Captain R. had to leave the dinner early, and as he passed down the narrow aisle, he put his hand on the shoulders of men letting him through. "When he arrived at me," Tanner wrote, "he put his big hand upon my head in the position of a blessing—somehow I felt I had God's blessing as far as mortal erring man could give it. He was, I know, as blind as when Isaac blessed Esau. It would seem that men have to give God Bless signs when they should prefer not to—but as in Biblical times a blessing once given could not easily be changed."[103]

In interactions like this one Tanner experienced a continuation of the racial prejudice that had driven him from America. He tried to be objective, writing of it with irony and pity. Yet when he attempted to paint American soldiers, his feelings were more directly involved and his need for control was so great that these paintings lack the humanity of his religious works.

Discharged in 1919, Tanner returned to Trépied exhausted. His home and studio needed repairs, but most of all, Tanner himself needed time to sort out his feelings and reorient himself in the strange new world that followed World War I. The old art standards and values had vanished. The Salon was sneered at by young artists. Interest—indeed, excitement—now focused on

Henry Ossawa Tanner as he appeared in the 1920s.

the modern artists, on Georges Braque, Pablo Picasso, André Derain, Henri Matisse, Joan Miró, Marcel Duchamp, Wassily Kandinsky, and the Cubist, Dada, and Surrealist movements. The Impressionists, who had been avant-garde when Tanner was developing, were now cast aside as old-fashioned. A pervasive sense of disenchantment and disbelief in old values prevailed. Women threw away their corsets, bobbed their hair, and smoked in public. The revelations that secret treaties for markets and resources in Africa, Asia, and the Middle East, rather than a belief in democracy, had been the primary motives in bringing nations into the war alienated millions. The whole fabric of prewar values had been torn asunder.

Faith had become a joke, and religious painting based on affirmative belief now appeared pathetically unreal. Always dismayed by superficiality in religious painting, Tanner could hardly believe that Paris galleries were exhibiting work in which angels with tricolored wings were carrying the dead from the Battle of the Marne to God. Yet Tanner clung to his belief in faith and salvation. Aesthetically, he was more alone than ever.

Paradoxically, in America, the land of the new, there was little interest in the modern art movements except among a few artists. Tanner's reputation and sales in America grew steadily, making him feel all was

not lost. He began to paint again, developing a new version of his first prize-winner, *Daniel in the Lions' Den*—a kind of starting over that helped restore his own faith. In a California exhibition that included work by Childe Hassam, William Merritt Chase, and Robert Henri, his new *Daniel* won honors and was purchased before the show opened.[104]

Tanner, gaining confidence, painted new versions of *Flight into Egypt*. Optimistic, he and Jessie built a new home and studio in Trépied, and he prepared for a large New York show in January 1924. On the eve of his sailing, the French government appointed him a chevalier of the Legion of Honor in recognition of his contributions to France. Tanner, so long alienated from his native land, felt it was his greatest honor.

In New York his paintings sold well and old friends, like Du Bois, visited him. In Philadelphia he was saddened only by the fact that his father had died. About this time the African Methodist Episcopal church commissioned Tanner, who had sculptural talent, to create a bas-relief plaque to commemorate its founding. Tanner designed the plaque as a decorative lintel over a double door with a depiction of the Reverend Richard Allen and his wife in the blacksmith shop that became the first AME church, now the Mother Bethel Church in Philadelphia. It was to be cast in bronze in multiples so that branch churches throughout the nation might also have it. Although Tanner modeled the plaque, for reasons that are now obscure the casting was never carried out.[105] The original still rests in the basement of Mother Bethel.

To increase his contact with young black people and their teachers, Tanner visited black schools and colleges, including Howard and the Cheyney Training School for Teachers (now Cheyney University of Pennsylvania) near Philadelphia, which commissioned a new version of *Nicodemus Visiting Jesus*. His recognition as the nation's outstanding religious painter brought him a commission to paint a portrait of Rabbi Stephen Wise, then one of the great religious leaders of America.[106] Earlier, using photographs, he had created a posthumous portrait of Booker T. Washington, whom he had known well and who had died in 1915.[107]

Yet Tanner was still not represented in the Metropolitan Museum of Art. Rankled by this omission, artist and critic Harrison Morris pointed out to the museum's trustees that the French government had purchased Tanner's work and awarded him the Legion of Honor. "Ought we over here in his home be less sensible to his merit?" asked Morris.[108] Confronted, the Metropolitan's curators agreed that a Tanner should be in its collection. Curtis promptly gave the museum *Sodom and Gomorrah*. This vertical painting, one of sev-

The Destruction of Sodom and Gomorrah (1928). This subject fascinated Tanner, who painted several versions of it with different titles. A vertical painting, given to the Metropolitan Museum in New York in 1926, was later sold and cannot now be located. The figures of Lot and his family were prominent in the foreground. In the version above, turbulent clouds of smoke, painted in a very free manner, express the Lord's wrathful raining of fire and brimstone on the wicked city. In contrast to the vertical painting, the fleeing figures of Lot and his family are tiny. In all versions Lot's wife, who looked back despite warnings, appears as a white pillar of salt. (20⅜ x 36″) High Museum of Art, Atlanta

eral versions, was outstanding for its color. Its presence in the museum stimulated many young black artists for the next thirty years.

Tanner's wife had been seriously ill with cancer since late 1924, and when she died on September 8, 1925, Tanner was devastated. Jessie's love had been an important support for him, and her passing left him deeply depressed, unable to interest himself in anything except his son, Jesse. When the Cheyney Training School asked whether its commissioned *Nicodemus Visiting Jesus* would be completed that year, Tanner was unable to answer. He ignored his inclusion in a Paris show of American artists, many of whom, like Walter Gay, were old friends. Only his son's completion of engineering studies at the London School of Mines aroused him, and he and Jesse went to the Riviera for the Christmas holidays. Before he went, he sent a contribution to James Weldon Johnson to help set up the Legal Defense Fund for the National Association for the Advancement of Colored People.

After a summer at Trépied, Tanner began to paint again, to travel to exhibitions, and to meet new people, among them Countee Cullen, whose poetry impressed him with its imagery drawn from African-American experiences. By January 1927 he had prepared a large exhibition for the Grand Central Art Galleries in New York. In February one of these paintings won the National Arts Club bronze medal and a $250 prize. A few

months later he was elected a full member of the National Academy of Design; his teacher Eakins had been elected only a few years earlier.[109] That spring Tanner completed *Nicodemus Visiting Jesus* for the Cheyney Training School.

In Chicago, the prestigious department store Carson Pirie Scott began to sell his work. Erwin S. Barrie, his dealer and director of the Grand Central Art Galleries, said later that anything Tanner painted could be sold in the 1920s, referring to him as "an ace."[110] His success revealed the strength of a deep religious strain in American life—a strain that stands in contrast to the abandonment of old values reflected in the flapper cartoons of John Held, Jr., bootleg booze, short skirts, H. L. Mencken's blasts at the "booboisie" and southern attitudes of superiority, Sinclair Lewis's satirical novel *Main Street,* and the recognition of jazz as serious music.

The war, the chaos of the art world, the deaths of his mother, father, and wife, all caused Tanner, in his despair, to depend on his religious faith with a profound inner desperation. He felt himself tried as the early biblical disciples had been tried. In his loneliness, his paintings became more mystical. Through prayers, always part of his daily life, he tried to "let God guide" him, consciously seeking what his son later called "a sort of mystical fourth dimension."[111]

It was at this time that Tanner came under subtle attack. Living in Paris, he was inevitably isolated from the life of African-Americans—and when he was plagued by visiting tourists in Paris, he fled to Trépied. Yet he was very much aware of the emergence of black talent in all fields, as expressed in the March 1925 issue of *Survey Graphic,* which hailed the arrival of "the New Negro."

To his surprise, Tanner found himself both hailed and criticized in that issue, which was edited by Alain Locke, whom he knew. In an essay entitled "The Legacy of the Ancestral Arts," Locke called for black artists to develop a racial art in the spirit of African art, claiming:

> There have been notably successful Negro artists, but no development of a school of Negro art. One American painter of outstanding success is Henry O. Tanner. His career is a case in point.
>
> Though a professed painter of types, he has devoted his art talent mainly to the portrayal of Jewish Biblical types and subjects, and has never maturely touched the portrayal of the Negro subject. Warrantable enough—for to the individual talent in art one must never dictate—who can be certain what field the next Negro artist of note will command, or whether he will not be a landscapist or a master of still life or of purely decorative painting. But from the point of view of our artistic talent in bulk—it is a different matter. We ought and must have a school of Negro art, a local and racially representative tradition. And that we have not, explains why the generation of Negro artists succeeding Mr. Tanner had only the inspiration of his greatness to fire their ambitions, but not the guidance of a distinctive tradition to focus and direct their talent. Consequently, they fumbled and fell short of his international stride and reach.[112]

This essay rephrased Locke's demand that the black artist devote himself to racial themes. Despite his explicit praise of Tanner, Locke showed no cogent understanding of what Tanner had actually done or its relationship to black American experience. His essay also was confused in its remarks on Matisse, Picasso, and other modern artists who had studied African sculpture because they were fascinated by the possibilities of utilizing its design concepts, not because it was the work of black artists. At the time most American artists, including African-Americans, were baffled by the work of Picasso and Matisse.

As a result of Locke's article, Tanner was asked again and again by American visitors, black and white, why he was not painting African-American subjects. Small wonder that he felt many of his visitors "had little interest in or knowledge of what I was doing."[113]

Tanner knew that he represented something extraordinary to the young African-American artists who were emerging in many cities. In Washington they had organized themselves as The Tanner League and exhibited in Paul Lawrence Dunbar High School in 1922. The year before, Tanner had sent his *Christ Washing His Disciples' Feet* to an exhibition of the work of African-American artists in the Harlem Library as a way of encouraging them and expressing solidarity with them. Du Bois, who wrote frequently about art in *The Crisis,* characterized Tanner as the "dean" of America's black artists and published young artists' work on the magazine's cover.

Although he shut out tourists, Tanner kept his door open to black artists, who came as though on a pilgrimage.[114] One of the first was William Edouard Scott, who had been born in Indianapolis in 1884, studied at the Art Institute of Chicago, and became a portraitist and muralist. Scott studied with Tanner and thereafter always mentioned it in catalogs. Later known for his paintings of Haitian peasants, Scott won the

1927 Harmon gold medal.[115] Palmer Hayden, who won the first Harmon gold medal, also received helpful advice from Tanner, as did Laura Wheeler Waring of Philadelphia (who taught at the Cheyney Training School), W. H. Johnson, James A. Porter, Elizabeth Prophet, and Aaron Douglas.

Another visitor was Hale A. Woodruff, who became a well-known muralist and teacher at New York University. Many years later he recalled his discussion with Tanner of painting, old masters, and the modernists' revolt. "If a painter has something sound to offer, one can be a radical innovator and still remain in the tradition," Tanner told him, adding the qualifier: "Mind you, I did not say 'Academy.' " Tanner particularly praised Rembrandt and the Dutch painters for being "down to—and close to—the earth." Rembrandt had, in his opinion, not only dramatized religious subjects, but made them "eternally moving. . . . One must recognize that the Dutch had a sense of order, structure, and organization in which they believed their art should operate, but they brought to this also the important elements of humanity and feeling."[116]

Tanner told Woodruff that Claude Monet risked "losing a sense of form and structure" in his effort to achieve "atmospheric light." As for his own use of light, he said, "Light can be many things—light for illuminating an object or creating a mood; for purposes of dramatization as in a theatrical production. For myself, I see light chiefly as a means of achieving a luminosity, a luminosity not consisting of various light colors but luminosity within a limited color range—say, a blue or blue-green. There should be a glow which indeed consumes the theme or subject—a light glow which rises and falls in intensity as it moves through the painting."

Inquiring about young African-American artists, Tanner pointed out that he had left the United States "because of the unbearable racial practices." He asked if anything had changed, but he did not pursue this subject, for he was still unable to discuss racial prejudice without becoming emotional. This conversation, the only one of many between Tanner and young black artists to be reported at length, and his sending his painting to a Harlem exhibition contradict the slander that Tanner wanted nothing to do with black artists.

Preoccupied with his son's poor health and nervous exhaustion, Tanner was not alarmed by the New York stock market crash. Only when the Carson Pirie Scott store in Chicago cut the price of one of his paintings from $1,500 to $450 did Tanner grasp what was happening. His sales stopped. The American Art Association clubhouse in Paris, his second home for thirty years, had to close. Dollars dwindled in value and the franc sank even lower. To aid his son, who wanted to go into business, Tanner decided to sell his home and studio in Trépied. However, no buyers appeared and the people to whom he rented it were soon unable to pay the rent. When Joel E. Spingarn sent a personal appeal for help for the NAACP, Tanner felt compelled to write: ". . . my affairs are such that I cannot send my usual subscription."[117]

In 1934 Tanner was seventy-four years old and tired easily. He gave up painting large pictures in favor of small, intimate sketches on his favorite themes. He sold only a few paintings, mostly to American relatives who wanted to own something he painted. At times he lived in a little cottage across the road from the Curtises at Bourron on the Seine. His loneliness and sadness increased on learning of the deaths of his favorite sister, Mary, and his younger brother, Carlton. It did not seem right to outlive them.

Continuing to exhibit with the American Artists' Professional League in Paris, Tanner was troubled to find one of their luncheon meetings called off by a protest against the Hitler-Mussolini axis. It seemed unbelievable to Tanner that the world was on the verge of another world war.

Tanner understood what many artists did not, that art is an ongoing, ceaseless search, peculiarly timeless and yet time-bound. In his small sketches in his last years he explored all the nuances of his artistic capabilities, even though the language of his art belonged, both technically and in terms of content, to a period long gone. Religious in context, mystic in character, and sensitive in color, his last paintings portray characters searching in a dominating, mysterious, beautiful yet barren landscape. These works present a sealed-off, symbolic world in which simple, almost archaic forms appear in a color-drenched atmosphere of deep ultramarine, cobalt blue, vermilion, and earthy ochre. In his last paintings Tanner's art seems in complete harmony with the artist's inner being, his faith and his hope in humanity.

Tanner died in his sleep in his Paris apartment on rue de Fleurus, on May 25, 1937. He was buried at Sceaux, next to his beloved wife. Amid the turmoil of the Depression and threat of World War II, his work was forgotten. Most young black artists, working with white artists on Works Progress Administration (WPA) art projects, were emotionally involved in an effort to use their art to communicate the realities of social struggle as they saw them. Religious art had no appeal for them, and many had never heard of Tanner.

Writers dealing with the nineteenth century wrote

only of the Impressionists, Paul Cézanne, Cubism, and origins of the "modern movement." Critics were drawn to Georges Rouault as a religious painter. His tormented Christ and his other heavily outlined, impastoed figures expressed the existential alienation of modern man in a highly personalized manner. In America, the focus was on the rise of modern artists after the 1913 Armory show, the "Ashcan School of Eight," and the realism taught by Eakins, from which Tanner had departed.

Tanner's independence of art movements—of everything except his own inner experience as an African-American of the importance of hope, faith, and struggle—tended to isolate him. His work did not fit into theories of art and, in general, was ignored. In his 1943 book, *Modern Negro Art,* James A. Porter described some of Tanner's achievements. However, he did not recognize in Tanner's work any themes that he could identify with black experience in America. Alain Locke, belatedly realizing that Tanner's achievements were being obliterated, organized a small commemorative exhibit at the Philadelphia Alliance in 1945. Although still complaining that Tanner had not founded a "school of racial art," Locke, in his catalog commentary, pointed out that Tanner had "vindicated the Negro as an artist nationally and internationally. . . . For this he has a double claim on our memory."[118]

In 1956 the Metropolitan Museum quietly sold Tanner's *Sodom and Gomorrah* in a New York auction house, which left no major work by Tanner available to the public in the city with the largest black population in the world.[119] He was, at a time when barriers against black Americans were crumbling, a forgotten painter.

In 1967 a large exhibition of the work of African-American artists at the City University of New York attracted approximately 250,000 visitors. It included six large works by Tanner, escalating interest in his work thirty years after his death. That year, Erwin S. Barrie, Tanner's former dealer, obtained from Jesse O. Tanner seventy-five paintings and drawings for an exhibition. Most were small canvases created in Tanner's last years. Many, sold to black colleges before the exhibition, were not shown. Others were not even cleaned and properly framed.

Such inconsiderateness aroused John Canaday, the *New York Times* critic, who pointed out that the majority of the works were "small sketches of a free, personal, direct kind that may represent Henry Tanner at his best."[120] Praising the paintings, he called their inadequate presentation "a poor deal for a good man."

Canaday's review was followed by a large Tanner show by the Frederick Douglass Institute and the National Museum of American Art in Washington in 1969. This show toured major cities, bringing Tanner's work back to life and allowing crowds of people to once again stand before his canvases, all over America.

Nor has interest abated. In 1991 a much larger exhibition was organized by Dewey F. Mosby and Darrel Sewell of the Philadelphia Museum of Art. Its extensive catalog included an intimate essay on the unusual Tanner family by his grandniece Rae Minter-Alexander. This massive exhibition, sponsored by the Ford Motor Company, went to the Detroit Institute of Arts, the High Museum in Atlanta, and in 1992 to the M. H. de Young Museum in San Francisco.

A reexamination of Tanner's work reveals that his religious paintings are not simple illustrations or extensions of his religious upbringing. What sets them above such efforts is their depth of feeling and virtuoso color. Tanner's elimination of detail, the peculiarly static quality of his human figures even when they are supposedly in motion, and his frequent use of nonspecific figures—all contribute to his paintings' profoundly mystical and symbolic character. Some critics have linked him to Albert Pinkham Ryder, another American painter whose works possess a haunting mystic symbolism. One theme stated again and again in Tanner's lonely figures in bleak landscapes involved a mute, searching quality, a seeking of salvation, of justice, of refuge. He constantly emphasized, especially as he grew older, man's essential loneliness. Even when he portrays a group, the individuals are alone, isolated in an elegiac dignity, emerging in a world that gives the illusion of having been seen through eyes half-closed. It is this mystical quality that involves viewers in his efforts to portray the transcendent hope of salvation.

One of Tanner's favorite themes was the Good Shepherd, whose specific face remains mysteriously unseen in the shadows of his burnoose and flowing robes, and whose lambs form a triangular pattern about him. Although the Good Shepherd symbolizes the Christ figure, the shepherd is portrayed in such an original and undefined way that he could be anyone—man, woman, black, white, Arab, Jew, Asian. Only in some Good Shepherd paintings does the human figure dominate the spare, barren landscape that is symbolically the passageway to a better world. This was Tanner's hope for humankind.

In his initial work, when he was still under the influence of Eakins, Tanner held a mirror up to nature, painting in a rather realistic, academic, and sometimes illustrative manner. In this fashion he painted *The*

Thankful Poor, The Banjo Lesson, landscapes, the New Jersey coastal dunes, portraits of family members, and his genre paintings in France.

However, beginning with such works as *Daniel in the Lions' Den* and *The Raising of Lazarus,* he began to draw upon his own personal religious faith and to use light symbolically. In time his intuitive perceptions and understanding of religious feelings going back to his childhood enabled him to tap a steady source of energy within himself. He sought to express his true spirit in radiant light, coming from a mysterious unidentified source outside the painting, glowingly illuminating people as they emerge from a darkness of the spirit. This is the light of humanism found in Caravaggio and Rembrandt—a light that Tanner somehow extends to hope for all people.

Out of his youthful loneliness and a disassociation from much of the world he found around him, Tanner sought to find himself in relation to his beliefs—an effort releasing emotional energies that enabled him to create new ways of using color in a poetic interrelating of space and form. In his work Tanner repeatedly affirmed his religious faith. Even after World War I, when his expression of this faith ran counter to the fashions of the time, he continued to express his deep feelings about the plight of people in this world.

In his attainments, Tanner must be equated with artists who undertook similar lonely, visionary journeys of exploration, among them James Ensor, Odilon Redon, and Ryder. Through a life of courage and devotion, he was able to search within himself and eventually find a rhapsodic, transcendent art that is his artistic redemption.

OTHER SIGNIFICANT EARLY ARTISTS

Eugene Warburg created this portrait of John Young Mason, a Virginia legislator and judge, who later became secretary of the navy, attorney general, and United States minister to France from 1853 to 1859. Born in New Orleans, Warburg studied under Gabriel, a French sculptor. He presumably made this portrait in France while Mason was United States minister there. Warburg had a studio in New Orleans with his brother and won many commissions, particularly for cemetery monuments. In England the Duchess of Sutherland commissioned him to make bas-relief scenes from *Uncle Tom's Cabin.* Warburg died in Rome in 1861. (See James A. Porter, *Ten Afro-American Artists of the Nineteenth Century* [Washington, D.C.: Howard University, 1967].) (Marble, 22½″ h.) Virginia Historical Society, Richmond

John G. Chaplin, who reportedly studied in Düsseldorf, painted this portrait of the English poet laureate Robert Southey from an engraving. Although he was painting as early as 1856, his main income came from barbering in Huntingdon, Pennsylvania. Nancy S. Shedd of the Huntingdon County Historical Society has identified a number of his works, including pictures for the Altoona Opera House and portraits of Toussaint L'Ouverture and many Huntingdon citizens, among them J. M. Zuck, first president of Juniata College. Press reports indicate that Chaplin exhibited at the World's Columbian Exposition in Chicago in 1893 and the Louisiana Purchase Exposition in St. Louis in 1904. Born of free parents in Huntingdon on November 30, 1828, he first trained under Robert Douglass, Jr., an early African-American artist in Philadelphia, whose work has not survived. Chaplin died in Youngstown, Ohio, on January 5, 1907.

Charles Porter painted *Still Life with Flowers* in Paris in the 1880s. Born in Hartford, Connecticut, about 1850, he was known early for his talent but discrimination barred his path. By working at various jobs and giving drawing lessons, he was able to support himself for four terms at the National Academy of Design in New York and for a year with J. O. Eaton, a well-known Academy portraitist (though he never took up portraiture). Around 1878 he raised $1,000 by auctioning off his work, which enabled him to go to Paris. Correspondence indicates that Mark Twain made it possible for Porter to continue his studies there. Returning about 1884, Porter settled in Rockville, Connecticut, where he continued to create attractive, delicate still lifes of fruit, flowers, and vegetables, and landscapes. *Art and Artists in Connecticut,* published by H. W. French in 1879, praised him highly, and many of his works are owned by Hartford families. He died about 1923. In 1988 Helen Fusscas published *Charles Ethan Porter* (Marlborough: Connecticut Gallery), a book that may help rescue him from obscurity, for he is not listed in standard reference works. (14 x 18″) Wadsworth Atheneum, Hartford

Annie E. Walker, born in Alabama, drew *La Parisienne* in the late 1890s. Cooper Union confirmed that she graduated from its art school on May 29, 1895 (letter to authors, March 20, 1975). She later studied at the Académie Julien in Paris and exhibited in the 1896 Paris Salon. Whether Walker had contact with Henry Ossawa Tanner is not known. (See Porter, *Ten Afro-American Artists of the Nineteenth Century*.) (Charcoal, 36 x 22") Howard University Gallery of Art

Moses Williams, a slave owned by Charles Willson Peale, a leading artist of the Revolutionary era, cut these silhouettes with a physiognotrace at the Peale Museum in Philadelphia when Peale insisted that he find some way to earn a living so he could be freed. By 1803 he had become so skillful that people preferred his silhouettes. He earned enough money—at eight cents a silhouette—to buy a house and marry the Peales' white cook, who initially would not sit at the table with him. (See Charles C. Sellers, *Charles Willson Peale*, pt. 2, *Later Life* [Philadelphia: American Philosophical Society, 1947], p. 159.)

Spirited and talented, Augusta Savage emerged in the 1920s after studies at Cooper Union. When she won an opportunity to study abroad but then was denied it because of her race, she began a fight against discrimination that made her a leader among African-American artists. She delighted in portraying children, as this photograph of her modeling a garden figure of a faun in clay demonstrates. An outstanding teacher, she attracted black artistic talent and headed the Harlem Community Art Center, the largest WPA art project in the country. Photo: Hansel Meithe, *Life,* copyright Time, Inc.

THE TWENTIES AND THE BLACK
RENAISSANCE

World War I made it clear that the United States had emerged as a world power. Yet, except for overly idealized "patriotic" versions, American history was neither widely known nor understood. In fact, many European-oriented academicians still argued that America had no history—paralleling what they said about Africans. The idea that there was an American literature, music, theater, or art was not widely recognized either in this country or abroad.

This historical situation opened the way for development of an American cultural identity that was not dominated by European concepts. As a writer in *The Freeman,* one of the leading intellectual magazines of the day, put it: "The great hope of culture in America lies in the fact that we in this country have not yet agreed upon a definition of 'American culture.' The greatness of our opportunity consists in the very fact that thus far we have set up no definite boundaries of nationality where culture is concerned."[1]

From the perspective of today, it would seem that African-Americans recognized this situation as their opportunity to participate in the evolving American culture and way of life. In contrast to the many young writers and artists who felt disillusioned and alienated by World War I and who went to Paris in search of an acceptable identity as Americans, most black people had a proud sense of being Americans. And they strongly felt it was time to shuck off the stereotyped limitations imposed on them historically, including the old denial of their artistic ability. The emergence of a number of young black artists reflected this profound change among African-Americans. They knew that spirituals had won worldwide respect, and they saw that jazz had America up and dancing. They believed, as one analyst of the period, Nathan Irvin Huggins, has put it, that they "were on the threshold of a new day."[2]

Three major factors had given rise to this new attitude among African-Americans. First, some 200,000

black men had served in the savagery of World War I, and the black 369th Infantry from New York, alone among United States troops, had been decorated en masse by the French government with the Croix de Guerre for its heroism. The old ways were gone forever for these men, their families, their friends, black leaders, and intellectuals.

Second, millions of poor black people had silently, both individually and in family groups, left the South in a determined effort to improve their lot in northern cities. In 1910 eight of ten black Americans had resided in the eleven former Confederate states, with 90 percent living in rural areas with almost no schools. Jobs in northern factories, mills, and mines during World War I started this great migration, but it continued between 1920 and 1925, when some two million African-Americans left the South. The black population of Chicago rose from 44,102 persons in 1910 to 233,903 by 1930. New York, with 91,709 black persons in 1910, had 327,706 by 1930. Harlemites proudly called it "the black capital of the world."[3]

This major change in their economic and cultural circumstances, from rural to urban, contributed to African-Americans' general feeling that, despite difficulties, they were not helpless, that they were moving ahead. The mass migration helped provide a psychological basis for the optimistic feeling of "renaissance," the rebirth of black people as effective participants in American life. Leaving the South prompted individual and collective examinations by African-Americans of who they were, of their own thoughts and feelings, as well as their rights as Americans and the complexity of their abilities and aspirations.

Without this migration, the development of a significant group of African-American artists in the 1920s could not have occurred. In earlier periods, there had been only a few, isolated black artists. As long as the overwhelming majority of African-Americans lived in the impoverished rural South, there could not be a substantial number of black artists. Most of

the African-American artists who developed in the 1920s—Palmer Hayden, Malvin Gray Johnson, Richmond Barthé, James Lesesne Wells, Ellis Wilson, and Augusta Savage, to mention a few—were born in small southern towns.

Pride in African-American soldiers, whose front-line courage had been expected to end the denial of full citizenship rights for all black people, and the mass migration, in which nearly every African-American family participated in some way, contributed to the third factor—the great outpouring of creative energy by many talented African-Americans in all the arts, most noticeably in music and the theater. While it may be seen as an aspect of the fundamental change in African-Americans' attitudes toward themselves and their participation in American life, this creative activity had a synergistic effect, particularly on the demand for better conditions, education, and the encouragement of talented individuals. Even a poor, uneducated migrant could see that some African-Americans were now musical and theatrical "stars." To African-Americans as a group, this development meant great heights could be scaled. Intellectuals optimistically believed that discrimination and prejudice could be ended by demonstrating that African-Americans were capable doctors, judges, lawyers, writers, and artists. Their work, creating a bridge across ignorance and prejudice, was expected to win respect and full rights for black people.

Although this creative period has been generally called the "Harlem Renaissance," the term is a misnomer. Harlem's creativity was simply the most publicized and most diverse. The same kind of activity went on in Philadelphia, Chicago, Boston, Baltimore, and San Francisco, where the sculpture of Sargent Johnson was winning prizes. These efforts made many influential Americans aware of African-American poets, writers, musicians, artists, and theatrical stars. It was something new and disturbing to old ideas about the role of African-Americans in American life.

Although northern cities gave these aspiring artists some opportunities to see works of art, to visit museums and libraries, prejudice still kept them from receiving technical training at many art schools. The Art Students League, the National Academy of Design, and Cooper Union in New York and the Art Institute of Chicago were among the few schools that accepted black students. African-Americans were made to feel unwelcome at many art galleries and some libraries.

However, the artists' first concern was survival, not art. Hard work, long hours, and poor pay left little time for museums. W. H. Johnson labored as a longshoreman on the docks; Augusta Savage was a laundress. Cloyd L. Boykin worked as a janitor, and Palmer C. Hayden did odd jobs and cleaned apartments. All were constantly advised by people of both races to give up their hopes of becoming artists. Many were forced to do so. Carleton Thorpe, for example, exhibited paintings in a 1921 Harlem library show but was told he had no chance of becoming an artist because he was black. He took a darkroom job with Peter A. Juley, a specialist in photographing art, and gave up painting.[4]

A handful of older black artists encouraged and sometimes taught younger ones. Among them were William E. Braxton, a skilled and much-published Chicago illustrator; William McKnight Farrow, originally from Ohio, who acquired his own training while a curator's assistant at the Art Institute of Chicago, became an expert etcher, and taught etching there;[5] William Edouard Scott, who had studied with Henry Ossawa Tanner in France and become an illustrator and muralist; Laura Wheeler Waring, originally from Hartford, Connecticut, who trained at the Pennsylvania Academy of Fine Arts, studied in Rome and in Paris with Auguste Rodin, and taught at the Cheyney Training School for Teachers near Philadelphia. Having achieved some recognition, these older artists were admired by younger ones and served as their guides.

African-American identity was enhanced by the recognition that jazz was changing the nation's music—was indeed becoming its music. This was something very different from the sympathetic appreciation of religious spirituals. The rhythms of jazz set people to dancing; "we're living," people said, "in the Jazz Age." A new, fascinated awareness of black people, their spirit, and their capacity to live spread across America.

This helped to stimulate interest in the visual arts created by black artists. Between August 1 and September 30, 1921, the first large exhibition of work by African-American artists was displayed in the Harlem branch of the New York Public Library.[6] Nearly 200 paintings and sculptures, including some from Boston and Washington, D.C., had been assembled by an enthusiastic Harvard graduate, Augustus Granville Dill, whose Harlem bookstore became a mecca for young black writers. Tanner sent a painting to encourage younger artists. Five engravings by Patrick Reason, a lithographer during the 1830s, gave many New Yorkers their first inkling that there had been black artists in America long before the Civil War.

Other exhibits followed, such as the 1921 Tanner Art League show at the Dunbar High School in Washington, D.C., and the 1922 Wabash YMCA show in Chicago, which included the work of Farrow, Charles

C. Dawson, Arthur Wilson, and Ellis Wilson, who later made Haitian landscapes and people his central themes. In 1927 a major show was held at the Art Institute of Chicago under the sponsorship of the Chicago Women's Club. Called "The Negro in Art Week," it included African art as well as that of contemporary Chicago artists, work by Tanner, Edward M. Bannister, and Edmonia Lewis.[7] At this show Richmond Barthé was so successful with his clay portraits that he turned from painting to sculpture. Other exhibitors included Farrow, Scott, William A. Harper, Arthur Diggs, Aaron Douglas, John Hardrick, Hale A. Woodruff, Edwin A. Harleston, Leslie Rogers (the *Chicago Defender* cartoonist), and photographer King Ganaway. An unusual aspect of this show was its wide community sponsorship. In addition to the Chicago Women's Club, it was supported by other women's groups of both races, religious groups, the National Association for the Advancement of Colored People, and the Urban League. Among its patrons were nationally known Chicagoans, including attorney Clarence Darrow, sculptor Lorado Taft, attorney Harold Ickes, poet Carl Sandburg, and social worker Jane Addams. This sponsorship guaranteed wide publicity.

Long before this, W. E. B. Du Bois, who had known Tanner in Philadelphia, had begun publishing African-American artists' work on the cover of the NAACP magazine, *The Crisis.* The weekly *New York Age* and the Urban League's publication, *Opportunity,* also reproduced their work. Citing the example of Tanner, Du Bois particularly championed the development of artists.

Until these publications and exhibits appeared, few Americans had any idea that black artists existed. For the African-American artists, the exhibitions provided direct encouragement, and they demonstrated another aspect of the renaissance to African-Americans in general.

In New York the exciting spirit of self-discovery in this period was heightened by the concentration of the African-American community. It then occupied a narrow section of Manhattan, less than a fourth of Harlem today. This narrow strip above 125th Street—then a Jim Crow street, where many restaurants barred black people—provided a physical intimacy and identification with people and events. A newcomer from Georgia or the Carolinas might find himself walking side by side with the dignified Du Bois, the vivacious Florence Mills, or Noble Sissle and Eubie Blake, whose all-black musical *Shuffle Along* was making Broadway history. At the 135th Street branch of the public library one might find a display of paintings by black artists or see Arthur A. Schomburg arranging a display of African masks. Or one might glimpse James Weldon Johnson, the NAACP leader who had dramatized the need for a federal antilynching law, talking with Godfrey Nurse, one of the city's leading African-American physicians.

On most evenings the newcomer could hear street speakers, including Marcus Garvey calling for self-help and militant self-assertion in establishing an African nation. At the Gray Shop, Wallace Thurman, a novelist and managing editor of the labor-oriented *Messenger,* ran an almost continuous forum for writers and artists. Outside the Lafayette Theater, one might see famous performers like Bill "Bojangles" Robinson.

On 138th and 139th streets, between Seventh and Eighth avenues, many black professionals lived in handsome homes, some of which were designed by Stanford White. Off Lenox, in a block-size lot, Colonel Hubert Fauntleroy Julian was preparing a plane for a transatlantic flight; when he tested the engine, all Harlem heard it. On 137th Street one could dance at the Renaissance Casino and sometimes see the "Renaissance Five," whose ball handling dazzled the leading basketball teams of the era.

To many Harlemites, the renaissance meant the rebirth of a great black culture that had once created golden kingdoms in Africa. And just about everybody was participating in it. There were frequent parades by fraternal groups, such as Masons, Elks, Odd Fellows, and Moose, as well as religious and political organizations, with their members resplendent in uniforms, swinging down Seventh Avenue behind marching bands. In the evening thousands enlivened their social life by strolling along Harlem's main streets. "This is not simply going out for a walk," wrote James Weldon Johnson, "it is more like going out for an adventure."[8]

Artists like W. H. Johnson and Augusta Savage, who came from small southern towns, were greatly nourished and stimulated by what they found in Harlem—by a new sense of black identity and importance, of community, of power and talent. When she had tried to get portrait commissions among middle-class black people in Florida, Savage had been turned down. But in New York she did busts of both Du Bois and Garvey, the outstanding black leaders of the day, with critically divergent views, enormously different backgrounds, and sharply contrasting personalities. Each offered ideas and programs that appealed to tens of thousands, providing a cultural richness in their bitter rivalry unknown to African-American artists only a few years earlier. That both men considered artists important and arranged time to sit for an unknown young black woman artist gave all of Harlem's black artists a sense of pride and of their importance in the devel-

H. L. Mencken, the leading social and literary commentator of the 1920s, was one of many prominent Americans portrayed by O. Richard Reid. Born in Georgia in 1898, Reid studied at the Pennsylvania Academy of Fine Arts in Philadelphia and became noted as a portraitist (see *Opportunity*, February 1928). Just how he came to portray Mencken is unknown. But having known discrimination during World War I because of his German heritage, Mencken was sympathetic to African-Americans and published their work. Although he sometimes used chauvinistic terms, he was a friendly correspondent with James Weldon Johnson, W. E. B. Du Bois, and others. Photo: National Archives

opment of their own people's influence on American history.

The cities' greater social and personal freedom and the resultant spiritual and artistic freedom and sense of initiative also contributed to individual development, according to Hale Woodruff, a newcomer to New York whose drawing of young black artists at their easels appeared on the August 1928 cover of *The Crisis*. "I can't tell you how free I felt just being in the city," he said.[9]

Yet Woodruff also pointed out that, unlike the jazz musicians they were constantly advised to emulate, young black artists did not have opportunities to get together for regular exchanges, to give each other the support, response, and stimulation that foster a sense of artistic group identity. According to Woodruff, the young artists' work schedules as they struggled to earn a living, usually at menial jobs, and their differing levels of aesthetic experience worked against such exchanges.

In 1924 the editors of *Survey Graphic* magazine asked Alain L. Locke, the first African-American Rhodes scholar and head of the philosophy department at Howard University, to prepare a "Harlem" issue of their magazine. Drawing upon the work of many African-American writers, artists, and critics, Locke assembled a wide range of material that included poetry, drama, music, fiction, black history, folklore, literary criticism, discussion of the problems of black women, Du Bois's vision of the relationship of the colored peoples of the world, and other historical, sociological, and educational studies. In this way African-Americans themselves imaginatively and aesthetically presented what is now called "the black experience."[10]

The impact of this issue was far-reaching. Within a year, *The Crisis* published a symposium on "the criteria of Negro art," with many African-American writers and leaders presenting their views.[11] *The Nation* extended this discussion. William E. Harmon, a wealthy real estate developer, set up the Harmon Foundation to provide "Negro Achievement Awards," including one for art, and a group of New York black

writers and artists attempted to organize their own avant-garde magazine, *Fire!!* But nothing more objectively conveys the impact of the "Harlem" issue of *Survey Graphic,* published in March 1925, than the reprinting of its nucleus as a book in November because the demand for it was so great. Titled *The New Negro,* the book was enhanced by six distinctive African-based design panels by Aaron Douglas, representing his first efforts to create lyric, silhouette-style black figures in action. Their vitality immediately demonstrated how different the "new Negro" was. "The day of the 'aunties,' 'uncles,' and 'mammies' is done. Uncle Tom and Sambo have passed on," Locke wrote in his introduction.[12] For many influential Americans, *The New Negro* was the first demonstration of the rich cultural capabilities of African-Americans in fields other than music and the theater.

Two articles in *The New Negro* dealt specifically with black artists. One was written by Albert C. Barnes, one of the book's few white contributors, who had assembled a great collection of modern and African art on his estate outside Philadelphia. As proof of the creativeness of the African-American, Barnes cited songs and poetry as "the true infallible record of what the struggle [against oppression] has meant to his inner life. . . . This mystic, whom we have treated as a vagrant, has proved his possession of a power to create, out of his own soul and our own America, moving beauty of an individual character whose existence we never knew."[13]

The second article was Locke's essay on "the legacy of the ancestral arts," which strove to influence the direction of African-American artists. Locke was one of the relatively few Americans at the time who were aware that Pablo Picasso and Georges Braque had utilized African sculpture in developing Cubism in 1909. By illustrating his essay with photographs of African art, he hoped to stimulate a link between this ancient art and the development of African-American artists. While debatable in many respects, Locke's essay touched on vital, complex issues confronting the black American artist, and it remains a primary document in their history.

"The characteristic African art expressions are rigid, controlled, disciplined, abstract, conventionalized," Locke wrote. In contrast, he saw the work of black American artists as "free, exuberant, emotional, sentimental, human." He stressed that the "spirit of African expression, by and large, is disciplined, sophisticated, laconic, and fatalistic. The emotional temper of the American Negro is exactly the opposite. What we have thought primitive in the American Negro—his naiveté, his sentimentalism, his exuber-

ance, and his improvising spontaneity—are then neither characteristically African nor to be explained as an ancestral heritage. They are the result of his peculiar experience in America and the emotional upheaval of its trials and ordeals," essentially derived from environmental influences rather than "original artistic temperament."[14]

Locke knew that the African-American artist at that time felt no connection with African art. But because African art had influenced modern European art, he suggested,

> there is the possibility that the sensitive artistic mind of the American Negro, stimulated by a cultural pride and interest, will receive from African art a profound and galvanizing influence . . . the valuable and stimulating realization that the Negro is not a cultural foundling without his own inheritance. Our timid and apologetic imitativeness and overburdening sense of cultural indebtedness have, let us hope, their natural end in such knowledge and realization. . . . If the forefathers could so adroitly master these mediums . . . why not we?[15]

In addition to decreasing feelings of inferiority, what could be gained from African art was, Locke said, "the lesson of a classic background, the lesson of discipline and style of technical control pushed to the limits of technical mastery. A more highly stylized art does not exist than the African. If after absorbing the new content of American life and experience, and after assimilating new patterns of art, the original artistic endowment can be sufficiently augmented to express itself with equal power in more complex patterns and substance, the Negro may well become what some have predicted, the artist of American life."[16]

Through his optimistic essay and his personal access to patrons, important foundation heads, and educators, Locke shaped attitudes that influenced the development of African-American artists. At many levels, from art teachers to artists and philanthropists, he made many distinguished Americans aware of the emergence of African-American artists as a group. He also deepened the artists' own awareness of their cultural heritage. Visiting New York, Philadelphia, Chicago, and other cities, Locke often met with African-American artists. He provided them with an orientation and sense of direction in their relationships with one another and their own people, increasing their confidence in their potential to sound a new note in American art.

Although some of the concepts presented by Barnes and Locke lay beyond their technical skills, for

W. H. Johnson *Évisa* (1929). With its boiling landscape and staggering buildings, this painting shows the influence of Chaim Soutine on Johnson soon after he reached France. Johnson's studies in New York with Charles Hawthorne and George Luks, who approached painting emotionally, had prepared him to develop in an expressionistic direction, permitting him to release his tumultuous feelings of alienation. (21 x 25⅜″) Collection Estate of David and Helen Harriton, Minisink Hills, Pa.

most African-American artists *The New Negro* was a landmark. That black people had a history as artists and that their ancestors' art influenced modern art were facts of enormous psychological importance in erasing negative images of themselves and in shaping their own positive identity. Years later Hale Woodruff recalled his excitement as an isolated young art student when, in 1924, a sympathetic Indianapolis book dealer gave him a German book on African art. Until then Woodruff had not known, beyond his own inner feelings, that any black person could create anything of artistic value.

One idea that flowered during the Black Renaissance was that racial prejudice could be greatly reduced and alleviated by art, that the artist could refute the myth of racial inferiority. This idea, derived from the widespread acceptance of spirituals, was particularly advocated by James Weldon Johnson. He asserted that "through his artistic efforts the Negro is smashing [an] immemorial stereotype faster than he has ever done . . . impressing upon the national mind the con-

viction that he is a creator as well as a creature . . . helping to form American civilization."[17]

On an individual level, talent did seem to mitigate the painful sore of prejudice. The idea of the artist as a lever for achieving interracial socializing became very popular in some New York circles in the mid-1920s. Interracial socializing soon became the most publicized aspect of the Renaissance. At A'Leila Walker's salon, "The Dark Tower," white intellectuals, publishers, producers, and rich socialites could meet talented black writers.

However, few young African-American visual artists took on this role. Except for Aaron Douglas and Bruce Nugent, who was both a writer and an artist, they were infrequent visitors at "The Dark Tower." Some, like W. H. Johnson and Augusta Savage, never came, for they were too busy working to survive and trying to learn how to solve technical problems. Their working hours already limited their visits to museums, galleries, and libraries.

While James Weldon Johnson's concept had some validity, it applied to relatively few individuals. Most

young black artists and writers were concerned with the fundamental problem of being black in white America and the need for broader economic and social changes than Johnson's concept promised. Meeting in Douglas's apartment one night in 1926, a group of seven, including Nugent, Langston Hughes, Wallace Thurman, Zora Neale Hurston, Gwendolyn Bennett, and John P. Davis, decided to publish a quarterly magazine "devoted to the Younger Negro Artists" and entitled *Fire!!*

Hughes outlined their goal: "We young Negro artists who create now intend to express our individual dark-skinned selves without fear or shame. If white people are pleased, we are glad. If they are not, it doesn't matter. If colored people are pleased, we are glad. If they are not, their displeasure doesn't matter either."[18]

Few people, however, saw the one issue of *Fire!!* that was published. In it, contradicting Johnson's concept, the young artists and writers expressed their belief that the barrier of racial prejudice had to be overcome by economic, social, and political pressure—it could not be overcome by art alone. As Hughes's statement makes clear, the creators of *Fire!!* were struggling with their dependency on both black and white audiences. This complex, biracial dependency was at the core of the struggle to establish an African-American identity.

While Johnson's goal was the admission of African-Americans to American life, Du Bois offered a more complex view. He suggested that the unique understanding and insight gained by black experience could change the qualities of American life. Addressing the NAACP convention, Du Bois asserted that it was not only civil rights that "we are after. . . . We want to be Americans, full-fledged Americans, with all the rights of other American citizens. But is that all? Do we simply want to be Americans? Once in a while through all of us flashes some clairvoyance, some clear idea of what America really is. We who are dark can see America in a way that white Americans cannot. And seeing our country thus, are we satisfied with its present goals and ideals?"[19]

For young black artists, Johnson's and Du Bois's ideas raised disturbing questions about their feelings and identity as African-Americans, their African heritage, and their role in American life. In addition to coming up with the rent and acquiring technical know-how, they had to confront the controversial question of how their people should be portrayed.

Debate about how African-Americans should be depicted arose in many quarters and took many forms after publication of *The New Negro*. Centuries of abuse had made many African-Americans extremely self-conscious and suspicious about portrayals of their lives. A novel, play, or painting that depicted black people gambling, dancing, drinking, loitering, sloppily dressed—anything that seemed to support the stereotypes applied to black people—was certain to be attacked regardless of aesthetic truth. In their search for an acceptable identity as Americans, some black people wanted to see their lives glorified. A similar phenomenon can be found in some Irish people's reaction to their portrayal by Sean O'Casey and James Joyce, who illuminated their weaknesses as fallible human beings as well as their strengths.

Du Bois particularly concerned himself with this question, writing in 1920:

> It is not that we are ashamed of our color and blood. We are instinctively and almost unconsciously ashamed of the caricatures done of our darker shades. Black is caricature is our half-conscious thought and we shun in print and paint that which we love in life. . . . We remain afraid of black pictures because they are cruel reminders of the crimes of the Sunday "comics" and "Nigger" minstrels. Off with these thought chains and inchoate soul-shrinkings, and let us train ourselves to see beauty in "black."[20]

Du Bois was not alone in raising the question of how African-Americans should be portrayed. During the twenties, many intellectuals, writers, and artists of both races debated this issue and whether African-American artists were under any obligation to portray black people in a positive way—a question that came sharply into focus with Archibald J. Motley, Jr.'s portrayal of night life in what he called "Bronzeville."

Du Bois formalized this debate by publishing a long series of responses to this question in *The Crisis*, beginning in March 1926.[21] The poet Countee Cullen believed that black artists did have such an obligation, but that each artist had to "find his treasure where his heart lies."[22] Vachel Lindsay, who had attempted to capture the speech rhythms of black people in his poetry, felt what mattered most was the artist's "own experience and his inmost perceptions of truth and beauty, in its severest interpretation, should be his only criteria."[23]

H. L. Mencken, the twenties' most influential critic, who had published many articles and stories favorable to black people in *Smart Set* and the *American Mercury*, felt this was not the time to worry about how black people were presented. He urged a satiric attack on the racial foolishness and inconsistencies of the majority. He asserted that "the remedy of the Negro is not to bellow for justice—that is, not to try and apply

scientific criteria to works of art. His remedy is to make works of art that pay the white man off in his own coin. The white man, it seems to me, is extremely ridiculous. He looks ridiculous to me, a white man myself. To the Negro, he must be a hilarious spectacle indeed. Why isn't the spectacle better described? Let the Negro sculptors spit on their hands. What a chance!"[24]

Related to the question of how African-Americans should be portrayed was the question of a distinct racial style urged by Locke. In *The New Negro* he had argued that the contemporary black artist lacked a mature tradition to follow and appealed for a consideration of African art as the real heritage of African-American artists. He wrote:

> There is a real and vital connection between this new artistic respect for African idiom [in "modern art"] and the natural ambition of Negro artists for a racial idiom in their art expression. . . . Only the most reactionary conventions of art, then, stand between the Negro artist and the frank experimental development of those fresh idioms. This movement would, we think, be well under way . . . but for the conventionalism which racial disparagement has forced upon the Negro mind in America. . . . The Negro physiognomy must be freshly and objectively conceived on its own patterns if it is ever to be seriously and importantly interpreted. . . . We ought and must have a school of Negro art, a local and racially representative tradition.[25]

Although he never precisely defined a "school of Negro art," Locke wrote many essays reiterating his plea, and he exhibited art from the Congo to stimulate awareness of the "legacy of the ancestral arts." He was supported by others, such as Arthur A. Schomburg, curator of the 135th Street branch of the New York Public Library and founder of the great collection of African-American history that bears his name. Schomburg argued: "History must restore what slavery took away."[26]

A different perspective on the nature of African-American art was expressed in *The Nation* by the conservative black journalist George S. Schuyler:

> The Aframerican is merely a lampblacked Anglo-Saxon. If the European immigrant after two or three generations of exposure to our schools, politics, advertising, moral crusades, and restaurants becomes indistinguishable from the mass of Americans of older stock (despite the influence of the foreign language press), how much truer must it be of the sons of Ham who have been subjected to what the uplifters

call Americanism for the last 300 years. . . . As for the literature, painting, and sculpture of Aframericans, such as there is, it is identical in kind with the literature, painting, and sculpture of white Americans; that is, it shows more or less evidence of European influence.[27]

Schuyler, who modeled his literary style on that of H. L. Mencken, was attacking Locke's concept of a "racial school of art" and the idea that African-American artists could produce an art that differed from that of other American artists. There was some truth in what he said. What was considered art in America had been determined by the white majority. Young black artists, struggling to learn their craft, unable to obtain formal training, scrambling to exist, were simply trying to gain some acceptance as artists by doing traditional work. In a day when white-sheeted Klansmen were marching in many parts of the country, they were challenging the prevailing stereotype which denied that African-Americans could be artists. Most of them exhibited in churches and at state fairs, where their work was often displayed with the needlework of the "handicapped." This in some ways was a recognition of the deprivations suffered by African-Americans, and in other ways an insulting continuation of the racial stereotype.

Schuyler did not deal with the fact that the more talented the artists were, the more they were subjected to pressure to paint in ways that the majority perceived as "primitive." That perception required—indeed, demanded—a degree of awkwardness or crudity, violent color, and sensuality. Catering to that idea became the easiest way for an African-American artist or writer to gain attention from dealers, influential collectors, and publishers—the gatekeepers of recognition and acceptance.

Pressure on African-American artists to work in a "primitive" style was intensified by social and cultural factors, specifically by the presentation of warped, sensationalized black characters in novels and plays such as Julia Peterkin's novel *Scarlet Sister Mary,* Dorothy and DuBose Heyward's *Porgy,* and Eugene O'Neill's *Emperor Jones.* Their emotionally distorted black characters derived from—and fostered—the stereotype that African-Americans were unschooled, ignorant, superstitiously religious, immoral, incapable of forethought or intelligence, and controlled by sensuality and fear. These characters were, in varying degrees, racist caricatures, not based on objective observation or insight into the African-American character.

Because these novels and plays were successful, African-American writers and artists were expected to follow such models—and to be even more "primitive."

Fortunately, there were other models. The translations in the mid-1920s of René Maran's *Batouala,* an absorbing story of African village life, deeply impressed many black artists and intellectuals. Maran was a Frenchman of African descent. Winning the Goncourt prize in 1921, his book was, in some respects, a forerunner of Zora Neale Hurston's authentic and penetrating presentation of African-American folkways.

In addition, the naturalism that characterized the writings of Theodore Dreiser, Frank Norris, and Upton Sinclair, as well as the art of John Sloan, George Luks, and others, was a rapidly growing force. A tenet of naturalism was that artists should represent people and events with objectivity, without preconceptions, and this viewpoint increasingly began to inform African-American critical writing.

Rebelling against prevailing preconceptions, Langston Hughes refused the demand of a patron who had rejected his poem satirizing the idle rich, saying, "It's not you," and had asked him to write something different. As Hughes explained: "She wanted me to be primitive and know and feel the intuitions of the primitive. But, unfortunately, I did not feel the primitive surging within me, and so I could not live and write as though I did. I was only an American Negro—who had loved the surface of Africa and the rhythms of Africa—but I was not Africa. I was Chicago and Kansas City and Broadway and Harlem."[28]

Similarly, Aaron Douglas and other artists who had patrons were sometimes told their work was "not you." Some patrons looked upon the education and professional training of black artists as destructive to their "natural" abilities.

The demand for the African-American artist to be "primitive" has persisted to this day, and it has been the source of much misunderstanding and confusion. In the 1920s, the word *primitive* tended to isolate black artists from other American artists, and yet it became, in the 1920s, what was expected of them.

Because the term *primitive* continues to be used inappropriately, clarification of its meaning in relation to African-American artists is essential. The word, which is derived from the Latin *primus,* meaning "first," came to be used in reference to archaeology and anthropology. In brief, these disciplines applied the term to early, original, and basic forms of societal and cultural organizations as well as to housing and craft products. Then ethnologists, describing the cultural artifacts of past societies, applied the term to objects fashioned with crude tools and, ultimately, to peasant handicraft work. Initially such objects, including religious and symbolic statues and pictorial representations, were preserved for their ethnological interest. However, after the discovery of the ancient African, Aztec, and Inca cultures, which were demonstrably advanced and had developed sophisticated ceramic, mineral, and metallurgical technology, it was gradually recognized that these objects were not "primitive" but based on disciplined artistic and cultural concepts and traditions, and required aesthetic consideration.

By the 1920s, the word *primitive* in relation to the arts meant to be unschooled and indifferent to moral and legal codes, without thought or intellectual substance. Freudian concepts of the repression of an individual's natural sexual instincts by "civilization" were popular in American intellectual circles at the time, and an oversimplification of these concepts contributed to the demand for "primitive" expression by African-American artists, with particular emphasis on violent color and sensuous expression. To many white intellectuals and artists, the black American was the opposite of dehumanizing industrialization—a natural man, unfettered by the customs, morals, and character of the organization of modern society. In works like *Emperor Jones,* when a black man goes against his "primitive" nature, he meets with disaster.

Generally, to whites, the term came to mean a style that was crude and unschooled in the "stilted affectations of the more cultured styles and conceptions," as V. F. Calverton phrased it in the thirties.[29] This misuse of the term arose from a distorted perception of black people, dating back to the days of slavery.

Today, similar misuses continue and the term *primitive* has lost any clear meaning.[30] What does it mean, for example, to refer to African sculpture, a highly sophisticated art form, as "primitive art," and then use the same term for the work of Grandma Moses and other folk artists? In this and other contexts the term carries a note of disparagement—implying that this is not "real" art.

African-American artists were continually confronted with the question: Who would buy their work? Directing their work to either a black or a white audience carried severe limitations. In seeking appreciation from a white audience, they faced possible suppression of their inner feelings and convictions. On the other hand, the black audience had its own particular taboos about subject matter. It also offered considerably fewer opportunities for support.

Artists' responses to this situation varied. Some, notably Sargent Johnson, Aaron Douglas, Richmond Barthé, and James Lesesne Wells, experimented with

African styles. James A. Porter and others felt that the "self-conscious pursuit of the primitive" would further separate Negro art and artists from American art and artists. They "insisted that the Negro [artist] should encompass all experience, not attempting to suppress non-Negro influence, for such suppression meant intellectual and aesthetic negativism."[31]

Hughes rejected any denial of racial experience, recalling a young man who said to him, " 'I want to be a poet—not a Negro poet.' . . . And I was sorry the young man said that, for no great poet has been afraid of being himself. And I doubted that, with his desire to run away spiritually from his race, this would ever be a great poet. But this is the mountain standing in the way of any true Negro art in America—this urge within the race toward whiteness, the desire to pour racial identity into the mold of American standardization, and to be as little Negro and as much American as possible."[32]

None of the spokesmen for these varying views ever abandoned his point. Locke continued to be a persistent, important influence, and his endorsement often meant a foundation grant. He jabbed, goaded, and held up the popularity of jazz as an inspiration. Jazz musicians were basking "in the sunlight and warmth of a proud and positive race-consciousness" while "our artists were still for the most part in an eclipse of chilly doubt and disparagement."[33] However, Locke's plea for a return to "the legacy of the ancestral arts" was challenged in 1927 by the African-American sociologist E. Franklin Frazier. He pointed out that developing group experiences and traditions and utilizing such experiences in artistic creativity "is entirely different from seeking in the biological inheritance of the race for new values, attitudes and a different order of mentality." Biological inheritance could not provide a "unique culture."[34]

African-American artists' difficult struggle to achieve identity was evident in exhibitions by the Harmon Foundation between 1928 and 1935.[35] Although it presented achievement awards to African-Americans in nine areas of endeavor, including religion and business, the Harmon Foundation is remembered today only for its recognition of African-American artists. An expression of the idea that art could help break down racial prejudice, the foundation's touring shows frankly accepted segregation in the South in trying to win recognition for black talent. The exhibitions helped African-American artists become aware of one another, and to gain some public attention. By 1935 some 400 black artists from all over the nation were "in regular touch with the foundation."[36]

The Harmon exhibitions accepted all kinds of work—traditional, naive, academic, abstract, and ex-

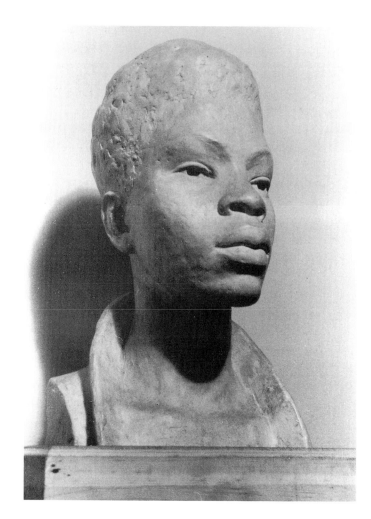

Richmond Barthé *West Indian Girl* (1930). This sculpture is representative of Barthé's early concern with the African-American types that he met on coming to New York. He exhibited this work in the 1931 Harmon Foundation show. Photo: National Archives

perimental. Porter, who exhibited, later remarked that the jury's selections for prizes showed "too liberal taste in subject matter and too little concern for execution."[37] Although disclaiming any point of view, the foundation's catalogs urged black artists "to create a genuine interpretation of racial background" and published Locke's exhortations on the "ancestral arts." Each successive show exhibited not only more work than earlier exhibitions, but also more black subject matter—a significant, if oversimplified, indication of growing self-acceptance.

The Harmon exhibitions were the largest and most publicized effort at the time to encourage African-American artists and show what they were doing. What was confusing, both aesthetically and in terms of black identity, was the assembling of very different types of work at all levels of achievement—bringing together a Cubist, a Romantic, an illustrator, and a naive—and calling them all representative of "Negro art" simply because the artists were black.

This situation drew criticism from African-American artists with the first public exhibition in 1928 (earlier competitions were not public). The artist-poet Gwendolyn Bennett, later a leader of the Harlem Artists Guild, complained that the works shown "lack the essence of artistic permanency. . . . There can be no cultural contribution unless something distinctive is given, something heightened and developed within the whole form that did not exist before the artist's hand took part in its molding. But where in this exhibition is there any such deftness of hand?"[38]

A few years later, in 1934, Mary Beattie Brady, the director of the Harmon Foundation and selector of its juries, was stung when Romare Bearden, a young Harlem artist, severely criticized its exhibitions as misguided, however well intentioned, because they lacked artistic standards and no unified aesthetic or social philosophy existed among African-American artists. Under the title "The Negro Artist and Modern Art," he argued for abandoning the "outmoded academic practices of the past," which most black artists were following in seeking acceptance as artists, and for the creation of an art that genuinely reflected the black artist's life and character. He condemned the Harmon Foundation:

> Its attitude from the beginning has been of a coddling and patronizing nature. It has encouraged the artist to exhibit long before he has mastered the technical equipment of his medium. By its choice of the type of work it favors, it has allowed the Negro artist to accept standards that are both artificial and corrupt.
>
> It is time for the Negro artist to stop making excuses for his work. If he must exhibit, let it be in exhibitions of the caliber of "The Carnegie Exposition." Here among the best artists of the world his work will stand or fall according to its merits. A concrete example of the accepted attitude towards the Negro artist recently occurred in California where an exhibition coupled the work of Negro artists with that of the blind. It is obvious that in this case there is definitely a dual standard of appraisal.[39]

Yet whatever its faults aesthetically and from an African-American viewpoint, the Harmon Foundation brought encouraging public attention to the development of African-American artists in a critical period.[40] Without its activities, exhibitions, and publicity, many artists would not have survived as artists, and its awards often identified important leaders among them. It particularly stimulated the formation of art departments in African-American colleges through its traveling shows, which generally had a higher artistic level than the exhibitions themselves.

The Harmon shows demonstrated that there were many African-American artists and that black subject matter—the lives, activities, and portraits of African-Americans—was a legitimate, valuable, and unique part of American life, worthy of artistic expression and the unique province of black artists. How some of the significant black artists of the twenties developed—their problems, what they created, what influenced them, how individual they each were, and how they survived—provides insight into many aspects of American cultural life in that period.

Evolution of the Negro Dance (1935), one of Douglas's most decorative murals, was painted directly on plaster in what was a recreation room at the 135th Street YMCA in New York. This photograph was made in the 1930s, and the mural has since deteriorated badly. Efforts are being made to raise funds for its repair and reconstruction. (76 x 182″) 135th Street YMCA, New York

AARON DOUGLAS

The artist most closely identified with the Harlem Renaissance was Aaron Douglas, who came to New York in 1925 from Kansas and Nebraska. His bold and distinctive work combined a sharp, angular style with a sophisticated sense of design, using symbolic silhouettes of black people and objects. He illustrated many books, and his work was frequently reproduced in magazines, making it nationally known. To many Americans who came of age between the 1920s and the 1940s, Douglas was *the* black artist.

Moreover, Douglas was highly involved with the leading writers and intellectuals of the Harlem Renaissance. His preeminent stature among his own colleagues is evident in Langston Hughes's later remark about the Harlem Renaissance writers' creation of the magazine *Fire!!:* "It had to be on good paper . . . worthy of the drawings of Aaron Douglas."[1]

Aaron Douglas was born on May 26, 1899, in Topeka, Kansas, to Aaron and Elizabeth Douglas. He discovered his ability to draw at an early age and later recalled how his mother would hang up his drawings and paintings. "Both my parents worked," Douglas recollected, continuing:

> My mother took in work and she also went out to work, and I guess she is responsible for my becoming an artist. One of the families she worked for was the Malvane family, which I believe is still in Topeka. They were interested in art and established what is now the Malvane Museum of Art at Washburn University in Topeka. I guess my mother must have talked to them about me because one day she came home with a magazine that they had given her. It had in it a reproduction of a painting by Tanner. It was his painting of Christ and Nicodemus meeting in the moonlight on a rooftop. I remember the painting very well. I spent hours poring over it, and that helped to lead me to deciding to become an artist.

Douglas had the opportunity to acquire a better formal education than most black artists who migrated to New York in the 1920s. At the University of Nebraska in Lincoln he studied "fine arts"—a liberal arts course that included drawing, painting, and art history. During World War I he spent one wartime semester in a Student Army Training Camp, where he painted a portrait of General John J. Pershing, which was sent to Washington. On his return to college, he studied drawing under Blanche O. Grant, who later joined the art colony in Taos, New Mexico. She steadily encouraged Douglas, and he won a prize for general excellence in drawing.

At the time, Douglas later recalled, all life drawing was done from a draped model, "and that made an enormous difference." Once, in the summer of 1922, while studying psychology and education at the University of Kansas, he peeked into a life drawing class there. "I saw what the students were doing and decided that they were miles ahead of us. We couldn't use the undraped model in Nebraska, I guess, because of the Victorian attitudes that prevailed there, but I hate to say anything against Nebraska because in so many ways it was fine. I was the only black student there. Because I was sturdy and friendly, I became popular with both faculty and students."

Douglas graduated from Nebraska in 1922. He received a Bachelor of Fine Arts degree from the University of Kansas in 1923. From 1923 to the summer of 1925, he taught art at Lincoln High School in Topeka, Kansas; he was the first art teacher the school had had. Although Douglas dreamed of studying in Paris, letters from Ethel Ray and her friend the writer Eric Waldrond, whose novel *Tropic Death* had just been published, prompted him to come to New York.[2] He arrived in 1925, in the thick of the expanding, socializing movement of black artists in Harlem.

Ray introduced Douglas to her employer, Charles S. Johnson, a sociologist and editor of the Urban League publication, *Opportunity*. Through Johnson,

Douglas met the artist Winold Reiss, who invited him to his studio. It was the first professional artist's studio he had entered, except for one he had seen on a class tour as a boy.

Reiss, the son of a Bavarian landscapist, had established himself in Europe with very detailed drawings of folk types in his native Tyrol, as well as in Sweden, Holland, and the Black Forest area of Germany.[3] Reiss's drawings were realistic, and his best efforts were penetrating character studies in the German tradition of Albrecht Dürer and Hans Holbein. On coming to America, Reiss was inspired by the Native Americans, who held a mystical fascination for Europeans. He made a number of colored drawings of Plains and Pueblo Indians and of Mexican peasants. These studies, which used decorative, cultural, and historical elements in presenting their subjects, brought him to the attention of influential black leaders, such as Johnson and Alain Locke. Eventually Reiss was asked by Locke to design and illustrate the "Harlem" issue of *Survey Graphic*.

Listen, Lord—A Prayer (1925). Douglas drew this black-and-white illustration for the opening poem in James Weldon Johnson's *God's Trombones,* and created others for each of the seven "sermons in verse." He later painted these compositions in color. New York Public Library

Reiss taught painting and drawing in his studio, and he was particularly helpful to minority students, providing excellent training in traditional drawing, often without tuition fees. Reiss, for example, offered Douglas the opportunity to study with him without cost. Under this experienced teacher, Douglas developed his penchant for exactitude and bold design.

Encouraged by Reiss, Douglas soon began to do drawings in charcoal and colored chalk of black Americans. When the "Harlem" issue of *Survey Graphic* was re-created in book form as *The New Negro,* Locke and Reiss gave six pages to drawings by Douglas that utilized decorative African elements.[4]

In his drawings Douglas established a strongly personal style. Utilizing black silhouettes with an elegant, stylized angularity and reducing objects to their basic shapes, as in Cubist paintings, he created relationships among the flat figural groups that have a rhythmic movement similar to that in Greek vase painting. Sometimes these figures were dancing.

Douglas's black-and-white drawings reached a wide audience through *Vanity Fair* and other magazines, and he soon became recognized as the most outstanding artist of the Harlem Renaissance. Douglas himself considered his illustrations for James Weldon Johnson's 1925 book of poems based on Negro sermons, *God's Trombones,* as representing his most mature and important black-and-white work.

Douglas also painted portraits and landscapes in oil and watercolor, but these works were very different stylistically from his black-and-white drawings. In his easel paintings Douglas used form and color to give a sense of volume, in contrast to the flat patterns of his drawings. These paintings tended to be naturalistic and somewhat romantically conceived, with little of the Postimpressionists' optical analysis of color, which interested young American artists, such as Stuart Davis and Charles Sheeler, in the late 1920s. The emphasis was on the careful delineation of a freely drawn sketch, which aimed to catch the vitality of the subject.

The strong design quality of Douglas's black-and-white drawings and the excitement created by his dancing figures prompted the owner of the Club Ebony, a popular Harlem nightclub of the 1920s, to commission a mural. Douglas was paid $700, an enormous sum for a Harlem artist at the time. When the club opened, Douglas's mural was widely praised.

One of the people who came to see the mural was Albert C. Barnes, who had amassed a fortune with his patent medicine Argyrol and had used this money to indulge his real interest in collecting modern art and writing about it. Barnes had established an art school

Triborough Bridge (1935), one of Douglas's most unusual landscapes, is not only a complex urban scene but may be interpreted symbolically. It depicts unemployed, winter-clad New Yorkers in a park with barren trees looking toward a sunlit bridge, a symbol of construction and hope. Heavy steel girders of the Elevated (industry) frame the scene (their environment and their lives). (Approx. 28 x 36") Amistad Research Center, Tulane University

on his estate in Merion, Pennsylvania, outside Philadelphia. While admiring Douglas's mural, Barnes believed that Douglas could benefit from studying at the Merion school, where he might discover ways of better integrating color with his basic black-and-white approach. With this in mind, Barnes offered Douglas a tuition-free scholarship at his school plus a stipend of $125 a month in 1928. Douglas gladly accepted.

Shortly before his meeting with Barnes, while Douglas was still at work on his Club Ebony mural, Locke and Langston Hughes took Douglas with a portfolio of his drawings to the home of a wealthy New York woman, Mrs. Charlotte Mason. Enthusiastic about Douglas's work, she bought two drawings at $125 each—more money than he had ever received for his drawings. And, as with Hughes and Zora Neale Hurston, whom she was subsidizing, she offered continuing support to Douglas, with talk about black primitive spirituality. She insisted, however, he never reveal her name, always call her the "Godmother," and regularly report on what he was working on.

Mrs. Mason was in her seventies. She was the widow of Rufus Osgood Mason, a noted surgeon who had believed hypnosis and psychic powers were healing agents.[5] He also believed that great spiritual powers resided in the "primitive" and "child races," terms he used for Native Americans and African-Americans. He had died in 1903 but Mrs. Mason, who shared his psychic beliefs, pursued these interests by supporting, directing, and controlling, through her money and emotional approval or disapproval, black writers and

artists, specifically Locke, Hughes, and Hurston. Hughes later wrote that she considered black people "America's great link with the primitive . . . that there was mystery and mysticism and spontaneous harmony in their souls . . . that we had a deep well of the spirit within us and that we should keep it pure and deep."[6]

Douglas soon found that the "Godmother" was very demanding and controlling. Hughes has described how the influence of this aging, possessive woman, on whom he became emotionally and financially dependent, became so pernicious that he was driven to sever the relationship, a traumatic event in his life.[7] Similarly, Douglas found that the patronage he first welcomed was increasingly stressful.

One evening, as Douglas finished his classwork at the Barnes school, he was astonished to be approached by Mrs. Mason's servant. She told Douglas that his patron had had her chauffeur drive them down from New York and that Mrs. Mason was waiting in the car to speak with him. In the car Douglas learned that the Godmother wanted him to give up studying at the Barnes school immediately and return to New York with her. She felt that any additional training would be harmful, curbing his natural instincts. Douglas must, she said, be governed only by his emotions to preserve his "primitivism." But Douglas considered her demand completely unreasonable and said pointedly that he was benefiting from his studies and would stay until he completed his scholarship.

Shortly after this incident, Carl Van Vechten asked Douglas to illustrate one of his books. Douglas agreed

to do so, but again the Godmother intruded, urging him to give up the assignment. Her calls became so persistent and so disruptive that he decided to delay the project and went to Nashville, Tennessee, where the possibility of his doing some murals had been raised by the president of Fisk University.

From there, Douglas went to Chicago in late 1929 to create a mural in the Sherman Hotel's College Inn ballroom. Meanwhile, Van Vechten, who had written in praise of Douglas and had helped introduce him to *Vanity Fair* and other magazines, became angry with Douglas's failure to illustrate his book and withdrew his offer. Douglas felt he had paid an excessive price for the Godmother's help before he freed himself. Married, stable, more secure in his art than Hughes and Hurston, he was less vulnerable to Mrs. Mason's manipulative "love" and money than they were. Apparently he ended the relationship by ignoring her demands, which was intolerable for her.[8]

In Chicago Douglas completed his College Inn ballroom mural in 1930. Edwin A. Harleston of Charleston, South Carolina, whose painting had won the 1925 Amy Spingarn prize, helped Douglas transfer the mural to the hotel walls.[9] (This mural, like the Club Ebony mural, was later destroyed when ownership of the building changed.) By the time the Chicago mural was finished, the Fisk University murals had been approved, and Douglas moved to Nashville to complete them, with Harleston continuing as his assistant.

Douglas's murals are related in style to his decorative black-and-white designs. His mural style is also indebted to Reiss and to Art Deco's stress on vertiginous, curvilinear forms. In his murals Douglas first arranged a series of concentric circles expanding from a fixed point, much like the reverberations from a pebble thrown into a still pond. He then superimposed figural elements over the circular design. To compensate for the dynamic optical rhythms of the circles, he painted the figures in flat silhouettes, avoiding an eye-troubling concatenation of form and color. Colors were poised in relationship to each other as well as to the overall design. Douglas usually kept the colors within a restrained, grayed range, but a figure might have three or four different values of color, as if several different color spotlights had been focused on the silhouette. He often favored a red-green harmony, creating a warm-cool coloration that helped to give depth and volume to his murals. No attempt, however, was made to capture the realism that characterized his portraits. While the forms and colors move toward one another in overlapping oppositions, the linear boundaries are carefully designed to organize and pacify the murals so that the eye moves easily across their surfaces.

In his critical history of the Harlem Renaissance, Nathan Irvin Huggins observed that Douglas's work was "abstract for philosophical reasons, not for painterly reasons,"[10] but it is difficult to understand how, in any artist's work, these two concerns can be separated. In fact, in commenting on his illustrations for *God's Trombones,* Douglas contradicts Huggins's assertion: "I tried to keep my forms very stark and geometric with my main emphasis on the human body. I tried to portray everything not in a realistic but [an] abstract way—simplified and abstract as . . . in the spirituals. In fact, I used the starkness of the old spirituals as my model—and at the same time I tried to make my painting modern."

In stating this, Douglas confirmed his technical concerns and their relation to all the visual, historical, and social factors that influenced his vision. These influences were never narrow or limited. When Romare Bearden visited Douglas's home some years ago, he found Douglas absorbed in a book with color reproductions of Russian icons of the Byzantine era. Douglas then explained the affinities between these ancient icons and modern painting. In his work Douglas also demonstrated that he was a perceptive student of ancient Egyptian art, African tribal art, and Renaissance painting.

With money he managed to "pinch off," to use his expression, from his mural commissions, Douglas and his wife, Alta Mae Sawyer, a high school sweetheart whom he had married in 1926, went to Paris to study. Determined to be independent of the Godmother, Douglas and his wife had endured many deprivations to save enough money for this period of study. That he was spending his own hard-earned money obsessed Douglas; he studied and worked compulsively, afraid of wasting a minute.

He first enrolled in the Académie de la Grande Chaumière, one of the best-known Parisian schools, but then transferred to the Académie Scandinave. This school, organized under the auspices of Norwegian artists, had established European artists who came as visiting professors once a week. Douglas took up sculpture for the first time, studying painting in the morning and sculpture in the afternoon. He studied under Charles Despiau, a modern portrait sculptor; Henri Waroquier, a School of Paris painter; and Othon Friesz, a former Fauvist painter whose approach was both decorative and expressionistic.

One of the few distractions Douglas permitted himself was conversation with J. A. Rodgers, a journalist who later wrote several books on African-American history. Rodgers introduced him to Palmer

Hayden, who had won the Harmon Foundation gold medal and $400 in 1926, and who had also come to Europe to study. As Douglas wanted to meet Henry Ossawa Tanner, his youthful idol, Hayden arranged for them to go to Tanner's studio. Tanner was, Douglas later recalled, a "down-to-earth" man who chewed tobacco and asked him many questions about his studies. Tanner was particularly interested in Douglas's sculpture studies and, recalling his own modeling studies, encouraged his efforts. He also asked Douglas to return, saying that he had worked out a particular method of mixing paints and would show it to him. However, Douglas felt so pressed to continue with his own studies that he did not return. Later, he considered this a great loss because Tanner was undoubtedly referring to his method of working with glazes, about which he was ordinarily very secretive.

Of his Paris studies, Douglas said in 1972:

Today I would say that I didn't know how to study and work; at that time I did it the American way. I wanted to get my money's worth, and I worked at it like I was laying brick. I knew my money wouldn't last and I was afraid of wasting it. If the model was on the stand, I felt I should be working.

The European students proceeded quite differently. A European student would come in and look at the model. If he liked what he saw, he might work. If he got tired, he quit. If he didn't like what he saw in the first place, he would just leave and go drink wine in some café. They were more indulgent towards themselves than I could be.

Even when I came to recognize that what I was doing was wrong, I couldn't change it. It was my money and I was terrified that I would waste it. And so it went. Many years later I realized that at that time there simply wasn't any other way for me to study because that's the way I was at the time.

On his return from Paris, his money gone, Douglas had a difficult time. He eventually secured a commission in 1933 for the newly built Harlem YMCA[11] and, a year later, under the Treasury Public Works of Art Project, a commission for four murals at the Countee Cullen Branch of the New York Public Library (this was a very limited project for established professional artists). He also did portraits of friends and landscapes, which were usually painted along the banks of the Harlem River, north of the old Polo Grounds.[12]

In 1928 Douglas had shown in the first public Harmon exhibition of African-American artists and was astonished at the number of participating artists. After returning from Europe, he found that the number of African-American artists had greatly increased, but that they were having trouble gaining recognition as artists in order to qualify for the art projects under the Works Progress Administration. Even when recognized as artists, they were denied supervisory positions, no matter how well qualified. This situation, as well as a new awareness of their special problems as members of an oppressed race, brought about the organization of the Harlem Artists Guild.

Douglas, elected first president of the Guild, played an influential role in its successful battle with the WPA to obtain recognition for black artists. He came to know many young black artists, among them Ernest Crichlow, James Yeargans, Jacob Lawrence, Charles Alston, and Henry W. "Mike" Bannarn. Although Douglas was only in his mid-thirties at the time, the young Harlem artists generally called him the "Dean." He frequently visited "306"—Alston and Bannarn's studio and a major gathering place for Harlem artists, intellectuals, poets, writers, critics, journalists, dancers, and creative people of all kinds in the thirties.

In 1934 Douglas completed his murals on African-American history in the public library. In these murals, which he titled *Aspects of Negro Life,* he extended some of the basic aesthetic concepts first advanced in his illustrations for *God's Trombones.* As he noted in 1949:

The first of the four panels reveals the Negro in an African setting and emphasizes the strongly rhythmic arts of music, the dance, and sculpture, which have influenced the modern world possibly more profoundly than any other phase of African life. The fetish, the drummer, the dancers, in the formal language of space and color, recreate the exhilaration, the ecstasy, the rhythmic pulsation of life in ancient Africa.

The second panel is composed of three sections covering periods from slavery through the Reconstruction. From right to left: the first section depicts the slaves' doubt and uncertainty, transformed into exultation at the reading of the Emancipation Proclamation; in the second section, the figure standing on the box symbolizes the careers of outstanding Negro leaders during this time; the third section shows the departure of the Union soldiers from the South and the onslaught of the Klan that followed.

The third panel, *An Idyll of the Deep South,* portrays Negroes toiling in the fields, singing and dancing in a lighter mood, and mourning as they prepare to take away a man who has been lynched.

The Negro in an African Setting and ***Song of the Towers*** (1933). Douglas's most famous murals, painted under PWA sponsorship in the Countee Cullen Branch of the New York Public Library, portray the life of African-American people historically. The series, titled *Aspects of Negro Life,* starts with an African scene (left) emphasizing their vitality and rhythmic arts of music, dance, and sculpture. (6 x 6') (Douglas repeated the small fetish figure in the center in other murals not in this series.) In *Song of the Towers* (right) the saxophone player represents the African-American will to self-expression and spontaneous creativeness in all the arts that marked the Renaissance of the 1920s. (88 x 88") Schomburg Center for Research in Black Culture, New York Public Library

In the fourth panel, *Song of the Towers,* the first section on the right, showing a figure fleeing from the clutching hand of serfdom, is symbolic of the migrations of Negroes from the South and the Caribbean into the urban and industrial life of America during and just after World War I; the second section represents the will to self-expression, the spontaneous creativeness of the late 1920s, which spread vigorously throughout all the arts in an expression of anxiety and yearning from the soul of the Negro people; the last section of this panel attempts to recreate the confusion, the dejection and frustration resulting from the Depression of the 1930s.[13]

These murals demonstrate the importance of design in artistic statement. Drawing on the history of African-Americans, he endowed his subjects with elegant but powerful distinction. In these abstract silhouettes, he found the opportunity to express the dignity of their lives. The concentric circles of the design create large, wavelike rhythms, which play against the figures, giving them balance and nobility. In fact, these murals have a classical starkness. The sobriety of

the limited palette, the ordered surface activity with its decorum and balanced compositional elements, the deft yet flat emphasis of the figures and objects, all make for this classical comparison. The same qualities are present in Douglas's 1930 murals at Fisk University and his 1931 mural depicting Harriet Tubman at Bennett College in Greensboro, North Carolina.

Douglas, whose own apartment on Edgecomb Avenue was another center for writers and artists, considered the destruction of African religions, languages, and cultures under slavery a basic cause for the delayed development of black artists and sculptors in America. In a historic paper before the First American Artists Congress in 1936, he poked sarcastic fun at the short-lived interest in black artists in the 1920s "renaissance": "When unsuspecting Negroes were found with a brush in their hands, they were immediately hauled away and held for interpretation." Turning serious, he observed:

What the Negro artist should paint and how he should paint it can't accurately be determined without reference to specific social conditions. . . . Our chief concern has been to establish and maintain recogni-

Douglas's lively, flat black silhouettes impressed many publishes, editors, and artists but upset some academically trained African-American critics. Few realized that he was inspired by the classic black silhouettes on Greek vases, such as **The Return of Hephaistos** (right), a masterpiece by Lydos in the sixth century B.C. (22³⁄₂₆″ h.) Metropolitan Museum of Art, New York

tion of our essential humanity, in other words, complete social and political equality. This has been a difficult fight as we have been the constant object of attack by all manner of propaganda from nursery rhymes to false scientific racial theories. . . . But the Negro artist, unlike the white artist, has never known the big house. He is essentially a product of the masses and can never take a position above or beyond their level. This simple fact is often overlooked by the Negro artist and almost always by those who in the past have offered what they sincerely considered to be help and friendship.[14]

Douglas's remarks helped many artists understand the special problems of the black artist and why many of them felt the Harlem Artists Guild was needed.

In 1937 Douglas received a grant from the Julius Rosenwald Fund for studies in the South and in Haiti. In 1939, at the urging of Charles S. Johnson, who had become professor of sociology at Fisk, Douglas accepted a part-time position there, teaching drawing and painting. At first he taught only the spring semester, being unwilling to leave New York completely. However, in 1944, after completing his work for a master's degree at Teachers College, Columbia University, he became a full-time professor of art at Fisk. Later he headed the department, retiring in 1966.

Douglas's black-and-white drawings in *The New Negro* demonstrate that he was one of the first artists, along with Pablo Picasso, Constantin Brancusi, Amedeo Modigliani, and Paul Klee, to infuse the art of

Africa into his own work. However, just as the art of these masters was not immediately appreciated, so too was Douglas initially condemned by some critics who considered his work grotesque. Even so astute a critic as James A. Porter attacked Douglas's work as that of an artist

who took literally the advice of racial apologists and, without a clear conception of African decoration, attempted to imitate in stilted fashion the surface patterns and geometric shapes of African sculpture. The early paintings and drawings and book illustrations of Aaron Douglas exemplify this weakness. The influence of African decoration on Douglas' style is apparent to the close observer. It emerges in flat and arid angularities and magnifications of forms which, though decorative, had the dynamic effect one might expect from the dismemberment of a traditional art for the sake of rearranging the motifs thus plundered. Their representational value is almost negligible while their modernism is dominant. However, it must be noted that Mr. Douglas' early style in its general effect bears but scant relationship to the powerful forms and religious message of African Negro art.[15]

This outburst against one of the truly innovative black artists of the 1920s demonstrates the reaction of many academic artists to painting that did not present black people as well-dressed citizens, charmingly preoccupied in comfortable surroundings. The same attitude was expressed by members of the black middle

Aaron Douglas, photographed in 1933 by Carl Van Vechten. Courtesy of Joseph Solomon, Yale University Library, and Sidney A. Mauriber

class who were ashamed of jazz, even if it meant denying their unique black heritage.

While in later years Porter came to appreciate the aesthetic value of Douglas's work, his initial reaction was not uncommon. One can find little appreciation of African sculpture in American books and periodicals of the period. In fact, at the time books dealing with African sculpture were rare and usually European in origin. In the attacks on his work, Douglas suffered the fate of many other pioneers in art.

Douglas's approach arose not so much from an understanding of modern art as from his considered view that his work should present a unified portrait of black people in relation to their spirituality. Even in his early drawings, his work connects an impressive and poetic feeling of concern with the great elements of nature, such as the sun, the land, and the foliage, as well as with black people. He emphasized their gift for music as symbolic of the mingling of many voices in making up the inner fabric of life. Through the use of universal symbols, he asserted his belief that art can be the deepest communicative channel between races. Douglas felt that he could best overcome the great distances of space and time that separate the African and African-American lifestyles with symbols expressing features of both experiences.

A lively but reflective man, Douglas believed many of the cultural contributions to American life by black people have not been recognized. As an example, he cited the Lindy Hop, a dance that became popular after Charles Lindbergh's transatlantic flight. In his view, this exuberant dance, in which the girl was swung into the air, expressed mankind's defiance of gravity. It was an expression of life itself, he said, "celebrating the flight of Lindbergh in a way that no American poet, artist, or writer has been able to do." Douglas felt that this dance originated with black people because of their "closeness to life," adding that "the black man's relationship to life has such richness and such understanding that the young black artist should never neglect it."

In his own work Douglas always celebrated the agility of black people in adapting to life, from the jungle to urban factories, churches, and nightclubs. As if to exemplify this activity, Douglas never stopped trying to improve his work, even long after he formally retired. For example, late in life he began to rethink his use of color.

Much earlier, in 1926–27, Barnes, a leading authority on modern art, saw Douglas's recently completed Club Ebony mural and praised it. But Barnes also said to Douglas: "Now you ought to do it in color." This remark deeply puzzled Douglas. "At the time, I know now, I didn't understand anything about color," he said more than forty years later, continuing:

I thought I did, but I actually didn't, and that is why Barnes's remark stayed with me. I particularly didn't understand anything about the range of color and how to work with it. At that time blue was blue to me. I had very little range. I didn't properly understand that there were a lot of blues—and a lot more after them.

If I had had the time, I might have learned how to introduce color into my work as an element in itself. But, basically, I believe that I would have resisted such thinking because I thought my use of color was right. I just hadn't the time to paint enough. I didn't know how to work with color. I didn't have the idea that you can make a color and throw it away, make another and throw it away, and make another and throw it away, and make another and keep it. I simply didn't understand about experimenting and working with color, that you could spend all day or all week working with one color, playing around with it until you got something.

Thus, in the 1970s, when he himself was in his

The Composer, Douglas's 1967 portrait of classical musician William Hurt demonstrates his ability as a portraitist to capture sensitivity and strength. (20 x 16″) Carl Van Vechten Gallery of Fine Arts, Fisk University, Nashville

seventies, after years of study of how color might be applied to his work, Douglas confronted anew the murals he had completed at Fisk in 1930–31. He started redoing and refurbishing them in terms of color, delighted to be doing, as he put it, "things with color I didn't know how to do at the time."

In 1971, in renewed appreciation of his pivotal role in aesthetically linking the African past to black American life, Douglas was given a major retrospective exhibition at Fisk University.[16] Thereafter, although he continued to work in his studio, he gave up many activities, declining commissions for murals and illustrations. He lived quietly, reevaluating his ideas and work, coming occasionally to New York to see friends and exhibitions. (His wife, Alta, had died in 1958.)

Douglas died in Nashville on February 2, 1979. At that time David Driskell, the artist–art historian who had succeeded him as head of the Fisk art department, noted that Douglas took "the iconography of African art and gave it a perspective which was readily accepted into black American culture."[17] For Douglas, the ability to express his own vision was critical. Years earlier, when Romare Bearden voiced his admiration for Douglas's craftsmanship, Douglas replied, "Technique in itself is not enough. It is important for the artist to develop the power to convey emotion . . . the artist's technique, no matter how brilliant it is, should never obscure his vision."[18]

Douglas's vision helped change America's concept of its black people by celebrating their past and their active contributions to all forms of American life, industrial as well as cultural. He offered a new way of seeing the African-American that was recognizable to all. The impact of his work on young African-American artists over a period of sixty years has been profoundly synergistic.

RICHMOND BARTHÉ

The black figures that Richmond Barthé modeled in a lyric, romantic, and often monumental style expressed the aspirations of a community that was almost immediately drawn to his imagery. Whether his subjects were such nationally known African-American leaders as Booker T. Washington or simply people to whom he was artistically attracted, Barthé's work of the 1920s and 1930s is clearly that of an artist who empathized with his people.

Barthé "has come to us at a time when we are sadly in need of real inspiration—of that spiritual food that heartens and strengthens . . . hopes that embody the willingness to do the larger and truer things in life," said William H. A. Moore in *Opportunity* in November 1928.[1]

In focusing on black people as his subjects, Barthé joined a few other pioneers. Where Palmer Hayden turned to memories of his life in the South and Archibald J. Motley, Jr., was drawn to the surging vitality of black social life after dark in the city, Barthé sought delineation of character through the marks of physiognomy and stance. Aesthetically, he brought a new insight to the individuality and physical grace of all types of black people.

A handsome and gracious man, who took a traditionally based approach to art, Barthé very early found his milieu. Once out of art school, he worked steadily as a professional artist, becoming one of the first contemporary black artists to support himself in this way. Never caught up in social movements, he was fascinated with portrait sculpture. He was able to move socially among those persons who wanted portrait sculpture and could afford it. Indeed, his poise made him sought after in wealthy and fashionably elite circles and undoubtedly helped to win commissions. His concern with personalities and with dancing led him into theatrical circles, where he came to know people intimately, from the stars to the chorus dancers. In work other than portraiture, Barthé often attempted to capture some action at a dramatic peak, giving his

Woman with a Scythe (1944) was shown in the 1945 annual exhibition of the Whitney Museum of American Art. In this nude figure, Barthé's powerful rhythmic sense is fully expressed. (Plaster, 25″ h.) Photo: National Archives

art a livelier quality than the work of many contemporaries.

That his work was instantly accessible to the public, never baffling with symbolism or abstract forms, contributed to Barthé's popularity. Often reproduced in the press, his statues helped to establish the image of the "New Negro."

The Boxer (1942). Barthé has emphasized the athlete's dancerlike rhythmic grace by elongating his legs and torso. It is one of his most famous works. (Bronze, 18¾″ h.) Metropolitan Museum of Art, New York

George Washington Carver. The famous Tuskegee scientist was portrayed twice by Barthé. This statue shows Carver in his laboratory; the original is at Tuskegee Institute and this copy at Fisk University. Barthé made another, more formal portrait for the Hall of Fame colonnade at Bronx Community College, which also contains his portrait of Booker T. Washington. (Plaster, 27″ h.) Carl Van Vechten Gallery of Fine Arts, Fisk University, Nashville

His work also won praise from academicians, from whose traditions his art emerged. James A. Porter, for example, referring to three small bronzes (*The Harmonica Player, Shoe-shine Boy,* and *The Boxer*), called them "so close to perfection . . . that their effect upon the spectator is transporting."[2]

Yet despite the universal appeal of his work, critical attention to the work of such abstract sculptors as Constantin Brancusi and Henry Moore after World War II made much of Barthé's work seem peculiarly dated and limited. Moreover, as a sensitive and complex man, he increasingly suffered from internal conflicts that made his life in Manhattan stressful. Finally, in the late forties, Barthé left the United States for Jamaica, where initially he found life less trying. Many of his British friends, like Noël Coward, as well as wealthy British aristocrats, came there to escape England's harsh winters. Still later, he settled in Florence, Italy, and he spent his final years in California.

Today, Barthé's sculpture is in the Whitney Museum of American Art, the Metropolitan Museum of Art, the Schomburg Center for Research in Black Culture, and many private collections all over the world. The only sculptor with two portrait busts—of Booker T. Washington and George Washington Carver—in the serpentine portico of the Hall of Fame in New York, Barthé asserted that being black was a help rather than a hindrance to his being an artist.

Barthé was born on January 28, 1901, in Bay St. Louis, Mississippi, a Gulf Coast summer retreat for wealthy New Orleans families that was famous for its beaches and one of the largest Catholic parishes in the South. His parents were of African, French, and Native American descent. His father, Richmond Barthé, Sr., died at the age of twenty-two, when his son was only a few months old. His mother, Marie Clementine Robateau,

Booker T. Washington (1946). Washington, who emerged as the leader of African-Americans in the oppressive years that followed the collapse of Reconstruction, was portrayed by Barthé as a powerful man of vision. (Plaster, 28½″ h.) Schomburg Center for Research in Black Culture, New York Public Library

whose people had been free blacks in St. Martinsville, Louisiana, supported the family through her sewing for six years. She then married William Franklin, Richmond's godfather, a working man who also played the cornet in a band.

Barthé's drawing ability was discovered very early. "When I was crawling on the floor, my mother gave me paper and pencil to play with," he later recalled. "It kept me quiet while she did her errands. At six years old I started painting. A lady my mother sewed for gave me a set of watercolors. By that time, I could draw very well." His drawings won family admiration: "My mother and I would give names to the people I drew and make up stories about them. My stepfather admired them."

As a boy, Barthé helped his stepfather deliver ice during the summer. A Mrs. Lorenzen from New Orleans "didn't like my working on the ice truck. She said that carrying ice on my shoulder would give me rheumatism. She bought my first pair of long pants and sent me with a letter to see her friend, Mrs. [Harry] Pond, asking her to give me a job. Mrs. Pond took me to New Orleans to work and live with them and I stayed there until I was sent to Chicago to study art at the age of twenty-three."

During his years of employment in the various homes of the wealthy Pond family, helped by the considerateness of his employers, Barthé developed a natural poise and graciousness. His social ease is one of the first characteristics that his friends recall about him.

Through the Pond family, Barthé met Leslie Ducros, a *New Orleans Times-Picayune* writer. She introduced him to Lyle Saxon, the paper's critic, who posed

for Barthé and criticized his work. "We used to plan that some day he would give up his job on the paper and write his first book and I would leave the Ponds, become an artist and have my first exhibition. Both our dreams came true," Barthé recalled. Later a novelist, Saxon died in 1946.[3]

Impressed by a painting of Christ that Barthé had done for a church festival, the Reverend Jack Kane, pastor of the Catholic Blessed Sacrament Church, inquired into Barthé's background and problems. Finding no local art school would accept black students, Father Kane paid "with his own money," according to Barthé, for him to attend the Art Institute of Chicago. Barthé partially supported himself for these four years, from 1924 to 1928, as a waiter in a French restaurant.

In Chicago Barthé met a number of black artists at the Art Institute. One was Archibald J. Motley, Jr., who was beginning to achieve some recognition at the institute and who held a Sunday drawing class for other black artists in his studio, which Barthé attended. Most of these students could not attend the institute for lack of funds or because of their work schedules.

The greatest influence on Barthé's development was a painter, Charles Schroeder, who taught summer and Saturday classes at the Art Institute for more than thirty years. Under his guidance, Barthé studied anatomy and figure construction, both at the institute and privately. It was Schroeder's suggestion that ultimately made Barthé turn to sculpture. As Barthé explained it:

One day, during the last year I was with him, he asked me to do a couple of heads in clay, saying that they would give me a feeling for a third dimension

Supplication, also called ***Mother and Son*** (1939), frankly modeled after Michelangelo's *Pietà,* depicts an African-American mother holding the body of her lynched son. One of the few works by Barthé that could be considered a protest, it was exhibited at the New York World's Fair in 1939. A shipping accident destroyed it while it was being returned from the 1940 American Negro Exposition in Chicago. Photo: National Archives

in my painting. He said not to bother casting them—just throw them back into the clay box. I did heads of two classmates, one male and one female. They turned out so well, I cast and patined them and they were shown during "The Negro in Art Week" [at the Art Institute, sponsored by the Chicago Women's Club].[4] The critics praised them and I was asked to do busts of Henry O. Tanner and Toussaint L'Ouverture for the Lake County Children's Home in Gary, Indiana.

At the opening of this exhibition . . . four Jubilee Singers sang. I went home and from memory did a small head of one of them—*The Jubilee Singer.* A photo of it was used on the cover of *Crisis.* I sold many copies of it. I showed this and photographs of other first attempts to Jo Davidson and Lorado Taft [prominent American sculptors of the time], and they both advised that I keep away from instructors, that I had something in my work, a spiritual quality, that I could lose if I was influenced by an instructor. Since I knew anatomy, I did not need anyone to help me with proportions.

Thus began Barthé's career as a sculptor. His particular gift was in modeling a figure or face with a certain elegance and sensitivity. In contrast to many present-day sculptors, Barthé had little feeling for carving and very rarely did it. Clay was undoubtedly a medium more congenial to Barthé's talent; most American sculptors then followed the tradition of Augustus Saint-Gaudens of modeling figures in clay for later casting.

At times, particularly early in his career, Barthé's

work reflected the racial conflicts of the United States. One such work is *Head of a Tortured Negro.* Later, at the 1939 New York World's Fair, Barthé exhibited *Mother and Son,* an eloquent depiction of a black mother mourning over her dead son, whose neck shows rope marks.[5] These themes of protest had a genuine and deep reality to Barthé, who had come from Mississippi, where lynchings were common in his boyhood.

Soon after his work appeared in *The Crisis,* Barthé was offered a one-man show in New York. Feeling he was not ready for it, he declined and spent 1929 studying at the Art Students League in New York. On returning to Chicago in 1930, he exhibited forty pieces at the Women's City Club. Fortunately for his continued development, he was awarded, on the strength of his first exhibition, a Julius Rosenwald Fund fellowship.

Barthé's work won an honorable mention in the 1929 Harmon exhibition, and his first one-man show in New York at the Caz-Delbo Gallery in 1931 won high critical praise. Edward Alden Jewell, the influential *New York Times* critic, characterized Barthé as "a sculptor of unmistakable promise," noting that his "modeling is most sensitive, communicating at once the spirit of the subject and the spirit that distinguishes all of this young sculptor's aspirations. Richmond Barthé penetrates far beneath the surface, honestly seeking essentials, and never . . . stooping to polish off an interpretation with superficial allure. There is no cleverness, no damaging slickness in this sculpture. Some of the readings deserve, indeed, to be called profound."[6]

Left: **Blackberry Woman** (1932) was one of the first works by a contemporary African-American sculptor to be purchased by the Whitney Museum of American Art. Elegant in its dignity, it was cast in bronze. (34⅛″ h.) Whitney Museum of American Art, New York

Right: **African Dancer** (1932) excited crowds at the 1933 annual exhibition of the Whitney Museum with its rhythmic vitality. Barthé was drawn into theatrical and dance circles in New York soon after his arrival from Chicago. He studied dance with Mary Radin of the Martha Graham group. Whitney Museum of American Art, New York

Jewell reported that an interviewer (who may have been Jewell) had asked Barthé about his response to Alain Locke's call for a racial art. Barthé responded, "I don't think art is racial, but I do feel that a Negro can portray the inner feelings of the Negro people better than a white man can."[7]

Barthé's New York success brought him permanently to New York, and his Rosenwald grant was renewed. The esteem with which he was held by his gallery was reflected in 1933 when, on moving to Rockefeller Center, the Caz-Delbo Gallery opened with an exhibition of Barthé's work surrounded by old master drawings.

Barthé also exhibited at the 1933 Chicago World's Fair with Tanner and Motley. Copies of his portrait of a leading African educator, James Aggrey, commissioned by the Phelps-Stokes Fund, were distributed in many African countries. In 1934 Xavier University, a prominent Catholic institution in New Orleans and now one of the few institutions in the South to provide training for sculptors in casting, awarded him an honorary master of arts degree.

Much interested in Barthé's work, Gertrude V. Whitney, herself a sculptor, and Juliana Force, then director of the Whitney Museum of American Art in New York, arranged another exhibition of his sculpture. The museum bought three statues from the show: *Blackberry Woman, African Dancer,* and *The Comedian.*

Recognition from all these sources, particularly the Whitney, prompted other museums and collectors to seek his work. Although Barthé worked briefly as a "duster" in an admirer's antique shop,[8] his work was soon in such demand that he was able to devote himself entirely to his art. His success was such that, late in 1934, he was able to go to Europe. This tour of European museums and galleries, in his words, "opened up a new world" and led to exhibitions abroad. Today his work is in private collections in many countries.

During the 1930s, like many other African-American artists, Barthé was fascinated by dance. To deepen his own feeling and understanding of the body's musculature, Barthé joined a modern dance group under Mary Radin at Martha Graham's studio. His figures of dancers, lyric portrayals of the body in motion, are among his best works, achieving their effects through linear qualities rather than volume and mass. His dance experiences were of considerable help to Barthé when, in 1937, he was commissioned by the Treasury Public Works of Art Project to create two eight-by-forty-foot bas-relief panels for the Harlem River Housing Project amphitheater. In one panel he depicted black dancers, and in the other, the "Exodus" scene from the 1930 Pulitzer Prize winner, *The Green Pastures.*

In March 1939 Barthé's largest exhibition, with eighteen bronzes, opened at the Arden Galleries in New

Relief frieze for the Harlem River Houses, commissioned in 1937 by the United States Treasury Department. Barthé based the figures on the Exodus scene from *The Green Pastures,* a theatrical hit of the 1930s, and on an African-American dance troupe. There were two bas-relief panels, each 8½ x 40′.

York. Critically acclaimed, it helped him gain a Guggenheim fellowship in 1940 and again in 1941.

When the United States entered World War II, circumstances combined to place Barthé under severe strain. In his absorption with his art and his social success, Barthé somehow remained fixed in attitudes characteristic of the Harlem Renaissance. For most black artists those attitudes had vanished with the Depression, when, as Langston Hughes put it, they discovered black people "were no longer in vogue."[9] But Barthé had never experienced this change in the social tides, and with the coming of the war he found himself in demand for political and social functions related to the war. He became the most highly publicized black artist in the country.

What underlay the publicizing of Barthé was the need to mobilize black manpower for the war effort and to convince both black and white citizens, as well as the Allies, that the United States was, despite segregation and discrimination, democratic. Barthé was included in programs of all kinds. The New York City radio station WNYC dramatized his life. The Office of War Information filmed Barthé at work and displayed much of his work; the film was shown in the United States and abroad.

Barthé was awarded the James J. Hoey Award for Interracial Justice, and nearly every interracial organization published material about him. In 1942 he was awarded a prize at the "Artists for Victory" exhibition, a show organized to stimulate artist participation in war propaganda efforts. As Barthé later summed it up, "This was the answer to Hitler and the Japanese who said that 'America talks democracy, but look at the American Negro.' " He added, "I think I have gotten more publicity than most white artists, much of it because I was a Negro."

However, publicity is not the goal of art, as Barthé always knew. While he enjoyed the attention, the official citations, and the supper invitations, much of this activity distracted him from creative work, and none of it provided steady financial support. At a time when he was one of the most highly publicized black artists in the nation, he was barely able to support himself.

Barthé's work in this period included a bust of the Hearst journalist Arthur Brisbane, an eighty-foot frieze for the Kingsborough Housing Project in Brooklyn, and sculpture for the Social Security Board Building in Washington, D.C. He also turned out three Christ figures for Catholic churches and institutions, which, as a devout Catholic, meant a great deal to him. He wanted to emphasize Christ's humanity, personal charm, and popularity, he said, adding, "Jesus was always being asked out to dinner. People were crazy about him."[10]

During these war years, Barthé created heroic statues of black generals of the past, including Toussaint L'Ouverture and General Jean Jacques Dessalines, the first important black military leaders in the Western Hemisphere.[11] These monumental works stand in Port au Prince, Haiti, and his portrait of Toussaint L'Ouverture appears on Haitian coins.

Profound changes in aesthetic values and concepts following World War II tended to cut Barthé off from the most dynamic currents in sculpture. Aesthetic interest moved in the direction of Abstract Expressionism, stimulating acceptance and enthusiasm for the symbolic imagery of Brancusi, the eloquent forms of Henry Moore, and ultimately for the welded-steel abstractions of David Smith. In this ground swell even the status of Jo Davidson and Jacob Epstein, the foremost modeling portraitist of America and England, sagged. In contrast, the work of Jacques Lipchitz, who had come to the United States during the war as a refugee, gained favor with expressionistic dramatizations of ancient myths.

All of this tended to push Barthé into the backwaters of public interest, for he was neither an innovator nor an experimentalist, but very much a

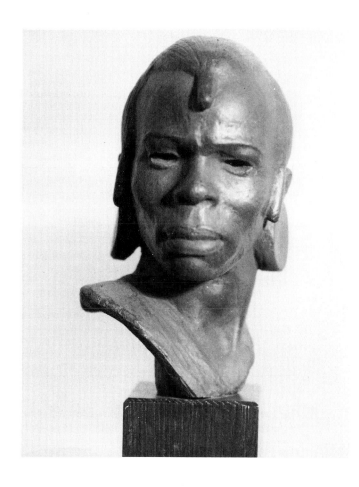

Shilluk Warrior (1934) was one of eighteen sculptures shown by Barthé in the Harmon Foundation's last exhibition in 1935, which featured only his work, Sargent Johnson's sculptures, and Malvin Gray Johnson's paintings. Although a small head according to Barthé's half brother Louis Franklin, this sculpture has a monumental character and alert directness. The Shilluks are a tall Nilotic people who typically have "a fierce, sometimes a proud, haughty look," according to Diedrich Westermann. Many plaster copies of this work were made but they cannot be located today. Photo: National Archives

traditionalist. Always absorbed in how emotional and spiritual feelings express themselves in physiognomy, movement, stance, and gesture, he was not drawn to symbolism or mythology. New materials did not attract him nor did the work of Elie Nadelman, whose concern with social types offered a new concept in American sculpture. If Barthé admired anyone, it was Auguste Rodin. However, Barthé's work moved toward the lyrical rather than the intense dramatizations that Rodin created.

That Barthé had not been on the WPA separated him from most artists, and that he rarely got to Harlem isolated him from African-American artists. Being highly publicized during the war had further distanced him.

Previously interested in a wide range of black personalities and types, he now turned almost exclusively to portraiture of wealthy people and particularly of theatrical stars. From his first arrival in New York he was attracted to theatrical people and increasingly traveled in their circles. In these postwar years Barthé turned to an extraordinarily difficult type of portrai-

ture, one which in itself is a severely demanding and restrictive art form. Barthé's first attempt at such portraiture was a head, *The Comedian,* which was purchased by the Whitney Museum. His interest—indeed, his fascination—in stage stars was reinforced by an early success. In 1930 an African-American folk drama about getting into heaven written by Marc Connelly, *The Green Pastures,* had become a memorable hit, running for years. Its star was the brilliant African-American actor Richard B. Harrison, who had earlier gained a national reputation with dramatic readings and interpretations of Shakespearean roles. In *The Green Pastures* he appeared as "de Lawd" in the plain black suit of a black preacher who is confronted with the perplexing life problems of various sinners. Harrison won the Spingarn medal of the National Association

Life Mask of Rose McClendon (1932). McClendon became one of the first African-American theatrical stars in *Deep River* in 1926, in *Mulatto,* and in many other plays. This sculpture was exhibited by Barthé in the Harmon exhibition of 1933. Photo: National Archives

Left: **Sargent Johnson** ***Forever Free*** (1935) began with Johnson carving a large piece of redwood to create the basic figures. He then covered it with several coats of gesso and fine linen, sanding each coat before applying the next. Finally, the whole statue was highly polished, giving it a smooth surface and high luster. To do this, Johnson adapted the polychrome techniques used by ancient Greek, Egyptian, and Asian artists. This sculpture evolved from a series of mother-and-child drawings and lithographs. A powerful yet simple statue, *Forever Free* has been Johnson's most popular work and widely exhibited. (Polychrome wood, 36″ h.) San Francisco Museum of Modern Art

Below: ***The Bull.*** Almost alone among African-American artists, Johnson was an innovator, constantly experimenting with new techniques. He created porcelain-enameled steel plates such as *The Bull*, and with such techniques created huge murals of Western pioneering scenes. (Enameled steel, 16 x 12½″) Collection Dr. and Mrs. Jack D. Gordon, San Francisco

Above: ***The Domino Players*** (1943) recalls the family life that Pippin valued. This small painting, authentic in its detail, has a monumental character. (Oil on composition board, 12¾ x 22″) The Phillips Collection, Washington, D.C.

Left: ***Man on Bench*** (1946), one of Pippin's last paintings, reflects his isolation and despair. Success as an artist had not brought him a peaceful family life but conflict and misunderstanding. (13 x 18″) Collection Mrs. Sidney E. (Roberta) Cohn, New York

Horace Pippin *Holy Mountain III* (1945) represented Pippin's profound hope for peace and brotherhood, the end of racism, symbolized by the biblical lion and lamb lying down together. Untrained, Pippin painted in a flat modern way. (30 x 36″) Hirshhorn Museum and Sculpture Garden, Washington, D.C.

John Brown Going to His Hanging (1942). A master of color and design, Pippin portrayed some important events in African-American history. The woman in the right corner represents his grandmother, who told him the story of Brown's hanging. (24 x 30″) Pennsylvania Academy of Fine Arts, Philadelphia

Fruit Trees and Mountains (1936–38), painted by Johnson during a Norwegian coastal trip, shows his mastery of Expressionism. Hitler's rise and a desire to portray his own people prompted Johnson's return to the United States. (Oil on burlap, 28 x 35⅛") National Museum of American Art

W. H. Johnson **Mount Calvary** (ca. 1944), with a crucified black Christ and mourning black women, reflects Johnson's deep identification with his people. It also demonstrates his adaptation of the expressionistic style he developed in Europe to depict the feelings of many African-Americans. His "new style" shocked many, but he felt it was an extension of his past work. (Oil on paperboard, 27¼ x 33⅛") National Museum of American Art

Hale A. Woodruff *The Cardplayers* (1978) shows the influence of Cézanne and Cubism on Woodruff, although modified by time. In an earlier version Palmer Hayden posed as a cardplayer. (36 x 42″) Collection Vivian and John Hewitt, New York

Forest Fire (1939), a watercolor painted on a Colorado trip, shows Woodruff's mastery of that medium and his prompt response to his surroundings. (Watercolor, 14 x 18″)

Celestial Gate (1969) was inspired by Woodruff's study of Ashanti gold weights and Dogon granary doors. While he was in some ways a precursor of Abstract Expressionism, his abstractions were always derived from African subjects. (50 x 56″) Spelman College, Atlanta

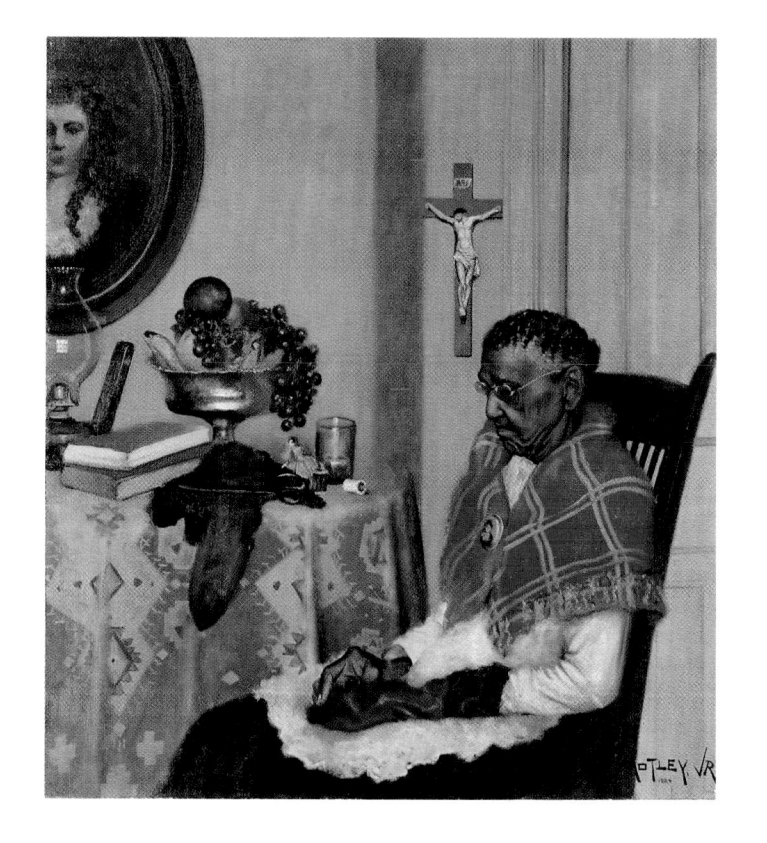

Right: **Mending Socks** (1924) won the popular prize at the Newark Museum in 1927. Motley considered this portrait of his beloved grandmother his best. Conveying a sense of dignity and usefulness in old age, it became his most popular work. (43⅞ x 40″) Ackland Art Museum, Chapel Hill, N.C.

Below: **Blues** (1929), painted in Paris when Motley was on a Guggenheim fellowship, captures the essence of an interracial jazz nightclub. Motley created such complex compositions by working initially with abstract shapes in color. (36 x 42″) Collection Archie Motley and Valerie Gerard Browne

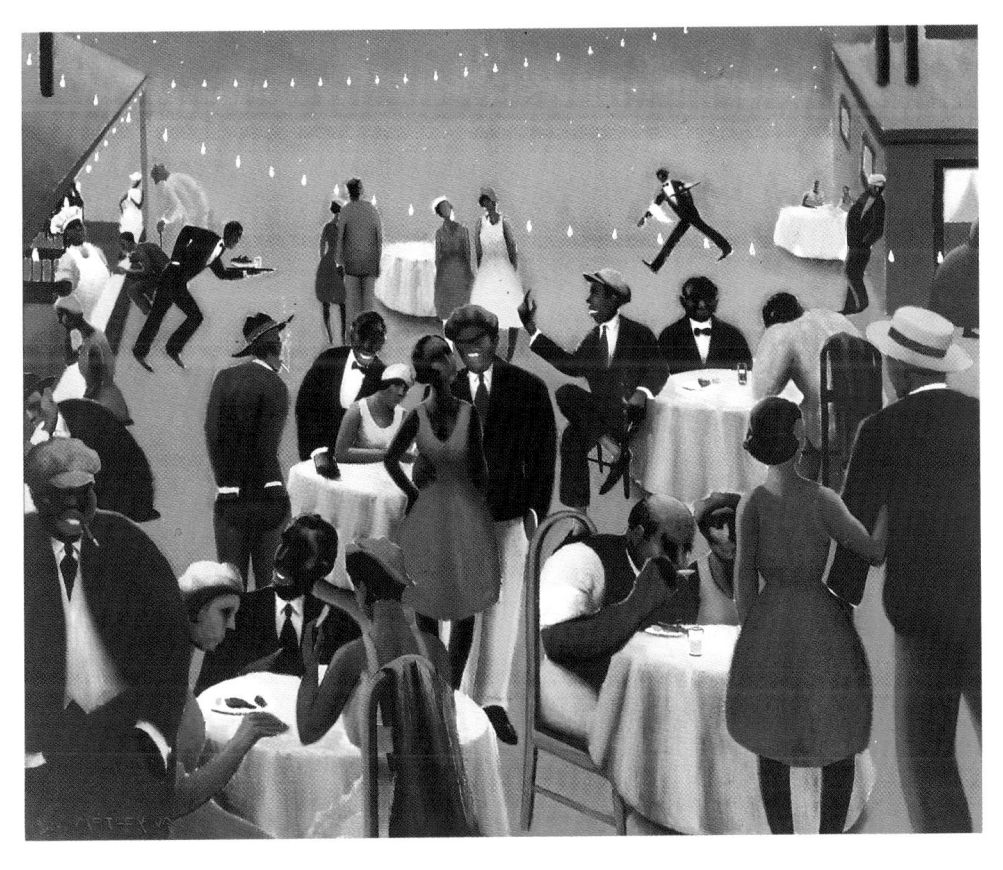

Archibald J. Motley, Jr. *Barbecue* (1934) combines Motley's fascination with light at night with his focus on black city nightlife. In this scene, the animated silhouetted figures, glowing background, and strings of lights create a mood suggestive of a strong jazz beat. Nothing like this had been seen in American painting before. In the PWAP exhibition at the Corcoran Gallery, it helped convince Congress that American art was worthwhile. (36¼ x 40⅛″) Howard University Gallery of Art

Left: *Octoroon* (1922) was typical of portraits Motley did of beautiful women of mixed racial ancestry in the 1920s. He then turned to livelier street and club scenes. (37½ x 29¾″) Collection Judge Norma Y. Dotson, Detroit

Below: *The Liar* (1936) reflects Motley's ability to capture the tensions in a group of black men. In such paintings Motley portrayed real human qualities that were disturbing to pretentious people. (32 x 36″) Howard University Gallery of Art

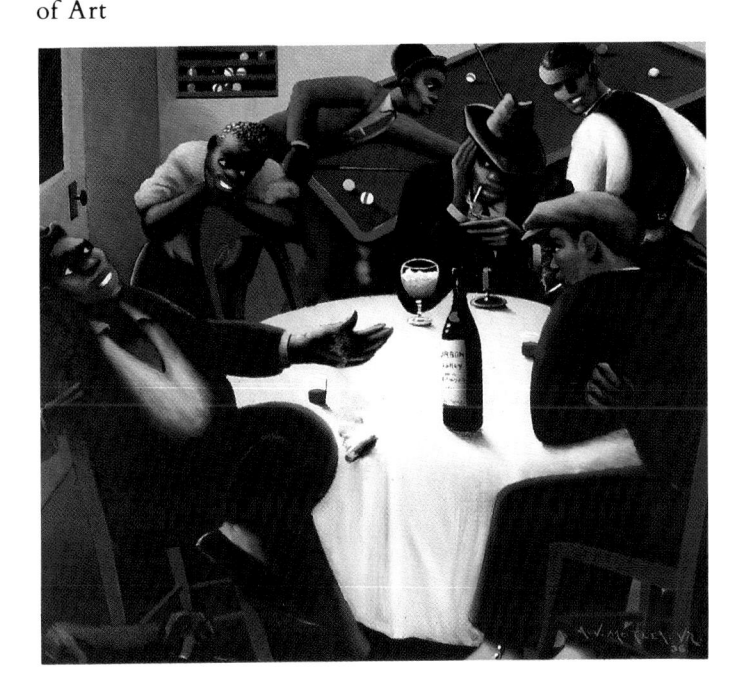

Above: **Aaron Douglas** *Aspects of Negro Life: From Slavery Through Reconstruction* (1934) marked the progress of African-Americans. It reflected Douglas's great ability to make the past part of the present. This mural was one of a series created by Douglas during the Depression for the Harlem branch of the public library under the Public Works of Art Project. (60 x 128") Schomburg Center for Research in Black Culture, New York Public Library

Left: **Building More Stately Mansions** (1944) demonstrates Douglas's growing mastery of color and his use of Egyptian art to symbolize a haunting African past. He was the first artist to link modern African-Americans with their African heritage. Identifying his people—not machines—as a constructive force in American life, he used concentric rings to symbolize the need for education of their children in building the "stately mansions" of the future. His flat, elongated silhouettes of black figures, advanced for their time, created a new image of African-Americans. (54 x 42") Carl Van Vechten Gallery of Fine Arts, Fisk University, Nashville

Laurence Olivier as Hotspur in Shakespeare's *King Henry IV* (ca. 1940) is one of Barthé's best portraits of actors in roles they made famous. Critic Henry McBride felt Barthé's Hotspur "places the theatre very much in his debt and sets a fashion to be emulated." This is a photograph of a plaster cast owned by Louis Franklin. The bronze could not be located. (18″ h.)

for the Advancement of Colored People for his performance, which he played over 1,600 times. Barthé, intrigued by the theater and deeply religious, made a portrait bust of "de Lawd" as he appeared in the play.[12] His portrait was acclaimed by theater critics.

This success, and the popular response to his mask of Rose McClendon, the star of *Deep River, Abraham's Bosom,* and *Mulatto,* led Barthé to embark on a series of portraits of stars in their favorite or current roles. In 1942, at the Arden Galleries, he exhibited portraits of Maurice Evans as Richard II and John Gielgud as Hamlet. Such sculpture was an exceedingly ambitious effort, requiring interpretation of the dramatic character as well as the personality and likeness of the star. Moreover, the series was uncommissioned yet inevitably highly publicized. Once Barthé started on this project, he had to "capture" stars whom he initially did not know well in order to have enough portraits for a full exhibition, creating greater tension for himself. Economically, the series required an enormous investment of time and energy. Eventually he added Laurence Olivier as Hotspur, Katharine Cornell as Candida, Judith Anderson as Mary, and others. While the stars were not collectors, there was always the chance that they or some admirer might purchase the work. To complete this series, Barthé was kept in a state of feverish anxiety and activity. He also was winning new honors—an award of $500 and recognition from the National Institute of Arts and Letters in 1946.

When his theater portraits were exhibited at Grand Central Art Galleries in the spring of 1947, the critical response was favorable but bland. Emily Genauer, then the *New York World-Telegram* critic, more perceptive than others, applauded the "excellent likenesses," but recognized that something else was happening: "In their over-elaboration of meaningless details of costume and feature, they are made commonplace and quite empty of inner meaning."[13] In short, the very quality that had made his earlier portraits of black working people so perceptive and meaningful was missing from his portraits of the famous actors. Barthé sought, in an ambitious way, to portray both the role, for which the actor was famous, and the actor as a serious artist. Although he worked hard, these portraits were somehow caught up in superficial theatrical pretense, with costumes and likenesses, but not the force of the actor's personality.

In this situation the internal and external pressures of Barthé's life brought him to a crisis. He was dissatisfied with himself and his work and without friends. Old English friends, like Noël Coward, had gone back to England. Both Harrison and McClendon had died. The theater he felt a part of was gone. So was the prewar Harlem he had occasionally visited; its artists were scattered. And the critical excitement over abstract sculpture left him feeling estranged and abandoned. In a certain sense his whole milieu had vanished.

Depressed and anxious, he reached a state of nervous exhaustion. "My nerve ends were sick and the doctor ordered me to leave New York," Barthé recalled. "He said there was too much tension for me. A friend bought a home in Jamaica and invited me down—and I went and fell in love with the beauty of the island. I built a home there and was very happy in it." By 1950 many of his old friends, including English theatrical stars, were visiting him there.

On the Caribbean island Barthé gradually resumed work, turning out many portraits and small figures with a steady flow of commissions from wealthy American and British tourists. In March 1966, he wrote to a friend: "Tourists come here to see paintings, sculpture, my seashell collection, old Jamaican furniture. . . . I raise my own coffee, chocolate, breadfruits, bananas, and plantain. . . . I enjoy the easy life with the rolling hills, pure air, and beautiful flowers. . . . I don't think I shall ever want to live any place else. I don't like cities and rushing anymore."[14]

However, in the mid-1960s, when the civil rights

143

Lindy Hop (1939) celebrated the exuberant dances of the 1930s when the Lindy Hop and jitterbugging were invented at the Savoy Ballroom in Harlem. According to Barthé's brother, many copies of this work were made. Photo: National Archives

movement was stirring the nation, Barthé's work was remembered by those seeking to change the image of the black American. Responding to an invitation to return to his birthplace, Barthé was delighted when the mayor of Bay St. Louis held a reception and presented him with the key to the city. Another reception was held at St. Augustine's Seminary, a Catholic school for black priests. There was also a reception at Tulane University, giving New Orleans artists and students a chance to meet Barthé, who had once been barred from study in that city. Still later, in 1971, a street in Bay St. Louis was named for him. These events were heavily covered by the press and television.

Barthé's triumphal visit to the South further stimulated tourist visits to his Jamaican home, a two-acre plot he called "Ioalus." As the home and studio of Jamaica's only internationally known artist, it became a tourist showplace. The pattern of hectic social activity that had driven Barthé from New York now reappeared. In the same letter in which he rejoiced over his

pleasures in Jamaica, he also revealed things were getting out of control. He wrote: "I have been so busy with unfinished work, unanswered letters, and tourists. . . . Since the first of January I have had 118 tourists sign my guest book. I am trying to get enough work finished for a one-man show in New York."[15]

Almost twenty years had lapsed since Barthé had had a show, but, as the pace on the island became faster, it became apparent to him that he could not put together an exhibition, that he had to get off the island to escape its pressures. "With the coming of all the hotels, the people and the atmosphere of the islands changed," he later said. "So in 1969 I decided to leave. I spent the winter in Switzerland and in April 1970 I came down to Florence and decided this is where I shall stay. I love it here, surrounded by the great art of the Renaissance, where buildings never change."[16]

Barthé went to Florence by way of England, where he did a bust of an old friend, Lady Hailes; he had previously made one of Lord Hailes. He continued to make such busts, but remained in Europe, writing occasionally to Louis Franklin, his half brother who was close to him, and a few friends such as Bruce Nugent and sculptor John Rhoden, who had studied with him in the 1940s.

In the late 1970s Barthé, aging and alone in a foreign country, isolated by the death of old friends and ignorance of his work among younger people, decided he had had enough of Italy. In 1977 he disposed of his few possessions and came to Pasadena, California, prompted perhaps by a sister in San Francisco. An African-American woman, Esther Jones, who owned an apartment complex and knew of his earlier achievements, let him have a small apartment at reduced rent. He was soon in contact with the African-American artist Charles White, who lived in nearby Altadena. Barthé and White had known one another in Chicago and shared strong academic roots. White and his wife Frances found Barthé still had his charming ways, often telling fascinating stories in the form of parables and fables. However, he appeared indifferent to material needs in a mystical way. Recognizing that Barthé was impoverished, they found that he was denied Social Security benefits because, under its rules, he had never been employed and had been out of the country for decades. Californians who knew Barthé's past were shocked. Nanette Turner, a magazine writer, interviewed Barthé and, on a studio visit, gave her story to actor James Garner, then working on a television series, "The Rockford Files."

Impressed by Barthé's talent and disturbed by his neglect, Garner asked to meet Barthé, who had always had great rapport with theatrical people. The two became friends. Garner quietly paid Barthé's rent and,

James Garner (ca. 1981). The actor quietly befriended Barthé in his last days, paying his rent and medical expenses. Barthé made this bust and the two small heads of women in gratitude. (Bronze, 16″ h.) Collection James Garner, Hollywood

with friends, tried again to get Barthé Social Security funds, without success. Meanwhile Charles White had died, but Frances White continued to help.

Others also helped. Esther Jones began a successful drive to have their street named Barthé Drive, which lifted his morale. Barthé's eightieth birthday was celebrated with a party of friends hosted by Garner. A Barthé Historical Society, headed by Lee Brown of the California Institute of Technology, raised about $3,000, which was enlarged by grants from the Mosley Foundation of South Pasadena; this money funded thirty Barthé scholarships in the fine arts.

In appreciation of Garner's help, Barthé modeled a portrait head of the actor, which is believed to have been his last sculpture. Shortly after that, in 1986, Barthé gradually lost strength and energy and fell terminally ill. Garner, paying for all Barthé's medical expenses, kept his role private, known only to Barthé's close friends.

Barthé died March 5, 1989.[17] He had willed his work to Garner, who, feeling he knew nothing about art, turned it over, as Barthé had suggested in his will, to Samella Lewis, an art historian and founding director of the Museum of African American Art in Los Angeles.[18] Those Barthé sculptures previously on loan to the Schomburg Center in New York were given to it, and Lewis has planned a major memorial exhibition of Barthé's work.

Barthé emerged as the outstanding academic sculptor of the Black Renaissance, and his work continued to demonstrate a compelling unity in theme and style over a period of more than sixty years. This unity is all the more striking because of the changes not only in the social milieu but also in the concepts of art during this period; Abstract Expressionism, for example, soon became outmoded. What Barthé's life and work make clear is the individuality of African-American artists. Although they share a racial identity and, especially in the 1920s, certain common experiences, each works out of his or her own experience and vision of the world.

A sensitive, creative man, and the least parochial of the black artists of the 1920s, Barthé at times offered contradictory accounts of his past. Although he himself was not allowed to study in New Orleans, he later recalled no difficulties, claiming, "While I was there I met no problems because of color. From the very beginning of my career I exhibited along with white artists and I was invited to join their groups. I was a member of the Sculptors Guild, the Audubon Artists—a director for one year—and the National Sculpture Society. I found that being a Negro was an asset, not a hindrance."

Barthé desired to be identified as a black artist. In the late 1960s he was deeply hurt when an exhibition committee selecting work that demonstrated the contribution of African-American artists to American art omitted his work. With works in public and private

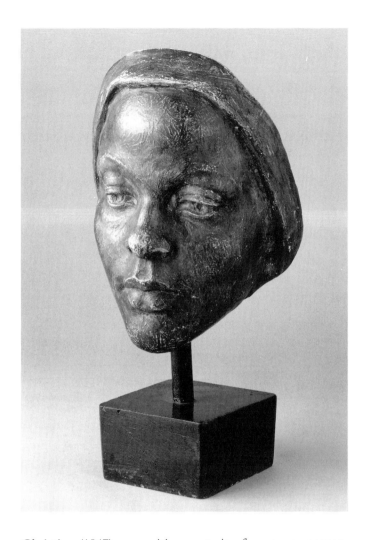

Christina (1947), a sensitive portrait of a young woman, demonstrated that Barthé could push his artistic traditionalism to its limits. This work won first prize for sculpture at the 1948 exhibition at Atlanta University (Plaster, 9½" h.) Collection Clark-Atlanta University

collections all over the world, he felt he deserved more than this, saying, "I don't know any Negro, living or dead, who has done more than I have in sculpture."

Asked what he considered his most significant work, Barthé responded, "I don't know. My favorites are—the *Mother,* with her lynched son; *Come Unto Me,* a six-foot figure of Jesus;[19] and *The Awakening of Africa.*" Interestingly, these works express a social and racial consciousness not generally associated with Barthé.

Barthé's major commitment was at all times to his art. In contrast, another black sculptor of the period, Augusta Savage, worked within the Harlem community with total dedication to her students, often to the sacrifice of her own artistic development.

When Barthé began modeling in the 1920s, American sculpture was dominated by the concepts that had produced Augustus Saint-Gaudens, Daniel Chester French, and Lorado Taft. These traditional concepts were fundamental to Barthé's art—and to that of most American sculptors of that period, such as Jo Davidson.

During his initial and most productive period, Barthé portrayed black Americans and their spirit in a lyric way—a view that was new to most Americans. His outlook throughout his work was based on his observance of universal human qualities and was not restricted to black subject matter. No matter how or where he has lived, his work possesses a marked thematic and stylistic unity.

In his best work, done mostly in the 1930s and 1940s, Barthé created a tension between the repose and supple action of his figures. In his full figures, the movements flow upward and outward with an expressive intensity that derives from a deep appreciation of human vitality. The genuine movement in his work frees it from the frozen world of Neoclassical sculpture. Barthé was always aware that as a sculptor he was, in his art, singing in praise of the beauty of the body. In this, he did not overlook the passions, the sadnesses and felicities, of life. Within the traditions of his period, Barthé must be considered one of the most distinguished contributors to American sculpture.

ARCHIBALD J. MOTLEY, JR.

A member of a talented, closely knit African-American family with high aspirations, Archibald J. Motley, Jr., emerged as an artist at a time when Henry Ossawa Tanner was the only widely recognized American artist of African descent. Very different in their techniques and fundamental aesthetic and philosophical concepts, Tanner and Motley demonstrated the range of ability of black artists and the significant change in the attitudes of black Americans that took place between the early 1900s and the 1920s. While Tanner was a more fluent technician, Motley was the first artist to establish the social life of African-Americans in cities as memorable subject matter. Where Tanner turned to mystic religious symbolism to express his feelings, Motley sought to portray the spirit of urban black neighborhoods, usually in a twilight or evening atmosphere.

Today Motley's work is recognized as a superb, joyous celebration of the vitality of urban African-Americans as well as an unparalleled picture of their social activities in the 1920s and early 1930s. His paintings reflect the experiences of a man sensitive to social forces, who turned to the life he knew best for his subject matter. Motley dealt cogently with subject matter that not only most African-American artists during the early 1920s, but most white artists as well, considered undignified for high artistic expression. It was the work of artists such as George Bellows, Glenn Coleman, George Luks, and John Sloan, together with the novels of Upton Sinclair, Theodore Dreiser, and Frank Norris, that turned attention to the world of the American city.

In Motley's paintings there is an intense personal urgency based on his complete conviction of the importance of what he saw. "It is my earnest desire and ambition to express the American Negro honestly and sincerely, neither to add nor detract. . . . [I] believe Negro art is someday going to contribute to our culture, our civilization," Motley said.[1] This belief, making up for some shortcomings in technique, holds one

fascinated with his teeming world. The people he portrayed are hurrying, gesturing, going someplace—and rushing to get there. And in this activity his paintings assert something that goes beyond black neighborhood life: it is both a self-respect—a liking of one's self—and a promise of something interesting and good, a promise that ignores the roles to which American society then restricted its black people. In these early paintings Motley directly expressed the deep feelings that underlay the concept of the "New Negro" and made the onlooker wonder how the inherent drama would unfold. In this sense, his work differed profoundly from that of Tanner, whose religious painting had moved Paris a quarter of a century earlier. Motley's characters played jazz, not hymns. "I feel my work is peculiarly American, a sincere personal expression of the age, and I hope a contribution to society. . . . [It] is, indeed, a racial expression and one making use of great opportunities which have long been neglected in America. The Negro is part of America and the Negro is part of our great American art," Motley asserted.[2]

Archibald Motley, Sr., and his wife, Mary Huff, became the parents of Archibald, Jr., on October 7, 1891, in New Orleans, where the senior Motley operated a general merchandise store. But eighteen months later threats from white competitors forced his father to abandon his store and the family to begin a search for a new home. They tried Buffalo and St. Louis before settling in Chicago, where his father became a Pullman porter and the family moved into a quiet neighborhood on the West Side. Eventually Archibald, Sr., bought a small but comfortable house on West 60th Street, which the family occupied for the next seventy years. Under the care of his grandmother, Archibald Motley, Jr., grew up in this house. Here he listened to his father and A. Philip Randolph plan the organizing of the Pullman porters' union at the dining room table. At the same table, he later watched his young nephew Willard,

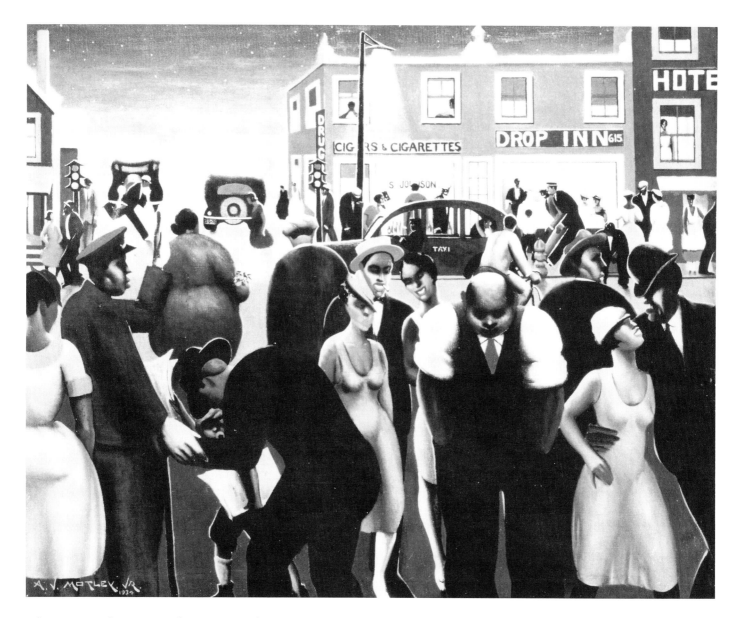

who was to become a famous novelist, struggle to write.

Young Archibald discovered at an early age that he had an unusual gift for drawing. He compulsively filled his school tablets with sketches. By the time he reached high school, he had become convinced that he could do nothing else and told his father to give up ideas of his becoming a doctor. He resolutely pursued his goal of becoming an artist. Later, when he began to court an attractive girl of German descent who lived across the street, Edith Granzo, he warned her that his art would always come first. This did not deter her, and she waited twelve years to marry him.

His father, who was in charge of a buffet Pullman car on a famous train, the Wolverine, considered art "risky" and suggested architecture to Archibald as a field that was more "practical." One of his father's frequent Wolverine guests was Dr. Frank Gunsaulus, then head of the Armour Institute (now the Illinois Institute of Technology). On learning of Archibald's interests, Gunsaulus offered him a four-year scholar-

Black Belt (1934). Motley, the first artist to focus on black nightlife in the cities, was fascinated by its vitality and diversity. The mixture of light from both natural and artificial sources intrigued him, and he made it a characteristic of many of his best nighttime street paintings. (33 x 40″) Hampton University Museum, Hampton, Va.

ship in architecture at the Armour Institute. Years later Motley recalled, "I told him no, that I'd never make an architect. I said, 'I want to do something completely out of my soul, out of my mind.' " Appreciating such determination, Gunsaulus agreed to pay for Archibald's first year at the Art Institute of Chicago.

Motley began his formal training at the Art Institute of Chicago before World War I. After the first year he gained a tuition-paying job—dusting statuary; moving chairs, podiums, and easels; and doing other tasks. This work and other odd jobs, plus twenty-five cents a day from his father, enabled him to stay for four years. At the institute Motley formed a close, lifelong friend-

ship with two other young aspiring artists, Joseph Tonanek and William Schwartz, later well-known Chicago artists.

Motley encountered none of the prejudice at the institute that plagued many young black artists. As he recalled later: "I was treated with the greatest respect, not only by the faculty but by the students as well." There were a few other African-American students at the institute at the time, including Charles C. Dawson, William McKnight Farrow, and William Edouard Scott.

Motley developed rapidly, studying drawing with John Norton, basic composition with Albert Krehbiel, and figure and portrait painting with Karl Buehr. However, he felt he learned the most from George Walcott, who taught "composition with color." Under Walcott, Motley learned to compose by sectioning off his canvas into a grid of rectangles. He would color a large area, then select and color small and intermediate spaces, imposing color values of varying intensity. On achieving a satisfying abstract relationship of these colors and shapes, he would develop the figures and objects.

Motley's education was considerably broadened during the summer vacation of 1917, when his father got him a job as a porter on trains that his father worked. "We traveled all over the country, from Hoboken to Los Angeles, north and south," Motley recollected. He found the travel stimulating and educational. Not only did he see a great deal of the country's varying landscape and major cities, with their diverse social conditions, but the porter's job enabled him to sketch between stops.

During that summer Motley began to paint. Lacking money for canvas, he used old railroad laundry bags. One of his best works, a portrait of his grandmother titled *Mending Socks,* was painted on this material.

After completing his Art Institute studies in 1918, Motley frequently painted with his friends Schwartz and Tonanek at Schwartz's studio in suburban Berwyn. Turned down every time he applied for commercial art jobs,[3] he supported himself by working as a laborer, coal heaver, steamfitter's helper, and plumber.

In 1919 he returned to the Art Institute to audit a series of lectures by George Bellows, who presented a robust and democratic view of city life in realistic paintings that teem with action in their brilliant colors and slashing wet brushwork. Bellows had helped organize the Armory show of 1913, which introduced European modern art concepts to America. Yet Bellows's own emphasis was not on Cubism, but on a vigorous portrayal of the tumultuous struggle of life that he saw around him. In the tradition of Thomas Eakins and Winslow Homer, and his own teacher Robert Henri, Bellows portrayed African-Americans with a keen appreciation of their humanity and dignity. Bellows's insistence on recognizing the art in everyday neighborhood activities reinforced Motley's own feelings and ideas.

Yet at this time Motley was terrified of failure. Fear of rejection kept him from submitting work to the institute's annual show. "In school you always depend upon that instructor to straighten you out," he later said. "When you are alone, a lot of people lose their confidence. I lost a lot of confidence."

Finally, in 1921, Tonanek insisted that Motley submit a recently completed portrait of his mother. When that painting was well received, Motley rapidly gained confidence. In 1923 he showed several other portraits and his first major composition, *Black and Tan Cabaret,* depicting an interracial nightclub and reflecting some of his own experiences with Edith Granzo, whom he married in 1924. While the institute jury accepted this painting, it was not mentioned by reviewers.

Then, in 1925, Motley's work won high praise. The portrait of his grandmother, *Mending Socks,* was very popular. His striking portrait of the wife of a Chicago physician, titled *A Mulatress* in line with the racial terminology of the day, won the $200 Frank G. Logan Prize. Another painting, *Syncopation,* received the $200 Joseph Eisendrath Award.[4] These paintings have not been located.

Motley had been advised by Farrow, who was then president of the African-American Chicago Art League and had long been employed by the Art Institute, not to submit *Syncopation* because, in his opinion, this dance hall scene reiterated racist stereotypes of black "low life," dwelling on jazz and sexuality. Farrow warned that the painting would not be accepted. Motley later told Elaine D. Woodall, "The [black artists] were awfully afraid, years ago, of sending anything that was Negroid to any of the exhibitions. Well, I, myself, felt they belonged. . . . I said [to Farrow], 'I'm going to send this painting in.' Not only was the painting awarded a prize, but reviewers praised it."[5] Even Farrow commented favorably.

Motley had exhibited his work earlier at the Municipal Pier, where it attracted a French critic, Count Chabrier. Just as French critics had recognized the musical merits of jazz before it was taken seriously in the United States, Count Chabrier saw in Motley's tender portraits and vital depictions of African-American so-

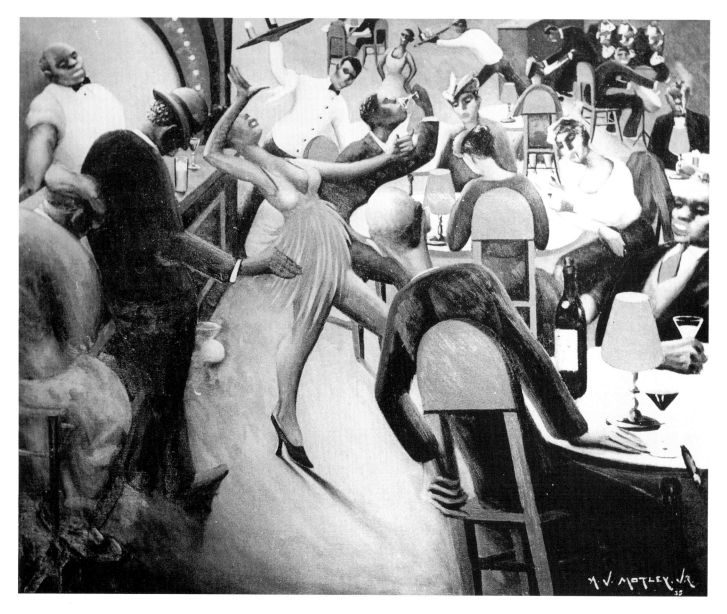

Saturday Night (1935) broke the taboos—which were an effort to deny the caricatures of blacks—against depicting African-Americans dancing, drinking, and gambling. Motley's people are active, lively individuals, not stereotypes. (37 x 45″) Howard University Gallery of Art

cial life something very new and different in American art. He corresponded with Motley and, in 1925, published two articles about him in *Revue du Vrai et du Beau,* a Paris art magazine.[6] This recognition encouraged Motley and impressed art circles in Chicago and New York.

Recognition also came from Chicago artists, who elected him director of the Chicago No-Jury Society of Art, making him the first African-American artist to be named to this post.[7] The exhibition put together by this group of independent artists was an important way for young, nonacademic, and abstract artists to win attention.

Robert B. Harsche, the Art Institute director, felt Motley needed assistance in gaining national recognition, and he helped get Motley's *Mending Socks* into the 1927 exhibition "Paintings and Watercolors by Liv-

ing American Artists" at the Newark Museum in New Jersey. There Motley's painting won the "most popular" prize. Harsche also got Motley to enter the Harmon exhibition in 1928, and his *Black Belt* won the gold medal. Harsche then personally toured leading New York galleries seeking an exhibition for Motley. Three galleries were interested, and Motley decided he would be best represented by George Hellman of the New Galleries, who offered him an immediate one-man show. It was "the first one-man show to be held by a Negro since Tanner," according to the 1933 Harmon catalog.

Edward Alden Jewell, the *New York Times* art critic and one of the nation's most influential art writers, devoted a major magazine article to Motley and his work—"A Negro Artist Plumbs the Negro Soul."[8] Visually, the article contrasted *Waganda [Uganda]*

Kikuyu God of Fire (1927), a fantasy about African religious beliefs, was prompted by a dealer's suggestion. It was shown in a 1928 New York exhibition, which Motley said changed his life because Chicago collectors had ignored him. (36⅛ x 44¼") Collection Judge Norma Y. Dotson, Detroit

Charm-makers, a fantasy of African dance rituals now lost, with his prize-winning African-American dance hall scene, *Syncopation.*[9]

In a sense, Motley seems to have been trying in these African fantasies to connect Alain Locke's "ancestral legacy" with contemporary African-American city life. This is hinted at by Jewell, who cited Motley's pioneer effort to forge "a substantial link in the chain of Negro culture in this country." Jewell described Motley's paintings in this way:

> Glistening dusky bodies, stamping or gliding, shouting or silent, are silhouetted against hot ritual fires. Myriad age-old racial memories drift up from Africa and glowing islands of the sea to color more recent ghostly memories of plantation days when black was black and slaves were slaves; and these memories sift, finally, through Negro life in northern cities of the present, leaving everywhere their imprint and merging with a rich blur of tribal echoes. Such are the themes and the material that enter into this artist's work. . . .
>
> . . . The ancient traits and impulses of his ancestors in Africa, Haiti, or wherever they found their habitation, trace here a milestone on the unending march; but the phantasmagoria is fascinatingly spiced with modern molds into which so much of the old race-life has been poured. The same fundamental rhythms are found, whether the setting be a jungle presided over by witchcraft or a cabaret rocking with the syncopation of jazz.[10]

Praising Motley's eloquence, Jewell said that "he has caught the spirit of life at moments both high and deep; and it is doubtless the underlying seriousness in his work that forces the spectator to pause and try to understand what he had done, what it is his steady aim to accomplish." Noting that Motley's road had been difficult because of prejudice, Jewell quoted him as saying, " 'I believe, deep in my heart, that the dark tinge of my skin is the thing that has been my making. For, you see, I have had to work 100 per cent harder to realize my ambition.' " Jewell also quoted an unnamed critic, who defined Motley's ambition in this way: " 'It is to arouse in his own people a love of art, and he feels that his goal can be reached most effectively if his people see themselves as the center of some artistic expression.' "[11]

Jewell's review had a direct impact. Twenty-two of the twenty-six paintings in Motley's show immediately sold, netting him between $6,000 and $7,000.[12] Before this he had not sold a painting in Chicago, but now collectors and dealers sought his work. After surviving on part-time jobs as a plumber or laborer for years, Motley, at the age of thirty-seven, was at last able to devote himself entirely to his painting. The Jewell review, Motley said when he was eighty years old, "changed my life."[13] Although some African-American leaders continued to object to his scenes of dancing, gambling, and nightlife because of the stereotypes of sensuous black women and sporty males, Motley had succeeded in establishing the artistic validity of black city life. He had also shown that the Black Renaissance was not just a Harlem phenomenon.

Considering the liveliness of the people in his paintings and the realism of the record he created of black city life in the 1920s and early 1930s, it is interesting that Motley worked in an abstract manner in the initial compositional phases. After visualizing the painting for "weeks, sometimes months," he began with numerous abstract pencil sketches, then moved to geometrical forms, and finally worked on color and spatial relations. What absorbed him most was the interaction of colors when two lights of a different character oppose one another; this concern is often an identifying characteristic of his work. As he said in an essay on his methods written after he won the Harmon gold medal:

I have always possessed a sincere love for the play of light in painting, and especially the combination of moonlight and artificial light. *Black Belt* [his prize-winning work] was born of that desire, and secondly, to depict street scenes wherein I could produce a great variety of Negro characters. This painting was built first in the stem shape, the round or oval next, the square or oblong shape, and finally the triangular shape [all common compositional concepts].

The color problem was this—"an arrangement of light and color." Early moonlight and shadows not too dark (out of doors). First, harmonize the color of the moonlight and the artificial light. In the background, plain sky, walls. A window of a house [with] artificial light shining through the windows and curtains or houses in the background. Let the illuminated shadow of artificial light remain to show the two effects of light, moonlight, and artificial light. Keep one of the two lights showing through the other.[14]

The combination of artificial and natural light and a concentration on the colors created within their shadows continued to preoccupy Motley throughout his life. His essay, which reveals his thoroughly professional approach, goes on to discuss in detail some of the major concepts of American painting of the 1920s. It also presents Motley's ideas about portraying black people, a subject that many African-American and white intellectuals were then discussing:

For many years artists have depicted the Negro as the ignorant, southern "darky," to be portrayed on canvas as something humorous; an old southern black Negro gulping a large piece of watermelon; one with a banjo on his knee, possibly a "crapshooter" or a cotton-picker or a chicken thief. This material is obsolete and I sincerely hope that with the progress the Negro has made, he deserves to be represented in his true perspective, with dignity, honesty, integrity, intelligence and understanding. Progress is not going to be made by going backward. The Negro is no more the lazy, happy-go-lucky shiftless person he was shortly after the Civil War. Progress has changed all this. In my painting I have tried to paint the Negro as I have seen him and as I feel him, in myself without adding or detracting, just being frankly honest.[15]

Although reflecting some stereotyped myths about black history, Motley's 1929 statement was significant historically. He articulated what many African-American artists were trying to express. While Tanner had felt that he had to demonstrate that an African-American artist could successfully compete in the leading European art circles, those of the 1920s turned to portraying their own people in a very direct way. For Motley, who lived and had his studio in a white neighborhood, this meant he had to travel to Chicago's South Side. Despite his focus on African-American life and dedication to its authentic portrayal, he was a detached observer. As he later explained:

I never associated much with colored people because, you know, I always lived in white neighborhoods. I used to go out of the neighborhood and go in colored districts and pool halls and what they called saloons, where they gathered. And I'd go there just to study them and make sketches. . . . I made quite a study of them. I enjoyed them. They have such a peculiar, subtle sense of humor. It's impressive, very, very impressive. I just enjoyed being around them, and listening to them. I never said anything. I always had big eyes and big ears. I used to go in those poolrooms. . . . They have certain Negroid expressions, which white people never use and that are individual for them, and I enjoyed that very, very much.

About this time Motley painted a self-portrait that remained in his possession all his life. Almost full-length, it shows a nude model in the background, a crucifix on the wall (he had been a devout Catholic all his life), and a statue symbolizing labor. "That statue represented my race in that painting," he later said. "I felt that my race had always had to struggle, to labor, and that labor was its history in this country. In the old plantation days, cutting cane and picking cotton—all that was labor. My father had worked hard and I have had to do a lot of hard work and overcome a lot of difficulties to become an artist. So I felt labor represented my people."

During this period Motley taught a Sunday drawing class for young artists with advanced skills, one of

Dans la Rue (1929). Although the street and café life of Paris caught Motley's eye as did that of Chicago's South Side, this scene has a postcard picturesqueness and, not surprisingly, lacks Motley's identification with the people. (23¾ x 28½") Schomburg Center for Research in Black Culture, New York Public Library

whom was Richmond Barthé. He was also in touch with a small group of older black artists in Chicago. The best-known member of this group was Farrow, who had been born in Dayton, Ohio, in 1885, and had won one of the Art Institute's drawing prizes in 1915 and its top etching prize in 1928. For years Farrow had worked as an assistant curator in charge of temporary exhibitions, reinstalling the Egyptian collection, and the print shop; he also taught etching. Others in the group were Charles C. Dawson and Arthur Diggs. Dawson, born in Brunswick, Georgia, in 1889, was educated at Tuskegee Institute, studied at the Art Students League in New York, worked as a newspaper illustrator, painted the Urban League murals for the 1933 Chicago World's Fair, and published privately a book of linoleum-block prints, *The A.B.C. of Great Negroes.* Diggs, born in Missouri in 1888, worked in the Reinhardt Galleries and painted decorative screens, as well as three murals for the Children's Home at Maywood, Illinois. Among the younger Chicago artists were E. Simms Campbell, later famous as an *Esquire* and Hearst syndicated cartoonist; Charles Sebree; and Eldzier Cortor, who sometimes came to Motley's home.

In 1929, after winning the Harmon gold medal, Motley received a Guggenheim Fellowship for a year's study in Europe, where lack of prejudice about interracial marriages made life easier for him and his wife. Alone among the black artists who went to Europe, he made no effort to contact Tanner. In fact, he isolated himself from fellow Americans altogether and never met the other black artists, such as Hale Woodruff, Palmer

Hayden, Augusta Savage, and W. H. Johnson, who were living there at the time. He ignored invitations, he later said, because "I think when you go to a foreign country, you don't go there to see Americans." Talking over these and other views with a Russian-born sculptor, Benny Greenstein, eventually led to their sharing a Montmartre studio. There Motley did two of his most famous paintings, *Jockey Club, Paris,* which reflects his interest in the color effects of different kinds of light at night, and *Blues,* a lively interracial nightclub scene. Aesthetically, however, Europe did not change Motley's work.

When he returned to the United States, the Depression had already begun. On a trip to Pine Bluff, Arkansas, he painted *Holy Rollers* and several portraits, including his mother's brother, *Uncle Bob,* "an old lumberjack, short but tough," who kept a Bible on the table and "cussed every minute." This portrait won a prize the following year in a show of Guggenheim Fellows in New York. His work was exhibited at the Whitney Museum of American Art in New York and the Toledo Museum of Art in Ohio.

On returning to Chicago, Motley was employed by one of the first federal art programs, the Public Works of Art Project; fourteen of his paintings were placed in public buildings in Chicago. Later, Motley was made a supervisor on the Works Progress Administration art project.

In 1935 Motley left the WPA project because, after competing with 220 artists in a U.S. Treasury contest, he was chosen to do a mural for one of fourteen Illinois post offices. Motley's assignment for the mural—really a panel painting—was Wood River, a small town near Alton in southern Illinois. When he visited the site,

Motley was astonished to see people parting window curtains to look at him. Men even climbed out of barber chairs to stare as he passed. The genial postmaster, who invited Motley to dinner, explained that because no black people lived there, everyone was fascinated by the presence of a black artist. After completing the mural, *U.S. Mail,* a "closeup" of a stagecoach pulling uphill, Motley returned to the WPA project in Chicago.

In 1940, as a result of many economic and political factors, the WPA art projects were phased out. Motley returned to easel painting on his own. He was by far the best-known black artist in Chicago, and there was a demand for his work.

Motley painted steadily in the early 1940s, but in 1945 he suffered a severe depression when his wife died after refusing a relatively simple surgical procedure that would have saved her life. Their only child, Archie, was then only fourteen years old.[16]

Motley became so depressed that he was unable to paint. Several months after his wife's death, in an effort

Jockey Club, Paris (1929). Sensual promise characterizes this Parisian evening scene outside an American nightclub. The relaxed black doorman supplies an interracial note. This is one of Motley's most famous paintings. (26 x 32″) Schomburg Center for Research in Black Culture, New York Public Library

to overcome his depression, he went to work in a large studio factory that employed 125 artists in decorating plastic shower curtains. This mechanical work was a far cry from the aesthetic problems that had absorbed him for years. In the factory the design was laid down in heavy black lines on a large table. The transparent plastic was placed on top of it, and the artist directly transferred the design to the plastic curtain.[17]

Motley found the work relaxing. He rejoiced to find "that I was in the midst of wonderful people. You could make good money but the important thing was the relationship with the people. They were wonderful, lovely people from all over the world—Finland, Ger-

many, Italy, America, Russia. All very interesting and helpful. It was wonderful therapy for me. It pulled me out of the depths of my sorrow."

But the healing process was not rapid. Motley continued this factory work for eight years and only very gradually resumed painting, largely as a result of his nephew's efforts. In the 1930s, when Archibald Motley was in his prime as a painter, his nephew Willard, twenty years younger, was just beginning to become a writer. Willard greatly admired his uncle and through him met a number of young black artists who revered Archibald for his achievements. Archibald's efforts had helped direct their attention to black people, their activities, and their neighborhoods as subjects. In 1940, when these talented young artists exhibited at Hull House, Willard described the studios and work of Eldzier Cortor, Charles Davis, Ramon Gabriel, Charles Sebree, and Charles White in detail in *Opportunity*.[18]

By the early 1950s Willard Motley had achieved national recognition with his first novel, *Knock on Any Door* (a best-seller in 1947–48), and other writings.[19] In 1953 he established a home in Cuernavaca, Mexico, and insisted that Archibald come for a prolonged visit. There Archibald found himself renewed as an artist. In the Mexican people and that country's bright, mountainous landscape, he discovered fresh and very different subject matter. Moreover, Mexico's lack of virulent racial prejudice made it a haven from the harsh intolerance in the United States. In his first six months in Mexico, Motley completed twelve canvases, which he sold soon after his return to Chicago.

When interest in the cultural contributions of black Americans developed in the 1960s, the demand for Motley's work increased. What became clear to art historians was that Motley was the first significant African-American artist to devote himself to the life of urban black people. A city dweller all his life, he was not drawn to rural scenes, as were such contemporaries as W. H. Johnson and Malvin Gray Johnson.

Although he was one of the most successful black artists to emerge in the 1920s, Motley was in certain ways isolated from other black artists. At the time, sustained by his close and loving family, he felt no need to end this isolation. Even when he traveled abroad, he did not alter his isolated stance. While he knew other black artists in Chicago and had warm, friendly relationships with them, his closest ties were with Joseph Tonanek and William Schwartz, who had originally worked with him as students at the Art Institute. More than fifty years later, they were still in close contact.

Reviewing his life's work, Motley said that it did not pass through different phases of development: "I think it has basically remained the same. It has been in a steady direction, and I believe it has improved—at least I hope it has."

If Motley did not change, the world around him did, moving in on him both literally and symbolically. In the late 1960s the city life of African-Americans, with its bad housing, poor schools, and unemployment, became a major theme of young black artists in works that contrasted to Motley's celebration of black life. These artists criticized Motley for not portraying such victimizations. Motley, whose dignified portraits of his grandmother and other black people represented his concern and sincere appreciation of them, was deeply hurt. "I don't know why they feel that way," he said, "but I know they criticize me, that they say a lot of these things are sort of Uncle Tomish and all that stuff. . . . They want something a little more militant. . . . I have never hated a man in my life, regardless of race or color or creed, and I hope to God I never shall. Personally, I think I have been a much happier man for it. I think when a person hates he only makes himself miserable. And the guy they're hating, he doesn't know anything about it, so he doesn't give a damn."

By the early 1970s, however, conditions in his old neighborhood had reached a point where Motley made up his mind to move. "People here no longer know who I am or what I have done," he remarked. In a televised WMAQ-NBC interview in 1972, which displayed his work to millions, Motley denounced racial prejudice as he discussed his work.[20] On April 14 of that year, some of the pain he felt from criticism by the militants was eased when the National Conference of Artists (an organization of African-American artists, teachers, and administrators) honored him with a dinner, a gift of money, and a plaque recognizing his historical role in the development of America's black artists.

At the time Motley was still working on a large painting he had begun in 1963 to celebrate the 100th anniversary of the Emancipation Proclamation—"the Centennial, we call it," he said. He expected it to be finished that year. But instead of a parade of progress, it became a haunted history of violence as Motley's despair deepened over the explosive struggle for civil rights. The painting became a religious allegory, including many portraits and historical scenes, such as the assassinations of President John F. Kennedy and the Reverend Martin Luther King, Jr., the killing of black children in the bombing of an Alabama black church, and the revival of the Klan. In 1972, nearly

ten years after he began, Motley was still working on this painting, of which he said, "I have in it this very deep feeling—that's why I used a lot of blues in it. I have got that blue feeling."

Originally titled *1963—The First 100 Years—1863,* it acquired an inscription as part of its composition that reflected Motley's deep religiosity: *He Amongst You Who Is Without Sin Shall Cast the First Stone—Forgive Them, Father, For They Know Not What They Do.* This large canvas, so different from his paintings of the 1920s, remained a work that Motley never felt was finished, although he stopped work on it when he left his old neighborhood in the late 1970s.

Despite the recognition he received in the late 1920s, Motley and his work have been shockingly neglected and omitted from American art histories. In 1977 Elaine D. Woodall listed 105 Motley paintings out of an estimated lifetime production of 400 to 500, but she was able to locate only 31, most of which were held by the Motley family and a few African-American colleges.[21] Our efforts to locate Motley murals in three Chicago-area schools failed. In two, there was no record or even memory of them. In the third, the principal reported he had been told the music room had once had three Motley panels—one was a dance scene, the second showed black children, and the third portrayed "black musicians in a parade similar to the type one sees in pictures of New Orleans."[22] A former band director had felt Motley's musicians were not holding their instruments "properly," and this may have been the rationale for the mural's destruction. Undoubtedly, the mural was Motley's depiction of the funeral bands that originated jazz in New Orleans, his birthplace. As *Stomp* and other paintings reveal, Motley loved jazz.

Motley died on January 16, 1981, at his Chicago home. The year before he was one of ten African-American artists honored by President Jimmy Carter, and some of his paintings were exhibited at the Corcoran Gallery of Art in Washington as part of a group show of the work of these artists, held at the suggestion of the National Conference of Negro Artists. This was followed in 1988 by an exhibition of more of his work, together with that of Eldzier Cortor and Hughie Lee-Smith, in New York at Kenkeleba House.[23] This art center on the Lower East Side seeks to nurture young minority artists by alternating exhibitions of their work with work by significant minority artists of the past, such as Motley.

Motley's importance lies in his recognition that African-American city life, its energy and optimism, can be the subject of art. That he had the courage to focus on this subject matter at a time when it was frowned upon, and even denounced, makes him a key figure in the history of African-American artists and American art.

In recent years Jontyle T. Robinson of Winthrop College, aided and encouraged by Archie Motley, the artist's only child and curator of manuscripts at the Chicago Historical Society, located more than 100 paintings that were previously considered lost. Her research formed the basis of an extensive exhibition celebrating the artist's centennial and sponsored by the Chicago Historical Society.[24] After its showing in Chicago in 1991, the exhibition moved to the Studio Museum in Harlem, the High Museum/Georgia Pacific Gallery in Atlanta, and the Corcoran Gallery in Washington. This exhibition and its catalog, by Robinson and Wendy Greenhouse, constitute a major step toward overcoming decades of neglect.

PALMER C. HAYDEN

In 1926 an unknown, mostly self-taught African-American painter, Palmer C. Hayden, born and bred in the South, won the gold medal at the Harmon Foundation's first national competition of the work of black artists. This annoyed some academically trained artists, who felt his paintings did not meet their standards. But for Hayden, a huge man who had spent most of his life until then as a laborer and soldier, it was a lucky step forward in his long artistic march. When he died in 1973, it was clear that Hayden had made a unique contribution to the cultural life of America.

Of all the artists to develop during the Black Renaissance, Hayden is the most misunderstood. His simplicity and single-mindedness were often interpreted as naïveté. His themes, which were for the most part imaginative projections of his unique experiences, were too often seen as a simple kind of folklore. His early life and adulthood required him to engage in the most arduous type of labor and led to his being referred to as "a working man who also painted." Yet Hayden was unconcerned about what people had to say about him, for he was well aware of his own worth and the artistic direction that was best for him. The real, the essential, the substantial Palmer Hayden was an artist almost from childhood and he continued to be one throughout his life.

As a member of a large family living marginally in a flag-stop southern town, Hayden had to wait until he was able to earn enough money to support himself before he could pursue his art studies in snatched hours and minutes. For him, the road to artistic maturity was long and rugged. The way he melded his experiences as a working man and an artist into a cogent artistic whole is most evident in his series on John Henry. These paintings convey the vitality and spirit of black people in confronting life. To translate John Henry's story with such feeling, Hayden undertook an intensive, comprehensive preparation. He studied the stories and songs about this legendary black railroad worker; he consulted the leading authority on John Henry; and

he visited the West Virginia sites where he had worked. *The Legend of John Henry, the Natural Man* has become Hayden's most famous work, and has been exhibited all over the country since it was completed in 1947. John Henry was a man Hayden understood and, in some respects, resembled.

Hayden, whose original name was Peyton Cole Hedgeman, was born on January 15, 1890, in what he called "a little shack" at a railroad flag stop, Widewater, Virginia. His father, James Hedgeman, had been born in slavery and had been given a shack and four acres after the Civil War. He worked "on the fishing shore" of Widewater for its principal landowners, the Waller family. Palmer's mother was Nancy Belle Cole, daughter of a Moncure, one of the first families of Virginia.[1] He was the fifth of ten children. The Moncures, acknowledging their relationship to Hayden's mother in their own way, provided some help in caring for the family.

Hayden started drawing when he received a slate at school. His first drawing showed a hill with grazing cows. His mother, laughing, said he made the cows "too potbellied." But even that little attention from his busy mother "encouraged me to overcome that," Hayden later said. At school the teacher praised his drawing and told him to "keep at it and you'll be a famous artist." Caught between the more powerful and more verbal older children and the younger children who needed his mother's attention, Hayden considered anything that got him some special recognition important. He said later that as a young boy he was extremely timid about putting himself "forward in any way." He had a secret wish to make music with a fiddle but was too overwhelmed by his fears to tell anyone about it.

Like his older brothers and sisters, when Hayden was old enough, he set out for work in Washington, D.C. At seventeen he began his first job as a drugstore

errand boy and porter. Throughout his adolescence he had drawn fishing boats and sailboats on the Potomac, so he hoped to become a commercial illustrator or cartoonist. In Washington he published a newspaper ad: "Young artist would like job as assistant to commercial artist." A Georgetown artist asked to see his samples but, "When he saw me, he said, 'Oh, I didn't know you were colored,' and closed the door and that ended the interview. I rather expected it but I thought it might not happen."

Entranced by vaudeville songs about Coney Island in New York, Hayden spent a summer there carrying visitors' baggage. Cold weather drove him home to work in a fertilizer factory not far from where the Marine base at Quantico now exists. In the spring, in "a rambling spirit," he joined the Buffalo Bill Circus, then shifted to Ringling Brothers' Circus. He toured the nation with it, working as a roustabout or "roughneck," to use his term.

What Hayden liked best about the circus was that once the tents were up, he was free to draw. Many performers, whom he called "kinkers" (an old circus term), commissioned portraits for publicity purposes. He drew clowns, trick bicycle riders, trapeze artists, and a contortionist, "The Frog Man." His skill made him famous on the circus lot and, he recalled, "I made a lot of money at it."

He also learned to swing a sledgehammer and drove in tent stakes in a gang of four to eight roustabouts, all swinging their hammers in a rhythmic sequence. Years later he painted a sledgehammer gang in the *Legend of John Henry* series.

Sometime in the spring of 1908 Hayden got a job driving a team that hauled clay to brickyards. Then he hopped freights to Boston, where he worked as a sandhog until a man recruiting for Chesapeake Bay oyster boats signed him up.

"You were supposed to stay aboard for thirty days," Hayden recalled, "but the work was hard and it was bitter cold and wet and the bosses were mean. An old man wasn't moving fast enough so the captain hit him with a piece of rope. That old man jumped overboard. I thought he was going to drown. But they swung around and fished him out because they couldn't afford to let that story get out." In the bitter cold Hayden's hands became painfully frostbitten. Finally, he demanded that he be put ashore. The captain, bawling him out for not staying his full thirty days, put him ashore at the nearest point. Hayden felt lucky to have escaped without losing his fingers.

A year later he got a job as a sandhog in a shaft being dug at 42nd Street and Fifth Avenue in New York for the Catskill water conduit. A nearby U.S. Army recruiting station advertised: "Join the Army and See the World." Recalling his mother's advice that if he had to roam, he ought to join the army so he would at least get a place to eat and sleep, Hayden asked the recruiting sergeant if he could enlist. He needed a reference—something he later learned was required only of African-Americans—so he asked the timekeeper at the shaft. Annoyed at having to change his books, the timekeeper reluctantly wrote the reference, but when Hayden took it to the recruiting station, he saw that it gave his name as Palmer C. Hayden, not Peyton C. Hedgeman. "I was afraid to tell them and afraid to go back." Thus, in November 1911, he became Palmer C. Hayden, U.S. Army Private.[2]

The army assigned Hayden to the black Company A, 24th Infantry Regiment, paid him fifteen dollars a month, and sent him to the Philippines. He served on the islands of Panay, Negros, Luzon, and Corregidor. Although the climate was hot and army maneuvers arduous, he had pleasant memories of the Filipinos who came to the camp, sold peanuts and other things to the soldiers, and laundered their best uniforms. "I had a girlfriend I was fond of," he recalled. During his stay, he made many pen-and-ink drawings of his fellow soldiers and the Filipino people, of marketplaces, people working, and "scenery," to use his term. In 1914 he was discharged in San Francisco with a ticket to Washington, D.C.

By the time Hayden got to Washington, World War I had broken out in Europe. Learning that a detachment of black cavalrymen, a part of the Tenth Cavalry, was stationed at West Point, he decided to join it, since he was familiar with horses. His principal duty was to take care of the horses on which cadets learned to ride.

His enlistment ended in 1917, but by then the United States was involved in World War I and all discharges were stopped. Yet Hayden's cavalry troop never left West Point. Occasionally, Hayden and some of his soldier friends felt they should join the fighting in Europe, but "once I had occasion to go down to Camp Upton, which was an embarkation point, and I saw the soldiers, mostly all draftees from the South, I decided I didn't want to go with them." He stayed at West Point until mustered out in 1920.

At West Point, Hayden frequently drew his fellow cavalrymen as well as African-Americans in nearby Newburgh, the troopers' off-duty center. During his off-hours he was allowed to take a horse and ride anywhere, an experience that gave him a great sense of freedom. He also took pleasure in seeing the Hudson Valley from many different perspectives. Sometimes he sketched landscape scenes. His talent was admired by his comrades and Newburgh people.

A soldier gave him the name of a commercial artist

in New York, to whom Hayden took his drawings for criticism and advice.[3] The artist encouraged him, suggesting he continue to sketch soldiers, horses, and their activities as well as seek artistic training. Taking this advice, Hayden decided to attempt to become an artist.

After nearly ten years of army life, at the age of thirty, Hayden overcame his old feelings of unworthiness and tried to become a commercial illustrator. Since his military record gave him preferential status at the post office, Hayden got a job there on the night shift so that he could attend a six-week course in painting and drawing at Columbia University in the summer of 1920. His instructors were Atwell and Flegal in drawing and painting, and Heckman in illustration,[4] but what he found most beneficial was the contact with the other students. "You see what the others are doing and all that helps you more than what the instructor tells you," he said later.

Hayden continued working in the post office for the next five years, painting at night. Then, realizing that he wanted to be a fine arts painter, not a commercial illustrator, he became increasingly unwilling to give his daylight hours to the post office. His absentee record finally led to his dismissal.

By this time Hayden had moved to Greenwich Village to be near other artists, but his timidity prevented his forming mutually helpful, ongoing relationships with them. He lived and worked in almost total isolation, in a three-dollar-a-week room, surviving by taking part-time jobs, including housecleaning.

One day Hayden met another black artist from Virginia, Cloyd Boykin. Their "down home" memories helped them become close friends, even though Boykin "never went through what I did," as Hayden put it. Boykin, born in Hampton in 1877, had first studied electrical engineering at Hampton University and later studied for the ministry. On deciding to take up painting, at which he showed considerable talent, Boykin did a portrait of Wendell Phillips, which won him a fellowship to study at Boston's School of the Museum of Fine Arts and later in Europe.

Recognizing Hayden's lack of confidence and his difficulties as a painter, Boykin helped and encouraged him. Although, when they first met, Boykin lived in a mid-Manhattan building where he was a janitor, he later moved into the same Greenwich Village building that Hayden lived in. They did not paint together, but they met daily to talk, and they sometimes watched each other work.

Boykin made Hayden aware of the fact that all artists, and especially black artists, had a hard time establishing themselves—until then, Hayden had thought only he had such difficulties. As a result, Hayden decided to portray Boykin at work in his cellar quarters and completed *The Janitor Paints a Picture,* which is now in the National Museum of American Art in Washington, D.C. In this painting Hayden combined realism and fantasy, a characteristic of his work. He depicted Boykin at his easel, amid brooms, dustpans, and trash cans, painting a mother and her child. They were not Boykin's family but, as Hayden explained, "all artists have been concerned with painting the mother and child." Hayden included an alarm clock because a janitor had to be alert for packages being delivered at certain times and tasks needing to be performed at other times. To symbolize the artist, Hayden showed Boykin wearing a beret. "It's a sort of protest painting," Hayden recalled. "I painted it because no one called Boykin the artist. They called him the janitor."[5]

Hayden got a studio cleaning job with Victor Perard, who taught painting at Cooper Union. Perard gave Hayden advice and occasional lessons. Sometimes he took Hayden to his home in New Jersey for weekend painting trips, all of which convinced Hayden of his need for more training.

Then Hayden met a black man who had been a cook at a summer art colony, run by Asa E. Randall, in Boothbay Harbor, Maine. He suggested Hayden go there, so Hayden wrote Randall, saying that he had no money but would be willing to work in return for instruction. Randall told him to come. "That was the real turning point for me," Hayden later recalled. "Randall was the instructor, and I began to realize things, to make better connections about everything," to understand relationships in composition and color with greater depth than before.

Hayden's greatest opportunity developed from another chance encounter. One evening, as he was going home from a window-washing job, an unknown man stopped him and asked if he wanted a few hours' work moving furniture. Hayden readily accepted. En route to the job, the man cautioned that they would be working for a spinster who was very particular about whom she let into her home. He suggested they pretend that they always worked together. At the woman's apartment both men worked steadily until the other man had to go, leaving Hayden to finish the work. When the last piece of furniture was finally in place, the woman asked Hayden to return once or twice a week to clean and dust her apartment. During one of these visits she learned of Hayden's desire to become a painter.

In 1926 she showed him a brochure from her church. It announced the "William E. Harmon Awards for Distinguished Achievement Among Negroes" and

The Janitor Paints a Picture (1936) was considered a protest painting by Hayden. It was based on the experience of an older artist friend in New York, Cloyd L. Boykin, who had to find time to paint while serving as a janitor. The prominence of the clock points up the constant demands of the janitor's work. Hayden admired Boykin and felt it was wrong that no one considered him an artist but just a janitor who painted. An earlier version was criticized as caricaturing blacks. (39⅛ x 32⅞")
National Museum of American Art

Boothbay Harbor, Maine (1926) was one of Hayden's early waterfront scenes. To study with Asa Randall at the Commonwealth Art Colony at Boothbay, he worked as a cook. One of his Boothbay waterfront scenes won the Harmon Award of 1926. Ethnic American Art Slide Library, University of South Alabama, Mobile. Photo: National Archives

said that the work of black artists would be considered and given prizes. After she suggested that Hayden enter his work, he promptly entered a painting of a Portland fishing boat that he had done on returning from Boothbay Harbor in Maine.

To his great astonishment and delight, his painting won the $400 first prize. That Hayden was a totally unknown artist from the South aroused considerable interest in Harlem and among African-Americans everywhere. New York newspapers, and especially the African-American press, reported it. Although there was criticism that his work was inferior to that of more highly trained painters, the critics said it symbolized the arrival in the city of talented black artists from the South who had overcome monumental hardships.

Years later, Hayden reflected, "The lady said, 'Now you've made something to talk about. Now's the time you should go abroad.' So then she gave me $3,000 to send me to Paris. It was unbelievable—if it hadn't happened to me—but it did! Her name? I never did tell it. When she gave me the money, I said, 'I would like to tell everybody about this great thing you've done for me.' 'Oh,' she said, 'I'd rather not—I'd rather be anonymous because I don't have so much money and once people get to knowing that, I'd be hounded by everyone who wants a gift for this one and another.' So I never did tell the name. I just won't tell who she was."

In March 1927 Hayden went to Paris. As a result of winning the Harmon prize, he had met Laura Wheeler Waring,[6] an exceptionally well trained African-American painter who taught at what was then called the Cheyney Training School for Teachers outside Philadelphia. She knew Henry Ossawa Tanner and suggested that Hayden go to see Tanner in Paris.

Tanner, who knew of Hayden's prize, cordially received him. "Tanner was shy but not hard to get acquainted with," Hayden recalled some forty-five years later. Recognizing that Hayden's southern background had shaped his concepts of interracial relationships, Tanner gave him much useful advice on the French people and their attitudes, habits, and customs—how they perceived black people and "how to live with them," as Hayden put it. "I remember he told me when I was getting a studio to be sure and tip the concierge when I moved in because otherwise she might tear up my mail."

Hayden at first brought his work to Tanner. "He usually made some complimentary remark," Hayden remembered, "but I didn't continue to go to him for that because he was not a teacher and he didn't like to talk too much. I don't really know whether he thought they were good or bad; he never did say. I can't recall anything specific that he said about my work."

"Tanner was not against modern painting," Hayden declared. "I know because one day I brought him a canvas, and when I started to unwrap it, I said, 'Now I'm going to show you something modern.' Of course, today I know that it wasn't really modern, but I thought it was then. Well, when I said that, Tanner said, 'Oh, that's all right. I like modern painting if it's good.'"

"Tanner never said anything discouraging to you," according to Hayden. "He was shy and he wasn't the

Fétiche et Fleurs (1932–33), which includes African weaving as well as a fetish, won the Rockfeller Award in the 1933 Harmon exhibition. Unlike Hayden's usual work, it has been acclaimed in recent years as pointing a direction for African-American artists, and linked to Alain Locke's interest in African art. Hayden had met Locke in Paris and regarded some African art as "fine," according to an interview, but added that in his opinion it had "no meaning to we Americans." (23½ x 29″) Museum of African American Art, Los Angeles

kind of person who would say much about you to your face. He did compliment another artist from the South, William Johnson." Tanner told Hayden that Johnson, who had gone to Denmark, "had a lot of talent."

Among other things, Tanner told Hayden that he himself had had to come to France to achieve recognition. At times he told Hayden a little about his experiments in mixing glazes. However, Hayden was less interested in this than the fact that Tanner liked to paint on a composition board he obtained from the United States.

In Paris, Hayden also met Alain Locke, who brought African art to the attention of black American artists. "I remember him going down to Africa to get it," Hayden recalled. Although Hayden admired African art, he did not identify with it. Still, in *Fétiche et Fleurs,* a painting that later won a prize and was widely reproduced, he made an African weaving as well as an African fetish sculpture a part of his composition.[7]

Yet Hayden did not care for Cubism and other forms of modern art. Hayden always tried to tell a story with his paintings, and he felt this couldn't be done with Cubism and most modern art. When he had first seen Marcel Duchamp's *Nude Descending a Staircase* at the old Whitney Museum on 8th Street in Greenwich Village, he could not decipher the nude. Even when it was pointed out, he recalled, "I thought it was like one of those picture puzzles in the newspaper, where you draw a line from one dot to the next to get the picture."

Chance played a great role in Hayden's career. He had a very unusual bit of good luck when he tried to learn French. Responding to an advertisement of a French teacher in the Paris *Herald-Tribune,* he discov-

ered the address was nearby. The teacher, Mlle. Renée Martine, came from a very old Parisian family that was friendly with Clivette Le Fèvre, a well-known sculptor and painter who was an instructor at the École des Beaux Arts. On discovering that Hayden was a painter, Mlle. Martine arranged for Hayden to take his paintings to Le Fèvre, who agreed to criticize and tutor him privately. Hayden took his work regularly to Le Fèvre's studio. Le Fèvre thought that Hayden's palette was particularly well suited to painting Parisian scenes and took him around Paris on several occasions to show him possible scenes for compositions.

However, Hayden soon grew restless with Le Fèvre's instruction. Impatient for recognition, he went to the Galerie Bernheim Jeune and paid forty dollars for a one-man show in November 1928. Le Fèvre was very upset, told Hayden that he was not ready for a one-man show, and refused to see him or his work again. Although the show was mentioned in a few newspapers, it was a failure, and Hayden concluded that Le Fèvre was right. Later, he participated in two group shows—the Salon des Tuileries in 1930 and the 1931 American Legion Exhibition in Paris—but he never saw Le Fèvre again.

One stimulus to Hayden's development as an artist in Paris came from exposure to the art in the Louvre. But even more important was the experience of living outside the racial restrictions of the United States, which gave him confidence in himself. He recalled, "At first I didn't want to be known as American. I wanted to be known as being from Martinique or some other French possession. But then I found that you got better treatment if the French knew you were an American.

162

Top left: ***When John Henry Was a Baby, He Was Born with a Hammer in His Hand.*** The Big Bend Tunnel is shown in the distance. Top right: ***John Henry on the Right, Steam Drill on the Left*** depicts the competition in which John Henry triumphed over the machine. Bottom: ***He Died wid His Hammer in His Hand.*** John Henry in death is surrounded by friends and fellow workers, who know they have seen a mighty, legendary deed by a black man. (All 30 x 40″) Museum of African American Art, Los Angeles

The ***John Henry*** series (1944–47), Hayden's most famous group of paintings, has been widely shown in the United States. He first heard the ballad as a boy from his father, and many years later went to West Virginia where a real-life John Henry had worked on the Big Bend railroad tunnel. His sketches illustrating lines of the ballad became the basis of the twelve paintings in the series, three of which are shown here. The series was given to the Museum of African American Art in Los Angeles by Miriam Hayden, his widow.

I used to spread out the Paris *Herald-Tribune* so they would know I was an American. And Mlle. Martine told me that, too. She said I should never let the French people speak to me with the familiar 'you' form, that I should always insist on the formal 'you.' And I did that, and they were always very respectful."

Hayden had come to Paris with approximately $3,000. He sustained himself partly by sending paintings back to the Harmon Foundation, where Mary Beattie Brady undertook to exhibit and sell them. However, the sales were not enough to maintain Hayden. Mlle. Martine, knowing of Hayden's dwindling funds, offered one of her rooms free. Through her generosity, he was able to stay five years, returning to New York in 1932.

Hayden left Paris without any regrets, feeling that he had "lived out my time there, wasn't getting anywhere there." In New York Brady, who had championed Hayden's work since his winning of the first Harmon prize six years earlier, created a job for him at the Harmon Foundation. He helped prepare exhibitions of the works of black artists to be shipped to various African-American schools and colleges. Brady was energetic and full of ideas on how to promote an interest in African-American artists, although her attitude sometimes seemed patronizing and she was resented by some black artists. Nevertheless, her efforts were advanced for their time. Among other activities, she produced a movie, titled *How to Paint a Picture,* in which Hayden, working at a location just south of the Brooklyn Bridge, painted a harbor scene complete with tugboats and ships. This film was then made available to schools and colleges.

Hayden worked for the Harmon Foundation until the Works Progress Administration art projects came into existence. Initially, African-American artists were not readily accepted by WPA administrators, who considered them only as laborers; few had heard of black artists. Hayden's Harmon prize demonstrated that he was an artist, and as a veteran he was entitled to preferential treatment. The WPA also required official poverty. "You had to go on relief to qualify," Hayden recalled. "That bothered a lot of people, but I did it." Assigned to the WPA easel project, he painted at home, primarily New York waterfront scenes.

Hayden met socially with many young African-American artists who were campaigning to end discrimination in the WPA. Many were searching for black heroes of the American past. Their ideas interested Hayden because for many years he had wanted to portray "John Henry, the natural man." As a boy on Virginia's "fishing shore," he had often heard his

father and older workers on the wharves sing this ballad of a powerful, "steel-driving" black man who, using a sledgehammer, had outproduced a man with a steam drill. Earlier, Hayden had made a series of watercolor sketches of Hiawatha, and these prompted him to think of portraying John Henry's life in a series, each painting illustrating a part of the ballad.

He confided his plans to Miriam Hoffman, a schoolteacher who later became his wife. "I didn't know there was anything real about it," he recalled. "I thought it was just a myth—like Paul Bunyan." One day, in the public library, Hoffman found a book called *John Henry: A Folklore Story,* by Louis W. Chappell, an English professor at the University of West Virginia.[8] And "that made me more interested in doing it—a true story," said Hayden. Chappell traced the ballad to a strong African-American worker named John Henry, who in 1870–71 had actually helped build the mile-long Big Bend Tunnel on the Chesapeake and Ohio Railroad on the Greenbriar River, near White Sulphur Springs.

Hayden corresponded with Chappell. Then, in August 1940, he resigned from the WPA, married Hoffman, and drove with her to Talcott, West Virginia, near the Big Bend Tunnel. He sketched the mountains, the tunnel, the railroad shops and shacks, and the rippling river. "Professor Chappell told me just the way it happened, about the people he interviewed," Hayden said. "Some old-timers claimed they remembered John Henry."

As Hayden described it, once back in New York, much stimulated by his trip and talks with Chappell, "I picked out a line from each verse—'John Henry was a baby on his mammy's knee' . . . 'John Henry was the best in the land' . . . 'John Henry had a woman and the dress she wore was blue' . . . and then I'd make the painting." The series had a total of twelve paintings.

The *John Henry* series was first shown at Sarah Lawrence College and then at the Argent Galleries in New York City in 1947. When it was exhibited at the Countee Cullen branch of the New York Public Library in Harlem in 1952, Hayden prepared a statement in which he emphasized that John Henry symbolized the physical strength of black people, their chief asset in earlier days. But he also stressed that "John Henry was not made up of whole cloth—the Negro counterpart of the mythical Paul Bunyan—but did live and work in the Big Bend Tunnel in West Virginia." For Hayden, John Henry was also a symbol of African-Americans leaving agriculture to enter the industrial life of the country.

Both as a song and as a symbol, John Henry was a part of Hayden's life from childhood on. John Henry's

life was the kind that Hayden himself had lived for many years. Thus, it is not surprising that this work combines fantasy with a surrealistic juxtaposition of reality. Although Hayden's figures often have a certain stiffness, sometimes resembling the work of naive painters, they are always integral to the composition, giving it an essential authenticity.[9]

Since its completion, the *John Henry* series has been almost continuously on tour, traveling to Hampton University, and then to one locality after another across the nation. This notable contribution to American folklore is now at the Museum of African American Art in Los Angeles.[10] Hayden's other paintings have been widely exhibited.[11]

Except for his marine paintings, Hayden drew heavily on his memory and his imagination, which often gives his work a certain narrative quality. He explained:

> I remember scenes from when I was a child in Virginia, and try to paint them from memory. I remember the bunkhouse at the factory where I used to work, and laborers in the brickyard at Haverstraw, and some of the roustabouts in the circus, and some of the soldiers in the army. Certain things—a parade, mounting a guard, or . . . a group doing something together—come out in my memory.
>
> Sometimes I hear an outlandish story and I try to paint that. When I was at West Point, we soldiers used to go to Newburgh, which is about twelve miles up the river above West Point, to get "turned on," so to speak. Well, I heard this story about what hap-

pened at Newburgh at the Hudson-Fulton C[enten]nial, a way back in 1909, an incident where on[e of] the roustabouts around town called "Tricky Sam["] shot a good old fellow named "Father Lamb," and[] so I made a painting about that.

When Tricky Sam Shot Father Lamb was criticized, according to Hayden, by some influential black people who felt his portrayal ridiculed blacks. On the other hand, "Langston Hughes saw it and he liked it very much, but, of course, he liked folk things and used them in his poetry."

One of the paintings that Hayden did during his WPA days, *Midsummer Night in Harlem,* was widely reproduced. This work showed the crowded living conditions in Harlem, and it, too, was criticized. The criticism made little difference to Hayden. "I just tried to tell it like it is," he said. "Never did hesitate. Some people are too thin-skinned."

Although he got to know many black artists casually at parties, he knew many more and their work through the outdoor art shows in Greenwich Village, which began in the early 1930s under the sponsorship of Gertrude Whitney. "That's where I got to know most artists, including W. H. Johnson and Beauford Delaney and Joseph Delaney." These outdoor shows became, during the Depression, a major way for an artist to sell his work.

Hayden insisted at all times on being himself, shrugging off attempts in the 1950s to get him to become an abstract painter. "I've been told to get rid of that old style if you want to be somebody," he commented. "Splash it around, do abstract, they tell me."

Moonlight at the Crossroads was an important painting in Hayden's inner life but has rarely been exhibited. As a poor boy in Virginia he yearned to play the violin, but could not afford it. Years later he dreamed of this boy with a violin at a crossroads. It seemed to represent the turning point where Hayden gave up on the violin and took the road that led to his becoming an artist. Photo: National Archives, Ethnic American Art Slide Library, University of South Alabama, Mobile

The Baptizing Day (1945) arose from Hayden's memories of this important ritual in rural black life. He said in an interview, "I paint what Negroes, colored people, did. Us [African] Americans, we're a brand-new race, raised and manufactured in the United States. I do like to paint what they did. I know black people, colored people that I grew up with, understand them and know them." (25 x 35″) Museum of African American Art, Los Angeles

Earlier, he had been given similar advice about painting "African." But Hayden was interested only in paintings that tell a story. "I paint what us Negroes, colored people, us Americans know. We're a brand-new race, raised and manufactured in the United States. I do like to paint what they did."

Hayden did not have any particular favorite painter from the past. Asked to name his favorite among his own paintings, he answered, "I haven't painted it yet. I always hope I'll do better. The truth is, I never thought much of my own work. I never was satisfied with it."

What hurt his development as an artist most, Hayden felt, was "my schooling. It never broke me out of being timid. I couldn't get up and say two lines. In anything like a modern school they'd try to break me out of that."

Many of Hayden's paintings deal with his memories of the life of African-Americans in the rural South, such as *Hog Killing Time in Virginia, Preaching Hellfire and Brimstone, The Baptizing Day, Milking Time,* and *Music.* One of his most poignant paintings, *Moonlight at the Crossroads,* shows a child with a fiddle at a moonlit crossroads. As a poor black boy in Virginia in the 1890s, Hayden had wanted a fiddle but had had no way of getting one. He regretted this all his life, believing that if he had had a violin as a child his life might have been different. This is why he placed the child at the crossroads. He used the moonlight to represent the secret quality of his childhood wish.

Hayden often painted dreams, trying to render them quite faithfully. Yet he considered dreams "not very creative. The dream gives you the whole thing, including the colors." One such painting shows a black Tenth Cavalryman galloping on a snorting white horse in the desert (now in the collection of the National Museum of American Art).

Hayden's memories of his life as a soldier intrigued him. In the 1970s he began a historical series on African-American soldiers, covering the period between World War I and the end of segregated units in the United States Army. Commissioned by the New York Creative Arts Public Service Program, the only one of these paintings to be completed shows a formation of African-American cavalrymen at West Point as President and Mrs. Woodrow Wilson alight from an open car. While the top-hatted president faces away, Mrs. Wilson studies the black cavalrymen. "I was one of those men, and she looked me straight in the eye. I'll never forget it," Hayden told his wife as he worked on the painting.[12]

This essentially personal reaction to an event governed the content of Hayden's work. It was what made the event important to him, and it made him impervious to fluctuations in art styles. If he could communicate what was important to him emotionally, that was all that mattered to him.

When Hayden died on February 18, 1973, at the Veterans Administration Hospital in Manhattan, he was eighty-three years old. He had painted to the very end of his life, working in a small room with north light on West 56th Street in New York.

Undoubtedly, Hayden is the leading folklorist among black American artists.[13] His life is an aston-

ishing story of a working man's determination not to abandon his aesthetic impulses and to become an artist despite his often frustrating timidity about moving outside accepted modes of expression and occupations. Yet when chance brought opportunity, he was ready to make the most of it.

This was clearly demonstrated in 1988, when Samella Lewis, the founding director of the Museum of African American Art in Los Angeles, organized a full-scale exhibition of his work, "Echoes of the Past: The Narrative Artistry of Palmer C. Hayden," at that museum. It included, as well as the *John Henry* series, a

great range of paintings. Some were drawn from memories of his childhood days in the South and on what he called "the fishing shore" of Chesapeake Bay, from his days as a laborer and cavalryman, from stories of incidents in African-American life. Many, painted in a high key, reflected his determination to record the ordinary activities of African-American lives with great honesty. He sought to portray his people as they were, with a lively, sometimes humorous, appreciation of their character, attitudes, and vitality.

These qualities make Hayden hard to classify. Should he be considered a folk painter or a naive? The answer, of course, is that he is neither. Technically, he was quite expert. In some of Hayden's paintings, such as the *Hog Killing Time in Virginia,* the nuances of color and form are beautifully realized, almost as well as in any of the great Postimpressionist works. In other paintings, there is almost a surrealistic, perhaps even nightmarish, quality, as in his *Midsummer Night in Harlem.* Clearly, like many artists, he does not fit into a neat compartment.

Hayden had something of real import to express. Although it took him a long time to develop as an artist, once he had acquired his direction, he never strayed from it. His works were always clear, both in form and content. In his strongest paintings, such as those in the *John Henry* series, he combined his imaginings with his experiences as a laborer in an expression that, in his own mind, had much more to do with actuality than with myth.

AUGUSTA SAVAGE

The most popular work in a huge New York exhibition of African-American artists in 1967 was a plaster head of an attractive boy modeled almost forty years earlier. *Gamin,* which has moved people ever since Augusta Savage created it, is one of the few fully realized works of an artist whose total output was small and uneven.

Brilliant, friendly, fierce, and difficult at times even for her friends, Augusta Christine Savage had to overcome prejudice against her as a black and as a woman, in a period of history when women had only just won the right to vote. When her efforts to become an important sculptor were overwhelmed by the Depression, she turned to nurturing young black artists in New York. For a generation of such artists, her influence was critical. She did more than teach in an academic sense. She sought talent. She found jobs for young artists and helped them focus on their own experiences and values. She fought political battles that helped hundreds of Works Progress Administration artists regardless of race. In these struggles her resources, emotional and aesthetic, were depleted. More than a decade before she died in 1962, she abandoned all efforts to create and isolated herself.

Yet her talent and her responses to the problems she faced made Savage one of the most significant leaders of black artists to emerge in the 1920s. She was perhaps the first who could be identified as a black nationalist.

Augusta Fells (Savage) was born, she always said, "at the dark of the moon," on February 29, 1892, in Green Cove Springs, near Jacksonville, Florida.[1] She was the seventh child of a very poor fundamentalist preacher, the Reverend Edward Fells, and his wife, Cornelia. They had seven more children after Augusta; only nine of the fourteen reached adulthood.

Green Cove Springs was a brick-making town, abounding in clay, and Augusta discovered her skill in modeling ducks, pigs, and chickens at an early age. She was so drawn to the clay pits that she became a truant. Her father feared she was "fashioning graven images in a Godly house" and beat her. "My father licked me five or six times a week and almost whipped all the art out of me," she said later.[2]

When she was about fifteen years old, her father became the minister of a West Palm Beach congregation, which improved the family's circumstances. At her new school Augusta's sensitive poetry won her teachers' admiration and her truancy ended. When a local potter gave her clay, she modeled an eighteen-inch Virgin Mary that made her father regret his earlier harshness. With the potter donating the clay, the school board accepted the principal's recommendation that Augusta, though still a student, be paid a dollar a day for every day she taught modeling in the last six months of her senior year.[3] This satisfying experience gave her a lifelong interest in teaching.

During this period, in 1907, Augusta Fells married John T. Moore and they had a daughter. Soon after, Moore died and Augusta returned with her child to her parents.

Knowing Palm Beach's main business was catering to tourists, Augusta showed the county fair superintendent, George Graham Currie, an array of amusing farm animals. He gave her a booth, and her ducks and other animals became a major attraction. The delighted fair officials, initially apprehensive about a black girl having a booth, voted her a $25 prize and special ribbon for the most original exhibit. When the fair ended, Augusta had earned $175—a fantastic sum for a poor black girl in Florida at the time.[4]

Currie came to believe deeply in Augusta's talent and commissioned a portrait of himself.[5] This stimulated her to seek similar commissions among well-to-do black people of Jacksonville. They were unwilling, however, to become the paying sitters of an unknown

young sculptor. Then Currie, who had once met Solon Borglum (the sculptor father of Gutzon Borglum, who carved the presidential heads on Mount Rushmore), wrote him about Augusta and urged her to go to New York to study art.

On the eve of her departure, Augusta expressed her gratitude to Currie in verse:

<div align="center">

MY SOUL'S GETHSEMANE

At the forks of life's high road
 alone I stand,
And the hour of my temptation
 is at hand,
In my soul's Gethsemane
 I still have your faith in me,
And it strengthens me
 to know you understand.[6]

</div>

Arriving in New York with $4.60, Augusta Savage went to see Solon Borglum. He pointed out that the young ladies who "study with me are the children of the rich and pay immense fees."[7] He suggested she study instead at Cooper Union because it charged no tuition, and he wrote a letter urging her admission to its registrar, Kate Reynolds.

At Cooper Union an unknown young black man persuaded Reynolds to see Savage's work. Overnight, she modeled the head of a Harlem minister, and this work, along with Borglum's letter, won her immediate admission in October 1921. During this time she also met and married James Savage, a carpenter, but divorced him within a few months. Her name on Cooper Union records, however, was Savage, and she left it that way.

The sculpture course was a four-year program. Her instructors passed Savage through the first year's work in two weeks and through the second year's in a month. She then was admitted to a life class taught by George T. Brewster, a well-known portrait sculptor. However, a few months later, by February 1922, she had exhausted her funds. Impressed by Savage's talent, Reynolds, the registrar, immediately got her a temporary job and called an emergency meeting of the Cooper Union Advisory Council. For the first time in the school's history, the council voted to supply funds for a student, covering room, board, and carfare.[8]

Long after she was doing notable portraits herself, Savage continued in Brewster's classes. Years later, when she had more confidence, she said: "I didn't know how good I was."[9]

Early in 1923 Savage sought admission to a summer art school sponsored by the French government

Gamin (1929), a portrait of an attractive street-smart boy, won Augusta Savage acclaim from the time it was first shown. All Harlem recognized her talent and supported her. In 1967 *Gamin* was voted the most popular of 250 works shown at the "Evolution of Afro-American Artists" exhibition at the City College of New York. (Plaster, 9¼" h.) Schomburg Center for Research in Black Culture, New York Public Library

in Fontainebleau, outside Paris. One hundred young American women were to be selected for it by a committee of eminent American artists and architects. Tuition would be free, but the fare to France and living expenses, estimated at $500, would have to be borne by those accepted. Savage paid a $35 application fee when friends promised the needed $500. She was then informed she had to supply two references, but before she could send the references, her $35 was returned. The committee, "with regret," rejected her.

Knowing she was more qualified than some who were accepted, Savage was disappointed and enraged. She decided to fight her rejection by exposing the committee's bias. When the Ethical Culture Society leader

<div align="center">

169

</div>

Alfred W. Martin learned of Savage's rejection, he promised to fight it if the story was true. He asked Ernest Peixotto, the internationally known artist heading the Fontainebleau committee, for an explanation. Peixotto replied that Savage's application was not accompanied by two references, but he also "frankly" added that the committee felt this avoided a difficult situation for the accepted "southern" girls. They would all have to travel on the same ship, eat together, work in the same classes, and this would have been "embarrassing" to Savage.[10]

Martin, denouncing such flagrant racial discrimination, called for reconsideration by the committee, which included the president of the National Academy of Design, Edwin Blashfield; the president of the Society of Beaux-Arts Architecture, James Gamble Rogers; and Hermon A. MacNeil, a leader of the National Sculpture Society. That "intelligent" and "liberal" artists practiced racial discrimination made first page news in New York and stimulated a *Nation* editorial on May 9, 1923. Harlem ministers and leading scholars, such as the Columbia University anthropologist Franz Boas, assailed the committee.[11] In the *New York World* of May 20, 1923, Augusta Savage gave her own point of view:

> I don't care much for myself because I will get along all right here, but other and better colored students might wish to apply sometime. This is the first year the school is open and I am the first colored girl to apply. I don't like to see them establish a precedent. . . . Democracy is a strange thing. My brother was good enough to be accepted in one of the regiments that saw service in France during the war, but it seems his sister is not good enough to be a guest of the country for which he fought. . . . How am I to compete with other American artists if I am not to be given the same opportunity?

The uproar continued. Martin sailed to France to protest in person to French authorities. Emmett J. Scott of Howard University compared the committee's action to a recent Missouri lynching. Boas, in an open letter to Peixotto, ridiculed the committee's "narrow racial prejudice."

The committee avoided the press, but one member concluded it had been wrong. He was sculptor Hermon A. MacNeil, who many years earlier had briefly shared a Paris studio with Henry Ossawa Tanner and knew that he had been driven abroad by prejudice. A sensitive portrayer of Native Americans, he tried to make amends by inviting Savage to study with him. She accepted and in later years cited him as one of her teachers.[12]

This struggle brought Savage, then thirty-one years old, national attention. But even more important was that, as a result, she became an experienced fighter in the struggle for equal rights. She not only made many Americans aware of unknown black artists in their midst, but in the character of her fight she expressed the existence of the "new Negro."

Savage paid a heavy price for taking the lead in this fight. She was one of the first black American artists to challenge the art establishment head-on and, due to circumstances beyond her control, that struggle—rather than her art—came to be where she spent much of her life's energies. Throughout the rest of her life she was considered a troublemaker by those whose racial prejudice she exposed—a group that included influential artists, museum curators and directors, dealers, foundation personnel, critics, and government officials. No one knows how many times she was excluded from exhibits, galleries, and museums because of this confrontation.

Working in Manhattan steam laundries to earn money needed by her family, Savage was sustained by knowing that an earlier black woman sculptor, Meta Vaux Warrick Fuller, had studied at the Colarossi Academy in Rome in 1899 and later with Auguste Rodin.[13] Gradually Savage realized that the black artist was caught in the economic plight of African-Americans as a whole and that she could not escape their struggles. When her father was paralyzed by a stroke, she brought her parents north to live with her, and when a hurricane destroyed their home and killed her brother, the rest of the family came too. For a while she had nine people in her three-room apartment on West 137th Street.[14]

Yet she did not stop her studies. A librarian, Sadie Peterson, was impressed by Savage's persistent study of art history in the Harlem branch library and quietly arranged for the Friends of the Library to commission her to create a portrait bust of W. E. B. Du Bois. Considered the finest portrait ever made of Du Bois, the bust was formally presented to the library in 1923. "Militancy, intelligence, and resolve are present in every plane," Elton C. Fax, a painter and writer, wrote of this bust in 1962.[15]

This success brought more commissions, the most important of which was a portrait of Du Bois's bitter enemy Marcus Garvey, the black nationalist who, through his Universal Negro Improvement Association, urged black people to develop self-reliance and to take pride in their African heritage. With his massive head and small alert eyes, Garvey was not an easy subject. Yet Savage captured his intelligence, his thrusting determination, and his self-dramatizing, insistent

Marcus Garvey (ca. 1930). Garvey, head of the Universal Negro Improvement Association, sat for Savage on Sunday mornings. In 1970 his widow, Amy Jacques Garvey, posed with Savage's powerful portrait in her Jamaica home. Savage's husband, Robert L. Poston, was Garvey's close aide. Martin Luther King, Jr., described Garvey in 1965 as "the first man . . . to give millions of Negroes a sense of dignity and destiny." Photo: Quito O'Brien, Jamaica, B.W.I.

pride. Unlike the Du Bois portrait, which was displayed in the Harlem branch library for over twenty-five years, the Garvey portrait was seen only in a few black newspapers on completion. Today it is in his widow's home in Jamaica.[16]

Through the Garvey commission, Savage came to know one of his most trusted assistants, Robert L. Poston, secretary general of the Universal Negro Improvement Association. Soon after completing the bust, she married Poston. But whatever happiness Augusta found was soon shattered when Poston, sent to Liberia to set up a Garvey colony, died on a steamship on his way home.[17] This was another blow to an already embittered young woman.

Her contact with Du Bois, Garvey, and Poston deepened Savage's loving identification with black people. It also gave her a sense of the need for black leadership and the qualities required for it. Although Du Bois and Garvey were enemies, both were able, profoundly influential, and deeply concerned with redefining relations between the white and black races. From this time onward, Savage became consciously absorbed in trying to fight for and lead black people, an effort that had many ramifications for her as an artist.

Interestingly, although this was a period when increasing numbers of white Americans were aiding black writers and artists, no such help came to Savage. Her daily life was spent in hard work and coping with family problems; only at night could she make her small figures. She did not participate in the interracial socializing that was the most talked-about aspect of the Harlem Renaissance. Yet she knew all the people involved and they knew her. After her confrontation with the Fontainebleau committee, inviting this overworked young woman to interracial soirées with publishers, editors, and critics may have seemed to risk upsetting the social applecart. Alain Locke, whose recommendation was the key to philanthropic support, was not interested in her work.

In 1925 Du Bois secured a scholarship for Savage at the Royal Academy of Fine Arts in Rome.[18] It provided both tuition and working materials, always a financial burden for sculptors. However, the fare and

171

The Pugilist (1943), a small but excellent example of Savage's ability to express character, has been cast in bronze since this photo was made. (8″ h.) Schomburg Center for Research in Black Culture, New York Public Library

living expenses, estimated to total $1,500, were not included, and she was not able to raise this sum. Once again, it seemed to her that her aesthetic development was frustrated by economic circumstances arising from discrimination.

Yet Savage never stopped modeling. Resilient and determined, she made many small clay portraits of ordinary people or types, such as the *Young Boxer,* which became part of her "permanent" exhibition at the Harlem branch library. She also had the satisfaction of having her work accepted at the Sesquicentennial Exposition in Philadelphia.

One day Savage coaxed an attractive boy she met near her studio into posing for her. Casually questioning and joking with him as she worked, she created a portrait representative of thousands of young black boys who lived on the streets and whose knowledge of life and people far exceeded their years. Her portrait caught the liveliness, the tenderness, and the sly wisdom of such boys. She titled it *Gamin*.

Immediately recognized as outstanding, *Gamin* moved everyone who saw it. Two prominent Harlem businessmen, Eugene Kinckle Jones, of the National Urban League, and John E. Nail, a real estate operator and father-in-law of James Weldon Johnson, agreed that funds had to be raised for Savage to study abroad; they knew the Fontainebleau story. Jones turned to the Julius Rosenwald Fund, established by the president of Sears Roebuck to aid minority groups. An art expert, assigned by the foundation to evaluate her work, was so enthusiastic that Savage was immediately awarded two successive fellowships.[19] In addition, each award was increased from $1,500 to $1,800 per year in special recognition of her merit and her problems in supporting herself.

Knowledge of Savage's Fontainebleau troubles was, in fact, so widespread among black Americans that when her fellowships were announced, many wanted to help pay for her travel and wardrobe so that her funds could go entirely for study, sculpture tools and materials, and living expenses. Fund-raising parties were held in Harlem and Greenwich Village. Many black women's groups sent money. Black teachers at Florida A & M collected fifty dollars for her. Few artists have ever received this kind of support from ordinary people. Augusta Savage was their artist. They also knew the pain of discrimination and wanted to help someone with talent overcome it.

In September 1929 Savage enrolled in a leading Paris art school, the Académie de la Grande Chaumière. She also began studies with Félix Benneteau-Desgrois, a winner of the Grand Prix of Rome in 1909 and the portraitist of many well-known French actors and political figures. To Eugene Kinckle Jones, she soon wrote of Benneteau: "Although he does not speak English, we manage to understand each other. He is very strict but patient with me. I am very sure that I shall be able to make great progress under his instruction. He promises to enter my work in the Salon in May if I work hard."[20]

The next year Savage's work won citations in the fall and spring Salons. An African figure she created was selected for medallion reproduction at the French Colonial Exposition.[21]

In Paris, Savage studied briefly with Charles Despiau, one of the great modern portraitists. Despiau emphasized expressive modeling and sensitivity to the emotional outlook of the subject, something Savage had demonstrated in *Gamin*. At the time Despiau had turned from the flowing movements of Rodin to the severe and formal figures of archaic sculpture in his

search for simplicity. When Savage continued her studies by traveling through France, Belgium, and Germany, she sought out archaic sculpture in cathedrals, churches, and museums.

In Europe Savage evolved a personal viewpoint that allowed her to consider anything potential subject matter, whether a panther chasing a gazelle, a gesture, or an emotion. But however "free," her efforts tended to be more decorative than innovative in terms of concept, material, and treatment. Leading modern sculptors such as Constantin Brancusi or Jacob Epstein apparently did not interest her. Nor did any relationship between Cubism and African art.

Later, referring in a distorted way to Locke's plea for African-American artists to study the "ancestral arts of Africa" for the psychological benefits, Savage asserted she was "opposed to the theory of critics that the American Negro should produce African art." Instead, she emphasized the culture black and white Americans share. "For the last 300 years we have had the same cultural background, the same system, the same standard of beauty as white Americans. In art schools we draw from Greek casts. We study the small mouth, the proportions of the features and limbs. It is impossible to go back to primitive art for our models." However, she added, "there are certain traits and inherent racial characteristics which occur frequently in Negro artists' work which may approach the primitive." As examples, she cited "the sense of rhythm and spontaneous imagination."[22]

By the end of 1931, when Savage had exhausted her Rosenwald funds, the Depression had overtaken the world, virtually ending art sales. Savage, however, was not daunted. Economic depression had been the permanent state of her world for many years, and she had managed to survive in spite of it. Returning to America, she had spirit, strength, and a new confidence born of her studies abroad.

In New York Savage's work was accepted at the innovative Argent Gallery and at the Art Anderson Galleries, which exhibited such well-known artists as Max Weber and sculptor Robert Laurent. But her immediate survival depended on commissioned portraits of such prominent black leaders as James Weldon Johnson and the surgeon Dr. Walter L. Gray Crump. She also did a portrait of Major Edward Bowes, whose radio "Amateur Hour" then enthralled America. Her sensitive 1934 bust of Ted Upshure, a handicapped Greenwich Village musician and entertainer, so impressed other artists that she became the first black artist to be elected to the National Association of Women Painters and Sculptors.

As the Depression deepened, Savage began teaching in the Savage Studio of Arts and Crafts, located in a basement apartment on West 143rd Street.[23] She had a way of making friends and immediately becoming part of the neighborhood. Soon young people interested in art began to gather there, and she obtained a $1,500 grant from the Carnegie Foundation to teach children. If a boy or girl stopped before the window in which she displayed work, she was at the door, crying, "Come on in! Come on in!" She insisted her librarian friend Anne Judge Bennis bring delinquent boys to her studio "because they ought to know there are black artists."[24]

She attracted the gifted like the Pied Piper. Her students included Norman Lewis, whose paintings are now in many museums; the developing sculptor and potter William Artis, who later became an art teacher; the painter and illustrator Ernest Crichlow; and Elton C. Fax. What gave Savage special stature among Harlem's young artists was that although she had achieved important recognition and studied abroad, she had settled in their midst instead of disappearing "downtown." She opened her studio to anyone who wanted to paint, draw, carve, or model.

Former students describe Savage as an inspiring teacher. Yet words generally fail them when asked to describe what was so different in her approach. The clearest account of her teaching comes from a nonartist, the well-known black social psychologist Kenneth B. Clark, whose research was the basis of the 1954 U.S. Supreme Court decision outlawing school segregation. In the early 1930s Clark, attracted to art and preferring clay modeling to painting, enrolled in Savage's class. "Once I was doing this nude," he told Jervis Anderson, "and was having trouble with the breasts. Gwendolyn Knight [who developed into a fine artist] was sitting next to me, and I kept looking at her, to see whether I could make a breast that looked like a breast. Gwen knew what I was doing, but she would not help me. Augusta came along and said, 'Kenneth, you're having trouble with that breast.' I said, 'Yes, I am.' And she simply opened her blouse and showed me her breast."[25]

This incident provides insight into her grasp of her students' needs and her readiness to dramatize that art must ignore social convention in seeking reality. Although Clark decided he had only mediocre talent and presently gave up art, he had learned that artists "communicate something about the human predicament with a reality and depth that are beyond words. It was Augusta Savage who implanted in me the respect and envy I feel for artists, and I thank her for lighting that spark."[26]

"Augusta had a way with people" is how she was most frequently described by the Harlem artists who

Gwendolyn Knight (1934). Knight, a Savage student when she posed for this portrait, both painted and sculpted with distinction. She married Jacob Lawrence in 1941. (17½″ h.) Collection Gwendolyn and Jacob Lawrence, Seattle

knew her.[27] Yet no one was close to her. However brilliant and striking, warm and friendly she was, she could also be moody and distant at times. While she could cajole, coax, humor, and laugh, most artists also remember that she could at times be very stern, sharp, demanding, capable of attacking with rage, especially if she felt she was not taken seriously. Her moods were not to be trifled with.

Savage strongly believed that everyone possesses some artistic ability, and as the WPA federal art projects developed, her studio school evolved into the Harlem Community Art Center. Under her direction some 1,500 people of all ages participated in its workshops, which ranged from fine arts to weaving, pottery, photography, sewing, and quilting. Its interracial staff included Vacla Vytlacil, later an important abstract artist. The art center was the largest in the nation, and its students' work was exhibited in special shows at the Metropolitan Museum of Art, New York University, and the Harlem YWCA.[28]

The WPA revived old but acute problems in new forms for Savage. Initially ignorant of African-American artists, WPA administrators refused to hire them until overwhelming evidence from the Harmon files, universities, colleges, galleries, and leading white artists demonstrated their existence. The deeper struggle with racism was whether a black artist could supervise white artists.

Whether Savage could direct the Harlem Community Art Center was one aspect of this struggle—which she won hands down. But the WPA supervisory question revived her own deep, bitter feelings of having been cheated years earlier by the Fontainebleau committee. It galled her to have bureaucrats—all of whom were white—making decisions about African-Americans' opportunities and activities. She could not stand the fact that people without art experience made decisions that were critical for black artists. As a result, she clashed repeatedly with Mary Beattie Brady, director of the Harmon Foundation, who controlled its exhibitions of black artists' work and selected its juries, but at the same time readily admitted knowing nothing about art and spoke condescendingly about what African-Americans needed (see pages 255–57).

Ultimately, the struggle over WPA supervisory jobs resulted in the organizing of the Harlem Artists Guild, in which Savage played a major role, becoming its first vice president and later president. She emerged as a strong leader. Her prestige as an accomplished artist was one element in her authority. Her personality was another.

Completely identifying with poor black people, she had a fierce, imperious manner in dealing with anyone she felt to be racist. She knew how to arouse black voters and to shake politicians. Government officials were left stunned and speechless when she led delegations to demand WPA jobs for black artists and to demand that black history be included in murals for schools, libraries, and post offices. She also insisted on supervisory jobs for experienced black artists.

Her personal contact with the three most influential black leaders of the time—Du Bois, Garvey, and James Weldon Johnson, with their very different styles, philosophies, and aims—gave Savage a perceptive grasp of the roots of power and what leadership requires.

Bust of a Woman (1934), in white marble, was one of Savage's most unusual works. Its romanticism derived from Rodin. It may have been done to demonstrate her versatility. Its location is unknown. Photo: *Metropolitan* magazine, New York

Through her teaching and by personal demonstration, she tried to develop racial consciousness and pride along with artistic talent. To deepen Guild members' understanding of their difficulties—artistic, social, and political—she organized the Vanguard Club, which met weekly to discuss the issues in black artists' work and lives. These discussions sharpened the demands of both the WPA artists' union and the Harlem Artists Guild for more jobs. The group also strengthened its political clout in the community through exhibitions in churches and schools. Soon, however, various people began to charge that the Vanguard group was "Communist."[29]

In 1935 Savage resigned from the Vanguard leadership, claiming that it had been taken over by Communists—a course she doubtless considered political self-preservation.[30] These repeated attacks contributed to the end of the busy Harlem Community Art Center and its constructive role in Harlem lives. Richard D. McKinzie, in his history of the WPA art projects, *The New Deal for Artists,* points out that the congressional

opponents of Franklin D. Roosevelt's social programs, many of whom were racist southern politicians, forced major WPA cutbacks and launched a massive assault in 1938. "The cultural projects were to be their first targets. They could charge radicalism and corruption, and by exploiting the peculiarities of the projects in New York City [with such "frills" as large numbers of WPA actors, dancers, artists, writers; the large Harlem Community Art Center; and the demand of the Harlem Artists Guild for exemptions from cutbacks], they would win their point with a majority of legislators."[31] By 1939 the WPA art projects were reduced to virtually nothing.

At times friends told Savage that she was wasting her talent on teaching and political struggles, but she rarely revealed any feelings of conflict. Once, when Bennis came into her apartment full of excitement about having just heard Marian Anderson sing, Savage said, "I'm just as important, just as much an artist as Marian

Anderson, and you don't act like that after being with me." She "was really hurt," Bennis remembered.[32]

On another occasion, however, Savage said, "I have created nothing really beautiful, really lasting. But if I can inspire one of these youngsters to develop the talent I know they possess, then my monument will be their work. No one could ask for more than that."[33] In this sense Savage succeeded, even if one counts only the work of Norman Lewis and Jacob Lawrence, both of whom were significantly helped by her. At the same time her statement reflects an inner demoralization concerning her own artistic development.

One cannot be certain about the factors, subjective and external, that cause changes in an artist's work; even the artist may not be fully aware of the pressures to which she or he is responding. But in the case of Savage, a profound change took place that was apparent by the mid-1930s. Instead of continuing to do sensitive portraits, such as that of Du Bois and *Gamin*, she turned to other subject matter. James A. Porter attributed this shift to the influence of her European studies. As he saw it, they caused "the setting aside of her convictions [in order] to learn techniques and to communicate a certain *joie de vivre*—but [one] which happened to be trivial."[34]

Savage's actual production dwindled by the mid-1930s. Many of the pieces she exhibited were done in Europe. Her new work lacked the significance that many had come to expect. In the late 1930s she modeled a sleek, semiclad girl with a hairdo suggesting a cat's ears and called it *The Cat*. She created a small dancing girl, *Suzie Q*, and a male companion, *Truckin'*. Another work, *Green Apples*, portrayed a small boy holding his stomach in distress. Although her friends defended her, some African-American artists were openly critical of the way she was using her talents. Locke complained she was attempting to go beyond her technical competence.[35]

The major factor in producing these changes may well have been the prolonged Depression. As Savage's understanding of the depth of the Depression grew, as she fought social and political battles every day over a period of years—first to gain WPA work-relief projects, then to preserve them—she inevitably came to a new assessment of what she personally, as an artist, was up against. The problem of trying to feed a family on $4.29 a week was overwhelming.

At the 1931 Salons of America exhibition, Savage and other artists, including Reginald Marsh, Max Weber, and Robert Laurent, agreed to set a price on their work and to refuse to cut that price regardless of how desperate their need might be. During the Depression, despite such interracial unity, hundreds of artists were driven from the field. In such a situation the ex-pectation of creating monumental and memorable sculpture seemed ridiculous.

In 1935 Savage created a life-size group—with a pensive young black woman sitting on a rock and looking at what a Chicago critic called "an uncertain future."[36] Beside her, crouching in a frightened way, is a black man. She called this work *Realization*. Some thirty Harlem citizens contributed funds to have this statue, which reflected their appreciation of such situations, cast in bronze. Such casting was something Savage had never been able to afford.

Encouraged, she created a larger-than-life-size antiwar memorial, *After the Glory*, the following year. It depicted an African-American grandmother, a mother, and a child gazing into space in search of the missing son, husband, and father. Funds for casting this work could not be raised. Her inability to get support from conventional sources and the inability of black people to fund her work as a result of their poverty often left Savage feeling bitter. Yet she kept trying.

Nevertheless, Savage seemed to have come to the conclusion that her opportunity for creating memorable sculpture—and the chance of a poor black woman becoming a great sculptor—had disappeared forever, destroyed by the Depression. Her art became wholly secondary to her work as an encouraging teacher and a determined organizer.

Savage was therefore astonished in early December 1937, when the World's Fair Corporation announced that it was commissioning her to create a large statue reflecting "the American Negro's contribution to music, especially to song."[37] Three other leading women sculptors—Gertrude V. Whitney, Malvina Hoffman, and Brenda Putnam—were also commissioned to do sculptures. Eventually Savage took as her theme *Lift Every Voice and Sing*, "the Negro national anthem" composed by James Weldon and Rosamond Johnson, and announced she was taking a year's leave of absence from her directorship of the Harlem Community Art Center to do the statue.

After months of preparation, working from a small clay model in the backyard of the building in which another African-American artist, Louise Jefferson, had her studio, Savage created a huge harp—sixteen feet tall—whose strings were a line of singing black children. A huge forearm and hand with the fingers curving upward, symbolizing God's gift, formed the base of the harp in the foreground, where a kneeling young black man symbolically offered a plaque with musical notes on it to represent the musical gifts of black people. Cast in plaster, *Lift Every Voice*

Lift Every Voice and Sing (1939), also known as *The Harp*, became Augusta Savage's best-known work. Commissioned by the 1939 New York World's Fair, it was inspired by James Weldon Johnson's African-American anthem. Its complexity created aesthetic problems that centered on the kneeling man and his plaque with words and symbols of the song. Small (11″ h.) metal copies were sold as souvenirs. (Plaster with black paint finish, 16′ h.) Photo: Carl Van Vechten, Yale University Library

and Sing was blackened with paint to give it a basaltlike finish.

Of the four commissioned statues, *Lift Every Voice and Sing* was the most popular, most photographed, and most publicized. Because it was linked to the spirituals, and people rarely saw black faces in sculpture, its deficiencies as a work of art were overlooked. People liked it and sent postcard pictures of it from the fair, and it brought Savage national attention from the mass media. Yet, as a work of art, many artists thought that it was a superficial mixture of fantasy and realism, and poorly composed.[38] After the fair, Savage did not have funds to cast or store it, so it was smashed by bulldozers demolishing the fair's buildings—an event that went unnoticed in the press.

Months before the destruction of her statue, Savage discovered to her consternation that her leave of absence would not be accepted by the WPA administration. In its view Savage was now privately employed—

the goal of the WPA. Savage had helped her friend Gwendolyn Bennett, an able, well-trained artist and teacher, take over the position of director of the Harlem Community Art Center on what she assumed was a temporary basis. In the end Savage was left a famous but poor, unemployed black artist. The politicians and bureaucrats who had found her a jabbing thorn in their sides were finally rid of her as director of the center. It is even possible that her World's Fair Commission was arranged with this outcome in mind. Finally, in February 1938, she was made a consultant to the project at $1,800 a year and in July a project supervisor at $1,750 yearly.[39] Although better known than ever, she no longer had the authority and platform she once had and she resigned in mid-April 1939.

Savage had already decided to renew her struggle to establish herself as an important artist and an authority on African-American art on different planes. To take advantage of the still-booming World's Fair publicity, she planned an exhibition of her own work. She had never had a one-woman show and had neither

Terpischore at Rest (1932), also known as *Reclining Nude*, was later cut in marble. William Artis preserved this photograph of the original clay model. Collection Ersa H. Poston, New York

critical endorsements nor museum credits. She felt keenly that she had never won a Harmon award.

And she had another plan—to open her own art gallery on Harlem's 125th Street. She was encouraged to think along these lines by the past support she had had from Harlem people even when she was unknown. And she had created the largest community art center in the nation there. She hoped the exhibition would bring critical honors and reinforce the attractiveness and status of her Harlem gallery.

Her exhibition opened at the Argent Gallery soon after she left the WPA. However, most of the work exhibited was not new, some dating back to her European days (for she had not had time to create while fighting for WPA jobs).

Unfortunately, her exhibition did not win high praise. The *Art News* of May 27, 1939, in one of the most favorable notices, said her work revealed "if not a startlingly original artist, an accomplished practitioner. In addition to an assortment of lively heads, of which the shining black Belgium marble *Woman of Martinique* is probably the finest, there are such figure pieces as the lithe *Terpischore at Rest,* and a feline female entitled *The Cat.* The Rodin-inspired *Creation* was perhaps a mistake. Miss Savage seemed to be at her best in such expressions of personal humor as the small group of nuns, *Sisters in the Rain,* and in her strong portraits."

Savage was deeply hurt. Just when her name was best known, she felt destroyed by a combination of factors: her political activism had not only alienated

the politicians and WPA administrators, but also diverted her energies from her art. In addition, she recognized that the coming of World War II would wipe out the WPA art projects she had struggled to establish and preserve as a means of training young black artists.

Despite her disappointments, Savage rallied by going ahead with her private art gallery, the Salon of Contemporary Negro Art, on the third floor of a building on 125th Street. Some 500 people of both races turned up for its opening on June 8, 1939. She exhibited the work of many African-American artists including that of Richmond Barthé, Gwendolyn Knight, Ronald Joseph, Norman Lewis, Beauford Delaney, Ernest Crichlow, James Lesesne Wells, Elba Lightfoot, and Ellis Wilson. However, the people of Harlem had no money for art and the people who had money for art were not inclined to look for it in Harlem. She was soon forced to close the gallery.

Amid the ruins of her plans, Savage remained determined to gain a place for herself. Her situation was much like the one she faced when she first came to New York. The difference was that she was now nationally known, experienced in dealing with organizations and political struggles. Gaining the sponsorship of the now-defunct Architectural League of Washington, she planned a nine-city midwestern tour with her work to conclude with the opening of the American Negro Exposition in Chicago in July 1940.[40] Early in May she came to Chicago from Gary, Indiana, and set up an exhibition in Perrin Hall, adjacent to the Chicago Auditorium. Her statues included *Gamin,* a garden

fountain figure, *The Cat*, her portrait of James Weldon Johnson, a teak carving titled *Envy, Realization,* and other works.[41]

To mark the opening of her exhibition, she presented a provocative and highly personal history of art, "Crisis: Past and Present," in the Chicago Auditorium recital hall.[42] Introduced by Edward R. Embree, head of the Rosenwald Fund, she held an audience, which included many prominent social figures, spellbound with her stories of her own struggles to become an artist. To reach Chicago African-Americans, she set up a three-day exhibition, May 6–9, at the Southside YWCA, appearing three times a day, from nine o'clock in the morning until nine at night, to discuss her work.[43] Thousands of African-American schoolchildren came to see and hear her.[44]

Yet this intensive effort did not result in significant sales or commissions. Socialites did not know what to do about her sculptures of black people. And Chicago's African-Americans, like those in New York, did not have the money to buy her work. In her remarks Savage lamented that only two of many African-American homes that she visited had works by African-American artists. Such artists should not have to depend on WPA projects, she said.[45]

This grim situation forced her to abandon her tour, although the details are unclear (records of the Architectural League of Washington no longer exist). The heavy cost of moving her large works to New York makes it uncertain that they were returned. *Realization* and other works were apparently either destroyed or abandoned. They cannot be found today.

In any case, when the art exhibition of the American Negro Exposition opened on July 4 at the Tanner Galleries in Chicago, Savage was represented only by *Prima Donna,* a carved hardwood statue, perhaps inspired by the rise of Marian Anderson.[46] Simplified in its handling of masses and seemingly influenced by Elie Nadelman, it departed from her usually detailed realism in portraying a type. Certainly Savage hoped for honors and positive critical attention. However, young Elizabeth Catlett's *Mother and Child* won first prize and Barthé's *Shoe-shine Boy* second prize. No honorable mention came her way, and today *Prima Donna* cannot be located.

Undoubtedly Savage felt rejected by her own people. She may have even abandoned or destroyed her work.

Returning to New York, depressed and embittered, Savage gave up. She saw only a few old personal friends, like Bennis, who had nothing to do with art.[47] In the early 1940s she moved to an old chicken farm

James Weldon Johnson (1939). Courage and serious purposefulness are expressed in Savage's 1939 portrait of Johnson, poet, leader of the NAACP struggle against lynching, and co-author, with his brother J. Rosamond, of the classic *Books of American Negro Spirituals.* Harlem considered him one of its greatest heros. (Plaster, 17 x 9 x 9½") Schomburg Center for Research in Black Culture, New York Public Library

in Saugerties, New York, near the Woodstock art colony. Yet she made no effort to meet Woodstock artists and instead worked as an assistant for a commercial mushroom grower. Nor did she attempt any art. What she wanted, she told friends, was complete isolation. She told Bennis that she was disgusted and sick of New York.

A neighboring farm family, discovering who she was, set up a place for her to work on sculpture in one of their buildings, but she apparently never used it. Yet, "in a sense Augusta couldn't stop working," Bennis said later. "If you sat down on the grass with her, she'd pick up a twig, or grass, or dirt, or anything, and start shaping it, trying to do something with it." According to Bennis, Savage kept only one piece of sculpture at the farm: "It was something I always called 'Aspiration,' although I don't know what Augusta called it. It was wood—and like a long flame shooting up from two entwined hands, and very beautiful."[48]

179

Head of a Boy (ca. 1935), carved in black marble, was one of Savage's few works in stone. Its present location is unknown. This picture was preserved by her student William E. Artis, later a prolific sculptor, ceramicist, and educator.

In the late 1950s her health deteriorated, and in 1961 her daughter, Irene Allen, convinced her to return to Allen's home in the city, where she could be cared for. Eventually hospitalized, she died on March 27, 1962. Fax, one of the few artists to visit her in Saugerties, pointed out that "during the seventeen years preceding her death . . . Augusta Savage lived in virtual professional exile."[49]

Today, much of Savage's work cannot be located. There are not even photographs of many statues. Fax believed that her best works never returned from Chicago. In October 1988 Deirdre L. Bibby, the Schom-

burg Center's art curator, organized an exhibition of Savage's work under the title "Augusta Savage and the Art Schools of Harlem" at the center.[50] A large group of her former students, including Lawrence, Knight, Crichlow, and Fax, participated in a panel discussion of her teaching and personal memories of the Harlem Community Art Center. Many photographs of Savage at work made by Marvin and Morgan Smith, once her students, made the exhibition unusual. The work of many students, some of whom had become well known, was displayed. However, only nineteen small pieces of Savage's work could be located; nine were gifts to the Schomburg Center from Lorraine Lucas, the stepdaughter of Irene Allen.

Some of her work disappeared under curious circumstances, the most mysterious being the theft of her magnificent bust of Du Bois from the Harlem branch of the New York Public Library. Known to generations of library users, it sat undisturbed in the 135th Street library from 1923 until 1960. According to Jean Blackwell Hutson, then head of the Schomburg collection, an unknown African-American man tried to take the statue one evening, saying that Savage had requested him to do so.[51] When librarians insisted that it belonged to the library, he surrendered it willingly. The incident was forgotten. But on October 26, 1960, the bust was discovered to be missing and has never been found. Some librarians believe that Savage did indeed send someone to get it and that she destroyed it, possibly because she no longer admired Du Bois.

Fax has said that, "like most American Negroes, her awareness of race was made to supersede her awareness of what she, a gifted, trained human being, was prepared to offer society."[52] Despite her enormous talent and drive, Savage's creative efforts were first cruelly frustrated by discrimination and then crushed by the Depression and the struggles in which she found herself. Her importance lies not so much in her own work as it does in her heroic efforts to aid the development of subsequent generations of African-American artists. Her hope of nurturing young black artists—"My monument will be in their work"—has been fully realized. At the same time her sharp self-assessment—"I have created nothing really beautiful, really lasting"—is not exactly true, as *Gamin* testifies more than half a century later.

MALVIN GRAY JOHNSON

"Prefers Negro subject matter" is how the 1933 Harmon Foundation catalog characterized Malvin Gray Johnson, an inspired and innovative artist, who died unexpectedly a year later, on the eve of his full development of a highly individualized modern style. The 1935 Harmon exhibition was dedicated to him, featuring thirty-five oils and eighteen watercolors. Today, except for a few paintings in the Schomburg Center for Research in Black Culture in New York and the National Museum of American Art in Washington, D.C., Johnson's work is scattered and there is very little information about him.[1]

Johnson, who was called "Gray" by his friends, was born in Greensboro, North Carolina, in the heart of tobacco-raising country, on January 28, 1896. His family moved to New York when he was a boy. Although he discovered his artistic talent at an early age and decided to become an artist, he could not afford to enter the National Academy of Design until he was twenty-five years old. He studied there with well-known academicians Ivan Olinsky, Charles Curran, and H. Bolton Jones in 1921, 1926, and 1927. The five-year gap in his studies was necessitated by his need to earn tuition at menial jobs.[2] Eventually he supported himself as a commercial artist while painting at night and on weekends.

Johnson's first recognition came in early 1928, when he won the $250 Otto H. Kahn prize at the Harmon exhibition for a painting titled *Swing Low, Sweet Chariot,* an attempt to express the theme of that famous spiritual. The award stimulated him to further efforts in interpreting the spirituals. For example, in the 1930 Harmon show, he exhibited *Mighty Day, I Know the Lord Laid His Hands on Me,* and *Climbing Up the Mountain.* In 1931 he exhibited *Roll, Jordan, Roll,* as well as a sympathetic portrait of an African-American woman, which he titled *Meditation,* and *Water Boy.* Johnson also exhibited at the Anderson Galleries in 1931 and in the Depression-born Washington Square Outdoor show in 1932. One of his paintings,

Negro Masks (1932) was first shown at the Harmon exhibition of 1933. It expressed Johnson's identification with Africa. When he painted his self-portrait, the masks were made part of the background. (28⅛ x 19⅛") Hampton University Museum, Hampton, Va.

Negress, was purchased by the Whitney Museum of American Art.

His studies of Impressionism and awareness of the individuality of some innovative American painters "lifted him out of his earlier scholastic manner," according to James A. Porter, a teacher at Howard University.[3] "He became an experimentalist, first with color, solving problems of reflected light and of direct light with glasses of water and other still-life objects," Porter noted. "Subsequently there was a turning from these essays to deeper problems of form," based on his study of African sculpture and its influence on modern

Marching Elks (ca. 1933) reflects Johnson's search for simplification of forms, but it also gains from the rhythmic repetition of the Elks' costumes. Harlem in the 1920s and 1930s held many such parades. Photo: National Archives

European painting. When Johnson painted a self-portrait, he made African masks a part of the background.

Beginning with his paintings of African-American city life in 1931, Johnson gradually abandoned academic concepts to apply Paul Cézanne's dictum that all objects could essentially be reduced to a cone, a cylinder, and a square. His reductionistic efforts linked him to such American artists as Arthur Dove and Charles Demuth. Johnson may also have been aware of the Chinese masters of reduction, who are said to have studied an object for years, absorbing every detail into their very being before making a single brushstroke. In a few lines they were able to delineate mountains, trees, and rocks—a distilla-tion of long analytical observation and reflection on the nature of these elements.

This was the direction that Johnson took when in 1933, fulfilling a promise to himself to paint southern black people, he went to Brightwood, Virginia. There he made a series of watercolors from which he later made oil paintings of African-Americans—thinning corn, picking beans, washing clothes, raking hay, picnicking, in old age, at revival meetings, and in chain gangs, as well as in their southern landscapes.[4]

Porter, who was fascinated by Johnson's swift transition from a traditional academic style to a modern one, remembered: "Artistic or creative fervor was of the essence of this man. . . . I shall never forget my first meeting with him, when his apparent relaxation

Picking Beans (1933) was one of a series of watercolors done by Johnson during a two-month visit to Brightwood, Virginia. In them he abandoned the academic techniques of his training to simplify forms and color in a modern style. Unfortunately, he died suddenly in October 1934 while plans for a one-man show were under way. Of thirty-five oils and eighteen watercolors by Johnson in the 1935 Harmon memorial exhibition, few can be located today. They survive in photographs from that exhibition in the National Archives. Photo: National Archives

Self-portrait (1934) is similar to Johnson's portraits of a soldier and a postman, except that the self-portrait includes the African masks in the background. (38⅛ x 30″) National Museum of American Art

Southern Landscape (1933) was one of three landscapes in oils with this title included in the 1935 memorial exhibition of the Harmon Foundation. In its simplifications, it is as though Johnson were teaching himself to see in a new way. Photo: National Archives

and poise of mind masked for a while his more electric quality, with which I became more impressed at subsequent meetings."[5] Johnson alternated between incisive speech and quick sardonic humor, Porter said, and "one could trace in it a slight tinge of bitterness and exasperation. No doubt he felt the pressures that everywhere have forced apart the modern artist and the society of which he could be the interpreter."

As already noted, one of Johnson's major inspirations was his study of African sculpture, which expresses an object's spiritual and psychological essence in simple forms. Johnson increasingly sought to convey the fundamental structure of a figure or object. In his Brightwood watercolors, his reductionist approach brought him close to a Cubist style in his treatment of simplified masses.

His development as a highly individual modern painter prompted Delphic Studios in New York to plan a one-man show. This was regarded by African-American artists, and by Mary Beattie Brady of the Harmon Foundation, as a real breakthrough because galleries at that time were not exhibiting the work of black artists. However, before that could take place, he died suddenly on October 4, 1934.[6]

Johnson ranks as one of the promising innovative artists of his day who, like Stuart Davis and Marsden Hartley, found a forceful personal style of expression. His death stunned the small group of African-American artists who knew him. He was a relatively isolated figure, busy at work during the day and painting at night. He was not a frequenter of "306," the apartment of Charles Alston and Henry W. Bannarn, which was the intellectual and social center for Harlem artists.

While some of Johnson's work was preserved by the Harmon Foundation and some of it found its way to the Schomburg Center as gifts, most of it was scattered after his death. Records and data about him are sparse. His widow remarried, and efforts to locate her have failed.

The significance of Johnson lies in the fact that in the space of a few years he challenged the academic traditionalism that then dominated American art and that held most African-American artists in its grip in their efforts to win acceptance as artists. This is why Porter eulogized him in an essay in *Opportunity*, and why this essay was reprinted in the catalog for the 1935 Harmon show, where he was the only painter of the three artists exhibited.

W. H. JOHNSON

Sometime in 1918, seventeen-year-old William Henry Johnson, determined to be an artist, arrived in New York with his uncle from a small South Carolina town. They became stevedores, loading ships with war supplies for what seemed, by southern standards, enormous pay. To help his mother feed his brothers, sisters, and disabled father, Johnson lived in cold, cheap rooms and worked nights too—washing dishes, toting bags, cooking, and doing odd jobs. After three years he had saved enough to start the five-year painting course at the National Academy of Design. Thus Johnson began a career marked by great promise yet shattered by tragedy.

After receiving a superb training, Johnson spent more than a decade in Europe, aided by two leading American artists, George Luks and Charles Hawthorne. Although his work won praise in Scandinavia, his habit of exhibiting in craft shops with his Danish wife, an accomplished weaver and ceramicist, resulted in his work being overlooked by influential critics and collectors. The rise of Nazism, which besides being racist was violently against modern art, drove him back to America, which he had left because of its racism.

In the United States his expressionistic work, which was very unusual for an American painter at the time, did not receive sustained interest from dealers, collectors, or museums. He also found that two African-American painters, Horace Pippin and Jacob Lawrence, had—without academic training—gained the national recognition he sought with their paintings of the history and everyday experiences of black people. Their achievement apparently prompted Johnson to portray African-Americans in a simplified, expressionistic manner, utilizing the flat style of modern art. In this way, Johnson added a new dimension to Expressionism, which itself had African antecedents.

However, his effort was tragically cut short by an insidious luetic infection, contracted many years earlier, which so destroyed his mind and body that he was unable to recognize friends or paint. Because he was considered a painter of great promise, the bulk of his work was saved by Mary Beattie Brady of the Harmon Foundation and given to the National Museum of American Art, then called the National Collection of Fine Art, in Washington, D.C. That this large body of work was intact and on its premises resulted in Johnson's becoming the first modern African-American artist to be given an extensive exhibition by this museum. As the show was being prepared, he died.

What Johnson might have been if he had not been struck down in his prime will remain unknown. His efforts to achieve singularity as a painter illuminate not only artists' problems in general, but those of African-American artists in particular.

Johnson was born on March 18, 1901, in Florence, South Carolina, then a small, mule-drawn town with railroad repair shops, sawmills, and cotton gins. His mother, Alice Johnson, was of black and Sioux ancestry. His father, reportedly a well-known Florence white man, contributed nothing toward his son's upbringing. His mother soon married a black man who diligently provided for his family. They had two sons and two daughters.

Then an accident disabled Johnson's stepfather, and his mother supported the family by washing, ironing, and cooking for white families and later by working at the YMCA. Young William earned pennies carrying hot dinner pails to railroad shop workers, but most of the time he stayed home to look after the other children and do household chores. At spring planting and harvest time, he worked in the fields. Like most poor southern children, he did not get much education.

At an early age, however, Johnson discovered he could draw. His sister recalled his mother saying he learned by copying "Maggie and Jiggs," the comic strip.[1] A sympathetic teacher, watching him draw faces

and figures in the dirt with a stick, began supplying him with paper and pencils. He made a pencil sketch of another helpful teacher, Leona M. Webster.[2]

In his teens Johnson dropped out of school both to earn more money for his family and to prepare to become an artist. Direct and impulsive, once Johnson learned New York was America's art center, he felt he had to go there. When his uncle decided to seek higher wages in wartime New York, his mother agreed to young William's accompanying him. That he continued to send her money from New York reflects his compassionate awareness of her problems.

Not until 1921 did Johnson have enough money to start his art training. Knowing that because he was black his work would be severely scrutinized, Johnson selected the most rigid and academic training available—at the school of the National Academy of Design. He apparently considered his impulsiveness a weakness and deliberately sought a training requiring maximum control; he may also have chosen the National Academy because its students were accepted as professional artists on completion of their studies. The Art Students League, which would have been technically less rigorous and provided greater independence, probably appeared too loose and risky for him, both in a subjective psychological sense and with regard to objective educational considerations.

Johnson entered the antique-cast drawing class of Charles L. Hinton, a well-known academician, on probation on October 4, 1921. His earnestness and rapid mastery led to his winning an honorable mention in the spring competition. With this, his probation was over, and he advanced to life drawing. The next year, winning a still life prize, he moved into painting.

Johnson's prizes brought him to the attention of Charles W. Hawthorne, who ranks with Thomas Eakins and Robert Henri among America's inspiring teachers. While Hawthorne emphasized the spontaneity of the visible brushstroke, his main concern was poetic vision: "Anything under the sun is beautiful if you have the vision—it is the seeing of the thing that makes it so The painter must show people more than they already see Here is where art comes in."[3] Edwin Dickinson, later a famous teacher himself, said Hawthorne's ability to demonstrate his principles "created an atmosphere of security and hope."[4]

Such an atmosphere was something Johnson needed very much. Heartened by Hawthorne's attention, he worked tirelessly. Finding Johnson was working nights and weekends to support himself, Hawthorne feared the youth's talent would be crushed by poverty and prejudice before he could mature as an artist. From 1923 through 1925 he gave Johnson a summer job maintaining tennis courts at his Cape Cod School of Art plus free tuition so that he could continue painting without a letup.[5]

At the National Academy Johnson won the important Cannon prize in 1924 and again in 1926; he also won the Hallgarten prize in 1925 and five other prizes. But he did not win the school's most coveted award—a year's study in Europe. Johnson, Hawthorne, and several other National Academy artists felt he had been passed over because he was black,[6] especially since Augusta Savage's angry struggle had made some New York artists aware of prejudice (see pages 169–70).

Hawthorne decided racial prejudice was so strong in the United States that Johnson could gain recognition here only if he first won it in Europe as Henry Ossawa Tanner had. As a result, Hawthorne tried to raise $1,000 for Johnson, which was then sufficient for a year's study abroad.

Hawthorne had already interested George Luks in Johnson's work. One of "The Eight," a group of realists who broke with tradition, Luks focused on the vitality of working people.[7] He let Johnson study with him in return for Johnson's cleaning his brushes and studio. Impulsive and vigorous, Luks expressed his basic attitude in these terms: "Art—my slats! I can paint with a shoestring dipped in lard. Technique did you say? My slats! . . . It's in you or it isn't. Who taught Shakespeare technique? Guts! Life! Life! That's my technique."[8]

Luks's approach acted as a first step in Johnson's development in an expressionistic direction. More immediately, Luks contributed $600 to Hawthorne's $1,000 fund, enabling Johnson to reach Paris in November 1926.[9]

In Paris a new kind of life began for W. H. Johnson, as he now called himself. Free of the need to earn a living and the humiliations of racial prejudice, he became excited by the Paris art world and its successive art movements. At the time much attention centered on Paul Gauguin, whose journal had recently been published, as well as a biography. Johnson was drawn to Gauguin, not because of his theory of color harmonies and design, but because of his depiction of people of color—the Tahitians—with simplicity and reverence.

By Western traditions these people seemed exotic, sensual, and mysterious. Gauguin, who had abandoned a banker's middle-class life in Denmark to find himself as an artist, believed that machine-dominated civilization was destroying creativity. To escape, he went first to Martinique in the Caribbean, then to Tahiti. In his autobiographical *Noa Noa,* Gauguin romanticized

Landscape, Cagnes-sur-Mer (1928–29). This southern French village attracted Johnson because it was here that Soutine painted some of his most frenzied landscapes. Hale Woodruff also came to Cagnes-sur-Mer, which had an art colony, but missed Johnson by a few days. (21 x 25⅜") Collection, Estate of David and Helen Harriton, Minisink Hills, Pa.

Tahitian life as a "natural" way of life that permitted him to use his feelings and imagination in art: "I was reborn . . . man purer and stronger came to life within me . . . from now on I was a true savage."[10] The Tahitians were "primitive," Gauguin said, and so was he. Actually, Gauguin—an acute student of Impressionism and of one of its founders, Camille Pissarro—was extremely knowledgeable about Western art.

Johnson promptly declared himself a "primitive." In so identifying himself, he could express and even explain his own frustration and alienation in dealing with a complex industrialized society that cruelly discriminated against black people and that often made cooped-up city living ridiculous to a country boy. Johnson used the word *primitive* to mean a sensitive man whose inner life lay outside a culture that imposed on him strict requirements on how he should behave and even paint. In Gauguin, Johnson saw a modern master who, attempting to be true to his deepest creative feelings, adopted and indeed glorified the simplicity, directness, and spiritual quality of a people of color. Years later, the first thing that people recalled about Johnson was that he called himself "primitive."[11] Although his use of the term was confused, he took joy in it.

Johnson did not try to paint like Gauguin, for he was not interested in an analytic approach to design and color. In Paris he recognized that painting from the "gut," to use Luks's term, need not be limited (as Luks was) to romantic realism. There could be, as he discovered in Chaim Soutine's Expressionist canvases, an emotional type of painting that in conventional terms seemed bizarre, yet contained the essence of truth.

At the time Soutine's work was what was new. His first major show was held in 1927, a year after Johnson's arrival. Instantly drawn to Soutine's work, Johnson began to work in his style, simplifying his subject matter, expressing emotional reactions in exaggerated distortions, and squeezing colors directly from the tube to create a thick impasto. In his attempt to absorb everything about Soutine, Johnson painted young pastry cooks, just as Soutine did. He moved to hilly Cagnes-sur-Mer in southern France, where Soutine had created his beef and fowl carcass paintings and his frenzied landscapes with tumbling houses. Working in Soutine's style, Johnson created paintings in which the landscape appears to be a boiling sea.

His Soutine studies helped Johnson release his own long-suppressed emotions aesthetically. As Adelyn D. Breeskin has observed, "the most far-reaching influence on his work of the next eight years was to remain that of Soutine."[12]

Yet Johnson's work differs significantly from that

of Soutine, whose canvases often reflect a morbid preoccupation with death. The famous oscillating movement in Soutine's work is at times frenzied and almost hysterical. In contrast, the movement in Johnson's canvases is expressed in rhythmic exuberance and delight in his subject matter, and an ability to distort yet control the scene.

Through Soutine, Johnson found a way of uniting his inner self with his painting. He was not the careful, intellectual artist involved in the arduous balancing of forces that Paul Cézanne was. Nor could he work over a long period on one painting in the patient, contemplative manner of Georges Seurat. Like other Expressionists, such as Oskar Kokoschka and Edvard Munch, whose work he admired greatly, Johnson had an intense need to react immediately and emotionally to what he saw and felt. With their spontaneity, Johnson and other Expressionists often achieve a brilliant immediacy, drawing the viewer into the existential drama of their vision.

Although its roots can be traced back to Albrecht Dürer's contemporary, Matthias Grünewald, modern Expressionism seemed a new phenomenon in 1927. Munch and Max Beckmann were not known to many Americans then. In placing himself in a newly developing trend, Johnson had high hopes. He had his first one-man exhibition, which still reflected the influence of Hawthorne and Luks, at the Students and Artists Club in Paris, November 2–23, 1927, a year after arriving. His second exhibition, in Nice in the winter of 1928–29, revealed the influence of Soutine. To his great disappointment, neither show attracted attention.

Part of his disappointment stemmed from his strong expectations of success after visiting Henry Ossawa Tanner at Trépied, in Brittany's Pas de Calais, soon after arriving. Tanner had just won the National Arts Club medal and was about to be elected a full member of the National Academy of Design. Meeting Tanner in his large, well-established studio-home—a black artist who was very successful in Europe—had a deep impact on Johnson, and he even grew a mustache and goatee resembling Tanner's. Unquestionably Johnson hoped for the kind of success Tanner had won. Tanner, impressed by Johnson's intensive training, praised his talent to Palmer Hayden, another black American artist then in Paris.[13]

In 1929 in Cagnes-sur-Mer Johnson met a gifted Danish tapestry weaver and ceramicist, Holcha Krake. A love affair developed, although she was fifteen years older. Enjoying his company, Krake, her sister Musse, and her brother-in-law Christopher Voll, a sculptor, invited Johnson to tour European art centers with them. He accepted with delight.

Visiting museums and galleries in Europe with his new friends, Johnson uneasily began to realize that winning recognition in its chaotic art world was more difficult than he had supposed. One had to compete with thousands of well-trained artists; prizes at the American National Academy of Design meant nothing. Neither did his own shows. He was still counted as only a student. He began to realize what he had that was different was his African-American heritage.

That he was affectionately accepted by Holcha Krake, her family in Odense, Denmark, and her artist friends and that he encountered little prejudice increased his desire to prove himself. So did Tanner's personal encouragement. Yet even his happiness with Krake seemed to create an insidious problem, as though committing himself to marriage with her would destroy his sense of identity as a African-American;[14] he

Minnie (1930), painted in Johnson's full-brush expressionistic style, has an objective virtuosity that few portraits attain because it is also based on a sympathetic understanding of the subject's personality. (17 x 12⅛") National Museum of American Art

Jacobia Hotel (1930). This sagging, ramshackle building seemed a perfect subject for Johnson's style in his hometown of Florence, North Carolina. He was arrested for painting it, reportedly because it had become a brothel but also probably because he was black. His arrest deepened his alienation. (19½ x 23⅛") National Museum of American Art

might vanish in contentment. Not having seen his mother and family for three years, he feared his roots were drying up.

Johnson decided that to be taken seriously in Europe, he had to establish himself as a painter of significance in America. Hayden, who had won the Harmon gold medal without much training, assured him he could win such a prize easily. Therefore, in November 1929, Johnson returned to New York, rented a cheap, cold loft, and entered six paintings in the coming Harmon exhibition.

The Harmon jury included his former mentor George Luks, who was impressed by Johnson's Expressionist work. He convinced his fellow jurors that Johnson's paintings were more than just the best entry. In awarding Johnson the 1930 Harmon gold medal and $400 first prize, the jury stated: "We think he is one of our coming painters. He is a real modernist. He has been spontaneous, vigorous, firm and direct. He has shown a great thing in art—it is the expression of man himself."[15] Mary Beattie Brady, impressed by Luks's and the other jurors' discussions, selected four of Johnson's paintings for a traveling Harmon show.

Much stimulated, Johnson took many canvases to Florence to show his mother. Some paintings were displayed at a meeting of county teachers and a larger exhibition was held at the YMCA. In reporting John-

son's Harmon prize, the *Florence Morning News* emphasized that he was the son of Alice Johnson, who had faithfully served the YMCA for the past twelve years: "Her husband a cripple, she has been the sole support of her two girls and three boys. The public generally is invited to inspect the work of this humble Florence Negro youth whose real genius may some day make the city of his birth famous."[16]

However, a few days later, while painting the Jacobia Hotel, whose sagging porticoes lent themselves to his turbulent style, Johnson was arrested and jailed by the Florence police.[17] Unknown to Johnson, the building had become the local brothel. No one knows whether it was this embarrassing fact or anger at Johnson's achieving national recognition as an artist, something blacks were not supposed to do, that prompted the police action. His arrest deeply embittered Johnson. He had worked hard to achieve distinction. If he needed anything to send him back to Europe, being jailed in his hometown without cause was it. He did not return for fourteen years.

Johnson married Holcha Krake in May 1930 in Kerteminde, a Danish fishing village where they could live cheaply. Painting waterfront scenes and fishermen, Johnson came to admire the fishermen and their atti-

City Gates, Kairouan (1932). This holy Islamic city, second only to Mecca, was painted during Johnson's first visit to the North African coast with Holcha Krake, his Danish wife and a gifted ceramicist. Johnson strongly identified with Tunisian Arabs. (Watercolor and pencil) National Museum of American Art

tudes toward nature and themselves in their struggles for survival. He called them "primitive." Later, in 1932, when he and Kraké lived in Tunisian Arab villages and together studied wool dyeing, weaving, and pottery, Johnson felt the same way about the Arabs. He made many quick watercolor sketches of Arab people, bazaars, and street scenes, with white buildings shimmering in the sunlight. Because of his dark face, Arabs sometimes mistook him as an Arab and welcomed him into their homes. Their concern for their inner feelings and belief that these feelings were aligned with the mysterious forces of nature, such as the life-giving sun, impressed him.

Romanticizing the Danish fishermen and Arabs, Johnson asserted in interviews that such "primitive" people understood art better than so-called cultivated and educated people because "we are . . . closer to the sun."[18] He also said: "I feel myself both a primitive man and a cultured painter."[19] In describing himself as "primitive," Johnson was expressing the alienation he and many artists keenly felt. He ignored the fact that the term, as understood by the public at large, was pejorative and disturbing to many African-Americans, since it was a characterization that was used to deny them housing, jobs, education, and votes.

The Johnsons visited Tanner before settling in Odense, Denmark, in 1932. They also bicycled and camped in Sweden, Norway, and parts of Germany.

Exhibiting in craft shops and small galleries, they found it increasingly difficult to earn a living in the deepening world depression. Johnson wrote Brady at the Harmon Foundation, seeking a teaching post in a black college.[20] Few black colleges then had art courses, and Brady held out only the hope that she might sell one of his paintings to a college. Their meager funds came from sales of Krake's work.

Johnson's vivid paintings of Norwegian fjords and landscapes impressed some Swedish critics, who found his colors and distortions "violent" yet "a consistent way of apprehending the Norwegian nature."[21] In Washington, D.C., forty years later, Breeskin, reviewing more than 1,100 works by Johnson, concluded that he had "reached the height of his powers as an Expressionist painter" in his springtime studies of the flowering fruit trees in Volda, a small town on Norway's west coast, and of the Lofoten harbor in Norway.[22] Yet at the time he sold very few paintings.

In Oslo the Johnsons met Pola Gauguin, the painter's son, who was a critic, and Rolf Stenersen, who admired Johnson's work.[23] They introduced the Johnsons to the aging Edvard Munch, the great Expressionist pioneer whose woodcuts Johnson hoped to equal. At that time Munch's work, along with that of other modern artists, had come under ferocious attack from Adolf Hitler, now chancellor of Germany. He assailed modern art as "sub-human, a Jewish invention

aiming at the disintegration of the Nordic spirit," and "Bolshevik."[24]

To Johnson, Hitler's views were nothing new in some ways. As an African-American from the South, he had heard such expressions as "sub-human" and "destroying racial purity" directed against his people, but not against art. As the Nazi attack mounted, museum curators were dismissed, and modern art was barred and ridiculed in Nazi exhibitions of work by the insane. One aspect of the Nazi attack was the fact that modern art had African origins; the Nazis called it "nigger art." Such "degenerate art" was seized—the work of Vincent Van Gogh, Pablo Picasso, Paul Gauguin, Georges Braque, Henri Matisse, Oskar Kokoschka, Wilhelm Lehmbruck, Emil Nolde, Ernst Kirchner, Otto Dix, and Paul Klee. According to the art historian Werner Haftmann, "Artists were persecuted even in the seclusion of their studios: the most important of them were forbidden to paint, the prohibition being enforced by police inspection. Modern art went underground."[25]

Sun Setting, Denmark (1930–32). Powerful elements in nature such as the sun, mountains, or spring provided Johnson with subject matter that he carried out with great emotional intensity. (Oil on burlap, 20¾ x 25¾″) National Museum of American Art

The Nazi attack was built on the hatred of many traditionalists and academicians for modern art. Hitler provided a racist rationale for such hatred. As an African-American and a modern artist, Johnson felt himself in double jeopardy. He also felt isolated, since at that time most other American artists had little interest in modern art.

When the Nazis occupied the Rhineland without opposition in 1936, Johnson concluded that Europe, once his haven from racism, was no longer safe for a modern black artist. His observations of the Nazi attacks on Jews, combined with his visits to Africa, France, and Scandinavia, gave him a new understanding of how racism is used to divide people. While he

had found understanding and love with Holcha Krake, more than ten years' work in Europe had not yielded sustaining artistic recognition, adding to his deep disappointment and frustration. He began to feel, somewhat desperately, the need for a new vision of his own people and their lives in the United States. He wanted to return.

Traveling on a small Norwegian coastal steamer in June 1937, the Johnsons met David and Helen Harriton of New York. David was also an artist, and the two couples became friends, talking of art and the possibility of war, with Johnson expressing a desire to portray his own people.

That fall Johnson wrote to the Harritons, saying that he and Holcha were coming to the United States. Fearing the prejudice they would encounter, the Harritons tried to discourage them. But Johnson wrote again that they were coming—"that they feared there would be a war in Europe which he wished to avoid, and also because he felt the need to come back to his own country and paint his own people," the Harritons said later.[26]

On Thanksgiving Day, 1938, the Harritons met the Johnsons' ship and invited them to stay with them until they could find a home. Two weeks later the Johnsons moved into a cold loft on West 15th Street. Krake was surprised by the degree of hostility toward an interracial marriage. Johnson was unable to find work or sell his paintings. In February 1939, Johnson and Krake had a joint exhibit at the Artists' Gallery and, through the efforts of some black artists, Johnson's paintings were also exhibited at the Labor Club at the same time. But there were no buyers. This continued lack of appreciation hurt.

Johnson found adjustment to life in America difficult. A severe Depression had replaced the booming twenties, and he was no longer a promising youth. In 1926 Hawthorne had raised $1,000 for him. Now, over twelve years later, no one particularly felt he deserved more support, although Mary Brady tried faithfully to sell his work. And while in 1926 there were only a few black artists, by 1939 several hundred in New York alone were recognized and accepted on Works Progress Administration art projects. Two black painters—Horace Pippin and Jacob Lawrence—had already achieved the recognition that still eluded Johnson. With his superb training, his encouragement by Hawthorne, Luks, and Tanner, his long experience in Europe, and his critical success in Sweden, Johnson felt humiliated by his status in America.

At first Johnson could not even get on the WPA since its funding had been curtailed. He had to wait for an opening, which did not come until May 26, 1939, when he was hired as a teacher at the Harlem Community Art Center. Feeling better trained, more experienced, and more talented than other black WPA artists, Johnson proudly held himself apart from their social, educational, and political activities. Although he had firsthand knowledge of the Nazi attacks on modern art, he rarely spoke of it. Although he exhibited with the Harlem Artists Guild, he did not join it and remained an isolated figure, at times critically overbearing toward other black artists. To young black artists, who knew of his Harmon award and his long European stay, this aloof, handsome, erect man with a mustache and goatee, always wearing a beret, personified the grand master of romantic novels and films.

His imperiousness is reflected in a letter to Brady the year before his return: "I must say to you that you shall demand a higher price for my paintings for I am no ordinary American Negro painter. I am recognized by known Americans and Europeans as a painter of value so I must demand respect."[27] Brady tried very hard to get Johnson included in the Baltimore Museum of Art's 1939 exhibition of "Contemporary Negro Art," but the curator in charge rejected all his work, to her dismay and that of Alain Locke. She later recalled that after he returned to New York, Johnson became increasingly difficult to deal with, arrogant and demanding.[28] Today, in light of his later mental deterioration, his grandiosity would appear to be one of the first manifestations of his illness.

While awaiting WPA employment, Johnson began developing a new style for the portrayal of his people. Impressed by the work of Pippin and Lawrence, he began painting in what he called his "primitive" style, which differed from the "full brush" style he had developed under Hawthorne and extended with his Soutine studies. His new work, based on memories of biblical stories and spirituals, was carried out in a flat, heavily outlined style with brilliant color contrasts. Breeskin has suggested that although Johnson was not religious, the stress and racial prejudice he encountered in the United States "may have led him to concentrate on religious subjects as a stabilizing and comforting source of strength."[29]

Like Tanner's paintings, Johnson's work is an intimate reflection of black experience in America. But the two artists convey very different messages. Tanner's paintings are mysteriously centered about an undefined, mystically illuminated Christ figure, a symbol of hope. In contrast, Johnson straightforwardly depicts a black Christ on the cross, mourned by black women, with two black men crucified on either side. Painted

Jesus and the Three Marys (1939). In adapting his expressionistic style to what he called "painting my people," Johnson began with religious subjects and a starkly simplified manner. Although not religious in the sense that Tanner was, he had been raised in the southern black church and knew the feeling of identification of many black people with the crucified Jesus. He tried to express it in this early study. It is more emotionally painted than *Mount Calvary*. (Oil on cardboard, 37¼ x 34¼") Clark–Atlanta University

Fletcher (1939), a strong portrait of an African-American youth dressed in his Sunday best, gains its touching authenicity through both its objectivity and its total identification with the subject. (36 x 29″) National Museum of American Art

in a two-dimensional, seemingly naive way, Johnson's work has a simple but stark brilliance that is totally different from anything Tanner would have conceived. There is no message of hope. Instead, Johnson says that this is the way things are: black people, even the best of them, have been crucified.

Yet Tanner's influence should not be dismissed. While he was not at all religious in the deep sense that Tanner was, from his conversations with Tanner and study of his work, Johnson gained a new understanding of the profound role of religion in the historic struggles of black Americans.

Although startling to his friends, Johnson's new work was less a change in style than in content, showing a deeper acceptance of his people and their lives. The paintings are still Expressionist, but they are calm and assured rather than turbulent. Johnson himself described this work as "not a change but a development," a new aspect of an absorbing idea—"to give, in simple and stark form, the story of the Negro as he has existed."[30]

In his new work Johnson moved sharply away from other Expressionist artists' approach to religious subjects. Emil Nolde, for example, spent years studying the demonic in the religious art of Russia, Japan, and Polynesia, seeking tormented facial expressions for ferocious crucifixion scenes. In contrast, Johnson's people are dignified, noble, and calm. For Johnson, black people were untouched and pure, outside the commercialized world of materialistic success. Yet unlike Gauguin's Tahitians, they are not mysterious and distant but familiar, possessing a friendly warmth.

Technically, Johnson's new style reveals his expertise in simplification. The paintings are composed with heavy outlines, suggesting stained-glass church windows. They continue, however, to use Expressionist spatial distortions—a pictorial device that captured Johnson's emotional response to life's experiences.

Although he occasionally returned to his turbulent, thick impasto manner, Johnson seemed to find his simplified "folk" style deeply satisfying. Influenced by Lawrence's Harlem scenes, Johnson gradually expanded his subject matter, moving from biblical to street musicians, bicycling boys, Lindy-Hoppers, farm activities, chain gangs, churchgoing, and baptisms, as well as portraits. Sometimes his work humorously exposed human pretensions. He often made multiple silkscreen prints, which could be sold cheaper than one-of-a-kind oil paintings.

In 1941 his paintings were included in two major New York exhibitions—"Contemporary Negro Art" at the McMillen interior-decorating firm and "American Negro Art: 19th and 20th Centuries" at the Downtown Gallery.[31] Unfortunately, Pearl Harbor obliterated public interest in these shows, and no dealer showed any interest in handling his work.

Recognition was very slow in coming, and Johnson's situation had worsened. Early in 1941 a fire destroyed many of his paintings and studies, Krake's loom and tapestries, as well as their personal possessions.[32] The couple had difficulty finding a new home, and the place they found was cold and without conveniences.

By this time the cry of "Communist" by Martin Dies and his House-Un-American Activities Committee had forced the closing of the Harlem Community Art Center, where Johnson had taught under WPA auspices. Johnson, however, had foreseen the closing and had already resigned in August 1939, transferring to the WPA mural project, on which he remained until January 1943.[33] He then managed to get defense factory jobs.

After Pearl Harbor museums began organizing exhibitions in support of the war effort; one of the biggest was the Metropolitan Museum's "Artists for Victory Exhibition" in 1942. Becoming very conscious of the

Street Musicians (ca. 1940). As he became more confident about his style, Johnson moved away from religious themes to make pertinent and often humorous observations of aspects of African-American life. His hazard: drifting into caricature. (Gouache, 17 x 13″) Oakland Museum, Oakland, Calif.

involvement of African-Americans in the armed forces, Johnson used his new style to portray black soldiers in training, learning how to assemble a machine gun, boarding troop ships, lying on the ground under fire, and returning wounded on stretchers. He made silkscreen prints of some of these tempera works. (While on the WPA, Johnson had learned how to make silkscreen prints in a project that produced war and defense posters.)

One of Johnson's war-oriented paintings, *Training,* which depicted African-American soldiers drilling, was purchased in an open competition sponsored by the Office of Emergency Management for inclusion in a major exhibition, "American Artists' Record of War and Defense."[34] First exhibited at the National Gallery of Art in Washington, this show then moved to the Museum of Modern Art in New York, the Art Institute of Chicago, and the Layton Gallery in Milwaukee, Wisconsin. However, each museum could select paintings it wanted to show, depending on available space. For reasons now unknown, Johnson's painting was not shown in New York.

Possibly his painting was not considered dramatic enough. While most artists in the wartime shows depicted dramatic and heroic charges, desperate hand-to-hand combat, diving planes, bursting bombs, and plunging destroyers, Johnson focused primarily on activities that in themselves were peaceful—black people doing their jobs as soldiers and nurses in a matter-of-fact way. Even when he depicted black soldiers moving forward under fire, the scene was a calm one. There were no false dramatics.

When these tempera paintings, as well as scenes of civilian life, were exhibited by the Wakefield Gallery in 1943, critics realized their unique merit. Howard Devree of the *New York Times* noted that Johnson's work "reveals on closer acquaintance a lot of keen observation and shrewd setting forth of ideas in what seems an authentic Negro idiom."[35] Mentioning some of the street scenes, such as *Going to Church,* that were in the show, he concluded: "Johnson . . . has happily hit upon an individual expression in clear, fresh color—something akin to the spirituals, which is sufficient praise."

Robert Beverly Hale, later the Metropolitan Museum's curator of American paintings, praised Johnson's style as being "altogether independent of white influences." He also asserted that Johnson "is the only artist we have so far encountered who has been able to cope with the war. His secret: understatement, humor, and a deep human understanding."[36] In his war paintings Johnson maintained his vision of the essential humanity, sincerity, and untainted purity of his people; they had, in a certain sense, nothing to do with the killing.

In June 1942, as part of National Negro Achievement Day, Johnson received a "Certificate of Honor for distinguished service to America in art," but after this small token of recognition, disaster struck. That November Holcha Krake developed symptoms of breast cancer. At the time she complained to the Harritons that Johnson occasionally behaved strangely although she attributed his behavior to overwork. When Krake died in January 1943, Johnson was devastated. Unable to accept her death, he exhibited her work with his whenever possible. Friends felt he was never the same.

What no one realized was that, in addition to his grief and depression, Johnson was suffering from increasingly severe mental deterioration. The strange behavior Krake reported was part of a progressive decline in intellectual ability, accompanied by frequent signs of irritation and delusions of grandeur. For a time, however, Johnson was still able to paint.

In 1944, for the first time in fourteen years, he

Station Stop, Red Cross Ambulance (1940–41). The participation of African-Americans in the segregated American armed forces provided Johnson with new material. Here black Red Cross nurses and first-aid men unloading wounded black soldiers are depicted without a trace of sentimentality. (Gouache, pen and ink with pencil on paper, 18½ x 22³⁄₁₆″) National Museum of American Art

Lessons in a Soldier's Life (1941–42) depicts African-Americans learning how to operate machine guns with deadpan seriousness. In Johnson's wartime scenes everyone is doing his job in a matter-of-fact, undramatic way. (Gouache, pen and ink on paper, 15 x 18⅛″) National Museum of American Art

Under Fire (1941) is the only painting Johnson made of African-Americans advancing under fire, planes overhead. There are no false heroics, no overly dramatized hand-to-hand fighting: simply an acceptance of the war, of one's self and one's duty—something else to put up with— which reflected the attitude of many African-Americans. (Gouache, pen and ink on paper, 15 x 18⅞″) National Museum of American Art

Going to Church (1940–41), one of Johnson's most widely reproduced paintings, accurately depicts African-American church-going in the rural South of his youth. Its design is masterful in its unity and balance. Not until Johnson's paintings of African-American life became known in the 1950s did appreciation grow among his people as they recognized themselves and their lives. (Oil on burlap, 38⅛ x 44⅛″) National Museum of American Art

returned to Florence, South Carolina, to visit his mother, perhaps hoping to overcome his grief with a new start. He painted a number of portraits of his mother, the most impressive of which is a straightforward picture of her in her rocking chair. A picture of his deceased stepfather hangs on the wall behind her while kittens play beside her chair. Johnson called the painting *Mom and Dad.* Of a similar painting, he said: "I am a Negro and proud. My mother was black as I have shown in my portrait of her sitting with folded hands and an expression of resignation, in a simple polka-dot dress."[37] He also painted portraits of his young nieces during this visit, and these works have an unusual warmth and understanding.

In his pathological mourning for Krake, Johnson decided to return to Denmark and marry her recently widowed sister, Musse Voll, whom he had met in France in 1928. Working overtime in the busy Brooklyn navy yard, he tried to live as economically as possible in order to finance his return to Denmark. He saw almost no one, neglected his own care, and became difficult to talk to, according to the Harritons. To help him, they commissioned portraits of their daughter Carol and of Helen Harriton's mother, Carrie Smith. Johnson's painting of Carol was traditional, but he portrayed Carrie Smith in his flat modern style, evoking the portrait of his own mother, and even using the same color for the chair.

Secluding himself, Johnson began to work on a historical series, *Fighters for Freedom,* collecting books and newspaper and magazine clippings on African-

American history. From these materials, he created montage panels depicting highlights from the lives of the "freedom fighters." In the John Brown panel, for example, he portrayed various abolitionists and followers of Brown as well as Brown's cabin in Osawatomie, Kansas, his hanging, and his burial site on his Adirondack farm. Dominating the panel is Johnson's version of the famous Thomas Hovenden painting showing a black mother holding up her baby to be kissed by Brown on his way to the gallows. Another panel traced the life of George Washington Carver, showing him being greeted by President Franklin D. Roosevelt in the end. Still another panel, *Women Builders,* portrayed pioneering black women educators with sketches of their schools. A *Life* photograph led to a panel showing Roosevelt, Winston Churchill, and Chiang Kai-shek. In the best panels of this series—the ones depicting the Underground Railroad and other events in African-American history—Johnson achieved a remarkable legendary or idealized folk quality.

However, paresis, the result of a luetic infection contracted years earlier, was rapidly destroying his skills.[38] He lost his ability to manage spatial relationships in composing. Unaware of his own deterioration, he traced portraits and awkwardly designed montage panels.

Nevertheless by 1946, through overtime work and great frugality, he had saved the nearly incredible sum of $16,000 and sailed for Denmark, taking all of his and Krake's work. His fantasy of marrying Musse Voll

Mom and Dad (1944). Painted on Johnson's first visit to Florence fourteen years after being arrested there, this portrait of his mother and his deceased stepfather (whose portrait hangs behind her) is deeply felt but disciplined. Its severity is relieved only by the playful kittens. (Oil on board, 31 x 25³/₁₆″) National Museum of American Art

collapsed immediately with her rejection of his proposal. Nevertheless, he stayed with the Krakes for six months. Then, deciding to exhibit in Oslo, he went there but was presently found wandering in the streets. Identified through the Traveler's Aid Society, he was returned to New York where he spent the rest of his life—approximately twenty-three years—in the state hospital at Central Islip. (He was admitted on December 1, 1947.) He did not recognize anyone and showed no interest in painting. He died on April 13, 1970.

Earlier, in 1947, the Krake family had shipped nearly all of Johnson's work and much of Krake's weaving to the Harritons. They stored the work in a warehouse because no one then knew what the outcome of Johnson's illness would be. For nine years the work gathered dust and the storage bills went unpaid. The warehouse then demanded that the bills be paid or the work would be thrown out as garbage. The Harritons informed Mary Brady who, knowing Luks's esteem for Johnson's work, became determined to save it. She went to court to have the Harmon Foundation

appointed trustee of Johnson's work, paid the storage bills, and after personally throwing out many prints, dusty canvases, and weavings, trucked the remainder to the foundation's offices.³⁹ On liquidating the foundation in 1967, she transferred most of Johnson's work to what is now the National Museum of American Art; some major paintings were also given to African-American colleges. Thus, almost miraculously, much of Johnson's work was preserved—more than 1,100 paintings, drawings, etchings, woodcuts, and silkscreen prints.

Johnson's tragic career brings to mind the woman in D. H. Lawrence's story "The Rocking-Horse Winner," which opens: "There was a woman who was beautiful, who started with all the advantages, yet she had no luck."⁴⁰ Johnson had talent, the advantages of superb training, and the support of well-known artists. He escaped the tormenting racial prejudice of the United States to develop his art in a more congenial place— but then was driven out by the rise of Nazism. Moreover, his career in Europe was not the success he had hoped for. In some ways his early Expressionist style was simply an extension of the "full brush" approach of Hawthorne and Luks. In any case his European landscapes did not seem more noteworthy than those of other young Expressionists.

Tanner also went to Europe to escape racial prejudice, but the differences between the two artists are illuminating. Once Tanner had established himself in Paris, he turned to his own childhood religious memories and feelings. They provided a resonant core of experience around which he developed his artistic vision of humankind. Johnson, however, did not identify and utilize a similar core of experiences. He seemed to have had little to turn to except his anger over prejudice and his alienation. His desire to be accepted as a modern European Expressionist, divorced from his own black experience, prevented a profound statement of these feelings; his European paintings do not in any way reflect black experience. Probably as a consequence, he was constantly restless, always searching for new places in which to work. Few painters have been in such constant motion. In some respects his life was a desperate effort to be somewhere else and become something else. In his own mind, he confused alienation with being "primitive"—a transformation he could not achieve in actual life.

When Johnson was forced to return to America as his only place of refuge, his feelings of identity as a European Expressionist painter were shattered. His demand that Brady recognize that he was "no ordinary American Negro painter" expressed his fear that, as a

European Expressionist, he was nobody. After twelve years abroad, he was forced, in effect, to say to himself: "Look at all that I have done—and what has it got me?" Even in Europe his self-examination directed him to his experiences as an African-American.

In this crisis of identity, Johnson remembered Tanner. Summoning up his own childhood memories of biblical tales and churchgoing, he saw anew the role religion played in black life. Johnson began to recognize the calmness and acceptance with which his people approached problems—theirs and the world's. This reevaluation led him to adopt a linear approach with flat, unshaded figures. His schematic new style was derived not from European models but from two African-American artists, Pippin and Lawrence, as was his subject matter. Yet Johnson never equaled them. The untrained Pippin had an innate sense of color, form, and design that gave his work a feeling of "rightness." As Eugène Delacroix once said, "Feeling works miracles."[41] And Lawrence had his own natural way of creating simplicity out of the complex rhythms of Harlem streets.

In portraying his memories of biblical stories, southern rural life, and social activities among black people. Johnson had trouble with a linear style that required a high degree of identification and empathy. At times his old style, old viewpoint, and feelings of superiority seeped through. His efforts to be charmingly naive sometimes slid into caricature. At times his paintings seem to be deliberate attempts, by someone highly trained and conditioned by other values, to appear naive.

In many ways Johnson's work demonstrates the virtues and weaknesses of most black artists of the twenties. It was such a struggle simply to become an artist that many were unable to shake off the outmoded model of the academy and the false sense of achievement that the academy represented. In their prolonged sacrifices and the hard work—whether laboring in a steam laundry like Augusta Savage or on the docks like Johnson—it took to achieve schooling and recognition, they inevitably were driven toward the academic standards to end their uncertainties, to prove they were artists.

Johnson's initial aim was to please his teachers—a necessary and natural first step. Yet, once on his own, he lacked original vision.

Life and art are more complex than Johnson understood, and he apparently did not have an organizing intelligence to help him express his feelings, although he sought to do so in many places—America, France, Denmark, Africa, Norway, Sweden. In contrast, Horace Pippin, without leaving his kitchen, indifferent to art training, expressed in his work a superb intelligence and feeling for color and design that guided his considerations and his wounded arm faultlessly. What Pippin was able to do was to organize and express his feelings. Art begins when the artist is able to incorporate in his vision not only an assessment of his reality but also an assertion that his statement itself is valuable. The latter is often absent in Johnson's work.

With the exception of Aaron Douglas, Archibald Motley, Jr., and Palmer Hayden, who initially demonstrated distinguishing visions of African-American life, Johnson and most African-American artists of the 1920s did not significantly broaden our awareness of artistic values and the qualities of human experience in the United States. Life is, after all, confusing. The artist discriminates, selects, and transforms a complex state of feelings into his aesthetic statement. In this process the artist works with both his intellect and his feelings. Even in a world torn apart by the intellect, the true artist always manages to find a pathway to the heart. This does not happen in Johnson's work.

What Johnson did produce does not place him in the front rank of American painters of his period. Or with such notable German Expressionists as Max Beckmann, Emil Nolde, Karl Schmidt-Rottluff, or Ernst Kirchner. Johnson's contribution was to advance Expressionism in a new way and into an area that lay beyond the experience of Europeans—the ordinary life of African-Americans.

HALE A. WOODRUFF

In the 1960s several black artists in New York formed Spiral, a group that met regularly to discuss the relationship of their art and their lives with African-Americans' efforts in the South to win full civil rights. One artist who constantly added depth and wisdom to these exchanges was Hale A. Woodruff. His voice had the authority of true experience. As a young painter in the Midwest in the 1920s, Woodruff had been moved by the same influences—Paul Cézanne and the Cubist movement—that prompted Stuart Davis and Alfred Maurer, and he had liberated himself from the restraining traditionalist concepts then dominating American art. Despite poverty, he pushed his way through to Paris and maintained his Cézanne-stimulated studies in France for four years. Unlike some of his fellow expatriates, he went to great lengths to meet Henry Ossawa Tanner and talk to him about his ideas on art. Admiring African art and understanding its relationship to Cubism and Pablo Picasso's work, he began to collect it.

When he returned to the United States in 1931, the misery of the Depression gave Woodruff a new perception of his own people and modern art. He began teaching black students in the Deep South to draw and paint what they saw and what they experienced. He also went to Mexico to study with Diego Rivera, an exponent of the mural as a method of teaching oppressed people their history. At Talladega College in Alabama, he then created his strong, linear *Amistad* murals, a brilliant portrayal of the slaves who mutinied and were freed when tried in the United States. At Atlanta University he initiated the annual exhibitions of the work of black artists that for more than a quarter-century provided a powerful stimulus for black artists all over the United States. In 1966, at New York University, where he taught from 1946 until 1967, students elected him "Great Teacher," a singular annual honor reflecting their appreciation of his efforts to teach and, in Woodruff's case, to learn from them.

Woodruff's was never the pessimistic voice of the past. Optimism expressed itself in everything he said; his next painting would be better. He laughed over the past, although he told stories of personal experiences that revealed its pain and the depths of prejudice he had encountered. He focused on the new generation of unknown African-American artists and their concern for their own people and their history. Working with them gave him a sense of commitment rewarded—and renewed. "A great teacher learns from students how to be a great teacher," he said.

Woodruff was on the cutting edge of American art for over fifty years. He never lost his interest in murals and their role in defining the relationship of the artist to his people. Yet his own work became increasingly nonrepresentational after World War II, making him a precursor of the Abstract Expressionist movement. What was unique and special in his abstract work was its African imagery. He found African design an aid to achieving a deeper, more satisfying expression of his own artistic vision. Honored by prizes and fellowships, Woodruff was a seminal figure, influencing hundreds of artists and art educators, until his death in his eightieth year in 1980. His friends included such leading artists as Jack Tworkov and Willem de Kooning.

Hale Aspacio Woodruff was born in Cairo, Illinois, on August 26, 1900. His father, George Woodruff, died soon after his birth. His young mother, Augusta Bell Woodruff, moved to Nashville, Tennessee, to become a domestic. Her work often necessitated leaving young Hale for hours. An only child, he found activities he could enjoy doing alone. His mother was skillful enough with a pencil to show Hale the rudiments of drawing. To her delight, he began to draw at an early age and was soon copying newspaper cartoons and engravings in the family Bible. "Years later I found out that they were by Gustave Doré," he said. He also drew from "the excellent Greek and Roman statues

from my ancient history textbooks. I learned wherever I could." At Pearl High School he was the school paper's cartoonist.

On graduating in 1918, he and his closest friend, George Gore, got summer jobs in Indianapolis "as house-boys in a big hotel, scrubbing carpets, and anything else they gave us to do. We talked a lot about what we were going to be. George wanted to be a journalist and I said I only wanted to be an artist," Woodruff remembered.

That fall Gore, later president of Florida Agricultural and Mechanical College, entered DePauw University and Hale began his art studies at the John Herron Art Institute in Indianapolis. The "colored" YMCA gave him a room in return for his services as a desk clerk. He got five dollars a week for a cartoon dealing with political and racial problems from a local black newspaper. He also lettered sales-counter posters for local stores. These efforts, and his mother's help, enabled him to attend the only art school in Indianapolis.

The Herron Art Institute, located in a small brick building, had about forty students, including one other black student, William Holloway, who later left to become the *Pittsburgh Courier* cartoonist. Woodruff's instructor was William Forsythe, who had studied in Munich and was a friend of the well-known American artist William Merritt Chase. Forsythe, like Chase, believed in the "juicy brush" technique—loading a brush with pigment and working quickly with great facility. "Forsythe was a very good teacher," Woodruff said fifty years later, when he himself was considered an excellent teacher. Herron instructors concentrated on the human figure, and Woodruff became a superb draftsman. In his seventies, he rated drawing his greatest skill.

Forsythe taught the triangular compositional precepts of Harold Haven Brown. "Forsythe once pointed out that I had tilted a roof so much that it did not work well with the other triangles in the composition," Woodruff recalled. Brown's influence was lasting. To his surprise, Woodruff later found that a painting he did in France, when he was consciously trying to apply Cézanne's concepts, reflected Brown's triangular rules as much as it did Cézanne's ideas.

Eventually, unable to pay the year's full tuition in advance, Woodruff was forced to give up his Herron studies. He went to Chicago, hoping better job opportunities there would permit him to study part-time at the Art Institute. However, after a few sessions at the institute, he felt that he could do as well on his own. He returned to Indianapolis and his old "Y" job. Through its lecture series he had already met a number of outstanding African-American leaders, among them

William Pickens, Sr.,[1] whose portrait he later painted; W. E. B. Du Bois; John S. Hope of Morehouse College (who was later to play an important role in his life); Walter White of the National Association for the Advancement of Colored People; and many others. Those who excited him most were the poet Countee Cullen[2] and the painter William Edouard Scott, who discussed studying with Tanner in France. Woodruff had learned of Tanner through *The Crisis,* and Scott's stories gave him hope that he could study abroad.

Woodruff also began painting landscapes, something not taught at Herron. At times he sketched in nearby Browne county, but he had to work such long hours that his landscapes were often imaginary. He exhibited at the Indiana State Fair, the Indianapolis Museum, the Herron Art Institute, the YMCA, and a local gallery.

While still at Herron, Woodruff became friendly with German-born Herman Lieber, who ran an art supply store. In 1923 Lieber gave him a book titled *Afrikanische Plastik* by Carl Einstein, published by Ernst Wasmuth in Berlin, and said he should learn something of the art of his own people. Recalling this incident, Woodruff commented:

> You can't imagine the effect that book had on me. Part of the effect was due to the fact that as a black artist I felt very much alone there in Indianapolis. I had heard of Tanner, but I had never heard of the significance of the impact of African art. Yet here it was! And all written up in German, a language I didn't understand! Yet published with beautiful photographs and treated with great seriousness and respect! Plainly sculptures of black people, my people, they were considered very beautiful by these German art experts! The whole idea that this could be so was like an explosion. It was a real turning point for me. I was just astonished at this enormous discovery.

Fifty years later Woodruff still treasured this book. It made him one of the first African-American artists to study African art intensively and to be influenced by it.

Woodruff wanted very much to study abroad. Learning from "Y" publications of the new Harmon competition for black artists in 1926, he painted a large canvas depicting two alert, dignified older black women standing together. He won second prize, a bronze medal, and $100 in the first of these competitions.[3]

This success changed Woodruff's life. Mary Beattie Brady, the Harmon director, was trained as a jour-

Two Old Women, painted in Indianapolis, won the bronze prize in the first (1926) Harmon exhibit. This recognition led to local support for Woodruff's desire to study modern art in Europe. Photo courtesy of the artist

nalist at Columbia University. She wired Indianapolis newspapers that an unknown black artist in the local "colored" YMCA had won an important national art contest. Not only did the local press "jump on it," Woodruff recalled, "but Governor [Ed] Jackson called up and asked if he could have the honor of coming to the YMCA to present the medal to me. We black people just did not get this kind of attention in Indianapolis in those days."

When the press reported Woodruff hoped to study abroad, a ladies' literary club in nearby Franklin invited him to exhibit his paintings and have supper with them. Woodruff recalled: "This was supposedly Klan country! Yet here they were giving me $150 along with praise. Knowing the history and reality of the way we

were treated day in and day out, it was virtually unbelievable!"

The *Indianapolis Star* offered Woodruff $10 for each Parisian scene he illustrated and wrote about,[4] and his old friend Herman Lieber offered to try to sell his paintings. In New York Walter White obtained a $250 gift from philanthropist Otto H. Kahn for him, and Du Bois put one of Woodruff's sketches showing young black artists at their easels on the cover of *The Crisis* and paid him $25.[5] With that, Woodruff was off to Paris, third class, on September 3, 1927.

In Paris his fellow Harmon Prize-winner, Palmer Hayden, found him a room and Woodruff enrolled at the Académie Moderne and the Académie Scandinave. However, excited by the work of Claude Monet, whose memorial exhibition at the Jeu de Paume museum had recently opened, Woodruff decided he could learn more in museums than in school. In the Luxembourg Museum he found Tanner's *Raising of Lazarus*. The more he studied this 1897 prize-winner, the more he felt he had to see Tanner, talk to him, and

Medieval Chartres (1927–29). Chartres fascinated Woodruff as it did many other artists, including W. H. Johnson. Woodruff also made watercolors of the place. However, Cézanne's influence ended such picturesqueness. Photo courtesy of the artist

show him his own work. Tanner was, for young African-American artists, a great hero. Yet his letters asking Tanner for an appointment went unanswered.

Hearing Tanner was at his studio-home in Etaples, on the Channel coast, Woodruff decided to seek him out. Late in 1927, on a cold, rainy day, he reached Tanner's home, carrying a portfolio of his work. Recognizing the portfolio as part of the attire of a young art student rather than a tourist, Tanner invited him in. That afternoon Woodruff had an extraordinary discussion with Tanner, who encouraged him but also suggested that he consider man and his humanity in a historical sense as a subject.

Because Woodruff's work showed him to be a serious artist, Tanner went on to discuss Peter Paul Rubens, Jan Vermeer, El Greco, and many other artists. He reflected on his own work in relationship to Rembrandt and the Dutch school and their use of light. He also revealed his own efforts to achieve pervasive luminosity through new glazing methods.

At one point Tanner asked a few penetrating ques-

tions about young black artists and racial prejudice in the United States, but he did not pursue the matter. At another point he discussed some of the work Woodruff was seeing in Paris. He felt that Monet, whom Woodruff admired, risked the loss of "a sense of form and structure." Then Tanner asked: "Who is your real artist-god?"

"Cézanne," replied Woodruff. Reflecting a moment, Tanner said: "All right! A real master—space, color, light, form—all of it. He is in the tradition yet is a real innovator. You have made a good choice!"

That Tanner had accepted him as an artist and shared his views and problems encouraged Woodruff. So did the fact that, contrary to rumor, Tanner showed a genuine interest in young black artists and racial problems in America. Although he never adopted Tanner's artistic concepts, the impact of this visit on Woodruff was lasting, and his recollections of this talk became the most authentic record of Tanner's artistic concerns.[6] Many years later Woodruff concluded that Tanner was more than the leading black painter of the turn of the

century: "He was one of the truly great painters, regardless of race, to come out of America."

Another stimulating incident was meeting Alain Locke, the Howard University philosophy professor who had become the foremost African-American collector of African art. Locke took him to a "flea" market, where for two dollars Woodruff bought a small but beautiful Bembe ancestral fetish figure from the Congo. After this experience, which marked the beginning of Woodruff's extensive collection of African art, he did many figures and landscapes in the "structural style of the African sculptor and of Cézanne." He recalled being particularly impressed by Cézanne's *Boy in a Red Vest* and the African art in the flea market. "I went back again and again and, between the Cézannes and the African work, I was off and winging."

Circumstances prevented Woodruff and Hayden from sharing a studio, although they saw one another often and Woodruff used Hayden's hands for a model in one painting.[7] Early in 1928 Woodruff left the city of Paris for a suburb to live—mostly on rice pudding—with three other American artists, Forrest Wiggins, Charles Law, and Robert Miller; his share of the rent was eight dollars a month. When his friends had to leave, Woodruff was without food for several days. Finally he borrowed trolley fare from the landlady to go to Paris, where he found a $200 check from a sale of a painting by the Harmon Foundation.

Woodruff then went south to Cagnes-sur-Mer, a well-known art colony. Intrigued by the area's cascading hills, which had stimulated Chaim Soutine and W. H. Johnson (whom he just missed meeting), he began painting landscapes in Cézanne's manner. In this he succeeded, making Woodruff an important modern American painter of the late 1920s, even if his work of that period remained generally unknown for many years. During his stay, Pierre-Auguste Renoir's sons and various French artists fascinated him with stories of Amedeo Modigliani's days in Cagnes-sur-Mer. "I felt Modigliani really dove into African sculpture and came out with something that, while it showed the influence of his African studies, nevertheless was his own art," he later said.

Economically, however, Woodruff was in dire straits. When Walter White informed him that Otto H. Kahn was in Paris, Woodruff hastened there to show his work. Kahn gave him another $250. Eventually Woodruff survived as a road-gang laborer, his dark skin fooling French authorities into thinking he was a Moroccan French citizen and therefore eligible for work.

After four years abroad, Woodruff returned to the United States. John Hope, president of the newly formed Atlanta University, who was keenly aware of the work of Edward M. Bannister and Tanner and who had met Woodruff in Indianapolis, offered him an art instructorship. Thus in 1931 Woodruff became the first African-American artist with extensive training and experience abroad to teach art in a southern black university.

Woodruff's aesthetic ideas changed swiftly under the impact of the Depression and the problems of trying to teach art to black young people in two basement rooms in Spelman College (part of Atlanta University) in the segregated South. Seeing the struggles of African-Americans to obtain relief allocations or jobs in the cities or to eke out a miserable existence in the South's one-crop economy led him to question the value of much that he had learned abroad. Cubism and modern art did not say anything meaningful to most Americans, he concluded, and they did not seem appropriate for teaching drawing and painting to beginners. Faced with eager students, but almost no art resources, he tried to be realistic and helpful. "He was down to earth. . . . He did not use fancy aesthetic language that had no meaning to us," Wilmer Jennings remembered.[8] One of his two rooms was both his office and his studio. He urged students to come at any hour, letting them see that he was constantly working on his own to encourage them.

Woodruff used the college library for a continuous display of work by black artists. Sometimes he could put up only photographs of work in previous Harmon shows, but sometimes he held one-man shows of artists such as Palmer Hayden, Allan Freelon, and William Edouard Scott. Woodruff made student exhibitions a feature of commencement week. He secured a Carnegie Corporation gift of 5,000 photographic slides of paintings, sculpture, and architecture. Later, he obtained a traveling exhibition from the Whitney Museum of American Art of the work of George Bellows, Leon Kroll, Eugene Speicher, Reginald Marsh, and Georgia O'Keeffe. He set up a show of Bannisters and Tanners owned by Hope and J. J. Haverty, an Atlanta businessman and collector, as well as an exhibition demonstrating the art of printmaking.

Many of Woodruff's efforts were directed at making art more accessible. Woodruff lectured at the exhibitions, presenting popular art lessons that drew most of the student body and much of the faculty. The student exhibitions steadily demonstrated their progress. In his teaching, Woodruff introduced printmaking with woodcuts and linoleum blocks. Prints put the art of students into the hands of their families and friends and gave it a meaning it could not otherwise have had. His own woodcuts were superb.

Woodruff was determined to open all channels of art to his students and the African-American community. Soon after he arrived he took the trolley to the High Museum of Art and walked past an astonished black man sweeping its steps. Inside he insisted on seeing the director. Identifying his own background in art and his role as a teacher at Atlanta University, he gained permission to bring his student classes to the museum. When he came out, the man sweeping the steps told him he was the first black man he had ever seen go into the museum. "Well, I won't be the last," said Woodruff.[9]

Initially Woodruff's relations with the museum were uncertain and uneasy. When he appeared, for instance, for a lecture by Grant Wood, whose paintings *American Gothic* and *Daughters of Revolution* had provoked much controversy, Woodruff was denied admission. The next day Wood learned of this. In a rebuff to the museum officials, Wood called Woodruff and asked if he could visit him at Spelman. The two artists had an enjoyable day together.[10] This incident helped break down residual prejudice among museum officials.

Woodruff first brought his class to the museum in the early 1930s. The precise date is forgotten, but not the experience. Entering this once-forbidden place made more of an impression on the students than any of the paintings they saw. One student recalled: ". . . it was a very big thing when Woodruff took us to the High Museum. He had to get special permission because blacks didn't go in there at all unless they worked there, for they were not welcome to any of the shows. You couldn't just walk in there as a viewer. . . . I remember his taking his class to the gallery, but there really wasn't much there. Yet it was really wonderful since it was our first contact with a museum.[11] Another said: "Woodruff took you into the community, to the High Museum of Art—these were first steps for blacks. . . . We saw his work hang there. In other words, Mr. Woodruff was very much like Fred Douglass. Although segregation was in Atlanta, Woodruff was such a powerful person, such an articulate man, we had a chance to see something there. . . . We were all proud of him."[12]

As a result of Woodruff's initiative, the color bar at the High Museum began to erode long before the sit-ins of the 1960s. Now considered one of the outstanding museums in the South, it has presented many one-person shows of significant black artists as well as large group shows. By linking art with democratic progress, Woodruff gave art a meaning in Atlanta's African-American community it never had before. By regularly bringing the traveling Harmon exhibitions to Spelman he connected the students as well as the

Tornado (ca. 1933). Woodruff taught his Atlanta students to paint their surroundings and social conditions. His depiction of the devastation by a tornado prompted *Time* to sneer at "the outhouse school of art," ignoring Woodruff's philosophic and aesthetic reasoning. He found this attitude discouraging for his students. Photo courtesy of the artist

local community to the world of art outside Atlanta. In 1933 the Harmon show included his work as well as that of one of his best students, Wilmer Jennings, which gave the entire university and the community a new appreciation of what was being achieved in their midst.

By that time, in order to create in his advanced students a sense of identity and purpose, Woodruff had organized them into a "Painters' Guild." Regionalism had replaced traditionalism in American art, and Woodruff led his "Guild" out of the studio to paint their region—Georgia's red-clay hills, piney woods, and scrawny barnyards. These expeditions made them part of the latest movement in American art. "We are interested in expressing the South as a field, as a territory; its peculiar rundown landscapes, its social and economic problems, and Negro people," Woodruff told *Time*. "The students and I . . . used to talk about these problems. Not only talked about them, we ex-

Returning Home (1935) was created by Woodruff in Atlanta to express his outrage over the ramshackle housing that discrimination forced on African-Americans. (Woodcut print, 18 x 14″) Hampton University Museum, Hampton, Va.

perienced them. . . . You'll see their work reflects our interest in the Negro sociological theme or scene."[13]

Time, although recognizing that Atlanta University was becoming an outstanding art center in the South, sneered at these efforts, calling the work "Outhouse Art" because some students included privies in their Georgia landscapes. "It hurt," Woodruff recalled. "It made it seem that we were concerned with getting a two-seater into every painting. It hurt the students more than it bothered me, for it made it seem that whatever efforts we made, such publications would ridicule us."

A more difficult problem was what Woodruff called the "absence" of black artists on the national scene. Segregation and prejudice effectively blocked recognition of black artists in museums, art magazines, and the academic world everywhere, not only in the South. After its 1935 show the Harmon Foundation ended its New York exhibitions. "This situation led me to the idea of an all-Negro annual for the purpose of (1) offering a place to show, (2) providing an op-

portunity to earn a little money through purchase prizes, and (3) establishing a collection of art by Negroes at Atlanta University, which would be available to students, schools, and other institutions," Woodruff later explained.[14]

Woodruff convinced the university's leaders that it should undertake such an annual exhibition, the first continuing show to be organized entirely under black auspices. The initial exhibition opened on April 29, 1942, with 107 paintings from 62 artists. Aaron Douglas gave an address at the opening, and the Harmon Foundation provided a first prize, the $250 John Hope Award. By 1945, despite the war, hundreds of artists were exhibiting in what was now a juried show with $1,400 in prize money. By 1970 these exhibitions, whose ever-increasing size created enormous administrative problems, were discontinued, much to Woodruff's discontent. Confident that black artists could now compete with all other artists, he wanted the exhibitions opened up to all American artists. In any case, by the time they ended these annual exhibitions had

Poor Man's Cotton (1934) emphasizes the rhythmic movements of African-Americans in hoeing cotton, not complaining of their hardships. Woodruff's view was characteristically positive, saluting their vitality. (Watercolor, $30^1/_{22}$ x 22") Newark Museum

created an important collection of 350 works of art by African-American artists at Atlanta University.

During the 1930s Woodruff increasingly saw art as a way of meeting the needs of the African-American community as a whole. Like many other American artists during the Depression, he was attracted to the Mexican muralists—Diego Rivera, José Orozco, David Siqueiros, and others—who used their work to increase the self-esteem of their poor fellow-countrymen as well as their knowledge of their own history. To Woodruff, this seemed an ideal way to relate African-American and African history to black people in the United States. He also felt that learning how to paint murals would enhance his own development as an artist.

Gaining a grant to study Mexican art in July 1934,

Woodruff disregarded the indignities that tormented African-Americans trying to travel into Mexico and found Rivera painting his famous Hotel Reforma mural in Mexico City. He introduced himself to this master muralist, explaining his desire to work with him. Rivera said that as long as Woodruff did not expect to be paid, he could join the crew preparing the walls and mixing the paint.

"Rivera was, like other Mexican artists, a purist about his colors," Woodruff said. "He put me to work with two other assistants grinding colors. We ground them on a marble slab with a marble brick, working all night, so that the colors would be fresh and ready when Rivera arrived in the morning. Just before he arrived, we used lampblack on perforated cartoons of the figures and thus transferred them to the wall. When Rivera got there, we passed fresh batches of color up to him and did whatever else he needed."

Troubadour (ca. 1934) captures the soul-singing essence of the South's black folk singers, who were part of African-American rural life. Photo courtesy of the artist

Going on to study other murals in Taxco and Cuernavaca, he met many Mexican artists and writers as well as American intellectuals, including René d'Harnoncourt, later the director of the Museum of Modern Art.

On returning to Atlanta, Woodruff did two murals under the Works Progress Administration art projects. He was assisted by an outstanding student, Wilmer Jennings. One mural was a bland pictorialization of black people that he later disliked. The second, in the Atlanta School of Social Work, consisted of two panels, *Shantytown* and *Mudhill*. Ralph McGill, later the editor of the *Atlanta Constitution,* called these the works of a "modern master." He wrote: "They are worth more, they say more, than all the studies on economics and the need for slum clearance and better housing."[15]

This experience prepared Woodruff to paint a mural series at Talladega College, a small African-American institution in Alabama, not far from Atlanta, which had no art department. Its president, Buell M. Gallagher, later the head of City College of New York, was determined to break down the self-demeaning attitude toward African-Americans that then pervaded many black colleges. He told Woodruff the college would like him to paint a series of murals about the *Amistad* mutiny in its new library to show students that their people were not willingly made slaves.

Woodruff himself had not heard of the 1839 *Amistad* mutiny, but he began intensive research. He learned that the revolt of the slaves aboard the Spanish slave ship *Amistad* had been led by the African prince Cinque. Tried on charges of murder and mutiny in a United States court, Cinque and his fellow Africans were acquitted and returned to their homeland. The legal process took three years. One of the chief defense lawyers was former president John Quincy Adams, who came out of retirement to argue the right of free men to revolt with arms against slavery.

Woodruff's most intensive research was pictorial. In Yale's libraries in New Haven he learned that a Connecticut abolitionist artist, Nathaniel Jocelyn, had made portraits of Cinque and twenty other slaves in the mutiny. Ultimately, Woodruff located portraits of all trial participants except the prosecutor; in the mural the prosecutor has his back to the viewer. Woodruff portrayed himself, his hand supporting his head, as a slave defendant.

In these murals, notable for their linear composition and brilliant color as well as their historical accuracy, Woodruff made a unique contribution to African-American history and demonstrated a role for artists that was generally unknown in this country. Du Bois paid for color reproductions of the mural to accompany his own historical article on the *Amistad* mutiny in the African-American literary journal *Phylon*.[16]

The Talladega murals convinced Atlanta University officials to agree to Woodruff's repeated requests to create murals on "the art of the Negro" for its Trevor Arnett Library. However, a satisfactory teaching-painting schedule could not be immediately worked out. Meanwhile, Woodruff was awarded a Rosenwald

Fellowship in 1943, and it was renewed in 1944, enabling him to study and paint in New York for two years.

This fellowship ended Woodruff's prolonged isolation in the South. Recalling this award, he said, "These are the things that break an artist's heart, the great disappointments that hurt. I had repeatedly applied for a Rosenwald Fellowship years before—and I didn't get it. I later discovered that the man whose endorsement I needed had not given it. He disliked my modernist work and thought I should be painting in a more literal 'African style,' whatever that means. And so I didn't get the fellowship at a time when my development was in a critical stage."

After segregated Atlanta, Woodruff particularly enjoyed the social freedom of New York as well as its vast art resources, museums, galleries, libraries, and schools. He could talk freely with many artists, critics, curators, and collectors about new concepts and directions, current shows of past and present artists, and what might be learned. World War II was gradually being won and questions about political, social, and artistic problems after the war filled the air. Most of all, he enjoyed his discussions with a growing group of able young African-American artists—something that had been unknown a decade earlier.

In 1934 Woodruff had married Theresa Ada Baker, a teacher from Topeka, Kansas, whom he had courted—mostly by mail—since 1921. In 1935 their son Roy, now an artist, was born. When they moved to New York, they established themselves in a loft on Eighth Avenue near 55th Street. To divide their working and living quarters, Woodruff built a large screen and invited visiting artists to draw and paint on it. Many did so, among them Charles Alston, Henry W. Bannarn, Ernest Crichlow, Norman Lewis, and Romare Bearden. When the Woodruffs moved, the screen was cut up to preserve these unique "mementos."

Woodruff impressed New York's art circles. Few American artists had his firsthand knowledge of the art centers of France, Parisian artists, Rivera's work in Mexico, and the traditions and problems of American art. Woodruff's own work was admired, and he had achieved national recognition for his teaching in the Deep South.

Not surprisingly, just a year after he returned to Atlanta, Woodruff was appointed an associate professor of art at New York University, so he came back to New York. Although teaching cut heavily into his energy, Woodruff felt it helped him as an artist. "You can learn from a good student or a bad one," he liked to say. "I have never taught how to do something. I have tried to recognize what the students are trying to do—and let them do it. I just try to light a fire under their coattails. No two students are alike—and that helps make teaching interesting, really absorbing."

To his delight, teaching in New York offered Woodruff the opportunity to participate in the activities and ideas stirring in what had become the most creative art center in the world. The ending of World War II, which had sustained the democratic idealism and concern with ordinary people characteristic of the WPA art projects, brought about a shift in values and concepts that had previously dominated the art world. With the presence in the United States of many well-known European artist refugees—Fernand Léger, André Masson, Jacques Lipchitz, Marc Chagall, Piet Mondrian, and others—many American artists had a chance to talk with them, even watch them work, a process that made them less godlike. At the other end, as soldiers, hundreds of young American artists had found that Europe in itself was not magical.

A new movement among artists was developing in New York. These artists, including Willem de Kooning, Arshile Gorky, and Robert Motherwell, already had an understanding of Cubism and modern art. Now they wanted to explore a subjective and rhythmic mode of expression in contradiction to the socially conscious work that had prevailed for several decades. Eventually these artists became the New York school of Abstract Expressionism.

In this atmosphere Woodruff increasingly worked in an abstract manner. But unlike the subjective "action-born" imagery of the incipient New York Abstract Expressionist movement, Woodruff's "figurations" evolved from improvised images of Ashanti gold weights, very small symbolic figures. These works, and later his *Celestial Gate* series, were precursors of Abstract Expressionism, but they had an African essence that related them to the heritage of African-Americans. These paintings served as part of his preparation for his mural series *The Art of the Negro,* although this was still an unsettled question with Atlanta University at the time.

Woodruff always felt that his teaching and counseling schedule did not allow him sufficient time for painting. Yet this situation did not preclude other projects. In 1948 Woodruff and Charles Alston, who had won considerable recognition as a WPA muralist, were commissioned to paint two large murals on black history in California for the Golden State Mutual Life Insurance Company in Los Angeles. That summer they toured California to dig up historical material.

The murals were for a building designed by Paul Williams, an African-American architect. They were painted separately by the two artists but in the same

The *Amistad* mutiny trial murals at Talladega College in Alabama (1938–39) are Woodruff's most famous work. The mutiny of fifty-four slaves aboard the *Amistad* against their Spanish captors succeeded (top left). Recognizing that they could not navigate, they spared two of the crew on their promise to steer the ship back to Africa. But the slavers turned the ship into United States waters and eventually landed at New Bedford. Charged with piracy by the Spanish shipowners, the Africans were successfully defended by abolitionist lawyers and former U.S. president John Quincy Adams as having the right to revolt against slavery (bottom). Black churches and abolitionists in many cities raised funds for their defense and to aid their return to Africa in 1841 (top right). Woodruff used portraits of all participants to add authenticity to his murals and included himself as a juror. (Overall dimensions of the three murals, 42 x 78″)

Working with Charles Alston on this project for the Golden State Mutual Life Insurance Company (1948–49), Woodruff modified the linear style he had used in his *Amistad* murals to harmonize with Alston's style. His mural depicts the African-American participants in California history as pioneers, gold miners, fishermen, Pony Express riders; the creation of their own newspaper, *The Elevator*; their work on the Golden Gate Bridge; and their struggle for schools, homes, and justice. Photo: Herbert Gehr

studio. Alston painted the early colonial period, while Woodruff covered California history after the 1849 discovery of gold. Each panel, nine by sixteen feet, was painted on canvas in New York, then shipped to California for wall mounting.

The California experience led directly to a resumption of Woodruff's efforts to paint the six panels of *The Art of the Negro* for Atlanta University. Woodruff offered to paint the murals in New York if he was given a free hand, for in both the Talladega and California murals the subject had been dictated. "In the Talladega murals I was able to employ a linear style. In the California murals, since Alston and I worked together, I tended to abandon my style so that the panels would be compatible," Woodruff said. "But in the Atlanta murals I could select the subject and paint as I wanted."

The Atlanta University murals were completed in New York in 1951. The first panel concerns the styles and forms of African art; the second, the influence of the art of black Africa on the cultures of ancient Greece, Rome, and Egypt. The third depicts the destruction

of African culture, symbolized by the looting and burning of Benin. The fourth panel shows parallels between African and pre-Columbian, Native American, and Oceanic art forms, considering all of them basic forms of human aesthetic expression. The fifth panel demonstrates the influence of African art on modern painting and sculpture, as reflected in the art of Modigliani, Picasso, Lipchitz, Henry Moore, and others. The sixth portrays the important black artists of history, starting with the cave artists of Africa and including older African-American artists, such as Tanner, Bannister, and Robert S. Duncanson, as well as such contemporaries as Alston, Jacob Lawrence, and Richmond Barthé.

Woodruff's style varies with each panel to accommodate the subject matter. At times it becomes abstract in its treatment of African imagery. Both emotionally and aesthetically, the *Art of the Negro* murals synthesize many elements in Woodruff's background with the emerging abstract movement of the early 1950s in New York. He considered these murals to be one of his major achievements.

212

Abstract (ca. 1960) demonstrated Woodruff's ability to compose energetic, rhythmic canvases in the Abstract Expressionist style and color. Later he turned to abstractions derived from Ashanti gold weights and other African-designed elements. Photo courtesy of the artist

———

By 1955 Woodruff's work had become completely abstract, although based on the African motifs and forms that had first appeared in his woodcuts in Atlanta. He particularly regretted not knowing in his childhood that Africans produced great art, saying:

We were told that we were only slaves and savages and not shown this art. I feel that if the great Greek and Roman antique sculpture can inspire a white artist, certainly the work of my ancestors in Africa can inspire me. I don't say this on a tit-for-tat basis, but simply because it compares favorably with the great art of Europe, the art of Asia, with pre-Columbian and [American] Indian art.

I have tried to study African art in order to assimilate it into my being, not to copy but to seek the essence of it, its spirit and quality as art. There are many mistakes made in talking and writing about the influence of African art, it seems to me. It is a great pity that while people generally credit African art with having set off Cubism, they do not understand how superficially some artists, whatever their intent, used African art.

I have never taught African art to my students or pushed it in any way. It is a kind of personal interest and feeling that you can't impose on others. If students seek it out, that is fine, that is something they do then for themselves, and I am delighted to offer them the benefit of my experiences. I have consistently advised students that blackness alone will not imbue their works with greatness or immortality. Whatever the source or theme of their expression, the answer to that question will rest finally in their attaining the highest possible level of achievement and transcendence in their work as art.

In my opinion, Modigliani was the only European artist of the early school of Paris period who really got deep into the essentials of African art and then, by integrating it with his own vision, made something of his own. This is more manifest in Modigliani's few sculptures than in his larger output of paintings.

The greatness of African art, while admittedly a source of inspiration and interest to the twentieth-century artist, does not lie in this fact alone. African art possesses those basic and inherent qualities of all great art. It is in this sense that it should be judged.

In 1962 Woodruff became one of the founding members of Spiral, which met weekly to discuss the problems of being a black artist in white America. These discussions helped members clarify their identity as African-Americans and their goals as artists. Woodruff's own synthesis of modern trends in art with his long struggle as a black man to make his own unique contribution to American culture drew young artists to him. In turn, their interest contributed to his commitment to finding elements in African imagery that he could use for his own contemporary vision.

In 1966, two years before Woodruff retired from New York University, its students elected him "Great Teacher," reflecting his wide influence. His students included several generations of artists and art teachers, among them the painters Larry Rivers and Robert Goodnough, the watercolorist Erwin Greenberg, the jewelry designer Wilmer Jennings, Eugene Grigsby of the University of Arizona, Vernon Winslow, head of the art department of Dillard University in New Orleans, Augustus Freundlich, chairman of the art department of Syracuse University, John Howard of the University of Arkansas, and Edward Colker, dean at the State University of New York at Purchase.[17]

In 1966 Woodruff showed slides of his *Amistad* murals in Sierra Leone to descendants of the mutineers who made African and American history. This experience sharpened his awareness of the cultural diversity of African peoples, evoking a wish for their unity. In his *Celestial Gate* series, an abstracted Dogon granary door is decorated, not with Dogon symbols, but with Woodruff's symbols of Ashanti gold weights—a deliberate combining of different tribal cultures in an aesthetic unity. His *Ancestral Memory* also represents an aesthetic unity, with its large red mask forming an iconographic symbol of the continent. This work was intended for the First World Festival of Black Art at Dakar, but Woodruff withdrew from the exhibition to protest its politicalization. Nevertheless, his wish for unity remains expressed.

Woodruff's concern with African imagery did not eliminate other observations. At times he painted landscapes in brilliant slashing colors in an Expressionist manner. He also created a series on children playing in which he emphasized action, depicting a girl skipping rope, for example.

This drawing, one of a *Monkey Man* series that Woodruff did in the early 1970s, was based on his studies of African fetishes and figures. (Crayon on paper, 33½ x 26") Photo: Harry Henderson

Howard Conat, head of New York University's creative division, has noted that Woodruff's evolving style over the years came from "the deepening urgency of his determination to strive for the highest possible level of qualitative excellence in the mode of expression that he, rather than other artists, critics, or dealers, felt most appropriate. Woodruff calls his shots, and his aim is correctly high."[18]

Almost every day, for more than a decade after his university retirement, Woodruff drew sculpturally conceived torso figures inspired by Shango, the thunder god of the Yoruba people in Nigeria. He chose the torso for his studies, he said, because "while the head and limbs control the torso's action and animation, its bulk carries their weight and properties. This is why *Winged Victory* lives today." Such studies, he felt, brought him close to what he called his own particular vision and its own unity. This unity was apparent when a major retrospective exhibition of Woodruff's work was organized in 1979 at the Studio Museum in Harlem by its director, Mary Schmidt-Campbell. By this time

Torso No. 1 (1978). In his last years Woodruff drew and painted many torso figures inspired by African sculpture. He explained to writer Albert Murray: "In African sculpture the human body is rendered in terms of a series of riffs on cylindrical forms . . . and it adds up to a much more sophistcated aesthetic statement than is represented by the human torsos in Greek sculpture." (Charcoal on paper, 25 x 20") Metropolitan Museum of Art, New York

his work was in the collections of the Metropolitan Museum of Art, the Detroit Institute of Arts, the Newark Museum, and many black colleges and universities.

Woodruff continued to work into his eightieth year. He died in New York on September 26, 1980. Several years before his death, talking to the novelist Albert Murray, Woodruff said: ". . . any black artist who claims that he is creating black art must begin with some black image. The black image can be the environment, it can be the look on a man's face. It can be anything. It's got to have this kind of pin-pointed point of departure. But if it's worth its while, it's also got to be universal in its broader impact and its presence."[19] It is this universality that Woodruff sought, and it is what makes him a seminal figure, whose importance has only begun to be recognized.

Woodruff created an imagery that, as Mary Schmidt-Campbell put it in summing up his fifty years of painting, "is not intrusive or protesting, but one which quietly celebrates the beauty and strength of Afro-Americans and their rich cultural heritage."[20]

SARGENT JOHNSON

"It is the pure American Negro I am concerned with, aiming to show the natural beauty and dignity in that characteristic lip and that characteristic hair, bearing, and manner; and I wish to show that beauty not so much to the white man as to the Negro himself. Unless I can interest my race, I am sunk."[1]

With these words, Sargent Claude Johnson, one of America's most versatile black artists, described his goals in 1935. Although he won many honors, particularly in San Francisco, Johnson has been largely omitted from accounts of American art in the 1920s and 1930s. One reason may be that, ignoring contemporary Western aesthetics, he persistently used color in his statues. He was also a daring innovator, creating huge murals on enameled porcelain steel panels. Today's increasing awareness of the world's pluralism, of the cultures of Africa, pre-Columbian, America, and Asia, may stimulate a new appreciation of Johnson, for he turned to these cultures, rather than traditional Western art, for inspiration and ideas.

A short, cheerful man, Johnson's personality reflected his confidence. Consuelo Kanaga, whose photography recorded much of the history of the period and who knew him well, said: "He was beautiful in his spirit, the way he talked, the way he thought, the way he worked, the way he felt. I don't mean he didn't have problems. He did—terrible problems—but he was still beautiful. It was his spirit, the way he looked at everything."[2] Clay Spohn, a painter friend since the 1930s, called him "one of the few persons I have ever known who seemed perennially happy, joyous, exuberant in living. . . . For he really had the love of life and was always willing to share his enthusiasm."[3]

Johnson's works "have a gentleness, an inner fire, and a great spiritual calm," emphasized Evangeline J. Montgomery in her monograph accompanying the Oakland Museum's 1971 retrospective exhibition. She related his work to West African tribal art as well as to Mexican, Art Deco, and Cubist art.[4] She might

well have added classical Egyptian and early Greek sculpture.

Born in Boston on October 7, 1887, Johnson was the third of six children. His father, Anderson Johnson, was of Swedish descent, and his mother, Lizzie Jackson Johnson, had African-American and Cherokee ancestors. The serious illnesses of his parents combined with the stressful problems that beset interracial marriages at the time (including social ostracism and the inability to find work and decent housing) made his early life turbulent. In 1897, when young Sargent was ten years old, his father died. His mother, ill with tuberculosis, lived another five years but was increasingly incapacitated.

After their father's death, the six Johnson children were temporarily taken in by their mother's brother, Sherman William Jackson, a high school principal in Washington, D.C., and his wife, May Howard Jackson, a recognized sculptor. Born in 1877 in Philadelphia and trained at the Pennsylvania Academy of Fine Arts, she was an expert modeler, although her concepts were not original. Her work, shown in major museums, included portraits of African-American leaders. She also taught art to black children in Washington.[5]

Observing his aunt as she modeled, Sargent Johnson began his first attempts at sculpture. His aunt's efforts made a lasting impression and, in a sense, established a goal that did not seem impossible. When the Johnson children were presently sent to their mother's parents in Alexandria, Virginia, young Sargent continued his efforts at modeling clay, trying to copy lambs and angels in a nearby tombstone cutter's shed.

However, the care of the children proved too much for the aging grandparents. In 1902, when their mother died, the children were separated. The boys were sent to the Sisters of Charity Orphanage in Worcester, Massachusetts, while the girls went to a Catholic

This portrait of Johnson is by Consuelo Kanaga, a leading photographer of the 1930s. She considered him inspiring: "It was his spirit . . . beautiful in the way he looked at everything." Photo: Consuelo Kanaga, Croton-on-Hudson, N.Y.

school for African-American and Native American girls in Pennsylvania. This was the last time the girls saw Sargent. According to Montgomery, some Johnson children had difficulty in identifying with their African-American heritage and lived as Caucasians or Native Americans, but Sargent Johnson chose to be considered black and lived his life as an African-American.

As an adolescent in the orphanage, Johnson attended public school and worked in the Sisters of Charity Hospital. While convalescing after a long illness, he began painting. At one point he copied pictures chosen by the nuns onto the greenhouse wall with whatever paint he could find in the workshop. Interested in singing because he had a pleasant voice, he was later sent to a Boston music school, but he soon abandoned it for a night-school course in drawing and painting.

Johnson's transition from boy to man, from student to artist, is largely undocumented. He reportedly left Boston and lived for a while with relatives in Chicago, who considered his desire to become an artist unrealistic for an orphaned black boy. At some point Johnson determined to go to California. When he arrived in San Francisco, where he first worked, and what he did are unknown.[6] Apparently he arrived some time

before the great Oakland fair of 1915, the Panama-Pacific International Exposition, which exhibited the work of West Coast artists and greatly stimulated the art community. Soon after his arrival he studied drawing and painting at the avant-garde A. W. Best School of Art, according to Montgomery.[7]

Johnson was twenty-eight years old in 1915, the year he married Pearl Lawson, an attractive woman from Georgia of African-American, English, and French Creole descent. He worked as a fitter for Schlusser and Brothers in 1917, but three years later he was tinting photographs and the next year he became a framer in the city's busiest frame shop, Valdespino Framers.

This was a critical period for Johnson. Nourished by San Francisco's cosmopolitan atmosphere, its relative social freedom and its casual acceptance of racial differences and the aesthetic values of different cultures, Johnson determined shortly after he married that he must now make a major effort to become a sculptor. At the mature age of thirty-two years, he began studying at the California School of Fine Arts with two of the best-known sculptors on the West Coast. He worked for two years with Ralph Stackpole and for one year with Beniamino Bufano. Twice he won student prizes.[8] On leaving school, he worked as a framer to survive, but he also continued to work with Bufano as an assistant. Traces of Bufano's influence can still be seen in Johnson's later work.

In San Francisco Johnson's development was influenced by factors that differed from the experience of black artists on the East Coast. West Coast artists were relatively isolated from the influence of European art trends, but at the same time they were continually exposed to Asian art. Both sailors and millionaires brought back art from every Asian country. The art of Asia, exhibited everywhere from museums to curio shops, was widely admired and collected. People were also aware of the work of the Native Americans of British Columbia, whose totem poles represented some of the most original and distinctive art on the continent. California artists, and particularly Johnson, were also strongly influenced by the art of Aztec and Mayan cultures in Mexico and Central America.

As a result of all these influences, California or Pacific sculpture differed from the "mainstream" contemporary sculpture of the time in several ways. First, the sculpture tended to be treated as a precious *objet d'art,* highly polished and worked over in a craft sense. At the same time the work had an underlying conceptual simplicity, so that when it was polished, it tended

Elizabeth Gee (1925), portrait of an Asian neighbor's child, first brought Johnson recognition at a San Francisco Art Association exhibition and later at the New York Harmon exhibition. (Glazed stoneware, 13⅛″ h.) San Francisco Museum of Modern Art

Chester (1931), portrait of an African-American boy, differs sharply from most portraits in its classic simplicity and in the thoughtfulness of the subject. It appeared in the 1931 Harmon exhibition. (Terra-cotta, 10⅞″ h.) San Francisco Museum of Modern Art

to have a static and decorative appearance rather than a dynamic one. In addition, the sculpture was at times derived from natural objects, ranging from driftwood to peculiarly shaped stones, rather than being a design wholly imposed by the sculptor on the material. Both Bufano and Johnson adopted the Asian and Northwest Native American practice of coloring their sculpture— and they knew that ancient Egyptian and Greek sculptors had painted and gilded their work.

In this period Johnson was becoming increasingly aware of his African heritage through discussions about Alain Locke's book *The New Negro,* the Harlem Renaissance, and reports of eastern exhibitions of Congo and other African art. In the midst of all the other influences, Johnson sought to establish his identity as a black American artist. Years later he said: "I had a tough time in the early days. They didn't give me much of a chance. They didn't know who I was, but I had made up my mind that I was going to be an artist."[9] Although never identified, "they" apparently refers to early San Francisco employers and acquaintances who tried to discourage his artistic ambitions.

Artistically, Johnson was fascinated by new techniques and was constantly experimenting, especially with the use of glazes on porcelain figures. His constant experiments may have seemed to indicate a lack of focus and resolution in direction, but were a process of learning that aided his later innovating.

The birth of his daughter, Pearl Adele, in 1923 helped Johnson gain a specific focus. She awoke in him a delight in children, and he made many studies of her and other cherubic infants, usually in glazed terra-cotta. Seemingly simple and straightforward in line, these portraits express an appealing innocence and beauty. Never sentimental nor caught up in excessive detail, their buoyancy conveys the spiritual essence of new life.

One of these statues was a ceramic bust, glazed in color, of a Chinese neighbor's child, *Elizabeth Gee.* It was Johnson's first work to win newspaper attention. In the same year, 1925, Johnson's study *Pearl* received a medal at the San Francisco Art Exhibition. As a re-

Copper Mask (ca. 1935) is an example of Johnson's effort to establish the aesthetic qualities of African-American faces. He sought to overcome the damage to self-esteem done by caricatures. San Francisco Museum of Modern Art. Right: Profile of *Copper Mask*. Photo: National Archives

sult, when the Harmon Foundation exhibitions began in 1926, Johnson was invited to show his work. In the 1928 Harmon show he won the Otto H. Kahn prize with *Sammy,* a portrait of a black youth. In 1929 he won the Harmon bronze award, and his work became part of the Harmon traveling exhibits. Thousands came to see these exhibitions at the Oakland Municipal Art Gallery in 1930 and 1931.[10] Johnson, already well known in the Bay area, was the only Californian in these shows. Several copies of a terra-cotta portrait of a young boy, *Chester,* were sold, including one to the German minister to Italy, a casual visitor. The San Diego Fine Arts Gallery purchased *Esther,* and *Sammy* was also sold.

In the 1933 Harmon show Johnson exhibited an unusual study of his daughter that combined bronze with blue-green in a porcelain glaze. He also exhibited a drawing of a mother and child and a striking draw-

ing titled *Defiant,* depicting a mother holding a small girl and boy close to her. These works won the $150 Ogden prize for the most outstanding combination of materials.

Some eastern commentators, however, considered Johnson's work superficial and decorative, primarily because glazing was associated with lamp bases and pottery in their minds. For example, James A. Porter, although conceding Johnson was "diverting" and "lively," cast him aside as a serious artist: "His work leans more to the decorative side, and his talent is more precisely that of a ceramic artist."[11] Yet Johnson was able to impose, as all significant artists do, his own vision and meaning on his work.

The tolerant atmosphere of San Francisco enabled Johnson to establish a rapport with other Bay area artists, who in turn helped him. In many ways his relationship with the area's artists resembled that of

10' x 28' redwood with touches of Chinese Red & gold Sargent Johnson

This carved redwood music panel (1937), created for the California School for the Blind in a building now part of the University of California at Berkeley, was Johnson's first large WPA project. It screened organ pipes. His notes indicate he used Chinese red and gold to highlight certain sections. (Redwood, 10 x 28') Photo: National Archives

Edward M. Bannister in Providence, Rhode Island, some fifty years earlier. In 1932 Johnson was elected to the San Francisco Art Association and, two years later, to its Council Board. Since Bannister, no black artist in the East had then achieved comparable peer recognition.

In his own people Johnson found much that was inspiring. He often made masks, usually in copper, in African styles, some of which were idealized portraits, such as *Negro Mother*. Frequently he turned to the classic mother-child theme in his drawings, lithographs, paintings, and sculpture. (Albert M. Bender purchased and gave many of these works to the San Francisco Museum of Art.) Johnson also created several murals for black congregations in the Oakland area in this period.

In a backyard studio on Park Street in Berkeley in 1935, Johnson created what many consider his greatest work, *Forever Free*. Based on his earlier drawing *Defiant*, this polychrome wood sculpture depicts in a highly stylized way a black mother with her two children gathered close to her side by her protecting arms. Johnson began by carving the piece in redwood; then he sanded and covered it with coats of gesso and fine linen, sanding it again after each layer. Finally, he painted it, coloring

the skirt black, the blouse white, and the flesh areas a rich copper brown. The whole statue is polished to a very high luster. Simple but dramatic, it resembles African sculpture in its stylistic severity and spiritual strength. Indeed, in creating it, Johnson made use of techniques from Egypt, Asia, and Africa.

Forever Free won the 1935 San Francisco Art Association medal for sculpture.[12] Impressive in its aesthetic simplicity, it was widely reproduced and influenced many artists, including the photographer Consuelo Kanaga and the composer William Grant Still, whose music Johnson had always liked because of its African-American themes. After *Forever Free* achieved national recognition, it was purchased and given to the San Francisco Museum of Modern Art by Albert M. Bender.

Johnson's *Forever Free* differs significantly from Edmonia Lewis's work of the same title. Her sculpture, created soon after the Emancipation Proclamation, depicts a black man holding one arm aloft with a broken manacle dangling from his wrist to symbolize his new freedom. At his side, protected by his other hand, a kneeling young black woman turns her face upward in supplication, her hands clasped in prayer. In Johnson's statue the man has disappeared and the woman, although looking upward with hope, is erect and immovable, firmly protecting her children. The differ-

Johnson made these drawings for low-relief sculptures on the San Francisco Aquatic Park Bathhouse under the WPA. Cut in green slate, the reliefs are over the main entrance to what is now the exhibition hall, Museum of the Golden Gate National Park. (5 x 48′) Photo: National Archives

ence between these statues dramatizes the changes in attitudes among black Americans between 1867 and 1935.

The instant success of *Forever Free* prompted the *San Francisco Chronicle* to interview Johnson at length on October 6, 1935. Observing that he worked with equal facility in wood, ceramics, oils, watercolors, and graphics, the *Chronicle* quoted Johnson as saying:

> I am producing strictly a Negro art, studying not the culturally mixed Negro of the cities, but the more primitive slave type as existed in this country during the period of slave importation. Very few artists have gone into the history of the Negro in America, cutting back to the sources and origins of the life of the race in this country. . . .
>
> The slogan for the Negro artist should be "Go South, young man!" Too many Negro artists go to Europe and come back imitators of Cézanne, Matisse, or Picasso, and this attitude is not only a weakness of the artists, but of their racial public. In all artistic circles I hear too much talking and too much theorizing. All their theories do not help me any, and I have but one technical hobby to ride: I am interested in applying color to sculpture as the Egyptian, Greek, and other ancient people did. I try to apply color without destroying the natural expression of sculp-

> ture, putting it on pure and in large masses without breaking up the surfaces of the form and respecting the planes and contours of sculpturesque expression. I am concerned with color, not solely as a technical problem, but also as a means of heightening the racial character of my work. The Negroes are a colorful race; they call for an art as colorful as they can be made.

At the time that he received all this recognition, Johnson was going through a difficult period in his domestic life. His wife was susceptible to emotional upsets, and in 1936 the couple separated. Pearl remained with her mother. Later, in 1947, Johnson's wife had to be hospitalized at Stockton State Hospital and she stayed there until she died in 1964. Johnson visited her during those years.

When the Works Progress Administration art project began in California in 1936, Johnson was one of the first artists hired. He began in the position of a senior sculptor, because of his thorough knowledge. Soon he was promoted to assistant supervisor, then assistant state supervisor, and finally unit supervisor—without the struggle required in the East and elsewhere to win such posts for African-American artists.

The cost of materials is often a deterrent to the

In 1940 Johnson's design won him the commission for this athletic frieze (executed 1942) for the George Washington High School in San Francisco. The award outraged Beniamino Bufano, Johnson's former teacher, who felt his own design should have won, and ended their friendship. (Cast concrete, 10 x 185') Photo: Larry Merkle, San Francisco

development of sculptors. The WPA program provided Johnson with his first opportunity to work on a large scale. In the well-equipped WPA studios, he could use any technique and tackle massive projects. One of the first of these was a twenty-two-foot-long organ screen for the California School for the Blind in Berkeley. Carved in redwood, the screen was a celebration of music. In its center panel, Johnson featured singers, whose faces resembled the masks of African-Americans he had created earlier. In other panels he carved birds and forest animals as well as a harp.

Two years later, for the Golden Gate International Exhibition, Johnson created massive cast-stone Inca riders astride llamas. He also designed low-relief sculptures for San Francisco's Aquatic Park. These sculptures, incised in green Vermont slate, were installed in what is now the exhibition hall of the Museum of the Golden Gate National Park. The entrance panels depict men of the sea and marine life. The promenade panel, facing the Bay, is a mosaic mural in varying shades of green, black, and white. These diverse public projects established Johnson as a sculptor with a range of abilities.

In 1940 the San Francisco Art Commission opened a competition for the design of a low-relief frieze to cover a retaining wall at George Washington High School's football field. Most Bay area sculptors entered designs, but Bufano, the best-known and most influ-

ential artist on the West Coast, was expected to win. When Johnson was declared the winner, Bufano was infuriated. He assailed the award to his former student publicly and privately, ending their long friendship. The frieze, executed in concrete in 1942, still stands.

In this tumultuous period Johnson also turned out many lithographs, one of which, *Singing Saints,* attracted much attention. Its simple design created a feeling of rhythm that impressed museums and collectors; 150 copies were sold. Part of the print's success may be attributed to Johnson's love of music. He had enjoyed singing since childhood and had learned to play the guitar to accompany his singing.

Johnson longed to study abroad—not in Europe, but in Mexico and Asia. Awarded the Abraham Rosenberg Scholarship in 1944 and again in 1949, he made extended trips to Mexico and continued to travel there for twenty years. He was particularly attracted to southern Mexico, near Oaxaca, where archaeologists were looking for pre-Columbian pottery and sculpture. He was often invited to join American archaeologists at their excavation sites. He also visited Chichén Itzá in the Yucatán to study the decorative patterns on ancient buildings and the polychrome Chelula pottery, which featured mythological animals, flowers, and heroes.

He was particularly fascinated by black clay pots

made by Zapotec Indians and Mexicans in San Bartolo Coyotepoc, near Oaxaca. When fired by a slow wood-reduction process at relatively low temperatures, the clay develops a smoky black color. Johnson worked small amounts of this clay into small figures in his hotel. Many of these figures are now in private collections. One, *The Politician,* caricatured the "big mouth" who does nothing but talk—a type that greatly annoyed Johnson during the Depression.

In 1947 Johnson advanced in a new direction when he met Mr. Mahoney, a partner in the Paine-Mahoney Company, which produced enameled signs on steel plates. He invited Johnson to use their shop to create aesthetic porcelain panels on steel. Working with brilliant colors, Johnson produced approximately 100 panels over the next twenty years on a great variety of themes—religious, mother-and-child, multiracial, and antiwar. He also did abstract designs. Often he painted his design on a white ground coat that had been previously fired. At times he worked with porcelain en-

Lenox Avenue (1938), a subtle, delicately balanced linear lithograph, evokes that avenue's famous swinging jazz nightspots. (Lithograph, 14¾ x 10½") Oakland Museum, Oakland, Calif.

223

Singing Saints (1940) reflects Johnson's love of music; he sang and played the guitar. This lithograph, purchased by many museums and collectors, was widely reproduced in the 1940s. (Lithograph, 18¼ x 15½″) Oakland Museum, Oakland, Calif.

amels that were fired every few minutes at 1,500 degrees Fahrenheit. Some panels were done in relief. Others ranged from small trivets to huge decorative works.

Ultimately this work led to commissions for large enameled panels. One of the first was a brilliant abstract mural of pots and pans that was mounted over a store entrance in San Francisco.[13] The Paine-Mahoney Company then employed Johnson to create several huge enameled murals. One, for Harold's, a gambling casino in Reno, depicted pioneers in wagon trains crossing the Sierras. It is seventy-eight by thirty-nine feet, reportedly the largest mural ever created by this method. Another, twenty-five by fifty feet, was made for the West Club Casino in Las Vegas and is now in the Salt Lake Palace in Salt Lake City, Utah. In these large works, Johnson created the most important figures and directed other artists, who worked on the backgrounds.

In 1948 the Matson Navigation Company commissioned Johnson to carve a large mahogany panel depicting Hawaiian leaders and warriors for its SS *Lurline*. In 1956 it commissioned two large ceramic tile walls for the SS *Monterey*. John Allan Ryan assisted Johnson in making these murals, his last large works.

Johnson strongly opposed the contemporary view that color "contaminated" sculptural materials. "Sculpture was never meant to be colorless," he asserted. "There is no reason why it should be; most ancient sculpture, with the exception of the late Greek, was polychrome." He continued to create polychrome wood figures expressing universal themes.

A readiness to experiment was one of Johnson's outstanding characteristics. After studying metal sculpture techniques with Clair Van Falkenstein, he

created welded sculpture that combined wire forms with enameled steel.

Johnson also studied Asian religions, particularly Shintoism. In 1958 a patron financed his seven-month trip to Japan to visit its Shinto shrines and study Japanese art.

Although he suffered severe anginal pains from the late 1940s on, Johnson remained very productive, and his work was consistently high in quality. Among San Francisco artists, he was held in the highest esteem. One of his last acts was to offer to etch a mother-child plate for a benefit for an organization of African-American artists.

Johnson died of a heart attack in San Francisco on October 10, 1967, at the age of eighty. A few years later, in 1971, Montgomery, with Marjorie Arkelian and others, organized a major retrospective show of his work at the Oakland Museum. It was his first one-man exhibition.

Throughout the years Johnson's work was singularly consistent. Strongly influenced by African and pre-Columbian sculpture, it was eminently suited to architectural use. His clean, direct shapes create handsome volumes in three-dimensional space. The forms are never accidental and express his motifs clearly. Even when massive, his sculpture never seems heavy. His fine portrait heads, use of polychrome techniques on simple, chaste volumes, and ongoing experimentation establish Sargent Johnson as one of the most unusual and versatile African-American artists to emerge in the 1920s.

Members of the Harlem Artists Guild regularly mounted the picket lines of the WPA Artists Union to protest cutbacks. Among them were Norman Lewis (in striped shirt, holding union banner) and Gwendolyn Bennett, who succeeded Augusta Savage as head of the Harlem Community Art Center. The young woman on the left is unidentified, but behind her is painter Frederick Perry. The man on the right is an Artists Union organizer. The struggle over jobs prevented development of the Guild's ambitious cultural program.

EMERGENCE OF AFRICAN-AMERICAN ARTISTS DURING THE DEPRESSION

Paradoxically, it was during the Great Depression of the 1930s that significant numbers of African-American artists were able to work at their art full time for the first time, through the government work-relief art projects. For black artists, these projects ended their isolation from training, from the practice of their craft, and from expert discussion of the aesthetic concerns that form the traditions and mainstream of American art. Moreover, while black Americans had generally been denied union membership until the founding of the Committee for Industrial Organization in 1935, black artists were immediately welcomed into the Artists Union of America and its predecessor, the Artists Committee for Action. Black artists in New York, where most were located, were suddenly no longer outsiders, but participants in American cultural life. Their world changed, and they looked at themselves, their tasks as artists, and their people in a new way.

What particularly distinguished African-American artists was their close identification with their people and their hardships. No other group of American artists had this characteristic to the same degree. As they mastered difficult technical problems, black artists also confronted the complex issue of commitment to social change and its relationship to art.

In every age, artists must come to terms with the major concerns of their time. During the Depression era of failing banks, massive unemployment, and bankrupt social attitudes, nearly all artists were concerned with social justice, with the need to ensure economic security through minimum-wage and labor laws as well as unions, and with the looming menace of war created by Nazi aggression in Europe, Benito Mussolini's invasion of Ethiopia, and the fascist uprising in Spain. Black artists were especially concerned with social justice, with the discrimination that deprived their families not only of jobs, education, and housing but even of relief. Earlier, education had been considered the primary way of alleviating the plight of black peo-

ple, but with the Depression this changed. Unemployment among African-Americans, twice that of other Americans, made protest demonstrations a way of life for many black people. They turned to support the New Deal of Franklin D. Roosevelt, who had first won their attention by daring to call lynching murder. (In 1934, twenty-eight black Americans were lynched.)

Thoughtfully and angrily, African-Americans discussed who they were and what they might become—in kitchens and on curbstones, on breadlines and job lines, in churches and saloons. They also talked with action: with rent parties, sit-ins in welfare offices, mass demonstrations, picket lines, and the blocking of evictions. They called these and other actions "the movement"—the active, caring effort by African-Americans to help one another. Sculptor Augusta Savage embodied "the movement" when, after failing to get talented Jacob Lawrence on the Works Progress Administration art project because he was a year too young, she hunted him up the next year, when he was eligible, and made sure he was accepted as an artist and not just put on relief with the hope of odd jobs. In many ways James Weldon Johnson, the activist poet and author then heading the National Association for the Advancement of Colored People, epitomized "the movement" with his selfless organizing against lynching and discrimination. "The movement" was a positive, proud, and participatory realization of what it meant to be black and American—not on the soirée scale of the Harlem Renaissance, but on a mass scale. Everybody, it seemed, was in "the movement."

Well-known artists were having difficulty selling their work in galleries, even at low prices, and government art projects were opposed as "not useful work." In this situation, New York artists turned to self-help, holding "sidewalk shows" near Washington Square. Beauford and Joseph Delaney were among the first black artists to participate, and at one of these shows Palmer Hayden sold a painting of a church to its priest.[1] Knowing such shows could not support

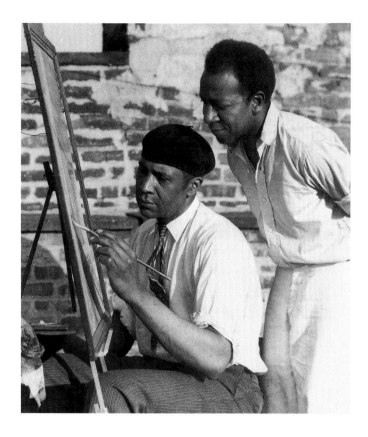

Palmer Hayden, observed by Beauford Delaney, painting at a Washington Square outdoor show in the early 1930s. Mary Beattie Brady of the Harmon Foundation later made a silent movie showing how Hayden painted a picture, which was distributed to black colleges to stimulate their interest in art.

artists, Audrey McMahon, director of the College Art Association, and her colleague Frances Pollak, obtained $20,000 from a municipal art committee and employed artists to teach crafts and paint murals in churches and neighborhood centers.[2] Among the black artists they employed were sculptor and potter William E. Artis and painter Richard M. Lindsey, who taught children soap carving, painting, and model plane building. A Carnegie Foundation grant, administered by the CAA, employed painters Charles Alston, Palmer Hayden, and Susie McIver, as well as printmaker James Lesesne Wells, in a similar program in the basement of the Harlem branch library.[3]

Augusta Savage's studio, also supported by the Carnegie Foundation, became the principal meeting place for young black artists. Although everyone was "broke," an optimistic excitement pervaded their thinking and activities. Part of this stemmed from the effort throughout Harlem to win jobs from the city's utilities and subways. Each employed 10,000 people, but only a handful were black—and they worked only as porters. Boycotts and publicity were Harlem's weapons. On Tuesdays people in Harlem refused to use any electricity or gas, and they demanded operators to handle all phone calls. Buses ran empty. On 125th Street the slogan was "Don't Buy Where You Can't Work."[4]

How African-American artists might use their abilities to win these campaigns was discussed nightly at Savage's studio. There young black artists shared a resolute camaraderie and an exuberant feeling of moral strength. Believing there was a "New Day A-coming," they were determined to be part of it.

African-American artists were not the only artists trying to change things. In September 1932 unemployed artists demanded that the state pay all artists a living wage or buy their work, astonishing relief officials.[5] Such ideas were common among artists. In May 1933, the painter George Biddle wrote his old classmate President Roosevelt, urging government-sponsored artwork. He cited murals painted by Mexican artists "on plumbers' wages." Young American artists, he wrote, "would be eager to express these [New Deal] ideals in a permanent form."[6] Biddle's letter resulted in the first federal Public Works of Art Project in December 1933, under the auspices of the U.S. Treasury, the custodian of all federal buildings.

Initially, need was supposed to be PWAP's only job criterion because its funds came from the Civil Works Administration, a work relief program. However, differing interpretations as to who was eligible caused confusion and a storm of protests from artists. Edward Bruce, PWAP's chief administrator, was an artist who had become the Treasury's silver expert. He felt PWAP should aid the most qualified artists who were unemployed. Yet in New York the regional director was Juliana Force, head of the Whitney Museum of American Art, who first announced, "This is a relief measure. We are interested in only one thing about any artist, that is 'Is he in need of employment?' "[7] That brought applications from nearly 4,000 artists. She then hired a few well-known artists and presently announced that Washington had eliminated the words "needy" and "relief" from PWAP considerations.[8] Most African-American artists were turned down because they could not prove they were artists. Who ever heard of a black artist? With few exceptions, they had no formal training, had no published reviews of their work, and were not known to museums and art circles. The PWAP staff suggested they apply for laboring jobs under the Civil Works Administration.

Bruce's qualifying requirements were denounced by artists, but influential people in established art institutions supported his views. Many legitimate artists who considered the PWAP a relief agency found it "particularly humiliating to flunk its 'quality' test and be rejected."[9] Anxious for congressional approval, Bruce also set "the American scene" as the theme of all work. Abstract, Cubist, and even some traditional

art forms were ruled out. "Any artist who paints a nude for PWAP should have his head examined," said one PWAP official.[10]

Only a handful of African-American artists, all academically trained or professionally recognized, were among the 3,500 artists in PWAP's four-and-a-half-month existence. Among them were Lester Mathew, who created a mural on black life for the San Francisco Negro Community Center; Samuel Joseph Brown, who did watercolors in Philadelphia; Alan Rohan Crite, who painted Boston neighborhood scenes that are now prized as historical records; Wilmer Jennings, who did a mural for Washington High School in Atlanta; Elton C. Fax, who painted a mural for Dunbar High School in Baltimore; J. H. D. Robinson, who painted New York scenes; Palmer Hayden, who portrayed New York harbor boats; Archibald Motley, Jr., who did fourteen paintings that were later distributed to federal offices in Chicago; Dan Terry Reid, who depicted Chicago streets and made pastel portraits of Washington notables; and Aaron Douglas, whose four murals for the 135th Street branch of the New York Public Library are now considered among the most innovative and significant works created under PWAP.[11] Only Motley's *Barbecue* and Reid's *West Side Alley* were included in an exhibition of 500 works at the Corcoran Gallery of Art to demonstrate the value of government art projects.[12] Although short-lived, PWAP made everyone aware of American art and that government art projects could be successful.

Even before the first government program, Mary Beattie Brady had recognized that black artists' lack of formal training and professional recognition might be a problem. To combat this, she included brief biographies of all African-American artists exhibiting or "in touch" with the Harmon Foundation in the 1931 Harmon catalog and the two that followed. Many artists later used these citations to demonstrate their professional acceptance as artists. Yet the contradictory statements by PWAP officials about job criteria—"Need is not in my vocabulary," Juliana Force once told protesting artists[13]—left most black artists feeling they were denied consideration.

Initially, African-Americans had been encouraged by President Roosevelt's call to "put people to work."[14] But after two years—with 4.3 million families plus 7 million single people receiving government aid and more than 50 percent of the black working population unemployed—it was clear that the Depression had not been overcome. Moreover, state welfare agencies were dominated by racial prejudice. In the North, black families obtained relief only through determined protest

demonstrations. In Jacksonville, Florida, 15,000 black families on relief received only 45 percent of relief funds while 5,000 white families got 55 percent.[15]

African-American artists received a hard blow when Brady decided in 1933 not to have a Harmon exhibit in 1934. She felt that because PWAP had created a new perspective, with qualified black artists being paid to work on government projects, the Harmon exhibits were no longer needed. Prospects for black artists never seemed dimmer.

The artists' problems were intimately connected with those of other African-Americans, many of whom were discussing ways of changing their situation, including socialism. At the time many American intellectuals had become convinced that some form of socialism was inevitable in the United States. Reexamining their abilities, their history, and their future, thousands of black Americans began to see that their role at the bottom of the ladder was not necessarily the place where, by some divine law, they would always have to be. Charles C. Seifert's YMCA lectures on past black achievements in Africa and the United States were packed.

Meanwhile, New Deal proposals for work relief were being furiously attacked by a coalition of southern Democrats and conservative northern Republicans as "communist," "socialist," and "destroying American character," laying down a hysterical pattern of fear that would smolder and fume for twenty years. The Communist party's opposition to discrimination and defense of the Scottsboro youths falsely accused of rape provoked and sharpened the analysis of many black Americans of how they were oppressed and by whom.

During the long cold winter of 1933–34, as relief funds dwindled and the police broke up demonstrations, demand for real change pervaded Harlem and other black communities. In meetings in their homes, in churches, at welfare demonstrations, and in the black press, influential African-American leaders reviewed how society used black people: how they were demeaned, oppressed, exploited, and divided; and how this affected their relationships with unions, religious groups, political parties, and one another. Their continued helplessness and inability to escape poverty, bad housing, poor education, and lack of jobs were, thousands saw, destroying them.

African-Americans' frustration and anger eventually culminated in an explosive riot in Harlem in March 1935. It began with an incident at a 125th Street store and ended with three dead and two million dollars in damages. The riot was caused, an official investigation held, by the "resentments of the people of Harlem against racial discrimination and poverty."[16]

Two days before the riot, black artists and Harlem

leaders expressed such feelings in a more positive way—in an exhibition supported by leading citizens. Many black artists had been upset by Mary Beattie Brady's personal decision not to have a 1934 Harmon exhibition. Recognizing that prejudice made them dependent on white whims—Brady's or others'—the artists felt that they should not have to look "downtown" for recognition, that their work should regularly be shown first in Harlem, and that black people should be made aware that they had artists in their midst as a means of raising group self-esteem. In December 1934 *Opportunity* had published the first criticism of the Harmon exhibitions to appear in a black publication.[17] It attacked the lack of aesthetic standards in the Harmon shows that led to the indiscriminate lumping of all kinds of work—from sophisticated abstractions to beginners' crude illustrations—under the rubric "Negro art" when, as art, there was nothing Negro about these works.

Aaron Douglas, Augusta Savage, and Charles Alston discussed these points with Harlem ministers, educators, physicians, and labor leaders. A few weeks later nearly 100 influential black New Yorkers, headed by A. Philip Randolph, formed the Harlem Art Committee. On March 17, at the 137th Street YWCA, the committee exhibited the work of sixty-five black artists plus the work of the pupils of eight.

This exhibition sought to remind Harlem people that art was part of their African heritage. At that time there were four well-publicized exhibitions of African art "downtown." The Museum of Modern Art had just opened a major exhibition of African art and three leading New York galleries—Pierre Matisse, Curt Valentin, and Midtown—followed with their own shows of African art.[18] For many, these exhibitions put black people in a new context—as artistic creators, the stimulators of modern art. Seeing Alain Locke's African sculptures in the poor light of the 135th Street branch library was not the same as seeing similar works dramatically displayed in the Museum of Modern Art. Young African-American artists instantly recognized that these works were being treated with great respect by the very art world that so often discriminated against them. They felt they were on the verge of discovering themselves—not by imitating African art, but in their own feelings and responses to their own culture. Individually and collectively, these young artists felt more confident and assertive.

No one felt their new assertiveness more than Brady, who was irritated by criticism of the Harmon shows, although she welcomed the Harlem Art Committee. Almost ten years had passed since the first Harmon awards. Now, in the midst of the Depression, with federal art projects being discussed and Harlem

staging its own shows, she decided that the foundation had basically completed its mission and that in the future she would only help art departments in black colleges with slides, films, and traveling exhibitions. In early 1935 she staged the final Harmon show. Only the work of three artists—Richmond Barthé, Malvin Gray Johnson, and Sargent Johnson—was exhibited. The catalog reviewed the art activities of African-Americans and their colleges, and provided biographical notes on past exhibitors. After that, it seemed that African-American artists would be on their own.

In April 1935, as the last Harmon exhibition was being mounted at the Delphic Studios in New York, Congress appropriated work relief funds. President Roosevelt immediately created the Works Progress Administration under which work relief projects were established. Most were for construction, but some were for artists, writers, actors, and musicians. Roosevelt told state WPA administrators: "We cannot discriminate in any work . . . either because of race or religion or politics,"[19] which cemented the mass defection of African-Americans from the Republican party.

Heading the WPA art project, Holger Cahill fully accepted FDR's objective, as expressed by Harry L. Hopkins: "taking 3,500,000 people off relief and putting them to work."[20] With a background in Aztec and folk art, Cahill had none of Edward Bruce's anxieties about quality; he believed ideas about quality changed like fashions in women's hats. He felt the important thing was to prevent the deterioration of older artists' skills, which would occur if the skills went unused, and to develop young artists for the future—a critical difference from the ideas dominating the PWAP.[21] Hardly less important for African-American artists was that Audrey McMahon headed "Fed One" in New York. Not only did she recognize that the project covered models, stage designers, and commercial artists, but she was familiar with black artists' work from the joint College Art Association–Harmon traveling exhibits and contact with Brady. She had also personally bought the work of a black artist.[22]

"Getting on the project" became the most exciting prospect for the several hundred black artists concentrated in New York; there were also sizable groups in Chicago, Philadelphia, Boston, Washington, and San Francisco. At last they had a chance to learn almost anything in the field of art—and get paid while they practiced. Nearly all met the first requirement: being on relief. Artists seeking work in the "creative" easel division were asked for reviews, catalogs of one-person

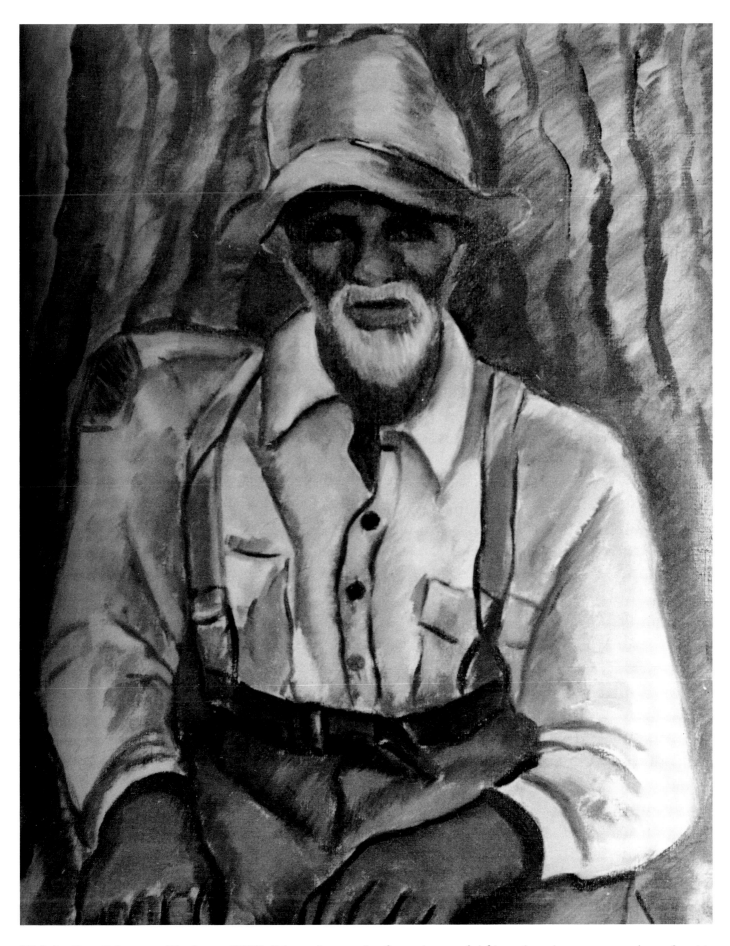

Malvin Gray Johnson *Henderson* (1933). Johnson's portrait of an aging rural African-American was a product of a visit he made to Virigina in the early 1930s. It also reflects his efforts to simplify in a flat modern style. In some catalogs the portrait is called ***Uncle Bob,*** but ***Henderson*** was its title in the 1935 Harmon exhibition. Johnson is remembered for his idealism and his search for ways to become a better artist. Photo: National Archives

and group shows, and dealers' opinions.[23] At first few young black artists could meet this requirement, and most became teachers in adult and children's classes, assistants to muralists and sculptors, or illustrators. Some chose workshops producing lithographs, etchings, silkscreen prints, and woodcuts, or those building exhibitions, models, and frames. They often transferred from one type of work to another after mastering a particular skill. Outside the project, on their own time, most worked hard at their painting or sculpture.

Few restrictions were put on what a WPA artist might do. They were free to portray black neighborhoods, bad housing, breadlines, and the terrors of lynching. Many well-known artists, including George Bellows, Thomas Hart Benton, Reginald Marsh, John Steuart Curry, Biddle, Isamu Noguchi, and Jośe Orozco, joined unknown young black artists in an NAACP exhibition at the Arthur V. Newton Gallery in New York.[24] Dramatizing the injustice of lynching, the exhibit aroused support for a federal antilynching law. Exhibiting with such well-known artists enormously stimulated the black artists—among them Henry W. Bannarn, Allan Freelon, Malvin Gray Johnson, Wilmer Jennings, and Hale Woodruff.

One of the main benefits of the WPA program was the time it gave artists to develop their skills and their ideas. An artist's development requires close, continuous application over a prolonged period—without any certainty that the artist will ultimately be able to support himself or herself. It takes many hours just to learn how to do a simple wash drawing. Through the WPA, for the first time, many black artists were able to devote themselves fully to their art. With the WPA providing a subsistence wage, paper, canvas, paints, brushes, clay, wood, stone, and even assistants for sculptors working with heavy materials, African-American artists now had time to practice the technical aspects of their craft. They could make repeated studies, reexamining what they were doing as their aesthetic understanding deepened. They could research old methods and explore a variety of modern techniques. Sometimes their studies broke new ground. In San Francisco Sargent Johnson experimented with the use of color and fabric in sculpture. In Philadelphia Dox Thrash and his colleagues developed the steely black, high-quality Carborundum print.[25] Many artists in New York, among them Norman Lewis and Ernest Crichlow, preferred to teach. Joseph Delaney made pencil drawings of colonial sugar bowls and silverware for the American Index of Design,[26] one of the most impressive and lasting productions of the WPA, while Ellis Wilson constructed miniature buildings for a model of the entire city.

Easel artists, like Jacob Lawrence, worked in their studios—usually at home. In order to discuss problems together, some black artists took studios in the same buildings or nearby. The time allocated for a painting depended on its size. A 16-by-20-inch or 20-by-24-inch painting was allowed four weeks; a 24-by-36-inch work, six weeks. With watercolor or gouache, two works per month were required. Murals were painted on-site or in WPA-rented lofts under the supervision of experienced artists. As mural assistants, young African-American artists learned to master the design problems inherent in distortions in scale over large areas and how to do fresco painting on wet plaster. They also learned to prepare canvas murals for later mounting at the site, the technique used by Charles Alston and Vertis Hayes in the Harlem Hospital murals.

One of the most stimulating and satisfying aspects of WPA work for African-American artists was contact with experienced, often nationally known artists. A friendly democratic spirit and an atmosphere of mutual respect prevailed. Everyone was paid the same equalizing $23.80 a week. Except for some administrators, everyone had passed through the need test—a home relief investigation. Working conditions created opportunities for informal contact and conversations, often while standing in line to be paid,[27] so black artists could ask experienced artists personal questions about techniques, concepts, art history, training, and philosophy, including preferred subjects and the political uses of art. Such conversations not only became part of the learning process, but also made black artists feel accepted as equals who were also seeking a high level of art.

Increasingly, art discussions everywhere dealt with the social and political uses of art, with the creation of a democratic art that "would shape the intended nature of our society," in Thomas Hart Benton's later phrase.[28] Contributing to the democratic spirit that marked the WPA art projects was the Artists Union of America (which later affiliated with the CIO as Local 60). The union became an ideological battleground. Its publication, *Art Front*, emphasized political efforts to maintain the WPA. While publishing general cultural articles, it also became the main forum for debates between Benton and the Social Realists and for disputes over other concerns, including Alain Locke's call for African-American artists to find guidance in African art.

All foreign influences were denounced by Benton, although he concentrated his fire on European influences such as Cubism, Marxist Social Realism, and the Mexican muralists such as Diego Rivera. Benton, who along with Grant Wood and John Steuart Curry became known as a "Regionalist," demanded the de-

velopment of an "indigenous American art," an "imagery . . . which would carry unmistakably American meanings for Americans and for as many of them as possible."[29]

In 1935 *Art Front* published a long question-and-answer interview with Benton, much of which was devoted to attacking Marxist concepts of art. His most startling response was that he believed the future of American art lay in the Middle West "because the Middle West is going to dominate the social changes due in this country and will thereby determine the nature of the phenomena to which the artist must react if he is to make forms which are not imitations of other forms."[30]

Stuart Davis, whose abstract art had obviously been influenced by European movements and who was head of the Artists Union, wrote a blistering response to Benton, who "ballyhoos himself as the ancestrally qualified savior of American painting. . . . Regional jingoism and racial chauvinism will not have a place in this great art of the future." Among other things, Davis attacked Benton for an anti-Semitic caricature in one work and for caricatures "of crap shooting and barefoot shuffling negroes."[31] African-American artists, attracted to the ideas and art of the Mexican muralists, followed this controversy with intense interest.

Art Front became the means through which many American artists learned for the first time of African-American artists and their special problems. It published an exposure of how the myths of racism and nationalism distort art, written by Meyer Schapiro, later one of the nation's preeminent critics and art historians.[32] It also published an unsigned statement, presumably by Gwendolyn Bennett, on the purpose of the Harlem Artists Guild.[33] In another article James A. Porter of Howard University heatedly attacked Alain Locke's repeated call for African-American artists to develop "a racial art." Porter called his Howard colleague's idea "dangerous," asserting it could lead to segregation of African-American artists, rather than helping them become part of the mainstream of American art.[34]

The union publication made many artists aware of how African-American artists were demeaned. For example, it revealed the efforts of the white superintendent of Harlem Hospital to determine black subject matter in its murals.[35] Through *Art Front* black artists applauded their inclusion in the Texas Centennial Exposition but opposed Mary Beattie Brady's selecting the work to be shown. Pointing out that she had no qualifications as an art expert, they asserted that she and the Harmon Foundation already "had too much influence over Negro art and as an arbiter of the Negro artists' fate through philanthropic endeavors."[36]

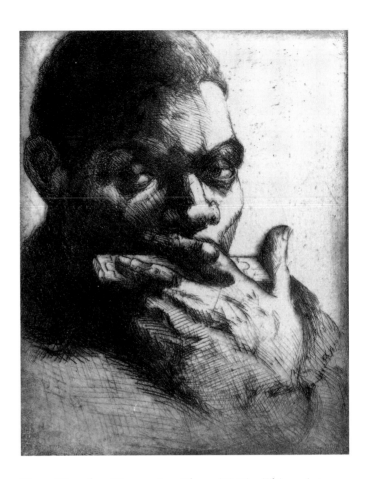

Dox Thrash *Harmonica Blues* (1940). This print was made by Thrash when he was on the WPA in Philadelphia. While he is best known as the discoverer of the Carborundum print process, it is often forgotten that he was an outstanding artist. Using very fine to coarse Carborundum to resurface lithograph stones, he was able to achieve an unusual range of tones in his prints. Born in Griffin, Georgia, in 1893, Thrash studied art initially by correspondence courses but eventually attended the Art Institute of Chicago. He turned to printmaking under the influence of Earl Horter of the Graphic Sketch Club of Philadelphia. Philadelphia Free Library

Certain leading New York artists were particularly helpful. Stuart Davis, whose abstractions utilized well-known American signs as part of their design, readily discussed color as a force just as important as shapes and volumes within a work. He also revealed that he played jazz, boogie-woogie, and Earl Hines's "hot" piano while he worked, feeling this music reflected the tempo of America and letting it influence his spatial rhythms.[37] His attitude prompted some African-American artists to reevaluate this music, which in the early thirties was still considered vulgar by many black people.

Ilya Bolotowsky, later well known for his Mondrian-like organizations of space and color, and Vaclav Vytlacil, an abstractionist who later became a leading instructor at the Art Students League, came to Harlem regularly to teach. Vytlacil expressed views that ran

233

counter to the prevailing social concepts, and his review of black artists' work helped deepen their understanding of modern art and socially conscious painting. He demonstrated that realistic detail, often an obsession with young artists, produced trite work that lacked conceptual strength and worked against what the artist was trying to say.

Another helpful artist was Harry Gottlieb, a painter and union leader who, with Anthony Velonis, pioneered in serigraphy, the WPA-developed adaptation of silkscreen printing to fine-art reproduction. This achievement excited many artists; few people could afford a $300 painting, but many could afford a $10 silkscreen print. Gottlieb was close to many black artists and often came to Harlem to work with those learning the silkscreen process.[38]

What strongly differentiated this period from the Harlem Renaissance was that the employment of a large number of African-American artists gave them self-respect, the feeling that they were worthy of their pay and not dependent on patrons who felt sorry for them. These African-American artists believed that art was a means through which they could win new respect for their people.

Looking for a place where he and Henry W. Bannarn,[39] a sculptor, could teach WPA art classes, Charles Alston found an old red brick stable, with the faint scent of horses and hay, at 306 West 141st Street. It had an apartment on the top floor, another on the second floor, and a large spacious first floor, ideal for a studio class. He and Bannarn moved in, with Alston taking the top floor apartment.

Harlem then resembled a small town. Almost all creative people in the arts knew one another, as well as the leading ministers, physicians, lawyers, business leaders, and national political figures like James Weldon Johnson and W. E. B. Du Bois. Alston began inviting people he knew from the WPA to social parties. These turned into intellectual discussions, and 306 rapidly became a unique community institution. It particularly attracted artists, writers, musicians, actors, dancers, and designers, who were excited to discover one another's talents and views. Even Philadelphia, Washington, and Chicago artists showed up—and sometimes Alain Locke. On payday, the partying and discussions at times spilled over into the huge studio classroom. What black artists achieved in one field stimulated all the others, creating deeply satisfying waves of appreciation that went beyond mere applause. A similar phenomenon occurred in Chicago at the apartment of Katherine Dunham, then an anthropology student and later a world-famous dancer.[40]

At 306, Harlem artists, writers, dancers, poets, dramatists, actors, and intellectuals discussed ideas, aesthetic concepts, performances, and "the news," from a new play or book to a Supreme Court decision, focusing on the social and political implications for African-Americans. One could learn, for example, about Charles Seifert's research on African history, which provided a deeper perspective than the press regarding Benito Mussolini's invasion of Ethiopia. One could also hear new poems, new stories, and new ideas about art for the people, a Marxist analysis of Italian Renaissance art, arguments over Benton's demands for "American art," advocacy of the concepts of the Mexican muralists, hilarious accounts of how artists arrested in a WPA sit-down strike gave police names like "Pablo Picasso" and "Vincent Van Gogh," endless pros and cons about socially conscious art or abstract art, as well as assertions that easel painting was going the way of the "tin lizzie." More than anything, 306 evoked the feeling in African-American artists of belonging to a creative community, dedicated to the arts and to changing the image and status of black people. While individual artists and writers in the United States have at times been close, such as the critic Van Wyck Brooks and the artist John Sloan, there has been no comparable cross-disciplinary community center among Americans.

People came and went. One might find poets Langston Hughes and Countee Cullen; Ad Bates, who worked with the Doris Humphrey and Charles Weidman group in developing modern dance; actors Rex Ingram and Canada Lee; composer Frank Fields; musicologist Josh Lee; and dancer and drummer Asadata Dafora, later minister of culture in Sierra Leone. There were often such writers as Richard Wright, Claude McKay, Ralph Ellison, and William Attaway. And there were generally too many artists to count—sculptor Selma Burke, young Jacob Lawrence and Gwendolyn Knight (who married him), Aaron Douglas, Ernest Crichlow, Richard Lindsey, O. Richard Reid, Frederick Perry, James Yeargans, Robert Savon Pious, Bruce Nugent, and Sollace J. Glenn, who had become a union leader.

Occasionally there were visitors from "downtown." In the late thirties, some German refugee writers came—Ernst Toller, Stefan Zweig, Ludwig Renn, and others. What impressed these visitors most were the observant, expressive paintings of Harlem life that Lawrence had done on brown paper and that Alston, his teacher, showed to them.

From such attention, from participation in union affairs and the American Artists Congress, African-American artists gained a new sense of themselves individually and collectively. Aaron Douglas, noting that

234

the African-American artist of that day was suspended between white hostility and the ignorance of his own people, said the black artist "is essentially a product of the masses and can never take a position above or beyond their level. This simple fact is often overlooked by the Negro artist and almost always by those in the past who have offered what they sincerely considered to be help and friendship."[41] On the other hand, at a time when Mussolini's invading tanks and planes were being resisted by barefoot Ethiopians, Seifert created a world vision of black people, their problems, and their potential through his discussion of Ethiopian history. Artists were the intermediaries through whom the gods spoke in ancient Africa, said Seifert, and this aspect of their past contributed to the sense of self-discovery and excitement of these young artists.

Nothing was more stimulating to those who came to 306 than the WPA Negro Theatre Project, headed by Rose McClendon, the star of *Porgy and Bess,* and at her request, John Houseman, who had produced Virgil Thompson and Gertrude Stein's opera *Four Saints in Three Acts* with a black cast. Their first hit was *The Conjure Man Dies,* a comic mystery by Rudolph Fisher, a Harlem physician and novelist who often came to 306. They next produced *Macbeth,* with a black cast directed by Orson Welles. On opening night, the eighty-five-piece band of the Harlem Elks, marching in brilliant uniforms behind MACBETH BY WILLIAM SHAKESPEARE banners, drew 10,000 people to the theater, jamming traffic for blocks. Critics hailed its black cast and the play moved to Broadway, an enormous hit.[42]

This spectacular success initially bedazzled black artists, who knew the actors well. It then made them feel that with hard work the opportunity to become first-rate painters and sculptors and to change social attitudes toward all African-Americans lay nearly within their grasp. Much excited discussion at 306 flowed from this theatrical success.

Criticism and approval at 306 were powerful influences on the visual artists, particularly in establishing goals. The emphasis on fine-art painting and socially conscious art made Robert Pious, who wanted to be a commercial illustrator, so uncomfortable that he stopped coming. However, painting per se was not the main focus. The fundamental questions were whether art had a political and social meaning and purpose, and whether the 306 artists' efforts supported African-Americans in their struggle to secure their rights and the New Deal measures that moved in that direction. Obviously *Macbeth,* with a black cast, did have political, social, and cultural meaning—and it had strengthened popular support of the New Deal and WPA.

Among their peers at 306, black artists were confronted with the demand for an art that supported ideological goals—and the difficulties that arose when political considerations conflicted with their own feelings and beliefs. Although nearly everyone at 306 supported the New Deal, it was recognized to be a coalition that combined unions and liberals with southern Democrats who adamantly supported segregation. Moreover, it was opposed by most bankers, manufacturers, newspaper publishers, and other business leaders. In this situation the question no longer was, as Du Bois had posed it in the 1920s, how the African-American was to be portrayed, but also how other segments of society were to be depicted—the southern Democrats, employers, workers, unions, and police, as well as the military, which had broken up World War I veterans' bonus army encampment in 1932 and which, as the National Guard, was called out to stifle CIO strikes. The discussion of these questions at 306 was—and had to be—endless.

The concepts of three groups of artists attracted developing black artists: (1) Thomas Hart Benton, John Steuart Curry, and Grant Wood, whose emphasis on American "realism" had withered the traditional concern with vacuous "beauty"; (2) the socially conscious artists—sometimes called Social Realists or "protest painters"—who included William Gropper, Joe Jones, Philip Reisman, Anton Refregier, Philip Evergood, and Ben Shahn;[43] and (3) the Mexican muralists, such as Diego Rivera, José Orozco, and David Siqueiros, who had a comprehensive Marxist-based view of society.

In their interest in these concepts, black artists did not differ significantly from other American artists, many of whom believed art should contribute to changing social attitudes. This belief led to the study of earlier artists who had challenged the attitudes of their day, such as Francisco Goya, Pieter Brueghel, Honoré Daumier, Käthe Kollwitz, and George Grosz. These artists' penetrating emotional vigor in depicting social injustice contrasted sharply with the "realism" espoused by Benton, Curry, and Wood. Although the three midwestern Regionalists broke away from the shallowness of traditional painting, and Wood's satiric portraits *American Gothic* and *Daughters of Revolution* had an amusing tartness, their work increasingly moved toward decorative, stylized landscapes and depictions of such farm rituals as harvesting and planting. Their work did not carry the fierce advocacy of change that many socially conscious painters felt the times demanded, and this issue was, as indicated earlier, a storm center of American art in this period.[44]

African-American artists were particularly drawn

to the Mexican concept of aiding uneducated, impoverished peasants by depicting their revolutionary past. This approach seemed applicable to their own relationship to their own poor, oppressed people and paralleled Seifert's urging that African and African-American history be pictorialized. Creating murals in black churches, stores, and hospitals seemed an achievable goal. Would such murals not inspire black Americans to take pride in their people's contributions to humankind and American life? Could they stimulate the fight for democratic rights?

Rivera and Orozco, then working in the United States, came to Harlem several times to discuss their ideas and to win support for black artists. This led Charles Alston, in his Harlem Hospital mural, to dramatize black contributions to medicine, tracing the development of the healing art from the dancing and drumming of the African medicine man to the modern black surgeon who, in a well-equipped operating room, is the mural's central figure.

The Mexican artists' concepts had a prolonged effect on many black artists. However, few actually undertook murals, which are sizable, collaborative efforts. Moreover, most black artists, although intrigued by the Mexicans' premises, sought to express what they knew from experience rather than history. Their easel paintings usually reflected what they saw—shabbily dressed unemployed men or women, breadlines, soup kitchens, bad housing, poverty-stricken sharecroppers on barren land, and police harassment of labor and black people. This kind of work had personal validity and even urgency, because all WPA artists, having passed through the gauntlet of home relief investigations, knew that continuation of the WPA depended on political struggle. Through their work they wanted to arouse emotions leading to political action—specifically, continuation of the WPA, a federal antilynching law, equal job and educational opportunities, the improvement of living conditions, and advancement of unions.

At the time African-American artists felt themselves and their people under attack. The Republican National Committee had been attacking the WPA, the major employer of thousands of African-Americans, as a "boondoggle" since its inception. The art projects were described as wasting taxpayers' money by employing "hundreds of individuals belonging to the bellyache school of artists to daub our schools with so-called murals."[45] This charge simply was not true. Most WPA murals were optimistic, idealized portrayals of strong, pleasant people building roads or bridges, or planting or harvesting; they often concerned constructive local history.

Increasingly opposed to WPA costs—of which the art projects were a tiny fragment—Congress intensified political heat on the WPA. In January 1936 WPA employment was restricted to those on relief before November 1, 1935, and in March 1936, all hiring ended. Ostensibly, economic recovery made the WPA unnecessary. After the November 1936 elections, WPA employment was cut heavily, and within a year one million people were taken off the WPA.

These cuts were devastating for African-Americans. Not only were black artists dependent on the WPA at a crucial phase in their development, but many other African-Americans supported their families with WPA jobs. Many black artists put aside their artwork to rally political forces to stave off these cutbacks. They worked with any groups that were fighting for WPA jobs and more relief funds.

While some churches were active in this struggle, the Workers Alliance was the most influential group in Harlem in fighting relief cutbacks, systematically helping people on welfare obtain their allocations by sitting in on their meetings with relief personnel. The Workers Alliance directly opposed the WPA's cutback, as did the then-legal Communist party, which was also helping to organize the antidiscriminatory CIO. Black artists worked with these groups in rallying support for the WPA, considering them part of "the movement."

For artists, what significantly differentiated the Communist party from other parties was its view that art was a weapon and should be used as such.[46] Focusing on how workers, unions, and capitalists, as well as colonial powers and their subject peoples, were depicted, the Communist party's spokesmen argued for "Socialist Realism." Their model was the Soviet one in which the worker was always depicted as a hero, and the capitalist as evil. The applicability of this concept to American art and literature was discussed in many publications and settings, including 306.[47]

As committed participants in these sociopolitical struggles, African-American artists—and many others—faced the difficulty of finding a valid aesthetic expression for their feelings. The historically oriented Mexicans were not adequate guides on these questions. All too often the urgency and momentum of political struggles seemed to oversimplify issues and confuse art with propaganda. Yet earlier, when Emile Zola an Gustave Courbet presented a radical challenge to the social and political attitudes of their day, they did not lose sight of the textured realities of human character in conflict. Although Courbet revolutionized the

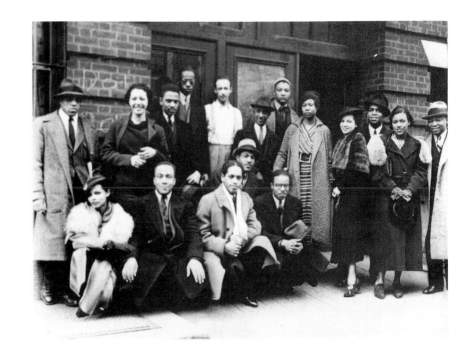

Artists on the WPA Harlem Hospital murals project, supervised by Charles Alston, were, as identified by Alston: front row (left to right), Gwendolyn Knight, Edgar Evans, Francisco Lord, Richard Lindsey, and Fred Coleman; standing (left to right), model-dancer Ad Bates, unidentified model, James Yeargan, Vertis Hayes, Alston, Cecil Gaylord, John Solace Glenn, Elba Lightfoot, Selma Day, Ronald Joseph, Georgette Seabrooke, and O. Richard Reid.

overly idealized art of his time with his realistic portraits of peasants and robust working girls, he maintained a clear grip on their humanity and the reality of their world. Zola could, when he felt his art required it, depict the venality of a worker or peasant as well as that of a rich person, and he could see virtues in both. Yet distinguishing valid artistic expression from what is a political statement, which may also arise from deep feelings, is not always easy, especially when one is forced to fight for one's creative life on the political level.

What particularly confronted African-American artists was the need to identify and separate their feelings about the lives of black people, including their own lives, from demands that their art arouse people to act politically. They wanted to be true to "the movement"—that massive common effort to break down prejudicial barriers—and they wanted to be true to themselves as artists.

Sometimes they failed to maintain their artistic integrity under various pressures. For example, a young artist did a powerful oil sketch based on his experiences during a violent police invasion of his neighborhood. On showing this painting at 306, friends told him he should make the angry faces of the black neighborhood people less fierce so that the police would appear more brutal and be more readily identified as villains. He complied—and effectively destroyed his own original artistic work.

One participant in the 306 discussions, Ralph Ellison, later described his own personal conflicts as a literary artist in this period. They apply in many ways to the visual artist. His greatest difficulty, Ellison wrote:

was the problem of revealing what he [the artist or writer] truly felt, rather than serving up what Negroes were supposed to feel, and were encouraged to feel. And linked to this was the difficulty, based on our long habit of deception and evasion, of depicting what really happened within our areas of American life, and putting down with honesty and without bowing to ideological expediencies the attitudes and values which give Negro American life its sense of wholeness and which render it bearable and human, and, when measured in our own terms, desirable.[48]

The marked erosion of artistic integrity can be seen in the work of Soviet and Nazi artists in the 1930s. In both countries art was reduced to reinforcing the ideological concepts of the government. Artists who expressed in either style or subject matter a personal viewpoint that did not support the approved doctrine or attitude were ostracized and denounced.

In the United States artists in the first government art program, PWAP, had been restricted as to what they might use as subject matter in an effort to win political approval for the program. Abstract art and nudes were forbidden and "American" subjects were required. Artists who did not comply were dropped and saw their work abandoned or destroyed. Artist George Biddle felt that the work, while technically able, was unimaginative and rarely the artists' best work.[49] Archibald Motley's very American mural depicting a stagecoach carrying the U.S. mail is a good example of what happened under PWAP. While technically able, it lacks the expressive vitality and authenticity of his scenes of urban black nightlife, such as *Barbecue, Blues,* or *Stomp.*

There is no simple answer to the question of where art and politics meet and/or separate. During the Depression a number of American artists were totally committed to using their art to fight against social oppression. In this commitment, they were also active politically and at times considered the social protest character of their art its most important aspect. Their work's popularity with those who shared their political views was reassuring. Some of these artists have since changed their approach. Others are now forgotten because their work is no longer of any consequence, the issues that prompted it having faded with time.

For the individual artist, there may be many twists and turns in attempting to find his or her true voice. For example, Norman Lewis, concerned with human and social values, was always active on the picket lines of the Artists Union. For years his paintings concentrated on the injustices of unemployment, bad housing, and evictions. Yet eventually Lewis abandoned that approach and turned to a lyrical abstract style inspired by his personal observations and experiences with nature. In doing so, he separated his artistic concerns from ideological considerations, demonstrating that political or social beliefs and activities need not determine what the artist paints.

Ben Shahn, whose concern with social injustice made him a powerful American artist, once stated: "Nonconformity is the basic precondition of art, as it is the precondition of good thinking and therefore of growth and happiness in people." Shahn believed creativity "requires nonconformity, or a want of satisfaction with things as they are."[50]

In Norman Lewis there was "a want of satisfaction" with what he was doing—"the precondition of art" in Shahn's terms. Lewis no longer restricted his painting, as he once had, to works expressing his political and social beliefs. Instead, he turned to abstract painting and had to endure the scorn of friends who felt he had deserted "the movement." The path he chose was the path of personal growth. He came to the conclusion that his paintings of evictions and breadlines did not help to settle those problems, and that his paintings of such scenes were not unique. In his observations of nature and feelings of wonder about it, he sensed that he had found a personal vision that might achieve some artistic distinction.

"A want of satisfaction with things as they are" had already prompted the formation of the Harlem Artists Guild in 1935. Although represented by the Artists Union on economic issues, many black artists felt that their common cultural background and African heritage, their strong identification with their people and dynamic community relationships (which did not exist among other American artists), and their ongoing struggles against racial prejudice and for civil rights set them apart and created unique concerns. The need for their own organization to bring forth "our special problems and special slants," in painter James Yeargans's phrase, was often discussed at 306. But it remained only talk until early in 1935, when WPA administrators refused to make qualified black artists supervisors. The underlying issue was racial prejudice.

Almost overnight the Harlem Artists Guild sprang into existence with about seventy-five members. Aaron Douglas was elected president and Augusta Savage, vice president; they were New York's best-known black artists. Dues were twenty-five cents a month; ten cents if you were unemployed. Black artists' right to be supervisors won instant support from Stuart Davis, president of the Artists Union. Audrey McMahon, who headed "Fed One," told the WPA headquarters in Washington that the Guild was right—and Charles Alston soon became the first black supervisor.[51]

Other problems immediately besieged the Guild. How could they help artists qualify—or requalify—for WPA employment? (Those laid off might requalify after six months if still unemployed.) How could they help artists find studio space in Harlem, or help newly arrived artists find living quarters? These and many other troublesome aspects of existence for poor black artists preoccupied Guild members. There was little time for developing cultural programs.

Inevitably, the Guild took over some Artists Union functions, and some black artists felt belonging to the Guild duplicated union membership. A number felt that at Guild meetings, in contrast to union meetings, they could speak more freely and with a greater certainty of being understood. They also disliked going "downtown" to union meetings; to some, it smacked of the old dependency on patrons. And some trusted the Guild grievance committee to fight harder for them than the union committee, whose members they did not know. As a result of all this, the Guild developed an informal "understanding" with union leaders that if members were active in Guild affairs, they would be given "credit" by the union.[52] This was critical because when a union is faced with firings, it usually fights hardest for the jobs of its most active members.

The "understanding" also provided certain benefits to the union leadership. They could let the Guild's own grievance committee argue with McMahon about layoffs, transfers, and eligibility. Moreover, a single call to the Guild could produce a picket line, and the Guild was also able to organize massive community protests

Left: **Charles H. Alston** *Blues Song* (1950–51) demonstrates Alston's sculptural values in portraying a subject he loved. In 1968 he exhibited eight paintings dealing with the blues. (51½ x 37½″) Collection Bert M. Mitchell, New York

Below left: ***Black Man, Black Woman, U.S.A.*** (1968) was considered by Alston to be one of his most important paintings. Intellectually derived from the observation of Ralph Ellison's "Invisible Man" that the African-American was not seen as a person in America, this work is artistically indebted to Egyptian portraits of pharaohs and queens in its regal simplicity. Although he always referred, in speaking, to this painting by this title, he was also ambivalent about it. In his 1968 exhibition, he titled it *Family No. 4*. Collection National Association for the Advancement of Colored People

Below right: ***Family No. 9*** (1968) was one of a long series. Alston, impressed with the caring traditions of black family life despite poverty during his travels in the rural South in the early 1940s, often turned to this theme.

Eldzier Cortor *Southern Gate* (1942–43) is a characteristic painting by Cortor, although more romantic than those contrasting the beauty of young women with shabby furnishings and peeling wallpaper. Originally drawn to abstract and Cubist painting as a young Chicago artist, Cortor became one of the first artists to emphasize the beauty of black women in portraits and figure studies. He has increasingly turned to making hand-colored prints and etchings in very limited editions, often of dancing figures and turbaned women. These figures are integrated into designs that reflect his admiration of Art Deco styling. (46¼ x 22″) National Museum of American Art

Figure Composition. Cortor is a master draftsman, whose distortions appear to enhance reality, as in this composition. He does not give such works titles in a literary sense, simply calling them "Classical Studies." (36 x 36″) Collection of the artist

Above: **Joseph Delaney** *Times Square, V-J Day* (1961) depicts masses of people trying to express their joy over the ending of World War II. Its fantasy elements, such as the crucifixions in the sky, add an expressive dimension to this historic scene, which Joseph Delaney painted sixteen years after he witnessed it. (8 x 10′) Frank H. McClung Museum, University of Tennessee, Knoxville

Left: **Beauford Delaney** *James Baldwin* (1963). Long his friend and also the son of a preacher, Baldwin was portrayed several times by Beauford Delaney, always in an expressionistic style. Baldwin asserted that he had learned about light from Delaney who, he said, "is seeing all the time." What Delaney, who began painting abstractions in the 1930s, saw in everything was color, even within colors. (24½ x 20¼″) Collection Mrs. James Jones, Sagaponack, N.Y.

Jacob Lawrence *The Ordeal of Alice* (1963). The inner rage that motivated Lawrence's powerful yet objective portrayal of African-Americans' lives appeared largely exhausted by 1950. However, the civil rights struggle refueled his rage. Inspired by incidents at Little Rock and elsewhere, Lawrence turned to surrealist fantasy to portray a black schoolgirl surrounded by the hobgoblins of hate and the masks of prejudice. She is bleeding from arrows, reminiscent of the classic portrayal of the martyred Saint Sebastian. (Egg tempera on hardboard, 19⅞ x 23⅞") Collection Gabrielle and Herbert Kayden

The Cabinetmaker (1957). Beginning about 1946, with a portrait of a seamstress and her sewing machine, Lawrence increasingly depicted African-Americans doing highly skilled work: watchmakers, carpenters, cabinetmakers, shoe repairmen. While he did do other paintings—on the theater, Africa, and sports—work, usually building, became his absorbing theme. These paintings on work enhanced the self-respect of African-Americans by identifying their positive contributions. Carried out in Lawrence's brilliant, analytical modern style, they replaced his earlier stark portrayals. (30½ x 22½″) Hirshhorn Museum and Sculpture Garden, Washington, D.C.

Left: **James A. Porter** *On a Cuban Bus* (1946) demonstrates Porter's ability to compose in a balanced, formal manner. The main figures are joined compactly, with the diagonal of the guitar giving variety to a composition held together by horizontal and vertical movements. This painting reflects Porter's long academic training, with the picturesqueness and vitality of the subjects its most attractive feature. (32 × 24″) Collection Dorothy Porter Wesley, Washington, D.C.

Below: *Tempest of the Niger* (1964) contrasts sharply with the painting above. Expressive of Porter's turbulent emotions on a visit to Africa after the Washington riots following Martin Luther King's assassination, *Tempest* represents the discarding of academic concepts that had for so long governed Porter. (29⅛ x 43⅛″) Collection Dorothy Porter Wesley, Washington, D.C.

Norman Lewis *Migrating Birds* (1954) won the popular prize at the Carnegie Museum's 1955 Pittsburgh International Exhibition. The museum, artists, and critics interpreted this event to mean that the public was ready to accept abstract art. The painting is characteristic of Lewis's work. It is based on his observations of nature, including the way people tend to conform—which was significant to Lewis, often a nonconformist. (40 x 60″) Carnegie Museum of Art, Pittsburgh

Seascape (1972) shows abstract figures of people enjoying the sea. It reflects Lewis's increasing use of color, but every aspect of the painting is meticulously controlled. This, and his concern with the phenomena of nature, distinguished his work from the splashy, subjective, and emotional character of work of many other Abstract Expressionists. (59 x 76″) Collection Ouida B. Lewis, New York

Ellis Wilson *Shore Leave* (1941). Exuberant in its rhythms and sensuality, this is one of Wilson's most unusual paintings. It differs sharply from the solemn portraits in a flat, modern style that he later painted of Haitians, whose personal dignity he greatly admired. (16 x 20″) Amistad Research Center, Tulane University

James Lesesne Wells *Dance of Salome* (1963) is one of Wells's most complex paintings, suggesting sensuality in its nude women and sweeping arcs. The severed head of John the Baptist appears discarded at Salome's feet. The checkerboard symbolizes the power play described in this story. Always a narrative painter, Wells was much influenced by the German Expressionists in the use of color, as this painting demonstrates. (36 x 50″) Urologic Associates, Chevy Chase, Md.

in Harlem—something other artists could not produce anywhere else in the nation.

Thus, from the start, economic problems competed with cultural activities for Guild members' energies. Nevertheless, the Guild organized exhibitions in Harlem churches and stores, raised funds with dances and parties, sponsored musical programs, and held symposia on African art and the status of artists in American society, in which Ruth Reeves (coordinator of the Index of American Design), Vaclav Vytlacil, Aaron Douglas, and various Guild members participated. Maintaining a strong rapport with Harlem civic, business, religious, and political leaders as well as people on all levels, the Guild fostered an optimistic enthusiasm, keeping everyone in touch with "the movement." Its communicating activities created a cohesive spirit and even privileges—black WPA artists, writers, actors, and dancers were admitted free to the Savoy Ballroom, for example. Many Guild members gathered nightly at a gnarled, 200-year-old oak called "The Tree of Hope," next to the Lafayette Theatre. Initially actors rubbed the tree for good luck in their performance. After a while, everybody rubbed it.

Guild members helped develop the WPA-sponsored Harlem Community Art Center under Augusta Savage's direction. When it opened in 1937, Eleanor Roosevelt came to applaud in person.[53] As one of four centers in New York and sixty-seven in the nation, it was part of the WPA's effort to "bring art to the people." The Harlem center soon became the largest in the country, with some 1,500 people enrolled.[54] With partial funding for materials coming from the Harlem Art Committee, headed by labor leader A. Philip Randolph, the center provided a large exhibition hall surrounded by studios, with free classes open to anyone. Drawing, painting, modeling, carving, printmaking, photography, pottery, weaving, quilting, dressmaking, and the like were taught. Many Guild members were instructors there, and some attended the classes for advanced students. Exhibiting famous works on loan from museums as well as the work of students and teachers, the center drew people of all ages and both sexes—"the cultural harbinger of a true and brilliant renaissance of the spirit of the Negro people in America," said Randolph.[55] The center's popularity strengthened political support of WPA art projects and the New Deal generally. In Chicago, the South Side Community Art Center, in the old Comiskey mansion, enjoyed a similar popularity.

Despite its successes, the Guild's plans to develop aesthetic discussions and to explore black heritage were never fulfilled. Too often its members were already exhausted by doing their daily work, dealing with personal problems, attending union meetings, and picketing against layoffs. More and more, the fight against layoffs dominated the Guild meeting discussions.

The constitution of the Harlem Artists Guild was drawn up in a shorthand notebook. Minutes were kept by a volunteer, Thelma Brunder.

In 1938 a new effort to destroy the New Deal by attacking the WPA art projects as centers of "communism" was led by Texas congressman Martin Dies, who created the House Un-American Activities Committee.[56] The HUAC attack started by presenting "volunteer" witnesses who smeared hundreds of people and organizations as "subversive" and "Communist," despite the fact that anyone had a legal right to join the Communist party and there was no objective evidence of subversion, treason, espionage, or sedition. One witness, Walter Steele, included the Camp Fire Girls among the "subversives" and called for destroying art "smeared upon walls . . . by Communists on federal relief."[57] No one was permitted to cross-examine Steele, and the press generally buried refutations on back pages. This became the basic pattern of HUAC hearings, which helped to destroy the WPA and culminated in the blacklisting disgraces of McCarthyism.[58]

The massive WPA cutbacks were fought vigorously by the Harlem Artists Guild. "We pitched into the fray the best we knew how," said Gwendolyn Bennett in summarizing her presidency during 1937–38.[59] Since the Depression had hit black Americans more severely than the general population, the Guild sought to exempt black artists from layoffs. Through its protests, it managed at one point to get all but four artists restored to the project for a while.

However, there were still 2,000 needy artists on the WPA waiting lists in New York. Many talented artists were driven out of the field. The Guild floundered and attendance dropped off. In July 1938, stepping down as president, Bennett felt the Guild's focus on jobs "had sown the seeds for much of the discontent that has raged in the Guild."[60] Some felt the Guild had only duplicated union efforts and neglected the distinctive cultural problems of black artists. The layoffs increasingly became permanent, and poor attendance could be interpreted as indicating that "the Guild has outlived its usefulness," suggested Frederick Perry, a painter and model, who was nominated as president but declined.[61]

The minutes of the December 13, 1938, meeting reveal that most members felt the Guild should concentrate on cultural interests, although Charles Alston's motion to make union membership a prerequisite to Guild membership carried easily. At that meeting discussion revolved around what was wrong with the Guild. Backing the cultural program "100%," James Yeargans felt Jacob Lawrence "had hit the nail on the head when he said some want to drive [the organization] and some want to paint. The Negro artist is not keeping up with the times—everything is organized. I do not believe we are going to receive equal rights in the cultural field if we expect the white man to give them to us. I see culture linked up with something very basic."

Lawrence responded, "I think the white man will recognize your culture if you have anything to give." Alston summed up, "In the long run we will not be judged by emergencies, but by achievements, and these only. Production is very important. We should see to it that the complete membership exhibits throughout the country. Our bid is for prestige. It is important for Guild members to appear in shows, nationally and internationally. Then our words and economic complaints will have weight."

However, what always overwhelmed such discussions was the struggle to hold onto WPA jobs. That December a Guild leaflet read: "Our Christmas present is here again—Our Santa Claus is the administration. He has placed layoffs on the Xmas tree for project workers. What does this mean to art workers in general, and to Negro artists in particular? We don't need to tell you—YOU KNOW!! With one big scoop all our cultural progress will be stopped. Our physical well-being is also at stake."[62]

In these struggles African-American artists were educated about the social content of art and its political uses. They also learned to work with others regardless of racial, aesthetic, and regional differences to achieve common economic goals. For the first time many black artists came to know and work in a common cause with white colleagues and compatriots.

Although the Guild played a vital role in black artists' economic survival, its inability to concentrate on cultural and aesthetic issues eroded its identity and purpose. Many drifted away, tired of hearing the same discussions they had heard at the union, at 306, and among friends. Those who remained were surprised to receive applications for membership from nonblack Harlem residents and feared a weakening of their cultural base, possibly an attempt to manipulate the group. Eventually a Japanese woman artist was admitted after much discussion.

Two weeks after the Guild's troubled December 13, 1938, meeting, a southern Democrat, Clifton Woodrum of Virginia, joined forces with a conservative New York Republican, John Taber, on the House Subcommittee on Appropriations. By June they had run WPA administrators through hearings four times, charging excessive costs and repeating Dies's theme that the art projects were "fraught with subversives."[63] Although another committee member, Clarence Cannon, denounced the falsity, irrelevance, and irresponsibility of the Dies committee testimony, the Woodrum-Taber coalition effectively ended the WPA, forcing furloughs for all who had been on its rolls for eighteen months.[64] This virtually cut off WPA employment for black artists. For black Americans as a whole, the WPA had been the only job in sight for a decade. By mid-1939 the last WPA art projects were teaching camouflage painting, kept alive with a defense rationale. The Harlem Community Art Center, despite local protests, had already staggered to its end.

Overlapping the WPA's end was the first museum recognition of black American artists as a group by the Baltimore Museum of Art. Some of its trustees had been impressed by the theory of a fellow trustee and art expert, Dr. J. Hall Pleasants, that many leading Baltimore families had been portrayed by a free black painter named "Joshua Johnston" in the 1790s and early 1800s. On learning of the trustees' interest in African-American artists—and recognizing that a museum exhibition in a "southern" city could be used to break

down prejudicial barriers elsewhere—Mary Beattie Brady and Alain Locke lost no time in proposing a group show entitled "Contemporary Negro Art." They had the active support of a committee of leading Baltimore African-Americans headed by Sarah Fernandis.

Presented February 3–19, 1939, this exhibition won wide press coverage. One gallery was devoted to Jacob Lawrence's striking *Toussaint L'Ouverture* series. Among the other artists represented by oils or watercolors were Charles Alston, Samuel J. Brown, Aaron Douglas, Elton C. Fax, Rex Goreleigh, Palmer Hayden, William Hayden, Malvin Gray Johnson, Sargent Johnson, Lois Mailou Jones, Norman Lewis, Ronald Moody, Archibald Motley, Jr., Robert L. Neal, Frederick Perry, and Florence V. Purviance. Henry W. Bannarn and Richmond Barthé showed sculpture. Many exhibited prints, including Robert Blackburn, Sollace J. Glenn, Louise E. Jefferson, Wilmer Jennings, Ronald Joseph, Richard Lindsey, Roland St. Johnson, Albert A. Smith, Dox Thrash, James Lesesne Wells, and Hale Woodruff.

The Baltimore exhibition prepared the ground in terms of status for two major commercial gallery shows in New York. The first was held at the McMillen interior-decorating firm in November 1941. The second, organized by Brady, Locke, and Edith Halpert, opened at the Downtown Gallery the first week of December 1941. Halpert's Downtown Gallery was outstanding in the field. She and Brady had already secured an agreement from an important group of dealers for each to select from the Downtown show two black artists whom they would regularly exhibit.[65] In this way, for the first time, a number of black artists would become a part of the gallery scene. This collective agreement was considered necessary to meet the problem of racial prejudice. Many dealers feared black visitors might drive customers away. If most important dealers showed such artists, it could be defended as commercial necessity "to meet the competition."

At the time no living black artist was represented in a New York gallery, since Henry Ossawa Tanner died in 1937. The Downtown show was considered critical in establishing the relationship of black artists to the professional art world and helping them to survive without the WPA.

However, the Downtown exhibition was overshadowed by the bombing of Pearl Harbor on December 7, 1941. Despite favorable press coverage, concern about the war washed out public interest. Uncertain of what World War II would mean economically, all but one dealer withdrew from the commitment to represent two black artists. Only Halpert made good on her pledge—to the considerable benefit of Jacob Lawrence and Horace Pippin.

Reviews of the Downtown exhibition reflected how critics of the time perceived the work of African-American artists. For example, Elizabeth McCausland considered the work "a result of the special social experience [the black artist] has had—namely, to be enslaved, to be 'emancipated', to be exploited, to be segregated, to be subjected to the ignominies of Jim Crowism, and finally, to the terrors of the noose. If his art is homogeneous, then it is because he has been forced to live in a black ghetto, walled about by the poverty, disease, and lack of opportunities. . . . When natural human creative aspirations break through, they bear on themselves the stamp of his particular knowledge."[66]

The *New Yorker* reviewer found the paintings "almost barbaric profusions of bright reds, rich blues, and resounding purples." Few other artists, the reviewer said, "work in so high a key and with such tonal intensity."[67]

These remarks exemplify the two basic and limited ways in which the work of African-American artists was considered. One view took a somewhat demeaning, however sympathetic, sociological perspective. This kind of thinking caused black artists' work to be displayed at a New Jersey state fair in a section reserved for the handicapped. The second view was largely emotional, fundamentally derived from stereotyped expectations about "primitive" people. Both perspectives neglected aesthetic consideration, a pattern that has continued to this day.

African-American painters and sculptors did not reflect the homogeneity suggested by McCausland. Beauford Delaney, even in the 1930s, painted in a vigorous expressionistic manner. Charles Alston ranged from realistic murals of black history to expressionistic portrayals of jazz singers. Hale Woodruff's canvases were influenced by Paul Cézanne and Cubism. Horace Pippin ignored perspective in balanced and formal designs rich in color. Many more examples could be cited. What the Downtown show did indicate was that a number of black artists had reached a promising spring. But then came the destructive storm of World War II, which ironically made racism one of its ideological issues.

Alain Leroy Locke founded the "New Negro" movement in the mid-1920s. At a time when few African-American artists could appreciate or identify with African art, Locke urged them to be inspired and guided by it in creating a "racial art." His work established him as a pioneer in recognizing the need to accept "the ancestral legacy." Photo: Moorland-Spingarn Research Center, Howard University

THREE INFLUENTIAL PEOPLE

Three people—Alain Leroy Locke, Charles Christopher Seifert, and Mary Beattie Brady—greatly influenced the development of African-American artists in the late 1920s and throughout the 1930s. Although they were not artists, what they did and said, what they supported, what they sought, and what they rejected was of critical importance for many black artists. Concerned with interracial relationships in America, each worked in highly individual ways. They are unique in American art history.

ALAIN LEROY LOCKE

Alain Leroy Locke, the first African-American Rhodes Scholar and a professor of philosophy at Howard University for forty years, was the leading African-American cultural critic and advocate of racial studies until he died in 1954. As early as 1915 he had petitioned the Howard administration for what are now often called "African studies."[1] The fireball of the African-American Renaissance, Locke was a pivotal figure for African-American artists, both as a group and for many individuals, in the mid-twenties and thirties.

In part, Locke's influence came from the fact that his educational triumphs made him highly respected in most cultural fields. By writing a program note or an exhibition catalog foreword, he could gain recognition for a black artist in a wide range of publications. He was in every sense a gatekeeper. Locke's endorsement often determined whether a black artist was given a foundation grant. He also secretly selected and brought to wealthy patrons, such as the "Godmother," Charlotte Mason, talented artists and writers whom she subsidized.

Most important in Locke's preeminence, both as an educator and critic, were his studies of African history and art. While other African-American intellectuals wrote extensively on music and other aspects of African-American creativity, Locke alone specialized in art. Although many middle-class black Americans then shunned their African ancestry and frowned over Marcus Garvey's black nationalism and call for a return to Africa, Locke championed African sculpture, weaving, pottery, and design as great art. He also sought to stimulate African-American artists' awareness of what he called "our ancestral arts," urging development of "a school of racial art."[2]

In 1925 he edited the "Harlem issue" of *Survey Graphic*, which was reformulated as a book, *The New Negro*.[3] Locke's inclusion in that seminal book of the African-influenced work of Aaron Douglas was the first demonstration to thousands of Americans that there were black artists in the United States and that Douglas had a proud and exciting new way of seeing Africans and African-Americans.

The New Negro led to Locke's becoming a consultant to Mary Beattie Brady, director of the Harmon Foundation. This gave Locke a voice in presenting its awards in eight fields; he nominated, for example, Langston Hughes for its poetry award in 1919.[4] He was especially interested in the Harmon art exhibitions from 1928 to 1935, then virtually the only way African-American artists could gain recognition. These shows, providing direct contact with many artists, kept him abreast of what they were doing. His prestige as an educator helped Brady stimulate the creation of art courses in black colleges, many of which felt art had no place in their "practical" curriculum.

Although he had a penchant for behind-the-scenes manipulation to gain and use power,[5] from 1925 to 1939 Locke played the role of preacher to African-American artists. His sermon: they should learn the lesson of the European artists—Pablo Picasso, Henri Matisse, André Derain—whose studies of African sculptural concepts led to the development of Cubism and modern art. Although introduced in America by the 1913 Armory show, Cubism and modern art had baffled most American artists—and there is no evidence that any of the few African-American artists at work at the

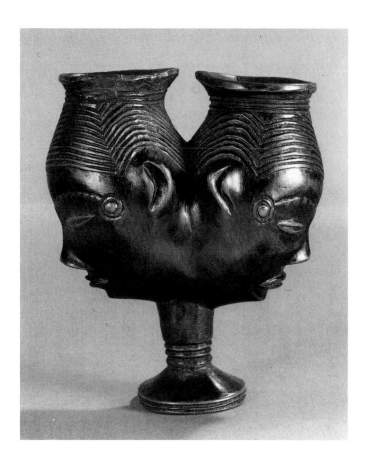

This delicate Bakuba ceremonial cup, carved in wood in Zaire and only six inches high, was one of many works of African art given by Locke in 1935 to what is now the Schomburg Center for Research in Black Culture. An avid collector of African art, Locke hoped to create a museum of such art in Harlem but was unable to raise sufficient funds. Photo: Frank Stewart, New York

time were influenced by it. But Locke felt that their African heritage provided the means by which African-American artists could vault into the front ranks of art—if they would only learn the lesson of the European artists.

Alain Leroy Locke was born in Philadelphia on September 13, 1886, to S. Pliny and Mary Hawkins Locke, teachers who were unusually well educated for African-Americans of their time.[6] They recognized their son was extraordinarily intelligent and advanced his education. When Locke was six years old, however, his father died. His mother, a disciple of Felix Adler, the educator who founded the Society for Ethical Culture, entered him in one of its pioneer schools. Locke later graduated from Central High School and the Philadelphia School of Pedagogy, intending to become a teacher. He won a scholarship to Harvard and brilliantly completed the course in three years, graduating magna cum laude in 1907. That year he also won a Rhodes Scholarship.

Introspective, studious, a pianist and violinist, Locke's isolated early life was far from that of most African-Americans. He overcame discrimination with his tact and intelligence. However, at Oxford University in England, despite his Rhodes Scholarship, his application was turned down by five colleges before he was accepted at Hertford College. He studied philosophy there until 1910. He then studied at the University of Berlin for a year.

At Oxford his most important experience was meeting a number of well-educated Africans. From them, he learned a new way of seeing America's racial and cultural problems and gained a new view of Africa and its history. The link between colonialism and the promulgation of the idea of racial inferiority of non-white people was explored in meetings of the African Union Society, of which Locke was a founder. The society's aim was to cultivate "thought and social intercourse between its members as prospective leaders of the African Race."[7] In short, Locke gained a world vision of races, interracial relationships, and Africa.

His interest in Africa was heightened by his gradually becoming aware that Picasso and Georges Braque had shattered traditional art with paintings that were stylistically suggested by African masks and sculptures. Their Cubist paintings had thrown the art world of Paris, and Europe in general, into turmoil. While it cannot be said that Locke understood the works of these artists immediately, what he did understand was that African sculpture had set off a revolution in art. It was the African connection that set him to dreaming of what African-American artists might do.

On his return to the United States, Locke, recognizing his ignorance of the life of most African-Americans, spent six months in the South. In 1912 he took a post teaching English at Howard University and eventually became a professor of philosophy there. Meanwhile, in 1916, he wrote his first book, *Race Contacts and Inter-racial Relations,* on subjects he had proposed at Howard as needing research and study. During World War I, Locke became the personnel officer and instructor on the war aims of the United States Army Training Corps at Howard University. His knowledge of colonialism in Africa and the hope that the war would end it made him an enthusiastic presenter of President Woodrow Wilson's anti-imperialistic war aims.

Although the imperialistic division of Africa continued after the war, Locke's interest in Africa and its art never abated. In 1924 he was on the scene when the tomb of King Tutankhamen was reopened.[8] Speaking of his visit, Locke emphasized that the world's first great "cultural renaissance" took place "in an African

setting and in a polyglot civilization that must have included more African and possibly even Negro components than will ordinarily be admitted."[9] This contact with the ancient African past gave Locke's vision of a black renaissance in America a messianic driving force.

The following year, in *The New Negro,* Locke sounded his trumpet call for African-American artists to awaken to what they might learn from African art. By this time he was fully acquainted with collections of such art in Paris and Berlin, and with that of Albert C. Barnes in this country. In the late 1920s Locke brought about the purchase the African art in the Blondiau-Theatre Arts collection for a proposed Harlem Museum of African Art;[10] this collection is now in the Schomburg Center for Research in Black Culture. However, while individual artists, such as Charles Alston, were much affected by handling various pieces in this collection, it remained difficult for most African-American artists to see how they could apply its severity in their own work. They also knew that the African concepts came out of a religious and cultural context of which they were ignorant. Locke himself had noted that what African art "is as a thing of beauty ranks it with the absolute standards of art . . . a pure art form capable of universal appreciation and comparison; what it is as an expression of African life and thought makes it equally precious as a cultural document, perhaps the ultimate key to the interpretation of the African mind."[11]

Although Locke never defined what he meant by racial art, he clearly wanted African-American artists to portray the life, personality, and character of their people. In the 1931 Harmon exhibition catalog, Locke rejoiced on the increasing use of African-American subject matter. He also praised the modernist styles of Aaron Douglas, W. H. Johnson, Hale Woodruff, Richmond Barthé, and Sargent Johnson. African art challenges the African-American artist to "recapture this heritage of creative originality, and to carry it to distinctive new achievement in a vital, new and racially expressive art," he wrote.[12] Locke knew his words would be read by active African-American artists at every level. Yet terms like "racially expressive art" only baffled and frustrated most of them. Many did not know what they were expected to do.

His closing remarks worried Mary Beattie Brady. He said: "In this downfall of classic models and Caucasian idols, one may see the passing of the childhood period of Negro art, and with the growing maturity of the Negro artists, the advent of a truly racial school of art expression."[13] Brady did not plan the Harmon exhibitions to foster "a racial school of art expression" or cause "the downfall of classic models and Caucasian idols." It seemed to her that he was advocating black nationalism. Yet Locke's authority was such that she dared not question him (see page 257).

Interestingly, especially since he knew that through the Harmon catalog he was directly addressing a large group of active African-American artists, in 1933 Locke dropped all mention of African art and modern European art and tried to correct some misunderstandings of his pleas. Locke admitted that most African-American artists had felt his demand for racialism meant a restriction on landscapes, still lifes, and abstractions. This was not intended. However, he felt that African-American artists had so far "either avoided racial subjects or treated them gingerly in what I used to call 'Nordic transcriptions.'" In contrast to the racial expressions found in poetry, music, and drama, Locke claimed there was nothing racial in the fine arts: "While the poets, playwrights, writers and musicians were in the sunlight and warmth of a proud and positive race-consciousness, our artists were still for the most part in an eclipse of chilly doubt and disparagement."[14] The growing popularity of jazz became a new measure of the failure of black artists to draw on their "ancestral legacy."

Locke cited the case of a young African-American painter who in 1929 refused to exhibit in a show of black artists because he wanted "recognition as a painter, not as a Negro painter."[15] Yet later this artist turned to portraying African-Americans on artistic and technical grounds and exhibited with other black artists. The change occurred, Locke believed, "primarily or entirely on artistic and technical rather than sentimental or sociological grounds . . . a sign of aesthetic objectivity and independence, and thus a double emancipation from apologetic timidity and academic imitation. Negro art does not restrict the Negro artist to growth in his own soil exclusively, but only to express himself in originality and unhampered sincerity."[16]

In a subtle response to critics like James A. Porter and to Brady's worries, he adopted Edward Bruce's PWAP demand for an "American" art to justify his demands for racial art, asserting that "by the very same logic and often by the very same means, it has been reasonable and necessary to promote and quicken the racial motive and inspiration of the hitherto isolated and disparaged Negro artist."[17]

There is no doubt that Locke's sermons stimulated excitement and inspiration among most African-American artists. Yet these artists faced problems in developing technical excellence in their craft and in gaining support for their work. The African-American population could barely support itself on a subsistence level during the Depression.

One of the sad and troubling aspects of the Harlem Renaissance was its dependency on white patronage, as Nathan Irvin Huggins has noted.[18] Soon after publishing *The New Negro,* Locke met the elderly, wealthy Charlotte Mason. Believing that the spirituality of the white race had been destroyed by artificial values and technology, she believed that "primitive people"—"the child races," such as the Native Americans and African-Americans—were the only spiritual hope of humankind, as long as they maintained their "primitivism."[19] She hoped to keep their primitivism from being destroyed by white civilization.

Charlotte Mason had acquired these ideas from her husband, Rufus Osgood Mason, a well-known surgeon who had died in 1903. He was unusual as a surgeon, for he believed in telepathy and other forms of parapsychology, publishing monographs on "Telepathy and the Subliminal Self" and the therapeutic use of hypnotism.[20] Charlotte Mason believed that she "could find leaders" among African-Americans who would help their people maintain their primitivism.[21] Locke, much impressed by her ideas and wealth, was to find the leaders for her.

In this fashion Locke began a dependency relationship, financial and emotional, that remains one of the mysteries of his life. He brought talented African-Americans to Mason, who subsidized them—the poet Langston Hughes, the artist Aaron Douglas, the anthropologist and novelist Zora Neale Hurston. Others got handouts, but Locke as well as Hughes, Douglas, and Hurston were subsidized. Hurston, for example, got $200 a month, and Hughes was treated even more lavishly. Locke's annual trips to Europe were financed for thirteen years and he may have received other funds. (Paul Robeson, whose singing Mason adored, refused her subsidy and guidance.)

Mason insisted on secrecy, a pledge that they must never reveal her name and must always call her the "Godmother." What she wanted from them was that they be "primitive" in their writing and painting—of which she was the judge.

Eventually Hughes and Douglas, and later Hurston, broke with the Godmother's demands, freeing themselves. However, Hughes had formed a deep emotional attachment to the Godmother, which made his break traumatic. Locke, too, apparently had a deep emotional attachment. When Mason was hospitalized for a broken hip that did not heal, Locke faithfully made his way to her bedside for thirteen years, regularly reporting in a spiteful way about Hughes. Yet after Mason was hospitalized, her influence on Locke waned and he no longer dwelt on the "primitivism"

that marked his earlier writing. There is no doubt that Hughes loved her, and it can be reasonably assumed that Locke felt the same way for he never broke with her. It is perhaps an indication of his attachment that he, a student of racism, accepted her anti-Semitism.[22]

Mason's influence on Locke, considering his intelligence, was considerable. In 1924 Locke wrote clearly about African art as both a pure art form and as a cultural document. But under Mason's influence, Michael R. Winston has noted, Locke claimed there was an "African or racial temperament" that characterized the African-American. This was contrary to scientific knowledge and to "Locke's own conception of race before he encountered Mrs. Mason," said Winston.[23]

On trips to France during the 1920s, subsidized by the Godmother, Locke had begun his collection of African art, and he continued to write and lecture on the relationships of the modern art of Picasso, Braque, and Amedeo Modigliani to African art. In 1936 Locke published *Negro Art: Past and Present,* which again emphasized the use of African art as an inspiration and guide for African-American artists.[24] In 1937 he was a founder of the Associates in Negro Folk Education, which published his 1940 book, *The Negro in Art.* In this book he showed work by early African-American artists, such as Robert S. Duncanson and Edward M. Bannister, and he drew heavily on work exhibited in the Harmon shows.[25] Locke also reproduced paintings by old masters, showing that Tintoretto, Albrecht Dürer, and Matthias Grünewald portrayed black subjects with dignity. He included Diego Velázquez's portrait of Juan de Pareja, now in the Metropolitan Museum of Art. It was an eye-opening book for most African-American artists and writers.

The Associates in Negro Folk Education also published eight "Bronze Booklets," which provided in an inexpensive format much material on African-American history and problems. When Locke's *Negro Art: Past and Present* appeared in this format, it was severely attacked by Porter, Locke's colleague at Howard, who had come to the conclusion that Locke's demands for racial art would lead to segregation of African-American artists.[26] Porter, who was teaching drawing and painting, knew most black artists, while Locke was relatively isolated from them.

Locke actively sought such contact, looking for African-American artists everywhere, often joining artists' street corner discussions in Harlem in the 1930s. Vigorously supporting the WPA art projects, he held that anything that advanced contemporary American art would advance black artists. At the same time he

pointed out that "the development of Negro art must come from an awakened interest of the Negro public in this matter. Negro churches, schools, organizations of all types should make Negro art vital and intimately effective in our group by studying it, circulating it, and commissioning it."[27]

By 1939, when he wrote the foreword to the catalog of the first museum show of African-American artists, presented by the Baltimore Museum of Art, he had softened his language regarding African art, explaining that "the indirect inoculation of African abstraction and simplification may lead, and in some cases has actually led, to slavish imitation and sterile sophistication. But African art, directly approached and sincerely studied, has lessons to teach of precisely opposite effect—lessons of vigorous simplicity and vitality."[28] He no longer called for racial art. It had already appeared, as the Baltimore Museum exhibition demonstrated.

As his summing up, Locke planned a book that would encompass the contributions of African-Americans in literature, poetry, drama, music, dance, and the fine arts. However, following his retirement from Howard in 1953, cardiac complications resulting from early rheumatic heart disease prevented its completion.[29] He died in New York in 1954.

Locke's call in 1915 for research and study of racial problems and his many essays and books on African-American cultural contributions remain intellectual springboards of many academic symposiums and lectures today. In the field of art, although he won no personal following among African-American artists, there is no doubt that he played a critical role in awakening African-American artists to African art, which in many cases was inspiring.[30] He also played a significant role in gaining recognition for African-American artists by colleges and universities, galleries and museums, and he contributed to the development of art courses in black colleges and universities. These institutions have since produced thousands of artists and art educators. Yet Locke will be remembered primarily for his heralding the attitudinal changes that characterized the "New Negro" movement, and certainly African-American artists were significant participants in that movement.

CHARLES CHRISTOPHER SEIFERT

A significant influence on many black artists in Harlem in the late 1920s and 1930s was Charles Christopher Seifert. Sometimes called "Professor" in recognition of his extraordinary knowledge of African and African-American history and his large library on these sub-

Charles C. Seifert influenced Jacob Lawrence and many other African-American artists with his extraordinary knowledge of black history in Africa and the Americas. Believing that art was essential to convey their heritage to African-Americans and to develop their self-esteem, Seifert enlisted two artists, Robert Savon Pious and Earl R. Sweeting, to illustrate incidents from the African past. They converted his basement into a studio where they worked during the 1930s under his direction. Seifert hung their works in his Ethiopian School of Research History, which many African-American schoolteachers attended because it was the only place to learn African history. All the paintings reproduced here are from the estate of Tiaya Goldie Seifert and were photographed by Frank Stewart of New York.

jects, Seifert sought out artists to help him in his self-appointed task of awakening African-Americans to their heritage. He believed, like the Mexican muralists, that through pictures and murals people could learn their own history.

When in 1935 the Museum of Modern Art staged one of the first major exhibits of African art in this country, Seifert took many groups of young black artists there in order to authenticate and demonstrate what he was teaching. Romare Bearden recalled being in such a group and his fascination as Seifert demonstrated the resemblance of an ax-carrying African war god to the Scandinavian god of war, Thor. What Seifert taught was in many ways similar to the "black studies" courses that more than thirty years later became part of the curriculum of many colleges.

Wife of King Solomon. Earl R. Sweeting's portrayal of King Solomon's queen, for whom the biblical Song of Songs was written, is based on the line "I am black but comely" (Song of Solomon, 1:5). Sweeting later spent ten years in Ghana at Kwame Nkrumah's invitation, painting important scenes in that nation's history.

Virgo Lauretana. Sweeting based this painting on a print owned by Seifert, showing the image of a black Virgin and Child in the shrine of the Holy House of the Virgin Mary in Loreto, Italy. The Virgin reportedly appeared there in a laurel grove about 1295. Sweeting (1904–1972) first learned to paint from his father, James A. Sweeting, a landscapist. In an interview Sweeting said that his father sold his canvases through a major New York dealer but could not visit the gallery except to deliver paintings. His canvases also sold in London.

The Hall of Karnak, as depicted by Robert Savon Pious, was derived from early biblical illustrations of this great hall (338 by 170 feet) built in 600 B.C. Seifert considered Egyptians to be Africans.

While Seifert influenced some artists directly—for example, stimulating Jacob Lawrence's *Toussaint L'Ouverture* series—his effect was more continuous on others. Two painters, Earl R. Sweeting and Robert Savon Pious, became his dedicated disciples and worked closely with him to illustrate African history.

Seifert published no books and virtually nothing was published about him in his lifetime. Yet his impact among influential people in Harlem was considerable; at one time Marcus Garvey, whose Universal Negro Improvement Association promoted a return to Africa by black Americans, lived in Seifert's home in order to have ready access to Seifert's books and personal knowledge. Academicians took Seifert seriously. He simply knew more about African and African-American history than most authorities.

The Finding of Moses (showing Moses as a black baby) was based by Pious on the account of the famous Jewish historian Josephus, one of the classical sources used by Seifert. Pious later became a leading illustrator, especially of African-American athletes. His portrait of Harriet Tubman is in the National Museum of American Art. Born in Mississippi in 1908, Pious died in New York in 1983.

———

Seifert was born in Barbados, in the British West Indies, in 1871. As a youth, he received expert schooling in carpentry and other construction skills. He was educated by the Christian Brethren, who later sent him out as a religious lecturer. However, he had developed a passionate interest in Africa, largely from reading some books owned by his father, a plantation overseer. Written by Englishmen prior to the spread of slavery in the eighteenth century, these books provided a more objective history of Africa than most later books, which asserted Africans had no history. From these books, Seifert became aware of the distortions in African history and developed a profound hunger for the facts. In 1910 he decided to devote his life to African-American history.

Coming to New York, Seifert soon became a building contractor. He erected many buildings and remodeled others. An unusually versatile man, he not only made his own champagne but also invented an effective insecticide.

As Seifert prospered, he bought books, manuscripts, maps, and African sculpture and artifacts. Soon his books numbered in the thousands, and he purchased a building at 313 West 137th Street, in which he established the Ethiopian School of Research History. (The name was intended to reflect a philosophy of research, rather than a place, and the fact that in the ancient past all Africans were referred to as Ethiopians.)

Here, surrounded by his books and paintings, Seifert taught small groups, which included many African-American college students and teachers. In his teaching, he had to prove the falseness of many assumptions about African and African-American history before he could get to his main points about the achievements in the African past, such as their trade and legal systems. One Hunter College student came to every session with erroneous statements her professors had made, which Seifert refuted with his research—but it took constant searching in his files and books for him to find the necessary facts. "Tell those facts to your professors," he would say.

African-American student groups in New York high schools and universities often invited Seifert to speak to them, and he gave an annual lecture series at the Harlem YMCA to packed audiences. He also lectured to Fisk University students and faculty. Many New York public school teachers attended his lectures, but most students were too poor to pay. Those who could paid twenty-five or fifty cents. Some students attended for years. Seifert was supported by his construction work and by these contributions, as well as by larger gifts from friends.

To Seifert, "history was more important than your own soul," according to his widow, Tiaya Goldie Seifert. He found in African and African-American history a way of dealing with the psychological problems of being black in a white world— the general feeling of low self-esteem, of being "nobody and no account." His discussions were, in this sense, therapeutic and healing. "If you came from a race of savages and cannibals, it is better to accept that than to hide it from yourself. But fortunately, history does not state that this is the case," he often said, going on to describe the ancient kingdoms of Africa—their courts and laws, great wealth, armies, commerce with China, development of iron and bronze casting, great stone temples and sculpture, including the bronze statues of Benin. He often told his pupils that he didn't care what their religious or political beliefs were. "You can be a better minister, a better Republican, Democrat or Communist—whatever you want to be—if you first accept yourself and your history."

Seifert's basic concept of history was that there is only one race—the human race—and "only one history

249

and one civilization; as one people dropped the torch of civilization, it passed over to other people." He constantly sought evidence of African culture in ancient Greece and Rome and in the cultures of Western Europe.

According to Tiaya Seifert, his devoted student from her high school days, "he thought of the Negro in this country as being in a psychological state or situation." He taught that if in this country there were no blacks, the dominant group would have had to create people who were so situated psychologically.[1] Seifert often pointed out how this kind of situation had been used in varying degrees against some nonblacks, such as new immigrant groups. "Therefore he taught that you had to establish a rapport with these [nonblack] people so that they could understand that while they could come here and reap the advantages of being white, it was an advantage only up to a certain level," said Tiaya Seifert. He believed that white people also had been cheated by not knowing the history of the black people.

In Seifert's view the basic factor in the plight of African-Americans was economic. He held that the early history of slavery showed that it was not initially as cruel as it was after the invention of the cotton gin. "As a justification for the economic exploitation of black people, it was necessary to deny them a place in history," Tiaya Seifert quoted her husband as saying. He asserted that the history of the achievements of Africans was not unknown, as nineteenth-century historians and statesmen claimed. His only extended manuscript, "Who Were the Ethiopians?" attempted to answer misconceptions about African history. He demonstrated that Africans were traditionally, as far back as biblical times, called Ethiopians, a designation then not limited to the present political state. Seifert gathered many ancient books, manuscripts, and maps that revealed knowledge of ancient African kingdoms and caravan routes, with oceans and seas marked "Ethiopian." He liked to point out that much of the work of the abolitionists was based on knowledge of these historical achievements.

An effort was made to win accreditation from the New York City Board of Education for Seifert's school as an in-service training center for public school teachers. William Leo Hansberry, the brilliant Howard University historian, was then teaching at the school with Seifert.[2] When a Columbia University evaluation of the school asserted that it lacked an adequate physical plant and that Professor Hansberry was "teaching African history, not Negro history," the Board of Education refused accreditation. This ended hopes of the school surviving. The severe impoverishment of Harlem in the Depression also led to a decline in contributions, so Seifert's school became instead the Charles C. Seifert Library in 1939.

Believing strongly that pictures could inform and dramatize the past and were an essential technique for informing African-Americans of their heritage, which schools omitted from texts, Seifert converted the basement of his library and school into a studio. There, in the 1930s, the young artists Robert Pious and Earl Sweeting worked on canvases depicting royal court scenes, temple activities, religious and legal courts, caravans, the casting of iron and bronze, and daily life in the ancient African kingdoms. Some of these paintings, which resemble nineteenth-century biblical illustrations, have been preserved. Sweeting later assembled his own African historical works and painted many scenes that became part of the national collection of Ghana, where he lived for many years.

Seifert continued teaching in small discussion groups until his death in 1949.

MARY BEATTIE BRADY

However ironic, the individual most effective in making many Americans aware of the nation's African-American artists in the mid-1920s and 1930s was a young Vassar graduate who originally knew nothing about art, nothing about the life of black people, and had never experienced the discrimination, prejudice, and economic pressure that crippled so much African-American talent. She was Mary Elizabeth Beattie Brady, the daughter of a late-nineteenth-century territorial governor of Sitka, an Alaskan island off British Columbia.

As the governor's family, the Bradys held a commanding position in the community and observed many rules—from devout Protestant worship to strict honesty, prudent management of oneself, Republican party loyalty, patriotism, and Christian service to humanity. This was the matrix in which Brady grew up. Her mother taught school to Native American children, and for a while after graduating from Vassar in 1916, Brady also taught school in Sitka. Then she decided to study journalism at Columbia University's School of Journalism. Recommended by her Columbia professors, she was offered a job doing public relations for a foundation set up by William E. Harmon, of whom she had never heard.

She took the job in November 1923. The foundation's principal activity then was a college student loan project, with six percent interest and many rules and regulations. The foundation also made grants for playgrounds in slum areas. After six weeks, "I told

Mary Beattie Brady became executive director of the Harmon Foundation after the death of William E. Harmon. She is shown here at a 1930s reception at the home of Eleanor Roosevelt, where she was exhibiting portraits she had commissioned of African-American leaders in many fields. However, only about a third were painted by an African-American artist, which shows a characteristic lack of sensitivity on Brady's part. Nevertheless she was an enormous help to the struggling African-American artists, giving them their first group recognition. Photo: National Archives

relations with African-Americans. The moral and legal justifications offered for power over minorities were embedded in her personality. Yet eventually, as director of the Harmon Foundation, she staged a series of competitions and exhibitions between 1926 and 1935 that brought African-American artists national attention as a group for the first time.

Brady helped hundreds of African-American artists at a time when few people even knew they existed. The Harmon Foundation made no grants. But Brady sometimes bought paintings to stave off evictions. She advanced money with paintings as collateral. For example, by lending Jacob Lawrence $100—more than he could repay—and taking his *Toussaint L'Ouverture* series as security, she preserved it intact, for which he was later grateful. She also saved thousands of other paintings, including many works by Malvin Gray Johnson and W. H. Johnson, which are now in national museums and African-American colleges. Yet many of her decisions were resented at the time by black artists. On October 8, 1969, in a long, sometimes rambling interview, Brady, still vigorous in her mid-seventies, frankly discussed the background and operations of the Harmon Foundation, black artists' resentment of her decisions, and the difficulties she confronted in the late 1920s and 1930s—a period when the race riots of 1919 were recent memories, the Ku Klux Klan had emerged in northern states, and galleries feared black artists would alienate their clientele. That interview is the basis of much that follows.

him frankly that I didn't like working for him. You're not a college man and you don't know what it is all about," Brady recalled, "and I just can't go along with your philosophy, and neither can I go along with your philosophy of grants to these communities that are going to buy permanent playlands."

Harmon, she recalled, "leaned back in his swivel chair and said, 'Young lady, I am going to tell you something: you are going to stay here and you are going to like it.' And he then began teaching me."

This conversation, which reflects Brady's challenging attitude toward things she disapproved of, began an unusual partnership. Without such an attitude, Brady could never have taken on the task of winning recognition for African-American artists.

An energetic and formidable authoritarian personality, as well as a self-acknowledged nonstop talker, she was accustomed from childhood to wielding power over minorities. Initially, Brady had only her Christian faith and her family's patronizing "teaching" attitude toward the Native Americans in Alaska to guide her

William E. Harmon's interest in African-Americans developed because his father had been a white officer in the "Tenth Cavalry (Colored)." Born deaf, Harmon spent his boyhood with sympathetic black enlisted men. They showed him how to do many things, taught him to ride and to hunt. "He killed his first buffalo with some of them on his twelfth birthday," Brady said. "He had great respect for Americans of Negro ancestry" and felt it important "for them to come forward educationally, economically, and culturally. He used to always say, 'Solve the economic problems [of African-Americans] and the cultural problems will take care of themselves.'" Moreover, according to Brady, Harmon had noted from census records that "a high percentage of people of Negro blood had other blood, chiefly American Indian, but also Caucasian blood. . . . He belonged to hunting clubs down south . . . and he knew that a great deal of the best blood in the South was flowing in Negro veins."

These were some of the things that Harmon taught Brady. A millionaire, he had made his fortune as a real

estate developer operating in twenty cities. He was, in Brady's words, "the grandfather of installment buying" in real estate, enabling working people to own their own homes.[1] Disturbed by the lives of slum children, he created the Playground Association to pressure developers into providing playgrounds. His social concerns led him to the directors of the Rockefeller and Russell Sage foundations and to Paul Kellogg of *Survey Graphic,* the original publisher of what became *The New Negro.* These contacts helped Harmon, a devout Episcopalian, to set up his own foundation to stimulate social progress through self-help, since he believed charity led to dependency and self-pity.

Once Harmon and Brady determined that their goal should be to change the way African-Americans saw themselves, and mixed in the idea of self-help, they embarked on a unique effort in American art history.

Because their research indicated that most "Americans of African descent"[2] did not know "what members of their group had accomplished," Harmon and Brady concluded that this lack of knowledge held back African-American progress. They therefore set out to change the self-image of African-Americans and the image that other Americans held of them. In 1925 they created the William E. Harmon Awards for Outstanding Achievements among Negroes in eight fields, including business and industry, music, literature, and art—the most neglected area.[3] As part of his self-help approach, Harmon did not believe in grants but instead awarded prizes and public recognition to outstanding achievers.

Highly conscious of the importance of religion in African-American life, Harmon and Brady signed a five-year contract with the Commission on Race Relations of the Federal Council of Churches to administer the awards program. The commission was headed by the prominent African-American sociologist George E. Haynes, a founder of the Urban League who was aware of such artists as Henry Ossawa Tanner, Edward M. Bannister, Edmonia Lewis, and others.[4]

Harmon never endowed his foundation but paid bills as they occurred. Not much money was involved—$4,000 a year in eight fields, with two awards in each (a gold medal with $400 and a bronze medal with $100), plus $3,000 a year for operating expenses.[5]

In art, five jurors, including three artists, one of whom was to be an African-American, were to select the two winners.[6] Both the Commission on Race Relations and the foundation had representatives on the jury who participated in the selection process but did not vote.

For the initial contest in 1926, announcements and leaflets in churches called for African-American artists

to send in work completed within the last two years. Nineteen responded, with Palmer Hayden winning the gold medal and Hale Woodruff the bronze, but there was no public exhibition.

In 1927 leaflets in churches drew forty-one artists. Brady enlisted the well-known illustrators Charles Dana Gibson and Neysa McMein as jurors,[7] as well as Dean William A. Boring of the Columbia School of Architecture and May Howard Jackson, then one of the few active black woman sculptors.[8] Jackson viewed the work separately because she could not arrive from Washington in time for the discussions, which virtually eliminated her influence and vote.

On the day of the judging, as Brady recalled it, "Neysa McMein and Charles Dana Gibson had met some place uptown before and arrived 'all tanked up' and wanted to give prizes to everyone." This infuriated Boring, "who was mad enough to want to biff 'em." However, the jurors calmed down and performed their function. When the winners were announced, more than fifty people, including a Rockefeller Foundation executive, asked to see the work. "How dumb not to have an exhibition!" Brady told herself. She immediately started planning a public exhibition for 1928 and searching for a place to hold it.

Finding a place to exhibit work by African-American artists now became part of Brady's education. She counted eighty-two rejections, including that of her own church—which shocked her the most. Commercial galleries either refused outright or insisted black visitors could attend only after regular hours, using rear entrances. Finally International House, a center for foreign students at Columbia University, opened its halls for the exhibition. Located not far from Harlem, but inconvenient for most New Yorkers, the exhibition was an astonishing success. According to Brady, in three weeks it drew 6,500 people, a record surpassed only by the new Museum of Modern Art, then in a brownstone, with its first Vincent Van Gogh show.[9] "We sold twenty-six items, and William Auerbach-Levy gave us a whole page in the *New York World*," Brady recalled. This was the first time that African-American artists as a group won press attention. To some people, the emergence of black artists seemed part of the "New Negro" movement launched by Alain Locke's book.

Having encountered the prejudice that African-Americans meet daily, Brady realized that quality, not charity or sympathy, had to be her primary tool in gaining acceptance for African-American artists. Unfortunately, the brightening future of the Harmon exhibitions was darkened by the death of William Harmon in mid-July 1928.

Harmon's death made it uncertain that the exhi-

bitions would continue after the contract with Haynes and the Commission on Race Relations ended in 1930. The Harmon family supported Brady's recommendation to continue but abandon awards in all fields except art, the only one to attract much attention. She also recommended ending the relationship with the commission.[10]

This put Brady in full charge in 1930, a situation she had privately longed for. It also reduced expenses, a critical factor in continuing because the foundation had no endowment.

Sensitive to her lack of artistic authority, she and her assistant, Evelyn S. Brown, joined the College Art Association and the Association of American Museums, which put them in contact with "authorities" on art—none of whom were African-Americans. Brady cultivated two leaders in the field—Juliana Force, the head of the new Whitney Museum of American Art, and Audrey McMahon, director of the College Art Association. (Later, when the Depression deepened, both headed government work relief programs for artists.) These contacts reinforced Brady's own growing sense of perspective and direction—toward gallery and museum acceptance of African-American artists.

This was an important difference from Haynes's approach. Haynes had built up, through the affiliation of the Commission on Race Relations with churches, numerous local community groups that supported interracial projects. Such groups played an important role initially in exhibiting and publicizing traveling Harmon shows. However, these groups had little interest in art, although sometimes a painting was sold. At best a larger and larger group of people saw the shows, but this did not advance recognition of African-American artists in the professional art world. Moreover, Brady, always a strategist, foresaw the day when the Harmon Foundation would cease to exist—and therefore she concluded that opening the doors of the established art institutions, galleries, and museums to African-American artists was the foundation's true mission.

Long before this Brady had seen the need for more prizes than the two offered by the foundation. In 1927 she got Haynes to ask wealthy Otto H. Kahn to give an annual prize, which Kahn did—$250. She now extended her efforts in this direction. Through what is now called networking, Brady not only located potential donors and sympathetic editors to publicize the exhibitions, but she was also well informed politically about what was happening in the mounting depression. As a result, when the Harmon gold and bronze awards ended in 1930, the daughter of Robert C. Ogden, a Wanamaker executive who had aided Tanner and been a Tuskegee trustee, provided a $150 prize. Mrs. John D. Rockefeller gave an annual $100 prize. Arthur A. Schomburg also contributed a $100 prize, as did John Hope, president of Atlanta University. Alain Locke offered a $100 portrait prize, and Arthur B. Spingarn and the Commission on Race Relations each put up $50 prizes.

In 1931, still uncertain that the exhibitions could continue because of economic conditions, Brady expanded the catalog to include "thumbnail" biographies of forty-eight African-American artists. The possibility of government art projects was then being discussed, especially by Juliana Force and Audrey McMahon. With great foresight, Brady realized that if such projects came into existence, some qualifying criteria would be set up. Most African-American artists had been denied formal training, but the Harmon catalog, she reasoned, could demonstrate that they were accepted as artists and had exhibited in a national show. This later proved invaluable for many African-American artists in seeking employment on government art projects.

After Gertrude Whitney bought Nancy Elizabeth Prophet's *Congolaise* and Richmond Barthé's *Blackberry Woman* in 1932 for the Whitney Museum, Brady felt she had an opening wedge into the museum field.[11] These were the first black artists to be purchased by museums since Tanner's work was purchased by the Philadelphia Museum of Art and the Art Institute of Chicago a generation earlier. And these purchases by the Whitney Museum could help in interesting others.

While these advances were appreciated by African-American artists in general, many of them had come to regard Brady's power over their work, and in the end their lives, with both fear and resentment. "Highhanded" was the term they generally applied to her decision-making because they had no voice in it and because they knew she knew nothing about art.[12] Indeed, she almost boasted of this.

Government art projects were still pipe dreams in 1931 and to break through the prejudicial barriers and dealers' fears that black artists' work would not sell, Brady guaranteed $4,500 to any gallery that would mount the Harmon show for a month. Since the Depression had virtually ended art sales, this was a very large sum—"a whopper," she said.

Brady had shrewdly brought into the jury process, which she had expanded, two dealers—Walter M. Grant, who was in charge of painting at the American Anderson Gallery, and Alon Bement, who was head of the Art Center and more of an art educator than a dealer.

In 1931 the head of the American Anderson Gal-

SELF-PORTRAIT *William H. Johnson*

EXHIBIT OF FINE ARTS
by
American Negro Artists

Presented by the
Harmon Foundation
and
The Commission on Race Relations
Federal Council of Churches

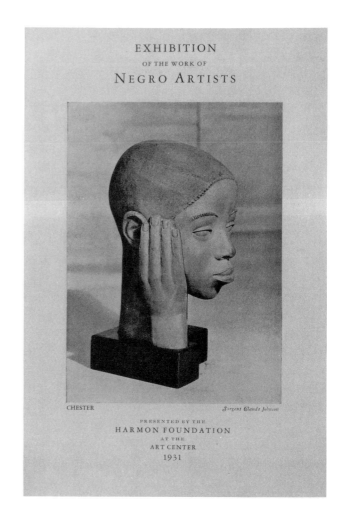

EXHIBITION
OF THE WORK OF
NEGRO ARTISTS

CHESTER *Sargent Claude Johnson*

PRESENTED BY THE
HARMON FOUNDATION
AT THE
ART CENTER
1931

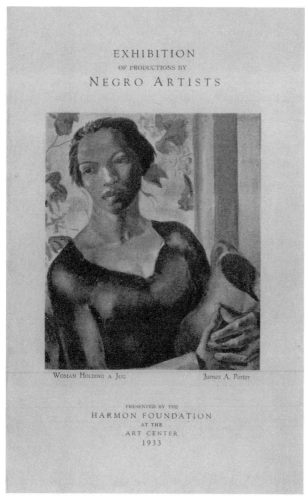

EXHIBITION
OF PRODUCTIONS BY
NEGRO ARTISTS

WOMAN HOLDING A JUG *James A. Porter*

PRESENTED BY THE
HARMON FOUNDATION
AT THE
ART CENTER
1933

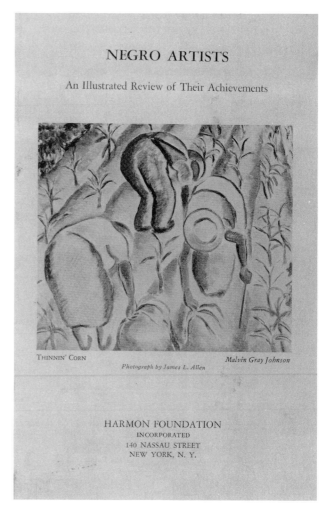

NEGRO ARTISTS

An Illustrated Review of Their Achievements

THINNIN' CORN *Malvin Gray Johnson*
Photograph by James L. Allen

HARMON FOUNDATION
INCORPORATED
140 NASSAU STREET
NEW YORK, N. Y.

lery, a Mr. Mitchell, was ready to sign the exhibition contract when Brady insisted at the last moment on a clause that "people will be admitted at all entrances, at all hours, without regard to race, creed or color."

"I can see his fat Shaeffer pen stopping in midair," Brady recalled, "and he said, 'Miss Brady, I never thought of that.' " Fearing a loss of southern clients, Mitchell backed off, unwilling to sign. "I got out on the street with Grant patting my shoulder. I was ready to cry, and I thought, 'Where do we go from here?' "

It wasn't much of a mystery. Brady simply headed for the Art Center on East 56th Street. There she and the Harmon exhibition were welcomed by Bement, who had been one of the jurors in 1930. Brady had achieved a breakthrough in her quest for gallery acceptance. The Art Center was a prestigious gallery, established as an arts educational center, with spacious rooms.

To give the exhibition historical perspective, the show included three works by Tanner, who was still painting in Paris, and three by Bannister, who had won the 1876 Centennial Exposition for oils. In addition, Locke brought six pieces of African sculpture that were installed in the entrance hall.[13] Something new and different had arrived in the midst of the elitist New York art world.

Much to the disappointment of African-American artists, Brady organized only traveling shows for 1932. She and Bement selected work for them from previous shows and the growing Harmon collection. These shows were administered by the Art Center. Brady later calculated that the traveling shows were seen by 350,000 people, about forty percent of whom were African-Americans.[14]

In 1933 the exhibition was again held in the Art Center. The jury included William Auerbach-Levy, who was both an etcher and art editor of the *New York World,* and James V. Herring, founder of the Howard art department. Sargent Johnson was awarded the Otto Kahn prize of $250 and Palmer Hayden won the $100 Rockefeller prize.

Again in 1934 there was no show because of economic conditions, but there were traveling exhibitions. With McMahon, Brady arranged for cosponsorship by the College Art Association for traveling Harmon exhibitions. To Brady, the name College Art Association implied quality, and she used it very effectively to open

new doors at museums and universities for exhibitions. Moreover, McMahon had shown a personal interest in African-American artists, buying a painting from the 1933 exhibition. Later, when McMahon headed the WPA art project in New York, Brady could contact her about needy artists. This eventually led to the belief, perhaps invalid, among some black artists that Brady could control who got WPA jobs, making her seem more powerful than ever.

The 1935 Harmon exhibition, the last, was held from April 22 to May 4 in a commercial gallery, the Delphic Studios. It presented the work of only three artists—sculptors Richmond Barthé and Sargent Johnson and painter Malvin Gray Johnson, who had died in the fall of 1934. Its catalog, titled *Negro Artists: An Illustrated Review of Their Achievements,* provided a historical review of the ten-year Harmon effort, reprinted James A. Porter's eulogy of Gray Johnson, and included brief reports on the activities of African-American artists and on how art departments in black colleges were developing.

By this time the WPA art projects had come into existence, dwarfing the Harmon prizes and exhibitions. Brady felt sign-off time had arrived for the Harmon Foundation. In the last catalog Brady included brief biographies of 109 artists who had participated in the Harmon shows, hoping to aid their chances of being employed by the federal art projects.

Another possible factor in ending the exhibitions was the fact that they were increasingly being criticized by black artists. Although she tried to reduce the complaints and tried to cooperate with African-American groups, Brady found the differences with her viewpoint, as expressed by Alain Locke, and the criticism difficult to tolerate.

The Harmon catalogs, in the self-congratulatory tradition of such publications, did not reflect the *Sturm und Drang* that accompanied the development of the Harmon exhibitions, especially the resentments of African-American artists caused by Brady's authoritarian personality and administrative style. The artists, some of whom were well trained, expected to be treated as though they knew something about art. Although acknowledging that she knew nothing of art, Brady nevertheless discounted and disregarded their knowl-

The Harmon Foundation's exhibition catalogs became a major source of information about African-American artists because they contained brief biographical sketches of those submitting work to the exhibitions. The exhibitions were not held annually, and the last featured the work of only three artists. Shown here are the covers of the catalogs for 1930, 1931, 1933, and 1935, featuring W. H. Johnson's *Self-portrait,* Sargent Johnson's *Chester,* James A. Porter's *Woman Holding a Jug,* and Malvin Gray Johnson's *Thinnin' Corn.*

edge. Well versed in moral and legal arguments justifying authority over minorities, she also tended to look upon most artists as irresponsible.

These resentments first arose when Brady commissioned portraits of Marian Anderson, W. E. B. Du Bois, Paul Robeson, James Weldon Johnson, and others, twenty-six in all. These portraits, part of the Harmon effort to make notable black achievers better known, were exhibited in many African-American colleges, schools, and churches, and reproduced in a portfolio.[15] The best portraits were done by Laura Wheeler Waring, who had won the Harmon gold medal in 1928, but most were done by a white artist "at a price I could afford," Brady recalled. At the time she did not consider other black artists capable of this work, and her failure to commission them to portray their own leaders was resented by many. Certainly Malvin Gray Johnson, Robert S. Pious, O. Richard Reid, and others were capable portraitists.

Although the community interracial groups established by Haynes and the Commission on Race Relations sought nondiscriminatory sites for exhibitions, if a segregated institution in the South asked for an exhibition, it usually got the show. To many African-American artists, this acceptance of segregation meant their own people could not see their work. At the then-segregated High Museum in Atlanta, African-Americans were admitted only during special hours.

In 1969, recalling this criticism, Brady justified the segregated shows, saying, "Now, my upbringing—we have the Native problem up in Alaska—and my idea was, and Mr. Harmon agreed with me—was that we should take several bites of the cherry, that you have to begin somewhere, and that once they [museum officials] saw the pictures didn't bite, and that you got a good review, other things would grow. Today we would say [to segregated museums], 'You can't have it,' but at that time you couldn't have gotten anywhere bucking the longtime social thing."

That their work was being judged by predominantly white juries, which Brady selected, and was being seen largely by white groups was also increasingly resented. Many artists discussed having shows in Harlem rather than "downtown."

Brady tried to reduce this criticism by various means, including sending the 1933 exhibition, after its showing at the Art Center, to the Harlem branch library, where it was cosponsored by the Harlem Adult Education Committee. Two months later, reflecting the deep feelings of many African-American artists, approximately 200 paintings rejected by the jurors were shown at the Harlem library. It was a way of stating that African-American artists wanted to be judged by their own people.

The resentments continued to mount as the traveling shows grew larger and Brady, sometimes assisted by Alon Bement, made the selections. In 1934 Romare Bearden, writing in *Opportunity,* characterized the Harmon Foundation as patronizing. He severely criticized its failure to set standards and its lumping all work together, from illustrations and amateur paintings to abstractions, under the unjustified label "Negro art" in its publicity.[16]

Years later, in an interview in 1969, Jacob Lawrence clarified the problem many African-American artists had with Brady's operational style by distinguishing two periods. Initially, he said that Brady and the Harmon Foundation "really encouraged, stimulated [artists by stepping] into a void, which would have been much worse had they not existed." Later, he explained, "they went through a very difficult period" when African-American artists sought to handle their own affairs.

> Earlier, they were almost like parents—they told you what to do, what to exhibit, and this and that. They never did grasp this change. . . . I don't think I can stress this too much. In the period in which they did function at their peak, they really did a wonderful job. . . . But they didn't grasp the idea that [all African-Americans were] moving into a different period, a period of not looking for, not needing this kind of patronage . . . [developing] self-reliance. . . . In the late thirties they could no longer function in the same way as they had earlier. I don't think they quite understood this. They didn't grasp the reasons why [African-Americans wanted to be self-reliant] and I don't think Miss Brady ever did grasp it. She never understood it.[17]

These resentments and criticisms were part of the background to Brady's repeated clashes with the sculptor Augusta Savage, who, after being cheated out of a fellowship abroad in the mid-1920s, had become a champion of the oppressed. At times Savage attacked Brady directly because she had no art training and yet was making critical decisions about black artists' work. Wanting to show statues she had made in Europe, Savage also attacked the Harmon rule that all work should have been done within two years. She tried to enter her popular *Gamin* in each show, but Brady allowed it only once. She also threatened to sue the foundation when a statue shipped from France arrived late and damaged. The suit never materialized, but with phone calls to Brady from Harlem leaders, Savage demonstrated that she could arouse all Harlem and threaten the entire Harmon program.

Brady came to regard Savage as a "vicious" enemy. She tried to get *Life* not to publish a picture of Savage

in an article on black artists. At one point Brady went to Frederick Keppel, president of the Carnegie Foundation, which was funding Savage's classes, to claim Savage was operating a "Communist cell" and urge withdrawal of her support. However, as Brady later recalled, Keppel "only laughed in a fatherly sort of way, you might say, and said, 'I don't think we have anything to worry about. These people just want to run their own show.' " He refused to share her views.

Brady, indoctrinated from childhood with a noblesse oblige attitude, felt betrayed by criticism from African-Americans whom she was trying to help. She neither forgave nor forgot criticism. In 1965 she recalled Bearden's article to David Driskell, whom she considered one of the "responsible" African-American artists, saying that Bearden "has made pretty much a full circle in his philosophical attitude. . . . Where formerly he seemed to object entirely to race, he has become pretty completely racial at the present time."[18] However, her comment is not an accurate reflection on Bearden's early work, possibly because he never exhibited in the Harmon shows.

Brady's differences with Alain Locke had a different and more philosophical character, although he disturbed her strategic sense of direction. Both Harmon and Brady had read the 1925 issue of *Survey Graphic* (later published as *The New Negro*), which Locke assembled and edited. An authority on race relations, and virtually the only African-American academician writing on African-American art, Locke was, along with Haynes, one of the few African-Americans that Brady consulted.

After she continued the exhibitions in 1930, Brady was pleased when Locke enthusiastically offered to write an essay for the 1931 exhibition catalog. But his essay, "The African Legacy and the Negro Artist," made her uneasy and suspicious. It revealed that he saw the exhibitions as leading to a racial school of art:

> One of the obvious advances of these successive Harmon exhibitions has been the steady increasing emphasis upon racial types and characters in the work submitted and displayed. In this downfall of classic models and Caucasian idols, one may see the passing of the childhood period of Negro art, and with the growing maturity of the Negro artist, the advent of a truly racial school of art.[19]

As Driskell has noted, this disturbed Brady, who held African-American artists should accept the standards and traditions of Western art.[20] Yet she could not risk offending Locke or challenging him in any way. She had no standing as an expert on art of any kind. He had, so to speak, all the marbles.

Nor could she reject his second essay, "The Negro Takes His Place in Art," for the 1933 catalog. Referring to Edward Bruce's demand for an "American" art in the Public Works of Art Project, Locke ended his 1933 essay: "And just as it has been a critical necessity to foster the development of a national character in the American art of our time, by the very same logic and often by the very same means, it has been reasonable to promote and quicken the racial motive and inspiration of the hitherto isolated and disparaged Negro artist."[21]

Locke appeared to Brady to be "dangerously near advocating a form of black nationalism," to quote Driskell.[22] Unable to challenge Locke's theories because she lacked the necessary knowledge, she simply backed away. She was gratified to find that James A. Porter, soon to become head of the art department at Howard University, did not share Locke's views and saw them as leading to the segregation of African-American artists.[23] But she did not forgive Porter, a winner of the 1933 Schomburg portrait prize, when he asserted ten years later that the Harmon juries were "too liberal in taste" and "too little concerned with execution."[24]

Brady never dared break with Locke lest she need in some way the authority he represented. And, indeed, she did need it when the possibility of a major museum show arose.

Brady's felt need for Locke's assistance had its origins in her goal of gaining gallery and museum acceptance of African-American artists. After the last Harmon exhibition in 1935, she began meeting regularly with Edith Halpert, a New York dealer esteemed for her progressive outlook and for recognizing significant trends in art. In the late 1930s, with the end of the federal arts program in sight, Brady felt survival of African-American artists depended on their being connected with commercial galleries. Halpert agreed that many of these artists belonged in galleries. She began discussions with other dealers to persuade a sizable group to show black artists following a major exhibition of their work in her Downtown Gallery. If a large group of dealers showed black artists, prejudice and fear might be overcome with the argument that competition made exhibiting black artists necessary. High quality had to be the selling point.

As part of this plan, Brady undertook to provide museum endorsement of that quality. She focused on the Baltimore Museum of Art. One of the nation's oldest, most respected museums, it was also in a "southern" city. Brady hoped that a major exhibition there would cause other museum walls to come tumbling down. She enlisted the support of Locke as an

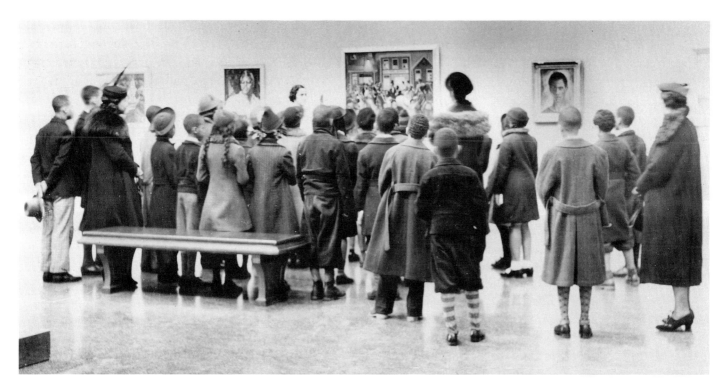

One of Brady's triumphs was the 1939 Baltimore Museum exhibition "Contemporary Negro Artists," in which she was aided by Alain Locke. The large painting is one of Archibald Motley's *Bronzeville* series. To its left is Elton C. Fax's portrait of a worker. The other paintings cannot be identified. This exhibition helped pave the way for dealers to accept work by African-American artists as being of high quality.

art expert. Together, with the support of a Baltimore committee of well-known African-Americans, headed by Sarah Fernandis, they asked the museum's trustees to become the first to present a large show of the work of African-American artists. One factor aiding the success of this proposal was that a local African-American artist, Elton C. Fax, had painted a PWAP mural at Dunbar High School in 1934. Depicting the rural southern black becoming an industrial worker, it excited leading PWAP officials.

As Brady recalled it, she had most of her discussions with the board president, Henry E. Treide, who was privately aware that another trustee, J. Hall Pleasants, had found evidence that an early Baltimore portraitist, Joshua Johnston, was possibly black. Locke, with his impressive credentials as a Rhodes Scholar, a Howard professor and an authority on African and African-American art, promised to write a catalog foreword. Handfuls of Harmon catalogs further convinced the trustees.

The exhibit was set for February 1939. The museum's quarterly magazine published an advance article on the coming exhibit, illustrated by one of Jacob Lawrence's *Toussaint L'Ouverture* paintings, and noting that Baltimore's Elton C. Fax was one of the artists.[25]

Meanwhile, back in New York, Brady and Locke escorted the museum's appointed curator to the studios of various African-American artists to make selections.[26] Brady later said she thought this might help Locke's representation as a critic, but undoubtedly she also wanted him along as an authority of art.

Among all the black artists, Brady had been most impressed by W. H. Johnson, who was given a glowing endorsement by the 1929 Harmon jury on which George Luks had served. However, to the astonishment of both Brady and Locke, the Baltimore curator rejected all of Johnson's work. "I couldn't get him to select a single Johnson, and we looked at several hundred," Brady recalled. The curator admitted Johnson had talent, but didn't care for his work. All the curator said was "Oh, he outlines." Brady, very upset, argued: "I'm not an artist. I'm not a critic, but this man has had fine recognition abroad, and this [exhibition] could be a turning point for him. I think you ought to get someone besides yourself, in whom you have confidence, to consider Johnson."

That remark angered the curator, who terminated the visit. Nothing Locke said helped. Johnson's exclusion from the Baltimore show was a deep disappointment to Brady.

Her disappointment was twisted and tortured into fear by increasingly unpleasant visits from Johnson to her office. He became sarcastic and snarling—"vicious," she said—in his contempt for her. His attitude may have been among the first symptoms of his tragic illness. Finally, in a threatening way, he demanded the return of all his work.

Frightened, Brady complied. Sometime afterward Johnson went off to Denmark, taking his work with

him (see pages 197–98). Months later he was found in the streets of Oslo, unable to identify himself or where he was. He was returned to the United States by the government and placed in a mental hospital. His paintings, shipped back, were stored by his friends David and Helen Harriton, in the hope that he would recover. But paresis destroyed that possibility.

In 1956 Brady learned that the storage company, after nine years of unpaid bills, was about to dump Johnson's work as garbage. She secured a court writ to act as his guardian, promising that the foundation would not profit from selling the work. At the warehouse, she recalled, she found his paintings "in horrible condition . . . with canvases rolled the wrong way. It was just horribly manhandled." Generations of rats had found the place cozy. Some boxes had been broken open and paintings taken, presumably by conservators from the state hospital seeking work they could sell to pay for Johnson's hospital care.

Aided by Palmer Hayden and her assistant, Evelyn Brown, working on a loading dock in the cold, Brady tried to save as much of Johnson's work as she could. "I threw out a lot of stuff. I'm ashamed of myself. I didn't really know its value—and so smelly," she recalled. The Harritons paid to have the salvaged works trucked to the Harmon Foundation offices.

In this fashion Brady saved from destruction nearly all the work by which Johnson is now known. At the time Johnson's work was considered nearly valueless by most dealers. This episode reveals the depth of Brady's dedication to advancing the cause of African-American artists and in a certain sense her faithfulness to her own values. Her efforts have only recently begun to be appreciated by the art world.

In 1969 Brady emphasized that the WPA art projects "did more than anything in our history to awaken our public to art." In the 1930s, because the WPA's full-time jobs made the Harmon prizes insignificant financially, Brady turned to getting African-American artists on the WPA rolls. Enclosing a Harmon list of 375 black artists, she wrote Holger Cahill, head of the WPA art projects, urging their employment. "I can't prove it," she later said, "but I think that had a great deal to do with opening opportunities with the WPA for [African-American] artists. I feel that if we hadn't done anything else, that would have been of service. . . . We had carried the ball, and I thought we had rendered our service."

The exhibitions, whatever their limitations, helped make African-American artists conscious of their talents and of themselves as a group, stimulated formation of art departments in black colleges, and alerted many influential people to the potential contributions of these artists to American art and cultural life. Obviously, the foundation might well have closed its doors in 1930 as the Depression loomed if Brady had had a less challenging character. In the last years of the foundation she devoted her major efforts to supplying slides, films, and exhibitions to black colleges and universities.

Within the art world, there began a slow, uneasy erosion of the attitudes among artists, dealers, museum curators and directors, educators, and critics that had barred consideration of the work of African-American artists. In addition, the public at large gained from the Harmon shows a slight awareness of black painters and sculptors. It was not what they had learned from Currier & Ives's *Darktown* series of caricatures, which were kept alive by radio's nightly "Amos 'n Andy" show.[27]

In 1967, amid the new consciousness of black contributions to American life brought about by the civil rights movement, Brady liquidated the Harmon Foundation. She offered first choice of its sizable collection to the National Museum of American Art, making it the largest repository of art by African-Americans. She divided the remainder among black colleges and universities, although earlier she had given some universities unusual works. Jacob Lawrence's *Toussaint L'Ouverture* series went, for example, to Fisk University.

In 1969 Brady, then in her late seventies, retired to her home in Patterson in Putnam County, north of New York City. Twenty years later, in 1989, Gary A. Reynolds and Beryl J. Wright of the Newark Museum organized a major exhibition of the work by artists who had participated in the Harmon shows. At that time Brady was ninety-five years old and in a nursing home.

Titled "Against the Odds," the Newark exhibition was a celebratory tribute to Brady's determined efforts, extraordinary in their time, to gain recognition for the African-American artists of sixty years ago. Today, the work of these modern pioneers is highly valued, sought after by collectors and museums, and the recognized equal of work produced by other American artists. Although it required a major change in public attitudes, brought about by the civil rights movement, before her mission was fulfilled, Mary Beattie Brady plainly made a difference in gaining recognition for African-American artists.

CHARLES H. ALSTON

An exceptionally skilled painter, sculptor, and teacher, Charles Henry Alston played a significant role in the activities of black artists in New York for nearly fifty years. His restless need for expression caused him to work in many different styles, with the result that he never evolved a readily identifiable personal style. Nevertheless, many of his paintings demonstrate a sculptural perception of large shapes and volumes, giving his figures a monumental quality even in small paintings. His work also reveals subtle African influences, which are totally integrated into his approach.

Alston's development was not typical of most African-American artists. His intensive training under very good teachers was complemented by his early introduction to African sculpture. Articulate and personable, he participated in the critical consciousness-raising activities of African-American artists in the 1930s. Indeed, during the 1930s his apartment-studio was the main center in Harlem for creative black people in all the arts. Today, his work, praised by many critics, is in major museums. Appointed a professor of art at the City College of New York in 1971, Alston also taught at one of the nation's leading art schools, the Art Students League, for more than a quarter of a century. Among his former students are some of America's best-known artists, including Jacob Lawrence, Robert Rauschenberg, and Paul Jenkins.

Alston's work ranges from caricatures of Harlem nightclubbers and absorbing abstractions to book illustrations, eloquent "protest" paintings, and large murals and sculptures that are stunning in concept and execution. His first murals, created in 1935 at Harlem Hospital, remain among the best in New York. His later murals, carried out in mosaic, adorn the Bronx County Family and Criminal Court buildings. Few American artists have had such a diverse record of achievement—a diversity reflected in the large retrospective exhibition of Alston's work, covering everything from cartoons to large oil paintings and sculpture, presented in 1990 at Kenkeleba House in New York. Yet outside Harlem and the New York art world, his name has remained largely unknown.

Charles Alston's background differed substantially in an economic sense from that of most black artists. Born in Charlotte, North Carolina, on November 28, 1907, he was the youngest of five children of the Reverend Primus Priss Alston and his wife, Anna Elizabeth Miller Alston. Booker T. Washington was then the most prominent African-American, and Alston's father, an Episcopalian minister and educator, was known as "the Booker T. Washington of Charlotte."

His father, fifty-nine years old when Charles was born, died when Charles was three. His mother, one of his father's pupils, was only sixteen years old when she married.

Exactly how or when he became interested in art Alston could not remember, since his family gave it no special emphasis. He recalled, however, being much stimulated by his inventive older brother Wendell, who set up his room as an electrical engineering laboratory with a NO ADMITTANCE sign on the door: "I remember copying his new designs for locomotives and fast automobiles."

Before he started to draw, Alston recalled, he modeled animals and figures with North Carolina's red clay. After modeling a head of Abraham Lincoln, he ambitiously sought to do a nude female figure. "I got into difficulty when I got to modeling the breasts," he said. "I remember calling an aunt and asking, would she show me her breasts. I got a spanking for that," he said.

Overall, his childhood in one of Charlotte's leading black families was "privileged" and "fairly happy," with a big house and "a fine horse and surrey," he said. Widowed, his mother married Harry Bearden, an uncle of Romare Bearden, and with him she had two daughters, Elizabeth and Rousmaniere. Elizabeth died in the

1916 polio epidemic. Charles had another half sister, Aida, who later married the concert singer Lawrence Winters. The family moved to New York in 1915, but Charles remained with his grandmother to complete the school year. Thereafter he attended New York schools, returning to his grandmother's every summer until he was fifteen years old, when she moved to New York.

Alston won his grammar school's art prize. His first oil painting, at age fourteen years, was a self-portrait. At DeWitt Clinton High School he became art editor of the school magazine and tried to copy such well-known illustrators as J. C. Leyendecker, of *Saturday Evening Post* and Arrow collar fame; Coles Phillips, who did Holeproof hosiery advertisements; and Rolfe Armstrong, who made exotic pastel portraits of Hollywood stars for *Photoplay* magazine.

It was "preordained," Alston said, that he would go to college. When the dormitory fees of the small New England college he had hoped to attend turned out to be too expensive, he entered Columbia University in 1925. While its art history faculty was excellent, its faculty in studio arts was academic and undistinguished. Because he was black, Alston was not permitted to draw from the nude female model. Although life drawing was a standard prerequisite for painting, it was eliminated from his required studies on the alleged grounds that he had been rated "excellent" in still life drawing. This was a blatant instance of how racial prejudice and hypocrisy continued to dominate a great university in the mid-1920s.

After a year working in a boys' after-school class, Alston was awarded the Arthur Wesley Dow Fellowship through the influence of Sally Tannahill, one of his principal teachers. This enabled him to earn a master's degree in fine arts at Columbia's Teachers College.

His favorite instructor, Charles Martin, a nationally known watercolorist of the modern school, "was a man with not much patience for the kind of teaching he generally had to do," Alston recalled. "His students were mostly teachers from the Midwest on leave to get their master's. As a result, I got very good training." Alston, younger than most students, was practically Martin's assistant, "like a monitor for him. . . . He was a tough man. He didn't soft-soap you about anything. If it was bad, it was bad. He didn't care how hard you had worked on it. I've seen those sweet little girls just cry after he got through with his criticism, but this was a good thing."

Tannahill also influenced Alston's development. An emancipated southern woman, she prepared him for design and lettering problems in commercial art. Her major forte was calligraphy, and she wrote several books about it, one of which included work by Alston.[1]

In 1930, as a term project, Alston illustrated and creatively lettered the title poem of Langston Hughes's *Weary Blues*.[2] "I did the lines of the poem as though they were notes of music on a scale," he recalled. This project led to a friendship with Hughes.

Years later, in 1975, Alston became the first recipient of the Distinguished Alumni Award of Columbia University.

Two significant events occurred in these early years. One was Alston's discovery and nurturing of the talents of a young African-American boy who would become one of America's leading painters— Jacob Lawrence. His work with Lawrence began while he was still at Teachers College. He had a part-time job directing the boys' after-school program at the Utopia Neighborhood House, which included athletics, a Cub Scout group, and an arts and crafts workshop. It was "a real slum area" with "really tough kids," Alston recalled. When Lawrence, ten years old, quiet and serious, was brought to the workshop by his mother, "I sensed in him an unusual and unique ability. I'm glad now I was smart enough to spot it. . . . Jake was a very serious, reliable, dependable kid, not the mischievous kind. . . . I spotted his ability and encouraged it as much as I could and tried to keep him away from any influences. I wouldn't even let him watch me paint, but I kept him supplied with materials. And when we really had anything to talk about, we'd talk about it. That went on well into his young manhood—until he married and became his own man. So I've always been very proud of him. I always thought of Jake, in some ways, like a son."

More significant in Alston's own evolution as an artist was his direct contact with African art in the late 1920s. How it came about reflects the intimacy and spontaneity among groups of young artists in Harlem at that time. On a street corner several artists were discussing a controversial play starring Helen Menken, *The Captive,* when someone recognized Alain Locke emerging from the subway and said, "There's Dr. Locke! Let's ask him." As Alston later explained, "He had seen the play in England, I believe, and we talked about it. . . . Leaving, he took my arm and said, 'Young man, I'd like to know you better,' and asked how he could get in touch with me. I was very flattered because he was such a big shot. . . . He had written *The New Negro* and I knew his name and what he had done."

"When Locke put on a show of African art at the 135th Street public library, one of its earliest exhibitions in the United States, he called me," Alston remarked. "I helped him arrange things, which gave me a chance to feel them and look at them and examine them." This direct sensory contact with African sculpture

Alston's sketches for WPA murals at Harlem Hospital traced the development of medicine from the chants, superstitions about animals, and dances of African witch doctors to the scientific discoveries of Pasteur, Virchow, and Roentgen and modern surgical procedures. Harlem Hospital Nurses' Residence

greatly excited Alston, who had an immediate opportunity to discuss these works with Locke, then one of the few authorities on African art in the country. Seeking all the books he could find on the subject, Alston was loaned many European studies by Erhard Weyhe, a Madison Avenue gallery owner, whose generosity Alston later viewed with amazement and renewed gratitude.

At the same time Charles Martin was making Alston aware of the modern movement in European art, particularly the work of the Post-Impressionists, the Cubists, and Amedeo Modigliani. That Modigliani had utilized African spatial concepts fascinated Alston, who prepared an extensive article on African art as part of his master's degree work. These experiences led to a persisting African influence in his own painting and sculpture. In 1969, he said jokingly, "I have to watch myself. If I'm doing a figurative painting, I still tend to elongate the neck"—a stylistic mannerism that Modigliani took from African art.

During the Depression, Alston initially worked on the WPA's easel project, but he was strongly attracted to the concepts of the Mexican muralists—José Orozco, Diego Rivera (whom he knew personally), and David Siqueiros—who saw art as a means of educating their impoverished people. When WPA funds made murals possible in schools, hospitals, post offices, and other public buildings, Alston transferred to the mural project and was assigned to the Harlem Hospital murals as a supervisor. It was there that he met his wife, Dr. Myra A. Logan, an intern at the hospital and later one of its surgeons.

At the hospital Alston guided the work of some twenty artists on decorative murals in the pediatric, nursing, and other units.[3] He himself created two major murals in the entrance lobby of the 136th Street building. His murals traced the origin of modern medicine from the African witch doctor to the great innovators of medical advances. At the center was a contemporary African-American surgeon in a well-equipped operating theater. African design themes contributed to the impact of the murals, which stimulated a new aware-

ness of black history among the hospital's thousands of visitors.

At the time the murals sparked controversy, and the hospital superintendent rejected them, asserting that the neighborhood might change someday to a white population.[4] A major backer of Alston's murals was the hospital's chief surgeon, Dr. Louis T. Wright, who quietly financed publicity about the controversy, arousing strong community support for the murals. Years later, Alston inscribed another Harlem Hospital mural: "To LTW AND SRE," referring to Wright and Sarah Reed Epes, his mainstays in the mural fight.

Installed over radiators without covers, sections of Alston's original murals have faded somewhat from the heat, as well as from cleaning with strong detergents. Yet they remain among the outstanding murals in New York City.[5] Some thirty-five years after the first murals, the hospital trustees asked Alston to create a new mosaic mural for the remodeled hospital, testifying to the black community's high esteem for his work.[6]

While working on the murals, Alston continued to do easel paintings. Earlier, during Prohibition, Alston had developed a profound appreciation of jazz, then considered disgraceful by many middle-class people, both black and white. He persistently followed jazz musicians, sketching them, as well as singers and customers, in speakeasies. "Practically every speakeasy had a backroom and singer," he said. "I always got to be friends with the singer. I was very fond of Billie Holiday and knew her when she was quite young. I knew Ethel Waters quite well. I rode in Bessie Smith's rumble seat when she used to go to make recordings."

Early in the 1930s Alston met another young jazz lover, John Hammond, who wanted to record jazz musicians. Alston became his guide. As Hammond, now legendary as a record producer, recalled it, "He quite literally changed my life, helped me to insights I would never have discovered on my own. . . . He was in the recording studio with me during that wonderful session with Bessie Smith, during which he made sketches of Teagarden, Chu Berry, and other musicians."[7]

From these experiences Alston developed a long and unusual series of paintings of blues singers and small jazz combos. His singers are often intensely expressive, occasionally sentimental, and at times both detached and monumental. They nearly always have some of the structural characteristics of expressive African sculpture. Alston himself said of these paintings: "There was just something earthy and lusty about these people that intrigued me. It was so direct, so real! I suppose there were certain aesthetic aspects. . . . They were all big women—so three-dimensional! I like to

Gin Mill (1930s), close to caricature yet capturing recognizable types, was a natural subject for Alston, who was very close to the leading jazz musicians who played in Harlem speakeasies and nightspots. Photo: National Archives

do sculpture and they were sculptural. Maybe I should have done them as sculpture, not as paintings."

During this period Alston became an influential teacher within the WPA art projects in Harlem. When the project at the 135th Street library overflowed, he was authorized to find quarters for an additional center. At 306 West 141st Street, he found an old stable whose hayloft could be converted into a large studio classroom. The building also contained two apartments, one of which he took. The other went to Henry W. "Mike" Bannarn, an African-American sculptor and fellow teacher then living in cramped YMCA quarters. Known as "306," the building became one of the leading intellectual and artistic centers of Harlem (see pages 234–35).

At the time there was much discussion about defending the WPA against cuts. "What we were all afraid of was the 'pink slip,' which meant you were dropped from the project," Alston recalled. He also remembered standing in line and talking with Arshile Gorky, later recognized as a major modern American painter, as they waited to get paid (Alston got thirty-three dollars a week as a supervisor).

Farm Boy, a study in which an intelligent and sensitive young boy is shown against a bleak, poverty-stricken background, won Alston first prize in the 1952 Atlanta University exhibition. The painting stemmed from his 1930 visits to southern farms. (25½ x 20″) Collection Clark-Atlanta University

Early in 1936, the WPA funds for the art classes ended. Alston, Bannarn, and other African-American artists tried to keep the art center going, establishing an advanced class for twenty-four young artists. Despite contributions from black artists and from the landlord, who considered the classes a community service, they could not maintain it.[8]

Discussion at 306 often concerned the plight of poverty-stricken African-Americans in the South, who were denied civil rights and education. Although born there, Alston felt he did not know the South. In 1936, to study the life of its black people, he asked a family friend, Rufus Clement, president of Atlanta University, for permission to use an old library building as his studio while he traveled widely, sketching and photographing both rural and urban life. A Farm Security Administration inspector, Giles Hubert, wanted company while checking various projects, and took Alston with him. As a result, "I got into places—rural places—I couldn't possibly have gotten into. I'd come in khakis with a camera and they just took it for granted that I was part of the official setup," he recalled. In

this fashion he covered Alabama, Mississippi, Arkansas, the Carolinas, and Georgia. Back in Atlanta, he used his photographs as the basis for paintings. He later felt this experience led to the sketches that ultimately became his *Family* series.

His southern trip deepened his friendship with Hale Woodruff. After years of study in Europe, Woodruff was teaching at Spelman College and feeling very isolated in the segregated South. Alston and Woodruff became a source of stimulation and support to each other. Woodruff was then completing his famous *Amistad* murals at Talladega College, and they spent much time discussing mural making. Nearly ten years later, in 1948, when the Golden State Mutual Life Insurance Company of Los Angeles, a black insurance company, asked Woodruff to create murals for its new building, he insisted Alston be his cocreator. Together they spent months touring California, studying its scenery, people, history, and problems before creating two murals.

Alston and Woodruff remained intimates for forty years, sharing many experiences and viewpoints. As a professor of art at New York University years later, Woodruff characterized Alston as "one of the most important artists of his time," whose "genius is nurtured by his inherent capacity to externalize, through visual means, the innermost qualities of his subjects."[9]

When he got back to New York, Alston did freelance commercial art, including many book jackets, among them jackets for books by Mississippi-born Eudora Welty and two African-American writers, poet Countee Cullen and novelist William Attaway, author of *Blood on the Forge.* Alston also created many record jackets. These experiences helped him decide to seek a full-fledged commercial career.

In the summer of 1941 Alston, who was familiar with publication processes and at ease with editors, aided Deborah Caulkins, art director of *Fortune,* in selecting a large group of Jacob Lawrence's *. . . And the Migrants Kept Coming* series for reproduction in that magazine, in conjunction with an article that deplored industries' failure to employ the migrating African-Americans.[10] Publication was timed to coincide with the opening of a large exhibition of the work of African-American artists at the Downtown Gallery. On seeing Alston's sketches of the life of black people in the South, Caulkins gave him an assignment to travel again through the South to illustrate an article on how racial discrimination prevented the use of America's total manpower in defense industries. He sketched in steel mills, army camps, mines, street corners, pool halls, and USO centers.[11]

This experience gave Alston an acute understand-

ing of the educational and informational needs of the wartime Roosevelt administration in relation to black Americans. He convinced the poet Archibald MacLeish, then high in the government hierarchy mobilizing support for the war effort, that he could make effective cartoons and posters, and he joined the staff of what became the Office of War Information in Washington. He drew a weekly cartoon panel distributed to the African-American press,[12] working under the direction of writer and editor Ted Poston, Augusta Savage's brother-in-law. However, Alston soon found he hated life in segregated Washington.

Alston tried to become an army artist-correspondent, but his efforts failed for unknown reasons. Then, to his surprise, Alston was drafted and assigned to the infantry—an experience that proved peculiarly destructive to his inner spirit as an artist. Although he had keenly felt the paradox of trying to rally support for a war against racism in segregated Washington, he had felt it was necessary, and he was proud that his work had helped arouse millions of black Americans to the Nazi danger. Nevertheless, it was a shock to be drafted, at age thirty-six, into the infantry, usually made up of young men. Alston felt that what he had been doing was rated as valueless.

However, Alston's talent and situation were not unknown. Immediately requisitioned by the colonel of the 372nd Infantry, an all-black regiment stationed in New York, he never completed basic training. Instead, he was assigned to making visual training aids and excused from living in barracks. In the army approximately a year, he was on furlough ninety-six days. His visual aid work amounted to almost nothing.

Later Alston was always embarrassed by his "very privileged army existence in spite of segregation. . . . When I talk to people who have been in the army and had it rough, I always feel a little ashamed." But he went on: "It was a very demoralizing thing. In the first place I was thirty-six years old and it was a complete change of all kinds of patterns. You finally get kind of blah about it. You just accept it. You get a numbness. Had there been opportunities——." He left this sentence unfinished. The army's failure to use his skills first enraged him, then made him cynical.

It led to Alston's abandoning all efforts to be a fine-arts painter. On discharge, he briefly studied commercial art at Pratt Institute, then assembled a portfolio of his work to show advertising agencies. He also rationalized going into commercial art by telling himself that since he was married, he had to support his home.

As a commercial artist, Alston was very successful, working for many major advertising agencies, book publishers, and such leading magazines as *Fortune, Collier's, Mademoiselle,* and *Men's Wear.* Making

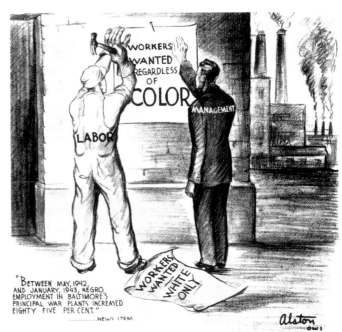

"A STEP IN THE RIGHT DIRECTION!!"

Hundreds of Alston cartoons for the Office of War Information were published in the African-American press to stimulate black participation in the war effort. However, working in segregated Washington made Alston acutely aware of discrimination and how it deprived the nation of talent and manpower.

a comfortable living, he initially enjoyed the demand for visual ideas to fit special editorial and advertising needs.

Continued exposure to the demands of commercial art, however, gradually eroded Alston's respect for it and himself. That so many people—art directors, clients, copywriters, and others—could tell him what to do, what to draw, what colors to use, was at first challenging, then annoying, then resented, and ultimately a cause of burning discontent. Seeing friends making sacrifices to paint made him feel that he was "ducking the issue." "I felt that I could do good painting and that I was selling myself cheap," Alston said. Finally, "it got to be such an intense feeling that I just said, 'I can't do this anymore,' and I stopped." When he told his wife, she said she supported "whatever decision you make."

Looking back, Alston reflected: "It was no great shakes. I don't consider it a brave act. . . . I didn't have children. . . . My wife, as a physician, made more money than I did. I still wanted to carry my load; I didn't want her to support me."

For a long time Alston wasn't sure he had made the right decision, but he was painting. In 1950 the Metropolitan Museum of Art held its first exhibition of contemporary art. Along with nearly 4,000 other artists from all parts of the country, Alston entered a

Painting, an abstract oil, won a 1950 competition at the Metropolitan Museum of Art. Its purchase by the museum decisively turned Alston away from illustration and toward full-time painting and sculpture. (50 x 36″) Metropolitan Museum of Art, New York

painting. Ultimately his was one of the few chosen for purchase by the Metropolitan. When the museum called to ask its price, Alston thought it was a friend playing a joke. He asked for $1,500, a ridiculous sum "considering my reputation at the time." But the museum bought it, which Alston considered "an exoneration or certification . . . the thing that made me feel comfortable with my decision."

That same year the Art Students League invited Alston to become an instructor, making him the first black artist to gain such recognition. According to Alston, in earlier years an unwritten rule at the League banned black students from drawing or painting the nude female model, "but sometimes if the student looked white, he was permitted to attend."

Several factors led to Alston's selection as an instructor. One was the Metropolitan purchase, another was his strong educational background, and still another was the demand by a number of black students for a black instructor, for the League had a tradition of allowing students to select instructors. Later, Jacob Lawrence, Hughie Lee-Smith, Norman Lewis, and Ernest Crichlow served as League instructors.[13]

As a teacher, Alston was highly regarded, and some of his students became very well known. He simultaneously taught part-time at the City College of New York and in 1971, after twenty years at the League, accepted a full professorship at CCNY. Teaching was an economic mainstay for Alston, as it has been for hundreds of other well-known artists.

However, Alston believed that beyond the "ABCs" of drawing and painting, "there's very little a teacher can teach." He always tried "to find out what the person is trying to get out and, perhaps because I have a little more knowledge than they have, helped them to clarify their problem and develop what their individuality is." At the annual League student exhibitions, Alston's students usually produced the most diversified work because of his teaching philosophy. "You have to convince a student to draw it as he sees it. That's why I wouldn't let Jake Lawrence see me paint," Alston said. He always considered himself "a painter who teaches rather than a teacher who paints."

In the mid-1950s Alston often exhibited at the John Heller Gallery in New York.[14] By that time his work was in the permanent collections of not only the Metropolitan, but also the Whitney Museum of American Art, the Butler Institute of Art, and the International Business Machines Corporation. In 1955 he completed murals for the Abraham Lincoln High School in Brooklyn and, in 1956–57, for the American Museum of Natural History. He also received a fellowship grant from the National Institute of Arts and Letters, which meant more as recognition than it did financially.

A persistent Alston theme has been "family." Generally he portrayed a man, woman, and child in a sculptural way, using shapes and forms to suggest large volumes. These paintings and their treatment are related to his study of African sculpture, his trips in the rural South, and his observations of urban scenes.

Strongly identifying with the civil rights movement of the late 1950s and 1960s, Alston painted many works—"protest paintings," he called them—that express this concern. He cited *You Never Really Meant It, Did You, Mr. Charlie?* as an example; it was based on black children going to school in Little Rock, Arkansas, surrounded by National Guardsmen.

In 1958 Alston created *Walking,* a painting that was suggested by a bus boycott by African-Americans in Birmingham, Alabama. It anticipated the civil rights marches in Selma, Alabama, and other cities. "The idea of a march was growing," Alston recalled. "It was in the air . . . and this painting just came. I called it *Walking* on purpose. It wasn't the militancy that you saw

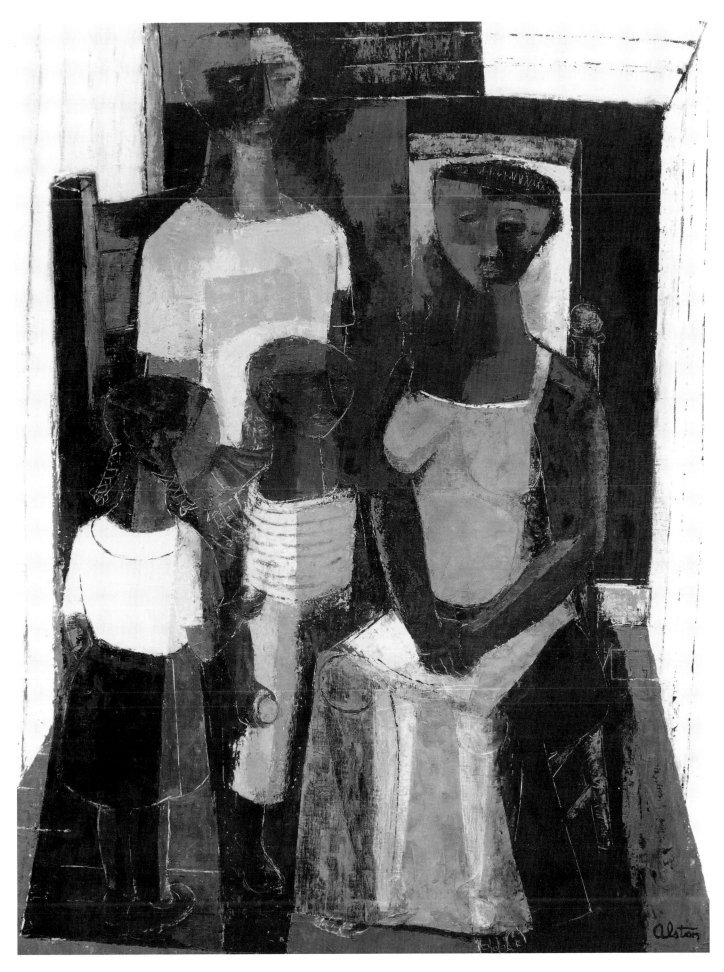

The Family (1955) demonstrates Alston's concern with volume, and the influence of African sculpture and of Modigliani, whose elongated necks he often adopted. Also present: Cubist analysis of forms and color. (48¼ x 35¾″) Whitney Museum of American Art, New York

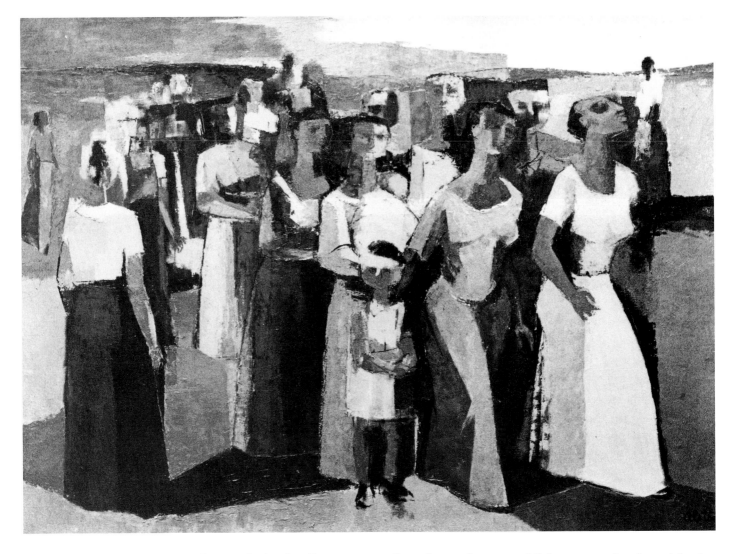

Walking, first exhibited in April 1958, depicted a diverse group of people moving toward light, unconsciously anticipating the 1960s civil rights marches. *New York Times* critic Howard Deveree said (May 25, 1958) that it had "an emotionally searching appeal as of a sad migration." Alston, honored that year by the National Institute of Arts and Letters, could not explain its origins: "It was in the air." (48 x 64") Collection Sydney Smith Gordon, Chicago

later. It was a very definite walk—no going back, no hesitation."[15] Prized by Alston because of its prophetic character, it became the basis of his mosaic mural for the lobby of the remodeled Harlem Hospital.

Alston was a member of Spiral, a group of New York African-American artists who met regularly for about two years to discuss the relationship of their art to the struggles of their people.[16] Of the influence of the civil rights movement, Alston said:

As an artist, as a citizen, and as a human being, particularly as a Negro, and having the sensitivities of an artist, it has to have some effect on you. I don't think the function of art in this area—unless you are just constituted that way—is to do propaganda or even social comment pictures. The very fact that these things are fact gets in your way. I think there's protest in all these paintings—even in *The Family, The Blues Singer*—but it's not a conscious protest. To me, how-

ever, the basically important thing is making a good picture. Whatever the theme happens to be or gets to be is inevitable, out of what your experience has been, and mine has been the experience of a black man in a fairly racist country. I do try to keep the universalities that make a painting a painting uppermost.

Citing the work of Honoré Daumier and Francisco Goya, Alston added: "There have been, in the history of art, great protest paintings. If a man happens to be a great artist, the art part of it dominates it completely. You get this beautiful wedding of the two factors."

Throughout his career Alston painted with great facility and a sure grasp of the essential elements of many different styles. He also liked to model and carve sculpture. Sometimes he painted in a realistic style and other times in a completely abstract way. What he did depended on how he felt about a visual image. Disliking being "pigeonholed," he attributed his multiple

styles to his curiosity and need to explore: "I don't go along with this insistence of critics that you develop a certain consistency—that has to make their job easier. The whole creative thing is one of exploration of new or different areas. I can't see this business of repeating and repeating and repeating. I believe in developing or exploring an idea until you've gotten out of it everything you can, and beyond that, let's look for unexplored areas."

Alston always refused to characterize himself as a black artist, reflecting the diversity of his work. He added, "If you mean by being a black artist, this business of being an exponent of a black art, I don't even consider myself that because I don't think there is such a thing. I don't think there's anything more American than what a black American does—it's so uniquely an American experience. So I just consider myself to be an artist who happens to be black, who happens to have lived through black experience, and inevitably, that's got to have its influence on your work, but if it is anything at all, it's American." His unwillingness or inability to develop an identifiable personal style undoubtedly was a factor in his not being more widely recognized.

One of Alston's most striking and best-known paintings, *Black Man, Black Woman, U.S.A.,* shows a young black couple, sitting erect and with dignity, but with featureless faces. Their posture is reminiscent of the regality of Egyptian pharaohs and queens as portrayed in their tombs. Now hanging in the headquarters of the National Association for the Advancement of Colored People, this painting developed from Alston's method of working. In his words:

> More often than not, the painting tells me what it is going to be. All of my paintings start very abstractly. I just throw some color on the canvas, push it around, and then sit back and relax and look at it, and various patterns become suggestive and sometimes an idea reveals itself with a great deal of strength. You look at it and then you push the painting in that direction. Then it becomes a conscious thing.
>
> The first part is completely intuitive, just pushing around paint the way you feel, and then you look at the shapes and features and they suggest things in terms of what you are thinking about, or that are unconsciously on your mind. When you see it, you begin developing it. That's the way most of my painting begins.
>
> And this one began that way, and then it gradually began to be two figures, and then I began making it into two specific kinds of figures. I had no idea of leaving them featureless except at that point—here again the painting spoke to me: that's the statement!

> All of a sudden I was aware that this is the way a great deal of white America sees black America. Sees them as faceless. They don't know them.

Alston felt the catalyst for the painting was an incident at a big party where "a sweet little white lady, the kind who has to bend over backwards explaining and proving to you that she's liberal," told him that her cook, Cora, was "just a darling, and Cora's been with us for nineteen years. She's just like one of the family." Having heard this kind of story over and over, Alston asked, "What's Cora's last name?" The woman did not know it. "Well, this is typical," said Alston, recalling the incident. "It's a faceless thing. So I said to myself, 'You just don't make faces on this one.'"

When questioned by Grace Glueck of the *New York Times* about how discrimination has hurt black artists by keeping them out of galleries and museums, Alston said: "It's not so much a question of galleries or museums refusing to show them. The real thing is that blacks miss out on social situations—the parties and gatherings where they might meet collectors and people important in the Establishment structure, who could open doors for them. So much is done in that way, and the Negro isn't privy to it."[17]

Long concerned with art as a form of communication, Alston did less and less abstract painting as the civil rights movement developed. Nevertheless, he considered the black-and-white abstractions in a retrospective show in 1968 to be among the most important he had done.[18] That show also included much work based on African themes, although Alston indicated that there was no "relationship to the African meaning of these themes. It's purely an aesthetic coming back. You like the forms. You like the pattern, the rhythm, that kind of thing. I don't know the first thing about the [African] meaning of these themes or what rituals they were related to." Instead, he drew upon African spatial concepts in the same way that such European artists as Pablo Picasso did.

When asked about other influences, Alston identified Modigliani, Picasso, El Greco, the Mexican muralists (particularly Orozco), and Egyptian, and Oceanic art as influencing his work at some point. In his early days, Eugene Speicher and Jules Pascin were also influences. "Aaron Douglas," he said, "was one of the first genuine artists I met. . . . I revered him. But he was not an influence on me."

At the time of his 1968 show, Alston said: "As an artist, formed culturally and environmentally in the traditions of western man, I am intensely interested in probing, exploring the problems of color, space and

Enormously facile, Alston enjoyed playing with the dynamic tensions of shape and color. In this abstraction, stimulated by modern European artists, he celebrated his favorite theme—family. Photo courtesy of the artist

form, which challenge all contemporary painters. However, as a black American, who sincerely believes in the ideals upon which this country was founded, I cannot but be sensitive and responsive in my painting to the injustice, the indignity, and hypocrisy suffered by black citizens."[19]

Alston dramatically expressed his meaning in a bust of the Reverend Martin Luther King, Jr., that reflects the inner tenacity and courage of King, creating a powerful image of a committed man calling for struggle. Although instantly recognizable, it is not the bland, idealized face seen in many King portraits. The National Museum of American Art, recognizing the striking qualities of Alston's portrait, requested a duplicate cast of the portrait, which was originally commissioned by the Reverend Donald Harrington of the Community Church of New York, where it still stands.

Alston created a considerable amount of sculpture, another aspect of his restlessness to explore. Sometimes he felt it was his true medium. Certainly, his painting is strongly marked by sculptural values.

In Alston's mind, however, murals offered the greatest opportunity to communicate. He was delighted in 1973 when Max Abramovitz, of the architectural firm of Harrison and Abramovitz, commissioned him to create two large mosaic murals for the Bronx County Family and Criminal Court buildings. The Criminal Court mural is an abstract representation of "equal justice for all." In contrast, the Family Court mural presents stylized images of people of all races living and playing together harmoniously. The murals were completed in 1975.

Earlier, in 1969, Alston had been appointed "painter member" of the New York City Art Commission by Mayor John V. Lindsay. Its eleven members approved all designs for city buildings and all works of art on city property. Alston was the first black artist to achieve this post and brought recognition, regardless of race, to many artists previously "passed over." In 1971 Alston received another honor: the Thomas B. Clarke Award of the National Academy of Design.

Although increasingly incapacitated by cancer, Alston was busy with ideas for work until he died on April 27, 1977. He felt satisfied, he told friends, that he had made "a contribution" to American life. The leaders of most Harlem organizations as well as many cultural figures of all races, such as John Hammond, paid tribute at his funeral, as did Robert Beverly Hale, his old colleague at the Art Students League and curator of American painting at the Metropolitan Museum of Art. In 1968 Hale had pointed out that Alston "was one of the few who has not forgotten the artist's great and ancient message—the state of compassion."[20] Alston's compassion and his great skills were demonstrated anew in 1990, thirteen years after his death, in a large retrospective exhibition at Kenkeleba House in New York.[21] It included his *New Yorker* cartoons, his drawings, his southern landscapes in watercolor, his jazz combos and blues singers (including his portrait of Bessie Smith), and a nearly abstract painting of the Hudson River Palisades, which expressed their mas-

Black and White No. 2 (1960) was one of an abstract series exhibited in 1968. Stimulated by other artists' work, Alston was proud of his ability to paint with great competence in many different styles. He felt he thus defied pigeonholing by critics.

Alston's portrait (1970) of the Reverend Martin Luther King, Jr., projects the frankness and inner strength of this confrontational civil rights leader rather than the conventional idealization of a hero. (Bronze, 12″ h.) Community Church of New York

siveness in a way, one felt, that had never been seen before.

The show also included some of his abstractions, which posed the question of why this artist never moved into the same groove that other WPA artists he knew did—Ad Reinhardt, Willem de Kooning, Jackson Pollock, and others who became well known as Abstract Expressionists. After all, his 1950 abstraction won the Metropolitan Museum purchase prize. One saw the answer in this exhibition, amid all the diversity, the variety of styles. He was an artist whose primary concern was his own people and their problems. That concern, that compassion, drove him, made him the artist he was. Yet he recognized "this ambivalance of involvement," calling it "the unique predicament of the black artist in America today. It is, for that matter, the predicament of any artist, black or white, who is concerned with the dignity of man. It is the 'Ivory Tower' and the 'nitty-gritty.' Art is the pursuit of truth as the artist perceives it. *Guernica* shows us that it can also be a powerful and effective weapon in the struggle for human decency."[22]

ELDZIER CORTOR

One of the first African-American artists to take the beauty of black women as his major theme, Eldzier Cortor first achieved popular recognition in 1946, when *Life* published one of his full-length seminude female figures. Today his work is in many private collections as well as those of the Library of Congress, Howard University, the American Federation of Art, the Musée du Peuple Haïtien, and other museums. For more than twenty-five years he has worked almost exclusively in lithography, creating prints of graceful but elongated black women that have been widely sold, primarily through the Associated American Artists of New York. Cortor has shunned the gallery affiliations that most artists find necessary. Regardless of movements in art, he has focused insistently on what he calls "classical compositions"—the solemn heads and figures of black women, sometimes in repose, sometimes dancing.

In 1940 Willard Motley, later known for *Knock on Any Door* and other novels of Chicago life, described that city's young black artists. "The other artists have all told me that Cortor is the most original of the group," he reported. "This is obvious when his work is studied. Here is a lithograph, here a palette-knife portrait, here a painting done in paint-tube technique, here something influenced by African sculpture, here a mural worked out on a small scale, here a sketch impressive in its simplicity of line and its living mood. . . . Each has the stamp of Cortor's originality."[1]

Yet the diversity described by Motley was abandoned by Cortor, who increasingly limited himself to lithography. Cortor himself puzzles over it, recalling with amused astonishment that he started out as an abstract painter. Today he calls himself a "group painter," by which he means simply a man whose life experiences are those of any African-American and whose paintings reflect them. In 1940 he told Motley, "I want to paint, never reach any set goal, always work towards an ideal."[2] It is a statement that still characterizes Cortor over fifty years later.

Cortor's parents, John and Ophelia Cortor, were economically more secure than most black people. They were also adventuresome and less traditional. A lively, intelligent man, John Cortor had traveled widely within the United States and served briefly as a revenue officer, chasing bootleggers. An able mechanic, he became a self-taught electrician. Determined that their family was not going to be held back by the racism that gripped Richmond, Virginia, where Eldzier was born on January 10, 1916, the Cortors moved to Chicago when he was about a year old. (Eldzier was named by his grandmother, who selected the name in accordance with a family religious tradition; he pronounces it "El-zee-oor)."

Many Chicago homes were then being converted to electricity, and John Cortor's earnings as an electrician soon enabled him and his wife to open a small grocery that also functioned as an electrical appliance repair shop. After a few years they moved to the West Side, where a number of black families, including the Motleys, had settled. John Cortor, always restless, turned to cars and motorcycles, and he eventually learned to fly a small plane, becoming one of America's first black pilots.

Despite his own adventuresomeness, John Cortor worried about Eldzier's becoming an artist, an ambition that arose from his earnest study of black characters in comic strips. He was familiar with Sunshine, the caretaker of Sparkplug in Billy DeBeck's "Barney Google," and Mushmouth in Frank Willard's "Moon Mullins"—two strips that continued the racial stereotypes laid down in Currier & Ives's *Darktown* series fifty years earlier. However, Cortor's favorite was "Bungleton Green," created by Leslie Rogers, which first appeared in the *Chicago Defender* of November 20,

Classical Study No. 34 (1971) is one of a series of heads of African-American women. Although this is not a large canvas, it is a powerful and sensual image. (14 x 18") Private collection

1920.[3] Bungleton Green was a naive black migrant from the rural South who was always getting into trouble in the big city. For example, Rogers's first panel showed a forlorn Bungleton complaining: "Blowin' in town with no jack is kind o' tough." A friend then shows him $500 collected from having been "brushed" by an automobile. Bungleton promptly lies down in the street to get "brushed." A car comes—and Bungleton lands in court on crutches and is sentenced to sixty days for blocking traffic. This strip, drawn first by Rogers, then by Henry Brown, Jay Jackson, and Chester Commodore, ended in 1963, when the civil rights movement created a new image of rural southern black people.

In the 1920s Cortor often copied "Bungleton Green," with the dream of creating his own strip. Katherine Irvin, a neighbor and editor of the weekly *Chicago Bee,* encouraged him and gave him a watercolor set.

Business setbacks in the Depression forced the Cortors to move to the South Side, where Eldzier entered Englewood High School. There he was encouraged by Miss Wilson, an art teacher who had been a St. Louis classmate of E. Simms Campbell, whose cartoons were then appearing regularly in *Judge* and the old *Life* magazine. In the school's poster shop he worked with Charles Sebree and Charles White, who frankly aspired to become fine-arts painters. Cortor, however, felt such work was beyond his ability.

Moreover, his father discouraged any talk of his becoming an artist, insisting that Eldzier learn something "practical"—electrical work. Cortor dropped out of school to work, but he attended evening drawing classes at the Chicago Art Institute. In 1935, having saved up tuition money, he enrolled as a full-time student.

As a museum-based school, the Art Institute was both stimulating and awesome for Cortor. Its collections included Rembrandt, Frans Hals, El Greco, Egyptian art, Italian Renaissance masters, Paul Cézanne, Edouard Manet, and others. "You're passing history while you're going to your classroom," recalled Cortor. He might not have been so overwhelmed if he had known that two of the museum's prize paintings were created by a still-living black artist, Henry Ossawa Tanner. Fortunately, an unusual teacher helped Cortor overcome his crushing awe.

Cortor's most absorbing course was art history, taught by a young Texas woman, Kathleen Blackshear. She could, Cortor said, relate "what happened in the history of art to the present." She demonstrated how Greek art evolved and lasted as an influence, what principles governed Egyptian art, the concepts and considerations that influenced the great masters of the Renaissance and those of Impressionism. Among other things, she insisted that students closely examine a Rembrandt, asking themselves: "How did he paint this?" By forcing them to see the underpainting, fingerprints, tracings of rags, and other details, "she made students . . . reconstruct the painting as if you were painting this painting yourself," Cortor recalled.

One day Blackshear led the class down Michigan Avenue to the Field Museum to confront what she said was some of the greatest art in the world: African

Considered the first African-American comic strip, "Bungleton Green," created by Leslie Rogers, began in the *Chicago Defender* on November 20, 1920. A greenhorn migrant from the South, Bungleton had trouble adapting to city ways. The strip stimulated many African-Americans, among them Cortor, to try to draw and paint. Courtesy *Chicago Defender*

sculpture. After pointing out this art's classic severity, emotional expressiveness, disciplined spatial concepts, and influence on the Cubist movement, she required her students to draw the sculptures until they had mastered these works' basic aesthetic characteristics.

"All of a sudden I could see . . . and I became very excited and I wanted to participate in this in some kind of way," Cortor recalled. Thus African sculpture ended his interest in cartoons and initiated his career as a fine-arts painter.

Blackshear's teaching was unusual for the time, her 1940 master's thesis was one of the first academic studies in a leading American art institution to consider black people's faces and figures aesthetically.[4] Black-shear "constantly encouraged me, even to the point of buying a few of my things," Cortor later told Elton C. Fax. "It was through contact with her that I came to appreciate the true meaning of art history, composition, and life drawing."[5]

Helping Cortor secure a scholarship to continue his studies for another year, Blackshear made him feel that he could indeed become a painter, that art was not "for the gods" but attainable by him. "It was her enthusiasm for African art that really got to me. That was the most important influence of all in my work. To this day you will find in my handling of the human figure that cylindrical quality I was taught by Miss Blackshear to appreciate in African sculpture," Cortor said in 1973.

After he completed his Art Institute studies, Black-shear helped Cortor qualify for employment on the WPA arts project.

At first, influenced by the relationship of African art to Cubism, Cortor decided he wanted to be a modern artist. In his second year at the Art Institute, he began to paint in an abstract style. But later, on the WPA project, he met George Neal, who had organized a group of young African-American artists that included Charles White, Charles Sebree, and Bernard Goss. Neal urged them to go into the streets of Chicago's South Side and paint the life of African-Americans in a documentary way. Neal was so eloquent that Cortor abandoned his abstract style. "I felt on the face of it, as a black, to be doing abstract—I just felt I couldn't afford it, that it wouldn't serve my purpose, to get over my message," he recollected.

Most artists in this group participated in WPA activities at the South Side Community Art Center, which resembled the Harlem Community Art Center in its community involvement and programs for actors, dancers, writers, and artists. Cortor taught drawing there and worked on murals.

Enormously stimulating to Cortor and other African-American artists at the time was the cross-fertilization of ideas in meetings with writers, actors, dancers, and musicians. Fifty years later Cortor still talked with enthusiasm of these sessions. In them he renewed his friendship with Willard Motley, met Archibald Motley, Jr., and writers like Margaret Walker and Richard Wright. "You had the dance with Katherine Dunham and Talley Beatty. You had Horace Cayton, the sociologist; Ted Ward, the playwright; but most of all, you had that certain atmosphere. You were all equalized. We were all in the same boat and it was a very nice atmosphere. We had about seventeen black artists in the group."

"People could grow," Cortor recalled. "Someone might come back from a Marian Anderson concert and there was excitement about that. They'd discuss other happenings in the arts." That all types of artists—from naive to abstract and academic, encompassing all types of political thought—were participants contributed to

Dance Composition VIII (1970) reflects Cortor's continuing fascination with dance. In recent years his elongated figures are painted with greater freedom, although the color is always restrained. (24 x 18″) Private collection

In *Dance Composition No. 35* (1981), an etching, Cortor placed elongated dancing figures against Art Deco designs of African derivation. He has found prints a major means of expression. (Intaglio, 25 x 22″) Collection of the artist

the richness of discussions, according to Cortor. Katherine Dunham, later a famous dancer but then a graduate anthropology student at the University of Chicago, made her apartment headquarters for many discussions and parties, functioning much as 306 did for New York artists.

Dancing and dancers particularly appealed to Cortor as subjects. Familiar with the ancient history of dance as well as the Charleston and Black Bottom, Cortor said, "I'm a sort of frustrated dancer. I do a lot of movements in my head."

Cortor has continued to pursue this interest. Many of his drawings, prints, and paintings are titled *Dance Composition*. He does not sketch dancers in action but studies their movements, making mental and sometimes written notes, from which he works in his Lower East Side studio in New York. "This is the way experienced artists work," Cortor explained. "Toulouse-Lautrec didn't run around sketching on the scene. He drew from memory and notes. Sometimes my notes are just a few written words."

One of Cortor's close friends then was Horace R.

Cayton, later coauthor of a major sociological study, *Black Metropolis*. Cayton led a WPA writers and library workers project that created the first bibliographic index to literature on the work of African-American artists.[6] It covered history, exhibitions, and writings, as well as references to African art here and abroad. With no WPA funds for publication, this valuable reference work was mimeographed but remained unknown.

Cayton, who came from Charleston, South Carolina, drew Cortor's attention to two items in the WPA bibliography. One reported African customs in decorating graves in South Carolina.[7] More exciting was a book on extensive Africanisms in the speech and customs of black people on the Sea Islands off the Carolina and Georgia coasts.[8] Black Sea Islanders spoke a dialect called "Gullah," a mixture of Portuguese, English, and many African tongues.

With Cayton's help, Cortor secured a Julius Rosenwald Fund fellowship to go there in 1940. Isolated from contemporary American culture, black Sea Islanders had retained many African attitudes to-

ward nature, agriculture, and religious and folk customs. They made their living from the sea, with the help of some gardening.

Feeling he had arrived at the end of a long era, Cortor was nevertheless fascinated by the African character of the people, their respect for nature, calm dignity, and preservation of their heritage of African customs. A year of drawing and painting there deepened his respect for these people and his sensitivity to their ways. "In some ways I might as well have been in Africa," Cortor said.

Back in Chicago, Cortor saw a major exhibition of classical French painters—Jacques-Louis David, Camille Corot, Eugène Delacroix, and others. Their technical excellence and thorough craftsmanship greatly impressed him, and a similar concern with technical quality has characterized Cortor's work ever since. He was even more impressed by the "epic style" in which they presented common subject matter—something he felt was lacking in his own documentary style. He decided that with his own adaptation of the "epic style," he could achieve something unique and desirable in the representation of black people.

While trying to develop such a style, he was disturbed by problems with paint chemistry, such as uneven drying of paint resulting in cracking. To learn how to solve these technical problems, he moved to New York, which offered greater opportunities for such studies than Chicago.

In New York he also discovered a new medium. During the WPA era, many artists had turned to printmaking rather than painting because lithographs could economically be made available to large numbers of people and gave the artist a greater return. For example, it might be easier for an artist to sell eight or ten prints at $25 than one canvas at $250. Therefore Cortor began to study woodblock printing techniques at Columbia University. This ultimately led to his concentration on lithographic printmaking.

During this period Cortor began to create striking studies of tall, nude black women. Lyrical, sensual, and romantically mysterious, they instantly won for him a reputation as a painter of distinction and one of the first to celebrate the beauty of black women. In these portraits, usually full length, he drew heavily on his exposure to African sculpture, elongating the figure and its cylindrical forms. His treatment of the figure was sculptural rather than emphasizing color and light, an approach giving the figure weight and dimension. The faces were always impassive. He made no attempt to minimize African features with an Anglo-Saxon idealization of the face and hair. Instead, his work celebrated African characteristics.

In some full-blown romantic paintings, the subject was presented with a bright bird on her shoulder, outdoors beside a wrought-iron fence and an urn-topped pillar. But a typical Cortor portrait of the mid-1940s depicted a very handsome young woman, often in a small, cluttered room, with fraying furnishings and paper peeling from the walls. The incongruity of this setting in relation to the beauty of the woman often enhanced the work as a whole, suggesting beauty limited by circumstances. Like Pablo Picasso, Cortor liked the compositional devices of showing a corner of a room and using a mirror. For example, one of his paintings seems to be a portrait of an old marble-topped Victorian bureau, but in its mirror appears a slender young woman.

In contrast to his fellow Chicagoan, Archibald Motley, Jr., who was generally drawn to the vitality and animation of individuals as members of a group, Cortor focused on the individual, portraying a tall, impassive, beautiful woman, classic in her pose, who is circumscribed by her surroundings. In fact, the milieu is such an integral part of these paintings that the subject can hardly be imagined in any other circumstance.

In 1946, reporting on one of the first group exhibitions of black artists since the 1939 Baltimore Museum show, *Life* magazine published one of Cortor's nude studies.[9] This picture won him considerable attention and a Guggenheim fellowship.

Using his Guggenheim fellowship, Cortor continued his studies of African descendants in the Western Hemisphere. He visited Cuba, Jamaica, and Haiti. In Haiti many African customs had been retained and there was an active, indigenous tradition of painting, centered on vigorous expression of folk mythology, which had gained worldwide interest as a cultural phenomenon. Living in the interior, Cortor was fascinated by the lives, attitudes, and symbols of the people, their dances, drumming, and voodoo practices. Learning to speak the local patois, he taught drawing at the Haitian Centre d'Art in Port-au-Prince.

Cortor remained in Haiti for two years. Compared with Cuba and Jamaica, he said, "Haiti is different. It is something that is there." In his view the outstanding characteristic of Haitian art then was that "they just go right ahead and be themselves." He explained:

> Their art was so involved with the symbolism of their culture that it would be impossible for anyone else to interpret it. It has so many symbols, including voodoo symbols, that, even if they were influenced by American things, it would still be their own. For

Americana (1946) won honorable mention in the 1947 Carnegie Museum Exhibition of American Painting in competition with the work of many well-known painters. It contrasts the beauty of a statuesque African-American woman with her impoverished home. Newspapers and pictures pasted on the wall include a magazine portrait of General Jan Smuts, a Boer leader who denied black Africans any role in South Africa's government and reinforced original apartheid laws. (60 x 30″) Collection Miriam and Stephen Cortor

McCarthy, drawing on the success of the Dies committee in killing the WPA, falsely accused whole groups of being "Communist." Guilt by association became the style of the day. A painter who had been on the WPA arts project was presumed to be a "Communist" by many frightened people.

For Cortor and many other artists devoted to black subject matter, this political hysteria was a disaster. To survive, many artists eliminated black subject matter, according to Cortor. "I know for myself, economically, it was a nose-dive," he recalled. Galleries claimed they couldn't find his work. "If you just drew—if you did anything with a problem in general, about what is happening around you—civil rights or something like that—you [were] a troublemaker. . . . You had no market." When it was pointed out that there was nothing agitational or political in his work, Cortor responded: "Just to paint black subject matter is part of social painting, too."

When his sales dropped sharply in the mid-1950s, Cortor went to Mexico. There he developed a greater interest in lithography, which had strong aesthetic roots among Mexican artists. He would have nothing to do with Abstract Expressionism. In fact, he considered the rise of the Abstract Expressionist movement, with its dealer-pushed waves of publicity, a part of the cold war—a time when nothing was said of the disappearance of socially conscious art.[10] In a few years, however, the cold war hysteria faded and Abstract Expressionism was dead. "The party was over" was how one of the movement's historians, John Gruen, put it.[11] Cortor then came back to the United States and devoted himself to lithography.

example, they have a mural in the Episcopal church there that is an early Christian sort of thing—Christ's birth—all done in Haitian terms, with a black Christ and local people. . . . What they have been able to do is take Catholicism and blend it with voodooism.

They absorb things which then become theirs.

Cortor's studies in Haiti, sketching women working in fields, dancing, pulling nets from the sea, and resting, strengthened his absorption with the grace of black female figures.

On returning from Haiti, Cortor lived first in Chicago, then New York. In the early 1950s Senator Joseph

In the early 1960s the civil rights movement stimulated an interest in black artists among some New York galleries—reversing the McCarthyite atmosphere of the 1950s. However, Cortor, feeling one could easily lose one's artistic integrity by following fads, did not resume a stable relationship with any dealer. He sold his lithographs through the Associated American

Classical Study No. 39: Woman with a Towel (1979). Time, place, and the identity of his subject have no place in Cortor's "classical studies," in contrast to some of his other paintings, which are very specific. For example, a still life focuses on his building's mailboxes. (28 x 22″) Collection of the artist

Still Life: Souvenir IV (1982) pays tribute to African-American boxers, like middleweight Tiger Flowers, who have "hung up their gloves" but whose achievements have raised the self-esteem of their people. A photograph of Joe Louis as a soldier, a Jack Johnson print, and Dempsey-Wills headlines reflect Cortor's appreciation. The straw hat and cane symbolize the styles of the "sports" of the 1920s. (57 x 33″) Private collection

Artists, finding a greater market for them than for his canvases, although he continued to send paintings to juried museum shows.

In 1973, along with Hughie Lee-Smith and Rex Goreleigh, Cortor exhibited a large number of works at the Museum of the National Center of Afro-American Artists in Roxbury, Massachusetts.[12] That show gave him the opportunity to see work done in the thirties and forties. "It was like looking at my children, my daughters. I feel I'm a better painter now— a neglected one but a better one," he commented.

By that time Cortor's goal was to make himself "the complete artist," able to do anything from mixing his own pigments to cutting matboards. To some extent, he became preoccupied with technique, creating a self-imposed demand for superb technical excellence. Underlying this attitude is a fear that plagues many black artists: "I don't want to be accepted—'because he's black,' or something like that," said Cortor. He entered juried museum shows because he considered them real competition.

Cortor sees his artistic vision as having been formed as a result of his early study of African sculp-

ture, of the Sea Islanders and Haitians, and of the French "epic" painters. What has changed—"improved," he said—is his technical quality. He believes that recognition or success in the external world does not depend on him—"I always refer to it in the light of what's happening around me. I don't think things are happening to me by myself . . . by what I do. . . . When I get breaks, it's because of certain other things." This attitude is not surprising in an artist who saw his recognition rise during the New Deal, with its growing awareness of the talent and rights of black people, and his neglect begin with the advent of the

Still Life: Past Revisited (1973) emerged from Cortor's memories of African-American life of the 1920s and 1930s: a Coca-Cola sign, a Bessie Smith poster and records, a small replica of the statue *End of the Trail,* a "cathedral"-style Philco radio, a drum with the names Erskine (Hawkins) and (Art) Tatum—all in a room with a cabinet of bric-a-brac and a jumbled tower of chairs and furniture. (66 x 60″) Collection of the artist

cold war and its paranoid suspicions. It is because of this that Cortor sees himself as a member of a group—the black people of the United States.

Cortor is not interested in the style of the moment. He focuses on black subject matter in what he considers "timeless" classical compositions "that can fit into any period—not locked into a style that will go out of date. There are things of mine dated in the forties and fifties that can fit into anything. I very carefully try to keep things from being the latest style—the latest thing." In the 1970s, for example, Cortor created many heads of young black women with no attempt to prettify them, offering a sharp contrast to the portraits of elegantly dressed women favored by Motley.

In 1988 Cortor was delighted to be shown in an unusual exhibition with two other artists with midwestern ties, Motley and Hughie Lee-Smith, at Kenkeleba House, a New York gallery that specializes in minority artists. The show gave New Yorkers their first opportunity to see a number of Cortor's paintings.[13]

One painting exhibited in the Kenkeleba House show by Cortor differs significantly from his classical female figures and heads. Titled *Still Life: Past Revisited,* and created in the early 1970s, it is a large, surrealistic, montagelike painting, which he described in this way: "It's just a revisit, a biography—a soul still life. It has all the things that, being a black person, passed through my life at some time or other. It's like an autobiography, like a secondhand shop with things thrown all around—symbols, black symbols, the things that as a black American I know people will identify."

Included are a Coca-Cola bottle, beautiful flowers wrapped in newspapers bearing headlines about the Scottsboro boys, old photographs, Billie Holiday and Bessie Smith records, and the sculptured head of an African queen with a price tag on it. A curio stand holds stacks of phonograph records, more photographs, and bottles. Next to it stands a totem pole created by chairs and old tables being sloppily stacked on top of one another.

In this painting, Cortor has summed up many memories of the life of black Americans born about the time of World War I. It reflects his identification as a member of that group and the great and small events of their history.

BEAUFORD DELANEY

No one who knew Beauford Delaney could forget him. An expatriate at the time of his death in 1978, he had become a legendary figure, celebrated by writers as diverse as Henry Miller, James Baldwin, and James Jones. In 1973, when a comprehensive exhibition of his work was presented at the Darthea Speyer Gallery in Paris, the American artist Georgia O'Keeffe recalled knowing him twenty-six years earlier: "He was a very special person—impossible to define. I think of him as a special experience and always with a feeling that it is fine to know he is living—somewhere—still being his special self—what I do not exactly know, but he is a special kind of thought."[1]

Beauford Delaney has no long list of museum credits, prizes, or awards. However, in 1978, when the Studio Museum in Harlem mounted its first "Black Master" exhibition, it was a major retrospective of Delaney's work. The show included many paintings created in France, where he had worked for nearly thirty years, and had an extensive catalog by Richard A. Long.[2]

Delaney himself never bothered much with worldly affairs. It was his vision that he followed. While his many portraits are related to the work of such European Expressionists as Jules Pascin and Chaim Soutine, his vivid abstractions swirl in vertiginous lines that evoke Vincent Van Gogh and the arabesques of Mark Tobey. In the early 1940s Beauford Delaney composed dense spiraling masses of color in a completely nonrepresentational way. He was indeed a precursor of the Abstract Expressionist movement, isolated by his single-mindedness more than anything else. Yet unlike the art of many Expressionists, his work is not anguishing, despairing, or wrathful, but a cultivated, rhythmic affirmation of his own lifestyle. He created regardless of circumstances, and this ability to concentrate in pursuit of his vision won him the regard of everyone who knew him. It moved people in all walks of life both to help him and, in some ways, to want to be like him.

What animated Delaney's vision was philosophical and personal. Although aware of distressing social problems, he did not join others in searching for solutions in the ordinary sense. This is reflected in a letter to Long during the civil rights struggles of the late 1960s:

> Don't forget that we are aware of the universal misery of our time and world and are trying in our various ways to contribute that which is relatively sane. . . . We have nothing but profound friendship. Our century is exploding in infinite ways. . . . We must continue in the midst of the seemingly impossible moments. . . . All of us must be ourselves and contain our belief in the healing of wounds which time, we hope, can bring about.[3]

Beauford Delaney was indeed "a special experience," to use O'Keeffe's phrase. What he painted in France differed from what he painted in the United States. Yet at all times he dealt seriously with some profound problems of art and life, attempting to define them in his own way with great intuition and personal dignity. At a time when many people lost their values, he was faithful to his, and he never felt the need to justify the importance of what he was doing. Although his interpretations often abandoned external reality, the relationship between him and his subject is always expressed in harmonious color. Very much in the same way that D. H. Lawrence spoke of "the powerful light of the emotions," emotion lit Delaney's work and provided its unity.

Beauford Delaney was born in Knoxville, Tennessee, on December 31, 1901. His parents named him for Beaufort, South Carolina, the coastal town they had come from and where in 1861 slaves, refusing to accompany fleeing masters, awaited invading Union forces. His father, the Reverend Joseph Samuel Dela-

ney, was a circuit-riding preacher and church builder of the Methodist Episcopal Church South. He would go into the hills of Tennessee and Virginia to locate an African-American community, build a church, and then move on to the next group. Sunday was scrupulously observed as a day of worship, with the whole family participating in the church services and work. Wednesday nights were for prayer meetings.

Both Beauford and his brother Joseph, who was three years younger, discovered their gift for drawing at an early age. Beauford had great charm, a strong appreciation of music, and an amusing ability to mimic. He also had a gift for getting attention and help. He graduated from Knoxville Colored High School with honors. Years later, his brother Joseph wrote: "Scholars of all grades in school as well as teachers and professional people of high rank gave Beauford time and understanding."[4] While he was working as a shoemaker's apprentice, his drawings were seen by an elderly white Knoxville artist, Lloyd Branson, who then gave him lessons. At Branson's urging, Beauford went to Boston where he studied art at the Massachusetts Normal School. He was then twenty-three years old.

At the school Beauford spent months of drawing from antique casts, while supporting himself by various menial jobs. Eventually he entered the evening life class at South Boston School of Art and the Copley Society. During this time he often visited the Boston Museum of Fine Arts and the Isabella Stewart Gardner Museum, where he acquired a considerable knowledge of European masters. At concerts at the Gardner Museum, he also discovered classical music and operatic arias. He became acquainted with Countee Cullen, who was then studying for his master's degree at Harvard and whose poetry in *The Crisis* and *Opportunity* delighted him.

In 1929 Delaney moved to Harlem and worked as a bellboy in a midtown hotel. However, his real work was making pastel portraits. He often sketched at Billy Pierce's Harlem dance studio, and he exhibited three portraits at the Whitney Studio Galleries, the museum's predecessor, in a group show from February 26 to March 8, 1930. His first one-man show consisted of five pastel portraits and ten charcoal drawings at the 135th Street branch of the New York Public Library, from May to June 1930. The May 1930 *Opportunity* published his portrait of Billy Pierce.

Although he sketched W. E. B. Du Bois in the *Crisis* office, Delaney was more attracted to W. C. Handy, "father of the blues," and to jazz leaders. He made sketches of Louis Armstrong, Duke Ellington, Ethel Waters, and other stars. He had also developed a passionate love of operatic music, frequently attending the Metropolitan Opera. Greatly admiring Marian

Portrait of a Man, a 1943 pastel, reflects Delaney's sensitivity and skills. However, such traditional painting did not fulfill his need to let his feelings for pure color guide him. (19⅛ x 17″) Newark Museum

Anderson, he painted her portrait from memory years later.

Meanwhile Delaney's friendliness and good humor won him a job as a telephone operator and handyman at the new Whitney Museum in Greenwich Village. He found an apartment nearby on Downing Street; his brother Joseph lived only a few doors away. In the mid-1930s he moved to a small studio on Greene Street, where he painted many of his best portraits, street scenes, and abstractions.

Delaney studied briefly with Thomas Hart Benton and John Sloan at the Art Students League and with Don Freeman, a painter and printmaker well known for lively, socially inspired portrayals of working people.

Although he sometimes came to parties at 306, the Harlem studio of Charles Alston and Henry W. Bannarn, and belonged to the Harlem Artists Guild,[5] Delaney formed his closest relationships with Greenwich Village artists and writers, as well as others who lived there. Among them were the theatrical caricaturist Al Hirschfeld and his wife, Dolly Haas, a former star in German cinema.

Delaney exhibited in the annual Washington

Square sidewalk shows and the Harmon exhibitions; his work was included in the 1934 Harmon traveling exhibition. On the WPA arts project, he served as Alston's assistant on his Harlem Hospital mural. However, unlike Alston's mural, Delaney's own work did not reflect historical themes on traditional and academic conceptions of reality, but followed a personal vision that gradually became more abstract and expressionistic. Although many of his street scenes were structured with heavy outlining, much of his work was completely abstract—bright, thick impasto swirls of color.

Delaney's spirit, charm, and confident outlook always delighted people. He befriended strangers and appeared indifferent to material comfort. His studio was sometimes so cold that he wore extra sweaters and a skating cap while he worked. Although he worried about getting money for rent, canvas, and paint, if someone admired a painting, Delaney was likely to give it to him in sheer happiness. He was always making new friends. In 1940 he met another black preacher's son, James Baldwin, and they became close friends. He painted Baldwin's portrait several times.

Enjoying his company, some friends irregularly supplied Delaney with a few dollars. Two, Harry Herschkowitz and Larry King, interested Henry Miller in Delaney, getting the novelist to send him money from California. Ultimately Miller significantly increased appreciation of Beauford Delaney and his work.

On meeting Delaney, Miller, who himself painted occasionally, immediately recognized a character whose existence and interest in abstract color suggested a way of dramatizing his attack on the conventional. In *The Air-Conditioned Nightmare* Miller describes America as "full of places. Empty places. . . . just jammed with empty souls." In contrast, he hails "the amazing and invariable Beauford Delaney," creating with much quasi-mystical exaggeration one of the most unusual portraits of an artist in American literature.[6]

Miller presents Beauford Delaney by name. While this reality adds impact to his dramatizing of the banality and sterility of much of American life, the character he describes is not factual but fictitious—a vast romanticizing of the artist that focuses on externals, such as the coldness of Delaney's studio, his lack of money, his love of color, and his willingness to help drunken strangers. Miller does not deal with Delaney's art, making only such statements as "The impression I carried away was one of being saturated in color and light. Poor in everything but pigment. With pigment he was as lavish as a millionaire."[7]

Observing that many would dismiss Delaney as insane because he was an abstract painter, Miller writes: "Few artists, I hasten to add, have ever impressed me as being more sane than Beauford Delaney. Beauford's sanity is something to dwell on: it occupies a niche of its own . . . the sort that one ascribes only to angels. It never deserts him, even when he is sorely harassed. On the contrary, in crucial moments it grows more intense, more luminous."[8]

However, instead of dealing with Delaney's serious efforts to find in abstract art ways of expressing his positive feelings and intuition, Miller inverts Delaney's values and thus neutralizes his real motivation and energy. Miller also uses the stereotypes of the artist and of the black man to create a patronizing, romantic picture of a mindless, visionary black artist:

> Beauford was an artist from before birth; he was an artist in the womb, and even before that. He was an artist in Africa, long before the white man began raiding that dark continent for slaves. Africa is the home of the artist, the one continent on this planet which is soul-possessed. . . .
>
> . . . He tackles each fresh canvas as though it were his first. He uses pigments lavishly though he knows not where the next tube will come from. He blesses himself when he begins and says "Amen" when he is through. He never curses his lot because he has never for a moment questioned his fate. He assumes full responsibility for success or failure. Should death interrupt the program, he knows he will resume work in the next incarnation. His people have waited for centuries to see justice rendered to them. Beauford is no different than his ancestors; he can bide his time. Should this Beauford Delaney fail, there are other Beaufords, all endowed with the same spirit, the same endurance, the same integrity, the same faith.[9]

Miller's romanticizing omits any real sense of the difficult color and compositional problems that Delaney sought to solve as a serious artist who chose to abandon representational painting for the totally abstract, to move against current trends in search of his own expressionistic affirmation of life. Although his "portrait" ostensibly celebrates Delaney, Miller's tone is often patronizing and his introduction to the book is chauvinistic.

What Miller took more seriously than Delaney's paintings was how the figure of a simple-minded, creative black artist, indifferent to material values but concerned with aesthetic and emotional ones, underlined and clarified Miller's own picture in *The Air-Conditioned Nightmare* of the lack of meaning,

dehumanization, and mechanical banality of much of American life. Yet the portrait of Delaney that Miller created helped to change Delaney's life.

Miller's literary portrait was originally published as an "Outcast" series chapbook by the prestigious Alicat Press in 1945 and gained wide circulation among influential literary New Yorkers in the growing subculture that valued Miller and other anti-Establishment figures.[10] Its inclusion in *Remember to Remember,* volume two of *The Air-Conditioned Nightmare,* drew much attention to Delaney. The book also included material on Abraham Rattner, a well-known American modernist, and the San Francisco sculptor Beniamino Bufano, both of whom were considered avant-garde, which gave extra credence to Miller's chapter on Delaney.

In group shows, the Abstract Expressionist movement was emerging, principally in Greenwich Village, and this too prompted more serious consideration of Delaney's abstract work. Michael L. Freilich, who dared to show unconventional and black artists in his RoKo Gallery in the Village, included Delaney's work in group exhibitions and later gave him one-man shows.[11] In 1947 Delaney's recognition broadened when, at the suggestion of the painter Humbert Howard, the Pyramid Club of Philadelphia, composed of leading black professionals there, presented a large exhibition of Delaney's work, an honor given only once a year.

Exhibitions at the Artists' Gallery in New York followed, and Delaney's 1949 show at the RoKo Gallery drew favorable attention. Part of this was due to the fact that appreciation of Abstract Expressionism was rapidly growing. If Beauford Delaney had not been Beauford Delaney, he might have joined that movement, for he had been painting in an abstract manner for many years. However, he did not identify himself in such a way and shied away from movements.

Friends felt Delaney was so caught up in simply surviving by painting portraits that he could not follow his own artistic impulses fully. This situation inspired friends to obtain a fellowship for him at Yaddo, the artists' colony near Saratoga, New York. There, working in a cottage in a bucolic setting, temporarily free of rent and many other problems, his work changed. His Greenwich Village street scenes, which Long has related to the "hieratic character of the Renaissance stage setting," gave way to a freer use of color, although he continued to use representational elements.[12]

Back in New York, at a party one evening a young friend asked Delaney what he would like to do most of all. Delaney responded that he'd like to go to Rome

Abstraction. In the late 1930s Delaney began to paint increasingly in an expressionistic and nonrepresentational manner, making him an Abstract Expressionist before that movement existed. Ultimately many of his canvases, such as this one painted in France, became intricate studies of swirling colors. (51 x 38″) Galerie Darthea Speyer, Paris

and work there; after decades of fascism, postwar Rome had burst forth with new artistic vitality. To Delaney's surprise, almost a year later, the young man returned and handed him money to go to Rome. The incident reflects the kind of impulse that Beauford Delaney inspired in people.

However, Delaney got only as far as Paris. There he met his old friend James Baldwin and decided to settle in a hotel on the Left Bank. His life in Paris differed substantially from what he had known in Greenwich Village, where his friends included not only artists but all kinds of people—tradesmen, mechanics, neighbors, children, and so forth. In Paris Delaney was dependent on a small circle of friends, among them the painter Herbert Gentry, who was then operating a nightclub. He failed to become fluent in French, which severely limited his contact with people and self-sufficiency. To be near his friends Bernard Hassell, the dancer, and Howard Swanson, the musician, Delaney moved to Clamart, a Paris suburb.

Delaney painted this portrait of his friend Howard Swanson, the African-American composer, in France in 1967. Some French critics initially mistook his intensely expressive style for that of a naive amateur. (39 x 32″) Galerie Darthea Speyer, Paris

This portrait of Darthea Speyer (1966), who befriended Delaney and showed his work in her Paris gallery in the 1970s, is expressive yet concerned with her beauty in a more conventional sense than some of his portraits. Galerie Darthea Speyer, Paris

His paintings in France can be grouped according to those produced in Clamart and those painted later in rue Vercingétorix. In Clamart, the heavy palette and use of outlining, which had previously characterized Delaney's work—and that of such German Expressionist painters as Max Beckmann, Karl Schmidt-Rottluff, Ernst Kirchner, and Emil Nolde—disappeared. Instead, his work developed a freer, lighter quality, without sharp contrasts between light and dark areas, and with harmonious, equal color values in the tradition of French Expressionist painting as represented by Jules Pascin and Chaim Soutine.

Delaney continued to paint representational portraits that were not realistic in color, maintaining an even color value with hardly any shadows or acutely contrasting accents. These expressionistic portraits were among his best works. In June 1960 a major exhibition of his Clamart output at a leading Paris gallery, Galerie Paul Fachetti, was a success critically, although not in sales.[13]

As a result of his economic instability, aesthetic anxieties, and alcoholism, Delaney collapsed emotionally on a trip to Greece later that year. Darthea Speyer, who headed art activities for the American Embassy, arranged for his hospitalization in Paris. Unfortunately, his Clamart studio had to be vacated and a number of his works were lost. Speyer greatly aided his rehabilitation by arranging an exhibition of his work at the American Cultural Center.[14] She also provided a steady stream of portrait clients, mostly visiting Americans, including her mother, brother, and housekeeper.

Delaney's friends also raised enough money through subscriptions to purchase a studio for his use in rue Vercingétorix. Restored to health, delighted with his new studio, Delaney began a highly productive period surrounded by friends, among them the novelist James Jones, who had moved to Paris. In 1964 Delaney received a Fairfield Foundation grant, which eased his financial anxieties. That December he exhibited his first productions from rue Vercingétorix at the Galerie Lambert. Baldwin and Jones wrote catalog commentaries.

Delaney's rue Vercingétorix paintings were carried

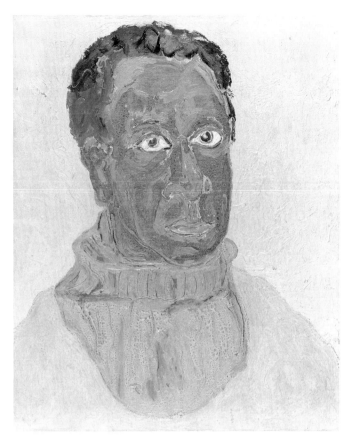

Delaney's striking portrait (1970) of Jean Genet, France's provocative playwright and author, is considered one of his best and is boldly signed. (36 x 24″) Collection Mrs. James Jones, Sagaponack, N.Y.

In this realistic but not photographic self-portrait, done in the 1970s, Delaney appears solemn and sad, as if trying to confront himself in an unsparing manner. (36 x 24″) Collection Mrs. James Jones, Sagaponack, N.Y.

out with "an extraordinary exhilaration," Long has noted, but lacked the thick impasto characteristic of his Clamart work. Some canvases, Long added, had "an overtone of melancholy imposed either by a somber palette or by the sheer power of clashing color-masses."[15] Such clashes were also not characteristic of Delaney's earlier work.

To improve his concentration on color and gain an increased luminosity in his work, Delaney had covered all the surfaces in his studio with white sheets and paper. In reviewing the Galerie Lambert exhibition, the French critic Guichard-Meili wrote: "It is clear that the eye which halts at the surface of these canvases, when they seem based on the modulation of a single color (yellow, most often), perceives only a small measure of their resonance. Only a methodical and extended exercise of vision will permit their being sensed and savoured amid and beneath the network of color tones, differentiated among themselves, the subtle play of this pink and that blue (of the same value), the movements of internal convection, the vibrations of underlying design."[16]

Guichard-Meili and other critics noted that Delaney's portraits, although representational, did not dif-

fer significantly in terms of color from his abstract work: "Background, clothing, hands and faces are the pretext for autonomous harmonies."[17] These portraits, some in pastel, included such well-known people as the French writer Jean Genet and Marian Anderson.

Delaney also painted landscapes at Baldwin's Côte d'Azur home, emphasizing the local cypresses in a swirling Van Gogh manner. He carried this mannerism into more abstract paintings, attributing the governing impulses of many of his arabesque and swirling abstractions to jazz rhythms. In 1967 the Musée Galliera in Paris presented an exhibition, "L'Age du Jazz," of these works.

During this period, Long, Jones, and Baldwin worked ceaselessly to get Delaney support. In 1968 the National Council on the Arts made unsolicited grants to thirty artists and awarded him $5,000. The following year Delaney went back to Knoxville to see his mother—"beautiful and saintly," he called her.[18] Finding there the pastel portrait he had made of her in 1933, he made a new one from memory on his return to Paris.

However, soon after Delaney's return to Paris he showed signs of impaired memory and orientation

typical of Alzheimer's disease. He had less and less ability to concentrate. He said he had no money when he did have it. He often walked out of restaurants without realizing he had not paid the bill, causing embarrassment. Darthea Speyer, who had opened her own gallery and who had become one of Delaney's closest friends, organized a major exhibition of his work to gain funds for his care. Its catalog included tributes and comments from Georgia O'Keeffe, James Baldwin, Henry Miller, and James Jones.

The problem of who would take care of this aging, increasingly disabled artist became public when *Le Monde* published "An American in Paris: The Plight of Beauford Delaney," which was reprinted in the *Manchester Guardian* on August 15, 1976. Because he had long been a resident artist of Paris and was gaining a distinguished reputation, and because it recognized the importance of artists to Paris, the French government took the extraordinary step of assuming responsibility for this American citizen, hospitalizing him and holding his paintings in trust, presumably to pay for hospitalization.

Beauford Delaney died on March 26, 1979, almost a year after his first major retrospective show in the United States opened at the Studio Museum in Harlem.[19] Long had secured the release of Delaney's paintings from the French government in Paris and supervised their shipment. The catalog reprinted Baldwin's 1964 comment, which ends: "Beauford's work leads the inner and the outer eye, directly and inexorably to a new confrontation with reality. At this moment one begins to apprehend the nature of his triumph, and the proof that it is a real one is that he makes it ours. Perhaps I should not say, flatly, what I believe—that he is a great painter; but I do know that great art can only be created out of love, and that no greater lover ever held a brush."[20]

He was buried in Paris after a funeral service that drew hundreds of Americans.

JOSEPH DELANEY

People were the primary concern of Joseph Delaney, who spent his life portraying them, usually in a freely expressionistic way. His work is at times reminiscent of Henri de Toulouse-Lautrec and, in some respects, of another portrayer of the American scene, Reginald Marsh. Yet there is an element of fantasy that distinguishes Delaney's work from Marsh's. His huge, exuberant *Times Square, V.J. Day* has touches of Surrealism in its tumultuous rendering of joyous humanity at a great moment in United States history. Although never as well known as his older brother Beauford, Joseph Delaney produced much striking and original work. *Times Square, V.J. Day* was one of the dominating works at the large "Evolution of Afro-American Artists" exhibition in New York in 1967, where it was shown for the first time, and his drawings are part of the famous Index of American Design.

In 1968, when the Studio Museum in Harlem presented the exhibition "Invisible Americans: Black Artists of the '30s," Joseph Delaney's *Waldorf Cafeteria,* depicting Greenwich Village's famous gathering place in the 1930s of poets, writers, artists, and "characters," was singled out by critics for special praise. He also painted many portraits of well-known people, among them Eartha Kitt, Eleanor Roosevelt, and Tallulah Bankhead. Yet most of his subjects were friends or passersby at the Washington Square Outdoor Art Show (he was one of the first black artists to exhibit in this show, starting in 1931 when Vernon Porter, Juliana Force, and Gertrude Whitney organized it). His work is in many private collections as well as that of the University of Arizona and has been exhibited at the Metropolitan Museum of Art and the National Academy of Art. In 1970 the Frank H. McClung Museum at the University of Tennessee in Knoxville presented a large show of his work, organized by Elsa Honig Fine, marking the first time he was honored in his hometown.

Joseph Delaney was born in Knoxville on September 13, 1904, the sixth son and the tenth child of the Reverend Joseph Samuel Delaney and Delia Johnson Delaney. The family moved many times during his childhood. In particular, Joseph remembered moving from Jefferson City to Harriman, Tennessee, now the site of Mossy Creek College, because his father conducted many revival meetings there. Growing up in a devout home, he remained a religious man.

Joseph was presumably interested in drawing by his older brother Beauford. He later remembered that "we were always doing something with our hands—modeling with the very red Tennessee clay, also copying pictures. One distinct difference in Beauford and myself was his multi-talents. Beauford could always strum a ukulele and sing like mad and could mimic with the best. Beauford and I were complete opposites; me, an introvert, and Beauford, an extrovert."[1]

Except for painting, virtually all the brothers' interests and tastes ran along very different lines. Joseph recalled that Beauford "was never happier than the day in 1969 when I visited Paris. He took me to the French Opera, which is truly great—but I will settle for Moulin Rouge any time."[2] Nothing explains why one black family in the South should produce two notable artists, each determinedly following his vision. Joseph felt their early religious training played an important part in their artistic development, although he never defined this.

Joseph's first encouragement from outside the family came in 1918, when he was fourteen years old. One of his sketches so pleased a teacher, Mrs. J. S. Dailey, that she bought it for fifty cents. That purchase made him feel his work was worthy, although he thought of drawing and painting as a hobby. Many years later, in 1970, when the McClung Museum opened its major exhibition of his work, Mrs. Dailey, ninety-two years old and still living in Knoxville, recalled his early work and took pride in having recognized his talent and helped him get started.[3]

Lobby of the Art Students League (1965). The League was a second home to Delaney, who came almost daily to draw. His painting depicts Stewart Klonis, the director, talking with Chris Bucheit, the building superintendent and creator of a simple student easel. Delaney studied with Thomas Hart Benton at the League and was a friend of another Benton student, Jackson Pollock. (37 x 54″) Estate of Joseph Delaney

After high school, Joseph Delaney "hit the road," working his way northward, doing odd jobs. In Cincinnati, Pittsburgh, Detroit, and Chicago, he worked as a waiter, but drew and painted for his own pleasure. In Chicago, in the mid-1920s, he worked in hotels and nightclubs, traveling to the South Side for his social life and to hear black musicians who were creating Chicago-style jazz. He frequently sketched jazz musicians.

In 1930, deciding to become a professional artist, Delaney came to New York to study at the Art Students League with Thomas Hart Benton, then the most controversial artist in America. In Benton's studio he became a friend of two other students, Jackson Pollock of Wyoming, who had not yet evolved his abstract style, and Bruce Mitchell. A dynamic influence, Benton called for the development of "American painting," work that reflected American history and conditions in a realistic way, with landscapes and scenes that broke away from both the academic traditionalists and the modernists of Paris. He charged that "coteries of highbrows, of critics, college art professors, and museum boys" were pushing the French modernists and controlled the best art schools and journals, preventing the development of an art based on American culture.[4] Benton's views brought about "a run-in," to use Delaney's term, with the dominant "traditionalist" group at the League. This culminated in Benton's resigning "after I had been in his class about five months," Delaney recalled. "He was a very independent man aesthetically."

Delaney was strongly influenced by Benton's demand for the American landscape with people. Benton's canvases were alive with men and women—working in the fields, threshing, picnicking, drinking in saloons. Carried out in a strong rhythmic style, his paintings were also unusual at the time because they often included African-Americans, working at anything from loading cotton on a riverboat to plowing. Delaney credited Benton with deepening his understanding of the use of color in composition. Interestingly, a form of composition that utilizes a spiraling rhythm is characteristic of many of the works of Benton, Pollock, and Delaney, although each used different subject matter.

At the League, Delaney continued his studies with Alexander Brook, who then painted barren southern landscapes occupied by a few black people, who face the viewer. Brook convinced Delaney his knowledge of anatomy was weak. He therefore turned to the League's famous anatomist, George B. Bridgman, for months of intensive study. Some forty years later Delaney still felt that he had learned much from Bridgman.

Survival during the Depression was a struggle. "I did all kinds of jobs," Delaney recalled. "I worked as a model. I washed windows, waited on tables, anything and everything." While living on Downing Street, he won a prize at the exhibition of the Greenwich Village Art Center, which was headed by Mrs. Maximillian Elser. "There were," he recalled, "a lot of ladies in those days who sponsored artists, gave them a little money, that sort of thing, invited them to suppers for their friends."

These women also arranged commissions for portraits. Delaney painted many portraits, including former Police Commissioner Edward P. Mulroney, and a Boy Scout executive, Stanley Harris. Chester Arthur, a grandson of the president, arranged for him to make a portrait of Olivia Wyndham, the goddaughter

His Last Known Address (ca. 1934) was painted during the Depression of the 1930s. The cross juxtaposes religion with the plight of this aged, homeless man. To survive, Delaney taught under the PWAP, the initial federal art program, and later drew for the Index of American Design under the WPA. (34 x 42″) University of Arizona Museum of Art, Tucson

Dr. Gladys Graham (1969). A friend of Delaney's, Dr. Graham wrote a column for African-American newspapers. Portraits were Delaney's principal means of support. Ethnic American Slide Library, University of South Alabama, Mobile

of Queen Victoria. She was one of a group of "downtown" socialites who visited Harlem cabarets, had friends on Harlem's "Sugar Hill," and liked the idea of sitting for a black artist. "When she came to my studio," Delaney recalled, "I thought I had never seen anyone so beautiful. There was some spark in her, the spark of an elegant and beautiful English lady." The portrait remained in Delaney's possession, although often exhibited, until a show of his work was arranged in England. Delaney then gave the portrait to the Bertrand Russell Foundation for Political Prisoners. "It belonged in England," Delaney said. "She was an English lady."

In 1936 Delaney taught drawing under a federal art program administered by the College Art Association. Later he participated in one of the WPA's outstanding achievements, the Index of American Design, which recorded the main types of American decorative art from colonial days through 1900. Working in the Metropolitan Museum's collections, he rendered in hard pencil, sometimes in watercolor, colonial sugar bowls and bottles, silver and pewter ware, and American-Dutch tapestries. One of his pencil drawings

of pewter ware was exhibited by the Library of Congress as an outstanding contribution to the Index.[5]

Delaney painted hundreds of portraits. One of the most striking depicts Dr. Gladys Graham, a columnist for the black press, whom he knew from childhood. However, he is best known for his expressionistic paintings of American scenes that were important to him—scenes that often include many people. Among these paintings are *Ice Skating in Central Park, Chelsea Bar, Penn Station: Troops Moving, War Bond Rally, Morning Subway,* and the *Lobby of the Art Students League,* which included his friends the artist Stewart Klonis and the building superintendent Chris Bucheit. Filled with people, each of these lively canvases has a distinctly different personality, but all are unified by Delaney's own expressive view, color, and composition.

Nowhere is this approach more evident than in *Times Square, V.J. Day,* where a writhing mass of exuberant people are "letting go" in a turbulent scene.

East River (1944) won the John Hope Award for Oils at the 1946 Atlanta University exhibition. It fully captures the turbulent waters and the power of the tugboat against the clouds and the city's skyscrapers. (13½ x 18″) Collection Clark-Atlanta University

Overhead, a mysterious cross appears in the sky with the words "Peace on Earth." These and other elements of fantasy make Delaney's work at times transcend the work of other painters of city scenes.

In *Times Square, V.J. Day* the subjects are not the naively "happy" people of the WPA style or Marsh's excited fleshy types. These people are hungrily rejoicing, knowing, bursting with tensions of all kinds—a laughing, hugging, gabbing, lurching, drunken mass, praying, squeezing, waving, and watching—in a bizarre scene that is purely American. The expressionistic style gives full vent to how Joseph Delaney himself felt that day in Times Square. At the same time it organizes what he saw. Although thousands of paintings have dealt with World War II, this huge uncommissioned canvas, the largest Delaney ever painted, is one of the best.

On V-J Day, Delaney recalled:

I heard the news on Grand Street. That's where I lived then, No. 69. . . . I started for Times Square, which always fascinated and excited me because I knew that's where it would be happening. When I came up out of the subway, I found such a mass of happy people—a great mass of joyous humanity. At first I couldn't move. People were just jammed together. Some crying, some laughing, some shouting, excited, everybody drawn together, touching.

I slowly worked my way up to 46th Street, where, near Father Duffy's statue, I could get the kind of perspective of the whole scene that I wanted—of thousands of people with overwhelming joy, just let-

ting go, as though everything terrible had ended. It was an unforgettable scene.

Yet although *Times Square, V.J. Day* seems spontaneous, Delaney did not make the painting until 1961, more than fifteen years after the event. "Maybe I wasn't ready," Delaney said, continuing:

But I never forgot it and it actually came about in this way. I go every week to the Art Students League to draw. I'm a life member and I can draw there free on Fridays. I believe it keeps me fresh with the body, which is important for a figure painter. Well, often I walk down from the League between sessions to Times Square because it always interests me. . . . It is my entertainment, just going there, and sometimes I sketch there.

One day I came upon this War Bond rally back in the forties and here was Cab Calloway's band playing in the midst of Times Square. I made a lot of sketches and in 1949 I made that painting. The overwhelming number of people you see are white and so I put into the scene Fred Neal, Eartha Kitt, and Bojangles [Bill Robinson] to represent the black artist.

After making several paintings of such Times Square scenes, Delaney realized that he had not painted the greatest scene he had ever witnessed there. "So I decided to do it. I thought about it a lot and then I bought this big canvas, the biggest I ever had, and all the paint, and so I did it."

Drawing upon his visual memories of the scene and his own feelings, he astonished his friends with the

Penn Station in Wartime (1943), painted freely and objectively, captured the diversity of the people and of the feelings being expressed in the great, dimly lit station as soldiers and sweethearts said goodbye and people of all ages both moved and waited as part of the war effort. (38 x 48⅛″) National Museum of American Art

final work. For years he had no way to exhibit it properly. Today the painting, owned by the McClung Museum, hangs in the library of the University of Tennessee, a gift from Delaney out of gratitude for its large 1970 exhibition of his work.[6]

In the mid-forties, before doing the Times Square scenes, Delaney painted a favorite haunt of the time, the Waldorf Cafeteria. Located on Sixth Avenue below Eighth Street, it was a noisy gathering place of Greenwich Village artists, writers, and "characters." The principal figure in the painting is Maxwell Bodenheim, a leading poet of the twenties, known later mainly for his ill-tempered obscenities. This painting particularly attracted critics when it was shown, over twenty years later, at the Studio Museum in Harlem. Robert Pincus-Witten, writing in *Artforum,* said, "A single artist of tremendous merit was revealed to me in terms of a developed, tough, and at moments, self-mocking Expressionism—Joseph Delaney. *Waldorf Cafeteria* is terrifically painted with a breadth and ease of caricature that would please an Ensor."[7] Some of Delaney's other

paintings suggested to Pincus-Witten the Expressionism of Oskar Kokoschka and the Romanticism of Yasuo Kuniyoshi.

Delaney's favorite painting, *Harlem Sunday Morning,* remained in his possession. It depicts masses of people going to church in Harlem, women and children in their best clothes and a man strumming on a guitar. "It's a story that appeals to me, it's got the feeling that I'm always after," the artist said.

In 1968 Delaney summarized many of his thoughts in a small pamphlet, "Thirty-six Years Exhibiting in the Washington Square Outdoor Art Show." Assailing racial discrimination, he called on black people to prepare themselves for all kinds of jobs and opportunities. Of beauty, he said: "Beauty is not always good to look at. It may appear in people who know the other side of reality, which is suffering." Describing himself as "basically a religious man," he wrote that "the divine plan for mankind is revealing the truth to the

Waldorf Cafeteria (1945). This Greenwich Village hangout for artists, writers, and colorful characters in the 1940s was also known as "the snake pit." The standing figure is said to be poet Maxwell Bodenheim, who was later murdered.

world. . . . Our communications have made the world a small place and all of us [are] living in a glass cage." As the son of a preacher, he liked to draw moral lessons from the events of his life, making them into brief sermons.

In 1974, Delaney decided to create his own anatomy textbook for artists, starting with what he learned from Benton, who—he explained—"called anatomy 'bumps' and 'hollows' but I've got my own ideas." Other developments intervened, however. One was a major exhibition at Princeton University in 1976, titled "Fragments of an American Life," which included ten of his paintings.

More important, and continuously distracting, was news of the deteriorating condition of his brother Beauford in Paris. When Beauford died in the spring of 1979, Joseph went to Paris to attend his funeral. He was touched to find that some 300 Americans came to the service and that a pastor from once segregated Tennessee, associated with the American church in Paris, eulogized Beauford. Later Joseph brought back from Paris many of his brother's works, nearly crowding himself out of his studio.

These events proved so disruptive and so expensive that he took a job with the Comprehensive Employment and Training Agency to document visually activities at the famous Henry Street Settlement House on the Lower East Side. This led, in 1982, to an exhibit at the settlement house of thirty-five of his paintings, including scenes from Coney Island, City Hall, and the Armistice Day and Thanksgiving Day parades, scenes crowded with people.[8]

Although Beauford and Joseph Delaney had not

Easter Parade (1969). This was one of a number of New York parades that Delaney loved to paint because of the buzzing crowds and the incongruity of the colorful costumes. Here people overlap to such an extent that each becomes part of the other. (72 x 48″) Knoxville Art Museum

been close for many years, Beauford's death had reunited the entire family, reviving old roots. In a brief catalog note for the Studio Museum's exhibition of Beauford's work, Joseph paid tribute "to our parents, who did their best bringing us up in the right way."[9]

Joseph Delaney returned to Knoxville as artist-in-residence at the University of Tennessee in 1985. The next year its Ewing Gallery presented a large exhibition of his work and he became a living resource for its art students. He died November 20, 1991, at the Knoxville Medical Center.

Possessing an exceptional insight into American people and their lives and singularly sensitive to emotions, events, and circumstances that all other artists ignored, Joseph Delaney was a daring painter, a compelling witness to our time. In the great biblical sense, his paintings testify.

JACOB LAWRENCE

Jacob Lawrence was hardly more than a youth when, in 1941, he was recognized as one of the most original artistic talents to develop in America. Almost from the beginning of his career his works have been sought by museums and major collectors. Unlike many artists whose styles pass through many phases, Lawrence's work has remained essentially the same, although becoming more sophisticated in composition and color. No matter what winds have blown in the art world— Social Realism, Surrealism, Abstract Expressionism, Pop, Op, Hard Edge, or Super-Realism—Lawrence has held to his vision. In the same sense that George Grosz created a striking portrait of Germany in the 1920s and early 1930s, when the Nazis were emerging, Lawrence created a complete picture of the life of black people in Harlem during the Depression.

If the work of all American artists were to be viewed as a historical continuum, that of Lawrence would seem to burst like a furious rocket upon it. His subject matter, his stylizing of figures, his method of painting, his indifference to the academic rules of drawing and perspective that trapped many American artists before him, his ignoring of artistic fashions and fads— all these have set him apart from the artistic conventions of the last fifty some years. Most artists need such conventions and many, attempting departures, might fail ignobly; Lawrence succeeded brilliantly. The Depression cannot be fully fathomed without reference to his work, one of the most eloquent social statements ever to come from an American artist.

Lawrence and his emergence were in direct contrast to the black artists who developed in the 1920s and earlier. They had to prove they were artists, to themselves and to the art public. These immediate predecessors included Hale Woodruff, W. H. Johnson, and Augusta Savage, all of whom carried out intense and prolonged studies in America and abroad along very traditional lines. In comparison, Lawrence had relatively little formal training. And where Henry Ossawa Tanner, confronting the problems of his day and

according to his very different background, had to express his experiences as a black American in religious themes, Lawrence dealt directly with what he saw and knew in Harlem: street preachers, clinic waiting rooms filled with the sick and crippled, curbstone checker players, pool halls, social club parades, people working, lovers and loungers. He dealt too, in a significant and direct way, with African-American history, composing narrative sequences of the past, unparalleled in the history of American art. This directness sets him apart from Archibald Motley, Jr., who tended to select themes that romanticized his basically realistic scenes.

Among the thousands of African-Americans migrating northward during World War I, Jacob Armstead Lawrence, from South Carolina, went to Atlantic City, where he met Rose Lee, from Virginia. They found jobs and married. Their son, Jacob, Jr., was born there on September 7, 1917. When their jobs played out, they moved to Easton, Pennsylvania, where Jacob, Sr., got a job in the anthracite mines. But hard times came, and he became a cook on a railroad dining car, called only when needed. The job took him away from his family, and the lack of steady work added to family problems and discord. The Lawrences now had three children, Geraldine and William having been born in Easton. Their marital differences mounted and finally they separated.[1]

Rose Lee Lawrence moved to Philadelphia, where she struggled to find work and care for her children. Young Jacob was often left in charge of his younger sister and brother. About 1927, believing opportunities for work might be better in New York, she found foster homes for the children and came to Harlem, returning to see them as often as she could. She was able to bring the children to New York about 1930.

The dislocating impact of these moves on Jacob was considerable. An anxious, dutiful, quiet boy, he was then thirteen years old and trying hard to cope

with what was expected of him by his mother, other adults, white schoolteachers, and new neighbors, including both older and younger boys and girls. He not only lost his old friends and status at a critical point in his development, but entered a totally new, confining environment. In Philadelphia, which has a one-family house tradition even in black neighborhoods, there was space to play and privacy. In contrast, Harlem was New York's most densely populated area; in 1930 approximately 233 people occupied a Harlem acre compared to 133 people per acre elsewhere in Manhattan. Economic conditions forced more and more people into Harlem to live with relatives.

Already anxious and upset over his uprooting, young Jacob felt cramped and pushed in Harlem. A stranger without alliances, his world had become a hazardous place and for several years he had a difficult time adjusting to it and silently withdrew.[2] His mother feared he would inevitably be drawn into a street gang. His school, Public School No. 89, was considered "rough" by many Harlem people.

Learning of an after-school arts and crafts program in the basement of the 135th Street branch of the public library, Rose Lee Lawrence enrolled her son. The program was directed by James Lesesne Wells, later a professor of art at Howard University (see pages 392–93). Jacob was assigned to Charles Alston, who was then completing his master's degree at Columbia University (see page 261). An excellent artist, Alston simply encouraged Lawrence to try to have fun with the available materials: soap to carve; reeds for basketry; wood for carpentry; crayons, pastels, and pencils for drawing; and poster colors for painting. Whatever Lawrence did, Alston praised. A few months later, when the Utopia Neighborhood Center set up a similar program with Alston in complete charge, Lawrence transferred to that center.

"I don't think I drew or painted before that any more than most kids do in school, or maybe on your own when you get something for Christmas like a set of paints," Lawrence said later. "Prior to going to the center I didn't have the encouragement or the materials available. Not that I wanted to, but at the center the materials were there, so right away it opens up a whole new area for you."

Supervised by someone who was not criticizing, urging, nagging, or pressuring him, Lawrence began to work with pleasure, increasing interest, and pride in what he could do. At first he almost obsessively made symmetrical geometric patterns, coloring them with primary colors. He found this enormously satisfying, and as his satisfaction increased, his patterns became more elaborate. Years later Lawrence believed that the patterns in some small, cheap Persian-type rugs at home stimulated this interest.

Constantly working at new patterns, Lawrence developed a method of putting a certain color into all shapes of one kind—making all triangles blue or all rectangles green. This method was later carried over into his painting of a narrative series. He might first have thirty paintings with only the blue finished in each. He might then put in all the greens or reds, and so on with each panel. When he completed the last color, the whole series was finished. This highly individual way of working gave his color a consistency from panel to panel.

More significantly, Lawrence's early concentration on patterns helped him to see patterns elsewhere: in architectural decorations, window placements, cornices, subway ties, marching paraders, and human activities of all kinds. Patterns also served to organize and reduce the chaos of his feelings; they brought life under *his* control—at least some of it.

Alston became convinced very early that Lawrence was unusually gifted. While other children asked, "What should I do now?" Lawrence "knew what he wanted to do and simply wanted to know how to do it. That's where I helped him. I decided it would be a mistake to try to teach him. He was teaching himself, finding his own way," Alston said later.[3]

The Utopia Neighborhood Center's art books and magazines were a constant stimulus to Lawrence. Finding an article on W. T. Benda and the papier-mâché masks that made Benda internationally famous, he immediately wanted to make masks. After Alston showed him how to mix papier-mâché, Lawrence plunged into making life-size decorative masks. Creations of his fantasies, his masks were colored in varying ways with pastels or paint. He did not know about African masks at the time.

Not long after this, Lawrence began creating neighborhood street scenes inside cardboard shipping cartons. Cutting away the top of a box, he would paint familiar neighborhood sights on the remaining three sides—groceries, funeral parlors, bargain furniture stores, barbershops, dilapidated tenements with broken windows, billboards, fruit stands, and newsstands. These box scenes resembled stage sets. Lawrence later described them as "places where I had lived." Asked about their resemblance to stage sets, he said: "I didn't know about the theater at that time . . . so I don't know how I happened to do this. . . . They were mostly street corners. . . . They were just like any two-dimensional painting—only they were three-dimensional." None of these boxes or the masks still exist.

Street Orator (1936). Concentrating on the rapt faces of the listeners rather than the dramatic spellbinder reflects Lawrence's originality and his freedom from conventional approaches. (23½ x 18″) Collection Gwendolyn and Jacob Lawrence, Seattle.

About this time, while looking at some art books at the center, Lawrence became interested in Pieter Brueghel because "he did the country peasant scenes and things like that. He used very bold forms, very primary colors relatively speaking, and so I could relate both form and color to Brueghel." Later he considered Brueghel to be a significant influence on his work.

Although Lawrence selected commercial art as his prime interest at Commercial High School, nothing he was taught seemed to have any bearing on his interests. One teacher, he recalled, did encourage him to write poetry, something he was also trying to do at the time. However, he became discouraged and gave it up. His schedule called for business arithmetic and business letter writing, which were perplexing and frustrating to him.

Lawrence's mother tried to keep his attention on schoolwork, but she could not overcome what the school inherently lacked—something that would relieve his feelings of anxiety, anger, frustration, and failure. Finally, after two moody years, young Jacob simply stopped going. He hunted for junk and old bottles on the streets to sell for a few pennies, ran errands, or did odd jobs. As the Depression deepened,

his mother lost her job and the family went on relief. The only thing that gave Lawrence any satisfaction was painting small Harlem street scenes. Mostly he depicted the red brick buildings, seeking patterns in their windows, fire escapes, and signs, but sometimes he included stylized figures of people. His mother, upset because he had quit school, had no sympathy for his interest in painting. Their mutual anxiety, frustration, and anger rose with continued deprivation.

Finally, in 1936, Lawrence was accepted by the Civilian Conservation Corps, a federal project set up under army command to get the young males of relief families off city streets and breadlines and give them work planting trees and building roads. At the CCC camp near Middletown, New York, Lawrence dug ditches for a dam. Finding he could do a man's work with satisfaction, he thought of drawing or painting only as a hobby.

When his mother's employment improved family circumstances, Lawrence returned to Harlem. He scurried endlessly for money, delivering laundry and running errands for a small storefront printer. In this way he saved enough money to buy a *Bronx Home News* delivery route. His mother urged him to get a post office civil service job, one of the few systems offering black Americans job security. But Lawrence's experiences in the CCC made him realize that without an education he was going to be permanently assigned to menial tasks.

During this period Lawrence did little painting until he discovered that Alston was teaching in a WPA art center at 306 West 141st Street. Alston sent him to the free classes at the Harlem Community Art Center directed by Augusta Savage at 125th Street and Lenox Avenue. Well-known African-Americans, such as James Weldon Johnson and the actress Rose McClendon, came there to pose for students. "While I didn't realize it at the time, I was greatly inspired and influenced because of my closeness to such personalities," Lawrence later told Elton Fax. "Young people today talk as though black experience is something new that they alone have discovered. Actually, what is happening now [the development of African-American studies] is an extension of what was happening then."[4]

Soon after dropping out of high school, Lawrence chanced upon one of Professor Charles Seifert's dis-

Clinic (1937), which depicts the sick and injured in a depressing waiting room without a sign of help, was based on Lawrence's own visits to the Harlem Hospital clinic at that time, he wrote the authors. (20 x 20″) Collection Gwendolyn and Jacob Lawrence, Seattle.

Bar 'n Grill (1937), with its blind musician and his trick begging dogs and its self-absorbed customers, demonstrates Lawrence's faithfulness to what he observed. It is a picture of despairing people. (Tempera on paper, 22¾ x 23¾″) Collection Gwendolyn and Jacob Lawrence, Seattle

cussions of African and African-American history at the 135th Street library. Fascinated, he became a regular attendant. When the Museum of Modern Art exhibited West African sculpture in 1935, Seifert inspired Lawrence to make one of his first trips "downtown" to the white man's world to see the exhibit. Impressed by the solemn African figures and the reverential way the museum displayed them, Lawrence promptly procured two small four-by-four-inch blocks of wood in an attempt to carve. "I didn't have any carving tools so I whittled more than I carved," he recalled. "The show made a great impression on me." It particularly demonstrated that black people were capable of significant art and were in themselves suitable subjects for such art. Previously, Lawrence's work had not always included people, but he now began to concentrate on them, emphasizing the humanity in the faces gathered around the legs of a street corner orator, in the sick and injured waiting in the Harlem Hospital clinic, in men seeking work, in step sitters and neighborhood scenes.

Seifert's discussions enriched Lawrence's understanding of and identification with his people, linking past struggles with current ones. Lawrence learned more about this in discussions at 306—Alston's apartment. Never very talkative, Lawrence plunged into an intense study of the history of black people, stimulated by anger over the omission of this history from school-

books and by his growing pride in black accomplishments in the past. He was particularly attracted to the heroism of Toussaint L'Ouverture, the Haitian military leader who had overthrown slavery and freed his tiny island country from foreign domination. Aided by Seifert, Lawrence read everything he could find about Toussaint. He decided he had found an appropriate subject for a portrait of a great black leader.

Feeling that no one picture, however dramatic, could convincingly express what had been achieved by Toussaint, Lawrence abandoned traditional portrait concepts and created, almost cinematically, a series of forty-one pictures. These narrative paintings begin with Columbus discovering Haiti, continue through Toussaint's birth and early life, his battles and victories, ending with his death in a French prison and the Haitian people's prevention of the restoration of slavery.

Everything in Lawrence's paintings was carried out with an intense effort to make it emotionally "real" to the viewer. As a narrative painter, Lawrence unknowingly closely resembled the Sienese Renaissance artist, who, as art historian George H. Edgell has pointed out, achieved his effects "by fields of color far flatter than any other Italian school and by line . . . [expressing] character and emotion by line."[5]

Lawrence's *Toussaint L'Ouverture* series shows Haitian people in realistic settings but without naturalistic detail, concentrating on the emotional reality of their

struggle. The faces of his subjects are masklike, utterly free of sentimentality; at the same time his painting is powerful and moving. The *Toussaint L'Ouverture* series makes it clear that Lawrence's long boyhood absorption with patterns gave him a unique vision and a grasp of their compositional uses. Singling out the essence of patterns in everything from blades of grass to leaping flames and marching troops, he created daring color patterns that gave his work impressive compositional strength.

By directing Lawrence's attention to the past, Seifert introduced him to subject matter through which he could freely and eloquently express the intense anger he felt over the degradation forced on black Americans and at the same time celebrate past achievements of black people. All of Lawrence's paintings dealing with American history and democracy, ultimately a significant portion of his work, derive from his relationship with Seifert, even when the subject matter is not African-American, as in his famous series on establishing democratic rights in the United States, *Struggle: From the History of the American People*.

If Seifert opened the past to Lawrence, Alston provided the key to the present and to becoming a professional artist. Alston's apartment, over the WPA art center at 306, was one of the intellectual centers of Harlem. There Lawrence heard discussions that ranged over every problem confronting black Americans, including all the social, political, and aesthetic aspects.

Proud of his pupil, Alston made all who came to 306 aware of Lawrence's bold Harlem scenes. To many, Lawrence symbolized the coming black artist. Some feared that, however talented, Lawrence would be crushed by the economic and racial problems that burdened America—and that had frustrated them. Therefore, they encouraged him, steadily included him in their ranks, and treated him with friendly warmth and respect—something he had seldom encountered.

Through Alston's influence, Lawrence received a scholarship to American Artists School, where Anton Refregier, Sol Wilson, and Eugene Morley taught. However, his need to earn money made his attendance so sporadic that he abandoned the effort, and these artists were not a significant influence on his work.

One day Augusta Savage learned from Lawrence that his economic difficulties had virtually forced him to stop painting. Remembering her own difficulties in getting started, she took Lawrence to the WPA headquarters and tried to get him on the payroll as an artist. Lawrence was ruled ineligible because he was not twenty-one years old. Considering this just another "turndown," Lawrence forgot about it in his scuffle to make a living; painting was only a hobby. Savage, however, did not forget his birthday. A year later, she looked him up, and again brought him to the WPA headquarters. This time she succeeded in getting him enrolled as an artist.

Assigned to the easel project, Lawrence could paint at home in whatever medium he chose, was provided with materials, and was paid approximately twenty-six dollars a week. Later, he said: "If Augusta Savage hadn't insisted on getting me onto the project, I don't think I would ever have become an artist. I'd be doing a menial job somewhere. It was a real turning point for me."

The most significant aspect of his WPA experience was that for the first time in his life he was free to paint all day, with time to study and develop his own technique, to experiment with oils and tempera, and to find out how to achieve the effects he desired. He could, moreover, feel that he was indeed an artist worthy of the name. As his skills increased, so did his confidence.

The WPA project, bringing all kinds of artists, writers, actors, and dancers together, stimulated a wide-ranging analytic discussion of the social content of art, amplifying the viewpoints expressed at 306 and broadening Lawrence's understanding of art. At WPA headquarters he met many writers like William Saroyan and Jay Leyda. He became active in the Artists Union and the Harlem Artists Guild, which was formed to deal with cultural problems unique to black artists.

Finding painting at home difficult, Lawrence first paid Henry "Mike" Bannarn a small fee to use his studio. Later he joined a group of artists in a dilapidated building, often lacking electricity and heated by small kerosene heaters, at 33 West 125th Street. Among the tenants were the abstract painter Ronald Joseph, Romare Bearden, and Claude McKay, whose first novel, *Home to Harlem*, had been a best-seller; McKay's 1937 book, *A Long Way from Home*, was widely discussed among black intellectuals because of his views on Marxism and black nationalism.

During this period Lawrence learned how to grind his own colors. After tracing his drawings onto gesso panels, he experimented with gouache and tempera. Bearden shared in these experiments, which were based on formulas in Max Doerner's *Methods and Materials of the Artist*. Once, attempting to avoid the foul odor of decaying eggs in mixing egg tempera, Lawrence tried ammonium chloride, which turned out to be just as bad. Such experiments and discussions with other WPA artists ended Lawrence's technical dependence on Alston.

The most inspiring aspect of Lawrence's life and

1

2

20

25

Toussaint L'Ouverture (1938). This series of forty-one paintings, inspired by the Haitian Revolution of 1795, was given a separate gallery in the 1939 Baltimore Museum exhibition of African-American artists and established Lawrence as a significant American artist and a powerful narrative painter. Although small (11 x 19″), the panels are monumental in character and fired with emotion. Lawrence himself wrote the captions. Four panels are reproduced here. No. 1. "Columbus discovered Haiti on December 6, 1492. . . . He is shown planting the official Spanish flag, under which he sailed." No. 2. "Mistreatment by the Spanish soldiers caused much trouble on the island and caused the death of Ancanca, a native queen, 1503. . . ." No. 20. "General Toussaint L'Ouverture, Statesman and military Genius, esteemed by the Spaniards, feared by the English, dreaded by the French, hated by the planters and reverenced by the Blacks." No. 25. "General Toussaint L'Ouverture defeats the English at Saline." United Church Board for Homeland Ministries, Amistad Research Center, Tulane University

This Is Harlem (1942–43). The first of thirty paintings in the Harlem series, this complex scene is one of Lawrence's outstanding paintings. Its organization suggests the Harlem streetcorners Lawrence created in cardboard boxes when he first started to paint. (Gouache on paper, 14⅜ x 21⅞") Hirshhorn Museum and Sculpture Garden, Washington, D.C.

work in this building was the camaraderie and stimulation he found in the day-and-night exchange of ideas with other artists and McKay, who had traveled extensively in Europe and the Soviet Union and who was often visited by other writers. One frequent visitor was William Attaway, whose novel *Blood on the Forge* was soon to appear. Lawrence, always a serious reader, enjoyed listening to these storytellers. Drawing on black history and folklore freely for their imagery and tales, these writers deepened Lawrence's appreciation of the resourcefulness of black people and further developed his sense of narrative, a major characteristic of his work.

In Lawrence's early work the composition itself was organized around story-telling Harlem scenes, and in many respects these works are like simplified news photos of the moment. In them each element is related to others through a geometrically based pattern, the result of Lawrence's search for elements yielding patterns.

Lawrence's narrative style thrust him against the main directions in which American painting was then beginning to move. Alston, as his teacher and an informed modern painter, delighted in Lawrence's flat shapes, amorphous figures, organizing patterns, and strong sense of flat color. These aspects of his work were compatible with the modern movement. However, his literary, story-telling quality was the complete antithesis of modern painting. Yet this narrative quality was, and still is, the essence of Lawrence's vision. Recognizing how this differentiated Lawrence, Alston called him "an original" and made no effort to scourge story telling from his work. Lawrence's persistence, in the face of the increasingly abstract development of American art over the next two decades, is all the more remarkable.

The futility of African-American artists depending on recognition from galleries and museums in the grip of prejudice was frequently discussed at 306—as well as what could be done about it. Why should black artists have to depend on the Harmon exhibitions? Why weren't there art shows in Harlem? Why couldn't they begin to recognize talent in their midst by running their own exhibitions, which would help make black people aware of their artistic abilities?

Discussion of these questions helped bring rec-

Young Jacob Lawrence was photographed on the steps of his Brooklyn home in 1943 by his friend Jay Leyda, the Melville expert, who first brought his work to the attention of the Museum of Modern Art. Photo: Jay Leyda, New York

ognition to Lawrence. The artists and writers who came to 306 were fascinated by Lawrence's indifference to academic rules and his intense modern portrayals of scenes they all knew. Ad Bates, a black cabinetmaker and pioneer in modern dance, became so enthusiastic about Lawrence's work that he converted his apartment into a temporary gallery to show it.

Not long after this, in 1939, the James Weldon Johnson Literary Guild sponsored an exhibition of Lawrence's work at the Harlem YMCA, his first publicized one-man show. Alston, in an introductory note, emphasized that Lawrence's development had been "dictated entirely by his own inner motivations. . . . He is particularly sensitive to the life about him; the joy, the suffering, the weakness, the strength of the people he sees every day. . . . Lawrence symbolizes, more than anyone I know, the vitality, the seriousness and promise of a new and socially conscious generation of Negro artists."[6]

When Lawrence's *Toussaint L'Ouverture* series was completed, the Reverend John LaFarge enthusiastically

arranged for the Catholic Interracial Council to exhibit it at its Manhattan headquarters. "That was my first showing outside Harlem," Lawrence recalled.[7]

Mary Beattie Brady of the Harmon Foundation and Alain Locke convinced the Baltimore Museum of Art that it should present the first major museum exhibition of African-American artists' work. At the suggestion of Locke and Elton C. Fax, a black Baltimore artist, Brady insisted that the entire *Toussaint L'Ouverture* series of forty-one paintings be shown, and thus an entire room was set aside for its display.[8] Lawrence, only twenty-one years old, did not realize what an impact his work would have on art critics who singled it out for high praise. This attention helped to win Lawrence three successive Julius Rosenwald Fund fellowships, enabling him to continue painting after the WPA ended (he was employed by the WPA only eighteen months).

On July 24, 1941, Lawrence married Gwendolyn Knight, one of Savage's pupils and a talented painter in her own right. On his first Rosenwald grant, Lawrence completed a series on John Brown. His second grant called for him to visit both urban and rural communities in the South, a trip that became the young artists' honeymoon. Their trip was financed in part by a $100 loan from Mary Brady against the entire *Toussaint L'Ouverture* series. Lawrence never redeemed the paintings, which were kept intact and protected by frames, something for which Lawrence was later very grateful. The series, initially loaned to Fisk University, was transferred in 1977 to a program that made it available to six black colleges in the South.[9]

The Lawrences selected New Orleans for the urban studies. The rural community they went to was Lenexa, Virginia, between Richmond and West Point, an isolated black community of 200 people on rich bottomland. Some of Lawrence's family had originally come from there, and his mother wrote to cousins to arrange for her son's visit. "I remembered as a kid hearing my mother talk about it when she was a child," he recalled in 1969. "It was all a big farm when she was a kid. . . . This was evidently very rich farmland on a river—about a mile from the river. . . . I remember when we first arrived, we couldn't understand the people. They spoke so fast and in a very clipped way. I later found out they were speaking something close to old English because they had been isolated so long."

Although distantly related to Lawrence, many of the people were suspicious of a stranger who didn't work in the fields, had no discernible job, and sent pictures back to New York. He felt he could not "go

out and work on location" and worked quietly in his room. This encounter with rural black people considerably deepened Lawrence's understanding of their lives, their psychology, and the emotional drive behind their migration north.

While in New Orleans, living in a room on Bienville Street found for them by the Urban League, the Lawrences heard the radio news flash that the Japanese had bombed Pearl Harbor—an event that wrecked plans to stimulate the development of a number of black artists, although it did not stop Lawrence. Jacob and Gwendolyn Lawrence did not know that months earlier Alain Locke, Mary Brady, and Edith Halpert had worked out an arrangement whereby leading dealers would regularly show the work of two black artists. The idea was that if all dealers did this, they could safely counter prejudice by blaming it on "the competition." The organizers believed that, without gallery acceptance, the survival of black artists would be seriously impeded. Linked to this consideration was the fact that the WPA arts project no longer existed. They felt that something had to be done to help these artists maintain themselves.

However, the attack on Pearl Harbor overwhelmed public interest. With only one exception, all the dealers, feeling uncertain of the future, withdrew from the agreement. The exception was Halpert, at whose Downtown Gallery the show was held. She asked to represent Jacob Lawrence and Horace Pippin in New York.

This was an important advance for Lawrence, for Halpert was one of New York's most prestigious dealers. As Lawrence later recalled:

Edith Halpert wrote me a letter in New Orleans and said she would like to become my dealer. Well, I didn't know what it was all about. In the first place, I didn't know what I was going to do later. I was on a fellowship. I thought that was good. I had no idea of going out and looking for a gallery. I didn't know the quality of a gallery to look for, even if I had thought about it. I didn't know how artists turned professional. And so I wrote back, "Sure." I had no idea that this was one of the top dealers in the country. It just never occurred to me. It was really fortunate for me to be selected by her.

There are three important areas in my life that I can think of. One was coming in contact with the Utopia Center as a child and being exposed to art. The other was Augusta Savage's seeing that I became a member of the WPA art project. And the third, up to that time, was Edith Halpert's inviting me to become a member of the Downtown Gallery. I im-

mediately started sending paintings back to New York and that was the beginning of my gallery involvement, which has been a happy experience.

During this period, with his Selective Service board twice deferring him, Lawrence painted one of his most famous narrative series, . . . *And the Migrants Kept Coming*. These small, twelve-by-eighteen-inch panels depicted, in unsentimental yet very moving terms, the mass migration of poor black families from the Deep South to northern cities. A family gathered around a table to read a letter from a member who had gone north, people waited for a train, children wrote numbers on a wall in the north. To create these scenes, Lawrence drew on family stories, his own childhood, and his experiences in rural Virginia.

By this time increasing numbers of influential people had become interested in Lawrence's work. One was Jay Leyda, later well known for his revealing study *The Log of Herman Melville* and his critical examination of Russian films. Leyda, who worked for the Museum of Modern Art, arranged for the Mexican muralist José Clemente Orozco to see the *Migrants* series and to meet Lawrence. Both artists were very much alike in their emotional roots and their drive to paint as a kind of protest against the way their people were treated. "The two artists were sympathetic to each other, even without a common language," Leyda later recalled.[10] Leyda also showed the series to Alfred H. Barr, Jr., head of the Museum of Modern Art, who became determined to obtain it.

When the series was at last exhibited, Duncan Phillips of the Phillips Memorial Gallery in Washington, D.C., was as determined as Barr to have it. Rather than bid against one another, the museums jointly bid one price for the entire series—$1,000—and then divided the paintings between them—the Museum of Modern Art taking the even numbers, the Phillips Gallery the odd ones. *Fortune* magazine, interested in aesthetically depicting significant socioeconomic developments, reproduced twenty-six of the *Migrants* series, in an unprecedented recognition of a young artist.[11]

On November 4, 1943, Lawrence was inducted into the U.S. Coast Guard as a steward's mate, the only rating then open to black Americans. Assigned to St. Augustine, Florida, he described it as "a tight little town. You see and feel prejudice everywhere. In the Hotel Ponce de Leon, where we were first stationed, the steward's mates were all stuck way up in the attic." Other incidents of prejudice followed, and Lawrence expressed his rage in caustic drawings.[12]

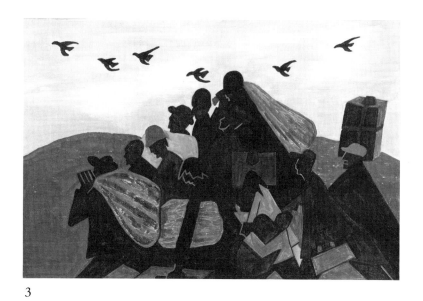

3

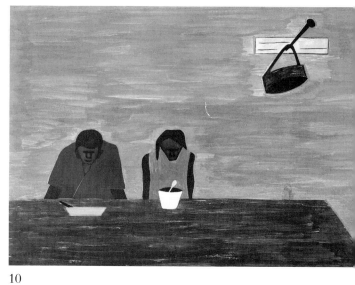

10

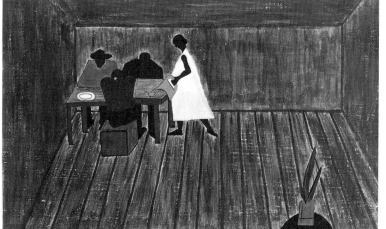

30

45

48

59

However, Lawrence's superior, Captain J. B. Rosenthal, a photographer, recognized his talent and selected him for the first racially integrated crew in the Coast Guard. Its commander, Lieutenant Carleton Skinner, later governor of Guam, was determined to develop his crew without regard to race. On board a small ship he created what Lawrence later called "the best democracy I've ever known."[13]

Lieutenant Skinner obtained a public relations rating for Lawrence, which enabled him to create a pictorial record of the Coast Guard. He then completed his service on a troopship that sailed to Italy, Egypt, and India.

Lawrence's Coast Guard paintings were later exhibited at the Museum of Modern Art in New York and the Boston Institute of Modern Art. Highly publicized as part of the war effort, these exhibitions demonstrated again Lawrence's ability to utilize patterns, ranging from portholes and bunks, to cannons and uniforms, in his compositions.

Museum and Coast Guard publicity made Lawrence one of America's best-known black artists; Horace Pippin and Richmond Barthé were the only other black artists to be widely publicized during this period. A modest man, Lawrence was disturbed by references to him as "America's No. 1 black artist," which somehow implied two standards—one for black artists and one for *real* artists. Many black artists have suffered from this impaling concept.

Some black artists, especially those who were academically trained, were mystified by Lawrence's work and his critical success. Those who tended to idealize their black subjects on the basis of Anglo-Saxon standards of beauty considered his men and women ugly.

Others, such as James A. Porter, hailed him as a virtuoso. "Freshness of vision is the most charming quality of this artist's work," Porter wrote in his book *Modern Negro Art,* published during World War II. "He sees the world for us. He has retained, from his age of innocence, that wholesomeness of comment that marks the efforts of an unspoiled artist. We are struck with the fact that so simple a technique can mobilize such power of color and movement. His art is founded on reality."[14]

Yet difficulties were mounting for Lawrence. Initially he had painted with a directness born of his intense rage, protesting the inhumanity of the way black people were forced to live. His own continued technical development on the WPA amplified his ability to express these feelings, as well as his deepening pride in and understanding of his people's history and struggles.

Although his success—unparalleled recognition for a black artist—tended to reduce his rage, his increasing ability and new subject matter, such as the *Migrants* series, at first compensated for this loss. His identification with black people remained intact—in fact, deepened through his historical studies. It was simultaneously strengthened by his own life experiences in Harlem, as a participant in the efforts of the Artists Union and the Harlem Artists Guild to prolong the life of the WPA, the major employer of black people. All of this helped to sustain Lawrence's basic feeling of angry protest.

The war, however, produced a total change in Lawrence's world. He was lifted out of the black community, and while his Coast Guard experiences contained bitter moments that kept his angry feelings against discrimination alive, it physically put him into intimate living contact with white men, of many different backgrounds and attitudes on race.

While the war against Nazi Germany could properly be interpreted as a war against racial discrimination, there were enough contradictions in the discriminatory treatment of black soldiers and sailors, as well as at home, to produce serious conflicts within Lawrence. Moreover, the type of service he was in, antisubmarine and troopship voyages, kept the harshness of actual combat remote. His paintings, although reflecting the tensions of the period in patterns of shipboard life, lacked the anger that distinguished his earlier work. Only when he painted the five-decker bunks deep in the troopship's hold, with tense black soldiers lying in them, did his angry concern with humanity show itself.

. . . And the Migrants Kept Coming (1940–41). Lawrence found another great theme for a series in the historic migration of African-Americans from the South. He again did his own research and wrote his own captions for sixty panels. Six representative panels are reproduced, each 12 x 18″, painted with casein on hardboard. Those with even numbers belong to the Museum of Modern Art, New York; those with odd numbers, to the Phillips Collection, Washington, D.C. No. 3. "In every town Negroes were leaving by the hundreds to go North to enter industry." No. 10. "They were very poor." No. 30. "In every home people who had not gone North met and tried to decided if they should go North." No. 45. "They arrived in Pittsburgh, one of the great industrial centers of the North, in large numbers." No. 48. "Housing for the Negroes was a very difficult problem." No. 59. "In the North the Negroes had freedom to vote."

John Brown (1941). John Brown's efforts to overcome slavery were the source for another series. Lawrence's great visual organizing ability enabled him to simplify Brown's actions in graphic images. All are in gouache on paper, 19½ by 13½″. John Brown formed an organization among the colored people of the Adirondack Woods to resist the capture of fugitive slaves (left). John Brown met with Frederick Douglass (above), but Douglass refused to go along with his attack on Harpers Ferry. Detroit Institute of Arts

One of the most significant aspects of Lawrence's war experiences was reflected in his inclusion of white people in his work in a sympathetic way. This is particularly true of a large series titled *War,* completed in 1946–47 after his discharge, and a new series on John Brown painted in the same period. Victory over the racist Nazis also helped diminish the rage characterizing his earlier work.

When the war ended, Lawrence was confronted with a major problem that had already troubled two other important, angry artists, George Grosz of Germany and José Orozco of Mexico: a loss in motivation. Each of these artists was—and still is—strongly identified with a particular social period in his country. Yet as conditions changed so did the inner feelings that sustained their work. Grosz, Orozco, and Lawrence developed their art out of a profound rage over social conditions. Orozco was enraged by the exploitation of his poor Mexican people and their land. Grosz was enraged by the German middle-class corruption of democracy, the brutality of militarism, and the support for the emerging Nazi movement. And Lawrence, although scarcely more than a boy, was enraged by his experiences as a young black American, by being kept ignorant of black history, and by what was expected of him by white America.

Because their rage is the source of their artistic drive, these artists are peculiarly linked to their time and place. After Grosz, for example, fled Nazi persecution to settle in America, he became a placid painter, showing none of the psychological insight and sharpness of line that characterized his work in Germany. Indeed, Grosz's work in the United States can hardly be reconciled with that done in Germany. Similarly, Orozco's work loses its significance outside Mexico and the period in which he worked.

Lawrence's work has continued to be important because the conditions that first stimulated him basically remain. But the diminution of his rage due to his success and the improvement of some social conditions created serious problems for him and certain changes in his work. While relatively little is known of the lives of Grosz and Orozco and the personal circumstances that contributed to their feelings of rage, critical events in Lawrence's life can be delineated.

Obviously, the end of the war brought about a new situation. The Harlem Artists Guild, which had helped to sustain his inner direction and thrust, had

disappeared; Augusta Savage had isolated herself upstate. The entire political atmosphere of the New Deal was gone, along with 306. The strong wartime coalition of labor, liberals, and African-Americans both waxed and waned—waxing in the struggles to organize unions and gain civil rights, better housing, better wages, and education, but ultimately waning under stepped-up attacks on such efforts as organized by "Communist fronts."

In this postwar period Lawrence sought to create a positive image of black people by showing them at work: a shoemaker, a seamstress, barbers, carpenters, and cabinetmakers. Some of these images may have been stimulated by his friendship with Ad Bates and his brother, skilled cabinetmakers.

At the time Lawrence wrote: "My belief is that it is most important for an artist to develop an approach and philosophy about life—if he has developed this philosophy, he does not put paint on canvas, he puts himself on canvas. . . . I think the most important part of painting is the feeling towards the subject and what the artist wishes to say about it."[15]

His words were a response to a query from Josef Albers, who had taught at the Bauhaus until it was closed by the Nazis and had come to Black Mountain College, an experimental school near Asheville, North Carolina. Albers liked Lawrence's statement and invited him to teach painting for eight weeks at the Black Mountain summer session, his first teaching opportunity. Operating as a community concerned with the arts, the school attracted advanced creative thinkers in all the arts. Also teaching painting that summer was the abstract artist Balcomb Greene. Lawrence taught two mornings a week, then was free to attend Albers's stimulating lecture-demonstrations, those of the Bauhaus architect Walter Gropius, or others. Gwendolyn Lawrence participated in dance studies. But racial tensions in this southern area were such that the Lawrences could not leave the campus during their eight-week stay.

Lawrence found he liked teaching; later, when he made teaching one of his main activities, he adopted many of Albers's ideas about teaching. At the time exposure to Albers's ideas and those of other artists confronted Lawrence, whose formal education was meager, with unfamiliar aesthetic and intellectual concepts that he could neither ignore nor dismiss. Albers introduced Lawrence to the Bauhaus stress on design, not only in painting but in many societal functions, including mass production. In painting Albers demonstrated the dynamic effect of color on shape, form, and spatial relationships.

Many of the Black Mountain artists were caught up in the concepts of Abstract Expressionism, virtually the opposite of Lawrence's narrative style and direct concern with social content. The summer before, Robert Motherwell, the movement's most articulate exponent, had taught there and shown that lyric abstract images might express the emotional truth of subjective feelings.

The long-term impact of all these concepts on Lawrence was considerable. On his return to New York, he gradually began to abandon the flat painting of figures and objects in favor of more stylized modeling, with a concern for notations of light and dark in figures. His previous emphasis on pattern became erratic. Although he completed his *War* series and received more praise and recognition than ever, his encounters at Black Mountain had shaken his confidence.

Moreover, improved social conditions, greater opportunities for black Americans in jobs and education under the GI bill, and sagging interest in socially conscious art—by 1948 paintings in the Pittsburgh Carnegie International were increasingly abstractions—contributed to Lawrence's increasing anxiety about his abilities. Fundamentally, Lawrence now confronted the problem of painting without his strongest motivating emotion. Instead, he had to deal with problems in painting that as a young artist, working with raw emotion and a controlling sense of pattern, he never considered. His anxiety grew apace.

Although honored with Pippin and Barthé at the Phillips Memorial Gallery in Washington in 1947, Lawrence was troubled by the recognition that poured down on him while many of his Harlem artist friends, whom he considered fine painters, were ignored. He grew nervous about painting problems he was now tackling. Like other artists, he was extremely sensitive and plagued with self-doubt. His success became unreal to him. Maybe, he felt, he had only been lucky. His painting grew erratic, sometimes heavily patterned. As Aline B. Louchheim Saarinen, a *New York Times* critic and an admiring friend of Lawrence, later pointed out, "something of the franticness and anxieties which must have been burdening him is reflected in some of the paintings of this period, where too-busy patterning, jagged angry points, and razzle-dazzle sparkles run rampant."[16]

Lawrence completed a series for *Fortune* on new opportunities for black people in the South.[17] He also illustrated Langston Hughes's *One-Way Ticket* with bitter black-and-white drawings.[18] By October 1949, however, Lawrence had reached a point of nervous collapse. He voluntarily entered Hillside, a leading New York psychiatric hospital. There Dr. Emanuel Klein, a psychoanalyst with a special interest in artists' emotional problems, treated him. Many artists have experienced periods of emotional upheaval. Vincent

In the Garden (1950) is one of Lawrence's most unusual paintings. During his hospitalization he did therapeutic gardening, and this painting expresses his satisfying memory of that work. (Casein on paper, 22 x 30″) Collection Dr. Abram and Frances Kanof, Brooklyn

Van Gogh is the best-known example of such turmoil. Another often-cited example is Jackson Pollock, whose abstract work reached a peak in the 1950s, but whose self-destructive alcoholism, symptomatic of his anxieties, led to his death. Fortunately, Lawrence was able to talk with his wife, Gwendolyn. As an artist herself, she had a deep understanding of his difficulties. With Klein, he traced some of his difficulties to anxieties experienced as a child, when his parents were impoverished and in conflict.

In the hospital Lawrence continued to paint, which was therapeutic. He created a series of eleven paintings entitled *Hospital,* reflecting the life of patients inside a modern psychiatric institution, including their need of psychoactive drugs, the circling self-isolation of the depressed, and the exuberant release found in folk dancing by many patients.[19] One of Lawrence's most unusual paintings, *In the Garden,* completed after his discharge, shows patients gardening under the open sky amid a profusion of brightly colored flowers and other plants. Gardening was very beneficial for Lawrence, as it was for Tanner during his depression. "It was exciting for me to do gardening," he later recalled, citing the painting as one whose creation gave him a special satisfaction. "It was the first time I've lived in the country. I didn't make any sketches. I remembered the feeling of it, and I tried to get that feeling" in the painting.

Lawrence emerged from the hospital with a much stronger understanding of his abilities and a more broadly based sense of identification. A major show built around the *Hospital* series, in October 1951, helped to pay for his treatment. His hospitalization was publicized, rather than concealed, to provoke interest and sympathy by comparison with Van Gogh, whose problems were being widely discussed at that time. This shocked many black artists.[20] In a *New York Times* article by Saarinen, Klein explained that Lawrence did not suffer from the self-destructive illness that troubled Van Gogh: "Unlike Van Gogh, Lawrence simply had nervous difficulties neither particularly complicated nor unique, which became so much of a burden that he voluntarily sought help. These paintings did not come from his temporary illness. As they always have—and it is true for most real artists—the paintings express the healthiest portion of his personality, the part that is in close touch with both the inner depths of his own feelings and with the outer world."[21]

On his discharge in July 1950, Lawrence returned to Bedford-Stuyvesant, Brooklyn's black community, where he had resided after the war. His work was less frantic, less intense, and broader in subject matter, often depicting moments of pleasure and amusement in the lives of black people. In some works, he returned to childhood memories and his beginnings in artistic expression. *Vaudeville,* for example, portrayed two slapstick black comedians. The harlequin costume of one comedian and the entire background of the painting resembled the kind of geometric patterns that preoccupied him as a boy at the Utopia Neighborhood Center.

During this period Lawrence created many paintings concerned with the theater and entertainment, among them *Comedy and Tragedy, The Concert,* and

Night after Night. Often attempts to portray the "drama backstage," these paintings externalized the kind of inner emotional reality that had characterized his earlier work and made it so moving. Their pleasant theatricality was in sharp contrast to the biting social comment of earlier work. In their change from earlier work, these works, although often brilliant in color and design, resembled the kind of change that took place in the paintings of George Grosz after he left Germany and came to America. A benign attitude increasingly expressed itself, although in some works, particularly those showing black men working at highly skilled occupations such as watchmaking, Lawrence seemed consciously concerned with raising black self-esteem. In some sense, these were paintings of rehabilitation, a kind of self-reassuring demonstration of his own abilities.

Any doubts Lawrence might have had about his abilities or status were diminished in 1953, when he became the first black American artist to be recognized by the National Institute of Arts and Letters. He was given its annual $1,000 grant in painting "in recognition of a gifted artist whose work is original in color and design and is touched with love of his fellow man."[22] In 1954 he received a Chapelbrook Foundation fellowship, which was renewed the next year. That year he was also elected national secretary of the Artists Equity Association, which was concerned with protecting artists' rights. He held this post until 1957, when he was elected president of the New York chapter, the largest, most active group in this organization, testifying to the esteem in which he was held by fellow artists. Later, in 1965, he became the first black artist to be elected a member of the National Institute of Arts and Letters.

Nevertheless, during the early 1950s, Lawrence had difficulty in finding a new focus for his work and his production was low. Although discrimination, bad housing, poor schools, and other social problems continued to plague their lives, more African-Americans than ever before were working—and sometimes at better jobs. The 1954 U.S. Supreme Court decision barring segregation in schools seemed to signal the end of the struggle for decent education for black children. Harlem itself had changed, and the close bonds between its artists and the community had vanished. Many of its artists, including Lawrence, had moved elsewhere in the city or left it altogether. The inner rage that had given Lawrence's earlier work its coherence and eloquence had abated at an accelerating rate as a result of external changes and his increased subjective satisfactions.

In the early 1950s, however, there was a new development. Senator Joseph McCarthy and others, taking advantage of the cold war hysteria associated with the Korean War, began harassing as "Communists" people who had been active in the "movement," as it was called in Harlem—the struggles for better housing and schools, for an end to discrimination, for unionization and the goals of the New Deal.

Even more challenging to Lawrence personally was the rapid development of the Abstract Expressionist movement, with its rejection of the value of social content in art in favor of subjective feelings, which its artists saw as freedom.[23] It was a refutation of all that Lawrence was attempting as an artist and in this way helped to renew Lawrence's rage.

In response to the climate of the 1950s, Lawrence, who had never lost his intense interest in history, began reading very widely on past American struggles to establish and maintain the democratic rights of free assembly and association, of freedom of speech and thought. Such basic constitutional rights had become critical issues.

With this new focus, working imaginatively from his reading, Lawrence abandoned his almost exclusive concern with the lives and concerns of black people and began to paint one of the largest historical series ever created by an American artist. Entitled *Struggle: From the History of the American People,* the series dramatized significant, often poignant moments in the nation's past in brilliant, expressive compositions. While highlighting the role of the common citizen rather than that of national leaders in an expression of social art at its highest level, the paintings often utilized abstraction as a powerful technique. Lawrence's subject matter ranged from ox-drawn wagon trains crossing prairies and Native American campfires to the role of ordinary people in well-known historical events.

Distinguishing these paintings in a sophisticated and moving way from most historical works was the attachment to each painting, in captionlike fashion, of some fragment of a little-known but very pertinent historical document. Nothing like this had ever been done before. Lawrence's old friend Jay Leyda and others assisted Lawrence in locating appropriate quotations.[24] For example, No. 18, *Exploration of the West—Lewis and Clark,* carried the following: " 'In all your intercourse with the natives, treat them in the most friendly and conciliatory manner which their conduct will admit. . . .'—Jefferson to Lewis and Clark, 1805." Another, No. 10, *Crossing the Delaware,* bore this excerpt: " 'We crossed the river at McKonkey's Ferry 9 miles above Trenton . . . the night was excessively severe . . . which the men bore without the least murmur. . . .'—Tench Tilghman, 27 December 1776."

The thirty paintings in this series won high critical praise. Saarinen, for example, wrote: "The subtleties of the whites; the clarity of blues; the stunning touches

Struggle: From the History of the American People (1955–56). This series, conceived and researched during the McCarthy era, emphasizes the heroic efforts of the American people to gain freedom and maintain constitutional rights and civil liberties for all. Lawrence's captions are often quotations from documents, such as letters. The panels, 12 x 16″, were painted with tempera on gesso. No. 10. ***Crossing the Delaware*** (left). No. 14. ***Peace*** (right).

of scarlet and the play of browns and blacks; the dramatic thrusts and counterthrusts of compositions; the wing-like sails and tents; the distillations of period and incidents, and even personalities into visual imagery: all these contribute to documents both vivid and moving."[25] Although many of the paintings were as small as ten by fourteen inches, they seemed astonishingly large because of Lawrence's mastery of compositional design.

In the *Struggle* series, Lawrence dealt with the American experience as a whole, seeing the struggle of black people as part of the struggle of all humankind for freedom. As in the *Toussaint L'Ouverture* series, Lawrence's paintings expressed the reality of the inner struggles of the ordinary person, an unusual achievement in that the viewer identified with these struggles. He expressed his deep feeling that life itself is a struggle for freedom, for both individuals and groups, encompassing war, building, migration, contending with nature, sacrifice, and vision. In their conceptional focus on the role of the common person and their imaginative execution, these paintings were a significant advance over the clichés of earlier American historical painting.

With completion of the *Struggle* series, Lawrence was less frequently moved to paint. In some ways he felt he had already said everything he had to say about the social conditions that confronted black people and could only repeat himself with less emotional force. The summer before he completed the *Struggle* series,

he returned to teaching, working at the Skowhegan School of Sculpture and Painting in Maine. He found it so stimulating that he did more and more of it, teaching at Five Towns Music and Art Foundation in Cedarhurst, Long Island, and later returning to Skowhegan for summer teaching. Teaching provided a stabilizing economic orderliness. Lawrence also found it gratifying and challenging aesthetically because students continually brought up new concepts as they carried out old ones.

Teaching, rather than painting, now preoccupied Lawrence. In 1956 he began teaching at Pratt Institute in Brooklyn, a leading professional school, and cut back further on his painting. In 1965 he went to Brandeis University for four months as an artist-in-residence and in 1966 began teaching at the New School for Social Research in New York. The next year he also became an instructor at the Art Students League, where his old teacher Charles Alston had long been guiding students. Teaching at both Pratt and the League was a considerably heavier teaching load than most artists carried, testifying to the satisfaction that Lawrence found in it.

In terms of painting, Lawrence was "coasting." In 1960 a major retrospective exhibition of his work, sponsored by the American Federation of Arts, opened at the Brooklyn Museum and then toured many cities, increasing the demand for his work.

The more Lawrence taught, the more sophisticated his own painting became. Even when the subject matter was the same, the simplicity of design and color

Parade (1960). Lawrence was fascinated by Harlem's many colorful parades, whose orderly lines and costumes appealed to his search for repeating patterns, a characteristic of his earliest work. (Egg tempera on hardboard, 23⅞ x 30⅛″) Hirshhorn Museum and Sculpture Garden, Washington, D.C.

that characterized earlier works was often abandoned for a more fragmented approach, with almost mosaic-like bits of color gradations used to model planes and create patterns. In 1969 Lawrence, naming *Street Orator, Couple, The Seamstress,* and *In the Garden* as some of his paintings that gave him a special retrospective feeling of success, said:

> At the time [of painting] I did not know the things I know now about painting. I wish I could do them today, and I am surprised: How did I do this? How did I know this? I wonder how I could have accomplished what I did at the time—not having much of a background, the kind I have now.
>
> This always amazes me. In fact, it is very frightening because they were done so early, and . . . in the context of what I'm doing right now, where it is difficult not to think of the form. Then I wasn't as much involved with the form as I was with the content. In order to express the content, I had to be involved with form, of course, but now—teaching—having done so much, you try to block it out at times because you realize this form can get in the way of other things, things that you are mostly involved with—the content. The ideal, of course, is to bring form and content together so that they become one. I didn't concern myself with these things when I was a youngster. Now I'm very much aware of them.

Lawrence's preoccupation with form and the slackening of his interest in content as his motivating rage eroded were intensified by the problems inherent in teaching. Content was almost automatically less important than form.

Africa had always been a kind of dreamland for Lawrence, as it was for nearly all of Seifert's students. With the emergence of new African nations after World War II, many black artists visited them, returning with much information on their contemporary art. Moreover, the rising civil rights movement and new attention to the "ancestral arts" further stimulated interest. In 1962, through the American Society of African Culture, the Mibari Club of Ibadan, Nigeria, requested an exhibition of Lawrence's work, inviting him to accompany it and discuss it. Delighted, Lawrence exhibited the *Migrants* series in Ibadan and Lagos and met that country's leading artists.

His visit revealed something Lawrence had not known he needed: new subject material. He returned to Nigeria in 1964 with his wife for eight months. Both Gwendolyn and Lawrence made many sketches and studies of day-to-day Nigerian life. From his observations, Lawrence created the *Nigeria* series—eight paintings and several important drawings. These paintings were simultaneously freer and yet more complex than most of his work. In *Meat Market,* for example, a geometric pattern of striped awnings organizes a bazaar scene containing many, many active figures. There is no shallow picturesqueness in these paintings. Instead, activity is emphasized, creating a feeling of energy that seems barely contained within the canvas. They are joyous, energetic works, fully assured but without the angry bite that characterized earlier works—which, of course, would be inappropriate in expressing the essence of the newly liberated Nigerians.

Between his two visits to Nigeria, and in sharp contrast to his exuberant Nigerian work, Lawrence

painted *The Ordeal of Alice,* his accumulated, enraged response to the abuse of black children in the South. Although it appears to focus on the situation in Little Rock, where black children entering school were subjected to intense hostility from whites, it was also set off by the killing of black children in the bombing of churches in Birmingham in 1963—the year this painting was created. Lawrence's painting portrays a black schoolgirl clutching her schoolbooks and bleeding from arrows like Saint Sebastian. She is surrounded by howling nightmarish figures—an incongruity heightened by bright flowers. It is a disturbing and accusing picture of innocence cruelly abused.

Two other pictures were created about this time. *Praying Ministers* shows clergymen of all faiths kneeling in prayer in their pursuit of civil rights for black Americans while armed National Guardsmen stand by. The second, *Struggle, 2,* a powerful drawing of a mounted policeman clubbing civil rights protestors, is dramatic, even shocking, with red daubs symbolizing the bloody violence. However, these works lack the depth of feeling that characterizes *The Ordeal of Alice.* Lawrence deeply identified with this child and perhaps worked from his own memories of cruel taunts and abuse at school.

Another of Lawrence's efforts in this period concerned children—a commissioned book for them entitled *Harriet and the Promised Land.* Years before Lawrence had painted a series on how Harriet Tubman had led some 300 slaves to freedom, graphically portraying the brutality of slavery and the hazards of escape. Pictorializing this story for children absorbed Lawrence because it called for a different use of his imagination. It was the kind of story he would have loved to read when he was a child. He also liked the idea that the series would be complete in a book, for most of his series were broken up and scattered among different buyers.

However, Lawrence's initial portrayal was too grim for some people. The publisher felt that in a book for children blood should not be depicted and Harriet Tubman should not be shown carrying a gun—which, historically, she did. (Lawrence made his own uncensored version for himself.) Even with these deletions, some people objected to the book. A New England librarian found its pictures disturbing "for children" and Tubman "grotesque and ugly," expressing the desire for a stereotyped Cinderella-like heroine. In a letter to the librarian, Lawrence replied: "If you had walked in the fields, stopping for short periods to be replenished by underground stations; if you couldn't feel secure until you reached the Canadian border, you, too, madam, would look grotesque and ugly. Isn't it sad that the oppressed often find themselves grotesque and ugly and find the oppressor refined and beautiful?"[26] Other people, however, praised Lawrence's Tubman, and it was rated one of the outstanding books of 1968. *Time* called it a "tour de force."

Many black artists became deeply involved emotionally in the civil rights movement as it swelled in the early 1960s. They asked themselves: What am I doing to support my people? What has my art, my talent, to do with my people? If it doesn't help them, who does it help? Why have museums been allowed to continue to exclude and omit black artists from their exhibitions and collections? These self-probing questions prompted Elizabeth Catlett, echoing W. E. B. Du Bois and Locke, to call for "all-black shows," which picketing soon brought about at major museums (see pages 424–25). Among some black artists, there was also an angry rejection of Western art and its aesthetic standards.

That black artists were often unknown in their own communities hurt. Artists of Lawrence's generation, who had known the closeness between Harlem artists, its community groups, leaders, and people in the thirties, saw the lack of self-esteem and helplessness of black artists as linked to this lack of a community relationship. Many turned to African history and culture—to the religious role of artists in those ancient communities, to the training of artists in familial guilds—for possible answers. That African art was not seriously studied in most art schools was another burning issue; some artists prepared study guides to African and African-American art.[27]

Out of the commingling of all these frustrating, painful, and humiliating concerns and feelings arose a demand for "Black Art." Although never satisfactorily defined, Black Art was characterized as a realistic or figurative art created by black artists, addressed to black Americans, that communicated a spirit of black pride and solidarity, of power and militancy in the struggle for full rights as Americans. It might sometimes draw on African design, in recognition of its heritage, and it was indifferent to the ideas of quality promulgated by art schools, dealers, and museums.

By 1968, when Lawrence participated in a symposium on the black artist at the Metropolitan Museum of Art, the term *Black Art* was an undefined commonplace.[28] Romare Bearden, Sam Gilliam, Richard Hunt, Tom Lloyd, William Williams, and Hale Woodruff also participated in this symposium. In his comments Lawrence first stressed the need to educate the white community about black artists' abilities: "I think they must

have a psychological block because they refuse to see and refuse to recognize what we can do. . . . We're always in *Negro* shows, not just shows. I don't know of any other ethnic group that has been given so much attention but ultimately forgotten."

Noting that black artists' relationships with the black community were not as good as in WPA days, Lawrence felt this relationship should be strengthened. At the same time, he said, black artists should not "tear [ourselves] away from the main community, not allowing people downtown to say. . . . 'Well, let's give them a little something and we can forget about them.' "

Lawrence frankly disliked the term *Black Art,* which Tom Lloyd kept calling for, saying, "It keeps bothering me. . . . 'Black Art.' I don't understand that . . . 'Black Art' means maybe something like 'Black Art of Africa' or something produced in the earlier days of America, in some of the ironworks throughout the South or things like that, which came out of the experience of a cultural group of people who happen to have been Africans. Here it would be more correct for us to say, 'art by Black people,' but not 'Black Art.' "

While an African-American artist may be strongly motivated by his feeling of racial identity and seek to serve the cause of his people, Lawrence observed, "all this will be incidental in the final judgment of his work. It may be important for him to express himself, but he's going to be judged by the criterion of all ages. And that judgment is not going to be on his motivation. That may be interesting to the historian and it may be interesting to just anyone, but it will have no validity when it comes to the question: what contribution has he made in the plastic area of art? This is it.

"All artists have this problem," Lawrence added, "not only Negro artists. I think it can be more intensified for the Negro artists because of the racial situation."

Lawrence's viewpoint offended some young, militant black artists. They cared not a whit for artistic standards. The only art that counted for them, as Tom Lloyd made clear,[29] was a realistic art that communicated racial pride and solidarity in the struggle for equal rights and that aroused greater militancy among black Americans. Often unaware of the struggles and cultural discussions of the Harlem Artists Guild in the WPA days, they felt they had discovered the civil rights struggle and the "movement." They were perplexed by artists like Norman Lewis, an Abstract Expressionist who believed that pickets and marching were required, but should not be confused with art, and that black artists should seek the highest aesthetic standards, not a separatist art, which seemed to invoke a double standard.

Confusion, tension, and bitterness flowed from the general inability to define Black Art in a satisfactory way, and it became more of a battle cry than anything else. Some militants held Lawrence to be an "Uncle Tom" because he was accepted in the art world controlled by whites despite the fact that his work had been consistently concerned with black history, self-esteem, and pride, and despite his incisive, acutely observed portrayals of social conditions. Speaking to Grace Glueck, Lawrence responded to the Uncle Tom accusation: "I don't regard it as personal—it's never said to me directly. But it's a healthy thing—the young ones should think this way. They push us into being more aggressive. It makes you think—if someone calls you an Uncle Tom, maybe you ask yourself, 'Am I?' "[30]

Some twenty years later, after the Black Art movement had peaked and black artists generally felt opportunities for them had opened up in the mainstreams of American art, Lawrence amended his original views. In conversations with Ellen Wheat, a University of Washington art historian who prepared a major catalog of his work, he said: "I used to say that the only black art is that art from Africa. And the criterion I used is when you look at it you can tell, just like you can tell Asian art, if it's traditional. Now I also add art from the black experience of figural content. The black art movement of the sixties was a good thing. . . . I think it gave a certain respect, a certain worthiness, which many people needed. It was very good that way. . . . To me [the label *Black Art*] doesn't matter. I worked out of my experience, and if somebody wants to call that black art, that's all right."[31]

In the 1960s, however, Lawrence was under heavy pressure from young militant art students, not to change his painting, but to abandon his standards and accept theirs. He told Wheat:

The only problem I had was the problem many artists had who had been attached to schools and were dealing with students [see Porter, pages 379–80]. You were always in a "damned if you do" and "damned if you don't" position. I was teaching at Pratt Institute, and that was the time when all the black students would sit together in the cafeteria. If you don't sit with these students, you were criticized, and if you did sit with the students, the attitude was "What are you doing here?" I had those kinds of problems, but they didn't bother me too much.

Of course, I was a black but I was also in a position of authority, and those students were striking out in all directions. If you were seen as part of the Establishment, they didn't realize your struggle had been as great as theirs. What I found is that you could

accept the health of this rebellion intellectually, but emotionally you couldn't. You'd want to tell these people, "Look, I've been through things, too, and so have the people before my generation, and they're the ones who made it possible for you to have this kind of protest."[32]

In 1969 Lawrence left Pratt and the League to teach for six months at California State College at Hayward, which introduced him to the multiracial attitudes of the West Coast. In June 1970 the National Association for the Advancement of Colored People presented Lawrence with its highest award, the Spingarn Medal, for using his artistic gifts and values in portraying "Negro life and history on the American scene." It praised "the compelling power of his work, which has opened to the world beyond these shores, a window on the Negro's condition in the United States."[33] He was the first artist to be so honored.

That summer he spent as visiting professor of art at the University of Washington in Seattle, which had been the base of a number of distinguished artists, such as Morris Graves and Mark Tobey. A year later the University of Washington offered Lawrence a full professorship.

Acceptance was difficult for many reasons but critical for Lawrence. The emotional demands of teaching at both Pratt and the League had become draining. He had little time or energy left for painting and felt he had reached a dead-end, where he could only repeat himself. Moreover, as the leading black painter in the world's black capital, he was under enormous social pressure—to serve on juries, to participate in Artists Equity affairs, to see young artists' work, to participate in black organizations and community affairs, to meet and talk with patrons, to socialize with old friends, to contribute his prints and presence at civil rights meetings. Talks with Gwendolyn, who understood Lawrence's needs and how encumbered he felt, settled the matter.

The Lawrences' decision to leave stunned many New Yorkers. However, perceptive friends recognized the move as a spiritual retreat—not a defeat but a chance to reorganize resources in a fresh environment.

In the relatively relaxed atmosphere of Seattle and its academic life, Lawrence enjoyed teaching and soon began to paint again. He turned now to a theme he had first dealt with some thirty years earlier—work. At that time he had portrayed a black watchmaker, a shoemaker, a cabinetmaker. Reviewing what had happened in America since the days when the slogan "Don't Buy Where You Can't Work" had aroused Har-

lem, he felt a sense of renewed interest and pride in the way many black Americans were succeeding in jobs as librarians, carpenters, construction workers, electricians. His own observations gave him a new sense of direction on an emotional foundation already in place. He had loved watching Ad Bates and his brother working with their cabinetmaking tools.

Pride in the achievements of his people—indeed, a celebration of their skills and achievements—took the place of the rage that had guided his hands as a young painter. He began to create paintings with the theme of builders. The multiple occupations and activities involved in building, the postures in nailing, sawing, carrying, climbing ladders, as well as the equipment, tools, and materials, offered Lawrence opportunities for virtuoso demonstrations of color and design. These paintings did not deal with historic leaders like Frederick Douglass. Instead, they portrayed ordinary people who were constructing, in Lawrence's views, families and lives as well as buildings, furniture, and the scaffolding of homes and industry.

The connection to building a family was particularly important to Lawrence. When in 1974, only three years after he went to Seattle, the Whitney Museum of American Art organized a major retrospective show of his work to travel to six cities, Lawrence tried to highlight builders as his main theme. He created a *Builders—Family* painting for the exhibition's catalog cover and poster.[34] It depicts a black father and mother with their two children, all neatly dressed, walking past a construction site where workmen, one of whom is white, are erecting a building.

Yet the significance of the builders theme as a new emphasis in Lawrence's work was largely lost on critics. After twenty years of being deluged with Abstract Expressionist splashes and novelties like Pop Art, they were astonished at Lawrence's direct representational paintings and the expressiveness of his early narratives. "This show is quite unlike anything we have seen on the museum circuit for many years," said Hilton Kramer in the *New York Times*.[35] Kramer particularly singled out as "extremely moving" Lawrence's dramatizations of the lives of Frederick Douglass, Toussaint L'Ouverture, Harriet Tubman, and John Brown, rating them as his greatest achievements.

"What gives these highly concentrated images their special intensity is Mr. Lawrence's gift for distilling an entire action in a single gesture," Kramer wrote. "Only an artist for whom history is a living issue—a matter of personal fate rather than intellectual choice—could have sustained so protracted a commitment to a vision that contradicts so many [of modern art's] established aesthetic pieties. . . . By restoring painting's narrative function to a contemporary task he has re-

Boy with Kite (1983). Lawrence showed his concern for all humankind in a brilliant series on the Hiroshima bombing, which were used to illustrate a limited edition of John Hersey's book *Hiroshima* in 1983. *Boy with Kite* was No. 7 in the series. These startling images of people whose irradiated heads have become white skulls reflects Lawrence's concern with the nuclear threat. The impact is delayed because the figures initially appear normal. (Gouache on paper, 23 x 17½") Collection Gwendolyn and Jacob Lawrence, Seattle

opened a whole realm of possibility that smart opinion long ago foreclosed. In terms of the art history of his time, this may turn out to be Mr. Lawrence's greatest distinction."[36]

Other artists also portrayed black America in the midst of the Depression, but Lawrence made it his own. As the French critic-historian Henri Focillon has pointed out, "There are at times artists who can own a particular phenomenon of nature—that after seeing the sky El Greco painted in *Toledo,* one cannot see the sky without seeing his work, a landscape without recalling [Claude] Lorrain."[37] In very much the same way, as an artist of Harlem during the Depression, Lawrence fashioned the artistic drama of that time and is the poet of that time and place.

In 1977 Lawrence was elected a member of the National Academy of Design. Many other honors and new forms of recognition have since been accorded him.

President Jimmy Carter asked Lawrence, along with Andy Warhol, Robert Rauschenberg, Jamie Wyeth, and Roy Lichtenstein, to depict his inauguration. The international quarterly *Black Art* devoted an issue to his work with an essay by Samella Lewis.[38] Offered a gift of an American painting for the Vatican Collection, Pope Paul VI asked for one by Jacob Lawrence; one of the builders-theme paintings was presented.

In 1983, shortly after he retired from the University of Washington, Lawrence was elected to the American Academy of Arts and Letters, the most select group of distinguished artists and writers in the nation. There are only fifty members, and a chair is filled only on death of a member. Lawrence was elected to Chair No. 41, previously held by William Merritt Chase, Charles Burchfield, and Ivan Albright, important figures in American art history. Lawrence is the second African-American to be so honored, novelist Ralph Ellison having been elected in 1975.

Twelve years after the Whitney exhibition, in 1986,

the Seattle Art Museum organized another major touring exhibition of Lawrence's work. It consisted mainly of work done in Seattle and amplified Lawrence's emphasis on builders. In the catalog's main essay, Ellen Wheat pointed out that for over seventeen years Lawrence "has concentrated almost without interruption on this theme and approach, a singularly consistent commitment." She found these paintings marked by a "classical serenity . . . more philosophic and objective, more symbolic, less regionally specific and emotive."[39] They also portray various ethnic groups working together toward a common constructive goal. Lawrence himself felt the content of his work had not changed so much as his color, prismatic colors being abandoned for "greyed, tonal colors."[40]

Although, with his builders theme, Lawrence turned frankly and positively to all humankind, there is a loss of emotional force in his muted tones and compositional busy-ness. The tautness of struggle has given way to a sophistication of design and subtle color harmonies that edge toward the decorative. This tendency can be seen even when Lawrence was striving for maximum impact, as in his illustrations for John Hersey's portrait of devastation, *Hiroshima,* done for the Limited Editions book club. These high-key illustrations, which have a universal quality, not limited by nationality or race, depict active human figures who have lost their facial flesh, whose heads have become red skulls turning white. The skulls are a shocking image. Yet they are distanced by presentation of the figures at full length, and their importance is somewhat dissipated amid distracting strong colors. The white-faced skulls become something that must be searched for.

Despite shifts in imagery and color range, Lawrence has remained true to his social viewpoint. When commissioned to create an "Images of Labor" poster for the union District 1199 as part of its Bread and Roses Project, he selected a Mark Twain quotation to illustrate.[41] Reproduced in his poster, it read: "Who are the oppressed? The many; the nations of the earth, the valuable personages, the workers; they that make the bread that the soft-handed and idle eat."

Lawrence strongly objects to the categorization of his work as "protest" painting. When President Carter invited Lawrence, along with nine other painters, to the White House in honor of his paintings protesting discrimination, Lawrence declined the invitation. "I never use the term protest in connection with my work. They just deal with the social scene. . . . They're how I feel about things," he said.[42]

What makes Lawrence singular among such well-known contemporary artists as Willem de Kooning, Franz Kline, Robert Motherwell, and Barnett Newman is his indifference to art movements and his closeness to American history, for the history of his people is embedded in it. This vision is reflected in his comments on visiting the White House for Carter's inauguration: "Just entering the White House, seeing the columns, you get a feeling of the country, a feeling of something very real, that has a great dimension. You think about the Civil War, the Revolution, about the founding of the country. You have a sense of history, of what man has achieved—it was all there: our intellectual capacity, and beyond that, our emotional sensibility. . . . This is the surreal thing I am trying to express."[43]

In a philosophical summing up, he said: "My pictures express my life and experience. I paint the things I know about, the things I have experienced. The things I have experienced extend into my national, racial, and class group. So I paint the American scene."[44]

With this commitment, Lawrence has altered American art history, reasserting the legitimacy of narrative painting as modern art. He has also dramatized the contributions of black Americans, in their quest for freedom and equal rights, to the nation's life and ideals.

NORMAN LEWIS

In the late 1940s and early 1950s, the concepts and methods that had preoccupied modern artists for more than thirty years seemed exhausted. In Europe, as well as America, artists sought change. Ultimately, the vital and daring American search for new approaches found its outlet in Abstract Expressionism, which rapidly became a major art movement. For the first time, an American style dominated the international art world. New York became its capital, and for nearly two decades was the focal point of contemporary modern art.

Willem de Kooning, Hans Hofmann, Franz Kline, Robert Motherwell, Barnett Newman, Jackson Pollock, Ad Reinhardt, Mark Rothko, David Smith, Clyfford Still, and Mark Tobey—alienated from the traditionalism of American art as well as from the repetitious quality of post-Cubist art in Europe—became the leaders of this international movement. Abstract Expressionism emphasized the dynamic, free expression of the innermost feelings of the individual. Abandoning the objectivity of the eye, most of these artists were concerned with color and shape only as they expressed spontaneous feelings derived from fantasy and passion. Often their works were carried out with vigorous physical expression of feeling as a means of allowing subconscious elements to emerge on the canvas. The Surrealists had called a similar free-association method of painting "automatism"—letting the hand "doodle." In the 1950s, when it involved emotional and physical energy, often of the whole body, it was commonly called "action" painting.

Working in the midst of these artists and personally well known to many of them, Norman W. Lewis was a lyrical Abstract Expressionist whose work differed in some significant respects from that of the others. While the canvases of many Abstract Expressionists reflected turbulent inner conflict, Lewis's work was quiet, concerned with a spaciousness that began with acceptance of the sky and the distancing sea. An intimacy with nature informed his serene paintings.

Lewis's art focused on the energies and tensions underlying the abstract forms of clouds, trees, and the sea, revealing in elegant, harmonious, and never-overpainted colors the natural unity of earth, sea, and air. Color was the agent of his revelations.

Highly individual, idealistic yet iconoclastic, Lewis created his own response to nature. Unable to fit in comfortably anywhere, he was in many ways like the restless frontiersman in American literature, who must exist outside accepted societal modes. In this sense his artistic forebears include Albert Pinkham Ryder, Charles Ives, and John Marin, each of whom also evokes something peculiarly American in his work. Lewis also belongs to a group of poetic painters that includes Paul Klee, Mark Tobey, and, in his last days, Robert S. Duncanson—all of whom seem to bring back reports from an unusual world, derived from their own observations of nature and formed by their inner vision.

In 1955 Lewis's poetic *Migrating Birds* won the popular prize of the Pittsburgh International Exhibition at the Carnegie Institute, a competition that included works by Henri Matisse and Pablo Picasso as well as leading American artists. In 1970–71 he received awards from the American Academy and National Institute of Arts and Letters. Yet widespread recognition eluded him. When, in 1976, the Graduate School of the City University of New York mounted a major Lewis retrospective, the art historian Milton W. Brown pointed out that despite a long and distinguished career, Lewis "is largely unknown to the art public and unrepresented in major American collections," except that of the Museum of Modern Art.[1]

While Lewis was disappointed and hurt by this neglect, the main thrust of his reaction was to deepen his identification with black people. He sought to inform and foster the development of his fellow African-American artists through frank discussions of aesthetics. He wanted to make them more knowledgeable and freer of cant than other American artists. He believed

Processional (1964) symbolized the growing civil rights marches of the late 1960s. It was exhibited at the only exhibition by Spiral, a group of New York African-American artists who sought to define their relationship to the lives of their people. All work in this show was restricted to black and white as a way of identifying the social conflict over civil rights for African-Americans. (38¼ x 57¾") Collection Ouida B. Lewis, New York

that being black could provide insights into many aspects of American life, particularly into the blind spots created by unquestioned attitudes and assumptions. Lewis was, throughout his life, a persistent questioner.

What he particularly sought to establish was a reaffirmation of Henry Ossawa Tanner's demand that black artists be allowed to be themselves first of all—that they not be burdened with assumptions. It is significant that when New York black artists met in the early 1960s to form Spiral, a group where they could discuss their role in American life and their relationship to the struggles of black people, they elected Norman Lewis their first president. He was recognized by this group as an artist who had made a long aesthetic journey before arriving at his poetic form of Abstract Expressionism.

Norman W. Lewis was born on July 23, 1909 on 133rd Street between Seventh and Eighth avenues in Harlem. His parents were from Bermuda, where his father, Wilfred Lewis, had been a fisherman, and his mother, Diana Lewis (her maiden name), had her own bakery. In New York, his father became a foreman on the Brooklyn docks, and his mother worked as a domestic to help support their three sons. Norman's brother Saul later became a violinist, playing with Chick Webb and Count Basie; his brother Johnnie went to Korea as a soldier and died soon afterward.

A closely knit family, the Lewises proudly considered themselves Caribbean. In the early 1920s, Lewis said, "there was a great deal of envy of West Indians, and so the three of us considered ourselves lucky." His heritage included both his mother's cooking and the Garvey movement, which Lewis remembered as a West Indian movement, not at first supported by black North Americans.

When Norman was growing up, from 1909 to the mid-1920s, Harlem was "a beautiful and exciting place." He attended Public School No. 5, whose student population was eighty percent white. Although he was interested in drawing and painting quite early, he did not pursue this interest as his older brother's musical efforts overshadowed everything else in the family and required all its resources. Both Norman and Johnnie were subordinated to Saul, Norman believed, partly because his parents appreciated Saul's musical activity and it paid well.

Bright, intellectually aware, observant, and prodded by his mother, Norman discovered the world and its history through books. In high school he studied commercial art and tried to copy J. C. Leyendecker, Norman Rockwell, and other prominent magazine illustrators. Working in the same size as published illustrations, Lewis could not place tiny highlights in the eyes and hair and considered his efforts failures. Years later he learned that these illustrators worked on a large scale, which made such highlights easy to create, and that their canvases were then mechanically reduced for publication.

When Lewis became discouraged by his messy failures, his parents offered no encouragement. Lewis later recalled his father's frequent assertions that art was "a white man's profession and hence you're wasting your time."

In his discouragement Lewis drifted after high school, doing odd jobs and learning to exist "on the street." When he realized that he wanted to be an artist, he didn't know how to go about it. However, he continuously read art books and slowly began to buy them. Eventually they filled one wall of his studio. "That's my real education," he liked to say, pointing to the wall.

For two years Lewis shipped out as a seaman on South American freighters. These trips were visually and intellectually stimulating; among other things, "I came to realize that it wasn't just black people who were exploited," he said later.

About 1930 Lewis was hired as a presser by Haig Kasebian, who ran a tailoring and dry cleaning store in Harlem and was an uncle of a then-unknown writer, William Saroyan. There Lewis learned to sew. More important, Kasebian became a "big brother," who encouraged his interest in art.

Lewis had often observed dusty footprints coming from a nearby basement store near Kasebian's. In it he could see sculptured figures. "One day I got enough gumption to go down into the basement," he recalled. "Liking shapes and figures, I wanted to get *into* this shop, and that's how I met Augusta Savage. She said I could come and work there if I wanted to."

Always strongly independent, Lewis was soon arguing with Savage, whom he initially viewed as a teacher. From the expensive art books he had bought, Lewis was familiar with El Greco and Persian prints as well as Paul Cézanne and the development of modern art, with Pablo Picasso and the development of Cubism, and with Vincent Van Gogh. He was also familiar with Amedeo Modigliani, who had been much influenced by African sculpture. What he had learned through his self-education did not always agree with what Savage taught. As they got better acquainted, they argued more, often violently, for Savage, often imperious, would brook no challenge. They argued, Lewis said, "because occasionally I would ask questions that she didn't answer to my satisfaction, and we used to get into arguments about what she was doing . . . like, well, she's not a sculptor, she's a modeler in clay and a sculptor cuts stone, which she never did. But thank heaven for her! Because she afforded me the opportunity to get started." Savage let Lewis paint as long as he liked—which was sometimes until two or three o'clock in the morning.

During this period Lewis's work and his dedication interested Robert and Lydia Minor. Robert Minor was one of America's great cartoonists before he abandoned cartooning to become a leading Communist Party spokesman; Lydia Minor was also an artist. The Minors provided tuition for Lewis to study with Raphael Soyer at the John Reed Club Art School. At the class, he later said, he "was frightened to death by the students. I wondered why they were studying with Raphael Soyer because they painted so damn well. I was intimidated . . . I suppose the thing that struck me was . . . my ignorance, which I didn't want anyone to know about. . . . So I set about teaching myself." He never went back, but he did exhibit in a John Reed

Johnny the Wanderer (1933) is representative of much of Lewis's work during the Depression of the 1930s. He deeply identified with the unemployed and homeless. Keeping warm with can fires was a common sight in New York. (37 x 30¾″) Collection Tarin M. Fuller, Oak Ridge, N.J.

Club group show in December 1933.[2] When the Metropolitan Museum of Art exhibited the work of Soyer's adult students, Lewis won an honorable mention for *Johnny the Wanderer,* an unemployed man trying to warm himself before a fire in an oil can.[3]

His rejection of formal study, Lewis later acknowledged, made his development slower and more difficult than it might have been. Nevertheless, it guaranteed his independence. During this period, the WPA arts project came into being, and offered training in all the rudiments of art, from grinding colors to gilding frames. Lewis tried to learn it all, always afraid his ignorance was showing. He thought, for example, the easel and mural projects required more skill than he had. Liking children, he felt he knew how to teach and motivate them, so he became a WPA-paid art teacher in a junior high school.

While teaching, Lewis worked in many other sections of the WPA projects to educate himself. Years later, he remembered discussions with Philip Evergood, Robert Gwathmey, Jack Levine, and other well-

known artists. "Listening to some of the ideas of these men reinforced my own excitement," he recalled. He also pulled proofs of Ben Shahn's lithographs and worked with Lee Krasner, later a well-known artist and Jackson Pollock's wife, as well as Ruth Gikow, another outstanding woman artist. "I took advantage of every opportunity to learn, even grinding colors," he said.

Lewis was active in the Artists Union and the Harlem Artists Guild. According to a dues book he preserved, there were only 118 black artists in the Artists Union. He tried to recruit more, recalling: "It was a helluva job to sell black artists on joining the union. They feared that it was communistic and later, teaching, I tried to get black teachers to join the union and they were reluctant because they were brainwashed."

However, the union made many black artists aware that they needed to work with the white artists to preserve the WPA art projects, which "offered black artists a chance to develop," according to Lewis. Through the union, camaraderie developed among black and white artists, Lewis said. "The rent in those days used to be $100 a month for an area, say, 100 by 100 feet. We used to give parties to try to pay the rent, and the white and black artists contributed their services to the community to continue the Harlem Community Art Center [which was] originally started by WPA artists." Through union activities, Lewis became a friend of Ad Reinhardt and sculptor David Smith, later leaders of the Abstract Expressionists.

When the WPA began sending artists to areas without art teachers, Lewis volunteered. To his dismay, he was sent to Greensboro, North Carolina. "It upset me because I'd never been south in such intimate circumstances," he recalled. Unable to tolerate segregation, he soon returned to New York. Other black artists, accepting the same assignment, managed to stick it out; among them were Rex Goreleigh, Ernest Crichlow, and Sarah Murrell, a fine watercolorist.

During his WPA days, Lewis painted in a Social Realist manner, depicting and protesting the calamities in the life of many poor black people: evictions, breadlines, lynchings, police brutality, and poor housing. Yet intellectually he was closely studying modern European paintings. This resulted in his painting *The Yellow Hat,* a portrait of a waiting young woman, whose bowed head focuses attention on her hat, her face unseen. A painting of classic simplicity and respose, in a style reminiscent of Cubism, it reflected Lewis's early orientation toward modernism.[4]

Although he made drawings of the African sculpture that was shown at the Museum of Modern Art in 1935, it played no direct influence on Lewis's work.

Meeting Place (ca. 1930), depicting a Harlem street bargain table, was one of a number of paintings in the 1930s in which Lewis took a lightly humorous view of some of the economic problems of life in the Depression. This set him apart from many artists, regardless of race, whose vision of life was only grim. (26 x 24″) Collection George and Joyce Wein, New York

He was more interested in how it influenced Modigliani, Picasso, Constantin Brancusi, and other contemporary European artists than in attempting to adopt its style directly.

Until World War II Lewis's canvases attempted to portray the social struggles of black Americans and the "togetherness," as he called it, of working people fighting against racial oppression and exploitation. However, this approach failed to express his deep feelings of wonder at the lyric beauty and rhythm of nature—the rising and falling of the sea, the sun's great arch, the mysterious comings and goings of night. At the time, believing that the social struggle had to come first, he put such feelings aside.

The Yellow Hat (1936) reflects Lewis's study of the Cubist movement and its analytic simplification and massing of forms. Lewis was largely self-taught and was a serious student of modern art long before he began to paint. (Oil on burlap, 36½ x 26″) Collection Ouida B. Lewis, New York

Dispossessed (1940), a Harlem eviction scene, expresses the sadness of a couple amidst their miscellaneous belongings. The piano indicates that these people were once prosperous. In another version, the mother comforts a child. (40 x 36″) Photo: National Archives

Jazz Musicians (1948), created after World War II when Lewis began moving toward abstraction, is a joyous exercise in free expression of his response to jazz rather than a banal representational work. (36 x 26″) Collection Ouida B. Lewis, New York

With the outbreak of World War II, discrimination in the armed forces prompted him to seek industrial work. He studied marine drafting but found nobody would hire a black marine draftsman. He then went to the Kaiser shipyards in Seattle, where he became a shipfitter. Instructed to hire a crew to weld ship plates, he was unable to get a crew, for white welders would not accept direction from a black shipfitter. He was then given useless, demoralizing tasks, such as crawling through the deepest holds of small aircraft carriers, which had already been launched, to see if any work had not been done.

Such hypocrisy of racial discrimination among people supposedly fighting a war against racism was too much for him. Embittered, he got a second job tending housing project lawns, and often slept on his shipyard job, perched like some drowsy night bird on a scaffold eight feet in the air. Even so, from time to time he would renew his efforts to earn his pay as a shipfitter until the threat of physical violence forced him to leave.[5]

During this period Lewis occasionally sketched "ideas for paintings," which gradually led him to abandon Social Realist painting for an increasingly abstract style. This was not an easy transition. Reexamining his earlier concept of the role painting played in social action, he gradually concluded that while social struggles were necessary and important, paintings about such themes did not move people to participate in them. His portrayals of evictions and lynchings had been of no help to anyone, he felt, saying, "This kind of painting did nothing to arrest these conditions, and to be effective one had to become involved physically—at least carrying a picket sign. This [physical involvement] said much more to the masses of people, who don't see that much painting. I don't think any kind of artistic protest stops situations."

Part of Lewis's inner conflict stemmed from the fact that nearly all his friends continued to think and work in terms of social protest painting. He could not turn to them for support as he struggled to accept the fact, as he later put it, "that a painting is made up of shapes whether they are recognizable or not. The whole composition can be very beautiful—not even

knowing what you are doing—if you dare. You suddenly become aware, after years of painting, that . . . if you arrange those shapes in any interesting fashion that might be visually stimulating, it doesn't have to be a form that you know. And seeing other things, like the individualism of certain artists, you realize they did just what they wanted to do—so why not me?"

Lewis's first "meek" experimental abstract shapes were not immediately recognizable. "That's the thing you've got to get used to," he said. "It's like smelling yourself. After a while you find you can stand yourself. Visually, these things are exciting and I think you don't even know at the moment what you've done. In retrospect you say: *Gee, I did that!* You feel excited . . . and that's how it happened with me."

In these early experiments, inspired by the shapes of rhododendrons, he was especially intrigued with working in black and seeing how the brushstroke "varied in its physical touch on the canvas from light to dark." The black had no racial or emotional significance. "It could have been blue . . . it could have been red." Of one experimental work, *Blending* (now in the Munson-Williams-Proctor Institute in Utica, New York), Lewis said: "Just as dissonance in music can be beautiful, certain arrangements in color have the same effect. The picture in Utica is a black picture. . . . I wanted to see if I could get out of black the suggestion of other nuances of color, using it in such a way as to arouse other colors."

Blending (ca. 1952) is one of a series of black-and-white abstractions in which black shapes are defined primarily by white backlighting (which has its own social meaning). Lewis was seriously concerned with defining African-Americans' character and contributions and observing how they blend into the larger white society. (54 x 41⅞″) Munson-Williams-Proctor Institute, Utica, N.Y.

Having rejected socially conscious painting as limiting his expression, Lewis was increasingly drawn to the Abstract Expressionist movement, some of whose leaders he had known through the WPA.[6] He attended Friday evening meetings at "The Club" (later called "The Subjects of the Artists School" and "Studio 35"), which de Kooning, Kline, and others organized in an 8th Street loft. There they talked endlessly about freedom—about being free of old traditions, old ideas, literary influences, PWAP- and WPA-type wholesomeness, Cubism, Picasso, Juan Gris, and indeed everything that had been done in art before. Trying to find the proper subject of the artists eventually led most to conclude that the true subject was paint itself and the act of painting as it arose from the artist's subjective feelings.

What attracted Lewis more than the Abstract Expressionists' aesthetic theories was their insistence on each artist's right to determine how he or she should paint. As a socially conscious individual, he had been under heavy pressure to paint pictures that expressed a sociopolitical viewpoint. The pressure came from his own beliefs and from others, especially friends holding similar views. This left no room for him to express his own feelings and concerns that were not part of the message of the moment.

Lewis was not the only one who felt this way. The Abstract Expressionist movement was largely made up of artists who felt their abilities as artists had been suppressed by painting WPA pictures celebrating work and wartime propaganda paintings. Very well trained and skillful, these artists also rejected the post-Cubism "modernism" in their drive to create something new. Yet there was division within the group. The European-born and trained artists, like de Kooning and Hofmann, felt they were continuing certain European traditions; de Kooning based himself upon the figurative tradition, for example. In contrast, the American-born painters, such as Pollock, Kline, Reinhardt, and Newman, rejected all past traditions and pushed aside drawing and design in a search for aesthetic purity. Initially, however, both groups agreed with Motherwell's statement that the movement was, at least in

Tenement I (1952) brought Lewis criticism and ostracism from friends who felt he had abandoned "the movement" by painting abstractions such as this. But Lewis felt picketing was more effective than painting in bringing about social change. (49½ x 30") Collection Ouida B. Lewis, New York

spirit, essentially international, "because beyond national differences, there are human similarities."[7] The problem was to be true to one's inner feelings—to anger, grief, joy, fear, hopelessness, or whatever these feelings might be—and put them on canvas in abstract form.

Lewis found that working from only his feelings was difficult and complex. Whatever success he had had was in a representational style and to paint in an abstract fashion after years of working in a representational manner produced strains and anxieties. He had to fight old habits of thinking and in the handling of his brushes. To counteract this, he studied J. M. W. Turner and Claude Monet because he thought that while their work was based on nature, it expressed their feelings rather than literal observations. He also constantly sought from nature itself a stimulus that would

help him find the sensitivity and delicate balance that he wanted to achieve. One morning, fishing off Long Island, he recalled, "it was foggy, and the sky and water catalyzed so that you could not see the point where they fell together. Fog, this etheral filter, fascinated me. It became the dominant undertone in much of my painting then."

There were other stresses. Social consciousness in painting was no longer taken seriously by many artists, although this was not true of most black artists who had been on the WPA. In meetings of the Abstract Expressionists, there was an "almost total absence of political discussions," according to Irving Sandler, a historian of the movement.[8] One aspect of this was what Sandler called "the dark side" of the "cold war": Senator Joseph McCarthy's hearings and Representative George Dondero's linking of modern art with communism had "generated a mood of repression, suspicion and fear, aggravating the pervasive social conformity."[9] Such fears and suspicions heightened Lewis's difficulties.

Another source of stress was that in order to survive he had to teach and most of his students wanted to work in a realistic way. Both Lewis and Ad Reinhardt taught at the Thomas Jefferson School of Social Science, which was oriented toward Social Realism. Eventually, feeling their integrity as artists was at stake, both left. To many of Lewis's old friends, this seemed like a desertion of the struggle against racial discrimination and oppression, although those who knew him best considered this nonsense.

As a result of all these factors, Lewis felt extremely isolated in asserting his right to paint as he felt. His dilemma was reflected in paintings symbolically preoccupied with individuality and how most people depend on others for approval and blindly follow others. These paintings contain patterns of small figures that, although abstract, are clearly human. These are small clusters of trailing figures, sometimes with an individual figure nearby. One of these paintings, *Tournament,* was directly stimulated by observing how people rarely act independently, according to Lewis. "A good example is people going into Macy's department store," he said. "There are several—even many—doors, and nobody says you have to go into one door. But everybody really waits . . . and then they follow one another into one particular door and ignore the other doors. And then someone will go into another door, and they will shift and go into that door. And then one individual will go in still another door rather than follow the others."

It wasn't only Lewis who felt isolated. Initially, the Abstract Expressionist movement was virtually an "underground" movement toward which the press and

critics were extremely hostile. As a result, among the artists, the movement was "a state of friendship," as John Ferrew put it.[10] These artists said of one another: "He should be 'in' which meant 'he is involved somewhere in the tensions and polarities of our thinking and through his work has made us see it.' "[11]

Lewis's poetic vision of nature was accepted by these artists, and their friendship kept Lewis going. Although the movement's Friday evening discussions focused on intense arguments about aesthetic concepts, what Lewis mainly got from these sessions was friendship and emotional support. "You need some kind of encouragement to work this way," he said later. Moreover, unlike the other Abstract Expressionists, Lewis had to face, from old artist friends as well as young black students, the hard-pressed charge that an involvement with Abstract Expressionism was a desertion of black people.[12] Some Abstract Expressionists, particularly Ad Reinhardt, understood this aspect of Lewis's ordeal and went out of their way to encourage him.

In 1949, after de Kooning's 1948 exhibition had aroused considerable interest in abstract art, Lewis was invited by Marian Willard to join the Willard Gallery, which handled the work of such outstanding artists as Mark Tobey, David Smith, and Lyonel Feininger. When Lewis's first shows were only briefly noted in the press, Feininger, already internationally famous, sought Lewis out to tell him not to be discouraged.

In participating in the historic three-day symposium in April 1950 at Studio 35, in which the emerging Abstract Expressionists threshed out their ideas and problems, Lewis alone raised the question of what relationship their art should have to the outside world— to people, the public. This was a constant question in discussions among African-American artists at 306. Lewis pointed out that at one time artists exhibited in cafés. He went on: "At one time they were exhibiting in the open-air shows in the Village. Then there was the Federal Art Project. People no longer have this intimacy with the artists, so that the public does not actually know what is going on in, what is being done by, the painter. I remember organizing for a union on the waterfront. People then didn't know the function of a union or what was good about it, but they gradually were made aware of it. They saw a need for it. The same is true of our relationship with the people; in making them aware of our relationships with the people. Certainly you are going to run into ignorance."

No one responded to Lewis's question except his friend Ad Reinhardt, who pressed the point, asking: "Exactly what is our involvement, our relationship with the outside world? I think everybody should be asked to say something about this."

Silence followed. Finally Alfred Barr, who was moderating the session, said, "Apparently, many people don't want to answer the question."

With that the discussion, as reported in *Modern Artists in America,*[13] rolled into limitless subjectivity.

Plainly when Lewis spoke, almost in the language of 306, of the relationship of art to people, the Abstract Expressionists preferred not to hear. Lewis's viewpoint set him apart and may have contributed to his isolation within the movement.

Finally, in 1952, recognition began to come. New York *Herald-Tribune* critic Carlyle Burrows wrote that Lewis's work was "decidedly one of an artist who works sensitively from natural impressions to achieve independent and personal statements. And though the form of his work, which is deliberately geometrical in patterns, suggests a fairly close appreciation of Feininger, it is not so directly derivative as in harmony with the expressions of modern symbolists from Klee to the present time. Especially interesting in Lewis' display are his muted colors suggesting shimmering marine impressions and nocturnal landscapes painted, not with great formal substance, it is true, but with tasteful, quite enchanting understatement."[14]

In *Art News,* a leading critic, Henry McBride, praised Lewis's work as "celestial navigation" and pointed out that the spaciousness of the Willard Gallery helped the work:

> Lewis needs plenty of room not only in his pictures to say what he has to say, but in a generous separation of them from each other. For Lewis is a poet of aerial moods, blowing cold in *Arctic Night* and warming considerably in the *Industrial Night,* and the two moods are twain and need to be kept apart.
>
> This is the more imperative since there is a temptation to think the artist is a musician as well as a painter, for he starts in softly on a blank page, like a musician improvising, and as he sees a suitable motif taking shape, swings into it with confidence, plays it up for what it is worth and then, satisfied that he has gone the whole way with it, permits it to fade softly out. This is his characteristic treatment although there are one or two exceptions, among them the already mentioned *Industrial Night,* which does not loom into view but presents the complete pageantry of a Pittsburghian night with a thousand glimmering lights combating the darkness. This probably is Lewis' best. He is not a realist. He is practically abstract, but he always has a theme which he lets you know. His *Awakening,* for instance, might be some modern scientist's version of the way life begins, with mists shaping into solids, and here and there slits of red to

Harlem Turns White (1955), filled with the small abstract figures that Lewis used to symbolize people, was intended to be provocative. It suggests that Harlem's people may lose their identity in a white mass. (50½ x 63″) Collection Ouida B. Lewis, New York

indicate a vital spark. . . . Lewis delves into ethereal matters which are immeasurable and which to compress might be dangerous.[15]

McBride's perceptive description increased interest in Lewis, although his paintings lacked the novelty and the violent color clashes that stimulated interest in other abstract artists. Instead, Lewis's reassuring serenity arose from his absorption with the essence of relationships in nature. His work was indeed, as some critics observed, akin to that of great Chinese and Japanese landscape painters.

Lewis, a city-bred man in the world's largest city, constantly sought out, studied, enjoyed, and probed relationships in nature in the midst of Harlem. Large tanks of goldfish crowded his studio along with exotic, often huge plants from all over the world. Fishing in small boats off Long Island, he studied not only man's relationship to the earth but the influence of environment on how all things grew and how man perceived them.

Yet, in discussing the relationship of his external environment to his work, Lewis told Charles Wendal Childs: "I'm a loner and paint out of a certain self-imposed remoteness. When I'm at work, I usually remove my state of mind from the Negro environment I live in. But this would, of course, apply to any environment because when I was in Europe it literally amounted to the same thing. I paint what's inside, and like to think of it as a very personal, very individual environment. Being Negro, of course, is part of what I feel, but in expressing all of what I am artistically, I often find myself in a visionary world, to which 125th

Street would prove limited and less than universal by comparison."[16]

Yet a flock of pigeons that Lewis kept on his rooftop may have been the stimulus for one of his best-known paintings, *Migrating Birds*. He regularly let his pigeons out for exercise flights. One incident with his birds was very disturbing to him. Immediately after the 1948 blizzard, he shoveled a rooftop path to his coop, fed his birds, and then let them fly aloft. He watched them as always as they wheeled away and moved out of sight. He then awaited their return. But they never came back—apparently unable to recognize their landmarks, which were obliterated by the great snow. Lewis could only hope that they were strong enough to fly south beyond the snowfall for food.

A few years later Lewis created his poetic *Migrating Birds*. Carried out in whites of varying intensity, the birds appear only as distant dots—a transformation of the small human figures that once preoccupied him. Of this canvas, Lewis said, "It was painted very thin and I made a special ground for it so that it would dry quickly. I played dots over dots, only partially covering, so that there was a third white—a more intense white."[17]

At the 1955 Pittsburgh International Exhibition at the Carnegie Institute, *Migrating Birds* became the overwhelming favorite of visitors. Critic Emily Genauer, writing in the New York *Herald-Tribune,* called this selection "one of the most significant of all events of the 1955 art year." Noting that popular prizes invariably went to pictures "either blatantly sentimental or meticulously realistic," she held that the selection of Lewis's work meant "the public of America is ready

to follow artists in their most imaginative flights—if they don't on the way lose sight of nature altogether [in order] to fly blindly in the midst of aesthetic theory."[18]

By 1955 the Abstract Expressionist movement had achieved a spectacular dominance in the international art world, overshadowing the later work of Picasso, Matisse, Marc Chagall, and others. For Lewis, the Carnegie prize was a satisfying triumph. Artists of the abstract movement looked upon his success as their success. Lewis's relationship with his dealers, the Willards, became close. Other Abstract Expressionists, however, outsold him—even without the kind of recognition he achieved. He continued to occupy the same small studio in Harlem, where his rent was fifty dollars a month, and waited for his sales to increase.

Winning the Carnegie prize led Lewis to believe that his paintings would now be in demand. It took several years for him to realize that this was not to be the case.

By the mid-fifties the Abstract Expressionist movement had already developed a "second generation," mostly students of the first group. Moreover, significant aesthetic differences and intense competition had emerged among the originators and the newcomers. To add to the intensity of these pressures, Abstract Expressionism, which had arisen from a fundamental aesthetic concern initially, had developed into big business in the Age of Affluence. In 1955 *Fortune,* noting the new art market, published a list of "growth" painters, all Abstract Expressionists.[19] Speculators went after them as if they were new electronic industries.

Earlier, Harold Rosenberg had coined the phrase "action painting" to sum up the intense emotional and physical activity that went into Abstract Expressionist canvases.[20] After *Life* showed Jackson Pollock dripping Duco automobile enamel on canvases on the floor—and the Museum of Modern Art saluted him with an exhibition—and after Franz Kline said, of course, he used housepainters' brushes to create his startling calligraphic black-and-white canvases, everyone was "into" Abstract Expressionism.

That the traditional drawings and rules of composition were not required in this style of painting opened the door to both mediocre artists and charlatans. Dealers hustled and promoted. The mass media, which traditionally considered artists "screwballs," were now impressed by the unexpected financial returns on "drip" painting; they hurried after artists who threw color on canvases at fifteen feet, shot it from squirt guns, and dribbled it from garden sprinkling cans. Soon amusement parks had machines that

Night Walker No. 2 (1956) shows abstract but human figures moving through an artificially luminous night in which the moon is blacked out. However abstract, this painting is not without meaning and may reflect Lewis's feelings about being in a gallery with many noted painters yet left very much alone and cut off from nature's light. (66 x 33½") Collection Ouida B. Lewis, New York

whirled cards onto which visitors could drop colors and create their own abstractions for twenty-five cents. Under these pressures, Abstract Expressionism faded, bleached by what was, in Sandler's opinion, "massive mediocrity."[21] Then came Color Field painting, Pop Art, and Op Art in a rapid search for more novelty.

Throughout these developments Lewis, the only black artist who could be considered a participant in the Abstract Expressionist movement from the start,

Arrival & Departure (1963) marked a further development in Lewis's paintings. Always thinly painted, they differed markedly from the slashing and splashing of most Abstract Expressionists. As a group, they increasingly tended to glow. (73 x 50″) New Jersey State Museum, Trenton

was largely ignored by collectors and museums, despite his Carnegie prize. Even though he had nine one-man shows with very favorable reviews for over a decade at a major gallery and was associated with leading members of the movement, "nothing happened," to use Lewis's phrase. "His painting appeared vastly economical of means in an era which delighted in fat painting, while the pale, sensitive color and general lyricism of mood that it implied was too easily neglected amidst the large scale dramas of American abstraction," said Thomas Lawson in his retrospective examination.[22]

Initially, Lewis had thought that all that was needed was hard work. He had high expectations about responses to his work and about what dealers did. Later,

discussing the fact that "nothing happened," he at times blamed being omitted from various group shows and being excluded from art parties on Long Island on racial grounds. He also blamed "not living downtown," which deprived him of much stimulating contact with other artists. And he had never recognized the intense competition he was up against for press attention; many artists sought out writers to get articles written about their work. He put his energy into his work and waited in a passive state for greater recognition, indifferent to changes in the real world. Although most African-American artists had left Harlem after World War II, Lewis recognized his isolation in remaining there only when it was pointed out to him. When his sculptor-friend David Smith first suggested

a new gallery might give him a fresh start, he did not leave the Willard Gallery. When he finally left, after more than a decade, he was too disillusioned to want to start with a new gallery.

Yet there was more to this complex and painful mixture of idealism, passivity, naiveté, frustration, and hard work than these factors. Not all artists in the Abstract Expressionist movement gained the same stature, regardless of their participation. What locked some capable artists into relative obscurity was generally a failure to develop personal concepts that significantly deepened or extended the approach. None of this is peculiar to Abstract Expressionism; it is characteristic of all art movements.

But Lewis, deeply disappointed and troubled, could not initially accept such an answer. He felt that his contribution—drawing on nature for his inspiration—had been as significant and important as that of any of the Abstract Expressionist pioneers. He had come to believe that because many of the leading Abstract Expressionists considered him their artistic equal, everyone would. Only after a long period of anguish was he able to relate what had happened to him to similar situations in literature, the theater, and sports.

Throughout this period of disappointment and disillusionment, Lewis never stopped producing work of high quality. Although his total output diminished, Lewis continued his lifelong commitment to the ideal in art—to making his best effort at all times, rejecting shortcuts, keeping his dedication deep and pure. This integrity was so central to his character and outlook that it always impressed those who met him. He simply was not subject to change in his idealistic stance as an artist. And from that viewpoint, he constantly sought to clarify aesthetic problems, particularly those unique to the black artist.

Teaching was Lewis's major means of survival. Under the WPA he taught for five years in a Harlem junior high school, and he felt that he could teach better than he could do anything else. "With children, I discovered, it was a question of knowing that they are liked and loved—so that they try to achieve," he said. "I found the kids often doing even better than what I could achieve"—which he attributed to their lack of preconceived notions. In the late 1960s Lewis taught in the Harlem Youth program, an effort to develop talent otherwise stifled by prejudice. Some of his students became architects, designers, and artists. In 1971 Lewis began teaching at the Art Students League. His classes included both young artists and retired people, who, he said, "in the autumn of their life turn to this because they can afford their habit and it is something they always wanted to do."

In 1973 Lewis, his wife Ouida Williams, and a young painter, Jackie Whitten, went to Greece. What interested him most was a mountain visible from his hotel window, which he began to draw at various times—in early morning and in the fading evening light. "But the mountain existed at night, too—even though I couldn't see it." This thought fascinated him. On his return Lewis created a series of large canvases concerned with emergence of the mountain in the blackness of night. These black mountain paintings somehow symbolized what Lewis sought: something unseen but that he knew was there, both from new experiences and from remembered feelings of the past.

In the 1970s Lewis increasingly won recognition and support from diverse sources, receiving grants from the Mark Rothko Foundation, the National Endowment for the Arts, and the Guggenheim Foundation, as well as important mural commissions for Boys High School in Brooklyn and the St. Albans High School on Long Island.

Norman Lewis died unexpectedly on August 27, 1979.[23] The art world periodically rediscovers neglected masters of past movements—artists who were often ignored in their lifetimes but possessed unusual qualities. This may be the fate of Norman Lewis, because much of his work remains unseen by the public and critics. It is like the mountain that fascinated him in Greece. It is there, awaiting some changing light to let it emerge.

HUGHIE LEE-SMITH

Hughie Lee-Smith, whose work has brought him many honors and awards, expresses a haunting sense of loneliness and alienation in his paintings of the American scene. Mysteriously, they convey the feeling that something good is missing—and yet somehow about to happen. His vast skies, desolate scenes, and distanced people, his blowing ribbons and colorful balloons, mix realism and fantasy in surrealistic juxtapositions that reflect the contradictions and paradoxes of American life.

Lee-Smith's career, in its own way, constitutes one such paradox. Despite excellent training, meticulous craftsmanship, numerous awards, honors, and election to membership in the National Academy of Design, Lee-Smith had to paint for fifty years before a major traveling retrospective exhibition in 1988 brought him national recognition.[1] It was as though he had been hiding all those years. "A Painter Finally Gets His Due," headlined a *New York Times* review.[2] "Tardy Brush with Acclaim," said the Philadelphia *Inquirer.*[3] Why did it take so long? asked nearly every critic. At least part of the answer is the isolating alienation pervasive in American life. In his case, Lee-Smith believes, that alienation has its roots in racial prejudice. Although never pursued consciously, alienation is so hauntingly rendered in his work that, regardless of race, most viewers are moved by it.

Although his palette has grown lighter over the years, Lee-Smith's work nearly always depicts young people in barren scenes of desolation. In *Maypole,* a painting characteristic of this basic pattern, a maypole's colored ribbons flutter in the wind in what would appear to be an abandoned playground. At a cracked wall at its distant end a single figure, a man, looks outward toward the ocean. At one side a barbed-wire strut atop a wall casts an ominous shadow. It is as though this playground, where children once romped in a joyful and colorful dance, had become a kind of concentration of spirits. Yet there is some kind of hope or promise in this scene expressed in the sky, the wind giving life

to the ribbons, and the lone man expectantly looking out toward distant seas.

Many of Lee-Smith's paintings, always rendered in a meticulous realistic style, seem almost to be urban stage sets for a play like Samuel Beckett's *Waiting for Godot;* one waits for the action to begin, for voices to be heard. His figures—men, women, children—are attractive, but they usually have their backs to the viewer, adding to their mystery and to a feeling of rejection and alienation. At the same time they are always tautly erect, heads up, fixed at times in something like a military "attention" stance, which helps to create the feeling of promise, of impending action. Part of the mystery in these paintings is how the people in them somehow balance the rubble, the cracked and crumbling concrete, decaying brick, abandoned tin cans, tricycles, and toys.

In his work Lee-Smith has taken the concept of loneliness—and the spiritual alienation from contemporary institutions—and given it a definite and recognizable configuration that many people can identify with. "Lee-Smith's surreal sense of disquiet and disjuncture conveys a psychic alienation and angst that allows him to avoid the pitfalls of didactic content while presenting a powerfully evocative image that addresses the social situation of his protagonists," observed Lowery Stokes Sims, of the Metropolitan Museum of Art curatorial staff, when the June Kelly Gallery in New York exhibited his recent work in 1987.[4]

Drawing on his life as a black American, Lee-Smith has found an aesthetic way of expressing his own experiences in a broad statement about the promise of American life and the shallowness of its realities. It is a statement that many Americans, regardless of their race or social status, share to some degree.

Lee-Smith's work, often characterized as metaphysical in recent years, has long been recognized for its distinguished craftsmanship and imaginative vision. In 1967 he was elected a full member of the National

Two Girls (1966). Together yet alone, the girls look toward distant shores as ribbons fly from a flimsy, abandoned lookout tower. The pier seems to be disintegrating and the dark sky holds no promise. Such mysterious scenes have prompted critics to describe Lee-Smith as a metaphysical artist. (34 x 36″) New Jersey State Museum, Trenton

now beginning to be widely appreciated and to move out of art magazines into such broad educational tools as high school texts.[5]

Hughie Lee Smith was born in Eustis, a small midland Florida town, on September 20, 1915, to Luther and Alice Williams Smith. His parents soon separated, and his mother moved to Cleveland, where she had friends and relatives, joining other families in the great migration from the South.

Hughie changed his last name to Lee-Smith later, when he and his art school classmates decided Smith was too ordinary a name for a distinguished painter. He combined his middle and last names with a hyphen "to give it a flavor that otherwise wouldn't be there." He has no memory of Eustis.

Lee-Smith started drawing at a very early age. "I drew all the time, and it became a natural thing. I breathed it. I dreamed it. Art was my whole being and I knew at an early age that it was my mission," he told Carol Wald, a well-known illustrator.[6] When he was in junior high school, friends and relatives, recognizing his talent, began giving him small reproductions of paintings and art books. He remembers particularly a book about Peter Paul Rubens, especially "his painting of heads of Negroes, their beautiful quality."

He attended an art school then called the Cleveland School of Art. When his mother learned of Saturday classes at the Cleveland Institute of Art for gifted children, she went to its director, William Milliken, and secured her son's admission. This also turned out to be a door opener for other black students. The classes, taught by Anthony Eterovic, emphasized classical drawing. "My whole orientation from the beginning was towards solid Renaissance kind of drawing and painting," Lee-Smith explained. "I was very much taken with chiaroscuro at the beginning and that has carried through all my work." An early influence was Caravaggio, a master of such dramatic light and shade.

In 1934 Lee-Smith won a *Scholastic* magazine scholarship that gave him a year's study at the Detroit Society of Arts and Crafts School. He then received a scholarship at the Cleveland Institute of Art. His most influential teachers were Karl Gaertner, Henry O. Keller, and Ralph Stohl, all well-known artists. Gaertner stressed "the importance of values," often using his own night scenes to illustrate his point. "I was terribly influenced by this kind of thing," Lee-Smith recalled. "My interest in Gaertner was his absolute control of values, his chiaroscuro approach to painting." Gaertner's influence has been reflected in Lee-Smith's painting ever since; there are no accidental effects.

Academy of Design, becoming the first African-American artist to achieve that status since Henry Ossawa Tanner was elected in 1927, forty years earlier. He has been active in its exhibitions, awards, membership committees, and as a member of its governing council. He served for two years, from 1980 to 1982, as president of the Audubon Artists, a large national organization of professional artists, and was vice president of the Artists' Fellowship, which aids needy professional artists. For nearly twenty years he taught at the Art Students League in New York, where the students select the faculty.

Since 1988 the demand for Lee-Smith's work has become so insistent that he took a sabbatical leave of absence from teaching to fulfill exhibition commitments and commissions, including a mural for the New Jersey Commerce building in Trenton. Earlier that year he completed a mosaic mural for the Prudential Life Insurance building in Washington, D.C. His paintings are in many museums and such private collections as those of Malcolm Forbes, Mrs. Edsel Ford, the E. R. Squibb Company, and the Golden State Insurance Company.

In more than fifty years of painting he has developed a complex but highly personal style that is only

Lee-Smith first won attention as a WPA artist with his prints and etchings, such as **The Kite Fliers** (ca. 1939). After World War II he devoted himself to painting. (Etching, 10 x 12″) Collection Nathan Lasnik, University Heights, Ohio

While Lee-Smith studied the drawing of masters like Jean-August Ingres in books, Keller, famous for his animal and circus paintings, was a more direct influence—with "his insistence on solid drawing, drawing that was alive—vigorous." Stohl taught Lee-Smith portraiture. "Those of us who went to the school at that time felt that we would get our best solid training out of that particular class, a specialization class. You worked from the model every day," he remembered.

If some of Lee-Smith's paintings resemble stage sets, it may be because he has had considerable theatrical experience. He studied acting with the Karamu Players, appearing in many plays, and continued acting until the mid-1950s. He was also strongly attracted to modern dance, and was a solo dancer in an interracial group that came out of the Doris Humphrey–Charles Weidman school.

On graduating from the Cleveland Institute of Art in 1938, Lee-Smith landed a job teaching art at Claflin College, in Orangeburg, North Carolina, a small black college then trying to develop art courses. During that year he married Mabel Everidge. In 1939 they moved to Detroit, where he became a father; in time his talented daughter Christina studied art.

Early in World War II Lee-Smith was employed by Ford as a sand molder in an experimental metallurgical laboratory. "I was a core maker and worked on experimental cores for the Wright airplane engine," he recalled.

Yet he continued to paint in his spare time. In 1943 one of his paintings won the purchase prize at the sec-

ond Atlanta University exhibition of the work of African-American artists. More recognition came when in his 1943 book, *Modern Negro Art,* James Porter praised Lee-Smith's work as a printmaker. Porter felt that Lee-Smith poured into his prints, such as *Artist's Life No. 1,* "all the exciting experience his mind can call up—sometimes with startling results. His work, for all its hyper-realistic quality, is never preconsecrated or dull."[7]

Lithography was something Lee-Smith had learned to do while working on the Ohio Art Project, a government program under the National Youth Administration, which supported him during his studies at the Cleveland Institute of Art. He was then part of a group of artists—including such talented African-American artists as Charles Sallee, Elmer Brown, George Hulsinger, William E. Smith, and Zell Ingram[8]—associated with Karamu House, a community center.

His Atlanta prize and Porter's praise were Lee-Smith's first recognition outside of Cleveland. This greatly encouraged him, but the war overrode everything at the time. In 1944 he joined the U.S. Navy as one of its "official" painters, creating "morale" paintings for nineteen months at the Great Lakes naval base.[9] He felt he had yet to make his real start.

After World War II Lee-Smith took a brief "refresher" course at the school of the Detroit Society of Arts and Crafts and obtained a degree at Wayne State University in 1953 on the GI Bill. His "refresher" was primarily a preparation for an exhibition at the Ten-Thirty Gallery in downtown Cleveland. In the course of this, he experimented with Surrealism, studying the work of Giorgio de Chirico and other Surrealists. One was Kurt Seligmann, a German Surrealist who came to the United States during the war. Many of Seligmann's canvases depict skeletons and other macabre figures from which flutter yards of mummylike swathings— a device that may have stimulated Lee-Smith's later use of ribbons and pennants.

However, he did not immediately pursue these Surrealist concepts, turning instead to Social Realism. "There was a very definite return in my work towards a kind of Social Realism," Lee-Smith recalled. "This was the kind of thing I was doing during the WPA days, making prints such as *The Wasteland* and *Artist's Life No. 1.*" The latter "had to do with the milieu, the situation in which the artist found himself in our society. A part of that lithograph has people marching with signs—and I've got the artist in a kind of 'ivory tower' situation. Most of us, during that period, were influenced by the social consciousness school, just as

Artist's Life No. 1 (ca. 1939). This etching made by Lee-Smith as a WPA artist in Cleveland reveals elements as diverse as dress design, a model, printmaking, and police brutality. Later in his development he abandoned such literalness for surrealistic symbolism, but retained a classical approach in technique. (12 x 10″) Collection Nathan Lasnik, University Heights, Ohio

youngsters during the fifties were influenced by the Abstract Expressionists."

For several years, Lee-Smith emphasized realism, depicting American life in a Social Realist way. During this period he returned to Detroit, where in 1951 he won the Michigan State Fair prize for oils, which stimulated interest in his work. He began to show regularly at the Detroit Artists Market, founded during the Depression to exhibit young artists.

Lee-Smith was impressed by the fact that whole blocks of a modern city, Detroit, were decaying, abandoned with gaping windows and missing steps. These blocks inspired such paintings as *Aftermath*. In 1955, when Howard University presented a one-man show of his work, Edgar Richardson, then director of the Detroit Institute of Arts, wrote: "one of his themes is the city in transition. Old buildings, silent and tenantless, yet alive in the evening light, stand brooding among the devastation and chaos of change. . . . This city of ours is both troubling, and beautiful in its sad-

ness."[10] The scenes he encountered in Detroit gave Lee-Smith a firm base in reality for paintings of desolation. Moreover, such scenes were not limited to Detroit but were becoming characteristic of many cities and towns. The phrase "inner city" was becoming common, and malls were beginning to appear.

At the time Lee-Smith was engaged in a kind of surrealistic life. For he was simultaneously teaching at the War Memorial Association in Grosse Pointe, Detroit's wealthiest suburb, the home of its auto magnates and millionaires. Some of his students there asked him to teach them privately at their homes; these included John Stroh, the founder of Stroh's Beer, and Anne Ford, the second wife of Henry Ford II. (Later, in New York, Charlotte Ford was one of his private students.) Some of his private students regularly bought his work.

In 1957 Lee-Smith won one of the nation's top painting prizes, the National Academy of Design's Emily Lowe award. That helped him decide the time had come for him to move to New York to further his own development. For a while he exhibited in various large New York galleries with indifferent success. His work was the antithesis of the emerging Abstract Expressionist movement, which was attracting all the press attention. Richardson suggested that he might do better with a small gallery such as Janet Nessler's Petite Gallery, which specialized in realistic work. Nessler liked Lee-Smith's work and he presently became one of her best-selling artists—in spite of Abstract Expressionist waves in the press.

However, life was not easy for Lee-Smith during this period. New York was a new city, and he felt there was much to learn. Moreover, his wife died in 1961, and for some time he was very much alone. Yet the quality of his work improved, and he won the National Academy of Design's 1963 purchase prize.

In the 1950s Lee-Smith emerged as a realistic painter of singularly imaginative character. Juries and awards committees in Michigan responded with prize after prize. Between his winning of the Maiuello prize of the Detroit Institute of Arts in 1951 and the purchase prize of the Michigan Academy of Science, Arts and Letters, he won eleven other noteworthy prizes.

One of his outstanding canvases of this period, *Boy on Roof,* depicted a black boy, seen from below, looking up at the flight of a flock of pigeons. Their grace, beauty, and freedom were juxtaposed with the dilapidated façade of the boy's tenement. Another painting, *Festival's End,* portrayed isolated young people—one of whom faces the viewer—on a desolate beach amid mysterious poles and drooping ribbons. This prize-

The Walls (1952), with balloons and bright clouds heightening the surrealism of the scene, shows a man climbing over a rotting brick wall, symbolizing prejudice, while another walks away. It was a prize-winning painting at the Detroit Institute of Arts. (16 x 52″) Private collection

winning painting is now in Lagos Museum as part of the Nigerian National Collection.

Lee-Smith had found a way of making a social comment that was very different from the 1930s scenes of breadlines, unemployed huddled by street fires, and sagging tenements. His evocative realism made feelings and memories a part of his painting. In *Boy on Roof,* the youth of the boy and the flight of the pigeons introduced a poignant note of hope for the boy. Often Lee-Smith's scenes were symbolic, related to the idealized Neoclassical painting of the nineteenth century, which often portrayed youths amid decaying ancient Roman columns and arches. However, he evoked a world of fantasy from the recognizable bric-a-brac of the American scene and the acknowledged plight of black youth.

Lee-Smith, who was then identified as a Romantic Realist, was in some ways the progenitor of the Photo-Realists, sometimes called the New Realists, who insisted on a return to objectivity after the subjectivity of Abstract Expressionism. They sought to interpret—through discarded objects or ones in daily use—the values of American society. By reproducing, in minute photographic detail, a shiny motorcycle or a little girl eating an ice cream cone in front of Disneyland, the New Realists depicted reality but symbolically addressed social values. While Lee-Smith did not project photographic images in creating his work, a method common to Photo-Realists, he did use realism to make a revealing statement about modern conditions.

One of the mysterious qualities of Lee-Smith's painting since the early 1960s is that one feels there is something within the painting that cannot be seen. This is an important element in Lee-Smith's achievement. "I am sincerely trying to get at something invisible and almost impossible to express," he told Wald. "I think my paintings have to do with an invisible life—a reality on a different level."[11]

Nearly every commentator on his work focuses first on the loneliness expressed in his canvases. In December 1987 two *Art News* reviewers wrote: "Alluring despite their austerity, Hughie Lee-Smith's images of solitary individuals elude definition."[12]

Yet Lee-Smith has defined it in rather concrete terms. As he told Wald:

In my case, aloneness, I think, has stemmed from the fact that I'm black. Unconsciously, it has a lot to do

As Lee-Smith moved into the 1960s his paintings, such as **Interval** (1960), became more mysterious and metaphysical, with flying banners added to decaying structures, and strangely isolated people. (36 x 48″) Collection of the artist

with alienation. The condition of the artist is already one of aloneness. Our work depends upon being alone, and we can appreciate the condition of aloneness more than other people. Being one of a group of outcasts in a society makes my sensitivity to the condition of aloneness much sharper than that of the average person. There is an isolation that every sensitive person feels; it is something all creative people recognize. And in all blacks there is awareness of their isolation from the mainstream of society. I felt it much more in my youth. Now I am not so affected by the alienation because I can appreciate my independence as a human being.[13]

Other experiences contributed to his feeling of aloneness. In 1961 his wife's death and his isolation from his grown-up daughter, who was in California, created a deep special kind of personal loneliness. He turned more than ever to his work, to discussing aesthetic and craft problems with other artists. Work is a great balance wheel for Lee-Smith and he tries to be thoroughly professional in the regularity of his work habits. "I always had a steady-on kind of attitude toward work," he said. "You do the work—period. I never think in terms of trying to do a great work or a masterpiece. I simply try to work out the problems the best I can."

His paintings gradually developed their deeper, metaphysical character. Two of these paintings, *Boy with Tire* and *Man with Balloons,* have been widely reproduced. As Lee-Smith explained:

The metaphysical phase really began in earnest in the early 1960s. In an almost unconscious, not at all de-

liberate way, it crept in. I was still with the Janet Nessler Gallery and it became much more pronounced in the late sixties. In that period my whole palette changed. There was the introduction of more white—so that the grays began to take over and a kind of fatality, I felt, developed in terms of the paint values themselves. I suppose this was an unconscious effort on my part to gain a feeling of forlornness. I never sat down and thought about it.

And I'm still in that kind of bag, you might say. I have the same feeling towards the world, even life. Perhaps it is even deeper. I think that as you grow older, you begin to be more philosophical—and much more concerned.

Although the fact is not well known, Lee-Smith has painted portraits throughout his career and regards portraiture as one of his specialties. Most of his portraits have been private commissions. One of his most unusual commissions came from the Maryland State Commission on Afro-American History and Culture for portraits of eminent black Marylanders, including Justice Thurgood Marshall, Harriet Tubman, Frederick Douglass, and Benjamin Banneker. Their portraits are a feature of the Banneker-Douglass Museum in Annapolis. With these works Lee-Smith moved into an area of painting that was new to him—African-American history. Recently, he was commissioned by the U.S. Navy to do a portrait of Admiral Samuel Gravely, the first black admiral, who commanded an Atlantic flotilla in the 1970s.

During much of his career Lee-Smith has taught

Boy with Tire (1952), in which a young African-American boy, with even his face in shadow, is depicted in a barren, decaying landscape, made a basic statement about life in America that Lee-Smith has reiterated in increasingly allegorical terms although his style is classical realism. (23¾ x 32½") Detroit Institute of Arts

different types of students in diverse settings. One of his most enjoyable teaching experiences was at Howard University, where he was an artist-in-residence from 1969 to 1971, and worked closely with many students. Toward the end of the civil rights movement, black art students revolted against their teachers' concern with Western art rather than African art (see page 379). "At the time I was rather a spokesman for the students at Howard," said Lee-Smith. "I was asked to articulate some of the ideas and aspirations of the young artists because I was with them and with a group in New York."

He particularly discussed these ideas with Porter, who as head of the art department was very disturbed by the demands of some students that studies of classical Western art and the Renaissance be abandoned and that Black Art be their only study. Looking back years later, Lee-Smith said:

> I took a rather positive attitude toward the whole movement because I knew it was necessary in that historical period in order to give some sort of recognition to black artists. I thought it was historically necessary to stir up the waters.
>
> However, there comes a point at which it becomes self-defeating. It becomes self-segregating if you pursue this too far. Therefore, I've never done what you might call Black Art. The Black Art movement served its purpose historically but it should not become separatist. There is a real difference.
>
> Basically, we have to educate millions of people. The real point is that all artists, not just black artists, have a helluva time.

Of his students at the Art Students League, where he began teaching in 1972, Lee-Smith said: "My students were serious. They knew where they wanted to go. They were hungry for technical information. You could walk into any of my classes and hear the proverbial pin drop. They felt they were in a tradition and that the Art Students League was a place where many great artists had studied. They were serious thinkers and I talked with them a great deal." His teaching emphasized thorough craftsmanship, study of old masters, and the establishment of a value scheme with a monochromatic underpainting before turning to color.

In 1978 Lee-Smith gave up his solitary life, marrying Patricia Ferry, a former student, and moving into Manhattan. A new enthusiasm and social activity marked these developments, which eventually led the couple to seek a larger home in East Windsor, near Princeton, New Jersey. In 1981 he was elected president of Audubon Artists, whose 600 artists form one of the largest groups of professional artists in the country; its annual exhibition is so large that in recent years it has had to be staged in two sections.

Such recognition by his peers gave Lee-Smith considerable satisfaction. It demonstrated their complete acceptance of a black artist. Earlier, in an April 1968 interview in *Art Gallery* by Jay Jacobson, Lee-Smith had sharply pointed out:

> The Negro is not yet considered—in the white or black community—upon his merits as an artist. As far as the whites are concerned, he is an exotique, and he has to paint like one [i.e., "primitive"] or he's not even considered. And for the black, if he's had any

Above: **Hughie Lee-Smith** *Impedimenta* (1958). In this painting Lee-Smith creates a haunting portrait of young people isolated and immobilized by unseen impedimenta, in a barren, decaying environment with turbulent clouds overhead. Nothing seems wrong but they seem unable to help themselves. (24 x 35″) Parrish Art Museum, Southampton, N.Y.

Left: *Temptation* (1991) marks the development of an optimistic spirit within Lee-Smith, the result of growing interest in him and his work. While the figure is taut and mysterious, the environment is not barren and decaying but alive with color and a clown, a symbol of gaiety. (48 x 36″) June Kelly Gallery, New York

Palmer C. Hayden *No Easy Riders* (1948–50) reflects Hayden's appreciation of the value and pleasures of unpretentious friendships among African-Americans, their enjoyment of one another's company, jokes, stories, and songs. (27¼ x 35¼") Museum of African American Art, Los Angeles

The Blue Nile (1964). Hayden was often inspired by dreams. This watercolor is a dream about black life on the Nile in the time of the pharaohs. Like much of his work, it expresses his slyly ironic sense of humor (Watercolor, 19 x 26½"). Collection Camille Billops, New York

Charles White *Wanted Poster No. 17* (1971). Charles White found old WANTED posters seeking runaway slaves, which he used as backgrounds for a powerful series. Adding symbols of the Confederacy and the names of those sold as slaves to his portrait of a grieving black mother and her bewildered child, about to be separated by being sold, White achieved a transcendent effect that deeply moved thousands of people. In this way White kept alive the tradition of socially conscious art at a time when other African-American artists turned to abstract painting, then very fashionable. (60¾ x 30¼″) Flint Institute of Arts, Flint, Mich.

Above: **Lois Mailou Jones** *Ubi Girl from Tai Region, Nigeria* (1972) was inspired by a trip to Africa and reflects Jones's strong feeling for design. It is her best-known work. While teaching design at Howard University for over forty years, Jones never stopped painting, and she particularly encouraged African-American public school art teachers, among them Alma Thomas, to paint and exhibit regularly. (Acrylic, 59 x 43⅛″) Museum of Fine Arts, Boston

Left: *Jennie* (1943) is an excellent example of Jones's ability to portray people at work with dignity. (36 × 28½″) Howard University Gallery of Art

John T. Biggers *Jubilee: Ghana Harvest Festival* (1957). Biggers first won attention in Texas with homey murals of African-Americans engaged in farm rituals and with African scenes such as *Jubilee*. These were painted in a traditional style while he was leading the development of an art department at Texas Southern University. (Mixed media on canvas, 38⅜ x 98″) Houston Museum of Fine Arts

Four Square City (1987) demonstrates the more modern and abstract manner that Biggers developed after retiring from TSU. Inspired by African-American folklore, *Four Square City* is based on the patterns of triangles created by the peaked roofs of rows of African-derived "shotgun" houses, common in the South. (Acrylic on canvas, 56 x 56″) Collection of the artist

Alma W. Thomas *Light Blue Nursery* (1968). Unlike the hard-edge colorists who used masking tape to secure geometric color strips, Thomas penciled in her irregular shapes, then brushed in her color rather freely, letting white provide a sharp rhythmic accent. Many watercolor studies preceded painting. (Acrylic, 50 x 48″) National Museum of American Art

Wind and Crepe Myrtle Concerto (1973) is a subtle and lyrical painting in which the white ground is replaced by dark greens and yellow-greens that flicker magically. This painting so enchanted the late Joshua C. Taylor that when he was director of the National Museum of American Art, he kept it in his office. (Acrylic on canvas) National Museum of American Art

Red Azaleas Singing and Dancing Rock and Roll Music (1976). Sometimes, Thomas used only one color plus white spaces shaped by rhythmic patterns to express her vision of color and life. (42½ × 156¾″) National Museum of American Art

Richard Mayhew *Counterpoint* (1968). Here Mayhew tries to express the essence of a remembered landscape, using color to create shapes and a mood or atmosphere. This is not an identifiable scene, but an impression rendered in nature's colors. John Canaday has pointed out (*New York Times,* November 8, 1969) that although Mayhew is not an Abstract Expressionist, his paintings, "regarded simply as pattern surfaces of rich color richly applied, are fully satisfying in accordance with abstract premises." (40 × 40″) Midtown Galleries, New York

Southern Breeze (1986). In finding his path as a landscapist, Mayhew abandoned conventional realism in favor of abstract renderings. These establish their reality through color values that are not realistic, in a kind of paradoxical magic. Mayhew has a profound love for the countryside—its forests, fields, swamps, and rock outcroppings—and a knowledge of optics. Yet he works from memory, from feelings that evoke colors and that in turn evoke a specific scene. He has brought a new vision to the great tradition of American landscape painting. (32 × 35″) Collection ATT

Man Standing on His Head (1970) reflects Lee-Smith's great precision in realistic detail and his ability to use everything from industrial tanks to circus tents, cracked walls, and human beings as symbols of social significance. The man standing on his head is white and screaming. A black man watches this performance from afar. (36 x 46″) New Jersey State Museum, Trenton

In ***Hard Hat*** (1980) Lee-Smith appears more optimistic, introducing positive symbols. A new brick wall, although targeted, is under construction alongside a cracked old foundation. Yet arrows point ambivalently in both directions and the alienated man in the hard hat appears challenging. (36 x 30″) Collection of the artist

kind of success, he's held up as a model. Not as an artist, but as a model Negro. One might say there's really not a great deal of difference between the present and the nineteenth century as far as black artists are concerned."[14]

In the spring of 1988, Lee-Smith was one of three black artists with midwestern origins exhibited at Kenkeleba House, a gallery in New York. The others were Archibald Motley, Jr., and Eldzier Cortor. The mysterious unseen but felt element in his high-key canvases stood in sharp contrast to Motley's portraits and animated night scenes of black city life and Cortor's gracefully elongated, sometimes dancing black women. While all three could be defined as realistic painters, the diversity of their aesthetic expression demonstrated the falsity of stereotypes about black artists.

The more one sees Lee-Smith's juxtaposition of a desolate, crumbling material world and windblown ribbons in an attractive sky, the more one looks at his alert, unbowed yet frozen people, the more one becomes aware that what is unseen is a certain optimism,

not an ominous threat, about the future. To quote Sims, "that sense of optimism, of future triumph . . . persists. It is a powerful artistic achievement."[15]

In 1987, when he was seventy-two years old, a subtle expressionistic change developed in Lee-Smith's paintings. His muted optimism, once symbolized by sunny skies and energetic if unseen wind, became less muted. Most striking was a painting titled *Passage,* in which a young black woman smiles with satisfaction at something that has happened. The human warmth of her smile is a stunning reversal of the unsmiling faces and taut figures of his earlier work.

Many factors contributed to this marked change in what had been the artist's elegiac vision. One was his happy marriage. Another was an ongoing, positive relationship with June Kelly, his new dealer, who had grasped the nettle that Lee-Smith, a classicist defying art trends of his time, was in grave danger of being completely overlooked. Still another factor was Zoltan Buki, curator of the New Jersey State Museum, who became fascinated by Lee-Smith's symbolic representations of our social and personal conflicts. He organized a large traveling retrospective exhibition

End of Act One (1987). In this painting Lee-Smith drew upon his early experience as an actor. Symbolically, on the left are stage flats and a make-believe house, and in the background a government building backdrop. The dressmaker's model awaits a change of costume, and while the young woman on the left has her back to the viewer—departing, so to speak—the young African woman on the right seems ready to appear in a new character. (32 x 34″) Collection George and Joyce Wein, New York

Passage (1982). This full-face portrayal of a smiling young woman marked a new development in Lee-Smith's painting. Her smile is a complete reversal of the mysterious unseen faces and backs of women in his earlier work. This change has resulted from a new optimism in Lee-Smith's outlook and life. (10 x 16″) Collection of the artist

of Lee-Smith's work. Opening in Trenton, New Jersey, it attracted critical attention from New York and Philadelphia publications. The exhibition then traveled to the Cultural Center in Chicago, the Butler Institute of American Art in Youngstown, Ohio, and the Studio Museum in Harlem. It won critical acclaim in the press and art journals. The African-American art historian Carroll Greene, Jr., noted that in the 1960s "a strong sense of transcendence had developed in Lee-Smith's work—a sense of spirituality beyond the physical universe."[16]

Of one of Lee-Smith's latest paintings, Greene wrote: "*Counterpoise II* gives the impression of two paintings in coexistence, suggesting perhaps two separate worlds. . . . The young black woman is rendered realistically, down to the creases in her skirt. In contrast, the young white woman is rendered abstractly, to the point of appearing to be a mere cut-out superimposed upon the white panel behind her."[17]

In this way Lee-Smith is now openly expressing the loneliness and alienation of the African-American trying to exist in two worlds. It is this quality that creates the dissonant feelings that, echolike, vibrate from these latest paintings.

After a 1989 exhibition of Lee-Smith's new work at the June Kelly Gallery, Gerrit Henry wrote in *Art in America:* "This was a masterly show; Lee-Smith is an elder statesman of the American imagination. His very fine technical accomplishments are gratifyingly matched by his obvious and abundant love for the human quandary."[18]

If Lee-Smith was once in danger of being overlooked, it is no longer true. An indication of how things have changed for him, and also how attitudes have changed in the South, is that the Mint Museum in Charlotte, North Carolina, is planning a new retrospective exhibition of his work in 1995, which will then tour major southern cities.

ELLIS WILSON

Ellis Wilson, who grew up in a small town in the tobacco country of Kentucky, became a leading interpreter of Haitian life. Unlike many other American artists attracted to Haiti, Wilson never drifted into the sentimental and picturesque. His work is objective and modern, and the people he depicted are not strangers but humanity itself, with all its grace, dignity, and mystery. Although he painted many documentary scenes of both rural and urban African-American life, it was his strongly stylized romantic scenes that won prizes in international competitions, museum and university exhibitions, a following among collectors, and honor in his native southern state.

Wilson's development as an artist was slow and characterized by a patient examination of his own feelings and observations. He was subtly influenced by El Greco, Aaron Douglas, and Horace Pippin, integrating these influences into his work.

A modest, even retiring man, Wilson was quietly proud of his prizes, but the exhibition he regarded as one of the high points of his life was a small show in the library in Mayfield, his hometown in Kentucky, for "all the folks to see," when he was fifty years old. The *Louisville Courier-Journal* published his work in color along with a photograph of him with his mother, then almost ninety years old. At the time he met Justus Bier, the paper's critic and head of the University of Louisville art department, who brought Wilson to the attention of many museums and collectors. That he was so honored in the town where, as a child, he was told to get off the sidewalks and let the white people pass created his deepest satisfaction. It was something beyond prizes.

Ellis Wilson, the fourth child of eight of Frank and Minnie Harden Wilson, was born on April 30, 1899, in Mayfield, Kentucky. His father was a barber and a skilled cabinetmaker, who made fiddles as well. As a young man, his father had also painted, usually working from photographs. Among Ellis Wilson's earliest memories are two paintings by his father: a very dark seascape in oil, which hung in their home, and a large painting of Christ driving money changers from the temple in the barbershop. His father had taken lessons from an itinerant art teacher.

The painting of Christ was done, Wilson believed, some years before he was born and impressed him deeply. Unfortunately, his father "had no time to paint after that—with the growing family and the business of making a living." Frank Wilson died in the mid-1930s.

As a boy, Ellis discovered he loved to draw—when he didn't have to work. His segregated school operated only six months a year, to let students work in the fields. Some black children had to work so much that they never got to school, and others couldn't stay the full six months. "We were fortunate—members of my family—that we could stay," Wilson said. To help his family, he got odd jobs. One day, while washing a dress shop's window, he drew a portrait with soap on it, immediately attracting a crowd. The delighted proprietor had him leave the portrait on the window and create a new one each week.

On completing grammar school, Wilson spent a disappointing two years at a free state school for black students in Frankfort, now Kentucky State College. The school taught only farming and teaching—not art, as he had expected. His father agreed to let him attend a summer course at the Art Institute of Chicago if he would then return to finish the Frankfort course and become a teacher. However, when he arrived in Chicago a major post–World War I race riot broke out. "I couldn't go downtown to the Art Institute," he recalled. "They were shooting and carrying on." In this way Wilson, a country boy, began his big city life.

Deciding he didn't want to be a rural schoolteacher, Wilson got a job in Chicago and began studying commercial art at the Art Institute, where he presently won the George E. Hoe and Charles S.

Field Workers (ca. 1950s) depicts a Haitian family going off to work. At that time Wilson still detailed facial features and gave figures a three-dimensional look, a style he later abandoned in favor of black silhouetted faces and a flat modern style that he felt was closer to what he actually saw at a distance. (29¾ x 34⅞″) National Museum of American Art

Peterson prizes, the latter with a poster on Africa. "Fine arts didn't enter my head," he recalled. "I thought—what is better than doing something you like if you're getting paid for it?" His tuition was $150 a year, which his father helped pay. "I would work in the summer and between the two of us, we made it," he said.

At the Art Institute Wilson met William McKnight Farrow, an expert in etching and its first black instructor. Through him Wilson became acquainted with other black artists, including Pauline Callis; Lawrence Wilson; Alice Evans, who soon went to Paris to study; Gus Ivory, a commercial poster artist; and the sculptor Richmond Barthé. Led by Farrow and Charles C. Dawson, then the most prominent African-American artists in Chicago, they formed the Chicago Art League in 1925.[1] Troubled by the prevalent racist attitude that art could not be created by black people, one of the Art League's first efforts was to dispel this attitude.

Their research established, for example, that Lottie Wilson Moss, of Niles, Michigan, was the first black artist to attend the Art Institute; her portraits of Abraham Lincoln and Sojourner Truth hung in the Esther Freer dormitory of Provident Hospital and at the White House during William McKinley's second administration (1900–01).[2] Another early black artist, Langston Mitchell, had become a Hearst news illustrator. William A. Harper, born in 1873 in Canada, had won honors at the Art Institute, and studied under Henry

Ossawa Tanner in 1903 in France, where he became a landscape painter; he died in Mexico in 1910.[3]

Even more exciting to Wilson was the Chicago Art League's major achievement—helping to organize the "Negro in Art Week," which the Chicago Women's Club sponsored at the Art Institute. African sculpture, paintings by Tanner and Edward M. Bannister, sculpture by Edmonia Lewis, and many works by Chicago's black artists were shown.[4]

The Chicago Art League also presented small exhibitions and discussions of members' work. Recalling the joy of these exhibitions and discussions, Wilson said that he knew Barthé, Ivory, Farrow, and Lawrence Wilson best. "At the time I was very shy, and as friends we weren't close. . . . Oh, they were good times! I had never before been in a group of artists—you know, creative black people. I thought: 'Gee, the Negroes are white!' It was just great to be numbered among them—for me, anyway."

Working in a YMCA cafeteria to support himself, Wilson attended the Art Institute for four years. He then worked for an interior decorator and did commercial artwork. In 1928 he moved to New York. However, even with Mary Beattie Brady pushing from the Harmon Foundation, no one would give him a job. A few drawings contributed to *The Crisis* brought no response. Finally, Wilson became a messenger for a

sporting goods store and later for a Wall Street brokerage house, where he eventually became a "board boy," recording grain transactions. At this point, feeling he had talent and nothing to lose, he turned to painting, studying portraiture and anatomy on weekends in the studio of Xavier Barille on 14th Street. His employer, Horace Gumble, "paid for my classes. He was that kind of person," Wilson said.

Meanwhile the Depression had begun. When the WPA art projects opened, Wilson quit his job and went on relief to become eligible for WPA employment. During this period he exhibited at the 135th Street branch of the New York Public Library, in Greenwich Village sidewalk shows, and in the Harmon exhibitions. In the 1933 Harmon show his work won an honorable mention. He painted still lifes and portraits in an academic style that reflected his timidity, but his compositions were solidly based. Each year he gained more confidence, using more color.

On the WPA Wilson was assigned to a little-known cartography project—a six-man group making huge three-dimensional maplike models of New York's five boroughs. Initially, he tried to get transferred to the easel project. But then he discovered its artists "were always getting pink slips," he said. So he stayed where he was and was steadily employed for six years, probably a record among black artists.

The WPA enabled him to become friends with many painters and sculptors, including Beauford and Joseph Delaney, who also had southern backgrounds. "And that's when I really started painting," he said. "I had moved down on East 18th Street, and they all lived down on Greene Street and that area, in lofts. They were all painting and visiting and talking and drinking wine. But it was really stimulating. It really got me to painting on my own. It was beautiful. . . . We made very little money, but things at that time—food and clothes—cost very little. Rent was very cheap. I was paying eighteen dollars a month for a cold-water place. It was a joy!"

In this new environment, Wilson lost much of his artistic timidity: "I just cut out completely from anything that looked like a portrait. . . . So the stuff really wasn't academic. It was freer. I was astounded. I just hit upon something."

One aspect of that "something" was the elongation of his figures of black people. At the Art Institute he had studied El Greco's use of such distortion, but this was made more meaningful in New York when he saw how Aaron Douglas used elongation to achieve a distinctive grace in his black silhouettes. The more he observed black men, women, and youths, the more he was aware of their tallness and their lithe, long legs

and arms. He carried these observations into his painting, as *Shore Leave* indicates. The elongated figures of African-American sailors dancing with their girlfriends gave Wilson an opportunity to add a sensual note to his essentially realistic painting of these rhythmic figures. This did not become a mannerism identifying all his work, but rather was an effect he applied selectively and that freed him from the sterility of mechanical realism. Wilson also gained from Douglas an understanding of the use of a single silhouetted figure, which ultimately became a characteristic of his work.

During the same period, Wilson became so enchanted with Horace Pippin's paintings of flowers and the life of black people that he went to Philadelphia to see a Pippin exhibition. Unfortunately, he had no opportunity to talk to Pippin. Pippin's brilliant color, his indifference to perspective, and his focus on the emotional reality rather than the physical also helped free Wilson from convention.

Pippin's impact on Wilson had still another dimension: it legitimized taking black people and their activities seriously. Pippin's paintings, such as his *Saturday Night Bath,* depict earnest, serious people. Wilson had a tendency to slide into somewhat humorous portrayals, as if afraid to be serious.

Wilson's initial application for a Guggenheim fellowship was turned down. He got a job in an aircraft engine factory, where he sketched defense workers at their jobs. When these drawings accompanied his 1944 Guggenheim application, he was awarded a fellowship, which was then renewed.

Wilson used his fellowship to portray southern black people and their activities: making turpentine with an old still, cutting lumber in the swamps, planing in sawmills, dancing, going to church or to market, harvesting and packing tobacco. "Whatever I found, I painted—and that loosened me up a lot, too," he said. In his hometown he portrayed youths performing his old job—"handing in" cured tobacco leaves to hogshead packers. On the South Carolina plantation of Mrs. John Robinson, who had purchased one of his paintings,[5] he painted *Field Hands*.

In Charleston, Wilson found the "open market," which resembled markets in the West Indies, stimulating. Realizing that any frank sketching would distract and disrupt the activities and people's attitudes, he hung around the market for days, slipping away momentarily to make small sketches of what he saw—the black people coming and going with baskets of flowers, vegetables of all sizes, or chickens, and the colorful stalls selling almost anything to clusters of

Fishermen's Wives (ca. 1950s). These women, cooperatively sorting and sharing the day's catch on the Haitian beach, fascinated Wilson. He painted such scenes from memory and written notes, feeling that sketching on the scene would disrupt the naturalness of the people. (35 x 46″) Permanent collection, Howard University Gallery of Art

people from the city, farms, and fishing towns. From these sketches he developed colorful paintings. When these paintings were exhibited at the Barnett-Aden Gallery in Washington, D.C., they promptly sold because they evoked memories of such markets among southern people of all races. Wilson considered *The Open Market at Charleston* one of his most important paintings.

At the Charleston market Wilson discovered the black people from the Sea Islands off the Carolinas, who walked erectly and, like Africans, balanced baskets on their heads. Their attitude and beauty intrigued him. Moving to Beaufort and then to Edisto Island, Wilson "often went on fishing trips with them, getting to know them quite well," he later said. "I was attracted by their simple poise and dignity." During this time Wilson began painting many pictures, including a fisherman toting a big catch, silhouetted in the fading blue of twilight; nets forming pyramidal tents on the beach; fishermen repairing nets; a widow by the sea; a young girl going fishing. Later, working from sketches in both oils and watercolors, Wilson finished these paintings in New York.

Wilson's Guggenheim award attracted the attention of Justus Bier, a leading art historian and critic. Bier understood what a persistent effort a poor Kentucky black youth had to make to win a Guggenheim fellowship. He was shocked that the J. B. Speed Museum in Louisville had never shown one of Wilson's paintings. In his opinion, Kentucky had no other artist who came close to Wilson's achievements.

Allen (1945), a portrait of an African-American worker, won first prize at the 1946 Atlanta University exhibition. Wilson later described himself as being "timid" at that time, afraid to try a more modern style. Collection Clark-Atlanta University

On learning, in 1949, that Wilson was coming to Mayfield to celebrate his fiftieth birthday with his mother, Bier asked Wilson to meet with him. Meanwhile the Graves County Library arranged a small exhibition that included some of Wilson's local scenes of black tobacco workers and clay miners, as well as of Sea Islands fishermen. Hundreds of Graves County residents came to meet Wilson and see his work.[6]

Bier, later director of the North Carolina Museum of Art, published color reproductions of Wilson's paintings in the *Courier-Journal*. When Wilson visited Louisville, Bier was able to assure him that the Speed Museum would give him a one-man show. This exhibition, consisting of nineteen carefully selected paintings, won Wilson attention from other museums and galleries. Bier followed up with more articles, making them part of a campaign to alter the southern image of African-Americans and to increase art facilities in Kentucky. "It seems tragic," he wrote, "that a man of Wilson's gifts had to leave his home state to get an art education."[7] Thereafter, the *Courier-Journal* regularly followed Wilson's career. Other African-American artists also benefitted—in 1951 the Art Center Association

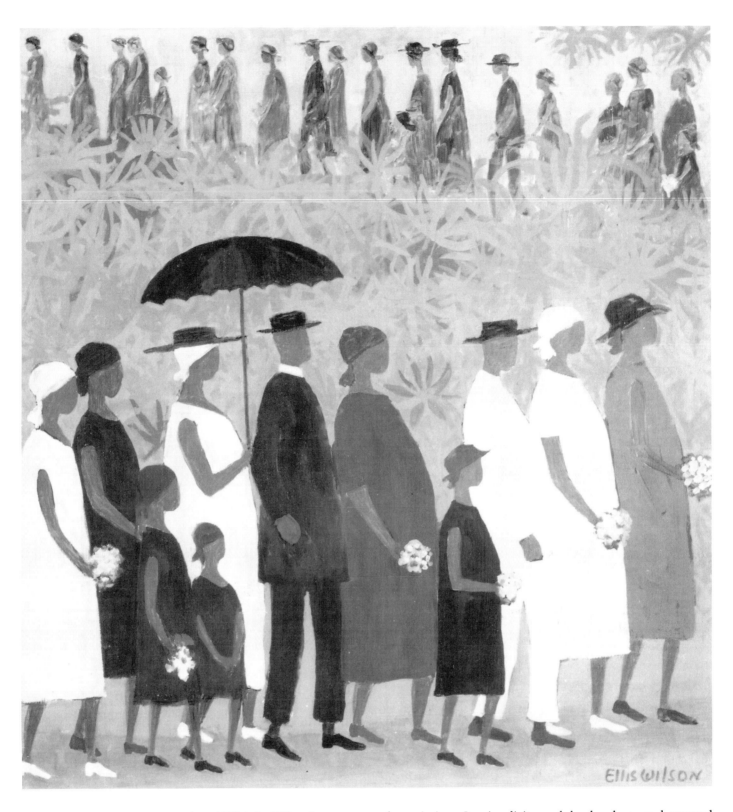

Haitian Funeral Procession (ca. 1950s) is Wilson's most popular painting. Its simplicity, subdued colors, and unusual composition and the eloquent dignity of the mourners make a profound statement about the loss of a loved one. The *New York Times* observed: "His intense colors and simple outlines invest them [Haitians] with almost heroic proportions and great simple dignity." (30½ x 29¼") Aaron Douglas Collection, Amistad Research Center, Tulane University

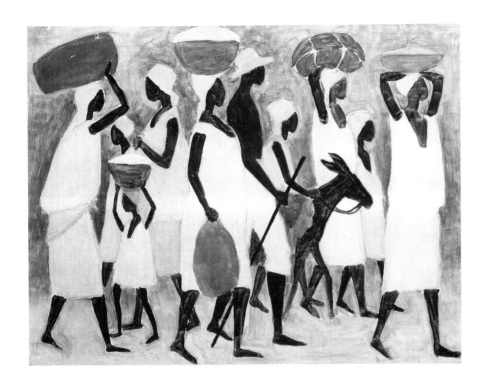

To Market (ca. 1954) reflects Wilson's develoment of a flat but colorful silhouette in his Haitian paintings. This break with his past work excited him and enhanced his reputation as a modern artist. (22⅜ x 28¹³/₁₆″) North Carolina Museum of Art, Raleigh

of Louisville dropped bylaws restricting exhibitions to the work of white artists, so that it might show two Wilson works—*Chinese Kites* and *Melons*—in its annual Kentucky and southern Indiana exhibition.[8]

In 1952 Wilson won the $3,000 second prize in the National Terry Art Exhibition in Miami, the largest exhibition ever held in the South; first prize went to Philip Evergood. Wilson's prize painting, based on his Charleston sketches, depicted a sturdy black fisherwoman, her back to a deep green sea, holding a huge pink fish across her belly and thighs while balancing another large fish on her head. Wilson admitted to Bier that he had never seen anyone with a fish on his head, "but they carried everything else on their heads."[9] This imaginative thrust carried Wilson far from his initial documentary approach.

In reviewing Wilson's second one-man show at the Contemporary Arts Gallery in 1951, the *Art News* reviewer asserted that Wilson "has invented an imaginative race of tall, regal Africans. The women are particularly fascinating, mysteriously faceless behind the slit in their long headdresses, carrying tasseled umbrellas. Limiting his forms permits Wilson to enrich his surfaces, scumbling thick colors over black and making backgrounds flicker with hue over hue."[10] This method of handling color became characteristic of his work; his subsequent visits to Haiti only heightened his use of color.

Wilson first visited Haiti in the early 1950s with his Haitian friend Milo Pierre Antoine, an artist and highly skilled cabinetmaker. Wilson found Haiti "very exciting," because "first of all, it was a black republic in

which they [black people] were in charge of everything—I'd never been to a place like that. And although they were black, I couldn't understand them—they spoke Creole and French. All that excited me. And then it was tropical. . . . I'd never seen a tropical place—and with the music, the drumming, the dancing, they were very artistic."

Coming from the rural South, Wilson strongly identified with the Haitian peasants, whom he saw coming to market carrying baskets of vegetables, fowl, flowers, and fruit atop their heads. He spent days observing them in the markets, at bus stops, along the wharves and beaches. His observations prompted a great leap in his painting. One day, as he recalled it, "It came to me that at a distance, you see these people coming and going—and you don't see their features. They're black—they're a mass of darkness—so I started painting the faces flat. That was a big step for me!"

His new observations moved him toward more stylized but appealing figures, in both form and color. Describing his Haitian paintings in 1954, Senta Bier, the wife of Justus Bier and also a critic, wrote about his very intense colors: "There are few gentle transitions, vermilion red appears beside carmine red, bluish-greens beside yellow greens—and yet he always achieves a perfect harmony through the addition of another color that pacifies the fighting opponent."[11] In his stylized presentation, Wilson often made use of Haitian architecture or foliage to create the background that he felt was necessary to set the stage for his richly painted personages. While his color is gay and romantic, his black figures are always earthy and impressive.

The Haitian people intrigued Wilson because, un-

342

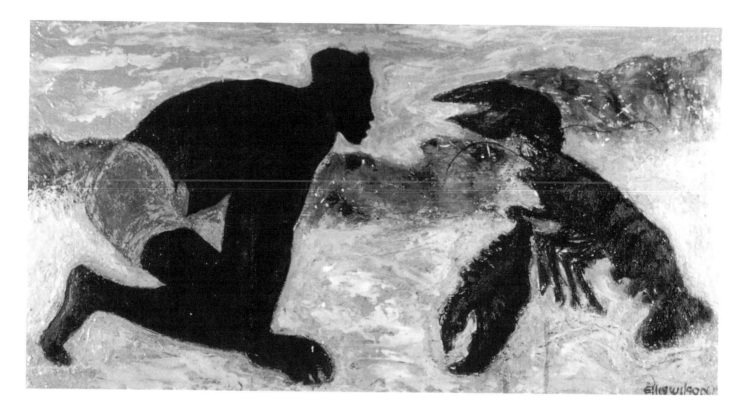

like Americans, who "laugh a lot," they had a seriousness that was part of their basic personality and contributed to their dignity. They would not say *bonjour,* unless they felt like it—"and I liked that," Wilson said. Physically, he considered the Haitians smaller than black Americans and "good-looking, very black, with small features and bones."

Wilson's comments help to explain the inspiration, depth of feeling, and outpouring of artistic expression that Haiti arouses in so many black artists in all fields—from the dances of Katherine Dunham and poems of Langston Hughes to the paintings of Eldzier Cortor and Jacob Lawrence. This stimulation has been reinforced by the concept of negritude, formulated by Léopold Sédar Senghor, Aimé Césaire, and Kwame Nkrumah, and derived from the work of the Haitian educator and sociologist Dr. Jean Price-Mars, who called attention to the artistic potential of the island's folklore shortly after the turn of the century.[12]

In 1971 Fisk University presented a retrospective exhibition of Wilson's work along with the ceramics and sculpture of William E. Artis. David C. Driskell, then head of its art department, pointed out that in Wilson's paintings, regardless of the scene—funeral or carnival—"one feels a closeness to the participants."[13]

Lobster and Man (ca. 1950). This vision of a beach, with the lobster nearly as big as the man, appealed to Wilson's sense of humor. In the same vein, he once painted a wholly imaginary picture of a woman on the beach carrying a large fish on her head.

Wilson continued to live and work in an East 18th Street studio in Manhattan that he had occupied for forty years. He painted only in the spring and summer, complaining, "In the winter it gets too dark and cold, and it makes a difference in the colors."

Reflecting on his life, Wilson said in 1974, "The only thing I regret is that my father died long before I had ever done anything at all. I would have loved for him to be living, especially when I got the Guggenheim." This first national recognition, thirty years earlier, remained in his own eyes his greatest achievement because he was then unknown.

Wilson, who never married, died on January 1, 1977, in French Hospital, New York, after a brief illness.[14] Although he was not an artistic innovator, his paintings changed perceptions of black people wherever they were shown. Millions of Americans have seen them on Bill Cosby's television shows. One program revolved around a Wilson painting of Haitians going to work in the fields.

343

James Hampton *The Throne of the Third Heaven of the Nations' Millennium General Assembly* (ca. 1950–65). Created in a Washington garage by Hampton, a government janitor, this imaginative, visionary throne was not discovered until he died in 1964. It is made of all kinds of objects—light bulbs, jelly glasses, gold and silver foil, cigarette packages, aluminum foil. At its top are the words FEAR NOT. Glittering under lights, it is on permanent display at the National Museum of American Art, where Lynda Roscoe Hartigan, curator of African-American art, has written an excellent description of how it was made. Hampton was born in Elloree, South Carolina, in 1909 and never married. He filled notebooks with religious predictions and statements from the Book of Revelations. The throne is his only production. (9 x 32′)

THE NAIVE, SELF-TAUGHT ARTISTS

Artists described as "naive" and "self-taught" are increasingly being recognized as often creating a more original and authentic art than that of the academically schooled artists, long considered the main representatives of American art. As Jean Lipman, the leading authority in this field, has pointed out, these artists have made "a central contribution to the mainstream of American culture."[1]

In this group are a number of African-American men and women. Two of these artists—William Edmondson and Horace Pippin—are among the most extraordinary artists the nation has produced. Other self-taught African-American artists include Minnie Evans of Wilmington, North Carolina, whose work has a psychedelic quality; Clementine Hunter, whose vision encompasses black life on the old Melrose Plantation in Louisiana; street-preaching Sister Gertrude Morgan of New Orleans, whose visions are biblical; Thomas J. Flanagan of Atlanta, who painted Georgia landscapes; Edgar Patience of Wilkes-Barre, Pennsylvania, who carved miners in coal; Elijah Pierce, whose whittled, painted figures first decorated his barbershop in Columbus, Ohio; Bill Traylor, a former slave of Benton, Alabama, who portrayed farm animals and people; and James Hampton, whose only known work, *The Throne of the Third Heaven of the Nations' Millennium General Assembly,* now sparkles in the National Museum of American Art, in Washington, D.C.

Although these artists are generally called "folk artists," in our culture this term carries a negative connotation, suggesting that they are not "real artists." This characterization developed out of the confusion of traditionally trained artists and critics, who were considered the authoritative designators of art in our society. They simply did not know how to deal with an art that arose outside traditional concepts. For a long time they referred to these unschooled artists as "primitive," mainly because their work lacked the technical expertise of schooled artists.

However, this term only added to the confusion, since these artists' work could not be equated in any way with the "primitive" art of Africa and Oceania, or of Mayans and other Native Americans. Unlike "folk art," the art of these other cultures is based on highly sophisticated, well-defined forms and carefully developed traditions related to philosophical and religious beliefs. For example, finely cast bronze Benin sculpture equals the best Renaissance sculpture in power, dignity, and realism. An elaborately traditional art, Benin sculpture was carried out only on "The Street of Sculptors" in the city of Benin. It was governed by familial guilds, specific concepts of form, and subject matter related to religious and social beliefs, and it required advanced casting techniques. In many ways it is a total contrast to the highly individualized approaches of American "folk art."

There is also a problem with the term *naive* when it is applied to artists like Henri Rousseau, one of the most original French painters of the late nineteenth century, and Pippin, who sometimes is called "the Rousseau of American art." Rousseau, a schoolteacher and musician, was a "Sunday painter" who knew painting technique very well. He wanted to paint like the late-nineteenth-century masters he admired, but he felt compelled to paint his visions, creating haunting scenes with an inquisitive lion in a moonlit desert or a tennis player leaping into midair while looking directly at the viewer. That he chose to ignore perspective and paint in a flat way with brilliant color caused him to be hailed by Pablo Picasso and others who were trying to break away from academic perspective and realism. This is why Rousseau is considered one of the most important artists of his time.

Similarly, Pippin, despite his lack of formal education, felt compelled at times to turn from home and farm scenes to express ideological and religious themes. In his *Holy Mountain* series, although the foregrounds are pleasant, almost subliminal in charm, the backgrounds contain cemetery crosses, turning the paintings into morality lessons. In his war paintings the

Sister Gertrude Morgan *Let's Make a Record* (ca. 1978). Born in Alabama, Morgan came to New Orleans in 1957, where she became a street preacher, painter, guitar player, and singer. Her paintings were, she said, messages from God. She emphasized singing and dancing as means of communicating with God, and indeed made records. After a divine message told her she was to be the bride of Christ, she wore only white. She died in 1980. (Tempera, acrylic, and pencil on paperboard, 12⅜ x 12″) National Museum of American Art

Elijah Pierce *The Funeral* (1933). Born in Mississippi in 1892, Pierce began whittling as a boy and first carved canes. In 1924 he married and settled in Columbus, Ohio. In the 1930s he opened a barbershop, which he decorated with carved panels, usually inspired by biblical statements. Often painted and varnished, these carvings are expressive, anecdotal, always moralizing, and touchingly humanistic. Pierce was widely exhibited before his death in 1984. Collection Boris Gruenwald.

soldiers are dehumanized by their gas masks—another lesson. In this regard, his work contrasts sharply with that of most folk artists, who are generally concerned with pleasant "things," not ideas, and with painting as recreation, not as a way of communicating moral concepts.

Despite their clear individuality, American folk artists possess certain common characteristics. With few exceptions, they come from economically and socially deprived areas, and their art has developed relatively late in life. John Kane was a housepainter; Morris Hirshfield, a garment factory worker; Grandma Moses, an isolated farmer's wife; Horace Pippin, a laborer-soldier; William Edmondson, a hospital orderly. Almost invariably they led ordinary, hard-working lives until, around the age of fifty years, they began to follow with stubborn persistence their artistic vision.

These artists' work is usually, though not always, bound to personal experiences. Grandma Moses, for example, created paintings of farm life, while Clementine Hunter depicted scenes that she witnessed during her years on the Melrose Plantation. Edgar Patience, a former coal miner, carved only in coal. Pippin began with war scenes he knew as a soldier.

Edmondson, to cite an exception, carved angels and animals of fantasy that he called "varmints."

One of the most important characteristics of these artists is that while each is original, as a group they have their own way of seeing and painting. Just as a child's painting can usually be recognized by a trained eye as a child's work, the characteristics of these artists resemble one another. The French artist Camille Bombois painted in a manner very close to that of the American Hirshfield. Grandma Moses was close in subject and form to those self-taught artists who created many Currier & Ives lithographs in the last century. These artists are guided by a way of observing reality that focuses on its emotional meaning to the artist, not conventional reality. They find formal art concepts meaningless. When exposed to such concepts at the Barnes Foundation school, Pippin said, "They got their way. I got mine." Herbert W. Hemphill, Jr., coauthor of *Twentieth-Century American Folk Artists,* points out that their vision "is a private one, a personal universe, a world of his or her making."[2] For example, Edmondson, from Nashville, Tennessee, did not know that what he did had artistic value until others told him so. Even then, it was not important to him.

Other identifying characteristics of this work are its often nearly symmetrical balance and its formal, almost classical arrangement. These aspects give it a certain serenity—a tranquillity. Never exciting, it may sometimes be amusing or touching, but the basic quality is calmness. Even Pippin's scenes of wartime bombing have this serenity.

The calmness grows out of the experiences of the artists themselves, expressing their wishes for a more tranquil, more pleasant, more peaceful time. They may be recalling a period of the past with pleasure. Or they may have a vision of how things ought to be, often structured around religious precepts—a vision eloquently expressed in Pippin's *Holy Mountain* paintings, where lions, tigers, lambs, and people of different races assemble peacefully together. Edmondson and James Hampton offer visions related to the Christian concept of the hereafter. Edmondson moved from tombstones to peaceful lambs and doves, to angels, and to preachers warning of sin and the hereafter. In a similar way, Rousseau confronted the destructiveness of the Industrial Revolution by seeking refuge in tranquil imaginary jungles and deserts with mysteriously fixed lions and sleeping women.

Another major characteristic of all these artists' work is the lack of a feeling of time and its passage. There are no shadows, as though a dream had been stopped in brilliant color photography. There is no accurate perspective, even when it is attempted. The light is flat and overall. This quality of arrested time contributes significantly to the formality and balance of the painting, its serenity and stillness.

Lastly, each of these artists considered his or her work and the vision that engendered it to be completely real. It was emotionally real. Pippin never saw any need for perspective and considered his treatment of flowers and lace antimacassars to be extremely real. Edmondson believed his "varmints" real. Rousseau believed his woman on a couch in the jungle was realistic.

In 1938 Jean Lipman, the first editor to publish extensive material on African-American artists, wrote a definition of naive, self-taught American artists that has stood the test of time. Such artists depend, she wrote, "upon what the artist knew rather than what he saw. . . . The degree of excellence in one of their paintings depends upon the clarity, energy, and coherence of the artist's mental picture rather than upon the beauty or interest actually inherent in the subject matter, and upon the artist's instinctive sense of color and design when transposing his mental pictures onto a painted surface rather than a technical facility. . . . The outstanding artists, unhampered by external requirements or restrictions, arrived at a power and originality and beauty which was not surpassed by the greatest of the academic American painters."[3]

In 1982 an exhibition of the work of twenty African-American folk artists, which opened at the Corcoran Gallery in Washington, D.C., and then moved to four more cities, clearly demonstrated the originality and individuality of these artists. The catalog, *Black Folk Art,* carried an essay by Jane Livingston describing this work, one on its origins and early manifestations by Regenia A. Perry, and another titled "Spiritual Epics: The Voyage and the Vision in Black Folk Art" by John Beardsley.[4]

Drawing upon African-American experiences, memories, and visions, these artists have made a unique and hitherto unknown contribution to American culture. Like other folk artists, their work exhibits a certain spirit of playfulness as well as a preoccupation with religious beliefs.

Mary and Martha shows Edmondson's remarkable ability to capture personality and character. He did not make preliminary sketches, but cut his figures directly out of the stone. A self-taught sculptor who never left his hometown of Nashville, Tennessee, in 1935 he was the first African-American to be given a one-man museum show. (14 x 16¾ x 5″) Hirshhorn Museum and Sculpture Garden, Washington, D.C.

WILLIAM EDMONDSON

The first African-American artist to achieve a one-man museum exhibition was William Edmondson. In 1937 his powerful, direct carving entranced patrons of the Museum of Modern Art in New York. Following that exhibition, many articles about this sculptor from Nashville, Tennessee, took his stories of religious visions literally, making him appear to be quaintly "touched." Yet he was far from being a simple man, and his remarkable figures—humans, sheep, doves, angels, black sports heroes like Jack Johnson, and imaginary "varmints"—attracted some of the nation's most sophisticated artists. Leading photographers, such as Louise Dahl-Wolfe, Consuelo Kanaga, and Edward Weston, went to Nashville to photograph him and his work. Weston asked that an Edmondson-carved stone be placed on his own grave.

The child of slaves, Edmondson was barely able to read but was extremely dexterous. He was also independent and sometimes ignored excessive demands by employers, saying, "God don't intend nobody to work themselves to death. Slave time is over."[1] Edmondson's faith in God was his final authority to act independently.

It was only during the Depression, when he was well over fifty years old, that Edmondson began to carve tombstones for poor black people from abandoned limestone curbing. Presently he cut doves and lambs from these stones, and then gradually began to make human figures, birds, and animals, carving directly without making preliminary drawings or models. His work resembles, in some respects, that of another direct carver, John B. Flannagan, one of the most gifted and daring sculptors of the 1920s.

In his sculpture Edmondson pursued a lively and positive view of people and nature that was based on an underlying emotional reality that he intuitively felt. In a *New York Times* interview explaining why this unknown black artist was given a one-man show by the Museum of Modern Art, its director, Alfred H. Barr, Jr., emphasized that, instead of painting, Ed-

mondson has "chosen to work in limestone, which he attacked with extraordinary courage and directness, to carve out simple, emphatic forms. The spirit of his work does not betray the inspiration which he believes to be his active guide."[2]

Edmondson did not seek acclaim. Referring in 1941 to his earlier discovery by Nashville poet Sidney Hirsch, Edmondson said, "I didn't know I was no artist until them folks come told me I was."[3] Except for a trip to Memphis, he never left Nashville, where he received little recognition during his lifetime. In 1939 he was given about a year's employment as a WPA artist. Later, in 1941, his work was exhibited at the Nashville Art Gallery, and in 1951, following his death, at the Nashville Artists Guild. In 1964 the Tennessee Fine Arts Center at Cheekwood, in Nashville, presented a large exhibition of his work. In *Visions in Stone,* a 1973 biographical sketch by Edmund L. Fuller was published, accompanying over 100 photographs of Edmondson's sculpture by Edward Weston and Roger Haile. Fuller notes that "William Edmondson was confronted by . . . racial, social, and economic boundaries, even as his sculptures were confined by the quality and shape of the available stone blocks. But these restrictions did not have the authority to determine the form of his existence or of his work. Instead it was through his powerful spirit, simple ways, and loving devotion that he created his own life and his own 'miracles' "[4]—the term Edmondson often used for his carved figures.

William Edmondson was born, as he put it, "of fore-parents [George and Jane] who were Edmondson and Compton slaves" in the Hillsboro Road section of Davidson County, adjacent to Nashville.[5] A family Bible recording his birth was destroyed by fire; the date was later estimated to be between 1863 and 1870.[6] His father died while William, his sister Sarah, and four brothers were quite young. His mother supported the family by working in the fields. As teenagers, the boys got

Horse. Having worked on a farm in his youth, Edmondson knew and emphasized the barrel-like bulk of heavy draft horses, their stance, and their great pulling power. Collection Estate of Consuelo Kanaga, Croton-on-Hudson, N.Y.

Sheep. As this work shows, Edmondson, although untrained, developed a masterly way of simplifying form and mass so that he could create the essence of an animal or person without getting trapped in unimportant detail. Collection Estate of Consuelo Kanaga, Croton-on-Hudson, N.Y.

jobs to help their mother, and all left home except William and his sister. Later, his mother took in some of her grandchildren by a daughter of an earlier marriage, including Mary Brown Seymore, who remembered the Edmondson brothers as having been "raised to be most respectful men." She also recalled that the grandchildren were treated "just like we were their children. [Edmondson's] mother was a person who saved and yet had what she wanted. She would say . . . 'Listen, we do Right because it's right to do Right. We don't do Right because somebody is watching us.' "[7] His mother's emphasis on respect, frugality, and honest simplicity, Fuller felt, characterized Edmondson's life and his sculpture.

Edmondson's education was minimal. *Time* reported that he "read large print with difficulty, writes scarcely at all."[8] Around 1900 Edmondson worked as a farmhand at the Whitland Farm, now overrun by expanding Nashville; he was also a groom at a racing stable. Later he worked in the Nashville, Chattanooga, and St. Louis Railway shops until he was injured in 1907.[9] He then went to work for the "all-white" Woman's Hospital, later the Baptist Hospital, as an orderly,

fireman, and handyman. He was known there for his independence and wit.

In 1931, after almost twenty-five years of service, Edmondson either quit or was "let go" because of "bad times." He and his sister Sarah owned their own home, a tiny story-and-a-half red brick cottage with a deep fifty-foot-wide lot, where he had a sizable vegetable garden. Although Sarah eventually married and left, Edmondson never married.

He soon got work as a stonemason's helper, mixing mortar and helping to cut and place stone. Carving stone deeply appealed to him. Not everyone could do it, he proudly said. That, once shaped, the stone endured intrigued him.

When building—and masonry—slumped as the Depression deepened, Edmondson gathered in his yard stones from wherever he could find them and built an open shed to shelter himself from the sun while carving. Mostly he gathered limestone curbstones that a city improvement project was replacing with concrete.

Squaring up the rough-cut curbstones with chisels he had forged and ground from old railroad spikes, Edmondson "dressed" these stones as tombstones and

Two Birds. Lifelike in their symmetry and grace, Edmondson's birds were initially carved in relief on tombstones, then as single figures. By the early 1930s he was carving them in pairs or trios. (6¼ x 7 x 9½″) Newark Museum

Jack Johnson. Johnson, the first African-American heavyweight boxer to gain the professional championship (1908–15), was the great hero of Edmondson's youth. The statue seems almost bursting with power. (16³⁄₁₆″ h.) Newark Museum

sold them for a few dollars to members of the black community. The steady ring of his hammer became a neighborhood sound. Working from a card lettered by the purchaser, he hand-carved names and dates. In most tombstone shops, letters were cut mechanically by sandblasting equipment.

The more stone Edmondson cut, the more he enjoyed it. Although there was no great demand for tombstones, he went on cutting and squaring up stones. As his mastery of carving increased, he began to cut traditional tombstone figures—lambs and doves. Instead of drawing and then modeling figures in clay and giving them to stone-cutting machine operators and polishers, Edmondson cut his figures directly out of the stone, chip by chip, bit by bit. It was slow, hard work, requiring great physical strength and tireless patience. His hammer never stopped. Yet he cut "stingily," as he put it, because his cutting power came entirely from his muscles.

In this slow, lonely work, Edmondson amused himself with fantasies about the subjects he cut from the stone. He had a rich sense of play, of biblical lore, and of humor. He also had a traditional storyteller's narrative gift. Years of working in the hospital among people who were sick and dying had taught him how to use his fantasies to amuse and ease people. He told his tombstone customers, who were troubled by memories and the death of loved ones, his fantasy stories.

Edmondson gradually extended his range from lambs and doves to rams, horses, lions, "critters," and "varmints" of all kinds, and to human figures—preachers with upraised warning fingers or Bibles, angels, dumplinglike "sisters," or the two-fisted Jack Johnson. Sometimes he cut a Crucifixion if the character of the stone suggested it. He also made birdbaths.

If anyone remarked on his ability, he said it was "the Lord's gift." Eventually he formulated it in this way: "First, He tol' me to make tombstones, then He tol' me to cut the figures. He give me them two things."[10] Edmondson knew what people expected a black man to say.

Edmondson's greatest limitation was the dimensions of the curbstone—generally no more than two feet wide, three to four feet long, and six to eight inches thick. He sometimes found, or a friend brought in, a fieldstone with a suggestive shape, but he could not afford marble. At times he salvaged limestone blocks that had greater depth from a building demolition, but moving such stones always presented difficulties. He had to entice strong friends and someone with a truck to help.

351

Edmondson's stone yard, photographed by Consuelo Kanaga in 1938, was filled with statues that became museum pieces. Visible are *The Preacher*, an early version of *Mary and Martha*, a bird, another preacher, and in the left foreground a turtle. Edmondson also liked to create "varmints"—beasts of his imagination.

Schoolteacher reflects Edmondson's ability to portray character—in a curbstone only five inches thick, stone most sculptors would reject. He made a series of schoolteachers. (13½ x 5 x 9½") Collection Mr. and Mrs. Alexander Brook, Long Island, N.Y.

Edmondson's simple figures were impressive and attractive. His direct carving method and the basic shallowness of the curbstone gave them a certain stiffness, but the directness of his approach and his economical cutting created sharp, expressive characterizations that seemed to defy the material in which they were cut. His birds and animals had delicate grace, balance, and characteristic poses. His people—ostensibly pious and solemn—were at the same time very human and even humorous in a sophisticated, droll way. Their postures, even their stony stiffness, always left something unsaid but felt, something profoundly suggestive of the inner feelings and outer pretenses of humans. They had a certain quaint picturesqueness but were also impressive works of art.

In about 1934–35, Sidney Hirsch came across Edmondson's tombstone yard and its doves, angels, sisters, lions, preachers and "varmints."[11] Hirsch was one of the "Fugitive Poets" associated with John Crowe

Ransom at Vanderbilt University, who saw in subsistence farming an escape from the ills of industrialization and therefore praised the South's agrarian past. Hirsch had spent years abroad and was familiar with modern and Chinese art. He immediately appreciated the artistic character of Edmondson's work and delighted in his stories of visions of God and of how he came to make each piece.

Hirsch took his friends Alfred and Elizabeth Starr to see Edmondson and his work. They promptly bought some pieces. When, in the summer of 1936, Louise Dahl-Wolfe and her husband, Meyer Wolfe, came to Nashville, the Starrs took them to see Edmondson.

Dahl-Wolfe, one of the nation's foremost fashion photographers, promptly photographed Edmondson at work and many of the statues in his yard. In New York she took her pictures to another Nashville friend of the Starrs, Tom Mabry, who also knew Edmondson. At the time Mabry was assistant to Alfred H. Barr, Jr., director of the Museum of Modern Art. A few years before, the paintings of a Pittsburgh housepainter, John Kane, had made the New York art world sensitive to the artistic quality of self-taught artists. In 1935 the Museum of Modern Art had scored an artistic triumph with its exhibit of African carving, demonstrating its

The Preacher. This central figure in the life of African-Americans was a favorite subject for Edmondson. All his preachers hold aloft the Bible, symbol of their authority, as both a warning and a promise. (16⅜ x 18½ x 6¾″) Newark Museum

relationship to modern painting. Thus, Mabry had little difficulty in convincing Barr that William Edmondson deserved to be the first black American artist to be given a one-man show by the Museum of Modern Art.[12]

The exhibit, held from October 9 to December 1, 1937, was a critical and popular success. Pictures of Edmondson's *Preacher* and *Martha and Mary* were widely reproduced. *Time* accompanied its story on Edmondson with Louise Dahl-Wolfe's photograph of him working with a small statue on his knee.[13] A year later when Barr assembled the exhibition "Three Centuries of Art in the United States" for the Jeu de Paume in Paris, he included one of Edmondson's sculptures along with work by Jo Davidson, Jacob Epstein, Augustus Saint-Gaudens, and George Grey Barnard.

Of course, not all the walls of racial prejudice fell down. At the time Louise Dahl-Wolfe was the leading photographer of *Harper's Bazaar,* and she tried very hard to get that magazine to publish an article about Edmondson. Carmel Snow, the editor, was willing but the publisher, William Randolph Hearst, "had this ter-rible prejudice about black people and he wouldn't allow them to be shown as anything but servants so I couldn't get it into the magazine," Dahl-Wolfe later explained.[14]

While the show brought Edmondson interviewers from all directions, it was not a great financial success. The Wolfes, who had paid the freight to move the stones to the museum from Nashville, kept most of the stones in their garage for several years until they were purchased. The museum purchased *Martha and Mary,* which the Wolfes had purchased earlier but which they relinquished because museum ownership meant both more money and prestige for Edmondson. As a result of the financial, freight, and shipping problems involved with the show, Alfred Starr, a Nashville theater operator, became Edmondson's business agent.[15]

The stunning critical success of Edmondson was a great shock to most of Nashville. The most immediate significant positive reaction was that he was put on the payroll of the local WPA art project.[16] But he did not get his first show in Nashville until 1941, and it was not until 1951 that the Nashville Artists Guild presented a large exhibit of his work.

Articles were written about Edmondson, based on interviews and reporting in quite literal fashion his fanciful, tongue-in-cheek stories of visions and God's commandments. Most of these stories simply conform to the southern stereotype of the ignorant, superstitiously religious black man.

For example, according to a 1941 interview by John Thompson in the *Nashville Tennessean,* God had appeared at the head of Edmondson's bed and talked to him "like a natural man" about the gift of stone cutting.[17] "He talked so loud he woke me up," Edmondson is reported as saying. "He tol' me he had somethin' for me." God instructed him to get a mallet and chisels. A week later "I heard a voice telling me to pick up my tools and start to work on a tombstone. I looked up in the sky and right there in the noon daylight He hung a tombstone out for me to make." According to Thompson he said tombstone models were "hung out" of the sky for more than two years until he learned how to make them.

"It's wonderful," Thompson reported him saying, "when God gives you something, you've got it for good, and yet you ain't got it. You got to do it and work for it. God keeps me so busy He won't let me stop to eat sometimes. It ain't got much style. God don't want much style, but he gives you wisdom and speeds you along." When Thompson questioned him about people buying his work, Edmondson reportedly

Mother and Child is one of the most sensitive and touching works created by Edmondson, who carved for the satisfaction he found in it. When told he was an artist, it was news to him—and he didn't particularly care. A sophisticated man in dealing with white people, he told them stories of God telling him what to do and of "mirkels" (miracles), which delighted feature writers. (12 x 4½ x 7") Newark Museum

told him: "You see, I got to do these things for my Heavenly Daddy whether folks buys them or not. He ain't never said nothing about pay for it."

Dahl-Wolfe explained:

You had to realize that William was very playful and fanciful in what he said. He'd make up things on the spur of the moment to explain things and you never knew whether that was the real reason. He made a little statue of a woman lifting her skirt and underneath that skirt was a pleated skirt. I asked him how he came to that idea. "Oh," he said, "that's a German woman lifting her skirt to keep it out of the mud"— and then he laughed when he saw your reaction. I would say that he was an old-fashioned southern black who was used to talking to white people in a way that was respectful but at the same time he often had his tongue in his cheek and was clowning.[18]

Similarly, Thompson, whose interview was filled with talk that often seemed foolishly and superstitiously visionary and stereotyped, cautioned that it would be a mistake to consider Edmondson, "with his constant talk of visitations and visions, as being a little 'touched,' simple and innocent though he may be. On the contrary, his native wit and humanity, which shows in virtually all his human figures, is apparent in his comments on his life and his own work."[19]

Edmondson's home and stone yard were in the black community, and he maintained strong connections with its people, attending the United Primitive Church. His sister and her family lived nearby.

When Aaron Douglas, who became head of the Fisk University art department in 1940, arrived in Nashville, he visited Edmondson. Douglas later described the artist as "a person with very little education and none at all from an art viewpoint. He worked from an instinctive point."[20] Douglas included one of Edmondson's sculptures in an exhibition at Spelman College. Later, Douglas (representing painting), James Weldon Johnson (poetry), and Edmondson (sculpture) participated in a discussion of art and how they got their ideas.[21]

By 1947, age made it impossible for Edmondson to lift heavy stone, so he worked on small figures in his shed, which he heated with a coal stove.[22] Alfred Starr managed his sales because he had so often been cheated by visitors. His health failed and by November 1950 he was bedridden, cared for by his sister Sarah and her family. He died of a heart attack on February 7, 1951.[23] He was buried in Mount Ararat Cemetery in Nashville, but a fire destroyed cemetery plot records and today nothing marks the tombstone maker's grave.

An exhibition followed his death, but the largest show of Edmondson's work was presented between April 12 and May 13, 1964, at the Tennessee Fine Arts Center at Cheekwood, Nashville. The catalog featured his quaint quotations about God and was titled "Will Edmondson's Mirkels." Nobody called him Will, said Dahl-Wolfe later, "we all called him William."[24] "Mirkels" is a slurred pronunciation of the word *miracles,* which amused a *Time* writer, who printed it without indicating its root, as though Edmondson had invented the word.[25]

Edmondson's work had remarkable similarities with that of his modern contemporary, the well-trained sculptor John B. Flannagan. Flannagan's concept of seeking stones whose natural shape suggested an image completely upset academic axioms about imposing

Consuelo Kanaga, a leading photographer of the 1930s, was impressed by Edmondson's inner spirituality—she recognized that he was no quaint fool. She photographed him at a moment when he was relaxed and enjoying his own stories about "mirkels." Ironically, this carver of tombstones, doves, and angels lies in an unmarked grave.

shapes on quarried stone and polishing them.[26] A tragic figure who committed suicide in 1942 due to lack of recognition, Flannagan wrote a profound statement on sculpture, which is now quoted in books on aesthetics. He asserted that an "occult attraction in the very shape of a rock as a sheer abstract form" stirred the depths of the artist's unconscious. "The eventual carving involuntarily evolves from the eternal nature of the stone itself, an abstract linear and cubical fantasy out of the fluctuating sequence of many creatures, of human life and animal life. . . . There exists an image within the rock, the creative act merely frees it."[27]

Flannagan may have seen Edmondson's exhibit at the Museum of Modern Art in 1937. Yet his own sculptural concepts were far advanced by that time, and neither can be said to have influenced the other.

Both sculptors used a chiseled, relatively rough surface rather than a high polish in their work. Both were attracted to animal shapes, but they differed sharply from other sculptors who used such subject matter. For example, Sargent Johnson, Beniamino Bufano, and Heinz Warneke often stylized their animal figures so much that they were trapped into making decorative, inevitably synthetic, shapes. In contrast, Edmondson's statues were derived from the volumes he saw suggested in specific pieces of stone. The particular stone, in other words, dictated the imagery. In this way, like Flannagan, he was engaged in high-quality abstraction. Both Edmondson and Flannagan achieved a simplicity of form that also maintained the integrity of the subject's voluminous mass in terms of sculpture, not in terms of drawing. They saw, conceived, and expressed the essence of the subject in terms of mass rather than a designed sequence of elements.

Much of the strength inherent in Edmondson's work stems from the fact that he worked in terms of volumes, not in linear planes, and that he cut directly into the stone without preliminary drawings. His subjects seem barely contained within the stone—they almost seem to burst from the stone. One does not feel such fullness and solidity in either Bufano's or Sargent Johnson's work.

Such carving has virtually disappeared today. Instead sculpture is usually constructed. This external assembling of materials bears little resemblance to the extracting of a form or figure from stone or wood in the method of the Egyptians, Michelangelo, and other great sculptors.

Edmondson worked all his creative life on poor-quality stone in small sizes. He always hoped, he told Thompson, that some day he could work on a large, life-size stone, but he could never afford it and no donor ever came forth. Nevertheless, Alfred Barr and others recognized his powers and his fierce, hammering search of truth. The emphasis put on his story telling, his quaintness, and his visions of God—all common survival techniques among black people—has prevented many people from seeing what he actually achieved and has denied Edmondson the recognition he deserves.

HORACE PIPPIN

Between 1930 and 1946 self-taught Horace Pippin became the first black painter to establish himself firmly as one of America's great masters of color and design. Today, major museums—the Metropolitan Museum of Art, Whitney Museum of American Art, Hirshhorn Museum, Phillips Collection, Philadelphia Museum of Art, Pennsylvania Academy of the Fine Arts, and others—own his works, and those that do not, seek them.

In contrast to other important self-taught American painters, who tended to repeat themselves, Pippin explored many different facets of black life and expressed humanity's yearning for universal peace in varying ways. He painted war scenes and flowers, street scenes and living rooms from Philadelphia's Main Line, biblical themes and American history, a Sunday morning breakfast and a Saturday night bath in a poor black family's home. Pippin's range establishes the extraordinary quality of his aesthetic consciousness and his ability to absorb and organize most of his experiences into visual expression. It goes far beyond the work of Edward Hicks, Joseph Pickett, and John Kane, who, while original, produced comparatively few paintings.

Pippin has properly been compared to Henri Rousseau, the French "Sunday painter" whose strong, direct color and indifference to perspective and other concepts of realism were hailed by Pablo Picasso and other modernists trying to break away from the academic standards of the time. When Rousseau's work appeared in the French Salon des Indépendants, critics did not know what to call the work of someone who ignored the prevailing academic concepts of reality and whose subject matter seemed taken from bizarre, exotic dreams. They called him "primitive," implying crude. Pippin has also been called "primitive," but the term undermines our understanding of his work and its origins, the great depths of his artistic consciousness, his powerful need to paint, and his development of a style that perfectly fitted his needs. None of this required the concepts of formal art training.

What has been most misunderstood about Pippin is the specific reality of his life. That reality governs his work, his themes, and their execution. Pippin's war-crippled arm forced him to work each stroke out mentally, constructing entire relationships of color and design in his head before lifting a brush. Far from being primitive or crude, he was highly advanced. As Holger Cahill pointed out in 1937, when Pippin was first introduced to the museum world, he belongs to those naive painters who are devoted to fact as a thing to be known and respected, but not necessarily a thing to be imitated. Surface realism means nothing to such artists because to them "realism becomes passion and not mere technique." They not only set down what they saw but, more important, they set down "what they know and what they feel."[1]

Although Pippin grew up in a rural area and had little education and no training in art, his need to organize and express the reality of his life visually cut through all impediments so directly and profoundly that he arrived at concepts in painting that were extremely modern—and that helped to create interest in his work. Pippin expressed the feelings and experiences of African-American life—its peculiar isolation and loneliness, its waste, terrors, beauty, dreams of peace and brotherhood. His scenes from the lives of black people are dominated by reality and filled with dignity and repose as well as the vigor and continuity of life. At the same time he painted flowers and lace doilies with unique precision, as if he were crocheting. He also turned to the historical past to create such masterpieces as *John Brown Going to His Hanging*. In all this, *his* reality dominates.

Horace Pippin was born on February 22, 1888, in West Chester, Pennsylvania, a Philadelphia suburb. Of his father, he knew nothing. His mother soon moved to Goshen, New York, where she had relatives and could get work as a domestic. Pippin grew up in this rural

Saturday Night Bath (1941) was patiently burned into a board with a poker, then painted. This painting of a ritual of African-American life was derived from Pippin's clear, affectionate memories of his own childhood in Goshen, New York. (9 x 12″) Collection Robert L. Montgomery II, São Paulo, Brazil

village, now famous for its harness horse racing, and attended a one-room school on Merry Hill through the eighth grade. In school he discovered his ability to draw, although his compulsion to draw got him into trouble. In spelling class, he later wrote, "if the word was dog, stove, dishpan or something like that, I had a sketch of the article at the end of the word. And the results were, I would have to stay in after school and finish my lesson the right way. This happened frequently and I just couldn't help it. The worse part was, I would get a beating when I got home, for coming home late, regardless of what I were kept in for."[2]

By copying a funny face in an advertisement, he won a box of crayons, watercolors, and two brushes, which he used to make a contribution to his Sunday school festival. "I got a yard of muslin, cut it into six pieces, then fringed the edge of each, making a doily out of them," he said. "On each I drew a Biblical picture such as Jesus Ascending, Elijah Ascending in the Chariot of Fire, Daniel in the Lion's Den, The Three Hebrew Children in the Fiery Furnace, Moses in the Fiery Bush and the Beggar at the Gates." When his teacher told him a woman had purchased his doilies, he was delighted. However, "one day about a month after the festival a lady standing in her door stopped me as I was going by on my way to school, and asked me if I wasn't Horace Pippin. I answered yes mam. She asked if I made the doilies. I told her yes. She said you certainly make some bum things. And she drew her hand from under her apron. And in her hand was a clean piece of fringed muslin. And she said look at this, I bought it at the festival with a picture on it. I washed it and this is all I have. I explained to her that the picture was only made of crayon and could not be washed."[3]

These experiences made Pippin aware of his talent, but he did not know how to develop it. A few years later, when he was fourteen, Pippin worked on a farm. One evening after supper, its owner, James Gaven, fell asleep at the table and young Horace sketched him as he slept. On awakening and seeing the drawing, Gavin "wanted to send me to school where I could take up drawing," Pippin later said.[4] However, his mother's illness forced him to go to work to support her. Thus, at fifteen, in 1903, Pippin began a seemingly endless series of labors, unloading coal, cutting wood, clearing fields, working in a feed store, going, as he put it, "from job to job." Three years later he got a job as a porter in the St. Elmo Hotel, where, friends said, he wouldn't last three weeks. He lasted seven years. Then the death of his mother in 1911 freed him, and the following year he headed for New Jersey.

Sensitive to the shape and color of everything he encountered from farm tools to dishpans and split-log benches, Pippin deeply absorbed the emotional orderliness of life in Goshen—its Saturday night baths, its seasonal farmwork, its mountain woodlands and summer hotels, the interracial harmony of its people gathering daily at the milkman's wagon, and its quiet, steadfast reliance on biblical values. These elements provided Pippin with images and themes all his life.

In Paterson, New Jersey, Pippin first got a job crating household goods and then in the hot, smoky foundry of the American Brakeshoe Company. When, in April 1917, the United States declared war, he rushed to enlist and proved himself a good soldier. He was made a corporal before his unit left Fort Dix, a fact of which he was always proud.

In the army Pippin occasionally sketched fellow soldiers and the terrain. Soon his outfit, the Fifteenth Infantry, was sent abroad, where it was transferred to the French command as the 369th Infantry, an all-volunteer black regiment except for its white officers. Pippin became an able squad leader.

In the fall of 1918, Corporal Pippin was shot in the right shoulder as he ran across no-man's-land, zigzagging from shell hole to shell hole. The bullet destroyed muscle, nerves, and bone. A French soldier bound up the wound and left him for the stretcher bearers. In considerable pain, losing much blood,

the you were strong.
and all we could do were
to waite

Gas Attack: One of Pippin's few notebook sketches to survive. He destroyed most, obeying security regulations on the grounds that sketches might aid the enemy. Photo: Peter A. Juley & Son, New York

Pippin clung to the hope that the doctors could mend his shattered arm. Until then that arm had given him his greatest pleasure and greatest self-distinction: his ability to draw. But in May 1919, after five months in army hospitals, he was discharged with his arm bound to his body to support it. Pippin felt that he could never draw again, and although he tried to accept it as God's will, he was very upset.

Even though he had loved to draw, Pippin did not consider himself an artist. Indeed, at that point little distinguished his life from that of thousands of other poor black men except that he had been a member of the heroic 369th Infantry, which had suffered severe losses under fire; the French government awarded the entire regiment the Croix de Guerre, a most unique honor.[5]

In France, before being wounded, Pippin sketched the rolling Champagne hills and mountains, as well as his own gas-masked patrols. Because security regulations called for it, he systematically destroyed his own innocent drawings. This brought the destructiveness of the war home to him in a very special way, for after being wounded, he frequently thought of his destroyed drawings.

Pippin was discharged from the army at Fort Ontario, on Lake Ontario, on May 22, 1919, in a state of emotional exhaustion. His old regiment, now called the "Harlem Hellfighters," had jubilantly paraded up New York's Fifth Avenue on its return, but Pippin's wounds prevented any such celebrations. Without a home, with his arm bound to him, he stoically made his way to West Chester, where his mother's relatives resided. There he began trying to live as a civilian with a useless right arm—difficult for a strong man who had worked hard all his life.

His relatives and other members of the black community in West Chester were kind and friendly. They tried to help him find a way to exist on his small soldier's pension. During the first few months, he met Jennie Ora Featherstone, a widow with a young son, and he married her on November 21, 1920. They settled down in a row house, where she took in washing because his pension could not support them.

Pippin rejoiced in his good fortune. What had seemed impossible a few months earlier now existed: a home and family life. He tried to find ways of supplementing their income and helped his wife with her work. He got a small wagon, loaded it with laundry, and pulled it with his good arm to pick up and deliver washings.

Still, the task of constructing a new and useful life was difficult. The relative calm of the prewar years was shattered, especially in terms of race relations. In *The Crisis* W. E. B. Du Bois had written when the 369th Infantry returned to Harlem: "We return. We return fighting. Make way for Democracy! We saved it and by the Great Jehovah, we will save it in the U.S.A. or know the reason why!"[6] That summer there were race riots in twenty-five major cities.

These incidents, in nearby Washington, D.C., and Baltimore, were only part of the turmoil for Pippin. He felt particularly helpless because of his arm. He had little to do but sit around and try to sort out his memories of the war. His mind was filled with details of a thousand soldiering experiences, including the look of a young black soldier who had a true premonition that he was about to die. The world he had known in Goshen and as a working man in New Jersey was gone. He felt uneasy about being supported by his wife's hard work, although she reassured him she did not mind.

Pippin was not the only American having a difficult time finding himself in the postwar wilderness. Sinclair Lewis's *Main Street* portrayed the narrow provincialism and aridity of American cultural life; T. S. Eliot called it *The Waste Land.* Artists and writers were leaving for France to find something they could iden-

tify with. In a country where the Ku Klux Klan had grown into a midwestern phenomenon as well as a southern one, what worried millions was "getting ahead" on the new "E-Z" payment plans and where to get some bootleg booze. Pippin felt further and further out of step.

The pressure within Pippin to find some path to calm and order mounted relentlessly. One winter he tried to write down his experiences in the war, his orders and how he had carried them out. By writing it all down Pippin hoped he could give some kind of meaning to intruding images of destruction, to his memories of how he and other black men had fought in gas masks on fantastic shell-burst nights. Black men had fought to show they could fight and to gain full rights for themselves and their people as citizens. But nobody believed the war was fought for democracy anymore. Instead, old values were challenged, even the Bible, in which Pippin believed deeply.

Ironically, Pippin found some relief in local American Legion meetings. Although he was a silent participant, he felt at home there. As a soldier he had done his duty and done it well, achieving an identity that was recognized by officers and other soldiers. The Legion's semimilitary but jocular meetings provided a satisfying connection with the past. He was probably one of the few members of the local post—perhaps the only one—entitled to wear the Croix de Guerre with silver star. His crippled arm, which made it impossible for him to salute during Legion rituals, won him the special attention reserved for wounded men in a veterans' organization.

The war had been the greatest single thing in Pippin's life. It was as a soldier that he won the only recognition given to him. Yet war could not be what life was about. Reconciling the war with the message of brotherhood emphasized in the Bible was impossible. Life was constructive, more important and more beautiful than war, as his new family, his memories of Goshen, and his observations of people in West Chester showed him. Still, his own life seemed to have slipped away. Visualizing scenes to which some of his deepest feelings were attached, he felt lost in the chaotic changes that had taken place in America, in his own life, in his personal being.

Then, Pippin related later, "I began to think of things I had always loved to do. First, I got together all the old cigar boxes that I could get and made fancy boxes out of them. . . . I was not satisfied with that sort of work. In the winter of 1925 I made my first burnt wood panels . . . this brought me back to my old self."[7]

Initially Pippin drew by burning lines into a board with a poker made red-hot in the kitchen stove. This slow process required a complete conception and no mistakes, erasure being impossible. He supported his wounded right arm by resting it on his knee. Later, as his arm grew stronger, he painted at a easel, supporting his disabled arm at the wrist with his left hand. Photo: *Friday,* January 11, 1941

Pippin had first tried to sketch on the lids of cigar boxes, but charcoal smudged on the hard, smooth surface. Observing the white-hot poker in the coal-burning kitchen stove, he tried to draw with it. Years before, as a boy in Goshen, he had seen drawings burned into wood. Called *pyrography,* such efforts were popular among white middle-class families. Kits that included alcohol-burning heaters and the needlelike tools to be heated, as well as drawings to be traced onto the wood, particularly pictures of young ladies done by Charles Dana Gibson, were widely sold. However, drawing with a hot poker presented quite a different problem.

Because of the helplessness of his right arm, Pippin had to hold the poker in his right hand, balancing that hand on his crossed knee, and then draw by shifting the wood board with his good left arm and hand. This was an extraordinary maneuver. To make certain lines he had to turn his drawing upside down, and he had to return the poker again and again to the fire until he painstakingly completed the visual outline already in his mind.

The End of the War: Starting Home (1931), an antiwar masterpiece, took Pippin three years to complete because he was obsessed by memories of the war in which he was badly wounded. Considering the frame part of the picture, he hand-carved the hand grenades, tanks, bombs, and helmets. (32 x 35″) Philadelphia Museum of Art

Despite the clumsiness of his method, Pippin was encouraged. He had found a way to regain the ability he had before the war, a way to put down what he saw in his mind's eye. "Still my shoulder and arm were so weak, I could not work long at a time, but I kept trying," he wrote.[8]

Working in this fashion, Pippin slowly created his first picture, burning it into an unused oak table leaf. It showed the edge of dark woods. Tree trunks were darkly burned into the board, with a horse and covered wagon being led through a snowstorm by the bent and lonely figure of a man. At its bottom he burned in the title: LOSING THE WAY. Then Pippin burned in his name and, to make the picture look more like a painting, varnished it.[9]

The daily effort strengthened his crippled arm. After a year he was able to lift his right arm, supporting it at the wrist so that his fingers could manipulate a brush. He had freed himself from his handicap and was able to draw and paint. The kitchen's unshaded light bulb was his main light source, for he worked mostly at night.

Scenes from the past now arose with such force in his memory that Pippin's efforts to paint were virtually efforts to save his life, to establish who he was. His need to paint was enormous, but unlike the artist who confronts the reality of a model, a still life, or the confluence of hills, Pippin confronted the reality of his past. His work is best understood as a journey, difficult but necessary, to seek out the past in his life and integrate it with the present.

His first major effort was an attempt to come to terms with his war experience. This painting occupied him for three years; he later said he gave it 100 coats. The scene depicts no-man's-land—a landscape in which everything has been mutilated and destroyed except the barbed wire, some posts, and the survivors. In its center German soldiers surrender with expressionless faces. The victors do not exult. The central German figure has his arms spread in a way that suggests a crucifix. Overhead, shells burst and a plane falls straight down, like an angel expelled from heaven. The paint is so thick it appears carved. Indeed, the frame, continuing the themes of violence from the picture, was carved by Pippin, surrounding the painting with symmetrically arranged grenades, gas masks, tanks, rifles, and bombs.

Considered one of the most antiwar works created in modern times, this painting, which Pippin titled *The End of the War: Starting Home,* does not have the realistic horrors of Francisco Goya's *Disasters of War* or the explosive surrealistic destruction characterizing Pablo Picasso's *Guernica.* Nor does it immediately shock. Only gradually does one become aware of its grim, relentless portrayal of the empty wastefulness and total desolation that makes the victors no better off than the losers.

In this painting Pippin directly expressed the reality of trench warfare in World War I as he experienced it. Its curious title is also part of that reality. "The End of the War" marks the beginning of "Starting Home," the soldier's dearest wish—the idealized past that is clung to amid the bizarre destruction of war. *Home* is

Cabin in the Cotton III (1944), Pippin's vision of what his people's life was like in the South, was based on the stories of his mother and relatives (he himself never saw the South's cotton fields and cabins). This is the third of four paintings with this title. All have a nostalgic aura of tranquillity. (24 x 30″) Collection Mr. and Mrs. Roy R. Neuberger, New York

the deepest theme in Pippin's work, and it is significant that this idea appears in his first major work, although only in the title. *Home* represents the past—everything that Pippin knew as a young boy about life among black people, their lives, religious feeling, and activity, as well as the beauty of nature.

Because painting was an extremely slow procedure for him, Pippin's initial output was low and physically exhausting. In 1931 he painted three more war pictures: *Shell Holes and Observation Balloon, Outpost Raid: Champagne Sector,* and *Gas Alarm Outpost: Argonne Sector.* In these paintings, carried out with muted, virtually monochromatic color, Pippin continued his report on his war experience. These paintings have the formal and balanced quality characteristic of Pippin's work. There are no shadows in them, and their scenes appear timeless, as though taken from a dream. They quietly pose the question: Why does man destroy?

In developing his skills as a painter, Pippin sometimes turned to the pictures on cheap calendars for subject matter. These pictures, which include *The Buffalo Hunt* and *The Blue Tiger,* lack the knowledge of details found in his best work. These might accurately be termed "practice" pictures, because they bear no relation to Pippin's inner life.

Usually, however, the activity of painting expressed Pippin's struggle with the creation of a new life for himself. It is not surprising that one of Pippin's early works portrayed Abraham Lincoln and his father building a cabin in the wilderness. It contains details—in the treatment of the stumps and building of the cabin—familiar to Pippin from his Goshen days. And it concerns the construction of a new home, a symbolic representation of what Pippin was doing by painting.

Soon after Pippin completed this work, he painted *Cabin in the Cotton I,* his first work to deal with the

life of black people. This painting does not sentimentalize but presents a serene harmony of humans and nature. Like Rousseau, who never saw the jungles he depicted, Pippin attempted to reconstruct a past in terms of reality as he understood it, even though he had never seen it. *Cabin in the Cotton* refers, of course, to the South and may have been inspired by the stories of his mother's elderly relatives. It is worth noting that the cabin and the people—an old woman and a small child—are seen at a distance, but the yard is filled with an enormous amount of accurate realistic detail: a rain barrel, washtubs, fencing, wagon wheels, an outdoor fireplace, sawbucks, chickens. Everything is in its traditional place.

Cabin in the Cotton had a specific meaning in terms of Pippin's development and personal life. Emotionally, a cabin symbolized home to him. It was first depicted in the process of being built, in the Lincoln painting. In *Cabin in the Cotton,* the cabin is complete yet the view is external. In time, as his skill and confidence grew, Pippin was able to enter the cabin—to portray women playing dominoes with children, the man of the house putting on his shoes, a Saturday night bath or a Sunday breakfast with hominy grits, eggs, and bacon. This is what the word *home* meant to him in the title of his first important work, *The End of the War: Starting Home*—peace and a life of tranquillity and dignity.

By 1936 Pippin felt confident enough to paint a portrait of his wife and another of Paul B. Dague, a deputy sheriff and commander of the Downingtown Legion post. With their balanced, evenly divided compositions, both portraits have a certain intensity. Dague is shown in his army dress uniform seated in front of a yellow wall at a table that has a gavel block with an American Legion emblem. Pippin's inclusion of this emblem is characteristic of his attention to detail, but it also symbolizes his own identity as an ex-soldier and what he had in common with Dague.

About this time, encouraged by friends, Pippin began to try to sell his paintings. A local shoemaker let him put one in his show window. So did the barber. One day, walking with his friend N. C. Wyeth, the illustrator and father of Andrew Wyeth, Christian Brinton saw *Cabin in the Cotton* in the shoemaker's window. Brinton, a professional critic and historian, whose major field was Asian art, was well informed on modern art. He and Wyeth were so delighted by the painting that they inquired about the artist and how he could be found. Brinton then sought Pippin out to see more of his work. He was amazed at Pippin's burnt-wood panels and impressed with his formal sense of composition and flat use of color without any attempt at perspective. Pippin had arrived at some of the fundamental characteristics of modern art in his attempt to be direct.

Brinton arranged for ten of Pippin's works to be shown at the West Chester Community Center on June 9, 1937. The exhibit included his war pictures and seven burnt-wood panels, including *Cabin in the Cotton,* which was purchased by the actor Charles Laughton. Several Philadelphia Main Line society ladies also purchased paintings and invited Pippin to teas. He later painted a portrait of one of these ladies, Mrs. W. Plunkett Stewart, on her horse. These women considered Pippin's work quaint and "primitive" because of its severity in composition and lack of traditional perspective, but they had genuine sympathy for him as a handicapped black man, and their patronage and friendship encouraged him.

Brinton called Pippin's work to the attention of Holger Cahill, then head of the WPA art projects, and Hudson Walker, a New York dealer. During the New Deal, as a reflection of its political emphasis on "the people," there was considerable enthusiasm about the potential of untrained native talent. The Museum of Modern Art invited Holger Cahill to organize a major exhibition of self-taught French and American painters. Rather than call them "primitive" or "naive," Cahill characterized them as "Masters of Popular Painting—Artists of the People." He included in the show the French painters Henri Rousseau and Camille Bombois and the Americans Edward Hicks, John Kane, Joseph Pickett, and Pippin. Cahill selected four works by Pippin, the only black American to be represented.

In a perceptive catalog essay, Cahill made several observations that seem particularly applicable to Pippin: "It would be a mistake to apply naturalistic and academic standards to the work of these masters of popular art. And yet these artists may be called, as they have been called, 'masters of reality.' So far as realistic effect is concerned they are in harmony with the best known contemporary practice." Of Pippin, he wrote: "With Horace Pippin we are in the field of the naive and instinctive painter who struggles to express emotionally-felt visual memories."[10]

Although the show was a critical success, no sales resulted for Pippin. Hudson Walker, unable to interest any collectors, did not exhibit his work. Nevertheless, the seriousness with which the work was taken by the museum and the art world, and the examples of Rousseau, Hicks, and other participating artists, gave Pippin a deeper trust of his own feelings and his ability to express them artistically.

In Philadelphia, a former artist turned dealer, Robert Carlen, had already exhibited Edward Hicks's

Christian Brinton (1940). Brinton, an art critic and specialist in Asian art, discovered Pippin on seeing one of his paintings in the window of a shoe-repair shop. He arranged for an exhibition of Pippin's work, and later posed for this portrait. Though grateful, Pippin did not care for Brinton's intellectual advice on how to paint, which may account for the severity and icy stare of the portrait. (21½ x 16″) Philadelphia Museum of Art

Peaceable Kingdom. He now offered Pippin a one-man show.[11] Pippin liked Carlen, perhaps because Carlen was young, sympathetic, and had been an artist himself. Carlen casually gave him materials and tips on technical problems.

As the Pippin show was about to be hung in mid-January 1940, Albert C. Barnes and his collaborator Violette de Mazia happened to visit Carlen's gallery.[12] Spotting one canvas, Barnes became so excited that he asked to see all the new artist's work. Ever since he had written on the potential of the black American artist in *The New Negro,* Barnes had been expecting fulfillment of his prediction. Pippin filled the bill. His enthusiasm knew few bounds. He and de Mazia bought *Abraham Lincoln and His Father Building Their Cabin on Pigeon Creek* and *Birmingham Meeting House* on the spot.

To launch a black artist in those days it was felt that a "committee of sponsorship" was needed. The crushing pressure of racial stereotypes had already obliterated the name of Henry Ossawa Tanner, even in his hometown of Philadelphia. Carlen assembled such a committee, which included General Smedley Butler, whose portrait Pippin had painted from photographs for his American Legion post; the author Roark Bradford; Holger Cahill; Alain Locke; and the presidents of two nearby black colleges, Leslie Pinckney Hill of Cheyney State College and Walter Livingston Wright of Lincoln University. Also included were Brinton, Mrs. W. Plunkett Stewart and other Main Line society ladies, and Dorothy V. Miller of the Museum of Modern Art.

Barnes insisted on discarding the initial catalog for a new one with an introduction written by "someone important"—who turned out to be him. In his essay, Barnes enthusiastically saluted Pippin for "a fresh insight into Nature," and as an artist who "tells about it simply, directly and in a language of his own." He continued: "One feels in Pippin's paintings a purpose, possibly not a conscious purpose, to attain a particular end, set by himself and pursued without leaning, or even drawing upon, the resources of previous painters. This explains why his work has the simplicity, directness, sincerity, naiveté, and vivid drama of a story told by an unspoiled Negro in his own words. It is probably not too much to say that he is the first important Negro painter to appear on the American scene."[13] While Barnes's comments reflect the general ignorance of earlier black artists and acceptance of the racial stereotype of the "unspoiled Negro," his enthusiasm helped to stimulate a very successful show.

Recognition can carry with it a serious threat to the integrity of the self-taught artist. Many such artists, once exposed to the professional art world, its concepts, and the commercial need for "something new," tend to lose their way. In Pippin's case, the first threat came from people who were excited by his work but annoyed by his lack of professional finishing. Pippin was more interested in his vision than fame, money, or praise. He gently set aside Brinton's suggestions on how to paint; later he painted a perceptive portrait of the scholar who "discovered" him. However, Barnes was not easily rebuffed. He believed nothing could be more stimulating for Pippin than to see the masterpieces of Paul Cézanne, Henri Matisse, and Pierre-Auguste Renoir. He insisted on taking Pippin on a grand tour of the Barnes collection and was disappointed when Pippin—ignoring Cézanne, Barnes's favorite painter and a key figure in modern art—preferred Renoir's lush color.

Barnes then wanted Pippin to attend art classes at the Barnes Foundation's professional art school. He

West Chester Court House (1940) demonstrates Pippin's skill as a designer, integrating into a harmonious composition many disparate elements: a clock tower, trees, a flag, a war memorial, lampposts, the building's white columns and stone walls, an old-fashioned drinking fountain, and an African-American newsboy. (22 x 28″) Pennsylvania Academy of Fine Arts

offered not only free tuition but a dollar a day for carfare. Somewhat reluctantly, Pippin accepted. After a few weeks, he stopped, saying: "My opinion of art is that a man should have a love for it, because it is my idea that he paints from his heart and his mind. To me it seems impossible for another to teach one of art."[14] To Carlen, his dealer, Pippin later said of the Barnes school, "There's nothing there for me. I got my own idea. They paint theirs."[15]

Pippin was equally impervious to commercialism. A *Vogue* art director got the idea of posing models in the latest fashions against backdrops designed by Salvador Dali, Giorgio de Chirico, and Pippin. It meant broadening the circle of people who knew his work. "I took him there," Carlen later said, "to interpret the foreign language the fashion magazine people speak, but it didn't work. It really wasn't the kind of thing he wanted to do, no matter how much fame or money was involved. It simply didn't mean anything to him. He wasn't impressed. Later in the afternoon, it was in the fall, when we were driving back across the Pulaski Skyway and the skies were brilliant with a rosy vermilion, suddenly Pippin said, "My God, Carlen, there's the color I want.' And he put that color into the *Woman at Samaria*."[16]

Paintings of all kinds now began to be produced by Pippin. His color was increasingly bright. In a 1936 painting, *The Lady of the Lake,* he had first indicated his love of flowers, and now flower paintings of astonishing brilliance in color and formal composition poured from him; among them were *Giant Daffodils, Two Pink Roses, Flowers and Books,* and *Roses with Red Chair.* He also painted a new version of *Birmingham Meeting House* and one of *West Chester Courthouse.*

These new works extended Pippin's mastery of color and his ability to use it to organize his compositions. His work often contained, in elaborate and accurate detail, something he had observed in the past, such as an antimacassar, a statue, or a chair. Pippin would sometimes search for months to find a chair type that he remembered and wanted to use in a composition, according to Carlen.

These paintings reflected the tranquillity that Pippin sought in his memories, even if they represented current scenes, as in *Birmingham Meeting House.* All is serene and all is balanced. If an imaginary line is traced down the center of Pippin's work, each side balances the other in a formal way. Moreover, his paintings are shadowless, which not only eliminates a sense of per-

364

spective but also creates the illusion of a scene frozen in time.

In March 1941, for another Pippin exhibition at Carlen's gallery, Barnes wrote a new catalog introduction. In it, he recognized Pippin's unusual use of bright color and observed that through his burnt-wood technique Pippin had achieved the expressiveness of Honoré Daumier and Cézanne.

A few months later, in a larger show in the Chicago Arts Club, Pippin exhibited *Christ Before Pilate* and *The Woman Taken in Adultery.* These were solemn formal scenes, drawn from biblical passages that had impressed Pippin during the years when he was trying to find some way to paint—or, as he put it, to become "his old self." What made these paintings different was their brilliant color and their simple, even severe, abstract design. The more Pippin worked, the more confident his abstract design and the more brilliant his color became—and the more productive he was.

In October 1941, a new show at the Bignou Gallery in New York displayed many of his flower paintings, among his most sophisticated achievements in color. Pippin's various shows won national attention and prepared leading New York dealers for Edith Halpert's proposal that each of them represent two major black artists after a major show of these artists' work in December 1941.

When Pippin came to the major exhibition of the work of African-American artists that opened at the Downtown Gallery in New York on December 7, 1941, he was the only living nationally known black artist in America. Isolated in West Chester, he did not know there were so many black artists, but he was not interested in being lionized. While he shook hands with many artists and looked carefully at all the work, he offered no comments and gave the young artists present the impression of a man who had to hurry on with his work.

However, the narrative paintings of Toussaint L'Ouverture that young Jacob Lawrence exhibited in that show apparently had some impact on Pippin. Soon after his return to West Chester, he painted his only narrative series, and it too concerned a hero: John Brown. The first painting, *John Brown Reading His Bible,* is an intense depiction of an intense young man, whose eyes stare blankly beyond the viewer toward some vision of the future. *The Trial of John Brown* is a stark portrayal of the wounded and now bearded, but still intense, Brown on trial for his life, lying on a stretcher at the feet of his prosecutor and jurors. In *John Brown Going to His Hanging,* a masterpiece now in the Pennsylvania Academy of the Fine Arts, nearly every-one in the crowd faces the wagon bearing the calm, rope-bound Brown but there is one massive, angry-looking black woman in the lower right corner who looks directly at the viewer.

In this series Pippin very nearly abandoned the tranquillity characteristic of his work. In the first two paintings the figure of Brown is expressed with great intensity. Pippin strongly identified with Brown. He personally knew what it was to lead men into battle—and what it must have been like for Brown to lead men into armed conflict against slavery. He also knew what it meant to lie wounded and helpless on a stretcher. He, too, had read the Bible in desperate hours as he sought to fulfill his personal vision. Yet in the last painting Pippin emphasized the tranquillity of John Brown, his arms bound to his side—as Pippin's arm once was—as he accepts his death. It is an ennobling scene. Indeed, there is an impressive stillness to this painting, as if Mathew Brady, the great Civil War photographer, had made a time exposure, freezing the action with the demand that everyone keep absolutely still for a whole minute.

The black woman in the corner had a special significance to Pippin, contributing to the personal and emotional character of these paintings. Pippin told Carlen that this woman was his grandmother and that she had personally witnessed the hanging of John Brown in Charlestown, Virginia, in 1859.[17] She had often told him, as a boy, the story of Brown's raid on Harpers Ferry, his trial and execution. And in the painting she is also the storyteller, facing the viewer in the classic stance of the narrator in the theater.

Pippin next painted three pictures that deal with historic figures in the emotional life of black people: *Abraham Lincoln the Great Emancipator, Christ on the Cross,* and a small panel, *Uncle Tom.* Where he had once worked laboriously, he now worked with confidence, using different techniques and color that constantly grew more brilliant.

In *Abraham Lincoln the Great Emancipator,* Lincoln is shown standing with Ulysses Grant, whose intense eyes, as others have noted, resemble those of John Brown. The composition is very formal, with the figures of Grant and Lincoln balanced by two Union soldiers. At the center is a kneeling, penitent white man. Hundreds of paintings have dealt with this theme. All show a kneeling slave giving his thanks to Lincoln. Pippin's view is significantly different. It is the white man who needs emancipation.

With a formal symmetry created by falling drops of bright red blood, *Christ on the Cross* is unusual in several ways. For one thing, Christ has a triangular mat of hair on his chest that accentuates the V-shape in the grain of the wood of the cross, as well as the V

of his beard and loins, forming an abstract pattern. Christ looks heavenward expectantly, not pathetically, and an inscription in unreadable Hebrew characters is nailed above him. The wound in his side is a gaping shell-burst shape. But the most unusual aspect of this painting is why it was done. Crucifixion scenes are very rare among American painters. But Pippin was religious and, like millions of other black Americans, strongly identified with the Christ figure, his suffering, and his message of forgiveness. Among Pippin's contemporaries, W. H. Johnson was one of the few who painted Crucifixion scenes; his Christ is sometimes black. Except for these paintings, a study by Thomas Eakins, and political cartoons, the Crucifixion theme is virtually unknown in American art.

Uncle Tom, in contrast to the Lincoln and Christ paintings, is heavy with thickly applied paint. A delicate white child is nestled tenderly in the arms of a singing or story-telling Uncle Tom in ragged clothes. Selden Rodman has called this the child's "paradoxical asylum." Yet Pippin would find nothing paradoxical about it. It is the reality of black people, generations of whom have nurtured white children. Painted in the early 1940s, when "Uncle Tom" was being rejected as a symbol of abject servility, it may well have represented both a reminder of the past and a new statement on the theme of forgiveness. Pippin's world of the past encompassed both John Brown and Uncle Tom.

In beginning to paint, Pippin was like a man starting an urgent and long journey into the remembered past. He now painted with increasing speed. He next did three new versions of *Cabin in the Cotton* and then turned directly to the theme of *home,* the life of black people. In several of his early burnt-wood panels, he had touched on this theme. Now, confident of his use of color, Pippin reconstructed the reality he knew: women playing dominoes in a kitchen where the cracked plaster showed the lathes, torn window blinds, children saying prayers to their mother, a mother bathing a child.

The reality of these very formal scenes stems from Pippin's closely observed memories. He has just the right kind of coffee pot, iron frying pans, baking pans, coal bucket, tubs, and chairs. And because Pippin was interested in reality, he did not idealize his characters. They have a certain solemnity, dignity, and timelessness. No perspective or shadows suggest distance or time. Even the floorboards move straight up and down. The scene is tranquil and fixed—stopped at some moment in history.

These pictures continue the theme of home, expressing some of the feelings Pippin had when he titled his first picture *The End of the War: Starting Home.* Although small in dimensions, they are all monumental in character. *Sunday Morning Breakfast, Saying Prayers,* and *The Domino Players* are some of Pippin's most outstanding paintings. They suggest the richness of warm relationships in black families despite poverty. The poverty is nothing, Pippin seems to say; what counts is love, work, play, and being yourself.

These pictures also represent Pippin's true grip on the past. When, in response to pressures created by World War II, he attempted work that responded to the immediate present, he never achieved the power of his paintings of the past. Paintings like *Victory Vase, A Tribute to Stalingrad, Victory Garden,* and *Mr. Prejudice* all seem superficial and ideological rather than deeply felt. Although he strongly supported the war against Nazism, Pippin hated war—and this ambiguity subtly expressed itself. The work that derives from Pippin's own inner needs and memories is both aesthetically superior and more effective in combatting prejudice than his attempts to deal with such issues directly. Pippin needed the past to be a great artist.

Pippin's works sold readily but new troubles developed. He was greatly disturbed by difficulties at home. His wife, whose tenderness and encouragement had helped him construct a new life and indeed become a new man, seemed to resent his success. Interviewers, collectors, and photographers kept arriving. *Friday* magazine published a photo story on how he worked and showed him with his family.[18] His work now sold regularly, so it was no longer necessary for his wife to take in washing, but she refused to consider stopping, despite Pippin's requests that she do so. Irritated, Pippin sought friendship and warmth in nearby saloons and in Philadelphia.

Actually Jennie Pippin was suffering from a form of mental illness exacerbated by the adjustments that Pippin's success brought about. Her old routines were her last hold on reality. Finally, in 1944, her condition worsened and Pippin was forced to commit her to the Norristown State Hospital.

These difficulties, and World War II, again turned Pippin to the Bible. Success itself had meant little to him. He was not impressed by museums, collectors, or money because they could not relieve his troubled feelings and provide the tranquillity he sought in every painting.

His continuing search for serenity now led him to create the first version of *Holy Mountain,* one of the most distinctive paintings in American art. Dealing with the interracial character of this country and its need for brotherhood and peace, the work is at once

Christmas Morning Breakfast (1945) depicts a good African-American boy, his necktie tied and hands folded, awaiting breakfast before opening his presents under the Christmas tree. A torn piece of blanket covers a broken window and part of a large hole in the plaster. In such memory pictures Pippin recorded the rituals, discipline, and caring qualities of his people despite poverty and oppression. (24 x 30″) Collection Estate of Edward G. Robinson

some to imitate it. Although Hicks does present animals and children together, *The Peaceable Kingdom* portrayed a peacemaking conference between Native Americans and Quakers. In response to friends' questions, Pippin wrote an explanation of his work:

> To my dear friends:
> To tell you why I painted the picture. It is the Holy Mountain, my Holy Mountain.
> Now my dear friends, the world is in a bad way at this time. I mean war. And men have never loved one another. There is trouble every place you go today. Then one thinks of peace, yes, there will be peace, so I look at Isaiah XI 6.1—there I found that there will be peace. I went over it 4 or 5 times in my mind. Every time I read it I got a new thought on it. So I went to work. Isaiah XI, the 6th verse to the 10th gave me the picture, and to think that all the animals that kill the weak ones will dwell together, like the wolf will dwell with the lamb, and the leopard shall lie down with the kid and calf and the young lion and the fatling together. . . .
> Now my picture would not be complete of today if the little ghost-like memory did not appear in the left of the picture. As the men are dying, today the little crosses tell us of them in the First World War and what is doing in the South—all of that we are going through now. But there will be peace.[19]

Holy Mountain was an explicit statement of Pippin's desire for peace. In earlier work this was represented in a scene from the past and in the serenity that pervades his paintings. *Holy Mountain* deals directly with that deep desire, combining not only his experiences in the war but also his religious feelings and the tranquillity of the mountains he knew as a boy.

In 1945–46, during the period when he was creating new versions of *Holy Mountain,* Pippin also painted some of his best-known works, among them *Victorian Interior* and *The Den,* from his memories of the home of Mrs. John D. N. Hamilton in suburban Paoli. The symmetrically decorated rooms greatly appealed to Pippin's sense of balance. He also returned to memories of his old home in Goshen, painting *Saturday Night Bath* and *The Milkman of Goshen. The Barracks,* a memory of World War I, showed four black soldiers in crude bunks. Each man is doing something different. They are together yet alone. Few paintings convey the loneliness and isolation of soldiers more sharply than this work.

In addition, during this period Pippin painted a number of flower still lifes and interiors that featured doilies and antimacassars. The delicate and always balanced patterns of lace and crochetwork had appealed

poetic, biblical, and uniquely American. The basic painting, which scarcely varies in its three completed versions, shows a young black boy wearing a white robe, standing with a shepherd's crook on the edge of deep woods atop a mountain. In the foreground, an unlikely variety of wild and domestic animals—a lion, goat, leopard, sheep, bears, cows, and wolves—mingle, while two small children crawl safely among them. There are bright birds in the trees.

The most significant changes in the series of paintings occur in the depths of the woods. In the first version there are not only soldiers fighting in the woods, but tiny white crosses, reminiscent of Arlington National Cemetery and its soldiers' graves. In the second version, the crosses are gone but the soldiers remain, and there are changes among the animals—primarily to simplify the composition. The third version, painted in 1946, is even more simplified. In all versions, the animals and sometimes the children look expectantly at the viewer.

Pippin had often seen Edward Hicks's *Peaceable Kingdom,* a notable work in its own right, at the Carlen Gallery, and *Holy Mountain* was initially considered by

The Milkman of Goshen (1942) depicts mothers waiting while the milkman pours milk from his large cans into their buckets, the way milk was once delivered. This interracial picture stems from Pippin's memory of the quiet harmony of the small town where he grew up. (25 x 31″) Collection Estate of Ruth Gordon Kainen, New York

to his sense of beauty since childhood, when he had fringed muslin to create a doily-like effect.

Although Pippin's work from this period is masterful, he continued to be greatly troubled by what had happened to him. He read and told Bible stories to his friends. About this time a movie company making a film based on Gustave Flaubert's novel *The Temptation of Saint Anthony* commissioned Pippin to paint this subject. (Many people in the theatrical world had already purchased Pippin's work, including John Garfield, Ruth Gordon, Charles Laughton, Clifford Odets, and S. J. Perelman.) Completed on January 16, 1946, this painting, one of the largest Pippin ever attempted, is a frank effort at symbolism. It lacks the accurately observed detail characterizing most of his work. A statement by Pippin about the painting reveals it to be a

visualization of his own life's problems, for Pippin clearly identifies with St. Anthony. The Devil, he explained, first clouded St. Anthony's vision, "then let him go. St. Anthony landed on the edge of a rocky cliff"—a harsh returning to reality that left him feeling "as if every bone in his body was broken, and he felt that Death would be better." This brought about a painful confrontation—either to give up hope of everlasting life or obtain it. He first felt that Death would be better, that he would do what Death told him to do. But then he "saw Lust. She told him to choose life and enjoy it."[20] Lust is the woman figure below the cliff. Thus a question is posed—but not answered—in the painting. In this biblical story Pippin sought some relief to the difficulties and mysteries of his life posed by the illness of his wife and his success.

Not long afterward, Pippin painted *Man on Bench*. A solitary old black man sits on a park bench in clothing of mixed coloring—gray trousers, black vest, and white shirt, with a coat and cap of World War I khaki. Behind him is the vivid green grass and the edge of the woods, with yellow-green tree leaves and a squirrel busy between the trees. The old man, one arm flung back, stares down at the ground. The playwright Clifford Odets, who once owned the painting, called it a picture "of deep despair."[21]

The painting differs from Pippin's other work in that the figure is not flat but painted in perspective. It is, as many have pointed out, a poignant self-portrait; it is the end of a journey, reflecting Pippin's loneliness and isolation.

This was Pippin's last completed painting. He had started a new version of *Holy Mountain*. He had drawn in the shape of the mountain, a blasted tree, and a lion, a tiger, and a wolf. None of the rich foliage that marked the earlier versions is present or indicated, and there are no children, although they may have been part of his vision. One of the most striking aspects of the work is that in this version the mountain itself is clearly visible—and it bears a compositional resemblance to the mountain in his first major work, *The End of the War: Starting Home*. This new *Holy Mountain* was clearly related to the recent end of World War II. Even though incomplete, its mountain provides an uncanny symmetry to Pippin's creative life as a painter.

Pippin died of a stroke on July 6, 1946.[22] His wife, who never knew of his death, died ten days later.

Today, with Pippin's relatively small but brilliant canvases in major museums and his name known around the world, it is difficult to realize that most of these works are the products of the last years of his life. In many ways they are an autobiographical summing up that is both eloquent and elegant, a distillation of reflection and appreciation of the beauty of nature and of the human spirit and vision.

Pippin's own life was primarily one of hard physical work and material impoverishment. A sensitive, extremely isolated man with little education, further handicapped by his wounded arm, he tried to exist in the limited role America permitted black people. Having grown up in a time of so-called innocence for America, he tried to accept its values, even though it assigned him to hard labor for life at poor pay. Most of these values were shaken and shattered by World War I. In that war, the 369th Infantry, the regiment of black men with whom he served, fought so valiantly that they were honored by the French government—but ignored by their own. Pippin did not receive the Purple Heart medal, supposedly given to all wounded Americans, until 1945, after another world war needing black support made the omission too conspicuous.

The America Pippin came back to after World War I was torn by race riots. The war had left him seriously disabled and deeply troubled spiritually. He sat helpless for years before his feelings compelled him to begin his great journey as an artist. Through his painting he asked, not as a philosopher but as an artist, What does my life mean? He did not study or imitate other artists, but focused on his own life and his own vision. He was not looking for fame or some self-aggrandizing way to escape from life but for a way to express his experiences. He never really had a studio. He needed a place to work and that could be the kitchen. It was as direct as that.

Unfortunately, stereotyped thinking has prevented full recognition of Pippin as a master artist. His work continues to be classed as that of a folk artist, which has excluded it from major exhibitions of American art here and abroad. And much of what has been written about Pippin has been distorted by ignorance, prejudice, and condescension. For example, Rodman, in his patronizing book published shortly after Pippin's death in 1946, subtly mocked Pippin's hanging in his living room photos of himself as a U.S. soldier and his framed discharge papers as a member of Company K, 369th Infantry. Rodman showed little awareness of the importance of this experience to Pippin or that this specific group of black soldiers, assigned to a cannon-fodder role under French generals, fought heroically to deny the racist myth that black men scared easily—winning, as a group, the Croix de Guerre. Rodman also portrayed Pippin as childlike and ignorant, noting misspellings and awkward grammar in Pippin's autobiographical essays without recognizing the pertinency, sophistication, logic, and wisdom of what Pippin said. Thus while Rodman was one of the first to recognize Pippin, he also helped frame the stereotyped way in which Pippin was seen by others.[23]

That Pippin owes nothing to earlier artists is an important aspect of his uniqueness. He is wholly an African-American artist. His life as a black American is the basis of everything he painted. When he at last emerged from the poverty-ridden role of a disabled black man on the wings of his own artistic vision, his achievements grew more and more impressive as he continued to develop. In contrast to many professional artists, who have often been destructively distracted by popular recognition, Pippin strode forward, creating in his last years some of his most powerful work—and this despite a greater isolation and loneliness than he had ever known before.

Most students in this 1938 drawing class at Howard University did not have easels. Interestingly, the model wears an African costume. The names of students and their instructor are not available. Photo: Moorland-Spingarn Research Center, Howard University

Vernon Winslow (left), director of the art department at Dillard University, invited his former teacher Hale Woodruff (right) to return as a guest lecturer and exhibit his work to students in 1982. In 1940 Elizabeth Catlett was appointed the first art department head at Dillard, but the administration did not believe African-American students needed art studies. Catlett experienced so much frustration that she resigned. Photo: Harry Henderson

ART DEPARTMENTS IN AFRICAN-AMERICAN COLLEGES

T he importance of art departments in African-American colleges and universities lies in the fact that in recent times the trustees, administrations, and faculties have altered their attitude toward art and its relationship to African-Americans. These schools now recognize art as a viable means of study, not only for cultural enrichment, but also as a possible means of livelihood for their students. They themselves employ numerous artists as teachers.

Since World War I, academic research into African and African-American art history has deepened and expanded on an unprecedented scale. As a result, African-American colleges and universities now emphasize their heritage of African art and the work of African-American artists of past generations. Numerous exhibitions in these institutions have shown African art as well as the work of Henry Ossawa Tanner, Edward M. Bannister, Charles White, Jacob Lawrence, Norman Lewis, Elizabeth Catlett, and many others. Student exhibitions provide a special kind of stimulus.

All this does not mean that other art is excluded, but rather that students are made aware of the work of African and African-American artists to a degree not found elsewhere. The basic principles of drawing, design, color, and composition, applicable to all artistic styles, are still emphasized. However, the goals today are not necessarily limited to producing art teachers for segregated schools as they once were.

Many schools now have extensive collections of art. Tougaloo College in Mississippi has, in addition to the work of African-American artists, the finest collection of modern art in that state. At Atlanta University, at the suggestion of Hale Woodruff, annual juried shows began in 1942. These exhibitions, offering cash and purchase awards, have created one of the largest collections in the world of African-Americans. In fact, by 1970 the size of the collection forced discontinuance of the annual shows. Exhibitions of works from the collection have toured many schools.

James V. Herring, trained in architectural rendering at Syracuse, gradually overcame—with watercolors—the resistance to art courses on the part of Howard trustees. College trustees had long held that African-Americans should study only "practical" matters. Herring, portrayed here in 1923 by James A. Porter, his student and eventual successor, changed their attitude at Howard, which led others to change. (30 x 25″) Permanent collection, Howard University Gallery of Art

The result of all these efforts is an expanding base for the development of outstanding African-American artists. The situation now is very different from the one African-American art students faced in the 1930s and earlier.

Woman Holding a Jug (1930) won the Schomburg portrait prize in the 1933 Harmon exhibition. While Porter had exhibited at the Pennsylvania Academy of Fine Arts and with various groups, this prize first brought him national attention as an artist. He was already teaching drawing and painting at Howard University, and this achievement added to his department's prestige within the university. (21¼ x 23″) Carl Van Vechten Gallery of Fine Arts, Fisk University, Nashville

JAMES A. PORTER

James A. Porter approached his art with an almost religious sense of mission to disprove the myth that African-Americans had no visual or plastic art. He was also a pioneer historian of early black artists in America; his *Modern Negro Art,* published in 1943, was the only bridge for African-American artists to their artistic forefathers, and remains a primary source today. In 1951 an entire issue of a leading art magazine, *Art in America,* was devoted to his early research on Robert S. Duncanson.

Despite his teaching, historical research, and administrative duties as head of the Howard University art department, Porter never stopped painting, mounting many one-man shows and executing numerous portraits, an art form that lent itself to his specific talents. His paintings tended to be elegantly realistic, detached, and academic until near the end of his life when, after a year-long visit to Africa, they became more expressionistic.

No comparable figure exists among American artists. Most art historians have never seriously used a brush, and most artists tend to be unaware of the social forces behind historical shifts in art.

The eighth child in a devout African Methodist Episcopal family, James A. Porter was born in Baltimore on December 22, 1905. He had five older brothers and two sisters. His father, the Reverend John Porter, hoped James would become a minister, as his own father and brother had been. However, after an older brother, John, who had become a painter, introduced James to drawing and painting, James decided that was what he wanted to do. On moving to Washington, the Reverend Porter brought James to the head of the art department at Howard University, James V. Herring. Perhaps he hoped that Herring would discourage James. Instead, Herring told him to follow his artistic feelings, and asked the Reverend Porter to send his son to Howard when he finished high school.

A perceptive judge of character and talent, Herring recognized that teenage James Porter had exceptional potential as an artist and scholar. He set about molding him as an artist, teacher, and eventual successor. At Armstrong High School, Porter led his class academically and was offered a tuition scholarship at Yale. Unable to afford room-and-board costs, however, he accepted a Howard scholarship, arranged by Herring, which permitted him to live at home.

At Howard, which Porter entered in 1923, his record was brilliant. Upon graduation, he accepted Herring's offer to teach drawing and painting, and spent the summer of 1927 studying art education at Teachers College at Columbia University. He simultaneously studied anatomy with the nation's leading anatomist, George Bridgman, and painting with Dmitri Romanovsky at the Art Students League.[1] He continued these courses the following summer.

In 1929 one of his paintings won an honorable mention in the Harmon exhibition, prompting him to exhibit in national juried shows, such as those of the American Water Color Society, the Pennsylvania Academy of Fine Arts, and the National Gallery of Art. In 1933 he won the Schomburg portrait prize in the Harmon exhibition with *Woman Holding a Jug,* a meticulously rendered painting of a young black woman.[2]

At the juried national exhibitions, what constantly irritated Porter was the surprise of officials, spectators, and critics that a black person could be a capable artist; Henry Ossawa Tanner, although still living, was already forgotten. One day Porter read a brief account in the *New York Age,* a now defunct black periodical, of the black Cincinnati artist Robert S. Duncanson and his success in the Civil War period. "How my eyes were opened to the neglect and deliberate indifference with which Negro efforts in the field were received," he wrote.[3] He began searching for more information about early African-American artists.

Night Raiders (1944), also known as ***When the Klan Passes By.*** Without being melodramatic, this painting expresses both the anxiety and the courage of an African-American family in the South during a terroristic Klan campaign. Stylistically, it is close to the work of Andrew Wyeth. (21½ x 29⅝") Collection Dorothy Porter Wesley, Washington, D.C.

At the Harlem branch library he met Dorothy Burnett, a research librarian who specialized in the writings of African-Americans before 1835. Their discussions about references and advertisements by unknown black artists led him to believe there were more black artists in early times than anyone suspected. These conversations also led to their marriage in 1929. Although Dorothy Porter wanted them to settle in New York, where she could support them through her library work, Porter insisted on returning to Howard. A year later she joined the Howard library, ultimately becoming its director and nationally known for her bibliographies on early black writers. She provided Porter with invaluable research assistance.

Herring, Porter, and others realized the need to educate art educators about black artists. They believed this would open art schools and exhibitions to black students, leading to recognition, sales, and even teaching appointments in art schools. Therefore, at meetings of the College Art Association, the only art organization open to them, Howard faculty members presented documentary material showing the work of black artisans in fine furniture, New Orleans iron balustrades, engravings, portraits, and jewelry. These skills were often described in advertisements for runaway slaves or by free blacks seeking commissions.

Porter, his wife, and his colleagues searched endlessly through the journals of early travelers, local histories, diaries, newspaper files, books, and academic studies. What they occasionally found could be inspiring: *Peterson's History of Rhode Island,* for example, revealed that Gilbert Stuart first learned to sketch by watching a talented slave draw portraits on the heads of casks, something omitted from standard accounts of Stuart's development.

Porter did not agree with Alain Locke's belief that information about the influence of African art on Pablo Picasso, Georges Braque, and Henri Matisse would alter attitudes about the artistic talent of black people.[4] Recognizing that few Americans then appreciated modern art, Porter believed historical information on early African-American artists would be more effective. Such information would also reduce resistance to art training among African-Americans, Porter believed, and help to engender pride in what black people had achieved.

In his research, Porter was spurred on, he later wrote, by "the constantly reiterated statement that 'the American Negro has no pictorial or plastic art'—a statement for which both white and Negro persons were responsible."[5] Systematically collecting material on black artisans and artists in every field from pottery to architecture, weaving, ironwork, engraving, and portraiture, he eventually made this research the basis for his master's degree at New York University.

Porter often worked for months with tantalizing references for exasperatingly meager results. For example, in *Nos Hommes et Notre Histoire* by Rodolph Desdunes, an obscure Creole schoolteacher in New Orleans, he identified three African-American pre–Civil War artists—the painter Alexander Pickhil, the sculptor Eugene Warburg, and his brother Daniel, an engraver and stone mason.[6]

In the *American Magazine of Art* (read by many art educators), Porter also reviewed a large exhibition of the work of contemporary black artists at the National Museum of the Smithsonian in 1933—an exhibition that the Howard faculty had brought about. The paintings meriting the closest attention, he wrote, were "the forthright productions founded on the real experience

of the artist rather than on foreign modes of expression [i.e. Cubism, Expressionism, and 'Africanism']."[7] His comment reflected the faculty's anxious desire for black artists to be accepted as traditional artists, not as novel innovators.

In 1935 Porter spent a part of a sabbatical year in Paris, studying medieval archaeology at the Sorbonne and extending his studies into Baroque art, especially the work of Rembrandt and the Flemish masters, which became lifelong interests. He visited Tanner, who inquired with great interest into his historical research—and then astonished him by giving him a portrait of the founder of the AME church, the Reverend Richard Allen, created by a black artist-minister, G. W. Hobbs of Baltimore.[8] Tanner's father, Bishop Benjamin Tanner, had preserved this pastel portrait, which became part of the Howard gallery collection. Thus, even in Paris, Porter found the work of early African-American artists.

On his return to the United States, Porter took his historical material to Jean Lipman, editor of *Art in America* and an expert on American folk art. She published Porter's work, the first systematic account of African-American artists and artisans to appear in a leading art magazine—in fact, virtually the first mention of African-Americans since Tanner won salon and museum prizes more than a quarter of a century earlier.[9]

This publication stimulated a search for additional data. At New York University in 1936 Porter was advised to expand his master's thesis into a doctoral thesis that included contemporary African-American artists. His research led Porter into a close examination of Alain Locke's proposal in "The Legacy of the Ancestral Arts" in *The New Negro* that African-American artists study African art forms and develop a racial school of art.[10] Porter had long been annoyed by Locke's presumptions about art and regarded Locke, a philosophy professor, as a "gate-crasher" in the field of American art.

In 1937 Porter was living in Harlem, completing his New York University work. He became acquainted with many of the African-American artists in the city, including Augusta Savage, Jacob Lawrence, Gwendolyn Bennett, Charles Alston, Romare Bearden, and many others. He visited the Harlem Community Art Center and he witnessed, so to speak, the turbulent struggles of these artists and the Artists Union to maintain the Works Progress Administration. He was also aware of the efforts of the Harlem Artists Guild to develop cultural programs reflecting their "ancestral heritage," as Locke, who was constantly around, phrased it.

Constance (1944) portrays Porter's daughter as a little girl. Strongly attached to his family, he painted a series of portraits of them as a group and as individuals. (Charcoal on paper, 31½ x 25½") Collection Constance Porter Uzelac, Marina del Rey, Calif.

Locke's activities, his attempts to involve himself with African-American artists and convert them to his ideas, irritated Porter, who was teaching young African-Americans to draw and paint. Nearly ten years before, Porter had read sociologist E. Franklin Frazier's analysis of Locke's statement that African art, which had influenced European modernists, "can scarcely have less influence upon the blood descendants."[11] Frazier pointed out that while group experience could provide materials for artistic creations, this was entirely different from "seeking the biological inheritance of the race for new values, attitudes, and a different order of mentality."[12] Porter also read in the Artists Union publication, *Art Front,* art historian Meyer Schapiro's article on race, nationality, and art.[13] Schapiro, exposing as false all stereotypes of nationality in art, attacked the advocacy of racialism in the work of African-American artists without naming its chief advocate, Locke. Moreover, Porter was deeply offended by Locke's criticism of Henry Ossawa Tanner and his persistent ignoring of what Tanner and Edward M. Bannister and other African-American artists had achieved.

In the summer of 1937, having gained his master's degree, Porter published an all-out attack on Locke in *Art Front*. Accompanying his article was a black box mourning the death of Tanner, who had recently died in Paris. Considering that they were both Howard faculty members, the attack was harsh and personal. Its opening sentences read:

Dr. Alain Leroy Locke's recent pamphlet, Negro Art: Past and Present, is intended to bolster his already wide reputation as a champion of Africanism in Negro art. This little pamphlet . . . is one of the greatest dangers to the Negro artist in recent years. It contains a narrow racialist point of view, presented in seductive language and with a presumption that is characteristic of the American 'gate-crasher.' Dr. Locke supports the defeatist philosophy of the 'segregationists.' Weakly, he has yielded to insistence of the white segregationist that there are inescapable internal differences between white and black, so general they cannot be defined, so particular that they cannot be reduced through rational investigation.[14]

Porter called it a serious error "to urge the Negro artist to adopt the forms used by the African artist. The Negro artist who 'adopts' such forms or imposes them on his ideas and the objects that embody them gives birth to a sterile art which would not have the crucial exigency that we associate with the arts of the African tribes. The 'primitive' artist, whether African or Polynesian, is at one with all the forms he uses, because these are dictated by the society in which he finds himself, which is in turn modified by the surrounding climatic and geographical conditions. To learn the truth of this, one need ask: Could Cubist art have been produced in Dahomey?"[15]

Porter pointed out that Cubism is "not merely the result of the impact of African forms upon European art practice."[16] Amedeo Modigliani, Pablo Picasso, Constantin Brancusi, and others did not merely imitate African forms, Porter said, but used and modified these forms to express their emotional experiences as Europeans.

Locke made no direct response to Porter's article. Over a period of years he softened his call for study of African forms and a racial school of art, which originally was only vaguely defined and hence open to misinterpretation. It also lacked a scientific foundation. By 1939 Locke was acknowledging that "the indirect inoculation of African abstraction and simplification may lead, and in some cases has actually led to slavish imitation and sterile sophistication."[17] However, while he dropped the idea of biological inheritance of African

values and traditions, Locke did not abandon his call for the study of African art.

During these years Porter worked steadily, night after night, on the research and writing of *Modern Negro Art*. In preparation for this book, he tried to define various aspects of African-American artists' work.[18] He argued that black artists were trying to prove themselves worthy of inclusion in the dominant culture, following prevailing artistic standards without attempting to be innovative. However, in trying to define an African-American art, he made the common error of confusing black subject matter with a black style or mode of expression. A painting of a black person is not a style, and it is style, rather than content alone, that determines the visual or plastic character of a work of art. The Italian Renaissance artists, for example, are identified not by what they painted but by their common style. In the same way, a Benin sculptor is recognized by his style in creating a figure, not by whether he portrays Africans.

Porter's confusion between style and content was continued in *Modern Negro Art*, which was published in 1943, largely at his own expense. Nevertheless, this book stood out as the first extended account of the development of African-American artists in the United States. While at times fragmentary and pedantic, Porter's pioneer effort was, as the painter Walter Pach said, "of permanent value and extreme importance." He called the book "testimony to the fact that the Negro does not stand apart in the civilization of the United States, but has an inherent share in it. The evolution of the Negro artist in America carries on the pattern of his white contemporaries."[19] The book's careful bibliography, prepared by Dorothy Porter, constituted one of its most valuable contributions. Student response to the book prompted Porter to introduce a course in African and African-American art, the first of its kind in any college.

Unfortunately, however, in part because it was published during World War II, the book was largely ignored outside African-American intellectual and art circles. In addition, some black artists quibbled that the title, *Modern Negro Art*, was inaccurate since much of the book dealt with history and few of the artists mentioned were "modern" in the sense of European "Modernism."

Porter continued his attack on Locke's ideas in *Modern Negro Art*, but acknowledged the issue of identity had sharply divided African-American intellectuals and writers, citing *The Crisis* symposium on how the African-American should be portrayed.[20] "One group contended that to avoid imitation of white traditions,"

Toromaquia (1962) is a powerful painting of a wounded and enraged bull, perhaps symbolizing both Africa and African-Americans. So much of Porter's energy went into his work as a teacher, art historian, and administrator that it is impossible to assess what his work as an artist might have been without these consuming interests. (48 x 36″) Collection Dorothy Porter Wesley, Washington, D.C.

Porter wrote, "the Negro must deny everything that might be construed as derivative from white experience; the other insisted that the Negro should encompass all experience, for such suppression meant intellectual and aesthetic negativism."[21]

This was an issue that could not be resolved, and after 1937 it runs like a thread through the rest of Porter's life and work.

By the late 1940s Porter had established an outline of the work of Robert S. Duncanson, whom he set out to rescue from obscurity. He spent years tracking down one painting after another and recruited Edward H. Dwight, then a young specialist in modern art at the Cincinnati Art Museum, to help. Eventually Dwight, who later became the director of the Munson-Williams-Proctor Institute and Museum in Utica, New York, identified more Duncansons than any other individual. Meanwhile Francis W. Robinson, a curator of medieval art at the Detroit Institute of Arts, and James D. Parks, who headed the art department at Lincoln University, in Jefferson City, Missouri, had begun their own Duncanson research. All traded information. After a decade of work, Porter published a long but preliminary article on Duncanson in the October 1951 issue of *Art in America*.[22]

Porter's work undoubtedly saved Duncanson from total obscurity. Conscientious art historians, such as Oliver Larkin, then included Duncanson in their comprehensive histories of American art, although most continued to ignore him until the civil rights movement prompted new consideration of black artists in America's past.

Porter's visits to New York made him aware that many African-American artists had come from the Caribbean. In addition, the African-Cuban painter Teodoro Ramos Blanco, who had exhibited in the 1933 Harmon show, had become his friend, often visiting his home and further stimulating his interest in Caribbean artists. When World War II ended, Porter obtained Rockefeller Foundation grants that enabled him to visit artists in Cuba and Haiti. Fluent in both Spanish and French, he spent hours with these artists, gathering slides of their work as well as historical material on African influences on their art. That he was fluent in Spanish helped Porter establish a deep rapport with these Caribbean artists. He also studied the work of Brazilian artists because they too had African roots. Porter's approach to African influence, grounded in direct observation, differed significantly from Locke's theorizing derived from the fact that African masks had influenced the development of Cubism by Picasso and Braque. The material Porter gathered eventually became the basis of a course on Latin American art.

Meanwhile Howard's enrollment had doubled as a result of the GI education bill, greatly increasing Porter's teaching schedule. When Herring retired in 1953, Porter became head of the department and director of the Howard University Gallery of Art. These new administrative duties reduced his time for painting and historical research. Albert J. Carter, curator of the gallery, found Porter "worked day and night. . . . His only relaxation was reading."[23]

Even then, what he read was historical; he worked until late at night, following references found by his wife. This highly professional husband-wife team, self-financed and highly motivated, uncovered many unknown areas of African-American art history. Yet each worked alone: Porter reading, making notes, and writing in his third-floor studio; Dorothy Porter in her library. Believing deeply in his work, she sometimes

The Haitian Lovers (1946), romantic yet not overly sentimental, is characteristic of Porter's work in this period. (Pastel on paper, 21¼ x 24¼″) Collection Constance Porter Uzelac, Marina del Rey, Calif.

gave up European trips so that he could afford to extend his studies.

As director of the Howard art gallery, Porter made a significant change in policy. Herring had presented interracial exhibits, showing the work of leading white artists with that of African-Americans, to demonstrate, particularly to critics, that black artists were qualitatively as good as these well-known artists. Feeling this had been sufficiently established, Porter emphasized the work of African-American artists. He gave one-person shows to Archibald Motley, Jr., Eldzier Cortor, Hughie Lee-Smith, Charles White, and many others. He also exhibited Cuban and Haitian artists to expose students to the diversity of talent and cultures among black artists.

To increase students' contact with working artists, he appointed artists-in-residence, one of whom was Charles White, who spent a year at Howard and whose work Porter greatly admired. Comparing White's work with Andrew Wyeth's, Porter said, "By looking at Wyeth one grasps more readily the universal values in White's art. By looking at White and then again at Wyeth, the latter's interest in a narrow human world may seem less clinical and more emphatic."[24]

During the 1950s American Abstract Expressionism had come to dominate the international art world. A few African-American artists were attempting to work in this style, and even those who maintained their fig-urative stance painted more freely, with bolder rhythms and colors. By the late 1950s and early 1960s, reflecting the civil rights movement, more and more young artists were trying to express their feelings and make their work relevant to the struggles of their people.[25]

Porter was sympathetic to and appreciative of these attitudes. Yet all this work differed sharply from his classical academic approach. In his early work Porter had portrayed picturesque, genre types in rich but very controlled colors, strongly modeled in light and shadow, in a manner related to the work of older American realists, such as Everett Shinn and George Luks. Realistic color and the vitality and expressiveness of figures in authentic backgrounds were his primary concerns, as exemplified in *On a Cuban Bus.*

Then, in 1963, at the height of the civil rights movement, Porter went to Africa on a year's leave to prepare a book on West African art and architecture. Dissatisfied with his work on the book, he laid it aside. Taking up his brushes, he found that he had come to a turning point in his work as an artist. Observing life on African beaches, in its villages and mountains, Porter experienced some release from the past.[26] Abandoning his meticulous realism, he painted more expressionistically than he had ever permitted himself to do before. There is no comparison with his past work. In *Storm Over Jos, Nigeria,* the brushstrokes and sweeping rhythms suggest a cataclysm of nature. *The Birth of Africa,* which he sometimes called *The Rebirth of Africa,* is a wholly imaginary painting whose importance lies in Porter's strong identification with that continent.

Porter now felt he had been unconsciously trying to express "African themes" in his work for some years and arranged an exhibition of his work between 1954 and 1964, to show "a significant culmination of ideas and development in my work of the past ten years."[27] One of the fascinating aspects of these "African theme" paintings was that they included a 1954 self-portrait and many American scenes and portraits, as well as the paintings done in Africa. The painting that departed most from his previous work was *Tempest of the Niger,* a turbulent, expressionistic work. Overall, these paintings marked, Porter hoped, the beginning of a "broader artistic penetration of Africa." He had not gone to Africa, he wrote, "with the intention of 'taking her portrait.'" The paintings were "much less the result of what I saw than of what I felt while in Africa."[28]

Porter's exhibition was held early in 1965 and was followed by an unusual honor in 1966. The National Gallery of Art selected him as one of the nation's best

378

Storm over Jos, Nigeria (1964) was one of the expressive paintings that Porter did during his trip to Africa in 1963–64. While he had been through the campus turmoil of the early 1960s, he discovered in Africa that he had new things to say and a new way of saying them. On his return he showed these and other paintings in 1965 as culmination of his ideas over the past decade. (19¾ x 28¾″) Collection Constance Porter Uzelac, Marina del Rey, Calif.

art teachers. He was presented with $500 and a medallion "for distinguished service to art" by Lady Bird Johnson, the First Lady.

The next year, Porter arranged a unique exhibition of "Ten Afro-American Artists of the Nineteenth Century" as part of the Howard centennial. The show gave the capital's many art experts, as well as his students, a look at a part of American art history unknown to them. Among the works exhibited were many Tanners, Edmonia Lewis's *Old Indian Arrowmaker and His Daughter,* Eugene Warburg's portrait bust of John Mason Young, and paintings by Duncanson, Bannister, and others.[29]

However, Porter's impressive celebration of these nineteenth-century black artists was followed by turmoil. Riots, including a major one in Washington, were set off by the assassination of the Reverend Martin Luther King, Jr., in 1968. While he supported the civil rights marches, Porter was deeply distressed when Howard students began to reject all Western art. When he was told that his students no longer wanted to study Rembrandt and Baroque art, but only African art, Dorothy Porter recalled that his response was: "I will give

them African art, Afro-American art, but they will also have Rembrandt, they will also have Baroque art. They'll have it all!" The student rebellion actually became a physical confrontation: the Porters were locked out of their offices and the gallery was seized.

The Porters lived near 14th Street, which was ablaze during the riots. "I thought he was going out of his mind as he watched," Dorothy Porter said. "He was terribly, psychologically upset." Three large paintings were stolen from the Howard gallery and Porter's portrait of Congressman Louis Crampton, who had won increased appropriations for the university, and for whom Howard's auditorium was named, was slashed. Curator Albert J. Carter later restored it.

These experiences greatly depressed Porter, although he recognized the cause of the riots as the failure of American society to give its African-American citizens their rights. These social upheavals formed the background of an essay in which he noted:

The principal distinction . . . between Afro-American art of the Nineteenth Century and that of today is a pervasive sense of malaise and spiritual alienation

379

Street of the Market, Zaria, Nigeria (1964) was painted during Porter's second visit to Africa. The vitality, creativity, and friendliness of the people confirmed that European colonialism had not crushed their spirit. His own awareness of his past views of and concerns with Africa prompted a reexamination of his past work and the discovery of African influences in it. (20 x 30" framed) Collection Dorothy Porter Wesley, Washington, D.C.

which turns up vividly in the work of the contemporary artist. This expression of disturbed or distraught feeling is scarcely comparable to the mournful or melancholy moods of the Negro Spiritual or the Negro worksong, for it contains strident harmonies and tensions of form, color, and feeling which in the plastic arts as well as in music connote the emotions of love, hatred, despair or triumph in such concentrated doses as never burdened the Spirituals.[30]

He concluded:

Yet it is unlikely that we shall ever have a truly great Afro-American artist among us until American society completely accepts the Negro and his valid interpreters. This wished-for relationship is still far from arriving although it is so much desired by all who love America and hope that she will fulfill the democratic promise of equality. . . . The present militancy of the Negro relative to this necessity has been interpreted as the actual conscience of America pricking her towards goals of social justice and more action. This, in fact, is a cultural upsurge of crucial importance, and it offers the artist and writer un-

precedented opportunities for the development of mobility and independence of creative thought and imagery.[31]

Although already seriously ill with cancer, Porter went to southern Rhodesia to chair a conference on Zimbabwe culture. There he became acutely ill. For the first time in its history, a Rhodesian hospital admitted a black man and treated him as though he were a European. Flown back to the United States, he underwent surgery and seemed to be recovering. He chaired a conference on African-American artists a week before he died on February 28, 1970.

Always formal, aloof, remote, yet yearning for personal contact with people interested in his painting and burning with a determination to win a place for black artists in American life, this tall, thin scholar was for many years the only chronicler of the past achievements of black artists. Without Porter's dedicated research in the early 1930s much of that past would have been lost forever. His historical scholarship, rather than his skillful painting or his gifted teaching, was his greatest contribution to our national heritage.

LOIS MAILOU JONES

In 1989 the Howard University Gallery of Art celebrated forty-seven years of teaching by one of its distinguished professors, Lois Mailou Jones, with a retrospective exhibition. This show demonstrated the transition of an academic painter to a modern, flat abstractionist, whose later work reflects her knowledge of African symbols and artifacts. Jones's paintings, always noted for their color, are strong in design, a characteristic dating back to her earliest Boston days and recognized in her academic position as "Professor of Design and Watercolor."

Her work has been awarded sixty prizes, beginning with a "first" in oils at the National Museum in 1940 and the Robert Woods Bliss landscape prize in 1941 at the Corcoran Gallery of Art in Washington. At that time the capital was segregated and Jones was afraid to go to the Corcoran to receive her award lest she be humiliated at the door.[1] She again won "firsts" in oils at the National Museum in 1947, 1960, and 1963. In 1949 she received the John Hope Award at the Atlanta University exhibition and its first prize for watercolor in 1952 and 1960. Her work is in major museums including the Hirshhorn Museum and Sculpture Garden, Phillips Collection, and Corcoran Gallery of Art, all in Washington, and the Metropolitan Museum of Art and Brooklyn Museum in New York. In 1974 her striking collage *Ubi Girl from Tai Region, Nigeria,* became the first by an African-American artist acquired by Boston's Museum of Fine Arts, in whose school she once studied. That museum also presented her work in a solo exhibition, the first African-American to be so honored.

In 1976 she presented her portrait of President Léopold Senghor of Senegal to him at his seventieth birthday in Dakar. Four years later she was one of ten African-American artists honored with a reception at the White House by President Jimmy Carter.

Yet, while she has won many awards, Jones is not truly well known. Many factors have contributed to this, and one may be that like many teachers, Jones never developed an identifiable personal style. Even after gaining considerable recognition for work embodying African symbols and masks, she went back in 1989 to painting French landscapes in the Post-Impressionist style that characterized her first paintings in France in the late 1930s. She called it completing "the circle of my career," according to Tritobia Benjamin.[2]

Jones's contribution, however, extends beyond her own art. She has been an encouraging teacher to literally thousands of Howard students, especially young women artists, some of whom are now well known.

Lois Mailou Jones was born in Boston on November 3, 1905, to Thomas V. and Carolyn D. Adams Jones. Her parents' Paterson, New Jersey, families had African, Dutch, and Native American ancestors. Living atop a big Boston office building, for which her father was the superintendent, her family was peculiarly isolated. Her father went to law school at night for nine years and graduated but never took the bar examination. Her brother, nine years older, was not her playmate, and she was often lonely. Her playground was the roof; it was "sad," she later said.

Her mother, an expert beautician, took her to wealthy white patrons' homes, where she saw paintings that stimulated her first efforts with crayons at the age of four years. Her mother was also an expert milliner, who made beautiful hats, and Jones now considers her mother an artist. She credits her mother with having awakened in her a desire to make something beautiful. Years later memories of these early days inspired her to make a painting titled *My Mother's Colorful Hats.*

Jones's artistic talent was recognized early. She attended the Boston High School of Practical Arts, where her counselor, Laura Wentworth, helped her obtain a scholarship to the vocational art school of Boston's Museum of Fine Arts. After her high school classes ended at 2 P.M., she worked in the museum school until 4:30 P.M. and on Saturdays. There, guided

Parade des Paysans (1965) won the 1962 Franz Bader Award of the Washington Society of Artists. It demonstrates Jones's facility in developing a modern style that is far from her Paris street scenes. Although she used color brilliantly, it did not lead to a highly identifiable personal style. What her students remember best is her spirited approach to art. (30 x 19") Collection Max Robinson, Washington, D.C.

by Henry Hunt Clarke, Alice Morse, and Phillip L. Hale, amid extensive collections of textiles and costumes, young Lois had an unusually rich exposure to art in her formative years. "I made the museum my home, drawing until it closed," she recalled.

Each June the Jones children and their mother moved to Martha's Vineyard, a vacation haven for rich Bostonians. There her maternal grandmother was a housekeeper for the wealthy but friendly Hatch family. Her grandmother and mother enjoyed an unusually pleasant and affectionate relationship with the Hatches; Lois is named for one of their children. Eventually the Jones family was able to buy its own home on the island.

On the Vineyard Jones's watercolor sketching was a daily routine. One day a gentleman watching her work pointed out that reflections of sailboat masts in the water do not slant down, but drop vertically. "He went on to say, 'You're a good painter, and if you'll bring your portfolio to me, I'll try to help you.' " He turned out to be Jonas Lie, then president of the National Academy of Design in New York. Although he did not live long after that incident and "I did not get the opportunity to take my work to him," Jones recalled, "it was encouraging."

As a teenager, Jones received even more personal attention and encouragement from two very talented African-Americans. One was Harry T. Burleigh, the internationally famous singer and composer who had introduced Antonin Dvořák to the spirituals; Dvořák then wove the spirituals' themes into his *New World* Symphony. Burleigh, whose initial appearance as a soloist at St. George's Church in New York had caused consternation, was certain of the gifts of black people. On the Vineyard he often gathered the African-American children on the island together, sometimes taking them to the movies. He talked to them about traveling abroad, telling them stories of his own success in Europe and England. "He felt we should go abroad [to escape prejudice] and, as he used to say, 'Try to make something of the importance of your life,' " Jones recalled.

In her early teens she also met sculptor Meta Vaux Warrick Fuller when they both worked on costumes for a black community theatrical in Boston. Fuller, who also went to the Vineyard each summer, had been a prize-winning student at the Pennsylvania School of Industrial Art in Philadelphia, and later studied at the Colarossi Academy in Rome and with Auguste Rodin in Paris. Her work initially depicted suffering, pain, and despair in such powerful symbolic terms that many found it disturbing.[3] After her marriage to Dr. Solomon Fuller, America's first black psychiatrist, her work lost this character and its emotional impact. Jones, in 1972, attributed this loss to Dr. Fuller's influence. "After her marriage she changed entirely. She then did busts and portraits."

When Jones told Meta Fuller of her desire for a career in art, "she was most considerate and encour-

aging." Fuller's coming to the Vineyard "enabled me to have a closer, continuing relationship with her. When I was about fifteen or sixteen years old she invited me to come to Framingham to see her studio—and that was wonderful! I'll never forget it!! A lovely memory!"

When Jones graduated from high school, Ludwig Frank offered her a scholarship at Designers Art School of Boston, providing she clean the studio every morning. She was shocked and dismayed by this condition, feeling other students would not consider her their peer if she also did the janitorial work. However, her mother volunteered to do the work for her, "and she did it, a great sacrifice for me, so that I would be free to study," Jones recalled.

Because her textile designs were outstanding, her fellow-students generally looked upon her with friendly admiration. A Georgia girl, who initially refused to sit beside her, later became a close friend when she saw what Jones could do. Still later, this girl, trying to help Jones get around the color barrier, took Jones's designs in her own portfolio to leading New York textile houses. "She really handicapped herself because my work was often taken and hers was not," Jones remembered. Her designs were made up by such major textile firms as Schumacher and F. A. Foster.

When Jones applied to the Museum of Fine Arts for work as an assistant teacher, she was told there were no openings. She was asked, "Have you ever thought of going South to help your people?"

Until then, although active in the African-American community, she had not thought of herself as black so much as a New England girl and had not perceived that she might play a role in the artistic development of black people. But one Sunday afternoon in 1927 at the "Forum," at which young African-American Bostonians gathered, Jones heard Charlotte Hawkins Brown of the Palmer Memorial Institute, an early black preparatory school in Sedalia, North Carolina, call for help: "We need you young people to help us in the South." Jones offered to establish an art department and, despite her youth, was promptly hired. Art departments in southern black schools were unknown at the time. Yet within two years she developed talented students and staged a striking exhibition of their work. The exhibition so impressed Professor James V. Herring, then starting the Howard University art department, that in 1930 he asked Jones to join the Howard faculty, which she did.

For the next forty-seven years she taught design, drawing, and watercolor painting to generations of Howard students, until she retired in 1977. A number of her students became significant contributors to contemporary American art. Among them are Eliza-beth Catlett, David Driskell, Lloyd McNeal, Malkia Roberts, Starmanda Bullock Featherstone, Bernard Brooks, Leo Robinson, Delilah Pierce, Georgia Jessup, Sylvia Snowden, Franklin White, Peter Robinson, and Tritobia Benjamin, who is now head of the Howard University Gallery of Art and the biographer of Jones.[4] Many more are now teaching in colleges, universities, and high schools.

While her ability as a teacher grew steadily, her development as a painter had to await her first sabbatical leave.

Although she painted with watercolors regularly during her first years at Howard, Jones was not satisfied with her work. She was also well aware of the fact that to be considered important an artist had to work in oils. Knowing she had a sabbatical leave coming up in 1937, she decided to spend that year studying painting in Paris, long the world's major art center, and was awarded a General Education Board fellowship to enable her to do so.

In Paris Albert A. Smith, an African-American painter who had won the Harmon bronze medal in 1929, found Jones a place to live.[5] Remaining in Paris after World War I, Smith had survived by playing jazz in Paris nightclubs. He painted weekends and in the summer in Spain. Smith advised Jones to study at the Académie Julien.[6] This had been the school at which Henry Ossawa Tanner found himself, and in planning to study in Paris, Jones had hoped to gain his guidance. Unfortunately, Tanner had died in May 1937, three months before Jones sailed.

At the Académie Julien she formed a close friendship with a young French woman painter, Celine Tabary, whose family virtually adopted her. It was at the Tabary home in Ponte Carlo in northern France that she painted the landscape that later won the John Hope Award at Atlanta University.

Feeling "shackle free" in France, Jones took up painting outdoors, a French tradition. She made many paintings of Paris street scenes. While painting on the banks of the Seine she was approached by Emile Bernard, the friend of Vincent Van Gogh and Paul Gauguin and a leader of the Synthetists (Symbolists). He offered both criticism and encouragement. He also allowed her to store her canvases and paints at his studio at the end of the day and continued to take an interest in her work. On the encouragement of her new friends, in 1938 she submitted her work to the Salon of the Société des Artistes Français and the Société des Artistes Indépendants, where they were accepted and hung. "Her painting has been in the tradition, but not in imitation, of [Paul] Cézanne," wrote James A. Porter, her Howard

Les Fétiches (1938), a striking and colorful composition painted in Paris, was one of the first results of Jones's early interest in African art. She advised students to go to Africa to see such art works in their social and religious context. (25½ x 21″) National Museum of American Art

Meditation (1944) won first honorable mention in the Salon des Artistes Français in Paris in 1966. It represents an African-American about to be lynched but whose prayerful attitude reflects none of the violence of such an event. Jones added a second title, *Mob Victim,* to help people understand the painting. (41¼ x 25″) Collection of the artist

colleague. "She has a commanding brush that does not allow a nuance of the poetry to escape. Sensuous color delicately adjusted to mood indicates the artistic perceptiveness of this young woman."[7]

Jones's work also showed African influence. Earlier, in the summer of 1934, she had attended a design class at Columbia University and studied the masks of various African groups. She made thirty small watercolor illustrations on index cards of the masks of non-Western cultures, including Eskimo and other Native American cultures.

While in New York at that time, she met the famous African dancer Asadata Dafora and designed masks for his dance troupe.[8] Through her friendship with Dafora she met Louis Vergniaud Pierre-Noël, a young Haitian artist who was also a student at Columbia. Together they attended Dafora's rehearsals, where she adjusted costumes, headdresses, and masks. During these tryouts, Pierre-Noël pointed out to her the similarities of Haitian dances and drumming to those employed by Dafora's African troupe.[9]

These experiences, plus her observation of African sculptures in Paris galleries and museums, prompted Jones to make *Les Fétiches* in 1938, a striking montage painting depicting masks from five African groups. During this period she also illustrated a book on African kings and queens by Carter G. Woodson, titled *African Heroes and Heroines.*[10]

At Howard her African masks and her success in Paris attracted the attention of Alain Locke. He immediately suggested that she should depict her own people as well as French landscapes. One of her most successful paintings, *Jennie* (done in 1943), resulted from these conversations with Locke. A portrait of a young black woman cleaning fish, it conveys this woman's humanity, dignity, and beauty. Another painting stimulated by conversations with Locke was

Rue Mont Cenis, Montmartre, Paris (1947) is one of many Paris street scenes and landscapes painted by Jones during sabbatical summers in France. Always colorful, these works reflect her affinity with leading Post-Impressionist artists of Europe. She stimulated African-American artists who taught in Washington public schools by turning her studio into a "Little Paris" for them to work in. (28 x 32¾") Collection of the artist

Meditation, an academic portrait of an elderly African-American man looking heavenward with his rope-trussed hands piously clasped in prayer. He shows neither pain nor fear. No menacing mob threatens. The result is the painting does not convey the violent character of the event supposedly depicted. Jones has said that the model for this painting was a black man who told her he had witnessed a lynching and that the victim had this attitude and pose.[11] The ambiguity of the painting has prompted its relabeling as *Mob Victim.*

In 1940 Celine Tabary came to Howard to teach. She and Jones converted Jones's studio into what they called "Little Paris," evoking a Parisian atmosphere with decorations. They invited other African-American artists to draw and paint with them. "We'd

chip in for a model or put up a still life and all worked together," Jones recalled. Many of the black artists had become schoolteachers and tended to give up their efforts to be artists. " 'You are teaching art and you should be painting,' I used to tell them," Jones said. The group included Delilah Pierce, Richard Dempsey, Lucille Robert, and Alma Thomas (see page 449). They exhibited together as the District of Columbia Art Association, naming Jones "Honorary Mother."

Jones and Tabary returned to France each summer. At Cabris, near where Henri Matisse and other modern artists worked, the two friends converted an old house into a studio. At this summer retreat Jones did many landscapes, structurally influenced by Cézanne but alive with her own sense of color.

Peasant Girl, Haiti (1954) sympathetically portrays a young girl in the marketplace with her wares. Such studies established Jones as a perceptive interpreter of the people of Haiti and their lives, and resulted in an invitation from the Haitian government to paint them. (31½ x 21″) Collection of the artist

One day Vergniaud Pierre-Noël showed up in Washington. He had become well known as an artist and graphic designer with the World Health Organization; later, in 1972, he created a prize-winning stamp celebrating World Health Day. Although corresponding occasionally since their studies at Columbia University, they had not seen each other. He had a big question, "Have you married yet?" She had the same question. With two nos, they decided to do something about their status. Jones likes to recall that her mother, disapproving of her single state, "used to warn, 'Some day you'll wake up and find yourself surrounded with pictures.'" But, "Tall, handsome Pierre reappeared in my life when that reminder from my mother seemed to be true," she told Tritobia Benjamin. "Pierre fit the bill—my ideal, my dreams; I loved the French and he was so cultural and the perfect gentleman."[12]

Moon Masque (1971), first exhibited at the Museum of Modern Art in New York, combines African design elements with African mythology about the moon. Although Jones had studied African masks in the 1930s, she was not knowledgeable about their relationship to religious beliefs and traditions until her trip to Africa in 1970–71. (Acrylic, collage on canvas, 41 x 29″) Collection of the artist

They were married in Cabris, France. "The mayor served champagne and the whole village celebrated," Jones recalled. "Pierre and I were the only blacks there."

The French villagers' attitudes sharply contrasted with those of Washington. There, Jones recalled, "black people were made to feel that they were not wanted nearly everywhere. It was a very unhappy place for me, a Bostonian who was not used to this kind of treatment. You could not go to the theater or restaurants. If you went to buy a dress, you were told not to try it on."

Yet Jones never lost confidence in herself. In 1955 she became the first African-American to be admitted to the Washington Society of Artists. Earlier, in the 1930s, she had been elected an officer of the Washington Watercolor Society.

Her marriage to Pierre-Noël placed Jones in an environment far different from that of Washington. Trop-

Homage to Osnogso (1971), though made up of many traditional symbols and designs from Africa, is boldly modern. Jones felt her African trip revealed ways in which African art influenced African-American artists. (Mixed media, 34 x 43¾″) Collection of the artist

Guli Mask (1971) presents a mysterious African mask and shield against a decorative background of many elements. It demonstrates Jones's strength as a creative designer. (Acrylic on canvas, 29 x 49″) Collection of the artist

ical Haiti became her second home, and inevitably her palette became more colorful, her painting freer. From her first visit, Jones fell in love with the island and its dark people. She rapidly made the acquaintance of Haiti's legendary artists, and she studied Haitian life, its rituals, the comings and goings at the marketplace, its people and their attitudes. A guest watercolor and painting instructor at the Centre d'Art and at the Foyer d'Art Plastique, she was invited to paint the Haitian landscape and people by the government. She also painted portraits of the Haitian president Paul Magloire and his wife. In 1955 she was awarded the "Diplôme Décoration de L'Ordre National, Honneur et Mérite au Grade de Chevalier."

While her landscapes grew more colorful, her paintings of Haitians grew simpler, flatter, and more abstract in canvases that were structurally cohesive and far from the impressionistic style that was once her mode. Paintings of the marketplace and bazaars, which offered opportunities for design as well as color, became some of her outstanding works. In one 1961

painting, *Vendeuses de Tissus,* cloth vendors are depicted holding their brightly colored fabrics before them while their black figures, arms, and legs create sharp angular contrasts. Such paintings led gradually to expressive, design-dominated abstract works that increasingly used African symbols and artifacts.

This tendency was enhanced by a prolonged visit to Africa in 1971, where Jones did research in fourteen countries. She visited museums, galleries, and artists' studios. Taking more than 1,000 photographs, she created a major slide collection of contemporary and ancestral African art for Howard University. Her visit also provided "a clearer picture of the various ways in which African art has influenced the work of the Afro-American artist. My work reflects the powerful influence of this close association." She also said:

Being basically a designer, I am always weaving together my research and my feelings—taking from textiles, carvings, and color—to press on canvas what I see and feel. As a painter, I am very dependent on design. With me design is basic. In *Ubi Girl from Tai Region,* I have drawn on three motifs—patterns from different parts of Africa that stem from their genius for such work, the beauty of a profile which I actually took from a piece of sculpture, and the realistic head of a Ubi girl being prepared for induction in a fertility ritual.

In another comment on this striking work, Jones said, "I was so interested and fascinated by this girl from the Tai Region in Nigeria. She was wearing the painted design on her face for a special ceremony. There was something about the deep look in her eyes that impressed me as being symbolic of Africa—so much so that I combined in that painting two masks from Zaire and also the profile of a huge fetish from the Ivory Coast, which seemed to me to give an over-all feeling of what I consider Africa."[13]

In 1972 the Museum of the National Center of Afro-American Artists in Roxbury, Massachusetts, and the Museum of Fine Arts in Boston collaborated in a fascinating exhibition of Jones's evolution as a painter. In a sense she had come full circle, having started as a student at the vocational school of the Museum of Fine Arts. Edmund Barry Gaither, director of the Museum of the National Center of Afro-American Artists, pointed out that Jones "is one of the few figures in American art to achieve a long, exciting and inspiring career in which there is no room for defeat, dullness, or trickery. . . . At times much harder than ours, she championed the black artist, but not just through the model of her energy and her determination, but through the quality of her work and her teaching."[14]

During the student eruptions at Howard following the assassination of Martin Luther King, Jr., Jones found herself defending earlier African-American artists because they had not painted "Black Art." In 1972 she defined "Black Art" as "works done by black artists in an effort to bring about an awareness that black artists exist. It established for them 'black identity.' " She noted that "this designation has resulted in the fostering of and presentation of numerous black art shows, stimulated recognition of the value of these works as a force in the development of America and encouraged black artists to exploit these opportunities in an effort to establish their place in American art on an equality basis." Later, in an effort to be more precise, she said, "As the movement develops, true black art concentrates almost entirely on the black experience," and "results in works which tend to serve as propaganda or even militant expressions as a means to promote the rights of black people." But Jones insisted that the decision on how and what to paint "rests with the artist alone. The works of Sam Gilliam and Richard Mayhew, who work independently of the ancestral heritage, support this fact."

As an artist who has made a transition from work that was modeled after the French Impressionist and Post-Impressionist painters to work that is abstract, modern, and African-influenced, Jones advocates that African-American artists go to Africa themselves to see "ancestral arts" in their original settings. She is very critical of "the superficial use of our black heritage, of African patterns. I personally am seeking to use what is classic in our African heritage in a classical way."

She hopes the "time will come when we will no longer need to attach the word 'black' to 'artist.' Let it be that black artists be referred to as 'artists' whose works are accepted universally on the strength of their merits."

JAMES LESESNE WELLS

A vigorous participant in the development of African-American artists in the late 1920s and 1930s, when he supervised Charles Alston and Palmer Hayden in teaching Harlem children, James Lesesne Wells taught graphic design for many years at Howard University. Scores of black artists, many of them well known today, studied with him.

In addition to teaching, he was an excellent painter and printmaker in his own right. His study of African art and German Expressionism in the early 1920s led him to bypass the traditionalist realism then dominating American art. In 1931 his modern, expressionistic *Flight into Egypt,* bold in its colors, won the Harmon exhibition gold medal. In 1933 he won the Harmon first prize for black-and-white work with a woodcut. Museums, such as the Phillips Memorial Gallery in Washington, which was oriented toward modern art, began to buy his work.

An American pioneer in the use of color in prints, Wells made a decision to specialize in printmaking at a time when prints were virtually ignored, because he felt they were something African-Americans could own. He is a master of the fine white-line woodcut, heightening the effects of this delicate, difficult technique with his strong sense of design and ability to express emotion. His expressionistic use of brilliant color has increased the impact of his woodcuts and lithographs, producing effects related to stained glass yet very different because of his intense style.

In contrast to the looseness and abstract quality of much work since the 1950s, Wells uses strong color, tight design, and a focus on human dilemmas. He celebrates life in white-line woodcuts and colorful linoleum prints. His statements, provocative and affirmative, draw one into their mysteries.

During the 1950s, when Wells won major prizes for paintings and prints on biblical themes, many people believed that was his only subject matter. Actually, there are few subjects concerning the African-American experience that he has not dealt with poign-

The Flight into Egypt (1929), brilliant in its unnaturalistic colors that stemmed from his study of German Expressionism, won the 1930 Harmon gold medal for Wells. Yet he largely abandoned painting to make prints, which he felt could be purchased by African-Americans. His prints are in many leading museum collections. (19½ x 23½″) Hampton University Museum, Hampton, Va.

antly. A profound humanism and a religious spirit make his work illuminating and revelatory. Aesthetically, his work has always been modern, with detail sacrificed for intensity and color used for emotional rather than descriptive purposes, as Jacob Kainen has noted.[1] He was one of the first African-American artists to find in African art concepts that helped him simplify his forms. Initially, this break with traditional realistic detail limited appreciation of his work to those already interested in modern expressionistic art, which was not popular at that time. But in the 1960s it led to new interest in his work.

Wells's decision, about 1933, to give priority to printmaking, rather than painting, resulted in obscuring his name to the art world. Print shows were very

African Phantasy (1932), a bold white-line print, aroused Alain Locke to describe Wells as "a force in the sane, non-melodramatic use of African motives and rhythms in design." Years later Wells said his greatest problem as an art educator stemmed from his "commitment to the use of African art as [a] source of inspiration and pride" (letter to the authors, October 3, 1974). Estate of James L. Wells

seldom reviewed, since prints were regarded as a secondary and derivative art form. Only in the 1970s, when inflation drove even wealthy collectors to prints, were they recognized as being as creatively important as paintings. Now they are produced by nearly all leading artists.

In 1977, when Howard University mounted a major retrospective exhibition of Wells's work of nearly fifty years, there were many striking linoleum prints, reflecting his 1969 visit to Africa and his enthusiasm for the people of Ghana and Nigeria, whose art had long inspired him.[2] In his eighties, Wells was still active, painting as well as making prints.

Wells's work is in many American museums and universities, including the Hampton Institute and Valentine Museum, both in Virginia; Talladega College in Alabama; the Thayer Museum of the University of Kansas; and the Phillips Collection, Howard University Gallery of Art, and the Graphics Division of the Smithsonian Institution, all in Washington.

———

James Lesesne Wells, born in Atlanta, Georgia, on November 2, 1902, was one of the five children of the Reverend Frederick W. and Hortensia Ruth Lesesne Wells. His father was a Baptist minister and his mother a teacher; later she became dean of women at Morris Brown University in Atlanta. His maternal grandfather, James McCune Lesesne, came from France by way of Martinique.

Wells's mother—"an artist of no mean ability," according to Wells—supplied him with crayons and watercolors at an early age and encouraged him to draw and paint. Helping to stencil the walls of a church annex led him to decide to become an artist. After his father's death, when his mother established a kindergarten, Wells became "her teaching assistant—at least, that's what she called me. I would go to the children, correct their drawings, and make suggestions about improving their work." Thus working at artistic expression and teaching became natural to Wells.

Wells prepared for college at the Baptist Academy, which became Florida Normal and Industrial Institute, in Jacksonville. In his first year, when thirteen years old, he won a first prize in painting and a second prize in woodworking at the Florida State Fair. On graduation, he lived with relatives in New York, intending to work that summer and then enter Lincoln University, near Philadelphia. However, financial problems forced him to continue working for two years, and during this time he studied drawing for one term under George Lawrence Nelson at the National Academy of Design. Wells remained at Lincoln, which then had no art program, only a year, transferring to Teachers College at Columbia University in New York. There he majored in art education, graduating in 1925. More than forty years later, he earned his master's degree there.

In 1923, on entering Columbia, Wells learned of an exhibition of African sculpture at the Brooklyn Museum of Art.[3] Staged by the museum's department of ethnology, this was one of the first shows of African art in New York.[4] Already a capable artist, Wells was so fascinated by it that he returned often, impressed by the "beauty of form," simplicity, and expressive character of these African carvings. This exposure significantly shaped much of Wells's later work.

Two teachers also influenced him. Millard Meiss, a Columbia art historian, introduced him to the work of Albrecht Dürer. Dürer's woodcuts particularly impressed Wells because at the time he was studying printmaking with Arthur Young. Young's discussions were often illustrated with examples of woodcuts by the German Expressionists—Ernst Kirchner, Karl Schmidt-Rottluff, Otto Müller, and Emile Nolde—as well as their Norwegian precursor, Edvard Munch.

These artists made woodcuts and lithographs one of their primary forms of expression, using brilliant, sometimes even harsh, color in unrealistic ways to heighten the expressive quality of their work.

Kirchner was frankly inspired by Dürer, so that Wells came to see the woodcut as a great classic but neglected art form. Moreover, Müller's lithographs often used African motifs, which Wells could instantly relate to the African sculpture he had seen. His studies also made him aware of the impact of African art on the development of Cubism. In addition, he was exposed to the violent, flat color of the Fauves—Henri Matisse, Georges Rouault, and André Derain—so disturbing to the realistic traditionalists. In these artists, Wells found many of the same qualities he admired in the German Expressionists.

Thus, almost from the start of his art education, Wells was carried past the traditionalist viewpoint into the related concepts of African sculpture, Cubism, and the expressionistic use of color. He was helped by his teachers to perceive prints as a major art form, not a secondary one. Although full integration of these influences into his work took some years, Wells was ahead of his time.

Immediately after graduating, Wells created block prints to illustrate articles in *Survey Graphic, Opportunity,* and other publications, including Willis Richardson's *Plays and Pageants of Negro Life.* He also had become acquainted with J. B. Neumann, whose New Art Circle gallery Wells often visited because it showed the prints of German Expressionists. Neumann took an interest in his work and included it in an exhibition of "International Modernists" in April 1929.

All of these activities attracted the attention of James V. Herring at Howard University, who invited Wells to join its art faculty that year. Wells taught clay modeling, ceramics, sculpture, metal and block printing. Initially, "I applied block printing primarily to the printing of textiles on unbleached muslin and cotton cloth," he said. This "practical" use of block printing satisfied those who felt anxious about teaching art to black students.

Wells continued to paint and in 1931 he won the Harmon gold medal and $400 with a small canvas, *The Flight into Egypt.* This expressionistic work had none of the realistic detail characteristic of most American painting at that time and none of the sentimentality that so often afflicts religious works. Even more unusual was its expressionistic use of color: "The Mother and Child rode a yellow donkey, led by Joseph, against a very simple landscape background of blue, green and blue," to quote Wells's own description. These unusual

Landscape and Figure, Senegal (1970), inspired by Wells's first visit to Africa, centers around the face of a Senegalese youth. Wells, who described himself as an "imagerist," had gone to Africa in 1969 to visit his photographer son, Jim Wells, who was there on an assignment from *Life.* He liked it so much that he stayed for months. (26 x 24″) Estate of James L. Wells

colors gave the painting a transcendent character that was far from the usual sentimental depiction of this biblical scene.

In other paintings in this period, such as *The Wanderers,* Wells employed the same simple composition and lack of detail, permitting bold shapes and colors, applied in thick impasto, to make his statement. James A. Porter, his colleague at Howard, felt that Wells achieved in these canvases "an effect of meditativeness and ecstatic revery, whether the works are religious paintings or landscapes."[5]

In the 1931 Harmon show Wells entered—besides *The Flight into Egypt*—five works based on African themes, bearing such titles as *African Fetish I, African Phantasy,* and *Mask Composition.* He was strongly supported in his use of African subjects by Alain Locke, whom he had first met in New York after publication of *The New Negro.* In Washington, Wells lived across the street from Locke so that their contacts were frequent.

Escape of the Spies from Canaan (1932) won the print award at the Harmon exhibition of 1933. Wells conveyed dramatic action in this white-line woodcut, which is difficult to achieve. He also gave new meaning to this biblical story by presenting its characters in modern dress. Estate of James L. Wells

Neumann, who had written a letter of recommendation to Herring to help Wells secure his teaching post at Howard,[6] continued to be influential. By exhibiting Wells's work, Neumann put him in the company of the most outstanding expressionistic artists of the period—Max Beckmann, Ernst Kirchner, and Otto Dix from Germany, and Max Weber, Marsden Hartley, and Arthur Dove in America. Two other important dealers, Curt Valentin, who occasionally exhibited African sculpture, and Andrew Weyhe, who encouraged black artists, also showed Wells's work.

In 1933 Wells, whose efforts now included woodcuts, linoleum blocks, etching, and lithography, won the Harmon exhibition's George E. Haynes prize for the best work in black and white with a woodcut, *Escape of the Spies from Canaan*. Carried out in evocative white lines, this print contained much action and mystery. To dramatize the biblical story, Wells presented the characters in modern dress.

Wells's repeated prize-winning introduced him to Mary Beattie Brady, director of the Harmon exhibitions, who impressed him with her dedication in trying to raise the status of black artists. "Her directness, and sometimes even bluntness, enhanced this dedication," in Wells's opinion.

By this time the Depression was radically altering social perspectives. Aided by a Carnegie grant, Brady and Ernestine Rose, director of the 135th Street branch of the New York Public Library, established a summer art workshop, with Wells as its director, in an old Harlem nightclub at 141st Street and Lexington Avenue. One of the first such workshops, it not only brought young people off the streets, but also offered them training. "Many of [these young people] became well known and a few, famous," Wells recalled, referring to Charles Alston and Jacob Lawrence. Palmer Hayden and Georgette Seabrooke, who studied painting at Cooper Union and sometimes exhibited in Harmon shows, were Wells's assistants. The forerunner of the Harlem Community Art Center, the workshop provided classes for children. There were also classes in printmaking, primarily linoleum cuts, textile design

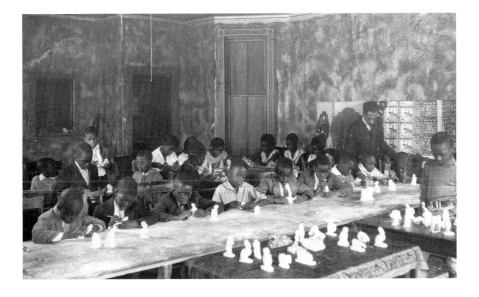

The first Harlem Art Workshop included a class in soap carving taught by Wells (standing at end of table), part of an after-school program for boys in Harlem early in the Depression. There were also classes for adults. His assistants were Palmer Hayden and Georgette Seabrooke. Photo: National Archives

using such cuts on fabrics, drawing, painting, and decorative screen painting. Wells directed this workshop for only two summers.

Directing the workshop brought Wells into close contact with most of New York's African-American artists and their ideas. One of the most prevalent ideas during the Depression was that art was separated from the great masses of the people by its cost, and that this could be remedied by lithographs, woodcuts, etchings, and other reproducible forms. The development of the fine-art serigraph by Works Progress Administration artists was a direct outgrowth of this belief. In addition, prints were seen as an economical way of communicating to African-Americans their history and shaping their political and social actions.

Thus, in 1933–34 Wells decided to devote himself to printmaking, refining his own techniques and giving it a special emphasis in his teaching. "Becoming aware of the social and economic conditions of the time and the awakening of the 'New Negro,' I felt that the graphic arts would lend itself readily to the projection of ideas about these issues," he later said. He resolved to attempt to express these ideas "without sacrificing good structure, form, and color."

Alain Locke had been closely following Wells's artistic and educational efforts. In 1935, in *Negro Art: Past and Present,* Locke wrote enthusiastically about Wells's "African series, of which *African Phantasy* and *Primitive Girl* are typical." He felt these paintings established Wells "as a force in the sane nonmelodramatic use of African motives and rhythms in design."[7] Citing Wells's Harmon prize for *The Flight into Egypt* and the purchase of *The Entry in Jerusalem* and *The Ox-Cart* by the Phillips Collection in Washington, Locke wrote that "his inclusion [in] one of the most authoritatively chosen collections of modernist art in the country ranks Wells as an ultra-modernist and a successful one. But while ultra-modern in composition and color scheme, many of his paintings have also an unusual mystical quality like *The Wanderers,* which reveals to some eyes a typical Negro note; which in his own words he attempts to express 'not in that sensational gusto so often typified as Negroid, but as that which possesses the quality of serenity, has sentiment without sentimentality, and rhythmic flow of lines and tones in pure and simple forms.' "[8]

Yet when Locke wrote this, Wells had already made the decision to put his talents into printmaking—a decision that must have been disappointing to Locke, even though it promised to reach large numbers of African-Americans with African-inspired art.

During this period Wells produced many high-quality prints that dealt with African-American history, industrial themes, and workers. Porter hailed Wells as the only black artist whose prints revealed the tonal range of the medium. "Wells prudently has adapted the lower registers of velvety gray tones to rend the smoky atmosphere of the steel mill and the power plant . . . achieving an interesting silhouette and compact massing to the benefit of the pattern," Porter wrote.[9]

To achieve still higher technical quality, Wells worked with Frank Nankivell, who was aiding B. F. Morrows on his definitive book *The Art of the Aquatint.* After World War II, he spent a sabbatical year working in Stanley Hayter's famous Atelier 17, then the most innovative center of etching and printmaking in the nation. Hayter, working from the theory of automatism, allowed his graver to cut freely into the plate while he used his other hand to shift the plate freely. From these unconsciously derived lines, the artist could work up areas of tones and reinforcing lines to evoke human or abstract shapes. Although Wells experimented with this approach, which freed him from old

The Destruction of Sodom (1958), a dramatic white-line wood engraving based on the biblical story, reflects Wells's deep religious feelings. A large portion of his work has been devoted to religious subjects, and it has won many prizes. Estate of James L. Wells

The Temptation of Eve (1965), a large, complex woodcut in which Eve's sensual face appears amid the vines and foliage of the Garden of Eden, greatly differs in its size and vigor from most wood engravings. (17 x 14″) National Museum of American Art

conceptual and attitudinal habits, he never adopted this method as his principal approach.

During the 1950s and 1960s, Wells continued to teach, and he won many prizes for his artwork. He received honorable mention at the Corcoran Gallery of Art's regional show in 1951, the George F. Muth engraving prize of the Washington Water Color Club in 1958, and its Muth purchase prize in 1959. He had a one-man exhibition of prints at the Smithsonian Institution in 1961 and won an honorable mention in New York at the Society of American Graphics in 1965. He also won many prizes in Washington exhibitions of religious art during this period.[10]

Washington was perhaps no longer the "artistic graveyard" it was in the 1930s, in the words of Jacob Kainen, who felt Wells had given up status in the art world by leaving New York. But Washington was still a segregated city, and Wells joined his brother-in-law, Eugene Davidson, president of the local NAACP chapter, in protesting the city's discriminatory customs in its lunch counters, its stores, and its nearly all-white

police department. The Wells and Davidson families were often harassed for their protests, and in 1957 a cross was burned in front of the home they shared.

This persecution undoubtedly contributed to Wells's religious themes and what Kainen described as "the spiritual intensity of his work." A well-known painter of the 1930s and curator of the Smithsonian graphic arts division, Kainen had followed Wells's work closely for several decades. He wrote:

> Wells is more than an artist with a deep concern for his fellow man. He carries many of his themes a step further into an apocalyptic world, a world of revelation and shifting lights. He is a knowledgeable painter deriving from the social scene art of the thirties, but also from certain aspects of Cubism and German Expressionism. . . . Instead of the neat illustrative technique and small format usually associated with wood engraving, Wells works on large blocks in a bold free style. He is not interested in the virtuoso production of tones and textures, but in rich contrasts of lights and darks. His work has a vigor, therefore, that is not often used in the medium today.[11]

In 1973, five years after Wells had retired from Howard, Fisk University mounted a one-man exhibition of his work. Its curator, Fred F. Bond, praised

Bus Stop, Ghana (1972) was inspired by Wells's visit to Africa in 1972. A large color linocut, it has an aesthetic character far removed from the banal depiction of people waiting for their bus. The brilliant rising sun of a new day amplifies the circular windows of the bus stop. (Linocut, 24 x 15¾″) Estate of James L. Wells

both to inspire and to provide technical guidance when young black artists emerged by the hundreds after World War II.

After retiring from Howard in 1968, Wells continued to paint and to make prints into his eighties. Color linoleum prints became his special forte. In *The Vamp,* as Richard Powell has pointed out, he "raised the ante on the Odalisque theme in modern art," empowering his figures "with a mystique and cutting edge rarely discernible in contemporary images of the female nude."[13]

In December 1986 the Washington Project for the Arts assembled a major exhibition of Wells's prints and selected oils, which moved to the Studio Museum in Harlem in the spring of 1988.[14] Powell, titling his essay "Phoenix Ascending," detailed the artist's life and his aesthetic evolution. Noting that Wells dealt in his mature years with such themes as seduction, violence, and blind ambition, Powell wrote that "it is precisely because Wells is introspective, intuitive, and comes from a spiritual vantage point that he can dig deeply into subjects and bring forth an abundance of socially relevant and highly critical art matter."[15]

Jacob Kainen pointed out that as Wells "has grown older, he has become wilder and more visionary. Certainly his late color linoleum prints are among the more memorable ones made recently in this country."[16] Michael Brenson concluded his *New York Times* review by praising Wells's work with these words: "This is an artist worth discovering."[17]

In 1990 this discovery was made by thousands at the Harmon exhibition, "Against the Odds," at the Newark Museum. They saw for the first time his prize-winning *Flight into Egypt,* a painting created sixty years ago, still modern and bright in its expressionistic colors and composition.

James Lesesne Wells died on January 20, 1993, at Howard University Hospital in Washington, D.C. In 1991 he had received the Living Legend Award at the National Black Arts Festival in Atlanta. Still active in 1992, he attended the memorial exhibition of James A. Porter's work at the Howard University Gallery of Art. In the field of printmaking he was a legend, both as an artist and as a teacher.

Wells's "ability to speak articulately of the spiritual aspects of the human condition from convictions of his personal vision."[12]

Wells has certainly been a pioneer in modern American printmaking—"I was one of the country's early printmakers, not black printmakers necessarily"—and he is a virtuoso in his field. Yet Wells is not an innovative artist in the sense of possessing a vision or style specifically and uniquely his own. Perhaps his own feeling about this aspect of his talent helped shape his decision to turn to printmaking. In any case he had the vision to see the importance of printmaking and devoted himself to achieving both a high technical level and an enhanced use and understanding of that medium. His work has always reflected with emotional vigor the experiences of African-Americans and his own early identification with African art as a source of inspiration. His great ability to teach a technical skill to students made him an important nurturer of many African-American artists. Wells had what was needed

Alma W. Thomas *Blue Asteroid* (1976). Although seemingly simple, this targetlike blue painting gains attention with the slight irregularities that occur in its centering dashes and its encircling rims. The viewer is drawn into it. (Acrylic on canvas, 36 x 36″) Hirshhorn Museum and Sculpture Garden, Washington, D.C.

POST–WORLD WAR II AFRICAN-AMERICAN ARTISTS

At the end of World War II the conditions confronting black artists initially appeared promising. Millions of Americans had become convinced that racial discrimination was wrong. Legislation against it was being considered. The payment of fifty dollars a month to all servicemen's families during the war, providing more cash to black families in the South than they had ever known before, had convinced many southern merchants that discrimination had kept the South poorer than it had to be. Moreover, with the formation of the United Nations and collapse of European colonial empires, new African nations were emerging, and this, too, contributed to a feeling of optimism.

The single most important factor immediately affecting the development of black artists was the GI Bill, which provided art school training, even training abroad. At established art schools, such as the Art Students League, black students were accepted in unprecedented numbers. Thus for black art students who had served in the armed forces there were opportunities for training that had not existed in the 1920s and 1930s.

In this atmosphere the disappearance of the Harlem Artists Guild aroused no concern. The morale of older black artists was lifted when the Albany Institute of History and Art in New York staged a large exhibition of their work; it received wide press attention, including a number of pages in *Life* magazine.[1] A few black artists were being exhibited in group shows and others, like Charles Alston and Robert S. Pious, were becoming successful illustrators. Many black artists now joined broad artists' organizations, such as Artists Equity, and left Harlem and other black neighborhoods. More black colleges opened up art departments, and the U.S. Supreme Court would soon rule segregation unconstitutional.

Yet discrimination and prejudice had not disappeared. Moreover, the cold war set the stage for Senator Joseph McCarthy to fabricate "Communist" accusations against many individuals and groups. "Guilt by association" made anyone connected with the Works Progress Administration art projects suspect. The Korean War, the Smith Act trials of Communist leaders, the Alger Hiss case, the Julius and Ethel Rosenberg case—all contributed to fearfulness about painting that reflected social consciousness. Even artists like Eldzier Cortor, whose painting concentrated on statuesque young black women, found themselves shunned by dealers and patrons.

Two other developments marked this period. One was the departure from the United States of a number of talented African-American artists, including Elizabeth Catlett. The second, rising in the wake of the galvanizing civil rights movement of the early 1960s, was the formation in New York of a small group called Spiral in the summer of 1963. These artists sought to identify and define African-American artists' relationship to their people's struggles and the possibility of aesthetic goals and styles that would distinguish their cultural uniqueness. Although short-lived, Spiral revived seminal questions that black artists first discussed in the 1920s and that continue to concern them.

Many artists have found it necessary to leave their native lands to escape attitudes that prevented their creative development, even though they risked losing their roots. James Joyce had to leave Ireland. Henry James sought refuge in England. Robert Frost went to England to gain recognition denied here.

Not so well recognized is that going abroad to gain the training and recognition denied by racial prejudice is a historical pattern among African-American artists. Such moves were critical for Robert S. Duncanson, Edmonia Lewis, and Henry Ossawa Tanner. In the 1920s Albert A. Smith supported himself as a jazz musician while studying and painting in France. Charles Hawthorne, convinced prejudice would prevent the

development of his student W. H. Johnson, raised money to finance his first year abroad; Johnson remained for twelve years.

A significant group of African-American artists have become permanent residents abroad. Elizabeth Catlett became a Mexican citizen, and others became citizens in Europe. No one knows exactly how many of these artists there are, but their absence represents a cultural loss to the United States. A few examples follow.

RONALD JOSEPH

Born in 1910 in Saint Kitts, in the British West Indies, Ronald Joseph was a child prodigy recognized by his teachers as a brilliant draftsman at age eleven years. In 1929, at age eighteen, he was considered the most promising artist in the New York schools, and he studied with H. E. Fritz.[2] The Metropolitan Museum of Art exhibited his work in a special show. Stimulated by Pablo Picasso and Juan Gris, as well as his studies with Vaclav Vytlacil, he became a pioneer abstractionist in the 1930s, when most American artists were Social Realists. Utilizing color planes, his work had a structural quality similar to the classic Cubism of Robert de la Fresnaye. It was exhibited in the historic 1939 show of black artists at the Baltimore Museum of Art.

After serving in World War II, Joseph studied in Peru, Paris, and Mexico. The rise of Abstract Expressionism gave him hope of recognition, but he followed objective concepts rather than the introspective feelings guiding its practitioners. His color values were restrained and balanced, while theirs were conflicting and violent. His work continued to be ignored. He pushed hand carts in the garment industry to survive.

Deeply angry, he borrowed money from the printmaker Robert Blackburn and went to Belgium, where he was successful.[3] In Brussels he has continued to paint. Few of his works have been seen in the United States since the 1950s.

In 1988 Ann Gibson, a Yale art historian specializing in American abstract art, located Joseph by phone from New York. She later met him in Brussels. A year later he came to the United States to participate in a panel discussion of "Black Printmakers and the WPA" with many old friends, including Blackburn.[4] He was first stunned, then delighted, to find himself remembered and applauded.

Interviewed, Joseph said he had settled in Brussels in 1956 and that his work had not changed:

> As a child I got swerved into Oriental art. I became passionate about the Japanese first, then afterwards I wondered why because I became fascinated with Chinese painting. So then I delved into the philosophy [of Chinese painting]. . . . You have to go behind the information, the poetry, and . . . sometimes the images [in my work] are so Chinese—it's all there. So I tried to work it out for myself in terms of elementals. I wanted to find out to what extent I could paint a painting from the inside—the inside of me. And I had to build up myself and my understanding of what has been said and what has been done. Now I can look at a representational painting and find an awful lot in it. Picasso is representational as far as I'm concerned. The more I delved into myself, the more I realized there was more to know. And I'm happy.[5]

In Belgium, as he refined his approach to Chinese painting and thinking about it, "I told myself I didn't want to be a fake Chinese painter . . . as a matter of fact, there are a lot of fake Chinese painters because it is one of the most refined arts that ever existed."

Although admitting he was influenced at one point by the French artist de la Fresnaye, he talked more about Gris, who "knocked me into a corner because of his logic and his interest in the form. There was a certain resemblance between his attitude and logic and—[to use] a phrase I got from Degas—the relationship between the form and expression."

Joseph has had few gallery shows in Brussels and felt his New York visit would help him move more consistently into exhibiting. He sold some drawings to pay for his trip. "I am very happy about that because now I can tell my wife" the trip was successful. He has been married for more than twenty years, and his son is a copilot on a European airline.

Being cut off, not only from America and the changes in the attitudes and status of African-Americans, but also by the type of painting he was doing, Joseph said, "I am afraid I became a somewhat totally introverted person for thinking and working. There was not enough relation to the outside." But his work had gradually begun to satisfy him; he felt that he was at last painting from "the inside." And "just when the whole became something rather direct and clear, I was called by Ann Gibson. I thought a miracle had happened, that that [call] was the meaning to my work. . . . I was very moved when I heard [her]. . . . It was just as if [there were] two forces, one that was directing me and the other putting me forward in the world."

Joseph returned to Brussels in 1989, promising to exhibit in the United States in the future. Unfortunately, he died suddenly in 1992.

LAWRENCE POTTER

Born in Mount Vernon, New York, on February 2, 1924, Hugh Lawrence Potter developed chronic asthma in childhood. Although he won the 1942 Art Institute of Minneapolis national competition and the 1943 *Scholastic* drawing competition, he did not enter Cooper Union until 1950.

Initially an Impressionist, then much influenced by the Cubists Georges Braque and Serge Poliakoff, Potter eventually became a Color Field painter. He went to Europe in the mid-1950s, exhibiting in Scandinavia and Paris, where he settled in 1959. He said he "didn't want to be boxed in" in the United States.[6]

Potter exhibited at the 1963 Salon de Mai, the Galeries du Puran Gernari in Paris, and the American Art Gallery in Copenhagen in 1965. He also participated in the Copenhagen exhibition "Ten Afro-American Artists Living and Working Abroad."

In Paris, Potter organized a protest march in support of the civil rights movement. Aesthetically, he tried to express with rhythmic color the character of the civil rights movement, which he saw as life itself—perhaps as a reflection of his own struggles to breathe. Although his works were carefully composed, his color was applied with spontaneity.

Potter died on January 11, 1966, from an asthma attack. More than twenty-five years later, in September 1991, New Yorkers had their first opportunity to see what he had achieved when the June Kelly Gallery brought from Paris a large selection of his work—abstractions, brilliant in color.

Expressing surprise at the contemporary look of work done by Potter roughly thirty years earlier, Walter Thompson described Potter's use of a floating plane of color "punctured by openings that permitted the space and color behind to come forward in controlled ways and act upon the surface of the plane," which "has the character of a veil or seems to be disintegrating. . . . The drama arises from the interaction of the background [or underlying] color with the color of the plane."[7] Thompson felt Potter had only needed more time to build and expand his concepts when he died at the age of forty.

WALTER WILLIAMS

Born in Brooklyn, New York, on August 11, 1920, Walter Williams did not begin to paint seriously until he was thirty years old. Before World War II he worked as a housepainter. The GI bill, however, enabled him to study at the Brooklyn Museum's school with Ben Shahn, Gregorio Prestopino, and the abstractionist Reuben Tam. A Greenwich Village dealer, Michael L. Freilich, included his work in RoKo Gallery exhibitions and gave him a one-man show in 1954.[8] A John Hay Whitney fellowship permitted him to go to Mexico in 1955, and he exhibited at the Mexican Northamerican Cultural Institute. After four years in Mexico he felt that freedom from racial prejudice was essential for his further development, so he went to Copenhagen.

Williams became widely recognized as an artist and printmaker in Europe in the 1960s and has had many successful shows in Copenhagen and elsewhere.[9] In 1964 he organized an exhibition in Copenhagen, "Ten Afro-American Artists Living and Working in Europe,"[10] which drew European attention to the number of black artists on that continent and the high quality of their work.

Prestopino greatly influenced Williams's approach to color and style, according to David Driskell, who arranged for Williams to spend some months at Fisk University as an artist-in-residence in 1968–69. Although Williams's work initially dealt realistically with cockfights and southern landscapes, in Denmark he has concentrated on imaginative memories of African-American life, evoking a romantic world in which black children reach for butterflies amid fields of flowers, often with a rusting high-wheeled hay-rake in the background. He does not portray the solemn black child seen in Jacob Lawrence's Harlem series, but an idyllic, innocent world that appears derived from Robert Louis Stevenson's *A Child's Garden of Verses*. Yet "his prints echo more than . . . childhood memories," wrote Driskell after visiting Williams in Copenhagen in 1967. "They also depict a dream world where the mind is at peace with nature and self."[11]

In recent years Williams, who became a Danish citizen in 1979, has not been in good health. In 1982 the Studio Museum in Harlem presented Williams's work as one of "Four Black Artists Living and Working Abroad."[12] His prints have been widely exhibited in American universities and colleges, and his work is in many museums, including the Metropolitan Museum of Art and the Brooklyn Museum in New York, the Walker Art Center in Minneapolis, and the National Museum of American Art in Washington.[13] He has also won various awards, most notably the 1972 Obrig prize of the National Academy of Design for a dark southern landscape with a pinkish sky.

HERBERT GENTRY

Herbert Gentry was born in Pittsburgh on July 17, 1919.[14] His parents separated, and his mother, a dancer,

brought him up in New York. At an early age he illustrated a children's book, *The Simba Lion* by George Lipscoll.

Wounded in France during World War II, he returned to Paris on the GI bill to study at the Ecole des Hautes Etudes and Le Grande Chaumière under Yves Brailler. For some time he also ran a Paris jazz nightclub that was an art gallery by day. He also produced USO-type shows for American troops abroad. During this time Gentry exhibited in the 1951 Paris Salon d'Automne and 1952 Salon de Mai. Finally, near nervous collapse, he went to Denmark to be near Danish painters he admired.

Increasingly Gentry was influenced by the expressionistic Cobra movement developed by Karel Appel, Asger Jorn, and Pierre Alechinsky in Belgium and Holland. In 1957, Gentry gave up figurative painting to create, from unconscious memories, canvases filled with multiple, masklike figures with great staring eyes.

In 1960 Gentry settled in Stockholm but he has frequently returned to the United States. In 1976 he was given a one-man show at the Swedish Royal Academy of Art. His work is in the Stedelijk Museum in Amsterdam, the Swedish National Museum and Moderna Museum in Stockholm, the Vikingsborg Konstmuseum in Helsingborg, and the Kresten Krestensen Collection and Royal Museum of Fine Arts in Copenhagen. He has had one-man shows in many European cities, New York, and Pittsburgh.

THE DEVELOPMENT OF SPIRAL

Informal talks among a small group of black artists led to a meeting at Romare Bearden's studio on July 5, 1963, "for the purpose of discussing the commitment of the Negro artist in the present struggle for civil liberties, and as a discussion group to consider common aesthetic problems," according to Bearden's minutelike notes.[15] The meeting preceded the August 28 March on Washington led by the Reverend Martin Luther King, Jr. In addition to Bearden, the meeting was attended by Hale Woodruff of the 1920s; Charles Alston, Norman Lewis, and James Yeargans of the 1930s; and three younger, then little-known artists: Felrath Hines, Richard Mayhew, and William Pritchard, a sculptor.[16] Soon they were joined by Merton Simpson and younger artists: Emma Amos, Reginald Gammon, and Alvin Hollingsworth. In time Calvin Douglas, Perry Ferguson, William Majors, and Earle Miller also joined. As artists, they ranged from Abstract Expressionists to social protest painters.

While direct support of the "freedom riders" in the South was one goal, from the start Norman Lewis emphasized the need to define and discuss aesthetic and philosophical problems unique to African-American artists—not "some illustrative statement that merely mirrored some present social conditions." Others agreed that they did not want "some gimmick that would pander to an interest in things Negroid," in Woodruff's words. Yeargans called for exploration of the cultural past to aid in the development of a distinct identity.

The older artists particularly recognized that the fundamental issue was the question of their identity as black artists in a white society—an issue that had emerged in the Harlem Renaissance of the 1920s and been restated in the Harlem Artists Guild's discussions in the 1930s. There were many aspects to this issue. For example, should an artist's work attempt to express directly the issues in the civil rights struggle in the tradition of social protest painting? Or might artistic achievement in itself enhance the status of black people? The history of the Impressionists, Fauves, and other art movements was reviewed anecdotally. There were also questions of standards, of a recognizable, identifying unity of expression, and of freedom of expression. For some artists, these questions amounted to introspective examinations because of their intense identification with those risking their lives in the South (see Mayhew chapter, pages 474–75).

Alston cited Pablo Picasso's *Guernica* as an example of what might be done. Pritchard pointed out that Picasso had dealt with "things of universal significance," making more than just a painting dedicated to a local incident. At the same time Lewis, the personal friend of many leading Abstract Expressionists, often expressed the hope that the group would seek to develop an aesthetic viewpoint at the highest level so that other American artists would regard them as leaders.

Suggesting that Western society was gravely ill, Bearden asserted that the way African-Americans were treated was part of this illness. Critical praise for "absurdity" and "anti-art" themes was, he held, evidence of its ill health. He felt that "either the Negro, through such figures as Dr. King, will give this country a transfusion it badly needs, or the Negro must reject the values of this society completely."

Early meetings were held twice monthly, sometimes at Studio 35, the Greenwich Village birthplace of Abstract Expressionism. Woodruff proposed the name "Spiral" for the group, suggesting Archimedes' spiral, ascending upward in ever broader circles, as its symbol of progress. It was a reflection, in those days of rage and riot, of his optimism, derived from his experiences in easing color barriers in Atlanta in the past.

Woodruff also suggested that the group be interracial, and this was initially agreed upon. However,

Charles White uses his original sketch to correct colors in a preliminary version of a 1939 mural, *Five Great Americans, or Progress of the American Negro,* painted while he was on the Illinois WPA Art Project. It was exhibited at the Library of Congress in 1940–41. (5 x 12′9″) Howard University Gallery of Art

making the group interracial at this point raised such unresolved questions about the purpose and identity of the group that its practice was deferred until some unity about the members' common cultural experiences and viewpoints as black artists could be established. In fact, because the group could not determine many aspects of its purpose and philosophy, the membership was frozen.

To bring the group together, Bearden and Pritchard were assigned the task of preparing a "credo" that would deal with the following questions: What should the role of the black artist in the mainstream of art be? Do black artists have something culturally unique to offer? If so, what is it? What does the black artist intend to say? What is the value of an artist who is conjointly an American and black? What can his or her significance be?

However, Bearden and Pritchard's draft was not deemed acceptable and was tabled, pending clarification of various issues. Trying to clarify the role of the African-American artist, in response to questions raised by others, Bearden contended that Western culture was in transition, that the tradition of materialism was ending—a tradition that, in favoring the objectivity of science, had lost sight of certain moral aspects in human relations. After all, he said, "science had devised a power to incinerate the world, and the men who control this power could, at best, be termed politicians. . . . It is the right of everyone now to reexamine history to see if Western culture offers the only solutions to man's purpose on earth." Noting that the fascists claimed many an intellectual in the 1930s, he asserted that "the Negro represents a clear force directed towards the best traditions of a democratic society. As Negro artists, we must determine what we want from American society."

By mid-October 1963 a storefront meeting place was established at 147 Christopher Street in the Village. The members had repainted and rewired the space to serve as a gallery. Each member contributed fifty dollars and was assessed ten dollars a month for rent and other expenses. By November Lewis, who insisted each artist had the right to freedom of expression, had been elected chairman of the group, and Bearden secretary-treasurer.

Many Spiral artists did not know one another's work. Whether individual artists should bring work to meetings for criticism raised new questions and created bitter dissension when it was done. How African-Americans should be portrayed and how each artist might establish a personal image were discussed heatedly. Hines pointed out that there were Jewish painters, like Marc Chagall, who painted Jewish subjects, while others did not. At an earlier meeting Hollingsworth had underlined the problems in creating an identifying style by remarking that even exponents of Pop Art painted in diverse ways. Lewis had insisted that the black artist should face his problems solely as an artist seeking universal truths, and he asserted that the slashing black figures on white of Franz Kline and the wholly black abstract convases of Ad Reinhardt, both white artists, "might represent something more Negroid than work done by black painters."

In an interview before his death, Alston reiterated some related views, which he had expressed at Spiral meetings.[17] He feared any attempt to set up separate standards for African-American artists, indicating: "I don't think there are black art standards. The greatest expression of black art is certainly African art, and it will hold up under any universal standards of quality. I think this is the criterion. Having a separate set of rules and qualities for black art doesn't make any sense. It has to have the aesthetic quality that any art— Chinese, African, Italian, German—has. They all have to meet certain standards of aesthetic excellence."

However, he continued, if "black consciousness or black affirmation" develops, "it may ultimately become a significant art form, but I haven't seen it yet and it certainly isn't possible out of the painters of my generation." While "Negro music comes out of a 'grass-roots' situation—very earthy, direct experi-

Richard Mayhew

Charles Alston

Norman Lewis

Nanette and Romare Bearden

Guests

Guests

Hale Woodruff

Reginald Gammon, Edward Harper

Vivian Brown

Bill Majors

The opening of the Spiral exhibition in New York on May 14, 1964, was photographed by James Rudin of the Yellow Poui Gallery in Grenada. Identifications were made by Reginald Gammon, a Spiral artist.

ences," he said, "what happens to the black artist of my generation or before? A kid who wants to be an artist is thrown immediately into the middle of Western art—the Renaissance, Greece, and so forth. It isn't something that comes out of the black folk experience."

When Alston expressed similar views at Spiral meetings, some members agreed. Those disagreeing agreed with some of his remarks, but argued that a style or method is a means to an end, not the end in itself. They felt the unique experiences of African-Americans might form the basis of a distinct identifying style, citing the Impressionist and Post-Impressionist movements as examples of styles that developed within the framework of Western art and yet were distinct in their values. The means of the Renaissance sculptor or a Dogon master were disparate, but both expressed their special vision of the world. Therefore African-American artists who develop from their own experiences and culture some unique way of envisioning life about them may create an identifying art of value and meaning, one that is uniquely theirs. This is not simply painting black subjects, but a way or manner of visualizing and painting, and not necessarily limited to black subject matter.

Some pointed out that Henry Ossawa Tanner, after long years of training in French academic methods, ultimately found his own way of expressing the profound religious vision that originated in his Methodist upbringing and that had nourished him all his life. However, this was a personal style, unique to him, not a movement that could be followed by others because they lacked the experiences of Tanner that made his vision meaningful in his time, that set his work apart

and emotionally carried it beyond the illustration of a biblical story.

When these questions could not be resolved immediately, the Spiral members agreed to hold an exhibition with each member contributing work done only in black and white in a symbolic recognition of the civil rights struggle. The proceeds were to go to civil rights groups. As a means of providing a certain aesthetic unity, Bearden proposed that the group make black-and-white collages, especially since newspaper and magazine photos offered a great resource to work with. However, except for Gammon and Mayhew, no one else thought this was worthwhile. In the end only Bearden, who had been working in an abstract manner, pursued it, creating his collage style.

The exhibition was held from May 14 to June 4, 1964.[18] After that, attendance at meetings dropped off. The landlord, having seen that the exhibition was well attended, raised the rent. Attendance dropped off further when differences in education, aesthetic goals, and views of competence could not be overcome. Moreover, individual artists had psychological and emotional expectations from the group that could not be met. Mayhew, who often served as a bridge between the views of the older artists and the younger ones, felt that Spiral should have a feeling of "family" but that this was missing. The younger artists did not know one another's work, and their feelings were hurt by critical comments from older artists. Mayhew felt most members were "invisible." The camaraderie Mayhew sought, Woodruff said, could only be developed through long association.

Sometime in the fall of 1965, Spiral meetings had virtually come to an end, although the publication of

402

Jeanne Siegel's article in *Art News* in May 1966 briefly stimulated interest.[19] Essentially Spiral belonged to the past by that time. While it was clear that Spiral, as a forum, forced recognition of aesthetic aspirations and problems related to African-American artists' identity, its discussions did not yield answers that would satisfy a very diverse group of black artists, each of whom brought to the group varying aesthetic beliefs and conditioning as well as emotional needs and expectations.

Mayhew, in conversations with Reginald Gammon in recent years and later in an interview, has insisted that Spiral never ended, but has simply taken another form, that it is alive and kicking in discussions among African-American artists all over the country. Mayhew cited Woodruff's use of the Archimedes spiral as a symbol:

> That's what has happened—like the spiral, it continues to extend, to engulf and encompass more and more black artists. As a result many groups of artists have come together, and now Spiral has become a kind of unusual mystique among them, a symbol of unification and aesthetic values.
>
> And many young African-American artists consider those in the original group who are now deceased like masters. And it's true, the people who were in the original Spiral group have excelled. Emma Amos has done excellent work and is really a strong artist. So is Reginald Gammon, who has continued to function. And Felrath Hines in Washington has done well as an artist. And I really feel Spiral contributed to my longevity as an artist, to my own development of aesthetic concepts as well as of my integrity.
>
> I would say that, in fact, what has developed has been even more productive than what the original formal group achieved. From a long-term viewpoint, Spiral was a very positive development for African-American artists. All those little negatives and minor things, the nitpicking, have just gone out the window because of the valid contribution that Spiral made. That contribution has helped to sustain many African-American artists.
>
> I have continued to be involved in that kind of extended concept—that of people, of African-American artists, coming together to discuss and to resolve questions. As a result I do lectures on Spiral. I take slides around and address the basic Spiral concept, which is concerned with supporting one another.[20]

Certainly there is widespread discussion among African-American artists about their aesthetic values and their relationship with their people. One example of this would be Samella S. Lewis, an artist and art historian, who advocates a strong relationship between African-American artists and their communities. She has insisted that "a primary obligation of Black artists is to understand and use, whenever possible, remembrances of the African cultural heritage."[21] Secondarily, they should use the power of art to inform and educate.

She also describes—or prescribes—certain requirements that African-American artists should conform to in order to meet their obligations to the African-American community. For example, their art should be functional, that is, "make sense to the audience for which it was created." It should also be "highly symbolic," employing "symbols common to black lives." Next it should "reflect a continuum of aesthetic principles derived from Africa, maintained during slavery, and emergent today." Lastly, the art should be relatively inexpensive and "enrich the physical appearance of the community."[22]

Samella Lewis's programmatic approach, while it differs sharply from some of the aesthetic concerns voiced at Spiral meetings, demonstrates the kind of solutions being offered in the search for an identifying style. In some ways it structurally resembles the requirements of Edward Bruce in the Public Works of Art Project, the original government art project, that its artists paint "American" subjects—no abstractions, no nudes, no distress. A significant difference is that Lewis's program is directed to an African-American audience rather than the American public as a whole.

At the time Spiral met the civil rights drive was nearing its peak. African-Americans were then rarely seen on television or in movies except as servants. While certain cultural conditions of that time no longer exist, the racial polarization of the cities has steadily worsened, as the Civil Rights Commission predicted it would. Whether an organization like Spiral can be developed to define and establish a unique aesthetic style reflecting African-American experience remains an unanswered question. Yet the emotional need also remains, recognized among African-American artists all over the country.

However, it should be understood that the question of identity is not peculiar to African-American artists. It is, Ralph Ellison has said, *the* American theme because America is a multicultural country.[23]

What the history of African-American artists demonstrates is their humanity and their need for self-expression, their heroic struggles despite prejudice and poverty to participate in the development of American art. Just as the changes of the last fifty years were unthinkable fifty years ago, the changes of the next fifty years are now unthinkable. But the presence of large numbers of maturing African-American artists may become a significant creative factor in the art of America in the twenty-first century.

Two Brothers Have I Had on Earth . . . (1965), one of White's most unusual works, suggests some impending action by two very different men. They are sheltered by a kind of tarpaulin against the storms of their environment. Although the painting is a clear statement of the interdependence of African-Americans, the source of the quotation is obscure. (Charcoal on board, 48 x 60″) Collection former Premier Sekou Touré of Guinea

CHARLES WHITE

The work of Charles White, one of America's best-known African-American artists, was largely limited to graphics, often on a scale considerably larger than that usually used in drawing. White believed that working primarily in black and white or sepia and white, which required an extraordinary and perfectionistic skill in draftsmanship, would sharpen the impact of his work and, through economical reproduction, make it available to millions. And he indeed reached millions. As James A. Porter observed, White was "one of the great voices among black Americans who . . . [were] among the real interpreters of the American Negro."[1] His meticulously rendered drawings and paintings, affirming the humanity and beauty of black people, moved many who had never previously recognized the aesthetic qualities of black figures and faces. In portraying black Americans, often in bitter circumstances, White sought to make a universal statement about the heroic efforts of humankind to be free of oppression. This ennobling vision distinguished White as an artist.

Although White won many national awards, he was ignored by leading critics during the reign of Abstract Expressionism because of his single-minded traditional style and focus on black working people. In that period he got more attention abroad than at home. However, during the civil rights struggles White's moving portraits of black men and women against a background of old runaway slave WANTED posters effectively expressed the feelings of millions.

One of the finest draftsmen in contemporary America, White was elected a full member of the National Academy of Design in 1972, the second African-American artist to be so recognized since the 1927 election of Henry Ossawa Tanner. With its passion and scrupulous style, the appeal of his work crossed all racial lines. When, in 1976, the High Museum in Atlanta presented a major exhibition entitled "The Work of Charles White," it was subtitled: "An American Experience."

A spirited but frail man whose output was limited by severe respiratory insufficiency, White died on October 3, 1979, at the age of sixty-one. Peter Clothier, dean of the Otis Art Institute in Los Angeles, where White taught for many years, pointed out that White's "vision necessarily transcended self and addressed the needs, the history, the conditions of life and aspirations of an entire people. To White, art was not an individual expression so much as a social imperative."[2]

One of the most distinctive and unusual aspects of White's work is his unswerving focus on social themes and humanistic values for about forty years. His work belongs to that spectrum of graphic commentary on social issues associated with Francisco Goya, Honoré Daumier, and Jean-Louis Forain. While some WPA artists, such as Franz Kline, Willem de Kooning, and Jackson Pollock, became famous innovators, White must be recognized as one of the few artists who kept the tradition of social themes alive in American art despite the enormous shifts in art—the rise and fall of many movements—since the 1930s.

Had White attempted "the 'high art' of his generation," to use Clothier's phrase,[3] he might have become simply another Abstract Expressionist. White was not an innovator, but he persevered. That he knew his strength as a draftsman and that he maintained his focus were what set him apart. He had a clear vision of what he was doing and why, which he stated to Willard Motley in 1940 with clarity and forcefulness.

Others might consider this a limitation, and White was aware of this, often asserting that he painted only one picture "in terms of my philosophy."[4] Indeed, he rejoiced in his "one picture." In persevering, he created images that crossed generational lines to evoke memories and hopes that fused the past and present. What changed over the years were his increasing technical skill, his mounting eloquence, and his greater freedom in expressing those "fragments of what is the total me," as he put it.[5]

405

Young Charles was born in Chicago on April 2, 1918.[7] His unmarried parents did not get along and separated when Charles was about three years old. His mother later married Clifton Marsh. However, Marsh, a laborer and later a post office worker, could find only menial jobs, and his continued frustration drove him into chronic alcoholism. Finally Charles's mother, the family's breadwinner, left Marsh.

White discovered at an early age that he could draw. When he was seven years old, his mother bought him an oil paint set—which he did not know how to use. Coming home from the Burke Elementary School one day, he found students from the Art Institute painting in a nearby park. Observing his fascination, a student explained how to mix paint and turpentine and stretch canvas, and mentioned that the class would be working there for a week. Each day when school closed young Charles raced there with his oil set. Using a window blind as his canvas, he painted a landscape. Although initially angered by his destruction of the blind, his mother treasured this painting until her death in 1977.

About this time his mother, conscious of her own lack of opportunities in music, decided her son must play the violin. By extra work and scrimping, she purchased an instrument and paid for lessons for nearly ten years. Although White gave up playing, this experience left him with an abiding interest in music.

In school White's drawings won a competition, permitting him to attend a Saturday "honors" class at the Art Institute taught by Dudley Craft Wilson, a critic and educator, and George Bueher, a talented painter, who demonstrated Wilson's comments. Charles Sebree and Margaret Goss Burroughs, who were also to make careers in art, attended this class.[8]

While his mother worked or shopped, White was often left in the library, where he read for information and entertainment, particularly biographies, classics, and novels by Jack London and Rafael Sabatini. He also found Alain Locke's anthology, *The New Negro,* which "opened new vistas for me. I never knew before that there were black artists or poets or writers. I was about thirteen years old and it was just before I got into high

White's understanding of black people, as expressed in his art, stemmed from his study of their history and deep identification with their struggles. One of his grandfathers had been a slave in Yazoo County, Mississippi, where his mother, Ethel Gary, began her life-long work as a domestic when she was eight years old.[6] As a girl she yearned to become a music teacher, but in pre–World War I Mississippi she never got the chance. At age sixteen, she was sent to Chicago to live with her mother's sister, who had left Mississippi earlier—it was through such networks of relatives that the great migration of black people was carried out.

In Chicago she met Charles White, Sr., a dining car waiter and construction worker of Creek descent.

school. It was the most influential book of them all in my development." For the first time he could perceive the contributions of black people to American culture—and an African heritage that was considered positive.

Stimulated by Locke's book, he became active in the high school drama club, designing sets for plays. He sought books on African art and asked questions about black participation in American history, about black writers and artists. He soon discovered that neither his textbooks nor teachers could tell him much about black soldiers or the origins of Br'er Rabbit. Resenting teachers who tried to squelch his questions, White, previously an outstanding student, became a persistent teenage truant.

When about fourteen or fifteen years old, White started earning money by lettering signs and, through this work, discovered other black artists at the Regal Theatre's large sign shop. There he met George E. Neal, a young black artist who, while supporting himself by lettering and illustrating small black publications, had attended the school of the Art Institute for two years. Neal had developed a pastel portrait style that emphasized the coiffures of beautiful young women, creating a steady demand for his work from beauty parlors.

Because of his formal training, Neal was hired to conduct children's art classes at the South Side Settlement House, and he included White in the class. The young black artists formed the Arts and Crafts Guild, electing Neal as president. He also "undertook to teach us," White said. "He was a particularly inspiring teacher. We used to have classes in his home. Eldzier Cortor, Charles Sebree, and Frank Neal, who wasn't related to him, as well as me, were all influenced by George." Others included Fred Hollingsworth Yassien, Bernard Goss, Margaret Goss Burroughs, and Earl Walker. "He got us out of the studio and into the street," White said. "He made us conscious of the beauty of those beat-up old shacks. He also taught us the craft aspects of painting technique, but the main thing was that he opened up areas that we had never considered. He made us conscious of the beauty of black people. He got us away from the old-time movie magazines that some of us, wanting to do illustrations, copied and were influenced by. George really turned us in the direction of life around us."(Neal's work was destroyed in a studio fire, and he died soon after that.)

The period during his studies with Neal was a troubled one. To escape his anguish over his conflicts with teachers and the angry scenes at home caused by Marsh's drinking, White often went to galleries and the Art Institute. When he was sixteen years old, a friend took him to a party at the studio of Katherine Dunham, who was then a graduate student in anthropology at the University of Chicago and beginning her dance career. There he met the poets Gwendolyn Brooks and Margaret Walker, later famous as the author of *Jubilee;* Archibald Motley, Jr.'s novelist nephew, Willard; the sociologist Horace Cayton; Richard Wright; and many other black writers, intellectuals, actors, and musicians. Through them he was exposed to new ideas in poetry, theater, politics, and black history. He even acted in a play directed by Theodore Ward, whose *Our Land* was produced on Broadway by Edward Dowling.

These new acquaintances, White felt, were the living embodiment of Locke's *New Negro.* Their conversation resembled those held at 306, Charles Alston's and Henry Bannarn's apartment in New York. Years later, when "being black" preoccupied many young African-American artists, White credited this group with "giving me my cultural orientation, my black orientation. We never thought about being black. It just was. Everybody was black. No discussion about it."[9]

Although White had conflicts with some of his teachers, his art teachers were aware of his talent, and went out of their way to keep him in school, encouraging him to enter scholarship competitions at two local art schools, the Chicago Academy of Fine Arts and the Frederick Mizen Academy of Art. But when he won, he was rejected because he was black; both schools asserted that notification of his winning had been an error. Later in one school's catalog he found the phrase: "For Caucasians Only."

His determination to become an artist alarmed his mother, who feared he would not be able to support himself. "I had to fight with her over being an artist," White recalled. "The only outside encouragement came from the high school art teachers. That I came in contact with black artists when I was about fourteen—the stimulus of finding others who shared common goals—that gave me stamina."[10]

His mother and art teachers did convince White that he needed a high school diploma, so he spent another year making up missed work. Encouraged by an art teacher, Elsa W. Schmidt, he won a national pencil sketch competition in 1937; the *National High School Weekly* bought his prize-winning sketch for five dollars. That May he also won, to his joy, a year's scholarship to the Art Institute, which meant that for the first time he would be directly receiving professional instruction.

Yet maintaining himself was difficult—he often walked sixty blocks to save carfare. With telephone calls to his mother for instructions, he managed to keep a job as "cook and valet." He later squeezed in a part-time job teaching drawing at St. Elizabeth's Catholic

High School. Despite these jobs, White determinedly completed the Art Institute's two-year course in one year.

His Art Institute training qualified White for WPA employment as an artist. His family had long met the other requirement: being on relief.

On the WPA White learned that the art he was most interested in—mural painting aimed at overcoming racial prejudice and ignorance—was considered political and could be destroyed politically. Throughout the WPA, the influence of Thomas Hart Benton, then the nation's best-known muralist, prevailed. In Chicago this WPA style was considered a kind of midwestern movement. Among its leaders were the socially conscious artists Mitchell Siporin, Edward Millman, Aaron Bohrod, David Fredenthal, and Joe Jones. Benton denounced modern art as "foreign" and saw the Depression as a battle between a "new, effective liberalism" and "the entrenched moneyed groups."[11]

Even before he got on the WPA, White had met Siporin and Millman. They had invited him, a teenager, to their studios to watch them work and to bring his own paintings for criticism and advice. They were, like White, interested in portraying American life and history and gave him serious attention—which he was not used to. They also introduced White to the ideas of the Mexican muralists, who used historical subjects to educate their illiterate and impoverished people on social issues. These concepts greatly excited White, as they did many artists at the time.

White found Millman and Siporin, leaders in what is now called the bland, "democratic" WPA style, to be excellent teachers. He was closest to Siporin, whose style was heavy and sculptural, as was White's early work. WPA-style painting had a "wholesome," photographic, and dispassionate character that lacked the vigor of deeply felt art. Yet, as White saw, Siporin and Millman were violently attacked by conservatives. The *Chicago Tribune's* campaign against "communistic" artists so terrified one school board that it plastered over Millman's panels on *Women's Contributions to American Progress*. When Millman, Siporin, and another Chicago Regionalist, Edgar Britton, won national mural competitions, the *Tribune* considered it part of "the great conspiracy."[12]

These controversies helped give White in his formative years a political understanding of the uses of art and prepared him for his own long effort to alter, especially among black Americans, what is now called "the black image." He knew that he wanted, above all, to reach his people with paintings that would give them confidence and pride in themselves. Abstract painting could not do that, and he rejected it, turning to the traditional in the belief that this style would best express his views. White also learned, during this period, much about African-American history as well as Marxist concepts of art as a political instrument. He defined his own views and role in these terms:

I feel a definite tie-up between all that has happened to the Negro in the past and the whole thinking and acting of the Negro now. Because the white man does not know the history of the Negro, he misunderstands him.

I am interested in the total, even propaganda, angle of painting, but I feel the job of everyone in the creative field is to picture the whole scene. The old masters pioneered in the technical field. I am interested in creating a style that is much more powerful, that will take in the technical and, at the same time, say what I have to say. Painting is the only weapon I have with which to fight what I resent. If I could write, I would write about it. If I could talk, I would talk about it. Since I paint, I must paint about it.[13]

White was only twenty-two years old in 1940 when he made these statements to Willard Motley. His statements project with remarkable accuracy his course as an artist, his development of excellent technical skill, his concern with African-American history, his desire to create a maximum impact on a maximum number of people, and his perception of himself as a fighter for black people—not a detached, aesthetic prober. Such a projection presumes conflict and White's life was marked with severe trials—physical, aesthetic, and political.

One of his WPA murals dramatized the efforts of five African-American leaders—Sojourner Truth, Frederick Douglass, George Washington Carver, Booker T. Washington, and Marian Anderson. Another mural, for the Chicago Public Library, was also completed but has disappeared. His depiction of black leaders prompted the Associated Negro Press to commission a mural on its achievements for the 1940 American Negro Exposition in Chicago. His drawing *There Were No Crops This Year* won the exposition's first prize.

While on the WPA project, White met the talented sculptor Elizabeth Catlett, who was then teaching at Dillard University in New Orleans. They married in 1941. Catlett was appointed head of the art department at Dillard, then a new black college built with WPA funds. On Alain Locke's recommendation, White received a $2,000 Rosenwald Foundation fellowship.

school. It was the most influential book of them all in my development." For the first time he could perceive the contributions of black people to American culture—and an African heritage that was considered positive.

Stimulated by Locke's book, he became active in the high school drama club, designing sets for plays. He sought books on African art and asked questions about black participation in American history, about black writers and artists. He soon discovered that neither his textbooks nor teachers could tell him much about black soldiers or the origins of Br'er Rabbit. Resenting teachers who tried to squelch his questions, White, previously an outstanding student, became a persistent teenage truant.

When about fourteen or fifteen years old, White started earning money by lettering signs and, through this work, discovered other black artists at the Regal Theatre's large sign shop. There he met George E. Neal, a young black artist who, while supporting himself by lettering and illustrating small black publications, had attended the school of the Art Institute for two years. Neal had developed a pastel portrait style that emphasized the coiffures of beautiful young women, creating a steady demand for his work from beauty parlors.

Because of his formal training, Neal was hired to conduct children's art classes at the South Side Settlement House, and he included White in the class. The young black artists formed the Arts and Crafts Guild, electing Neal as president. He also "undertook to teach us," White said. "He was a particularly inspiring teacher. We used to have classes in his home. Eldzier Cortor, Charles Sebree, and Frank Neal, who wasn't related to him, as well as me, were all influenced by George." Others included Fred Hollingsworth Yassien, Bernard Goss, Margaret Goss Burroughs, and Earl Walker. "He got us out of the studio and into the street," White said. "He made us conscious of the beauty of those beat-up old shacks. He also taught us the craft aspects of painting technique, but the main thing was that he opened up areas that we had never considered. He made us conscious of the beauty of black people. He got us away from the old-time movie magazines that some of us, wanting to do illustrations, copied and were influenced by. George really turned us in the direction of life around us."(Neal's work was destroyed in a studio fire, and he died soon after that.)

The period during his studies with Neal was a troubled one. To escape his anguish over his conflicts with teachers and the angry scenes at home caused by Marsh's drinking, White often went to galleries and the Art Institute. When he was sixteen years old, a friend took him to a party at the studio of Katherine Dunham, who was then a graduate student in anthropology at the University of Chicago and beginning her dance career. There he met the poets Gwendolyn Brooks and Margaret Walker, later famous as the author of *Jubilee;* Archibald Motley, Jr.'s novelist nephew, Willard; the sociologist Horace Cayton; Richard Wright; and many other black writers, intellectuals, actors, and musicians. Through them he was exposed to new ideas in poetry, theater, politics, and black history. He even acted in a play directed by Theodore Ward, whose *Our Land* was produced on Broadway by Edward Dowling.

These new acquaintances, White felt, were the living embodiment of Locke's *New Negro.* Their conversation resembled those held at 306, Charles Alston's and Henry Bannarn's apartment in New York. Years later, when "being black" preoccupied many young African-American artists, White credited this group with "giving me my cultural orientation, my black orientation. We never thought about being black. It just was. Everybody was black. No discussion about it."[9]

Although White had conflicts with some of his teachers, his art teachers were aware of his talent, and went out of their way to keep him in school, encouraging him to enter scholarship competitions at two local art schools, the Chicago Academy of Fine Arts and the Frederick Mizen Academy of Art. But when he won, he was rejected because he was black; both schools asserted that notification of his winning had been an error. Later in one school's catalog he found the phrase: "For Caucasians Only."

His determination to become an artist alarmed his mother, who feared he would not be able to support himself. "I had to fight with her over being an artist," White recalled. "The only outside encouragement came from the high school art teachers. That I came in contact with black artists when I was about fourteen—the stimulus of finding others who shared common goals—that gave me stamina."[10]

His mother and art teachers did convince White that he needed a high school diploma, so he spent another year making up missed work. Encouraged by an art teacher, Elsa W. Schmidt, he won a national pencil sketch competition in 1937; the *National High School Weekly* bought his prize-winning sketch for five dollars. That May he also won, to his joy, a year's scholarship to the Art Institute, which meant that for the first time he would be directly receiving professional instruction.

Yet maintaining himself was difficult—he often walked sixty blocks to save carfare. With telephone calls to his mother for instructions, he managed to keep a job as "cook and valet." He later squeezed in a part-time job teaching drawing at St. Elizabeth's Catholic

High School. Despite these jobs, White determinedly completed the Art Institute's two-year course in one year.

His Art Institute training qualified White for WPA employment as an artist. His family had long met the other requirement: being on relief.

On the WPA White learned that the art he was most interested in—mural painting aimed at overcoming racial prejudice and ignorance—was considered political and could be destroyed politically. Throughout the WPA, the influence of Thomas Hart Benton, then the nation's best-known muralist, prevailed. In Chicago this WPA style was considered a kind of midwestern movement. Among its leaders were the socially conscious artists Mitchell Siporin, Edward Millman, Aaron Bohrod, David Fredenthal, and Joe Jones. Benton denounced modern art as "foreign" and saw the Depression as a battle between a "new, effective liberalism" and "the entrenched moneyed groups."[11]

Even before he got on the WPA, White had met Siporin and Millman. They had invited him, a teenager, to their studios to watch them work and to bring his own paintings for criticism and advice. They were, like White, interested in portraying American life and history and gave him serious attention—which he was not used to. They also introduced White to the ideas of the Mexican muralists, who used historical subjects to educate their illiterate and impoverished people on social issues. These concepts greatly excited White, as they did many artists at the time.

White found Millman and Siporin, leaders in what is now called the bland, "democratic" WPA style, to be excellent teachers. He was closest to Siporin, whose style was heavy and sculptural, as was White's early work. WPA-style painting had a "wholesome," photographic, and dispassionate character that lacked the vigor of deeply felt art. Yet, as White saw, Siporin and Millman were violently attacked by conservatives. The *Chicago Tribune*'s campaign against "communistic" artists so terrified one school board that it plastered over Millman's panels on *Women's Contributions to American Progress.* When Millman, Siporin, and another Chicago Regionalist, Edgar Britton, won national mural competitions, the *Tribune* considered it part of "the great conspiracy."[12]

These controversies helped give White in his formative years a political understanding of the uses of art and prepared him for his own long effort to alter, especially among black Americans, what is now called "the black image." He knew that he wanted, above all, to reach his people with paintings that would give them confidence and pride in themselves. Abstract painting could not do that, and he rejected it, turning to the traditional in the belief that this style would best express his views. White also learned, during this period, much about African-American history as well as Marxist concepts of art as a political instrument. He defined his own views and role in these terms:

I feel a definite tie-up between all that has happened to the Negro in the past and the whole thinking and acting of the Negro now. Because the white man does not know the history of the Negro, he misunderstands him.

I am interested in the total, even propaganda, angle of painting, but I feel the job of everyone in the creative field is to picture the whole scene. The old masters pioneered in the technical field. I am interested in creating a style that is much more powerful, that will take in the technical and, at the same time, say what I have to say. Painting is the only weapon I have with which to fight what I resent. If I could write, I would write about it. If I could talk, I would talk about it. Since I paint, I must paint about it.[13]

White was only twenty-two years old in 1940 when he made these statements to Willard Motley. His statements project with remarkable accuracy his course as an artist, his development of excellent technical skill, his concern with African-American history, his desire to create a maximum impact on a maximum number of people, and his perception of himself as a fighter for black people—not a detached, aesthetic prober. Such a projection presumes conflict and White's life was marked with severe trials—physical, aesthetic, and political.

One of his WPA murals dramatized the efforts of five African-American leaders—Sojourner Truth, Frederick Douglass, George Washington Carver, Booker T. Washington, and Marian Anderson. Another mural, for the Chicago Public Library, was also completed but has disappeared. His depiction of black leaders prompted the Associated Negro Press to commission a mural on its achievements for the 1940 American Negro Exposition in Chicago. His drawing *There Were No Crops This Year* won the exposition's first prize.

While on the WPA project, White met the talented sculptor Elizabeth Catlett, who was then teaching at Dillard University in New Orleans. They married in 1941. Catlett was appointed head of the art department at Dillard, then a new black college built with WPA funds. On Alain Locke's recommendation, White received a $2,000 Rosenwald Foundation fellowship.

Contribution of the Negro to American Democracy (1943), a mural created by White at Hampton Institute, was widely praised. Its heavy, voluminous style reflects White's work at that period—indeed, much art of that time. The mural helped Hampton students realize that African-Americans could be artists. Artist John Biggers, then a student, eagerly posed for some of the figures. Hampton University, Hampton, Va.

At Dillard, both artists began learning about black life in the South. Although he had visited his Mississippi relatives as a child, White now met rural black people as an adult, studying their ways of working, socializing, churchgoing, and relaxing. He felt that at last he really experienced the life of his Mississippi ancestors—their living conditions, their work, their food and ways of cooking, their music, and their religious feelings. He was deeply drawn to the blues and religious songs, an experience that later enhanced his appreciation of the gospel singer Mahalia Jackson. In the 1950s White played her records as he worked, seeking to convey in his own work the moving faith expressed in her songs.[14] Such music, rather than jazz, was a constant inspiration for White.

Inevitably, White encountered the brutal enforcement of segregation. He was severely beaten for entering a New Orleans restaurant. In Hampton, Virginia, he was forced at gunpoint to the rear of a streetcar by the conductor. These experiences gave White a profound pride in the resistance of his people to oppression. He also acquired a scorching sense of anger that only deepened as he learned, over a period of fifteen years, of the lynching of three uncles and two cousins. But if his dedication was sharpened, so was his sense of the need for a completely disciplined mastery of his art.

Meanwhile, at Dillard, Catlett was running into administrative difficulties because art was then not considered important. Finally, in 1942, she and White concluded their own development as artists was more important than bureaucratic hassles. They came to New York, where the painter Ernest Crichlow introduced them to many black artists.

While Catlett began studies with the Cubist-influenced sculptor Ossip Zadkine, White followed painter Joseph Hirsch's suggestion that he study with Harry Sternberg, the Art Student League's leading instructor in lithography and etching. Sternberg "knew how to dig and probe and brought out what was dormant and latent," White said.

Sternberg's influence changed White's style. "I had created an imagery that was symbolic and stylized," White explained. "He had me go back to the figure. For example, all my heads looked alike. They were stylized. He got me away from that, to go back to the human face, to a more individualized face. He got me to pay more attention to what I saw."

A master technician, Sternberg is partially responsible for the elaborate rendering that characterizes White's work. He did this by stimulating White's interest in what could be achieved by using only black and white—if carried out with disciplined precision and virtuosity. White was entranced. "The more I painted," he said, "the more I got involved in drawing." Thus, without fanfare or even a deliberate decision, a turning point was reached, based on White's natural feeling and talent for drawing.

"The drawing just naturally evolved into dominance," he recalled. "I can't explain it myself. I just got into more and more black and white. Of course, it could be reproduced and that was an influence"—since White wanted to reach many people, especially his own people, who were poor. "Another thing, my great love for black and white was stimulated by Käthe Kollwitz," the German artist who worked primarily in black and white. "And then I just love to draw!" Although White never totally abandoned color, black-and-white or sepia-and-white tones became his trademark, and lithography his medium.

Good Night Irene (1952), also known as **Song,** showed a change in White's style. Influenced by Harry Sternberg of the Art Student's League, he dropped his stylized approach to concentrate on the humanity of his subjects. Sternberg also helped him understand what could be achieved in black and white. (46⅝ x 23¾″) Collection Harry Belafonte

During this period White met Viktor Lowenfeld, an Austrian-born psychologist and artist who was working at the Hampton Institute. He arranged for White and Catlett to teach there. White's concept of a mural on black contributions to American history complemented Lowenfeld's efforts to raise students' self-esteem by identifying with their heritage. White's Rosenwald grant was renewed so that he could paint this mural.

White and Catlett often spent hours with Lowenfeld, discussing art and listening to classical music.

Lowenfeld, who had discovered the therapeutic value of art in working with partially blind and mentally ill prisoners in Vienna, revealed to White the close relationship between artistic self-expression and self-esteem. He also pointed out that artistic self-expression could not be stopped by discrimination. "All this was new to me," White said, describing Lowenfeld as "a very brilliant, erudite man," particularly in "considering art in terms of its psychological aspects."

Lowenfeld enhanced White's understanding of his own work, giving him insights into why he painted as he did, and encouraged him. Virtually from the beginning of his career, White had presented ordinary black people on a heroic scale, inducing a strong emotional identification by the viewer. His work has often seemed specifically aimed at overcoming feelings of inadequacy, dependency, and depression through the use of massive images of black people, whose calm dignity and warm humanity testify to their integrity and inner mastery of poverty and oppression.

White's Hampton mural included such historical figures as Crispus Attucks, the first American to die in the Boston Massacre; Peter Salem, the Bunker Hill hero; Nat Turner and Denmark Vesey, who led slave revolts; and such leaders as Booker T. Washington, George Washington Carver, Max Yergan, and Paul Robeson. The mural was described as "a vigorous expression of protest against antidemocratic forces" by the *New York Times* of June 27, 1943, and it brought unusual recognition to White, then only twenty-five years old.

In 1943 White was drafted and assigned to do camouflage painting in an engineers' regiment. When the Mississippi overflowed in 1944, White's regiment was rushed in to sandbag dikes. White developed severe respiratory symptoms, which were diagnosed as tuberculosis, and was sent to the Veterans Administration hospital in Beacon, fifty miles north of New York, where he spent the next three years.

Physically and emotionally exhausted, White felt "no desire to work, and in the hospital I figured out that I had to devise my own therapy." Even when his lungs began to heal, he did not try to paint. He decided "not to do anything except reread everything I had read during my adolescence. I reread all of Jack London, Mark Twain—literally everything I had read during my early years." It was a way of reevaluating what had been important in his youth in light of his experiences and artistic goals.

Such reintegration enabled White to become very prolific after his discharge. Soon after returning to New York, he created enough work for a one-man

show at the American Contemporary Artists (ACA) Gallery in September 1947. The *New York Times* compared the eloquence of his work to that of the spirituals.[15] The *World Telegram* critic called his work that of "a mature, powerful, articulate talent. He paints Negroes, modeling their figures in blocky masses that might have been cut from granite. He works with tremendous intensity. His subjects are militant, fiery, strong. They are symbols rather than people—symbols of his race's unending battle for equality."[16]

That fall White and Catlett went to Mexico, where they enrolled in the Esmeralda School of Painting and worked at Mexico's famous graphic workshop Taller de Gráfica Popular. They lived for nearly a year in the home of David Siqueiros, the famous muralist whose Marxist opinions at times resulted in his imprisonment. At the Taller de Gráfica, White, resuming his lithographic studies, came to know Diego Rivera, Pablo O'Higgins, and many other famous Mexican artists.

The Mexican artists were more socially oriented than White had anticipated, being participants rather than just observers. "This was the first time that I became conscious of how I was actually relating to my own scene," he said.[17] He felt honored when the Mexican artists included his work in a handsome book of prints celebrating the workshop's twelfth anniversary.[18] Reflecting on his Mexican experience, he later said, "I saw artists working to create an art about and for the people. This has been the strongest influence in my whole approach. It clarified the direction in which I wanted to move."[19]

During this period White's marriage ended and his health, often precarious, deteriorated. His illness forced him to enter St. Anthony's Hospital in New York, where, after lung surgery, he was hospitalized for a year.

In 1946 White had won the Atlanta University purchase award for prints and, while convalescent, had been invited to contribute to the first portfolio created by the New York Graphic Workshop, joining some of the nation's best-known printmakers, such as Antonio Frasconi and Leonard Baskin. After his discharge, White regularly exhibited at the ACA Gallery with others concerned with social themes, including William Gropper, Jack Levine, Moses and Raphael Soyer, Philip Evergood, Aaron Goodelman, Anton Refregier, and Robert Gwathmey. Gropper and Gwathmey became his particular friends.

White also became acquainted with a wide range of Harlem's cultural leaders, including W. E. B. Du Bois, Ralph J. Bunche, Thurgood Marshall, Charles Alston, Langston Hughes, and Jacob Lawrence. Paul

Awaiting His Return (1943), a reminder that there were African-American Gold Star mothers and wives in World War II, was carried out in a highly stylized rendering of human features. This tended to make White's subjects symbols rather than individuals, and he later abandoned this stylization. (Lithograph, 15½ x 13") Howard University Gallery of Art

Robeson became a close friend.[20] He also renewed his acquaintance with Lorraine Hansberry, whom he had known in childhood; she was soon to write *Raisin in the Sun.* The singer Harry Belafonte and the actor Sidney Poitier, passionate admirers, drew attention to his work. A White drawing, *Folk Singer,* portrays Belafonte singing and some of his album covers carry White's drawings.

During these years White's interest gradually shifted from leaders of the past to ordinary black men and women. Yet the past is somehow, almost magically, present so that these figures take on a deep emotional and symbolic significance. His work became more fluid and rhythmic and less massive. It also became more realistic and humanistic, its social significance appearing almost as an afterglow—in contrast to earlier work, in which an almost academic social symbolism dominated.

In 1951 White's second ACA exhibition was devoted to portraits of black women that struck a haunt-

Ye Shall Inherit the Earth (1953), also known as **Guardian,** marked White's development of heroic portrayals of ordinary black people. Such people, rather than great historic leaders, became the main theme of his work in the 1960s. (Charcoal, 38 x 25″) Collection Laurence Roberts, Windsor, Calif.

welcomed by the German Academy of Art. In Czechoslovakia, Poland, East Germany, and the Soviet Union, he was invited to serve on exhibition juries.

The attention he received in Europe contrasted sharply with his treatment in the United States, where McCarthyism was on the rise and any black artists who had been on the WPA art projects were presumed to be subversive revolutionaries. Although life in Europe was attractive, White felt he could not remove himself from the struggle at home for equal rights and returned to the United States.

Like Tanner, he discovered attention in Europe created attention at home. The Metropolitan Museum of Art included his work in a 1952 exhibition. The American Academy of Arts and Letters gave him a one-man show the next year and the Whitney Museum of American Art purchased *Preacher.* He won the Atlanta University award in 1953, and his first portfolio of lithographs was published.[22] In 1954 the Marxist critic Sidney Finkelstein published favorable comments about White's work in his book *Realism and Art,* and these became part of an East German book on White that reproduced many of his lithographs.[23] The following year White was awarded the John Hay Whitney fellowship.

Yet McCarthyism made this a period of enormous strain and tension for White. Political struggle was not new to him, and he related it to art. He considered the struggle for the rights of African-Americans to be mainly political, rather than social. He had seen the WPA murals of Millman and Siporin attacked in Chicago as subversive in the 1930s, but that was nothing compared with the paralyzing 1950s atmosphere of guilt by association and faceless accusers. White was concerned about the plight of many friends—actors, writers, and artists like Paul Robeson and Canada Lee—whose careers were shattered. Although McCarthyism began to ebb after 1954, fear and blacklisting lingered. White was constantly called upon to help blacklisted friends, to speak on their behalf, and to give work to benefit exhibitions for groups fighting for constitutional rights, jobs, education, and against prejudice. Overtaxed, White again developed tuberculosis.

In an effort to regain his health, White and his wife moved to California. They lived in relative seclusion at the foot of the San Gabriel Mountains in Altadena, near Los Angeles. He gradually regained his health.

ing, responsive chord among thousands of people, from professional critics to casual visitors. These unsentimental portraits had a warm sensitivity, strength, and dignity. His subjects seemed immediately recognizable, as though one knew and liked them. African-American newspapers, such as the *Pittsburgh Courier,* the *Chicago Defender,* and New York's *Amsterdam News,* praised and reproduced his work. With his virtuoso demonstration of draftsmanship and recognition of women as towering figures in African-American life, White gained a widespread respect and admiration among his own people. "Women are the source of life. . . . I'm talking about the most fundamental of all of our sources. All of our energies come from our relationships with women," he told Sharon G. Fitzgerald in an interview.[21]

In 1950 White married Frances Barrett, a social worker whom he had first met nine years earlier at a furriers' union summer camp, where he was an art counselor. Honeymooning belatedly in Europe, they were delighted to find White's lithographs had achieved wide recognition. In France, Italy, and West Germany he was received as a distinguished artist; in Berlin he was

Awaken from Unknowing (1961) expresses the common historic feeling of African-Americans that their great potential can be realized through education—if they are given the opportunity. (Charcoal, 30½ x 55½″) Collection Tony Schwartz

Working next to a wooded park with a running stream, the city-bred White rejoiced, "I spent thirty years in apartments. It's ridiculous! I never cease to be awed by that expanse"—referring to the snowcapped mountains. "The terrain turns me on!"[24]

A new focus for White's strong, sometimes searing portraits of African-Americans came from the mounting civil rights campaign by black students and the Reverend Martin Luther King, Jr., and the Southern Christian Leadership Conference in the late 1950s and early 1960s. His exhibitions in 1958 at the University of California at Los Angeles and in 1959 at the Long Beach Museum of Art stimulated immediate interest in multiracial California. White's work addressed the issue of civil rights directly—not in depictions of brutal abuse—but in positive, humanistic, and moving portrayals of courageous black people surmounting difficulties with inner moral strength and calm dignity. These were the basic elements of the nonviolent civil rights movement.

At exhibitions at Howard and Atlanta University White again won purchase awards in 1961. His highly articulate discussion of his work and how it related to the civil rights movement at a 1964 Occidental College exhibition and at the Heritage Gallery in Los Angeles aroused such interest that many other colleges sought his exhibitions. In 1966 he exhibited at four more California colleges and made many television appearances, but they cut down on his production, so he gave them up.

Meanwhile, in 1965, White had begun teaching at the Otis Institute of Art in Los Angeles, bringing him into stimulating contact with young artists of all racial and ethnic groups. While he found his relationship with his peers limited, "the stimulation I get from young people is important to my own growth," he said. "The vitality and creativity of their thinking helps me."[25]

In 1967 a book of White's work, *Images of Dignity,* was published. In the introduction Porter praised White's ability to combine social criticism, history, and human compassion: "Traveling the way of the Negro in American life, he has forged the rejected fragments of human and social dignity and love, hope, and suffering into the very symbols of human patience, sacrifice, resignation and triumphant resistance."[26] This was particularly true of the series *J'Accuse,* bearing the title of Emile Zola's famous book about anti-Semitism in the Alfred Dreyfus case. These drawings movingly depict black people of all ages—a boy with a dove, a young jobless veteran, a set of women's heads emerging from a swirling flamelike mass, working women, and a massive, seated black mother, wrapped in a blanket, with gloves and cap, whose solemnity symbolizes resistance and the demand for human rights: "I'll not move until hell freezes over." In some drawings White uses cold weather to symbolize oppression. Most sub-

Willy J (1976) marked White's development of the white background, concentrating on the human being and his dilemma as an African-American. One does not know what Willy J's problem is, but his pockets are empty and he seems caught in a cobweb of lines that compositionally carry the work beyond the drawing of a figure. (58 x 56″) Collection Christine Perren

J'Accuse No. 1 (1966) and the series that followed express a basic attitude held by White. Using the title made famous by Emile Zola during the anti-Semitic Dreyfus case in France, White accuses American society of depriving and neglecting its African-American citizens—in this case a blind woman who lives in a cold white world. Yet in her dignity she seems unperturbed, warmed by her inner spiritual strength. (Charcoal and Wolff crayon on board) Collection Dr. and Mrs. Bertram V. Karpf

jects look directly at the viewer—*J'Accuse*—or hopefully heavenward.

The drawings stirred many Americans. In August 1966 *Ebony* reprinted the *J'Accuse* panel of black women's heads as a cover, a startling contrast to conventional magazine covers on newsstands. When White's portrait of a turbaned black woman was the poster for the 1967 "Evolution of Afro-American Artists" exhibition in New York, it became a collector's item.

White's realism ran directly counter to Abstract Expressionism, which at the time dominated American art. Leading critics ignored him, although professional artists and art educators followed his work. *American Artist,* for example, described in detail his "remark-

able" draftsmanship and how it was achieved with everything from rags and brushes to cotton swabs.[27]

In defining the unique character of White's achievement a comparison of his work and that of Jacob Lawrence is informative. Both were concerned with black history and social conditions. Their major difference is in terms of goals and aesthetics. Lawrence's goal is primarily aesthetic. His realism is not photographic, but emotionally expressive, conveyed by stance, gesture, and color. His blade of grass is not a reproduction of grass but a green blade. Lawrence's quiet emphasis on the humanity of black people includes their skills and pleasures despite poverty—at work, in a marching band, in the library, playing checkers on the curb, cuddling as lovers on a sofa, ironing. Far more detached in his artistic stance than White, Lawrence basically records a scene in a storytelling way and lets the viewer formulate his or her response.

Harriet (1972) reflects how White now saw great black leaders. This portrayal of Harriet Tubman differs enormously in its power and appeal from his 1943 Hampton mural. Is the starburst above her the North Star that guided hundred of slaves to freedom? (54 x 48″) Heritage Gallery, Los Angeles

While Lawrence may include several or many individuals in a scene, White usually concentrates on one individual. A more important difference is that White uses a photographic realism to achieve something more than photography can. However, the most important difference is White's vision of his societal role as an artist and how the artist should look at his subject. While Lawrence limits himself to an aesthetic statement, White's goal is to move viewers to act, to create an emotional awareness and attitude that will respond to social issues politically. In his early work White portrayed historic black leaders, but eventually he came to envisage ordinary black men and women as the real heroes of all struggles. This significant change makes everyone part of current, not past, struggles. He sees his subjects, black men and women who are instantly recognized as people everyone knows, as appealing and heroic, as well as oppressed. The oppression is often symbolized by the bleakness of the scene, which may be simply cold white space. His portrayal evokes such a sympathetic response that the viewer identifies with the subject and feels a binding need to help—indeed, to honor—this person. What White portrays, then, is spiritual beauty, humanity, and heroic character in the face of injustice.

Achieving this psychological identification is White's first task and flows from his vision of his role as an artist. Because many social problems confronting African-Americans have a political character, White seeks to engage the viewer in the problem-solving activity. An examination of two paintings makes this difference from Lawrence clear. In depicting the Harlem Hospital Clinic, Lawrence baldly records a number of poor sick, injured, and maimed black people waiting on benches in a grim, high-ceilinged room. Although each is different, they are not seen so much as a group but as individuals—suffering, dependent, worried, frightened. They are bandaged, sad, and sick. There is not even a promise of care. All this is treated as fact. The people are not prettified, romanticized, made heroic or hopeful. The impact of their portrayal comes from their suffering being treated objectively, without dramatization or special pleading.

It is difficult to imagine White creating such a picture, not merely because he rarely does large groups, but because he conceives of the artist as a molder of attitudes, and this concept governs his vision. In *J'Accuse No. 5,* White comes close to the theme of the sick and injured in Lawrence's clinic. A young black man—presumably unemployed—walks forward on an empty landscape toward the viewer. He has a short, massive coat, which is thrown capelike over his shoulders so that its stiff voluminous sleeves protrude, but they are empty of arms and hands. Leafless branches overhead emphasize the barrenness of the environment. In this fashion White dramatizes the plight of black youth in a world of discrimination, posing the question for the viewer: *What are you going to do about this?*

In the 1930s during the Depression, many artists adopted a societal role as artists similar to White's, attempting to reinforce democratic attitudes and traditions by depicting workers in heroic stances or cruelly exploited. They usually painted in a bland traditional style, with the content so crudely linked to specific issues that the work was artistically shallow. When political shifts resolved or changed the issue, the painting lost its meaning because aesthetic qualities had not been the artist's goal.

White avoided this by not tying his work to spe-

Wanted Poster No. 3 (1969), based on old slave posters White found in the late 1960s, is one of the most moving images in American art. Yet it has been largely ignored by critics and art historians. (Oil on board, 24 x 24″) Heritage Gallery, Los Angeles

J'Accuse No. 5 (1966) portrays a young African-American, presumably a veteran, unemployed and facing a cold white future under barren branches. It is one of White's most powerful images. (Charcoal on paper, 29 x 17″) Collection Pauline R. Plesset, Los Angeles

cific issues and by aesthetically emphasizing the humanity of his subject through his transcendent draftsmanship. What is unique about White is that, almost alone, he has maintained the viewpoint of the socially conscious artists of the 1930s. His subjects, worthy and heroic, are not merely survivors of poverty and discrimination, but moral victors. In contrast to Tanner's vision, which was rooted in African Methodism's concept of spiritual brotherhood, White's view is assertive and directive. And while his work immediately appeals to those already dedicated to political and social struggles against prejudice and discrimination, he has reached far beyond that group to millions of Americans. Compared with Goya and other socially conscious artists, White narrowed his field. Nevertheless,

by the mid-1960s he had achieved the goal he outlined in 1940 to Willard Motley, maintaining his viewpoint with great integrity and increasing personal satisfaction despite severe physical illness.

Late in the 1960s White came across some pre–Civil War posters advertising slave auctions and WANTED runaway slaves. An intensely introspective searcher for past feelings, White was inspired to use these evocative posters, complete with wrinkles and folds, as backgrounds for portraits of contemporary black Americans. It is shocking to see a twelve-year-old boy priced at $30, a man for $200, a woman for $1,200. Rendered in a thin oil wash, combining sepia and black tones, the historical elements give a haunting impact to these skillful portraits. Earlier, White had won a competition for a fellowship at Tamarind, the nation's most prestigious lithographic workshop, and he used this to reproduce the WANTED portrait series.[28]

These were years of major achievement for White. In 1971, 1972, and 1975, White won major prizes at the National Academy of Design exhibitions and was elected to full membership.[29] Years earlier, he had won

416

Homage to Langston Hughes (1971). White's virtuosity is displayed in this complex portrait of a young man, with the faint images of vaudevillians in top hats, the rising phoenix, stars, and paper-folds reminiscent of the WANTED posters. (48 x 48″) Collection Camille and William H. Cosby

a gold medal in a competition in East Germany and been elected a "corresponding member" of its Academy of Art. He was very proud of this honor and attended an anniversary meeting in Dresden in 1978.

With the WANTED series, White reached a creative peak that was difficult to surpass. He had exhausted in many ways his academic roots and began experimenting in a limited way with the use of color and abstract shapes as part of his design. His realistic treatment of subjects as diverse as a snail or a rose in full color as part of a portrait of a black person created a strange surrealistic effect. However symbolic, such effects worked against the humanistic realism so fundamental to his work. They reflected a search for expression within the tight framework of realism he had established for himself.

Increasingly disabled by respiratory insufficiency, White worked with the aid of an oxygen tank until his death. In 1980 he was posthumously honored by his inclusion in a group of ten older African-American artists recognized for their achievements by President Jimmy Carter at a White House reception held in conjunction with the twenty-second annual meeting of the National Conference of Artists.[30]

White believed art was vitally needed by African-Americans as a cohesive and unifying cultural force. "Without music, the brother would have been wiped out," he liked to say, referring to the long struggle against slavery and for civil rights.[31] But he also complained black Americans were not sufficiently demanding of visual artists. "They wouldn't stand for the junk in music that they tolerate in the visual arts," he said.[32] Not surprisingly, he was one of the organizers of the Black Academy of the Arts and Letters. He considered the term *Black Art* to be "meaningless. . . . There is no such thing. There is a black artist. There is African art, which is a style, a certain way of doing. It has an identity and is indigenous to a continent and its peoples. We [artists] have not developed anything indigenous—nothing indigenous like black music."[33]

From his years of teaching White believed that young artists, feeling responsible "only to themselves," may fail to recognize "the worth of self-discipline, the importance of it." But he was critical of the economic difficulties of young artists: "I can recall when I could not afford to do a drawing or painting larger than thirty by forty [inches]. . . . People are hindered by economics, not ability, and I resent this."[34]

In 1980 Peter Clothier observed that White's art, which opposed the subjective character of Abstract Expressionism, was "profoundly at odds with much of the art of its time, yet profoundly consonant with the history of a particular people at a particular time, and with an art history, an aesthetic which is older by far than Romanticism, and broader by far than the European continent and its sphere of influence."[35]

White called himself a romantic idealist who saw the world filled with unnecessary conflicts. "I've arrived at the point where I can see nothing organic in this society that says these things should exist," he said, citing unemployment and police brutality as examples.[36] He often reiterated that he "painted only one picture in terms of my philosophy. It hasn't changed. I always paint fragments of it. Your whole career comes out to be the sum total of one thing. You're one belief, one person. Whatever you are, whatever you've shaped—that's it! You are that individual. There's a thread in everything I've done. There's a continuity. I paint in fragments of what is the total me."[37]

ELIZABETH CATLETT

Washington-born Elizabeth Catlett is now a leading sculptor of Mexico, where she has lived since the mid-1950s, although she has often visited the United States. Her ideas and vision of the role of the black artist and art itself have earned her a unique place in the history of American art. In her work and her thinking she addresses the colored peoples of the world—of African, Asian, and Latin American countries—as well as all Americans.

Catlett's sculpture, although stylized, is derived from the human figure. Aesthetically, it is characterized by massive volumes and a few simple shapes, whose flowing intersection powerfully expresses a physical vigor. But her art is no less shaped by her social viewpoint, and she often uses expressionistic concepts and distorting techniques to make her point. In *Homage to My Young Black Sisters,* for example, the figure of the young girl is designed so that her right arm is raised and her face looks upward, creating a powerful upward thrust. This upward tilt of the head, characteristic of much of Catlett's work, derives from her vision of the potential of black people and the artist's role in their development.

"Art is important only to the extent that it helps in the liberation of our people. It is necessary only at this moment as an aid to our survival," she has held.[1] For her, touring eight southern black colleges with an exhibition of her prints was more important than a New York gallery show.

Catlett's stature as a sculptor is evident in her larger-than-life *Woman,* carved in wood—one of the most eloquent statues in the Mexican Museum of Modern Art. Her linoleum print *Malcolm X Speaks for Us* was selected by Mexico's top graphic artists as the best work of 1970 and was purchased by the National Institute of Fine Arts there. For many years she headed the sculpture department of the National University of Mexico, and she has been associated with its legendary printmaking workshop, Taller de Gráfica Popular. Winning a national competition, she created the

The Black Woman Speaks (1970), a powerful image carved in a tropical wood and then polychromed, symbolizes what Catlett has long represented in her art—a fearless and expressive voice against oppression, indifferent to fashionable trends. (16″ h.) Collection Thelma G. and David C. Driskell

twenty-four-foot bronze relief that now adorns Howard University's chemical engineering building. Her monumental bronze portrait of Louis Armstrong, commissioned by jazz fans, embellishes the New Orleans park honoring him. In 1981 she created life-size portraits of James Torres Bodet and José Vasconcelos, historically important Mexican educators, for the Secretariat of Education building in Mexico City.

Yet it is her social vision that adds a special di-

mension to Catlett's importance. In 1961, in a historic speech in Mexico City, she called for abandonment of the idea that all-black exhibitions necessarily meant accepting segregation. Calling for such exhibitions, study of black history, and the defining of black goals, she asserted there was "a difference between sitting in the back seat because you have to and because you want to."[2]

Until then, many African-American artists had shunned any racial identification. Catlett's speech marked a significant turning point for many black artists, writers, and intellectuals. It resulted in the formation of black artists' groups, such as Spiral in New York, and all-black exhibitions swept across the country. Instead of accepting a shut-out by galleries and museums, these all-black exhibitions brilliantly demonstrated the talent of black artists in all parts of the country, awakening millions of Americans to their existence for the first time. These exhibitions were the other side of an old coin—the picketing and protests of black artists against their continued exclusion from museum, educational, and governmental exhibitions that were dominated by unexamined prejudice.

In private life Elizabeth Catlett is the wife of Francisco Mora, a leading Mexican artist and printmaker, and the mother of three grown children, one of whom has made a film about his mother and her work. Mexico seems a natural home for Catlett because its great muralists' concepts on the social character of art are so compatible with hers. For example, the theme of *Political Prisoner* attracted her in 1971 not only because the imprisoning of people for their ideas had become part of the human condition the world over but also because she herself felt imprisoned for her color, her sex, and her ideas. She considered black people imprisoned socially, economically, politically, and aesthetically. Her sculpture and prints are deliberately intended to awaken black people to their potential. "Art for me must develop from a necessity within my people. It must answer a question, or wake somebody up, or give a shove in the right direction—our liberation," she has said.[3]

Elizabeth Catlett was born in Washington, D.C., on April 15, 1915, the youngest of three children of John and Mary Carson Catlett, both of whom had taught school. Her father, who taught mathematics at Tuskegee Institute and in Washington schools, died soon after her birth. Young Elizabeth was sometimes left with a family friend while her mother worked as a dressmaker. "I remember drawing and painting while at this lady's house . . . as a very happy part of my childhood," she said.

Malcolm X Speaks for Us (1969) showed by design that Malcolm X was not an isolated figure but expressed the feelings and aspirations of thousands of young African-Americans. It won first prize at the National Print Salon exhibition in Mexico City. (Linocut, 37 x 27¼") Museum of Modern Art, New York

At Dunbar High School, Elizabeth Catlett decided to become an artist and won a competitive examination for a scholarship to the Carnegie Institute of Technology in Pittsburgh, but was rejected because of her race. Forty years later she still spoke of the devastating pain of that rejection. Her mother induced her to enter Howard University in 1932, where she initially majored in design under Lois Mailou Jones, intending to become a textile designer. However, her art history professor, James V. Herring, loaned her a book on African sculpture, which impressed her. Moreover, her painting teacher, James A. Porter, showed her the work of the Mexican muralists and explained their concepts. This prompted her to change her major to painting.

Porter arranged for her to get a job on a pre-WPA mural project. But she was soon fired because "I was silly—I didn't do the work I was supposed to do. The money went to my head," she told Elton C. Fax.[4] Thereafter she worked hard, graduating with honors; in 1976 Howard presented her with its outstanding alumna award.

419

Mother and Child (ca. 1939), carved while Catlett was studying under Grant Wood at the University of Iowa, won first prize for sculpture at the 1940 American Negro Exposition in Chicago. (Limestone, 35⅝″ h.)

Homage to My Young Black Sisters (1968), unusual in its uplifted face and militant fist, was carved in tribute to the courageous young women in the voter-registration and civil rights movement in the South. (Cedarwood, 5′ 9″ h.) Collection Andrew Owens, New York

On graduating, Catlett obtained a post teaching art in a black high school in Durham, North Carolina, while supervising art education in eight elementary schools; her pay was $57.50 a month. What caught her by surprise was not the oppressiveness of segregation, but the mercenary and materialistic attitudes of some black people, the indifference to the needs of emotionally disturbed children, and the black educators who attempted to suppress teachers' demands for better pay. Being physically ejected from a teachers' meeting where she raised this issue forced her to examine social and economic relationships in a new light and deeply troubled her. Although her salary rose to $79 a month, she decided she could not continue in Durham.

At that time Grant Wood, then a leading influence in American art, headed the State University of Iowa art department. His critical attitude toward American self-righteousness pomposity, expressed in his satirical and widely reproduced *American Gothic* and *Daughters of Revolution,* intrigued Elizabeth Catlett. Learning that no extra tuition was imposed on non-Iowans, she sought her master's degree there. She found Wood to be a demanding but just teacher, who believed a master's candidate should achieve competence in all major art media. In modeling and carving, she discovered a satisfaction in feeling and working with her hands that she had not known in painting. "I like to feel something in my hands and to feel I am shaping or molding or changing something," she explained, recalling how much she had enjoyed sewing, knitting, and crocheting.

Although she continued to paint, Catlett moved increasingly into cutting her vision in wood and stone. She earned the first master's degree in fine arts awarded

The Singing Head (1975) has been a favorite theme with Catlett in tribute to the role of singing in African-American life. This version was carved in wood seven years after the first version was cast in bronze. In 1972 she carved the head in black marble, and in 1979 she did it in orange onyx. (9¼″ h.) Collection Mildred Sanders, Los Angeles

at the State University of Iowa. Her thesis was a distinctive stone statue of a black mother and child. The work took months to carve and delighted Grant Wood.

In Iowa Elizabeth Catlett found herself working with white people for the first time in her life. In this situation she took Grant Wood's advice to look to her own people for inspiration. She said later, "You might say that United States racism formed my artistic perspective and molded my life attitude from a very early age. Grant Wood, one of the first white people that I had contact with, emphasized that we should paint what we knew most intimately . . . and my people have always been just that—what I know most intimately." This is why she chose a black mother and child as the subject of her master's degree thesis.

The mother and child Catlett did for her thesis won first prize in sculpture at the American Negro Exposition in Chicago in 1940. There she met many young black artists, including Charles White, whom she presently married. Her academic excellence, enlarged by a course in ceramics at the Art Institute, and her Chicago prize won her an appointment as head of the art department at Dillard University, then a new black university, in New Orleans. However, the indifference of its administration to her efforts to develop a full art program prompted her to resign. She and White then came to New York, where White studied printmaking at the Art Students League under Harry Sternberg, who recommended that Catlett study with Ossip Zadkine.

Although now considered an important sculptor of the twentieth century, at the time Zadkine was an almost destitute refugee from World War II. He could not get foundation support, and his Cubist-influenced statues attracted few American collectors. "He was working in a heatless studio," Catlett recalled, "and I think I was his first student." She could manage to pay fifty dollars a month for only two months, but Zadkine let her continue in exchange for caring for his cats on weekends when he went away.

"I was most attracted to Zadkine because of the great vitality I saw in his work and him," Catlett recalled. "He was such a vital person when he was working and talking. I was enormously impressed with his great creativity. . . . We used to argue a lot about my doing black people." Zadkine felt art should begin from a humanistic international viewpoint. "I felt the contrary—that it should begin as a nationalistic experience and be projected towards international understanding, as our blues and spirituals do. They are our experience, but they are understood and felt everywhere." Regarding Zadkine's influence, Catlett later said, "It took me a long time—not to get over that [his ideas]—but to develop my own way of working, not Zadkine's way."

Catlett and White shared an interest in black history and a deep belief in the talent of black Americans. They were mutually supportive in challenging prejudice and in their aesthetic development. During this period White, despite his fragile health, was commissioned to paint a mural depicting historic African-American leaders at Hampton Institute in Virginia. As a result, both Catlett and White were given teaching assignments there by Viktor Lowenfeld, a stimulating psychologist and artist who was creating the institute's first art department.

For students, the very presence of Catlett and White, two black artists who had already achieved some recognition, shattered old racist myths that black people were incapable of art. Moreover, they could demonstrate art techniques and, in personal talks, reduce the students' feelings of hopelessness and isola-

tion. It was also exciting for Catlett and White to discover among the young southern black students, such as John Biggers, considerable artistic talent.[5]

Catlett and White had many evening discussions with Lowenfeld, who linked creativity to self-expression and self-esteem. He encouraged black artists at all levels to identify with their African heritage, as well as black participation in forging American history, and to take pride in black creativity. White's mural, portraying historic African-American leaders, was a fundamental demonstration of Lowenfeld's concepts.

Another influence on Catlett at this time, helping her to integrate philosophically and aesthetically many aspects of African-American creativity, was Hale Woodruff. He often visited Hampton from Atlanta, where he was teaching at Spelman College. Their discussions prepared Catlett for a critical teaching and leadership role among black artists.

When Catlett and White returned to New York, White was drafted into the army. He then developed tuberculosis and had to be hospitalized for years, until after World War II. Meanwhile, Catlett became one of the most active teachers at the George Washington Carver School in Harlem. Although scurrilously attacked by the notorious House Un-American Activities Committee as subversive, this school had the support of many responsible Harlem leaders and churchmen. Its director was the poet and painter Gwendolyn Bennett, a former president of the Harlem Artists Guild and director of the Harlem Community Art Center. Norman Lewis and Ernest Crichlow were also teachers.

From her experiences in North Carolina and at the Hampton Institute, Catlett believed deeply in awakening the aesthetic and creative feelings of her people whether their activity involved painting, sculpture, or crocheting. She went out into the streets to raise funds for the school, spoke at meetings, and as Fax once described it, "swept its floors and taught classes in sculpture and how to make a dress."[6]

These activities both inspired her and "brought me into contact with the kind of people I had never been in contact with before," she recalled. "I came from a middle-class family, even though my mother had to work hard. But the school brought me into contact with working people. For the first time I began to get an understanding of the great hunger for art and culture of ordinary black people."

In a sense the Carver art classes were an effort to continue those of the prewar WPA-sponsored Harlem Community Art Center. At that time, nearly ten years earlier, there had been a close, mutually developing relationship between Harlem's artists and its people.

Survivor (ca. 1978) is one of Catlett's strong images of women. In Mexico she became a highly creative printmaker at the Taller de Gráfica Popular, the leading printmaking studio. There she met and married Francisco Mora. While raising their three sons, she largely gave up sculpture for printmaking. (Linocut, $10\frac{7}{8}$ x $9\frac{7}{8}''$) Amistad Research Center, Tulane University

But the closing down of the WPA and World War II ended that, and after the war the social fabric of the community was different. The unity of Harlem's people, many of whom had worked on the WPA, with WPA artists was gone. The Harlem Community Art Center and the Harlem Artists Guild, as well as the spirited discussions at 306—the apartment of Charles Alston and Henry Bannarn—had disappeared. Augusta Savage, hurt and embittered, had left for the lonely peace of an isolated upstate farm. Moreover, the rampages of the HUAC were smearing and destroying careers. The congressional attack was not limited to the political Left. Anything modern or progressive in art came under attack. Congressman George A. Dondero was assailing abstract art as well as art with social content.[7] In this atmosphere the Carver school could not survive.

In 1946 Catlett won a Rosenwald Fund fellowship, which was renewed in 1947, enabling her to study in Mexico. There she became even more devoted to

the ideals of the muralists. "Coming directly from Harlem . . . strengthened my belief in an art for people, all kinds of people, and the necessity for their being able to participate aesthetically in our production as artists," she said. She studied with Francisco Zuniga, one of Mexico's leading sculptors, learning techniques of ceramic sculpture that dated back to pre-Hispanic times. She also studied wood carving with José Elarese and José L. Ruiz and eventually began making lithographic prints in the Taller de Gráfica Popular.

In time Catlett came to know virtually all of Mexico's major artists—including David Siqueiros, Diego Rivera, Pablo O'Higgins, Leopold Mendez, Alfredo Zalce, Rufino Tamayo, and Francisco Mora, whom she married after her divorce from Charles White, from whom she had long been separated. A painter and printmaker, Mora was a sensitive artist whose ancestors had been Tarascan, the native people of Michoacan, an area west of Mexico City.

Her marriage changed some of Catlett's cultural attitudes. "It ended," she said, "my great interest in material things—in having things and in keeping up with what other people have. When I lived in New York I had to have a coat every two years, and all kinds of things like that. My husband came from a very poor family, and I have since realized what is really basic in life: a place to live, and food, and doing the work you want to do—doing a job that means something to you instead of a job to make money."

Catlett continued: "I have also learned from Francisco what it means to be a really creative person. Working in the Taller de Gráfica . . . I learned that art is not something that people learn to do individually, that who does it is not important, but its use and its effects on people are what is most important." Instead of the traditional Western concept that emphasizes the individuality of the artist, she said:

> We work collectively. I still ask people's opinion while I am working: what they think of what I am doing. And if it is clear to them. We work collectively, though we criticize each other's work from a positive point of view, trying to help, trying to see what would better the work.
>
> We also work together. I remember a poster that Leopold and Pablo drew. They gave me the drawing and I developed the design for a silkscreen, but being very pregnant I couldn't do the screening myself, so someone else did that. The thinking of many people on one subject, or a piece of art or creating, can also work very well.

While her children were small, Catlett did relatively little sculpture although continuing to make

Dancing Figure (1961), capturing the vitality of a dancer's rhythmic movements, demonstrates that Catlett could follow the conventional path if she wanted to. However, she feels deeply that she should use her art to combat injustice. (Bronze, 17″ h.) Collection William Watson Hines III, New York

prints. At that time the United States was engulfed by McCarthyism. Its fears and accusations spread into Mexico, where Catlett was harassed because of her past associations and because her husband worked on behalf of Mexican railroad workers' unions.[8] Eventually, she became a Mexican citizen, which ended the harassment.

The quality of her work remained high. She won second prize in sculpture in the Atlanta University annual exhibition in 1956 and a diploma in printmaking at the First National Painting and Printmaking Exhibition in Mexico City. She also won an award at the International Graphics Exhibition in Leipzig in 1959.

By 1959 Catlett had become the first woman professor to head the sculpture department at the National

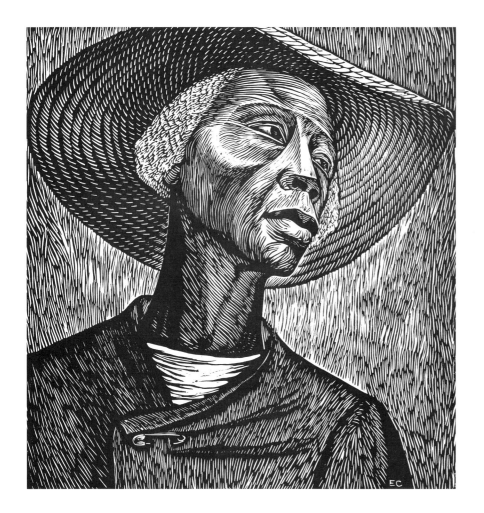

Sharecropper (1968), a striking portrait of an African-American woman, has been one of Catlett's most popular prints. Objective, both bold and massive, it suggests strength and evokes sympathy. (Linocut, 17 x 16½″) National Museum of American Art

School of Fine Arts at the National Autonomous University of Mexico. This initially disturbed some male faculty members, who avoided speaking to her. However, she was not upset by this; she had won major prizes and her work as a printmaker was being exhibited all over the world. Moreover, Mexico's leading artists at the Taller de Gráfica worked with her and respected her. As faculty members discovered her effectiveness as a teacher, her warmth and love of people, they abandoned their standoffish attitudes.

In 1962 Catlett won the Tlatilco Prize in the first Sculpture Biennial in Mexico and two years later the Xipe Totec prize. She is today considered one of Mexico's outstanding artists.

Having found a new home in Mexico, Catlett was in an excellent position to review the difficulties encountered by African-American artists in the United States from her own experiences, including her acceptance in Mexico and Europe. She knew their frustration and disappointments in trying to cope with prejudice. Learning of the civil rights movement by students in the South, she thoughtfully reexamined old concepts and attitudes among black artists and concluded that some of their ideas were faulty and self-defeating.

Her review was summed up in a 1961 speech, given as the keynote address at the National Conference of Artists, a newly organized group of art teachers in southern black colleges. Her words served as a powerful catalytic agent among black artists, asserting that their identity as African-Americans and their relationship to their people were critical in their development as artists and in gaining recognition. Her thoughts prompted black artists to organize groups to discuss their special problems as artists in America. While some of Catlett's ideas echoed those expressed by W. E. B. Du Bois in 1926, what gave them vigor and sharpness was the civil rights movement, the fierce concurrent struggle of colonial peoples in Africa and Asia to achieve independence, and the fact that black artists continued to be "overlooked" by those who controlled galleries and museums in the United States.

Catlett's speech occurred when Abstract Expressionism, proud of its total absence of content, still dominated the American art scene. This situation caused Catlett to point out that while black artists in the South were isolated and outside a nurturing environment, northern black artists were in danger of losing their identity "in the mass of American artists who must say nothing socially or even realistically."[9] She jibed sarcastically at black artists working in the then fashion-

able nonobjective style, saying: "They are accepted; they are no longer Negro; they are American; they are now equal."

Citing the Harlem Renaissance and WPA periods as eras of significant growth for black artists, Catlett called for new black group activities, asserting that "the group activity of Negro students in the South has made changes in two years we have not seen in more than fifty." She cast aside the old goal of being "an accepted artist," urging all-black exhibitions based on a proud identification with black people, not segregation: "We are through with segregation."

As she saw it, "We have to change our thinking on the question of group projects, group exhibitions and united interests. After all, we are Negroes, and leaving out the word does not change the reality. And have not all the historically proven greatest art movements in the world been on a group basis? What of Greek art, African art, Medieval art, and Modern art?" Instead of joining other American artists in rehashing European concepts, she suggested that there was "a whole new world of possibilities for expressing ourselves, with the Negro people as our principal source of inspiration."

Catlett rejected museum representation as a goal, noting that many black artists were widely exhibited. "What more must we prove?" she asked, putting forth a new goal: "That we are capable of making a contribution to American life that no one else can—the aesthetic interpretation of Negro life. No one knows the life of our people better than we do." The opportunity existed to do in the plastic arts what black musicians had done in jazz, she said, asserting: "We can create an essentially American art [in contrast to the rootless international character of abstract art], working towards what is basically an authentic national aesthetic expression. We can make an important contribution to the cultural wealth of this great historic period of the world in which we live." She urged black artists to consider their potential audience among the colored peoples of Latin America, Africa, and Asia.

This speech, expressing half-formed thoughts among many black artists, helped bring about many changes following its publication in *Freedomways*, which made it available to a much greater audience than those who originally heard it. Black artists everywhere discussed Catlett's ideas, their work and its relationship to their people, American art in general, and their efforts to achieve recognition. Black exhibitions, such as the historic "Evolution of Afro-American Artists 1800–1950" at City College of New York, helped change the attitudes of critics, galleries, museums, and collectors by changing the attitude of the public at

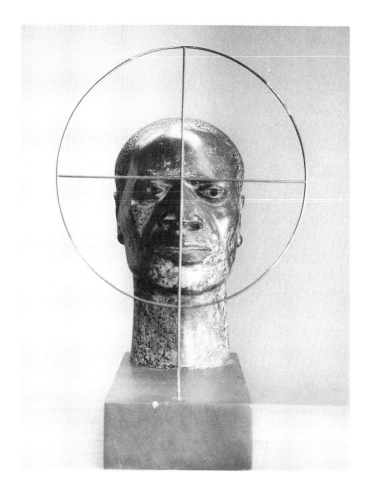

Target (1970) expresses Catlett's opposition to police brutality toward African-Americans here and the black people in South Africa. Created during the civil rights struggle, it seemed to echo what many saw on television as police attacked marching demonstrators. (Bronze, 13¼" h.) Amistad Research Center, Tulane University

large. By asserting themselves as black artists, they began to crack old molds of prejudice, even in the South. As Catlett said, "If we are artists, we no longer need to prove ourselves technically any more than our singers need to learn the European classics first and then sing spirituals. We will neither be free nor effective until we can reverse that procedure."

More than a decade after this pivotal speech, Catlett felt that many problems of black artists had been reduced and that their "greatest problem is how to get out of the rut that most American artists seem to be in. . . . I truly believe that the black liberation movement in the United States has given the black artist a chance that other Americans don't have—the chance to get out of that kind of freakiness and commercialism that seems to dominate United States art production. They have a chance to express the needs, the desires, and the cultural differences of a people. They are the only ones who can do it, and it is a very rich culture—the culture of black people."

Achieving this goal may require different forms of art, Catlett acknowledged, pointing out that in Mexico, mural art and lithography grew out of the 1910 Revolution and was related to the needs of the Mexican people. "I would say, after twenty-five years of working with these artists and seeing the forms develop in the people's art there, that the forms developed because of this art's reason for existence," she said.

Catlett's prints have been exhibited all over the world, being easier to transport than her sculpture. In 1970 she won a fellowship for study and travel in East Germany and the following year the British Council provided a grant for her to visit art schools in England. In 1978 she went to China and the Soviet Union with a group of nonartists, although she showed slides in China, discussed the work of black artists in America, and answered questions on Pop Art, Op Art, and Abstract Expressionism. She enjoys contact with nonartists, visiting Las Vegas and Los Angeles schools with Francisco Mora to talk to young people. At shows of her work she often demonstrates how prints are made and how patina on sculpture is achieved.

Her work has the same massive, rhythmic, expressive qualities that it did when she first emerged as a sculptor. It conveys positive strength, as her portraits of the poet Phillis Wheatley at Jackson State College in Mississippi and of Louis Armstrong demonstrate. Her portraits of Torres Bodet and Vasconcelos, who aided the development of murals as part of the national education of Mexico, have been ranked in quality with the best Mexican art. That they are installed in the Secretariat of Education building, where Diego Rivera has three floors of murals, pleases Catlett. Her work is in many museums, including the National Institute of Fine Arts in Mexico City, Metropolitan Museum of Art and Museum of Modern Art in New York, National Museum of American Art in Washington, High Museum in Atlanta, and National Museum of Czechoslovakia in Prague. It is also in the collections of Atlanta, Fisk, and Howard universities, as well as the State University of Iowa.[10]

Catlett often participated in symposiums at Scripps, Pomona, and their associated colleges in Claremont, California, which is easy to reach from her Cuernavaca home. One of her most recent works is a large mother and child, carved in wood, for the Clark Humanities Building at Scripps College. She loves carving in wood. This strong, nurturing mother figure with child is an image with which she deeply identifies, and it has been one of her most repeated themes, starting with her studies with Grant Wood nearly fifty years ago.

Catlett's talent has won her significant recognition in two very different cultures. Few artists' lives and works demonstrate so completely the complex factors that hers does. Alienated but focused by segregation, she was eventually pushed from the United States by reactions to her efforts to change the values and institutions that oppressed black people. Yet she in turn has matured through that conflict, awakening African-American artists to celebrate their identity. Her vision and her expressive approach to art have not strayed in the face of harsh struggles or popular trends. Indeed, her integrity as an artist has been heightened. She had remained steadfast to what she sees as the challenge of her times—the relationship of art to people. While continuing to assert that the black artists must go wherever black people are—the streets, churches, cultural centers, even prisons—Elizabeth Catlett also argues that "today it is difficult to wrap ourselves in 'blackness,' ignoring the rest of exploited humanity, for we are an integral part of it."[11]

JOHN T. BIGGERS

Few outstanding artists have been effective educators in schools or colleges (as opposed to professional art schools). However, John T. Biggers, a muralist who led in establishing a regional art center at predominantly black Texas Southern University in Houston, is an exception. His paintings and murals hang in museums, university centers, schools, libraries, union halls, and a home for aged African-Americans. His book of drawings of African life, *Ananse: The Web of Life in Africa,* was rated one of the most beautiful books of 1962. Today in much of Texas, Biggers's name is virtually synonymous with art. In May 1988 he was selected "Artist of the Year" by the Art League of Houston, the city's highest honor for its artists.

A devoted student of Viktor Lowenfeld, Biggers considers art a means of enhancing the identity and self-esteem of his people. He has aimed his work and that of his students not at galleries and museums but at the black communities of Texas and at Texans in general. He has not only helped black Texans see themselves in a positive way, but has also won new respect for them in a state with a long history of institutionalized racial prejudice.

Since he retired from teaching in 1983, his painting has become more abstract and freer in its expressiveness than earlier, when it was tightly traditional. Yet his teaching was far from traditional. Biggers asked students to focus directly on the question of self-identification: Who are you? The answer, unfolding over weeks, months, even years, became the basis of each student's art. His approach asked that students respect the conditions of their own American experience as well as that of their African heritage. While most art schools concentrate on technique, by raising the issue of self-identification first and dealing with the cultural blind spots and barriers to self-expression, Biggers significantly altered perspectives and relationships for black students in the Southwest. Where few African-American artists once existed, there are now many. By 1980 TSU had approximately 100 art majors and

This mural (ca. 1984; detail), created for the Christia V. Adair Park, honors an unusual teacher–choir director. Its theme is the spirit of music. It was painted in the style Biggers developed after retiring from TSU. (Acrylic) Christia V. Adair Park, Harris County, Texas

some 300 art education students. Nearly ninety percent of the black art teachers in Texas attended TSU, and many graduates are teaching in schools and colleges throughout the country. How this was achieved, often in the face of complex attitudinal struggles with edu-

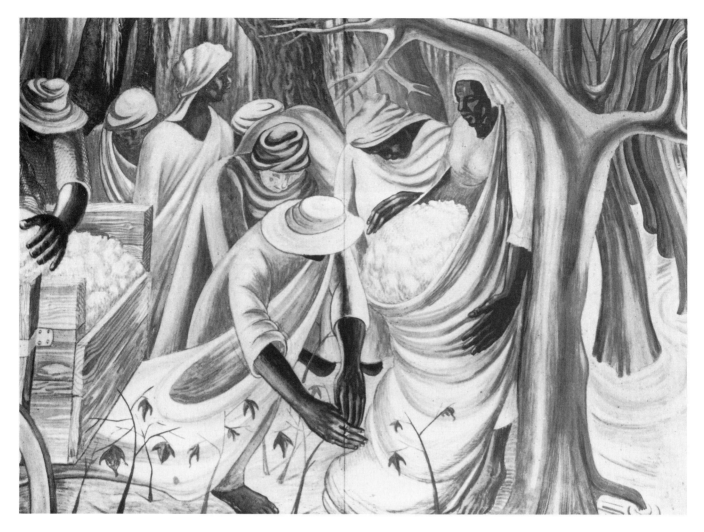

Detail of *The Harvesters* (1952). This mural with its sculpturally modeled figures was created by Biggers and his fellow artist Joseph Mack for the Eliza Johnson Home for Aged Negroes as "a gift of love and self-respect." It won more mural commissions for Biggers in Texas, and helped to overcome the belief that African-Americans were incapable of art. (Tempera, 9 x 60′) Eliza Johnson Home for Aged Negroes, Houston

cators who thirty years ago felt art had no place in a black school, has been detailed by Biggers and his colleague Carroll Simms, with John Edward Weems, in *Black Art in Houston: The Texas Southern University Experience*. The ultimate impact of their achievement cannot yet be estimated.

Biggers has received many educational awards,[1] but these honors do not reveal how effective he has been in using his artistic skills to alter attitudes toward black creativity in the arts. In 1981 Biggers completed a large mural for the Houston Music Hall, while Simms simultaneously created a major sculptural work for the building. To their delight, these commissions came from the city's governing body, testifying that Houston's leaders have changed their image of African-Americans.

Since retiring, Biggers has completed three more murals. In the Tom Bass Regional II Community Center for the elderly his mural is based on quiltmaking and African-American folklore. The Christia Adair

Park mural was inspired by, and interprets, a woman's life devoted to helping the needy. In Paris, Texas, his public library mural depicts three symbolic women emerging from a background consisting of a traditional quilt pattern. While it shows the influence of Charles White, this mural is more abstract that anything White created.

Following up on earlier trips, Biggers returned to Africa in the 1980s to make studies in Nairobi for a mural for the National Gas Company of Houston, and he completed another mural for Florida A&M's School of Business Administration. His retirement has freed him to paint more than ever.

Of how his painting has changed in recent years, Biggers said, "Mainly I have moved towards greater simplification, and towards a more abstract and freer treatment of my subject matter." These changes reflect his continuing artistic growth.

———

The launching of a large fishing boat through the surf, requiring many men, symbolized for Biggers the closeness of African life to the forces of nature. (From *Ananse: The Web of Life in Africa* [Austin: University of Texas Press, 1962], p. 38)

The *durbar,* a harvest festival in Ghana in which women's societies dance as groups, fascinated Biggers during his visit to West Africa in 1957. His drawings recorded many aspects of daily life there. (From *Ananse: The Web of Life in Africa,* p. 92)

Such scenes as this one of a mother passing by fishermen repairing their nets attracted Biggers, not for their picturesqueness so much as for their naturalness and their relationship to the earth and the sea. (From *Ananse: The Web of Life in Africa,* p. 40)

The dependence of Ghanians on the cassava plant impressed Biggers, who drew its tangled root structure. Its nurturing character inspired him to turn to organic growth as a major mural theme. (From *Ananse: The Web of Life in Africa,* p. 47)

Viktor Lowenfeld (wearing glasses) initiated art studies at Hampton Institute in 1939. A psychologist and artist and a refugee from Hitler, he sought to work with African-American students because his experience with deprived groups in Vienna had shown that art increased their self-respect and brought out hidden talent. Visiting artists at their work, he counseled them to paint what they knew. Charles White, Elizabeth Catlett, and John Biggers were among the artists stimulated by Lowenfeld. (See *Five Decades: John Biggers and the Hampton Art Tradition* [Hampton, Va.: Hampton University Museum, exhibition catalog, 1990]).

John T. Biggers, born in Gastonia, North Carolina, on April 24, 1924, was the youngest of seven children of the Reverend Paul A. and Cora Finger Biggers. His parents had attended Lincoln Academy, a nearby black secondary school supported by the American Missionary Society. Although principal of a three-room school and a Baptist preacher, his father both farmed and repaired shoes to make ends meet. His mother, Biggers remembered, "had an artist's perception. . . . She saw beauty in practically everything."

The Biggers children cared for their own gardens and made their own toys. With an older brother, John made a scale model of Gastonia, carving houses, laying out streets, using moss for lawns—"my first real exercise in creativity," he later said.[2]

Biggers grew up with a positive image of Africa from his father's spellbinding stories of black wit and wisdom based on African folklore. This was reinforced when he went to Lincoln Academy. Its principal, Henry McDowell, had spent twenty-five years there as a missionary and knew many African proverbs, which he applied to problems confronting black people in Gastonia.

Biggers's earliest memories of drawing were of copying religious pictures with his brothers and of their father "teaching us to write, stressing the beauty of well-designed capital letters and rhythmical writing." Mrs. Blue, his second-grade teacher, "had us copy the colored pictures of birds that came in Arm and Hammer baking soda boxes." At year's end Biggers could draw more than 100 birds from memory.[3]

Yet he had no overwhelming desire to be an artist. In 1936, when he was twelve years old, his father died, and his immediate goal became helping his mother. With seven children to support, she cooked for white families and later served as matron in an orphanage. His older brother Joe and John earned their way at the Lincoln Academy boarding school, with John rising at 4 A.M. to fire boilers in the school's eleven buildings. His supervisor, Dean Westerband, got him other jobs and inspired him to work his way through college.

Biggers entered Hampton Institute in 1941 as a work-study student, planning to study heating and plumbing as a result of his experience firing boilers. However, "one evening drawing class with Viktor Lowenfeld profoundly changed my life—and my goals," Biggers said. "I began my career as an artist and teacher."

Although Viktor Lowenfeld had a short professional life, dying in 1960, his impact on a number of African-American artists, including Charles White and Elizabeth Catlett, was significant. No one was more influenced than Biggers. To understand Biggers, one must understand Lowenfeld.

Lowenfeld was a psychologist who also had artistic talent. He gained his special insights into art in Vienna, where he initially worked with the mentally ill, prisoners, and the blind, asking them to draw, paint, and model in clay. His studies of these groups repeatedly demonstrated that art could be a means of establishing identity and overcoming feelings of inadequacy. Lowenfeld then applied his findings to child development, using art as a major means of helping a child develop identity, self-esteem, and confidence. He demonstrated that through "drawing," however unrealistic, children can express feelings and gain satisfactions that are directly related to how they feel about themselves. Following the publication of his 1947 book, *Creative and Mental Growth,* his impact on education was profound and worldwide; in the United States his book both altered and advanced art education.[4]

As a Jew in a nation overrun by Adolf Hitler, Lowenfeld had a profound understanding of racial prejudice and oppression, as well as the feelings of inadequacy, inner rage, and fear that such prejudice engenders.

After arriving in the United States in 1939 as a refugee, he immediately sought to work with black students and was hired as a psychologist at Hampton Institute.

Confident that artistic self-expression would help students gain self-esteem, Lowenfeld proposed to teach an art course. The administration and faculty resisted, asserting, "These students aren't interested in art."[5] Lowenfeld finally won permission for a one-night-a-week drawing class without academic credit. Of the 800 students, "about 750 came for this course," Biggers recalled. "The next year they let him set up a major in art."[6] Biggers promptly shifted from plumbing to art, worrying his mother.

One of Lowenfeld's first steps was to display and discuss African sculpture. Instead of emphasizing its role in stimulating modern art, he stressed its religious and social role in African culture and the feelings of awe, nobility, and moral aspiration that inspired African art. In so doing, he began to alter students' view of their African heritage, helping them to take pride in it and to recognize their own beauty. In drawing, for example, students no longer felt the need to make faces look Caucasian.

Yet, Biggers said, "African art—in fact, African culture generally—remained devoid of significance in our lives. I felt cut off from my heritage, which I suspected was estimable and something to be embraced."[7] Lowenfeld made Biggers feel he must visit Africa some day.

By asking them to identify places on campus suitable for sculpture and murals and then having them create such works, Lowenfeld enriched the students' vision of themselves. He also brought to the Hampton Institute two very talented young black artists, the painter Charles White and the sculptor Elizabeth Catlett, who were then married. This immediately wiped out the students' widespread belief that there were no real black artists.

At Hampton, White created a mural, *The Contribution of the Negro to American Democracy,* which reinforced everything that Lowenfeld taught. "We stood around him in awe, watching this master draftsman . . . model our heroes and ancestors . . . John Henry, Leadbelly, Shango, and Harriet-the-Moses," Biggers recalled.[8] He became White's "unknown apprentice," in his phrase, doing everything he could to help, even posing for some figures.

Biggers became determined to become a muralist, creating two murals as a student: *The Country Preacher* showed a traditional preacher giving a sermon that depicted African scenes, and *The Dying Soldier* showed a soldier's death on the battlefield, while the sky is filled with his childhood memories.[9] Biggers tried to work like White, seeking his eloquence. As he described it: "For a number of years, his influence caused me to turn out 'little Charles Whites.' "[10] At the 1981 rededication of White's mural, Biggers was the main speaker.

The Mexican concept of the mural as an educational tool to inform an impoverished people of their history and to build their self-esteem was often discussed by White, Biggers, and Lowenfeld. Lowenfeld helped Biggers recognize that the folk culture of rural African-Americans held rich traditions that could help them recognize their own beauty and wisdom, as well as take pride in what they did and their African heritage. As a result, "I began to see art not primarily as an individual expression of talent," Biggers said, "but as a responsibility to reflect the spirit and style of Negro people. It became an awesome responsibility to me, not a fun thing at all."[11] This viewpoint made him indifferent to the New York–centered art trends, galleries, and museums.

Although socially oriented, Biggers was not attracted to "social protest" painting. Instead, he sought to portray in a positive way the beauty, dignity, and value of rural black men and women as they performed ordinary tasks and celebrated their planting, harvests, and lives together. With Lowenfeld's "teaching of self-identification and self-esteem through art expression, at last I found a way to deal with the life-long yearning to speak in line, form, and color of the aspirations of the black man I had become. . . . Lowenfeld turned me on," Biggers explained.[12]

After navy service in World War II, Biggers followed Lowenfeld to Pennsylvania State University, where he had become head of the art department. Biggers helped illustrate the first edition of Lowenfeld's *Creative and Mental Growth.* Today Biggers characterizes Lowenfeld as the greatest art teacher of the twentieth century. He instilled in Biggers a great desire to study African life directly and to teach, for Biggers's Hampton experience made it clear that one artist alone, no matter how talented, could not alter the image of the black American—his new goal.

At Penn State Biggers earned his bachelor's and master's degrees in one year; he also married a Hampton classmate, Hazel Hales. On weekends he painted two murals in the Burrows Education Building: *Harvest Song,* showing people rejoicing over the earth's fruitfulness as a central figure sows seed for the future, and *Night of the Poor,* depicting the despair of poverty. Neither concerns black people exclusively.

In 1949 a Biggers painting portraying the river ritual familiar to most black southerners, *The Baptismal,* was exhibited in a Houston community center. It greatly impressed the influential Susan McAshan. She convinced the president of Texas Southern University,

The Web of Life (1975–76), a mural for the Science Building at Texas Southern University, was inspired by Biggers's cassava studies in Africa. The organic interdependence of all life became his guiding insight.

Detail of a mother and child, the central feature of Biggers's *Web of Life* mural.

Dr. R. O'Hara Lanier, who had formerly been president of Hampton Institute and happened to know Biggers and his wife, to hire him to establish its studio arts program.

Having witnessed the startup of an art department at Hampton helped Biggers establish one at TSU in the early 1950s, but it was a formidable struggle. The faculty and administration, as a result of their long conditioning, felt art was not a proper subject for black students. Biggers's colleague was Joseph L. Mack, another Lowenfeld student, who had already experienced two years of academic hostility to art programs for black students at Florida A&M. Given a small room with one-arm lecture chairs, no easels, no sculpture stands, not even a pad of newsprint, Biggers later said, he "initially wanted to commit an act of violence every time I opened the door."[13]

Biggers and Mack found their students so poorly

prepared in English that conventional art texts were useless. They turned to Lowenfeld's book, Alain Locke's *Negro in Art,* and Aline Saarinen's *Search for Form.* "To create an atmosphere and a much needed identity as artists," Biggers had the students saw the arms and backs off their lecture chairs, paint the walls gray, and begin designing and painting murals on the walls.[14] He told students not to worry about artistic standards, but to look within themselves and their own feelings and backgrounds for their subjects. Creativity, he told them, did not lie in the classroom or in books, but in finding ways to repossess the poetic sensibilities of their childhood—its spontaneity, enthusiasm, and pleasures.

However, the administration and faculty were appalled to learn students were going to depict African-Americans. Nor did they like Biggers's assertion that black people had been the great caretakers of the earth. "The general attitude," Biggers recalled, "was 'We've got to get away from the dirt.' "[15]

Recognizing that they could overcome faculty resistance only by outside recognition of quality, Biggers and Mack entered a juried show at the Houston Museum of Fine Arts. Biggers's Conté crayon drawing, *The Cradle,* won the purchase prize. The resultant press accounts boosted the status of the art department. Although segregation prevented Biggers from personally accepting his prize, his prize and Mack's excellent work soon helped end segregation at the Houston Museum. For the first time TSU faculty and administration members could visit the museum without restrictions. That the art department could in fact alter the Houston environment produced a noticeable change in faculty attitudes. When Biggers's *Young Mother* won the Atlanta University exhibition purchase prize in 1950, hostility withered.

To alter community attitudes, Biggers and Mack created a special faculty-student exhibition for the Texas Senate in 1951 that won that astonished body's praise. In 1952 they created two murals for the Eliza Johnson Home for Aged Negroes. *The Harvesters* celebrated people hewing wood, picking cotton, fishing, and baptizing. *The Gleaners* depicted a warm, storytelling kitchen with harvest fruits on the shelves and folks gathered round, cooking in the fireplace and quilting. Not long after that Biggers aroused enthusiasm in the black community with a YWCA mural on black women's role in American life and education. However, when he started painting the monumental Harriet Tubman holding a rifle as she led slaves to freedom, some women demanded he stop, saying he was disgracing black womanhood. Biggers stopped until YWCA officials convinced the group that his depiction was a positive one.[16]

More murals followed, including one at Carver High School in Naples, in northeastern Texas, and one at the International Longshoreman's Association, Local 872, of Houston. By painting these murals, mostly without pay, Biggers significantly altered attitudes in the university and black community toward art. The old attitude that black people were incapable of art and uninterested in it vanished under intensive press and television coverage of these murals, all of which were quite traditional in their aesthetics.

Lowenfeld had pointed out that a major difficulty of African-Americans was their inability to identify with their African heritage.[17] Biggers himself felt cut off from his heritage. However, in 1957 a UNESCO grant enabled him and his wife to spend six months in West Africa. There "I had a magnificent sense of coming home, of belonging," he said. Starting with the hotel clerk's "corn-rows," a hairdo he had known in North Carolina, Biggers readily identified many things in African life that he had seen or been taught as a child—"Africanisms in our life which we simply had not been able to claim," as he put it.[18]

Scholarly anthropologists, such as Melville Herskovits, had spent a lifetime trying to discover Africanisms surviving in black American life, without much success. According to Biggers, these scholars had not been able to recognize the African ways of doing many things, such as ways of standing, sitting, walking, handling hoes and tools, planting seeds, and weaving. Seeing African men and women building their own homes, at work in the field, cutting and shaping handles for axes and other tools, making shoes, weaving cloth for their own garments, fashioning their own chairs, was an exciting revelation for Biggers. He made many drawings of these activities, of fishermen and their boats, of trees and plants, including the fascinating cassava root, which Africans call "life" because survival may depend on it.

Biggers assembled his drawings into a book, *Ananse: The Web of African Life.* The title comes from *Ananse*—the heroic spider that, in West African folklore, outwits larger creatures with its web spinning, wit, and wiles. Br'er Rabbit is the closest equivalent in black American folklore.

Many of these drawings have the literalness of photographs, with close detail and carefully rendered modeling. In his best drawings, however, Biggers abandoned detailing to emphasize the natural rhythms created by human shapes and the movement of groups fishing, preparing food, going to market, shopping in bazaars, standing in lines, selling fish, drumming, and dancing. He was fascinated by clay and wooden sculptures in the fields, created when new crops were planted to encourage an abundant crop. After the harvest, they

Climbing Higher Mountains (1987) was inspired by a hymn popular among African-Americans. While not relinquishing human figures, Biggers developed complex geometric patterns that carried his work beyond his original traditional naturalism. (Acrylic, 40 x 45″) Hampton University Museum, Hampton, Va.

were left to disintegrate—and new ones were made for the new planting.

However, some experiences disturbed him. He was upset because some Africans accepted "the white man's images [of them] indiscriminately, for in the process the African belittles himself."[19] And he was "sickened" by an art school without a single African sculpture. Yet ultimately, having seen in another culture the very problems he confronted at TSU, Biggers gained new confidence in tackling them at home.

On returning to Houston from Africa, Biggers was asked to create a mural for TSU's new science building. Carroll Simms was asked to create a sculpture, and he did a soaring outdoor piece. In his mural Biggers chose to depict life as "a single great system of activity due to the close relationship between organisms," particularly the biological interdependence of humans and nature.[20] While some of his imagery was derived from his early biology studies, Biggers also drew upon the folklore concept of Mother Earth as a creative force, supporting through a great root system black female figures who are sowing and harvesting amid flowers, animals, and birds. Unlike many murals dealing with science, the emphasis is on our interdependence with nature—not on test tubes, computers, X rays, laser beams, and rockets in outer space, all of which Biggers tends to see as dehumanizing. When unveiled, the mural was hailed as "a national treasure" by Mimi Crossley of the *Houston Post*.[21]

Another Biggers mural, *Birth from the Sea*, dem-

onstrates a more imaginative approach than his earlier work. It centers on a black female figure, draped in wispy gauze, and an African fishing boat. Many female figures, robed in white, gather in concern on both sides as a fisherman on the right casts his net and a great fish creates waves in the background. A matriarchal figure on the left bends over her work "like God bending over the clay while making the first man," in Biggers's words.[22] This mural was created for the W. L. Johnson Branch of the Houston Public Library.

In 1977 Biggers created a mural on the theme of the "Family of Man" for the TSU Student Union building's cafeteria. Part of his effort has been to surround students with art at all times.

During this period Biggers helped determine the physical plant for the TSU Art Center, which was designed as a functional workshop rather than a traditional academic building. A block-long, one-story building with ample windows, it contains large studio areas for teaching drawing, design, painting, ceramics, and sculpture—matching the best art schools in the nation.

Until Biggers retired, each TSU art major was expected to complete a mural in his or her senior year. Wall space was allotted for them in various buildings. Poor murals, in concept or execution, were simply painted over by later students. At one point there were fifty murals on campus. However, since Biggers's retirement in 1983, the mural program has been largely abandoned. The Lowenfeld precepts of self-

Third Ward Housing (1985) depicts African-American women in front of rows of "shotgun" houses, which derive from African architecture and are found throughout the South. (A shotgun could be fired through such a house from front to back without hitting anything.) Their triangular roof peaks, and memories of his mother's quilts, inspired many of Biggers's geometric abstractions. (Conté crayon)

identification and self-expression that guided Biggers have been replaced by more traditional academic art school approaches. "I am disappointed," Biggers commented five years after his retirement, "but not bitter." He has the satisfaction of having established a major art school for black students—but not limited to them—where there was none.

In his murals certain themes are constantly repeated by Biggers—harvesting, planting, baptism, and other rituals of rural black relationships, as well as the vast root systems that intrigued him in Africa and that have become his symbol of Africa nurturing black life in America. These themes reflect his view of black people as the caretakers of the earth, a vision that arises from his own childhood.

Although his work has become freer and more abstract since he retired from teaching, Biggers's style is basically representational, with heavy, compact volumes that have a sculptural or three-dimensional character while maintaining a linear quality similar to that in Hale Woodruff's *Amistad* murals. Woodruff later used African design as a basis for abstract images, but Biggers's work stops short of such a radical departure from the traditional. His murals have a beauty and power that enable African-Americans to see themselves in these works and take pride in their roles in American life without insisting that is all they can do. The murals' rich folk history and appreciation of black history subtly suggest even greater capacities.

In a way Biggers's murals are his own form of African drums. In Africa, he said, "when I heard the great drums call the people, when I saw the people

respond with an enthusiasm unequalled by any other call of man or God, I rejoiced. I knew that many of these intrinsic African values would never be lost in the dehumanizing scientific age—just as they were not lost during the dark centuries of slavery."[23]

CARROLL H. SIMMS

Carroll H. Simms of Houston has quietly developed an international reputation among some important sculptors and African art experts as a modern sculptor uniquely influenced by West African art and an unusual teacher. Studies that began at Hampton Institute have carried him to the Toledo Museum School, the Cranbrook Academy of Art near Detroit, and the Slade School and Royal College of Art in London. In England he studied with the leading British authority on African art, William Fagg. He also studied at the University of Ibadan and the Ife and Benin museums in Nigeria. He spent two years in Africa, studying not the aesthetics of its sculpture, but its social and religious background.

In Houston, where his sculpture is prominently placed, the city council has cited Simms for his contributions to its beauty. In Nigeria he designed a garden of sacred Yoruba pottery for the Institute of African Studies in Ibadan. In England the Bishop of Coventry commissioned a crucifix by Simms that was later unveiled by Princess Margaret. Yet despite such achievements, Simms is not well known in the United States.

The reasons for this are diverse. Most of his energies have gone into teaching and developing Texas Southern University as an art center. In addition, he considers pottery as important an art form as sculpture, denying that it is just a craft. In this, his stance resembles that of William E. Artis, a distinguished sculptor of the 1930s who turned to the creation of unusual and artistic pottery and teaching at Nebraska State Teachers College.

Simms's sculpture is modern, symbolic, and abstract yet influenced by the traditions of West African art. He has done joint commissions with John Biggers in the Houston area. In these Biggers's murals deal with homey, recognizable black American themes, while Simms's sculptures evoke the African heritage of African-Americans.

Carroll Harris Simms comes from the same traditional social and religious background of rural black life in the South as Biggers. He was born in Bald Knob, Arkansas, on April 29, 1924, the second child of Tommie and Rosa Hazel Harris Sims.[1] His father was a talented mechanic who preferred one *m* in his name and vanished before Carroll Simms's birth. His mother returned with her children to her parents' home. Affectionate, warm, and authentic in their deep Baptist beliefs, Carroll's grandparents taught him and his sister never to be ashamed of being black, picking cotton, washing, ironing, toting wood, praying, and calling on the Lord when troubled. "We were taught to be proud that we were Negroes . . . that the South was our homeland . . . that if we got an education, we should stay in the South afterwards and strive to better the condition of other Negroes by teaching them," Simms recalled.[2] His great-grandfather, a freed slave, was the first schoolmaster of the Bald Knob Special School for Negroes, which all following generations, including Simms, attended.

Simms's impetus to create started from watching his grandmother make quilts and embroider. His health as a child was "frail." He brought a box of remnants to school and during recesses in inclement weather would "piece a quilt pattern,"[3] pinning pieces together in a design. Bald Knob was a rail center and his first drawings, of locomotives and trains, delighted his grandparents. Later he believed that watching his grandfather make shingles with an ax was an important "germinating force . . . behind my wanting to be an artist."[4]

Hard times in Bald Knob prompted his mother to move her family to Toledo, Ohio, in 1938. A white teacher in the Scott High School, Ethel Elliot, encouraged Simms's interest in art. Through a sister who taught at Hampton Institute, she arranged a scholarship there for Simms in 1944. "Hampton was a cultural shock to me," Simms said. "I'd never realized Negroes had an ordered institution anywhere. Just to look at

Man the Universe (1975–76), Simms's soaring sculpture for the Science Building at Texas Southern University in Houston, "was inspired by certain Negro spirituals," he said. It contrasts sharply with John Biggers's *Web of Life* mural for the same building, which seems almost subterranean in its organic nurturing. (Cast aluminum, 30 x 9′)

the place was to see a beautiful holy city."[5] He learned for the first time that there were African-American artists, such as Charles White and Hale Woodruff. The Hampton choir's singing of spirituals has been his life-long inspiration.

When he tried painting, Simms found it frightening. "I never could sense what perspective meant by creating an illusion," he recalled. "When I picked up paint I'd handle it like clay—I'd push, as in sculpture. I poked holes in the first canvas I tried to paint."[6] He swore he'd never paint again. The ceramics instructor, Joe Gilliard, introduced him to clay modeling and the potter's wheel, and Simms moved into sculpture. He found Viktor Lowenfeld's approach to art through self-identification enormously helpful, bolstering his self-confidence. Through Gilliard he met John Biggers, who was then in the navy but returned to Hampton to paint. Their basic training in Lowenfeld's approach later provided a strong foundation for their work together in developing an art program at TSU.

In 1945 Simms entered Toledo University and simultaneously began art studies at the Toledo Museum School of Fine Arts. Its patron, Molly Lockhart McKelvey, helped Simms become the first African-American to hold a scholarship. His work interested some "art-oriented" women for whom his mother worked as a domestic. One, Alada A. Ashley, gave him his first one-man show in her living room. Another, Idine Ayers, was a friend of the director of the Cranbrook Academy of Art in Bloomfield Hills, near Detroit. She and Molly McKelvey helped him get a scholarship to that school.

Segregation forced Simms to live in a room over the embalming room of a black funeral home six miles from the school. He was often so disturbed by this situation that he slept in the woods. Knowing the distance he had to travel, sympathetic students drove him home every evening. One night they smuggled him into the dormitory. When school authorities learned of this and that nobody had been disturbed by it, they ended dormitory segregation.

At Cranbrook, Simms first became familiar with sculptural concepts from the Romantic movement and Auguste Rodin through the English sculptor Henry Moore, whose abstract studies of Londoners sleeping in subways during the Blitz had created a new interest in sculpture. His principal instructors in sculpture were Berthold Schiwetz and William McVey. His studies also included jewelry-making, silkscreen fabric design, and lapidary metalsmithing. He continued to study ceramics with J. T. Abernathy. Simms won first prizes in sculpture at the Toledo Museum exhibitions in 1948 and 1949.

Mother Earth (1948), massive yet somehow humanized, shows Simms's originality. (Terra-cotta, 30 x 14 x 18″)

Resting (1948), created while Simms was at Cranbrook, has an amusing coziness about it. (Terra-cotta, 18½ x 8 x 6″) Collection of the artist

Zoltan Sepeshy, the Cranbrook director, personally invited Simms to his home to meet important visitors, such as the painter Yasuo Kuniyoshi, the abstract sculptor Alexander Archipenko, and the writer John Steinbeck. Sepeshy "helped me to overcome my initial shyness and fear of these renowned men, and at the same time offered me the chance of learning a great deal from them," Simms said.

When, in 1950, an instructorship in sculpture and ceramics at TSU opened, McVey strongly recommended Simms. There he resumed his acquaintance with John Biggers. At the time black students at TSU were so poorly prepared in English that they could not understand basic sculptural terms. Simms used a doughnut to explain sculptural concepts of volume and space. He was then able to discuss work like that of John Flannagan, who used fieldstones that suggested animal shapes, and to talk about the appropriate uses of other materials, such as alabaster, marble, onyx, and steel. He also used the sun's creation of the shadow of a tree to explain the term *abstract*. "It would have been impossible then to communicate with students in academic terms. And we would have frightened away art students from the beginning if we hadn't been rurally oriented ourselves," said Simms.[7]

Simms joined Biggers and Joseph Mack in trying to win recognition for African-American artists—and status for the department. In 1952 he took first prize in silkscreen textile design at the Dallas Museum of Fine Arts; he also won its first prize in jewelry in 1953. He also won Cranbrook's purchase prize in 1953. These prizes helped change the attitude that black people had no aesthetic talent. Texans had not associated African-Americans with prize-winning jewelry.

Awarded a two-year Fulbright grant in 1954–56, Simms studied at London's leading art school, the Slade, under sculptors F. E. McWilliam and Reginald Butler, as well as the school's head, Henry Coldstream. He also studied at the Royal College of Art, the Central School of Arts and Crafts, and the Morris Singer Bronze Foundry, where he worked as an apprentice to one of the most provocative sculptors of the twentieth century, Jacob Epstein. Several of Simms's own works bear witness to Epstein's impact, most notably *Prophet and Son,* a warm but severe work of carved walnut.

Simms often visited the British Museum's display of Ashanti gold weights and carved ivory, most of which depicts animals. One day a man introduced himself because he had observed Simms's close examinations. He was William Fagg, one of the world's leading authorities on African art. On learning Simms was an American sculptor, Fagg took him to his museum office, served tea, and began an intensive tutorship in African art, which continued throughout Simms's stay. Fagg took Simms to the basement of the museum to show him still uncataloged collections of African sculpture. From Fagg, Simms gained an unusual education in the art of all regions of Africa.

Fagg also pointed out what two other sculptor friends, William McVey and the noted Jacques Lipchitz, had told Simms—that his own head was "pure Benin."[8] Years later, when Simms visited Africa, he was presented to the *Oba* (king) of Benin, who looked at him with an amused smile. Simms was later told that the Oba was amused because this African-American looked like him. Sometime after his return to the United States, Simms created a bronze *Homage to a Shrine,* which is now in the Oba's palace. A two-piece work, it has the character of a sacred Benin work.

While his Slade studies gave Simms insight into the most modern sculpture in Europe and America, his work with Fagg greatly enhanced his understanding of African mythology and how it might be used in teaching and in his own sculpture. Interestingly, Simms and Biggers avoided showing slides of Benin, Ibo, Nok, and other African sculpture to students initially lest the students merely imitate these works without understanding and developing the creative processes that produced such classics. Simms didn't want his sculpture students "to depend on a school or fashion as sometimes happens with young art students exposed to Cézanne or Van Gogh. . . . They then know nothing other than to emulate the master." He and Biggers wanted their students' art to develop from their individual identification and feelings.

Homage to a Shrine (1970) evolved from Simms's study in Benin and other African countries of shrines, which are composed of various elements and may represent prayers for fertility or ample crops. Cast in bronze in Mexico, this work now rests in the palace of the Oba (king) in Benin. (Bronze, 27¼″ x 7½″ x 4′)

Christ and the Lambs, created for St. Oswald's Church, Tile Hill, Coventry, England. The Christ, a severe gaunt figure from which the cross has been eliminated, may be seen from the nearby highway. The lambs, designed to go at its feet, have not yet been cast for lack of funds. (Hammered bronze, 9' h.)

To stimulate such identifying processes, Simms encouraged students to find themselves in the character traits of various animals, birds, heroes, and insects in African folklore and mythology.[9] He then suggested they make symbolic representations of their own characters, using the African creatures. In this fashion students were free to deal with their own feelings about themselves, their aspirations, and how they wanted to deal with the world. All students were required to create self-portraits with symbolic headpieces based on African folklore. One young woman designed a crown consisting of a beetle (representing the fertility of life) on a turtle's back (timelessness). Her self-portrait, said Simms, "looked like that of a member of some royal family."[10]

Simms's sculpture moved steadily away from the realistic to the symbolic and abstract. In his first joint commission with Biggers, for the Eliza Johnson Home for Aged Negroes, Simms had created a wrinkled but strong couple, seated side by side, fishing. It gave no hint of the imaginative character his work later developed.

Simms's gift for the symbolic revealed itself in the crucifix designed for the wall of the then new St. Oswald Church at Tile Hill, Coventry, England, commissioned by the Bishop of Coventry, Neville Gorton. In that work Simms eliminated the cross itself, letting Christ's outstretched arms become the cross. The nine-foot figure of Christ is severe and elongated. "I wanted it to have meaning as a Negro crucifix," said Simms. "Christ symbolizes both himself and the cross. . . . [I wanted] to make the whole image one: Christ *and* the cross."[11] One arm is raised more sharply than the other and the rib cage is starkly emphasized; it is that of a starving man. Carried out in hammered bronze, with lambs at the feet of Christ, this is a strong work.[12] Simms credited his inspiration to hearing the Hampton choir sing Nathaniel Dett's arrangement of the spiritual "Listen to the Lambs."

Profoundly religious, Simms draws on the spirituals for inspiration but never in an obvious, literal way. For the TSU science building, Simms created a soaring, winged aluminum figure that appears to be moving toward circling planet rings. He describes it as a high-relief sculpture "with conventional, geometric and organic forms inspired by certain Negro spirituals."[13]

Water Angels (1960). The direct opposite of his massive works, the delicacy of this sculpture delighted Simms, who constantly experiments with new materials—in this case, clear Plexiglas. (Plexiglas, 3½′ x 8″ x 9″) Collection Jane Laffer Owen, New Harmony, Ind.

Woman with a Bird (1959), a fountain that feeds a pool, reflects Simms's willingness to depart from conventional concepts in an expressive manner. (Bronze, 3′ x 20″) Collection Mr. and Mrs. Philip Reichenbach, Houston

The African Queen Mother (1968) is composed of symbolic elements from African folklore. It "depicts sacred traditional life in Africa and aspects of African religious tradition in the New World," according to Simms, who also designed the circular reflecting pool in which it sits before the Martin Luther King Center of Communications at Texas Southern University. (Bronze, 12 x 4 x 17′)

Many of his works in Houston are fountains. *Woman with a Bird* is a three-foot-tall bronze abstract fountain at the University of Houston. *Jonah and the Whale* is a six-foot bronze symbolic of the biblical story.

Simms likes to work with different materials. He created a stained-glass window, *The Doves and the Sacrament,* for a private chapel, and used Plexiglas for a mural, *Longshoremen,* for the union hall of ILA Local 872 in Houston. For the Dowling Veterinary Clinic, he created a colorful Plexiglas mural of monkeys, crocodiles, and other African animals.

One of Simms's major works is *The African Queen Mother,* some twelve feet tall and seventeen feet long, designed to rest in a reflecting pool before the Martin Luther King Humanities Building at TSU. Although seemingly abstract, the sculpture is composed of many elements from African folklore. The composition is based on a reclining female figure, with her legs in front of her and arms outstretched. Her arms, out-

stretched upward, magically become her breasts. In one hand she holds a star, while her face geometrically symbolizes the cycles of the moon. Her lower torso is symbolic of a spider, which in Ghana's folklore gave all knowledge to humankind. She rests on the form of an alligator, and if one looks more closely, the entire figure rests on a beetle, which in Egypt was symbolic of the fertility of life. In part this work was inspired by an African folk story. In it, crocodiles formed a bridge for peaceful villagers to escape intruding warriors. When the warriors tried to follow, the crocodiles submerged, drowning the intruders. They then surfaced to permit the villagers to return home safely.

Simms went to Nigeria in 1968–69 to discover for himself the social and religious significance of African sculpture, something he had often discussed with Fagg. He made another trip in 1973. He had long regarded

A Garden of Ancient Yoruba Pottery was created by Simms in 1968 by invitation at the Institute of African Studies, University of Ibadan, Nigeria. Simms was delighted to find that in Africa pottery is considered as important artistically as sculpture. Both are held to express proverbial wisdom.

ceramics the equal artistically of sculpture and considered the designation of one as a craft and the other as art to be false. In Africa he was delighted to find that Akinsola A. Akiwowo of the University of Ibadan and Nigerian museum officials do not use the word art. Instead, they instructed him to call either sculpture or pottery a "sacred object" or an "antiquity." These officials would be designated "curators" in American museums, but in Nigeria they are called "custodians of tradition and culture" and rank as priests.[14] In West Africa, Simms found, "all of what we'd call 'sculpture' exists for a purpose. In the United States we open our King James Bible to find chapter and verses. There, when you look at a carving or even at some 'sacred hill' or 'sacred tree' on the landscape, you will find the proverbial wisdom of the ancestors."

Looking back, Simms identified three major turning points in his development. "First, the realization of certain permanent values, which relate to the integrity of my grandparents, inclusive of the church folk and neighbors surrounding the environment of my early childhood; second, studies at the Toledo Museum of Art, Hampton Institute, Cranbrook Art Academy, and in Africa and Europe; third, working at TSU and at the same time being allowed the privilege of creating art for the community." He spoke poetically of his discovery of his interest in sculpture and art "as the result of agriculture: the symphony of folklore—remembering the fable and poetry of the rainbow, the continuity of seasons, the forms, shapes, and colors of planting and harvest—the carving and tempering of farm tools—quiltmaking, sewing, and embroidery—to wash, to cook, to share in the disciplines of domestic order—and during childhood, having learned through worship a reverence for creation: genetically, a search for form and imagery was inspired."

Of his English and African studies, Simms said further, "The silent language of searching remains enhanced, aesthetically richer, of purpose and humanity." He finds beauty in the "struggle of man's existence

Shrine (1981) inspired by Simms's studies of the religious and cultural context of African art, has a massive character very unlike Western religious shrines. The bulging shapes on its top are sunfish and those on its side, a mother goose and gosling (shown below in detail), symbols of resurrection in African folklore. (Bronze, 3' x 6' x 20") Sculpture Garden, New Harmony, Ind.

because the gift of life is sacred and significant. Creative expression is worthy and symbolic of this truth." For him, art is "the universal spiritual force that makes the dignity, the heritage, and origin of black culture inseparable from all existence."

Simms retired from teaching in 1987 and went to England for a new look at its African collections and the work of its sculptors. Since then he has renewed his interest in jewelry design, especially its three-dimensional aspects. He has also been developing a figure of Saint Augustine and working on pottery. "I have always loved pottery as much as sculpture. This has shocked some friends, people with whom I trained, but I see it as something that can be a beautiful statement of man's presence on earth," Simms said.

He deeply regrets, however, not being able to set up a small foundry at TSU. "I spent a year learning to make castings at the Morris Singer foundry in London as Jacob Epstein's apprentice," he said. "I wanted a foundry to teach students how to cast small figures, eight or nine inches high, so they would understand

what their African ancestors achieved centuries ago. But I never got the support to do this and I still regret it."

Simms's own work binds him in a deeply satis-fying and religious way to his African ancestors and the needs of African-Americans today. He is, imaginatively and aesthetically, at one with himself and the world and all its creatures.

Guitar Solo (1981) was originally created in plaster and wood. Simms added elements to this abstract work that heighten its relationship to music. Commissioned by Mrs. Susan M. McMashan, Jr., for the lobby of the Houston Music Hall, it suggests both music and power. (Bronze, 11 x 4 x 2')

ALMA W. THOMAS

Alma W. Thomas began a new life as an artist when she retired after teaching art to black children in Washington, D.C., public schools for thirty-five years. Her canvases consist of thousands of small, irregular but usually rectangular spots of color, resembling tesserae, the small mosaic pieces used in Byzantine art. While tesserae may be used to create forms, in Thomas's work no recognizable image emerges. Instead, these accumulating strokes of color create vibrant, orchestrated stripes and circles, with color contrasts and harmonies of varying weight and density. The interplay of these colors causes resonating afterimages. Working with great precision, Thomas made color itself the qualitative element; it was not a decorative additive to form.

Alma Thomas's paintings belie her horse-and-buggy beginnings in Georgia before the turn of the century. Her work is sophisticated and modern, unsentimental, bright, provocative and evocative. It dances and sings. It established her as a major talent, at age eighty, when she was given one-woman shows at the Corcoran Gallery of Art in Washington and the Whitney Museum of American Art in New York. Critic Harold Rosenberg wrote that her paintings "brought new life to abstract painting in the 1970s."[1]

Inspired by the flickering leaves and flowers in her garden, memories of sunlit flower beds in childhood, and the astronauts' new spatial vision of the universe, she was nearly eighty years old when, despite arthritis and a failing heart, she concentrated on what she could do with only one intense color. She began adding curving wedges amid her rectangles, gaining a new lyricism in rhythms and space. She kept moving with new ideas. "I'm still developing," she said.[2]

Although considered a Washington Color Field painter and influenced by her friends Morris Louis, Kenneth Noland, and Gene Davis, Thomas was never drawn into their emphasis on technique and rigid formality. Instead, adapting the circles of Noland and stripes of Davis, she developed her own expressive and evocative style in a distinct contribution to the whole movement. Robert Doty, director of the Akron Art Institute, emphasized that color is "the catalyst for the emotions and sensations which her work transmits. She makes her colors expressive through an acute awareness of the vast range of value in color and the rhythmic course and flow of segments laid out on the canvas."[3] In his view Thomas continued the "strong expressionist tradition of American painting in the twentieth century," beginning with Arthur Dove and John Marin and continuing through Mark Rothko, Clyfford Still, and Adolph Gottlieb.

Thomas's paintings are in the Metropolitan Museum of Art, the Corcoran, the Whitney, the Hirshhorn Museum and Sculpture Garden, the Phillips Collection, private collections, and the collections of such colleges and universities as American, Fisk, Howard, George Washington, Georgetown, Iowa, and Tougaloo. The largest group of her paintings is held by the National Museum of American Art in Washington, D.C.

Yet such recognition hardly conveys the spirit that energizes her work. Joshua C. Taylor, the director of the National Museum of American Art, liked to keep one of her paintings, *Wind and Crepe Myrtle Concerto,* in his office. He came "to depend on the special pleasures of [its] bright and buoyant painting, radiating a remarkable gaiety and freshness. . . . In a magical way this frankly painted canvas was slyly evocative, storing up all manner of happy visual memories, and yet remained very much itself, a decorative painted surface of uncompromising flatness." Taylor concluded: "Alma Thomas was an artist, and I have long since come to realize that the qualities of joy and discovery that animated her provocative painting were hardly just a matter of artistic stance. They have, from the beginning, been basic toward her whole attitude toward life and art."[4] He had this painting in his office when he died in 1981.

A small woman who did her painting in her kitchen, Alma Thomas loved to dress in colorful,

fashionable clothes, an enthusiasm inherited from her mother. She rarely missed a museum or gallery opening. She was "Washington's very own artist," wrote her friend Adelyn D. Breeskin, an expert on contemporary art, and "stood out in a crowd because of her natural presence and her spontaneous enjoyment of festive occasions."[5]

Three years after Thomas's death in 1978 the National Museum of American Art developed a major exhibition of her work planned by Taylor and organized by the curator Merry A. Foresta.[6] This show was later presented at the Columbus Museum in Georgia, the Huntsville Museum in Alabama, and the Studio Museum in Harlem.

Although she often wryly contrasted her museum honors with her segregated Georgia childhood when "the only way to go in there [the library] as a Negro would be with a mop and bucket,"[7] Thomas determinedly ignored racial prejudice in terms of its stopping her. She was independent and iconoclastic, absorbed in a search for quality and dedicated to helping young black artists. As a founding vice president of the Barnett-Aden Gallery in Washington, she helped many young artists gain recognition. Her advice to them was to "get in the mainstream."[8] Her gallery activities were also very important in her own artistic development; she learned from everything she did.

Overcoming the barriers of being black, a woman, an artist, and growing old, she believed: "Creative art is for all time and is therefore independent of time. It is of all ages, of every land."[9]

Alma Woodsey Thomas was born in Columbus, Georgia, on September 22, 1891. She was the oldest of four daughters born to John Harris and Amelia Cantey Thomas. She was born with impaired hearing, which her mother always blamed on being frightened during pregnancy when a lynching gang came up the hill near their home with ropes and dogs. Then, recognizing her husband as one of the most respected black people in Columbus, they went away.

The Thomas family lived in a large, comfortable, middle-class home atop a hill, surrounded by trees, spacious gardens, and flower beds. Alma Thomas's father was a successful businessman and her aunts, who were schoolteachers, brought professors from Atlanta to visit. Sometimes Booker T. Washington came. Getting an education was the family's main concern. Summers were spent at the maternal grandfather's large cotton plantation, located next to his white brother's plantation, across the river in Alabama.

The beauty of nature enchanted young Alma. Her mother had a great love of color, made their clothes, and introduced Alma to creative work, painting flowers on black velvet—then a national hobby among women.

However, despairing over race riots in Atlanta in 1906, and believing their daughters could get a better education in Washington, the Thomas family moved in 1907. When the family was about to cross the Potomac River, she and her sister took off their shoes at the suggestion of their parents and knocked off the dust and sand of Georgia to begin a new life, she told David Driskell years later.[10] They then settled in a small house in the northwest section, where Alma Thomas and her younger sister, named John Maurice in honor of their father, lived for the next seventy years.

At Armstrong Technical High School, Thomas excelled in mathematics and science and talked of being an architect. A "modern" schoolhouse she designed was exhibited at the Smithsonian Institution in 1912. She felt the high school's art room was beautiful— "just like entering heaven."[11] She studied sewing, millinery, and cooking—all courses in which she could make things. Later at Miner Teachers Normal School, feeling outclassed by girls verbally more expressive than she was, she studied kindergarten teaching. She then taught arts and crafts for six years at the Thomas Garett Settlement House in Wilmington, Delaware, making costumes for children's carnivals and circuses and staging puppet shows.

Thus began a lifetime of teaching children to make things, to enjoy fantasy, color, play, and themselves. Her master's degree thesis at Teachers College, Columbia University, was on the use of marionettes, which attracted her because they permitted the expression of inhibited feelings. She directed many marionette shows at Shaw Junior High School in Washington and in 1935 studied with Tony Sarg, the world's great master in that field. In this lifetime of teaching, her emphasis was on helping children enjoy their own abilities and imagination.

After teaching in Wilmington, Thomas decided to study costume design and entered Howard University in 1921. There she met Professor James V. Herring, who induced her to give up costume design and become the first student in his new art department. Because she had made puppet heads, what attracted her most of all was sculpture. She made a number of small statues, mostly copies of classic heads, but also some Cubist-styled modern works and original heads of children.

Thomas's painting at the time was academic and undistinguished. However, having already worked as a teacher for six years, she was not a docile freshman, but a questioning, challenging one. "Our initial encounter," Herring later wrote, brought together "a

youthful teacher, pontifical and omniscient, and a young student, opinionated and not less omniscient. This beginning has given vivacity, character, and richness to an association which has endured."[12]

There is no doubt, as Breeskin has pointed out, that "Herring was a person of very high artistic standards, which he passed on to Alma and which she upheld through her entire professional career. He was, moreover, a man with an exceptionally wide range of knowledge about art, modern as well as traditional."[13] Thomas's continuing relationship with Herring was critical in her development over a very long period of time—roughly fifty years.

Upon graduating, Alma Thomas became an art teacher in Shaw Junior High School in Washington, where she taught black children, something she greatly enjoyed.

During these years she continued to paint, especially in watercolor, a medium for which she had a great affinity. Herring and Lois Mailou Jones, who had become an instructor in design at Howard, stimulated her efforts. During summers she went to New York, where she visited the Metropolitan and other museums to see the Western classics and Byzantine and Asian art. She also saw the work of pioneering modern European and American painters in Alfred Stieglitz's and other galleries. Her growing knowledge of these modern artists gave her a sense of their vitality and expressiveness. Yet, although her skill increased, her own painting continued to be quite traditional. In 1939 she won first prize in a Department of Commerce exhibition.

The most important development in Thomas's career—"pivotal," said her curator friend Adelyn Breeskin[14]—came in 1943, when Herring asked her to join him and Alonzo Aden in establishing the Barnett-Aden Gallery, the first private gallery in Washington to break the color line. She became the gallery's vice president. This was no mere formality. She participated in discussions with Herring and Aden on all aspects of contemporary American art, including which artists to show, and the issues raised earlier by Thomas Hart Benton, the Social Realists, and the abstract artists. She also met a continuing stream of well-known artists, studied their work, and became well acquainted with Washington's art circles, gallery owners, curators, and critics.

Herring insisted on their seeking and showing new work of high quality regardless of race or whether the artist was well known. With its impressive group shows, the Barnett-Aden Gallery became one of the first Washington galleries to exhibit modern American art, and this approach permitted the appropriate introduction of the work of relatively unknown black artists. These shows demonstrated that African-American artists' work would stand comparison with that of leading artists. Discussion of artists' work and the process of making selections for group shows put Thomas in a front-row seat during the dramatic transition of American art from the symbolic naturalism of the Depression to Abstract Expressionism.

Thomas experienced much of this transition personally as an artist. In 1946 she had joined the "Little Paris" group formed by Lois Mailou Jones and her friend Celine Tabary. Composed principally of black public school teachers and government employees, the group sketched and painted together, criticized and analyzed their progress, and exhibited together—all of which reinforced their desire to paint. Mutual support also helped its members cope with the discouraging attitude toward black artists then dominating Washington art galleries.

In 1950 her "Little Paris" activities prompted Thomas to study painting at the American University with Joe Summerford and Robert Gates. The abstract work of other students fascinated her: "The first time I was there, when they put a still life before me, I tried to paint it just as it was. When I looked in another room . . . they did not copy anything that was set before them."[15] Summerford held that a painting should be constructed "out of paint," meaning its compositional balance and tensions should be created by color and shape—not by how realistically something was depicted. Thomas presently began to introduce abstract areas of color into her representational work, as *Joe Summerford's Still Life* indicates.

She also began to utilize the Cubist-derived concepts of such modern European masters as Georges Braque and Pablo Picasso and the flatness of Henri Matisse, approaches that Lois Jones had often discussed. By 1954 Thomas was painting in the flat modern style of these artists. As the Abstract Expressionist movement gathered momentum in the wake of recognition of Jackson Pollock, Willem de Kooning, and Franz Kline, discussion of one of its basic concepts—uninhibited "action painting"—among advanced painting students further loosened her ties to representation.

In 1957 she studied at the American University with Jacob Kainen, a leading expressionist painter of the 1930s, a pioneer WPA printmaker, and later curator of drawings and prints at the National Museum of American Art. Surprised to find Thomas was "an artist, not a student," he encouraged her to paint in swatches of color, which increased her confidence in her ability to utilize color alone in creating a painting.

Joe Summerford's Still Life Study (1952) marks the beginning of Thomas's career as a serious painter. She was sixty years old when she began studies with Summerford at the American University in Washington, D.C. Although representational, this complex painting shows her tendency to turn to flat modern abstraction. (40 x 28") Hirshhorn Museum and Sculpture Garden, Washington, D.C.

Kainen was impressed by what he called Thomas's "non-sensibility" colors, defining them as colors "in which tonalities are sacrificed to obtain brighter, tougher relationships" than those derived from the "sensibility" colors seen in nature.[16] Yet Thomas was not yet prepared to abandon representation altogether. In Europe in 1958 with a group of Temple University art students, she produced the bustling *A Wharf at Rotterdam,* a painting that achieves its exploding de Kooning–like tensions with linear thrusts set against thick, scumbled white, cloudlike shapes and bright background colors.

Kainen brought many Washington painters to her home to see her work. She became personally acquainted with Louis, Noland, and Davis of the Wash-

ington Color Field group. Growing out of Abstract Expressionism and the work of Josef Albers, these artists organized canvases of pure color in stripes and circles. Unlike the splashy, emotional effects of the Abstract Expressionists, the Color Field painters' canvases were created with great precision, using meticulous staining techniques that allowed each section of color to hold its purity. They used masking tape to give their work its "hard edge." As an artist with a particular sensitivity to color, Thomas was influenced by these artists' ideas in organizing geometrical compositions of pure color—but not at all by their techniques. She proudly asserted she did not use masking tape but penciled in her small rectangles and wedges.

Thomas was still assimilating all these influences when, in 1960, she retired from public school teaching and turned to what she called "serious painting." She had already exhibited with the "Little Paris" group for ten years and in many Barnett-Aden group shows with well-known artists. A brilliant watercolorist, she would make as many as twenty watercolor studies in preparing an oil painting. And it was with watercolors that she made her solo debut as a professional artist. Her exhibition, at the DuPont Theatre Art Gallery under Barnett-Aden sponsorship, was an immediate success.

At this time some of Thomas's paintings were dark and semi-abstract, predominantly blues and browns worked with both palette knife and brush. Foresta considered that in some of these paintings "a transcendental feeling is tied to a specific religious theme."[17] Among these "blue abstractions," which she first began in the mid-1950s, are *Flight into Egypt* and *Two Women Approaching the Cathedral.*

However, these themes gave way to brighter colors and to a greater interest in abstraction based on colors in nature. Thomas sometimes experimented with the "hard edge" favored by some Color Field artists, as in *Watusi (Hard Edge),* now in the Hirshhorn Museum.

About this time Thomas discovered *The Art of Color* by the Bauhaus artist Johannes Itten, and intensively studied his ideas, carrying out his exercises in watercolor.[18] She liked to quote Itten's assertion: "Color is life; for a world without color appears to us as dead. Colors are primordial ideas, the children of light."

Severe chronic arthritis increasingly handicapped Thomas, and for two years, in the mid-1960s, she was hardly able to work. Indeed, she thought she would never paint again.[19] Young black artists, among them David Driskell and Sam Gilliam, Jr., who were aware

Watusi (Hard Edge) (1963). Thomas experimented in this work with the balancing of form and color and the overlapping of shapes. Most Washington colorists used masking tape to achieve "hard edges" to their shapes, and presumably Thomas did so in this work. The title, referring to the tall African people, is perhaps related to the verticality of the work and her own heritage. (Acrylic on canvas, 47⅝ x 44¼") Hirshhorn Museum and Sculpture Garden, Washington, D.C.

of the unique character of her work, encouraged her with their visits and discussions. When James A. Porter asked her to assemble a major retrospective show for Howard University's Gallery of Art in 1966, Thomas saw his invitation as an opportunity to "paint something different from anything I'd ever done. Different from anything I'd ever seen. I thought to myself, That must be accomplished."[20] She credited Paul Cézanne's unfinished painting of a landscape in the Phillips Collection with giving her the idea of using color to structure a painting.

To meet this challenge, Thomas evolved the specific style now recognized as her signature—playing color against color and over color with small, irregular rectangular shapes of dense, often intense color. She called these works "Earth Paintings" because they were inspired, she said, "by the display of azaleas at the Arboretum, the cherry blossoms, the circular flower beds, and the nurseries as seen from above by planes . . . and by the foliage of trees in the fall."[21] Although she had never flown at that time, she told Eleanor Munro, "I began to think about what I would see if I were in an airplane. You look down on things. You streak through the clouds so fast you don't know whether the flower below is a violet or what. You see only streaks of color. And so I began to paint as if I were in that plane."[22]

At the same time, and indeed since childhood, she had been fascinated by the way the leaves of a holly tree outside her living room window fluttered in the breeze, admitting and interrupting light, creating bright spots and then shadows on her floor. She was inspired by "leaves and flowers tossing in the wind as though they were singing and dancing . . . and the rays of sunrise flicking through the leaves, which add joy to their display."[23] Although she titled her paintings realistically—*Alma's Flower Garden, Spring Flowers near Jefferson Memorial,* and *Azaleas' Spring Display*—the works were wholly abstract organizations of pure, intense color. She liked to call them "Alma's Stripes."

Her work does not have the impersonal character of other Color Field painters. Instead of using masking tape, which enabled these painters to achieve their precise lines, eliminating the feeling of personal expression, Thomas first penciled in her mosaiclike, irregular rectangles, in order not to get lost in the pattern while doing the color work, and then deftly and precisely painted each one. This gave her work an expressionistic character that impressed critics and artists. Jacob Kainen, who knew of Thomas's study of European abstract artists, revealed the diversity of influences involved. "Miss Thomas certainly drew some of her basic ideas from Noland and Davis," he wrote, "but she also studied the work of Dorazio [an Italian artist noted for vibrant intersecting stripes and bars of color], Capogrossi [another Italian, who developed a hieroglyphic archetypical sign repeated in many backgrounds], Nay [a German Expressionist who turned to abstraction] and the French tachists" (who developed a way of painting similar to the "action painting" of the Abstract Expressionists).[24]

In 1970, excited by the astronauts' vision of the world and its universe, Thomas carried out a series of "Space Paintings," in which she used deeper and hotter colors to express the energy required to leave the earth. *Snoopy—Early Sun Display on Earth,* for example, is "made up predominantly of blue strokes . . . the paintings' circular form resembles a magnificent fantastical sun rising upon the world and growing more radiant at the edges as the sphere dissolves through the spectrum toward orange and yellow."[25] In *The Eclipse* waves of color radiate outward from a dark, solid blue sun, which is not centered but eccentrically placed to emphasize the passing moment of the eclipse. As

Snoopy—Early Sun Display on Earth (1970) was inspired by the Apollo space explorations, which created a new view of the planet Earth. The painting is made up primarily of blue strokes, growing more radiant with orange and yellow at the edges to suggest the rising sun. The title, from the "Peanuts" comic strip, reflects Thomas's playful abandonment of the conventional for a new view of color and form. (Acrylic on canvas, 50 x 48″) National Museum of American Art

Foresta has noted, "Much of the power of Alma Thomas' painting lies in the unevenness of the brushwork and the irregular size of the divisions of paint," as a result of which the surfaces of her paintings quiver "with pauses and accents, spaces, and presences."[26]

In April 1972, when she was eighty years old, Alma Thomas achieved her first museum recognition at the Whitney in New York, followed by a much larger show that fall at the Corcoran Gallery of Art in Washington. Later she had exhibitions at the Martha Jackson West Gallery in New York, at Fisk University's Carl Van Vechten Gallery, and at the Franz Bader Gallery in Washington. Critics and museum visitors accustomed to the quaint, nostalgic canvases of elderly folk artists were stunned by the brilliance of her work.

Although delighted with her success, Thomas was still tormented with chronic arthritis. One day she asked Adolphus Ealey, who had assumed responsibility for the Barnett-Aden collection, "Do you have any idea of what it's like to be caged in a 78-year-old body and to have the mind and energy of a 25-year-old? If I could only turn the clock back about 60 years I'd show them. I'll show them anyway."[27]

Increasingly, Alma Thomas turned from multicolored canvases to ones in which she concentrated on the power of a single color. *Antares,* with irregular flicks and specks of white flashing between textured strokes of a striking, rich red, was only a beginning. In that painting she continued her absorption with the ragged rectangles. A year later, she added intense blue wedges to her vertical rectangles on a white background. She also introduced flowerlike swirls that gave new accents to her canvases.

After that Thomas used abstract swirls freely to represent flowers, giving her paintings titles like *White Roses Sing and Sing* and *Scarlet Sage Dancing a Whirling Dervish.* In *Wind and Crepe Myrtle Concerto,* she painted over golden and graying grounds, instead of the usual white, with many subtle colors, using soft-edged strokes to arrive at a lyricism not achieved earlier. In *Hydrangea Spring Song,* using only blue and white, she created "a great wall covered with powerful calligraphic messages. Its blue and white simplicity has an Oriental finesse, re-echoed where the open areas link to the overall pattern with only a few broken shapes," wrote Foresta.[28] In the "Music Series," Thomas's arrangement evoked the polyrhythmic beats, pauses, and chords of sophisticated jazz.

Despite her disabling arthritis and growing aortic insufficiency, which often kept her in bed, she would rouse herself to work on large canvases in her kitchen and living room. According to Foresta, she often worked with one end of a large canvas in her lap while the rest of it was balanced against a sofa, absorbing the

452

Grassy Melodic Chant (1976) marked a new development in Thomas's vision. Her rectangles became many kinds of shapes which clustered in rhythmic patterns that differed and yet were the same. (Acrylic on canvas, 46 x 36″) National Museum of American Art

weight of the wooden canvas stretcher against her leg. Unable to back off in order to view her canvas from a distance, she simply kept turning the canvas to reach its unfinished areas.

In this fashion Thomas completed her largest work, the three panels of *Red Azaleas Singing and Dancing Rock and Roll Music,* one panel at a time. She was unable to view the whole work until it was completed. This large work begins with intense red shapes tightly clustered on a white ground, in the left panel, then progressively opens up so that its enlarging white spatial areas create new patterns and rhythms in the third panel.

Foresta summed up Thomas's achievement in this way: "If the paintings have a greatness of spirit and if their delightful and exuberant color and pattern convey a sparkling vitality and a *joie de vivre,* they also testify to the integrity of the artist's commitment to the vision of art that sustained her all her life."[29]

Earlier, in the 1960s, Thomas found time to participate in community programs dedicated to raising appreciation of black achievements, especially among black children. She joined Martin Luther King's March on Washington and made a series of paintings inspired by it. Although she ignored suggestions that she paint black subjects, she refused, as Ealey put it, "to recognize any ceiling whatever to black potential, particularly when it came to art."[30] She was fond of saying, "We artists are put on God's good earth to create. Some of us may be black, but that's not the important thing. The important thing is for us to create, to give form to what we have inside us. We can't accept any barriers, any limitations of any kind, on what we create or how we do it."[31]

In June 1977, in recognition of her achievements, Alma Thomas was invited to the White House by President Jimmy Carter. Then eighty-six years old, she had achieved more critical praise and museum attention than most American artists.

Her health was fragile. She died on February 24, 1978, while undergoing open heart surgery at Howard University Hospital.

Alma Thomas shattered many stifling attitudes—about being black and a woman, about old age, about color, about starting late, about teaching. "I have always enjoyed the progressive creativeness of the artist as he releases himself from the past," she wrote when Fisk University honored her in 1971 with a major show—before the art world discovered her.[32]

Color offered her a way to grow.

ED WILSON

With a freedom and imagination as modern as the conquest of outer space, Ed Wilson seeks to make a universal statement on the human condition. Rather than offering the massive volumes favored by many modern sculptors, his style is distinguished by rhythmic figurative forms set in oblique tension. While expressive and symbolic, his figures are not bound to a search for an idealized image as in Classical Greek, Benin, and other archetypal forms. Instead, there is a feeling of movement and a personalized feeling for what Wilson is saying through his sculpture. He is a romantic visionary, allegorical and free in a baroque sense. His humanistic vision is supported by a deeply felt philosophy, drawn from his experiences as an African-American and integrated with his aesthetic studies and insights.

Wilson is primarily a modeler, whose initial conventionality gave way to a richly expressive figurative style. Constantin Brancusi once said that when he started to do sculpture, he did not attempt to deal with the essence of forms, as he did later in famous works like *Bird in Flight*. Such simplicity may evolve, he said, once an artist has developed an understanding and complete control of his forms. Similarly, once Wilson achieved a complete knowledge of his forms, he no longer needed to spell out every detail in his work to reflect the bitter truths and great hopes of human experience.

Ed Wilson was born in Baltimore on March 28, 1925, to Edward N. Wilson, registrar of Morgan State College, and Alice McCabe Waring Wilson, previously a schoolteacher. Three years earlier a daughter, Frances, had been born. The Wilson family was urban, middle-class, and strong in its belief in education, although very much aware of the social, political, and economic world outside the college. Ed Wilson's parents always taught him that there was something more to life than the academic stepladder. Yet since his father was the college registrar for forty-two years—while presidents, trustees, new concepts and concerns came and went—he came to recognize that an academic institution provided a base for thought, reflection, and stimulation in preparation for participation in the broader social and artistic struggles of our time.

Wilson's artistic career budded between seven and ten years of age, when he was kept out of school by rheumatic fever for one year and then severely restricted in his activities. At home he occupied himself with creating cardboard models of towns—houses, stores, churches, factories. On returning to school, he drew and painted with skill, much encouraged by his art teachers. His father, worried about a black artist's economic difficulties, oriented him toward civil engineering and architecture. In 1943 he was accepted for studies in these subjects at the University of Iowa.

However, before he could begin, he was drafted. In the U.S. Air Force, he was assigned to a "housekeeping" unit commanded by a highly prejudiced officer. Taking a dislike to Wilson and another black soldier, this officer gave them only menial tasks. He denied Wilson's many requests for officer training school, radar and radio schools, or transfer to the infantry or paratroopers. A bitter struggle went on between this officer and these two GIs first in Georgia, then in Mississippi, and finally in the China-Burma-India theater. When the officer was at last rotated home, he told Wilson that he had been kept in the unit "to teach me a lesson."

These experiences, plus exposure to the oppressive segregation under which black Mississippians and Georgians lived, made Wilson feel there was no future in becoming a black architect. His military experiences made him decide that if he had one life to live, he wanted to be an artist. In 1946 he entered the University of Iowa under the GI Bill, enrolling in its studio art course, which had been initiated by Grant Wood some years earlier.

The new department head, Lester Longman, had

abandoned the focus on American Regionalism—the style that Wood had developed with Thomas Hart Benton and John Steuart Curry. Instead, Longman introduced concepts from modern art and brought to the campus several avant-garde artists from New York—James Lechay, Eugene Ludins, and Humberto Albrizio—whose expressionistic and abstract concepts greatly stimulated Wilson and other student artists.

Wilson began as a painter. However, after mastering the fundamental craft problems, he found himself dissatisfied because painting had to treat space illusionistically. He recognized that his perceptions, both real and imaginary, were always three-dimensional, concerned with depth, volumes, and masses. Encouraged by stories he heard of the black sculptor Elizabeth Catlett, who had studied under Grant Wood, he switched to sculpture. He found carving particularly satisfying and rapidly achieved a high level of competence. Although fascinated by African art, he could not relate it to his personal experiences and eventually turned to jazz "to find a sense of aesthetic-emotional balance between the black American experience and white American social reality."[1]

During this period Wilson married and became a father. On obtaining his master's degree in 1953, he began teaching art at North Carolina College (now North Carolina Central College), a black liberal arts college in Durham. There Wilson met and was greatly encouraged by William Zorach, a leading American sculptor, who had come to Durham to complete a memorial commission. Always sympathetic to the poor and oppressed, Zorach had been a signer of the call for the first American Artists Union in 1936. He had also been an instructor at the Art Students League for twenty years. There were few questions about sculptural techniques, aesthetics, or the teaching of art that Zorach could not illuminate. As a sculptor, he favored direct carving, and the two men formed a deep bond. "Zorach had the same sort of feeling that I did that canvas was not the challenge . . . and he was a kind of model for me. . . . His subjects were women and children and I was fascinated thematically by that," Wilson recalled.

For the next ten years, Wilson's discussions, correspondence, and visits with Zorach formed a warm, rich, nurturing relationship that greatly aided his development. "Having the opportunity to talk with him periodically until 1965 [shortly before Zorach's death] . . . was one of the significant turning points of my career," said Wilson. During this period Wilson carved in red hickory his expressive yet simple *Minority Man*.

Wilson regularly exhibited in the North Carolina Museum of Art's annual shows. He won the Baltimore Museum's portrait prize in 1956 and exhibited at a

Minority Man (1957), carved in North Carolina red hickory, satirized the begging attitude minority people were expected to assume by the majority. (39″ h.) State University of New York, Binghamton

Duke University show of North Carolina sculptors. His work in this show prompted Duke to commission a large bust of John Spencer Bassett, who had been dismissed from Trinity College (out of which Duke developed) because he published an early historical account of the cruel deprivations suffered by black North Carolinians. Wilson learned that the entire Trinity faculty had resigned in protest over Bassett's dismissal and forced his reinstatement. Through his research on Bassett, Wilson developed a gripping historical perspective on the black struggle for civil rights.

Coming to Durham had placed Wilson in one of the most turbulent centers of civil rights ferment since Reconstruction. In 1960, prompted by his air force experiences, Wilson became one of the few faculty activists "out in the streets during that time," helping organize the nonviolent protest movement. He wanted "to destroy the system that had brought about all that inhumanity," he declared. He was furious with African-Americans who, having won some niche in

Falling Man (1973). A symbolic representation of the fall of man in a world increasingly mechanized and dehumanized. It was installed on a column at the State University of New York in Binghamton in 1978. (Bronze, 5′ l.)

the social structure, hesitated to challenge discrimination. He was regarded, he said, "as being subversive, radical or rebellious because I challenged blacks and whites about the oppressive and restrictive nature of a segregated system."[2] He worked closely with Floyd McKissick, later the national leader of the Congress of Racial Equality, who was the group's strategist.

As the civil rights sit-ins, marches, and meetings increased, Wilson found the movement took more and more of his time and energy. Searching for philosophical and aesthetic direction for himself as well as historical precedents, he avidly read the works of Ralph Ellison, James Baldwin, and other African-American writers as he "lived" the cause. Between 1960 and 1964 he often worked to the point of exhaustion and almost as often reached peaks of exhilaration as the movement won increasing support.

Nevertheless, Wilson gradually realized that he had come to a critical period in his own development as an artist. He found two processes going on within himself. By participating in the struggle to end segregation, he found the "psychic split"—to use W. E. B. Du Bois's classic phrase for being black in white America—no longer troubled him and that he had gained "deep insight into the intricacies of a system that methodically calculated my dehumanization."[3] At the same time he had the troubling awareness that the needs of the civil rights movement were so huge that he could not personally meet them all, and that his concern for

ending segregation could become self-destructive if it became a personal obsession. His involvement "in the cause in the south almost led to my being consumed as an artist," Wilson said.[4] The movement left him neither time nor energy for sculpture. Yet if he stopped and took time to work on sculpture, it seemed an act of pure self-indulgence and indifference to the needs of his black brothers and sisters, engendering anxiety and guilt.

In the midst of his conflict Wilson read an interview with Ellison that, as he later recalled it, "said, in effect, 'Segregation is a state of mind.' It really struck me. It unlocked many things for me."[5] Reflecting on the implications of Ellison's statement, Wilson realized that "no one could really segregate you. There must be some complicity for a person to remain segregated—physically and intellectually." Years later, commissioned by Ellison's birthplace, Oklahoma City, Wilson created an unusual portrait of Ellison, who "gave me hope" and was a profound influence on his thinking.

Examining how he contributed to his own segregation, Wilson discovered that his cherished idea that the most creative black musicians were still playing jazz in the South, an idea that had helped him accept moving to North Carolina, was not valid. The best musicians had fled segregation to northern cities, where they flourished and made jazz *the* American music, not a regional phenomenon. He also realized that Ellison and Baldwin, whose work helped inspire the civil rights demonstrations, contributed to that struggle as artists without marching in every demonstration, as he had been attempting to do.

Wilson decided he might be more effective in combatting prejudice if he put his main efforts into his sculpture and exhibited it in the North—for in the South his opportunities were extremely limited, restricted almost entirely to black colleges. To assert himself as an artist, Wilson sought contact with galleries and artists in the North. He sent his work to group shows there. Soon it was being exhibited at the well-known Silvermine Guild in New Canaan, Connecticut, the Detroit Institute of Arts, and the Pennsylvania Academy of Fine Arts in Philadelphia. In 1961 his sculpture won the Howard University purchase prize.

Wilson's sculpture gained strength from the depth of his commitment to both his art and his people. As an admirer of Pieter Brueghel and Jacob Lawrence, artists who, although centuries apart, made the common people their subject, Wilson focused on ordinary black men and women as his subjects. In sculpture characterized by a moving simplicity, he tried to express their inner feelings of strength and self-worth. An earnest directness gave his work the impressive

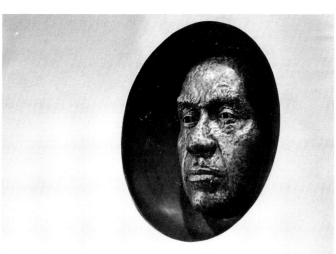

This portrait (1974–75) of Ralph Ellison, author of *The Invisible Man,* was commissioned by Oklahoma City, the writer's birthplace. Ellison was a particular inspiration to Wilson during the 1960s civil rights movement. (Stainless steel and bronze, 4 x 14′) Ralph Ellison Library, Oklahoma City

quality of truth—at once basic, naive, and yet sophisticated.

Recognition from northern art centers made Wilson more confident, coherent, and mature in his personal and aesthetic identity. If segregation was a state of mind, he thought, so was freedom. Why was he still carving wood when other modern sculptors were welding steel and casting metal? He abandoned carving to work in metal—welding and fabricating—taking a direction his old friend Zorach did not approve of, but even that was part of his self-liberation. In this fashion Wilson did not so much find himself as create himself aesthetically, with a new understanding of his art, his abilities, and his environment. His continued rereading of Ellison and Baldwin led him to decide that most creative black Americans had left the South because "the urban northern jungle provided the necessary mixture of ambush and camouflage for the Negro artist to 'sense' what freedom might be," he wrote. "I was also to learn, rather painfully, what freedom might be,

and that freedom is a state of mind. When this was understood, one would be able to pay whatever dues one had to in order to preserve it."[6]

Such thoughts prepared Wilson in 1964 to accept an invitation to develop a studio art program at Harpur College, the State University of New York at Binghamton, a liberal arts school that did not have a visual arts faculty at the time. The post was challenging— most of his students were white and many had already had art training.

His move released new creative energies. He exhibited at the annual show of the Munson-Williams-Proctor Museum in Utica, New York, and carried out a commission for Duke University. He also developed an architectural design for Greensboro, North Carolina, that established him as a sculptor with an unusual gift in using architectural concepts. A major exhibition of his work at Harpur in May 1966 resulted in his being commissioned to design a three-acre memorial park honoring President John F. Kennedy. The memorial

Wilson designed this triangular JFK Memorial Park with a needle-like, three-sided column (10′ h.), completed in 1969, in its center for downtown Binghamton, New York. The bronze relief panels on the column focus on those who avoid involvement in the issues and problems of life. "The Conformists" (below left) are one group symbolized; they quietly go along with anything. "The Uninspired" (below center) are present but empty, incapable of responding to life's opportunities. "The Dead" (below right) cannot respond to life itself. Wilson called these panels "The Seven Seals of Silence."

458

was commissioned by the *Binghamton Sun-Bulletin* Fund, which, along with citizen contributions and urban redevelopment resources, helped finance it.

Wilson developed the park in downtown Binghamton as a many-tiered triangle of granite and grassy slopes, with walking and sitting areas for viewing the sculpture. The tiered areas form the immediate environment of the monument, a ten-foot, triangular needle with rectangular shapes projecting from each side. These projections bear bronze relief sculptures as well as a quotation from President Kennedy and brief biographical data, although there is no portrait of him. The bronze reliefs, characterized by Wilson as "The Seven Seals of Silence," depict "the evils of noninvolvement in the demands, passions, and problems of life itself."[7] Portrayed are such uncommitted types as the compulsive conformist and the depraved. Strikingly original, the JFK Memorial Park won critical praise. More significantly, through this work, Wilson helped end the banal traditions of memorial sculpture. This commission was important in Wilson's development, helping him move more confidently toward freer expression of his own feelings and insights.

Wilson came to the conclusion that the African-American artist should "commit himself to seeking humanistic values and all those universal human values in world art—great world art—to begin to see the universal in specific experience. Jazz does this perfectly; the specific Negro experiences transcended into universally understood terms, as does Picasso's *Guernica,* as does African traditional sculpture."[8] He added that while he felt African-Americans had to overcome self-consciousness about being black, "The education of the American artist, whether he is black or white, should include exposure to African art, American jazz, the psychodynamics of the American scene. There is a strange vitality fermenting under all this racial tension in America and I want to see it erupt" aesthetically.[9]

Having personally felt dehumanized in the air force and under segregation, Wilson has made this one of his deepest, most expressive themes—always implying that people's complicity in their own dehumanization is a major part of the problem. Wilson's feelings were reinforced by his study of José Ortega y Gasset's prophetic 1930 classic, *The Revolt of the Masses.* In Wilson's first major effort to express this theme, he created an unusual relief panel of highly polished aluminum, *Second Genesis.* It features gleaming "humanoids—half-robot, half-human figures" who "symbolize a world in which technology has taken over." While derived from Wilson's military experiences and the casting of black people in mindless roles under seg-

regation, the work suggests a robot experience may be the fate of all humans. Just as Wilson finished *Second Genesis,* now in Lake Clifton High School in Baltimore, Alvin Toffler's *Future Shock* was published, "and there it was, all spelled out," said Wilson.

Another work, *Middle Passage,* reflects the complexity of his social and aesthetic considerations. Its title is derived from the middle of the long Atlantic crossing of slave ships, during which many chained slaves, jammed below decks, died from illness and the withering of their spirits. *Middle Passage,* in the New Boys High School in Brooklyn, New York, is related to dehumanization in an industrialized society as well as the fact that adolescence, often a stormy period of development, is in itself a "middle passage." The enslavement and marching of yoked coffles of slaves to the coast are depicted in the middle of three horizontal panels. Above and below are the cramped slaves on shipboard; vacant places mark where someone died. These works are based on drawings made at the time showing how "efficiently" slaves were jammed into these ships. This very original work, which curves inwardly so that the viewer is drawn into it, presents a searing lesson of man's inhumanity to man without being overly dramatic. Its great power lies in its massiveness and its matter-of-factness.

Wilson, now chairman of Harpur's art department, does his administrative work in a small studio adjacent to a large instructional one. Both are well equipped technically. In 1987 Wilson designed and built a large, bright and airy studio near his house for his own work. In the final processing of large works he hires students to help him.

Wilson finds teaching stimulating and the ideas of his students a resonating resource. Having taught in both a black college in the South and a predominantly white one in the North, he considers himself "closer to the American wellsprings of naive truth" than most artists.

For Wilson the artist, the university is a stimulating and nurturing environment that he has known all his life, one that gives him "a strange mixture of stimulation and isolation. "I find the isolation absolutely necessary in order to gestate—and to work. There's very little distraction. It gives me a library and time to read . . . [and] an opportunity to examine and to exercise, at least intellectually, some ideas. I have few academic friends, but the university setting has been a necessity for my development and continued work."

The university has also enabled Wilson to avoid the commercial art world. Except for public commissions, his work appears only in large institutional group shows and occasional one-man exhibitions, usually in

Right: Detail of **Second Genesis** (1969–71). Wilson's cold, polished humanoid figures suggest a robotlike future for those ranking technology above human values. Created in aluminum, this unusual sculpture comprises eight fabricated units and thirty-two cast pieces. Lake Clifton High School, Baltimore. Left: A closeup of one of the humanoids of **Second Genesis,** a protest against dehumanization in an overly mechanized and automated society.

educational institutions rather than commercial galleries. Of this, he said:

> I feel there is a devastating dichotomy between white Western humanistic efforts and white Western social and economic reality. Constantly assessing and adjusting to this situation has consumed an inordinate amount of my energy. This I resent deeply. I have, by personal choice, avoided the gallery system, as I wish to determine how I will be exploited, since as an artist, I know I will be exploited. Being a black American has influenced my thinking and subsequently my work. My view of this republic is obviously from its underbelly. My aesthetic is obviously out of line with the fashionable tastes of the United States art world.

One of Wilson's projects portrayed Harlem history for the New York State office building there. This effort led him to an aesthetic element he first identified in the writing of Ellison and Baldwin, the painting of Jacob Lawrence, and the later work of Romare Bearden—memory. An element that is emotional, tactile, colorful, sensuous, and tenuous in that it is fleeting, hard to grasp, yet definite in mood. "I cannot see any special

relationship that the Negro artist has now to American society except that if he were able to develop what Ellison refers to as 'memory,' " Wilson has said. "To me, Jacob Lawrence has this in his work. Jazz and all its antecedents have 'memory.' I feel most art work by Negroes before 1965 has been too documentary and programmatic."[10]

In his study of memory in art, Wilson has perceived a great need in American cultural life. In his view, memory concerns the past but suggests a future direction that possesses a unique combination: hopefulness arising amid the blues themes. In the development of jazz as the indigenous music of this country, a critical stage was reached when black musicians were able to overcome their isolation, meet, talk, play together, and exchange musical ideas expressive of their experience. "Hear me talkin' to ya" is how Louis Armstrong put it.

Contemporary black artists are beginning to recognize, as Wilson's work indicates, the profound universal needs of American life and to draw upon the special experience of being black in America in coping with that need in a positive way. Among American artists, African-American artists are the largest group with a unique common experience, and it is only now that this experience and their development has reached

Jazz Musicians (1982–84). Commissioned by the city of Baltimore for Douglass High School, this mural defies the rigidity of sculpture to celebrate the movement and feeling of a swinging jazz combo. (Bronze with painted steel frame, 4 x 12')

a stage when it may become a significant influence in American art. "It may be possible for the black artist," Wilson indicated, "to make a profound contribution to American art if he is able to bring humanistic values back into urban life. The health of this nation, in many respects, is tied up with the meaningful survival of urban masses. Maybe through the 'memory' of his not-so-human existence he might be in a better position to understand the bleak future of the anti-human pattern and inject a bit of humanism (soul). After all, isn't this what 'Bird,' Miles, Ray Charles, Malcolm X, Wright, Ellison, Baldwin, and others are all about?"[11]

Wilson considers his work thus far only preliminary to his main efforts. Nothing could illustrate his freedom from convention more than his *Homage to Ellington.* After years of concentration on the figure, he turned to the abstract to make an eloquent tribute to the black composer, whose bluesy yet invigorating music is embedded in American memory. This project led him to create, for the Baltimore Douglass School, a bronze relief panel in which jazz musicians and their instruments, despite the rigid character of the medium, appear to be in rhythmic motion, the way everyone remembers them.

However, in recent years Wilson has been stymied by the drying up of funding, which has delayed the completion of important works, among them *Homage to Ellington,* a portrait of Frederick Douglass for the National Park Service, and a Martin Luther King memorial for the Binghamton city hall. He has been able to complete and install a bronze portrait of Medgar Evers, the assassinated Mississippi civil rights leader, for the Brooklyn college bearing Evers's name. He also completed a portrait of Whitney M. Young, Jr., the former head of the Urban League who accidentally

drowned, and four casts of this have been installed in appropriate places.[12]

Wilson continues to develop his own sculpture and to find satisfaction in teaching, although he finds the passivity of students disturbing. Since 1975, he said, the students have become increasingly passive:

They are like an audience. They are not used to doing anything. Whatever they have put together in the past is something that comes in a kit, nothing that requires creativity. They don't know how to fashion a form or even a toy. The result is that you have to push them. They have little or no experience or desire to explore. Of course, they are a product of our contemporary culture and the expectation that technology will solve everything.

A few years ago I spoke to a class about this passivity. I asked them what this passivity, this laid-back attitude, was all about. A girl responded, "Fear." I asked, "Fear of what?" She said, "Fear of the future." I told them that when I got out of World War II there was nothing happening, and much uncertainty, but you have to jump in and in that way you will learn, even in a crisis. But they don't understand that because everything has been automatic for them. They all want the sure thing—and it's not going to be there for them. Maybe the times will change them, but it's a frightening prospect.

Especially for Wilson, whose memory of jumping into the civil rights struggle in the 1960s helped change the social environment for African-Americans, whose memory also includes his own aesthetic struggle to work in metal, and who feels he has not reached his most creative years.

461

JAMES W. WASHINGTON, JR.

James W. Washington, Jr., who began as a painter, has been recognized as one of the most distinguished sculptors of the Northwest since the 1960s. His fame has spread eastward to New York, Washington, D.C., and London. Carving directly in stone, usually animal or bird figures, he works in the tradition of John B. Flannagan, Aaron Ben-Shumuel, and William Edmondson. All these artists, far from imposing some design on the stone, find something in its texture and natural shape that suggests their creation. They seek a unity with nature that gives their work simplicity and a transcendental beauty.

A deeply religious observer of nature, Washington was aided in his studies as a painter and in his transition to sculptor by another deeply religious man, Mark Tobey, one of the masters of contemporary art. In his often monumental works, Washington has been influenced by historic Mexican sculpture, Classical sculpture, and the totem poles of the Pacific Northwest. He also keeps several African sculptures in his studio because he likes to study their qualities "along with all art."

Washington's vision and integrity have earned support from all segments of Seattle's population. He is spoken of as "Seattle's great black sculptor"[1] and as "a leading cultural force in the community."[2] It has not been unusual for a branch library to present "an evening with James W. Washington" because his talk is stimulating. He has received coverage in both the religious and art sections of Seattle's newspapers. In discussing his work, he links spirituality with nature and beauty: "I try to solidify myself with the cosmos, the absolute." Scornful of churches that "glory in their edifices" and eschew the idea that the human body "is the true temple of God," he is also critical of schools for failing to instill in each child belief in his or her talents.[3]

Washington enjoys an unusually high profile outside the art world. Not only is his work familiar to much of the local population, he has also had personal acquaintances with Seattle's mayors and the state's governors, past and present, as well as numerous educators and religious leaders. Both private and public demand for his work is considerable; it is prominently displayed in many of Seattle's libraries, schools, banks, and youth centers. Pleased with an eaglet sculpture that he made for their home, the Paul R. Smith family commissioned a larger work for the Seattle Center Playhouse. In 1976 he created a large obelisk of animal forms for Travers Keller's home on Mercer Island, and in 1978 the Seattle Arts Commission commissioned an image of the rare, prehistoric coelacanth, which is embedded in a sidewalk. A law firm displays his *Ashtal Altar.* In 1980 the Frye Art Museum gave him and his friend Josef Scaylea, chief photographer of the *Seattle Times,* a joint show in which Washington displayed some of his earliest sculpture for the first time, as well as some of his paintings.[4] His monumental *Obelisk with Phoenix and Esoteric Symbols of Nature* graces the lobby of the Sheraton Hotel and Towers.

Washington is neither a self-taught artist nor an isolated one, in the sense that Horace Pippin and William Edmondson were. His friends include artists as diverse as Mark Tobey and Jacob Lawrence, and he is constantly visited by many northwestern artists. He has visited seventeen countries in search of the universalities expressed in their art. He is a widely read, sophisticated religious mystic in search of spiritual and aesthetic truths.

James W. Washington, Jr., was born on November 10, 1909, in Gloster, a Mississippi Delta town near Natchez, to the Reverend James N. Washington, a preacher and cabinetmaker, and Lizzie Washington, who loved music and played the accordion. He was the third of five children, with two older sisters and two younger brothers. Both his parents had a creative and contemplative nature; he recalled that his mother "was interested in me—not just as her child—but as a

creative person, and would observe whatever I did and encourage me."

Washington's parents believed that every individual had something unique to contribute, whatever he or she did—whether plowing or fixing a roof. When Mrs. Washington noticed how carefully James took apart an old shoe he had found in an alley and how imaginatively he played with it, she convinced the local shoemaker, Arthur Samuels, that her son could help him. Washington recounted: "I went up there and began repairing shoes—and then began using my imagination. Soon I was doing things [Samuels] hadn't thought of in repairing shoes." To Washington, "this is a part of art because the word *art* can fit any vocation or avocation."

In his early teens Washington left home to live with his older sisters, who had settled in Mound Bayou, an all-black community near Greenville, Mississippi. For many years, Mound Bayou enjoyed an unusual degree of autonomy from state and federal control, and Washington later attributed his esteem for the talents of African-Americans to the time he spent there.

By the time he was fifteen, Washington's ability to visualize and draw had grown so acute that he would invite other boys to make any kind of mark on the ground or on a fence, and then, as he recalled, "without eradicating what they had done, make that mark part of a drawing of a man or a woman."

His shoemaking talents took him to a job making orthopedic shoes in the government shoe store at Camp Roberts in Little Rock, Arkansas. He went on to work for the Vicksburg, Michigan, utility company and learned the electrician's trade, but racial discrimination prevented him from finding employment in that capacity. Nevertheless, he applied his new skill to servicing homes in the black community. He then took a Civil Service examination to become an electrician's helper with the federal Mississippi riverboat fleet stationed in Vicksburg. He earned a marine electrician's rating, and in 1943 found work at the Bremerton Naval Shipyards in Seattle.

Washington had been painting since he was fifteen years old without seriously aspiring to become an artist. He had first exhibited in a group show presented by the WPA at the Vicksburg YMCA in 1938, and in a USO Club exhibition in Little Rock early in 1943. But in Seattle in the mid-1940s he began serious studies with artists, among them Glen Alps, now professor of art at the University of Washington, and Larry Louis Freund, who had come from Carnegie Tech to become the university's artist-in-residence. His most influential instructor, however, was to be Mark Tobey, who had studied art and calligraphy in China and Japan, and was deeply attracted to Zen. By 1945 Tobey was, along

Young Queen of Ethiopia (1956), carved in Indiana limestone soon after Washington gave up painting for sculpture, was conceived as a memorial to his and his wife's parents and relatives. (16½ x 6¾ x 9¾″) National Museum of American Art

with Morris Graves, one of the most prominent artists in the American Northwest. His mysterious canvases aroused interest in New York and even greater interest in Europe.

Largely self-taught, Tobey was impressed by Washington's work and spiritual outlook. Years before, in 1918, Tobey had become a convert to Bahaism, the tenets of which emphasize the spiritual unity and equality of humankind. Thereafter he sought to express unity in his abstract, calligraphic "white writing" paintings. Tobey was therefore an ideal teacher for Washington, who studied in a class with him between 1945 and 1948. Tobey greatly encouraged Washington, who often painted religious scenes in a direct way. One day Washington arrived early and found Tobey studying one of his paintings. Tobey told Washington: "You don't have to study under me or anyone else anymore. In this life you either have it or you don't. You have it. Your painting is complete and unified in your style."[5]

Washington recalls that Tobey so admired his work that "we began swapping work." He took two of his paintings to Tobey's studio, where Tobey gave him a choice of thirteen of his own paintings, from which Washington selected a self-portrait, an unusual subject for the abstract artist. Years later, when he visited

Young Boy of Athens (1956), Washington's first sculpture, was carved from a small volcanic stone that attracted him in Mexico in 1951. He brought it home. Five years later he felt summoned to carve it—and became a sculptor. Until then he had painted. (7″ h.) Collection of the artist

Tobey in Basel, Switzerland, he brought him a small "pocket piece" of his sculpture. Tobey gave him two more of his paintings in return.

Although Tobey's encouragement stimulated his development, neither Washington's painting nor his sculpture show any influence of Tobey's mystical canvases of swirling figures. When asked if his work resembled Tobey's, Washington replied: "My paintings were simple and direct. Tobey would never have wanted to swap if they had looked like his."

During the late 1940s, while supporting himself as a housepainter (as he proudly put it, a "paid-up member" of Local 300, the Housepainters and Decorators Union), Washington came to admire the work of the Mexican muralists. In 1951 he visited Diego Rivera and David Siqueiros.

As a result of his visit, Washington gave up painting to become a sculptor. His decision was not a conscious one, however. He later described the journey as both an aesthetic and spiritual quest, from which he hoped "to be uplifted in the arts as a result." In Mexico City he met Rivera, Siqueiros, and many other artists, some of whom suggested a visit to the pre-Columbian pyramids at Teotihuacán.

As he walked down the Avenue of the Dead from the Pyramid of the Sun to the Pyramid of the Moon, Washington noticed a small porous stone, about eight inches tall and six inches wide. He took it with him, then went on to make sketches from atop the Pyramid of the Moon. He carried the stone, half-forgotten, back to Seattle and kept it in his basement, where it sat for months. He recalled that the stone "kept worrying me until I went and got it, picked it up and wondered what it was all about. And then it came to me—sculpturing. But I didn't have any tools to do sculpture with, so I proceeded to find tools. That little stone became my first piece, *Young Boy of Athens*."

At first, Washington suffered considerable anxiety over his decision to become a sculptor. He recalled that Mark Tobey helped assuage his fears by telling him " 'Just leave your paintings where they are—and get to where you want to get in your sculpture, and then you can take care of the paintings.' I found this to be the best thing, focusing on one thing at a time."

It was not until 1956 that he had his first show as a sculptor, an exhibition at Seattle's Campus Music Gallery. Annual shows in Seattle followed, and from 1960 to 1964 the Willard Gallery in New York exhibited his work in group shows. In 1962 the Lee Nordness Gallery in New York presented a one-man exhibition. The Feingarten Galleries in San Francisco, the Haydon Calhoun Galleries in Dallas, and the Grosvenor Gallery in London have also shown his work. His work is now exhibited regularly by the Foster/White Gallery in Seattle. In 1968 he was commissioned to create six busts of famous African-Americans, among them Martin Luther King, Jr., Nat Turner, and Benjamin Banneker, for the Rotunda of Achievement in Philadelphia. By 1975 Washington was having difficulty keeping up with his commissions.

One of Washington's major works, the state-commissioned *Three Wonders of Nature,* is on the East Campus of the Washington State Capitol in Olympia.[6] Other pieces are on display in schools and major banks in Seattle and Tacoma. His work won purchase prizes at the San Francisco Museum of Art in 1956 and the Oakland Museum of Art in 1957. Another sculpture won second prize at the Seattle World's Fair in 1962. Washington is especially proud of his honorary doctorate from the Graduate Theological Union in Berkeley, an affiliate institution of the University of California that specializes in theology and African-American studies.

Washington has occupied a prominent place in Seattle's cultural life. He served at one time as president of Artists Equity. In 1965 the *Seattle Post-Intelligencer* magazine *Northwest Today* invited him, along with museum directors, architects, judges, and civic leaders, to contribute his ideas on the development of the arts in

Three Wonders of Nature (1973). Powerful, even frightening images characterize this major work at the Washington State Capitol in Olympia.

Seattle. May 20, 1973, was proclaimed "James W. Washington, Jr., Day" by then-mayor Wes Uhlman, and that same year, Governor Daniel J. Evans presented him with the Governor's Arts Award in recognition of his contributions.[7] As a lifelong Baptist, Washington was delighted when the Mount Zion Baptist Church in Seattle honored him as "a sensitive person attuned and alert to things spiritual,"[8] and seventeen of his works were exhibited at the American Baptist convention in San Diego in 1977.

Washington considers one of his finest works to be the six-and-a-half-ton *Obelisk,* the fifth of a series of sculptures on creation, which has been mounted at the Meany Public School in Seattle. Another important work is *My Testimony in Stone,* on display at the Odessa Brown Children's Clinic in Seattle. This 1981 sculpture features a large bird carved from a boulder, bearing symbols that express his philosophical and religious beliefs: "Knowledge of the symbols helps us to articulate with the cosmos. We become part of the universe. We and nature are one."[9] The sculpture, Washington explained, represents "life and how we find ourselves. Every one of us is an ideal individual but we must first find ourselves in order to reach our individual. Man must be able to venture outside of his known world by creative thinking."[10]

Washington is fascinated by the idea of "three," which is symbolized in *Testimony* by an equilateral triangle. He believes the proper study of any field should encompass past, present, and future: what has been done before, what is being done by one's contemporaries, and what one can do to develop one's own creativity. Washington also believes that the trinity is central to all things in nature: "for example, the major component parts of the atom is three—electron, proton, neutron; all colors derive from primary colors—red, yellow, blue; and every person has three natures—physical, mental, and spiritual."[11]

Testimony includes a pig—the Old Testament symbol of "forbidden food." For Washington, this is meant to signify that "we should be concerned about what is detrimental to us, about unwholesome things."[12]

In 1984 the National Museum of American Art acquired one of Washington's smaller works, *Young Queen of Ethiopia,* carved in 1956. Only sixteen and a half inches high, created out of Indiana limestone, this

465

My Testimony in Stone (1981), mysterious in its symbols, stands at the Odessa Brown Children's Clinic in Seattle. Deeply religious, Washington believes his symbols communicate universal truths to others. (45 x 26 x 60″) Photo: Charles Alder

Above: *Form of the Wounded Bird* (1989) evokes Morris Graves's famous *Wounded Bird* painting. Washington knew Graves, another symbolist and one of the most prominent artists in the Northwest. (6½ x 9 x 11″) Photo: Foster/White Gallery, Seattle

Left: *Life Emerging from an Egg and Symbols* (1989). The egg is one of Washington's favorite symbols; he considers that it represents all of life. (20 x 8 x 11″) Photo: Foster/White Gallery, Seattle

466

Obelisk and Phoenix with Esoteric Symbols of Nature (1982). This massive red granite obelisk, now in the lobby of a major Seattle hotel, is unusual in its formality and symbols. (68 x 23 x 13″) Collection Sheraton Hotel and Towers, Seattle

Oracle of Truth (1987), commissioned by the Mount Zion Baptist Church in Seattle, is covered with ancient symbols. These arresting images distinguish his work and "make it come alive," in Washington's own phrase. Photo: Foster/White Gallery, Seattle

work, according to Regina Hackett, art critic of the *Seattle Post-Intelligencer,* "radiates the kind of light Washington gets in his best work, as if each blow of his chisel released an animate power from the stone." The visionary quality that distinguishes Washington's work, she noted, is "neither in style nor out of it."[13]

In November 1987, his unusual *Oracle of Truth* was dedicated at the entrance of the Mount Zion Baptist Church of Seattle. It is a huge boulder, the top of which is shaped into a large, fuzzy-coated, supine lamb, whose body includes many ancient symbols. Color is used, not in the way Sargent Johnson used it, but in a more symbolic way: a human figure, for example, has a glowing red heart. The dedication of the work brought out religious leaders, politicians, prominent

figures in the arts in the Northwest, as well as the Mount Zion congregation. When all these leaders crowded around him to have their photos taken, Washington looked around distractedly, waving his hand and saying, "Let the children come up here. It's for the children."[14] For Washington, *Oracle of Truth* was an effort to make ancient symbols meaningful to children "seeking to find the truth"[15]—their own innate creativity. At the time he said: "The primary concern of the home, church, and the school should be to help each child find him or herself . . . our young people are trapped in this drug-infested society, and just to tell them to say 'No' to drug pushers is an uncouth cop-out."[16]

In an essay titled "Man Was Created to Think But Often Fails to Do So," Washington wrote that children who are not stimulated by parents and teachers to think creatively are unlikely to develop this faculty in later life. He cited his own early experiences in shoemaking and drawing as "creative playing and thinking which later developed into an ability to concentrate on a person, stone, or colors, and to envision the potentials of

Washington, shown here in 1980 carving *Sacrificial Lamb,* considers all his work symbolic. He told Paul Karlstrom, of the Archives of American Art, in 1988: "What is it that makes subject matter stand out? Is it the subject, is it the composition, or is it the spiritual force? I say it's the spiritual force." (Granite, 18″ h.) Collection Mr. and Mrs. Charles Kelley

each." Washington recounted conversations with young people preparing to go to college without clear goals or aspirations: "They had not been told in school that each was born with one or more talents, that they attended school for the development of those talents, and that when the talent is found, the very gates of hell cannot retard their progress."[17]

As for his own life and work, Washington declared: "What I am trying to say with my sculptures is that each one of us has something within us waiting to be released, and that something is spiritual, the spirit being the universality of life itself."[18]

Specifically, Washington has explained:

I take inanimate material and animate it. This is how I, as a co-creator with God, make my greatest contribution to life. I talk with everything. I talk with the stones. They reveal their potential in the intangible realm of how they can be energized into spirituality.

You can't explain an ultimate, but you can illustrate it. You take an inanimate material like a stone. You visualize the composition, then you shape its facets. And finally you breathe yourself into it and make it live. This is the universality of art and this is the universality of life itself.[19]

In 1989 LaMarr Harrington, director of the suburban Bellevue Art Museum, assembled a major retrospective exhibition of Washington's sculptures and paintings accompanied by a book-size catalog. Its appreciative essay by Paul Karlstrom, of the National Museum of American Art, may awaken eastern critics and historians to Washington's singular aesthetic vision.[20]

Washington, Karlstrom pointed out, is among "that small group of visual artists whose creative work is almost entirely determined by their personal philosophy," rather than by other artists and their work. With the most gifted visionaries, Karlstrom continued:

art truly becomes an approach to the realm of meaning which lies beyond experience and knowledge and yet tugs at the human heart and mind. . . . What identifies the true visionary, I believe, is the pure imaginative power to create images and forms in which the personal and subjective provide glimpses of the universal and transcendent. What is impressive about artists such as Washington is the perfection with which fundamental humanism, generosity of spirit, and depth of emotion are embodied in their simple and humble forms. It is this quality that emanates from Washington's sculptures of birds and small creatures. What sets them apart from a host of other animal sculptures is the inexplicable, yet undeniable, spirit in the stone.[21]

RICHARD MAYHEW

The unique American landscape and its interpretation by the Hudson River school initially won recognition for American art in Europe. A century later, when landscape painting was no longer in vogue anywhere, Richard Mayhew demonstrated that it was still possible to add new luster to the American vision in this field, with paintings that have a poetic serenity and an illusive quality of light.

Beginning in the 1960s, Mayhew's work astonished critics.[1] Of his 1965 Durlacher Gallery show in New York, the *Herald-Tribune* critic wrote: "This shock of our times is not to find an exhibition full of explosive abstractions, or paintings slit and shredded, or sculpture made of junk. It's to come on canvases like these dark and mysterious landscapes by Mayhew, which suggest Corot or Courbet. . . . He is both poet and superb technician."[2]

In 1969, pointing out that Mayhew must have gone through a period of "inner growth," John Canaday of the *New York Times* wrote: "The strength and certainty and sheer handsomeness of his new paintings are especially gratifying because he works in the neglected field of landscape—and was doing so as long as ten years ago, when there were so few young painters willing to go against the current of abstract expressionism, then all but universally triumphant."[3] In 1973 *Arts* magazine reported: "Richard Mayhew's landscapes are really incredible color abstractions . . . stunning and unexpected."[4] In 1988, writing in *Art in America,* Amy Fine Collins pointed out that Mayhew's "color captures not only various moods, but also the characteristic palettes of different American locales. The lush greens and deep purplish-blues of *Woodside* suggest the cool shadowy forests of the northeastern United States while the powdery, cosmetic shades of pink, peach, and lilac in *Desert Serenade* evoke the wastelands of the Far West. In the latter, the tints are so delicate they appear to tremble, as if we're viewing the scene through rising waves of heat."[5]

For more than thirty years Mayhew has created distinguished landscapes that are not limited to one section of the country. Even in their most abstract rendering, his paintings are unmistakably landscapes. They evoke the work of George Inness and, in their fleeting, illusory light, that of Henry Ossawa Tanner. Mayhew's paintings are derived from an intimacy and absorption with nature and our relationship to it, achieving mystery and beauty in combinations of color that are as surprising as they are evocative.

Mayhew's racial heritage, like that of Edmonia Lewis, includes both black and Native American strains. He had already achieved considerable recognition before he came to know many other black artists in the 1960s, primarily through the Spiral group's discussions of black artists' relationships to African-Americans and their struggles.

Mayhew's significance lies not only in his artistic achievements but also in the fact that he represents, in some respects, a bridge between the older black artists who developed through the WPA in the 1930s and those who, after World War II, attended art schools and matured during the turbulent civil rights movement of the 1960s and the rise of Abstract Expressionism. Although Mayhew was initially concerned only with aesthetics and his own work, his participation in the Spiral discussions enlarged and enriched his development as an artist—leading to his participation in community affairs and contributing to his success as a teacher.

When in 1978 the Studio Museum in Harlem presented an exhibition of Mayhew's landscapes, its director, Mary Schmidt-Campbell, pointed out that his paintings "suggest an intense dissatisfaction with the quality of life in urban communities" and that he creates "imaginary environments where the imagination could survive and thrive."[6]

Richard Mayhew was born on April 3, 1924, in Amityville, Long Island, then a quiet seaside village but now an aerospace center. His parents were Alvin

Mayhew, who had Shinnecock, African-American, and Portuguese forebears, and Lillian Goldman Mayhew, who was descended from Cherokees and African-Americans in North Carolina.

The Mayhew family was proud of its mixed racial heritage. Mayhew later discovered that his Shinnecock forefathers had participated in the Underground Railroad and ferried runaway slaves across Long Island Sound to Connecticut en route to Canada. Mayhew's paternal grandmother, Sarah Steele Mayhew, tutored him in Native American "nature lore, their ways and attitudes." Her teachings, he felt, contributed to his independence as well as his absorption with nature—"the Indian preoccupation," he said.

Although Mayhew drew no more than other children, he was fascinated by amateur artists vacationing in the summer in Amityville, and he watched them paint by the hour. "It seemed to be something magic—how images would come from the end of a brush in the hand," he said. He was further stimulated by various English art magazines, including *Apollo,* which his grandmother had collected. His father, who painted houses and signs, always had brushes and paints around, and Mayhew started painting with them—"very secretively"—fearing criticism. When he was fourteen years old, a visiting artist, accustomed to his watching, handed him a brush and said, "Try it." Other summer artists then encouraged him.

In the late 1930s Mayhew's family moved to New York, where he discovered the Metropolitan Museum of Art. Uncertain of what he sought, Mayhew visited

Sonata in G Minor (1987). Mayhew, although a constant student of landscape and nature, does not paint in the field in the manner of the French Impressionists. Instead he paints from memory, seeking to express moods. (50 x 90″) Midtown Galleries, New York

it often, at times methodically touring its galleries, at other times concentrating on specific artists. He was especially intrigued by Rembrandt's *Woman Cleaning Her Nails.* However, it was in Inness's paintings and that of other American landscapists that he found the sights and feelings he had experienced. This led him to recognize within himself the deep desire to be an artist. In the city he strongly missed the fields, swamps, and low-lying woods of Long Island. In a sense, the museum's landscapes provided a way of relieving his visual homesickness.

When his family moved back to Amityville, Mayhew, then about seventeen years old, was particularly satisfied to see again a shallow pond in the field back of their home. Its mirroring waters reflected the changing sky and the seasonal colors of the long grasses, bushes, and weeds bordering it. In his early landscapes this backyard pond is nearly always present in one form or another. Yet at the time, once he had the pond to look at, Mayhew was less concerned about being a painter.

Soon after World War II began, Mayhew was drafted and assigned to the marines, an experience that left him "unalterably opposed to militarism." On his discharge in 1945, Mayhew decided to become a

This untitled drawing by Mayhew shows his virtuosity in draftsmanship in creating a dense, voluminous landscape of trees and bushes. Photo: Midtown-Payson Gallery, New York

medical illustrator, apprenticing himself to Markson Peale Willson,[7] a medical artist who summered at Amityville. Under Willson's direction, Mayhew was rigidly trained in drawing and rendering anatomy, tissues, and organs as well as mechanical reproduction processes. He spent many hours at the New York Academy of Medicine studying Andreas Vesalius, Leonardo da Vinci, and other masters of medical anatomy. Years later Mayhew felt his rigid training with Willson and the basic restrictiveness of medical illustration delayed his discovery of his own creativity.

What helped Mayhew survive while making endless rounds of pharmaceutical companies, trying to sell his work, was singing. During his late adolescence in New York he had joined young black singing and dramatic groups. Possessing a rich, deep voice, he began to sing with "pick-up" jazz combos before the war. After his discharge from the marines, he began singing professionally with jazz groups playing at resorts on Long Island, in upstate New York, and in New England. Enjoying "the artistic sensitivity of the music and the emotional encounter with the audience," he continued to sing professionally until the early 1950s.

Soon after beginning freelance medical illustration, Mayhew, then twenty-one years old, began studies at the Brooklyn Museum of Art's school. While other young black artists were aided by working with older black artists, Mayhew was isolated and very much on his own. Studying first with Reuben Tam, a well-known abstract painter, Mayhew moved restlessly through a wide range of very different teachers, troubled by his own need for independence. Among these instructors were Edwin Dickinson, Victor Kandel, Gregorio Prestopino, Hans Hofmann, and Max Beckmann, the German Expressionist.

Years later, summing up what he learned, Mayhew said that Tam helped him develop "a sensitivity to space and intelligence, a consciousness of design and geometry in space." Beckmann particularly aided development of "spontaneity and freedom of emotional interpretation. . . . If it wasn't for working with Beckmann, I couldn't have been free—a new approach to surface painting, to color and form." With Prestopino, "there was a consciousness of social interpretation of form and space, which helped me incorporate certain thinking in painting. I wasn't involved any longer in just painting color. I was involved with, let's say, jazz on canvas: how to do this with a tree." Mayhew recalled following Dickinson to the Art Students League because that artist had a different approach in his "application of paint and control of the mixture of paint. . . . I learned that from him—a sensitivity of application in space in a poetic way. There's a certain poetry in his work which helped my thinking."

However, with all these instructors, Mayhew said, "I found that after a certain point they can't help you anymore. When a teacher reached the point where you know how to do this and you know how to do that— how to apply paint and how to control color—and he started to say, 'This is the way to do it'—that's the time I left." Yet these experiences with leading artists helped Mayhew formulate his own teaching concepts when he began teaching at the Brooklyn Museum. He later taught in many institutions and colleges and became a tenured professor at Penn State in 1982.

Mayhew began exhibiting still lifes and landscapes in group shows in the 1950s. He had his first solo exhibition in 1955 at the Brooklyn Museum, and another in 1957 at the Morris Gallery in New York. To survive, he shifted from medical illustration to children's books, designed lamps and chinaware, and painted portraits in New England resorts.

Spring Thaw (1982). Mayhew draws rapidly and prolifically from nature in a manner that suggests the volume and density as well as the shapes of shrubbery and trees but never falls into traditional linear patterns. These drawings, finished works in themselves, are then used in preparing his painting compositions.

During this period Mayhew became conscious of an urgent longing to capture in his work some of the mysteriously changing elements of nature first observed in his backyard pond; "it was always in the back of my mind." He was also fascinated by the way people "treasured and preserved certain things, things they held on to, that were part of their whole life. I was concerned with these objects and how personal they were, and the feeling of identity with people they had." This prompted intense study of the work of William M. Harnett and John F. Pieto, famous for their trompe l'oeil paintings of intimate mementos pinned to a wall in a startling illusion of reality. Mayhew tried to outdo them. While Harnett's mementos recalled the past nostalgically, Mayhew painted "sensitive items that people used in their contemporary existence, such as a wire coat hanger, and that had some significance in their life. Using such objects, I was very concerned about the geometry of two-dimensional space where the object was no deeper than three or four inches."

Soon the problem of illusion transferred itself to Mayhew's landscapes. Initially, he sought to present the timelessness of nature in spite of its constant changes. However, the changes obsessed him. In Maine one summer he discovered that every fifteen or twenty minutes there was a complete light change, frustrating his efforts to capture colors exactly. Using a photographic light meter to record changes on a single leaf, "I got so obsessional about this that I picked out a particular area, a particular limb on a tree, and came back two years in succession to check the light differences—how blue? how cool? I got caught up in terms of light and color—and the intensity of light and color in terms of warm and cool space—and also in the qual-

ities of reflected light, which changes the color." The problem of how to express this shifting color led Mayhew to studies in the science of optics, illusion, and space.

Beginning with his early shows, high critical praise followed Mayhew exhibitions year after year. In his work critics found influences from Europeans such as the Barbizon artists and Claude Monet, as well as such Americans as Winslow Homer and Thomas Eakins.[8] In *Arts* magazine, in December 1959, Sidney Tillum emphasized that Mayhew's landscapes "poised in their nostalgia are painted with . . . a sense of period, Americana style, without being able to place it. He paints meadows, thickets, and stands of trees in simple compositions, working his generalized masses for subtleties of texture and contrast complemented by the qualities of waxing and waning hours in which they are perceived. Inness may be of some assistance in locating the elegiac remoteness of Mayhew's landscapes, but Mayhew is not nearly so dexterous with detail, striving instead for the radicals of a flat conception while modulating his color values and considering his shapes for amicability to an implied depth."[9] To Mayhew's delight, *Apollo* magazine of London, which he had pored over as a boy, hailed "his vitality and freshness."[10]

A John Hay Whitney Foundation grant enabled Mayhew to study abroad in 1959. He continued his study of light in Tuscany, Italy, through generous advances from his dealer, Robert Isaacson, and grants from the Ingram Merrill and Tiffany foundations. In Tuscany, according to Mayhew, the peaked hills reflected light back into the haze of the dense atmosphere, returning it to the earth as a cool light—"in which I

The Big Sur (1989). This region of California's northern coast provided Mayhew with vast canyonlike distances and depths that challenged his flat brushwork. He dispensed altogether with the wind-shaped pines often used by artists to identify Big Sur. (48 x 50″) Midtown-Payson Galleries, New York

could see further." In southern France he found "a kind of heavy atmosphere with a warmer light—and there you couldn't see as far."

Before 1960 Mayhew's landscapes were concerned primarily with tonal space, using little color, but now he increasingly turned to color. He described this change in these terms: "In tonal space, instead of being concerned with a red tree, you'd be involved with just a brown tone or a dark, greenish brown tree—and with another force in space, with the shape itself, which often takes over and becomes the dominant factor in the creation of space. When color takes over, there is a double effect on the form, the color often taking away from the form, as many artists have noted."

Experimenting with tones, space, form, and illusion, Mayhew used a palette knife to scumble the paint, applying opaque paint over paint in a way that allows the underlying colors to show through at points in varying intensities. Scumbling, Mayhew found, would "diffuse the light hitting a flat surface and bounce it back to the eye in a different way." He preferred this technique to glazing, where a thin transparent layer of paint is applied over another layer of paint—a technique he had sometimes used in earlier works.

In his search for various effects, Mayhew at times changed the light he worked by, and many of his paintings are based on the idea that the light in which they will be seen will change the painting. He often considered varying the light in exhibitions to demonstrate how it influences the viewer's perceptions.

Mayhew wanted to use landscape to express "a universal space with the illusion of time," something he feels all people experience. Initially, his landscapes included human figures. However, he explained, "with the figures in, it set up a particular time and space. . . . As soon as I found out that I wanted a more universal statement I took the figures out."

Yet he did not want to omit "the humanistic element." As he put it: "How then does one create this feeling of man and nature? It becomes completely abstract. You're involved with just color, but I felt that by retaining elements of nature, such as bushes, trees, hills, ponds, and grasses, you hold onto this humanistic response. So at the height of the abstract period, my paintings stayed with the landscape." Gallery visitors were often entranced by these abstract qualities, saying, "It's not quite a landscape and yet it is a landscape. . . . It looks like Monet and yet it doesn't."

Following the 1963 March on Washington led by the Reverend Martin Luther King, Jr., a group of New York black artists met regularly to discuss their relationship to the civil rights movement and all aspects of their work as artists. Calling their group "Spiral" (see pages 401–3), these artists invited Mayhew to join them.[11] Until then, although casually acquainted with Jacob Lawrence, Mayhew did not know other black artists. Earlier, in 1958, Mayhew had been a fellow at the MacDowell Colony, where artists of all disciplines work individually during the day but meet for supper and discussion of aesthetic problems in the evening. There the concerns of the novelist and playwright Thornton Wilder, the composer Aaron Copland, and other nonvisual artists helped Mayhew realize the similarities of creative efforts in every field as well as the uniqueness of each artist. However, the Spiral artists' discussions, focusing on their racial heritage and current struggles as both artists and citizens, ranged beyond the MacDowell concerns.

What was exciting about Spiral, Mayhew said, was coming "to grips with ourselves in terms of how meaningful we were as artists. Are we being honest? Are we involved in some kind of game playing in our art? And since we felt that art should be involved in the uniqueness of the individual, are you—we asked ourselves—playing the game of the art world? For the first time black artists sat down and stared at each other across the table. It seemed phenomenal for black artists to get together that way." Mayhew felt Spiral confronted each artist with two important questions:

Sunset (1985). On repeated drives to the West Coast, Mayhew gathered what amounted to composite impressions of the changing landscape, which he later composed into specific scenes such as this work. (44 x 46″) Midtown Galleries, New York

"How relevant is what you are doing to the struggles of black people? And how honest is what you are doing?"

Older, "WPA-born" artists in Spiral were familiar with discussions of the use of art as propaganda and generally rejected such direct efforts, but the young artists, asserting this was a time to be "militant," called for such work. Mayhew played a special role in reconciling the two views. He recalled a young black painter asserting, "I've got to do protest painting!" To which Mayhew responded, "Do protest paintings—

not to protest but to be innovative and constructive in relationship to art and your relationship with the community. . . . Real protest painting or constructive painting should be involved with an uplifting and stimulating element." Mayhew did not consider painting "a fist" as constructive or innovative work "because many blacks in the community had been raising their fists for a long time, and they certainly knew about death and violence."

With such interpretations, Mayhew brought opposing opinions together. In one Spiral discussion he

recalled that a black jazz musician had once praised his landscapes, saying: "Man, that's the blues, warm and cool." Mayhew explained that he felt this characterization accurately identified his concern with warm and cool light and placed it in an African-American context. Moreover, the musician's words had called to mind the deep, poetic feelings Mayhew had experienced as a jazz singer—in fact, the idea of "painting the blues" then became something he consciously sought to achieve. After relating all this, he was pleased when a young advocate of "militant" painting conceded, "Well, if you're painting the blues, you don't have to paint the fist."

Spiral members often examined the relationship of the artist to the black community and to the community as a whole in America. They were much stimulated by new studies of African culture that delineated the specific community role of the African artisan-artist in creating works with a symbolic religious meaning, a role that had continued into the nineteenth century. In contrast, in the Western Euro-American world, socioeconomic developments eventually resulted in the artist being cast in the role of an entertainer, supported primarily by the indulgence of a patron. Such patronage had led to the isolation and alienation of the artist from the people as a whole because he or she had no communal function. In discussing the possibility of building positive, satisfying communal relationships derived from African traditions, the older Spiral artists often recalled the strong artist-community relationship in the Depression, when there was a recognition of the common interests of artists and black working people in defending the WPA programs.

The Spiral discussions encouraged Mayhew to develop a new relationship, as an artist, with the community in the Ramapo Mountains where he then resided. The community was composed of descendants of white and black people who had sought refuge in the mountains during the Revolution and intermarried with the Native Americans living there. This community, which had suffered from prejudice and exploitation for generations, was severely divided.

Mayhew led in establishing a community art center that drew upon the community's unusual racial and cultural heritage. Art instruction, theatrical and musical productions, as well as many craft and educational activities, created new community bonds, dissolving prejudicial attitudes and forming strong community-minded groups. This not only ended the traditional isolation of the artist, but demonstrated a way to prevent the racial and ethnic polarization seen in many communities.

Such activities may help define the artist's role in society, according to Mayhew:

What does the artist do? What is he here for? If I don't paint the kind of subject matter that relates to the community, maybe if I become involved with the community through an art center—maybe that is the role of the artist. How can community people relate to the artist? They do not always get a chance to go to museums and galleries. How can they respond and understand what art is all about unless there is a close rapport with the artist? Why can't we set up a community-art relationship by bringing in poetry, the theater, the visual arts and exhibitions, dance and music workshops where everyone can participate instead of being passive spectators? I felt this is what the role of the artist should be—being actively involved in his community where people can then appreciate what he is doing as a painter, because they then have a chance to see it and to know him.

Mayhew has carried out his efforts to relate all the arts in many ways. Acutely sensitive to tonal color balances in music and the spatial arrangements of notes in time, he has sometimes played Cecil Taylor recordings at his Midtown Gallery exhibitions in New York so that viewers could hear the music he worked by as they looked at the paintings. At the Henry Street Settlement House, he projected slides of paintings onto the stage as dancers, dressed in white so that their movement became part of the pictures, danced to the improvisations of jazz musicians, who were responding to both the slides and the moving dancers.[12]

Similar demonstrations at Smith and Hunter colleges, as well as San Jose College, have led Mayhew to develop courses in which art became the core of interdisciplinary studies of creativity. At Penn State Mayhew developed courses that drew upon faculty members in architecture, psychology, computer science, chemistry, music, art education, theater, film, and speech. These courses sought to illuminate the similarity of creative processes in science as well as art.

Mayhew retired from Penn State in 1991.

Teaching at San Jose College in California in 1975 led Mayhew to drive across the continent regularly for four years. The vast changes in landscape—the steep Palisades of the Hudson River and wooded hills of Pennsylvania, the flatlands and big sky of the prairie, the desert wastelands within sight of the thrusting peaks of the Rockies—fascinated him. He also became acutely aware that Americans are the most mobile people in history, that everywhere people are from somewhere else. This personal realization prompted him to study landscape in terms of the psychic experience of mobility. His finding that people sought landscapes with

Sunset (1985). On repeated drives to the West Coast, Mayhew gathered what amounted to composite impressions of the changing landscape, which he later composed into specific scenes such as this work. (44 x 46″) Midtown Galleries, New York

"How relevant is what you are doing to the struggles of black people? And how honest is what you are doing?"

Older, "WPA-born" artists in Spiral were familiar with discussions of the use of art as propaganda and generally rejected such direct efforts, but the young artists, asserting this was a time to be "militant," called for such work. Mayhew played a special role in reconciling the two views. He recalled a young black painter asserting, "I've got to do protest painting!" To which Mayhew responded, "Do protest paintings—

not to protest but to be innovative and constructive in relationship to art and your relationship with the community. . . . Real protest painting or constructive painting should be involved with an uplifting and stimulating element." Mayhew did not consider painting "a fist" as constructive or innovative work "because many blacks in the community had been raising their fists for a long time, and they certainly knew about death and violence."

With such interpretations, Mayhew brought opposing opinions together. In one Spiral discussion he

475

recalled that a black jazz musician had once praised his landscapes, saying: "Man, that's the blues, warm and cool." Mayhew explained that he felt this characterization accurately identified his concern with warm and cool light and placed it in an African-American context. Moreover, the musician's words had called to mind the deep, poetic feelings Mayhew had experienced as a jazz singer—in fact, the idea of "painting the blues" then became something he consciously sought to achieve. After relating all this, he was pleased when a young advocate of "militant" painting conceded, "Well, if you're painting the blues, you don't have to paint the fist."

Spiral members often examined the relationship of the artist to the black community and to the community as a whole in America. They were much stimulated by new studies of African culture that delineated the specific community role of the African artisan-artist in creating works with a symbolic religious meaning, a role that had continued into the nineteenth century. In contrast, in the Western Euro-American world, socioeconomic developments eventually resulted in the artist being cast in the role of an entertainer, supported primarily by the indulgence of a patron. Such patronage had led to the isolation and alienation of the artist from the people as a whole because he or she had no communal function. In discussing the possibility of building positive, satisfying communal relationships derived from African traditions, the older Spiral artists often recalled the strong artist-community relationship in the Depression, when there was a recognition of the common interests of artists and black working people in defending the WPA programs.

The Spiral discussions encouraged Mayhew to develop a new relationship, as an artist, with the community in the Ramapo Mountains where he then resided. The community was composed of descendants of white and black people who had sought refuge in the mountains during the Revolution and intermarried with the Native Americans living there. This community, which had suffered from prejudice and exploitation for generations, was severely divided.

Mayhew led in establishing a community art center that drew upon the community's unusual racial and cultural heritage. Art instruction, theatrical and musical productions, as well as many craft and educational activities, created new community bonds, dissolving prejudicial attitudes and forming strong community-minded groups. This not only ended the traditional isolation of the artist, but demonstrated a way to prevent the racial and ethnic polarization seen in many communities.

Such activities may help define the artist's role in society, according to Mayhew:

What does the artist do? What is he here for? If I don't paint the kind of subject matter that relates to the community, maybe if I become involved with the community through an art center—maybe that is the role of the artist. How can community people relate to the artist? They do not always get a chance to go to museums and galleries. How can they respond and understand what art is all about unless there is a close rapport with the artist? Why can't we set up a community-art relationship by bringing in poetry, the theater, the visual arts and exhibitions, dance and music workshops where everyone can participate instead of being passive spectators? I felt this is what the role of the artist should be—being actively involved in his community where people can then appreciate what he is doing as a painter, because they then have a chance to see it and to know him.

Mayhew has carried out his efforts to relate all the arts in many ways. Acutely sensitive to tonal color balances in music and the spatial arrangements of notes in time, he has sometimes played Cecil Taylor recordings at his Midtown Gallery exhibitions in New York so that viewers could hear the music he worked by as they looked at the paintings. At the Henry Street Settlement House, he projected slides of paintings onto the stage as dancers, dressed in white so that their movement became part of the pictures, danced to the improvisations of jazz musicians, who were responding to both the slides and the moving dancers.[12]

Similar demonstrations at Smith and Hunter colleges, as well as San Jose College, have led Mayhew to develop courses in which art became the core of interdisciplinary studies of creativity. At Penn State Mayhew developed courses that drew upon faculty members in architecture, psychology, computer science, chemistry, music, art education, theater, film, and speech. These courses sought to illuminate the similarity of creative processes in science as well as art.

Mayhew retired from Penn State in 1991.

Teaching at San Jose College in California in 1975 led Mayhew to drive across the continent regularly for four years. The vast changes in landscape—the steep Palisades of the Hudson River and wooded hills of Pennsylvania, the flatlands and big sky of the prairie, the desert wastelands within sight of the thrusting peaks of the Rockies—fascinated him. He also became acutely aware that Americans are the most mobile people in history, that everywhere people are from somewhere else. This personal realization prompted him to study landscape in terms of the psychic experience of mobility. His finding that people sought landscapes with

which they could identify led to profound changes in his work.

In the early 1980s, moving away from the abstract use of color to evoke a vague and mysterious landscape, his work centered on specific trees, glades, and thickets and resulted in realistic landscapes—a shock to those who had known his abstract work. In discussing this evolution, Mayhew pointed out that he had learned that "people only identify with a structural space. I found that, psychologically, space means something to them and, as a result, I moved towards the representational. Even though it might seem that I am going backwards [aesthetically], I feel this is a new insight into landscape and what it means to people."

Most landscapists work from sketches, photographs, and notes, but Mayhew did not use sketches or photographs. In his studio he relied on his memories. However, in working from memory, he found that when he tried to control what was happening on his canvas, the work became mechanical. When that happened, he found he needed to stop and allow what he called "a kind of spiritual internalized relationship with experiences" to take over. This has evolved into "an abstract approach—smearing paint on canvas and allowing experiences to emerge with no particular time factor." His "experiences" may be specific scenes and locations observed in nature, but they may also synthesize internalized elements from the Hudson River school, Impressionism, modern abstraction, and Color Field painting. In the end Mayhew's landscapes are characterized by close tonal harmonies and suggest in a mystical way, rather than depict, specific places.

What has absorbed Mayhew's energies has been a constant concern for knowledge and innovative change. This was first manifested in his frequent change of instructors. It is not mere restlessness. In a creative pursuit, he has moved from studying changes of light in nature to examining changes produced by nonvisual sources such as music, to exploring creativity and community relationships, to investigating psychic changes produced by mobility and memories of scenes. This ongoing search, in part stimulated by his participation in the Spiral discussions, has distinguished his

Spring '82 (1982) indicated Mayhew's turn toward a less abstract approach than he had used in the 1970s. (42 x 40″) Collection Mary K. Boyd, New York

art. His experiences and his work suggest that the African-American artist has a depth of resources and a potential for expression that is both unlimited and, to a large extent, untapped, in terms of memory and relationships with churches and other community groups.

In this context, it is interesting that Mayhew and others, such as Reginald Gammon, who recently retired from teaching at Western Michigan University, have talked of reviving Spiral. Although they abandoned it at the time in disagreements over goals, membership, and aesthetics, every artist who participated in its discussions felt they gained enormously from them. Basically, what Spiral put on the table for discussion was the question of the identity of black artists in America and how that identity might contribute to their aesthetic approach to art.

NOTES

Introduction

1. Joseph Pennell, *The Adventures of an Illustrator* (Boston: Little, Brown & Co., 1925), pp. 53–54.
2. Barbara Novak, *American Paintings of the Nineteenth Century* (New York: Frederick A. Praeger, 1969).
3. Arthur A. Schomburg, in *The New Negro*, ed. Alain L. Locke (New York: Albert and Charles Boni, 1925; reprint, New York: Atheneum, 1968), p. 237.
4. Metropolitan Museum of Art, *American Paradise: The World of the Hudson River School* (New York: Harry N. Abrams, 1987).
5. E. P. Richardson, *Painting in America* (New York: Thomas Y. Crowell, 1956).
6. Oliver W. Larkin, *Art and Life in the United States*, rev. ed. (New York: Holt, Rinehart & Winston, 1960).
7. Milton W. Brown, *American Painting from the Armory Show to the Depression* (Princeton, N.J.: Princeton University Press, 1955).
8. Barbara Rose, *American Art Since 1900* (New York: Frederick A. Praeger, 1967).
9. Richard D. McKinzie, *The New Deal for Artists* (Princeton, N.J.: Princeton University Press, 1973).
10. Cedric Dover, *American Negro Art* (Greenwich, Conn.: New York Graphic Society, 1960).
11. For an account of African methods and traditions that have been retained in pottery, basketry, weaving, carving, boat building, various handcrafts, and architecture, see John M. Vlach, *The Afro-American Tradition in Decorative Arts* (Cleveland: Cleveland Museum of Art, 1973; distributed by Indiana University Press).
12. Booker T. Washington, *The Story of the Negro* (New York: P. Smith, 1909), vol. 1, p. 8. "Years ago a magazine editor told me never to paint a Negro in any position except that of a servant," said Norman Rockwell, in the *Philadelphia Evening Bulletin*, Nov. 5, 1970, p. 5. He later identified the editor as George Horace Latimer of the *Saturday Evening Post*. During the school segregation crisis, Rockwell depicted a young black girl being escorted to school by U.S. marshals (*Look*, Jan. 1964). See *New York Times Magazine*, Feb. 28, 1971, and *102 Favorite Paintings by Norman Rockwell* (New York: Crown, 1978), p. 150.
13. Eldzier Cortor, author interview, Oct. 29, 1973.

The Late Eighteenth and Nineteenth Centuries

1. *News and Notes of the Maryland Historical Society* 5 (April 1977), p. 22. Johnston's name was often spelled without the *t*, but his signature and his first advertisement used the *t*.
2. See Guy C. McElroy, *Facing History: The Black Image in American Art, 1710–1940* (Washington, D.C.: Bedford Arts in association with the Corcoran Gallery of Art, 1990). This is a catalog of an exhibition at the Corcoran Gallery (Jan. 13–March 25), and Brooklyn Museum of Art (April 20–June 25, 1990).
3. Carolyn J. Weekley and Stiles Tuttle Colwill, with Leroy Graham and Mary Ellen Hayward, *Joshua Johnson, Freeman and Early American Portrait Painter* (Williamsburg and Baltimore: AbbyAldrich Rockefeller Folk Art Center, Colonial Williamsburg Foundation, and Maryland Historical Society, 1987).
4. J. Hall Pleasants, "Joshua Johnston, the First Black American Portrait Painter?" *Maryland Historical Magazine* 37 (June 1942), pp. 121–49. Reprints carry different page numbers, and the title's question mark has been deleted.
5. See *Contemporary Negro Art* (Baltimore: Baltimore Museum of Art, exhibition catalog, Feb. 3–19, 1939).
6. J. Hall Pleasants, Foreword, *Joshua Johnston* (Baltimore: Peale Museum, exhibition catalog, Jan. 11–Feb. 8, 1948).
7. In 1971 Susan Solomon, curator of the Newark Museum, asked if there was any family tradition relating the Gustin portrait to Johnston. Mrs. William H. Hunter, a relative of the deceased former owner, replied that "Joshua was the valet of Peale (I don't remember which one) & was a very bright Black young man. . . . This may not be all true . . . and I've no proof" (letter to Susan Solomon, Feb. 21, 1972). The story was not related when the Garbisches bought the portrait in 1961. When the authors queried the National Gallery of Art in 1975, Elize V. H. Ferber, curator in charge of art information, did not confirm the story, saying only, "We would like to believe that the picture was painted by a black artist" (letter, Jan. 17, 1975).
8. *Baltimore Sun*, July 11, 1973.
9. Sian Jones and Barbara Halstead, author interview, New York, Feb. 2, 1971.
10. See reproduction of Basil Brown portrait in *Johnson* (Folk Art Center), pp. 153–54.
11. See, for example, Romare Bearden and Harry Henderson, *Six Black Masters of American Art* (New York: Doubleday, 1972).
12. One such advertisement is reproduced in the Introduction; see page xvii.
13. His first advertisement was on December 19, 1798, in the *Baltimore Intelligencer*.
14. His second advertisement was in the *Baltimore Telegraphe* on October 11, 1802.
15. Pleasants, "Johnston," *Maryland Historical Magazine*, p. 125. Pleasants mistakenly called this the 1810 census in his article. The 1800 census describes the Joshua Johnston household as

having the following free white males: one under ten years; two over ten and under sixteen years; and one over twenty-six, under forty-five years. There were also the following free white females: two under ten years; one over ten and under sixteen years; and one over twenty-six, under forty-five years; and one other free person. Since this "free person" was not included in the listing of free white males or females, he or she is presumed to be an African-American. No slaves were in the household. See also *Johnson* (Folk Art Center), p. 58. The 1790 census listed a Joshua Johnston, who was not identified as black, in the Fell's Point section with his wife, a son, and two daughters. He was not listed in the 1820 census.

16. Ibid.
17. *Johnson* (Folk Art Center), see note 3.
18. Rita Reif, "New Attention for Early Black Artist," *New York Times,* Feb. 7, 1988, sec. H, p. 28. The painting, a portrait of Emma Van Name, was titled *Little Girl in Pink with a Goblet Filled with Strawberries.*
19. C. L. R. James, *Black Jacobins: Toussaint L'Ouverture and the Santo Domingo Revolution* (New York: Vintage Books, 1963).
20. Pleasants, with Howard Sill, wrote *Maryland Silver Smiths, 1715–1830* (Baltimore: Lord Baltimore Press, 1930).
21. Pleasants, "Johnston," *Maryland Historical Magazine,* p. 126.
22. Ibid., p. 127.
23. Quoted by Weekley in *Johnson* (Folk Art Center), p. 52 (Maryland Hall of Records, Annapolis, "Wills," 1777, vol. 3. p. 347).
24. Quoted by Weekley, in ibid. (undated, but presumably a 1777 letter by Charles Willson Peale, Smithsonian Institution, Peale Family Papers, series I, box 1, card 6).
25. Charles Coleman Sellers, *Charles Willson Peale* (New York: Charles Scribner's Sons, 1969), p. 167.
26. Sellers, *Charles Willson Peale* (Philadelphia: American Philosophical Society, 1947), vol. 1, p. 51. Named James, the man had vitiligo, a harmless disease causing depigmentation.
27. The Yarrow Mamout portrait is reproduced in ibid., vol. 2, fig. 38, opposite p. 325.
28. Sellers, *Peale* (1969), p. 182. After a visit to Washington at Mount Vernon in June 1804, Peale wrote in his diary, "a miserable situation to be surrounded by slaves, however kindly they may be used" (Collection of American Philosophical Society, Philadelphia).
29. Sellers, *Peale* (1969), p. 109.
30. Ibid., p. 306.
31. Sellers, *Peale* (1947), vol. 2, p. 159. Also Sellers, *Peale* (1969), pp. 77–78.
32. Sellers, *Peale* (1969), p. 200. Also Sellers, *Peale,* vol. 1, pp. 223–31.
33. Pleasants, "Johnston," *Maryland Historical Magazine,* p. 129.
34. *Johnson* (Folk Art Center), p. 53.
35. These painters included Charles Willson Peale, Rembrandt Peale, Charles Peale Polk, John Wesley Jarvis, Jeremiah Paul, Robert Edge Pine, John Frederick Kemmelmeyer, Marie Paul Chefdebien, William Clark, Jean Pierre Henri Elouis, Monsieur Faugere, William Joseph Williams, Phillip Abraham Peticolas, J. F. Duvivier, Thomas Ruckle, Lewis Pise (Pease), Francis Ayme, Moses Hand, Stephan Moranges, Charles Saint-Memin (who engraved his portraits and sold prints), Lewis Baconais, Francis Guy, Caleb Boyle, Nicholas Vincent Boudet and his son Dominic, and Edward Savage. Many of these artists were French and some were miniaturists. They are described by Stiles Tuttle Colwill in *Johnson* (Folk Art Center), pp. 69–94.
36. Ibid., p. 62.
37. Rev. Daniel Coker was listed in the 1817 directory as "minister of the African Bethel Church," living at the end of Potter Street, Old Town. He wrote the first pamphlet by an African-American in the United States attacking slavery—*A Dialogue between a Virginian and an African Minister* (Baltimore: Benjamin Edes, 1810).
38. Coker's background and career is summarized in Rayford W. Logan and Michael Winston, eds., *Dictionary of American Negro Biography* (New York: W. W. Norton, 1982).
39. Various authors disagree about the cause of Coker's resignation. See the summary of their disagreement in Clarence E. Walker, *A Rock in a Weary Land: A History of the AME Church in the Civil War* (Baton Rouge: Louisiana State University Press, 1982), p. 10, n. 11. Coker became a colonist and went to Liberia in 1820.
40. *Johnson* (Folk Art Center), p. 133.
41. The quotation is from Pleasants's files on these portraits. File no. 3696 referred to the portrait of a black man now titled *Unknown Cleric* and owned by Bowdoin College. File no. 3685 referred to the portrait that may be Rev. Daniel Coker, owned by the American Museum, Claverton Manor, Bath, England.
42. *Johnson* (Folk Art Center), p. 133.
43. Herbert Aptheker, *A Documentary History of the Negro People of U.S.* (New York: Citadel Press, 1969), p. 69.
44. Rev. Daniel A. Payne, *Recollections of Seventy Years* (reprint, New York: Arno Press and the *New York Times,* 1969), pp. 100–101.
45. The dealers were Mr. and Mrs. Richard H. Wood (Pleasants's file nos. 3696 and 3685).
46. Sian Jones details these similarities in *Johnson* (Folk Art Center), pp. 65–67.
47. Phoebe Jacobson, Hall of Records, Annapolis, author interview, Aug. 29, 1988.
48. Baltimore Cathedral Rectory, Aug. 15, 1974. Research conducted with the Reverend John J. Tierney, archivist.
49. St. Peter's Baptismal Register, Book A (1782–1801), p. 67.
50. Cathedral Baptismal Register, Book F (1827–1837), p. 12.
51. St. Peter's Baptismal Register, p. 145. Also, for her death, St. Peter's Register of Deaths, p. 62.
52. St. Peter's Baptismal Register, p. 237.
53. A typical entry (ibid., p. 67) reads: "June 9, 1793 Was baptized Ann (an adult) Negro slave of Mr. Oliver—Godmother, Sarah, Negro slave of Mr. Campbell, Fr. Beeston."
54. See citation of Sarah Johnston as the wife of Joshua Johnston in *Johnson* (Folk Art Center), p. 55.
55. Ibid., pp. 153–54.
56. Ibid., p. 148.
57. James A. Porter, *Modern Negro Art* (New York: Dryden Press, 1943), p. 28. This portrait was reproduced by Sidney Kaplan in *The Black Presence in the Era of the American Revolution, 1770–1800* (Greenwich, Conn.: New York Graphic Society and Smithsonian Institution Press, 1973), plate 4.
58. W. Dunlap, *History of Rise and Progress of Arts of Design in U.S.* (reprint, New York: Dover, 1969), p. 349.
59. Silvio A. Bedini, *Life of Benjamin Banneker* (New York: Charles Scribner's Sons, 1972), p. 152. This is the source of all our material on Banneker.
60. *Johnson* (Folk Art Center), p. 38.
61. Ibid.

Robert S. Duncanson

1. Perry Miller, *The Raven and the Whale* (New York: Harcourt Brace & World, 1956); John Stafford, *Literary Criticism of Young America* (Berkeley: University of California Press, 1952).

2. Seneca County lies between Lake Seneca and Lake Cayuga. The 1860 U.S. Census listed Duncanson as an artist, age thirty-eight, a mulatto, born in New York, making his birth date 1822.

3. Joseph D. Ketner II has grouped Duncanson's paintings according to themes and locales suggested by English literature, particularly by William Shakespeare, Sir Walter Scott, Alfred Tennyson, and Thomas Moore (*American Art Journal* 15 [Winter 1983], p. 35).

4. Charles Cist, *Sketches and Statistics of Cincinnati in 1851* (Cincinnati, W. H. Moore, 1851); C. F. Goss, *Cincinnati, the Queen City* (Chicago: S. J. Clark Publishing Co., 1912).

5. Constance Rourke, *American Humor: A Study of the National Character* (New York: Doubleday Anchor Books, 1953), pp. 70–90.

6. Wendell P. Dabney, *Cincinnati's Colored Citizens* (Cincinnati: Dabney Publishing Co., 1926; reprint, New York: Johnson Reprint Corp., 1970), p. 33. Also, C. G. Woodson, "Negroes of Cincinnati Prior to the Civil War," *Journal of Negro History* 1 (Jan. 1916), pp. 1–22.

7. See J. F. McDermott, *The Lost Panoramas of the Mississippi* (Chicago: University of Chicago Press, 1958); L. Perry, "Landscape Theatre in America," *Art in America* 65 (Nov.–Dec. 1977), pp. 52–61.

8. Rourke, *American Humor,* p. 72.

9. *History of Cincinnati and Hamilton County* (Cincinnati: S. B. Nelson & Co., 1894), p. 434, describes Mount Pleasant, its leading people, and their activities. See also the booklet "Once Upon a Hilltop," Mount Healthy Area Sesquicentennial, 1967.

10. Woodson, "Negroes of Cincinnati," p. 22.

11. Duncanson's portraits of Freeman G. Cary (1856) and William Cary (1855) were reproduced in *Art in America* 39 (Oct. 1951), pp. 124–25.

12. These assaults are described in J. M. Langston's autobiography, *From Virginia Plantation to the National Capitol* (Hartford, Conn.: American Publishing Co., 1894), pp. 62–67; *Reminiscences of Levi Coffin* (Cincinnati: Robert Clark Co., 1898), pp. 524–41; L. F. Litwack, *North of Slavery* (Chicago: University of Chicago Press, 1965), pp. 72–74, 100.

13. See the catalog *Second Annual Exhibition of Paintings and Statuary* (Cincinnati: Section of Fine Arts, Society for the Promotion of Useful Knowledge, 1842). See also E. H. Dwight, "Robert S. Duncanson," *Bulletin of the Historical and Philosophic Society of Ohio* 8 (July 1855), p. 203.

14. See G. C. Croce and David H. Wallace, *New-York Historical Society's Dictionary of Artists in America* (New Haven: Yale University Press, 1969); E. M. Clark, *Ohio Art and Artists* (Richmond: Garrett and Massie, 1932), p. 108.

15. E. H. Dwight, in *Museum Echoes* 27 (1954), p. 43; published by the Archeological and Historical Society, Columbus, Ohio.

16. J. D. Parks, *Robert S. Duncanson: 19th Century Black Romantic Painter* (Washington, D.C.: Associated Publishers, 1980), p. 5. According to Parks, Duncanson's relatives feared he would "pass into white society," but he never severed his African-American ties. Parks asserted that Duncanson was treated as white in Detroit and in his travels, and as black in Cincinnati.

17. Collection of Douglas Settlement House, Toledo, Ohio.

18. This story has circulated for nearly three-quarters of a century, with James A. Porter citing an unsupported anecdote to this effect from the *New York Age* of March 17, 1928, in his book *Modern Negro Art* (New York: Dryden Press, 1943), p. 43. Parks asserted, without substantiation, that Duncanson first went to England and Scotland to study in 1847–48, financed "by mem-
bers of the AntiSlavery Society and Nicolas Longworth" (*Duncanson,* p. 9). Joseph D. Ketner II placed Duncanson abroad before 1842 (*American Art Journal* 15 [Winter 1983], p. 37).

These projections fly in the face of the fact that abolitionists sought out, supported, and publicized talented African-Americans. They talked about them, wrote about them publicly, in their own correspondence, diaries, and books. Nothing of this sort has yet been established in the case of Duncanson. Individual Cincinnati abolitionists commissioned portraits and may have contributed individually to his 1853 trip to Europe, as Parks suggested. Longworth, no abolitionist, undoubtedly did so. That he gave Duncanson an enthusiastic introductory note to Hiram Powers indicates his readiness to help him. But that was after Duncanson painted the Belmont murals in 1848–49.

19. Contrary to earlier reports that Duncanson painted portraits of six members of the Berthelet family, recent studies attribute only one to him—that of William Berthelet as a boy; it is signed. The boy was a descendant of Pierre Berthelet, a fur trader who became Montreal's largest landowner and also owned much of the land on which Detroit was built. Pierre was godfather to one of his slave's children. (*Transactions and Proceedings of Royal Society of Canada,* 3rd series, sec. 2, vol. 37 [1943], pp. 57–76.)

20. H. N. Walker's notes of this exchange, copied by his daughter, Elizabeth Gray Walker, were given to Francis W. Robinson, curator of the Detroit Institute of Arts, on September 18, 1950. She and her brother gave this painting to the Detroit Institute of Arts, where it is today.

21. The Cass portrait is based on the "Lansdowne" portrait of George Washington by Gilbert Stuart, according to Guy McElroy, who assembled the *Duncanson Centennial Exhibition* (Cincinnati: Cincinnati Art Museum, catalog, 1972, p. 7). This popular but aesthetically weak composition may have been required by those who commissioned it because Cass was considered the "Washington" of Michigan.

22. Dwight has pointed out that as a result of Longworth's early support of Powers, the sculptor's international fame "inspired Cincinnatians to patronize local artists" ("Duncanson," p. 204). Powers's most famous statue, *The Greek Slave,* was exhibited at the Western Art Union in Cincinnati in 1851. A visiting Baltimore artist, F. B. Mayer, noting in 1851 that most local participating artists were landscapists, wrote: "The most eminent in landscape is Sonntag. . . . Whittredge [and] Duncanson (a Negro) also paint good landscapes" (in *With Pen and Pencil on the Frontier in 1851,* ed. B. L. Heilbron [St. Paul: Minnesota Historical Society, 1932]). Mayer's comment makes it clear that Duncanson was known as an African-American even to out-of-town visitors.

23. Clara Longworth de Chambrun, *Cincinnati: Story of the Queen City* (New York: Scribner's, 1939), p. 113.

24. Mrs. Taft's father had owned the mansion. W. H. Siple, the Taft Museum director, supervised the removal of three layers of wallpaper and varnish from these frescoes at Mrs. Taft's request. (*Bulletin of Cincinnati Art Museum* 4 [Jan. 1933], pp. 2–21.)

25. The 1850–51 Cincinnati business directory first lists Ball's studio on 4th Street below Walnut.

26. Duncanson is listed as a daguerreotypist only in the 1853 Cincinnati business directory. He may have worked with Ball for several years before this.

27. In an 1855 advertising pamphlet featuring the illustration from *Gleason's Pictorial,* Ball lists paintings by Duncanson. The city directory address for Duncanson the artist and for Ball was often

the same. Writing to E. H. Dwight on January 1, 1953, James A. Porter, who first noted the Ball-Duncanson connection ("Robert S. Duncanson," *Art in America* 41 [Oct. 1953], pp. 98–153), pointed out it was unlikely that two black daguerreotypists could have been equally successful in antebellum Cincinnati without a relationship tantamount to a partnership.

Ball moved and changed partners several times. From 1853 to 1857 he was at 28 and/or 30 West 4th Street. In 1857 his partner was Robert J. Harlan, who reportedly was the wealthiest African-American in Cincinnati. In 1858 Ball's partner was Alexander Thomas, and the studio was on McAllister Street, then at 120 West 4th Street. After 1861 Ball alone was listed as a photographer at 32 and/or 30 West 4th Street. In 1869 he moved to 154 West 4th Street.

28. *Favorite Poems of Henry Wadsworth Longfellow* (New York: Doubleday, 1947), p. 57.

29. William Lloyd Garrison, writing in *The Liberator* (Aug. 21, 1846), in an article datelined Cincinnati, July 29, said: "I had a great treat last evening in the view of some portraits and fancy pieces from the pencil of a Negro, who has had no instruction or knowledge of the art. He has been working as a housepainter, and employed his leisure time in these works of art, and they are really beautiful. . . . I saw these works in company with a lady from Nashville in whose family the wife of the artist was reared and brought up a slave." Was this artist Duncanson? Lack of positive identification by Garrison leaves this uncertain. If this was not Duncanson, another question is raised: Were there two highly skilled black artists in Cincinnati in 1846? Logic and history say no.

30. The 1861 Cincinnati directory lists Reuben Duncanson as a clerk, at same address as R. S. Duncanson; Dwight suggested this kinship ("Duncanson," pp. 203–11).

31. Croce and Wallace, *Dictionary*, p. 593.

32. Cist, *Sketches*, p. 125.

33. The painting was originally titled *Flood Waters, Blue Hole, Little Miami River.*

34. Author interview, Nov. 21, 1969.

35. This is Duncanson's only known portrayal of an African-American. It was criticized by the *Cincinnati Commercial Gazette* as follows: "AN UNCLE TOMITUDE—Uncle Tom, according to the artist, is a very stupid looking creature, and Eva, instead of being a fragile and fading floweret, is a rosy-complexioned, healthy seeming child, not a bit ethereal. She is complacently pointing toward a portion of the canvas which is deeply yellow, with a dusky-red fringe—probably intended to be a sunset. Tom has nearly all of her arm in his hand, as if intending to check the projected flight, and appears to inquire—'What goin' dar for?' " (quoted in the *Detroit Free Press,* April 21, 1853).

36. A letter by the Cincinnati miniaturist William Miller on April 10, praising Duncanson's work after his Italian journey, says: "His traveling companion, Sonntag, is still in New York" (cited by Dwight, "Duncanson," p. 206). McElroy suggested John Robinson Tait accompanied Duncanson and Sonntag (*Duncanson Centennial Exhibition,* p. 12). Other sources report Tait was already in Europe in 1852 (Croce and Wallace, *Dictionary,* p. 618). Tait may have joined them in Europe.

37. On June 12, 1852, Longworth wrote to Powers: "One of our most promising painters is a light Mulatto of the name of Duncanson. He is a man of great industry and worth. He may visit your city [New York] and is anxious to visit Europe" (Parks, *Duncanson,* p. 10).

38. Dwight, in *Museum Echoes,* p. 43.

39. Charlotte Cushman left no record of her friendship with Duncanson, according to Joseph Leach, author of her biography, *Bright Particular Star* (New Haven: Yale University Press, 1970), in letters to authors. Duncanson may actually have first met Cushman in Cincinnati, where she played with great success in 1850 (Leach, p. 234).

40. This letter is dated January 22, 1854. The letters to Junius R. Sloan from January to November 1895 are in the Spencer Collection, Newberry Library, Chicago. The letter of August 21 includes a sketch of a rose with verse; that of September 17, a sketch for an illustration of *Pilgrim's Progress.*

41. Richard S. Rust, Jr., letter to authors, April 2, 1970.

42. The 1860 U.S. Census lists Phoebe Duncanson, mulatto, age twenty-four, Kentucky-born. Their son, Milton J., is listed as five months old. Bertha is mentioned in letters by Mrs. Duncanson, then in Detroit, to Duncanson's mother, Mrs. Harlan, in 1872 and later, in 1884, in letters to R. D. Parker.

43. Duncanson's Detroit real estate transactions are recorded in Wayne County Register of Deeds (1811–1858), vol. 37 (City and County vols. 73–74), p. 31.

44. 1860 U.S. Census, recorded June 6, 1860.

45. Peter H. Clark, *The Black Brigade of Cincinnati* (Cincinnati: Joseph B. Boyd, 1884), p. 5.

46. John Peter Frankenstein, *American Art—Its Awful State* (Cincinnati, 1864; reprint, Bowling Green, Ohio: Bowling Green University Popular Press, 1972), p. 82. Neither Duncanson's *Niagara* nor that of George Loring Brown can be located. Brown's moonlit view was exhibited at the 1876 Centennial, and his *Niagara at Sunrise* at the Boston Athenaeum in 1962. See T. W. Leavitt, *George Loring Brown, Landscapes of Europe and America, 1834–1880* (Burlington, Vt.: Robert Hull Fleming Museum, exhibition catalog, 1973), p. 23.

47. Porter, "Duncanson," p. 133.

48. The *Toronto Globe* (Nov. 16, 1861, p. 2, col. 9), reported: "After the exhibition of Duncanson's paintings (over the store of Messrs. J.G. Joseph & Co.) they will be sold at 11 a.m." A list of the paintings has not been found, and whether Duncanson was present is unknown.

49. Clark, *Black Brigade,* p. 5.

50. Ibid. Details of this assault and Wallace's reaction are in the report of William H. Dickson to Governor John Brogh, January 12, 1864, in Clark, *Black Brigade,* pp. 14–21.

51. Ibid., p. 13. Clark reports the Black Brigade marched "with music playing, banners flying, to the corner where it was disbanded. . . . The Black Brigade, so ignominiously recruited, so insulted and outraged at its going forth, was everywhere received with kindly enthusiasm." Goss, *Cincinnati,* p. 212, reported that Colonel Dickson told the disbanding Black Brigade: "Go to your homes with a consciousness of having performed your duty, and of deserving (if you do not receive) protection of the law, and bearing with you the gratitude and respect of all honorable men," to which Goss added: "Without them Cincinnati might have been a blackened ruin."

52. Edward Radford of Irlam, near Congleton, England, reported this conversation, which was published under the heading "Canadian Photographers," *Art Journal* (London), New Series III, 1 (April 1864), p. 113. He also said that *The Land of the Lotus-Eaters* and *Western Tornado* were then (in May 1863) in Toronto and that replicas had been painted of the *Lotus-Eaters* as well as *Prairie Fire, Oenone,* and the *Vale of Ida* (with Mount Garganas and the Trojan city in the distance). He believed that several Duncansons had been purchased by the Marquis of Westminster. He also said that Duncanson had painted faster than any artist he had seen.

53. See J. Russell Harper and Stanley Triggs, eds., *Portrait of a Period: A Collection of W. A. Notman Photographs, 1856–1915* (Montreal: McGill University Press, 1967).

54. Dennis Reid, *"Our Own Country Canada": Being an Account of the National Aspirations of the Principal Landscape Artists in Montreal and Toronto, 1860–1890* (Ottawa: National Gallery of Canada, 1979), p. 35.

55. Ibid., p. 20.

56. Ibid., p. 96. One of Duncanson's Canadian collectors, J. C. Baker, helped finance Edson's later studies in England.

57. Ibid., p. 43; these paintings were *Chagnmon Mountain and Orford Lake, Falls of the Chaudiere, River St. Anne (below Quebec), Recollections of the Tropics,* two *Scenes on the Ottawa, Vale of Cashmere,* and a watercolor titled *Composition,* according to Michael Pantazzi, a curator at the National Gallery of Canada, May 28, 1984.

58. Reid, *"Our Own Country Canada,"* pp. 43–44.

59. Moncure D. Conway, *Testimonies Concerning Slavery* (London: Chapman and Hall, 1864), p. 72.

60. This painting was owned by Wendell P. Dabney in the 1950s when seen by Dwight, who considered it an incomplete attempt at a portrait of Charlotte Cushman as Lady Macbeth (Dwight, "Duncanson," p. 209). No evidence suggests Cushman knew of this portrait.

61. The Duchess of Sutherland was the sister of Sumner's friend Lord Morpeth, who came to Cincinnati in 1841 and met S. P. Chase and other abolitionists. Her daughter was one of Sumner's most faithful correspondents to the end of his life (*Memoirs and Letters of Charles Sumner,* ed. E. L. Pierce [Boston: Roberts Bros., 1877], vol. 2, p. 144 n.).

62. *Cincinnati Daily Gazette,* Nov. 24, 1865.

63. Letter to Mrs. Wade Hampton Whitby by Miner Kellogg in Dwight notes; Dwight, author interview, Nov. 21, 1969; see also Dwight, "Duncanson," p. 209.

64. *Art Journal* (London) 28 (Jan. 1, 1866), p. 93.

65. The Royal Collection acquired the painting about 1909 "in circumstance that are not clear today," Setterwall wrote the authors in January 1970. In 1959 a visiting curator from the Victoria and Albert Museum, London, noticed the *Lotus-Eaters* in the Swedish collection and told Setterwall of "American inquiries." Setterwall then sent a letter and photograph of the painting to the Detroit Institute of Arts because Duncanson had died in that city; he sent a copy of this January 26, 1959, letter to the authors. However, since the photograph was not directed to Francis W. Robinson, a curator in medieval art who had become interested in Duncanson as a hobby, the photo was ignored and nothing reached Porter, who had made the inquiries to English museums. On a list Robinson sent the authors, he had earlier lightly penciled "HM Coll. Sweden?" beside the *Lotus-Eaters,* indicating someone who had seen the photograph had spoken to him about it. Yet he had not followed up.

The *Lotus-Eaters* replica, referred to by Edward Radford (see note 52), was sold to Samuel T. Harris, according to Dwight (interview, Nov. 21, 1969). He learned that Harris died in Norwood, Ohio, on July 14, 1901, and his two surviving relatives knew nothing of the painting.

66. *The Catalogue of Pictures Exhibited at the Athenaeum, Bequeathed to Boston Museum of Fine Arts by Charles Sumner* (Boston: Rockwell and Churchill, 1874) lists etchings by Rembrandt, more than 100 engravings as well as paintings by Holbein, Gainsborough, Caravaggio, Lucas Cranach, Rembrandt Peale, Paolo Veronese, Salvator Rosa, Nicolas Poussin, and many other famous artists. One of Sumner's most famous antislavery speeches was inspired by Tintoretto's *Miracle of Saint Mark,* which depicts an angel freeing a slave. He bequeathed this painting to Joshua B. Smith, an African-American Massachusetts legislator, who had won the rescinding of the legislature's censure of Sumner, provoked by his proposing removal of the names of victories over Confederate forces from Union battle flags to help heal the wounds of the Civil War. See A. B. Johnson, "Recollections of Charles Sumner, II," *Scribner's Monthly/Century Magazine* 8 (Nov. 1875), p. 113.

67. Ibid.

68. Parks, *Duncanson,* p. 16.

69. Although using stereotypes such as "raving maniac" and never a witness to such episodes, F. C. Wright of Mount Healthy, who was related to the Laboiteaux family, may be correct in reporting that Duncanson's fellow artists in Cincinnati recalled "his occasional lapses, when he would become hysterical, at times dropping his brush, and laughing and weeping, before he could resume work" (*Cincinnati Enquirer,* Dec. 21, 1924).

70. According to the Hamilton County, Ohio, Recorder's Office, on July 2, 1872, Robert Harlan and his wife, Mary A. Harlan, sold a lot in Mount Healthy to Duncanson for $250. It was previously owned by Reuben Graham. Duncanson was at this time showing signs of irrationality, and his relationship with the Harlans is not clear. However, Harlan and Duncanson were well acquainted, Harlan having been Ball's partner in 1857. Harlan, who went to England for ten years in 1858, owned racehorses and Dumas House, the city's famous black hotel, an elaborate establishment with porches, parlors, and gambling rooms. Wendell P. Dabney, who inherited Dumas House and was an editor-publisher and historian of Cincinnati's African-American community, mentioned Harlan and Duncanson in describing gambling at the hotel. Black men, he wrote, "spurred by the example of their former owners or employers . . . gambled like gentlemen and the sky was their limit. . . . In the fifties, 'Sandy Shumate,' my great-uncle, was the owner. Well fitted was he for the role. A bachelor, handsome, debonair, bon vivant, he stood well with the boys of that period. Old Col. Harlan, reputed half-brother of Chief Justice Harlan; Pinchback, who afterward became temporarily governor of Louisiana; Alex Thomas, the city's leading photographer; Duncanson, the great painter . . . gay was the day when they foregathered" (*Cincinnati's Colored Citizens,* pp. 130–31).

Harlan's half brother was not the chief justice, but an associate justice. He wrote the famous dissent ("The Constitution is color-blind") in *Plessy v. Ferguson,* which legalized segregation. Active in politics, Harlan, who was made a colonel by President Rutherford B. Hayes, helped repeal Ohio's discriminatory "black laws." He died in 1897. See Rayford W. Logan and Michael Winston, *Dictionary of American Negro Biography* (New York: W. W. Norton, 1982), for details on his colorful life.

71. Parks, *Duncanson,* p. 30.

72. Ibid.

73. Johnson, "Recollections of Sumner," p. 113.

74. Parks, *Duncanson,* p. 32.

75. Letters to authors from Michigan Department of Mental Health, Sept. 28, 1971, and J. B. Sullivan, Wayne County Clerk, Oct. 20, 1971.

76. Louis Carp, M.D., published a detailed account of Gershwin's symptoms, treatment, and death from glioblastoma in *American Journal of Surgical Pathology* 3 (Oct. 1979), p. 1.

77. Johnson, "Recollections of Sumner," p. 113.

78. On August 19, 1884, Charles G. Loring, curator at the Boston

Museum of Fine Arts, wrote Mrs. Duncanson that the painting had been shipped to her. (Copy in Detroit Institute of Arts, Duncanson file.)

79. Phoebe Duncanson, letter to Ralzemond D. Parker, dated May 7, 1884.
80. *Detroit Tribune,* Dec. 26, 1872.
81. Rourke, *American Humor,* p. 90.

Edward M. Bannister

1. The first exhibition, "The Barbizon School in Providence, Edward Mitchell Bannister, 1828–1901," was held at the Olney Baptist Church, August 1–15, 1965. It prompted a more comprehensive exhibition, "Edward Mitchell Bannister, 1828–1901, Providence Artist," organized by and at the Museum of Art of the Rhode Island School of Design, March 23–April 3, 1966, for the Museum of African Art and the Frederick Douglass Institute (later incorporated into the Smithsonian Institution, Washington, D.C.).
2. The Kenkeleba House exhibition, May 10–June 27, 1992, had more than eighty paintings and drawings. Raised in Providence in an African-American family of artists, Corrine Jennings, co-director of Kenkeleba House, was aided in her extensive research by her intimate knowledge of the artistic and African-American communities of Providence, and by Juanita Holland. The catalog of the Kenkeleba exhibition was published as *Edward Mitchell Bannister, 1828–1901* (New York: Kenkeleba House and Whitney Museum of Art, 1992).
3. The portrait is undated. (Author interview with Jo-Ann Allison, supervisor of Bannister House, as it was then called; also booklet and correspondence, July 1, 1971.)
4. Information on Bannister's birth, parents, and childhood has been drawn from William Wells Brown, *The Black Man: His Antecedents, His Genius, and His Achievements* (Boston: James Redpath, 1863; reprint, New York: Kraus, 1969); obituary, *Providence Daily Journal,* Jan. 11, 1901, p. 8; and the following artists' manuscripts in the archives of the Rhode Island Historical Society in Providence: *Reminiscences* of George W. Whitaker; *Edward M. Bannister* by his student, W. Alden Brown; and *Bannister* by Sydney Burleigh.
5. Brown, *The Black Man,* p. 214.
6. Whitaker, *Reminiscences;* all quotations attributed to Whitaker hereafter are from his handwritten manuscript unless otherwise noted.
7. Whitaker, "Reminiscences," *Providence Magazine,* Feb. 1914, pp. 138–39; this article contains parts of his manuscript.
8. George L. Miner, *Angel's Lane* (Providence: Ackerman-Standard Press, 1948), p. 132, refers to Bannister as "Ned."
9. Brown, *The Black Man,* pp. 214–17.
10. Ibid., p. 214.
11. Ibid., p. 215.
12. Whitaker, *Reminiscences,* and *Edward Mitchell Bannister, 1828–1901, Providence Artist* (Providence: Museum of Art, Rhode Island School of Design, exhibition catalog, March 23–April 3, 1966).
13. W. Alden Brown, who was Bannister's student at one time, recalled a childhood visit to his studio when Bannister showed his mother a large painting, *Christ in the Garden of Gethsemane,* a work now lost.
14. This painting has not been located. It has been described as follows: "In the doctor's study hangs . . . a beautiful painting (*The Ship Outward Bound*) executed by a young colored artist, Mr. Edward Bannister, which is enclosed in its gilt frame, the work of a young colored mechanic, Mr. Jacob Andrew—the whole being a joint presentation to their professional friend" (W. C. Nell, *The Colored Patriots of the American Revolution and Survey of the Conditions and Prospects of Colored Americans* [Boston: Robert F. Wallcut, 1855], p. 318).
15. Reverend Howard DeGrasse Asbury of Hollis, New York, described these unsigned portraits of his great-grandparents to the authors in a letter, March 23, 1972.
16. *Kennedy Quarterly* 18 (April 1971), p. 131, published by the Kennedy Galleries, New York.
17. Whitaker identified this painting as *Jesus Led to Caiaphus* in his article "Reminiscences."
18. Bannister's attendance was reported by Whitaker, Alden Brown, Arnold, and others.
19. John Nelson Arnold, *Art and Artists in Rhode Island* (Providence: Rhode Island Citizens Association, 1905), p. 39. Milmore later became famous for his war memorial monuments; see Lorado Taft, *The History of American Sculpture* (reprint, New York: Arno Press, 1969), pp. 252–55.
20. Ralph Waldo Emerson, *Society and Solitude* (Boston: Houghton Mifflin & Co., 1897), pp. 50–51.
21. Brown erred in giving Bannister's name as Edwin, perhaps as a result of abbreviating Edward to "Edw." in his notes. G. C. Croce and David H. Wallace, *New-York Historical Society's Dictionary of Artists in America* (New Haven: Yale University Press, 1969), list both Edward M. and Edwin Bannister, the latter being described as "Artist. Born in Virginia c. 1823, working in Boston July 7, 1860, boarding there with his wife Christina, aged 30; he owned personal property valued at $200." The 1860 U.S. Census is cited as the source. We believe this entry refers to Edward M. Bannister because of the similarity of the names, the Boston location, the time period, and the wife's name being close to Christiana. Bannister may have given Virginia as his birthplace out of fear of immigration laws. The *Dictionary* did not report Bannister's 1876 Centennial prize for oils.

We have been unable to confirm the report that Bannister became an artist because he was challenged by an 1867 statement in the *New York Herald* that the "Negro seems to have an appreciation of art while being manifestly unable to produce it" (as reported by W. J. Simmons, *Men of Mark: Eminent, Progressive, and Rising* [Cleveland: Revel, 1887], p. 1129). This story is not mentioned by Brown, Whitaker, Arnold, or any of Bannister's fellow artists, and is contradicted by Brown's account of Bannister's early ability.
22. James M. McPherson, *The Negro's Civil War* (New York: Pantheon Books, 1965), p. 196.
23. *Bannister* (1966 exhibition catalog).
24. Of this portrait, Lydia Maria Child wrote to Colonel Shaw's mother on November 3, 1864: "I went to the Fair for Colored Soldiers. There I saw a full-length likeness of Robert, painted by Bannister, a colored artist. Over it was the touching and appropriate motto, 'Our Martyr.' To me, there is something very beautiful and pathetic in these efforts of a humble and oppressed people to canonize the memory of the young hero who died for them" (*Collected Correspondence of Lydia Maria Child, 1817–1880,* ed. Patricia G. Holland and Milton Meltzer, [Kraus-Thomson Organization, 1979, microfiche, 60/1585]; the original is in the Houghton Library, Harvard University, Cambridge, Mass.).
25. Bannister's prominence apparently made Nelson A. Primus, an African-American portrait painter from Hartford, Connecticut, who was then active in Boston, feel that Bannister should obtain commissions for him. When this did not happen to his satisfaction, he complained to his mother, July 10, 1865:

"Mr. Bannister is, I think, a little jealous of me. He says that I have got great taste in art, but does not try very hard to get me work. . . . Mr. Bannister has got on with white people here, they think a great deal of him. He is afraid that I would be liked as much as himself" (Primus Collection, Connecticut Historical Society, quoted by Samella Lewis, *Art: African American* [New York: Harcourt Brace Jovanovich, 1978], p. 38). We found no mention of Primus by Bannister and jealousy was not regarded as one of his traits by his Providence intimates.

26. *Providence Journal,* Jan. 11, 1901, p. 8, identified the locale of *Under the Oaks.*
27. Burleigh, *Bannister.*
28. *Christian Recorder,* Oct. 26, 1876.
29. *Christian Recorder,* Oct. 8, 1876.
30. Whitaker reported that Bannister learned who had purchased his painting by accident: "A niece of Mr. Duff's was a patron of Madame Carteaux, Mr. Bannister's wife . . . the niece told the Madame that her uncle bought a large painting some years since, called 'Under the Oaks,' painted by a Mr. Bannister of Providence." This led to Bannister being permitted to visit his work.
31. Miner, *Angel's Lane,* p. 132, reported in 1948 that "a bronze medal of the Centennial of 1876 is in the archives of the [Providence] Art Club, and is supposedly Bannister's award." However, Marjory Truell Dalenius, the Art Club secretary, wrote the authors, June 15, 1971, that she was unable to find the medal. It has apparently disappeared, although the club has the accompanying certificate of award.
32. *Bannister* (1966 exhibition catalog).
33. Whitaker's manuscript and Miner's detailed report, *Angel's Lane,* pp. 127–53, form the basis for our account of the formation of the Providence Art Club and of the "A. E. Club."
34. Manuscript in Rhode Island Historical Society archives; also cited by Lynda S. Hartigan, *Sharing Traditions: Five Black Artists in 19th Century America* (Washington, D.C.: National Museum of American Art, Smithsonian Press, 1985), p. 75.
35. Cited in Whitaker, *Reminiscences.*
36. Arnold, *Art and Artists,* p. 38.
37. *Providence Journal,* Jan. 11, 1901, p. 8.
38. The Bannister memorial stone was refurbished seventy-five years later by a community effort led by Mahler Ryder of the Rhode Island School of Design (*Providence Evening Bulletin,* June 14, 1976).
39. Arnold, *Art and Artists,* p. 38.
40. Ibid., p. 39.

Grafton T. Brown

1. P. Selz and P. Mills, "Regional Art in America," *Art in America* 57 (Sept. 1969), p. 108.
2. See Delilah L. Beasley, *Negro Trail Blazers of California* (Los Angeles: Times Mirror Printing and Binding House, 1919; reprint, San Francisco: R & E Research Associates, 1968), pp. 46, 49, 104. Opposition to slavery in California included many southerners, who did not want to be called "poor white trash" because they worked. Some slaves, brought to work in gold mines, earned their freedom, then mined on their own. Although black miners could not legally own mines in California, Beasley was "told by pioneer Negro miners that white miners had laws of their own and were often fair and kind to Negro miners."
3. 1862 San Francisco city directory.
4. Harry T. Peters, *California on Stone* (Garden City, N.Y.: Doubleday Doran & Co., 1935), pp. 89–90, 147; I. N. Phelps and Daniel C. Haskell, *American Historical Prints: Early Views of American Cities, Etc.* (New York: Phelps Stokes Collection, New York Public Library, 1933).
5. Photo of Brown at his easel, courtesy, Provincial Archives, Victoria, British Columbia.
6. Grafton T. Brown file, Oakland Museum, Oakland, Cal.
7. Letter to authors from B. P. Grimes, M.D., medical director, St. Peter State Hospital, St. Peter, Minnesota. The death certificate indicates Brown was buried in St. Paul.

Edmonia Lewis

1. Walter J. Clark, *Great American Sculptures* (New York: R. Worthington, 1878), p. 141.
2. Henry T. Tuckerman, *Book of the Artists* (New York: G. P. Putnam & Sons, 1867), pp. 603–4.
3. Although not confirmed, the birth date given by James A. Porter in *Modern Negro Art* (New York: Dryden Press, 1943, p. 57) is consistent with her Oberlin admission. Lewis reported it to be 1854 at U.S. Consulate in Rome in about 1895, which would have meant she entered Oberlin at age five (National Archives of the U.S., Rome Consulate Visitors Register, C14, vol. 22). However, this may have been just a typographical transposition of the 4 and 5.
4. A letter of August 25, 1868, from J. T. Gilkinson (Indian agent at Brantford, Ontario) to the Canadian secretary of state, reported that an unnamed Mike daughter married "a colr man named Lewis" (National Archives of Canada, Ottawa, Record Group 10, vol. 1868, file 560). Donald B. Smith, University of Calgary professor of history, found these records dealing with the Mike family in preparing his biography *Sacred Feathers: The Rev. Peter Jones and the Mississauga Indians* (Lincoln: University of Nebraska Press, 1987). Learning of our search for Edmonia Lewis's parents, he recalled the Gilkinson letter and kindly forwarded copies of it and other records to us. While circumstantial, it appears conclusive. One must ask how many African-American men named Lewis could have married a woman of Mississauga descent in the Niagara area at that time? Smith's book contains much information on the Mississauga and on prejudice, for Rev. Peter Jones (Kahkewaquonaby) was the son of a white father and a Mississauga woman, and he married a middle-class English woman who came to live on the reservation (see *Sacred Feathers,* pp. 131–49). Jones became a great Mississauga chief and addressed Queen Victoria in person in pursuit of Mississauga land claims.
5. The first council objection to John Mike was on October 6, 1837, at the Credit River Reserve. It called for denial of the annual government grant to John Mike and his children while agreeing that his Mississauga wife should receive a grant. Later council meetings urged that the Mike family be removed from the reservation. The ban was apparently ignored. In 1858 the council was still complaining about Mike children being on the New Credit reservation (National Archives of Canada, Record Group 10, vol. 834, pp. 706–7). Three unnamed Mike daughters were admitted to band membership until two married and one died; one married a white man and the other "a colr man named Lewis" (see note 4). The Mike sons did not receive government payments and one sued for them as late as 1885 (unidentified newspaper clipping, Oct. 21, 1885, National Archives of Canada, Ottawa, Record Group 10, vol. 2145, file 36857).
6. Lydia Maria Child, letter, *The Liberator,* Feb. 19, 1864, p. 31. A more extended report by Child appeared in *The Broken Fetter,* March 3, 1865, published during the Ladies Michigan

State Fair for Relief of Destitute, Detroit Commercial Advertiser and Tribune Co.

7. "How Edmonia Lewis Became an Artist," unsigned six-page pamphlet given to Harvard Library, Cambridge, Mass., by Charles Sumner, Nov. 1, 1870. This pamphlet's style and sentimentality suggest that it may have been written by Elizabeth Peabody, who wrote other sentimental accounts of Lewis. Its anonymity raises doubts about its accuracy on some points. It states Lewis was three years old when her mother died. A three-year-old is not asked to spend three years with her mother's people. There are other inconsistencies.

8. Child, in *Broken Fetter.*

9. See Henry R. Schoolcraft, *Algic Researches,* vol. I, *Indian Tales and Legends* (New York: Harper & Bros., 1839), and *The Myth of Hiawatha and Other Legends* (Philadelphia: J. B. Lippincott, 1856).

10. Interview with Edmonia Lewis, *The Athenaeum* (London), March 3, 1866, p. 302.

11. Child, in *Broken Fetter.*

12. The name *Wildfire* first appeared in "How Edmonia Lewis Became an Artist." In dealing with white people, Lewis aimed at their stereotyped views of Native Americans. She described her mother as "a wild Indian . . . born in Albany" in an interview with an Englishman writing for *The Athenaeum* (London), March 3, 1866. He did not recognize that "wild" Indians were not born in Albany, which was even then a major city.

13. Author interview, Jan. 28, 1991. Johnston is the author of *Ojibway Heritage* and *Ojibway Ceremonies* (Toronto: McClelland and Stewart, 1976 and 1982, respectively; reprint, Lincoln: University of Nebraska Press, 1976 and 1990, respectively).

14. Henry R. Schoolcraft, *Personal Memoirs of Residence of Thirty Years with the Indian Tribes on the American Frontiers, 1812–1842* (Philadelphia: Lippincott, Grambo & Co., 1851), p. 132. Basil Johnston tells amusing stories of pronunciation problems at his school in 1939 with "Xavier" becoming "Zubyeah" (*Indian School Days* [Norman: University of Oklahoma Press, 1988]), p. 9.

15. Lewis interview, *Athenaeum.*

16. See L. F. Litwack, *North of Slavery* (Chicago: University of Chicago Press, 1961), p. 141; R. V. Harlow, *Gerrit Smith* (New York: Henry Holt & Co., 1939), pp. 231–32.

17. Lewis referred to "McGraw" when interviewed in Rome (*Athenaeum*).

18. Unless otherwise noted, references to Oberlin College are based on Robert S. Fletcher's two-volume *History of Oberlin College* (Oberlin, Ohio: Oberlin College, 1943). Regarding perfectionism, see vol. 1, pp. 223–38.

19. Ibid., vol. 2, pp. 680–83.

20. The Keep home was described by Geoffrey Blodgett in "John Mercer Langston and the Case of Edmonia Lewis: Oberlin, 1862," *Journal of Negro History* 53 (July 1968), pp. 201–18.

21. Rev. Henry Cowles, in Fletcher, *Oberlin College,* vol. 2, p. 526.

22. Ibid., vol. 2, p. 718. Wyett taught from 1855 to 1875. A catalog in the Oberlin archives states: "The ladies of the first year receive a course in linear drawing without charge. For others the prices per term are as follows: Oil painting with use of models, $8; watercolor painting with the use of paints and brushes, $4; crayon drawing, term of 50 lessons, $4; linear drawing, $3."

23. The Oberlin archives contain only skimpy, incomplete records of Lewis's studies. In the winter term of 1859–60 in "Algebra B" she received grades of 6, 3¾, 4 in consecutive periods. Six is the highest grade. In the winter term of 1861–62 she studied "Mech," with grades, of 6, 4, 5, 3, 4, 3, 1½. What "Mech" studies were cannot be ascertained. She was also listed for "Rhet B," presumably rhetoric (literature), with no grades, perhaps because of her pronunciation difficulties. In the spring term of 1861 she was listed as "ex" in "Con Sec" and "Miss L. Couch"—which may mean excused. What these courses covered is unknown and no grades are listed. Her second-year "Comp" (composition) grades were 6, 6, 0, 6; the zero may indicate illness. These few records do not account for all her studies. Her drawing lessons are not listed, presumably because no credit was given for them. Other records have been lost.

24. Fletcher, *Oberlin College,* vol. 2, pp. 414–15.

25. Blodgett, "Langston and Lewis," p. 203.

26. Ibid., pp. 204–5.

27. Fletcher, *Oberlin College,* vol. 1, p. 379.

28. Blodgett, "Langston and Lewis," p. 206, reports an "impatience to see Edmonia punished . . . delay in the execution of justice seemed intolerable. . . . If Oberlin authorities could not handle their colored folk, others would."

29. John Mercer Langston, *From Virginia Plantation to the Nation's Capitol* (Hartford, Conn.: American Publishing Co., 1894), p. 176. A chapter in Langston's autobiography (pp. 171–80), the only substantial account by a participant in the trial, is the primary source of our account; there are no court records and only scattered, incomplete press accounts. Writing from memory some thirty-two years later, with some inconsequential errors in dates, Langston named no names—these were established by Blodgett, "Langston and Lewis"—including those of the accusing girls, witnesses, justices, and lawyers.

30. Blodgett, "Langston and Lewis," p. 206.

31. *Cleveland Leader,* March 3, 1862. Despite the conclusion of the two justices exonerating Lewis in a hostile atmosphere, Blodgett's interpretation of the corpus delicti defense implies that it was a lawyer's trick. To support his interpretation, he cites two "scholarly" accounts. One was Fletcher's two-sentence dismissal of Lewis as an "adventuress" without saying anything relevant (*Oberlin College,* vol. 2, p. 533). In describing her later success as an artist, Fletcher inserted two disbelieving exclamation points (!!). The second was Porter's comment that the facts in the case were "almost unbelievable" (*Modern Negro Art,* p. 177). Porter's statement refers to the "almost unbelievable" abuse of a young African-American woman, not the girls' accusations or the outcome of the trial.

32. Langston, *From Virginia Plantation,* p. 179.

33. Blodgett, "Langston and Lewis," p. 206.

34. Langston, *From Virginia Plantation,* p. 179.

35. Student Fred Allen, writing to student A. A. Wright on January 30, 1863, a year after Lewis's exoneration, reported she was upset because she had not been invited to a skating club party and that "young Keep," Father Keep's grandson, had been prevailed upon to invite "the wench," adding he wouldn't have done it: "All I can say is: 'Look out for Spanish flies.' " Later Allen wrote that she had caused no trouble at the skating party (Oberlin archives).

36. *Larousse Encyclopedia of Mythology* (London: Batchworth Press, 1959), p. 129. The drawing (14¼ by 12 inches) is signed "Edmonia Lewis," but not titled by her. Its subject was identified by Wayne Craven and John Crawford (of the University of Delaware and Index of American Sculpture) as derived from the classical sculpture *Urania,* circa 1775–99, now in the

Vatican Museum. See also art historian Marcia Goldberg's "New Discoveries: A Drawing by Edmonia Lewis," *American Art Journal*, Nov. 1977, p. 104; also "More Information on the Edmonia Lewis Drawing," *American Art Journal*, May 1978, p. 112.

37. Marcia Goldberg and W. E. Bigglestone (Oberlin College archivist), "A Wedding Gift of 1862," *Oberlin Alumni Magazine*, Jan.–Feb. 1977.

38. "Professor" Crouch's teaching method was described as "peculiar" in the *Oberlin Students Monthly* (Aug. 1860). Crouch is not listed in standard biographical references and a search by Ohio Historical Society archivist Tauni Graham did not identify him (letter to authors, July 20, 1987).

39. Crouch's charges were dismissed by Justice Bushnell, one of the two justices presiding at the hearing on poisoning charges, for lack of evidence (*Lorain County News*, Feb. 25, 1863).

40. J. N. Fitch was Crouch's landlord, an old-time abolitionist, Sunday school leader, and very influential. His charge that Lewis stole a picture frame was apparently never filed for lack of evidence. However, he publicly voiced his charge, which was referred to in a letter by student Clara Hale, February 26, 1863 (Oberlin archives). Her letter, which is not free of racial bias, indicates that Dascomb had already made up her mind not to admit Lewis to her final semester even though this would prevent her graduation.

41. Schoolcraft, *Hiawatha*, p. xxi.

42. Child, letter, *Liberator*, Feb. 19, 1864, p. 31.

43. Monroe A. Majors, *Noted Negro Women* (Chicago: Donohue and Henneberry, 1893), p. 28.

44. Child, letter, *Liberator*, Feb. 19, 1864, p. 31.

45. Child, in *Broken Fetter*.

46. Ibid.

47. Ibid.

48. Ibid.

49. This story appeared in the 1870 pamphlet "How Edmonia Lewis Became an Artist," in the *New National Era* (May 4, 1871), and was then repeated often, even in recent accounts. Lewis may have told this story in playing upon the white stereotype of African-Americans as illiterate and not aware of the fine arts.

50. The Oberlin men are listed in Luis F. Emilio's *History of the Fifty-fourth Regiment of Massachusetts Volunteer Infantry, 1863–1865* (Boston: Boston Book Co., 1894; reprint, New York: Arno Press/New York Times, 1969); see also Fletcher, *Oberlin College*, vol. 2, pp. 970–72.

51. Lydia Maria Child to Sarah B. Shaw (Shaw's mother), 1870, (*The Collected Correspondence of Lydia Maria Child*, ed. Patricia G. Holland and Milton Meltzer [Kraus-Thomson Organization, 1979, microfiche, 74/1958]).

52. Child, letter, *Liberator*, Jan. 20, 1865.

53. Ibid.

54. Ibid.

55. *Liberator*, Dec. 9, 1864, p. 199.

56. Child, *Broken Fetter*, p. 26.

57. Ibid., p. 1.

58. Child to Harriet Winslow Sewall, June 6, 1868: "I besought her not to undertake to work in marble for two or three, or four years to come. . . . If in the course of years, she produced something really good, people would be ready enough to propose to put it in marble for her" (Robie-Sewall Papers, Massachusetts Historical Society, Boston).

59. *National Anti-Slavery Standard* (New York), Aug. 12, 1865. "How Lewis Became an Artist" gives the date as August 26, but the *Standard*'s news account is closer to sailing time and appears more accurate in details.

60. Child, *Broken Fetter*, p. 26.

61. *San Jose* (Cal.) *Daily Mercury*, Sept. 19, 1873, p. 3.

62. Child, quoting Lewis's letter to Theodore Tilton, editor of *The Independent*, April 5, 1866 (*Collected Correspondence of Child*, 64/1716).

63. Henry James, *William Wetmore Story and His Friends* (Boston: Houghton Mifflin & Co., 1903), vol. 1, p. 102.

64. Harriet Hosmer, *Letters and Memories*, ed. Cornelia Carr (New York: Moffat, Yard, and Co., 1912), p. 27.

65. See Joseph Leach's excellent biography, *Bright Particular Star: The Life and Times of Charlotte Cushman* (New Haven: Yale University Press, 1970).

66. Ibid., p. 210.

67. Sally Mercer became Cushman's maid and dresser at age fourteen. When playing New Orleans and other southern cities, Cushman stayed in private homes so that Sally would not be embarrassed by Jim Crow laws at hotels. She also warned theater managers to protect Sally. In Rome, at Cushman's home, 38 Via Gregoriana, Mercer became the household manager. (See Leach, *Star*, pp. 217, 226, 246, 375, 398; also *Charlotte Cushman: Her Letters and Memories of Her Life*, ed. Emma Stebbins [Boston: Houghton, Osgood & Co., 1878], pp. 37–38. Stebbins did not mention Edmonia Lewis, an indication of her attitude toward Lewis.)

68. Phebe Hanaford, *Daughters of America* (Augusta, Maine: True and Co., 1882), p. 297.

69. *Art Journal* (London), 1866, p. 177.

70. Lewis to Child, copied to Theodore Tilton, April 5, 1866 (*Collected Correspondence of Child*, 64/1716).

71. Lewis interview, *Athenaeum*, p. 302.

72. *Lorain County News*, March 28–April 4, 1866, p. 3.

73. Charlotte Cushman to Moses Pond, Boston YMCA, May 1, 1867 (Library of Congress, C. Cushman Papers, vol. 3, no. 901–2; published in *The Elevator*, June 12, 1868).

74. YMCA acceptance letter, Dec. 5, 1867. The statue is believed to have been destroyed in 1910, when the YMCA burned to the ground (Solon B. Cousins, YMCA official, letter to authors, Aug. 25, 1969).

75. *The Freedmen's Record* (Jan. 1867) reported that Edmonia Lewis "sent us a photograph of a new design for a group called *The Morning of Liberty*, representing a standing male figure, casting off his chains and a young girl kneeling beside him." See James A. Porter, "Versatile Interests of the Early Negro Artist: A Neglected Chapter of American Art History," *Art in America* 24 (Jan. 1936), pp. 22–27.

76. In an 1870 letter to Sarah B. Shaw, Child described the unannounced shipment to Sewall and some difficulties in raising funds. She apparently felt blamed by others for Lewis's action. She also considered *Forever Free* a poor work, refusing to publicize it. Elizabeth Peabody—who, Child said, wrote "a flaming description of it for the *Christian Register*"—rebuked Child for her "critical mood." Peabody said, "As the work of a colored girl, it ought to be praised." Child responded: "I should praise really good work all the more gladly because it was done by a colored artist, but to my mind, Art is sacred, as well as philanthropy, and do not think it was either wise or kind to encourage a girl, merely because she is colored, to spoil good marble by making it into poor statues" (*Collected Correspondence of Child*, 74/1958).

77. Lewis to Maria W. Chapman, May 1, 1868 (Boston Public Library). In earlier letters to Chapman, on February 5 and

August 6, 1867, Lewis, who was a phonetic speller, sent photographs of the group (*Forever Free*), which she intended as a gift to Garrison. She sometimes called the statue "my Freedman." In the February 5 letter she said that: "If every black man in the United States would give a penny each I could very soon be able to do my part. I will not take anything for my labor. Mr. Garrison has given his whole life for my father's people and I think I might give him a few months work." Chapman apparently criticized the group and in the August 6 letter, Lewis said she had made changes. She said she would contribute $200 given to her by Nathaniel Bowditch and George Loring, Boston abolitionists. Before the end of 1868, she wrote, the group "would be in the hands of dear Mr. Garrison who has indeed been the friend of the poor slave." These two letters were published in Porter's *Modern Negro Art* in an appendix (pp. 171–72) in 1943, but not understood to refer to *Forever Free*, a statue then unknown to Porter.

78. Child to Shaw, 1870 (*Collected Correspondence of Child*, 74/1958).
79. Child to Harriet W. Sewall, June 6, 1868 (ibid., 69/1839). Sewall's wife had complained to Child about Lewis's shipment.
80. Anne Whitney to Sarah Whitney, May 2, 1867 (Anne Whitney Correspondence, Wellesley College Library, Wellesley, Mass.).
81. Ibid., Feb. 9, 1868.
82. Ibid.
83. Child to Sarah B. Shaw, April 8, 1866 (New York Public Library).
84. James, *Story*, vol. 1, p. 258.
85. Anne to Sarah Whitney, Feb. 7, 1869 (Whitney Correspondence).
86. Charlotte Cushman to Elizabeth Peabody, July 23, 1869 (Massachusetts Historical Society).
87. Laura Curtis Bullard, letter from Rome, *New National Era*, May 4, 1871, p. 1; this publication was edited by Frederick Douglass.
88. Anne to Sarah Whitney, Feb. 9, 1868 (Whitney Correspondence).
89. *The Rosary*, Feb. 1909, pp. 322–23.
90. Anne to Sarah Whitney, Oct. 28, 1867 (Whitney Correspondence).
91. Ibid., Feb. 9, 1868.
92. Although St. Joseph's Society of the Sacred Heart was founded in 1866, the first Josephite priests did not arrive in Baltimore until December 1871. (*New Catholic Encyclopedia* [New York: McGraw-Hill, 1967], vol. 7, p. 1119). A detailed account of this order, its mission, and conflict over African-Americans becoming priests appears in Stephen J. Ochs, *Desegregating the Altar: The Josephites and the Struggle for Black Priests* (Baton Rouge: Louisiana State University Press, 1990).
93. John Crichton Stuart was the third Marquis of Bute, of Mount Stuart, Isle of Bute, western Scotland. He gained high honors at Harrow and Oxford (*British Dictionary of National Biography*, suppl. 22, p. 1238). On December 8, 1868, he formally joined the Roman Catholic church and went to Rome to visit the Vatican (Catherine Armet, Bute archivist, letter to authors, July 5, 1979). Bute's conversion suggested to Benjamin Disraeli the plot of his novel *Lothair*.
94. Bullard, letter, *New National Era*. In May 1870, for one dollar, Bullard purchased the feminist publication *Revolution*, founded by Elizabeth Cady Stanton and Susan B. Anthony. Bullard was an heir to a fortune made from Dr. Winslow's Soothing Syrup, a morphine-loaded concoction used to put children asleep and ultimately banned. Friendly with Lewis, she bought her *Wedding of Hiawatha*. Lewis may have stayed at her Brooklyn home during New York visits, since Emily Faithfull reported that she met Lewis there (*Three Visits to America* [New York: Fowler & Wells, 1884], p. 284). Another Curtis heir, Atherton Curtis, became Henry Ossawa Tanner's close friend and chief patron.
95. The Marquis of Bute went to Rome in February 1869 for a brief stay and returned in November for some months (phone conversation from Glasgow with Catherine Armet, Bute archivist). In a letter to the authors, July 5, 1979, Armet wrote: "I have found no evidence of his patronage of this sculptress nor any of her work; neither am I aware of the altarpiece you describe. He is known to have made gifts to Churches and Convents so it is very possible that an Edmonia Lewis may have been given in that way but I have seen no evidence of it." Inquiries to Catholic institutions in England have proved fruitless.
96. *The Rosary*, Feb. 1909, pp. 222–23.
97. Bullard, letter, *New National Era*.
98. Child to Shaw, 1870 (*Collected Correspondence of Child*, 74/1958).
99. Anne to Sarah Whitney, Feb. 7, 1869 (Whitney Correspondence).
100. Ibid. The English financier, a Mr. Cholmley, may have been the husband of a Mrs. Cholmley who was attempting to become a sculptor and was very friendly with Lewis. She made a small bust of Lewis, in which she depicted "soft flaccid hair" on one side of the head to represent her Mississauga mother, and "woolly" hair on the other side to represent her African-American father ("The Studios of Rome," *Art Journal* [London] 32 [1870], p. 77). Anne Whitney considered the Cholmleys "best friends" with Lewis (Anne to Sarah Whitney, Feb. 7, 1869 [Whitney Correspondence]).
101. Jones, his successful business and political strategies, hospitality, and views are well described by Robert L. McCaul, *Black Struggle for Public Schooling in 19th Century Illinois* (Carbondale, Ill.: Southern Illinois University Press, 1987); Arna W. Bontemps and Jack Conroy, *Any Place But Here* (New York: Hill and Wang, 1945), pp. 44–52; R. W. Logan and M. R. Winston, eds., *Dictionary of American Negro Biography* (New York: W. W. Norton, 1982), pp. 366–67.
102. *Chicago Tribune*, Aug. 29 and Sept. 6, 1870.
103. Anne to Sarah Whitney, Jan. 14, 1871 (Whitney Correspondence). Other reports have put this figure at $3,000 (San Francisco *Pacific Appeal*, Aug. 16, 1873). Raffles were a common way for nineteenth-century artists to dispose of their work, usually through cooperative artists' associations called "art-unions" (see Margaret F. Thorp, *The Literary Sculptors* [Durham, N.C.: Duke University Press, 1965], p. 162. An unidentified Chicago man also reportedly bought the statue, according to some accounts.
104. Anne to Sarah Whitney, Feb. 7, 1869 (Whitney Correspondence).
105. Tuckerman, *Book of the Artists*, pp. 603–4.
106. Anne to Sarah Whitney, Feb. 7, 1869 (Whitney Correspondence).
107. Ibid.
108. Ibid.
109. Ibid., Jan. 20, 1870.
110. Ibid., March 19, 1870.
111. Ibid., Dec. 12, 1869.

112. Ibid.

113. Ibid.

114. Elizabeth Peabody's unsigned report in *The Christian Register*, identified by Child in a letter to Shaw (see note 76), was quoted at length by Hanaford, *Daughters*, pp. 296–98.

115. *San Francisco Chronicle*, Sept. 30, 1873. This was first reported by Bullard in the *Woman's Journal* (Aug. 16, 1873), where she said the gold medal award was for "*Sleeping Children*" and another gold medal was awarded for *Cupid Caught in a Trap*. On August 30 the *Chronicle*, in an article preceding the Lewis exhibition, reported that the *Wooing of Hiawatha* had won the gold medal at Naples. We believe the September 30 reference to be correct because the modeling of the children is superb and the later date indicates an unacknowledged correction. The African-American *Pacific Appeal* (Sept. 6, 1873) also reported that *Awake* and *Asleep* won the Naples gold medal. Efforts to obtain information from Naples have been futile, possibly because the institution no longer exists or has changed its name.

116. *San Francisco Chronicle*, Aug. 26, 1873. An article reprinted from *The Commonwealth* (location unknown) in the *Pacific Appeal* (Aug. 16, 1873, p. 1) and the *San Jose Daily Mercury* (Sept. 19, 1873, p. 3) described Lewis as "a pupil of Hiram Powers."

117. This bust, mentioned in news reports, has not been located. It was reportedly in the "historical rooms" at Central Park, New York (*San Jose Patriot*, Sept. 27, 1873) and at "Central Park" (*Elevator*, Sept. 6, 1873; *San Jose Daily Mercury*, Sept. 22, 1873).

118. *Pacific Appeal*, Sept. 6, 1873. The *San Francisco Chronicle* (Sept. 3, 1873) reported "over a hundred persons on Monday [the first day] and as many yesterday" (the second day).

119. *The Elevator* reported the proposed reception on September 6, 1873. Her suggestion that the Lincoln bust be purchased appeared in the *Pacific Appeal* the same day.

120. *Pacific Appeal*, Aug. 16, 1873.

121. *San Francisco Chronicle*, Sept. 3, 1873.

122. *Elevator*, Sept. 6, 1873.

123. See *San Jose Daily Mercury*, Sept. 19, 22, 27, 1873.

124. *Elevator*, Oct. 10, 1873.

125. The "Official Catalogue" (Philadelphia: U.S. Centennial Commission, International Exhibition, Art Department, 1876) lists on p. 52 "Edmonia Lewis, No. 1231: Death of Cleopatra" and on p. 59 "No. 1409, Asleep (group in marble); Hiawatha's Marriage; Old Arrow-Maker and His Daughter (groups in marble); terra-cotta busts: Henry W. Longfellow, Charles Sumner, John Brown."

126. J. S. Ingram, *The Centennial Exposition* (Philadelphia: Hubbard Bros., 1876), p. 372.

127. A. A. Wright, Oberlin archives, box 1.

128. *Oberlin Review*, Nov. 1876, p. 201.

129. Clark, *Great American Sculptures*, p. 141.

130. W. E. B. Du Bois, *The Philadelphia Negro* (1899; reprint, New York: Schocken Books, 1967), pp. 7, 195, 310. Du Bois felt that middle-class African-Americans were isolated from black working people, a condition aggravated by the arrival of many freedmen after the Civil War. "Above all," he wrote, "the better classes of the Negroes should recognize their duty toward the masses" (p. 392).

131. *Christian Recorder*, Oct. 26, 1878.

132. John P. Sampson, letter, *Christian Recorder*, Oct. 8, 1876.

133. Bullard reported in *The Woman's Journal* (Dec. 21, 1878) that Lewis believed Grant would be the next U.S. president.

134. *Chicago Tribune*, Sept. 6, 7, 1878.

135. *Chicago Tribune*, Nov. 6, 1878.

136. *Woman's Journal*, Jan. 4, 1879, p. 1.

137. Bullard, in *Woman's Journal*, March 10, 1883, p. 1. The oldest Roman Catholic church in this country to seek African-American parishioners is St. Francis in Baltimore, and presumably it was the church for which this relief panel was created. However, the panel has not been located. Bullard's brief report adds, "Miss Lewis has also recently finished a statue of the Virgin Mary for the Marquis of Bute," but this has not been located either.

138. *Diary of Frederick Douglass, 1886–94* (Library of Congress, Manuscript Division, Frederick Douglass Papers, Microfilm Reel No. 1). In Rome the Douglasses stayed at the Palazzo Moroni, which was the home of Caroline Remond Putnam, her son Edmund Quincy Putnam, and her sisters. Edmonia Lewis was a frequent visitor (see William S. McFeely, *Frederick Douglass* [New York: W. W. Norton, 1991] pp. 328–29).

139. According to the diary of Douglass (ibid., Jan. 28, 1887), Gates was an artist and philanthropist who had "done a great deal for the colored people" and was a friend of Lewis. However, Adela E. R. Orpen, who was raised by Gates and became her biographer, does not reveal her philanthropy in *The Chronicles of the Sid* (New York: F. H. Revell Co., 1897; reprint, Freeport, N.Y.: Books for Libraries Press, 1972). Gates's papers at Antioch College do not mention Edmonia Lewis, Frederick Douglass, or Charles Remond (Nina D. Mytt, curator, Antioch College Library, letter to author, Jan. 17, 1992).

140. Douglass diary, Jan. 31, 1887.

141. Lorado Taft, *History of American Sculpture* (reprint, New York: Arno Press, 1969), p. 212.

142. *The Rosary*, Feb. 1909, pp. 322–23.

143. *Chicago Times*, May 24, 1879; *Pacific Appeal*, June 6, 1879.

144. Obituary, *Chicago Tribune*, Aug. 10, 1915, p. 10. An intimate of Bathhouse John Coughlin and Hinky Dink Kenna, Condon owned gambling dens and racetracks and organized the protection of gambling as a business, using the police as his enforcers. See also Lloyd Wendt and Herman Kogan, *Lords of the Levee* (New York: Bobbs Merrill, 1943), pp. 10, 18, 31, 58, 67, 115, 176.

145. Ron Grossman, in *Chicago Tribune*, June 20, 1988, sec. 5, pp. 1, 5. Grossman was tipped off to the discovery of *Cleopatra* by Marilyn Robinson, whose research inquiries led to its identification.

146. Ibid. Confirmatory telephone interviews, Nov. 8, 1991, with Harold P. Adams and Lorraine Aichinger, on whose property *The Death of Cleopatra* rested and who aided in saving it.

Henry Ossawa Tanner

1. Author interview, Aug. 11, 1966.

2. Benjamin T. Tanner, "Day Book" (C. G. Woodson Collection of Negro Papers, Library of Congress, Washington, D.C.).

3. Avery College was originally the Allegheny Institute and Mission Church; its endowment now offers scholarships to African-American youths at the University of Pittsburgh (*Western Pennsylvania Historical Magazine* 43 [1960], pp. 19–22). Robert S. Duncanson presented Avery with a painting in gratitude for his educational efforts among African-Americans (see W. J. Simmons, *Men of Mark: Eminent, Progressive, and Rising* [Cleveland: Revel, 1877; reprint, Chicago: Johnson Publishing Co., 1970]; also *Dictionary of American Biography*, vol. 18, p. 296).

4. Henry Ossawa Tanner, "The Story of an Artist's Life," *World's Work* 18 (June 1909), p. 11662.

5. Benjamin Quarles, *Blacks on John Brown* (Urbana: University of Illinois Press, 1972), pp. 23–24.

6. The origin of this name was a family secret. However, William Duckry, Henry's first cousin, told W. A. Simon that his mother had related that Rev. Benjamin Tanner "was singularly impressed with this Biblical, patriarchal figure, John Brown. He thereupon seized the coincidence of the birth of his first son and the death of this great figure by naming his son Henry Ossawa, the latter a corruption of the name Osawatomie. This, for Benjamin T. Tanner, was positive protest" (W. A. Simon, "Henry O. Tanner" [Ph.D. dissertation, New York University, 1960], pp. 49–51).

7. Tanner, "Story," *World's Work*, p. 11662.

8. His books included *The Origins of the Negro; Is the Negro Cursed?; The Negro, African, and American; An Apology for African Methodism;* and *The Negro in Holy Writ.*

9. Carter G. Woodson, in *Negro History Bulletin*, April 1947.

10. James Weldon Johnson and J. Rosamond Johnson, *The Book of American Negro Spirituals* (New York: Viking Press, 1925), p. 20.

11. James A. Porter discusses Douglas's career in *Modern Negro Art* (New York: Dryden Press, 1943) pp. 30–35.

12. Reproduced in *Philadelphia African Americans: Color, Class & Style 1840–1940* (Philadelphia: Museum of Balch Institute for Ethnic Studies, exhibition catalog, 1988), pp. 96–97.

13. Porter, *Modern Negro Art*, pp. 39–42.

14. Tanner, "Story," *World's Work*, p. 11662.

15. Among them were *A Foggy Morning* by William W. Cowell, *A Morning at Long Beach* by Prosper Senat, *Storm at Sea* by James Hamilton, and *Breezy Day Off Dieppe* by Franklin Dulin Briscoe (ibid., p. 11663).

16. Professor John P. Sampson wrote a lengthy letter calling attention to Edmonia Lewis and her statues (*Christian Recorder*, Oct. 8, 1876).

17. *Christian Recorder*, Oct. 26, 1876; Douglass praised Bannister's painting.

18. William Wells Brown, *The Black Man: His Antecedents, His Genius, and His Achievements* (Boston: James Redpath, 1863; reprint, New York: Kraus, 1969), p. 214.

19. Tanner, "Story," *World's Work*, p. 11663.

20. Ibid. Marcia Mathews, *Henry Ossawa Tanner* (Chicago: University of Chicago Press, 1969), p. 15, identified this artist as Williams.

21. Tanner, "Story," *World's Work*, pp. 11663–4; Mathews, *Tanner*, pp. 15, 23, identified Price.

22. Tanner convalesced at Wardner's Rainbow Lake Inn, located in the 100,000 acres offered free blacks on easy terms by abolitionist Gerrit Smith about 1858, and near John Brown's farm at North Elba (Dewey F. Mosby and Darrel Sewell, *Henry Ossawa Tanner* [Philadelphia: Philadelphia Museum of Art, 1991], p. 58; this is a comprehensive exhibition catalog).

23. Lloyd Goodrich, *Thomas Eakins* (Washington, D.C.: National Gallery of Art, 1961), p. 20.

24. Eakins's emphasis on the nude may have caused some embarrassment for Tanner, a minister's son. Sadie Tanner Mossell Alexander, his niece, could not recall ever seeing a nude study by him although his drawings, sketches, and clay models were everywhere in the home. Perhaps in deference to his family's sensibilities, he did not display such work. His drawings of male nudes and his paintings certainly reflect a sound knowledge of the figure (Simon, "Tanner," p. 84).

25. Joseph Pennell, *The Adventures of an Illustrator* (Boston: Little, Brown & Co., 1925), pp. 53–54. Pennell died in 1925 and was given a large memorial exhibit at the Metropolitan Museum of Art, which continued to ignore Tanner's recognition abroad until 1926, when Atherton Curtis presented it with *Sodom and Gomorrah.* See Elwood C. Parry III, *Three Nineteenth Century Afro-American Artists* (Cedar Rapids, Iowa: Cedar Rapids Art Center, 1980), n.p.

26. Tanner, "Story," *World's Work*, p. 11664.

27. Ibid., p. 11665.

28. Ibid.

29. Rev. W. S. Scarborough, a close friend of the Tanner family, is the principal source of information on Hovenden's influence. He wrote that Hovenden gave Tanner "a comprehension of and sympathy with the broader and deeper things of life and art" ("Henry Ossian Tanner," *Southern Workman*, Dec. 1902, p. 662). These probably were private sessions because Hovenden did not teach at the Pennsylvania Academy until after Eakins left in 1886. No record of Tanner's academy instructors or subjects exists (Diana M. Gray, registrar, Pennsylvania Academy of Fine Arts, letter to authors, April 21, 1971).

In his article, Scarborough confused Tanner's middle name with that of the first African-American cadet at West Point, Henry Ossian Flipper. That his close family friend did not know the name and its origin reflects how closely it was held as a family secret.

30. Jessie Fauset, "Henry Ossawa Tanner," *The Crisis* 27 (April 24), pp. 255–56. After tuition began to be charged, Eakins won permission to admit Tanner as a free student in the life class, according to minutes of the Academy Committee on Instruction, January 30, 1884, found by Mosby (*Tanner* [Philadelphia Museum of Art], p. 60).

31. Payne established the first black college "art room and museum" at Wilberforce University about 1878 with his own and solicited funds after its trustees refused to do so (see Daniel A. Payne, *Recollections of 70 Years* [reprint, New York: Arno/New York Times, 1968], pp. 228–29).

32. Tanner used the phrase "battle of life" in recounting painful attacks on him in his autobiographical essay in *World's Work*, p. 11665.

33. Ibid.

34. Simmons, *Men of Mark.*

35. Tanner, "Story," *World's Work*, p. 11666.

36. Simon, "Tanner," cites an "open letter" by Bishop Hartzell relating how the artists had to meet surreptitiously (Blue Ash, Ohio, Dec. 26, 1924). Carolyn G. C. Romeyn suggests this artist was Harry Wilson Barnitz ("Henry O. Tanner: Atlanta Interlude," *Atlanta Historical Society Journal* 27 [1983–4], pp. 27–40).

37. See Mathews, *Tanner*, p. 36.

38. Years later, in 1902, Tanner painted a strong portrait of the bishop, which is now at Hampton University, Hampton, Virginia.

39. His photograph of the cottage of Wesley Clifford, a Clark University instructor, initiated this profitable enterprise. Clifford and Tanner became lifelong friends (Mathews, *Tanner*, p. 37).

40. Payne, *Recollections*, p. 241. The bust was given to Central State College, Wilberforce, Ohio.

41. Mosby suggests that "Mr. E" was Eakins, who sometimes aided students (*Tanner* [Philadelphia Museum of Art], p. 63).

42. Tanner, "Story," *World's Work*, p. 11770.

43. Ibid.
44. Scarborough, "Tanner," p. 664.
45. Tanner, "Story," *World's Work,* p. 11771.
46. Ibid.
47. Ibid.
48. Mosby and Sewell, *Tanner* (Philadelphia Museum of Art), p. 122.
49. His expenses for the year totaled $365. Tanner, "Story," *World's Work,* p. 11772.
50. Ibid.
51. Ibid., p. 11664.
52. F. P. Noble, *Our Day* 12 (Oct. 1893); cited by Sewell in *Tanner* (Philadelphia Museum of Art), p. 116.
53. Tanner's handwritten statement, Pennsylvania School for the Deaf, Philadelphia; cited by Sewell, ibid.
54. *Daily Evening Telegraph,* Oct. 7, 1893.
55. Research by Mosby and Sewell has revealed that the 1894 Salon listing of *La Leçon de Musique* did not refer to *The Bagpipe Lesson,* as long assumed, but to *The Banjo Lesson* (*Tanner* [Philadelphia Museum of Art], p. 122).
56. *Southern Workman* 22 (Nov. 1894), p. 187.
57. Tanner's handwritten statement; cited by Sewell, in *Tanner* (Philadelphia Museum of Art), p. 116.
58. Ogden, an early enthusiast for Tanner's work, had an absorbing interest in education of African-Americans in the South. He was the main organizer of the Southern Education Board, which in the late 1890s brought northern philanthropists and southern liberals together to improve education for blacks. No African-Americans were on the board. Ogden annually brought northern philanthropists south in Pullman cars to show off progress at Tuskegee, Hampton, and other institutions. On encountering the White Supremacy movement, the board decided it was necessary to educate the whites first in order to win approval of black education. The southern members effectively controlled the board because northerners feared offending them. The amount of money raised for black colleges and institutions was small compared to what went to white universities. The board never challenged segregation. This background helps to explain Ogden's denying Tanner a place with other American artists in the Cotton States Exposition. See Louis R. Harlan, *Separate But Unequal* (Chapel Hill: University of North Carolina Press, 1958; reprint, New York: Atheneum, 1968).
59. Louis R. Harlan, ed., *The Booker T. Washington Papers* (Urbana: University of Illinois Press, 1977–1989), vol. 4, p. 58; cited by Mosby, in *Tanner* (Philadelphia Museum of Art), p. 95.
60. *Philadelphia Inquirer,* Nov. 21, 1970.
61. *Philadelphia Inquirer,* Dec. 11, 1981.
62. Tanner, "Story," *World's Work,* p. 11772.
63. Scarborough, "Tanner," pp. 665–66.
64. Ibid., p. 666.
65. Mathews, *Tanner,* p. 73.
66. Tanner, "Story," *World's Work,* p. 11772.
67. Ibid.
68. Ibid.
69. Ibid., p. 11773.
70. Ibid.
71. *Boston Herald,* June 13, 1897.
72. James H. Young, *The Toadstool Millionaires* (Princeton, N.J.: Princeton University Press, 1971), p. 247.
73. Tanner, letter to Eunice Tietjens, May 25, 1914 (Tanner Collection, Archives of American Art, Smithsonian Institution, Washington, D.C.).
74. Quoted but not credited, *St. Louis Post Dispatch,* July 12, 1914.
75. Helen Cole, "Henry O. Tanner, Painter," *Brush and Pencil* 6 (June 1900), pp. 98–107.
76. Ibid., p. 100.
77. Tanner, "Story," *World's Work,* p. 11774.
78. Ibid.
79. Ibid.
80. Mathews, *Tanner,* p. 97.
81. Vance Thompson, *Cosmopolitan* 29 (May 1900), p. 18.
82. *Ladies' Home Journal,* Sept., Oct., Nov., Dec. 1902.
83. In 1901 the Curtises bought "the Mellows place, near the old Winthrop Cowdin residence, and erected a small stone building on the grounds near their home to house their art treasures," and established a "Free Reading Room," which became the Mount Kisco Public Library, as part of their plan for an art colony and museum (Michael Steinfeld, library director, letter to authors, April 8, 1971).
84. Simon, "Tanner," p. 144.
85. Tanner to Tietjens, May 25, 1914. Reflecting his emotional disturbance in discussing racism in the United States, Tanner mixed up his fractions in discussing his own background, saying: "Now I am a Negro. Does not the ¾ of English blood in my veins, which when it flowed in 'pure' Anglo-Saxon men and which has done in the past effective and distinguished work in the U.S.—does this not count for anything? Does the ¼ or ⅛ of 'pure' Negro blood in my veins count for all. I believe it, the Negro blood, counts and counts to my advantage—though it has caused me sometimes a life of great humiliation and sorrow but that it is the source of all my talent (if I have any) I do not believe, any more than I believe it all comes from my English ancestors.

 "I suppose, according to the distorted way things are seen in the States, my blond curly-headed little boy would be 'Negro.' " (Cited by Mathews, *Tanner,* p. 142.)
86. Tanner, "Story," *World's Work,* p. 11775.
87. Ibid., p. 11774.
88. "*The Disciples at Emmaus* was stolen by the Germans in the last war [World War II] and is probably in some collection over there. I personally tried hard to track it down" (Jesse O. Tanner, Tanner's son, letter to authors, Nov. 18, 1969).
89. Even by the values of that day, the museums did not pay Tanner much money for his paintings: *The Annunciation,* $1,750; *The Disciples at Emmaus,* $760; *Christ at the Home of Mary and Martha,* $500. In 1904 he asked Booker T. Washington if Washington could not get $2,000 from Andrew Carnegie "for a square chance to see what I really could do" (Mosby, in *Tanner* [Philadelphia Museum of Art], p. 154–55).
90. Booker T. Washington, quoted in *Current Literature* 45 (Oct. 1908), p. 405.
91. *Chicago Tribune,* Feb. 2, 1911.
92. *New York American,* April 14, 1913.
93. Tanner "Jotting," 1909 (Tanner Collection, Archives of American Art, Smithsonian Institution, Washington, D.C.).
94. Milton W. Brown, *The Story of the Armory Show* (New York: Abbeville Press, 1988), pp. 159, 170.
95. Milton W. Brown, *American Painting from the Armory Show to the Depression* (Princeton, N.J.: Princeton University Press, 1955), p. 50.
96. Unfinished letter of Sept. 14, 1914 (Mathews, *Tanner,* p. 156).
97. Atherton Curtis to Tanner, letter of July 29, 1916 (Mathews, *Tanner,* pp. 157–60).
98. Ibid.

99. Ambassador Walter Hines Page (to Britain), who was acquainted with Tanner's paintings, and Ambassador William G. Sharp (to France) supported Tanner's plan. His commission was most unusual. (See Mathews, *Tanner,* p. 161.)

100. Today this is a recognized rehabilitation therapy. See booklet by H. D. Brooks and C. J. Oppenheim, "Horticulture as a Therapeutic Aid" (New York: Rusk Institute of Rehabilitation Medicine, New York University Medical Center, 1973).

101. Notably the 369th Regiment, in which Horace Pippin served, and the 365th, 371st, and 372nd Infantry Regiments.

102. Mathews, *Tanner,* pp. 176–77.

103. Ibid.

104. Purchased by Mr. and Mrs. William P. Harrison, now in Los Angeles County Museum of Art, this painting is horizontal rather than vertical, as the original was. As noted earlier, in this painting Daniel looks downward. In the original he looked upward, "the head turned toward the window above" (*New York Times,* April 29, 1896).

105. The plaque was shown to Harry Henderson on September 3, 1966, by F. L. Williams, a leading member of the congregation. Tanner sued the church, reportedly over its cancellation of reproduction rights; he was represented by Raymond Pace Alexander, husband of Sadie Tanner Mossell Alexander (Mosby, in *Tanner* [Philadelphia Museum of Art], p. 246).

106. Letter to authors from Judge Justine Wise Polier, Rabbi Wise's daughter (Sept. 14, 1966): "He did a great canvas in wonderful purple and greens and somehow, in various movings, it disappeared. It always hung in our living room at home and I have been very sad about its disappearance."

107. Painted in 1917 from photographs and his own memories of Washington, this strong likeness was commissioned by the Iowa Federation of Colored Women's Clubs, which was probably influenced by an Iowa collector of Tanner's work, J. S. Carpenter (Sewell, in *Tanner* [Philadelphia Museum of Art], pp. 256–67).

108. Mathews, *Tanner,* p. 186.

109. Ibid., p. 202.

110. Author interview, Aug. 11, 1966.

111. Mathews, *Tanner,* p. xiv.

112. Alain L. Locke, ed., *The New Negro* (reprint, New York: Atheneum, 1968), pp. 265–66.

113. Hale A. Woodruff, "My Meeting with Henry O. Tanner," *The Crisis* 77 (Jan. 1970), p. 7.

114. In *American Negro Art* (Greenwich, Conn.: New York Graphic Society, 1960), Cedric Dover presented an ill-informed assessment of Tanner: "a weak-looking man, uncritical and egotistic, he had the capacity, as weak men often do, of choosing a career and pursuing it with increasing skill" and he "reminded [young black artists who sought his help] that they could have it as artists, not Negroes" (p. 29). Nothing supports these statements, which are in part derived from Alain L. Locke, but they have circulated for years as a result of Dover's book. An English-trained anthropologist who taught briefly at Fisk University, Dover saw the need for a book on African-American artists, but knew nothing about art and did little research.

115. Harmon Foundation catalogs, 1931–35.

116. Woodruff, "Meeting with Tanner."

117. Tanner to Joel E. Spingarn, July 1933 (Tanner Collection, Archives of American Art). On April 14, 1934, Tanner complained to his old friend James R. Hopkins, then teaching art at Ohio State University, of "struggling to make a picture, and struggling to sell or get orders ahead. When a picture is completed by blood and tears, our patron has lost his money and is too poor to pay for it." This was prompted by J. J. Haverty's rejection of a commissioned work in February 1934, saying that when he ordered the work, "I was flush with money. At this point I am in the gutter in money matters. The depression has made us all poor" (Tanner Collection).

118. Philadelphia *Art Alliance Bulletin,* Oct. 1945, p. 6.

119. The Metropolitan Museum quietly sold this painting through the Plaza Art Galleries in New York on June 7, 1956, to May Onsen of Washington, D.C. In 1958 her friend Helena Pinckney sold it to a Baltimore man. In 1970 Pinckney, then in a nursing home, told Onsen that she could not remember the name of the buyer (Onsen, letter to authors, Jan. 10, 1970). This painting is vertical and not the horizontal *Destruction of Sodom and Gomorrah* formerly in the Haig Tashjian Collection.

120. *New York Times,* Nov. 19, 1967, p. D31.

The Twenties and the Black Renaissance

1. G. T. Robinson, *The Freeman Book* (New York: B. W. Huebsch, 1924), p. 97.

2. Nathan Irvin Huggins, *Harlem Renaissance* (New York: Oxford University Press, 1971), p. 5.

3. For migration's impact on Chicago, see St. Clair Drake and Horace R. Cayton, *Black Metropolis* (New York: Harper & Row, 1962), p. 52. For its impact on New York, see Gilbert Osofsky, *Harlem: The Making of a Ghetto* (New York: Harper & Row, 1968), p. 128.

4. Thorpe, who was listed in the catalog of the 1921 exhibition at the 135th Street branch of the New York Public Library, told this to the authors in 1967, when they were searching Juley's files for photographs of Tanner's work.

5. For background on Farrow, see *The Negro in Chicago, 1779–1927,* vol. 1 (Chicago: Washington Intercollegiate Club, 1927), p. 96. Also, Theresa Dickson Cederholm, ed., *Afro-American Artists* (Boston: Trustees of the Boston Public Library, 1973).

6. There were much earlier shows. In October 1905 the Colored Men's Branch of the Brooklyn YMCA on Carleton Avenue exhibited forty-five paintings by William E. Braxton, Samuel O. Collins, W. O. Thompson, and Clinton DeVillis. Another exhibition was held there in 1913 and the NAACP held an exhibition in its New York offices that year in conjunction with its annual meeting. In 1917 the Arts and Letters Society of Chicago exhibited paintings and drawings by Charles Dawson, William M. Farrow, William Harper, and Archibald J. Motley, Jr. In August 1918 the Negro Library Association exhibited work by Braxton, Collins, DeVillis, Thompson, Robert H. Lewis, Robert H. Hampton, Albert A. Smith, Ella Spencer, Laura Wheeler Waring, Richard Lonsdale Brown, and William Edouard Scott. This exhibition also included books, manuscripts, and twenty-one African sculptures from the Modern Art Gallery of Marius de Zaya. In 1919 the Tanner Art Students Society at Dunbar High School in Washington, D.C., exhibited some thirty paintings and six sculptures by Scott, Waring, Julien Abele, Meta Vaux Warrick Fuller, May Howard Jackson, and John E. Washington. See Beryl J. Wright, "The Harmon Foundation in Context," in *Against the Odds: African-American Artists and the Harmon Foundation* (Newark, N.J.: Newark Museum, exhibition catalog, 1989), pp. 13–25.

7. "The Negro in Art Week" was suggested by Alain L. Locke to Zonia Baber of the University of Chicago and Chicago Women's Club. It was scheduled from November 16 to 27,

1927. When attendance averaged 800 a day, the institute extended the show to December 4 (*The Negro in Chicago,* vol. 1–2, p. 27).

8. James Weldon Johnson, *Black Manhattan* (New York: Atheneum, 1968), p. 163.

9. Hale A. Woodruff, undated letter to authors, c. 1971.

10. W. E. B. Du Bois, "The Criteria of Negro Art," *The Crisis* 32 (Oct. 1926), p. 290. This was his speech at the NAACP convention. It followed a questionnaire (*The Crisis* [Feb. 1926], p. 165) on "how to treat the Negro in art," which was sent to leading publishers, writers, and artists of both races who responded in subsequent issues. Among them were Sherwood Anderson, Benjamin Brawley, Charles W. Chesnutt, Countee Cullen, J. Herbert Engbeck, Jessie Fauset, DuBose Heyward, Langston Hughes, Georgia Douglas Johnson, Robert T. Kerlin, A. A. Knopf, Sinclair Lewis, Vachel Lindsay, Otto F. Mack, Haldane McFall, H. L. Mencken, Mary W. Ovington, Julia Peterkin, William Lyon Phelps, Joel E. Spingarn, Walter White, and Carl Van Vechten.

11. Alain L. Locke, ed., *The New Negro* (New York: Albert & Charles Boni, 1925; reprint, New York: Atheneum, 1968).

12. Ibid., p. 5.

13. Ibid., pp. 21, 24.

14. Ibid., p. 254.

15. Ibid., p. 256.

16. Ibid., p. 258.

17. Johnson, *Black Manhattan,* pp. 283–84.

18. Langston Hughes, in *Fire!!,* vol. 1, no. 1; quoted in his reminiscing account, "The Twenties: Harlem and Its Negritude," *African Forum* 1 (Spring 1966), pp. 11–20.

19. Du Bois, "Criteria," p. 290.

20. W. E. B. Du Bois, "Opinions of W. E. B. Du Bois: In Black," *The Crisis* 20 (Oct. 1920), pp. 263–64.

21. W. E. B. Du Bois, "The Negro in Art," *The Crisis* 32 (March 1926), p. 219.

22. Countee Cullen, in *The Crisis* 32 (Aug. 1926), p. 193.

23. Vachel Lindsay, in *The Crisis* 32 (May 1926), pp. 35–36.

24. H. L. Mencken, in *The Crisis* 32 (March 1926), p. 220. Although Mencken used racist terms at times, he was sympathetic to African-Americans in the 1920s and corresponded with Du Bois, George S. Schuyler, and James Weldon Johnson. In 1922 he suggested to Johnson "a history of ragtime, establish names and dates accurately. . . . It ought to be done. Then you might do similar essays on negro poets, and negro painters and sculptors, and so have a second book on the negro as an artist." (See Charles Scruggs, *The Sage in Harlem: H. L. Mencken and the Black Writers of the 1920s* [Baltimore: Johns Hopkins University Press, 1984], p. 191, n. 16.)

25. Locke, *The New Negro,* pp. 262–66.

26. In ibid., p. 231.

27. George S. Schuyler, "The Negro Art-Hokum," *The Nation* 122 (June 16, 1926), pp. 663–64.

28. Langston Hughes, *The Big Sea* (New York: A. A. Knopf, 1945; reprint, New York: Hill & Wang, 1968), pp. 312–30.

29. V. F. Calverton, in *America Now: Civilization in the United States,* ed. H. E. Stearns (New York: Scribner's, 1938), p. 496.

30. For example, Peter and Linda Murray, eds., *Penguin Dictionary of Art and Artists* (Harmondsworth, England: Penguin Books, 1978), describe *primitive* as "a word that is now almost meaningless," noting that it originally applied to Netherlandish and Italian artists before 1500, and all Italian painters between Giotto and Raphael, although these artists have "no obvious connection with the naive, unsophisticated, unspoilt vision consistent with amateur, or 'Sunday' painter status." They cite Edward Hicks, Jean-Jacques Rousseau, and Grandma Moses as examples of how the definition has blurred.

31. James A. Porter, *Modern Negro Art* (New York: Dryden Press, 1943), p. 100.

32. Langston Hughes, "The Negro Artist and the Racial Mountain," *The Nation* 122 (June 23, 1926), pp. 662–64.

33. Alain Locke, *Negro Art: Past and Present* (Washington, D.C.: Associates in Negro Education, 1936; reprint, New York: Arno Press and *The New York Times,* 1969), p. 119.

34. E. Franklin Frazier, "Racial Self-Expression," in *Ebony and Topaz,* ed. C. S. Johnson (New York: Opportunity, 1927; reprint, Freeport, N.Y.: Books for Libraries Press, Black Heritage Library Collection, 1971), p. 119.

35. The Harmon exhibitions were not yearly and initially not public, although there were juries and awards in 1926 and 1927. The first public exhibition was in 1928, followed by exhibitions in 1929, 1930, 1931, and 1933. The 1935 exhibition was limited to the work of three artists—Richmond Barthé, Malvin Gray Johnson, and Sargent Johnson.

36. *Negro Artists: An Illustrated Review of Their Achievements* (New York: Harmon Foundation, exhibition catalog, 1935), p. 5.

37. Porter, *Modern Negro Art,* p. 107.

38. Gwendolyn Bennett, in *The Southern Workman* 57 (March 1928), pp. 111–12.

39. Romare H. Bearden, "The Negro and Modern Art," *Opportunity* 12 (Dec. 1934), pp. 371–73.

40. See David Driskell, "Mary Beattie Brady and the Administration of the Harmon Foundation," in *Against the Odds* (Newark Museum), pp. 59–69.

Aaron Douglas

This chapter is based on Romare Bearden's conversations with Aaron Douglas over many years as well as interviews and correspondence with him beginning in 1970. The last interview occurred on January 4, 1972. Unless otherwise noted, Douglas's statements are from these interviews and correspondence.

1. Langston Hughes, *The Big Sea* (New York: A. A. Knopf, 1945; reprint, New York: Hill & Wang, 1968), p. 236.

2. Douglas slept on Ethel Ray Nance's couch and worked in *The Crisis* mailroom (David L. Lewis, "Dr. Johnson's Friends," *Massachusetts Review* 20 [Autumn 1979], p. 509; also Ethel Ray Nance Transcript, Nov. 18, 1970, p. 27 [Fisk University Library Oral History Program]).

3. Reiss has at times been mistakenly identified as an African-American. His background is accurately summarized in Alain L. Locke, ed., *The New Negro* (reprint, New York: Atheneum, 1968), pp. 419–20.

4. Ibid., p. 420, carried a brief biographical note on Douglas.

5. Dr. Mason was a respected authority in parapsychology. See Faith Berry, *Langston Hughes, Before and Beyond Harlem* (Westport, Conn.: Lawrence Hill & Co., 1989), p. 87.

6. Hughes, *Big Sea,* p. 316.

7. Ibid., pp. 324–39.

8. Arnold Ampersad, in his comprehensive *Life of Langston Hughes* (New York: Oxford University Press, 1986, vol. 1, pp. 124–81), provides many details about the turbulent emotional relationships of Hughes and Hurston with Mrs. Mason but no details on Douglas's dealings with her. Douglas revealed her demands in a interview with Romare Bearden in 1970.

9. Edwin Augustus Harleston, a member of an old free black family of Charleston, South Carolina, was the son of a steamboat captain. He first won attention in Atlanta as an athlete. He gave up Harvard to study art for seven years at the School of the Museum of Fine Arts in Boston, supporting himself as a seaman. In 1925 his portrait of Pierre Du Pont won the Amy E. Spingarn prize of *The Crisis*. To gain financial stability he became a Charleston undertaker, but died unexpectedly early in 1933. See Harmon Foundation exhibition catalogs, 1931–35.

10. Nathan Irvin Huggins, *Harlem Renaissance* (New York: Oxford University Press, 1971), p. 172.

11. By 1991 the YMCA mural had deteriorated, with paint flaking off in many places. Deirdre L. Bibby, head of the Schomburg Center's art department, told the authors a committee was seeking funds to restore it. Changes had also taken place in the "Y," with the recreation room, for which the mural had been painted, becoming a beauty parlor.

12. Exhibited, Caz-Delbo Gallery, New York, 1933.

13. Douglas notes, "Aspects of Negro Life," Oct. 27, 1949, published by Countee Cullen Branch, New York Public Library.

14. Douglas, "The Negro in American Culture," *First American Artists Congress, 1936* (New York: 1936); Gwendolyn Bennett, then a vice president of the Harlem Artists Guild, also spoke. She had studied at the Barnes School on a scholarship when Douglas was there.

15. James A. Porter, *Modern Negro Art* (New York: Dryden Press, 1943), pp. 104–5.

16. *Paintings by Aaron Douglas* (Nashville, Tenn.: Fisk University, exhibition catalog, March 21–April 15, 1971).

17. Quoted in obituary, *New York Times*, Feb. 22, 1979.

18. Romare Bearden, "A Final Farewell to Aaron Douglas," *New York Amsterdam News*, Feb. 24, 1979.

Richmond Barthé

Unless otherwise noted, quotations from Richmond Barthé and most of the biographical material in this chapter are based on his responses from Florence, Italy, to questions from the authors, August 26, 1972. Conversations with his brother, Louis J. Franklin (Dec. 18 and 29, 1989), Kathy Register of the Pasadena Star-News *(March 16, 1989), Esther Jones (Dec. 18, 1989), Samella Lewis (Jan. 2 and March 13, 1990), and Mary Ann Rey (James Garner's assistant), magazine writer Nanette Turner, and Frances White (all June 1–3, 1992) clarified the events of Barthé's last days.*

1. William H. A. Moore, in *Opportunity* 19 (Nov. 1928), p. 334.

2. James A. Porter, *Modern Negro Art* (New York: Dryden Press, 1943), p. 137.

3. Saxon wrote *Father Mississippi* (1927), *Children of Strangers* (1937), and other books about southern life, and directed the WPA Louisiana Federal Writers Project.

4. See *The Negro in Chicago, 1779–1927* (Chicago: Washington Intercollegiate Club, 1927), p. 223. Barthé is listed as a member of the African-American Art League of Chicago (p. 83).

5. Only photographs of this work remain. It was accidentally destroyed in transit after being exhibited at the American Negro Exposition in Chicago in 1940.

6. *New York Times*, Dec. 18, 1931, p. 28.

7. Ibid.

8. *Negro Artists: An Illustrated Review of Their Achievements* (New York: Harmon Foundation, exhibition catalog, 1935). This exhibition displayed the work of only three artists: Barthé, Malvin Gray Johnson, and Sargent Johnson.

9. Langston Hughes, *The Big Sea* (New York: A. A. Knopf, 1945; reprint, New York: Hill & Wang, 1968), pp. 223–28.

10. *Current Biography*, 1940, p. 57.

11. Barthé was reportedly commissioned to create a heroic military figure for the U.S. Military Academy, but M. J. McAfee, West Point Museum curator, wrote the authors on August 26, 1976, that it could not be located and that many files on both completed and suspended projects had been destroyed.

12. Meta Vaux Warrick Fuller also portrayed Harrison as "de Lawd," seated on a bench as in the play in 1935. Her sculpture is reproduced in Porter, *Modern Negro Art*, unpaged section.

13. Reviews summarized in *Art News*, April 1947, p. 48.

14. Barthé to Henry Ghent, March 21, 1966.

15. Ibid.

16. Ibid.

17. Kathy Register, obituary, *Pasadena Star-News*, March 7, 1989; *New York Times*, March 16, 1989.

18. According to Mary Ann Rey, Garner's assistant.

19. Deeply religious, Barthé did three portraits of Christ. *The Angry Christ* is in the Schomburg Center; the six-foot bronze, "*Come Unto Me*," *Christ*, is in the Church of St. Jude in Montgomery, Alabama; the third portrait is in the Clark-Atlanta University collection.

Archibald J. Motley, Jr.

Unless otherwise indicated all quotations attributed to Archibald J. Motley, Jr., are from two interviews with him, May 6 and June 6, 1972, which are the basis of much of this chapter. We have also drawn upon the work of Elaine D. Woodall, "Archibald J. Motley, Jr.: American Artist of the Afro-American People, 1891–1928" (M.A. thesis, Pennsylvania State University, 1977), and her article "Archibald Motley and the Art Institute of Chicago: 1914–30," Chicago History 9 (Spring 1979), pp. 53–57. In addition, we have utilized the research of Jontyle T. Robinson, who located more than 100 "lost" Motley paintings, including many portraits of now unknown women and fantasies of African scenes and gods. See Carroll Greene, Jr., Afro-American Art 1986 (Washington, D.C.: Visions Foundation, 1987), pp. 28–34, and Robinson's essay in the exhibition catalog Three Masters: Cortor, Lee-Smith, and Motley (New York: Kenkeleba Gallery, 1988), pp. 42–45.

1. Jacob Z. Jacobson, ed., *Art of Today: Chicago, 1933* (Chicago: L. M. Stein, 1933), p. 93. Motley was the only African-American artist asked to make a statement for this book. His friend William Schwartz also made a statement.

2. Ibid.; quoted by Woodall, in *Chicago History*, p. 9.

3. Ibid., p. 54.

4. *Bulletin of the Art Institute of Chicago*, March 1925, p. 36.

5. Woodall, in *Chicago History*, p. 55.

6. Count Chabrier, in *Revue du Vrai et du Beau*, Feb. 16 and July 10, 1925.

7. Woodall, in *Chicago History*, p. 56.

8. Edward Alden Jewell, "A Negro Artist Plumbs the Negro Soul," *New York Times Magazine*, March 25, 1928, pp. 8, 22.

9. Jontyle T. Robinson and Wendy Greenhouse believe that Motley's African scenes were suggested by his New York dealer, George Hellman, who, in a letter, urged the exhibition contain "some paintings showing various phases of negro life in its

more dramatic aspects—scenes, perhaps, in which the voo-doo element as well as the cabaret element, but especially the latter—enter." The letter says nothing of Africa. Robinson and Greenhouse believe Motley drew upon his grandmother's stories of East Africa for his fantasies. He himself was never in Africa (Jontyle T. Robinson and Wendy Greenhouse, *The Art of Archibald J. Motley, Jr.* [Chicago: Chicago Historical Society, exhibition catalog, 1991], p. 11).

10. Jewell, "A Negro Artist."
11. Ibid.
12. Woodall, in *Chicago History*, p. 56.
13. Ibid.
14. Archibald J. Motley, Jr., "How I Solve My Painting Problems," 1929 (Harmon Foundation Collection, Library of Congress, Washington, D.C.).
15. Ibid.
16. Archie Motley is now curator of manuscripts, Chicago Historical Society.
17. "Shower Curtain Artists," *Ebony* (Feb. 1953), pp. 85–86, describes this factory but does not mention Motley; see also "Top Negro Artist Works in Factory Job," *Chicago Sunday Tribune,* Dec. 2, 1956, p. 3, and *Chicago Sun-Times,* Dec. 2, 1956, p. 3.
18. Willard Motley, "Negro Art in Chicago," *Opportunity* 18 (June 1940), p. 19–22, 28.
19. Willard Motley also wrote *We Fished All Night* (1951), *Let No Man Write My Epitaph* (1958), and *Let Noon Be Fair* (1966).
20. "The Last Leaf," interview by Warren Saunder, produced by William Heit; another interview in this period was by critic Harold Hayden, *Chicago Sun-Times,* Showcase sec., Aug. 29, 1971.
21. Woodall, "Motley: American Artist," appendix A.
22. Claude Mazzocco, principal of Nichols Middle School, Evanston, Ill., letter to authors, July 16, 1980.
23. Robinson and Greenhouse, *Art of Motley.*
24. Ibid.

Palmer C. Hayden

Much of this chapter, and all quotations attributed to Palmer C. Hayden, unless otherwise noted, are based on interviews at his New York studio, May 22 and 29, 1969.

1. Rev. Moncure D. Conway, who aided Robert S. Duncanson, was related to this family. Conway broke with his family over slavery; see his *Testimonies Concerning Slavery* (London: Chapman & Hall, 1864).
2. Peyton C. Hedgeman wrote his parents about his name change, which disturbed their Moncure kin. They pointed out that if anything happened to him as a soldier his family would not be notified and that all his rights as a citizen and later as a veteran were in jeopardy. In the 1920s Hayden and his mother went to court to win the right to have the name "Palmer C. Hayden" entered on his birth certificate. Hayden was told that once he had the name "Palmer C. Hayden" on army records, he could not get rid of it without sacrificing his rights as a veteran in terms of medical care and preferential employment. Consequently he decided to keep his new name.
3. Hayden could not recall this artist's name.
4. Hayden recalled Heckman; Atwell and Flegal were identified as his other instructors by Kathleen O'Donnell, Office of Registrar, Columbia University, July 23, 1974.

5. Later, from about 1928 to 1929, Cloyd L. Boykin (who was born in Hampton, Virginia, in 1877) operated an arts and crafts shop, the African Art Center, on Grove Street in New York. He restored and appraised paintings. He exhibited his own work in the 1931 Harmon exhibition. In Boston in 1935 he established the Primitive African Art Center, an arts and crafts school. Dr. Edward Everett Hale had sponsored his earlier ministerial studies.
6. Laura Wheeler Waring, born in Hartford, Connecticut, in 1887, studied at the Pennsylvania Academy of Fine Arts and in 1914 won the Cresson Traveling Scholarship for study abroad. After studies at the Académie de la Grande Chaumière in Paris in 1924–25, she won the Harmon exhibition gold medal in 1927. Primarily a portraitist, she exhibited at the Corcoran Gallery in Washington, Art Institute of Chicago, Pennsylvania Academy of Fine Arts, New York Water Color Club, and the Harmon exhibitions of 1928, 1930, and 1931. For the Harmon portrait series of "outstanding Americans of Negro origin," she portrayed singers Harry T. Burleigh and Marian Anderson, religious leader George Edmund Haynes, poet and NAACP leader James Weldon Johnson, author Jessie R. Fauset, sociologist W. E. B. Du Bois, and scientist George Washington Carver. She died on February 3, 1948.
7. *Fétiche et Fleurs* won the $100 Mrs. John D. Rockefeller, Jr., Award in the 1933 Harmon show. Hayden's work was shown in the Harmon exhibitions in 1926, 1928, 1929, 1930, 1931, and 1933.
8. Louis W. Chappell, *John Henry: A Folklore Study* (Jena, La.: Fromman, 1933; reprint, Port Washington, N.Y.: Kennikat Press, 1968). Hayden was not aware until much later of research on John Henry by Guy B. Johnson in *Ebony and Topaz,* ed. Charles J. Johnson (New York: Opportunity, 1927; reprint, Freeport, N.Y.: Books for Libraries Press, Heritage Collection, 1971).
9. Some twenty-five years after Hayden's *John Henry* series was first exhibited, a John Henry Memorial Park, on land donated by the Chesapeake and Ohio Railroad at the mouth of the Big Bend Tunnel, was established through the efforts of a former C&O porter, Ross Evans. A larger-than-life bronze of John Henry by Charles O. Cooper of Williamston, Michigan, has been erected at this site (David P. Schultz, in Ossining *Citizen-Register,* Aug. 7, 1972, p. 5).
10. See *Echoes of Our Past: The Narrative Artistry of Palmer C. Hayden* (Los Angeles: Museum of African American Art, exhibition catalog, 1988).
11. Hayden exhibited in the 1939 Baltimore Museum of Art show, which opened the door for African-American artists to exhibit in commercial galleries; the 1940 American Negro Exposition in Chicago; the 1942 Downtown Gallery exhibition; the 1967 exhibition at the City University of New York; and the 1968 "Black Artists of the '30s" exhibition of the Studio Museum in Harlem.
12. Quoted by Sam Norkin, in *New York Sunday News,* April 15, 1973.
13. The Carl Van Vechten Gallery of Fine Arts, Fisk University, combined the *John Henry* series with other Hayden paintings reflecting African-American folklore for a special exhibition, February 22–March 20, 1970. One of these paintings, *The Baptizing Day,* exhibited at the 1945 Albany Museum of Art and Science show and reproduced in *Life,* July 22, 1946, stimulated much interest in Hayden's work.

Augusta Savage

1. Savage's death certificate gives this date. See sketch by Dewitt S. Dykes, Jr., in *Notable American Women: The Modern Period* (Cambridge, Mass.: Belknap Press of Harvard University Press, 1980), pp. 627–29. Confusion has arisen because she gave her birth date as 1901 on a passport (Deirdre L. Bibby, *Augusta Savage and the Art Schools of Harlem* [New York: Schomburg Center for Research in Black Culture, New York Public Library, exhibition catalog, 1988], p. 27). See also *Pittsburgh Courier*, May 5, 1934.
2. Unidentified newspaper clipping in Augusta Savage file, Schomburg Center, 1969; missing in 1983. Elton C. Fax referred to it (*AMSAC* [American Society of African Culture] *Newsletter*, Suppl. Oct. 1962) and he said to the authors: "Augusta Savage herself told me that" (Oct. 27, 1983).
3. From an unidentified, undated, but apparently late 1923 article by Eric Walrond (Savage file, Schomburg Center).
4. Ibid.
5. Currie dedicated a poem to Savage in his book *Songs of Florida*, quoted by Walrond.
6. Walrond.
7. Ibid.
8. Ibid. Walrond interviewed Kate Reynolds.
9. *New York Times*, Dec. 9, 1937.
10. *New York World*, April 5 and April 30, 1923; *Baltimore Afro-American*, April 27, 1923; *New York Times*, May 3, 1923.
11. *New York World*, May 10, 1923; among the protesters were Rev. Thomas M. O'Keefe, Rev. J. W. Brown, and Dr. Emmett J. Scott.
12. *Exhibition of the Work of Negro Artists* (New York: Harmon Foundation, exhibition catalog, 1931), p. 46.
13. Savage apparently had no contact with Meta Vaux Warrick, who was older but still her contemporary. Born in Philadelphia, June 9, 1877, Warrick studied first at the Pennsylvania School of Industrial Art, where she won a prize for a crucifix showing Christ in agony, and later in Rome and Paris with Rodin. Her early work, preoccupied with pain, suffering, and despair, disturbed many people. A 1910 studio fire destroyed nearly all of it, but some works have been described by Benjamin Brawley, who characterized them as grim but "vital . . . from them speaks the very tragedy of the Negro race in the New World" (*The Negro Genius* [New York: Dodd, Mead & Co, 1937], pp. 134–39). In 1909 Warrick married Dr. Solomon Fuller, the first African-American psychiatrist, and afterward turned to portraits and social themes, such as the black migration to the North (*Exodus*). See Rayford W. Logan and Michael R. Winston, eds., *Dictionary of American Negro Biography* (New York: W. W. Norton, 1982), pp. 245–47. Also James A. Porter, *Modern Negro Art* (New York: Dryden Press, 1943), pp. 86–94; Alain L. Locke, *Negro Art: Past and Present* (Washington, D.C.: Associates in Negro Folk Education, 1936; reprint, New York: Arno Press/New York Times, 1968), pp. 28–30; Theresa O. Cederholm, *Afro-American Artists* (Boston: Trustees of the Boston Public Library, 1973).
14. *Norfolk* [Virginia] *Journal & Guide*, Oct. 19, 1929.
15. Fax, in *AMSAC Newsletter*.
16. Amy Jacques Garvey, the widow of Marcus Garvey, recalled Savage coming Sunday mornings to make studies (letter to authors, Oct. 1, 1970).
17. Amy Jacques Garvey described Poston's mission in *Garvey and Garveyism* (New York: Macmillan-Collier Books, 1970), p. 149.
18. Savage's brief autobiographical sketch in *The Crisis* (Aug. 1929), p. 269.
19. The expert was Professor Charles F. Richards, the art director of the General Education Board of New York (*Norfolk Journal & Guide*, Oct. 19, 1929).
20. *Amsterdam News* (New York), Nov. 6, 1929.
21. *Chicago Whip*, Aug. 15, 1931.
22. *Pittsburgh Courier*, Aug. 29, 1936.
23. *Negro Artists: An Illustrated Review of Their Achievements* (New York: Harmon Foundation, exhibition catalog, 1935) described the studio; a Dutch-born illustrator, Angela Straeter, was Savage's assistant.
24. Anne Judge Bennis, author interview, March 28, 1972.
25. Jervis Anderson, *This Was Harlem: A Cultural Portrait, 1900–1950* (New York: Farrar, Straus, & Giroux, 1982), pp. 273–74.
26. Ibid.
27. Norman Lewis, Ernest Crichlow, and Elton C. Fax were among the former students interviewed about Savage.
28. James H. Baker, "Art Comes to People of Harlem," *The Crisis* 46 (March 1939), pp. 78–80; Sophia Steinbach, "Harlem Goes in for Art," *Opportunity* 14 (April 1936), p. 114; "1600 Study Art in Harlem," *Art Digest* 13 (April 15, 1939), p. 15.
29. Mary Beattie Brady was one who charged this; author interview, Oct. 8, 1969.
30. Reported by her brother-in-law, Ted Poston, in *Metropolitan*, Jan. 1935, pp. 28, 51, 66.
31. Richard D. McKinzie, *The New Deal for Artists* (Princeton, N.J.: Princeton University Press, 1973), pp. 101–2.
32. Bennis, interview.
33. Poston, in *Metropolitan*.
34. Porter, *Modern Negro Art*, p. 138
35. Locke, *Negro Art*, p. 77.
36. In "The Art Notebook," a column the *Chicago Bee*, May 10, 1940, William Carter called *Realization* Savage's "most ambitious piece and surely one of her masterpieces." He described the man as crouched beside the woman "as a child would crouch beside its mother—afraid" (Savage file, Schomburg Center). Contributors to casting *Realization* were listed by the *Amsterdam News*, March 7, 1936.
37. World's Fair press release (Savage file, Schomburg Center); *New York Times*, Dec. 9, 1937.
38. "There was sculptural inconsistency, however, in the realistic treatment of the heads and in the handling of the compositionally unrelated kneeling figure holding a plaque. Enlarged to near-heroic size, those errors became more glaring and less complimentary to an otherwise original and distinctive design," wrote Fax in the *AMSAC Newsletter*.
39. WPA Records of Employment (Francis V. O'Connor papers, Archives of American Art, Smithsonian Institution, Washington, D.C., microfilm roll 1090, frame 0906).
40. An unidentified Chicago newspaper article, undated but apparently late April or early May, described her tour, her lecture in the Chicago Auditorium recital hall, and her exhibition at Perrin Hall; the previous six cities on the tour were not named. It reported a committee of 100 was sponsoring her Chicago visit; Frances Taylor Moseley was general chairman of the Chicago arrangements (Savage file, Schomburg Center).
41. Ibid. An undated *Chicago Bee* clipping shows a photograph of Savage at work on the full-scale model for *After the Glory*, her antiwar memorial statue (Savage file, Schomburg Center). This statue was apparently destroyed when Savage could not obtain funds for its casting. The photo was part of the publicity that preceded her Chicago visit. Although an unidentified newspaper clipping suggests *Realization* was to be exhibited at the

Art Institute of Chicago, this did not happen (John W. Smith, Art Institute archivist, author interview, July 6, 1992).

42. An undated, unidentified Chicago African-American newspaper clipping of a column titled "Typovision" by Elizabeth Galbreath reported the Savage lecture included references to "four whippings a day" and family disasters (Savage file, Schomburg Center).

43. An unidentified newspaper clipping, May 4, 1940, describes her YMCA appearances and social events linked to her visit (Savage file, Schomburg Center).

44. The *Chicago Herald-American,* May 9, 1940, describes visits of "more than ten thousand Negro students of Chicago schools" to Savage's exhibit at the YWCA and includes a photograph of *Gamin.* The "Art and Artists" column by Ernest Heitkamp, *Chicago Herald-American,* May 12, 1940, also describes her YWCA exhibit.

45. Carter, "The Art Notebook," *Chicago Bee,* May 11, 1940 (Savage file, Schomburg Center). William Carter won first prize in oils at the first Atlanta University exhibition in 1942 and became a well-known African-American artist in Chicago.

46. *Exhibition of the Art of the American Negro* (Chicago: Tanner Galleries, catalog of the American Negro Exposition, July 4–Sept. 2, 1940).

47. Bennis, interview.

48. Ibid.

49. Elton C. Fax, author interview, April 23, 1978.

50. Bibby, *Savage and Art Schools of Harlem.*

51. Jean Blackwell Hutson, author interview, April 20, 1970; letter to authors, July 5, 1974.

52. Fax, in *AMSAC Newsletter.*

Malvin Gray Johnson

1. The Harmon Foundation exhibition catalogs are a primary source of information. Johnson exhibited in these shows in 1928, 1929, 1930, 1931, 1933, and 1935.

2. Records of the National Academy of Design, New York.

3. James A. Porter, "Malvin Gray Johnson," *Opportunity* 13 (Oct. 1935), p. 117.

4. Mary Beattie Brady showed these watercolors to one of the authors during a visit to her office in August 1966.

5. Porter, "Malvin Gray Johnson."

6. Brady, author interview.

W. H. Johnson

Much of the data in this chapter, but not its interpretation, is based on the extensively researched biographical sketch and comprehensive catalog William H. Johnson, *prepared by Adelyn D. Breeskin, senior curatorial adviser, and Jan K. Mulhert, for the Johnson exhibition at the National Collection of Fine Arts (now the National Museum of American Art), November 5, 1971–January 9, 1972. Breeskin also kindly made available her unpublished notes. She was aided by Mary Beattie Brady, who had saved Johnson's work from destruction, and Brady's Harmon assistant, Evelyn Brown Younger; by Helen Harriton; and by many others who knew Johnson. We were also aided by Brady, who described her experiences with Johnson and the salvaging of his work (author interview, Oct. 9, 1969).*

1. *Florence* [South Carolina] *Morning News,* Nov. 3, 1971, interviewed one of Johnson's surviving sisters, Lillian Cooper, and people who employed his mother.

2. Breeskin, *Johnson,* p. 11; p. 22, n. 1.

3. *Hawthorne on Painting: From Students' Notes Collected by Mrs. Charles W. Hawthorne* (New York: Dover Publications, 1960), p. 17.

4. Ibid., p. v.

5. Breeskin, *Johnson,* pp. 11–12.

6. Ibid.

7. Luks's interest in working people "led him with consistent logic to do a few strong and appealing Negro types that in their day had a revolutionary influence," wrote Alain L. Locke, *Negro Art: Past and Present* (Washington, D.C.: Associates in Negro Folk Education, 1936; reprint, New York: Arno Press/New York Times, 1968), pp. 47–48. Locke credited Luks and Bellows with significantly changing the way African-Americans were portrayed.

8. Sam Hunter, *Modern American Painting and Sculpture* (New York: Dell Publishing Co., 1959), p. 35. This statement is often quoted.

9. Locke, *Negro Art,* p. 48.

10. Paul Gauguin, *Noa Noa* (1901; reprint, New York: Noonday Press, 1957), p. 51.

11. Mary Beattie Brady and others reported this to the authors.

12. Breeskin, *Johnson,* p. 13.

13. Palmer Hayden, author interview, May 22, 1969.

14. In Europe Johnson's identity was constantly questioned. He was taken for a Moor, an Indian, a North African; David Harriton first thought him an Arab, an error many Arabs made. Johnson told Nora Holt that he always answered queries: "I am a Negro" (*Amsterdam News* [New York], March 9, 1946).

15. *Exhibit of Fine Arts by American Negro Artists* (New York: Harmon Foundation and Commission on Race Relations, Federal Council of Churches, exhibition catalog, Jan. 7–19, 1930).

16. *Florence Morning News,* circa April 1930.

17. Breeskin, *Johnson,* p. 14; the *Florence News,* Nov. 4, 1971, noted the National Collection of Fine Arts exhibition and suggested the Florence Museum acquire some of Johnson's work.

18. Cited by Breeskin, *Johnson,* p. 14; p. 22, n. 15; and Dr. Rank, "Artistic Crossbreeding Culminates in Copenhagen: The Significance of the Fisherman of Kerteminde and the Arabs of North Africa," Copenhagen newspaper, circa 1937.

19. Cited by Breeskin, *Johnson,* p. 22, n. 12; Thomasius, "Interview of the Day with an Indian—and Negro Blood in His Veins," in Copenhagen newspaper, circa 1935.

20. Breeskin, *Johnson,* p. 16; letter in Library of Congress, Manuscript Division.

21. An undated Stockholm newspaper article by Y.B. said: "His art is not easy to characterize. It could best be described as a primitive expression with its heavy forms and violent color treatment. The landscapes are brutal, the colors explode and go rushing along in broad streams, the mountains resemble Cyclopean blocks on the point of tumbling over and the small cottages seem to be creased by giant hands. In all the dynamic violence, however, there is some kind of barbaric style, a forced way indeed but yet a consistent way of apprehending the Norwegian nature."

Another critic, V——e, in *Arbetarbladet,* Gavle, Sweden, circa December 1937, wrote: "There is something violent, explosive in his temperament which is reflected in these fjord and mountain scenes. It seems as if the force and power of this landscape has awakened to life something in his artist's soul, something that has to come out with eruptive force."

22. Breeskin, *Johnson,* p. 16.

23. Rolf Stenersen bought Johnson's work and Pola Gauguin

praised it, but complained that one gallery had not adequately displayed Johnson's work: "Because of the strength of each picture, its great simplicity and primitive expressiveness are constantly being disturbed by a similar picture being close to it" (unpublished note, Breeskin/Johnson file, library, National Museum of American Art, Washington, D.C.). Over 100 Scandinavian press articles from Johnson's scrapbook, lacking publication names and dates, are in the Johnson file.

24. Werner Haftmann, *Painting in the Twentieth Century* (New York: Praeger, 1972), vol. 1, pp. 304–6. Haftmann notes that Hitler's attack on modern art began in 1933; see also H. B. Chipp, P. Selz, and J. C. Taylor, *Theories of Modern Art* (Berkeley & Los Angeles: University of California Press, 1968), pp. 478–81. Silver Fox Press, Redding, Connecticut, published a facsimile of the original Nazi catalog *Degenerate Art,* while the New York gallery La Boétie exhibited the type of art banned (*New York Times,* April 23, 1972).

25. Haftmann, *Painting,* vol. 1, p. 305.

26. Breeskin, *Johnson,* Appendix I, pp. 195–96; excerpt from letter by Harritons to Mary B. Brady.

27. Cited by Breeskin, *Johnson,* p. 16; letter of Sept. 24, 1937, in Library of Congress, Manuscript Division.

28. Brady, author interview, Oct. 9, 1969.

29. Breeskin, *Johnson,* p. 16.

30. Ibid., p. 18; Nora Holt, in *Amsterdam News,* March 9, 1946.

31. McMillen Inc., New York, Oct. 16–Nov. 7, 1941; Downtown Gallery, Dec. 9, 1941–Jan. 3, 1942.

32. Breeskin, *Johnson,* p. 26.

33. Johnson taught at the Harlem Community Art Center only from May 26 until August 31, 1939 (WPA employment records, F. V. O'Connor papers, Archives of American Art, Smithsonian Institution); he was then employed by the WPA fine arts project until January 13, 1943 (Breeskin, *Johnson,* p. 26).

34. "The American Artists' Record of War and Defense" consisted of drawings and prints purchased by the Office of Emergency Management from entries submitted in an open national competition and exhibited at the National Gallery, Washington, D.C., February 7–March 8, 1942. Its open competition contrasted with the Metropolitan exhibition, which had a controversial jury.

35. Howard Devree, in *New York Times,* May 2, 1943, sec. III, p. 7.

36. Robert Beverly Hale, in *Art News* 42 (May 14, 1943), p. 22.

37. Breeskin, *Johnson,* p. 19; Holt, in *Amsterdam News.*

38. A luetic infection, after ten to twenty years, eventually causes dementia paralytica (paresis) with severe convolutional atrophy, degeneration, and loss of nerve cells, particularly in the brain's frontal lobes, with progressive mental deterioration. Johnson showed no symptoms of the congenital form of the disease. See L. M. Davidoff and E. H. Feiring, *Practical Neurology* (New York: Lansberger Medical Books, 1955), pp. 241–42.

39. Brady was aided by Evelyn Brown Younger, her assistant, and Palmer Hayden, who worked part-time for the Harmon Foundation, packing traveling exhibitions.

40. D. H. Lawrence, *The Tales of D. H. Lawrence* (London: Martin Sacker, 1934), p. 967.

41. *The Journal of Eugène Delacroix* (New York: Covici-Friede, 1937; reprint, New York: Crown Publishers 1948), p. 564.

Hale A. Woodruff

This chapter, including biographical information and all quotations attributed to Hale A. Woodruff, unless otherwise indicated, is based on interviews with him April 16, 1967, April 27, 1972, and June 2, 1973, as well as letters April 14 and June 3, 1974, supplemented by many informal conversations and discussions in New York and one at Dillard University, New Orleans, where Woodruff was a guest lecturer in 1978. Additional material is drawn from Hale Woodruff: Fifty Years of His Art *(New York: Studio Museum in Harlem, exhibition catalog, April 29–June 24, 1979).*

1. William Pickens, Sr., helped Du Bois organize the "Niagara movement" that led to the formation of the NAACP.

2. Countee Cullen became Woodruff's friend, bought his work, and often played cards with him and Palmer Hayden in France, inspiring Woodruff's *Cardplayers.*

3. Woodruff submitted five paintings; four were landscapes.

4. Arranged by Lucille Morehouse, art editor of the *Indianapolis Star.* Woodruff's illustrated articles started in January 1928 and continued bimonthly for fourteen months (Winifred Stoelting, "From Indianapolis to France," *Woodruff* (Studio Museum), p. 13.

5. *The Crisis* 35 (Aug. 1928), cover.

6. *The Crisis* (Jan. 1970), pp. 7–12.

7. The painting was *Old Woman Peeling Apples,* 1927, reproduced in *Woodruff* (Studio Museum), p. 11.

8. Wilmer Jennings quoted in ibid., p. 18.

9. Albert Murray interview in ibid., p. 80.

10. Winifred Stoelting, "Teaching at Atlanta," ibid., p. 18.

11. Jenelsie Walden Holloway, professor of art, Spelman College, Atlanta University, quoted in ibid., p. 20.

12. Hayward Oubre of Alabama State College quoted in ibid., p. 20.

13. *Time,* Sept. 21, 1942, p. 74.

14. Stoelting, "Teaching," *Woodruff* (Studio Museum), p. 21.

15. *Atlanta Constitution,* Dec. 18, 1935; reprinted *Opportunity* (Jan. 1936).

16. *Phylon* 2 (First quarter, 1941), p. 4; in an accompanying note, Du Bois wrote: "Woodruff of Atlanta dropped his wet brushes, packed the rainbow into his knapsack and rode post-haste and Jim Crow into Alabama. There he dreamed upon the walls of Savery Library the thing of color and beauty portrayed on the opposite page, to keep the memory of Cinque, of the friendship, and the day when he and his men, with their staunch white friends, struck a blow for the freedom of mankind."

17. Woodruff's distinguished former students also included Howard Fussiner, painter and professor of art at Yale University, and Hans Peter Kahn, a painter who formerly taught at Cornell University. Some students have developed a new generation of black artists and educators. For example, Jeff Donaldson, teaching at Howard University, was a student of John Howard.

18. Foreword, *Hale Woodruff: An Exhibition of Selected Paintings and Drawings, 1927–1967,* (New York: Loeb Student Center, New York University, exhibition catalog, May 15–June 8, 1967).

19. Albert Murray interview in *Woodruff* (Studio Museum), p. 85.

20. Mary Schmidt-Campbell, "Hale Woodruff: Fifty Years of His Art," in ibid., p. 57. In 1979 New York Public School No. 224 in Brooklyn was named for him. In April 1981, Atlanta University paid tribute to Woodruff's initiation of its art collections and to his mural *The Art of the Negro* with a major exhibition, "Homage to Hale Woodruff."

Sargent Johnson

1. Interview in *San Francisco Chronicle,* Oct. 6, 1935.
2. Consuelo Kanaga, author interview, March 12, 1971. Her photograph of a black mother and children in Edward Steichen's *Family of Man* (New York: Museum of Modern Art, 1953) was inspired by Johnson's *Forever Free.*
3. Quoted by Evangeline J. Montgomery, *Sargent Johnson* (Oakland, Calif.: Oakland Museum, exhibition catalog, 1971), p. 30. This monograph is a basic informational source on Johnson. As the museum's consultant on African-American artists, Montgomery interviewed Johnson, his family members, and his friends, and prepared its retrospective Johnson exhibition (Feb. 23–March 21, 1971) with the assistance of Marjorie Arkelian, the museum's art historian, and others.
4. Ibid., p. 31.
5. May Howard Jackson (1877–1931) exhibited at the Corcoran Gallery, Washington, D.C., and the National Academy of Design, New York. James A. Porter was one of her students (see his *Modern Negro Art* [New York: Dryden Press, 1943], pp. 92–93).
6. Johnson's obituary (*Oakland Tribune,* Oct. 12, 1967) reported he arrived in the Bay area when he was twenty-one years old, in 1909. However, Montgomery gives his arrival as 1915 (*Johnson,* p. 10).
7. Montgomery, *Johnson,* p. 10.
8. Ibid. He studied at the California School of Fine Arts from 1919 to 1923, and from 1940 to 1942.
9. Ibid., p. 9.
10. Ibid., p. 12. Montgomery attributes these figures to Delilah L. Beasley, in *Oakland Tribune,* Oct. 12, 1967.
11. Porter, *Modern Negro Art,* p. 139.
12. The 1935 Harmon exhibition featured Johnson, along with Malvin Gray Johnson and Richmond Barthé. It carried a brief sketch and picture of Sargent Johnson.
13. This panel, for the Nathan Dohrmann store, was destroyed with the building. Johnson also created a decorative map in enameled porcelain steel of Richmond, California, for its city hall.

Emergence of African-American Artists During the Depression

1. Beauford Delaney worked at the Whitney Museum of American Art, which helped organize these shows. On Hayden's sale, see *Negro Artists-An Illustrated Review of Their Achievements* (New York: Harmon Foundation, exhibition catalog, 1935), p. 38.
2. Audrey McMahon, in F. V. O'Connor, ed., *New Deal Art Projects: Anthology of Memoirs* (Washington, D.C.: Smithsonian Institution Press, 1972), pp. 52–54. See also Richard D. McKinzie, *New Deal for Artists* (Princeton, N.J.: Princeton University Press, 1973), p. 77.
3. There may have been others. These artists were identified by cross-referencing interviews and Harmon catalog biographies.
4. Roi Ottley and W. J. Weatherby, eds., *The Negro in New York* (New York: Praeger, 1969), p. 268; N. Coombs, *The Black Experience* (New York: Hippocrene Books, 1972), p. 172.
5. Demand voiced by Phil Bard, head of Unemployed Artists Group (McKinzie, *New Deal,* p. 77).
6. George Biddle, *An American Artist's Story* (Boston: Houghton Mifflin, 1939), pp. 265–68.
7. McKinzie, *New Deal,* p. 13.
8. Ibid., p. 14.

9. Ibid., p. 13.
10. Ibid., p. 23.
11. Names were obtained by cross-referencing Harmon files with interviews. Under PWAP, Richard M. Lindsey and Joseph Delaney taught, and James L. Allen photographed African-American leaders.
12. *Negro Artists* (Harmon catalog, 1935), pp. 53 (Motley), 55 (Reid).
13. McKinzie, *New Deal,* p. 15.
14. Leslie H. Fischel, Jr., "The Negro in the New Deal Era," in B. Sternsher, ed., *The Negro in Depression and War* (Chicago: Quadrangle Books, 1969), p. 7.
15. Ibid., p. 9; also Broadus Mitchell, *Economic History of the United States,* vol. 9, *The Depression Decade, 1929–1941* (New York: Rinehart & Co.,1947), p. 103.
16. *Amsterdam News,* July 18, 1936; see also E. F. Frazier, in *American Journal of Sociology* 43 (July 1937), pp. 72–88.
17. Romare Bearden, in *Opportunity* 12 (Dec. 1934), pp. 371–73.
18. Matisse, March 30–April 20, 1935; Valentin, April 15–17, 1935; Midtown, March 17–April 1, 1936.
19. Fischel, "Negro in New Deal," p. 9.
20. McKenzie, *New Deal,* p. 80.
21. Cahill held that Congress appropriated WPA funds "to preserve the skills of the unemployed," not for artistic quality. Artists not qualifying for the easel project were employed in socially useful ways, such as teaching (McKinzie, *New Deal,* pp. 53–73). Bruce's elitist attitude on PWAP had resulted in hiring only 289 artists, not the 450 for whom there were funds, infuriating the American Artists Congress and its secretary, Stuart Davis (ibid., p. 41).
22. A still life by Louis Vaughn from the first Harmon-CAA traveling exhibition. One of the first black artists on the WPA easel project, Vaughn, born in 1910, was chronically depressed and committed suicide in 1938.
23. An undated, apparently early questionnaire and partial listing of New York African-American artists and their WPA assignments, developed by Hubert Malkus for the WPA Information Office and found in the files of the Harlem Artists Guild, indicates there were only three black artists on the easel project initially—Sollace J. Glenn, Sarah Murrell, and Louis Vaughn. Later Charles Alston, Jacob Lawrence, and many others were members.
24. "An Art Commentary on Lynching," Arthur U. Newton Gallery, New York. The exhibition catalog included essays by Erskine Caldwell and Sherwood Anderson; Pearl Buck addressed the opening.
25. James A. Porter, *Modern Negro Art* (New York: Dryden Press, 1943), pp. 165–66.
26. Delaney's renderings of a sugar bowl and a bottle for toilet water are in the Index of American Design files, National Gallery of Art, Washington, D.C.
27. Charles Alston, author interview, May 1, 1969.
28. Thomas H. Benton, "What's Holding Back American Art?" *Saturday Review of Literature* 34 (Dec. 15, 1951), pp. 9–11, 38; reprinted in Matthew Baigell, ed., *A Thomas Hart Benton Miscellany* (Lawrence: University of Kansas Press, 1971), p. 105.
29. Benton's attempts in the 1930s to define what he meant by "American art" were often emotional and never clear, although he clearly and vehemently opposed modern European art, as exemplified by Picasso, and Marxist concepts of art. This quotation is from his 1951 statement in John I. H. Bauer, ed., *New Art in America* (Greenwich, Conn.: New York Graphic Society, 1951), p. 131; reprinted in Baigell, *Benton Miscellany,* p. 38.

Notes to pages 216–233

30. Benton, in *Art Front* 1 (April 1935), p. 2. Fearing *Art Front* would not publish his responses to its questions, Benton sent them to *Art Digest*, which published them (March 15, 1935, p. 20). Reprinted in Baigell, *Benton Miscellany*, pp. 58–65.

31. Stuart Davis, "A Rejoinder to Thomas Benton," *Art Digest* 1 (April 1935), p. 32; reprinted in David Shapiro, ed., *Social Realism* (New York: Frederick Ungar, 1973), pp. 102–6.

32. Meyer Schapiro, "Race, Nationality, and Art," *Art Front* 2 (March 1936), pp. 10–12.

33. "Harlem Artists Guild," presumably by Gwendolyn Bennett, *Art Front* 2 (April 1936), pp. 4–5. Another article on the Guild, by Bennett, appeared in *Art Front* 3 (April 1937), p. 20.

Bennett, born in Giddings, Texas, in 1902, studied painting at Pratt Institute in New York and the Académie Julien in Paris, and art education at Columbia University. She taught at Howard University and Tennessee State College, and directed the Harlem Community Art Center from 1937 to 1941 "when she was removed because of her political views," according to Porter, *Modern Negro Art*, p. 130. Also a poet of distinction, she subsequently left the field.

34. James A. Porter, "Negro Artists and Racial Bias," *Art Front* 2 (June–July 1936), pp. 8–9.

35. "Harlem Hospital Mural," *Art Front* 2 (April 1936), p. 3.

36. *Art Front* 2 (July–Aug. 1936), pp. 4–5.

37. Quoted by Katherine Kuh, in Barbara Rose, ed., *Readings in American Art Since 1900* (New York: Frederick A. Praeger, 1968), pp. 125–26.

38. The Harlem Arts Guild wrote Gottlieb on January 26, 1936: "So close has been our association with you through the Artists Union, the Artists Congress, and through your own personal interest in us and our problems that news of your illness comes to us with the same shock and attendant worry that accompanies the knowledge that all is not well with one of our own members," signed by Gwendolyn Bennett, president, and Norman Lewis, corresponding secretary (Harlem Artists Guild file).

39. Bannarn, born in Wetunka, Oklahoma, July 17, 1910, studied at the Minnesota School of Art and won first prize at the Minneapolis Institute of Arts in 1932. Awarded a scholarship to the Art Students League, he showed much promise but died sometime in the late 1940s or early 1950s.

40. Artists visiting Dunham's gatherings included Charles White, Eldzier Cortor, Margaret G. Burroughs, Charles Davis, Charles Sebree, Bernard and Margaret Walker Goss, Elizabeth Catlett, William Carter, and Earl Walker (Charles White interview, Hatch-Billops Oral History of Black Arts, New York).

41. Aaron Douglas, "The Negro in American Culture, *Proceedings of First American Artists Congress Against War and Fascism* (New York, 1936), pp. 12–16.

42. John Houseman, *Run-through* (New York: Simon & Schuster, 1972) details this success (pp. 175–201).

43. "In the Thirties social art . . . became a broad expression extending far beyond the limits its critics have implied, until today one cannot deny its importance in the history of American art," according to Milton Brown, *American Painting from the Armory Show to the Depression* (Princeton, N.J.: Princeton University Press, 1955), p. 191.

44. McKinzie considered the major differences between the Regionalists and Social Realists "lay in the degree of nativism each embraced and the amount of social comment each thought appropriate" (*New Deal*, p. 106). See also Matthew Baigell, *American Painting in the Thirties* (New York: Frederick A. Praeger, 1970).

45. McKinzie, *New Deal*, p. 18.

46. Variations on this theme were developed by many socially conscious but noncommunist individuals. Max Lerner, for example, became well known through his book *Ideas Are Weapons* (New York: Viking, 1939).

47. Milton Brown, a leading art historian of the period, observed: "Although Socialist Realism did not dominate the art of the period, it was at least for a time the eye of a storm of controversy. It polarized artistic attitudes, ideologically and aesthetically, by postulating the premises of social relevance and communication as a requisite of art. The more radical, Marxist-oriented artists of the John Reed Club saw all art as an expression of the class struggle, from which it followed that the conscious artist had to accept the consequences of his political and social allegiance. And since art was a weapon in the struggle, it must be communicative on the broadest level. Of course, many artists did not accept the political convictions or philosophic arguments of the social realists, and many who did refused to equate art with propaganda" (in *Social Art, 1900–1945* [1981 exhibition catalog, published for fiftieth anniversary of ACA Galleries, New York, a major exhibitor of such work]).

In recent years Social Realism has been differentiated from Socialist Realism by some commentators. See Shapiro, *Social Realism*.

48. Ralph Ellison, *Shadow and Act* (New York: New American Library, 1966), p. xviii.

49. George Biddle, in *American Scholar* 9 (July 1940), pp. 327–28.

50. Ben Shahn, *The Shape of Content* (New York: Vintage Books, 1957), p. 88.

51. Alston, author interview, May 1, 1969.

52. Minutes, Harlem Artists Guild, Nov. 29, Dec. 13, 1938.

53. See "My Day," *Amsterdam News*, Dec. 25, 1937.

54. See *Art Digest* 13 (April 15, 1939), p. 15; *Opportunity* 14 (April 1936), p. 114; *The Crisis* 46 (March 1939), pp. 78–80.

55. *The Crisis* 46 (March 1939), pp. 78–80.

56. McKinzie, *New Deal*, pp. 155–65. See also Walter Goodman, *The Committee: The Extraordinary Career of the House Committee on Un-American Activities* (New York: Farrar, Straus & Giroux, 1968); A. R. Ogden, *The Dies Committee, 1938–1944* (Washington, D.C.: Catholic University of America Press, 1945); Frank J. Donner, *The Un-Americans* (New York: Ballantine Books, 1961), and Eric Bentley, ed., *Thirty Years of Treason: Excerpts from HUAC Hearings* (New York: Viking, 1971).

57. McKinzie, *New Deal*, p. 156.

58. Ibid. In *New Deal Art Projects*, O'Connor reported that some thirty years later former WPA artists expressed a reluctance to be interviewed because they still feared "that the association with the WPA will in some way insinuate their affiliation with 'subversive' organizations" (p. 2).

59. Minutes, Harlem Artists Guild, July 2, 1938.

60. Ibid.

61. Ibid., Dec. 13, 1938.

62. Leaflet, Harlem Artists Guild, Dec. 6, 1938.

63. McKinzie, *New Deal*, p. 158.

64. Ibid., p. 163.

65. Brady emphasized this exhibition in a series of conversations (beginning in July 1966), at the Harmon Foundation office (Aug 10, 1966), and in an interview at her New York apartment (Oct. 8, 1969).

66. Elizabeth McCausland, in *Springfield* [Mass.] *Sunday Union and Republican*, Dec. 21, 1941.

67. Robert M. Coates, "Negro Art," *The New Yorker*, Dec. 27, 1941, pp. 52–53.

Alain Leroy Locke

The principal source for biographical information on Alain Leroy Locke was Michael R. Winston's excellent sketch in Rayford Logan and Michael R. Winston, eds., The Dictionary of American Negro Biography *(New York: W. W. Norton, 1982). Locke's own books and essays as well as the 1931 and 1933 Harmon Foundation exhibition catalogs were the sources for his ideas unless otherwise noted. Other sources were Nathan Irvin Huggins,* Harlem Renaissance *(New York: Oxford University Press, 1971), and for the period, Jervis Anderson,* This Was Harlem 1900–1950 *(New York: Farrar, Straus & Giroux, 1981). Locke's relationships with Charlotte Mason and Langston Hughes are detailed by Faith Berry in* Langston Hughes, Before and Beyond Harlem *(Westport, Conn.: Lawrence Hill Publishing Co., 1983) and in even more detail by Arnold Rampersad,* Life of Langston Hughes, 1902–1941, *vol. 1 (New York: Oxford University Press, 1986). Bearden knew Locke, and interviews with Charles Alston and Hale Woodruff, both of whom knew Locke, contributed to our information and understanding.*

1. Winston, in *Dictionary*, p. 399.
2. Alain Locke, ed., *The New Negro* (New York: Albert and Charles Boni, 1925; reprint, New York: Atheneum, 1968), p. 254.
3. Ibid.
4. Rampersad, *Hughes*, p. 197.
5. Ibid., p. 67.
6. Locke's mother, Mary Hawkins Locke, was a descendant of Charles Shorter, a free African-American soldier in the War of 1812, who started the family tradition of education. Pliny Locke was the son of Ishmael Locke, a Salem, New Jersey, teacher who was sent by Quakers to Cambridge University in England. For four years he established schools in Liberia and later became the principal of the Institute for Colored Youth in Philadelphia. His son, Pliny Ishmael Locke, Alain's father, graduated from the institute in 1867, taught mathematics there for two years, then taught freedmen in North Carolina for two years. He then graduated from Howard University Law School and became a clerk in the Philadelphia post office. See Winston, in *Dictionary*, p. 398.
7. Ibid., p. 399.
8. Ibid., p. 400. Locke, given sabbatical leave and the blessing of Howard University, was aided by the French Oriental Archeological Society of Cairo.
9. Locke's remarks at the American Negro Academy meeting, Dec. 28, 1928; quoted in ibid.
10. The purchase of this collection was financed by Charlotte Mason and Charles E. Nail, an African-American real estate operator and father-in-law of James Weldon Johnson. However, funds to establish a museum building could not be raised.
11. Quoted by Winston, in *Dictionary*, p. 481, from Locke's article "The Concept of Race as Applied to Social Culture," *Howard University Review*, May 1924.
12. Alain Locke, "The African Legacy and the Negro Artist," in *Exhibition of the Work of Negro Artists* (New York: Harmon Foundation, exhibition catalog, 1931), pp. 10–12.
13. Ibid.
14. Alain Locke, "The Negro Takes His Place in American Art" in *Exhibition of the Productions by Negro Artists* (New York: Harmon Foundation, exhibition catalog, 1933), pp. 9–12.
15. Ibid. This case bears a striking resemblance to that of the young poet cited by Langston Hughes in his essay "The Negro Artist and the Racial Mountain" (*The Nation* 122 [June 23, 1926], pp. 692–94). But Hughes suggests the poet's statement that he wants to be "a poet—not a Negro poet" means he unconsciously wants to be white. Locke's young painter, on the other hand, simply comes to recognize African-Americans can be appropriate subjects on technical grounds. Locke certainly had read Hughes's essay but, avoiding the question Hughes raised, comes to a different conclusion.
16. Locke, "The Negro Takes His Place."
17. Ibid.
18. Huggins, *Harlem Renaissance*, pp. 118, 129–36.
19. Berry, *Hughes*, pp. 87–88.
20. Ibid.
21. Rampersad, *Life of Hughes*, p. 147.
22. See Berry, *Hughes*, pp. 115–16; also Rampersad, *Life of Hughes*, p. 175. Considering his Oxford discussions of colonialism and racism, it seems contradictory that Locke also accompanied Mason to lectures by General Jan Smuts, who served as prime minister of South Africa and was an exponent of British colonialism and a founder of apartheid.
23. Quoted by Winston, in *Dictionary*, p. 401.
24. Alain Locke, *Negro Art: Past and Present* (Washington, D.C.: Associates in Negro Folk Education, 1936; reprint, New York: Arno Press/New York Times, 1969).
25. Alain Locke, Foreword, *The Negro in Art* (Washington, D.C.: Associates in Negro Folk Education, 1940).
26. Porter's strongest attack appeared in the New York Artists Union publication, *Art Front* 3 (July–Aug. 1937), pp. 8–9. Accusing Locke of ignoring the achievements of such nineteenth-century African-American artists as Duncanson and Bannister, he said, "The 'primitive' artist, whether African or Polynesian, is at one with the forms he used because these are dictated by the society in which he finds himself, which in turn is modified by surrounding climatic and geographical conditions. . . . The special qualities of tribal art must result not from any unique racial character, but from influential phases within the particular culture from which it comes. Thus, Cubism is not merely the result of the impact of African forms upon European art practice. Could Cubist art have been produced in Dahomey?" In *Modern Negro Art* (New York: Dryden Press, 1943, pp. 99–107), Porter continued his attack, citing sociologist E. Franklin Frazier's rejection of the biological inheritance of values, attitudes, and "a different order of mentality."
27. Locke, *Negro Art: Past and Present*, pp. 120–21.
28. Alain Locke, Foreword, *Contemporary Negro Art* (Baltimore: Baltimore Museum of Art, exhibition catalog, 1939).
29. Margaret Just Butcher, working with Locke's papers, wrote *The Negro in American Culture* (New York: A. A. Knopf, 1964) in an effort to complete Locke's plan.
30. Charles Alston reported to the authors that at one such meeting Locke invited him to help arrange an exhibition of African sculpture at the Harlem branch of the public library. Physically handling these objects, Alston said, greatly impressed him and gave him insight into their artistic character.

Charles Christopher Seifert

The material on Charles C. Seifert is based on recollections of many artists, including Charles Alston, Romare Bearden, Jacob Lawrence, Robert Savon Pious, and Earl R. Sweeting, and on an interview with his widow, Tiaya Goldie Seifert, at her New York home on January 17, 1971. The quotations attributed to Seifert come from the interview with his widow.

1. Earl Conrad, whose book *The Invention of the Negro* (New York: Paul S. Eriksson, 1966) provides a history of the development of the concept of racial inferiority as a justification for slavery, felt Seifert defined the process too narrowly, according to Tiaya Seifert (author interview). However, Seifert is not mentioned in Conrad's book.

2. William L. Hansberry, in *Howard University* (Washington, D.C.: Howard University, 1973), p. 46. Hansberry was the author of a two-volume work, *The William Leo Hansberry African History Notebook* (Washington, D.C.: Howard University Press, 1977; reprint, ed. Joseph E. Harris, 1981). Ernest A. Hooton of Harvard considered that Hansberry's African studies had made him "certainly the most competent authority on the subject" (Michael R. Winston, *Howard University Department of History, 1913–1973* [Washington, D.C.: Howard University Press, 1973], p. 94).

Mary Beattie Brady

As noted in the text, an interview with Mary Beattie Brady on October 8, 1969, and conversations with her that began in July 1966 provided much of the information in this chapter, including all biographical information and all quotations attributed to her, unless otherwise noted. On August 10, 1966, she showed more than 100 paintings and described her efforts to exhibit and preserve them. We were also aided by the Harmon Foundation catalogs, which she provided. In addition, we are indebted to the research and essays of Gary A. Reynolds, Beryl J. Wright, and David Driskell in Against the Odds *(Newark, N.J.: Newark Museum, 1989), an exhibition catalog of artists who participated in the Harmon competitions and exhibitions between 1926 and 1935. Conversations with some of the participating artists, notably Hale Woodruff, Palmer Hayden, Charles Alston, Elton C. Fax, Jacob Lawrence, and James L. Wells, also contributed to our understanding of Brady and her role in the Harmon Foundation aims and operations.*

1. Obituary, *New York Times,* July 16, 1928.

2. Brady often said she preferred this phrase, as the only accurate designation, to the terms "Negro" and "Afro-American." However, "Negro" was used in all the Harmon Foundation's publicity and its catalogs.

3. Other fields included science and invention, education, religious services, and improvement of race relations (which was also open to whites, but offered only a bronze medal). See Gary Reynolds, "An Experiment in Inductive Service," in *Against the Odds,* p. 29.

4. George E. Haynes, *The Trend of the Races* (New York: Council of Women for Home Missions Educational Movement, 1922), p. 19.

5. In contrast to these sums, Harmon established the Religious Motion Picture Foundation with $50,000 in 1925 and by 1929 had spent $250,000 on silent films of biblical scenes and stories. These films, intended to supplement sermons, had limited appeal to churches (see Reynolds, in *Against the Odds,* p. 29). Brady later made films showing the work of black artists and one of Palmer Hayden painting a picture. These films stimulated the development of art departments in African-American colleges.

6. Reynolds, in *Against the Odds,* p. 30. Initially Haynes selected the jurors, but their solicitation, which in effect meant their selection, gradually passed to Brady.

7. Of her 1927 selection of Neysa McMein and Charles Dana Gibson as jurors, Brady later said: "If I had known anything about art, I wouldn't have selected them."

8. Jackson, born in Philadelphia in 1877, studied at the Pennsyl-
vania Academy of Fine Arts. An able portraitist, she exhibited at the Corcoran Gallery of Art in Washington in 1915 and the National Academy of Design in New York in 1916. She won the Harmon bronze award for sculpture in 1928. She died on July 12, 1931. (See Theresa D. Cederholm, ed., *Afro-American Artists,* [Boston: Trustees of Boston Public Library, 1973]).

9. Brady's figures may be correct, but for the three shows at International House (1927, 1928, and 1929) average attendance varied between two and three thousand (Reynolds, in *Against the Odds,* p. 35).

10. Ibid., p. 56. The support of the Harmon family is indicated in the 1931 Harmon catalog, listing William Burke Harmon as president and Helen Griffiths Harmon as vice president of the Harmon Foundation.

11. Brady proudly reported the Whitney Museum's purchase of Barthé's and Prophet's work in the 1932 Harmon catalog (p. 18).

 A graduate of the Rhode Island School of Design in 1918, Prophet studied in Paris under Victor Segoffin, a leading French portraitist. Her statues in the Paris Salons of 1926 and 1929 won critical praise. Henry Ossawa Tanner enthusiastically wrote the Harmon Foundation about her, urging her recognition, and in 1930 she won its gold medal. She was highly praised by W. E. B. Du Bois (unsigned articles in *The Crisis* 36 [Dec. 1929], p. 407; 39 [Oct. 1932], p. 315) and by Countee Cullen (*Opportunity* 8 [July 1930], p. 204). Gertrude Whitney purchased *Congolaise* when she saw it in a 1932 Newport (Rhode Island) Art Association exhibition.

 At Du Bois's urging, Spelman College appointed Prophet as an instructor in modeling and art history at a good salary and provided her with a large studio. Yet she was unable to create significant work in Atlanta. Her teaching also failed. After nearly ten years, she left in 1944 and was hospitalized for a nervous breakdown. Brady, who saw her in Atlanta, said: "She never really did anything. She kept these clay figures wrapped and kept them wet. I'd say to Miss Reed [then president of Spelman]: 'Why don't you make her work?' She just wasn't accomplishing anything. . . . She had these students and she wasn't getting anyplace with them. . . .I think she had ability, but there was something—you see, her personality was all askew. You couldn't really work with her to get anywhere. . . . What I am trying to show you is that when an effort was made to put Nancy Prophet in a position where she could grow, they [the efforts] were frustrated." Hale Woodruff, who was teaching drawing and painting in Atlanta at the same time, confirmed Prophet's poor teaching methods and inability to work with others (author interview, May 23, 1975).

 Returning to Providence, Rhode Island, Prophet was unable to resume creative work or teach. Embittered and frustrated, Prophet, whose father was a Narragansett Indian and whose mother was of "mixed" parentage, denied her African-American heritage although her main support and recognition in the United States had come from African-Americans. She wrote Cedric Dover that as an anthropologist he "must certainly know . . . I am not a negro" (Dover, *American Negro Art* [Greenwich, Conn.: New York Graphic Society, 1960], p. 56). Prophet died in Providence on December 13, 1960 (*Providence Journal,* Dec. 14, 1960, p. 21; Dec. 18, 1960, p. 46). Extensive research by Blossom S. Kirschenbaum ("Nancy Elizabeth Prophet, Sculptor," *Sage* 4 [Spring 1987], pp. 45–52) has revealed many aspects of Prophet's tragic life.

12. All the African-American artists asked about Brady recalled her "high-handed" method of operating and complaints. However, Palmer Hayden, who was employed by her, felt much

criticism was unjustified. All felt, in retrospect, that she had been a significant help to black artists, although they felt she could have been more sensitive and more willing to consult with them than she was.

13. These African works were borrowed from the Harlem Museum of African Art, which Locke had helped establish in the Harlem branch of the New York Public Library (now the Schomburg Center for Research in Black Culture). They included a Bakuba chieftain's statuette, a Bakuba ceremonial cup, a jewel box and a mask from the Congo, as well as ivory and rhinoceros horn talismans and a Kasai dance mask from the Belgian Congo.

14. Reported under "By-Products," *Exhibition of the Productions by Negro Artists* (New York: Harmon Foundation, exhibition catalog, 1933), p. 19.

15. The portfolio was titled *Portraits of Outstanding Americans of Negro Origin, Painted by Two Women Artists, Laura Wheeler Waring and Betsy Graves Reyneau*. The original portraits were given to the National Portrait Gallery, Smithsonian Institution, Washington, D.C. Brady felt there had been a poor response to the series.

16. Romare Bearden, "The Negro and Modern Art," *Opportunity* 12 (Dec. 1934), pp. 371–72.

17. Jacob Lawrence, author interview, June 3, 1969.

18. David Driskell, "Mary Beattie Brady and the Administration of the Harmon Foundation," in *Against the Odds*, p. 67.

19. Alain Locke, "The African Legacy and the Negro Artist," in *Exhibition of the Work of Negro Artists* (New York: Harmon Foundation, exhibition catalog, 1931), pp. 9–12.

20. Driskell, in *Against the Odds*, p. 65.

21. Alain Locke, "The Negro Takes His Place in Art," in *Exhibition of Negro Artists* (1933 Harmon catalog), pp. 9–12.

22. Driskell, in *Against the Odds*, p. 66.

23. During the 1930s and 1940s Porter constantly attacked Locke's views as leading to segregation. See *Art Front* 3 (July–Aug. 1937), pp. 8–9, and his book *Modern Negro Art* (New York: Dryden Press, 1943), pp. 98–104.

24. Porter, *Modern Negro Art*, p. 107.

25. Jean McGleughlin, "Exhibition of Negro Art," *Baltimore Museum of Art Quarterly* 3 (Winter 1938–39). Fax, born in Baltimore in 1909, was trained as an artist at Syracuse University. He eventually came to New York and was befriended by Augusta Savage. He taught at Claflin University in 1935. Primarily an illustrator, he also wrote a number of books, including *Garvey: The Story of a Pioneer Black Nationalist, 17 Black Artists,* and *Through Black Eyes* (describing his journeys in East Africa and Russia). All were published by Dodd, Mead & Co. (author interview, Sept. 15, 1974).

26. Brady was unable to recall this curator's name and efforts to secure it elsewhere failed.

27. The "Amos 'n Andy" show, radio's most popular nightly show in the 1930s, declined in popularity steadily in the early 1940s, ending its nightly run in 1943. This reflected changes in public attitudes toward African-Americans as a result of the New Deal requirement of fair employment practices and the drafting of African-American soldiers. A once-a-week format failed to win a large audience although the show staggered on into the 1950s, finally becoming a disk-jockey show, "The Amos 'n Andy Music Hall." A TV version, attacked by the NAACP as racist, ended in 1960 as the civil rights drive developed.

Charles H. Alston

All biographical data and quotations attributed to Charles H. Alston, unless otherwise indicated, are based on an interview with him at his Edgecombe Avenue studio on May 1, 1969. This information was supplemented by many subsequent conversations and correspondence. Alston was known to Romare Bearden since childhood and since 1940 to Harry Henderson. See also Harry Henderson, "Remembering Charles Alston," in Charles Alston, Artist and Teacher *(New York: Kenkeleba House, retrospective exhibition catalog, May 13–July 1, 1990).*

1. Sallie B. Tannahill, *Ps and Qs: A Book on the Art of Letter Arrangement* (New York: Doubleday Doran, 1938).

2. Langston Hughes, *Weary Blues* (New York: Alfred A. Knopf, 1926). Alston's project, which concerned only the title poem, was not published.

3. One of his assistants was Beauford Delaney, later well known as an early abstract painter.

4. "Harlem Artists Guild and Artists Union Charge L. T. Dermody with Discrimination by Rejection of Four Murals by Negro Artists for Harlem Hospital WPA Project," *New York Times,* Feb. 22, 1936, p. 13.

5. Alston's original murals were moved as a protective measure to the lobby of the Women's Pavilion when the Harlem Hospital lobby was remodeled.

6. The new mosaic mural in the lobby, titled *Man Emerging from the Darkness of Poverty and Ignorance into the Light of a Better World,* is based on Alston's painting *Walking*.

7. John Hammond, letter to Aida Winters Wishonant (Alston's half sister), May 19, 1977, read at funeral service.

8. "Creative Negroes: Harlem Has Its Artists Workng Under Difficult Conditions," *Literary Digest* 122 (Aug. 1, 1936), p. 22.

9. Hale Woodruff, in *Charles Alston* (New York: Gallery of Modern Art, exhibition catalog, 1968).

10. *Fortune* 24 (Nov. 1941), pp. 102–9.

11. *Fortune* 25 (June 1942), pp. 77–80.

12. Some of these cartoons were exhibited along with Alston's paintings and sculpture at the Randall Galleries, New York, April 30–May 14, 1980. As part of this exhibition, selected cartoons were republished as *The Drawings of Charles Alston* (Washington, D.C.: National Archives Trust Fund Board, 1980).

13. On being invited to become a League instructor, Alston feared he was being used and told Stewart Klonis, its director, that he did not want to be a "token Negro." Klonis just laughed and said, "Let's not make an issue of it." Alston then surprised Klonis by telling him that his friend Duke Ellington had studied drawing there years earlier.

14. Alston's third Heller exhibition, April 24–May 12, 1956, included fourteen paintings and two sculptures. After his fourth show in 1958 critic Emily Genauer wrote: "Charles Alston continues to elude pigeon-holing," referring to his different styles. "His newest canvases sometimes are almost fauve-brilliant in color. . . . In any vein his work is strong, individual for all its variety, and extremely gifted" (quoted in *Alston* [Gallery of Modern Art]). Lawrence Campbell, reviewing the same show, wrote: "Alston's best paintings are when his emotions and interests are involved without his feeling they ought to be involved. Paintings like *Blues Song, Blues Singer,* and *School Girl* have emotional appeal. Paintings like *The Face of the Mob* and *Walking*—about the Birmingham transportation strike—are more effective as statements about style than as a social protest" (*Art News* 27 [April 1958], p. 17).

15. *Walking* is owned by Sidney Smith Gordon of Chicago, who saw a newspaper reproduction of it, sent her mother to see it, and bought it on her mother's approval.
16. Jeanne Siegel, "Why Spiral?" *Art News* 65 (Sept. 1966), p. 48.
17. Quoted by Grace Glueck, "Art Notes: The Best Painter I Can Possibly Be," *New York Times,* Dec. 8, 1968.
18. Sponsored by Fairleigh Dickinson University, this exhibition was held at the Gallery of Modern Art, New York, Dec. 3, 1968–Jan. 5, 1969. It included thirty-one paintings and three sculptures.
19. Statement by Alston released at the opening of his 1968 retrospective show at the Gallery of Modern Art and widely quoted by commentators.
20. Ibid.
21. *Alston, Artist and Teacher* (Kenkeleba House). This exhibition, organized by Corrine Jennings and Joe Overstreet, far exceeded anything seen during Alston's lifetime. The catalog included an essay by Gylbert Coker on Alston's murals entitled "The Legacy."
22. Alston statement, Gallery of Modern Art.

Eldzier Cortor

Unless otherwise indicated the quotations attributed to Eldzier Cortor and his biographical data come from interviews on October 29 and November 27, 1973, as well as a follow-up interview on January 13, 1988.

1. Willard Motley, "Negro Art in Chicago," *Opportunity* 18 (June 1940), p. 19.
2. Ibid.
3. Information on "Bungleton Green" was furnished by F. D. Sengstacke of the *Chicago Defender* and Chester Commodore, who drew it for ten years.
4. Kathleen Blackshear's thesis, "Studies of Negroes from 1924–40" (Ryerson Library, Art Institute of Chicago), consists of 102 mounted photographs of persons, paintings, and sculptures.
5. Elton C. Fax, *17 Black Artists* (New York: Dodd, Mead & Co., 1971), p. 87.
6. *Subject Index to Literature on Negro Art,* prepared by the Chicago Public Library, WPA Omnibus Project. A disintegrating copy, dated July 28, 1941, was found by the authors in the New York Public Library.
7. See *Journal of American Folklore* 4 (July–Sept. 1891), p. 214.
8. Guy B. Johnson, *Folk Culture on St. Helena Island, South Carolina* (Chapel Hill: University of North Carolina Press, 1930).
9. *Life,* July 22, 1946.
10. An exception would be the critic Emily Genauer. Noting that Van Wyck Brooks had pointed out that "avant-garde" (leading) writers were viewing "the concerns of mankind as none of their business" and escaping "into abstractions and symbols," Genauer defended the artists' use of abstractions and symbols to communicate the turbulence of "our times." But she agreed that "Artists, too, have disassociated themselves from social problems. . . . In the field of art the real evil of control by the avant-garde," which Brooks held "benumbed and sterilized" young writers, "stems from the potentially valuable function of discovering new talent." She took this occasion to hail Jacob Lawrence for his courage in painting the *Struggle: From the History of the American People* series, the first thirty panels of which were shown at the Alan Gallery (*New York Herald-Tribune Book Review,* Jan. 6, 1957, p. 10).
11. John Gruen, *The Party's Over* (New York: Viking Press, 1972).
12. *Reality Expanded—Hughie Lee-Smith, Rex Goreleigh, Eldzier Cortor* (Roxbury, Mass.: Museum of National Center of Afro-American Artists, exhibition catalog, 1973).
13. *Three Masters—Eldzier Cortor, Hughie Lee-Smith, Archibald Motley* (New York: Kenkeleba Gallery, exhibition catalog, 1988). This catalog includes an essay on Cortor by Corinne Jennings.

Beauford Delaney

1. Georgia O'Keeffe, in *Beauford Delaney Exhibition* (Paris: Galerie Darthea Speyer, exhibition catalog, 1973). The catalog also includes statements by James Baldwin, James Jones, and Henry Miller.
2. Richard A. Long, *Beauford Delaney: A Retrospective* (New York: Studio Museum in Harlem, exhibition catalog, April 9–July 2, 1978). This unpaginated catalog was the basis for many details in this chapter. Reviewing the exhibition, critic John Russell wrote that Delaney was "an uninhibited colorist (though never an unintelligent one). He could take Greene Street in the days before Soho had even been named and fragment it in terms of a fire-escape, a hydrant, a grating, and a gull or two that had been blown inland. He could make abstract paintings: a high-keyed slither of paint that led to Tobeyesque entanglements of color" (*New York Times,* April 14, 1978).
 Another reviewer (*Art News* 77 [June 1978], p. 202) observed: "The work is completely coherent in the path of its development, independent of the style of the period. Neither eccentric nor ignorant of his contemporaries, Delaney appears to have entered the mainstream only on those occasions when it coincided with his own progress. The result is the expression of a capable realist won over to abstraction through his fascination with the qualities of light, a kind of blend of van Gogh with [Clyfford] Still and [Jackson] Pollock."
3. Long, *Delaney: A Retrospective.*
4. Joseph Delaney, "Beauford Delaney, My Brother," in ibid.
5. Records of the Harlem Artists Guild.
6. Henry Miller, *The Air-Conditioned Nightmare,* vol. 2, *Remember to Remember* (New York: New Directions, 1945), pp. xv, 15–34.
7. Ibid., p. 18.
8. Ibid., p. 19.
9. Ibid., p. 7.
10. Henry Miller, *The Amazing and Invariable Beauford Delaney* (Yonkers, N.Y.: Alicat Book Shop); this was no. 2 of the "Outcast" series of chapbooks, issued twice yearly.
11. Michael L. Freilich, author interview, 1974; see also Freilich's obituary, *New York Times,* Feb. 12, 1975.
12. Long, *Delaney: A Retrospective.*
13. *Beauford Delaney* (Paris: Galerie Paul Fachetti, exhibition catalog, June 1960); introductory note by Julien Avard.
14. Exhibition of Beauford Delaney, Joe Downing, and Caroline Lee, American Cultural Center, Paris, Jan. 24–Feb. 11, 1961.
15. Long, *Delaney: A Retrospective.*
16. Guichard-Meili in ibid.
17. Ibid.
18. Long, *Delaney: A Retrospective.*
19. *New York Times,* April 1, 1979.
20. Long, *Delaney: A Retrospective.*

Joseph Delaney

Unless otherwise noted, biographical data and quotations attributed to Joseph Delaney are from conversations and interviews with him on September 11, 14, and 21, 1974; March 29, 1981; and June 7, 1982. Another source was Sam Yates of the Frank H. McClung Museum, University of Tennessee, who presented a major exhibition of Delaney's work in 1986.

1. Joseph Delaney, "My Brother, Beauford Delaney," in Richard A. Long, *Beauford Delaney: A Retrospective* (New York: Studio Museum in Harlem, exhibition catalog, April 9–July 2, 1978).
2. Ibid.
3. Elsa Honig Fine, *Joseph Delaney/1970* (Knoxville: Frank H. McClung Museum, University of Tennessee, exhibition catalog, Sept. 27–Oct. 15, 1970).
4. See Matthew Baigell, ed., *A Thomas Hart Benton Miscellany: Selections from his Published Opinions, 1916–60* (Lawrence: University of Kansas Press, 1971). See also Benton's *An American in Art* (Lawrence: University of Kansas Press, 1969).
5. Joseph Delaney did not recall specific pieces he drew or which drawings were exhibited. "I might pick out a spoon or fork and do that. The office had the last word. After you turned in your work you lost track of it." He could not recall the name of his supervisor. Two of his drawings have been found in the Index of American Design file, National Gallery of Art, but many drawings in the file have not yet been identified.
6. Donald R. Hunt, library director, University of Tennessee, letter to authors, March 20, 1981.
7. Robert Pincus-Witten (*Artforum* 7 [Feb. 1969], p. 65) made this comment in reviewing "Invisible Americans: Black Artists of the 1930s," an exhibition at the Studio Museum in Harlem hastily assembled in protest of the Whitney Museum's failure to include any of these artists in an exhibition of art of the 1930s. Pincus-Witten stated: "That an artist of the stature of Joseph Delaney . . . was in fact overlooked in the Whitney selection is, in itself, testimony that the central contention of the black artists is true—that the white critical world is, in fact, unaware of major black achievement." Hilton Kramer also singled out Delaney's *Waldorf Cafeteria* painting as meritorious (*New York Times*, Nov. 24, 1968).
8. *New York Times*, Feb. 12, 1982.
9. *Delaney, "My Brother."*

Jacob Lawrence

The quotations attributed to Jacob Lawrence, unless otherwise indicated, are from an interview at his New York home on June 3, 1969. Much of the biographical information is also from this interview, as well as an interview with Charles Alston on May 1, 1969. Other sources included old friends, such as Bearden, who had known Lawrence since the early 1930s, Mary Beattie Brady of the Harmon Foundation, and Ellen H. Wheat, whose master's thesis ultimately led to her comprehensive study Jacob Lawrence, American Painter *(Seattle: University of Washington Press and Seattle Art Museum, 1986).*

1. For some years after his parents' separation Lawrence did not know his father's whereabouts, but he later found that his father had a small store in Harlem. His father bought him a violin and gave him a weekly allowance. He took violin lessons from Joshua Lee, later a network musicologist. (Lawrence discussed his relationship with his father with Ellen Wheat in 1983 and 1984. [See Wheat, *Lawrence*, pp. 30–31, 194 n. 25]).
2. Elton C. Fax, *17 Black Artists* (New York: Dodd, Mead & Co., 1971), p. 148.
3. Alston interview, 1969.
4. Fax, *Black Artists*, p. 152.
5. George H. Edgell, *A History of Sienese Painting* (New York: Dial Press, 1932), p. 9. Cesar Paoli, an Italian art historian, and Thomas Ashby, a Roman classics scholar, have observed: "The special characteristics of [Sienese] masters are freshness of color, vivacity of expression, and distinct originality," a comment applying to Lawrence's work (see "Sienese Art," *Encyclopaedia Britannica*, 1942).
6. Quoted by Milton W. Brown, in *Jacob Lawrence* (New York: Whitney Museum of American Art, exhibition catalog, 1974), p. 9.
7. Fax, *Black Artists*, p. 154.
8. Ibid., p. 155.
9. The *Toussaint L'Ouverture* series, based at the Amistad Research Center, Tulane University, is almost continuously on tour. It was transferred from Fisk University to the Board of Homeland Ministries of the United Church of Christ, which established the College Museum Collaborative Program for six black colleges in the South under the American Missionary Society. (See David C. Driskell, in *Against the Odds* [Newark, N.J.: Newark Museum, exhibition catalog, 1989], p. 68.)
10. Jay Leyda, letter to authors, Dec. 1, 1969.
11. *Fortune* (Nov. 1941) published these paintings after Alston brought them to the attention of its art editor, Deborah Caulkins. Alain Locke wrote a brief accompanying text.
12. Among other things, a white woman refused to sit next to Gwendolyn Lawrence at a Christmas dinner. See Aline B. Louchheim Saarinen, "An Artist Reports on the Troubled Mind," *New York Times Magazine*, Oct. 15, 1950.
13. Aline B. Louchheim Saarinen, *Jacob Lawrence* (New York: American Federation of Arts, exhibition catalog, 1960), p. 8.
14. James A. Porter, *Modern Negro Art* (New York: Dryden Press, 1943), p. 151.
15. Quoted by Wheat, *Lawrence*, p. 73.
16. Saarinen, *Lawrence*, p. 8.
17. Some of these ten paintings were published by *Fortune* (Aug. 1948) but others were not, for reasons now unknown, according to Libby Watterson of *Fortune*, letter to authors, July 21, 1980.
18. Langston Hughes, *One-Way Ticket* (New York: Alfred A. Knopf, 1948).
19. Saarinen, "Artist Reports."
20. Fax, *Black Artists*, p. 161.
21. Saarinen, "Artist Reports."
22. Citation of National Institute of Arts and Letters.
23. The leading spokesman of Abstract Expressionism, Robert Motherwell, wrote: "The emergence of abstract art is a sign that there are still men of feeling in the world. Men who know how to respect and to follow their inner feelings, no matter how irrational or absurd they may first appear. From their perspective, it is the social world that tends to appear irrational and absurd. . . . Nothing as innovative as abstract art could have come in to existence, save as a consequence of a most profound, relentless, unquenchable need. The need is for felt experience—intense, immediate, direct, subtle, unified, warm, vivid, rhythmic" (*What Abstract Art Means to Me* [New York: Museum of Modern Art, 1951]); reprinted in Frank O'Hara, *Motherwell* [New York: Museum of Modern Art, 1965], p. 45).
24. Leyda, in his 1969 letter, said: "This was no more than attaching to each painting . . . not a title, but a fragment of a contem-

porary document. These fragments served as captions at the exhibition and in the catalogue."

25. Saarinen, *Lawrence*, p. 9.

26. Quoted by Wheat, *Lawrence*, p. 116. The book was also attacked by other children's librarians, who asserted that it presupposed "a certain level of maturity and perception" (*School Library Journal*, Oct. 1970, p. 100).

27. Claude Lockhart Clark, an African-American artist of the 1930s teaching at Merritt College, Oakland, California, wrote and illustrated one guide ("A Black Art Perspective: A Black Teacher's Guide to the Black Art Visual Curriculum," 1970).

28. "The Black Artist in America: A Symposium," *Metropolitan Museum of Art Bulletin* 27 (Jan. 1969), pp. 245–61.

29. With no support from other panelists, Lloyd, a sculptor who works with light, thought African-American artists should live in black communities, adding, "I don't think we are involved. I think there are a lot of Black artists that aren't making a living and that are not communicating with the people in the ghetto. I mean like nothing's happening. So if some form of separatism is going to make things happen, I'm all for it" (ibid).

30. Grace Glueck, in *New York Times*, June 3, 1974, p. 38.

31. Wheat, *Lawrence*, p. 114.

32. Ibid., p. 113.

33. Spingarn Medal brochure (listing all winners since 1914), National Association for the Advancement of Colored People. See also *The Crisis* 77 (Aug.–Sept. 1970), pp. 266–67, which includes Lawrence's response.

34. *Lawrence* (Whitney Museum). The exhibition was at the Whitney from May to July 1974 and then traveled to the St. Louis Art Museum, Birmingham Museum of Art, Seattle Art Museum, William Rockhill Nelson Gallery of Art and Atkins Museum of Fine Arts in Kansas City, and New Orleans Museum of Art.

35. Hilton Kramer, in *New York Times*, May 18, 1974.

36. Ibid.

37. Henri Focillon, quoted by Bearden in his notes, but the source remains undocumented. Bearden may have read it in France in 1950 when studying there.

38. *Black Art* 5:3 (1982).

39. Wheat, *Lawrence*, pp. 143–45. After the exhibition was shown at the Seattle Art Museum, it traveled to the Oakland Museum, High Museum of Art in Atlanta; Phillips Collection in Washington, D.C., Dallas Museum of Art, and Brooklyn Museum.

40. Ibid., p. 143.

41. Thirty-two artists participated in the Images of Labor project commissioned by the National Union of Hospital and Health Care Workers. Each artist selected a quotation related to labor to illustrate. The works were exhibited at the Smithsonian Museum of American History in July 1981 and then traveled to major cities.

42. Wheat, *Lawrence*, p. 114, quoting Stan Nast, "Painter Lawrence Is Honored for a 'Protest' That Was Life," *Seattle Post-Intelligencer*, April 5, 1980. The other invited artists were Richmond Barthé, Romare Bearden, Margaret Burroughs, Ernest Crichlow, Lois Mailou Jones, Archibald J. Motley, Jr., James Lesesne Wells, Charles White, and Hale Woodruff (*New York Times*, April 3, 1980, sec. 3, p. 22).

43. Jacob Lawrence, informal talk after he attended Carter's inauguration, University of Washington, Jan. 25, 1977; quoted by Wheat, *Lawrence*, p. 150.

44. Jacob Lawrence, "Philosophy of Art," statement made at the

request of the Whitney Museum on purchasing *Depression* from the *Hospital* series in 1950; also cited by Wheat, *Lawrence*, p. 192.

Norman Lewis
Unless otherwise indicated, the biographical information and all quotations attributed to Norman Lewis are based on extensive interviews at his studio on October 10 and 17, 1973, and follow-up conversations. Bearden knew Lewis from the early 1930s.

1. Milton W. Brown, Foreword, *Norman Lewis: A Retrospective* (New York: Graduate School and University Center, City University of New York, exhibition catalog, 1976). Held from October to November 1976, the exhibition was prepared by Thomas Lawson. The Museum of Modern Art owns a 1952 drawing by Lewis (Aileen Chuk, letter to authors, Feb. 18, 1988).

2. Lawson, in *Lewis: Retrospective*.

3. Ibid.

4. Lewis signed this 1934 painting "Norman," joking that its two syllables would identify him with Van Gogh. This reflects Lewis's humor.

5. "I quit that job because I couldn't stand the discrimination," Lewis later said. "Negroes couldn't get into the union and 300 were fired because they were not members. Then there were too many strange accidents where Negroes got hurt and there was too much intimidation and it was too hard for a Negro to be anything except a laborer" (quoted in *New York Post*, Oct. 6, 1943).

6. Art historian Ann Gibson has discussed Lewis's critical turn from socially conscious painting to Abstract Expressionism in *Norman Lewis: From the Harlem Renaissance to Abstraction* (New York: Kenkeleba Gallery, exhibition catalog, May 10–June 25, 1989).

7. Frank O'Hara, *Robert Motherwell* (New York: Museum of Modern Art, 1965), p. 8.

8. Irving Sandler, *The New York School: The Painters and Sculptors of the Fifties* (New York: Harper & Row, 1978), p. 7. Earlier (*Art News* 60 [Nov. 1962], p. 15), Sandler had characterized Lewis as a "veteran New York abstractionist," yet his book, a general history of Abstract Expressionism, does not mention Lewis, reflecting the exclusion of Lewis from what Ann Gibson calls the "canon of Abstract Expressionism" (see note 12).

9. Sandler, *New York School*, p. 20.

10. Ibid., p.1.

11. Ibid.

12. Ann Gibson concluded from this exchange that the criteria for inclusion in the "canon of Abstract Expressionism" may have been "stacked against African-Americans" (in *Artforum* 30 [March 1992], pp. 66–74).

13. Robert Motherwell and Ad Reinhardt, eds., *Modern Artists in America* (New York: Wittenborn-Schultz, 1952). This is a transcript of the symposium.

14. Carlyle Burrows, in *New York Herald-Tribune*, Nov. 8, 1952.

15. From "Henry McBride" in *Art News*, December 1952, pp. 47, 67.

16. Undated manuscript by Charles Wendal Childs, given to authors by Lewis, p. 2.

17. Parker Tyler, reviewing a 1954 exhibition that first showed *Migrating Birds*, called it "a tour-de-force of chinoise delicacy, the graceful swath of crane-like birds being made of deft, cameo, infinitely inventive abstract strokes" (*Art News* 53 [Nov. 1954], p. 53).

18. Emily Genauer, in *New York Herald-Tribune Book Review,* Jan. 1, 1956, p. 10.
19. Eric Hodgins and Parker Lesley, "The Great International Art Market," *Fortune* 52 (Dec. 1955), p. 118; 53 (Jan. 1956), p. 122. Ticking off bargains, the authors asserted no American, living or dead, is worth $25,000 and put $500 as the top price for African-American artists.
20. Harold Rosenberg, in *Art News* 51 (Dec. 1952), p. 21.
21. Sandler, *New York School,* p. 287.
22. Lawson, in *Lewis: Retrospective.*
23. *New York Times,* Aug. 29, 1979.

Hughie Lee-Smith
Unless otherwise noted, the biographical information and all quotations attributed to Hughie Lee-Smith are based on an interview at the Art Students League, February 26, 1974, with follow-up interviews February 2, 1975; April 14, 1981; and May 12, 1988.

1. *Hughie Lee-Smith Retrospective Exhibition* (Trenton: New Jersey State Museum, exhibition catalog, Nov. 5, 1988–Jan. 2, 1989), with essay by Lowery S. Sims.
2. *New York Times* (N.J. edition), Dec. 4, 1988.
3. *Philadelphia Inquirer,* Dec. 19, 1988.
4. Lowery S. Sims, Foreword, *Hughie Lee-Smith* (New York: June Kelly Gallery, exhibition catalog, Sept. 19–Oct. 17, 1987).
5. Fannie Safier, Margaret Ferry, John Kuehn, and Wanda Schindley, *Adventures in Appreciation* (New York: Harcourt Brace Jovanovich, 1989), reproduced *Boy on a Roof.* Fannie Safier and Cleve Griffin, eds., *An Anthology of African-American Literature* (New York: Harcourt Brace Jovanovich, 1992) reproduced *Slum Song* and *The Wall.*
6. Carol Wald, "The Metaphysical World of Hughie Lee-Smith," *American Artist* 43 (Oct. 1978), pp. 48-53, 101, 102.
7. James A. Porter, *Modern Negro Art* (New York: Dryden Press, 1943), p. 164; see also pp. 129, 160.
8. For brief biographical notes on these artists, see Theresa Cederholm, ed., *Afro-American Artists* (Boston: Trustees of Boston Public Library, 1973).
9. A photograph of a naval scene painting by Lee-Smith was found in 1992 in the National Archives.
10. Edgar Richardson, Foreword, *Hughie Lee-Smith* (Washington, D.C.: Howard University Art Gallery, exhibition catalog, Nov. 1955); quoted by Margaret J. Butcher, *The Negro in American Culture* (New York: Alfred A. Knopf, 1964), p. 240.
11. Wald, "Metaphysical World," p. 49.
12. Susan Kandel and Elizabeth Hayt-Atkins, in *Art News* 86 (Dec. 1987), p. 158.
13. Wald, "Metaphysical World," p. 101.
14. Jay Jacobson, interview with Hughie Lee-Smith, *The Art Gallery* 7 (April 1968), pp. 29–31.
15. Sims, Foreword.
16. Carroll Greene, Jr., "Hughie Lee-Smith Breakthrough," *American Visions* 5 (Aug. 1990), pp. 26–31.
17. Ibid.
18. Gerrit Henry, in *Art in America* 78 (Feb. 1990), p. 165.

Ellis Wilson
The biographical data and all quotations attributed to Ellis Wilson, unless otherwise indicated, are based on an interview with him at his studio at 123 East 18th Street, New York, on February 6, 1974. The biographical information has been supplemented by the Harmon Foundation catalogs and the entry in Theresa Cederholm, ed., Afro-American Artists (Boston: Trustees of Boston Public Library, 1973), pp. 311–12.

1. *The Negro in Chicago, 1779–1927,* published by the Washington Intercollegiate Club of Chicago in 1927, provides the only known account of the Chicago Art League and lists Wilson as a member (p. 83).
2. Ibid.
3. Cederholm, *Afro-American Artists,* p. 118.
4. See "The Twenties and the Black Renaissance," note 7, p. 492
5. A collector of Americana, Mrs. Robinson, of Anderson, South Carolina, purchased Wilson's 1939 painting *Kentucky Graveyard,* of the Woolridge family memorial in the Mayfield cemetery which consists of life-size statues of the entire family—father, mother, and children. Wilson said that as a child, "it scared the britches off me." The painting is now in the Everhart Museum in Scranton, Pennsylvania. It came to the museum from the collection of John L. Robertson, of Scranton.
6. Harry Bolser, "Mayfield Sees Its Artist's Work," *Louisville Courier-Journal,* April 30, 1947.
7. Justus Bier, in *Louisville Courier-Journal,* April 30, 1950.
8. *Louisville Courier-Journal,* April 15, 1951.
9. *Louisville Courier-Journal,* April 30, 1950.
10. *Art News* 50 (April 1951), p. 48.
11. Senta Bier, in *Louisville Courier-Journal,* Feb. 14, 1954.
12. A. H. Berrian and Richard A. Long, eds., *Negritude: Essays and Studies* (Hampton, Va.: Hampton Institute Press, 1967), pp. 24–38.
13. David C. Driskell, *Paintings by Ellis Wilson, Ceramics and Sculpture by William E. Artis,* (Nashville: Carl Van Vechten Gallery of Fine Arts, Fisk University, exhibition catalog, April 18–June 2, 1971).
14. *New York Times,* Jan. 6, 1977.

The Naive, Self-Taught Artists
1. Jean Lipman, in *Art in America* 26 (Oct. 1938), pp. 171–77; reprinted as Foreword in Jean Lipman and Tom Armstrong, eds., *American Folk Painters of Three Centuries* (New York: Whitney Museum of American Art, 1980).
2. Herbert W. Hemphill, Jr., and Julia Weismann, *Twentieth-Century American Folk Artists* (New York: Dutton, 1974), pp. 10–11.
3. Lipman, Foreword, *American Folk Painters.*
4. Jane Livingston and John Beardsley, eds., *Black Folk Art in America 1930–1980* (Jackson: University Press of Mississippi and Center for Study of Southern Culture, exhibition catalog, 1982). The exhibition moved from the Corcoran Gallery of Art to the J. B. Speed Museum, Louisville, Kentucky; Brooklyn Museum, New York; Craft and Folk Art Museum, Los Angeles; and Institute for the Arts, Rice University, Houston, Texas.

William Edmondson
1. Edmund L. Fuller, with photographs by Edward Weston and Roger Haile, *Visions in Stone: Sculpture of William Edmondson* (Pittsburgh: University of Pittsburgh Press, 1973), p. 6.

2. *New York Times,* Oct. 9, 1937.

3. John Thompson, in *Nashville Tennessean,* Feb. 9, 1941.

4. Fuller, *Visions,* p. 6.

5. Thompson, in *Nashville Tennessean.*

6. Fuller (*Visions,* p. 27) found a "William Edmondson" listed in Nashville directories as far back as 1882. Although there is no assurance that this is the same William Edmondson, it casts considerable doubt on his estimated age on his death certificate, which gave him a birth date in 1883.

7. Ibid., p. 4.

8. *Time,* Nov. 1, 1937, p. 52.

9. Thompson, in *Nashville Tennessean.* This information presumably came directly from Edmondson when he was interviewed.

10. Bill Woolsey, in "Persistent Primitive," *Nashville Tennessean Magazine,* Dec. 14, 1947.

11. Louise Dahl-Wolfe, author interview June 5, 1973.

12. The then-new museum was temporarily housed in Rockefeller Center, and twelve pieces were exhibited without a catalog although press releases were issued.

13. *Time,* Nov. 1, 1937, p. 52.

14. Dahl-Wolfe, interview.

15. Ibid.

16. His WPA employment began on November 20, 1939, at $79.30 a month and terminated because of "quota reduction" on June 7, 1940. Reemployed at $73.20 a month on November 11, 1940, he was dropped in another quota reduction on June 26, 1941.

17. Thompson, in *Nashville Tennessean.*

18. Dahl-Wolfe, interview.

19. Thompson, in *Nashville Tennessean.* Thomas P. Mims, a sculptor-in-residence at Vanderbilt University, wrote an admiring appreciation of Edmondson for the 1964 exhibition catalog of the Tennessee Fine Arts Center, comparing him with Henri Rousseau and John Kane. He said, "With a few crude tools and myriad forest of gravestones, he sought his way towards his meaningful world."

20. Aaron Douglas, author interview, June 10, 1973.

21. Thirty years later Douglas recalled this event as enjoyable but admitted, "I can't recall now exactly what anybody said."

22. Woolsey, in *Nashville Tennessean Magazine.*

23. *Nashville Tennessean,* Feb. 9, 1951. Fuller (*Visions,* p. 27) reports the death certificate listed as contributing causes of death advanced arteriosclerosis and vitamin deficiency.

24. Dahl-Wolfe, interview.

25. *Time,* Nov. 1, 1937, p. 52.

26. Robert J. Forsyth, *John B. Flannagan, Sculpture/Drawings, 1924–38* (St. Paul: Minnesota Museum of Art, exhibition catalog, 1973). The exhibition was shown at the Weyhe Gallery, New York; the Minnesota Museum of Art, St. Paul; and the Tweed Museum of Art, University of Minnesota, Duluth.

27. John B. Flannagan, "The Image in the Rock," *Magazine of Art* 35 (March 1942), pp. 90–95; see also Susanne K. Langer, *Reflections on Art* (Baltimore: Johns Hopkins University Press, 1958), p. 298.

Horace Pippin

Unless otherwise indicated, information about Pippin's life is drawn from three main sources: (1) his autobiography, "My Life Story," which deals mostly with his childhood and war experiences and was originally published in Selden Rodman's Horace Pippin *(New York: Quadrangle Press, 1947); (2) an interview with his dealer, Robert Carlen, May 20, 1970;*

and (3) Jerome Klein, "Art the Hard Way," Friday Magazine, Jan. 17, 1941, pp. 22–23. The pictures of Pippin and his family in Rodman's book are from Friday.

1. Holger Cahill, *Masters of Popular Painting—Artists of the People* (New York: Museum of Modern Art, exhibition catalog, 1938); this catalog also contains Pippin's statement to Dorothy C. Miller, "How I Paint," detailing how he worked.

2. "My Life Story," in Rodman, *Pippin,* p. 77.

3. Ibid.

4. Ibid., p. 78

5. The heroic 369th Regiment set a record of 191 days on the front without losing a foot of ground or a single man being taken prisoner. But they were badly treated by the U.S. officers, and when asked to sing "My Country 'Tis of Thee" on November 23, 1918, they stood silent (Roi Ottley and W. J. Weatherby, *The Negro in New York* [New York: Praeger, 1969], pp. 204–205). There are books and many articles on this regiment. One of its white commanding officers wrote: "We were under fire 191 days [and] lost in battle, killed or wounded, about 1,500 men"—of whom 1,100 were lost in the ten-day Meuse-Argonne offensive. "We never lost a prisoner . . . [or] a foot of ground" (Arthur W. Little, *From Harlem to Rhine* [New York: Covici Friede, 1936], p. xi).

6. *The Crisis* 18 (May 1919), pp. 13–14.

7. Pippin, "How I Paint," in Cahill, *Popular Painting.*

8. Pippin, "My Life Story," p. 80.

9. Rodman, *Pippin,* p. 11.

10. Cahill, *Popular Painting.*

11. Robert Carlen, letter to authors, April 27, 1970, and interview, May 20, 1970.

12. Carlen interview.

13. Albert C. Barnes, Foreword, *Horace Pippin* (Philadelphia: Carlen Gallery, exhibition catalog, Jan. 10–Feb. 18, 1940).

14. Pippin, "How I Paint."

15. Carlen quoting Pippin, in Carlen interview.

16. Ibid.

17. Ibid.; Rodman erred in describing this woman as Pippin's mother.

18. Klein, "Art the Hard Way."

19. Rodman, *Pippin,* p. 20.

20. Horace Pippin, statement, Bel Ami competition, American Federation of Arts.

21. Rodman, *Pippin,* p. 23.

22. Obituary, *New York Times,* July 7, 1946.

23. Rodman, *Pippin.*

James A. Porter

The biographical information, unless otherwise noted, is based on an interview with Dorothy B. Porter by Pat Gloster, using the authors' questions, and a follow-up author interview on February 4, 1975. Additional sources include an interview with Albert J. Carter, July 28, 1973; biographical data in Opportunity *11 (Feb. 1933), p. 47; and James A. Porter, Artist and Art Historian: The Memory of the Legacy (Washington, D.C.: Howard University Gallery of Art, exhibition catalog, Oct. 15, 1992–Jan. 8, 1993). The opening of this exhibition was accompanied by a two-day symposium in which Porter and his work were discussed by John Hope Franklin and many others, including Porter's colleagues and former students Starmanda Bullock Featherstone, guest curator of the exhibition, and David Driskell, whose exhibition "Two Centuries of Black American Art" and its catalog (Los Angeles County*

Museum and Alfred A. Knopf, 1976) carried forward into the 1970s and 1980s Porter's concern with the history of African-American artists.

1. *James A. Porter, Retrospective Exhibition* (Washington, D.C.: Howard University Gallery of Art, exhibition catalog, Jan. 22–Feb. 26, 1965).
2. Cover, *Exhibition of the Productions by Negro Artists* (New York: Harmon Foundation, exhibition catalog, 1933), p. 51. Porter exhibited in the Harmon shows in 1928, 1929, 1930, and 1933.
3. James A. Porter, *Modern Negro Art* (New York: Dryden Press, 1943), p. vi; referring to *New York Age*, March 17, 1928.
4. See Alain Locke, *Negro Art: Past and Present* (1936; reprint, New York: Arno Press/New York Times, 1969), pp. 34–42.
5. Porter, *Modern Negro Art*, p. vi.
6. Porter first spelled the name Warbourg, following Desdunes's *Nos Hommes et Notre Histoire* (Montreal: Arbnour and Dupont, 1911). Eugene Warburg studied with the French sculptor Gabriel and did many portraits and bas-relief scenes from *Uncle Tom's Cabin* for the Duchess of Sutherland, an abolitionist. He died in Rome about 1861. His sculpture posthumously represented Louisiana at the 1862 Paris Exposition, according to Desdunes. Pickhil destroyed his own work over criticism and died between 1840 and 1850. Little is known of Daniel Warburg.

 Porter's research also led him to accept the belief that the artist Julien Hudson was an African-American. However, Patricia Grady of the Historic New Orleans Collection, Kemper and Leila Williams Foundation, reported in 1989 to the Louisiana Historical Association that a search of contemporary newspapers, obituaries, and census data as well as other sources provided no positive information that Hudson was an African-American or that his widely reproduced self-portrait was indeed a self-portrait.
7. James A. Porter, "Negro Art in Review," *American Magazine of Art* 27 (Jan. 1934), pp. 16–27.
8. Porter reported Hobbs's existence in *Modern Negro Art*, p. 29, citing J. A. Handy's *Scraps of African Methodist Episcopal History*.
9. James A. Porter, "Versatile Interests of the Early Negro Artist: A Neglected Chapter of American Art History," *Art in America* 24 (Jan. 1936), pp. 16–27.
10. Alain Locke, *The New Negro* (New York: Albert and Charles Boni, 1925; reprint, New York: Atheneum, 1968), pp. 254–67. Locke continued his advocacy in essays for the Harmon catalogs and in other publications.
11. Ibid., p. 256. Locke first wrote about African art influencing African-American artists in mystical terms: "We must believe that there still slumbers in the blood something which once stirred will react with peculiar emotional intensity toward it [African art]. If by nothing more mystical than the sense of a cultural past. . . . Nothing is more galvanizing than the sense of a cultural past. . . . But surely also in the struggle for a racial idiom of expression there would come to some creative minds among us from a closer knowledge of it, hints of a new technique, enlightening and interpretative revelations of the mysterious substrata of feeling our characteristically intense emotionality or at the very least, incentives toward fresher and bolder forms of artistic expression and a lessening of that timid imitativeness which at present hampers all but our very best artists" (Locke, "A Note on African Art," *Opportunity* 2 [May 1924], pp. 134–38).
12. E. Franklin Frazier, "Racial Self-Expression" in Charles S. Johnson, ed., *Ebony and Topaz* (reprint, Freeport, N.Y.: Black Heritage Library Collection, Books for Libraries Press, 1971), p. 119.
13. Meyer Schapiro, "Race, Nationality, and Art," *Art Front* 2 (March 1936), pp. 10–12.
14. James A. Porter, "The Negro Artist and Racial Bias," *Art Front* 3 (July–Aug. 1937), p. 8.
15. Ibid., p. 9.
16. Ibid.
17. Alain Locke, Foreword, *Contemporary Negro Art* (Baltimore: Baltimore Museum of Art, exhibition catalog, Feb. 3–19, 1939).
18. James A. Porter, "Four Problems in the History of Negro Art," *Journal of Negro History* 27 (Jan. 1942), pp. 9–36.
19. Walter Pach, in Porter, *Modern Negro Art*, p. 9.
20. W. E. B. Du Bois, "The Criteria of Negro Art," initiated this symposium, *The Crisis* 32 (Oct. 1926), p. 290, following a questionnaire on "how to treat the Negro in art" (*The Crisis*, Feb. 1926). The responses were published over a period of months.
21. Porter, *Modern Negro Art*, p. 100.
22. James A. Porter, "Robert S. Duncanson, Midwestern Romantic-Realist," *Art in America* 30 (Oct. 1951), pp. 99–154; see also addendum in *Art in America* 42 (Oct. 1954), pp. 220–21.
23. Carter interview.
24. James A. Porter, "Afro-American Art at Floodtide," *Arts in Society* 5 (Summer-Fall 1968), p. 264.
25. See Jeanne Siegel, "Why Spiral?" *Art News* 65 (Sept. 1966), pp. 48–49, 51, 67, 68.
26. See Jeff R. Donaldson, Foreword, *Porter, Artist and Art Historian*, p. 12.
27. *Porter, Retrospective.*
28. Ibid.
29. *Ten Afro-American Artists of the Nineteenth Century* (Washington, D.C.: Howard University Gallery of Art, exhibition catalog, Feb. 3–March 30, 1967).
30. Porter, "Afro-American Art at Floodtide," p. 258.
31. Ibid., p. 270.

Lois Mailou Jones

All quotations attributed to Lois Mailou Jones, unless otherwise noted, are based on her written responses to the authors' questions on October 22, 1972, and an interview at her Washington home, November 17, 1972. The biographical data is drawn from these sources, as well as from Tritobia Benjamin, The World of Lois Mailou Jones *(Washington, D.C.: Meridian House, 1990). Other sources include Edmund Barry Gaither, Introduction,* Reflective Moments *(Boston: Museum of the National Center of Afro-American Artists and Museum of Fine Arts, Boston, retrospective exhibition catalog, March 11–April 15, 1973), and Margaret M. Striar, "Artist in Transition,"* Essence *3 (Nov. 1972), pp. 44–45, 70.*

1. The painting was submitted by a white friend to conceal the fact that the artist was an African-American.
2. Benjamin, *Jones*, p. 9.
3. Much of Fuller's work, destroyed in a fire in 1910, cannot be evaluated today. However, Benjamin Brawley, in his book *The Negro Genius* (New York: Dodd, Mead & Co., 1937), pp. 184–89, described some of these early works. *The Wretched* depicted seven forms of human anguish. Another sculpture portrayed a soldier staggering under the weight of the rotting body of a fallen comrade, searching for a burial place. *Secret Sorrow* showed a gaunt man eating his own heart. Oedipus, realizing he has killed his father and married his mother, was depicted

tearing his eyes out. A model commemorating the Emancipation Proclamation showed a newly free black youth and maiden beneath a gnarled tree whose branches, resembling a human hand, stretched over them. "Humanity is pushing them out into the world while at the same time the hand of Fate, with obstacles and drawbacks, is restraining them in the exercise of their freedom," wrote Brawley, who saw in this work "the very tragedy of the Negro race in the New World."

4. Tritobia Benjamin's doctoral thesis on Jones evolved into a biography, a synopsis of which was published as *The World of Lois Mailou Jones* (Washington, D.C.: Meridian House International, exhibition catalog, Jan. 26–March 18, 1990). The exhibition has been on a continuous tour and will return to Washington in 1994.
5. Smith attended the National Academy of Design, where he won the 1916 Suydam bronze medal for antique drawing and an honorable mention in the life class. He won more prizes in 1917, 1918, and 1920 (Sylvia Lochan, registrar of National Academy, letter to authors). Also a talented musician, he helped introduce jazz in France while in the U.S. Army. Although he won the Harmon bronze medal in 1929, he never returned to the United States and died in Paris in 1940. See Theresa D. Cederholm, ed., *Afro-American Artists* (Boston: Trustees of the Boston Public Library, 1973).
6. She may have decided to study there herself, for this was a favorite school for Americans. Her instructors were Joseph Berges, Jules Adler, G. Maury, and Pierre Montezin.
7. James A. Porter, *Modern Negro Art* (New York: Dryden Press, 1943), p. 125.
8. Dafora, an outstanding African dancer, had considerable impact on dance in the United States. See Richard A. Long, *The Black Tradition in American Dance* (New York: Rizzoli, 1989), pp. 47–52.
9. Benjamin, *Jones*, p. 6.
10. Carter G. Woodson, *African Heroes and Heroines*, rev. ed. (Washington, D.C.: Associated Publishers, 1939).
11. Betty Parry, "Lois Mailou Jones: Indefatigable Black Woman Artist," *Washington Post*, Feb. 23, 1983, p. DC 6.
12. Benjamin, *Jones*, p. 7.
13. "American Artist Develops New Technique Using African Designs," *Amannee* 4, no. 6 (1973); published by the United States Information Service, Accra.
14. Gaither, in *Reflective Moments*.

James Lesesne Wells

Unless otherwise indicated, the biographical data and all quotations attributed to James Lesesne Wells are based on his written responses, October 3 and November 18, 1974, to the authors' questions because recent throat surgery had made speech too difficult for him. A follow-up interview was conducted with his son, Jim Wells, on September 21, 1981.

1. Jacob Kainen, Foreword, *James Lesesne Wells* (Washington, D.C.: Barnett-Aden Gallery, exhibition catalog, April–May 1950).
2. "James Lesesne Wells," exhibition, Howard University Gallery of Art, Washington, D.C., Jan. 12–Feb. 12, 1977. Wells went to Africa at the suggestion of his son, Jim Wells, a contract photographer for Time-Life, who was then at work on a film there. Wells traveled widely in Ghana, Senegal, and Liberia for three months before going to Spain and France.
3. The Brooklyn Museum's exhibit of African art consisted mainly of masks and sculptures from the Belgian Congo, accompanied by notes on their origins by Stewart Cullin. These notes were unpublished according to the Chicago WPA Subject Index Guide to Literature on Negro Art.
4. Alfred Stieglitz exhibited African sculpture in his small "Photo-Secession" gallery at 291 Fifth Avenue, New York, in 1909, but not much is known today about what was shown. See Barbara Rose, *American Art Since 1900* (New York: Frederick A. Praeger, 1967), p. 36.
5. James A. Porter, *Modern Negro Art* (New York: Dryden Press, 1943), p. 123.
6. Richard Powell, "Phoenix Ascending," in *James Lesesne Wells: Sixty Years in Art* (Washington, D.C.: Washington Project for the Arts, exhibition catalog, 1986), p. 13.
7. Alain Locke, *Negro Art: Past and Present* (Washington, D.C.: Associates in Negro Folk Education, 1936; reprint, New York: Arno Press/New York Times, 1969), pp. 75–76.
8. Ibid.
9. Porter, *Modern Negro Art*, p. 163.
10. Second prize at the Federation of Churches exhibition, Washington, 1958; first merit prize at Washington Religious Art Exhibition; first prize in graphics at St. Andrews Religious Art Exhibition, Arlington, Virginia, 1965; first prize, Founders Church Religious Art Exhibition, Washington, 1967.
11. Jacob Kainen, Foreword, *Paintings and Prints by James L. Wells* (Washington, D.C.: Howard University Gallery of Arts, exhibition catalog, Nov. 1965).
12. Fred F. Bond, "The James L. Wells Phenomenon," in *James L. Wells* (Nashville, Tenn.: Carl Van Vechten Gallery of Fine Arts, Fisk University, exhibition catalog, Dec. 3, 1972–Jan. 31, 1973).
13. Powell, "Phoenix Ascending," p. 34. Powell's essay title repeats the title of one of Wells's prints.
14. This major exhibition was curated and organized by Richard Powell and Jock Reynolds. Jacob Kainen contributed an appreciation of Wells's work to the catalog.
15. Powell, "Phoenix Ascending," p. 34.
16. Jacob Kainen, "Appreciation," in *Wells: Sixty Years*, p. 3.
17. Michael Brenson, in *New York Times*, April 22, 1988.

Post–World War II African-American Artists

1. *Life*, July 22, 1946.
2. *Time*, June 24, 1929.
3. Robert H. Blackburn, author interview, Nov. 3, 1976. At the time Joseph did not respond to authors' inquiries.
4. The symposium printmakers were all people Joseph had worked with: Blackburn, Ernest Crichlow, Riva Helfond, Hughie Lee-Smith, and Raymond Steth. Deirdre L. Bibby was moderator and curator of the exhibition. Leslie King Hammon, Eleanor Traylor, and William Seraile were discussants.
5. Ronald Joseph, author interview, Lehman College, City University of New York, Feb. 25, 1989. All quotations from Joseph are from this interview.
6. Alwyn Potter, Lawrence's brother, telephone conversation and letter to authors, Oct. 25, 1975. Additional information came from Herbert Gentry, letters to authors, April 22 and May 12, 1975.
7. Walter Thompson, in *Art in America* 80 (Jan. 1992), p. 111.
8. Michael Freilich, author conversation, June 6, 1974.
9. Walter Williams, letters to authors, June 9 and June 16, 1982.
10. *Ten Afro-American Artists Living and Working in Europe: Paintings,*

Drawings, Collages (Copenhagen, exhibition catalog, June 11–30, 1964). The artists were Beauford Delaney and Larry Potter in Paris; Harvey Tristan Cropper, Herbert Gentry, Arthur Hardie, and Clifford Jackson in Stockholm; Norma Morgan in England; Sam Middleton in Amsterdam; Earl Miller in Munich; and Walter Williams in Copenhagen.

11. David Driskell, Foreword, *Joint Exhibition of the Work of Walter Williams and John Rhoden* (Nashville, Tenn.: Fisk University, Carl Van Vechten Art Gallery of Fine Arts, exhibition catalog, April 23–May 20, 1967).

12. The three other artists were Herbert Gentry, Clifford Jackson, and Sam Middleton. See *Four Black Artists Living and Working Abroad* (New York: Studio Museum in Harlem, exhibition catalog, 1982). An earlier recognition in the United States of African-American artists working abroad was an exhibition at the University Art Museum, University of Texas in Austin, March 29–May 3, 1970. James E. Lewis, who then headed the art department at Morgan State University in Baltimore, wrote a historical essay, which included Henry Ossawa Tanner and Beauford Delaney but emphasized contemporary artists. The young artists included in the exhibition were Edward Clark in Paris, Herbert Gentry in Stockholm, Bill Hutson in France, Lawrence Compton Kolowole in Paris, and Sam Middleton in Amsterdam (*Afro-American Artists Abroad* [Austin: University of Texas Art Museum, exhibition catalog, 1970]).

13. Williams is represented in the United States by the Terry Dintenfass Gallery, New York.

14. Herbert Gentry, author interview, Bearden studio, New York, April 11, 1974.

15. All quotations in this section, unless otherwise noted, are from Romare Bearden's Spiral notes. The information is also based on conversations with Charles Alston, Reginald Gammon, Norman Lewis, and Richard Mayhew.

16. Also present was the well-known African-American writer Albert Murray, Bearden's friend.

17. Charles Alston, author interview, May 1, 1969. All quotations from Alston in this section are from this interview.

18. On March 17, 1964, Bearden wrote to Mary Beattie Brady, director of the Harmon Foundation, describing Spiral, its purpose, and the upcoming exhibition. On returning from a visit to African-American colleges in the South, she responded on April 14, 1964: "I see some wonderful opportunities for you people in Spiral, and I hope you will move forward on a broad range and building on a solid foundation, and building broadly and securely. . . . I am eager to see you younger people to move forward on this broad front, and I believe that the things you will accomplish will be far greater than the little things such as an organization as this is has been able to do during the long hard years of learning by doing, and of cracking ice all along the way."

19. Jeanne Siegel, "Why Spiral?" *Art News* 65 (Sept. 1966), pp. 48–51, 67, 68.

20. Author interview, Dec. 17, 1992.

21. Samella S. Lewis, *Art: African American* (New York: Harcourt Brace Jovanovich, 1978), p. 4.

22. Ibid.

23. Ralph Ellison, *Shadow and Act* (New York: New American Library, 1966), pp. 177–78. The quotation is from an interview in the *Paris Review* in 1955.

Charles White

The biographical information and all quotations attributed to Charles White, unless otherwise indicated, are from an interview with him on September 23, 1973. Other sources include correspondence with his wife, Frances Barrett White, and Benjamin Horowitz, his friend and dealer; an interview by James Hatch and Camille Billops at White's Altadena, California, home, December 21, 1970 (in the Hatch-Billops Oral History Collection, City University of New York); Elton C. Fax, 17 Black Artists *(New York: Dodd, Mead & Co., 1971);* Images of Dignity: The Drawings of Charles White *(Los Angeles: Ward P. Ritchie Press, 1967), a book prepared by Horowitz; and an issue of* Freedomways *devoted to White (vol. 20, no. 3, 1980), which included interviews, memoirs of friends and artists, and an extensive bibliography.*

1. James A. Porter, in *Images of Dignity*, p. 3.
2. Peter Clothier, "The Story of White's Art Is the Story of a Struggle," *Freedomways*, p. 144.
3. Ibid.
4. Sharon G. Fitzgerald, "Charles White in Person" (Sept. 1977 interview), *Freedomways*, p. 161.
5. Ibid.
6. Edmund W. Gordon, "First and Foremost an Artist," *Freedomways*, p. 136. Gordon's article quotes an interview with White describing his mother's work in a film by Carlton Moss, *Drawings from Life/Charles White* (Artisan Productions, Hollywood, Calif., 1979).
7. Ibid.
8. Margaret G. Burroughs, "He Will Always Be a Chicago Artist to Me," *Freedomways*, p. 151. Burroughs and White were teenagers together and shared many experiences as young artists. A well-known Chicago artist, she founded the DuSable Museum of African-American Art in Chicago.
9. White, Hatch-Billops interview.
10. Ibid.
11. Richard D. McKinzie, *The New Deal for Artists* (Princeton, N.J.: Princeton University Press, 1973), p. 110; Thomas Hart Benton, "Art and Social Struggle: Reply to Rivera" and "Interview in *Art Front*," in Matthew Baigell, ed., *A Thomas Hart Benton Miscellany* (Lawrence: University Press of Kansas, 1971), pp. 39–49, 58–65; see also Benton's autobiography, *An American in Art* (Lawrence: University Press of Kansas, 1969).
12. McKinzie, *New Deal*, p. 110.
13. Quoted in Willard Motley, "Negro Art in Chicago," *Opportunity* 18 (Jan. 1940), pp. 19–22.
14. Sidney Poitier, "Brothuhs," *Freedomways*, p. 196.
15. Quoted in *Images of Dignity*, p. 19.
16. Ibid.
17. Interview with Joseph E. Young, in *Three Graphic Artists: Charles White, David Hammons, Timothy Washington* (Los Angeles/Santa Barbara: Los Angeles County Museum of Art/Santa Barbara Museum of Art, exhibition catalog, 1971), p. 6.
18. El Taller de Gráfica Popular, *Doce Años de Obra Artística Collectiva* (Mexico City: La Stampa Mexicana, 1949).
19. Quoted by John Pittman, "He Was an Implacable Critic of His Own Creations," *Freedomways*, p. 191.
20. White's tribute *Paul Robeson: Itt Alloc* was published by Europa Konyvkiado, Hungary.
21. Fitzgerald, "White in Person," p. 161.
22. *The Art of Charles White—Portfolio of Six Drawings* (New York: New Century Publishers, 1953).
23. Sidney Finkelstein, *Realism in Art* (New York: International

Publishers, 1954); *Charles White: Ein Kunstler Amerikas* (Dresden: Veb Verlag der Kunst, 1955).

24. White, Hatch-Billops interview.
25. Ibid.
26. Porter, in *Images of Dignity,* p. 5.
27. Janice Lovoos, "The Remarkable Draughtsmanship of Charles White," *American Artist* 26 (June/July/Aug. 1962), pp. 96–102.
28. "WANTED" Series Portfolio (Los Angeles, Heritage Gallery). See "Reviews and Previews—Charles White," *Art News* 69 (April 1970), p. 76; also *Arts* 44 (April 1970), p. 66.
29. In 1971 White won the Adolph and Clara Obrig prize and was elected an associate member; in 1972 he won the 147th annual Isaac N. Maynard prize; and in 1974 he was elected a member. In 1975 he again won the Obrig prize.
30. "Black Artists Honored at White House," *New York Times,* April 3, 1980. Those honored, in addition to White, were Richmond Barthé, Romare Bearden, Margaret Burroughs, Ernest Crichlow, Lois Mailou Jones, Jacob Lawrence, Archibald Motley, Jr., James L. Wells, Charles White, and Hale Woodruff. The Corcoran Gallery of Art exhibited characteristic works of these artists and there were workshop meetings with younger artists. See *Jet* 58 (April 24, 1980).
31. White, Hatch-Billops interview.
32. Ibid.
33. Ibid.
34. Ibid.
35. Clothier, "Story of White's Art," p. 141.
36. White, Hatch-Billops interview.
37. Fitzgerald, "White in Person," p. 161.

Elizabeth Catlett

Unless otherwise indicated, the biographical data and all quotations attributed to Elizabeth Catlett are based on her taped responses to the authors' questions in January 1974 and a follow-up interview, January 5, 1982. Supplemental information has been drawn from Elton C. Fax, 17 Black Artists *(New York: Dodd, Mead & Co., 1971).*

1. Elizabeth Catlett, in Samella S. Lewis and Ruth G. Waddy, eds., *Black Artists on Art,* vol. 2, (Los Angeles: Contemporary Crafts, 1971), p. 107.
2. Elizabeth Catlett, "The Negro People and American Art," *Freedomways* 1 (1961), p. 79.
3. *Black Artists,* p. 107.
4. Fax, *17 Black Artists,* p. 17
5. Catlett arranged for Samella Lewis, one of her Dillard students, to enter Hampton. A painter and sculptor who became an art historian, Lewis later taught at Scripps College, Claremont, California, and wrote an extensive study titled *The Art of Elizabeth Catlett* (Claremont, Calif.: Hancraft Studios, 1983). She also wrote *Art: African American* (New York: Harcourt Brace Jovanovich, 1978).
6. Fax, *17 Black Artists,* p. 24.
7. See "Still Life with Red Herring" and "The Political and the Artistic," *Harper's* 199 (Sept. 1949), pp. 100–101; Aline Louchheim, "Six Abstractionists Defend Their Art," *New York Times Magazine,* Jan. 21, 1951, pp. 16–17; Alfred H. Barr, "Is Modern Art Communistic?" *New York Times Magazine,* Dec. 14, 1952.
8. Fax, *17 Black Artists,* p. 27.
9. All quotations from this speech are in Catlett, "The Negro People and American Art," pp. 74–80.
10. Major U.S. exhibitions include Studio Museum in Harlem,

New York, Sept. 26–Jan. 9, 1972; Van Vechten Gallery, Fisk University, Nashville, Tenn. April 15–May 5, 1973.
11. Elizabeth Catlett, "The Role of the Black Artist," address to 1975 National Conference of Artists, reprinted in *The Black Scholar* 6 (June 1975), pp. 10–14.

John T. Biggers

The biographical information and quotations attributed to John Biggers, unless otherwise indicated, are based on a telephone interview with him, February 18, 1974, and follow-up interviews, August 18, 1981, and May 9, 1988. Other sources were Elton C. Fax, 17 Black Artists *(New York: Dodd, Mead & Co., 1971); Biggers's autobiographical* Ananse: The Web of Life in Africa *(Austin: University of Texas Press, 1962); John T. Biggers and Carroll H. Simms, with John Edward Weems,* Black Art in Houston: The Texas Southern University Experience *(College Station: Texas A&M University Press, 1978).*

1. The 1964 Piper Foundation Professor Award for outstanding scholarly and academic achievement, 1968 Danforth Foundation E. Harris Harbison Award for distinguished teaching, 1972 Pennsylvania State University Distinguished Alumnus Award, and many visiting lectureships and professorships.
2. Fax, *17 Black Artists,* p. 269.
3. Biggers and Simms, *Black Art,* p. 4.
4. Viktor Lowenfeld, *Creative and Mental Growth* (New York: Macmillan, 1947); since Lowenfeld's death later editions, with updated research, have been coauthored by W. L. Brittain.
5. Biggers and Simms, *Black Art,* p. 7, quoting F. H. Wardlaw, "Black Leaders in Texas" (Texas Historical Society).
6. Fax, *17 Black Artists,* p. 275.
7. Biggers, *Ananse,* p. 4.
8. John Biggers, "His Influence Caused Me to Turn Out Little Charles Whites," *Freedomways* 20, no. 3 (1980), pp. 175–76.
9. Reproduced in Biggers and Simms, *Black Art,* p. 76
10. Biggers, "Little Charles Whites."
11. Biggers and Simms, *Black Art,* pp. 7–8.
12. Fax, *17 Black Artists,* p. 273.
13. Biggers and Simms, *Black Art,* pp. 17–18, 27.
14. Ibid., p. 17.
15. Ibid., p. 33.
16. Ibid., p. 62; at Lowenfeld's suggestion, Biggers kept every note, sketch, and photograph made for this mural, which became the basis of his doctorate.
17. After starting the Hampton art department and working with young black artists for three years, Lowenfeld identified three psychological factors critically influencing the development of black artists in America and an art specific to them: (1) loss of a direct relationship with African ancestors despite a psychological relationship to African culture, even if negatively expressed; (2) the ambiguous status of African-Americans in terms of civil rights, which has both positive and negative effects on development of a specific African-American art; and (3) the influence and traditions of Western civilization, which has tended to exclude all peoples of color including Asians and has inhibited the development of a genuine African-American art. Lowenfeld's unusual article, "New Negro Art in America," illustrated by Biggers, was published in *Design* (46 [Sept. 1944], pp. 20–21, 29), a specialized art magazine. It was never cited by writers in this field, such as Alain Locke or James A. Porter, and may not have been known to them.
18. See also Biggers, *Ananse,* pp. 29–30.
19. Ibid., p. 30.

20. Biggers and Simms, *Black Art*, p. 75.
21. Mimi Crossley, "Spotlight," *Houston Post*, July 25, 1976, p. 15.
22. Biggers and Simms, *Black Art*, p. 76.
23. Biggers, *Ananse*, p. 30.

Carroll H. Simms

Unless otherwise indicated, the biographical information and quotations attributed to Carroll Simms are based on his written responses to the authors' questions, February 18, 1974; a follow-up interview, March 22, 1988; and a two-day visit at Henderson's home in November 1990. Another primary source was John T. Biggers and Carroll Simms, with John Edward Weems, Black Art in Houston: The Texas Southern University Experience *(College Station: Texas A&M University Press, 1978).*

1. His mother's grandfather was a Choctaw.
2. Biggers and Simms, *Black Art*, p. 9.
3. Ibid., p. 11.
4. Ibid.
5. Ibid., p. 13.
6. Ibid., p. 80.
7. Ibid., pp. 27–30.
8. Ibid., p. 84.
9. See Paul Radin, ed., *African Folk Tales* (Princeton, N.J.: Princeton University Press, 1970).
10. Biggers and Simms, *Black Art*, p. 51.
11. Ibid., p. 86.
12. Insufficient funds prevented the casting of the lambs that, in Simms's model, were at Christ's feet. Simms has been promised the statue will be completed eventually.
13. Biggers and Simms, *Black Art*, p. 82.
14. Ibid., p. 84.

Alma W. Thomas

The primary biographical sources include an interview with Alma Thomas by Pat Gloster, using the authors' previously submitted questions, on January 22, 1974. Although revealing, the interview was limited because Thomas would not permit recording and often ignored questions, saying people had distorted what she said. Yet she still said much that was of interest. Another major source was Merry A. Foresta, A Life in Art: Alma Thomas 1891–1978 *(Washington, D.C.: National Museum of American Art, exhibition catalog, 1982); this catalog contained memoirs of Thomas by Adelyn D. Breeskin and Adolphus Ealey. Yet another source was Eleanor Munro, "The Late Springtime of Alma Thomas,"* Washington Post Magazine, *April 7, 1979, pp. 18–24, which contains much information on her early life in the South; it was reprinted in Munro's* Originals: American Women Artists *(New York: Simon & Schuster, 1979), pp. 189–97.*

1. Harold Rosenberg, "The Art World: Being Outside," *The New Yorker*, Aug. 22, 1977, pp. 83–86.
2. Thomas, Gloster interview.
3. Robert Doty, Introduction, *Alma W. Thomas: Recent Painting 1975–76* (New York: Martha Jackson West Gallery, exhibition catalog, Oct. 23–Nov. 17, 1976).
4. Joshua C. Taylor, in *Alma Thomas Paintings* (New York: Martha Jackson West Gallery, Oct. 10–Nov. 3, 1973).
5. Adelyn D. Breeskin, "Alma Thomas: An Appreciation," in *A Life in Art*, pp. 7–8.

6. Foresta prepared the catalog of the National Museum of American Art exhibition and wrote its comprehensive essay.
7. Quoted by Munro, "Late Springtime of Thomas," p. 23.
8. Thomas, Gloster interview.
9. Interview by H. E. Mahal, "Approaches to Inhumanity," *Art Gallery* 13 (April 1970), p. 36.
10. David Driskell, Foreword, *Alma W. Thomas: Recent Paintings* (Nashville, Tenn.: Carl Van Vechten Gallery of Fine Arts, Fisk University, exhibition catalog, Oct. 10–Nov. 12, 1971).
11. Munro, "Late Springtime of Thomas," p. 23.
12. James V. Herring, Foreword, *Alma W. Thomas: Retrospective Exhibition, 1959–1966* (Washington, D.C.: Howard University Gallery of Art, exhibition catalog, April 24–May 17, 1966).
13. Breeskin, "Thomas: An Appreciation," p. 19.
14. Ibid.
15. Quoted by Foresta, *Life in Art*, p. 19.
16. Jacob Kainen, Introduction, *Alma W. Thomas: Retrospective* (Washington, D.C.: Corcoran Gallery of Art, exhibition catalog, Sept. 8–Oct. 15, 1972).
17. Foresta, *Life in Art*, p. 20.
18. Johannes Itten, *The Art of Color: Subjective Experience and the Objective Rationale of Color* (New York: Reinhold, 1961).
19. Munro, "Late Springtime of Thomas," p. 23.
20. Ibid., p. 24.
21. Artist's statement, in *Thomas* (Van Vechten Gallery).
22. Quoted by Munro, "Late Springtime of Thomas," p. 24.
23. Quoted by Foresta, *Life in Art*, p. 23; from Thomas Papers, Archives of American Art, Smithsonian Institution.
24. Kainen, Introduction.
25. Foresta, *Life in Art*, p. 26; "Snoopy" was the name given the lunar module for the Apollo Space Mission, May 1969.
26. Ibid., pp. 26–27.
27. Adolphus Ealey, "Remembering Alma," in ibid., p. 12.
28. Ibid., p. 32.
29. Foresta, *Life in Art*, p. 34.
30. Ealey, "Remembering Alma," p. 12.
31. Ibid.
32. Artist's statement, in *Thomas* (Van Vechten Gallery).

Ed Wilson

Unless otherwise indicated, the biographical data and all quotations attributed to Ed Wilson are based on his responses to a questionnaire, April 23, 1975; interviews on May 6 and 27, 1975, and February 25, 1982; correspondence; and conversations in January 1986 and on November 23, 1992.

1. Ed Wilson, "A Statement," *Art and Society* (Fall–Winter 1968–69), pp. 411–17.
2. Ibid.
3. Ibid.
4. Ibid.
5. Ralph Ellison interview, "A Very Stern Discipline," *Harper's*, March 23, 1969.
6. Author interview, May 6, 1975. Wilson referred to Ellison's rebuttal of Irving Howe's essay "Black Boys and Native Sons," in *Dissent* (Autumn 1963), in *The New Leader* (Dec. 9, 1963; Feb. 3, 1964).
7. Wilson explained that, although a monument to President John F. Kennedy, "it bears no likeness. Instead the 'Seven Seals' depict the evils of noninvolvement in the demands, passions, and problems of life itself. In bold and dramatic form, the

plaques portray variations on the theme of withdrawal from the struggles of humanity. These are: The Maimed and the Ignorant . . . The Conformist, The Uninspired, The Rejected, The Depraved, The Invisible, The Dead" (Dedication program, "The Seven Seals of Silence," Binghamton, New York, Oct. 28, 1969).

8. Wilson, "Statement," p. 412.
9. Ibid.
10. Ibid., p. 411.
11. Ibid., p. 416.
12. One cast went to Whitney Young's birthplace in Simpsonville, Kentucky, another to Columbia University, a third to the Urban League headquarters, and a fourth to a Chicago "magnet" school.

James W. Washington, Jr.

Unless otherwise indicated, biographical data and all quotations attributed to James W. Washington, Jr., are based on correspondence and interviews with him, March 3 and April 20, 1975; March 24, 1982; and March 7, 1988. Another major source was Patricia L. Lucas, "James Washington: A Sculptor of Stone and Spirit," Seattle Times Magazine, July 6, 1980, pp. 8–10.

1. Lucas, "Washington," p. 9.
2. *The Arts Newsletter* (Seattle and Kings County Arts Commissions), Oct. 1974, p. 1; mentioning Washington's scheduled appearance at a local library.
3. Lucas, "Washington," p. 9. *The American Baptist* (May 1977) quotes Washington as telling the *Seattle Times* religion editor, Ray Ruppert, that his efforts to express life and spirit in stone follow "God's principle. When He got the clay together and made man, man was not alive. God had to breathe life into him."
4. Frye Art Museum, Seattle, July 8–Aug. 3, 1980 (*Seattle Times*, July 6, 1980).
5. Lucas, "Washington," p. 9.
6. James Laughlin, in his article "The Mysteries of Life . . . More Art on the Hill" (*Daily Olympian*, April 7, 1973, p. 1), describes the placing of the three pieces. He quotes Washington, who was present, as saying: "All life is in threes and sevens. The three mysteries of life begin with the atom and its formation. Then there is the egg, the sperm, and the genes. From the female and the male comes the first two and the genes are the result. In every individual there are three natures . . . the physical, the mental and the spiritual."
7. Governor Evans's citation noted Washington's "outstanding accomplishment in sculpture" and that "Mark Tobey, with whom he studied for a year, has said Washington's works are 'vivid reactions to life and are complete and unified in his own style,' a style which is intimate, captivating, and filled with spiritual force" (James L. Haseltine, executive director of Washington State Arts Commission, letter to authors, May 20, 1975).
8. This ceremony took place on November 22, 1987, with Seattle Councilman Norman B. Rice as master of ceremonies.
9. Sue Chin, " 'My Testimony in Stone,' " *Seattle Arts* (Seattle Arts Commission) 5 (Oct. 1981), p. 1.
10. Ibid.
11. Ibid. See also note 6.
12. Ibid.
13. Regina Hackett, in *Seattle Post-Intelligencer*, Oct. 12, 1984.
14. Ibid.
15. Ibid.
16. James Washington, "The Oracle of Truth" (Seattle: Mount Zion Baptist Church, Nov. 22, 1987), a booklet explaining the symbols of his statue.
17. James Washington, "Man Was Created to Think But Often Fails to Do So," quoted in Lucas, "Washington," p. 10.
18. Ibid.
19. Chin, " 'My Testimony.' "
20. Paul J. Karlstrom, *The Spirit in the Stone: The Visionary Art of James W. Washington, Jr.* (Seattle: University of Washington Press and the Bellevue Museum, exhibition catalog, 1989). Karlstrom, the West Coast regional director of the Archives of American Art, Smithsonian Institution, conducted five hours of interviews with Washington.
21. Ibid., pp. 3–4.

Richard Mayhew

The biographical data and all quotations attributed to Richard Mayhew, unless otherwise indicated, are based on an extended interview with him at his New City, New York, home on November 4, 1973, with follow-up interviews on January 6, 1974; July 20, 1980; June 28 and July 10, 1982; and May 21, 1988.

1. Mayhew's work attracted critical attention very early; see reviews in *Arts*, March 1957, Dec. 1959; *New York Times*, Oct. 25, 1959; *Apollo* (London), Dec. 1959. Stuart Preston, in *New York Times*, May 6, 1961, and Emily Genauer, in *New York Herald-Tribune*, May 7, 1961, were also among the first to recognize his talent. Genauer noted his landscapes were "in the great tradition."
2. Emily Genauer, in *New York Herald-Tribune*, Oct. 5, 1963.
3. John Canaday, in *New York Times*, Nov. 8, 1969.
4. *Arts*, Feb. 1973; a review of Mayhew's show at the Midtown Gallery, Feb. 13–March 3, 1973.
5. Amy Fine Collins, in *Art in America*, Feb. 1988.
6. Mary Schmidt-Campbell, in *Richard Mayhew: An American Abstractionist* (New York: Studio Museum in Harlem, exhibition catalog, 1978).
7. Related to Charles Willson Peale (1741–1821), a famous American artist who held antislavery views.
8. See review in *Arts*, March 1957.
9. Sidney Tillum, in *Arts* 34 (Dec. 1959), p. 68.
10. Marvin D. Schwartz, in *Apollo* (London), Dec. 1959.
11. Jeanne Siegel, "Why Spiral?" *Art News* 65 (Sept. 1966), pp. 48–51, 67, 68. Although he was an active member, Mayhew's name was omitted by Siegel, perhaps because he was out of town when the article was prepared.
12. Schmidt-Campbell, in *Mayhew: American Abstractionist*.

INDEX

Numbers in *italics* refer to illustrations or their captions. References to the color plates are in **boldface**.

515

ILLUSTRATION CREDITS

Introduction

Portrait believed to be of Rev. Richard Allen: Moorland-Spingarn Research Center, Howard University, Washington, D.C.

Portrait of Phillis Wheatley by Scipio Moorhead: Moorland-Spingarn Research Center, Howard University, Washington, D.C.

Bari wooden figure of man: Musée de l'Homme, Paris

Wrought-iron figure of man from Virginia: Collection Adele Earnest, Stony Point, N.Y.

Bronze Benin figure of rooster: Metropolitan Museum of Art, New York

Woodcarving of rooster: Index of American Design, National Gallery of Art

Nok clay head: National Commission for Museums and Monuments, Lagos, Nigeria

Bronze Ife figure: National Commission for Museums and Monuments, Lagos, Nigeria

Wrought-iron balconies, New Orleans: From John M. Vlach, *The Afro-American Tradition in Decorative Arts* (Cleveland, Ohio: Cleveland Museum of Art, 1978). Photo: Martin Linsey. Reprinted with permission

The Late Eighteenth and Nineteenth Centuries: The Question of Joshua Johnston

Portrait of Mrs. Thomas Everette: Maryland Historical Society Museum, Baltimore

Portrait of Mrs. John Moale: Abby Aldrich Rockefeller Folk Art Center, Williamsburg, Va.

Portrait of Sarah Ogden Gustin: National Gallery of Art

Joshua Johnston's signature on petition: Baltimore City Archives

Detail from portrait of Basil Brown: Private collection, courtesy Washburn Gallery, New York

Matched portraits of two African-Americans: Bowdoin College Museum of Art, Brunswick, Maine, and American Museum, Bath, England

Portrait of Daniel Coker: Courtesy of *Research/Penn State*

Page from baptismal records of St. Peter's Church, Baltimore: Baltimore Diocese, Cathedral Archives

Robert S. Duncanson

Blue Hole, Little Miami River: Cincinnati Art Museum. Gift of Norbert Heerman and Arthur Helbig

Land of the Lotus-Eaters: His Majesty's Royal Collection, Stockholm, Sweden

Mount Royal: National Gallery of Canada, Ottawa, Ontario

Fruit Still Life: © Detroit Institute of Arts. Gift of the Estates of Miss Elizabeth Gray Walker and Mr. Henry Lyster Walker

The Rising Mist: Cincinnati Art Museum. Gift of Mrs. George Minot Stearns in memory of George Minot Stearns

Man Fishing: Courtesy of Babcock Galleries, New York. Photo: Geoffrey Clements Inc.

Longworth murals: Taft Museum, Cincinnati

J. P. Ball's Daguerreotypy Salon: General Research Division, New York Public Library, Astor, Lenox, and Tilden Foundations

Landscape with Classical Ruins, Recollections of Italy: Howard University Gallery of Art, Washington, D.C.

Classical Italian Landscape with Temple of Venus by W. L. Sonntag: Collection of Corcoran Gallery of Art, Washington, D.C. Gift of Charles A. Munn and Victor G. Fischer in Memory of Orson P. Munn

Letter from Duncanson to Junius Sloan: Newberry Library, Chicago

Portrait of Richard Rust I: Collection Richard S. Rust III, Cincinnati

The Cave: Collection Richard S. Rust III, Cincinnati

Portrait of Nicholas Longworth: Fine Arts Collection, University of Cincinnati

Photo of Duncanson by W. A. Notman: Notman Photographic Archives, McCord Museum, McGill University, Montreal

Canadian Falls: National Gallery of Canada, Ottawa, Ontario

Ellen's Isle, Lake Katrine: Detroit Institute of Arts. Gift of Estate of Razlemond D. Parker

Sunset on the New England Coast: Reproduction courtesy of Cincinnati Art Musum

Edward M. Bannister

In Morton Park, Newport, R.I., Looking Southward: National Museum of American Art, Smithsonian Institution. Gift of William G. Miller

Sabin Point, Narragansett Bay: Brown University, Gardner House, Providence, R.I.

Edward M. Bannister photo: Courtesy of Rhode Island Historical Society, Providence

Portrait of Christiana Carteaux Bannister: Courtesy of Bannister Nursing Care Center, Providence, R.I. Photo: Fred Kelman

Dorchester, Massachusetts: National Museum of American Art, Smithsonian Institution. Gift of Dr. Charles Mandell

Moon over a Harbor: National Museum of American Art, Smithsonian Institution. Gift of M. Alan and Melvin Frank

Preparatory sketch for *Under the Oaks:* Courtesy of the Trustees of the Boston Public Library

Oak Trees: National Museum of American Art, Smithsonian Institution. Gift of M. Alan and Melvin Frank

George Whitaker on founding of Providence Art Club: Courtesy of Rhode Island Historical Society, Providence

Landscape with a Man on a Horse: National Museum of American Art, Smithsonian Institution. Gift of Irwin M. Sparr

Approaching Storm: National Museum of American Art, Smithsonian Institution. Gift of William G. Miller

Untitled landscape: National Museum of American Art, Smithsonian Institution. Gift of Louis J. Shatkin

Sunset: National Museum of American Art, Smithsonian Institution. Gift of Eliot and Rhonda Littland

Bannister memorial photo: Courtesy of the Trustees of the Boston Public Library

Grafton T. Brown

Mount Tacoma: Oakland Museum, Oakland, Calif.

Grand Canyon of the Yellow Stone from Hayden Point: Oakland Museum, Oakland, Calif.

Edmonia Lewis

Portrait of the Reverend John Keep by Alonzo Pease: Oberlin College Archives, Oberlin, Ohio

Photo of Mrs. Marianne Dascomb: Oberlin College Archives, Oberlin, Ohio

Portrait of John Mercer Langston: Schomburg Center for Research in Black Culture, New York Public Library

Urania: Oberlin College Archives, Oberlin, Ohio

John Brown by Edward A. Brackett: Museum and Library of Boston Athenaeum

Colonel Robert Gould Shaw: Museum of the African Meetinghouse, Boston

John Brown by Edmonia Lewis: Wilberforce University. Photo: Harry Henderson

Forever Free: Permanent Collection, Howard University Gallery of Art, Washington, D.C. Photo: Andrew Bradtke, Silver Spring, Md.

Copy of Michelangelo's *Moses* by Edmonia Lewis: National Museum of American Art, Smithsonian Institution. Gift of Mr. and Mrs. Alfred T. Morris, Jr.

Henry Wadsworth Longfellow: Schlesinger Library of the History of Women, Radcliffe College, Boston

Hagar: National Museum of American Art, Smithsonian Institution. Gift of Delta Sigma Theta Sorority, Inc.

The Old Indian Arrowmaker and His Daughter: Permanent Collection, Howard University Gallery of Art, Washington, D.C. Photo: Frederick H. Levenson

Hygieia: Grave of Dr. Harriot Hunt, Mount Auburn Cemetery, Cambridge, Mass. Photo: Harry Henderson

Asleep and *Awake:* San Jose Public Library, San Jose, Calif. Photos: Harry Henderson

The Death of Cleopatra: Forest Park Historical Association, Forest Park, Ill. Photo: Dr. Frank Orland

Edmonia Lewis's *carte de visite* photo: Schomburg Center for Research in Black Culture, New York Public Library

Henry Ossawa Tanner

The Raising of Lazarus: Musée National d'Art Moderne, Compiègne

The Banjo Lesson: Hampton University Museum, Hampton, Va.

Nicodemus Visiting Jesus: Pennsylvania Academy of Fine Arts, Philadelphia

The Good Shepherd: Jane Voorhees Zimmerli Art Museum, Rutgers University, New Brunswick, N.J.

Fisherman Returning at Night: Collection Merton Simpson, New York

Midday, Tangiers: Private collection. Courtesy of Sotheby's Inc., New York

Sarah Miller Tanner and Bishop Benjamin Tanner: Photo: Harmon Foundation

Portrait of Tanner by Thomas Eakins: The Hyde Collection, Glen Falls, N.Y.

Zoo etching: National Archives, Harmon Collection

Negro Boy Dancing by Thomas Eakins: Metropolitan Museum of Art, New York

The Thankful Poor: Collection William H. and Camille Cosby, New York

Daniel in the Lions' Den (1895): Present location unknown. Photo: National Archives

Daniel in the Lions' Den (1916): Los Angeles County Museum of Art, Mr. and Mrs. William Preston Harrison Collection

Study for *The Annunciation:* Present location unknown. Photo: Peter A. Juley & Son

The Annunciation: Philadelphia Museum of Art, W. P. Wilstach Collection

Jews at the Jerusalem Wailing Wall: Museum of Art, Rhode Island School of Design, Providence

Drawing of Jessie Olssen: Present location unknown. Photo: National Archives

Moonlight Hebron: Milwaukee Art Center. Gift of Mr. and Mrs. Thomas Whipple Dunbar

Two Disciples at the Tomb: Art Institute of Chicago

Disciples on the Sea of Galilee: Toledo Museum of Art, Toledo, Ohio. Gift of Frank W. Gunsaulus, Chicago

Angels Appearing Before the Shepherds: National Museum of American Art, Smithsonian Institution. Gift of Mr. and Mrs. Norman B. Robbins

Henry Ossawa Tanner in the 1920s: Photo: Harmon Foundation

The Destruction of Sodom and Gomorrah: High Museum of Art, Atlanta, Ga.

Other Significant Early Artists

Landscape by David Bustil Bowser: Collection Historical Society of Pennsylvania, Philadelphia

Fruit with Watermelon by Joseph Proctor: Collection Andy Williams, Palm Springs, Calif. Photo: Phil Stern

Portrait of John Young Mason by Eugene Warburg: Virginia Historical Society, Richmond

Portrait of Robert Southey by John G. Chaplin: Nancy S. Shedd, Huntingdon County Historical Society, Huntingdon, Pa.

Still Life with Flowers by Charles Porter: Wadsworth Atheneum, Hartford, Conn., Ella Gallup Sumner and Mary Catlin Sumner Collection

La Parisienne by Annie E. Walker: Permanent Collection, Howard University Gallery of Art, Washington, D.C.

Silhouettes by Moses Williams: Reprinted from *Charles Willson Peale,* pt. 2, *Later Life* by Charles C. Sellers (Philadelphia: American Philosophical Society, 1947), p. 159

The Twenties and the Black Renaissance

Augusta Savage modeling a faun in clay: Photo: Hans Meithe, *Life,* copyright Time, Inc.

Portrait of H. L. Mencken by O. Richard Reid: Photo: National Archives

Aaron Douglas

Aspects of Negro Life: From Slavery Through Reconstruction: Schomburg Center for Research in Black Culture, Art and Artifacts Division, New York Public Library, Astor, Lenox, and Tilden Foundations

Building More Stately Mansions: Carl Van Vechten Gallery of Fine Arts, Fisk University, Nashville, Tenn.

Evolution of the Negro Dance: 135th Street YMCA, New York

Listen, Lord—A Prayer: New York Public Library

Triborough Bridge: Amistad Research Center, Tulane University, New Orleans

Aspects of Negro Life: The Negro in an African Setting: Schomburg Center for Research in Black Culture, New York Public Library

Aspects of Negro Life: Song of the Towers: Schomburg Center for Research in Black Culture, New York Public Library

The Return of Hephaistos (Greek vase): Metropolitan Museum of Art, New York

Aaron Douglas, 1933: Photo: Carl Van Vechten, Beineke Rare Books and Manuscripts Library, Yale University. Estate of Carl Van Vechten. Courtesy of Joseph Solomon, Yale University Library, and Sidney A. Mauriber

The Composer: Carl Van Vechten Gallery of Fine Arts, Fisk University, Nashville, Tenn. Photo: Greg Engleberg

Richmond Barthé

Woman with a Scythe: Photo: National Archives

The Boxer: Metropolitan Museum of Art, New York

George Washington Carver: Carl Van Vechten Gallery of Fine Arts, Fisk University, Nashville, Tenn. Photo: National Archives

Booker T. Washington: Schomburg Center for Research in Black Culture, New York Library. Photo: Harry Henderson

Supplication (or *Mother and Son*): Photo: National Archives

Blackberry Woman: Whitney Museum of American Art, New York

African Dancer: Whitney Museum of American Art, New York. Photo: Peter A. Juley & Son

Relief frieze for Harlem River Houses: Photo: National Archives

Shilluk Warrior: Photo: National Archives

Life Mask of Rose McClendon: Present location unknown. Photo: National Archives

Laurence Olivier as Hotspur: Collection Louis Franklin, Queens, N.Y. Photo: Harry Henderson

Lindy Hop: Present location unknown. Photo: National Archives

James Garner bust and heads: Collection James Garner, Hollywood, Calif. Photo: Phil Stern

Christina: Collection Clark-Atlanta University, Atlanta, Ga. Photo: Michael McKelvey

West Indian Girl: Present location unknown. Photo: National Archives

Archibald J. Motley, Jr.

Barbecue: Permanent Collection, Howard University Gallery of Art, Washington, D.C.

Octoroon: Collection Judge Norma Y. Dotson, Detroit. Photo: Bill Sanders, Detroit

The Liar: Permanent Collection, Howard University Gallery of Art, Washington, D.C.

Mending Socks: Ackland Art Museum, Chapel Hill, N.C.

Blues: Collection Valerie and Archibald Motley. Photograph © 1991, The Art Institute of Chicago. All rights reserved

Black Belt: Hampton University Museum, Hampton, Va.

Saturday Night: Permanent Collection, Howard University Gallery of Art, Washington, D.C.

Kikuyu God of Fire: Collection Judge Norma Y. Dotson, Detroit. Photo: Bill Sanders, Detroit

Dans la Rue: Schomburg Center for Research in Black Culture, Art and Artifacts Division, New York Public Library

Jockey Club, Paris: Schomburg Center for Research in Black Culture, Art and Artifacts Division, New York Public Library

Palmer C. Hayden

No Easy Riders: Museum of African American Art, Los Angeles

The Blue Nile: Collection Camille Billops, New York

The Janitor Paints a Picture: National Museum of American Art, Smithsonian Institution. Gift of the Harmon Foundation

Boothbay Harbor, Maine: Ethnic American Art Slide Library, University of South Alabama, Mobile. Photo: National Archives

Fétiche et Fleurs: Museum of African American Art, Los Angeles

The *John Henry* series—*When John Henry Was a Baby, He Was Born with a Hammer in His Hand; John Henry on the Right, Steam Drill on the Left; He Died with His Hammer in His Hand:* Museum of African American Art, Los Angeles

Moonlight at the Crossroads: Ethnic American Art Slide Library, University of South Alabama, Mobile. Photo: National Archives

The Baptizing Day: Museum of African American Art, Los Angeles

The Blues Singer: Museum of African American Art, Los Angeles

Augusta Savage

Gamin: Schomburg Center for Research in Black Culture, New York Public Library. Photo: Harry Henderson

Marcus Garvey: Collection Estate of Mrs. Amy Jacques Garvey. Photo: Quito O'Brien, Jamaica, B.W.I.

The Pugilist: Schomburg Center for Research in Black Culture, New York Public Library. Photo: Harry Henderson

Gwendolyn Knight: Collection Gwendolyn and Jacob Lawrence, Seattle, Wash.

Bust of a Woman: Present location unknown. Photo: *Metropolitan* magazine, New York

Lift Every Voice and Sing: Photo: Carl Van Vechten, Beineke Rare Books and Manuscripts Library, Yale University. Estate of Carl Van Vechten

Terpischore at Rest (or *Reclining Nude*): Collection Ersa H. Poston, New York. Photo: William Artis

James Weldon Johnson: Schomburg Center for Research in Black Culture, New York Public Library. Photo: Harry Henderson

Head of a Boy: Present location unknown. Photo: *Metropolitan* magazine, New York

Malvin Gray Johnson

Negro Masks: Hampton University Museum, Hampton, Va.

Marching Elks: Present location unknown. Photo: National Archives

Picking Beans: Present location unknown. Photo: National Archives

Self-Portrait: National Museum of American Art, Smithsonian In-

stitution. Gift of the Harmon Foundation. Photo: National Archives

Southern Landscape: Present location unknown. Photo: National Archives

Henderson: Present location unknown. Photo: National Archives

W. H. Johnson

Mount Calvary: National Museum of American Art, Smithsonian Institution

Fruit Trees and Mountains: National Museum of American Art, Smithsonian Institution

Landscape, Cagnes-sur-Mer: Collection Estate of David and Helen Harriton, Minisink Hills, Pa. Photo: Glenn A. Taylor

Minnie: National Museum of American Art, Smithsonian Institution. Gift of the Harmon Foundation

Jacobia Hotel: National Museum of American Art, Smithsonian Institution. Gift of the Harmon Foundation

City Gates, Kairouan: National Museum of American Art, Smithsonian Institution. Gift of the Harmon Foundation

Sun Setting, Denmark: National Museum of American Art, Smithsonian Institution. Gift of the Harmon Foundation

Jesus and the Three Marys: Collection Clark-Atlanta University, Atlanta, Ga.

Fletcher: National Museum of American Art, Smithsonian Institution. Gift of the Harmon Foundation

Street Musicians: Oakland Museum, Oakland, Calif.

Station Stop, Red Cross Ambulance: National Museum of American Art, Smithsonian Foundation. Gift of the Harmon Foundation

Lessons in a Soldier's Life: National Museum of American Art, Smithsonian Institution. Gift of the Harmon Foundation

Under Fire: National Museum of American Art, Smithsonian Institution. Gift of the Harmon Foundation

Going to Church: National Museum of American Art, Smithsonian Institution. Gift of the Harmon Foundation

Mom and Dad: National Museum of American Art, Smithsonian Institution. Gift of the Harmon Foundation

Évisa: Collection Estate of David and Helen Harriton, Minisink Hills, Pa. Photo: Glenn A. Taylor

Hale A. Woodruff

The Cardplayers: Collection Vivian and John H. Hewitt, New York

Forest Fire: Present location unknown. Photo: Harry Henderson

Celestial Gate: Collection Spelman College, Atlanta, Ga.

Two Old Women: Present location unknown. Photo courtesy of the artist

Medieval Chartres: Present location unknown. Photo courtesy of the artist

Tornado: Present location unknown. Photo courtesy of the artist

Returning Home: Hampton University Museum, Hampton, Va.

Poor Man's Cotton: Newark Museum, Newark, N.J. Sophronia Anderson Bequest

Troubadour: Present location unknown. Photo courtesy of the artist

Amistad mutiny trial murals: Talladega College, Talladega, Ala.

Golden State Mutual Life mural: Photo: Herbert Gehr

Abstract: Present location unknown. Photo courtesy of the artist

Monkey Man (drawing from series): Present location unknown. Photo: Harry Henderson

Torso No. 1: Metropolitan Museum of Art, New York. Photo courtesy of the artist

Sargent Johnson

Forever Free: San Francisco Museum of Modern Art

The Bull: Collection Dr. and Mrs. Jack D. Gordon, San Francisco

Sargent Johnson ca. 1934 by Consuelo Kanaga: Collection Estate of Consuelo Kanaga, Croton-on-Hudson, N.Y.

Elizabeth Gee: San Francisco Museum of Modern Art, Albert M. Bender Collection. Gift of Albert M. Bender

Chester: San Francisco Museum of Modern Art, Albert M. Bender Collection. Gift of Albert M. Bender. Photo: National Archives

Copper Mask and profile of *Copper Mask:* San Francisco Museum of Modern Art, Albert M. Bender Collection. Gift of Albert M. Bender. Photos: National Archives

Carved redwood music panel: University of California, Berkeley. Photo: National Archives

Drawings of relief panels: Museum of the Golden Gate National Park, San Francisco. Photo: National Archives

Athletic frieze, George Washington High School: Photo: Larry Merkle, San Francisco

Lenox Avenue: Oakland Museum, Oakland, Calif. Lent by M. H. deYoung Memorial Museum, San Francisco

Singing Saints: Oakland Museum, Oakland, Calif. Gift of Arthur C. Painter. Photo: M. Lee Fatherree

Emergence of African-American Artists During the Depression

Members of Harlem Artists Guild on picket line of the WPA Artists Union: Collection Harry Henderson

Palmer Hayden and Beauford Delaney in Washington Square in early 1930s: Photo: National Archives, Harmon Collection

Harmonica Blues by Dox Thrash: Philadelphia Free Library

Artists on the WPA Harlem Hospital murals project: Collection Harry Henderson

Constitution of the Harlem Artists Guild: Collection Harry Henderson

Three Influential People

Alain Leroy Locke: Photo: Moorland-Spingarn Research Center, Howard University

Bakuba cup: Schomburg Center for Research in Black Culture, New York Public Library

Charles C. Seifert: Photo: Collection Estate of Tiaya Goldie Seifert

Wife of King Solomon by Earl R. Sweeting: Collection Estate of Tiaya Goldie Seifert. Photo: Frank Stewart, New York

Virgo Lauretana by Earl R. Sweeting: Collection Estate of Tiaya Goldie Seifert. Photo: Frank Stewart, New York

The Hall of Karnak by Robert Savon Pious: Collection Estate of Tiaya Goldie Seifert. Photo: Frank Stewart, New York

The Finding of Moses by Robert Savon Pious: Collection Estate of Tiaya Goldie Seifert. Photo: Frank Stewart, New York

Mary Beattie Brady: Photo: National Archives

Harmon Foundation exhibition catalogs: Collection Harry Henderson

''Contemporary Negro Artists'' exhibition, Baltimore Museum of Art, 1939: Photo: National Archives

Charles H. Alston

Blues Song: Collection Bert M. Mitchell, New York. Photo: Frank Stewart, New York

Black Man, Black Woman, U.S.A.: Collection National Association

for the Advancement of Colored People. Photo: Harry Henderson.

Family No. 9: Present location unknown. Photo: Harry Henderson

Harlem Hospital murals: Harlem Hospital Nurses' Residence, New York. Photo: National Archives

Gin Mill: Photo: National Archives

Farm Boy: Collection Clark-Atlanta University, Atlanta, Ga. Photo: Michael McKelvey

Wartime cartoons: Office of War Information, National Archives

Painting: Metropolitan Museum of Art, New York, Arthur H. Hearn Fund. All rights reserved

The Family: Whitney Museum of American Art, New York

Walking: Collection Sydney Smith Gordon, Chicago

Untitled abstraction: Courtesy of the artist. Photo: Charles Alston

Black and White No. 2: Present location unknown. Photo: Harry Henderson

Portrait of Martin Luther King: Community Church of New York. Photo: Harry Henderson

Eldzier Cortor

Southern Gate: Collection National Museum of American Art, Smithsonian Institution. Photo: Richard DiLiberto

Figure Composition: Courtesy of the artist

Classical Study No. 34: Private collection

"Bungleton Green" comic strip: Courtesy *Chicago Defender*

Dance Composition VIII: Private collection

Dance Composition No. 35: Courtesy of the artist

Americana: Collection Miriam and Stephen Cortor

Classical Study No. 39: Woman with a Towel: Courtesy of the artist

Still Life: Souvenir IV: Private collection

Still Life: Past Revisited: Courtesy of the artist

All Cortor works reproduced by permission of the artist

Beauford Delaney

James Baldwin: Collection Mrs. James Jones, Sagaponack, N.Y. Photo: Manu Sassoonian

Portrait of a Man: Newark Museum, Newark, N.J.

Abstraction: Galerie Darthea Speyer, Paris

Portrait of Howard Swanson: Galerie Darthea Speyer, Paris

Portrait of Darthea Speyer: Galerie Darthea Speyer, Paris

Portrait of Jean Genet: Collection Mrs. James Jones, Sagaponack, N.Y. Photo: Manu Sassoonian

Self-portrait: Collection Mrs. James Jones, Sagaponack, N.Y. Photo: Manu Sassoonian

Joseph Delaney

Times Square, V-J Day: University of Tennessee, Frank H. McClung Museum. Photo: Nick Myers

Lobby of the Art Students League: Estate of Joseph Delaney. Ethnic American Art Slide Library, University of South Alabama, Mobile

His Last Known Address: University of Arizona Museum of Art, Tucson. Gift of C. Leonard Pfeiffer

Dr. Gladys Graham: Ethnic American Art Slide Library, University of South Alabama, Mobile

East River: Collection Clark-Atlanta University, Atlanta, Ga.

Penn Station in Wartime: National Museum of American Art, Smithsonian Institution. Gift of Joseph Delaney

Waldorf Cafeteria: Present location unknown

Easter Parade: Knoxville Art Museum, Knoxville, Tenn. Photo: Frank Stewart, New York

Jacob Lawrence

The Ordeal of Alice: Collection Gabrielle and Herbert Kayden

The Cabinetmaker: Joseph H. Hirshhorn Museum and Sculpture Garden, Smithsonian Institution. Gift of Joseph H. Hirshhorn, 1966

Street Orator: Collection Gwendolyn and Jacob Lawrence, Seattle, Wash.

Clinic: Collection Gwendolyn and Jacob Lawrence, Seattle, Wash.

Bar 'n Grill: Collection Gwendolyn and Jacob Lawrence, Seattle, Wash.

Toussaint L'Ouverture series, Nos. 1, 2, 25: Amistad Research Center, Tulane University, New Orleans

This Is Harlem: Joseph H. Hirshhorn Museum and Sculpture Garden, Smithsonian Institution. Gift of Joseph H. Hirshhorn, 1966. Photo: Lee Stalsworth

Young Jacob Lawrence: Photo: Jay Leyda, New York

Migrants series: Nos. 3, 45, 59: The Phillips Collection, Washington, D.C. Nos. 10, 30, 48: Museum of Modern Art, New York

John Brown in Adirondack woods: Detroit Institute of Arts. Gift of Gwendolyn and Jacob Lawrence

John Brown and Frederick Douglass: Detroit Institute of Arts. Gift of Gwendolyn and Jacob Lawrence

In the Garden: Collection Dr. Abram and Frances Kanof, Brooklyn, N.Y.

Struggle series, Nos. 10 and 14: Present location unknown. Photo: Geoffrey Clements

Parade: Joseph H. Hirshhorn Museum and Sculpture Garden, Smithsonian Institution

Boy with Kite: Collection Gwendolyn and Jacob Lawrence, Seattle, Wash.

All Lawrence works reproduced by permission of the artist

Norman Lewis

Migrating Birds: Carnegie Museum of Art, Pittsburgh. Gift of Sidney S. Feldman

Seascape: Collection Ouida B. Lewis, New York

Processional: Collection Ouida B. Lewis, New York

Johnny the Wanderer: Collection Tarin M. Fuller, Oak Ridge, N.J.

Meeting Place: Collection George and Joyce Wein, New York

The Yellow Hat: Collection Ouida B. Lewis, New York

Dispossessed: Present location unknown. Photo: National Archives

Jazz Musicians: Collection Ouida B. Lewis, New York

Blending: Munson-Williams-Proctor Institute, Utica, N.Y.

Tenement I: Collection Ouida B. Lewis, New York

Harlem Turns White: Collection Ouida B. Lewis, New York

Night Walker No. 2: Collection Ouida B. Lewis, New York

Arrival & Departure: New Jersey State Museum, Trenton

Hughie Lee-Smith

Impedimenta: Parrish Art Museum, Southampton, N.Y.

Temptation: Courtesy of June Kelly Gallery, New York

Two Girls: Collection New Jersey State Museum, Trenton

The Kite Flyers: Collection Nathan Lasnik, University Heights, Ohio

Artist's Life No. 1: Collection Nathan Lasnik, University Heights, Ohio

The Walls: Courtesy of June Kelly Gallery, New York

Interval: Courtesy of June Kelly Gallery, New York

Boy with Tire: © Detroit Institute of Arts. Gift of Dr. S. B. Milton, Dr. James A. Owen, Dr. B. F. Seabrooks, and Dr. A. E. Thomas, Jr.

Man Standing on His Head: New Jersey State Museum, Trenton

Hard Hat: Courtesy of June Kelly Gallery, New York

End of Act One: Collection George and Joyce Wein, New York

Passage: Courtesy of the artist

All Lee-Smith works reproduced by permission of the artist

Ellis Wilson

Shore Leave: Amistad Research Center, Tulane University, New Orleans

Field Workers: National Museum of American Art, Smithsonian Institution. Gift of the Harmon Foundation

Fishermen's Wives: Permanent Collection, Howard University Gallery of Art, Washington, D.C.

Allen: Collection Clark-Atlanta University, Atlanta, Ga.

Haitian Funeral Procession: Amistad Research Center, Tulane University, New Orleans, Aaron Douglas Collection

To Market: North Carolina Museum of Art, Raleigh

Lobster and Man: Present location unknown

The Naive, Self-Taught Artists

The Throne of the Third Heaven of the Nations' Millennium General Assembly by James Hampton: National Museum of American Art, Smithsonian Institution

Let's Make a Record by Sister Gertrude Morgan: National Museum of American Art, Smithsonian Institution

The Funeral by Elijah Pierce: Collection Boris Gruenwald

Figures and Construction by Bill Traylor: Luise Ross Gallery, New York

William Edmondson

Mary and Martha: Joseph H. Hirshhorn Museum and Sculpture Garden, Smithsonian Institution. Gift of Joseph Hirshhorn, 1972

Horse: Collection Estate of Consuelo Kanaga, Croton-on-Hudson, N.Y.

Sheep: Collection Estate of Consuelo Kanaga, Croton-on-Hudson, N.Y.

Two Birds: Newark Museum, Newark, N.J. Gift of Mrs. Rene Pingeon and an anonymous fund in memory of Margaret Chubb Parsons, 1978

Jack Johnson: Newark Museum, Newark, N.J. Gift of Edmund L. Fuller, Jr., 1985. Photo: Roger Haile

Schoolteacher: Collection Mr. and Mrs. Alexander Brook, Long Island, N.Y. Photo: Roger Haile

Photo of Edmondson's stone yard by Consuelo Kanaga: Collection Estate of Consuelo Kanaga, Croton-on-Hudson, N.Y.

The Preacher: Newark Museum, Newark, N.J. Gift of Edmund L. Fuller, Jr., 1985. Photo: Roger Haile

Mother and Child: Newark Museum, Newark, N.J. Gift of Edmund L. Fuller. Photo: Roger Haile

William Edmundson: Photo: Consuelo Kanaga. Collection Estate of Consuelo Kanaga, Croton-on-Hudson, N.Y.

Horace Pippin

Holy Mountain III: Joseph Hirshhorn Museum and Sculpture Garden, Smithsonian Institution

John Brown Going to His Hanging: Pennsylvania Academy of the Fine Arts, Philadelphia

The Domino Players: The Phillips Collection, Washington, D.C.

Man on Bench: Collection Mrs. Sydney E. (Roberta) Cohn, New York

Saturday Night Bath: Collection Robert L. Montgomery II, São Paulo, Brazil

Gas Attack: Present location unknown. Photo: Peter A. Juley & Son, N.Y.

Horace Pippin at work: Photo: *Friday,* January 11, 1941

The End of the War: Starting Home: Philadelphia Museum of Art. Gift of Robert Carlen

Cabin in the Cotton III: Collection Mr. and Mrs. Roy R. Neuberger. Photo: Geoffrey Clements

Christian Brinton: Philadelphia Museum of Art

West Chester Court House: Pennsylvania Academy of Fine Arts, Philadelphia

Christmas Morning Breakfast: Collection Estate of Edward G. Robinson

The Milkman of Goshen: Collection Estate of Ruth Gordon Kainen, New York

Art Departments in African-American Colleges

Howard University drawing class, 1938: Moorland-Spingarn Research Center, Howard University, Washington, D.C.

Vernon Winslow and Hale Woodruff at Dillard University, 1982: Photo: Harry Henderson

James A. Porter

On a Cuban Bus: Collection Dorothy Porter Wesley, Washington, D.C. Photo: Milan Uzelac

Tempest of the Niger: Collection Dorothy Porter Wesley, Washington, D.C. Photo: Milan Uzelac

Woman Holding a Jug: Carl Van Vechten Gallery of Fine Arts, Fisk University, Nashville, Tenn.

Night Raiders (or *When the Klan Passes By*): Collection Dorothy Porter Wesley, Washington, D.C. Photo: Milan Uzelac

Constance: Collection Constance Porter Uzelac, Marina del Rey, Calif. Photo: Milan Uzelac

Toromaquia: Collection Dorothy Porter Wesley, Washington, D.C. Photo: Milan Uzelac

The Haitian Lovers: Collection Constance Porter Uzelac, Marina del Rey, Calif. Photo: Milan Uzelac

Storm over Jos, Nigeria: Collection Constance Porter Uzelac, Marina del Rey, Calif. Photo: Milan Uzelac

Street of the Market, Zaria, Nigeria: Collection Dorothy Porter Wesley, Washington, D.C. Photo: Milan Uzelac

Portrait of James V. Herring: Permanent Collection, Howard University Gallery of Art, Washington, D.C.

Lois Mailou Jones

Ubi Girl from Tai Region, Nigeria: Museum of Fine Arts, Boston

Jennie: Permanent Collection, Howard University Gallery of Art, Washington, D.C.

Parade des Paysans: Collection Max Robinson (Adolphus Ealey), Washington, D.C.

Meditation (or *Mob Victim*): Collection of the artist

Les Fétiches: National Museum of American Art, Smithsonian Institution. Museum purchase made possible by Mrs. N. H. Green, Dr. R. Harlan, and Francis Musgrave

Rue Mont Cenis, Montmartre, Paris: Collection of the artist
Peasant Girl, Haiti: Collection of the artist
Moon Masque: Collection of the artist
Homage to Osnogso: Collection of the artist
Guli Masque: Collection of the artist
All Jones works reproduced by permission of the artist

James Lesesne Wells
Dance of Salome: Urologic Associates, Chevy Chase, Md.
The Flight into Egypt: Hampton University Museum, Hampton, Va.
African Phantasy: Estate of James L. Wells
Landscape and Figure, Senegal: Estate of James L. Wells
Escape of the Spies from Canaan: Estate of James L. Wells
Wells in the first Harlem Art Workshop: Photo: National Archives
The Temptation of Eve: National Museum of American Art, Smithsonian Institution
The Destruction of Sodom: Estate of James L. Wells
Bus Stop, Ghana: Estate of James L. Wells
All Wells works reproduced by permission of the Estate of James L. Wells

Post–World War II African-American Artists
Charles White correcting his 1939 mural *Five Great Americans* from his original sketch: Howard University Gallery of Art, Washington, D.C.
Opening of the Spiral exhibition in New York, May 14, 1964: Photo: James Rudin, Yellow Poui Gallery, Grenada

Charles White
Wanted Poster No. 17: Flint Institute of Arts, Flint, Mich.
Two Brothers Have I Had on Earth . . . : Collection Sekou Touré, Guinea
Take My Mother Home: Collection Dr. Richard Simms, Harbor City, Calif.
Contribution of the Negro to American Democracy: Hampton University, Hampton, Va.
Goodnight Irene: Collection Harry Belafonte
Awaiting His Return: Howard University Gallery of Art, Washington, D.C.
Ye Shall Inherit the Earth: Collection Laurence Roberts, Windsor, Calif.
Awaken from Unknowing: Collection Tony Schwartz
J'Accuse No. 1: Collection Dr. and Mrs. Bertram V. Karpf
Willy J: Collection Christine Perren
Harriet: Courtesy of the Heritage Gallery, Los Angeles
J'Accuse No. 5: Collection Pauline R. Plesset, Los Angeles
Wanted Poster No. 3: Courtesy of the Heritage Gallery, Los Angeles
Homage to Langston Hughes: Collection Camille and William H. Cosby, Jr.
All White works reproduced by permission of the Heritage Gallery, Los Angeles

Elizabeth Catlett
The Black Woman Speaks: Collection Thelma G. and David C. Driskell
Malcolm X Speaks for Us: Collection of Museum of Modern Art, New York
Homage to My Young Black Sisters: Collection Andrew Owens, New York. Photo: Lloyd W. Yearwood

Mother and Child: Courtesy of University of Iowa Library
The Singing Head: Collection Mildred Sanders, Los Angeles. Photo: Phil Stern
Survivor: Amistad Research Center, Tulane University, New Orleans
Dancing Figure: Collection William Watson Hines III, New York
Sharecropper: National Museum of American Art, Smithsonian Institution. Museum Purchase
Target: Amistad Research Center, Tulane University, New Orleans

John T. Biggers
Jubilee: Ghana Harvest Festival: Museum of Fine Arts of Houston, Texas. Museum purchase with funds provided by Texas Eastern Corporation
Four Square City: Collection of the artist
Mural for Christia V. Adair Park, Harris County, Texas: Photo: John T. Biggers
Harvesters (detail of mural): Eliza Johnson Home for Aged Negroes, Houston, Texas. Photo: John T. Biggers
"Fishing Boat," "Durbar Festival," "Fishermen Repairing Nets," and "Cassava Root": From *Ananse: The Web of Life in Africa* by John T. Biggers (Austin: University of Texas Press, 1962). Reprinted by permission of the author
Viktor Lowenfeld photo: Collection Hampton University Museum, Hampton, Va.
The Web of Life (mural and detail): Texas Southern University, Houston. Photos: John T. Biggers
Climbing Higher Mountains: Hampton University, Hampton, Va. Courtesy of the artist
Third Ward Housing: Courtesy of the artist

Carroll H. Simms
Man the Universe: Texas Southern University, Houston. Photo courtesy of the artist
Mother Earth: Present location unknown. Photo courtesy of the artist
Resting: Collection of the artist
Homage to a Shrine: Palace of the Oba, Benin. Photo courtesy of the artist
Christ and the Lambs: St. Oswald's Church, Coventry, England. Photo courtesy of the artist
Water Angels: Collection Jane Laffer Owen, New Harmony, Ind. Photo courtesy of the artist
Woman with a Bird: Collection Mr. and Mrs. Philip Reichenbach, Houston, Texas. Photo courtesy of the artist
The African Queen Mother: Texas Southern University, Houston. Photo courtesy of the artist
A Garden of Ancient Yoruba Pottery: University of Ibadan, Nigeria. Photo courtesy of the artist
Shrine and detail: Sculpture Garden, New Harmony, Ind. Photo courtesy of the artist
Guitar Solo: Houston Music Hall, Houston, Texas. Photo courtesy of the artist
All Simms works reproduced by permission of the artist

Alma W. Thomas
Light Blue Nursery: National Museum of American Art, Smithsonian Institution. Gift of Alma W. Thomas
Wind and Crepe Myrtle Concerto: National Museum of American Art, Smithsonian Institution. Gift of Vincent Melzac

Red Azaleas Singing and Dancing Rock and Roll Music: National Museum of American Art, Smithsonian Institution. Gift of Alma W. Thomas

Joe Summerford's Still Lift Study: Joseph H. Hirshhorn Museum and Sculpture Garden, Smithsonian Institution. Gift of Vincent Melzac, 1976

Watusi, Hard Edge: Joseph H. Hirshhorn Museum and Sculpture Garden, Smithsonian Institution. Gift of Vincent Melzac, 1976

Snoopy—Early Sun Display on Earth: National Museum of American Art, Smithsonian Institution. Gift of Vincent Melzac

Grassy Melodic Chant: National Museum of American Art, Smithsonian Institution

Blue Asteroid: Joseph H. Hirshhorn Museum and Sculpture Garden, Smithsonian Institution. Gift of Joseph H. Hirshhorn, 1980

Ed Wilson

Minority Man: State University of New York, Binghamton. Photo: Ed Wilson

Falling Man: State University of New York, Binghamton. Photo: Ed Wilson

Portrait of Ralph Ellison: Ralph Ellison Library, Oklahoma City. Photo: Ed Wilson

JFK Memorial Park, column, and relief panels: City of Binghamton, N.Y. Photos: Ed Wilson

Second Genesis (detail) and closeup of humanoid figure: Lake Clifton High School, Baltimore. Photos: Ed Wilson

Jazz Musicians: Douglass High School, Baltimore. Photo: Ed Wilson

All Ed Wilson works reproduced by permission of the artist

James W. Washington, Jr.

Young Queen of Ethiopia: National Museum of American Art, Smithsonian Institution. Gift of the artist

Young Boy of Athens: Collection of the artist. Photo: Mary Randlett

Three Wonders of Nature: Washington State Arts Commission, Olympia

My Testimony in Stone: The City of Seattle's Artwork Collection. Photo: Charles Alder

Form of the Wounded Bird: Courtesy of Foster/White Gallery, Seattle, Wash.

Life Emerging from an Egg and Symbols: Courtesy of Foster/White Gallery, Seattle, Wash.

Obelisk and Phoenix with Esoteric Symbols of Nature: Collection Sheraton Hotel and Towers, Seattle, Wash. Photo: Josef Scaylea

Oracle of Truth: Mount Zion Baptist Church. Foster/White Gallery. Photo: Josef Scaylea

Washington at work on *Sacrificial Lamb:* Collection Mr. and Mrs. Charles Kelley. Photo: Josef Scaylea, Seattle, Wash.

Richard Mayhew

Counterpoint: Midtown Galleries, New York

Southern Breeze: Collection AT&T

Sonata in G Minor: Midtown Galleries, New York

Untitled drawing: Midtown-Payson Galleries, New York

Spring Thaw: Present location unknown. Courtesy of the artist

The Big Sur: Midtown-Payson Galleries, New York

Sunset: Midtown Galleries, New York

Spring '82: Collection Mary K. Boyd, New York

All Mayhew works reproduced by permission of the artist

PERMISSIONS ACKNOWLEDGMENTS

Grateful acknowledgment is made to the following for permission to reprint previously published material:

American Artist: Excerpts from "The Metaphysical World of Hughie Lee-Smith" by Carol Wald from *American Artist,* October 1978. Reprinted by permission.

Art News: Excerpts from "By Henry McBride" from *Art News,* December 1952, pp. 47, 67. Reprinted by permission.

Arts in Society: Excerpts from "A Statement" by Ed Wilson from *Arts in Society,* Fall/Winter 1968–1969. Reprinted by permission.

John T. Biggers: Four illustrations from *Ananse: The Web of Life in Africa* by John Biggers. Reprinted by permission of the author.

The Metropolitan Museum of Art: Excerpts from "The Black Artist in America" from *Metropolitan Museum of Art Bulletin,* vol. 27, January 1969. Copyright © 1969 by The Metropolitan Museum of Art. Reprinted by permission.

New Directions Publishing Corp.: Excerpts from *The Air-Conditioned Nightmare* by Henry Miller. Copyright 1945 by New Directions Publishing Corp. Reprinted by permission of New Directions Publishing Corp.

The New York Times: Excerpts from "A Negro Artist Plumbs the Negro Soul" by Edward Alden Jewell, March 25, 1928. Copyright © 1928 by The New York Times Company. Reprinted by permission.

San Francisco Chronicle: Excerpts from an interview in *San Francisco Chronicle,* October 6, 1935. Copyright © San Francisco Chronicle. Reprinted by permission.

Seattle Art Museum and University of Washington Press: Excerpts from *Jacob Lawrence, American Painter* by Ellen Wheat. Copyright © 1986 by Patricia Hills and Ellen Wheat. Reprinted by permission of Seattle Art Museum and University of Washington Press.

Seattle Arts: Excerpts from "My Testimony in Stone" by Sue Chin from *Seattle Arts,* October 1981. Reprinted by permission.

Times Books: Excerpts from *Horace Pippin* by Selden Rodman. Copyright 1947 by Quadrangle Press. Reprinted by permission.

The University of Chicago Press: Excerpts from *Henry Ossawa Tanner* by Marcia Mathews. University of Chicago Press, 1969. Reprinted by permission of the publisher.

ROMARE BEARDEN

Romare Bearden was born in Charlotte, North Carolina, on September 2, 1912, and spent his early boyhood in Harlem. His father was a New York city employee and his mother, Bessye Bearden, was the New York correspondent of the *Chicago Defender,* a founder of the Negro Women's Democratic Association, and a friend of Eleanor Roosevelt. He attended Boston University, then transferred to New York University, where he graduated in 1935.

Bearden was drawing political cartoons for the *Baltimore Afro-American* when he began to study at the Art Students League, which led to his decision to paint. To support himself, he became a welfare caseworker. After serving in the U.S. Army, he resumed painting. His first show was at the Kootz Gallery, and was bought out by collector Samuel Lewisohn. In 1950 he went to Paris, where he devoted his time to studying literature, philosophy, and the work of old and modern masters.

Upon his return to the United States, Bearden tried cartooning and song-writing to support himself. Many of his songs were recorded, and he became a member of ASCAP. In 1963 he helped found Spiral, which sought to relate the work of African-American artists to the civil rights movement and to their people in general.

Bearden's revolutionary use of collage led to his recognition as a modern master. In 1971 he was given a major show at the Museum of Modern Art in New York. Exhibited in Europe, Japan, and throughout the United States, he was awarded an honorary degree by Carnegie University in 1980; that same year he was honored by President Jimmy Carter with nine other African-American artists. In 1987 he was awarded the National Medal of Arts by President Ronald Reagan.

Bearden coauthored *A Painter's Mind* with Carl Holty in 1969, and *Six Black Masters of American Art* with Harry Henderson in 1972.

He died on March 12, 1988, in New York after a long illness.

HARRY HENDERSON

Harry Henderson graduated from Penn State in 1936, and worked on various Pennsylvania newspapers. Coming to New York in the late 1930s as a free-lance magazine writer, he joined the staff of *Friday* magazine, where an article on Horace Pippin interested him in African-American artists. When that magazine was suspended, he continued to free-lance, writing for *Collier's, Cosmopolitan, Harper's, Reader's Digest, Redbook,* and numerous medical journals, among others. His 1951 *Argosy* investigation of the frame-up of an African-American, Silas Rogers, for the murder of a policeman in Virginia resulted in Rogers being freed after eight years in prison.

Henderson collaborated with Romare Bearden on a previous book, *Six Black Masters of American Art.* He is also coauthor of *Your Inner Child of the Past,* with Dr. Hugh Missildine. He currently lives in Croton-on-the-Hudson, New York.